A PRIVATE PASSION

A PRIVATE PASSION

19th-Century Paintings and Drawings from the
Grenville L. Winthrop Collection, Harvard University

Edited by Stephan Wolohojian,
 with the assistance of Anna Tahinci

THE METROPOLITAN MUSEUM OF ART
YALE UNIVERSITY PRESS

This catalogue is published in conjunction with the exhibition "A Private Passion: 19th-Century Paintings and Drawings from the Grenville L. Winthrop Collection, Harvard University," Musée des Beaux-Arts, Lyon, March 15–May 26, 2003; The National Gallery, London, June 25–September 14, 2003; The Metropolitan Museum of Art, New York, October 23, 2003–January 25, 2004.

The exhibition was organized by the Fogg Art Museum, Harvard University, Cambridge, Massachusetts, in collaboration with Ville de Lyon, Musée des Beaux-Arts and Réunion des Musées Nationaux; The National Gallery, London; and The Metropolitan Museum of Art, New York.

The exhibition catalogue is made possible by the Samuel I. Newhouse Foundation Inc. and the Doris Duke Fund for Publications.

Published by The Metropolitan Museum of Art, New York
John P. O'Neill, Editor in Chief
Margaret Aspinwall, Senior Editor
Jean Wagner, Bibliographer
Bruce Campbell, Designer
Gwen Roginsky and Elisa Frohlich, Production
Robert Weisberg and Minjee Cho, Desktop Publishing

Typeset in Fournier by Tina Thompson
Separations by Professional Graphics Inc., Rockford, Illinois
Printed and bound by Mondadori Printing, S.p.A., Verona, Italy

Jacket/cover: Jean-Auguste-Dominique Ingres, *Raphael and the Fornarina*, 1814 (cat. no. 53)
Frontispiece: Vincent van Gogh, *The Blue Cart (Harvest at La Crau)*, 1888 (cat. no. 46)

LIBRARY OF CONGRESS CATALOGING-IN-PUBLICATION DATA

A private passion: 19th-century paintings and drawings from the Grenville L. Winthrop Collection, Harvard University / edited
 by Stephan Wolohojian, with the assistance of Anna Tahinci
 p. cm.
 Catalog of an exhibition held at the Metropolitan Museum of Art, New York, N.Y. , Oct. 23, 2003–Jan. 25, 2004.
 Includes bibliographical references and index.
 ISBN 1-58839-076-4 (hc.)—ISBN 1-58839-077-2 (pbk.)—ISBN 0-300-09884-7 (Yale University Press)
 1. Art, Modern—19th century—Exhibitions. 2. Winthrop, Grenville Lindall, 1864–1943—Art collections—
 Exhibitions. 3. Art—Private collections—Massachusetts—Cambridge—Exhibitions. 4. Fogg Art Museum—Exhibitions.
 I. Wolohojian, Stephan. II. Tahinci, Anna. III. Metropolitan Museum of Art (New York, N.Y.)

N6450.P75 2003

759'.05'0747444—dc21 2003046331

Contents

Directors' Foreword vii

Organizers of the Exhibition ix

Contributors to the Catalogue x

Acknowledgments xii

A PRIVATE PASSION *by Stephan Wolohojian* 3

FRENCH SCHOOL

Catalogue numbers 1–133 48

GERMAN SCHOOL

Catalogue numbers 134-138 318

BRITISH SCHOOL

Catalogue numbers 139–196 328

AMERICAN SCHOOL

Catalogue numbers 197–219 440

Concordance of Fogg Art Museum Inventory Numbers and Catalogue Numbers 479

Bibliography 481

Index of Former Owners 523

General Index 527

Directors' Foreword

Responding to a request that Grenville L. Winthrop consider leaving his collection to a museum in Washington, D.C., he wrote in 1938:

> I admit that more people of the "general public" will visit Washington than Cambridge, but I am not so much interested in the general public as I am in the Younger Generation whom I want to teach in their impressionable years and to prove to them that true art is founded on traditions and is not the product of any one country or century and that *Beauty* may be found in all countries and in all periods, provided the eye can be trained to find it.

In 1943, Winthrop bequeathed his entire collection, some four thousand objects, to Harvard College and its museums, for the benefit of its students in perpetuity. This act, unparalleled in Harvard's history, would instantly make the Fogg Art Museum a place of international importance to scholars and lovers of art. It would also make the Winthrop collection one of the least familiar to the general public.

There is no Winthrop Museum, no wing, no gallery that heralds the gift to the Fogg. Winthrop's modesty was such that few visitors to Harvard's Art Museums today are aware that its incomparable collection of early Chinese jades and archaic bronzes, Buddhist sculpture, and extraordinary holdings of nineteenth-century French art and Pre-Raphaelite masters are due, in large part, to his munificence. But generations of Harvard students have understood the singular experience of studying works of art in the original, rather than in reproduction. It is an experience made richer by repeated contact with and unlimited access to the objects, whether through group discussions guided by an instructor or solitary visits to the museum's galleries and study rooms. It is also an experience that has nurtured successive classes of museum curators and directors over the past sixty years. Without doubt, Winthrop's gift to Harvard has shaped the development of museums across the United States.

Winthrop's enterprise distinguishes itself in the two-fold interest that motivated it. On the one hand, it is encyclopedic and represents a good four thousand years of artistic production. Winthrop's pursuits brought Neolithic Chinese jades and Mesoamerican sculpture together with work by Auguste Rodin and Aristide Maillol, Paul Manship and Eric Gill. His active eye led him to early Italian panel painting and to drawings of then-modern masters, such as Henri Matisse and George Bellows. On the other hand, his collection is not just an assemblage of a broad spectrum of extraordinary objects. In the field of nineteenth-century Western painting, it is unique: it is the only collection, anywhere, to represent, at a uniformly high level of quality, the complete history of American, British, and French painting and drawing.

Harvard has always respected Winthrop's wish that his collection be available for study at the university. Therefore, for more than sixty years it has not loaned a single object from his

bequest to any exhibition, now matter how important. However, an impending closing of the museum for architectural renovation created a new opportunity, and we are grateful to James Cuno, former director of the Harvard University Art Museums, for proposing that this legendary collection be made available for a unique exhibition of nineteenth-century drawings and paintings to be shared with museum visitors in Lyon, London, and New York.

For his sterling work as the guiding intelligence of the exhibition and author of the introductory essay, we thank Stephan Wolohojian, curator in the Fogg's Department of Paintings, Sculpture and Decorative Arts, as well as William W. Robinson, Maida and George Abrams Curator of Drawings, and Miriam Stewart, assistant curator in that department. We are also grateful to the curators of the participating institutions: Gary Tinterow, Engelhard Curator of 19th-Century European Painting at The Metropolitan Museum of Art, assisted by Rebecca A. Rabinow; Christopher Riopelle, Curator of 19th-Century Paintings at The National Gallery, London; and the curators in France who assisted in various ways throughout the gestation of the project: Jean-Pierre Cuzin, Anne Distel, and Henri Loyrette.

The organization of the exhibition has involved many staff members at all our museums. For their assistance in organizing the exhibition, we acknowledge Rebecca Wright, Manager of Grants and Traveling Exhibitions, and Maureen Donovan, Registrar, at the Harvard University Art Museums. At The National Gallery, London, we thank Michael Wilson, Head of Exhibitions; Mary Hersov and Joanna Kent in the Exhibitions Department; and Rosalie Cass, Registrar; and at The Metropolitan Museum of Art, Linda M. Sylling, Manager for Special Exhibitions and Gallery Installations; Martha Deese, Senior Assistant for Exhibitions; Herbert M. Moskowitz, Chief Registrar; and Kathryn Calley Galitz, Research Associate in the Department of European Paintings.

It is out of respect for Grenville Winthrop's regard for beauty and its dissemination through educating the eye to find it that Harvard chose to share this collection, which has never been fully published, with a wider audience. Hence, a primary goal of this project has been to produce a publication worthy of the collection. Thanks to some sixty-three authors and to John O'Neill and the Editorial Department of the Metropolitan Museum, that goal was amply accomplished. Thus, when the objects return to Cambridge, Harvard students will be able to study them with new knowledge about Winthrop and the extraordinary works he collected.

Marjorie B. Cohn
Acting Director
Harvard University Art Museums,
Cambridge, Massachusetts

Francine Mariani-Ducray
President
Direction des Musées de France

Philippe de Montebello
Director
The Metropolitan Museum of Art, New York

Vincent Pomarède
Director
Musée des Beaux-Arts, Lyon

Charles Saumarez Smith
Director
The National Gallery, London

Organizers of the Exhibition

Exhibition Committee

Jean-Pierre Cuzin
Conservateur Général du Patrimoine chargé du Département des Peintures, Musée du Louvre, Paris

Henri Loyrette
Président-Directeur, Musée du Louvre, Paris

Christopher Riopelle
Curator of 19th-Century Paintings, The National Gallery, London

Gary Tinterow
Engelhard Curator of 19th-Century European Painting, The Metropolitan Museum of Art, New York

Stephan Wolohojian
Curator, Department of Paintings, Sculpture and Decorative Arts, Fogg Art Museum, Harvard University Art Museums, Cambridge, Massachusetts

Curators of the Exhibition

Vincent Pomarède
Conservateur en Chef du Patrimoine, Directeur du Musée des Beaux-Arts de Lyon

Christopher Riopelle
Curator of 19th-Century Paintings, The National Gallery, London

Gary Tinterow
Engelhard Curator of 19th-Century European Painting, The Metropolitan Museum of Art, New York
assisted by Rebecca A. Rabinow
Assistant Research Curator, European Paintings, The Metropolitan Museum of Art, New York

Stephan Wolohojian
Curator, Department of Paintings, Sculpture and Decorative Arts, Fogg Art Museum, Harvard University Art Museums, Cambridge, Massachusetts

Contributors to the Catalogue

Robyn Asleson, Independent Scholar

Tim Barringer, Assistant Professor, Department of History of Art, Yale University, New Haven

David P. Becker, Independent Scholar

Francesca G. Bewer, Associate Curator for Research, Straus Center for Conservation, Harvard University Art Museums

David Bindman, Professor, Department of History of Art, University College London

Yve-Alain Bois, Joseph Pulitzer Jr. Professor of Modern Art, Department of History of Art and Architecture, Harvard University

Judith Bronkhurst, Witt Library, Courtauld Institute of Art, London

Barbara Bryant, Independent Scholar

Stephen Calloway, Department of Word and Image, Victoria and Albert Museum, London

Nicolai Cikovsky Jr., Independent Scholar

Alvin L. Clark Jr., The J. E. Horvitz Research Curator, Drawing Department, Fogg Art Museum, Harvard University Art Museums

Marjorie B. Cohn, Acting Director, Harvard University Art Museums, and Carl A. Weyerhaeuser Curator of Prints, Fogg Art Museum

Harry Cooper, Curator of Modern Art, Fogg Art Museum, Harvard University Art Museums

Jean-Pierre Cuzin, Conservateur Général du Patrimoine chargé du Département des Peintures, Musée du Louvre, Paris

Douglas Druick, Curator of Prints, Drawings and European Paintings, The Art Institute of Chicago

Trevor Fairbrother, Independent Scholar and Curator

Sarah Faunce, Director, Courbet Catalogue Raisonné Project, New York

Kathryn Calley Galitz, Research Associate, European Paintings, The Metropolitan Museum of Art, New York

Dario Gamboni, Professor, Kunsthistorisch Instituut, Universiteit van Amsterdam

Kenneth Garlick, Independent Scholar

Ivan Gaskell, Margaret S. Winthrop Curator, Department of Paintings, Sculpture and Decorative Arts, Fogg Art Museum, Harvard University Art Museums

Margaret Morgan Grasselli, Curator of Old Master Drawings, National Gallery of Art, Washington, D.C.

Alastair Ian Grieve, Professor, School of World Art Studies and Museology, University of East Anglia, Norwich

Robin Hamlyn, Senior Curator, Tate Collections, London

Sarah Herring, Assistant Curator, The National Gallery, London

Donna M. Hunter, Associate Dean, Division of Graduate Studies, University of California, Santa Cruz

Colta Ives, Curator, Drawings and Prints, The Metropolitan Museum of Art, New York

Rachel Jacoff, Margaret E. Deffenbaugh and LeRoy T. Carlson Professor in Comparative Literature and Professor of Italian, Wellesley College

Barthélémy Jobert, Professor of Modern Art History, Université de Grenoble

Frances Suzman Jowell, Independent Scholar

Claudie Judrin, Conservateur en Chef chargé du Département des Dessins et de la Collection de Rodin, Musée Rodin, Paris

Sarah B. Kianovsky, Assistant Curator, Department of Paintings, Sculpture and Decorative Arts, Fogg Art Museum, Harvard University Art Museums

Geneviève Lacambre, Conservateur Général Honoraire au Musée d'Orsay, Paris

Sylvain Laveissière, Conservateur en Chef au Département des Peintures, Musée du Louvre, Paris

Antoinette Le Normand-Romain, Conservateur Général des Sculptures, Musée Rodin, Paris

Anne Leonard, Department of History of Art and Architecture, Harvard University

Alexandra R. Murphy, Independent Scholar

Patrick Noon, Patrick and Aimeé Butler Curator, The Minneapolis Institute of Arts

Richard Ormond, Independent Art Historian

Michael Pantazzi, Curator, European Art, National Gallery of Canada, Ottawa

Vincent Pomarède, Conservateur en Chef du Patrimoine, Directeur du Musée des Beaux-Arts de Lyon

Louis-Antoine Prat, Chargé de mission au Département des Arts Graphiques, Musée du Louvre, Paris

Aimée Brown Price, Independent Scholar

Rebecca A. Rabinow, Assistant Research Curator, European Paintings, The Metropolitan Museum of Art, New York

Christopher Riopelle, Curator of 19th-Century Paintings, The National Gallery, London

William W. Robinson, Maida and George Abrams Curator of Drawings, Fogg Art Museum, Harvard University Art Museums

Pierre Rosenberg, Membre de l'Académie Française, Paris

Richard Shone, Editor, *The Burlington Magazine*, London

Theodore E. Stebbins Jr., Curator of American Art, Fogg Art Museum, Harvard University Art Museums

Susan Alyson Stein, Associate Curator, European Paintings, The Metropolitan Museum of Art, New York

Miriam Stewart, Assistant Curator, Drawing Department, Fogg Art Museum, Harvard University Art Museums

Margret Stuffmann, Independent Scholar

Anna Tahinci, Independent Scholar

Gary Tinterow, Engelhard Curator of 19th-Century European Painting, The Metropolitan Museum of Art, New York

Aileen Tsui, Lecturer and Mellon Postdoctoral Fellow, Department of Art History and Archaeology, Columbia University, New York

Robert Upstone, Curator, Tate Collections, London

Malcolm Warner, Senior Curator, Kimbell Art Museum, Fort Worth

Gail S. Weinberg, Independent Scholar

Wheelock Whitney, Independent Scholar

John Wilmerding, Christopher B. Sarofim '86 Professor of American Art, Department of Art and Archaeology, Princeton University

Stephan Wolohojian, Curator, Department of Paintings, Sculpture and Decorative Arts, Fogg Art Museum, Harvard University Art Museums

Linda Gertner Zatlin, Professor, Department of English and Linguistics, Morehouse College, Atlanta

Henri Zerner, Professor of History of Art and Architecture, Department of History of Art and Architecture, Harvard University

Acknowledgments

The year 2003 marks the sixtieth anniversary of the bequest of Grenville L. Winthrop's vast collection to the Fogg Art Museum. Since that time, it has become one of the museum's core collections, providing an art-historical foundation to generations of Harvard students and material for scholarly analysis and debate. Anyone examining Winthrop and his nineteenth-century collection studies in the shadow of Marjorie "Jerry" Cohn. My understanding of this elusive collector was first shaped by her "Turner-Ruskin-Norton-Winthrop" (1993), and her indispensable research for that project provided the groundwork for many parts of the introductory essay of this catalogue. The methodical study she, along with Susan L. Siegfried, made of Ingres's works in the Fogg Museum, of which Winthrop's collection forms the core, was my introduction as a young student to that artist. Subsequent students, as well as the authors of this catalogue who have worked on French drawings in this collection, have had the advantage of Agnes Mongan's *David to Corot: French Drawings in the Fogg Art Museum* (1996). She was assisted on that project by Miriam Stewart, whose knowledgeable and cheerful assistance is well known to everyone who has worked on drawings at the Fogg. I now join the legions of scholars beholden to her for the exceptional attention she gave to drawing-related matters for this project, from the early organizational stages to the careful editing of entries.

The study of Grenville Winthrop has been greatly facilitated by the admirable family history recently written by his great-niece Dorothy Wexler (1998). I have relied heavily on this candid and endearing account of his generation of Winthrops and have also benefited from its author's help on several occasions. I owe thanks as well to Cornelia Brooke Gilder and Julia Conklin Peters for their help on matters related to Winthrop in Lenox and for sharing with me, unfortunately too late to make modifications here, their chapter on Groton Place from a manuscript for a forthcoming book on the estates of Lenox, Massachusetts.

The bold idea for an international loan exhibition of Winthrop's collection was James Cuno's. The project's success is due to his support, encouragement, and extraordinary diplomacy. Among other things, I am personally grateful to him for his wise counsel and for committing the necessary resources to see this venture to completion.

The project itself would not have been realized without the outstanding assistance of Anna Tahinci, who devoted unflagging energy to every facet of it. I am especially indebted to her archival sleuthing and research assistance and for her remarkable effort in bringing this volume into being.

Since it was understood that this exhibition would not be held at the Harvard University Art Museums, where the Grenville L. Winthrop collection permanently resides, we asked curatorial representatives from the borrowing institutions to come to Cambridge, and we charged them

with the difficult task of tailoring an exhibition to their institutions and audiences. I thank Christopher Riopelle and Michael Wilson but especially Gary Tinterow for so generously sharing with us their experienced knowledge on all matters. I would also like to acknowledge the help of Jean-Pierre Cuzin and Henri Loyrette at the organizational stages.

The catalogue entries at the core of this volume were written by more than sixty specialists, invited to write on works in their particular area of expertise. I would like to thank them again for their willingness to share their knowledge and the careful attention they devoted to this project. The scholarly importance of this volume is due to them.

Such a large undertaking requires the help of many. Almost everyone at the Harvard University Art Museums has provided assistance on some level to the preparation of this catalogue and to the organization of the exhibition. However, special thanks are due Maureen Donovan, Francine Flynn, Rachel Vargas, and the other registrars; Craigen Bowen, Teri Hensick, Kate Olivier, Craig Uram, Caroline Clawson, and their colleagues in the Straus Center for Conservation; Rebecca Wright, Manager of Traveling Exhibitions; and our archivist, Abigail Smith. Peter Siegal and his talented staff of photographers in the department of Digital Resources produced new images for all of the primary illustrations in the catalogue. I am grateful for the support of my department colleagues, Ivan Gaskell and Sarah Kianovsky, and owe a special debt to Kerry Schauber for editing and standardizing the provenance for each object in the catalogue.

Additional thanks are due to Nick Baker, Matthew Barone, Evelyn Bavier, Jay Beebe, Richard Benefield, Shelley Bennett, Laurie Benson, Francesca G. Bewer, Dianne Bilbey, Philippe Bordes, Catherine Chagneau, Alvin Lorenzo Clark Jr., Philip Conisbee, Louisa Connor, Melva Croal, Robin Crighton, Jane Cuccurullo, Dorothy Davila, Joan Dillon, Anne Driesse, Michael Dumas, Katherine Eustace, Jessica Feather, Margaret Morgan Grasselli, Sandra Grindlay, Adrian Le Harivel, Susannah Hutchinson, Sara Jablon, Rachel Jacoff, Katya Kallsen, Charlotte Karney, Narayan Khandekar, Anne Rose Kitagawa, Penley Knipe, Edouard Kopp, Diana Larsen, Anne Leonard, Claire Lesemann, Henry Lie, Allan MacIntyre, Porter Mansfield, Kate Smith Maurer, Hope Mayo, Gillian McMullen, Asher Miller, Peta Motture, Robert Mowry, Melissa Moy, Kim Muir, Charles Nugent, Kimberly Orcutt, Robert Peterson, Michael Phipps, Gianfranco Pocobene, Vincent Pomarède, John Poynter, Derek Pullen, Rebecca A. Rabinow, Aileen Ribiero, William Robinson, Michael Rocke, Pierre Rosenberg, Helen Smailes, Theodore E. Stebbins Jr., William Stoneman, Katie Urbanic, Philip Ward-Jackson, Gail S. Weinberg, Robert Winthrop, and Gabrielle van Zuylen. With a project of this scale, I certainly received help from others whose names I have overlooked. My sincere thanks and apologies to them.

This catalogue would never have seen fruition without the support of John O'Neill, editor in chief at The Metropolitan Museum of Art, and the efforts of Editorial Department members Gwen Roginsky, Margaret Chace succeeding Ann Lucke, Peter Antony, Elisa Frohlich, Robert Weisberg, and Minjee Cho. Margaret Aspinwall fashioned the disparate elements of text into a cohesive book with patience and unmatched organizational ability; the editorial team included Jean Wagner, Richard Slovak, Fronia W. Simpson, and Nancy Cohen. Translation of texts submitted in French was done by Jane Marie Todd. Bruce Campbell's fine design brings the variety of material into clear focus.

The help and support of Florence and Gabrielle Wolohojian, Marina van Zuylen and Simon have made it possible for me to find nothing but pleasure in my work.

Stephan Wolohojian
Curator
Department of Paintings,
Sculpture and Decorative Arts
Fogg Art Museum
Harvard University Art Museums

A PRIVATE PASSION

Fig. 1. Grenville L. Winthrop in his garden at Groton Place, Lenox, Massachusetts. Harvard University Art Museums Archives

A Private Passion

STEPHAN WOLOHOJIAN

After a lonely dinner, chiefly of fruit and vegetables, he would read some favorite book, or work on a card catalogue of his treasures, before the more relaxing pastime of the long evening would commence. Proust could have done the scene justice. The quiet cork-lined rooms [were] disturbed only by the chimes of the fine collection of grandfather clocks that stood in the rooms, hallways and on most of the landings. They were carefully adjusted so that their mellow bells reverberated successively without interfering with one another, and while their delicate peals vibrated through the house the master would move about the shadows hanging his drawings or cataloguing them, or rearranging the Chinese jades and gilt bronzes.

Far into the night he might be discovered cleaning verdigris from some strange Chinese ritual instrument, and his face would light up when his industry was rewarded by the discovery of gleaming precious metal under the layer of green metallic mold. Such self-imposed labors were for him like baths in a fountain of youth, and sustained him through his last years, but there is something poignantly pathetic in the life of one who . . . becomes a solitary lonely figure in spite of great wealth. Had Henry James known of these activities, he might have left us an incomparable novelette of this enthusiast who had love affairs with especially favored bibelots, and who, by force of his passion for beauty, actually brought the glory of his . . . items to life.[1]

These lines written by one of his closest friends provide the most evocative image of Grenville Lindall Winthrop (1864–1943), who in the first four decades of the twentieth century amassed one of the most important, yet least well known, collections ever assembled in the United States. Royal Cortissoz, critic at the *New York Herald Tribune* for nearly a half century, described the man who brought it together as "the most discriminating eclectic that America has ever known amongst collectors."[2] The headline in the *New York Times* announcing his bequest to the Fogg Art Museum at Harvard University described the gift of the Winthrop collection as "the most valuable given to a university."[3] In an age in which philanthropic records seem to be broken on a regular basis, Winthrop's bequest of about four thousand objects remains the largest single gift of its kind.

Winthrop's collection claimed objects from almost every culture and historical period, each placed with considerable attention in the house he built for it in New York City (see figs. 2, 52). Beyond its remarkable encyclopedic scope are even more impressive focused strengths. Winthrop brought together one of the most important private collections of

1. Birnbaum 1960, p. 21.
2. As quoted in the *Harvard Alumni Bulletin* 46 (January 8, 1944), p. 211. The high esteem in which Cortissoz held the collection is amply evident in various essays collected in his book *The Painter's Craft* (1930).
3. *New York Times*, October 17, 1943, sec. 1, p. 50.

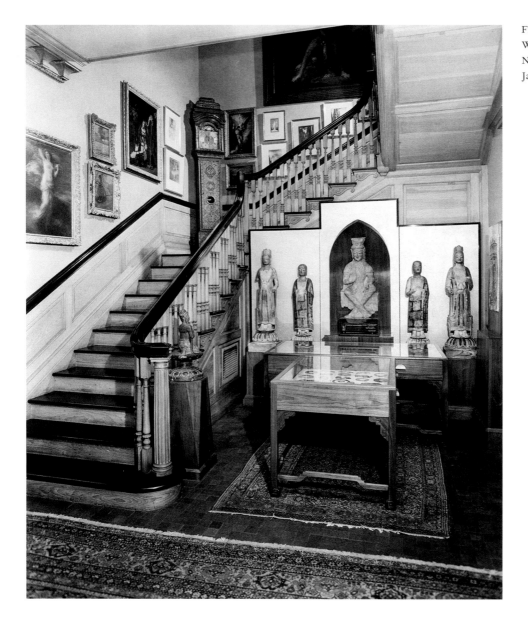

Fig. 2. First-floor hall in Grenville L. Winthrop's house at 15 East 81st Street, New York, 1943. HUAM Archives (photo: James K. Ufford)

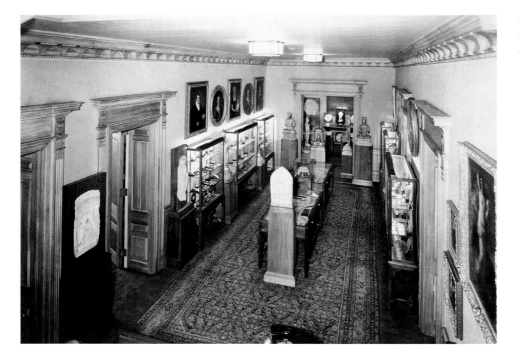

Fig. 3. First-floor inner hall of Winthrop's New York house, 1943. HUAM Archives (photo: James K. Ufford)

Asian art ever realized (fig. 3). Sharing the rarefied chambers of his private world was a noteworthy collection of clocks, nineteenth-century prints, early Wedgwood, and treasures from Egyptian and Mesoamerican cultures. In the realm of nineteenth-century art Winthrop held more works by Jean-Auguste-Dominique Ingres than any other private collector of his day. He amassed dozens of works by such masters as James Abbott McNeill Whistler, William Blake, Gustave Moreau, Aubrey Beardsley, Edward Burne-Jones, John Flaxman, Dante Gabriel Rossetti, Théodore Gericault, and Auguste Rodin. That he did not lend objects from his collection and that it was later bequeathed to his college, where it has remained since 1943, has made the depth of the collection unknown except to students and specialists, and its full scope in certain fields difficult to assess. The frustration this produced was eloquently voiced in a letter from Walter Pach, organizer of the provocative Armory Show of 1913, to the director of the Metropolitan Museum in New York:

> Dear Mr. Winlock,
>
> I write to suggest an exhibition which would, I think, be of very great interest to the public and to the museum.
>
> It is that of the collection of Mr. Grenville Winthrop, or of a part of it (I do not know its full extent).
>
> Ever since I first saw it, I have thought it the finest collection in America, because it is at once original—creative, and directed to showing the tradition which has most value for our thinking on art today, especially in the field of painting.
>
> Such works of the old masters as are found in other collections, say that of Mr. Philip Lehman or Mr. Widener, may well be of greater value if considered from the viewpoint of the centuries to come, but we have already a splendid group of such things in the Museum,—which does not represent the schools to be studied at Mr. Winthrop's house with anything like the adequacy one finds there. For my own personal benefit I should like to see Mr. Winthrop's treasures in galleries where I could spend long, quiet moments before them, instead of moving along steadily as one is tempted if not led to do in a private house. And if this is true with me, whose consideration of European-American art has led to the conviction that the line from Seventeenth Century France down through David, Ingres, Géricault, and Delacroix is the essential line leading to the art of today, I think I may say without vanity (since I have given much study to the subject) that it would be of still greater value to the public to have an opportunity like this—one that America has never had before, save in piecing together the impressions from various of our museums and exhibitions.[4]

The overview of Winthrop's holdings in Western art in the present exhibition displays a mere fraction of his collection in that area, but it is hoped that fulfilling at last Pach's desire to spend long, quiet moments before these treasures will not only illuminate the richness of Winthrop's collection but restore its proper place in the history of collecting in America.

Shy and reclusive by nature, Grenville Winthrop has been hard to assess. The description of the solitary man, alone but for the company of his objects, which he slowly uncovers, arranges, and then rearranges, comes startlingly close to that of a real-life des Esseintes—although Winthrop did not spend his early years exploring the decadent pleasures, such as

4. Pach, letter to Herbert E. Winlock, February 11, 1937, Archives, The Metropolitan Museum of Art, New York.

they were, of New York and New England. In fact his puritanical circle could not have been more different from the aristocratic Parisian models for Huysmans's fictional figure. Yet few models, literary or otherwise, help us fully to understand Winthrop and his motivation to collect. The explanations often put forth to decipher the impulsion of so many Americans of his generation to accumulate objects seem of little use. Born into the mainstream of American high society, he needed nothing to secure his social position. One could even argue the contrary: that in his straitlaced and reserved puritanical niche, there was not only little need but also little desire to provide such tangible displays of wealth.

To complicate matters further, Winthrop—unlike Isabella Gardner, John G. Johnson, or John Quinn—kept a measured distance from the process of his collecting. He seems to have had no interest in participating in the culture of the grand tour, which regularly inspired his peers to set sail for Europe, where they would visit museums and dealers only to return home, appetite for art well whetted, and surround themselves with rare and costly objects. Once installed in grand settings, these treasures often helped to satisfy their owners' desire to relive or claim distinguished ancestry through the appropriation of materials past. Winthrop was happy to stay home, in predictable confines, and have his treasures, already sorted through and vetted by his advisers, brought to him.[5]

If little else can be said of Grenville Winthrop, he was proud of his ancestry, which was indeed unassailable. Born into privilege in 1864, he was the second son in the ninth generation of an unbroken line of Winthrop males descending from two colonial governors: John Winthrop of the Massachusetts Bay Colony and his son John Jr. of Connecticut. Although the Winthrop name has strong New England associations, Grenville was born into the New York branch of the family. His father, Robert Winthrop, was initially a partner in the banking firm of Drexel and Company, but when Anthony Drexel decided on a merger with J. Pierpont Morgan in 1871, Robert started a private banking company under his own name. The Winthrops were proud of their long and illustrious roots and acutely conscious of their social standing. However, the Winthrops' financial position was in fact owed to Grenville's mother, Kate Taylor Winthrop, daughter of Moses Taylor, one of New York's wealthiest businessmen and president of City Bank. When he died in 1882, Kate inherited a fifth of her father's sizable estate. Though clearly well to do by any standard, Winthrop's inherited funds would never provide him with the vast financial resources that other great American captains of industry had at their disposal.

Regardless of his means, Grenville grew up in a world in which social notoriety or anything more than an understated display of affluence would have been frowned upon. Indeed, despite their wealth and position in New York society, the Winthrops led a relatively modest existence. *Town Topics*, the New York society journal, dismissed Grenville's childhood home as an "old-fashioned brick house . . . probably the plainest residence today on Fifth Avenue."[6] And then in 1892, long after most of their neighbors had left their residences on

5. For an early appraisal of Winthrop's efforts in relationship to those of other American collectors, see Brimo 1938, pp. 89, 130.

6. Copies of the inventories made in 1827 and 1855 of the Winthrop family portraits are kept in the archives of the Harvard University Loans and Portraits Collection. On Kate Winthrop (and for a fine family history in general), see Wexler 1998, p. 44.

lower Fifth Avenue, the Winthrops moved to a statelier house in the Murray Hill neighborhood, joining the company of other established families rather than the wealthy parvenus building opulent mansions on upper Fifth Avenue.[7]

Grenville's childhood could have come straight out of an Edith Wharton novel. Wharton, incidentally one of his mother's close friends, would often stop by their somber new house for tea, in the company of Sara Delano Roosevelt or another well-positioned member of New York "nob" society. In imposing rooms, surrounded by portraits of Winthrop ancestors,[8] these women would track and assess the social faux pas and successes of their day—perhaps even those of Kate Winthrop's neighbor, J. P. Morgan, who by the turn of the century was working on plans for an impressive house at the other end of her block for his burgeoning art collection.

Winthrop rarely reveals himself through his letters, nor can one infer much from remarks made by those who knew him—even members of his family and his closest associates were kept at arm's length. He was certainly shy, fastidious, and, later in life, downright reclusive; he shielded himself behind a screen of perfect manners. He was not alone in this: many male Winthrops have been described as shy and aloof, in addition to having an obsession with their ancestry.[9] Winthrop placed a genealogical tree prominently on his desk and his coat of arms over the main entrance and on important mantels in his houses. He too was grave and had "a natural privacy [that] surrounded him," which was described as being awe-inspiring when combined with his stubbornness and aristocratic courtesy.[10] In a letter penned to Sara Norton, shortly after Winthrop bought a summer house in Massachusetts, Wharton wrote: "I had a visit from Grenville Winthrop yesterday. . . . The fact is, I had thought him (with every virtue under heaven) a rather opaque body. . . . He had nice tastes, certainly . . . but he seems to me to want digging out & airing. . . ."[11] Nearly twenty-five years later, after a long tenure together on projects for the Lenox Library Association, Wharton could unequivocally exclaim, "I never was intimate with Grenville—the very word is a contradiction!"[12]

Winthrop was not without a sense of humor about his shyness. Philip Hofer, who founded the Department of Printing and Graphic Arts at Harvard's Houghton Library and was an impressive collector in his own right, recalled visiting Winthrop as a young student at the collector's home in New York in the 1920s. Accompanied by his mother and armed with a letter of introduction, Hofer was greeted at the door by a butler who conveyed the news that Mr. Winthrop was indisposed but that he would show them through the collection. When they arrived in the library, Hofer glanced at what appeared to be a seventeenth-century Dutch portrait in which the distinguished sitter, in a great ruff, looked suspiciously like the butler (fig. 4). Hofer looked askance at the butler and then back at the painting. Winthrop said nothing on that visit but later admitted that he, the butler, and the person depicted in the portrait, made for him by his restorer Marcel Jules Rougeron, were all one

7. The Winthrops moved into their corner house at Park Avenue and 37th Street in the year of Robert Winthrop's death.

8. At the marriage of Grenville's youngest sister, Albertina ("Tina"), in 1904, *Town Topics* described the setting as having "a great wide hall with big square rooms on each side, the library all in dark covered oak with its halls decorated by portraits of illustrious ancestors"; Wexler 1998, p. 47. Many of the portraits in Grenville's house described here and later were subsequently donated to Harvard University.

9. Wharton characterized her good friend Egerton, Grenville's cousin, as being subject to "fits of shyness which made him appear either stiff or affected." Grenville's elder brother, Dudley, was described as "gruff," and his younger brother Frederic, besides being "solemn and formal," had a terrible stutter; Wexler 1998, p. 61.

10. Birnbaum 1960, p. 182.

11. Wharton, letter to Norton, September 30, 1902; Wharton 1988, p. 72.

12. Wharton, letter to Mary Caldwalader Jones, June 12, 1925; Wharton 1988, p. 485.

13. As told by Hofer to Janet Cox (1975, p. 35). Many students later recalled being tested by Winthrop during visits to the collection.

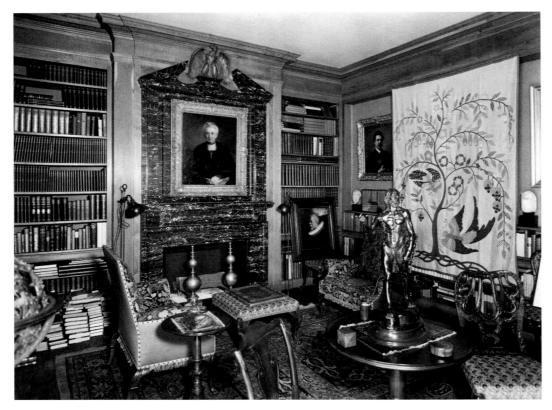

Fig. 4. Library of Winthrop's New York house, 1943. HUAM Archives (photo: James K. Ufford)

and the same.[13] Many visitors who were guided through the collection by Winthrop as himself and failed to recognize the spurious nature of the painting would often see their tour draw to an abrupt end.

Like most of his kin, Winthrop went to Harvard, lived in one of its most exclusive private dormitories, was chosen to be a member of the elite Porcellian Club, and, behaving like a proper gentleman, coasted by with limited academic achievement. He matriculated in a class that included the philosopher George Santayana and two classmates who would also become notable collectors: Charles Loeser and William Randolph Hearst.[14] Members of the graduating class of 1886 were among the first to be allowed to break away from a formal and set university curriculum and to be given the freedom to design their own course of study rich with electives. For all of his rigidity and predictability, Winthrop seems to have embraced the open system, designing a curriculum that included a heavy component of courses in geology and art history.[15]

Among the most popular elective courses at Harvard in the last quarter of the nineteenth century were the lectures given by Charles Eliot Norton, who became the university's first professor of fine arts and developed one of America's earliest programs in art history. A close friend of the English art critic John Ruskin and the poet, critic, and editor James Russell Lowell, founder of the Dante Society and of the Archaeological Institute of America, Norton had intellectual interests that spread far beyond the parameters of formal art history. The throngs of students drawn to the charismatic professor's lectures were

14. Although Winthrop seems to have been on relatively friendly terms with Hearst (he refers to him as "Billy" in a letter to Paul Sachs, April 26, 1937, Harvard University Art Museums [henceforth HUAM] Archives), his world and those of Santayana and Loeser seem not to have collided. For a discussion of the various intellectual currents in what that author terms the "Harvard Circle" in the 1880s, see Klingenstein 1998, esp. pp. 10–18.

15. See Cohn 1993, esp. p. 33, for a complete account of his undergraduate studies.

served a feast of cultural, historical, and literary analyses that informed the moral and intellectual thought of a generation. Although it has been argued that many of the students who took Norton's classes were there for the easy grade, Edward W. Forbes, one of Norton's students and later director of the Fogg Art Museum, wrote that "if you ask anyone who was at Harvard during these years—doctor, lawyer, scientist or businessman—from what courses he received the most, the answer would most probably be, 'From Professor Norton's fine arts courses.' Though there were loafers and athletes who took the courses because they were easy to pass, even for them I think it was a case of: 'and those who came to scoff, remained to pray.'"[16]

Winthrop was among those who came under Norton's spell, taking two of his popular large survey courses of Italian art and civilization. Fifty years later, Winthrop could write, "I look back upon his friendship with reverence and upon his lectures with keen delight—."[17] For Norton, as for Ruskin, the study of art was a profound inquiry into the nature of beauty. It was a key to understanding civilization and, more crucially, understanding the soul. Norton's teachings were painstakingly transcribed in Winthrop's beautifully written notebooks (see fig. 5), the margins of which are dense with highlighted generalizations such as "man's soul idealizes nature"; "Beauty is that which gives pleasure to the soul of man"; and a much-repeated "Nortonism," "Beauty is better than the good because it includes the good."

In his last semester at Harvard, Winthrop enrolled in Norton's class on Venetian art. Later that year Bernard Berenson took his first course with the legendary teacher. While at Harvard, Winthrop certainly had ample opportunity to meet Berenson, who was in the graduating class behind him, but it is unclear when they had occasion to strike up a friendship, which even if not terribly intimate would be constant until the end of Winthrop's life. For Berenson, however, that first semester in Norton's class presented him with the opportunity of forming a relationship of a much higher order. Among those who came to "pray" and to audit the great man's lectures was Isabella Gardner. At these lectures, Berenson received his introduction both to the study of art and to the young Mrs. Gardner, who offered him a

16. Forbes 1955, p. 2. For Norton in general, see Turner 1999. For Norton at Harvard, see Fasanelli 1967, pp. 251–58.
17. Winthrop, letter to Birnbaum, August 23, 1936, Martin Birnbaum Papers, Archives of American Art, Smithsonian Institution, Washington, D.C.

Fig. 5. Page in Winthrop's notebook from the lectures of Charles Eliot Norton at Harvard, 1886. HUAM Archives

Fig. 6. Winthrop's scrapbook, ca. 1900–1906. HUAM Archives

stipend to further his studies in Italy.[18] With the conclusion of that semester, art history and collecting in America would never be the same. In many ways, this generation of Norton's students formed a new breed of collector: what one could label the alumnus collector. Not only would Loeser, Berenson, Winthrop, and Forbes become formidable collectors, but their ambition was driven by the educational benefit of their enterprise and a conviction about its usefulness for future generations of students. Each bequeathed his collection to his alma mater.

After college, Winthrop stayed in Cambridge to study law. With his degree to practice in hand he returned to New York, eventually setting up a partnership with James B. Ludlow and Frederick Phillips. In 1892, at age twenty-eight, he married Mary Tallmadge Trevor, a young woman from his New York circle who lived with her widowed mother in New York City and on an estate along the Hudson River.[19] After a June society wedding at the Trevors' country property, the couple settled into a comfortable house in Murray Hill near their mothers.[20] Within nine months they had a baby girl, Emily, and another, Kate, before the turn of the century. Winthrop was ill suited to being a lawyer and his professional practice soon failed. Having limited interest in pursuing another profession, and perhaps even work itself, he retired completely in 1896, just four years after his marriage, and relied on siblings and their heirs to manage his affairs for the rest of his life.[21]

It is clear that by the following year Winthrop was already keeping an eye on the world of art. He was a regular reader of the *Magazine of Art* and began to keep a scrapbook with an odd assortment of clippings. In it he pasted auction records, essays on artists (among them Burne-Jones, Puvis de Chavannes, and Sandro Botticelli), a series of clippings on the

18. Mrs. "Jack" Gardner contributed to a fund awarded to the "Parker Fellows." On Berenson, see Samuels 1979, p. 50. Unfortunately, Samuels makes no mention of his subject's relationship to Winthrop. Berenson is also interesting in this context, as he too bequeathed his entire collection and library to Harvard University.

19. The Trevor estate, Glenview, is now the Hudson River Museum of Westchester, in Yonkers, N.Y. The massive twenty-four-room house, designed by Charles Williams Clinton in 1876–77, preserves a fine Aesthetic Movement interior. For an overview, see Dwyer 2001, pp. 184–91.

20. In typical fashion, the wedding was carefully reported by the press. See, for instance, the *New York Times*, June 3, 1892, p. 8. On their return to New York City, the Winthrops lived at 10 East 37th Street, where Winthrop remained until 1927.

21. By the turn of the century, Winthrop's affairs were eventually taken over by his youngest brother, Beekman, and his other siblings. His younger brother Frederic also retired soon after marriage.

opening of the Wallace Collection in London, which he seems to have followed with considerable interest, and notices on other collectors and collections as well (fig. 6).[22] Among these topical or critical articles, the ever-careful Winthrop also inserted printed advice on such topics as how to judge a picture or how to open a book so as not to break its cover. He was also taken by illustrations of *Chimera* and the *Apparition* in an article on Gustave Moreau; it is easy to imagine Winthrop's excitement years later when he would acquire his own versions of these paintings by the artist (cat. nos. 93, 95).

By the time Winthrop stopped working, he must have recognized that his marriage was less than successful. Little is known about Mary Winthrop, but for her the union was certainly not a happy one, and in the spring of 1900, perhaps suffering from an extended postpartum depression after the birth of their second daughter, she left New York City for her family home in Yonkers.[23] Winthrop seems to have been unable to cope with her condition. He spent that summer far away, on the North Shore of Massachusetts, with his brother Frederic. Mary did not join him when he returned to New York that fall. Then, in early December, newspapers reported her unexpected death—which, it has been speculated, was suicide.

Although Emily and Kate, who was only a year old, were well provided for financially at their mother's death, money could not rear and nurture them. Overnight the girls were left in the care of their stiff and reticent father. Seeking advice from experts and specialists, Winthrop was determined to do everything he could to keep his girls from their mother's emotional fate, and with few professional obligations to distract him, he could easily keep a close eye on their upbringing. In response to the suggestion that they maintain a balanced and well-regulated diet, he hired a vegetarian chef and adopted a vegetarian regimen himself, which he maintained for the rest of his life. Winthrop was also advised to prevent the girls from being overstimulated and agitated emotionally.[24] As a result he insisted that they remain at home and be taught by tutors there, at a time when most girls of their circle would have been attending one of the many private schools catering to them in New York City.

Unlike his brother Frederic, who after the tragic death of his own wife in 1907 openly mourned and memorialized her with prominently displayed portraits, which remained in place even after he remarried, the ways in which Winthrop faced his shattered world are not so clear. He renewed old acquaintanceships from school, most importantly with Francis Bullard but also with Berenson, who was about to begin his legendary career. From Saint Moritz in September 1904, Berenson wrote of "how nice it was [earlier in the year] to drop in upon you, to chat with you, to catch peeks of your dear youngsters, & to watch your nascent interest in the surfaces of pictures."[25] Even if Winthrop cannot be counted among Berenson's intimates, their correspondence is between friends—Berenson calls him Winthrop, Winthrop calls him Berenson. Over the years they discussed such pleasures as

22. Two matching scrapbooks with material dating from ca. 1900–1906 survive in the HUAM Archives. In addition to the articles on the Wallace Collection, Winthrop pasted material on Adolphe de Rothschild and Isabella Gardner. Wexler (1998, p. 334) mentions that his brother Frederic kept similar books with any clippings he could find on Winthrop ancestry.

23. Mary was one of three children from John Trevor's second marriage to Emily Norwood. Trevor, who died in 1870, formed the brokerage firm of Trevor and Colgate and was president of the board of trustees of the University of Rochester. He was also a benefactor of Colgate College, the American Museum of Natural History, and other organizations.

24. Wexler 1998, p. 228.

25. Berenson, letter to Winthrop, September 11, 1904, HUAM Archives.

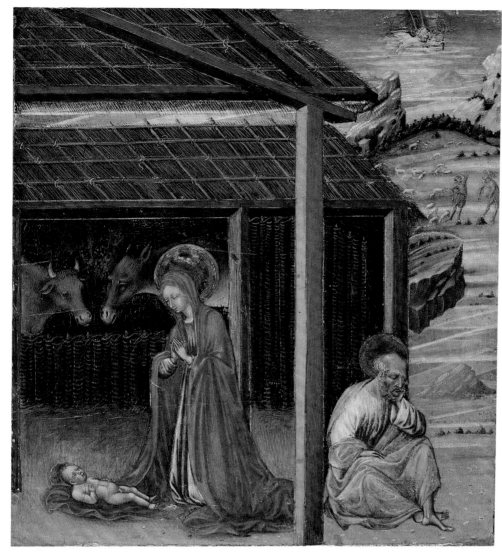

Fig. 7. Giovanni di Paolo, *The Nativity*, ca. 1455. Tempera and gold leaf on panel, 10½ x 9¼ in. (26.7 x 23.5 cm). Fogg Art Museum, Bequest of Grenville L. Winthrop, 1943.112

traveling by car (according to Berenson, the "most delightful way invented as you are not obliged to pass anywhere a moment longer than you like, & between stops you get refreshed, almost re-newed by the air you breathe in your swift motion") or opinions on people or art (Winthrop declares, "I am not in sympathy with the Surrealists, the Daddists [*sic*] and their ilk and am thrilled with the knowledge that your new book will be of a general nature about how art goes down and how it recovers").[26] And often they discussed more serious matters—the possibility of war and, as expected, the acquisition of works of art.

Before the turn of the century, most likely while setting up house in New York, Winthrop gathered an unremarkably eclectic collection, typical of patrician tastes of the period: paintings by Narcisse-Virgile Diaz de la Peña, the odd pair of eighteenth-century paintings he purchased as the work of Nicolas Lancret, canvases attributed to Camille Corot and Pierre Mignard, and other similar works.[27] Through their renewed association, Berenson seems to have convinced, or as he would prefer to have his clients think, advised Winthrop to acquire Italian paintings. Winthrop was happy to accept his recommendations but asserted, "I

26. Ibid., December 18, 1904; Winthrop, letter to Berenson, January 21, 1937, Berenson Archives, Villa I Tatti, Settignano, Florence.

27. Diaz de la Peña, *Les séductions de l'amour* (1939.94) and *Le maléfice* (1939.95); *Portraits of Monsieur and Madame Gaignat*, thought to be by Lancret (1943.255, 1943.256); attributed to Corot, *Goatherd in a Landscape* (1943.220); attributed to Mignard, *Portrait of the Duchesse d'Aiguillon* (1943.1349). One of the earliest acquisitions for which we have a record is a copy of *La comédienne* by Antoine Watteau (1943.1354), which Winthrop bought in 1895 as a major work by Jean-Honoré Fragonard. Winthrop acquired most of these from dealers such as Bonaventure and Brandus in New York in the early years of the 20th century. It is difficult to determine the size of the collection at this time, since many of these works subsequently were sold or eventually made their way to his estate in Lenox, Mass.

28. Winthrop, letter to Berenson, May 31, 1909, relating to the purchase of a poorly preserved plaster relief after the marble by Desiderio da Settignano in Turin (1929.10).

29. Winthrop, letter to Berenson, December 18, 1910, Berenson Archives, I Tatti.

30. Ibid., April 20, 1911.

31. Among the other paintings acquired through Berenson are the *Virgin and Child*, workshop of Botticelli (1943.105); a *Portrait of a Man*, after Giovanni Battista Moroni (1942.200); a poorly preserved *Virgin and Child*, by Vincenzo Foppa (1939.100); and an equally ruined and reworked *Madonna* from the Bellini workshop (1943.103).

32. Winthrop, letter to Berenson, April 30, 1914, Berenson Archives, I Tatti. A full assessment of the Winthrop-Berenson relationship has yet to be made. Their renewed relationship developed for more than half a decade before Winthrop was bold enough to make his first purchase. Winthrop must have recognized the problematic nature of Berenson's offerings in both price and quality. His experiences with Berenson certainly

intend to follow your advice in certain matters and at certain times until your advice becomes so bad that even my eyes can detect the fact."[28] It appears that by the mid-1920s his better judgment had convinced him to shy away from the legendary dealer-connoisseur's advice, but over the course of about two decades Winthrop, "desirous of learning & acquiring good things," purchased about a dozen paintings from Berenson, always in an attempt to upgrade his holdings.[29]

In a letter of 1911, noting his "delight" in his acquisition of a small *Nativity* by Giovanni di Paolo (fig. 7), he wrote, "I have parted with almost all my modern paintings. The last two to go were a Ziem and a Rico, which I traded for a delightful 'Madonna & Child' by the Master of the Ursula Legend. You know the painting. It was in Mr. Widener's collection and given by him in part payment for a Vermeer of Delft." In what would become typical deference to his advisers, he tentatively added, "I hope you approve."[30] With the exception of the Giovanni di Paolo, an important *Crucifixion* by Pietro Lorenzetti, and the equally interesting, and better preserved, *Man of Sorrows* by Roberto Oderisi (fig. 8), Winthrop's acquisitions through

Fig. 8. Roberto Oderisi, *Man of Sorrows*, ca. 1350. Tempera and gold leaf on panel, 24¼ x 15 in. (62.2 x 38 cm). Fogg Art Museum, Gift of Grenville L. Winthrop, Class of 1886, 1937.49

Berenson were second tier at best.[31] Although their business relationship eventually waned, the two remained friends, Winthrop referring "all to Bernhard [*sic*] Berenson Esq. of Settignano . . . stating that the said B.B. possesses the Divine Gift in addition to great knowledge."[32]

If the pictures Winthrop was collecting at the time were not terribly distinguished, he developed an independent passion for Wedgwood, Tassie, and other ceramics, which as a result of his committed pursuit swelled into a collection of nearly two hundred pieces. At its core was an impressive group of landmark trophies, such as an original subscription Portland Vase, the first of these prized Wedgwood vessels to come to America (fig. 9).[33] While Winthrop was collecting these fragile ceramics, he also embarked on a collection of a different sort: objects from Asia. Over the years that collection would develop in tandem with his Western holdings, and there were many instances in which his acquisitions in each field were in direct competition for his limited resources. Unlike his interests in other areas, although he certainly benefited from a privileged relationship with Kichijiro Tanaka at Yamanaka and Company in New York, it appears that Winthrop independently began to devote himself to the study and collection of Asian art, with a particular interest in China. By all accounts the importance of this collection surpasses his efforts in other

must have made clear the perils of collecting old masters within his means and equally convinced him of the advantages of collecting in other, less pursued fields. For further discussion on Berenson and Winthrop, see Rubin 2000, pp. 216–18.

33. Winthrop's vase is marked *9* and *Trevor*, which is thought to refer to John Trevor, who received his copy in 1797. Winthrop had earlier included an article on the vessel in his scrapbook: Smith 1903, pp. 309–12. Winthrop also acquired the original ticket of admission and visitor guide,

Fig. 9. Josiah Wedgwood, Portland Vase, ca. 1795. Black jasper with polished and undercut figures in white relief, 10½ x 7 in. (26 x 17.8 cm). Fogg Art Museum, Bequest of Grenville L. Winthrop, 1943.1181

areas.[34] To this day, no other collector has been able to assemble a comparable collection of ancient Chinese jades and bronzes. A rare insight into the importance of this material for Winthrop is gleaned from the ever-savvy Berenson, who in his attempt to convince his classmate to buy the *Crucifixion* by Pietro Lorenzetti, wrote, "And I don't know of another painting in which the sublimest qualities of Sienese & Chinese art are so beautifully harmonized. It almost might be a T'ang painting."[35]

Winthrop also became an avid collector of prints, thanks in part to his association with his former Harvard classmate Francis Bullard, who lived a short walk from Winthrop's large Lenox estate. In 1902 Winthrop bought the Elms in Lenox, a staid summer colony in the Berkshires, in western Massachusetts, where his mother and other members of patroon society also had properties. In these bucolic hills Winthrop enlisted the help of Carrere and Hastings, architects of the New York Public Library, among other grand projects, to transform a late Victorian fieldstone house into an overscale stone "cottage," capped by a steep overhanging slate roof pierced by dormer windows in an attempt to disguise the sizable mansion as a modest country house.[36] Ever conscious of his ancestral roots, Winthrop renamed the property Groton Place, after the English village of his forebears (fig. 10).[37] This capacious but unlyrical pile of stone enclosed a formally laid out interior organized by a stately enfilade of well-proportioned rooms on the ground floor and long corridors that seemed to distance family members more than connect them in a maze of chambers and antechambers above.[38] Winthrop set his massive cottage, by itself atypical of any in the region, into an equally atypical landscape, described most aptly by Marjorie Cohn as Turnerian.[39]

Winthrop began to develop a specialized interest in J. M. W. Turner in part from the close relationship he developed with Bullard. Santayana described the much-admired aesthete, who lived with his widowed mother, Charles Eliot Norton's elder sister, as being in "fortunately delicate health," which allowed him to pursue an aesthetic life rather than a profes-

"Abstract of Mr. Wedgwood's conjectures on the bas reliefs of the Portland Vase."

34. It is difficult to understand the full range of Winthrop's collecting interests in Asian art, as no study was available before this essay went to press. Records in the Metropolitan Museum Archives reveal that he was already lending objects, albeit few, to that institution by the close of the first decade of the 20th century. On Winthrop's jades, see the now-classic study by Max Loehr, *Ancient Chinese Jades from the Grenville L. Winthrop Collection in the Fogg Art Museum, Harvard University* (Cambridge, Mass., 1975).

35. Berenson, letter to Winthrop, January 23, 1918, HUAM Archives.

36. Cohn 1993, p. 54. The architect charged with the project was Julius Gaylor, who would later become a successful society architect in New York, designing several houses for the Winthrop family and Winthrop's own residence in New York City.

37. Winthrop's other siblings also named properties after the English village. Dudley called his thirty-seven-square-mile South Carolina hunting compound Groton Plantation, and Frederic named his country home in Hamilton, Mass., Groton House Farm.

38. A real estate brochure preserved in the Lenox Library Association describes the house as having eleven bedrooms, seven rooms for servants, two artesian wells, three coal-burning furnaces, a fireproof wall, and battened doors to lock off the servants' wing. It was also in 1902 that Edith Wharton rebuilt the Mount.

39. Cohn 1993, pp. 52–54.

sional career. By the time of his premature death in 1913, Bullard had unquestionably become Winthrop's closest friend. During their summers in Lenox, they spent long hours together, studying and cataloguing their rare impressions of prints from Turner's large series of landscape studies, the *Liber Studiorum,* Bullard patiently honing Winthrop's critical eye with the purchase of every new impression.[40] As a result of their association, Winthrop amassed a formidable collection of prints by or after Turner, more than four hundred of which he left to the Fogg Art Museum.[41] Bullard's influence on Winthrop was considerable, and the intimacy they shared, particularly in the context of the reserved Winthrop, merits closer attention. Most remarkably, the cultured aesthete who had spent significant time studying abroad seems to have been able to convince Winthrop, who eschewed the pleasures of travel in favor of the predictability of routine, to set off on several European tours.[42] After Bullard's death Winthrop never crossed the Atlantic again.

Winthrop's association with Bullard in Lenox was an entirely new kind of relationship for him. It is unclear whether they had been friends in college. Although from a prominent Boston Brahmin family, Bullard did not have Winthrop's financial means, keeping him from the same social clubs and the like. Their years after college also could not have been more different. While Winthrop purposefully stayed in Cambridge to gain a profession, Bullard followed the more bohemian route of Loeser, Berenson, and other promising intellectuals who went abroad. Bullard left for Germany, where he studied philosophy, and when his frail constitution finally weakened from the trials of Teutonic life, he went south of the Alps to Italy to recuperate. Back in Boston he continued to devote himself to aesthetics and to the study and collection of Turner prints.[43] Bullard belonged to an entirely new breed of American collector who was collecting for aesthetic quality. In the small biography devoted to him by Frits Lugt, he is described as "the first American collector to insist, in prints, on

40. Cohn (ibid., p. 46) has vividly conveyed the full dimension of their friendship and collecting interests.

41. A rough list is provided in Cambridge, Mass., 1969, pp. 253–54. Winthrop continued to try to acquire Turner prints until the mid-1930s. In 1936, Alexander J. Finberg, of the Cotswold Gallery, London, assessed that Winthrop lacked only 12 prints to complete his series of the *Liber,* one of which was known in only one impression.

42. It is possible to conclude that Winthrop made only three trips abroad and that these occurred only in the decade of his friendship with Bullard. The first, in 1905, is mentioned by Edward W. Forbes, director of the Fogg, who reported having met Winthrop, who "was just beginning to collect," in Italy; see Forbes 1955, pp. 49–50. Winthrop is also recorded aboard ship, on RMS *Baltic* in 1907, in a letter written by Bullard to Norton asking for his interpretation of Albrecht Dürer's *Knight, Death and the Dragon,* which Bullard had just purchased (March 16, 1907, HUAM Archives). It is unclear whether Bullard accompanied Winthrop again in 1909, when the latter may have gone to England to visit the town of

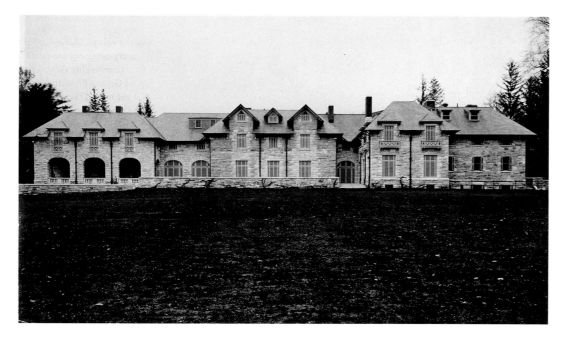

Fig. 10. South front of Groton Place, 1906. HUAM Archives

the quality of the impressions."[44] Paul Sachs, a formidable collector in his own right, concurred, claiming that Bullard "was free from the weakness of the average collector of his day for mere quantity." This he admired in Bullard's carefully chosen works by Dürer, in his unparalleled set of Turner's *Liber Studiorum,* and in his remarkable series of Canaletto etchings.[45] At their core Bullard's collecting interests were given birth by Ruskin and bred by Norton and Charles Herbert Moore, but they were subsequently governed by an entirely new aesthetic sensibility, one that centered on the work of art itself.

The extended companionship of Bullard introduced Winthrop to something far greater than Europe and prints. Bullard spurred his enthusiasm for the British Aesthetic Movement and for an aestheticism, grounded in the writings of Walter Pater, that liberated art from the moral talons of Ruskin and Norton.[46] An agnostic, Pater rejected the idea that beauty can only be good and moral, contending that it could be evil and decadent at the same time.[47] It is impossible to assess the intoxicating effect of his *Studies in the History of the Renaissance* (1873)—the book that Oscar Wilde claimed "has had such a strange influence over my life"—and the antidotal effect it must have had on students of Norton. It was one of the rare underlined and annotated books in Berenson's library. More crucially, Winthrop's most frequently quoted pronouncement on art must certainly have descended from that line in Pater, so central to the Aesthetic Movement: "*All art constantly aspires towards the condition of music.*"[48] In later years, trying to lavish his greatest praise on the work of the Pre-Raphaelites, Winthrop wrote that "their best works are full of music."[49] While it is probable that Winthrop had encountered discussions about Pater in his undergraduate years, it is clear that the English writer figured in Winthrop's and Bullard's later exchanges. Bullard's calling card slipped into Winthrop's copy of Pater's *Greek Studies* reads: "How are you this morning, Mr. Winthrop—not that I care a damn—but ask simply for the sake of making conversation! and send a copy of 'Greek Studies' which please keep in remembrance of pleasant days in Boston and Ashfield."[50] Those days were certainly not forgotten. At Bullard's death in 1913, his noteworthy collection of prints was bequeathed to the Museum of Fine Arts in Boston. To memorialize his friendship, Winthrop funded and closely edited a deluxe memorial catalogue of Bullard's Turner collection as "a 'labour of love' on my part undertaken in memory of a friend who stood first in my esteem and affection."[51] Bullard remembered him and his daughters with a gift of three drawings by Burne-Jones (see cat. no. 160).

It was only a year after this, in 1914, that Martin Birnbaum, who would become Winthrop's trusted agent, remembered meeting the collector for the first time. Birnbaum, an immensely intriguing figure, could as easily have been a secret agent as a dealer in works of art (fig. 11). His oldest friend, the writer Upton Sinclair (who modeled Lanny, in his Lanny Budd series, after him), recalled how after Birnbaum had left a Hollywood dinner at which Charlie Chaplin was present, Chaplin and the host, taken by Birnbaum's mysterious charm,

Groton. Surviving records from this trip indicate that Winthrop purchased some copies of Turner watercolors directly from William Ward in Surrey, who also sold him an Italian panel of the *Virgin and Child,* now attributed to Nicolo di Tomaso (1939.103), on May 15, 1909. Cohn (1993, pp. 37–38), following Birnbaum's later recollection, places this trip in 1911.

43. Bullard eventually became chairman of the Visiting Committee to the Print Department at the Museum of Fine Arts, Boston.

44. "Il fut le premier collectionneur américain à insister, dans les estampes, sur la qualité des épreuves"; Lugt 1921 and Lugt 1956, no. 982.

45. Cohn 1993, p. 41.

46. For an overview on Pater, see Levey 1978.

47. It is through Pater that Oscar Wilde contended that art existed only for itself, rejecting nature in favor of the man-made creations.

48. "The School of Giorgione," in Pater 1873, p. 106. One of the rare lines italicized in the book, Winthrop's thought is also quoted in Royal Cortissoz's announcement of the Winthrop bequest in the New York *Herald Tribune,* October 17, 1943: "'I never buy anything,' he would say, 'unless it has music in it.'"

49. Winthrop, letter to Birnbaum, July 7, 1936, Birnbaum Papers, Archives of American Art.

50. In contrast to the other salutations in the preserved correspondence, Bullard is the only one who called Winthrop "Grenville." I owe the discovery of the calling card to Tim Rohan (1995, p. 4).

51. Cohn 1993, p. 38. The volume was printed privately: *A Catalogue of the Collection of Prints from the* Liber Studiorum *of Joseph Mallord William Turner, Formed by the Late Francis Bullard of Boston, Massachusetts, and Bequeathed by Him to the Museum of Fine Arts in Boston* (Boston, 1916).

were convinced that he was a German spy. A lawyer by training, an art dealer by vocation, but a violinist at heart, Birnbaum was as colorful as Winthrop was drab. The union between the lively and peripatetic Birnbaum, impetuously flitting from Paris to Taormina or from Athens to Berlin, and the staid and sedentary Winthrop, keeping his steady path between New York and Lenox, would seem an unlikely one; however, it proved to be a perfect match. In the decades that followed, Birnbaum eventually became the key figure in the formation of Winthrop's collection of Western art, scouting the world for available treasures to send back and install in Winthrop's New York residence.[52]

Here is the moment of their crucial first meeting, as recalled by Birnbaum: Winthrop, naturally courteous,

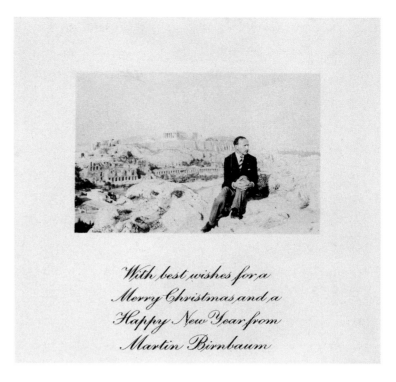

With best wishes for a Merry Christmas and a Happy New Year from Martin Birnbaum

walked into Birnbaum's New York gallery on Madison Avenue to see one of his exhibitions—Birnbaum credits himself with having been the first in America to mount shows on Oskar Kokoschka, Lyonel Feininger, Paul Klee, James Ensor, Edvard Munch, Paul Manship, and many other artists. In the course of conversation Winthrop "explained that he thought of really starting a collection, but that he did not want to compete with wealthy American amateurs who gathered costly groups of Dutch, English or Italian old masters under their roofs. He wanted virgin fields to plow, and although plans were only vaguely entertained it was clear that he did not wish to collect in a mere desultory way. Quite naturally, I suggested one of my personal enthusiasms—the collection of drawings by the salient figures of the nineteenth century."[53] As described by Birnbaum, Winthrop's relationship with him, in the collector's reliance on and deference to his advice and opinion, was similar to the one he had had with Bullard; in Bullard's case Winthrop adopted his enthusiasm for collecting prints, and in Birnbaum's, his interest in the nineteenth century. However, no one could have predicted the vigor with which Winthrop would now pursue his collecting interests. In the decades that followed, what began as a "collection of drawings by the salient figures of the nineteenth century" would become a hoard of more than a thousand paintings, drawings, and sculptures from the period, with Winthrop insisting that "beauty" be the only measure for their selection.

A translator of the poetry of Paul Verlaine, a failed playwright, a trained lawyer, but more remarkably a violinist of considerable talent—to say that Birnbaum was an eclectic figure is not to do him full justice. Many were the occasions, be it before an august crowd in the palatial residence of Chen Chi Fou in Beijing or alone at Groton Place with Winthrop, when Birnbaum would tune his violin and perform an after-dinner serenade. When doing

52. Birnbaum's memoir (1960), published almost two decades after Winthrop's death, is a primary source not only on the collector but also on other collectors and on the art world in general in the first half of the 20th century.
53. Birnbaum 1960, p. 184.

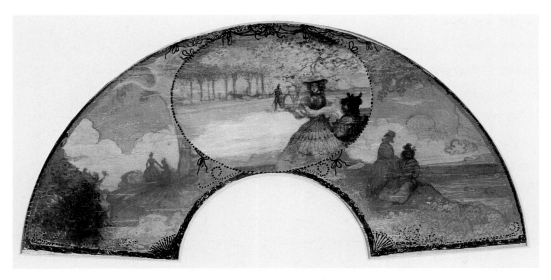

Fig. 12. Charles Conder, *The Rendezvous*, ca. 1900. Watercolor on silk fan, 5⅛ x 16½ in. (12.9 cm. x 42 cm). Fogg Art Museum, Bequest of Grenville L. Winthrop, 1943.464

business in Germany he would determine whether the better prize—and price—were to be had if he concealed that he was an American and carried out his transactions in fluent German. In native French he would write subtle letters entreating impoverished heirs to part with their treasured heirlooms. In Venice, as a commissioner of American exhibits at the Biennale, he must have been received like one of the foreign dignitaries of lore who would come to the Byzantine city as ambassadors from distant shores.

When Birnbaum first met Winthrop in 1914, he was head of the New York branch of the Berlin Photographic Company, a publisher of photographs and art books, which had a gallery space where Birnbaum was able to mount his own exhibits. Through his association with artists and collectors, Birnbaum quickly moved into the inner circle of the art world, going to private collections around the country to photograph objects for publication and then putting on exhibitions back in New York; Ernst Barlach, Beardsley, Charles Conder, John Marin, and John Sloan were some of the artists he presented. Birnbaum also distinguished himself as a critic. Over the years he published many volumes of essays on topics as diverse as Oscar Wilde, John Singer Sargent, and contemporary German art. Before World War I, Birnbaum also began an intimate association with Charles Ricketts and Charles Shannon, the renowned artist-aesthetes who, at the time, were living in their legendary house on the property of the great English collector Sir Edmund Davis. Birnbaum found refuge and inspiration in their refined home, famous for the rarefied settings they produced to house their rich and varied collection. The lifelong friendship established with these artist-connoisseurs spliced Birnbaum into the central line of British artistic movements from the Pre-Raphaelites to the Aesthetic Movement and their followers. This was the very sensibility that nurtured the eye of Bullard, and in this way Birnbaum was his suitable heir. But clearly the life of this violin virtuoso and vagabond art dealer could not have been more different from that of the Bostonian aesthete.

Winthrop's relationship with Birnbaum did not develop fully until after 1916, when Birnbaum joined the firm of Scott and Fowles, after Fowles went down on the *Lusitania*. Birnbaum encouraged the stodgy white-glove company, which specialized in stocking houses around the country with respectable collections of old masters, to branch out and show more modern artists such as Édouard Manet, Whistler, Sargent, Winslow Homer, Ingres, and Edgar Degas.[54] At the same time, he continued to present new talent. Of these, the Americans Manship and Maxfield Parrish are best known today, but he also championed the work of Jules Pascin, Edmund Dulac, Maurice Sterne, and other artists who now are considered less salient but in their day were among the anointed princes of the avant-garde. The remnants of these interests are found in countless ways in Winthrop's collection: in fine fans by Conder, in sculptures by Manship such as his extraordinary *Celestial Sphere*, of which Winthrop's example is the first cast; and in a drawing by Parrish (figs. 12–14).[55]

While Birnbaum was sniffing out his next catch in Europe, Winthrop kept a straight course between New York and Lenox, where he would spend long summers continuing his landscaping efforts at Groton Place.[56] On these 150-plus acres he spared no labor or expense. Local lore has it that he had forty men mowing the lush lawns around the estate.[57]

54. Among the now public collections that are most indebted to the firm is the Taft Museum of Art, Cincinnati. For Scott and Fowles and Birnbaum's position there, see Birnbaum 1960, p. 153. The museum's recent two-volume catalogue makes no mention of Birnbaum's efforts in building that collection; see Sullivan and Meyer 1995.

55. Winthrop would later become friends with Manship; see Winthrop, letter to Mrs. Manship, April 26, 1941, Birnbaum Papers, Archives of American Art. His collection includes works by the artist in a variety of media, among them first casts of bronze sculptures, the intimate marble of the artist's daughter (*Sarah Jane Manship*, 1943.1035), and drawings. Ever mindful of being fair and honest, Winthrop wrote concerning the *Celestial Sphere*, "I do not want the sculptor to

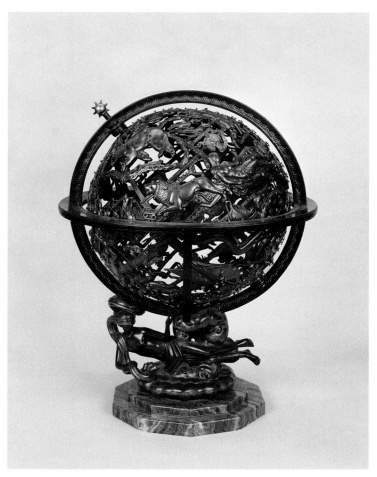

Fig. 13. Paul Manship, *Celestial Sphere*, 1934. Bronze, H. 24 in. (61 cm), diam. 20 in. (50.8 cm). Fogg Art Museum, Bequest of Grenville L. Winthrop, 1943.1113

Fig. 14. Maxfield Parrish, *A Hill Prayer*, 1899. Black ink over graphite, 14⅛ x 9¾ in. (35.8 x 24.7 cm). Fogg Art Museum, Bequest of Grenville L. Winthrop, 1943.578

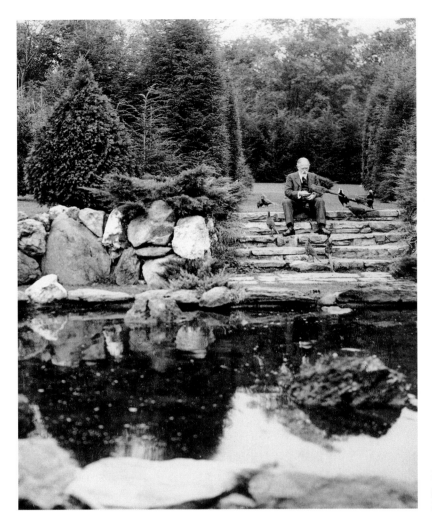

Fig. 15. Winthrop in his garden at Groton Place. HUAM Archives

Buttressing such stories are impressive facts, such as that Winthrop bought large tracts of land on the peak of Bald Head Mountain, which dominates Lenox's western views, so as to maintain his carefully contrived vistas.[58] Winthrop had very strong ideas about landscape design. In a letter to Paul Sachs he gave a rare aesthetic insight into his project, writing that the grounds represented the "kind of landscape work I am so keen to have the schools teach the coming generation—

Simplicity
Proportion
Scale } Culminating in Beauty" [59]
Balance
Harmony

There were no gardens at Groton Place. Instead, the subtle nuances of the carefully chosen clusters of foliage, whispering exotic chords as the wind blew chimes hidden within them, were pierced by legions of elegantly plumed birds—according to some accounts, numbering more than five hundred. Peacocks and pheasants—"living jewels," Winthrop called them—provided a movable pageant of color as they roamed about the property, as if

be 'out' owing to unforeseen difficulties—so please use your tact, find out and let me make good any loss"; Winthrop, letter to Birnbaum, June 16, 1935, Birnbaum Papers, Archives of American Art.

56. Although he clearly shied away from social activity in Lenox, Winthrop was a pillar of the public library, on the board of which he served as president and to which he bequeathed a sizable endowment. In New York, he served as president of the Board of Trustees of Women's Hospital.

57. Wexler 1998, p. 221.

58. Winthrop deeded the land to the Pleasant Valley Bird and Wild Flower Sanctuary Association of Berkshire County in 1938. It is now part of the Berkshire County Land Trust and Conservation Fund, Yokun Ridge. I am grateful to George S. Wislocki, president of the Berkshire Natural Resources Council, for this information.

Fig. 16. Winthrop's aquarium at Groton Place. Lenox Library Association, Edwin Hale Lincoln Archives, vol. 8, no. 407

Winthrop had taken the opulent adornments of an Aesthetic Movement interior outdoors (figs. 1, 15). A reminder of the period fancy for flower beds and borders is the often-retold story of the disgruntled ladies of a distinguished garden club who, after being shown around the estate, asked whether Winthrop would show them his garden, only to find that there was none to see. If Winthrop's innovative landscape was not received admiringly by some of his visitors, it did earn him the Hunnewell Gold Medal of 1934, for "developing the capabilities of the location in the highest degree, and presenting the most successful examples in science, skill and taste, as applied to the embellishment of a country residence," in the state of Massachusetts.[60]

Groton Place developed into a quirky compound. Over the years Winthrop, who took "an absorbing interest in it," added an oriental garden, a small "museum" of natural history, and an aquarium, which a surviving photograph shows looking disconcertingly like Homer's *Mink Pond* (cat. no. 202), a gem he would add to his collection in later years (fig. 16).[61] Winthrop also built a sculpture studio for his elder daughter, Emily, who became an artist of some repute, having studied with the sculptor Daniel Chester French, another Berkshires resident and an acquaintance of her father.[62]

For Winthrop, 1924 proved to be a momentous year. By the end of summer Emily was thirty-one and her sister Kate was close to celebrating her twenty-fifth birthday. The previous year a cousin had written that it was "pathetic, the way they were brought up."[63] Apparently Kate, a fully grown adult, was still riding a tiny pony. Winthrop had not only kept his daughters from going to school, but he was oppressively vigilant about their social lives, even insisting that he be informed of all the people they would meet while on vacation at his siblings' houses. At home the girls were subjected to Winthrop's unbending habits and rigid schedule, policed by a corps of nearly fifty clocks (figs. 17, 18).[64] At the established hour they would join their father for an austere vegetarian repast, "getting all dressed up and sitting stiffly all evening stifling yawns." His family found dining with him "a terrible

59. Winthrop, letter to Sachs, September 28, 1934, HUAM Archives.
60. See Farrington 1955, pp. 37, 185 (quote), 193. In its first eighty years, only thirty-five gardens were singled out for such a distinction. By the mid-1950s the honor ceased to be awarded as it became difficult to meet the requirements; see "Gold Medal Estate with No Flowers," *Horticulture* 13, no. 15 (1935), p. 355.
61. "A Visit to the Berkshire Hills," *Horticulture* 20, no. 10 (September 5, 1914), p. 357.
62. Exhibited regularly at numerous institutions, Emily Winthrop Miles's sculpture was shown in a memorial exhibition at the Southern Vermont Art Center, Manchester, in 1964. She was also a poet and a photographer.
63. Wexler 1998, p. 213.
64. In his typical reliance on the expertise of others, Winthrop acquired most of his clocks (about forty-eight in all) through Sydney Letts in London. Letts would send watercolors of the clocks for Winthrop's approval. In 1915 Letts wrote, "I appreciate very much indeed the confidence you kindly put in my taste"; letter to Winthrop, December 9, 1915, HUAM Archives.

thing. We were hungry, but not until the clock rang the appointed hour could we go into dinner," and afterward one "had to stay up until bedtime, no matter what."[65]

It is not surprising to learn that Winthrop's daughters became malcontent and restless. One of their cousins thought they were unkind to their grandmother, who lived nearby, but were even more malicious to their father. "Emily and Kate are very mean to him. They bobbed their hair and bought automobiles and got licenses without consulting him and they knew he hated bobbed hair. I should think they'd love him enough to at least talk over their plans with him."[66] Such plans perhaps could not be discussed. While on an overnight trip to New York in early September, Winthrop was certainly shocked to learn that both his daughters had profited from his absence by eloping. Emily had become the bride of her chauffeur, and Kate had gone off with her father's electrician. The *New York Times* found the headline worthy of its front page.[67] Happy to have such a dramatic tale of upstairs-downstairs romance in the downtime of late summer, it continued to track the story with zeal for days. For the shy, socially conscious, and impeccably well-mannered Winthrop, the story was more than he could bear. Winthrop, "shocked and grieved," never fully recovered from the

65. Wexler 1998, p. 223.
66. Ibid., p. 213.
67. *New York Times*, September 7, 1924, p. 1.

Fig. 17. Otto van Meurs, longcase musical clock, ca. 1720. Inlaid oak case with gilt brass ornaments, 9 ft. 2½ in. (280.7 cm). Fogg Art Museum, Bequest of Grenville L. Winthrop, 1943.0947

Fig. 18. *Left:* John Thwaites, musical mantel clock, 1786. Tortoiseshell case with silver and enameled-silver mounts, 15⅜ x 6 in. (39.4 x 15.2 cm). 1943.943. *Center:* John Paulet, traveling clock, ca. 1705–10. Silver and gilt case, without handle, 6½ x 3¾ in. (16.5 x 9.5 cm). 1943.1067. *Right:* Daniel Quare, bracket clock, ca. 1710. Ebonized wood case with brass mounts, 21 x 10½ in. (53.3 x 26.7 cm). 1943.1525. All, Fogg Art Museum, Bequest of Grenville L. Winthrop

Fig. 19. Draft of
a cablegram.
HUAM Archives

incident. Abandoned and alone, he turned entirely to art and collecting, which he embraced
with new fervor and deepened interest.[68]

For his interest in Western art, the change in Winthrop's personal situation took place at
an opportune moment. Within a year and a half of the calamitous family event, Birnbaum
left Scott and Fowles and retired from commercial art dealing. In a few months he was back
in Europe as Winthrop's emissary, casing out collectors and collections to find objects to
send back to New York. Although Winthrop placed full trust in his agent's decisions,
Birnbaum rarely made a move without his consent. Birnbaum sent streams of letters with
critical assessments of his discoveries, providing Winthrop with detailed lists ranking the
objects both by importance and by price. As if Birnbaum were conducting a top-secret mis-
sion, Winthrop was to send his purchasing order only by number or an abbreviated code—
which prevents us from gleaning any critical reception on Winthrop's part to Birnbaum's
proposals. For example, "Buy one" (fig. 19) was the only reply necessary for Birnbaum to
acquire Rodin's exquisite bronze bust of Mariana Russell (cat. no. 118).

This process of acquisition at arm's length certainly suited Winthrop well, but it could
not have contrasted more with Birnbaum's enthusiasm for hands-on transactions. The latter
delighted in the discovery of lesser-known objects and in establishing close relationships
with private collectors and artists' heirs. If Winthrop was acutely conscious of social pedi-
gree, Birnbaum showed an equal interest in the provenance of a work of art. He entered
into direct correspondence—even at times close friendship—with such notable collectors
as Baron Vitta, the duc de Trévise, the Rothschilds, and the heirs of Ingres, Théodore
Chassériau, George Frederic Watts, and William Holman Hunt. In so doing he could chart
a straight course to the objects he wished to acquire and eliminate the dealer-middleman.

Birnbaum rarely bought from auctions or from established galleries. Indeed, he loved
being embroiled in family affairs and in complicated intrigues. He was the kind and patient

68. Although he and Emily, who
quickly abandoned married life
to pursue her career as an artist,
would eventually become rec-
onciled, his relationship with
Kate remained strained and he
seems to have met his grand-
sons only once; Wexler 1998,
p. 227. In addition to her own
artistic pursuits, Emily collected
about 900 pieces of Wedgwood
and more than 150 paste medal-
lions by Tassie, now at the
Brooklyn Museum of Art; see
Gorely and Schwartz 1965. Her
sizable collection of Early
American pressed glass is now
in the Metropolitan Museum.
Her house in Sharon, Conn.,
is now the Audubon Society's
Emily Winthrop Miles Sanc-
tuary. Kate followed her passion
for horses, setting up a farm in
Richmond, Mass., only miles
from her father's estate. Green
Meads Farm remains in her
family to this day.

dealer, always there with a solution and a handkerchief to dry the tears. He breathlessly wrote to Winthrop of a visit with Jacques-Émile Blanche: "And now to the third act of this almost unbearably hot and humid day. Jacques Blanche, the famous painter who owns one of the most celebrated collections here, is in need of cash. I spent a most interesting, but rather sad interview with him at his wonderful home on Rue Doctor [sic] Blanche. His wife was in tears. . . . He would only sell drawings because in such a vast collection his friends will not miss them. All are gifts from his deceased friends Rodin, Manet, Whistler and Legros."[69] Poor Mme Blanche. Birnbaum was after Rodin's unique bronze *Study for "Romeo and Juliet,"* which he was able to win for Winthrop's collection (cat. no. 126). Its absence from their collection could certainly not go unnoticed.

Birnbaum left no strategy untried. If needed, he even resorted to what he termed "a subterfuge recommended by Sir Joseph Duveen," which was to provide the seller with a replica of the object, as in the case of Ingres's drawn portrait of Countess Apponyi (cat. no. 62), which he plucked from Jean-Léon Gérôme's daughter in exchange for a copy.[70] There were other occasions when Birnbaum's offer to relieve people of their inheritance was seen as a favor, as in the case of Rossetti's celebrated *Blessed Damozel* (cat. no. 188), which had annoyed its owner's wife because she could never find an appropriate place to hang it.[71]

One of Birnbaum's most successful ways of obtaining works was to reassure reluctant heirs and collectors that their treasures would not be sold again but instead given to a museum. "Strictly between ourselves," he wrote to convince Ricketts to part with his beloved Blakes, "that means they will go to a museum eventually."[72] This strategy worked especially well with the immediate heirs of artists.[73] In endless pursuit of some works by Chassériau to add to Winthrop's collection, he wrote to the artist's nephew, "Well aware of the high esteem in which you hold the memory of the illustrious master, may I remind you that in allowing a few of his drawings to be sent to America, to be eventually placed in the museum to which my friend's collection will ultimately go, you will be adding to his renown."[74] Understanding the advantage of having his uncle's work known to a larger audience yet unwilling to relinquish anything in his own collection, which was already promised to the Louvre in Paris, the baron put Birnbaum in contact with other relatives and collectors. The result was the acquisition of the large *Arab Horsemen Carrying Away Their Dead* (cat. no. 7), arguably the most important painting in America by this friend of Ingres and Moreau.

In his dealings with Winthrop, Birnbaum was scrupulously honest. It is difficult to find discrepancies between his receipts and the prices he quoted to Winthrop. He was careful never to overcharge and would always recalculate his commission (a fixed 10 percent) to reflect any further reduction in price. Both parties kept meticulous records. In one exchange Winthrop, clearly puzzled by an error in bookkeeping, asked, "How could this item have escaped us? For we both are super-exact and prompt in business transactions. . . . You can

69. Birnbaum to Winthrop, June 12, 1931, HUAM Archives.
70. Birnbaum 1960, p. 189.
71. Ibid., p. 209.
72. Birnbaum, letter to Ricketts, March 11, 1929, Birnbaum Papers, Archives of American Art.
73. Such was also the case with Watts and Hunt.
74. "Sachant combien vous vénérez la mémoire de l'illustre Maître, je voudrais vous rapeller [sic] qu'en consentant à l'envoi de quelques uns de ses dessins en Amerique pour y être placé eventuellement dans le Musée auquel la collection de mon ami est destinée, vous augmenteriez son renom." Birnbaum continued: "Veuillez comprendre que je ne désire aucun bénéfice dans cette affaire, et je peux ajouter que je tâcherai d'intéresser ce Monsieur dans le livre inédit de Benedite sur Chasseriau qui se prépare actuellement,—naturellement il me serait d'autant plus facile à faire ceci si je réussissais à lui procurer ces dessins" (Please understand that I do not seek any personal gain in this matter, and I might add that I will attempt to interest my client in Benedite's unpublished book on Chasseriau—of course it would be much easier if I managed to get these drawings for him); Birnbaum, letter to Baron de Chassériau, September 23, 1927, Birnbaum Papers, Archives of American Art.

imagine how mortified I am."[75] Birnbaum keenly sought to secure the lowest possible price, either by offering a cash deal before a public sale or by buying directly from the collectors themselves. He was proud of his bargaining skills, once writing, "I never give up hope with these French gentlemen and my brief experiences with Egyptian merchants (who can give post graduate courses to Scotch Jews), is proving very valuable."[76] From the collection of Reginald Davis, brother of the noted collector Sir Edmund Davis, he secured Honoré Daumier's remarkable *The Butcher* (cat. no. 14), as well as Ingres's *Virgil Reading the "Aeneid" to Augustus* (cat. no. 75, along with two studies for an earlier version, cat. nos. 51, 52), for little more than $9,000, a sum that may also have included Moreau's *Saint Sebastian and the Angel* (fig. 32), bought through the French dealer Dubourg. A few months later, the Wadsworth Atheneum in Hartford, Connecticut, paid $16,000 for a single drawing by Daumier: *The Saltimbanques Changing Place.*[77]

The equal attention devoted to the artistic cultures of both sides of the English Channel is truly the greatest distinction of Winthrop's ambitious collecting in the field of nineteenth-century art. There were certainly others in the fields in which he worked whose collections may have surpassed his in specific strengths, such as that of Samuel Bancroft Jr. of Delaware, America's first great collector of the Pre-Raphaelites, or, in the case of Ingres, the drawings in the collection of Léon Bonnat.[78] But no other collector in America or Europe could claim the depth of Winthrop's reach in both French and British art together. Here Winthrop's venture remains unique—and he would not have achieved its dual strength without Birnbaum's intervention. Although it is clear that Winthrop had adopted Norton's interest in Pre-Raphaelite art and fostered it through collecting in later decades, he showed no committed interest in things French until his collaboration with his trusted agent.

If the interest in England and France can be split between collector and agent, the important question of whether the idea to collect drawings was Winthrop's or Birnbaum's (as the latter claimed) remains. Even though collecting in America had reached an impressive height by the first decades of the twentieth century, the collecting of drawings was an untried and unappreciated enthusiasm when Winthrop's early efforts began. None of the collecting tycoons gave much notice to them. The two major drawings collections, those of Morgan and Cornelius Vanderbilt, were amassed uncritically, through the wholesale purchase of previously assembled collections. Thus Winthrop and slightly later Paul Sachs of the Fogg were pioneers in their endeavors to build a critical collection of works on paper, especially on such a scale.[79] These vanguard collectors, methodically building their cabinet sheet by precious sheet, developed a new sensibility and appreciation for works on paper that inspired and even consumed a new generation of collectors in America. That Winthrop recognized the importance of his achievement and took a personal interest in it is revealed in the fact that he placed his drawings foremost in importance in his statement of bequest: "I give and bequeath to . . . Harvard College . . . for the use of the Fogg Art Museum . . . *my*

75. Winthrop, letter to Birnbaum, March 27, 1930, Birnbaum Papers, Archives of American Art.
76. Birnbaum, letter to Winthrop, August 4, 1927, HUAM Archives.
77. Gaddis 2000, p. 96.
78. On Bancroft, see Toohey 1995. For an overview of Bonnat's collection of French drawings, see Paris 1979a.
79. This enthusiasm was also shared by Charles Loeser, whose collection of old master drawings now forms the backbone of the Fogg's collection of Italian drawings. However, Loeser's collection remained in Italy until its bequest to the museum in 1932 and had very little connection to the history of collecting in America. For an overview of that collection, see Oberhuber 1979.

collection of drawings [author's emphasis], including my watercolor and pastel drawings . . .
and all other works of art. . . ."[80]

One of the extraordinary ways in which Winthrop and Birnbaum went about their
endeavor was to bring together large groups of images by key figures. The work of Ingres
is one such keystone in the collection.[81] Assessing matters in 1935, Birnbaum wrote,
"Naturally certain groups have become more important than others . . . in the field of pic-
tures no one can dispute . . . that you have the finest existing collection of works by Ingres.
With a few additions, it will rank with those of the Louvre and at Montauban. For that rea-
son, I think every sacrifice should be made to enhance the beauty and interest of this group,
even if you are forced by such a decision to ignore other fields."[82] Although Winthrop may
never have been able to obtain the additions Birnbaum imagined, by the time of his death he
had amassed the largest private collection of works by the artist, representing every period
in his career.[83]

Among the first works Birnbaum (who was still at Scott and Fowles) discovered for him
was the large drawing *The Martyrdom of Saint Symphorien* (cat. no. 79), described by
Théophile Gautier as a work "which captures the thought of the master in its purest, most
essential, most direct form."[84] Birnbaum came upon it in London. He advanced cautiously
because of its undistinguished provenance and its absence from the more recent Ingres liter-
ature. Having decided that the drawing was right, he showed it to John Singer Sargent—
according to Birnbaum, an Ingres enthusiast—and then had it flown to Paris to have the
further opinion of Henry Lapauze.[85] With both aesthetic and critical confidence in the draw-
ing secured, he acquired it for Winthrop. Over a decade later, Birnbaum obtained two oil
studies for the painted composition, one from the collection of the comtesse de Béhague and
another from Baron Vitta (cat. nos. 70, 71).

Finished and portrait drawings by Ingres would remain a focus of Winthrop's Ingres
pursuits. In 1922 Birnbaum secured the *Portrait of the Forestier Family* (cat. no. 64), begin-
ning a collection that would later include such important works as Ingres's largest and most
important group portrait, *Portrait of the Family of Lucien Bonaparte* (cat. no. 55), and the
Portrait of Mrs. George Vesey and Her Daughter Elizabeth Vesey (cat. no. 57), a drawing that
Degas had coveted earlier. If Winthrop's tastes were for the finished drawing, Birnbaum
recognized the importance of studies in helping to understand fully the working process of
the artist: "I am in favor of items like 'Hands' in a collection intended for students."[86]
Winthrop's core of paintings by Ingres includes such gems as his early *Raphael and the
Fornarina* (cat. no. 53), which Birnbaum had pulled from public sale by telegram negotia-
tions with Baron Henri de Rothschild, who was yachting in the Aegean;[87] the portrait
Joseph-Antoine de Nogent (cat. no. 54), which he also secured from the collection of Baron
Vitta; and his intimate *Madame Frédéric Reiset*, his late *Self-Portrait*, and, of course, the
famous *Odalisque with the Slave* (cat. nos. 74, 80, 72).

80. Testament of Grenville L. Winthrop, dated December 6, 1940, Probate Court, Pittsfield, Mass.
81. For the collection of works by Ingres, see Cambridge, Mass., 1980b.
82. Birnbaum, letter to Winthrop, May 10, 1935, HUAM Archives.
83. The collection includes forty-four works securely given to the master and six of questionable attribution.
84. "[Q]ue le saisir la pensée du maître dans sa forme la plus pure, la plus nécessaire, la plus directe"; Gautier 1860, pp. 323–24.
85. Sargent also shared his enthusiasm for Ingres with Winthrop: "I must thank you for the pleasure you have given me in sending on the photographs of those exquisite Ingres drawings—those two groups of the Jordan Family are among the most beautiful I know. They will be a valuable addition to my scrapbook where I collect everything by Ingres that I can lay my hands on"; Sargent, letter to Winthrop, February 28, 1924, HUAM Archives.
86. Birnbaum, letter to Paul Sachs, 1931, HUAM Archives.
87. Birnbaum, letter to Winthrop, July 27, 1931, HUAM Archives. Birnbaum secured it for the bargain price of $15,000.

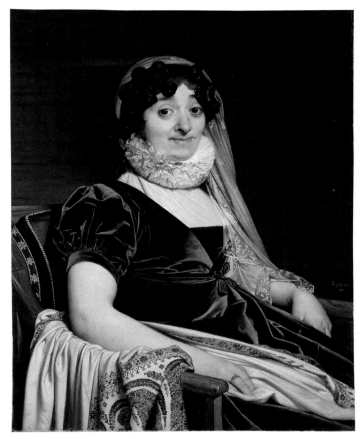

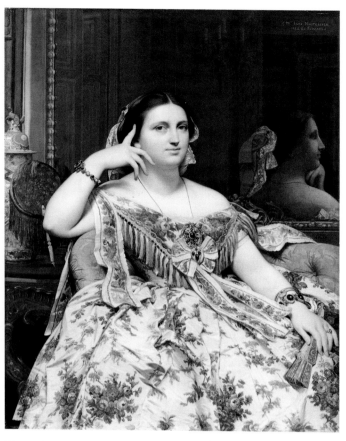

Fig. 20. Jean-Auguste-Dominique Ingres, *Comtesse de Tournon*, 1812. Oil on canvas, 36¼ x 28¾ in. (92 x 73 cm). Philadelphia Museum of Art, The Henry P. McIlhenny Collection in Memory of Frances P. McIlhenny, 1986-26-22

Fig. 21. Jean-Auguste-Dominique Ingres, *Madame Paul-Sigisbert Moitessier*, 1856. Oil on canvas, 47¼ x 36¼ in. (120 x 92.1 cm). National Gallery, London, NG 4821

Obviously the long-term project to represent the artist fully was made difficult by the scarcity—and elevated price—of important paintings. But those factors alone may not explain why Winthrop acquired certain works by Ingres and not others. In one instance Birnbaum resisted because of decorum. Having seen the *Odalisque en Grisaille* (now at the Metropolitan Museum) on the walls of Ingres's heirs, he cautioned Winthrop that "this figure is entirely nude. . . . She would . . . seem strange in your house, except in a room devoted to Ingres exclusively." On the other hand, Birnbaum reassured him that the nude figures in the *Golden Age* (cat. no. 81), which he hoped Winthrop would acquire, "were only about two or three inches high."[88] It appears that such trepidation was Birnbaum's alone; Winthrop seems not to have shared these objections. On his own he acquired the sensuous *Odalisque with the Slave,* and on the advice of Paul Sachs he bought one of Ingres's most beautifully seductive nude studies, that for his *Roger Freeing Angelica* (cat. no. 60). Then there were other matters of taste. The "very beautiful" and "harmonious" *Madame Reiset* was chosen over "the portrait of the ugly Countess de Tournon" (fig. 20), which Birnbaum would not consider since, he wrote Winthrop, "I know you would prefer this smaller example which is so beautiful."[89] In other instances, negotiations were stalled or cut off. Frustrated by his lengthy negotiations to secure works from Ingres heirs who reneged

88. Ibid., June 12, 1928: "Item 38 A famous large oil (in black and white!) Study of the great Odalisque in the Louvre (page 132 Lapauze.) this figure is entirely nude. Some critics prefer it to the Louvre canvas. In any case a great Ingres and unique. She would however seem strange in your house, except in a room devoted to Ingres exclusively. Fcs 425,000 asked."
89. Ibid., May 10, 1935.

on several deals, Birnbaum confessed to Winthrop, "There is apparently nothing to be done,—and I feel disgusted with people who would do that sort of thing. . . ."[90]

Perhaps the portrait that Birnbaum and Winthrop had always hoped to hang among the other Ingres works was *Madame Moitessier* (National Gallery, London; fig. 21). As early as 1928 Birnbaum believed that "there is still a remote hope that the great Ingres portrait (with the flowered dress) may be offered. If it is, I shall seize it and carry it off. . . ."[91] He pursued it again after the Lapauze sale, writing, "I got in touch with the owner of the famous Moitessier portrait and if it comes on the market, I feel fairly certain that it will be offered to me.—There is no immediate prospect of this however."[92] And then in 1934 the portrait was offered to Birnbaum, but he did not "seize it and carry it off." On the contrary, he explained to Winthrop that "it would cost over $65,000.00," consoling himself that by turning it down, "no great bargain has escaped us."[93] Even if so, a great painting had, and when the opportunity presented itself again in 1936, it was too late. Winthrop had already overstretched his resources with the purchase of Jacques-Louis David's celebrated portrait *Emmanuel Joseph Sieyès* (cat. no. 21), which Birnbaum snatched up with immediate payment while it was being crated to be shipped to London for consideration by the National Gallery. Coincidentally, Birnbaum's failure to pursue the Ingres—claiming ultimately that they "did not like the pose of the lady's hand, pressing a plump finger against her head"—made the great portrait available for London to acquire. Although it took little time for Winthrop to find out what had happened to the Ingres portrait that had escaped him, it was only later that Kenneth Clark, director of the National Gallery, saw the David on Winthrop's wall in New York and learned how it had mysteriously vanished.

Although the *Sieyès*, David's deeply felt likeness of his fellow republican, is Winthrop's only painting that is still securely lodged in that artist's oeuvre, the collector also brought together what at the time was an unmatched resource for the study of that artist: his greatest prize in the David group is two sketchbooks, almost pristine in condition, filled with preparatory drawings for the artist's monumental *Coronation of the Emperor Napoleon I and the Crowning of the Empress Joséphine at Notre-Dame (Le Sacre)* (cat. nos. 19, 20). Birnbaum found these, along with another portrait of Napoleon that he failed to acquire, in the possession of the heirs of the duc de Bassano.[94] Their purchase was a rare instance in

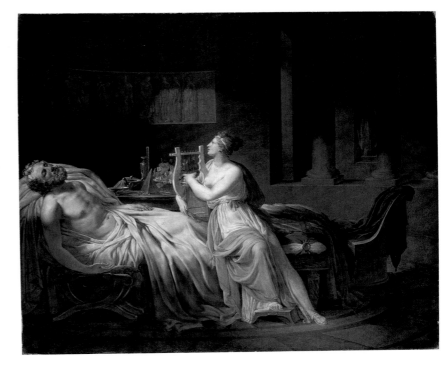

Fig. 22. Attributed to Jacques-Louis David, *Homer and Calliope*, 1812. Oil on canvas, 33⅛ x 39½ in. (84 x 100.4 cm). Fogg Art Museum, Bequest of Grenville L. Winthrop, 1943.231

90. Ibid., October 4, 1928. In the end, they did acquire the *Golden Age* and the watercolor of *The Bather*.
91. Ibid.; never prone to rashness, Birnbaum continued by qualifying, "if the price does not exceed $52,000." On January 4, 1929, he wrote to Winthrop again, "I am told that the fine portrait of Mdme Moitessier with the flowered dress can be secured for not less than $80,000.00"; HUAM Archives.
92. Ibid., July 3, 1929.
93. Ibid., December 4, 1934. Since Winthrop paid $75,000 a year later for the *Odalisque with the Slave*, it would appear that the cost would not have been a consideration for him.
94. As was Lawrence's tender portrait of the young king of Rome (cat. no. 178).

which Winthrop's agent did not place him first. Trying to keep like with like, Birnbaum offered the sketchbooks to the young Henry McIlhenny, for whom he had procured David's double oil portrait of *Pius VII and Cardinal Caprara,* and then urged George Blumenthal to secure the rest of the objects, which included a portrait by Sir Thomas Lawrence (cat. no. 178), for the Metropolitan Museum. Only after McIlhenny did not respond and Blumenthal refused to consider the acquisition on the grounds that it was unethical of him, as a friend of France, to remove such objects from French soil did he offer the lot to Winthrop.[95]

Winthrop had lived with a painting by David since his earliest years as a collector. In 1903 he purchased the much-admired *Portrait of a Young Woman* (cat. no. 23), a perfect eighteenth-century character study, which was exhibited at the Metropolitan Museum early in the century as a David but can no longer be convincingly given to him.[96] However, the David group did not take shape until the mid-1930s with Winthrop's acquisition of the large *Study for "The Oath of the Tennis Court"* (cat. no. 17) and the *Homer and Calliope,* signed and dated 1812 (fig. 22). Birnbaum had passed up many pictures that had carelessly been attributed to David, waiting patiently to find what he termed "authentic examples" for the collection. His enthusiasm for this "truly magnificent" painting (which once belonged to the French composer Ambroise Thomas) was such that he wrote Winthrop: "you simply must have it. I am practically buying it now. . . . "[97] Although few today would share Birnbaum's unqualified enthusiasm, no one has proposed a satisfactory attribution for this important Neoclassical composition. On the other hand, with further study, other works that once were attributed to David now have convincing attributions to others. Such is the case with the fine *Portrait of Tournelle, called Dublin,* also signed "David," which is by Adelaïde Labille-Guiard (cat. no. 84).

There are no attributional doubts about the compositional drawing for the *Oath of the Tennis Court.* It was a gift of the artist to his pupil José de Madrazo y Agudo and remained in the careful care of several generations of that family of artists until Birnbaum acquired it from the artist Mariano Fortuny y Madrazo. Birnbaum immediately began to gather an entire group of related drawings around it (figs. 23–29).[98] None of these fine studies is now attributed to the master, but their number and variety are reminders of the type of in-depth study around one object that Winthrop's collection made possible. These drawings, along with the *Coronation* sketchbooks (containing more than one hundred pages of studies in them) and a group of more than thirty early drawings in the *Roman Album* (cat. no. 16), formed, by any standard, an impressive digest of David's graphic work.

Winthrop was proud of these groups, writing, "The David and Ingres groups must now rank well up when compared with the groups by these men in other private collections. They certainly should be studied by the so-called artists of today, who ignore (perhaps by necessity) all drawing."[99] Such strengths appealed to the collector. He did the same with

95. Birnbaum 1960, p.196.
96. On April 29, 1911, Winthrop is recorded as having lent the portrait to the Metropolitan, along with his recently acquired Giovanni di Paolo (fig. 7) and the *Madonna and Child* by the Master of the Saint Ursula Legend (1943.97).
97. Birnbaum, letter to Winthrop, June 4, 1935, HUAM Archives.
98. Ibid., January 8, 1936.
99. Winthrop, letter to Birnbaum, March 5, 1936, Birnbaum Papers, Archives of American Art.

Fig. 23. Jean-Pierre Norblin de la Gourdaine, *Study for "The Oath of the Tennis Court,"* ca. 1804–5. Pale and dark gray wash over black chalk on bluish white laid paper, 9 x 11⅞ in. (23 x 30 cm). Fogg Art Museum, Bequest of Grenville L. Winthrop, 1943.801

Fig. 24. Jean-Pierre Norblin de la Gourdaine, *Study for "The Oath of the Tennis Court,"* ca. 1804–5. Pale and dark gray wash over black chalk on white laid paper, 11⅜ x 17⅜ in. (29 x 44 cm). Fogg Art Museum, Bequest of Grenville L. Winthrop, 1943.803

Moreau, forming a remarkable collection of more than a dozen works that includes large salon-scale paintings, *Jacob and the Angel* (cat. no. 96) and *The Infant Moses* (fig. 30), as well as intimate watercolors—from the classicizing *Aphrodite* (cat. no. 94) to the later *Poet and Satyrs* (fig. 31)—and a group of smaller paintings, such as his *Saint Sebastian and the Angel* (fig. 32). Winthrop also put together an impressive group of drawings by Pierre-Paul Prud'hon, an artist of an entirely different sensibility to these others (cat. nos. 100–105).[100]

In addition, he continued to deepen his Pre-Raphaelite holdings into his later years. In 1934 Birnbaum wrote, "It is thrilling to think that in one season the 'Six Days of Creation' [Burne-Jones, cat. nos. 161–165], the 'Sir Galahad' [Watts, cat. no. 194] and the 'Blessed Damozel' [Rossetti, cat. no. 188] may reach you through my efforts" and "make a group second to none extant."[101] Winthrop took an active interest in refining his collection of British art. "It seems to me," he wrote Birnbaum, that the collection of Blakes "needs to be strengthened by drawings in which Blake uses a basis of symmetry," and then he provided a shopping list of such objects, on which he was unfortunately never able to check off any items.[102]

Birnbaum's collecting efforts went beyond the simple acquisition of masterpieces. He later recalled that "aside

Fig. 25. Verso of fig. 24

Fig. 26. Jean-Pierre Norblin de la Gourdaine, *The Oath of the Tennis Court*, 1805/1814. Gray and brown wash, white gouache, and graphite over black and brown ink on tracing paper, 20⅛ x 30¾ in. (51 x 78 cm). Fogg Art Museum, Bequest of Grenville L. Winthrop, 1943.804

Fig. 27. Jean-Pierre Norblin de la Gourdaine, *Study for "The Oath of the Tennis Court,"* ca. 1804–5. Pale and dark gray wash over black chalk on white laid paper, 9½ x 14⅜ in. (24 x 36.5 cm). Fogg Art Museum, Bequest of Grenville L. Winthrop, 1943.802

Fig. 28. Verso of fig. 27

Fig. 29. Dominique-Vivant Denon, *Study of Robespierre and Dubois-Crancé in "The Oath of the Tennis Court,"* ca. 1790. Black ink and gray wash over graphite on tracing paper, 9½ x 7¼ in. (24 x 18.5 cm). Fogg Art Museum, Bequest of Grenville L. Winthrop, 1943.800

from their fitness and importance," he chose only objects with Winthrop's "taste and leanings in mind."[103] He added, "Important artists not particularly well presented in American collections were favored, and when we discovered items that showed the influence of one artist on another—as for instance Rowlandson on Gericault and Daumier—every effort was made to secure such related drawings."[104] Adviser and collector alike seem to have been constantly mindful of bringing the work of artists who were not well represented in America to its shores. In convincing Winthrop to acquire Gericault's *White Horse Tavern* (cat. no. 44) Birnbaum stressed that "it is a work we sorely *need* in America [fig. 33]."[105] The collection's depth through encyclopedic acquisition distinguished their endeavor—in fact, made it unique. In no other private collection, and indeed in few museums, could one study

100. For these, see Clark (1997) 2001, pp. 177–201.
101. Birnbaum, letter to Winthrop, July 18, 1934, HUAM Archives.
102. Winthrop, letter to Birnbaum, July 19, 1929, Birnbaum Papers, Archives of American Art.
103. Birnbaum 1960, p. 187.
104. Ibid.
105. Birnbaum, letter to Winthrop, June 9, 1930, HUAM Archives.

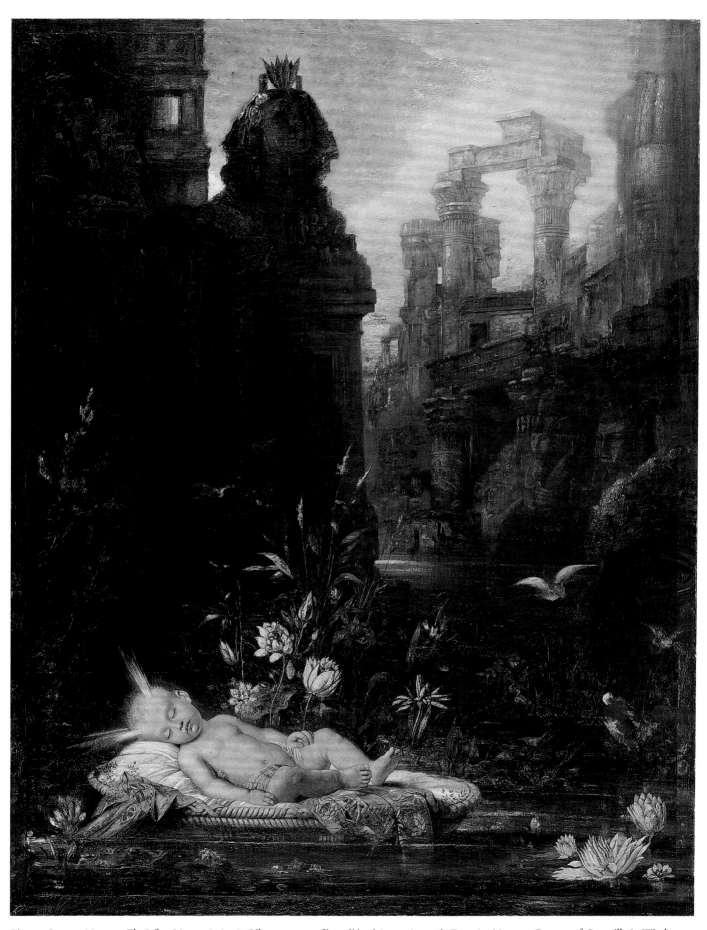

Fig. 30. Gustave Moreau, *The Infant Moses*, 1876–78. Oil on canvas, 72⅞ x 53⅝ in. (185 x 136.21 cm). Fogg Art Museum, Bequest of Grenville L. Winthrop, 1943.262

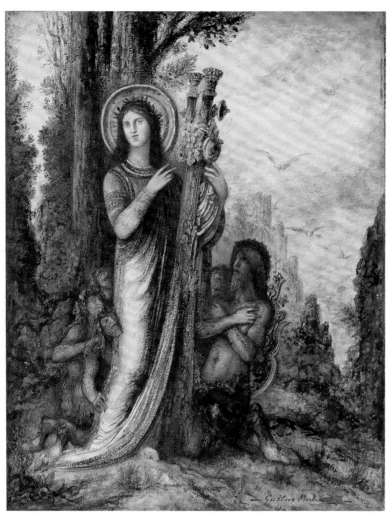

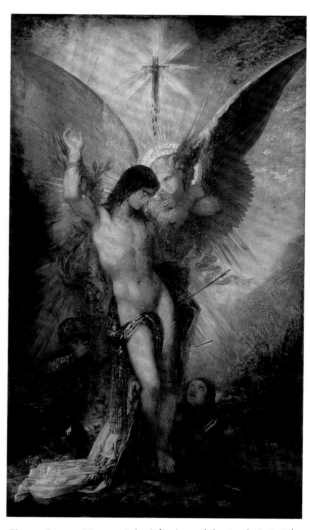

Fig. 31. Gustave Moreau, *Poet and Satyrs*, ca. 1890–95. Watercolor, oil (and/or varnish?), and lead white on off-white paper, 12 x 9¼ in. (30.4 x 23.4 cm). Fogg Art Museum, Bequest of Grenville L. Winthrop, 1943.389

Fig. 32. Gustave Moreau, *Saint Sebastian and the Angel*, 1876. Oil on panel, 27⅜ x 15⅝ in. (69.5 x 39.7 cm). Fogg Art Museum, Bequest of Grenville L. Winthrop 1943.265

Fig. 33. Installation of works by Gericault and Prud'hon in the reception room in Winthrop's New York house, 1943. HUAM Archives (photo: James K. Ufford)

the work of the great as well as the now often-forgotten artists of the nineteenth century in such extraordinary depth and variety. In areas such as Pre-Raphaelite and Symbolist art the collection was without equal. Indeed, by the end of his life Winthrop's holdings became as much a collection of the "salient figures of the nineteenth century" as an archive of its rich traditions.

Winthrop collected independently of Birnbaum as well, as is amply evidenced by his extraordinary collection of Asian art. He was always willing to accept works quietly from friends in need. Seeing that Philip Hofer was strapped for cash during the Great Depression, he offered to buy the drawings Hofer owned from the *Au cirque* series by Henri de Toulouse-Lautrec (see cat. no. 133).[106] Royal Cortissoz, after parting with some of his beloved drawings to raise funds for the care of his ailing wife, consoled himself by writing, "They go to a true home of beauty, in a perfect house. . . ."[107] In fact, in the area of Western art Winthrop made some of his

Fig. 34. Jean-Baptiste-Siméon Chardin, *Portrait of a Man*, 1773. Pastel on paper, 21⅜ x 17⅜ in. (54.4 x 44.2 cm). Fogg Art Museum, Gift of Grenville L. Winthrop, Class of 1886, 1939.89

most impressive purchases independently. He acquired Jean-Baptiste-Siméon Chardin's dazzling late pastel *Portrait of a Man* (fig. 34), and even in the final year of his life, surely knowing that he would never see it installed at home, he purchased Canaletto's *Piazza San Marco, Venice* (fig. 35). Through Wildenstein and Company in New York, he made some of his most remarkable acquisitions in the area of his and Birnbaum's focused interest. Among the works on this roster are Pierre-Auguste Renoir's *Spring Bouquet* (cat. no. 110), Daumier's *Scapin* (cat. no. 15), Claude Monet's *Road toward the Farm Saint-Siméon, Honfleur* (cat. no. 91), Vincent van Gogh's *Blue Cart* (cat. no. 46), and Ingres's *Odalisque with the Slave*,

Fig. 35. Canaletto, *Piazza San Marco, Venice*, ca. 1730–35. Oil on canvas, 30 x 46¾ in. (76.2 x 118.8 cm). Fogg Art Museum, Bequest of Grenville L. Winthrop, 1943.106

as well as his powerful late *Self-Portrait* (cat. nos. 72, 80).

Birnbaum was generally pleased and encouraged these additions, but he also responded candidly to them.[108] After all, he had encouraged Winthrop to acquire Ingres's *Self-Portrait* as early as 1929, when he had discovered it still hanging on a wall of the artist's descendants the Ramels. Although at the time the unknown and unpublished painting was met with suspicion, Birnbaum was convinced that this was the finest of the self-portraits—although perhaps unfinished—and he set out to establish its authenticity. In a letter to Winthrop, he triumphantly reported, "I found the *original will* in the handwriting of Ingres or signed by him, at an old family attorney's office and I am photographing it. It refers to this portrait and his wife's portrait as 'painted by my own hand'! Then I took the portrait out of the frame and found it was signed!"[109] At the time, however, on the advice of others, Winthrop passed up the opportunity to add

Fig. 36. Unknown artist, *Man in a Felt Hat*, early 19th century. Oil on canvas, 29⅝ x 27⅛ in. (75.2 x 69 cm). Fogg Art Museum, Bequest of Grenville L. Winthrop, 1943.250

what is now recognized as one of the great portraits of Ingres's last years; he purchased it seven years later from Wildenstein. On learning of this, Birnbaum wrote of his keen interest in the acquisition but stated bluntly, "I only hope that it is in its original condition," and that "you won't have to pay too much."[110] In fact, during the Great Depression, Winthrop paid $45,000 for the picture that Birnbaum had offered to him for about $25,000 at the height of the financial markets before the crash.

Fig. 37. Ingres Room in Winthrop's New York house, 1943. HUAM Archives (photo: James K. Ufford)

Fig. 38. Thomas Couture, *Romans of the Decadence*, 1847. Oil on canvas, 23⅜ x 35⅞ in. (59.4 x 91.1 cm). Fogg Art Museum, Bequest of Grenville L. Winthrop, 1943.224

Birnbaum was less enthusiastic about other independent acquisitions. When Winthrop acquired the now-disputed *Portrait of a Man in a Black Felt Hat* (fig. 36), seen in the far corner of his Ingres Room (fig. 37), as an early Ingres from Jacques Seligmann in 1935, Birnbaum expressed his reservations about it in no uncertain terms. "There are many works by Ingres which I do not like as much," he wrote, but although the painting is a "really fascinating . . . and . . . beautiful original portrait . . . it is not by Ingres," and "I shall advise . . . removing the Ingres label!"[111] "Please understand," he wrote, "I like the picture *very* much indeed, no matter who painted it."[112]

Birnbaum understood Winthrop's pleasure at seeing students come to New York and learn directly from the works in his collection, and he recognized what could be gained from the study of large groups by one artist as well as from broad sweeps through particular fields. In the undisturbed quiet of Winthrop's home, students could study, in extraordinary number, a steady stream of nineteenth-century masterpieces, but they could also look at the art in a variety of contexts. One could look at the work of David and also assess the heritage of his classicism. Winthrop's remarkable collection of Moreaus could be seen along with paintings by Burne-Jones, an artist the French master admired, or next to the work of Flaxman, an artist from whom he learned. Through the groupings of such diverse works as the *Romans of the Decadence* (fig. 38), the early portrait *Paul Barroilhet* (fig. 39), and the satirical *Illness of Pierrot* (fig. 40), one could appreciate the eclecticism of Thomas Couture.

106. Cox 1975, p. 32.
107. Cortissoz, letter to Winthrop, October 22, 1934, HUAM Archives.
108. Birnbaum often alerted Winthrop to the possibility of forgeries on the market. To one such caution Winthrop replied, "I am glad you warned me against forged Daumier & Ingres for today I received a telephone message from a 57th-Street dealer asking me to stop in to see an Ingres drawing. I shall stop in but shall not buy it even though it prove to be 'a right one'"; Winthrop, letter to Birnbaum, April 30, 1930, Birnbaum Papers, Archives of American Art.
109. Birnbaum, letter to Winthrop, May 24, 1929, HUAM Archives.
110. Ibid., June 17, 1936.
111. Ibid., January 8, 1936.
112. Ibid., January 31, 1936.
113. Ibid., January 4, 1929.

Under Winthrop's roof Moreau's Salome could be looked at next to Beardsley's; Flaxman's illustrations of Dante, next to Blake's; and Dante in turn could be thought about through Rossetti's obsessive meditations. Winthrop himself, who was profoundly moved by the music-bound aestheticism of Pater, must have found much personal satisfaction in looking at the music-making siren playing "wild notes" in Rossetti's *Sea Spell* or at Whistler's subtle pictorial Nocturnes and Harmonies (cat. nos. 212, 213, 215, 216). At no time was the teaching aspect of the collection forgotten. In fact, Winthrop was probably reassured by the pedagogical usefulness of his pursuit because that divorced it from the frivolous. Learning of a midyear visit to the collection, Birnbaum wrote to Winthrop, "I hope the Harvard boys enjoyed their treat."[113]

"Treat" seems an inadequate term to describe what awaited students in New York. Winthrop's

Fig. 39. Thomas Couture, *Paul Barroilhet (1810–1871)*, 1849. Oil on canvas, 39⅜ x 32¼ in. (100 x 81.9 cm). Fogg Art Museum, Bequest of Grenville L. Winthrop, 1943.223

Fig. 40. Thomas Couture, *The Illness of Pierrot*, 1859–60. Black and white chalk on gray paper, 18⅜ x 24⅛ in. (46.7 x 61.3 cm). Fogg Art Museum, Bequest of Grenville L. Winthrop, 1943.793

Fig. 41. The exterior of 15 East 81st Street, New York, 2002 (photo: Photograph Studio, The Metropolitan Museum of Art)

Fig. 42. Winthrop's desk in his New York house, 1943. HUAM Archives (photo: James K. Ufford)

treasures were displayed together, either by artist or by period, in a veritable museum. By the middle of the 1920s he had run out of space. Recognizing that his house would no longer accommodate his burgeoning collection, he built a new house a few steps from the Metropolitan Museum.[114] This abode, at 15 East Eighty-first Street, was nothing less than a self-portrait. Relying on the services of Julius Gayler as he had for Groton Place, Winthrop filled the large double lot, nestled among imposing limestone buildings, with a seemingly modest Georgian Revival town house (fig. 41). By now in his mid-sixties, his daughters off living independent lives, he essentially built a home for his collection, with a bedroom reserved for himself and a guest room for his brother Beekman. Passing under the Winthrop crest, which remains above the door today, the visitor to Number 15, as it was called, was met with chamber after chamber of obsessively arranged and classified objects from all reaches of his collection. Mesoamerican masks were carefully placed on tables beneath gold-ground Italian paintings; Shang dynasty bronzes and Korean Buddhas were displayed in the company of French drawings.[115] Each room in the maze of chambers was fitted with suites of objects organized by general subject. There was the Ingres Room, the

Fig. 43. Winthrop's desk, 1943. HUAM Archives (photo: James K. Ufford)

Fig. 44. Blake Room in Winthrop's New York house, 1943. HUAM Archives (photo: James K. Ufford)

Fig. 46. One panel of John La Farge, *When the Morning Stars Sang Together and All the Sons of God Shouted for Joy*, ca. 1884–85. Leaded, rippled, and smooth opalescent glass with fired enamel paints, 34½ x 24⅜ in. (87.6 x 61.9 cm). Fogg Art Museum, Bequest of Grenville L. Winthrop, 1943.1080A

Fig. 45. Window wall of the Blake Room in Winthrop's New York house, 1943. HUAM Archives (photo: James K. Ufford)

Pre-Raphaelite Room, the Gill-Beardsley-Bonington Room. These quarters were Winthrop's private world and its objects his passion. With the utmost care and attention, and always in his impeccable handwriting, Winthrop painstakingly catalogued each object that arrived at Number 15 on a file card and registered its price in a journal (fig. 42).[116] Among the various objects on the desk at which he worked, next to a surrogate portrait of himself through his proud family tree, Winthrop kept a portrait of Birnbaum, a poignant reminder of the joint nature of their enterprise (fig. 43).

Upon the arrival of Birnbaum's discoveries, Winthrop could personally assess his acqui-

114. Although he did not move there until 1927, Winthrop had acquired the land on January 20, 1898; Offices of the New York City and County Register, Liber 4255, p. 56. Winthrop presumably entertained the possibility of moving there earlier. The construction of Fifth Avenue's first apartment tower about 1910 (McKim, Mead and White's 998 Fifth Avenue) a few doors down may have deterred him from doing so.

sitions for the first time. This done, he methodically proceeded to have them restored, reframed, or mounted, and then installed in the secure confines of Number 15. The fastidious collector—who was so taken by order and arrangement that he kept drawn records of seating plans from dinner parties (down to recording the shape of the table at which he sat)—devoted hour after solitary hour to studying and arranging his treasures, creating ensembles that were worlds unto themselves. These meticulously measured installations would then need to be further reworked and refined to accommodate the constant stream of additions. By the end Winthrop had covered nearly every inch of wall space. When he drew open the curtains of the Blake Room, a vault of more than fifty works by that artist, the double-hung rows of drawings of the *Book of Job* and Dante's *Divine Comedy* were bathed in the luminous light emanating from John La Farge's stained glass of Blake's singing angels in plate 14 for his *Book of Job*, which Winthrop had set into the room's window (figs. 44–46). Over the fireplace, he installed Blake's *Christ Blessing* (cat. no. 144), a work that once belonged to the pioneering American collector James Jackson Jarves.[117]

Fig. 47. John Singer Sargent, *The Honorable Laura Lister*, 1896. Oil on canvas, 66½ x 45⅜ in. (168.9 x 115.3 cm). Fogg Art Museum, Bequest of Grenville L. Winthrop, 1943.156

As he had been with his daughters, Winthrop was highly protective of his treasures and loath to seeing them leave his home. So strong were his feelings against lending that after his move to Number 15, he made it a rule not to allow them to leave. As a result less than a handful of works was ever seen outside the fixed installations of his private dwelling. He contributed La Farge's *Dawn* (cat. no. 206) to the 1936 retrospective at the Metropolitan Museum and then, reluctantly, a painting he personally prized by Sargent, *The Honorable Laura Lister* (fig. 47), for a 1941 exhibition at Knoedler as a testimonial to his friend the critic Royal Cortissoz.[118] In each case the paintings were lent anonymously. The final instance was the loan of his watercolor illustrations of Blake's *Book of Job* to an exhibition at the Pierpont Morgan Library, New York, that brought together all three versions. When Hofer and J. P. Morgan Jr., who owned the others, arranged to have the books reproduced in color abroad, Winthrop wrote, "I have refused to allow my drawings to leave No. 15. . . . I am willing to share the expense of the publication but not willing to run the risk of damage to the drawings—I hope you think I am right for I do not wish to appear narrow in this matter."[119] The frustration with this policy was an often-voiced lament by museum directors as well: "the unfortunate thing is that Mr. Winthrop, after full and due consideration, has decided not to lend his collections or objects from them. He has talked to me and written to me with very obvious frankness on his feelings about the matter, and I have no reason to suppose that he has changed his mind."[120] The collection *was* Number 15. With any work missing, the whole was deficient. For Winthrop it was all or nothing.

115. Between 1931 and 1941, Winthrop also purchased some seventeen pieces of sculpture from the Aztec, Mixtec, Toltec, Totonac, and Teotihuacan cultures, from Joseph Brummer in New York. Through Brummer he also acquired medieval and Egyptian sculptures and an important series of Achaemenid reliefs. The earliest record of transactions with the noted dealer dates from 1925.
116. Winthrop's register, running from 1927 to 1937, also records potential purchases.
117. Winthrop took an active interest in his collection of Blakes, writing, "Do you think there is a chance of adding desirably to the Blake drawings? And of

With Birnbaum's help Winthrop attended to every detail of the display and arrangement. Before he even received Rodin's fragile wax bust *Puvis de Chavannes* (a personal gift from the sculptor to his executor, Léonce Bénédite; fig. 48), he carried out Birnbaum's plans for a suitable mount: "The enclosed slip shows the plan of the base of the Rodin wax bust of Puvis. It is *seven* inches high, and it would be well to have Newcomb make a wooden base about an inch high, and also to order a glass case similar to those protecting the French busts."[121]

With few exceptions Winthrop placed each of his precious drawings by Prud'hon and van Gogh, his watercolors by Homer and Sargent, indeed nearly every drawing he owned, in a highly polished gold frame milled to his exacting design, which he conceived as a way of lending uniformity to his holdings (fig. 49). He programmatically discarded period mats and mounts to float the liberated sheet within a carefully crafted mat, allowing the drawn specimen to be analytically studied right to its edges. At the foot of each mat Winthrop had the name of the artist and title of the work carefully inscribed. Over the years these have become objects in their own right, cursorily referred to as a "Winthrop package" (fig. 50). For the treatment of pictures and drawings, Birnbaum

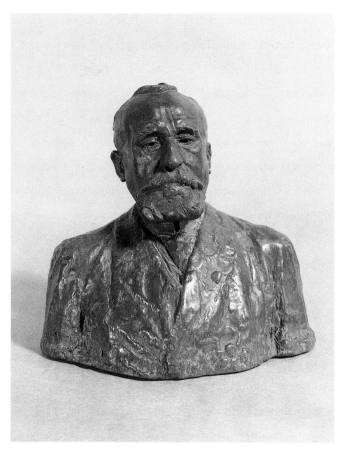

Fig. 48. Auguste Rodin, *Pierre-Cécile Puvis de Chavannes*, 1891. Wax, tinted green, 7 x 6⅞ x 4½ in. (17.8 x 17.3 x 11.4 cm). Fogg Art Museum, Bequest of Grenville L. Winthrop, 1943.1281

Fig. 49. Ingres corridor in Winthrop's New York house, 1943. HUAM Archives (photo: James K. Ufford)

Fig. 50. Thomas Couture, *Day Dreaming (Soap Bubbles)*, 1859. Black and white chalk on gray paper, 23 x 17¾ in. (58.3 x 45 cm). Fogg Art Museum, Bequest of Grenville L. Winthrop, 1943.792

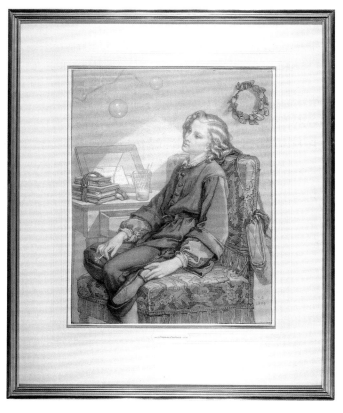

often sent careful instructions: "Again, I hope you will agree that the picture should be carefully cleaned and varnished, *but if possible* not relined. The Nogent should not be touched. (I think the Reiset frame should be beautifully regilded in antique light gold, but the Ingres frame retained. I think it was painted with rounded corners.) The 'Ossian' probably is a trifle larger, and of course it should be reframed,—the mat to have the usual inscription which Clayton should copy correctly from Lapauze,—The labels on the back of the Reiset to be carefully preserved."[122] Bent on maintaining aesthetic unity in his installations, Winthrop regarded or disregarded such advice as he saw fit.

The aesthetic merit of the Winthrop package is still open to debate, but it is impossible not to lament the loss of historical record that resulted from his clinical decisions. Through Winthrop's programmatic treatment, for example, the only Burne-Jones frame to be written about in contemporary English reviews—the elaborate structure encasing the six panels of the *Days of Creation*—was done away with so that the days could be hung as discrete images on both sides of Rossetti's *Blessed Damozel* (fig. 51; cat. nos. 161–165, 188).[123] The tragic consequences of the decision to remove the celebrated period frame is made clearer by the artist's handwritten inscription on the reverse of each painting, which reads: "This picture is not complete by itself but is No. [X] of a series of six water colour pictures representing the Days of Creation which are placed in a frame designed by the Painter, from which he desires they may not be removed." Sadly, this was not the only example. The artist-designed frame for Moreau's *Saint Sebastian,* recorded in letters and in watercolor, and the frame for Hunt's *Miracle of the Sacred Fire,* among others, were further casualties.

While Birnbaum was scouting for art in Europe or off discovering exotic corners of the world, Winthrop spent his days methodically seeing to the arrangement of his collection. He would report on the covers he had made for the cases for the Chinese jades, on his satisfaction with new lighting for the objects, or on the frames he had chosen for paintings. Likewise, Birnbaum would share his ideas about the project of installation and look forward to working on it when he was back in New York. "It will be great fun hanging the 'grand' staircase in October—always with the finest single example of each of your groups: Blake, Daumier, Ingres, Beardsley, Delacroix, Whistler, Burne-Jones, Sargeant [*sic*], etc. This stairway will be a key and a taste of the treasures in the house. I hope the thought appeals to you, for it will involve only slight changes in the present hanging."[124] Although Birnbaum may have placed some of the larger pictures at Number 15, it is fair to assume that the intricate relationships among objects were manifestations of Winthrop's vision. He certainly staged the uncanny face-off between a New Kingdom portrait of a man and a fifth-century Bodhisattva, as well as the curious audience of Tibetan deer gazing up at Degas's *Dancer* in the second-floor stairwell (fig. 52). However, there are certain things that could have been done only by Birnbaum. For instance, the trenchant juxtaposition of Albert Sterner's portrait of Winthrop with Renoir's of Victor Chocquet (cat. no. 112)—that rarest type of discriminating collector who with limited means held firm to his convictions to amass an

investigating further the drawing attributed to Fuseli by some critics? Any drawing with doubt clinging to it must be removed from the Blake room. Do you not agree?"; Winthrop, letter to Birnbaum, May 27, 1928, Birnbaum Papers, Archives of American Art.

118. New York 1936, no. 24; New York 1941, no. 33.

119. Winthrop, letter to Birnbaum, August 31, 1930, HUAM Archives.

120. Herbert E. Winlock, letter to Walter Pach, February 13, 1937, Archives, The Metropolitan Museum of Art, New York.

121. Birnbaum, letter to Winthrop, June 12, 1928, HUAM Archives.

122. Ibid., May 19, 1935.

123. Mitchell and Roberts 2000, p. 365. The tragedy of this is made worse by the disappearance of the *Fourth Day*, from Dunster House, Harvard University, in 1970.

124. Birnbaum, letter to Winthrop, August 4, 1927, HUAM Archives.

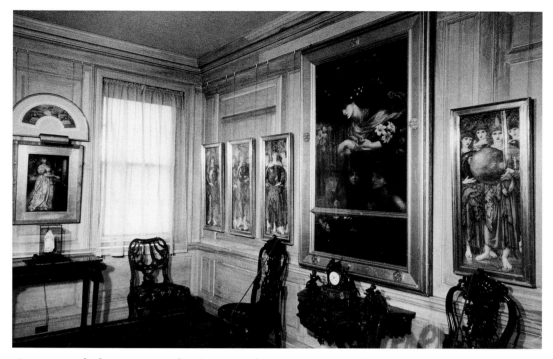

Fig. 51. Pre-Raphaelite Room in Winthrop's New York house, 1943. HUAM Archives (photo: James K. Ufford)

extraordinary collection—must have been Birnbaum's tribute to Winthrop's pioneering efforts (fig. 53).[125]

Although it is essentially forgotten today, Winthrop's collection was well known and much admired by specialists of his day. As he did with his objects, Winthrop kept a faithful list of everyone who passed through the doors of his house, carefully entering their names into a running ledger. Visits from his family and from Birnbaum were recorded, as was a veritable who's who of New York society and the international art world. As one would expect, the watchful eye of dealers often passed through to scan the developments in the collection: among them, Joseph Duveen, Colin Agnew, René Gimpel, Joseph Brummer, Pierre Matisse, and the Wildensteins. Then there were Nelson Rockefeller, Eleanor Roosevelt, the Walter Gays, Henry Francis du Pont, and William Randolph Hearst (who visited with Marion Davies), as well as the other great New York collectors, Henry Clay Frick, George Blumenthal, Percy Selden Straus, and Robert Lehman. There was the gamut of artists and scholars, among them Diego Rivera, Paul Manship, Erwin Panofsky, Oswald Siren, and Max Friedländer.[126] And then there were the students, who came to learn from direct contact with the originals in Winthrop's collection. From Yale or from Harvard, they came on annual study trips to New York. Many of these young scholars and aspiring art historians would become the bright lights of the next generation. Among the students who visited from Harvard were Henry McIlhenny, Joseph Pulitzer, Lincoln Kirstein, and John Walker, as well as many others who would become the future impresarios of American culture. Winthrop took great pleasure from these visits and as early as 1929 seriously began to consider leaving his collection to the legions of students that would follow them.

125. It is interesting to note that Birnbaum was not involved with the acquisition of any of Winthrop's paintings by Renoir.
126. Winthrop also maintained what might even be called friendships with Cortissoz, Manship (see note 55 above), and Augustus Tack.

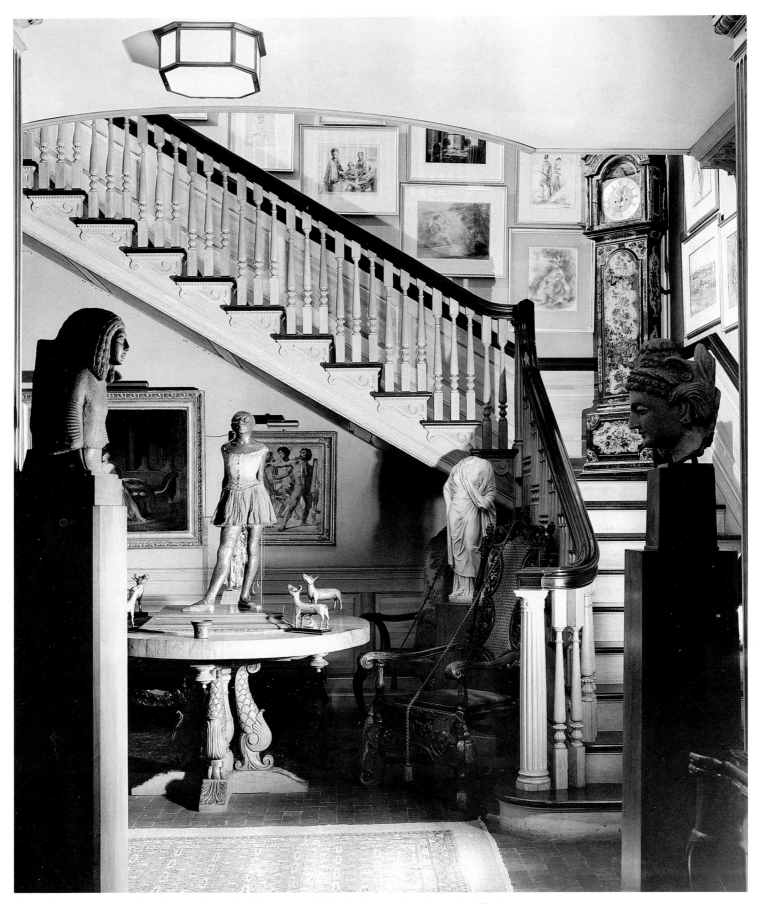

Fig. 52. Second-floor stairwell in Winthrop's New York house, 1943. HUAM Archives (photo: James K. Ufford)

Fig. 53. Second-floor hall in Winthrop's New York house, 1943. HUAM Archives (photo: James K. Ufford)

What seemed clear and certain to Winthrop did not to others. He responded with conviction to a lengthy plea that he consider donating his collection to the then nascent National Gallery of Art in Washington, D.C., where, it was argued, it would be available to the general public "and not only a selected group of college students."[127] "I admit that more people of the 'general public' will visit Washington than Cambridge," he responded, "but I am not so much interested in the general public as I am in the Younger Generation whom I want to reach in their impressionable years and to prove to them that true art is founded on traditions and is not the product of any one country or century and that *Beauty* may be found in all countries and in all periods, provided the eye be trained to find it."[128] Winthrop's friends had other ideas as well. Writing in 1936, Birnbaum pleaded with him to keep the collection in New York.

> I shall always feel strongly in favour of allowing the collection to remain in New York, just as you have built it up. . . . Aside from any special educational plan, the collection would, I think, be a more powerful influence for good in New York . . . [where] they would be dealing with a special institution. . . . It is fairly safe to say that the influence of the collection at Cambridge would be in the main limited to Harvard students, whereas in New York, where special arrangements could be made by curators and post graduate students of *all* universities, attracted by a group of museums like the Metropolitan, Frick, Modern Museum, Whitney, Hispanic & Morgan foundations,—the Winthrop Museum . . . would have a unique distinction, and not form a part of another museum, in which sooner or later it would be lost.[129]

These sentiments were shared by Cortissoz, who confided to Birnbaum that, "for years I have been hammering away on its remaining in New York. . . . Only last Wednesday I was at the house and returned to the subject. Well, we shall see. Meanwhile I hope."[130] However,

127. Herbert Friedman, curator at the Smithsonian Institution, Washington, D.C., letter to Winthrop, July 1, 1938, HUAM Archives.
128. Winthrop, draft copy of letter to Friedman, July 11, 1938, HUAM Archives.
129. Birnbaum, letter to Winthrop, February 4, 1936, HUAM Archives.
130. Cortissoz, letter to Birnbaum, November 30, 1935, Birnbaum Papers, Archives of American Art.

Winthrop was not swayed by others' arguments. In 1937 he wrote to the president of Harvard promising the unconditional bequest of his entire collection to his alma mater, "with every hope that . . . [it] may prove for generations to become a benefit to students of art and lovers of beauty." [131]

At the time these arrangements were finalized, no one would have been able to imagine the remarkable ways in which the collection would continue to develop. Indeed, instead of seeing his collecting interests wane, Winthrop still embraced his passion with vigor and even took it in new directions. In 1940 he acquired his first work by Paul Gauguin, and in the following year he acquired two dozen Whistlers en masse from the Hunt Henderson collection in New Orleans, including his great *Nocturne in Blue and Silver* (cat. no. 212), the first Whistler ever to be given that musical term to define its genre. [132]

In the last three years of his life alone, with the Great Depression not yet completely over, Winthrop, then over seventy-five years old, acquired such key works as Ford Madox Brown's *Self-Portrait* (in 1939; cat. no. 153), Rodin's *Eternal Idol* (in 1939; cat. no. 119), Homer's *Mink Pond* (in 1941; cat. no. 202), Eugène Delacroix's pastel *Christ Walking on the Waters* (in 1941; cat. no. 30), Canaletto's *Piazza San Marco* (in 1942; fig. 35), Renoir's *Spring Bouquet* (in 1942; cat. no. 110), and only months before his death, Charles Willson Peale's large portrait of *George Washington*, which for generations had remained with the heirs of the marquis de Lafayette. [133] Until the very end, weakened and frail, he was "busy with his beauty," [134] buying works by Matthijs Maris, Jongkind, Antoine-Louis Barye, Richard Parkes Bonington, and Frédéric Bazille. In October 1942, he sent one of his last letters to his trusted friend:

> My dear Mr. Birnbaum:—
> Many thanks to you. I think this has been a very successful Autumn. I am sure
> Prof. S. [Sachs] will agree.
> Again many thanks,
> Sincerely, G.L.W.
> P.S. I am delighted." [135]

131. Winthrop, copy of letter to James B. Conant, president of Harvard University, May 24, 1937, HUAM Archives.

132. Birnbaum would often press Winthrop to branch out into later French drawing. Writing to Winthrop from Florence, August 14, 1927, Birnbaum offered "Two good drawings by Monet. They are pencil drawings, one a figure, one a landscape. Of course they are not good drawings, but very fine examples of Monet who was a poor draughtsman altho' a great Impressionist Painter"; HUAM Archives.

133. Charles Willson Peale, *Portrait of George Washington*, 1784, 1943.144. The painting, modeled after the artist's Annapolis portrait, was sent by the Virginia legislature to Thomas Jefferson in France to serve as a model for a statue by Jean-Antoine Houdon. It remained with the heirs of Lafayette's brother-in-law, the vicomte de Noailles, until 1930, when it was acquired by an American collector.

134. In 1921, Winthrop's niece recorded that her uncle was always "busy with his beauty"; Wexler 1998, p. 152.

135. Winthrop, letter to Birnbaum, October 20, 1942, Birnbaum Papers, Archives of American Art.

A PRIVATE PASSION

All works in this catalogue are in the Fogg Art Museum, Harvard University Art Museums, Cambridge, Massachusetts, unless otherwise noted.

Antoine-Louis Barye

Paris, 1795–Paris, 1875

1. *Tiger Attacking a Peacock,* ca. 1830–40

Plaster covered in tinted wax
6½ x 18¾ x 6⅞ in. (16.5 x 47.6 x 17.5 cm)
Signed on top of base, on tiger's left: BARYE
1943.1023

Especially skilled at sculpting carnivorous creatures attacking their prey, Barye often modeled such groups, and the naturalistic detail of his sculptures was highly appreciated in both monumental and tabletop format. His *Tiger Attacking a Peacock* was conceived as a pendant to the *Tiger Attacking a Pelican.*[1]

Birnbaum wanted to acquire a Barye model for Winthrop as early as 1932, when he first mentioned such an acquisition to his patron: "I also saw Schoeller again. He is building a country place and I am certain that he would be willing to let me have a carefully selected group of Barye's *models* in bronze, & *original wax figures* (Barye covered plaster with wax & made his delicate touches in the latter medium). If you

favour this, please tell me in a general way how large a sum you would care to devote to the group and I will discreetly approach the problem."[2]

Birnbaum would have to wait until 1940 to buy such a piece for Winthrop: "I secured the Tiger and Peacock, Barye's superb original model, for the low sum of $440.00! In Paris, it would have cost (if such an item were available) between two and three thousand dollars. Hardly had the hammer fallen when another bidder claimed that he had made a higher bid. The auctioneer looked at me and saw that I would protest if he undertook to re-open the bidding!" In the same letter, Birnbaum noted the damage to the piece: "The beak of the peacock ought to be repaired (I am sure Manship would do it). However, nothing will be done till you see it."[3]

Birnbaum's enthusiasm is justified, since the *Tiger Attacking a Peacock* is a *chef modèle* that represents an important stage in the

making of a Barye bronze.[4] The plaster-and-wax modeling procedure was apparently unique to Barye, who, from his original mold in clay, would cast a plaster *chef modèle,* which he would rework with more plaster and wax. The wax, a material softer than the plaster and more easily modeled, would be carved and incised so that the fine details of surface texture could be reproduced exactly in the bronze to be cast from it. This unique bronze, in turn, would serve as a model from which an edition of bronze casts could be produced. Traces of French sand inside the base of the Winthrop model confirm that it was used to make a sand mold, the first step in the bronze sand-casting process.

Key measurements made by Arthur Beale and Jeanne Wasserman[5] indicate that the tiger is related in size to the vertical tiger climbing up the right side of the elephant in the *Tiger Hunt* group, which was cast in 1836 as the centerpiece of the table

Fig. 54. Antoine-Louis Barye, *Tiger Attacking a Peacock,* after 1876. Bronze, 17¾ x 6¼ x 6⅞ in. (45.1 x 15.9 x 17.5 cm). Nelson-Atkins Museum of Art, Kansas City, Mo.; Gift of Mrs. Justin L. Mooney, 65-6/1

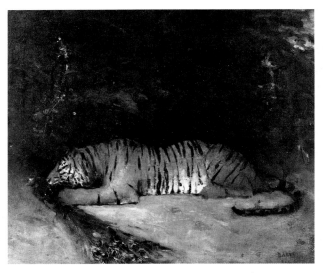

Fig. 55. Antoine-Louis Barye, *Tiger Devouring a Peacock,* ca. 1830–40. Oil on canvas, 15 x 18 in. (38.1 x 45.7 cm). M. H. de Young Memorial Museum, Fine Arts Museums of San Francisco; Memorial gift from Dr. T. Edward and Tullah Hanley, Bradford, Pa., 69.30.9

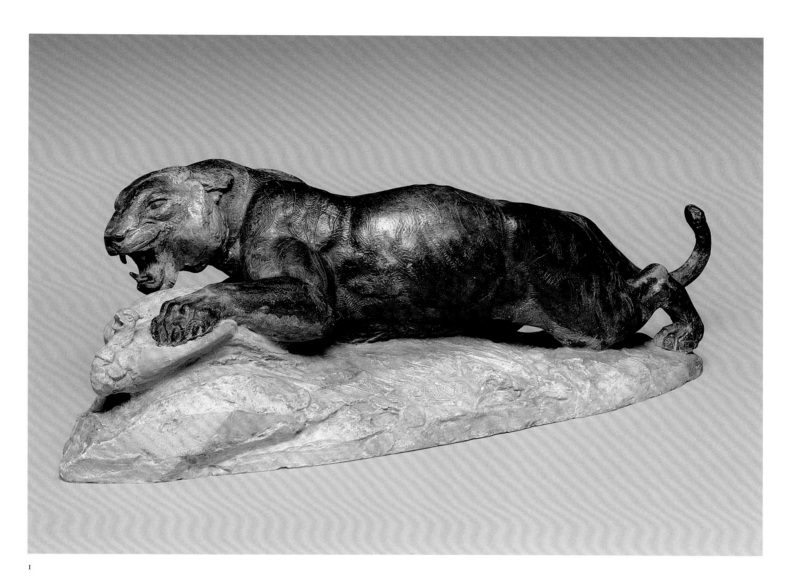

1

decoration commissioned by the duc d'Orléans. The adaptation of the vertical tiger to the horizontal figure pouncing on its prey explains the need for the alterations that appear on this model. Both the fore- and hind legs have been lengthened, the tiger's left haunch is pressed inward, and its head has been brought close to the peacock by means of a wedge of plaster inserted into the nape of the neck.

Winthrop's plaster-and-wax model is illustrated in Saunier with the title *Lioness Seizing a Peacock*. From this illustration it is clear that the Fogg's model has suffered some damage. The peacock's bill is indeed broken off. Evidently the repairs Birnbaum suggested were never made.

The bronze edition from this model

before it was broken was evidently small, since so far the only casts known are the two in American museums. The bronzes in the Nelson-Atkins Museum of Art (fig. 54), and the M. H. de Young Memorial Museum in San Francisco (1967.10) were cast by the Barbedienne foundry, and on both casts the peacock's bill and wing are intact, as in Saunier's illustration,[6] and the tiger's tail looks slightly different. Since the *Tiger Attacking a Peacock* does not appear in any existent Barye sale catalogues, the Barbedienne edition is presumably the only one. Barbedienne probably acquired the plaster-and-wax model in the Barye sale at the Hôtel Drouot in 1876, just after the artist's death.[7] The subject appears again in bronze in Barbedienne's own 1893 cata-

logue of works by Barye.[8] Barbedienne showed the plaster-and-wax *modèle* in the 1889 exhibition at the École des Beaux-Arts.[9]

The damage to the *chef modèle* occurred after these bronzes were cast, possibly during the process of casting the edition. Perhaps Barbedienne never made a master bronze model, as Barye would have done for a large edition. Instead, he could have used the plaster-and-wax piece directly as a model. Barye also created an oil painting on the same subject, but much tamer and without the tension of the sculpture (fig. 55).

Anna Tahinci

1. A bronze cast of *Tiger Attacking a Pelican* is now in a Parisian private collection.
2. Birnbaum, letter to Winthrop, February 4, 1932, Harvard University Art Museums Archives.

3. Birnbaum, letter to Winthrop, October 18, 1940, Harvard University Art Museums Archives.

4. In another letter, dated November 1, 1940 (Harvard University Art Museums Archives), Birnbaum wrote to Paul Sachs: "By the way, only last month, there was added a superlative water colour of two leopards by Barye [*Two Jaguars in Their Lair;* cat. no. 3], and what is more important an original unique model (plaster & wax) by Barye of a tiger devouring a peacock, one of the finest items of the kind I have ever seen!"

5. Cambridge, Mass., 1975–76b, p. 85.

6. Saunier (1925a, p. 62, fig. 22) notes that it is an "unedited plaster, collection Zoubaloff."

7. Hôtel Drouot, Paris, February 7, 1876, no. 548.

8. Barbedienne 1893, p. 3.

9. Paris 1889a, no. 589.

PROVENANCE: Barye sale, Hôtel Drouot, Paris, February 7, 1876, no. 548 (Fr 940); purchased at that sale by Ferdinand Barbedienne through Henri Alfred Jacquemart, Paris; Jacques Zoubaloff, Paris, by 1925; his sale, Galerie Georges Petit, Paris, June 16–17, 1927, no. 211 (bought in); Jerome Stonborough; his sale, Parke-Bernet, New York, October 18, 1940, no. 58 ($440); acquired at that sale through Martin Birnbaum by Grenville L. Winthrop; his bequest to the Fogg Art Museum, 1943.

EXHIBITIONS: Paris 1889a, no. 589; Cambridge, Mass., 1943–44, p. 4; Cambridge, Mass., 1975–76b, no. 4; Cambridge, Mass., 1981, no. 31.

REFERENCE: Saunier 1925a, p. 62, fig. 22.

2. *A Jaguar in a Landscape,* ca. 1833

Watercolor, gouache, pastel, lead white, and light varnish, with scratchwork, on cream wove paper
7¼ x 9⅛ in. (18.5 x 23.1 cm)
Signed in black ink, lower right: Barye
1943.340

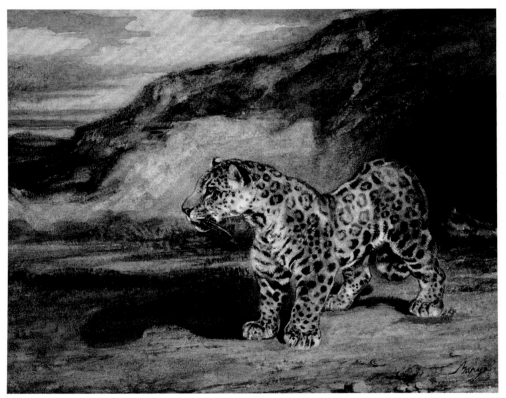

2

As the leading animalier of nineteenth-century France, Antoine-Louis Barye often studied wild beasts from life and depicted many in combat. Obsessed with the anatomical precision of animals, Barye visited the museums of zoology and natural history at the Jardin des Plantes, where he studied proportions of animals with actual measurements taken from live and dead specimens, skeletons, and dissections that he witnessed.

This early watercolor shows a jaguar standing in front of his freshly killed prey, an alligator, in a landscape against a group of hills. The brushstrokes of the somber background exist only to give a setting to the central figure and to accentuate the extensive detail of the animal. The jaguar has been portrayed realistically. Barely visible behind his predator, the alligator is indicated with rapid strokes of red paint suggesting that the victim is soaked in blood.

Barye was inspired by Romanticism, and particularly by the paintings of his friend Eugène Delacroix, in the way he painted this dramatic presentation of a dominant beast with brilliant clarity. The strength of animals in terms of their brutal killing in an effort to live is a Romantic idea that attracted Barye. In contrast to the dark background, the jaguar seems to be in sharp focus. The strong shadow suggests that he is standing in some form of light, which emphasizes the theatrical chiaroscuro effects. The numerous layers of paint and the use of lead white for its whiskers accentuate its realism and three-dimensional quality, as if the subject had been sculpted out of paint. Barye's use of scraping with a tooth exposes cream paper, and this creates highlights with a different reflection from that of the white lead paint.

Martin Birnbaum bought this drawing for Grenville Winthrop in Paris in June 1931, when he wrote to Winthrop: "Baron Henri de Rothschild is about to sell a number of 19th century items at public auction, the proceeds of which are to go to a fund to

erect a Rothschild Museum. I have seen the items and they are almost incredibly fine.— I suggested that he might do better to sell them privately. . . . I have noted the following items . . . #26 A leopard in a landscape, water colour by Barye.—This is a work which I have no way of describing.—It is *much finer* than yours,—*finer* than any in the Louvre, or in the celebrated Schoeller collection.—If we can secure it for $3,000 or $3,500 we must not let it go.—About size of your examples."[1]

Anna Tahinci

1. Birnbaum, letter to Winthrop, June 3, 1931, Harvard University Art Museums Archives.

PROVENANCE: Baron Henri de Rothschild, Paris; acquired from him through Martin Birnbaum by Grenville L. Winthrop, June 1931; his bequest to the Fogg Art Museum, 1943.

REFERENCES: Zieseniss 1954, p. 69, no. C4, illus.; Wasserman 1982, p. 94, illus.; Mongan 1996, pp. 2–3, no. 2, illus.

3. *Two Jaguars in Their Lair,* after 1848

Watercolor, gouache, and varnish, with scratch-work, on cream wove paper
4⅛ x 6⅞ in. (10.5 x 17.5 cm)
Inscribed in red ink, lower left: BARYE.
Verso: slight graphite sketch
1943.338

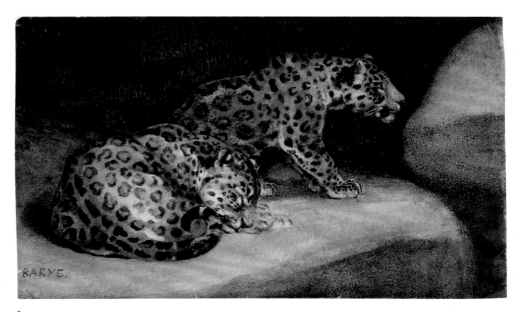

3

Fascinated by animal subjects and a professor of zoological drawing at the Muséum National d'Histoire Naturelle in Paris from 1854 until his death in 1875, Barye, who was an assiduous visitor to the Parc Zoologique, studied, drew, and sometimes dissected and made casts from wild animals. Using these studies he would then execute watercolors, statues, and statuettes that were either calm and accurate or furiously Romantic in vein. A lover of felines, he was familiar with the merciless struggles of nature. Starting with a precise knowledge of the muscles under the pelt, he depicted the ferocious expressions of animals as vanquishers of their enemies.

This tiny watercolor epitomizes Barye's mature style. Sculpting his figures out of rich colors, Barye combines several mediums: watercolor, gouache, lead-white highlights, scratched-in lines for whiskers and fur, and varnishes of various colors and densities. He developed the surface of his watercolor as he would patinate a bronze. The signature in capital letters and in red ink is, according to Zieseniss, an indication that the watercolor was made after 1848.[1]

Birnbaum bought this watercolor for Winthrop at the sale of Jerome Stonborough's collection on October 17, 1940, for $220. In a letter dated November 1, 1940, Birnbaum wrote to Paul Sachs: "By the way, only last month, there was added a superlative water colour of two leopards by Barye."[2] As a result, the Barye holdings of Winthrop's collection comprised four watercolors[3] and six sculptures.[4]

Anna Tahinci

1. Zieseniss 1954, p. 33.
2. Birnbaum, letter to Sachs, November 1, 1940, Harvard University Art Museums Archives.

3. *Two Tigers Fighting* (1943.337), *Two Jaguars in Their Lair* (cat. no. 3), *Tiger in Its Lair* (1943.339), and *A Jaguar in a Landscape* (cat. no. 2).
4. Four bronze sculptures: *Walking Lion* (1943.1126), *Eagle with Outstretched Wings and Open Beak* (1943.1127), *Reclining Panther* (1943.1284), and *A Jaguar Devouring a Hare* (1943.1395); the plaster and wax sculpture *Tiger Attacking a Peacock* (cat. no. 1); and the wax sculpture *Deer* (1943.1086).

PROVENANCE: (?) Liard (Zieseniss 1954, no. C29); Jerome Stonborough; his sale, Parke-Bernet, New York, October 17, 1940, no. 8 ($220); acquired at that sale through Martin Birnbaum by Grenville L. Winthrop; his bequest to the Fogg Art Museum, 1943.

REFERENCES: Zieseniss 1954, p. 72, no. C29, illus.; Wasserman 1982, p. 94, illus.; Mongan 1996, p. 3, no. 4, illus.

Félix-Auguste-Joseph Bracquemond

Paris, 1833–Sèvres, France, 1914

4. *Self-Portrait*, 1853

Pastel, graphite, and metallic (bronze simulating gold) paint on wove paper, attached to paper, attached to linen or canvas
Sheet 36 x 27 in. (92.9 x 68.2 cm); original strainer 41¾ x 29½ in. (105.5 x 75.5 cm)
Inscribed in reddish gray gouache, upper left: F. BRACQUEMOND. pictor chalcographus / anno / aet 20 / 1853 dicipulus Jos Guichard; left margin: B; on original paper mount in graphite, lower left: Felix / Bracquemond / pictor / chalcographus; top: F. Bracquemond / pictor chalcographus / anno / aet 20 / 1853; in black chalk, center left edge: pictor / chalcographus / faciebat ab ipso / anno / aet 20 / 1853 / dicipulus / Jos
1943.836

Martin Birnbaum was enthusiastic, if imprecise, in his description of this picture to Grenville Winthrop: "An incomparable self portrait by Bracquemond (half length in his studio with sculpture and holding a glass of chemical liquid (?)). It is a masterpiece (pastel) of great beauty."[1] The inscription on the pastel translates as "painter printmaker, age 20 in the year 1853, pupil of Joseph Guichard." Behind Bracquemond loom the frame and star wheel of an intaglio press; a copperplate and a burin lie on the table in front of him. The "glass" is a bottle of mordant, colored blue by copper dissolved out of an etching bath. The accessories and pedigree in tandem with the manifest self-confidence of the young man, barely old enough to raise a mustache, assert mastery in printmaking, a profession at the bottom of the traditional hierarchy of the fine arts.

Bracquemond, an orphan apprenticed to a commercial lithographer as a teenager, lived next door to Joseph Guichard, a pupil

of Jean-Auguste-Dominique Ingres. Guichard was struck by Bracquemond's talent and set him to copying plaster casts, and on the basis of the drawings accepted him as a student. Noting his pupil's preference for pen and ink, Guichard suggested that he try etching, which the youth taught himself from a borrowed copy of Diderot's *Encyclopédie*. In 1852 the nineteen-year-old made a stunning debut with a print that some still consider his masterpiece, *Le Haut d'un battant de porte*, which was followed by a series of striking etched portraits the next year, the same year that his *Self-Portrait* announced his ambitions for the status of printmaking at the Salon.[2]

Although the presentation of the printmaker's art in the *Self-Portrait* is conservative—note that the tool is an engraver's burin and not an etcher's needle, and that the plaster bust alludes to academic training in the Ingres vein[3]—Bracquemond moved quickly into advanced artistic circles. Together with the artist Alphonse Legros and the printer-publisher Alfred Cadart, in 1861–62 he founded the Société des Aquafortistes, which would bring the etching revival, already current in Britain, to the fore in France. He became the amanuensis to painters such as Édouard Manet, James Tissot, Edgar Degas, Mary Cassatt, and Camille Pissarro when they approached the complexities of etching practice such as aquatint. He exhibited prints with the Impressionists in the 1870s, and in 1879–80 he collaborated with Degas, Cassatt, and Pissarro on *Le Jour et la nuit,* an unrealized periodical that would have featured original etchings. In 1893 the first plate of the first

issue of *L'Estampe originale*, the publication that marked the zenith of prestige for prints in France, was a portrait etching by Bracquemond.

Yet one must see this print as a kind of retrospective homage. In their letters Degas and Pissarro indicated that they thought of Bracquemond as a technician, albeit a useful one. Degas wrote sarcastically that laying an aquatint ground "was very difficult if you believe Master Bracquemond. If you only want to make original prints, perhaps it's easy enough."[4] It was the prints of Bracquemond, however, and his early associates in the etching revival that found favor with collectors, as Pissarro ruefully acknowledged after only Degas had complimented him on a print on exhibition in 1891: "As for the amateurs, I assure you that what they find good is Charles Jacques, Buhot, Bracquemond. . . . But a print with feeling, no!"[5]

Degas and Pissarro were right: regardless of Bracquemond's technical inventiveness and ambitions, the concept and style of his etchings remained conservative. Early in the twentieth century the etcher, who also had an extensive career as a designer of ceramics and other furnishings, collaborated with Jules Chéret and Auguste Rodin in the decor of a villa belonging to Baron Joseph Vitta. Vitta's art collection included many works by Ingres, and among them was his little painting of Joseph-Antoine de Nogent (cat. no. 54). One marvels at the serendipitous coincidence in the Winthrop Collection of the two portraits, the one by Ingres, the other by a student of a student of Ingres. A response to Ingres's *Self-*

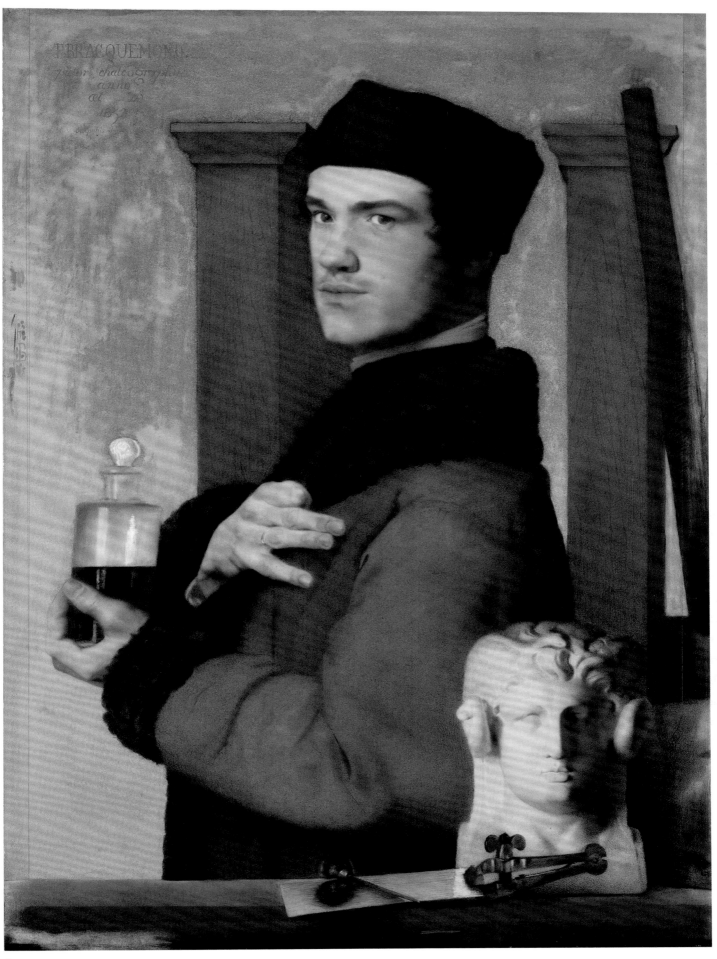

4

Portrait at the Age of Twenty-Four is manifest in Bracquemond's *Self-Portrait* at age twenty.[6]

Marjorie B. Cohn

1. Birnbaum, letter to Winthrop, June 2, 1939, Harvard University Art Museums Archives.
2. See Béraldi 1885–92, vol. 3 (1885), and Bouillon 1987 for Bracquemond's prints of this period and further biographical information.
3. The sculpture, probably a plaster cast, seems to be a view of one side of a double-faced sculpture, this side representing the Egyptian god Amon. For a comparable object, see *Lexicon Iconographicum* 1981–99, vol. 1 (1981), no. 155.
4. Degas 1931, pp. 33–34; Edgar Degas, letter to Camille Pissarro, [ca. 1880]: "C'est très difficile, si on croit Maître Bracquemond. En ne voulant faire que des gravures d'art original, c'est peut-être assez facile." Note also the tone in Degas's letter to Bracquemond, [1879–80] (Degas 1931, p. 29): "Les grains marchent, même sans vous . . ." (The aquatint grounds get along, even without you . . .).
5. Pissarro 1980–91, vol. 3 (1988), p. 31; Camille Pissarro, letter to Lucien Pissarro, February 10, 1891: "Quant aux amateurs, je t'assure qu'ils trouvent de très bien, c'est Charles Jacque, Buhot, Bracquemond. . . . Mais une gravure de sensation, non!"
6. The Ingres *Self-Portrait* is now at the Musée Condé, Chantilly (Wildenstein 1954, no. 17).

PROVENANCE: Alfred Morrison, England, by 1878; Mrs. Mary Davis, London, by 1907; Sir Edmund Davis, J.P., London; his sale, Christie's, London, July 7, 1939, no. 29 (£90.6); acquired at that sale through Martin Birnbaum by Grenville L. Winthrop; his bequest to the Fogg Art Museum, 1943.

EXHIBITIONS: Paris (Salon) 1853, no. 169; Paris (Salon) 1907, no. 12.

REFERENCES: Burty 1878, p. 294; Lostalot 1884, pp. 422, 424; Béraldi 1885–92, vol. 3 (1885), no. 1; Geffroy in Paris 1909, p. iii; Weitenkampf 1912, p. 220; Getscher in Wooster 1974, p. 13; Mongan 1978, unpag.; Bouillon 1987, pp. 8, 9, cover illus.; Rappard-Boon in Amsterdam 1993–94, p. 7, fig. 1.

Rodolphe Bresdin

Le Fresne, France, 1822–Sèvres, France, 1885

5. *Women in a Landscape,* ca. 1859–60

Black ink, gray wash, slight touches of white gouache, on thick off-white wove paper with embossed decorative border (trimmed)
Image 8⅞ x 5¾ in. (22.6 x 14.5 cm); sheet 9½ x 6¼ in. (24.2 x 16 cm)
Inscribed in black ink, lower right: rodolphe Bresdin
1943.773

Martin Birnbaum offered this drawing to Grenville Winthrop in June 1936, describing Rodolphe Bresdin as a "peculiar French artist who influenced Redon & others and is sought for by the best collectors here although still almost unknown in America," and this sheet as "the most important drawing by him I have ever come across."[1] Winthrop agreed, with "many thanks," to acquire it, and thereby indeed became one of the first American collectors to acquire a drawing by Bresdin.[2] *Women in a Landscape* is certainly among the Bresdin drawings with the highest degree of inspiration and finish, executed in his trademark black ink (also called India ink, or *encre de Chine*) on bristol board, with an embossed border that

Bresdin used as a decorative frame for his composition.[3]

Although undated, the high finish and intimacy of this sheet is typical of a large group of drawings from the late 1850s, during Bresdin's productive nine-year sojourn in Toulouse.[4] There his draftsmanship had decisively resolved itself, from more tentative, self-taught beginnings in Paris. The treatment of the women's bodies, featuring the most delicate stippling with the point of a fine pen nib, as well as subtle volumetric shading with gray wash, testifies to Bresdin's obsessive style. He has set the carefully delineated, rather static figures within a more loosely resolved landscape of rocks and vegetation, reveling in the fine, and freer, details of branch and leaf, bird and cloud. Comparable drawings include *Schamyl in his Youth* of 1859, several *Peasant Interiors* of 1860, and *The Good Samaritan* of the same year.[5]

The Winthrop drawing presents a highly elaborated and intriguing variation on a commonly depicted theme in the work

Fig. 56. Rodolphe Bresdin, *Two Bathers*, 1861. Etching, image 4⅛ x 2⅜ in. (10.5 x 6 cm). The Metropolitan Museum of Art, New York; Gift of F. H. Hirschland, 1950, 50.575.22

of Bresdin, that of female bathers in a landscape, often confronted by Death or his stand-ins. Many works from the 1850s show Death lurking in the landscape, most notably the prints *Hunters Surprised by Death*, *Bather and Time*, and *Bather and Death*, and several depictions of Death with young mothers and children.[6] He thus handily combined his lifelong penchants for unspoiled landscapes, the macabre, and buxom women in various states of undress. The juxtaposition within the Winthrop drawing of the skeleton at lower right with the group of figures, along with the classical temples in the distance, has also prompted scholars to venture this composition as Bresdin's version of the "et in Arcadia ego" theme, referring to the presence of Death even within the idyllic realm of Arcadia.[7]

None of the figures in Bresdin's composition appear to look at any others. Further, none of the four nude figures look out of the picture. In contrast, two of the three clothed women stare rather blankly toward the viewer, while the figure swathed in mourning black pays explicit attention to the skeleton. The elaborate composition, the carefully realized setting, and even the dimensions of the Winthrop sheet combine to present an eerie pendant to one of Bresdin's most famed lithographs, *The Comedy of Death* of 1854,[8] a decidedly less idyllic confrontation with mortality.

Two other works are closely related to *Women in a Landscape*. A drawing on tracing paper in the Bibliothèque Nationale de France, Paris, appears to be a precise "record" of the Winthrop sheet, with some variations, most notably the addition of a large tree at the right and an eighth figure, seen from the back, seated between the two women on the left.[9] Odilon Redon noted Bresdin's process of making careful tracings of his highly finished drawings, to have a record of them if they were sold.[10]

5

These tracings also served as source material for further drawings and/or prints, as indeed seems to be the case with the Paris sheet. Bresdin utilized two of the figures in the Winthrop/Paris composition for an 1861 etching, *Two Bathers* (fig. 56),[11] one of a series of fourteen illustrations (including

a frontispiece) that he supplied to *La Revue fantaisiste*, a short-lived literary journal edited by Catulle Mendès.[12]

The Paris tracing carries direct evidence of Bresdin's working method, for a group of three figures in that drawing has been indented for transfer: the two women

appearing in the etching and the clothed woman at the far left of the Paris/ Winthrop composition, along with the large pots at her side. In fact, Bresdin did transfer all three figures to the etching plate but then decided to obscure the third woman with luxuriant undergrowth, which isolates and threatens to engulf the two nude bathers. Given Bresdin's rather shaky figural draftsmanship, it is very likely that he had originally traced all the figures in the Winthrop composition from contemporary book illustrations, thus explaining in part the awkwardness of their layered, even collaged, relationships to one another.[13] He was at his most natural and organic in the rocky landscape and lush vegetation, soon to be so triumphantly displayed in his lithographic masterpiece of 1861, *The Good Samaritan*.[14]

David P. Becker

1. Birnbaum, letter to Winthrop, June 24, 1936, Harvard University Art Museums Archives. Although the drawing is not described more specifically, *Women* is assumed to be the sheet referred to in this letter, as it is the most elaborate of three Bresdin works that Winthrop eventually acquired. The other two are *Rocky Landscape with a Distant Town* (1943.772; Van Gelder 1976, vol. 1, p. 96, fig. 103) and *Medieval Town* (study for *My Dream* [first version]), 1882 (1943.774; ibid., p. 136, fig. 136). In addition to three further sheets, Harvard University Art Museums purchased in 1993 a significant group of eighty-five drawings formerly in the Schwarz collection, Amsterdam.

2. Other notable early collectors were Samuel P. Avery (whose collection is now in the New York Public Library), George A. Lucas (Baltimore Museum of Art), Walter S. Brewster (Art Institute of Chicago), and J. B. Neumann (The Metropolitan Museum of Art). The last, a well-known dealer in Berlin and New York, published the first illustrated compilation of Bresdin's oeuvre in 1929. The Art Institute of Chicago prepared a major loan exhibition in 1931.

3. Such cards, some with elaborately lacelike cut borders, were used by a number of artists and photographers, in addition to their more mundane use as visiting cards; see Becker 2000, p. 22 and n. 17. By far the majority of Bresdin's known drawings were executed on tracing paper, an integral part of his artistic process of tracing graphic sources, assembling his compositions, and finally recording his finished works.

4. Van Gelder (1976, vol. 1, p. 84, fig. 85) dated the Winthrop sheet ca. 1859; Préaud (in Paris 2000, p. 167) places it "without doubt in the 1850s."

5. Van Gelder 1976, vol. 1, pp. 29 (fig. 17), 63 (fig. 59), 64–65 (figs. 61–63), and 73 (fig. 73).

6. Ibid., vol. 2, nos. 88–90; for depictions of Death with mothers and children, see, for example, ibid., vol. 1, p. 67, figs. 67, 68, and the 1861 etching *The Mother and Death*, ibid., vol. 2, no. 104. Préaud (in Paris 2000, p. 159) has suggested this subject may be a reference to Bresdin's recent liaison with Rose-Cécile Maleterre, whom he married in 1865. Their first child was born in 1859; six of their children survived infancy (see Van Gelder 1976, vol. 1, pp. 161–62). The Metropolitan Museum owns a particularly striking drawing of this subject, traditionally called *Nightmare* (52.508.9).

7. Van Gelder 1976, vol. 2, p. 76, under no. 102; Préaud in Paris 2000, p. 167. The classic discussion of this pictorial motif is Panofsky 1955. An intriguing contrast within the Winthrop Collection is Ingres's virtually contemporaneous painting of *The Golden Age* (cat. no. 81).

8. Van Gelder 1976, vol. 2, no 84.

9. Préaud in Paris 2000, p. 167, no. 136, illus.

10. Redon 1987, p. 80.

11. Van Gelder 1976, vol. 2, no. 102 i/ii.

12. For a description of *La Revue fantaisiste*, see Van Gelder 1976, vol. 1, pp. 165–66. See also Préaud in Paris 2000, pp. 36–38, and Becker 1998–99, pp. 22–23. It appeared only from February to November of 1861 and featured articles by Théophile Gautier, Champfleury, Théodore de Banville, and Alcide Dusolier, among others. Bresdin's *Two Bathers* appeared in the May 15 issue; it should be said that none of Bresdin's illustrations bore any relation to the texts.

13. For discussion of his practice of tracing sources, see Becker 2000, pp. 24–26.

14. Van Gelder 1976, vol. 2, no. 100.

PROVENANCE: Acquired from Martin Birnbaum by Grenville L. Winthrop, June 1936 ($280); his bequest to the Fogg Art Museum, 1943.

REFERENCES: Cologne–Frankfurt 1972–73, no. 21.12; Van Gelder 1976, vol. 1, p. 84, fig. 85; Préaud in Paris 2000, p. 167, under no. 136.

Théodore Chassériau

Santa Bárbara de Samaná, Santo Domingo, 1819–Paris, 1856

6. *Portrait of Victor Dupré* (?), ca. 1835–36

Graphite and black crayon on off-white laid paper
16 3/8 x 11 1/4 in. (41.8 x 28.7 cm)
Signed in graphite, lower right: T. Chassériau
1943.780

Théodore Chassériau, like his master Jean-Auguste-Dominique Ingres, devoted a long series of portraits in graphite to his acquaintances. This drawing, of unusually large dimensions for Chassériau, is one of the first in the series. Although produced over a period of two decades, fewer than a hundred of these works are known, the first of them appearing about 1834. The models are generally depicted to the mid-thigh and are sometimes surrounded by a few familiar objects. Unlike Ingres, however, Chassériau never placed them in a landscape.[1]

Agnes Mongan dates the Winthrop drawing to about 1841. It would be tempting to push that date back considerably, to about 1835–36, both for reasons of style and to allow for comparison with other works. This would make it possible to connect the execution of this portrait, which is both bold and fairly schematic, to *A Fellow Student of Chassériau's at Ingres's Studio*

6

tious drawing, serve as good confirmation for a date of about 1835–36, which would not contradict the age of the model, if it truly is Victor Dupré. Then aged between nineteen and twenty-one, he could have grown a short beard to appear older.

Born in Limoges on June 18, 1816, Léon-Victor Dupré died in Paris in 1879. He was the student of his brother, the famous landscape painter Jules Dupré (1811–1889). He exhibited at the Salon in 1839 and seventeen times thereafter, until 1878. His pictures, primarily regional landscapes, today are rarely to be found in public collections. Some of his canvases are in the collections of the museums at Chartres and Douai. His connection to Chassériau may have been established when the latter was a student in Ingres's studio (until 1834). But a relation between the two is not attested by any source other than Dupré family tradition, repeated by Martin Birnbaum to Grenville L. Winthrop,[5] which makes Victor Dupré the model for this portrait.

Louis-Antoine Prat

1. On this subject, see Prat in Paris–Strasbourg–New York 2002–3, pp. 22–29.
2. Sandoz 1986, no. 82, illus.
3. Prat 1988a, no. 1059, illus.
4. See *Portrait Drawing of a Young Family in Medieval Costume*, art market, Paris.
5. Birnbaum, letters to Winthrop, January 8 and 14, 1936, Harvard University Art Museums Archives.

PROVENANCE: Dupré family; Baron Joseph Vitta, Paris; acquired through Martin Birnbaum by Grenville L. Winthrop, January 1936 (Fr 8,500); his bequest to the Fogg Art Museum, 1943.

EXHIBITIONS: Cambridge, Mass., 1946a, p. 18; Cambridge, Mass., 1969, no. 109.

REFERENCES: Mongan 1949, illus. p. 156; Sandoz 1986, no. 96, illus. (with erroneous reference to no. 64); Prat 1988b, no. 33; Mongan 1996, no. 54, illus.

(current location unknown),[2] dated 1834, in which the volumes of the clothing are treated similarly as large masses and the details of the folds are scarcely delineated. *Standing Portrait of a Young Man*, dated 1835 and signed with the monogram *T.C.* (Louvre, Paris),[3] displays the same simplified character, almost devoid of shadow. In addition, beginning in 1837,[4] Chassériau made his signature in a different way: thereafter, he systematically inscribed the first *S* of his family name as a capital letter. He varied the orthography of his first name, however, depending on the situation, writing variously *Th.*, *Th^re*, or *Théodore*. Hence, the simple initial *T* and the absence of the capital *S* in the signature of the Winthrop portrait, a large and ambi-

7. *Arab Horsemen Carrying Away Their Dead,* or *Arab Horsemen Carrying Away Their Dead after a Clash with the Spahis,* 1850

Oil on canvas
66⅞ x 99⅞ in. (169.9 x 253.7 cm)[1]
Signed and dated lower right: Th. Chassériau
1850[2]
1943.219

Chassériau's orientalist works depend on the subtle balance the painter sought to establish among various sources: literary and poetic references, a realist treatment based on memories accumulated during his trip to Algeria, and his prolific and original imagination, which drew on numerous references to the art of the old masters.

Like Eugène Delacroix, who used the intense experience of his visit to Morocco for imaginary and purely theoretical representations of the Orient, Chassériau, during the two months he spent in Constantine and then in Algiers, from May to July 1846, elaborated a new aesthetic conception. No longer evocative of a reconstituted Orient, it was based, above all, on a truthful depiction—truthful because it had been experienced—of an eternal reality. During those few months in Algeria, his credo was "I work and I look," a motto that sums up the humility of his approach, which was radically realist. Did he not declare that "nothing shines more than nature, nothing is more radiant," later adding in his personal notes: "Consider this truth: that one must see the masters and antiquity through nature; otherwise, one is no longer anything but a worn-out memory; if one does, on the contrary, one is a living memory."

Could Chassériau really have witnessed such a scene during his stay in Algeria, as Marc Sandoz suggests?[3] Or might the episode depicted in the Winthrop painting be the product of the painter's fertile imagination? On the one hand, the letters Chassériau sent to his brother recount his relations with French soldiers, engaged in sometimes violent battles with the Kabyle and Arab communities of Algeria.[4] On the other hand, Chassériau's reserved and cautious temperament kept him away from such battles.[5]

A study of many preliminary drawings for this painting appears to confirm its purely imaginary character. Apart from a drawing in graphite housed in the Louvre (RF 25524), which, according to Louis-Antoine Prat, might have been executed from life in Algeria in 1846[6]—it shows the dead Arab and the men carrying away the wounded who would subsequently appear in the painting—Chassériau seems to have planned this work as he did his history paintings, accumulating studies for the postures of the human and animal figures present in the scene. Reinforcing that thesis, an autograph note by the painter, of an unknown date, clearly fixes the subject of the painting without reference to a scene actually witnessed: "Do a group of dead Arabs that the [erasure] of the Arab horsemen are carrying away the wandering horses in the background that horsemen are bringing back with their own a mounted horseman keeps a tight rein in the foreground an Arab horse [erasure] beard that sniffs its master lying in front."[7]

In fact, the majority of the twenty or so preliminary drawings for the painting inventoried by Prat[8] are of bodies in various poses, sometimes very elaborated, which often refer to the art of the old masters. Thus, Chassériau patiently studied, with no apparent link to any witnessed scene, each of the details of the painting. For example, he did not hesitate to evoke a translation of the body of Christ in the study for *Arab Carrying Wounded Man and Women in Sorrow* (RF 25523) or to replicate the composition of Raphael's *Entombment* in another sketch (RF 25371).

In that spirit, the present work was composed as a frieze, like ancient bas-reliefs or classical paintings. Chassériau constructed the painting as three successive planes: the foreground is composed of corpses lying on the ground; the middle ground is formed by the living who are carrying away the dead, on foot and horseback; and the background is a sunny landscape and more horsemen, collecting the dead in the distance. Nevertheless, the solid composition and the subtlety of the classical influences take nothing away from the realism of the scene and its dramatic force. Moreover, the vigor of the colors and the realism of the costumes, combined with the total absence of pathos and a simplicity of treatment in the postures of the human figures, reinforce the contemporary aspect of that episode.

Chassériau valued the painting; he included it in a list of paintings executed about 1850, giving it the title "Cavaliers arabes enlevant leurs morts" (Arab horsemen carrying away their dead).[9] When he exhibited the painting at the Salon of 1850–51, critics made no allusion to events in Algeria and reacted according to their traditional ideological camps. Hence, although L. de Geoffroy condemned the painting's "confused composition,"[10] Théophile Gautier fully embraced his friend's approach, speaking of "Homeric grandeur" and asserting two years later that "one imagines in no other way the Greeks and Trojans collecting their dead under the ramparts of Ilium, after one of those battles where the gods stood up for the mortals."[11]

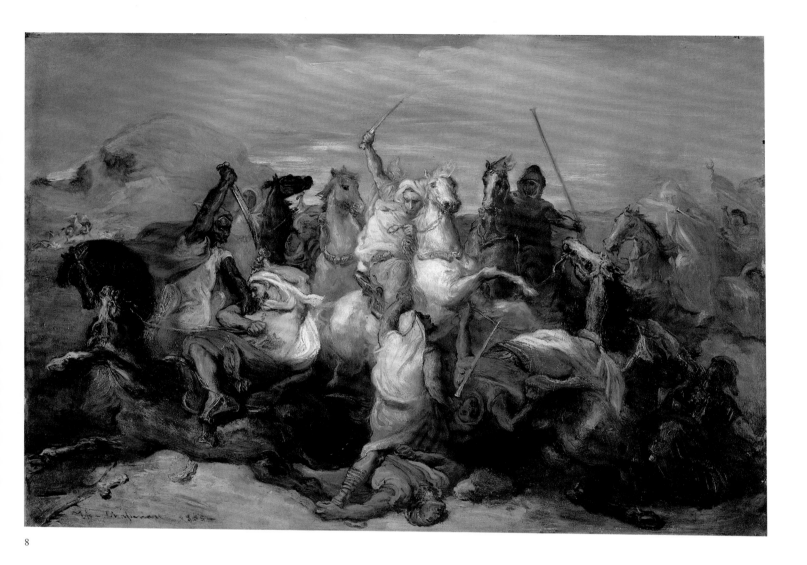

8

Circassian kanglar" (dagger); 41, "a Kabyle saber"; 42, "A Persian dagger"; 43, "A Tunisian dagger damascened in silver"; and 44, "A yataghan from Tunis."[2]

In spite of the complexity of its composition and the many references it contains, only two preliminary drawings for this work are known: one conceptualizes the recumbent horse at the left of the canvas (Louvre, RF 24415), while the other seems to be an actual study for the principal group (Louvre, verso of RF 25522). Moreover, this work may appear under the title "Battle" on a list of his paintings Chassériau exe-

cuted between 1853 and 1855 (Louvre, album RF 26082, fol. 11r).

Vincent Pomarède

1. Sterling (in Paris 1933) cites the dimensions 15⅝ x 18⅜ in. (39.5 x 46.5 cm); Sandoz (1974) repeats the same error: 39 x 46 cm.
2. Dupays 1857, p. 176.
3. Sandoz (1974, no. 143) believes this work was part of the Khalil-Bey collection and that it was auctioned at the Khalil-Bey sale (Hôtel Drouot, Paris, January 16–18, 1868, as "Combat de cavaliers arabes, 0,38 x 0,52"), but the dimensions given at that sale do not correspond, nor does the description given in the sale catalogue of Khalil-Bey (who possessed another work by Chassériau dealing with the same subject, *Battle between the Spahis and the Kabyles on the Edge of a Ravine*, now at the Smith College Museum of Art); it is probable that Sandoz confused the two paintings.

PROVENANCE:[3] Robert Journet, Paris, before 1932; Jacques Seligmann and Co., New York; acquired from them by Grenville L. Winthrop, October 23, 1935 ($4,500); his gift to the Fogg Art Museum, 1942.

EXHIBITIONS: Paris 1930b, no. 145; Paris 1933, no. 82 ("Arab Battle"); Cambridge, Mass., 1942, p. 6; Cambridge, Mass., 1943, no. 20; Cambridge, Mass., 1943–44, p. 7; Cambridge, Mass., 1946a, p. 17; Cambridge, Mass., 1977a; Tokyo 2002, no. 16.

REFERENCES: Chevillard 1893, perhaps no. 162 ("Spahis surpris par des arabes. Vente Théodore Chassériau"); Bénédite [1931], vol. 2, illus. p. 488; Seligman 1961, p. 149, pl. 46b; Sandoz 1974, p. 284, no. 143, pl. 133; Haskell 1982, illus. p. 44; Haskell 1987, illus. p. 180; Prat 1988a, pp. 257, 697; Bowron 1990, fig. 290.

Gustave Courbet

Ornans, France, 1819–La Tour-de-Peilz, Switzerland, 1877

9. *The Smoker,* or *Profile Portrait of the Artist with a Pipe,* ca. 1845

Charcoal on white wove paper
7⅜ x 5½ in. (18.7 x 13.9 cm.)
Signed in monogram, lower left: G C
1943.788

This drawing is currently titled *Profile Portrait of the Artist with a Pipe.* I suggest a modified title here because of the confusions that have occurred in the literature between it and another charcoal drawing by Gustave Courbet in the Wadsworth Atheneum in Hartford, titled *Man with a Pipe,* and also signed with a monograph at the lower left. Such confusions are scattered throughout the provenances of the several works that bear this generic title,[1] but the Winthrop drawing can be set apart from these by the fact that it is a profile, in

9

Fig. 57. Gustave Courbet, *Les Amants dans la campagne,* ca. 1845. Oil on canvas, 30½ x 23⅝ in. (77.5 x 60 cm). Musée des Beaux-Arts, Lyon (photo: Réunion des Musées Nationaux / Art Resource, NY)

contrast to all of the images related to the well-known *L'Homme à la pipe* in the Musée Fabre in Montpellier. In addition, in its earliest publication in 1882, it is titled *Le Fumeur, profil.*[2]

The drawing represents the artist as he appeared in the mid- and later 1840s: slim, with full dark hair and a short beard. On his head is a visored cap, tied at the back (referred to by Charles Léger as a "cas-

quette").[3] This clearly is country gear, as is the differently cut but equally sturdy hat worn by the figure in the Hartford self-portrait drawing mentioned above. The latter, more finished drawing, though not a study, is clearly related to the persona of intense concentration presented in the Montpellier painting *L'Homme à la pipe;* the Winthrop drawing, on the other hand, can be most closely linked to the quite

different figure of Courbet in *Les Amants dans la campagne*, a painting in the museum at Lyon that probably dates to 1845 (fig. 57).[4] In this painting we see similarities to the drawing in the rather fine profile, beard, and cut of hair. The expression of the male face in the painting is somewhat deliberately "romantic," however, while that of the drawing is relaxed and genial.

There is also a small oil sketch in the Murauchi Museum near Tokyo that treats a very similar theme of an attached couple walking in the countryside, seen from behind in *profil perdu*. Here the male figure wears a cap of the same type seen in the Winthrop drawing. The drawing is rapid and sketchy, with the marks of the charcoal ranging from soft rubbing to the sharp, deep black indications of the curling hair. It is reasonable to suppose that the Winthrop drawing, though not a study for the painting, was made around the time Courbet was developing this pastoral theme.

The left side of the sheet was cut at some point, as indicated by the interruption of the letter "G" in the large monogram signature.

Sarah Faunce

1. See Northampton–Williamstown 1976–77, pp. 91–92; Fernier 1977–78, vol. 2, p. 288; Léger 1929, p. 213; and Riat 1906, p. 46. Ownership by the critic Jules-Antoine Castagnary, who was close to Courbet in the 1860s and 1870s, has been attributed to a few of these generically titled works, with no certain documentation. This provenance also turns up in Fernier's entry on the Winthrop *Smoker*, probably based on confusions made between it and a *Man with a Pipe* in Riat 1906, Léger 1929, and elsewhere. The Smith College catalogue (Northampton–Williamstown 1976–77) does not mention Castagnary ownership in connection with the Fogg drawing, and it is unlikely because he is not listed as its lender to the Paris 1882 memorial show. Furthermore, the drawing was in the Courbet estate sale that took place the following month, without indication that Castagnary had owned it. It is possible, however, that it did not find a buyer at that sale, and that Juliette Courbet, Courbet's sister and heir, could have given it to Castagnary. The owner of the Hartford drawing is listed in the memorial exhibition catalogue (Paris 1882, no. 131) as the widow of Honoré Daumier.
2. Hôtel Drouot, Paris, June 28, 1882, no. 47.
3. Léger 1948, p. 30.
4. De Forges 1973, p. 27, draws attention to this similarity. The Lyon painting, while signed and dated 1844, was listed in the artist's 1855 Paris exhibition as dated 1845. Courbet was often casual about dates, and the style of the painting is definitely closer to that of his maturity than to works dated to the previous year.

PROVENANCE: Courbet sale, Hôtel Drouot, Paris, June 28, 1882, no. 47 (unsold, per annotation in sale cat.); (possibly Jules-Antoine Castagnary, Paris); Claude Roger-Marx, Paris; acquired through Martin Birnbaum by Grenville L. Winthrop, May 1931 (Fr 25,000); his bequest to the Fogg Art Museum, 1943.

EXHIBITIONS: Paris 1882, no. 138; Berlin 1930, no. 94.

REFERENCES: Estignard 1896, p. 152; Riat 1906, p. 46; Léger 1929, p. 217; Léger 1931, p. 390, fig. 3; Léger 1948, pp. 30–31; de Forges 1973, p. 27, fig. 32; Foucart 1977, illus. p. 15; Fernier 1977–78, p. 288, no. 22, illus.; Stuffmann 1978, p. 339, fig. 309a; Fried 1982, p. 644, fig. 13; Ornans 1984, no. 22, illus.; Courthion 1985, illus. p. 135; Fried 1990, p. 109, fig. 50; Foucart 1995, illus. p. 7; Georgel 1995, illus. p. 25; Saywell 1998, p. 30.

10. *The Painter at His Easel*, ca. 1847–48

Black chalk with traces of charcoal, graphite outlines on the palette and along the lower edge of the coat lapels, on cream antique laid paper
21⅞ x 13⅛ in. (55.4 x 33.5 cm)
1943.787

This drawing has long been understood to be one of the considerable number of self-portraits that Courbet made during the first fifteen years of his artistic life, from his learning years in the museums and informal studios of Paris to the full maturity announced by his masterwork of 1855, *The Studio of the Painter*.[1] Looking back from 1854, Courbet wrote to his patron Alfred Bruyas that "j'ai fait dans ma vie bien de portraits de moi, au fur et à mesure que je changeais de situation d'ésprit; j'ai écrit ma vie, en un mot" (I have made in my life quite a few portraits of myself, according to the movements of my mind and spirit; in a word, I have written my life).[2] These images were thus the embodiments of states of consciousness that the artist experienced during his years of working toward his goal of making an authentic art for his time. Some were described as a "portrait de l'auteur"; in others he took on the guise of another persona: the Cellist, the Desperate Man, the Wounded Man.

The Winthrop drawing, neutrally titled *Le Peintre à son chevalet* in Courbet's famous one-man show in 1855, is confirmed as a self-portrait by the Quillenbois caricature of that date, captioned "M. Courbet enrhumé" (fig. 58). Here the artist's brush becomes a mop, his nightcap a dunce cap, his black beard enormous, and his skinny shanks encased in striped long johns. Such ridicule could not have occurred when the drawing was first shown in the Salon of 1849,[3] the year the artist's work first received serious attention. The display of seven works included *After Dinner at Ornans*, which was widely admired and even purchased by the state for the museum at Lille. *Le Peintre*, as the Winthrop drawing was called then, would have been seen as very much akin to that monumental painting in its distinctive tonal character, its close-up placement of the figure in its interior space, and its mood of serious concentration.

Fig. 58. "M. Courbet enrhumé," in *L'illustration*, July 21, 1855, p. 52.

The drawing is not, however, directly related to that or any other painting; very few of Courbet's small number of drawings are. And the majority of the drawings come, like the self-portraits on canvas, from these first fifteen years. *The Painter at His Easel*, like *Young Woman with a Guitar* (cat. no. 11), was made as an independent, fully realized work of art ready for display in the Salon. It is also a complete and self-contained image of solid forms in space and light, which creates a sense of color through the richness of its tonal values and textures. The strongly tonal style of Courbet's drawings of this period reveals the choice of a young man alert to what was new in a milieu in which academic norms were still very powerful. This type of realist tonal drawing appeared in the 1830s, spurred by the emergence of charcoal as a drawing tool, and closely related to the invention and spread of lithography in the earlier part of the century.[4]

Courbet would have seen something in

Paris of the lithographic work of Théodore Gericault and Eugène Delacroix and Alexandre-Gabriel Decamps, and he certainly would have been familiar with the lithographic imagery of the *Voyages pittoresques* and even more so with the illustrated magazines and papers containing the work of Achille Deveria, Philippe-Auguste Jeanron, Daumier, and many others. As a young artist who was more painter than draftsman, Courbet would have been drawn to the tonal, nonlinear character of much of this imagery; the subject matter of popular journalism, drawn from the life around him, would have been an equal attraction. He would also have seen how the new medium of charcoal drawing acted in the hands of someone like Théodore Rousseau to create a new way of representing the fugitive, nonlinear qualities of landscape. All of these sources, which fused in Courbet's mind to produce the several remarkable black chalk/charcoal drawings that we know, were equally

at the heart of his thinking as a painter.

Thus *The Painter at His Easel* takes its own place among the painted self-portraits that provide an imagery of the artist's developing consciousness. The figure here is that of the painter with the basic necessities of life: easel and stretched canvas, chair and table, palette and brush. He is bundled up against the cold of a drafty studio; his right arm is strong, but he is thin, intense, and more than a bit melancholy. He is the artist of "la vie de bohème," the life of the artist who struggles on the margins of society, with little money to live on. For many young artists coming to Paris in the 1840s, this was no myth or pose but a reality at a time when the idea of "la vie de bohème" was just beginning to take literary form. It was Courbet's world in the Paris of the 1840s; although he had a father who could spare the money to support his study, the funds were minimal and came only grudgingly because of the son's refusal to enter the career-building structure of the École des Beaux-Arts. The drawing is an image both of this time in Courbet's life and of the larger concept of the artist as a solitary, working on the margins and against the odds to achieve his goal—a concept that became a cultural force for the rest of the nineteenth century and beyond.

Sarah Faunce

1. Boyer 1997. This excellent short piece is a further welcome step in disposing of that tenacious myth of the Courbet literature from earliest times: Courbet as "Narcisse paysan." The seemingly large number of early self-portraits by Courbet was long taken as evidence of the artist's deplorable vanity and narcissism, as though he were a fop who could not tear himself away from the mirror.
2. Courbet 1992, no. 54-2, p. 122.
3. De Forges 1972, p. 455. Research in the Archives des Musées Nationaux has led de Forges to a convincing argument that "*Le Peintre*, dessin," registered as being in the Salon of 1849, is the Winthrop drawing, titled more specifically by Courbet in the 1855 catalogue as *Le Peintre à son chevalet*, no. 41.
4. Chu 1980. This article is the most complete discussion that I know of about the context of realist drawing in the early to mid-19th century, its connection to the use of lithography in both fine and popu-

10

lar art, and the links between lithography and the rise of a new landscape vision.

PROVENANCE: Juliette Courbet, sister of the artist; (Felix?) Gérard; Claude Roger-Marx, Paris; acquired from him through Martin Birnbaum by Grenville L. Winthrop, September 1938 (Fr 82,500 for cat. nos. 10 and 11); his bequest to the Fogg Art Museum, 1943.

EXHIBITIONS: Paris (Salon) 1849, no. 450; Paris 1855a, no. 41; Paris 1867b, no. 111; Paris 1882, no. 135; Paris 1900a, no. 835; London 1938, no. 32.

REFERENCES: Estignard 1896, pp. 151–52; Riat 1906, pp. 44 (illus.), 133, 386; Fontainas 1921, p. 85; Léger 1929, p. 217; Courthion 1931, pp. 78, 84; Shoolman and Slatkin 1950, p. 166, pl. 94; de Forges 1972, p. 455, fig. 5; de Forges 1973, no. 42, illus.; Foucart 1977, illus. p. 87; Fernier 1977–78, vol. 2, p. 286, no. 17, illus.; Stuffmann 1978, p. 326, fig. 2; Chu 1980, pp. 25–27, fig. 39; Jirat-Wasiutynski and Jirat-Wasiutynski 1980, p. 133, fig. 15; Fried 1982, p. 631, fig. 7; Ornans 1984, fig. 24; Courthion 1985, p. 134, illus.; Fried 1990, p. 95, illus. p. 96; Jirat-Wasiutynski 1990, p. 123, fig. 6; Foucart 1995, illus. p. 39; Boyer 1997, p. 34, illus.

11. *Young Woman with a Guitar, Reverie*, ca. 1847–48

Black chalk on cream wove paper
17¾ x 11¼ in. (45 x 28.6 cm)
Signed in monogram, lower left: G.C.
1943.790

Although shorter by ten centimeters and not so vertical in proportion, this important tonal drawing seems to be a natural companion to *The Painter at His Easel* (cat. no. 10). Both are constructed in Courbet's tonal drawing style of the later 1840s, building form from dark to light, and retaining a tenebrist atmosphere. The two drawings even have the details of the chair in common, as well as the attention to the fabric pattern, here striped and in the other checkered. The traditional identification of the model as Courbet's sister Zélie is not assured, since Courbet gave the piece its general title in 1855 and 1867; however, the figure's youth at the date of the drawing, and the softly rounded face and gentle aspect are attributes of the several studies in oil that the painter did specifically name as portraits of Zélie.

Courbet often used his sisters and other local people as models for his paintings of "les moeurs de campagne" (country manners), which formed the substance of the artist's extraordinary series of works that shook the critical establishment between 1850 and 1855. In one sense their possession of living actuality was important to his project, but at the same time their personal identity did not matter. This image of a quiet moment of domestic music making and reverie signifies not so much a specific person as a state of mind and an aspect of the daily life of a small-town family such as Courbet's own. The two drawings, close in time, technique, and style, present in effect several pairs of opposites in Courbet's mind: city and country, male and female, solitary austerity and domestic comfort, art as effort and art as reverie.

The attribution and provenance of *Young Woman with a Guitar* were well established during Courbet's lifetime, since it was exhibited and documented at the two self-organized exhibitions in 1855 and 1867, as well as in the 1882 memorial exhibition that Jules-Antoine Castagnary organized.[1] In each of these exhibitions the drawing was titled "Jeune Fille à la guitare, reverie"; in the 1882 exhibition a parenthesis was added describing it as a "portrait de Mlle Zélie Courbet." The questions of provenance emerge only after this time, from contradictory published information that is often difficult to confirm. To begin with, a document of 1886, a catalogue of the Besançon museum's collection, lists four drawings given in 1885 by Juliette Courbet, the artist's youngest sister and heir. One of these is titled "Une Guitariste," with a description and dimensions that fit this Winthrop drawing.[2] The next reference is in 1896, in the book of Alexandre Estignard, one of the two earliest writers who attempted to make an overview of Courbet's painting career during the lifetime of Juliette. In a chronological list of the artist's works, he specified that two Winthrop drawings—"*Portrait de Courbet* (dessin). Le peintre en robe de chambre et en bonnet de coton" (cat. no. 10) and the "*Jeune fille à la guitare*. Reverie. Portrait de Mademoiselle Zélie Courbet (crayon noir)"—were at the time of writing owned by Juliette.[3] However, on the same page is listed a drawing titled "*Une Guitariste* (Fusain)," said to be at the museum in Besançon. Either these are two different drawings or Estignard, confused by the change in title in the 1886 catalogue, made an error in turning them into two different drawings. The fact that the dimensions in the 1886 catalogue are just the same as those of this Winthrop drawing argues in favor of the second interpretation. The only Courbet drawings in the Besançon collection at present are the three others that Juliette gave in 1885, and none of these represents a guitar player.

The confusion continues in the book on Courbet published in 1906 by Georges Riat, the second of the two writers who had access to Juliette. Riat titled his reproduction of the Winthrop drawing "La Guitariste (Zélie Courbet)" but listed it as being neither with Juliette nor in the Besançon museum but, together with *The Painter at His Easel,* "formerly in the Gérard Collection."[4] Thus Riat, though using the new title given to the drawing in the 1886 Besançon catalogue, placed the drawing not there but as having already, by 1906, left the Gérard collection. The Gérard ownership has not been documented, but the reference was presumably to the family of Félix Gérard, father and son, who were dealers and experts in the Parisian art market and who not only had handled but owned a considerable number of Courbet's paintings.

Charles Léger, in his book of 1929, mentioned the gift to Besançon of a drawing he titled "Femme à la guitare," and he reported that a curator who had been at the museum since 1900 had never seen it there.[5] That curator was Adolphe Chudant, whose term was in fact from 1909 to 1929.[6] Thus, if the 1885 gift had been made, the drawing itself had disappeared, presumably sometime between that year and 1909. Yet writers over the years—among others, Louis Aragon and Marie-Thérèse de Forges—referred to its presence in that museum on the basis of the early catalogue cited above.[7] Meanwhile, of course, the drawing

had entered the collection of Claude Roger-Marx (1888–1977), probably in the 1920s and possibly even earlier, as he may have inherited it from his father, Roger Marx (1859–1913), also a critic and enthusiast of the art of his own time. Robert Fernier's provenance in his catalogue entry does not help to answer the questions raised by this history.[8] He alluded to an 1885 gift of this drawing to Besançon, citing Estignard as a source for this information while ignoring the *Young Woman with a Guitar, Reverie,* listed on the same page in Estignard's book. At the same time he contradicted this by placing the drawing among the works of Courbet in Juliette's 1915 bequest to her friends Mme de Tastes and Mme LaPierre.

Based on current evidence gathered from various archival sources by Françoise Soulier-François, curator of drawings at Besançon, the clear alternatives appear to me to be: 1) the Winthrop drawing was given to Besançon in 1885 and subsequently disappeared sometime before 1909, until its reappearance in the collection of Roger-Marx; and 2) although there were some who at the time may have believed that the drawing was made a gift, ownership in fact remained with Juliette until some later time, possibly until her death. Some of the archival evidence, particularly in letters by Juliette, points to the second alternative, but at present there is no definitive proof either way.[9]

Sarah Faunce

11

1. De Forges (1972, pp. 452, 456) proposed that an even earlier appearance may have been in the group of eleven works that Courbet submitted to the Salon of 1849. A drawing referred to as "*Mlle Zélie, dessin,*" with framed dimensions, was one of four pieces that were not accepted for display.
2. Castan 1886, p. 201, no. 567, and Castan 1889, p. 116.
3. Estignard 1896, p. 152.
4. Riat 1906, pp. 45, 386.

5. Léger 1929, pp. 211–13.
6. Letter of June 22, 2001, to this writer from Françoise Soulier-François, curator of drawings at the Musée des Beaux-Arts et d'Archéologie, Besançon, to whom I am greatly indebted for her sharing of her archival research. She quotes from a letter written by Chudant to Léger in 1928: "Malgré

toutes mes recherches faites il y a longtemps déjà je n'ai jamais pu retrouver le dessin de Courbet *Une Guitariste*" (In spite of all my research done over a long time now, I have never been able to find the Courbet drawing *Une Guitariste*).
7. Aragon 1952, p. 207; de Forges 1972, p. 454.
8. Fernier 1977–78, vol. 2, p. 290, no. 25.

9. For example, in a letter of February 24, 1885, cited by Mme Soulier-François, Juliette wrote that "M. Fanard [a local artist active in museum affairs at the time] m'a supplié de lui donner deux dessins de Gustave et de lui prêter le portrait de Zélie jouant à la guitare, ce que j'ai fait, seulement je retirarai bientôt parce que je ne veux pas qu'on le copie ni qu'on le photographie . . ." (M. Fanard has begged me to give him two drawings by Gustave and to lend him the portrait of Zélie playing the guitar, which I have done, only I will take it back soon because I don't want it to be copied or photographed). The clear distinction between "donner" and "prêter" is significant in these circumstances.

PROVENANCE: Juliette Courbet, sister of the artist; either bequeathed by her to Mme de Tastes and Mme Lapierre or sold to (Felix?) Gérard; Claude Roger-Marx, Paris; acquired from him through Martin Birnbaum by Grenville L. Winthrop, September 1938 (Fr 82,500 for cat. nos. 10 and 11); his bequest to the Fogg Art Museum, 1943.

EXHIBITIONS: Paris 1855a, no. 40; Paris 1867b, no. 113; Paris 1882, no. 132.

REFERENCES: Castan 1886, no. 567; Castan 1889, p. 116; Estignard 1896, p. 152; Riat 1906, pp. 45 (illus.), 133, 386; Fontainas 1921, p. 85; Léger 1929, pp. 211, 213; Courthion 1931, pp. 78, 84; Léger 1948, p. 30; Mack 1951, p. 43; Aragon 1952, p. 207, pl. 5; Lemoyne de Forges 1972, pp. 452ff., fig. 4; Fernier 1977–78, vol. 2, p. 290, no. 25, illus.; Stuffmann 1978, p. 326, fig. 1; Courthion 1985, illus. p. 135.

Honoré-Victorin Daumier

Marseille, France, 1808–Valmondois, France, 1879

12. *A Woman with a Basket and a Child by the Hand, Walking with a Crowd of People,* ca. 1848–50

Black lithographic crayon over charcoal and chalk, gray wash, and a touch of red chalk on off-white laid paper
16 3/4 x 12 in. (42.5 x 30.6 cm)
Inscribed in graphite, lower left: N 2
1943.796

Honoré Daumier produced more than fifteen paintings and an equal number of drawings that show women walking their children through the Paris streets, on their way to market, or to school, or to the laundry barges on the Seine. He seems to have taken singular pleasure in the interplay between young and old, and in the opportunity to compare the proportions of their bodies and the rhythms of their gaits. Striving to realize their distinctive contours in this drawing, he progressively layered soft lines of charcoal and chalk, finally zeroing in with a few sharp strokes of a lithographic crayon.

This supple and touching drawing, which focuses on a striding mother who turns back over her shoulder to encourage her lagging toddler, seems closest to Daumier's earliest drawings and paintings (from the mid- to late 1840s) on the walking-mother-and-child(ren) theme.[1] However, the hurried pace of the multiple figures in this scene and the fact that most of them are shown from the back suggest this drawing may be at the forefront of an entirely different series of compositions, originating about 1850 on the theme of Fugitives.[2]

Daumier's fascination with fleeing crowds, which manifested itself for close to twenty years, is likely to have been stirred by urban upheavals he himself witnessed during the Revolution of 1848, the cholera epidemic of 1849, and the coup d'état of 1851, events that drove throngs of Parisians into exile.[3] But this particular crowd, less dense and desperate than those of his Fugitives, may simply be struggling on its way to market during the early morning rush hour.[4] The street traffic of Paris, which increased at a furious rate during Daumier's lifetime, was regularly the leitmotif of his art.

Colta Ives

1. For example, the paintings *Woman and Child on a Bridge at Night*, Phillips Collection, Washington, D.C. (Maison 1968, vol. 1, no. I-9), and *On the Street in Paris*, Ordrupgaardsamlingen, Charlottenlund, Copenhagen (ibid., no. I-8); and two drawings (ibid., vol. 2, nos. 234, 235).
2. For example, a drawing in the Musée du Louvre, Paris (ibid., vol. 2, no. 819); a painted plaster relief in the National Gallery of Australia, Canberra (Gobin 1952, no. 65); and an oil on panel on loan to the National Gallery, London (Maison 1968, vol. 1, no. I-27). A comparably dynamic study of a mother and children moving in haste is *Mother and Two Children*, Whitworth Art Gallery, University of Manchester (ibid., vol. 2, no. 243). Very close to the Winthrop drawing in its technique and understanding of a posture bent backward and weighted on one foot is the *Study of Female Dancers*, Musée du Louvre, Paris (ibid., no. 474).
3. See Édouard Papet and Henri Loyrette in Ottawa–Paris–Washington 1999–2000, pp. 288–301.
4. See *The Market*, private collection (Maison 1968, vol. 2, no. 531).

PROVENANCE: Paul Bureau, Paris, by 1910; Nicolas Auguste Hazard, Orrouy; his sale, Hôtel Drouot, Paris, December 10, 1919, no. 321 (Fr 5,400); André Schoeller, Paris; Maurice Gobin, Paris, by 1921; Scott and Fowles, New York; acquired from them by Grenville L. Winthrop, January 20, 1922 ($2,500); his bequest to the Fogg Art Museum, 1943.

EXHIBITIONS: Paris 1878a, no. 128 (as "Le Marché"); Paris 1910, no. 160; Basel 1921, no. 64; Cambridge, Mass., 1943–44, p. 10.

REFERENCES: Fuchs 1927, no. 230a; Mongan 1944b, illus. p. 23; Gobin 1952, p. 302; Adhémar 1954b, no. 11; Paris 1954, p. 19, pl. 11; Homer 1958, p. 58, fig. 6; Maison 1960, p. 19, no. 32, fig. 32; Moskowitz 1962, vol. 3, pl. 754 and facing page; Maison 1968, vol. 2, no. 729, pl. 287; Symmons 1979, p. 75, pl. 52; Jirat-Wasiutynski and Jirat-Wasiutynski 1980, p. 128; Passeron 1981, p. 84, pl. 36; Laughton 1991, pp. 100–101, fig. 7.5; Wechsler 1999, pp. 40–41.

12

13. *The Print Amateur (L'Amateur d'estampes)*, ca. 1855

Oil on wood panel
13 x 9⅜ in. (33 x 24 cm)
Signed with initials, lower right: h.D.
1943.226

A fascination with images, no less than a curiosity for the spectacle of the street or the stage, was a favorite Daumier topos from his earliest days as a lithographer. Men stopping to look at posters and prints, art amateurs of every sort, mesmerized spectators, grown-ups and children peeping through holes in fences—in short, every form of irrepressible need to look.[1] The onlooker is never the person one expects and is treated, by turns, with affection or irony. One might well speculate that this was merely an artist's fantasy were it not, in Daumier's case, for the proof that public reaction to his images for the press was immediate.

The earliest, if posthumous, recorded title for the work is slightly misleading, suggestive as it is of a gentle activity, whereas the picture addresses something more universal about the seduction of images.[2] On a sunny but chilly day, in front of a print stand, a man in a top hat bends his ungainly frame to look closely at a print. Under his arm is a roll of paper, doubtless another print he has just bought. Beyond him a workman stands transfixed before a different image while a woman huddled in her shawl looks on inquisitively. In the foreground, a street urchin neglects his younger sibling in order to ferret out a sheet from a portfolio.

The design is known in two versions of roughly the same dimensions, the Winthrop panel and a later, more carefully finished work now in the Dallas Museum of Art.[3] Closely connected with these is a variant at one time owned by Camille Corot,

now in a private collection, which shares the mise-en-scène and some of the figures but shows the group of onlookers half-length, from up close.[4] The Winthrop version, the earliest of the three and likely dating from the mid-1850s, was purchased at an unknown date, presumably from Daumier, by the collector Alfred Saucède who owned three other paintings by the artist. The second version belonged to Louis Lemaire, a considerable Daumier enthusiast and the owner of seven paintings and more than fifty drawings. It is one of the vagaries of history that works from the more accessible Lemaire collection were exhibited in the great Daumier retrospective of 1878 while the Saucède paintings were tied up, first in a move and then in the collector's sale that took place on the day of Daumier's funeral.

Karl Eric Maison observed that the more carefully executed Dallas panel was likely painted specifically for the market.[5] One wonders if this was the case, as collectors were primarily interested in the artist's drawings. Daumier no doubt varied his effects and certainly sold both types of paintings—relatively sketchy and highly finished—sometimes to the same collectors. The Winthrop painting belongs to a rather small group of works in which the drawing is allowed to remain relatively manifest and escaped extensive repainting.[6] The Dallas version belongs to an almost equally small group of painterly works mostly executed in the early 1860s, when Daumier experimented for a while with uncommonly finished watercolors.[7]

Little attention has been paid to the images—paintings, drawings, or prints—that Daumier incorporated into his own work. With rare exceptions these are variations on his own compositions. In the

Dallas *Print Amateur* the center is held by an archetypal Daumier design of a mother with two children. Here, the images are too sketchy for unequivocal interpretation, but one can still distinguish a characteristic Daumier sheet with a cluster of heads and, just above the man's top hat, the embryo of a composition with a reclining man attended by a standing figure, surely a scene from Molière's *Imaginary Invalid*. This scene appears again, more clearly defined, in the privately owned variant of the composition.

Michael Pantazzi

1. In his review of the 1878 Daumier exhibition, Marius Vachon (1878, p. 3) made a point of listing the wide typology of connoisseurs and collectors that he had distinguished in the artist's work.
2. There is nevertheless a precedent in favor of the title: the direct ancestor of the painting is a Daumier woodcut, *L'Amateur de caricatures*, published in *Le charivari*, April 28, 1840; see Bouvy 1933, vol. 1, no. 327.
3. Maison 1968, vol. 1, no. I-145. According to Erich Klossowski (1923, p. 119, no. 360D), a painting identical to this work but signed at lower left was recorded in Zürich in 1917; an inferior copy with a monogram at lower right and lacking one figure belonged in the 20th century to the critic Théodore Duret. It was published at least twice but has been since dismissed by Maison (1968, vol. 1, p. 90, under no. I-70) and Georgel and Mandel (1972, no. 328, illus.).
4. Maison 1968, vol. 1, no. I-138, now in a private collection.
5. Ibid., p. 90, under no. I-71.
6. Such arguments must be made cautiously since, over time, the paint surface has been abraded and subjected to extensive restoration.
7. It may be noted that in Daumier's case a high degree of finish was occasionally required to conceal a discarded composition on the same panel.

PROVENANCE: Alfred Saucède, Paris; his sale, Hôtel Drouot, Paris, February 14, 1879, no. 8 (as "L'Amateur de gravures"; Fr 610); purchased at that sale by Adolphe Victor Geoffroy Dechaume, Paris; Henri Garnier, Paris; his sale, Galerie Georges Petit, Paris, December 3–4, 1894, no. 40 (as "Les curieux à l'étalage"; Fr 2,900); purchased at that sale by Durand-Ruel, Paris; Cyrus J. Lawrence, New York; his sale, American Art Association, New York, January 21–22, 1910, no. 37 (as "Les curieux à l'étalage"; $2,600); purchased at that sale by Eugene Glaenzer and Co., New York; J. Pierpont Morgan, New York; acquired through Knoedler and Co., New York, by Grenville L. Winthrop, December 11, 1935 ($12,000); his bequest to the Fogg Art Museum, 1943.

EXHIBITIONS: Cambridge, Mass., 1943–44, p. 10; Cambridge, Mass., 1977a.

13

REFERENCES: Escholier 1923, pl. facing p. 122 (as "Les Curieux"); Fontainas 1923, unnumbered pl. [6] (as "Les curieux à l'étalage"); Klossowski 1923, p. 119, nos. 360A, 360C, pl. 115; Sadleir 1924, pl. 14; Lassaigne 1938, pl. 63; Adhémar 1954a, note and pl. 83; Maison 1968, vol. 1, no. I-70, and pp. 124–25 under no. I-138, 129 under no. I-46, pl. 53; Georgel and Mandel 1972, pp. 96–97, no. 102, pl. xxi; Bowron 1990, fig. 308; Ottawa–Paris–Washington 1999–2000, p. 398, under no. 247.

14. *The Butcher,* ca. 1860

*Watercolor, black ink, graphite, and black
lithographic crayon on cream wove paper
(two sheets joined irregularly across center)*
13¼ x 9½ in. (33.5 x 24.2 cm)
Signed in ink, lower left: h. Daumier
1943.347

Daumier found the heartbeat of his own
work by observing Parisians doing theirs:
lawyers pleading cases, actors making
faces, washerwomen hauling laundry, con-
noisseurs critiquing. During the winter of
1857–58, he turned his attention to the
city's butchers, whose nefarious practices
had come under public scrutiny, and out-
lined the trade's abuses in twelve litho-
graphs published in *Le Charivari*.[1] The
government's decree of March 24, 1858,
imposed new regulations that eventually
helped to lower prices and clean up
appalling shops.

In the caricatures he issued in the popu-
lar press, Daumier twisted cranky butchers'
features to make them look as nasty as their
business. But when he later cast the dusky
meat locker as a scene of naturalistic
drama, the butcher became transformed
into a tragic figure with, so to speak, his

own cross to bear. Of the seven drawings Daumier is known to have produced on this theme, the two owned by the Fogg Art Museum are the handsomest and most stirring.[2] Both are infused with the warm and focused light of Baroque art that also bathes the beautifully disturbing painting of the *Butchered Ox* by Rembrandt, which entered the collection of the Musée du Louvre in Paris in 1857.

The Winthrop drawing is composed of two sheets of paper, evidently joined so that the artist could surround the butcher with a reconsidered lineup of hanging meat. Its lifeless anonymity contrasts with the muscled worker, straining magnificently to position a heavy carcass.

When Winthrop's agent Martin Birnbaum discovered this work in Paris in 1927,

he wrote excitedly to his client on June 18: "I have found the *finest* water colour by Daumier that I have *ever* seen . . ."; and again, a fortnight later, on July 31: "If you can possibly see your way clear to buy the Daumier No. 31 Butcher with a Beef, permit me to *urge* you to buy it. I have just seen it again. . . . The Daumier is finer than anything in the Petit Palais, and I went expressly to the Museum to refresh my memory before becoming too enthusiastic. I am more convinced than ever that here we have a masterpiece which we shall not surpass. . . . In spite of the subject, this is a very *pleasing* picture."[3]

Colta Ives

1. The series *Messieurs les Bouchers* was published between November 1857 and March 1858. See Delteil (1925–30) 1969, nos. 3010–21.

2. The other Fogg drawing is 1927.202. See Maison 1968, vol. 2, nos. 260–65, and another in Stuffmann's discussion of the butcher subjects in Frankfurt–New York 1992–93, pp. 147–49.

3. Quoted from letters in the Harvard University Art Museums Archives.

PROVENANCE: Etienne Bignou, Paris; Reginald Davis, Paris; acquired through Martin Birnbaum by Grenville L. Winthrop, November 1927; his bequest to the Fogg Art Museum, 1943.

EXHIBITIONS: Cambridge, Mass., 1943–44, p. 10; Cambridge, Mass., 1969, no. 107; Cambridge, Mass., 1977b, no. 15.

REFERENCES: Fuchs 1927, p. 57, no. 239; Zervos and Fuchs 1928, facing p. 185; Lemann 1936, p. 16; Adhémar 1954b, pl. 25; Maison 1960, p. 20, no. 43; Moskowitz 1962, vol. 3, pl. 755 and facing page; Moskowitz and Sérullaz 1962, illus. p. 45; Bowness 1965, illus. p. 45; Maison 1968, vol. 2, no. 264, pl. 63; Vincent 1968, p. 93, pl. 29; Roy 1971, p. 63; Kusano, Abe, and Takashina 1972, pl. 1; Symmons 1979, pp. 86–87, no. 67; Finch 1991, pp. 154–55, fig. 202; Laughton 1991, p. 109, fig. 7.21; Laughton 1996, p. 41; Wechsler 1999, pp. 48–49.

15. *Scapin*, or *Scapin and Géronte*, 1860–62

Oil on wood panel
13¼ x 10⅛ in. (33.6 x 25.7 cm)
1943.225

Since Charles Baudelaire first drew attention to the fact that Daumier was Molière's visual heir, sharing the same simple, incisive, and direct view of the world, the observation has become commonplace. Rather less has been said about Molière as a source of inspiration for Daumier, a much-loved quarry that the artist preserved mainly for his paintings and studies, largely invisible to the public. Somewhat surprisingly, he derived greater comic effects for his printed work from a different quarter: the tragedies of Pierre Corneille and Jean Racine.

Molière raised Scapin from the rank of a popular, background comic role from the

commedia dell'arte to a title part for the legitimate stage in *Les Fourberies de Scapin (Scapin, the Trickster)*. It may be said that Daumier further transformed the character, refined it, and gave it greater weight, intensity, and the sort of witty cruelty required to successfully intimidate masters. For all intent and purposes Scapin is now remembered as Daumier conceived him in his great *Scapin et Crispin* in the Musée d'Orsay, Paris. However, two additional panels divided between the Fogg Art Museum and the Musée d'Orsay are more specifically connected with Molière's play.

Both panels depict the scene in which Scapin has imparted to Géronte the false news that his son has been captured by Turkish pirates and enjoys the proceeds of his lie. As observed by Henri Loyrette, one

should consider the Winthrop and Orsay panels together as pendants.[1] Thus, one can read them as alternate, perhaps even sequential, impressions of a comedic situation involving cause and effect: on the one hand Scapin, absorbed in his stratagems; on the other his victim, reduced to hopelessness. In the Orsay version Géronte is paralyzed with terror; in the Winthrop panel his howl of anguish and his frantically raised hands are all the more effective as they are partly concealed from the viewer.[2]

When she first published the painting in 1966, Catherine Blanton noted that Daumier left it incomplete.[3] This is indeed the case for both pictures, Orsay and Winthrop. The Orsay *Scapin* was painted on top of another composition, set in an interior. Daumier sketched the figures—

with Scapin more fully developed than Géronte, whose body is merely blocked in— and then covered with broad brushstrokes only part of the background.[4] At the upper right corner of the Orsay *Scapin* the underlying painted interior is exposed, incongruously revealing on the wall an alien oval framed picture.

The Winthrop painting, surely the second in the sequence, is—or was—more finished than its Orsay counterpart but went through at least two transformations. At first the panel proved too narrow for the composition and was enlarged with strips at both sides; thus, the pentimenti under the figure of Scapin presumably belong to that previous state of the panel. It is likely that in the subsequent incarnation of the picture, Géronte's head was inclined at a different angle and his hands were positioned more closely together—traces of which are still visible. Unhappy with the results, Daumier altered the figure, broadly blocked in the area of the hands, which are not connected to the body, and focused more precisely on the head.

Blanton, followed less explicitly by Karl Eric Maison, presented for primarily aesthetic reasons the hypothesis that Géronte's head and hands are posthumous additions by someone who attempted to improve the painting.[5] In fact, everything argues in favor of Daumier proceeding exactly in the manner he is known to have usually worked—or reworked—that is, to start spontaneously and leave the rest for another time.

The question of whether the painting is finished is to a degree only of technical interest. From about 1850, when Daumier made his mark as a painter, he was pursued by the rumor that he was unable to complete his works.[6] In 1878, however, the artist—always his own harshest critic— chose to lend the Winthrop and Orsay *Scapin*s, as they were, to his retrospective. The matter is more significant than might at first appear, because he lent few works and had been extremely careful with the selection. Indeed, his omissions from the retrospective—for instance, the great, early *Women Pursued by Satyrs* (Montreal Museum of Fine Arts) and *The Miller, His Son, and the Ass* (Burrell Collection, Glasgow), both of which he still owned— are as telling as his contributions. One of the revelations of the 1878 exhibition was in fact how broad and informal his true style was.[7]

Michael Pantazzi

1. See Loyrette in Ottawa–Paris–Washington 1999– 2000, p. 353, no. 203.

2. The same aesthetic of fear informs other Molièresque situations that Daumier depicted, notably those in which Argan, the imaginary invalid, faces his medical tormentors.
3. Blanton 1966, p. 512.
4. A group of studies related to the Orsay panel is instructive in showing the genesis of the composition. One of these (Maison 1968, vol. 2, no. 471) explores the possibility of one of the figures seen from the back, as in the Winthrop painting. See ibid., nos. 470–73.
5. Blanton 1966, p. 512. A laboratory report has established the additions to be later, which they are, but they should be considered autograph.
6. The matter actually concerned two large official commissions that Daumier never completed.
7. See Pelletan 1878, p. 2: "Il me semble trouver dans les peintures, toutes très largement executées, la plupart laissées à l'état d'ébauche, d'Honoré Daumier, quelque chose qu'on chercherait rarement ailleurs: la traduction puissante de la vie moderne" (MP's translation: "I seem to find in Honoré Daumier's paintings, all very broadly painted and most left at the state of sketch, something one would rarely search for elsewhere: the powerful rendition of modern life").

PROVENANCE: Acquired from the artist by M. Turquois, Paris, 1878; his daughters, Mme Dulac and Mlle Turquois, until at least 1928; purchased from Mme Dulac by Wildenstein and Co., New York; acquired from them by Grenville L. Winthrop, January 8, 1931 ($36,800); his bequest to the Fogg Art Museum, 1943.

EXHIBITIONS: Paris 1878a, no. 83; Paris 1901, no. 77; Copenhagen–Stockholm–Oslo 1928, no. 37; Cambridge, Mass., 1977a.

REFERENCES: Alexandre 1888, p. 374; Klossowski 1923, p. 92, no. 73; Scheiwiller 1936, pl. 22; Blanton 1966, pp. 511–16, figs. 1, 40, 43; Maison 1968, vol. 1, no. I-128, pl. 126; Georgel and Mandel 1972, pp. 102–3, no. 168, pl. 33; Mortimer 1986, p. 181, no. 206, illus.; Bowron 1990, fig. 310.

Jacques-Louis David

Paris, 1748–Brussels, 1825

16. *Roman Album No. 1*, 1775–80

Folio album: 19 sheets of cream modern laid paper (first 5 blank), mounted with 31 drawings, including 6 on tracing paper, bound in brown quarter leather binding, brown marbled boards; the spine has been almost totally lost[1]
Album 20½ x 13¾ in. (52 x 34.7 cm); sheets 19¾ x 13⅜ in. (50 x 34 cm)
Inscribed on the front cover in brown ink, above center: N° 1
Folios numbered in black ink, upper right; many of the drawings initialed in brown ink by David's sons, Eugène and Jules[2]
1943.1815.19

David spent time in Rome on two occasions, from November 4, 1775, to July 17, 1780, and from October 8, 1784, to late August 1785. Whereas his second stay was primarily devoted to painting *The Oath of the Horatii* (Louvre, Paris), he dedicated his first journey to drawing (winner of the Grand Prix, he stayed in the Eternal City as a pensionnaire of the Académie de France). There, he copied the most famous works of classical antiquity and a few Renaissance and seventeenth-century paintings, and drew landscapes of Rome and surrounding areas. On his return to Paris, he dismantled the sketchbooks he had used in Rome and glued the drawings onto the sheets of two (or three) large albums, which he kept throughout his life (these have been reconstituted in the recently published catalogue raisonné of David's drawings).

After David's death on December 29, 1825, his sons and heirs, Jules and Eugène David, initialed each drawing. Between February 25, 1826 (the date of the inventory after the artist's death), and April 17, 1826 (the first David sale), they transformed the two (or three) albums—to which the artist had added a few supplementary drawings over the years—into twelve. These are the famous Roman albums, not to be confused with David's sketchbooks, which are composed, for the most part, of studies for the artist's principal paintings. Nine albums have now been identified (in addition to Winthrop's at the Fogg, there are two at the Louvre; others are in Stockholm, Washington, D.C., New York [Pierpont Morgan Library], and Los Angeles [Getty Research Institute]; and two others have been dismembered). Originally, the twelve Roman albums contained slightly under a thousand drawings and more than one hundred and fifty tracings of prints. Seven hundred and fifty of them, tracings included, are known today. Each album, when it survived in its original form, was made up of twenty-one to twenty-six sheets. Each begins with copies of works from classical antiquity or paintings of old masters. Next come the landscapes, followed by the tracings (not initialed). The Roman albums are of key importance: for the artist and his students, who had free access to them, they were a permanent source of inspiration, the stockpile from which David drew constantly throughout his career.

Of the nine Roman albums known today, three have undergone considerable alterations: two were carved up after World War II, and the one at the Fogg was roughly handled and mutilated on several occasions. Today, the Winthrop album contains only nineteen sheets, on which are glued thirty-one drawings, including six tracings. In 1826 it supposedly contained eighty, plus eight tracings. These numbers indicate the extent of the excisions it underwent between 1826 and 1936, the date of its purchase by Grenville Winthrop from the vicomte Béranger. In addition, the new assemblage of the album no longer respects the old order or the logic of the albums as is described above. It seems probable that the most easily marketable drawings were removed.

The album is not lacking in interest, however. It includes fine copies of works of classical antiquity, which, in David's time, belonged to the principal Roman collections, as well as interesting copies after the old masters, two landscapes in black crayon, and finally, tracings. But not all the drawings in the album are in David's hand.

Illustrated here is sheet 9 on which three drawings appear, executed in black chalk or black crayon and gray wash, measuring, respectively, 5⅝ by 3½ inches (14.1 x 8.9 cm), 5⅝ by 4⅛ inches (14.3 x 10.2 cm), and 5⅝ by 4⅛ inches (14.2 x 10.4 cm). All three are initialed and bear inscriptions, in David's hand, in black crayon: *Tiarini alli mendicanti, pour la composition,* and *pendant tiarini Salvator.* Indeed, the three pictures copied by David are still attributed to the Bolognese painter Alessandro Tiarini (1577–1668). All three could be seen in the eighteenth century in Bologna, in, respectively, Santa Maria dei Mendicanti (today in the Louvre), San Domenico (where the picture remains), and San Salvatore (that picture also remains there). They are *The Penitence of Saint Joseph, Saint Dominic Resuscitating a Child,* and *The Holy Family.* If it is certain that David passed through

16, fol. 9

Tiarini's compositions influenced David's own work would require further research.

Pierre Rosenberg

1. For a precise description of the album, see Mongan 1996, no. 66.
2. Lugt 1921, nos. 839 and 1437, respectively.

PROVENANCE: David sale, A. N. Pérignon, Paris, April 17, 1826, and following days, part of no. 66 (withdrawn); second David sale, Hôtel des Ventes, Paris, March 11, 1835, part of no. 16; acquired by "baron J. (Jules?) David"; Henri, vicomte de Béranger; acquired from him through Martin Birnbaum by Grenville L. Winthrop, January 1936 (Fr 30,000); his bequest to the Fogg Art Museum, 1943.

REFERENCES FOR THE ALBUM: Coggins 1968, pp. 260–62, 264 n. 8; Mongan 1975, pp. 319–26, figs. 204–9; Mongan 1996, no. 66, illus. (all drawings); Rosenberg and Prat 2002, nos. 452–82.

REFERENCES FOR THE THREE DRAWINGS ON FOLIO 9: Mongan 1975, pp. 321–22, 325 n. 7, figs. 204, 205 (*The Penitence of Saint Joseph* and *Saint Dominic Resuscitating a Child*); Howard 1976, p. 113, n. 127; Michel in Rome 1981–82, pp. 90, 95 n. 2; Sérullaz in Rome 1981–82, pp. 65, 68 n. 29, fig. 12 (*Saint Dominic Resuscitating a Child* and *The Holy Family*); Mongan 1996, pp. 44–45, illus.; Rosenberg 2001, p. 498, illus.; Rosenberg and Prat 2002, nos. 466–68, illus.

Bologna in 1775, it is no less certain that he copied the three large compositions by Tiarini on his way back to France, in 1780. David's taste for the Bolognese artists, Domenichino in particular, is well known. The inscription on the second drawing indicates what he wished to retain from Tiarini's paintings: *composition*. Whether

17. *Study for "The Oath of the Tennis Court,"* 1790–91

Brown and black ink and graphite on off-white antique laid paper, squared in graphite over the group at lower left. Originally folded in sixteenths
26 x 39 in. (66.2 x 99 cm)
Inscribed in graphite, *lower left:* les pierres / sont Blanches; *center left:* 8 planches sur le couloir; *above:* 3 p-4, 2 p-6, 8 plus, 2 p-8
Verso: one-quarter of sheet covered with brown wash tests (?)
Watermark: Shield with beehive / J HONIG / ZOONEN
1943.799

On June 20, 1789, at Versailles, the deputies of the Third Estate, finding the door to the meeting room locked, went to the nearby tennis court and, under the leadership of their chairman, the astronomer Jean-Sylvain Bailly, took an oath never to disband until they had written a constitution.

If the event depicted is well known, the genesis of David's work may not be. At the Jacobin Club on October 28, 1790, Edmond Louis Alexis Dubois-Crancé moved that the historic hall where the oath had been taken be preserved and that "the beautiful moment of the oath" be the subject "of a canvas thirty feet high by twenty feet wide, with which the association will pay tribute to the National Assembly, to decorate the meeting room." It was reported that "The painting was unanimously entrusted to the talent of M. David."[1] An engraving after the picture was envisioned as a fund-raiser, but it had little success. David rapidly began to work, dashing ideas onto paper, both as written instructions and as sketches, as shown in two sketchbooks, one at Versailles and one at the Louvre (RF 36942).

A large drawing at Versailles (fig. 59)—which was to serve as both a model for the engraving and the basis for the canvas that was never completed (David abandoned it for political reasons, after painting four

heads and leaving the rest in the state of a rough sketch in outline [Musée de Versailles])—was completed in May 1791. It was exhibited in the artist's studio from the end of the month until at least June 3, when the *Feuille du jour* mentions that people "are thronging to the home of M. David to admire the beautiful drawing he has made in bister of the famous oath at the tennis court."[2]

The composition, which was shown at the Salon of 1791, hanging strategically under the *Horatii,* had thus been conceived within a few months. For all intents and purposes, it was the "fruit of a constant, yearlong labor." Bertrand Barère de Vieuzac thus characterized the work at the tribune of the Constituent Assembly on September 28, 1791, when he tried to get David to take up the project again by guaranteeing a public commission.[3]

The Winthrop drawing stands as the most important milestone in the genesis of that composition. As has often been emphasized, the large sheet, which is only a few centimeters smaller than the drawing shown at the Salon, reveals David's working method. Étienne-Jean Delécluze believed that the architect Charles Moreau helped David establish the architectural structure of his composition, and I agree. But Jules David claimed it was Ignace-Eugène-Marie Degotti[4]—who would later assist David in the settings for the pictures commemorating Napoleon's coronation in December 1804—who helped the artist David in the drawings for the *Oath.* Some authors have also noticed that the Winthrop drawing provides a slightly broader perspective view than the drawing at Versailles: two ceiling beams instead of one are visible, and the empty space in the lower part of the foreground is slightly wider. David arranged groups in the foreground, some of which would later be concealed by other groups (the board set on two chairs at left, onto which a few deputies have climbed, for instance, will no longer be visible). He drew the figures

Fig. 59. Jacques-Louis David, *The Oath of the Tennis Court at Versailles, June 20, 1789,* 1791. Pen and brown ink, and brown wash with white highlights on paper, 26 x 39¾ in. (66 x 101 cm). Musée National des Châteaux de Versailles et de Trianon, MV 8409 (photo: RMN—Gérard Blot)

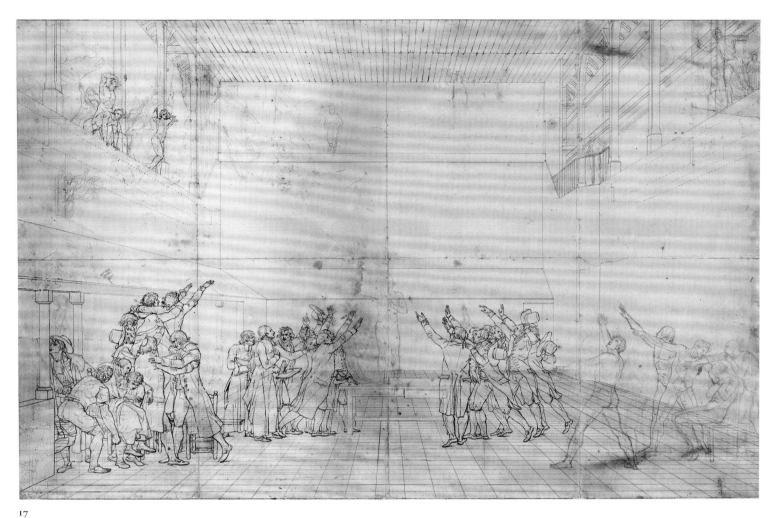

17

either nude, in graphite, or clothed, in pen, or both at once, as in the case of the man at the extreme left, who is supporting Maupetit de la Mayenne's chair (and who is not yet wearing the infamous Phrygian cap of the final drawing; his face does not show). An interesting asymmetry here, not reproduced later, is the realist detail of the open drawer in the central table. On the right is the single deputy, Martin d'Auch, who refused to swear.

The upper part is remarkable in more than one respect. First, a figure on the back wall suggests the presence of a gallery there. It would be eliminated from the final design, even though it existed in the original building (see the sketch David made of

it on fol. 33v of the Versailles album). Second, there are architectural differences from the Versailles drawing on the right, where a gallery can be made out. Finally, on the left, the presence of the figures studied nude (which also appears in the Louvre sketchbook) is less surprising than that of a woman near the second pillar with her arm raised. David studied her again below, farther to the left. The introduction into the large study of an anomalous element is a good indication of the intermediate state of the drawing. The woman, in fact, reappears on folios 17 recto and verso in the Louvre sketchbook but does not appear in the completed drawing at Versailles.

The Winthrop drawing, which unfortu-

nately was not included in the retrospectives devoted to David in 1989 and thus could not be compared with the sheet at Versailles, leaves a curious impression. Like the drawing of the setting for *The Coronation of Napoleon and the Crowning of Joséphine* (Louvre), it includes parts at different stages of completion, making an appreciation of it difficult. Even more disagreeable are the counterproofs of the lower figures in the upper part of the sheet (proving that the sheet was folded before the ink was dry). The impression of a stage set is very strong here, accentuated by the partially empty space across which the actors are scattered. The setting also brings to mind Poussin and his famous

perspective box, which made it possible to arrange figures in space in an equally rigorous manner.

Louis-Antoine Prat

1. Bordes (1983, p. 48) quotes the account of the session at the Jacobin Club given by Brissot in *Le patriote François*.
2. *Feuille du jour*, June 3, 1791, p. 528.
3. Ibid.
4. David 1880–82, vol. 1, p. 420.

PROVENANCE: Given by the artist to his student José de Madrazo y Agudo; his son Federigo de Madrazo y Kuntz; his son Mariano Fortuny y Marsal; his son Mariano Fortuny y Madrazo; acquired through Martin Birnbaum by Grenville L. Winthrop, October 1934 (Fr 25,000); his bequest to the Fogg Art Museum, 1943.

EXHIBITION: Cambridge, Mass., 1943–44, p. 3.

REFERENCES: Dowd 1948, p. 38, n. 57, pl. 8; Nash 1973, pp. 98, 111, 222 n. 270, fig. 121; Bordes 1980, p. 569; Schnapper 1980, pp. 108, 112, fig. 53; Sérullaz 1980, p. 107, n. 14; Bordes 1983, no. 24, fig. 83, and pp. 42, 50, 57, 104 nn. 129–30, p. 196 under no. 13, p. 198 under no. 17, p. 199 under no. 19, p. 212 under no. 26 (fol. 20v), p. 228 under no. 27 (fols. 17v, 20v), p. 229 under no. 27 (fol. 22r); Kemp 1986, pp. 167 (fig. 5), 169; Lévêque 1989, illus. p. 99; Noël 1989, illus. p. 33; Schnapper in Paris–Versailles 1989–90, pp. 246–48, fig. 74; Milhau 1990, p. 98; Sérullaz 1991, under nos. 197, 207, 226 (fol. 20v, 22r); Volpi 1994, pp. 288–89, fig. 3 (reversed); Mongan 1996, no. 69, illus., and pp. 68 under no. 71 (fol. 14 r), 80; Rosenberg and Prat 2002, no. 116, illus.

18. *Pierre-Marie Baille and Charles Beauvais de Préault,* 1794

Black ink and gray wash over black chalk, with traces of red chalk at left, squared in black chalk, on white laid paper
8⅝ x 7⅜ in. (22.2 x 18.7 cm)
Inscribed in black ink, lower center: pierre Bayle et beauvais
Initialed in brown ink by Eugène David (lower left) and Jules David (lower right)[1]
1943.805

Two large drawings by David, one at the Louvre and one at the Musée Carnavalet (figs. 60, 61), both called *Triumph of the French People,* are usually assigned the date of 1794. The Winthrop drawing is directly related to the figure group at the right of the drawing at the Carnavalet. The genesis of the two large drawings has given rise to many hypotheses based on the figures that appear in the drawings and the swift-moving political events of the time.

Alexandre Lenoir, the creator of the Musée des Monuments Français, who owned the Carnavalet drawing, explained in his 1835 memoirs that the drawing, an "allegory having to do with the revolutionary system . . . was commissioned from the artist by the authorities for a curtain designed for a special performance that was to take place at the Opéra after a political event; the music and words of the play were similar to the subject requested."[2] Yet what performance Lenoir referred to and when it took place are still a matter of debate.[3]

The drawing in the Louvre has often been described as a narrative frieze. The chariot, pulled by four oxen, advances toward the left, crushing the emblems of the monarchy. Hercules, symbolizing the French People, sits enthroned, with Liberty (holding the Phrygian cap at the end of a lance) and Equality (presenting the level) on his knees. Seated in front of them are the allegorical figures of Science, Art, Commerce, and Plenty. On the left a large procession accompanies the chariot. Two nude men repel the privileged "scoundrels" with their blades, and the scoundrels jostle one another to get away.

On the right, the heroes of freedom following the chariot are easily recognizable: Cornelia and her sons, the Gracchi; Brutus; William Tell and his son holding up an apple; then the two modern martyrs Marat and Lepeltier. Several of them are lifting palm branches.

The Carnavalet drawing clarifies the scene: on the left, among the men fleeing, is a figure on horseback; the king (who does not look like Louis XVI) wears a mantle with an ermine collar; one of the figures armed with swords is clothed. David placed the central part in relief by putting a dark background behind the figures; the group of martyrs on the right is defined by similar means. Marat is turning toward the viewer;

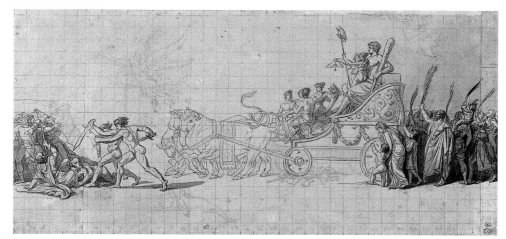

Fig. 60. Jacques-Louis David, *Triumph of the French People,* 1794. Graphite, black ink, and gray wash. Département des Arts Graphiques, Musée du Louvre, Paris, RF 71 (photo: RMN—Michèle Bellot)

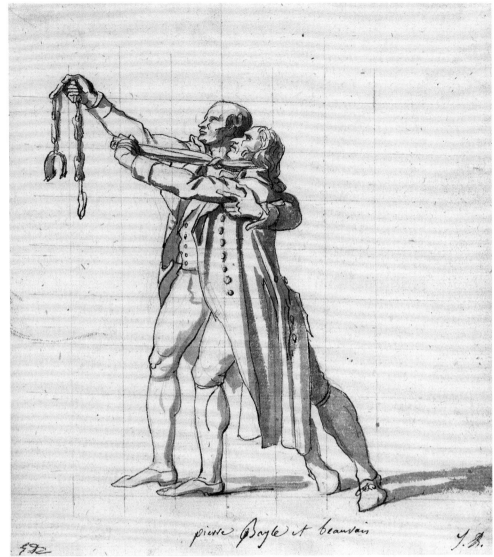

18

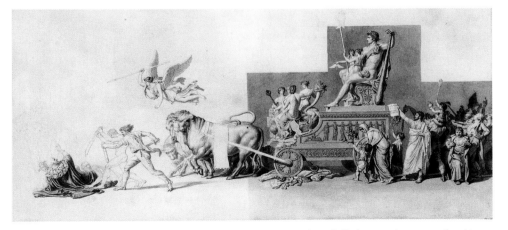

Fig. 61. Jacques-Louis David, *Triumph of the French People*, 1794. Black chalk, brown ink, gray wash, white highlights, 12⅞ x 28⅜ in. (32.7 x 72 cm). Musée Carnavalet, Paris, D. 4852

on his knees, he exposes his chest, becoming the intercessor between those looking and those marching. Behind him are the heroes with their attributes, whom David celebrated in a report on July 11 (23 Messidor) on the occasion of a festival honoring Bara and Viala, two youthful martyrs to the Revolution.[4] Lepeltier clasps his left side, where Paris struck him; Baille pulls on the tie with which he was strangled (or committed suicide); Beauvais shows the chains in which the English held him prisoner in Montpellier; Fabre de l'Hérault, in the background, wears a hat and raises the sword that struck him; Chalier displays the knife of the guillotine (the guillotine only half decapitated him, and he had to be finished off with the knife); and Gasparin shows the vial of poison that was administered to him.

The Winthrop drawing appeared in David's posthumous sale in 1826, with another drawing depicting Chalier, a figure also found on the extreme left of *Triumph*. But in 1827 Pierre-Alexandre Coupin referred to three, not two, drawings: "three full-length portraits, but of small dimensions, executed in pen and wash, of Pierre Bayle, Beauvais, and Chalier, famous revolutionaries. . . . They were designed to be part of the decorations for a backdrop made specially for a play in which the triumph of freedom was to be celebrated at the opera. This design was never realized."[5] Obviously, the "three portraits" correspond to the two drawings composing number 56 at the posthumous 1826 sale. The preparatory drawing for the figure of Chalier has been lost.

Coupin's reference to a "backdrop made specially for a play" makes the intended purpose of the two large drawings in the Louvre and in the Carnavalet even more mysterious, since it suggests they were designs, not for the curtain itself, but for the backdrop of the set of a play.

The present drawing, which David used later with practically no changes—though the two figures would be partly concealed by Marat and Lepeltier—in the Carnavalet preparatory drawing for *Triumph*, depicts two representatives of the Convention sent to Toulon in 1793. They were handed over to the English by the royalists when British troops occupied the city. Baille (1750–1793) was strangled (or committed suicide?) in prison, the night of September 1, 1793. Beauvais (1750–1794) was believed to be dead at the time, but he was later released and died, on March 28, 1794, as a result of his captivity. Hence the chains and the tie that the two martyrs are displaying. But, though the allegory is exploited in a heavy-handed manner, the fraternal intensity of the two figures still evokes the fervor of the deputies in the *Oath at the Tennis Court*.

Louis-Antoine Prat

1. Lugt 1921, nos. 839 and 1437, respectively.
2. Lenoir 1835.
3. Schnapper (1980, pp. 142–45) linked these designs to a play, *La réunion du dix août* (*Meeting of August 10*) by Bouquier and Moline, performed at the Opéra on April 5, 1794, a few days after the death, on March 28, 1794, of Beauvais de Préault. Later, in 1988, Schnapper pointed out that Beauvais had been believed dead as of December 1793. In addition, the Committee of Public Safety decided, on April 16, 1794, to move the Opéra from its old premises on the boulevard Saint-Martin to the building of the Théâtre National on the rue de la Loi. A new curtain for the new location was perfectly conceivable. Schnapper thus proposed to date the two drawings between April 16 and May 7, 1794, because, on the latter date, Robespierre reactivated the cult of Bara and added that of Viala, two youthful martyrs (Schnapper 1988, pp. 111–12). It would therefore be logical that, after May 7, David would include the two children among his martyrs, which, however, is not the case.
4. Yet a year later, in 1989–90, Sérullaz pointed out that the Opéra was not moved until after 9 Thermidor (July 27, 1794), at a time when no official commission could have been given to David, who was implicated with the Montagnards (Schnapper in Paris–Versailles 1989–90, no. 123). Bordes (1993, pp. 336–41) gave as the precise day when David decided on the composition for the group of martyrs the April 7 session of the Convention, during which

Baille, Beauvais, Gasparin, and Fabre de l'Hérault were celebrated. David added Chalier, "whose cult was then at its height." Bordes plausibly asserted that the drawing inspired the July 11 report and not the reverse. The Carnavalet drawing can thus be dated between April and the beginning of July 1794.
5. David 1880–82, vol. 1, pp. 208ff.
6. Coupin 1827, p. 58. Cantaloube (1860, p. 297) repeated the same description of *three* portraits.

PROVENANCE: David sale, A. N. Pérignon, Paris, April 17, 1826, and following days, part of no. 56 (with a drawing depicting Chalier; Fr 160); purchased at that sale by M. Defresne; Édouard Mortier, fifth duc de Trévise; his sale, Sotheby's, London, July 9, 1936, no. 79 (£11); acquired at that sale through Martin Birnbaum by Grenville L. Winthrop; his bequest to the Fogg Art Museum, 1943.

EXHIBITION: Cambridge, Mass., 1943–44, p. 3.

REFERENCES: Coupin 1827, p. 58; Cantaloube 1860, p. 297; David 1880–82, vol. 1, p. 657; Dowd 1948, pl. 16; Hautecoeur 1954, p. 125, n. 29 (which mistakenly places the drawing in an album at the Fogg); Dowd 1960, p. 18, n. 33; Wildenstein and Wildenstein 1973, no. 2062-56; Schnapper 1980, p. 144; Schnapper 1988, pp. 111, 116 n. 7, pl. 10, fig. 2; Sérullaz in Paris–Versailles 1989–90, under no. 124, fig. 86; Mongan 1996, no. 70, illus.; Rosenberg and Prat 2002, no. 132, illus.

19. *Sketchbook No. 14: Studies for "The Coronation of Napoleon I,"* 1805–6

29 leaves of off-white antique laid paper in a bound octavo volume, green quarter leather binding, green speckled boards[1]
Sketchbook 9⅝ x 7½ in. (24.3 x 18.8 cm); leaves 9⅜ x 7⅛ in. (23.7 x 17.9 cm)
Inscribed on the front cover in black ink: N° 14
Folios numbered discontinuously (pages were removed after numbering) in brown ink, upper right of rectos, 1 through 34; missing folios are 3, 9, 16, 21, and 25;[2] *five unnumbered pages were also removed*
Folios initialed in brown ink by David's son Eugène[3]
1943.1815.12

It is important not to confuse the albums with the sketchbooks: David's albums were

made in Rome and contain the copies the young artist drew during his first visit to that city (see cat. no. 16). The sketchbooks have a completely different history.

Fourteen sketchbooks are known today (eight belong to the Louvre, two to the Fogg [Winthrop collection; see also cat. no. 20], one to the Art Institute of Chicago, one to the museum in the château of Versailles, and two are in private collections), plus two dismembered sketchbooks. The number of pages in each sketchbook varies considerably, from twenty-two to eighty-three, constituting a total of eight hundred sheets, sometimes with drawings on both the front

and the back. David drew in his sketchbooks starting from both ends; hence, in each sketchbook, a considerable number of drawings are upside down.

We do not know how many sketchbooks there were originally; there were twenty-four at David's posthumous sale in April 1826. They have come down to us in very different states of preservation: some are relatively intact; others were more or less mistreated over the years, often heavily handled. Pages were torn out (sometimes by David himself) to be sold separately; drawings were added in some cases; and so on. The various page numbers legible on

19, fol. 2v

Fig. 62. Jacques-Louis David, *The Coronation of the Emperor Napoleon I and the Crowning of the Empress Joséphine at Notre-Dame on December 2, 1804*, 1805–7. Oil on canvas, 20 ft. 4½ in. x 32 ft. 1⅜ in. (621 x 979 cm). Musée du Louvre, Paris, 3699 (photo: RMN—Hervé Lewandowski)

each sheet are evidence of the transformations over time. These do not make understanding the logic of the sketchbooks any easier, insofar as there was any logic to them originally.

The sketchbooks include copies after antiquity or the old masters, drawings from the model or from life, studies for the more or less famous participants in the events depicted in the painter's chief historical compositions, and finally, overall drawings, which are particularly important for an understanding of David's creative process. These studies are very often squared up and frequently include useful annotations in David's hand. With three exceptions, the sketchbooks were initialed sheet by sheet by David's sons. As it may seem obvious, I ordered the fourteen surviving sketchbooks chronologically in the recently published catalogue raisonné of David's drawings. But in fact, David used his sketchbooks throughout his life, opening an old one to draw on a page that had remained blank. Even during his exile in Brussels, he added to his sketchbooks studies for works he was preparing at the time. Studying David's sketchbooks is exciting and indispensable for anyone interested in the artist but raises many problems.

Sketchbook 14 is primarily devoted to *The Coronation of Napoleon and the Crowning of Joséphine* (fig. 62).[4] It illustrates the painting in many ways, in particular, portraying a few of the most famous participants in the event, but also adding the artist's notes, which appear at the beginning and end of the sketchbook and aid in its interpretation.

The sketchbook by no means has survived in perfect condition: sheets were torn out, probably during David's lifetime, before the remaining folios were numbered from 1 to 34. Although it is not clear when the sheets were numbered (most probably by the heirs), it was done a very long time ago. Since the numbers were added, five

19, fol. 4r

19, fol. 12r

folios have been removed. In addition, there is a fairly large number of drawings on the backs of sheets. Unusual for David, only one drawing is upside down (fol. 26r) and the folios are initialed only by Eugène, not by both sons.

As we have already stated, the drawings were done in preparation for *The Coronation of Napoleon and the Crowning of Joséphine*. Some were used faithfully by David for his enormous painting without any notable modifications. Yet others the artist used, not for the painting, but for the compositional drawing recently acquired by the Fondation Napoléon in Paris, a study whose full significance has not yet been determined.[5]

That study dates from 1805. A drawing in sketchbook 14 (fol. 2v) shows Napoleon with his right arm in position to place a crown on his own head. It was only in May

1807 that David decided to abandon that as the subject of the coronation painting in favor of the crowning of Joséphine, a fact that allows us to give an approximate date for this sheet. It is likely that the sketchbook, which contains drawings that are exceptionally homogeneous in style, was used between 1805 and 1807 (though some doubt remains because some of the drawings in the Winthrop sketchbook are so close to the final painting that a few scholars have considered them to be repetitions David did while in Brussels).

Among studies of some of the most illustrious dignitaries who participated at the anointing—the coronation—are those of the emperor (a key drawing) and the empress (fol. 4r). Members of the imperial family—Joseph, Louis, the uncle Cardinal Joseph Fesch, and Princesses Hortense, Élisa, Pauline, and Caroline—occupy

places of prominence, as do the son-in-law, Murat, and the daughter-in-law, Julie Clary. Also present are the second and third consuls Cambacérès and Lebrun, Berthier, and the unavoidable Talleyrand. One image is particularly moving: that of Pope Pius VII, nude, his hands resting on his knees (fol. 12r). And one series of drawings is especially interesting, depicting Cardinal Caprara, first copied *D'après nature* (fol. 19r), then revised and corrected (fols. 17v, 18r) until the final stage, in the study David would use for the painting (fol. 18v).

Pierre Rosenberg

1. For a detailed description of the album, see Mongan 1996, no. 71. David acquired this sketchbook from the paper manufacturer Coiffier, whose label appears inside the front cover.
2. "Berthier" is still legible on a piece remaining of fol. 16 after it was torn out. At least twelve sheets were removed before the sheets were numbered: between folios 5 and 6, 11 and 12 (?), 14 and 15, 19 and 20, 20 and 22 (two folios), 24 and 26 (two

19, fols. 17v–18r

19, fols. 18v–19r

folios), 29 and 30, 30 and 31, and 32 and 33 (two folios).

3. Lugt 1921, no. 839.
4. The event, which took place on December 2, 1804, has been masterfully described by Antoine Schnapper in Paris–Versailles 1989–90, pp. 399–418.
5. Rosenberg and Prat 2002, no. 201.

PROVENANCE: David sale, A. N. Pérignon, Paris, April 17, 1826, and following days, no. 75 or 79; Mme la duchesse de Bassano; Mlle de Bassano; acquired from her through Martin Birnbaum by Grenville L. Winthrop, November 1937 ($66,000 for cat. nos. 19 and 20); his bequest to the Fogg Art Museum, 1943.

EXHIBITIONS: Paris 1913, no. 269 or 270; Cambridge, Mass., 1969, no. 102a.

REFERENCES: Saunier 1925b, pp. 15, 16 n. 1; Bouchot-Saupique 1929, pp. 219–20; Saunier 1929, p. 413; Cantinelli 1930, p. 120; Dowd 1948, p. 195; Mongan 1949, p. 128; Sérullaz in Paris 1974–75, p. 417 n. 3; Mongan 1975, p. 319; Schnapper 1980, p. 234; Newhouse 1982–83, p. 19, n. 10; McPherson 1991, p. 196, n. 38; Mongan 1996, no. 71 (all fols. illus.); Rosenberg and Prat 2002, nos. 1641–71 (all fols. illus.).

20. *Sketchbook No. 20: Studies for "The Coronation of Napoleon I,"* 1805–24

62 leaves of off-white antique laid paper bound in a quarto volume, three-quarters green parchment binding, green marbled boards[1]
Sketchbook 8⅝ x 6¾ in. (21.8 x 17.1 cm); leaves 8¼ x 6½ in. (21 x 16.4 cm)
Inscribed on the front cover in brown ink: N° 20
Folios numbered discontinuously (pages were removed after numbering) in brown ink, upper right of rectos, 57 to 7, and lower left of versos, upside down, 1 to 8; folios 7 and 8 are numbered on recto and verso; four folios are not numbered (between 12 and 11, 17 and 16, 24 and 23, and 31 and 30); folios 15 and 6 are missing[2]
Majority of leaves inscribed in brown ink with initials of David's sons, Eugène and Jules[3]
1943.1815.13

On David's sketchbooks, see catalogue number 19.

The vast majority of studies in sketchbook 20, as in sketchbook 14, are for *The Coronation of Napoleon and the Crowning of Joséphine* (see fig. 62), but there are others: two sketches for *The Distribution of the Eagle Standards*, now at Versailles (fols. 57r and 56r), and a study for *Mars Disarmed by Venus and the Three Graces* in the Musées Royaux des Beaux-Arts, Brussels (fol. 56v), a painting done in Brussels between 1821 and 1824. The existence of that study seems to confirm that David took (all?) his sketchbooks with him while he was in exile in Brussels.

Because the sketchbook is devoted primarily to *The Coronation*, the vast majority of drawings are "noble" portraits. Included are studies for Napoleon crowning himself (see fols. 3r, 2v, and 2r); the emperor crowning Josephine (see fols. 55v–54r and 54v–53r); Madame-Mère (Laetizia Bonaparte, the emperor's mother) drawn from life on her arrival in Paris (she was in Lyon the day of the coronation, on December 2, 1804; fol. 43r) or in the loge in which David placed her in the painting (fol. 44v); portraits of Marshals Moncey, Lefebvre, Berthier, Sérurier, Pérignon, and Kellermann; Generals Junot and Duroc; and some of the ambassadors present at the ceremony. But there are also "anonymous" portraits or, at least, less famous dignitaries who have left little trace in history and whose names David did not inscribe on the drawing. If David did not label the drawings at the time or immediately afterward, when did he put these useful indications on his studies? Is there a relationship between these annotations and the fact that he drew many models—more than ten appear in this sketchbook alone—from memory during his exile in Brussels?[4]

In the majority of cases, David drew his models full-length. But, most of the time, for his painting, he retained only the upper body, head, or even a detail of the face. Usually, the drawings are squared for transfer (one, in red chalk), but David often squared only the part of his drawing he would use for his painting. Some of the squared portraits, often those depicted most frontally, bear in the center, above the model's head, a little cross in pen.[5] This mark appears in other sketchbooks as well and deserves more attention.

Most of the drawings in sketchbook 20 probably date from 1805–7: the latter date applies to the different drawings showing Napoleon crowning Joséphine and for the portrait of Madame-Mère (she is absent from the Fondation Napoléon's 1805 overall drawing; see cat. no. 19). In general, the drawings are very similar to the painting. The realism of the most beautiful is striking. Yet not all are of the same quality, and the authenticity of certain of them, minutely detailed and dry, can be questioned.

Certain drawings could be called historic such as the nude Napoleon holding the crown at arm's length with both hands (fol. 52r), or, of course, the study of Joséphine. Nevertheless, the rare self-portrait of David (fol. 57r), sketchbook in hand, observing the coronation, signals the artist's desire to inscribe his name next to that of the man he served.

Pierre Rosenberg

20, fols. 55v–54r

20, fols. 54v–53r

20, fol. 44v

20, fol. 43r

20, fol. 3r

20, fol. 2v

1. For a detailed description of the sketchbook, see Mongan 1996, no. 72. David acquired this sketchbook from the paper manufacturer Jollivet, whose label appears inside the front cover.
2. Several (four?) sheets were removed before they were numbered, notably between folios 51 and 50, 28 and 27, and 2 and 3.
3. Lugt, 1921, nos. 839 and 1437, respectively.
4. See Rosenberg and Prat 2002, nos. 1679, 1683, 1686, 1687, 1690, 1692, 1695, 1703, 1705, 1718, 1723, where the folios are renumbered from front to back.
5. See fols. 49r, 37r, 33r, 29r, and 12r.

PROVENANCE: David sale, A. N. Pérignon, Paris, April 17, 1826, and following days, no. 75 or 79; Mme la duchesse de Bassano; Mlle de Bassano, Paris; acquired from her through Martin Birnbaum by Grenville L. Winthrop, November 1937 ($66,000 for cat. nos. 19 and 20); his bequest to the Fogg Art Museum, 1943.

EXHIBITIONS: Paris 1913, no. 269 or 270; Cambridge, Mass., 1969, no. 102b.

REFERENCES: Saunier 1925b, pp. 15, 16 n. 1; Bouchot-Saupique 1929, pp. 219–20; Saunier 1929, p. 413; Cantinelli 1930, p. 120; Dowd 1948, p. 195; Mongan 1949, p. 128; Sérullaz in Paris 1974–75, p. 417 n. 3; Mongan 1975, p. 319; Schnapper 1980, p. 234; Newhouse 1982–83, pp. 19, 20, and nn. 10, 11; McPherson 1991, p. 196, n. 38; Mongan 1996, no. 72 (all fols. illus.); Rosenberg and Prat 2002, nos. 1672–732 (all fols. illus.).

21. *Emmanuel Joseph Sieyès*, 1817

Oil on canvas
38½ x 29⅛ in. (97.8 x 74 cm)
Signed and dated lower left: L. David / Bruxelles / 1817
Inscribed upper left and right corners: EMM. JOS. SIEYES. / ÆTATIS SUÆ 69.
1943.229

David painted this portrait of Emmanuel Joseph Sieyès (1748–1836) in 1817, when the two men were in exile in Brussels. David shows Sieyès as a member of the Third Estate, dressed simply (if luxuriously) in a dark blue redingote (the French term for the English riding coat), trousers (not the knee breeches of the ancien régime), and white waistcoat and cravat. On Sieyès's lap is a large red, windowpane-checked handkerchief, in his hand a large, plain snuffbox. He sits in an armchair upholstered in teal brocade or cut velvet, with a frame either lightly gilded or highly polished. Sieyès is placed before a subtly modulated wall on which the artist has placed inscriptions: at the top, in gold letters that look as if they had been carved into the wall, the sitter's name and age; in the lower left, in dark script, the artist's signature and the date and place of execution.

David had portrayed Sieyès once before, in a highly finished preparatory drawing for the *Oath of the Tennis Court* that was exhibited at the Salon of 1791 (fig. 59).[1] In both, David depicted Sieyès as a member of the bourgeoisie, especially appropriate dress for the author of the pamphlet *What Is the Third Estate?* and a contributor to the Declaration of the Rights of Man and the Citizen. The sober dress identifies Sieyès as an active citizen, a member of the "public establishment": a group of representatives selected from the mass of citizens on the basis of their person and their production of wealth or public service.[2]

In the drawing, Sieyès is placed at the center of the composition and shown bald, in a mood of quiet reflection. His sobriety is unexpected for a man who had introduced the motion that would form a National Assembly of those men gathered in the Tennis Court at Versailles on June 20, 1789. Sieyès intended that the National Assembly not disband until France had a constitution. A champion of the enfranchisement of the Third Estate—in 1789 a radical idea, in 1799 Sieyès presided over the transfer of power to Bonaparte on

18 Brumaire.[3] Voting for the death of Louis XVI in 1793 and supporting Napoleon during the Hundred Days led to Sieyès's exile in Brussels, where David was similarly in political exile. For sitter and artist to come together in Brussels is not surprising. David and Sieyès probably knew each other, or knew of each other, as early as 1789, since both had been leading political figures.[4]

In the 1817 portrait, in contrast to the earlier drawing, Sieyès is shown to be relaxed, considerably younger than his sixty-eight years,[5] and endowed with a full head of light-brown, tousled locks. Such a hairstyle, known as "à la Titus," was very fashionable about 1800 for women as well as men. Although it continued to be popular into the second decade of the nineteenth century, Sieyès dates himself by wearing it (especially since what we see is a wig). Dorothy Johnson has suggested that David represented Sieyès as he looked "in his prime, at the height of his political involvement."[6] Yet David has shown Sieyès neither as he looked in 1789 nor as he looked in 1817. Instead, as Delacroix said of David's art in general, the portrait is a

"composé singulier de réalisme et d'idéal."[7]

David's portrait was probably not intended for public display. Presumably, it hung in Sieyès's house in Brussels, which he shared with a nephew, his nephew's wife, and their five children. David had the portrait copied, apparently twice. One of those copies must have been the painting on view in David's studio in 1823, when Gros climbed on a chair to inspect it.[8] The portrait was also reproduced in a large, highly accomplished lithograph by Léon Noël (1807–1884). The existence of a print points to a general interest in owning an image of Sieyès.[9]

David introduced considerable artifice into this seemingly informal portrait. The wall—blank and with a fluctuating amount of light falling on it—suggests, not a bourgeois interior, but the space in which David worked as an artist. Continuing the emphasis on artistic means, the arms of the chair have been painted so as to accommodate the shape of Sieyès and his voluminous, unbuttoned coat rather than their shapes being determined by the inflexible parts of the chair. The materials of the frame of the chair and the band of shining metal on the snuffbox, ordinary details, echo the noble metal in the majuscules at the top of the canvas. By these subtle means David assures that we understand that we are in the presence of a notable person.

Donna M. Hunter

1. The drawing is on loan to the Musée National des Châteaux de Versailles et de Trianon from the Cabinet des Dessins at the Louvre. For good reproductions of the drawing and its various sections, see Bordes 1983, fig. 84; fig. 84d is a close-up of Sieyès.
2. Furet 1992, p. 48. Furet quotes from Sieyès's second pamphlet, *Vues sur les moyens d'exécution dont les représentans de la France pourront disposer en 1789.*
3. Keith M. Baker, "Sieyès," in Furet and Ozouf 1989, s.v.
4. There are, however, few published pieces of evidence attesting to a connection between the two. David and Sieyès had both been members of the first Committee of Public Instruction established in October 1792. In the spring of 1799 David congratulated Sieyès on being nominated as director (Marquant 1970, p. 85). Sieyès assumed his duties as director on May 16, 1799. In the same letter David recommended a man named Misset who had served as a coachman to Lavoisier, the Comité de Sûrété Générale, and Reubell, a director who served just prior to Sieyès. A second letter from David to Sieyès (3 Messidor VII / June 21, 1799) is mentioned in the inventory without comment. Sieyès's nephew is also said to have posed for the figure of Agamemnon in David's late mythology, *The Anger of Achilles* (1819; see Paris–Versailles 1989–90, p. 528).
 When David, exiled in Brussels, received an invitation from the king of Prussia to live at his court in Berlin, Sieyès, who had served as French ambassador at that same court during the Directory, advised David against accepting (Anon. 1824, p. 67). When Sieyès served as French ambassador in Berlin during the Directory, he had been stiff-necked about following court ceremonial and refused to wear court attire. David first declined the offer in a letter of March 26, 1816 (Wildenstein and Wildenstein 1973, no. 1775). The invitation appears to have been reissued in May 1816; it was again declined. Since Sieyès did not arrive in Brussels until January 1817, it would seem that his views on living at court were interpolated into a situation where he had not actually given his advice.
5. The Latin phrase "aetatis suae 69" refers to Sieyès in his sixty-ninth year. Since Sieyès did not arrive in Brussels until January 1817, the Latin phrase, if taken literally, would mean that his portrait was painted between the time of his arrival and his sixty-ninth birthday, on May 3, 1817.
6. Johnson 1993b, pp. 222, 224.
7. Delacroix 1981, p. 767 (February 22, 1860).
8. Jules David (1880–82, vol. 1, p. 649) mentions two painted copies of the portrait: one by Sophie Frémiet (1797–1867), a pupil of David during his Belgian years and wife of the sculptor Rudé, and one by Henri Decaisne (1799–1852), another Belgian pupil. Neither copy has surfaced. The copy by Sophie Frémiet was retouched by David, as was a copy she is known to have made of *Telemachus and Eucharis*. According to Jules David (ibid., p. 589), when Gros visited David in December 1823 and was shown the work in progress on *Mars Disarmed by Venus*, "Il remarqua aussi dans l'atelier un portrait de Sieyès, et monta meme sur une chaise pour mieux étudier les mains." Jules David's source appears to be the letter that Gros wrote to David the following September 19.
9. Léon Noël's folio-size lithograph can be seen in the Cabinet des Estampes, Bibliothèque Royale, Brussels (S. II, 119599). It is both a handsome and faithful reproduction. Undated, it was printed by Lemercier Bernard. The legend at the bottom of the sheet appears under "SIEYÈS": "Peint à Bruxelles pendant son exil, par Louis David également exilé." Jules David reproduced the painting as well in an etching (David 1880–82, vol. 2).

PROVENANCE: David to Emmanuel-Joseph Sieyès, Brussels, 1817; his niece Mme Combes, by 1856; by descent to vicomte Henri de Bérenger, Paris, by 1913; acquired from him through Martin Birnbaum via André Weil, Paris, by Grenville L. Winthrop, January 27, 1936 (Fr 300,000); his bequest to the Fogg Art Museum, 1943.

EXHIBITIONS: Paris 1913, no. 62; *Centenaire de l'Academie Française*, Paris, sometime between 1913 and 1936; Cambridge Mass., 1943–44, p. 3; Cambridge, Mass., 1969, no. 83; Cambridge, Mass., 1975–76a, no. 40; Cambridge, Mass., 1977a.

REFERENCES: Sias n.d.; Coupin 1827, pp. 42, 57; David 1880–82, vol. 1, p. 649, vol. 2, illus. in etching after the painting; Dorbec 1907, pp. 324–25; Cantinelli 1930, no. 144; Benesch 1944, p. 20; *Christian Science Monitor*, January 8, 1944, illus.; "Sixteen Reproductions" 1944, illus.; Fogg Art Museum 1945, p. 101, illus.; Levitine 1953, p. 335; Faison 1958, p. 118, fig. 16; Aymar 1967, pl. 32; Oshima 1976, p. 78, illus.; Brookner 1980, fig. 111; Schnapper 1982, pp. 283, 286, fig. 181; Mortimer 1985, p. 173, no. 197, illus.; Nanteuil 1985, p. 162, pl. 46; Leighton 1987, p. 17, fig. 13; Furet 1988, illus. p. 160; Michel 1988, illus. p. 123; Noël 1989, illus. p. 87; Roberts 1989, pp. 51, 64, 133, 191, 198, fig. 87; Paris–Versailles 1989–90, p. 513, fig. 142; Bowron 1990, fig. 257; Ferrier 1991, p. 157, illus.; Johnson 1993a, p. 1028; Johnson 1993b, pp. 222–24; Kimura et al. 1994, illus. p. 93; Stafford 1994, p. 120, fig. 92; Ribeiro 1995, pp. 108–9, fig. 116; Cuno et al. 1996, pp. 184–85; Johnson 1997, pp. 36–37, fig. 26; Monneret 1998, p. 189; London–Washington–New York 1999–2000, pp. 6, 7.

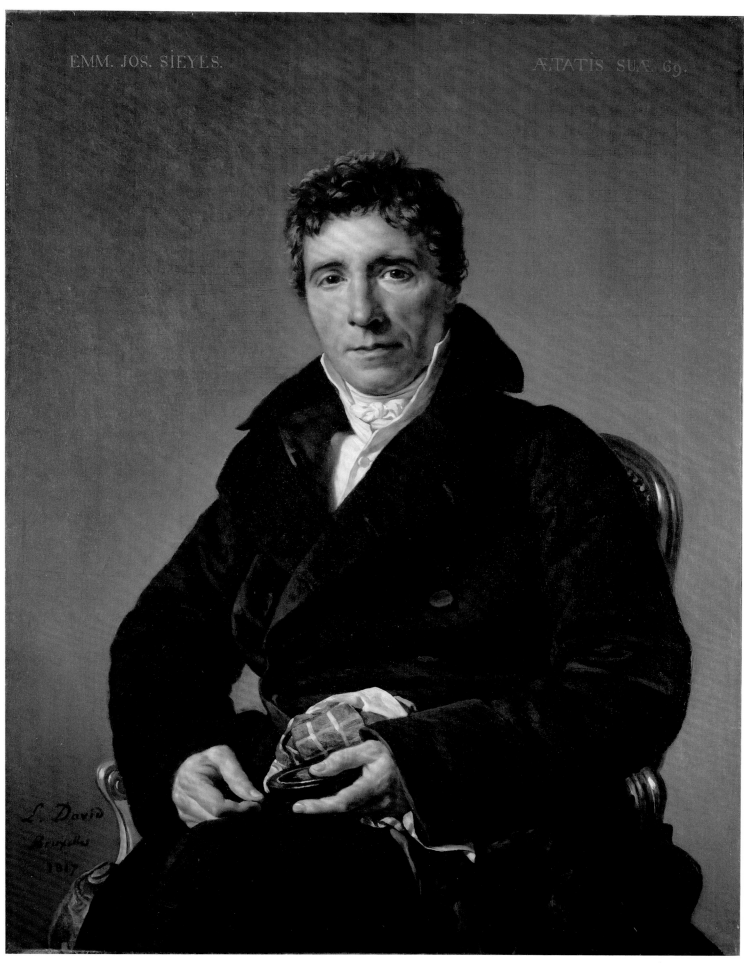

L. David
Bruxelles
1817

21

Jacques-Louis David and studio

22. *Emperor Napoleon I,* 1807

Oil on panel
34¾ x 23⅜ in. (88.27 x 59.37 cm)
Signed and dated in oil, lower right: L. DAVID.
1807
1943.228

The portrait of Napoleon Bonaparte in the Winthrop collection, attributed to Jacques-Louis David and his studio, is now known as *Emperor Napoleon I.* Yet the portrait is more exactly described as "Napoleon in Imperial Costume," since the regalia is the real subject of the painting. On December 2, 1804, Napoleon Bonaparte officially became Emperor Napoleon when he was crowned and enthroned in the cathedral of Notre Dame in Paris. On that day Napoleon wore these sumptuous robes, and *les honneurs impériaux* were displayed near him. The Winthrop painting alludes to the moment after the enthronement, when Napoleon descended the "large throne," holding the scepter in one hand and the hand of justice in the other, as Antoine Schnapper has suggested.

The Winthrop painting is related to a full-length portrait of Napoleon by David, now lost. Philippe Bordes and Alain Pougetoux have argued that the Winthrop painting served as the basis for a portrait of the emperor in coronation robes commissioned in 1808 by Napoleon's brother Jerome, the king of Westphalia.[1] This portrait was exhibited in the Salon of 1808.

The first attempt to fulfill an 1805 commission for Genoa, known from an oil sketch in Lille, resulted in a painting that Napoleon detested. It showed Napoleon nearly parallel to the picture plane, brandishing the scepter and hand of justice, flanked by large pillars on either side of the throne. It was said at the time that the work failed because a mediocre pupil of David's was responsible for the execution. In like manner, the lost painting for the king of Westphalia is believed to have been the product of two hands, David's and that of Georges Rouget, his collaborator on the large imperial canvases. David is said to have painted the head, Rouget everything else[2]—a fairly usual division of labor on portraits commissioned from such major and prolific seventeenth-century portraitists as Anthony van Dyck and Nicolas de Largillière.

Yet David is known to have painted portraits, even large ones, by himself, doing all the preparatory work directly on the canvas, in graphite or thin brown paint. The Westphalia and Genoa portraits are exceptions to this rule and point to a change in David's thinking about imperial commissions. A drawing in the Louvre, Paris (RF 23 077, fol. 47v), may explain the change. The drawing is in a sketchbook that delineates ideas for a set of very large history paintings commemorating the events around Napoleon's accession. The drawing shows a naked man whose facial features are barely indicated. As a preparatory drawing for a history painting, it assumes the solemnity of the projected painting. As such, the head, rather than functioning as the culmination of the figure, is simply part of the whole. The drawing became the model for the figure of Napoleon in the Winthrop collection. The drawing is carefully squared, and a corresponding grid can be detected under the paint surface of the Winthrop portrait using infrared reflectography.

Donna M. Hunter

1. Bordes and Pougetoux doubt the authenticity of the date and signature, a doubt I share.
2. Schnapper 1989, p. 436. The evidence for the two hands is a remark written by Rouget himself, claiming that he painted the entire work except the head, which David, as usual, painted. Rouget also calls the Westphalia painting only a replica. But to say, as Rouget did, that the Westphalia painting was a replica does not necessarily mean that it was a replica of a painting carried out for another commission. For example, the king of Spain commissioned the famous image of Bonaparte crossing the Alps but received a replica, not the original.

PROVENANCE: David sale, A. N. Pérignon, Paris, April 17, 1826, and following days, no. 7 (Fr 2,201); purchased from that sale by (Louis-Joseph Auguste?) Coutan; his sale, Galerie Georges Petit, Paris, March 9, 1829, no. 20 (bought in, Fr 2,000); Ambroise Firmin Didot, by 1857; Moreau Wolsey; his sale, Hôtel Drouot, March 23–24, 1869, no. 34 (Fr 870); Richard Wallace, Paris and London; his widow, Lady Julia Amélie Castelnau Wallace, 1890; bequeathed by her to Sir John Murray Scott, 1897; bequeathed by him to Josephine Victoria Sackville-West, Lady Sackville of Knowle, 1912; purchased (with entire Richard Wallace collection) from her by Jacques Seligmann et Cie, Paris, 1913; acquired from Jacques Seligmann and Co., New York, by Grenville L. Winthrop, May 8, 1925 ($10,000); his bequest to the Fogg Art Museum, 1943.

EXHIBITION: Cambridge, Mass., 1943–44, p. 3.

REFERENCES: David 1880–82, vol. 1, p. 644 (as "Napoleon Ier, empereur, H. 1,35–L. 0, 59"); Benesch 1944, p. 21; Soulange Teissier, reproductive lithograph after the painting, commissioned by painting's owner, Ambroise Firmin Didot, printed by Lemercier, Paris, 1957; Seligman 1961, p. 149, pl. 45A; Wildenstein and Wildenstein 1973, pp. 244 (no. 7 under doc. 2062), 250 (possibly no. 6 under doc. 2087); Bordes and Pougetoux 1983, pp. 25 (fig. 8), 26, 29–30 n. 15, 32–33 n. 29; Paris–Versailles 1989–90, pp. 433 (fig. 118), 436, 616 (under "11, 13, 23 et 29 janvier 1811"); Bowron 1990, fig. 261; Pougetoux 1990.

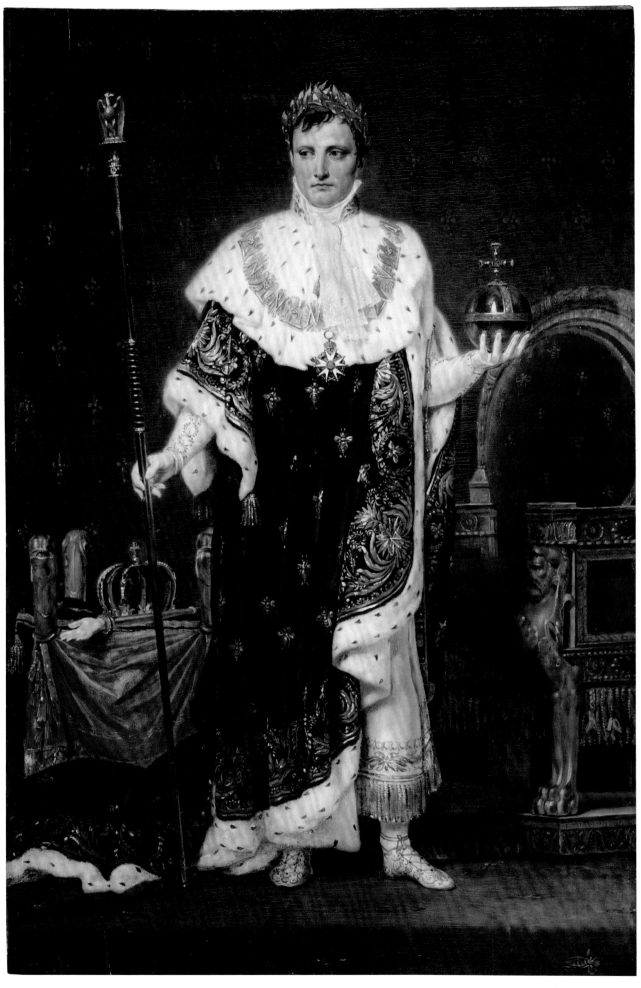

Circle of Jacques-Louis David

23. *Portrait of a Young Woman,* ca. 1800

Oil on canvas
29¾ x 22⅝ in. (75.6 x 57.5 cm)
1943.227

This unsigned portrait of a young woman, painted about 1800 by an unidentified artist, was attributed to Jacques-Louis David at the time of Grenville Winthrop's purchase in 1903.[1] Its composition reflects the influence of David's innovative portraits of the 1790s, in which he portrayed sitters with a startling directness, set against an austere, monochromatic background. Similarly, the young woman in this portrait gazes outward, and the contours of her figure are outlined against a neutral ground. The technique, however, distances the work from David's hand; notably, the uniform tonality of the background contrasts with the subtly modulated surface characteristic of David's portraits. This painting also lacks the detailed modeling and polished finish of portraits by such prominent Davidians as François Gérard and Anne-Louis Girodet. Yet by the end of the nineteenth century David was the most recognized and sought-after Neoclassical artist, and it is not surprising that this work, as well as similar portraits that appeared on the art market around 1900, was then attributed to David.[2] One of these works, a portrait of a girl holding a musical score (fig. 63), was only recently attributed to Sophie Guillemard (b. 1780), who was a pupil of Jean-Baptiste Regnault; that work, which was exhibited in the Salon of 1801, resembles the

Winthrop portrait in the sitter's pose and unaffected simplicity.[3] However, the lack of documentation on the present work and the widespread emulation of David's portrait style preclude a definitive attribution.

The young woman's white muslin gown reflects the vogue in the 1790s for fashion inspired by classical Greek art; the high waistline and short, fitted sleeves of her dress suggest a date of 1798 or 1799, in keeping with the fashions illustrated in the popular *Journal des dames et des modes.* While the sitter lacks such marks of social status as a cashmere shawl, women of all classes adopted a similar style of dress during the Directory (1795–99). Commenting on the phenomenon in his description of contemporary Paris at the close of the eighteenth century, Louis-Sébastien Mercier observed, "[There is] not a *petite maîtresse,* not a *grisette,* who does not decorate herself on Sunday with an Athenian muslin gown."[4] Rather than the elaborate *coiffure à l'antique* favored by upper-class women, the sitter wears a kerchief knotted on top of her head in a style popularized during the 1790s and known variously as *fichu à la paysanne* and *fichu à la Marat.* The latter term evokes the revolutionary Jean-Paul Marat, who in 1793 was assassinated as he bathed, his head allegedly swathed in a white headdress; this eponymous style was recorded in the *Journal des dames et des modes* of 1797.[5]

This portrait no longer retains its original format; strips of canvas were added along all four sides and the right side of the painting has been extensively

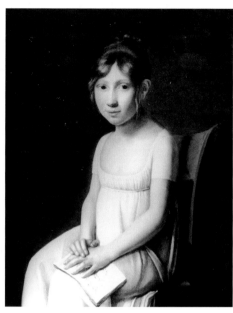

Fig. 63. Sophie Guillemard, *Portrait of a Young Lady Distracted from Her Music Lesson,* Salon of 1801. Oil on canvas attached to masonite, 29 x 23½ in. (73.7 x 59.7 cm). Cincinnati Art Museum, The John J. Emery Fund, 1917.369

inpainted, raising the possibility that this figure was once part of a larger composition, such as a group portrait.[6]

Kathryn Calley Galitz

1. Its attribution was changed between 1944 and 1969.
2. For further examples, see Oppenheimer 1997, pp. 38–44.
3. Ibid., pp. 40–42. I am especially grateful to Robert Rosenblum for noting the similarity between the two works and to Margaret Oppenheimer for sharing her thoughts regarding the attribution of the Winthrop portrait.
4. Mercier 1800, vol. 3, p. 136, as cited in Ribeiro 1988, pp. 128–29.
5. I thank Aileen Ribeiro for her generous assistance in identifying the sitter's headdress. On the *fichu à la Marat,* see Ribeiro 1988, p. 134.
6. See the conservation notes in the curatorial file in the Department of Paintings, Sculpture, and Decorative Arts, Fogg Art Museum. The practice of fragmenting group portraits was not uncommon; see, for example, two portraits by Louis-André-Gabriel Bouchet at the

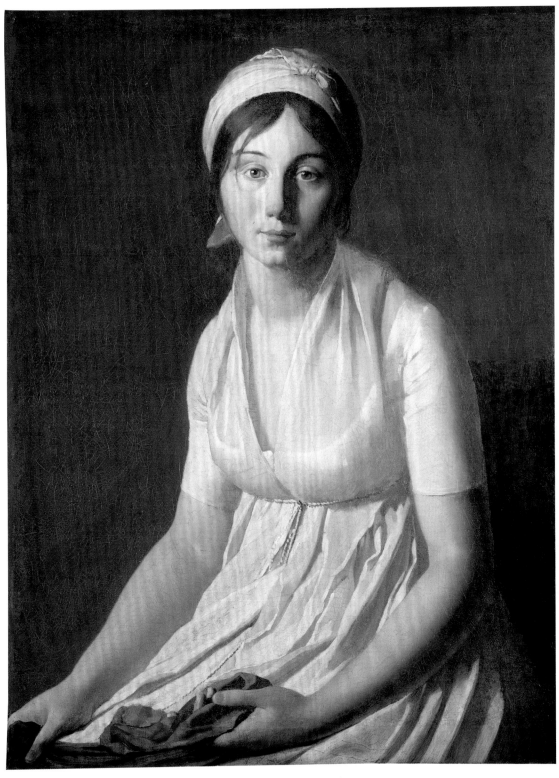

23

Detroit Institute of Arts, *Three Sisters*, 1812 (55.3), and *Family Group* (27.246), which were once part of a single group portrait.

PROVENANCE: E. F. Bonaventure Art Galleries, New York, 1903; acquired by Grenville L. Winthrop,

April 3, 1903 ($1,600); his bequest to the Fogg Art Museum, 1943.

EXHIBITIONS: The Metropolitan Museum of Art, New York, on general loan, April 29, 1911–March 6, 1912; Cambridge, Mass., 1943–44, p. 3.

REFERENCES: Metropolitan Museum 1911, p. 143; Fogg Art Museum 1943, illus. p. 58; "Winthrop Collection Goes to Fogg" 1943, illus. p. 8; "Sixteen Reproductions" 1944, illus.; Bowron 1990, fig. 260.

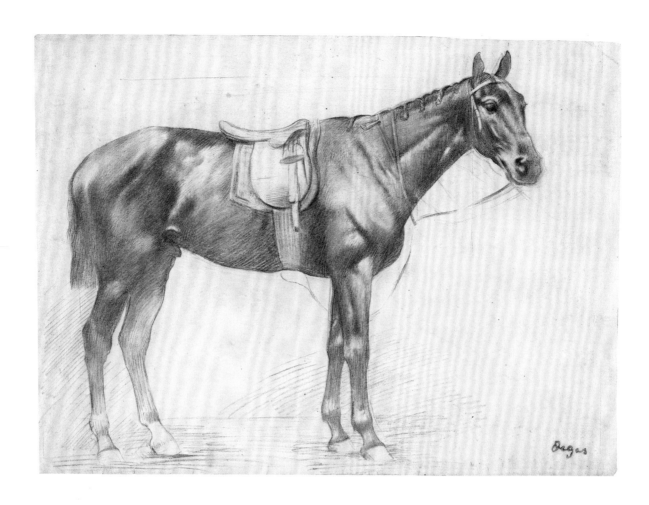

Hilaire-Germain-Edgar Degas

Paris, 1834–Paris, 1917

24. *Horse with Saddle and Bridle*, ca. 1869–70

Black chalk on off-white wove paper
9 x 12¼ in. (22.8 x 31 cm)
Red stamp of Degas sale, lower right
1943.810

There is no documentary evidence on which to pin the date of this superbly assured drawing. Suggestions by scholars have ranged from the early 1860s,[1] following Edgar Degas's return from study in Italy, to the early 1870s,[2] following his return from New Orleans. Most likely it dates from the end of the 1860s. It was at this time that Degas was most interested in

the turf. But as he told an interviewer in 1897 with characteristic modesty, "Even though I was quite familiar with 'the noblest conquest ever made by man,' even though I had had the opportunity to mount a horse quite often, even though I could distinguish a thoroughbred without too much difficulty, even though I had a fairly good understanding of the animal's anatomy and myology, having studied one of those plaster models found in all the caster's shops, I was completely ignorant of the mechanism of its movements, and knew infinitely less than any noncommissioned

officer, who, because of his years of meticulous practice, could imagine from a distance the way a certain horse would jump and respond."[3]

Jean Sutherland Boggs was the first scholar to note that Degas used the counterproof of this drawing for the mount at the far right of *The Depart for the Hunt* (fig. 64). The pose depicted in the Winthrop drawing does not appear in that painting or in any other equine composition by Degas, but it seems probable that this sheet was made in connection with that project. It is not known when Degas began work on

The Depart, yet there is good reason to think it was a product of his stay at the country house of his good friends the Valpinçons at Ménil-Hubert in Normandy. The most famous work to emerge from Degas's visit in summer 1869 is the exquisite *At the Races in the Countryside* (Museum of Fine Arts, Boston), which, according to remarks he made in letters to James Tissot, Degas hoped to sell in England.[4] It seems logical that *The Depart*, with its fine horses, hunting pinks, and gently rolling landscape, was also conceived for the English market. This helps explain the meticulous quality of the drawings for a picture that today looks very different. It has long been recognized that *The Depart* was made in at least two campaigns separated by a long period of time; it seems likely that initially it was painted in a tight and precise style, like that of *At the Races*, before it was repainted in its current, loose but luminous manner. And again like *At the Races*, it may well

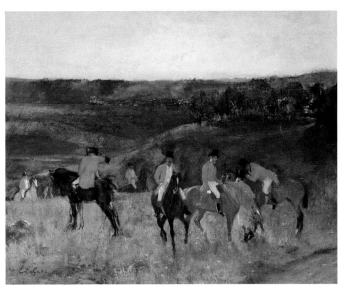

Fig. 64. Edgar Degas, *The Depart for the Hunt*, ca. 1863–65 and 1873. Oil on canvas, 27½ x 35 in. (70 x 89 cm). Galerie Schmit, Paris

have been begun at Ménil-Hubert in summer 1869, although it is possible, as others have suggested, that it was not begun until after Degas returned from England in 1871 or after he visited Liverpool on his way to New Orleans in 1873.[5]

As Boggs has remarked, the horse and its pose in the Winthrop drawing are similar, though not identical, to those of one of the earliest surviving sculptures of a horse, *Horse at Rest*.[6] The drawing and the sculpture are both related to a photograph

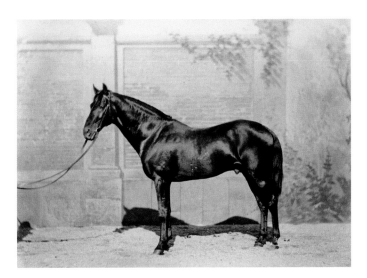

Fig. 65. Louis-Jean Delton, *Thoroughbred English Stallion Belonging to Count Aguado*, ca. 1867. Albumen print, 7⅜ x 10³⁄₁₆ in. (18.7 x 25.9 cm). J. Paul Getty Museum, Los Angeles

Fig. 66. Edgar Degas, *Sheet of Five Horse Studies*. Whereabouts unknown (after photograph in Fine Arts Library, Harvard University)

of a thoroughbred owned by Count Aguado (fig. 65). Aguado's horse, a sleek racing machine that is all neck and haunches, is finer than the animal in Degas's drawing. But the similarity of drawing to photograph is a vivid reminder that Degas often consulted photographs, as when he used a photograph of one of Vicomte Lepic's greyhounds as a model for the dog in *Lepic and His Daughters in the Place de la Concorde* (ca. 1875; State Hermitage, Saint Petersburg). However in the pentimenti of ears and muzzle the Winthrop drawing bears the traces of study from life.

The counterproof of this drawing is more carefully finished than the original.

Degas did not often work in chalk, so the intention to make a counterproof, which is best made with chalk, probably dictated the choice of medium. He drew the same horse on a sheet of five studies (fig. 66).[7]

Gary Tinterow

1. Rosenberg 1959.
2. Jean S. Boggs in Saint Louis–Philadelphia–Minneapolis 1967, no. 60. Boggs thought that the counterproof of this drawing dates to about 1873 and indicated that the drawing and counterproof, though different in effect, probably shared the same date.
3. Thiébault-Sisson 1921, quoted in Paris–Ottawa–New York 1988–89, p. 123.
4. Degas 1947, no. 3.
5. See Boggs in Washington 1998, p. 81, n. 17. It seems to me unlikely that the painting was conceived after 1873, although, as Boggs points out, one of the freely brushed essence drawings for one of the figures is dated 1873. I believe that these essence drawings were made for the second campaign of work on the picture. It remains possible that the painting was conceived in the early 1860s, in which case I would assign the Winthrop drawing the same date.
6. Rewald 1944, no. III; Boggs in Washington 1998, p. 84.
7. This drawing is not reproduced in the Degas atelier sales, and the current whereabouts are unknown.

PROVENANCE: Degas studio sale (part IV), Galerie Georges Petit, Paris, July 3, 1919, no. 209a; purchased at that sale by Reginald Davis; Scott and Fowles, New York; acquired from them by Grenville L. Winthrop, July 13, 1923 ($500); his bequest to the Fogg Art Museum, 1943.

REFERENCES: Rosenberg 1959, pp. xxiii, 105, 114, pl. 216; Boggs in Saint Louis–Philadelphia–Minneapolis 1967, pp. 98 (no. 60), 101 (fig. 60); Rosenberg 1974, pp. 143, 152, pl. 280; Washington 1998, pp. 84 (fig. 50), 85.

25. *Two Dancers Entering the Stage*, ca. 1876–78

Pastel and tempera (?) over monotype in black ink on white modern laid paper discolored to tan
Plate 12 3/8 x 11 in. (31.5 x 28.1 cm); sheet 15 x 13 3/4 in. (38.1 x 35 cm)
Inscribed in yellow chalk, lower left: Degas
Watermark: D & C BLAW
1943.812

"I had hardly arrived in London when I saw a pastel drawing which overwhelmed me, and I would strongly urge you to get it.—It is only 12 x 10½ in. in size & would cost you £3300:0:0 (Thirty three hundred pounds sterling) but it would rank as one of the finest items in your collection. . . . It represents two ballet girls on the stage. The pastel is exquisite, blonde & creamy; (the reproduction I saw *all red* & *hot* & ugly.) It is as fine as the Havemeyer pastels,—in other words, a real gem. It is not at all a high price for Degas,—and I am sure you would get a thrill whenever you saw it. It is as crisp and brilliant as if it had just been finished, and with your Whistler pastels, you would have the two greatest masters of the medium *in the 19th century* (for we must not forget la Tour & the other 18th century men) at their *best*."[1]

Time has not diminished the luster of this remarkable pastel, which is as luminous now as it was when Birnbaum bought it for Winthrop, thanks to the technique, which Degas invented in the mid-1870s, of placing intensely colored pastel over a preparation of dark monotype.[2] This method had the additional benefit to Degas of allowing him to replicate the same composition in two or sometimes three examples, after experimentation with "light field" mono-types. In "light field" monotypes, known since the mid-seventeenth century, the artist draws with ink on a smooth plate—glass or metal—and presses the plate on paper. In "dark field" monotypes, the entire plate is darkened with ink, and the highlights are removed with a rag, brush, or pointed instrument. The latter technique was well suited to suggest the dramatic light of the theater as well as the intimate light of boudoir and bath—primary subjects for Degas in the late 1870s. The monotype can be seen in this work in the shadows of the skirt and bodice of the principal dancer as well as in the vegetative sgraffito of the stage sets. As is typical, a number of adjustments were made directly in pastel; the top-hatted voyeur was added at the last minute. Normally, Degas would

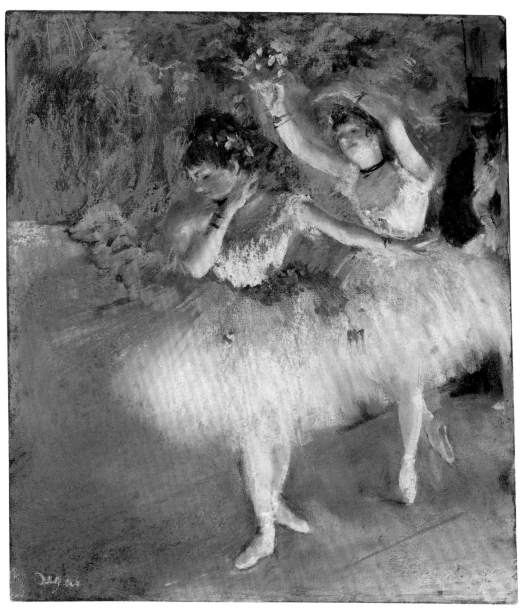

25

have kept the first, strongly inked impression of his monotype uncolored; he generally applied pastel only to weaker second and third impressions of the same plate. However, no cognate of this particular monotype is known.

The dealer César de Hauke stated in an undated letter that he sold this pastel to "an English dealer"—presumably Percy Moore Turner—having bought it from the Galerie Bernheim Jeune, which acquired it directly from Degas.[3] This, however, is unlikely: Degas developed the medium of monotype specifically in order to fabricate attractive works for quick sale. The date of this work, about 1876–78, conforms to the period when Degas needed a constant stream of cash to repay the debts incurred by his father, who died in 1874, on behalf of his profligate brother René. Thus Degas probably sold this work soon after he had made it. It then probably resurfaced during the First World War, when it fell into the orbit of Ambroise Vollard, who reproduced it in a 1918 album. Bernheim Jeune may have acquired it from Vollard, or perhaps he owned it in half-shares with him.

Gary Tinterow

1. Birnbaum, letter to Winthrop, June 23, 1928, Harvard University Art Museums Archives.
2. Fletcher and DeSantis (1989, p. 259) speculate that Degas also used highlights of casein in this work, as he had in others, but this has not yet been confirmed.

3. De Hauke, statement, Harvard University Art Museums Archives.

PROVENANCE: Possibly Ambroise Vollard, Paris; Bernheim Jeune, Paris, by 1918; purchased from them by César Mange de Hauke, Paris; Major (Percy Moore?) Turner, London; acquired from him through Martin Birnbaum by Grenville L. Winthrop, July 4, 1928

(£2,750); his bequest to the Fogg Art Museum, 1943.

EXHIBITIONS: Paris 1924a, no. 129; Cambridge, Mass., 1968, no. 2 (checklist no. 3); Cambridge, Mass., 1969, no. 11.

REFERENCES: Vollard 1918, tipped-in pl. (unnumbered) between pls. 33 and 34; Lafond 1918–19, vol. 1,

illus. facing p. 42 (as "Danseuses Saluant"); Lemoisne 1946–49, vol. 2 (1946), pp. 246–47, no. 448, fig. 448; Browse [1949], p. 355, no. 51, pl. 51; Janis 1967, pt. 1, pp. [23] (fig. 43), 27, pt. 2, p. 72; Fletcher and DeSantis 1989, pp. 256, 258 (fig. 3), 259–60, and passim; Boggs and Maheux 1992, pp. 50, [51], no. 6, pl. 6; Wisneski 1995, pp. 39–40, fig. 17.

Eugène Delacroix

Charenton-Saint-Maurice, France, 1798–Paris, 1863

26. *A Moorish Woman with Her Servant by the River*, 1832

Watercolor and graphite on white wove paper
6¼ x 7¼ in. (16 x 18.3 cm)
Signed in brown ink, lower left: Eug. Delacroix
1943.351

When Delacroix returned from Morocco, where, for six months, he had accompanied the diplomatic mission to the sultan led by the comte de Mornay, he spent several weeks in quarantine in Toulon, in July 1832. There he sorted through the large quantity of written and drawn documenta-tion he had accumulated during his stay in Tangier and then in Meknès, as well as his short escapade to the south of Spain. It was during that period, when he had time to mull things over, that he must have executed a series of eighteen water-colors as a way of thanking Mornay, with whose help he had been included in the embassy.

These watercolors were collected into an album, which was later dispersed in a public sale in 1877. The Winthrop collec-tion possesses two of them, this one and the *Black Africans Dancing in a Street in Tangier* (cat. no. 27). Two others are at the Louvre, Paris; two at the Metropolitan Museum, New York; one each at the Fine Arts Museums of San Francisco and the Los Angeles County Museum of Art; and four in private collections. Two others are known through old photographs, and four have been lost and are known only through the descriptions in the Mornay sale cata-logue.[1] Most are portraits of identifiable

Fig. 67. Eugène Delacroix, *Washerwomen of Morocco*, 1832. Graphite, 7⅛ x 9⅛ in. (18 x 23.1 cm). Département des Arts Graphiques, Musée du Louvre, Paris, RF 9258

Fig. 68. Eugène Delacroix, *Woman of Tangier Hanging the Wash*, 1833. Pen autolithograph, 7½ x 10⅜ in. (19 x 26.3 cm). Département des Estampes et de la Photographie, Bibliothèque Nationale de France, Paris

26

figures (Sultan Mulay Abd-ar-Rhamān; his minister of finances, Amin Bias; the kaid, Ben-Abu, who commanded the military escort assigned to Mornay; the dragoman of the French consulate in Tangier, Abraham Ben Shimol, along with his wife and daughter) or sites emblematic of the mission (Tangier, Meknès); or they are linked to precise episodes, attesting to anecdotes in which members of the embassy played a role. Several describe characteristic types. The most significant sheets combine these different aspects, and that is very likely the case here.

Throughout his stay, Delacroix was constantly fascinated by the women, whom he had difficulty meeting, much less drawing: inaccessible inside their homes (with the notable exception of the Jewish women, whom he approached with the help of Ben Shimol), they were in some sense invisible. "The women in the streets are like those houses. They are walking parcels," he wrote some ten years later in his *Souvenirs d'un voyage dans le Maroc.* "You notice, under the massive covering in which they are wrapped, only the two eyes that allow them to get around and the tips of their fingers, which draw up a large piece of shroud of sorts over the rest of their faces."[2] The entire text of *Souvenirs* is filled with notations on the women in Morocco and North Africa. As is well known, that interest was to lead to the composition *Women of Algiers in Their Apartment* (fig. 103).[3] In the watercolor in the Mornay album, the position of the woman on the right accen-

tuates her foot, for which the artist felt a real fascination.[4]

Nevertheless, he probably did not completely invent the scene of *A Moorish Woman with Her Servant.* If we are to believe the art critic Philippe Burty, who was in close contact with Delacroix at the end of his life (he was working on the catalogue of the artist's prints and would also write the sale catalogue after his death, as the main organizer of the sale per the artist's orders), one day Delacroix and his companions, on horseback in the country near Tangier, came on two women washing their linen. One of these women, in view of the Europeans, began to bathe in the river, where she revealed her charms. At that point Moors appeared, whereupon the two washerwomen screamed, fearful that they would be accused of being too obliging— unless they called out on their own, surprised to be observed and drawn. According to the account, Delacroix and his friends were pursued to the gates of Tangier while being shot at by the furious Arabs.[5]

The sketch Delacroix supposedly made on the spot is housed in the Louvre (fig. 67).[6] The composition, which has a number of variants in the details, is reversed with respect to the watercolor. The same is true for the pen lithograph executed by Delacroix in 1833 (fig. 68),[7] perhaps with a publication in mind. It also depicts a different setting, with the scene located, not in the country this time, but in town; in addition, the emphasis is now placed on the washerwoman and not on the woman bathing in the river, who has

been replaced by a child leaning on an amphora. This play of variations, characteristic of Delacroix's work when a theme particularly interested him, demonstrates the importance he granted to a subject that might otherwise be considered relatively minor and merely picturesque.

Barthélémy Jobert

1. See Arlette Sérullaz in Paris 1994–95, pp. 178–87.
2. "Les femmes dans les rues sont comme ces maisons. Ce sont des paquets ambulants. Vous n'en appercevez sous la couverture massive dont elles sont entortillées que les deux yeux qui leur servent à se conduire et le bout de leurs doigts qui ramènent sur le reste de leur visage un grand bout de cette espèce de suaire"; quoted in Delacroix 1999, p. 125.
3. Johnson 1981–89, vol. 3 (1993 ed.), no. 356.
4. See, for example, Delacroix 1999, p. 113.
5. The anecdote, which is plausible, is reported in Escholier 1926–29, vol. 2 (1927), p. 72, which cites Burty as a reference. I have been unable to find the original source in the writings or papers of Burty himself: it is therefore probably an oral tradition.
6. RF 9258; Sérullaz et al. 1984, vol. 2, p. 138, fig. 1573.
7. Delteil and Strauber (1908) 1997, no. 95.

PROVENANCE: Given by the artist to comte Charles de Mornay; his sale, Hôtel Drouot, Paris, March 29, 1877, no. 5 (Fr 1,000); purchased at that sale by Goupil; purchased from them by vicomte Paul Daru; his sale, Hôtel Drouot, Paris, June 5–6, 1877, no. 24 (Fr 360); Paul Rosenberg, Paris; Scott and Fowles, New York; acquired from them by Grenville L. Winthrop, February 2, 1923 ($1,000); his bequest to the Fogg Art Museum, 1943.

EXHIBITION: Cambridge, Mass., 1955, no. 15.

REFERENCES: Robaut 1885, no. 496; Escholier 1926–29, vol. 2 (1927), p. 72; Delacroix 1930, no. 17, pl. 17; Cambridge, Mass., 1946a, p. 10; Mongan 1951, illus. p. 22; Mongan 1963, pp. 28–29, 38 n. 23, pl. 20; Sérullaz et al. 1984, vol. 2, under no. 1573; Johnson 1981–89, vol. 3 (1986), under no. 169, fig. 4; Arama 1987, p. 217, no. 3; Dumur 1988, pp. 80–81, illus.; Daguerre de Hureaux 1993, pp. 191–97, illus.; Guégan 1994, pp. 60, 61, illus.; Paris 1994–95, pp. 178–80, fig. 3; Mongan 1996, no. 123, illus.; Jobert 1997, pp. 149–50; Jobert 1998, pp. 149–50; Paris 1998, p. 131; Daguerre de Hureaux 2000, pp. 20–21, illus.; Johnson 2003, pp. 92, 95, no. 5.

27. *Black Africans Dancing in a Street in Tangier*, 1832

Watercolor and graphite on white wove paper
9¼ x 7¼ in. (23.7 x 18.5 cm)
Signed in brown ink, lower center: Eug. Delacroix
1943.349

Like *A Moorish Woman with Her Servant by the River* (cat. no. 26), *Black Africans Dancing in a Street in Tangier* was part of the album executed by Delacroix during his quarantine in Toulon on his return from Morocco and was offered by him in gratitude to the comte de Mornay. The episode, which can be situated in the second half of April 1832, that is, after the return from the mission to Meknès and during his second stay in Tangier, is probably the one noted in an album in which Delacroix recorded and drew his impressions day to day. "The Negroes who came to dance at the Consulate and throughout the city. Woman in front of two covered with a haik and carrying a stick with a handkerchief at the end for alms."[1] There is an outline drawing, bearing Delacroix's studio stamp,

perhaps a preparatory study or a sketch executed on site, that was on the Paris market in 1975 (fig. 69). In that drawing, as in the definitive watercolor, Delacroix eliminated the figure of the woman and concentrated on the two black African dancers, who dance with castanets in their hands to the rhythm of the drum beat by an Arab.

Delacroix himself was very musical, as is attested particularly in his journal, and

during his stay in North Africa was sensitive to the music he heard there, totally unknown to him until that time. Thus, several paintings executed after 1832 feature musicmaking: the *Jewish Wedding in Morocco* (1837–41; Louvre, Paris), the *Jewish Musicians of Mogador* (1843–46; Louvre), and the *Arab Actors or Clowns* (1838; Musée des Beaux-Arts, Tours).[2]

The album Delacroix gave the comte de Mornay reveals the artist's creative process:

Fig. 69. Eugène Delacroix, *Moroccans Dancing in a Street in Tangier*, 1832. Graphite on tracing paper, 6¾ x 8½ in. (17 x 21.5 cm). Paris art market, Paul Prouté, 1975

27

it preserves written notations or drawings made during the journey itself—the events experienced, the places traveled, the people encountered. Captured on the spot or reworked in the evening, after the fact, they were used in part, during the weeks spent in Toulon, for the more finished watercolors he offered Mornay. They mark the first artistic distancing from a still very present reality. Then the concrete shape given to one subject or another would come into being both through the replication of artifacts Delacroix always kept (and to which various objects brought back from North Africa were added) and through the crystallization of one or another memory.

It is not incidental, in this respect, that the subjects of certain watercolors done in Toulon were repeated in paintings, sometimes several years apart. The most striking case is *Fanatics in Tangier*, of which there are two painted versions (1838, Minneapolis Institute of Arts; and 1857, Art Gallery of Ontario, Toronto).[3] *Black Africans Dancing in a Street in Tangier*, it seems, was not the object of such treatment, but it can be compared, at least thematically, with *Arab Actors or Clowns*, a subject that was directly taken up in the Mornay album (*Itinerant Actors*, a watercolor now at Los Angeles County Museum of Art).

Barthélémy Jobert

1. "Les nègres qui sont venus danser au Consulat et par la ville. femme devant deux couverte d'un haïk et portant un bâton avec un mouchoir au bout pour quêter"; Musée du Louvre, Paris, RF 39050, fol. 24r. See Sérullaz et al. 1984, vol. 2, p. 366.
2. Johnson 1981–89, vol. 3 (1993 ed.), nos. 366, 373, and 380, respectively.
3. Ibid., nos. 360 and 403, respectively.

PROVENANCE: Given by the artist to comte Charles de Mornay; his sale, Hôtel Drouot, Paris, March 29, 1877, no. 12 (Fr 1,110); purchased at that sale by L[eon?] Gauchez; baron Henri de Rothschild, Paris; acquired from him through Martin Birnbaum by Grenville L. Winthrop, June 1931; his bequest to the Fogg Art Museum, 1943.

EXHIBITIONS: Cambridge, Mass., 1946a, p. 10; Cambridge, Mass., 1955, no. 14.

REFERENCES: Robaut 1885, no. 503; Mongan 1963, pp. 29, 31 n. 24, pl. 21; Arama 1987, p. 217, no. 8; Paris 1994–95, pp. 178–80, fig. 3; Mongan 1996, no. 124, illus. Jobert 1997, pp. 149–50; Jobert 1998, pp. 149–50; Johnson 2003, pp. 92 (fig. 27), 93, 95, no. 12.

28. *A Turk Leading His Horse* or *Arab with Steed*, ca. 1832–33

Watercolor on white wove paper
8⅞ x 11¾ in. (22.6 x 30 cm)
Signed in brown ink, lower left: Eug. Delacroix
1943.354

A Turk Leading His Horse is not listed in the catalogue of Delacroix's paintings, drawings, and prints compiled in the late nineteenth century by Alfred Robaut, a work that is still the authority on the artist.[1] The work appeared only in 1925–26, under the title *Arab with Steed*, when Grenville Winthrop bought it for $1,500 from a New York dealer. Nevertheless, its subject, its style, the sureness and virtuosity of the treatment, and even the signature argue in favor of its authenticity. Agnes Mongan associates this sheet with three aquatints with comparable subjects, *Turk Saddling His Horse*, *Mamluk Holding Back His Horse*, and *Turk Mounting on Horseback*,

keeping the date of 1828 for the latter two and suggesting 1827–28 for *Arab Saddling His Horse*.[2]

I would like both to propose a different date and to provide more detail about the subject. First, the date of 1828 for the three aquatints is not unanimously endorsed by scholars; some propose an earlier date of 1824.[3] The theme of the horseman leading or saddling his horse was a permanent fixture in Delacroix's art until the end of his life: *Arab about to Saddle His Horse* in the Szépmüvészeti Múzeum, Budapest (fig. 72), which has certain details in common with this watercolor, for example, dates from 1857.[4]

Above all, however, it is the subject that impels us to retain a later date. As the earlier title suggests, the man is not a Turk but an Arab: many details compel us to see, not the imagined Orient contemporary with the

Massacres of Chios (1824), but North Africa as it was experienced and retranscribed on Delacroix's return from Morocco (1832). The costume worn by the horseman, the saddle in the right foreground, the tent on the left, the vegetation, the encampment in the background, the mountain setting, and, above all, the galloping horsemen who, by their silhouettes, immediately evoke the fantasias dear to Delacroix are so many realist elements found again in the watercolors and paintings inspired by the stay in Morocco. The elaborate composition is characteristic of Delacroix's early Moroccan work, with an object in the foreground, the saddle, which establishes contact with the viewer, and an element of the setting, the tent, that makes the connection to the background. Even the technique directly evokes the watercolors executed for the comte de Mornay in 1832. Therefore, *A Turk* or,

28

Fig. 70. Eugène Delacroix, *Arabian Fantasy before a Doorway in Meknès*, 1832. Watercolor over graphite, 6⅛ x 10¾ in. (15.6 x 27.2 cm). Département des Arts Graphiques, Musée du Louvre, Paris, RF 3372

Fig. 71. Eugène Delacroix, *Arabs and Horses near Tangier*, 1832. Transparent and opaque watercolor and graphite on wove paper, 6⅝ x 10⅜ in. (16.7 x 26.5 cm). Fine Arts Museums of San Francisco, Achenbach Foundation for Graphic Arts, Mildred Anna Williams Collection, 1951.35

Fig. 72. Eugène Delacroix, *Arab about to Saddle His Horse*, 1857. Oil on canvas, 19¾ x 24¼ in. (50 x 61.5 cm). Szépmüvészeti Múzeum, Budapest, 385.B

rather, *An Arab Leading His Horse* should be placed immediately after Delacroix's return from Morocco, and I suggest that it was one of the watercolors he presented at the Salon of 1833, under the generic title *Costumes of Morocco*. As is the case with the present sheet, these were obviously accomplished, elaborate sheets and not ordinary sketches intended for sale. The watercolor's absence from Robaut's catalogue could be explained thus: immediately purchased by a private collector, the work disappeared for more than a century and, not having been engraved or replicated on canvas, remained unknown to connoisseurs.

Barthélémy Jobert

1. Robaut 1885.
2. Mongan 1996, pp. 134–35; Delteil and Strauber (1908) 1997, pp. 18–23, nos. 9–11.
3. For a review of the arguments, see Paris 1998, pp. 76–77, and Jobert 2000, pp. 47–48, 59–60. Louis-Antoine Prat, in his published study of *Mamluk Holding Back His Horse*, leans toward 1828, however; see Paris 2001, pp. 38–39.
4. Johnson 1981–89, vol. 3 (1993 ed.), no. 404.

29. *Two Lions at Rest*, 1848

Watercolor, pastel, and graphite on white wove paper
10⅝ x 14 in. (27 x 35.7 cm)
Signed in graphite, lower left: Eug. Delacroix
1943.352

Since the publication of Alfred Robaut's catalogue raisonné of Delacroix's works (1885), this sheet has been dated 1848. Although nothing in Delacroix's correspondence or writings confirms the date, nothing has surfaced to invalidate it either, and it is perfectly logical both thematically and stylistically.

Delacroix became intensely interested in the anatomy of big cats about 1830. He worked particularly from nature, in the company of the sculptor Antoine-Louis Barye at the zoo of the Jardin des Plantes at the Muséum National d'Histoire Naturelle in Paris. This activity is recorded in the numerous studies that, as was his habit, Delacroix kept throughout his life. Works of the time on the theme of big cats intended for the public are few. The important ones are two lithographs, and they are among the artist's most spectacular: *Lion of Atlas* (fig. 74), which is not unrelated to *Two Lions at Rest;* and *Bengal Tiger*, drawn and published in the winter of 1829–30.[1] In addition, Delacroix exhibited the large

29

Fig. 74. Eugène Delacroix, *Lion of Atlas*, 1829–30. Lithograph, 13 x 18⅜ in. (33.1 x 46.6 cm). Département des Estampes et de la Photographie, Bibliothèque Nationale de France, Paris

Fig. 73. Eugène Delacroix, *Studies of Lions*, ca. 1830. Oil on canvas, 23⅞ x 19⅝ in. (60.7 x 49.8 cm). Private collection, Paris (photo: after Johnson 1981–89, vol. 2 [1981], pl. 48)

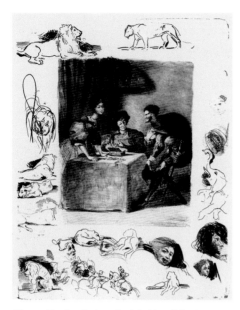

Fig. 75. Eugène Delacroix, *Mephistopheles Presents Himself at Martha's House*, 1828. Lithograph, first state with notations, stone 16 x 15 in. (40.5 x 31.8 cm), image 9½ x 7⅞ in. (24 x 20 cm). Département des Estampes et de la Photographie, Bibliothèque Nationale de France, Paris

Fig. 76. Eugène Delacroix, *Studies of Lions*, ca. 1828? Brush, pen and brown ink, graphite, 8⅛ x 11⅝ in. (20.5 x 29.7 cm). Département des Arts Graphiques, Musée du Louvre, Paris, RF 9673

painting *Young Tiger Playing with Its Mother*, at the Salon of 1831 (Louvre, Paris).[2]

It was only in the 1840s, and especially in the last fifteen years of his life, that Delacroix turned frequently to animal themes. Several reasons probably contributed to this concentration: the memory of his sojourn in Morocco, where he renewed his studies and impressions of the motif; the influence of Barye's sculptures, as Vincent Pomarède has rightly noted; the taste of art lovers, who favored these paintings over Delacroix's more usual literary subjects; and no doubt as well a purely aesthetic desire, that of rivaling the old masters, particularly Rubens.[3] The pinnacle was reached with the large *Lion Hunt*, specially painted for the Universal Exposition of 1855 (Musée des Beaux-Arts, Bordeaux).[4] In his last years, however, at the request of dealers who regularly commissioned them from him, Delacroix produced many small paintings with animal subjects, relying on his previous studies, which, as we have seen, went back more than twenty years.

Two Lions at Rest is part of this trend and illustrates how Delacroix repeated themes undertaken in his youth, then abandoned but never totally forgot.

Several related drawings or painted studies, most of them datable to the late 1820s, have been proposed as possible sources for this work (see fig. 76).[5] But the very manner in which the subject is treated recalls the Romantic period. Unlike the later works, which privileged the battle, the confrontation between beasts or with man, here Delacroix shows two animals simply at rest. He thus clearly moves closer to the studies done in his youth.[6] Barye, both in his drawings and in his sculptures, can also be considered a source of inspiration, albeit a distant one. Delacroix displays a dazzling technical virtuosity here, in the composition (the setting, with the central cleft in the rocky background, subtly accentuates the two animals while individualizing them) and in the very detailed treatment (the watercolor has been highlighted with pastel). The

drawing, by virtue of its accomplished technique and format, is in reality very close in conception to the paintings he was executing at the time. It was lithographed by Aglaüs Bouvenne long after Delacroix's death, in 1887, after the tracing Robaut had made of it.[7]

The provenance of the work is prestigious and also links it closely to that time: it belonged to Delacroix's cousin Joséphine de Forget, with whom he had been in love during his youth, with whom he reestablished calmer relations in the last years of the July Monarchy, and to whom he was close during the Second Empire. The artist liked to give his friends and relatives drawings or sketches: this is a remarkable and typical example of that practice.

Barthélémy Jobert

1. Delteil and Strauber (1908) 1997, nos. 79, 80.
2. Johnson 1981–89, vol. 1 (1981), no. 59.
3. See Paris–Philadelphia 1998–99, pp. 77–81.
4. Johnson 1981–89, vol. 3 (1993 ed.), no. 198.
5. See Mongan 1996, pp. 146–47.
6. See, in particular, the painted study in a private collection, ca. 1830, Johnson 1981–89, vol. 1 (1981), no. 56, from which the watercolor is directly derived (fig. 73),

as well as drawings housed in the Louvre, RF 1052, RF 1053, and RF 1054, reproduced in Sérullaz et al. 1984, vol. 1, pp. 385–86, and even the first state with notations (fig. 75) of *Mephistopheles Presents Himself at Martha's House*, a lithograph that is part of the *Faust* series of 1828; Delteil and Strauber (1908) 1997, no. 66-I.

7. See the annotated Robaut (1885) 1969, no. 264, p. 279; the engraving was exhibited at the Salon of 1887.

PROVENANCE: Delacroix to his cousin the baronne Tony de Forget, née Joséphine de Lavalette, Paris; Joseph John Kerrigan; Scott and Fowles, New York; acquired from them by Grenville L. Winthrop, February 17, 1939 ($3,000); his bequest to the Fogg Art Museum, 1943.

EXHIBITION: Cambridge, Mass., 1955, no. 16.

REFERENCES: Robaut 1885, no. 1053, illus.; Benesch 1944, illus. p. 21; Cambridge, Mass., 1946a, p. 10; Johnson 1981–89, vol. 1 (1981), p. 35; Mongan 1996, no. 136, illus.

30. *Christ Walking on the Waters*, 1852

Pastel on blue-gray wove paper, faded to tan
12⅞ x 9⅝ in. (32.6 x 24.5 cm)
1943.814

Pastels are relatively rare in Delacroix's body of work, as Lee Johnson has noted in the comprehensive study he devoted to them.[1] They allowed the artist to attempt, with the freedom made possible by drawing, effects of material and color similar to those of painting. Thus he sometimes used pastel to work out the details of a larger painting, for example, the famous studies for *Death of Sardanapalus*, housed in the Louvre and in the Art Institute of Chicago, or to prepare the composition as a whole. That is the case here: after a visit to the Musée des Beaux-Arts in Nancy in August 1857, where he had closely studied Peter Paul Rubens's *Christ Walking on the Waters* and *Jonah Thrown from the Boat*, Delacroix decided to treat the former theme himself. "Two pictures, sketches probably by Rubens, that struck me more than anything," he noted at the time in his journal. "The sea, a black and tormented blue, has an ideal truth. . . . *Saint Peter* has a cold pose; but the admirable thing about that man [Rubens] is that this does not diminish the impression. Standing in front of those paintings I feel the inner movement, the

Fig. 77. Eugène Delacroix, *Christ Walking on the Waters*, ca. 1857–60. Black chalk on tracing paper, 11⅞ x 9 in. (30 x 23 cm). Musée des Beaux-Arts, Rouen, 897-6.4

Fig. 78. Eugène Delacroix, *Christ Walking on the Waters*, 1852. Pen and brown ink, 9⅝ x 7½ in. (24.5 x 19.1 cm). Kunsthalle, Bremen, 62/225 (photo: Stickelmann, Bremen)

frisson, that a powerful piece of music provides."[2]

The dynamic composition of Delacroix's pastel undoubtedly comes from his meditation on the Rubens example: the linear diagonal in the foreground, composed of Peter and Christ, intersects with the coloristic diagonal in the middle ground, made of the section of red-orange mantle lifted by the wind and continued in the color of the boat. The contrasting vigorous colors reinforce the dramatic aspect of the scene,

with Peter on the verge of drowning, making this pastel less a preparatory study than an independent work in itself. (It belonged to Victor Chocquet, a major collector of Impressionist paintings who also owned a large number of works by Delacroix.)

The pastel was complemented by an outline drawing, in which the expressions of the figures are better indicated; the latter is now housed in the Musée des Beaux-Arts in Rouen (fig. 77; in the Kunsthalle of Bremen, there is also a rapid sketch that

reverses the orientation, which is actually closer to Rubens's painting [fig. 78]). The painting of this composition was undoubtedly started later, as attested in the journal: "The evening of this day [July 20, 1860], returned to the jetty in very fine weather; sea superb, though at low tide. There I see all the effects characteristic of my *Christ Walking on the Sea*."[3] If that painting was ever executed, it is now lost.[4] In any case, Delacroix's motivations for that project were probably not purely artistic. As Vincent Pomarède has argued, the religious themes the artist treated beginning in his youth but concentrated on in the last part of his career, ending with the mural paintings of Saint-Sulpice—a true aesthetic and spiritual testament—unquestionably touched him for personal and philosophical reasons.[5] Although raised in the skeptical and rationalist tradition inherited from the eighteenth-century Encylopédistes, Delacroix never ceased to inquire about God, particularly in his later years. Pomarède insists on the painter's preference of subjects representing the difficulties of faith, "all the hesitations and confusion of the Christian in the face of Christ's divine manifestations,"[6] which one cannot fail to link to his agnosticism. That is truly the case here, where Peter, in a boat at night with the apostles on the Lake of Gennesaret (at the time, Delacroix depicted Jesus and his disciples caught in the storm on several occasions), seeing Christ walking on the waters, joins him at his request. Becoming frightened in the face of the wind and waves, he sinks, begins to drown, and is saved only when his master extends his hand, then criticizes him after the fact for having doubted.

Barthélémy Jobert

1. Johnson 1995, pp. 136–37.
2. "Deux tableaux, esquisses probablement de Rubens, qui m'ont frappé plus que tout. La mer, d'un bleu noir et tourmenté, est d'une vérité idéale. . . . Le *Saint Pierre* a une pose froide: mais l'admirable de cet homme [Rubens], c'est que cela ne diminue point l'impression. Je sens devant ces tableaux ce mouvement intérieur, ce frisson que donne une musique puissante"; Delacroix 1981, p. 674.
3. "Le soir de ce jour [20 Juillet], retourné à la jetée par un très beau temps; la mer superbe, quoique à marée basse. J'y vois tous les effets propres à mon *Christ marchand sur la mer*"; ibid., p. 784.
4. See the overview of the hypotheses by Johnson 1981–86, vol. 3 (1993 ed.), pp. 287, 307, with a discussion of two possible works, L190, which has been lost since 1910, and M8, on the art market, which is very similar in composition but of doubtful attribution.
5. Paris–Philadelphia 1998–99, pp. 265–69.
6. Ibid., p. 269.

PROVENANCE: Delacroix sale, Hôtel Drouot, Paris, February 17–29, 1864, no. 369 (Fr 360; Lugt 1956, no. 838a); purchased at that sale by (?) Claburn; Victor Chocquet, Lille; Paul Arthur Chéramy, Paris; his sale, Galerie Georges Petit, Paris, May 5–7, 1908, no. 295 (Fr 420); purchased at that sale by Henri Haro; Raimundo de Castro Maya, Rio de Janeiro; purchased from him by Adolphe Stein, London, 1941 ($200); purchased from him by Wildenstein and Co., New York; acquired from them by Grenville L. Winthrop, August 26, 1941 ($1,750); his bequest to the Fogg Art Museum, 1943.

EXHIBITIONS: Cambridge, Mass., 1955, no. 34; Cambridge, Mass., 1969, no. 105.

REFERENCES: Robaut 1885, no. 1204, illus.; Cambridge, Mass., 1946a, p. 12; Tietze 1947, no. 130, illus.; Mongan 1951, illus. p. 23; Paris 1963, under no. 434; Johnson 1981–86, vol. 3 (1993 ed.), pp. 287, 307; Nice 1986, under no. 17; Johnson 1995, pp. 136–37, illus. p. 137; Mongan 1996, no. 141, illus.

Fig. 79. Attributed to Eugène Delacroix, *Christ Walking on the Waters*. Oil on canvas, 23½ x 19½ in. (60 x 50 cm). Private collection

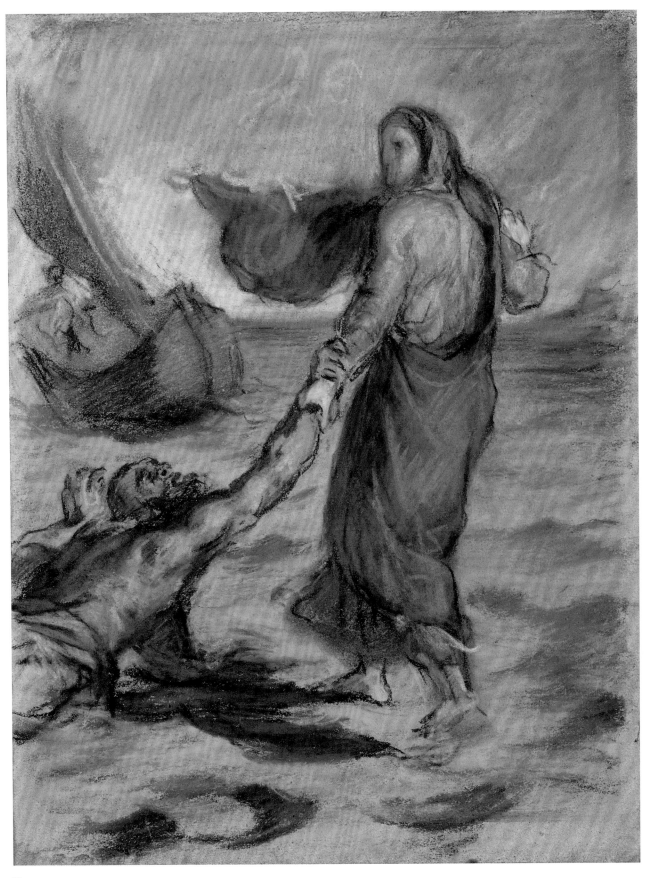

31. *A Turk Surrenders to a Greek Horseman*, 1856

Oil on canvas
31½ x 25¼ in. (80 x 64.1 cm)
Signed and dated lower left: Eug. Delacroix /
1856
1943.233

Delacroix placed great importance on the subject of a work, especially when it fell within the parameters of *ut pictura poesis*, the rivalry between painting and literature. The theme of his history paintings is always very precise, whatever the original source—history, legendary or real, ancient, classical, or contemporary literature, or even some musical composition. *Turk Surrenders to a Greek Horseman* is thus unusual in his body of work, since it has been interpreted both as an episode from the Greek War of Independence, which, strictly speaking, it is, and as a final version of the *Battle of the Giaour and the Pasha*, to which it can be linked, at least thematically.

Beginning in 1826, Delacroix drew several subjects, including this episode, from Byron's eponymous poem, "The Giaour, a Fragment of a Turkish Tale" (1813): in a first painting of 1826 (Art Institute of Chicago),[1] in a lithograph of 1827 (fig. 80),[2] and in another painting of 1835 (Musée du Petit Palais, Paris).[3]

It has often been thought that the Winthrop painting, which Alfred Robaut catalogued under the same title, represents a final version of the subject.[4] But, instead of Byron, Delacroix was thinking of an episode in the wars between the Greeks and the Turks, as indicated on the receipt transcribed in his journal when he sold it in April 1856 to the art dealer Tedesco: "Received from M. Tedesco, 1,600 francs for a canvas of 25: *Greek and Turk*, which I will deliver to him on the 25th of this month."[5]

Nevertheless, Byron may have lingered in his mind, since in July 1854 he noted, "Make,

for the Delamarre exhibition, *The Giaour Trampling the Pasha with His Horse.*"[6] *A Turk Surrenders to a Greek Horseman* is, in fact, closer in spirit to the 1827 lithograph than to the two paintings of 1826 and 1835, where the emphasis is placed on the battle between the two horsemen and not on the victory of the Giaour. It is also possible to link its composition to that of the central group in *Entry of the Crusaders in Constantinople* (1840; Louvre, Paris), of which Delacroix had recently painted a smaller, variant version (1852).[7]

The initial destination of the painting to a dealer does not signal a drop in ambition. In the mid-1850s Delacroix executed many small commissioned paintings and watercolors of high quality and nuanced in their many sources. Like the most successful artworks of that period, *Turk Surrenders to a Greek Horseman* reprises previous works in a final variation, combining two themes Delacroix favored in his youth and often associated in his mind: Byron, whom he never abandoned, and the Greek War of Independence. In the 1820s, that war had inspired two of his large masterpieces, the *Massacres of Chios* (1824; Louvre) and *Greece on the Ruins of Missolonghi* (1827; Musée des Beaux-Arts, Bordeaux),[8] as well as several small battle scenes. He returned to the theme in the last years of his life, in this case mixing literature and history.[9] *A Turk Surrenders to a Greek Horseman* thus synthesizes much of the painter's earlier inspiration with the formal experimentation of his last years, illustrating his constant, never completed artistic searching.

Barthélémy Jobert

1. Johnson 1981–89, vol. 1 (1981), no. 114.
2. Delteil and Strauber (1908) 1997, no. 55.
3. Johnson 1981–89, vol. 3 (1993 ed.), no. 257.
4. Robaut 1885, no. 1293.
5. "Reçu de M. Tedesco 1600 francs pour une toile de 25: *Grec et Turc*, que je lui livrerai le 25 courant"; Delacroix 1981, p. 576.

6. Ibid., p. 439.
7. Johnson 1981–89, vol. 3 (1993 ed.), nos. 274 and 302, respectively.
8. Ibid., vol. 1 (1981), nos. 105 and 98, respectively.
9. See Vincent Pomarède and Arlette Sérullaz in Paris–Philadelphia 1998–99, pp. 197–203, 223–24; and Arlette Sérullaz in Bordeaux–Paris–Athens 1996–97, pp. 41–44, 114–31.

PROVENANCE: Sold by the artist to Tedesco Frères, Paris, April 1856 (Fr 1,600); Léon Fraissinet, Marseille, by 1873; baron de Beurnonville; E. Secrétan, by 1885; his sale, Christie's, London, July 13, 1889, no. 14 (£1,250); purchased at that sale by Boussod, Valadon et Cie, Paris; purchased from them by Isidore Montaignac, October 4, 1890; George I. Seney, New York; purchased from him by Boussod, Valadon et Cie, Paris, March 9, 1892; purchased from them by F. L. Ames, New York, March 24, 1892; Louis Sarlin, Paris, by 1910; his sale, Galerie Georges Petit, Paris, March 2, 1918, no. 28; purchased (with entire Sarlin collection) at that sale by Herman Heilbuth, Copenhagen; sold, probably on his behalf, by Winkel and Magnusson, Copenhagen; (?) Hodebert, Paris, by 1929; (?) Renou, by 1930; acquired through Martin Birnbaum by Grenville L. Winthrop, November 30, 1930 (Fr 825,000); his bequest to the Fogg Art Museum, 1943.

EXHIBITIONS: Paris 1910, no. 66; Paris 1930a, no. 170; Cambridge, Mass., 1943–44, p. 10; Cambridge, Mass., 1955, no. 8; Cambridge, Mass., 1977a; Tokyo 2002, no. 14.

Fig. 80. Eugène Delacroix, *Battle of the Giaour and the Pasha*, 1827. Lithograph, first state with notations, 14 x 11⅜ in. (35.5 x 29 cm). Département des Estampes et de la Photographie, Bibliothèque Nationale de France, Paris

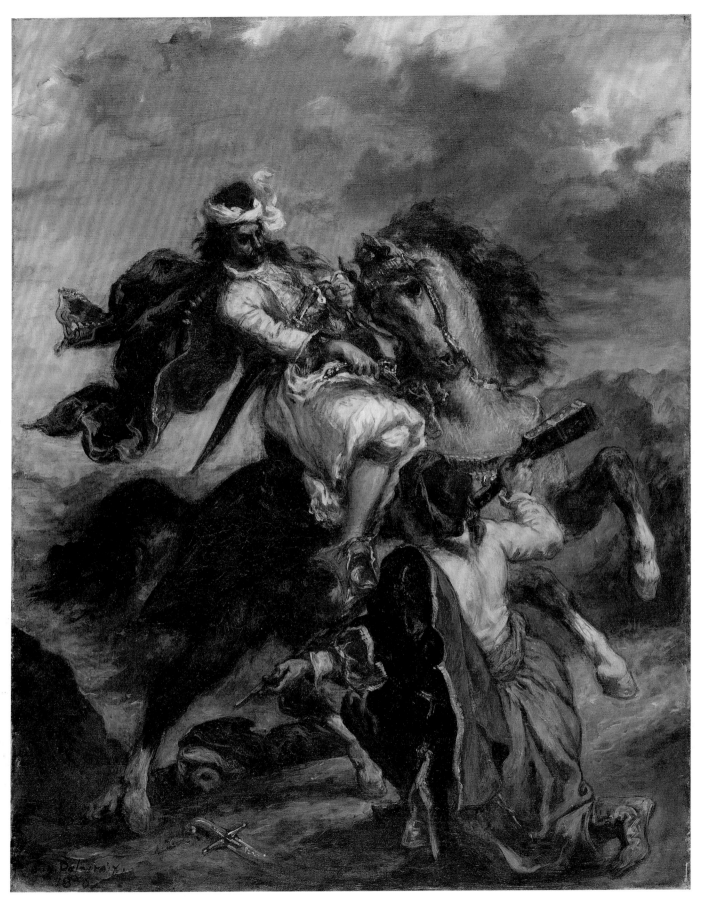

31

REFERENCES: Moreau 1873, p. 244, n. 1; Robaut 1885, no. 1293; Moreau-Nelaton 1916, vol. 2, p. 166, fig. 384; Escholier 1926–29, vol. 3, illus. facing p. 230; Huyghe 1930, pp. 117–34; Hourticq 1930, illus. p. 168; Florisoone 1938, illus.; Benesch 1944, p. 32; Cambridge, Mass., 1946, p. 9; Saco 1957, illus.; Faison 1958, p. 115, fig. 9; Farwell 1958, p. 66, no. 3; Birnbaum 1960, p. 200; de Montebello 1961, p. 11; Bernard 1971, p. 126, illus.; Trapp 1971, pp. 120, 122, fig. 62; Delacroix 1981, p. 576 n. 7 (and possibly p. 439 n. 1); Johnson 1981–89, vol. 1 (1981), p. 105, vol. 3 (1993 ed.), p. 142, no. 323; Mortimer 1985, p. 180, no. 205, illus.; Bowron 1990, fig. 291.

Ignace-Henri-Jean-Théodore Fantin-Latour

Grenoble, France, 1836–Buré, France, 1904

32. *Self-Portrait*, 1860

Oil on canvas
21⅜ x 16⅞ in. (54.29 x 42.86 cm)
Signed and dated, left edge: —avril 1860—Fantin
1943.239

Henri Fantin-Latour first showed at the
Salon in 1861. An admirer and early cham-
pion of Édouard Manet, Fantin quickly
earned a reputation for strict realism—
adhering to its doctrines so literally as to
largely restrict himself to inherently static
subjects, still lifes, and portraiture.
Beginning in the mid-1860s, he fulfilled his
ambition to realize grander compositions
with multiple figures and movement
through recourse to the imagination, as
well as inspiration by controversial con-
temporary composers, notably Richard
Wagner and Hector Berlioz. This strain
in Fantin's work allowed critics in the
1880s to herald him as a precursor of
Symbolism.

Like many artists, the young Fantin had
practical motivations for taking up self-
portraiture: he was, after all, his own most
reliable and affordable model. But art histo-
rians have long recognized that Fantin's
absorption in the genre, extending across
many media, is exceptional. The self-
portraits that he produced between 1854
and 1861 form a unique group within his
oeuvre, revealing his changing view of his
own character and artistic standing. At this
time, he had recently abandoned a brief
course of study at the École des Beaux-Arts
in Paris to strike out on his own. Though
by his own admission an indifferent stu-
dent, Fantin was intensely serious about his
artistic vocation. More than a profession, it
was the foundation of his identity, justify-

32

ing his existence and providing solace in
times of deprivation and self-doubt.

The presiding influence here is of course
Rembrandt van Rijn, whose work Fantin
studied assiduously in the Louvre. Despite
the tangible reference to the art of the past,
however, Fantin's painting is an index of
his own present. Having been imbued with

a Romantic understanding of Rembrandt's
psychological realism, Fantin adopted the
Dutch master's pictorial means to articulate
his own identity. In this oil self-portrait,
Fantin dispensed with the tools of his trade,
relying instead on tonality, on the contrast
of light and dark, to express a complex
dualism that was both aesthetic and charac-

terological. His intense interest in self-portraiture had disappeared by 1863, when he began to channel this Neo-Romantic sensibility into his "musical" compositions.

Douglas Druick

PROVENANCE: Arsène Alexandre, Paris; his sale, Galerie Georges Petit, Paris, May 18–19, 1903, no. 27 (Fr 6,000); Mme Victor Klotz, Paris; acquired from her through Martin Birnbaum by Grenville L. Winthrop, October 1934 (Fr 40,000); his bequest to the Fogg Art Museum, 1943.

EXHIBITION: Paris 1906, no. 9.

REFERENCES: Jullien 1909, p. 195 (under "1860"); Fantin-Latour 1911, p. 21, no. 140; Lucie-Smith 1977, pp. 147–48, no. 35, illus.; Bowron 1990, fig. 386.

33. *The Dubourg Family,* ca. 1878

Charcoal and black chalk on tan wove paper
14¼ x 16¼ in. (36.3 x 41.3 cm)
Signed and inscribed in black crayon, along bottom of sheet: h. Fantin / A Monsieur Viron dupuis mon tableau du Salon de 78.
1943.820A

Fantin-Latour met Victoria Dubourg—seen here at the left, wearing a coat and hat, with her parents and sister—in 1866 at the Musée du Louvre in Paris, where they both copied pictures. She was part of the circle around Édouard Manet, whom Fantin greatly admired and who served as a witness when Fantin and Victoria married, ten years later. It is Manet's adroitly composed and psychologically evasive painting *The Balcony* (1868; Musée d'Orsay, Paris) to which this image of Fantin's wife and in-laws invites comparison.

Like Manet, Fantin here declined to establish a clear narrative.[1] This was quite deliberate. Fantin regarded uncommissioned portraits as studies from nature, through which, as in still life, he could

33

refine his particular realism, characterized by a highly disciplined attention to resemblance together with a subtle revelation of what lies beyond mere appearance. To this end, he chose subjects within his own circle—artists, poets, and family members—rather than courting Parisian high society, and he addressed them with an austere treatment and a subdued palette. Critics interpreted Fantin's approach as an appropriate expression of a chastened national mood; France's defeat at the hands of the Prussians in 1870–71 was, in hindsight, traced to the opulent decadence that was the hallmark of fashionable portraiture of the 1860s.

Judging from preliminary studies for *The Dubourg Family*, Fantin settled on the compositional arrangement immediately, like a photographer capturing a pose.[2] And reviewers indeed likened his finished painting—shown at the 1878 Salon (no. 878)

and now in the Musée d'Orsay—to the photographic images emerging from the famous Nadar studio.[3] The issue of reproducibility is directly pertinent to the Winthrop sheet, although the medium in question is not photography but wood engraving, still the preferred method for reproducing paintings. Fantin made this drawing after his own painting expressly so that it could be published by *L'art* (the professional engraver Auguste-Hilaire Leveillé produced the print),[4] but unlike many translations of this sort, it satisfies as an independent work of art. Fantin, a master printmaker himself, adapted his draftsmanship to the engraver's exigencies, so that here we have a unique opportunity to understand the function of line—and the influence of Jean-Auguste-Dominique Ingres—in Fantin's work, so often dominated by tonality.

Douglas Druick

1. The family's affectless expressions, together with their dark clothing, led some critics and caricaturists to assume that the figures are in mourning. However, a date inscribed on a preparatory drawing reveals that the Dubourgs were in fact either leaving for or just returning from a traditional All Saints' Day visit to the cemetery. Paris–Ottawa–San Francisco 1982–83, p. 246, no. 85.
2. This directness was unusual; in other group portraits, Fantin was far more hesitant, experimenting with many variations before beginning to work on canvas.
3. See, for example, Blanche 1919, p. 24.
4. "Salon de 1878," *L'art* 3 (1878), p. 288; an example of the wood engraving is 1943.820B in the Winthrop collection at the Fogg.

PROVENANCE: Given by the artist to (?) Viron; possibly Musée du Luxembourg, Paris, by 1911; Scott and Fowles, New York; acquired from them by Grenville L. Winthrop, January 1923 ($1,200); his bequest to the Fogg Art Museum, 1943.

EXHIBITION: Cambridge, Mass., 1969, no. 119.

REFERENCES: Fantin-Latour 1911, p. 96, no. 916 (as Musée de Luxembourg, [Paris]); Lucie-Smith 1977, pp. 145–46, no. 14, illus.

Jean-Louis-André-Théodore Gericault

Rouen, France, 1791–Paris, 1824

34. *Roman Herdsmen*, 1816–17

Black chalk, brown wash, and white gouache on brown wove paper
8¼ x 11⅛ in. (20.9 x 28.1 cm)
Signed in brown wash, lower right: T. Gericault Rome.
1943.831

In the autumn of 1816 the twenty-five-year-old Théodore Gericault set off for Italy, where he spent a year that was to be crucial for his artistic growth.[1] He explored new subject matter, studied classical and Renaissance art, and developed new mastery in formal matters of composition and technique. *Roman Herdsmen* belongs to a

group of approximately twenty carefully finished drawings that date from his Italian visit and are executed in black chalk, delicate brown wash, and brilliant white gouache on a dark-toned paper.[2] Unlike the majority of Gericault's earlier drawings, which are mostly sketches or studies for unrealized projects, each of these drawings is complete in itself; in this case it is even signed and located in Rome.

Although most of the subjects of the Italian wash-and-gouache drawings derive from classical mythology, this one is taken from contemporary Roman life—the

tumultuous spectacle of cattle being rounded up from the surrounding countryside and driven by mounted herdsmen to the market in Rome for sale and slaughter. This genre subject had already been depicted in the popular etchings of Bartolomeo Pinelli (1781–1835)[3] and in the sketches of Gericault's colleague Antoine-Jean-Baptiste Thomas (1791–1834), who accompanied him in Rome.[4] Gericault also depicted the physical contest between the mounted herdsmen and the wild cattle in a series of exploratory sketches.[5]

In his finished version, however, Gericault

34

Fig. 81. Théodore Gericault, *Bouchers de Rome*, 1817. Crayon lithograph heightened with pen, 6⅞ x 9¾ in. (17.3 x 24.6 cm). Bibliothèque Nationale de France, Paris

transformed the subject into a monumental composition that owes little to popular picturesque imagery or his initial impressions; instead, it is reminiscent of antique relief sculpture and of High Renaissance art. The main herdsman on the ramping horse has been compared to a mounted warrior from Raphael's Vatican fresco of the *Meeting of Attila and Leo the Great*, and the head of his horse to the colossal bronze head in Naples from which Gericault made several careful pencil drawings during his excursion to Naples in the spring of 1817.[6] The figures are stacked back in restricted shallow space as if modeled in relief, the central herdsman emphatically modeled with brilliant

white gouache, dark wash, and black chalk hatchings—yet subtly linked to the more subdued background figures. The unity of the complex composition is assured by subtle means: the confluence of contours, deployment of light and dark tonal contrasts, careful use of controlling diagonals, and balanced juxtaposition of the architectural and landscape background. The group of massive animals, compressed yet retaining distinct movements, is driven forward by the three herdsmen, whose control is underlined by the compositional order of the scene.

Gericault used this finished version of his various depictions of the subject as the basis for his first experiment with the new technique of crayon lithography after his return to France: the *Bouchers de Rome* (fig. 81). It is likely that Gericault's recent achievements in tonal composition, as demonstrated in this work, contributed to his swift mastery of the new lithographic process and to his subsequent development of its expressive possibilities.[7] The subject of this lithograph is also associated thematically with his painting the *Cattle Market* (cat. no. 36).

Frances Suzman Jowell

1. For the most comprehensive account of this year, see Whitney 1997.
2. On the wash-and-gouache drawings, see Eitner 1973, pp. 3–4, and Eitner 1983, pp. 102–7.
3. Bartolomeo Pinelli, *Horsemen Leading Cattle into Rome for Slaughter*, 1816 (etching pl. 16 from Pinelli's *Nuova raccolta di cinquanta costumi pittoreschi*; see Matteson 1980, p. 77, fig. 8, and Whitney 1997, p. 74, fig. 96).

4. Thomas later published an album of lithographs, *Un an à Rome et dans ses environs* (Paris, 1823), in which the caption to his picturesque lithograph of the scene mentions the iron-tipped prods of the mounted herdsmen driving the cattle and their arrival into the city as "aussi effrayante qu'animée" (as terrifying as lively), cited by Whitney 1997, pp. 71, 72, fig. 90.
5. Some of these are known from tracings of lost drawings; see Whitney 1997, pp. 72–73.
6. Ibid., p. 74.
7. Eitner 1998.

REFERENCES: Pach 1945, fig. 7; Berger 1946, no. 21, pl. 21; Cambridge, Mass., 1946a, p. 15; Berger 1955, no. 25, pl. 25; Watrous 1957, p. 38; Novotny 1960, p. 86; Del Guercio 1963, pp. 40, 142, pl. 25; Spencer in New Haven 1969, p. 13; Eitner 1973, p. 6, n. 7; Zerner 1978, p. 481; Mattesson 1980, p. 76, fig. 9; Rouen 1981–82, p. 27, under no. 1; Grunchec 1982, p. 60, illus.; Eitner 1983, p. 140, fig. 122; Bazin 1987–97, vol. 4 (1990), pp. 21–22, 141, no. 1214, illus. facing p. 22; Mongan 1996, no. 168, illus.; Eitner 1998, p. 35.

35. *Study for the "Start of the Race of the Barberi Horses,"* 1817

Graphite on cream antique laid paper
14½ x 18⅞ in. (36.7 x 47.9 cm)
1943.830

This drawing was one of a long series of preparatory compositions for a project that was never realized—a lifesize painting inspired by the spectacular races of the riderless Barberi horses. This famous event, the high point of the annual Roman Carnival, was witnessed by the twenty-five-year-old Gericault in February 1817 during his year's stay in Italy.[1] Gericault's attempts to use the races—an established genre subject for popular prints[2]—as a theme for a major painting were to absorb much of his creative energy for the next seven months. He explored several versions, alternating between the start and finish of the race. According to Charles Clément, who published the first extensive account of the project in 1867, Gericault had already begun to transfer the final composition onto a thirty-foot canvas when he abruptly abandoned it to return to Paris, taking with him more than twenty painted oil sketches and innumerable drawings.[3]

From the approximately eighty-five paintings and drawings in various media that are known today[4] it is possible to trace the gradual evolution of the composition, from initial exploratory representations of the race in all its picturesque and topical detail to later idealized classicized versions—or visions—of the start of the race. The ostensible source of the subject was an observed contemporary event, but Gericault's changing conception of the composition, increasingly informed by his responses to Renaissance and classical art, transformed memories of the actual tumultuous event into a seemingly timeless, classical heroic vision—for which the oil sketch in the Louvre, Paris, is generally agreed to be the final existing version.

Winthrop's drawing belongs to this later stage of the project and is most closely associated with the famous oil sketch in the Getty Museum (fig. 82) and an ink tracing in a private collection.[5] The Fogg drawing probably preceded both:[6] it reveals Gericault at a generative, exploratory stage of composition, his graphite pencil ranging over the page, seeking to work out the different aspects of the composition without concern for the overall uniformity of execution. On the contrary, varied pencil strokes seem to record his changing concepts, and repetitive lines that revise positions of the moving figures are left in place, revealing "the processes of the moving hand."[7]

The drawing has inconsistencies of scale and dress, as well as varying degrees of

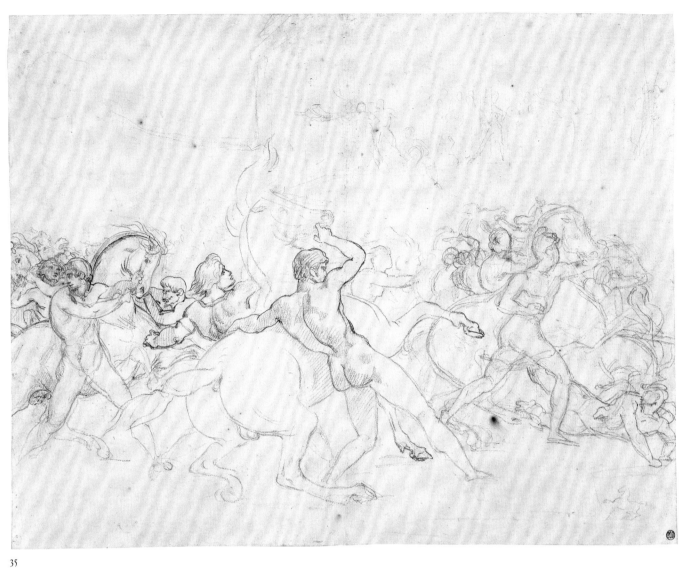

35

definition. The overall left to right direc-
tion of groups of men restraining horses is
dominated by the central group of two
muscular figures with the huge, powerful,
half-rearing stallion; one figure is clothed,
the other a heroic nude. The group is
united by the echoing contours of bodies
and limbs, which synchronize their move-
ments. The contours of the men are
sharply defined, and their bodies are mod-
eled by lightly applied pencil hatchings; the
rearing horse is sketched with more fluent,
impulsive lines. The classicizing central
group is flanked by tumultuous pandemo-
nium. To the left the disordered struggle is
variously drawn: definite contours and

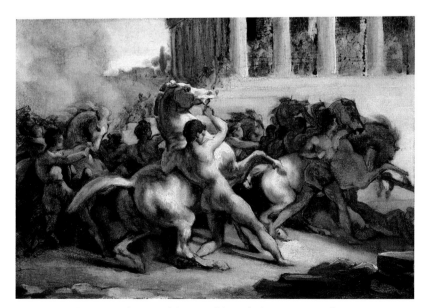

Fig. 82. Théodore Gericault, *Start of the Race of the Barberi Horses*, 1817. Oil on paper
mounted on canvas, 7⅞ x 11½ in. (19.9 x 29.9 cm). J. Paul Getty Museum, Los Angeles,
85.PC.406

detailed facial expression combined with summarily sketched figures, and almost abstract arcs imposed on the arched neck of a horse and its tamer. To the right, at the starting rope, a fallen man and horse with an indeterminate number of struggling men and horses are stacked back in space, lightly and roughly sketched. In the background is a faintly drawn raised colonnade with spectators.

A wide range of art contributed to Gericault's changing conception of the composition. These include such diverse works as drawings and popular prints by contemporary artists such as Bartolomeo Pinelli and Antoine-Jean-Baptiste Thomas, earlier aquatints of 1805 by G. B. Romero after drawings by Giovanni Battista Dell'Era of the start and finish of the Barberi races, Italian High Renaissance art (in particular by Raphael), and classical sculpture in Rome and in Naples. The memory of Guillaume Coustou's *Horse Tamers* (then in the Champs-Élysées, Paris) may also have played a part.[8]

The chosen subject emphasizes physical conflict: in all the preparatory sketches, men and horses are shown as competing protagonists—an elemental conflict between man and beast. The final version of the race, for which Winthrop's is a preparatory drawing, suggests a momentary balance of physical conflict or of powerful forces held in check. Why he abandoned the project and abruptly returned to France is a matter for conjecture, for which various reasons, both artistic and personal, have been suggested. Some early biographers mentioned pressing personal reasons that may have prompted his sudden return to Paris, where he resumed a doomed clandestine affair with his aunt.[9] But it is more

likely that Gericault may have ultimately realized he had undertaken an inherently impossible task: the creation of a monumental contemporary history painting, based on a genre subject (traditionally represented by popular prints) but executed in the grand style in an antique setting and lacking any obvious narrative subject.[10] This drawing combines an image of momentary resolved conflict in the balanced central group with the unresolved chaos and mayhem of action and struggle on either side.

This drawing was acquired by one of Gericault's loyal friends, Alexandre Colin, who produced several reproductions of Gericault's drawings—including, according to Clément, a few proofs of a facsimile lithograph of this drawing.

Frances Suzman Jowell

1. For the most comprehensive study of this crucial year of Gericault's career, see Whitney 1997.
2. See Bazin 1987–97, vol. 4 (1990), pp. 35–66, on traditional popular representations of the event.
3. Although some of these had been lost by the 1860s, Clément (1879, pp. 93–110) was able to suggest the evolution of the projected composition. For later accounts of the project, see Eitner 1983, pp. 117–34; Bazin 1987–97, vol. 4 (1990), pp. 67–79; and Whitney 1997, pp. 89–155.
4. Whitney 1997, pp. 92–93.
5. Bazin 1987–97, vol. 4 (1990), p. 204, no. 1369.
6. Lorenz Eitner considers the Fogg drawing to be a variant of the Getty oil sketch, and the subject of a pen tracing in the Chevrier-Marcille collection; see Eitner 1983, pp. 128–29, 338 n. 96. Wheelock Whitney concurs that the pen tracing is probably based on the Fogg drawing but suggests that the Getty oil sketch was executed slightly later than the two drawings; see Whitney 1997, pp. 136–40.
7. The phrase is taken from Petherbridge (in Bristol 1991–92, p. 11), from a general discussion on the fluid nature of drawing, and its concern with movement in all its aspects.
8. The most comprehensive exploration of Gericault's artistic sources is by Whitney 1997, who takes into consideration earlier research by Jullian 1966, Matteson 1980, and Eitner 1983.
9. Eitner 1983, p. 123; for views of the earliest biographers, see also Jowell 1996, pp. 779–80.
10. This issue has been discussed in various terms. Eitner considers it in the context of critical recep-

tion and artistic convention: "[H]e had gone from genre to a grand style and format, without considering the conventions that still governed the exhibition and critical acceptance of large paintings. . . . [H]e would have produced a work incomprehensible to the period: a painting of heroic format and grand style without recognizable subject" (Eitner 1983, pp. 133–34). Régis Michel insists on the inherent impossibility of combining an antique and a modern subject: "Now the two registers are scarcely reconcilable. They are even mutually exclusive: here the antique and the modern have contradictory intentions and an irreducible aesthetic. Géricault's sketches alternate between *two* languages: the narrative of the event in the density of its contingency, the desire for timelessness in the abstraction of classicism. . . . [A]ntiquity and modernity are here *synchronized*. The artist explores conjointly the resources of both. In vain. Modernity is a prisoner of the picturesque. And antiquity is a tributary of convention. Hence the abandonment of the subject" (Or, les deux registres ne se concilient guère. Même, ils s'excluent: l'antique et le moderne sont ici d'intention contradictoire et d'esthétique irréductible. Les esquisses de Géricault alternant les *deux* langages: le récit de l'évenement dans l'épaisseur de sa contingence, le désir d'intemporalité dans l'abstraction du classicisme. . . . [L]'antique et le moderne sont ici d'usage *synchrone*. L'artiste en explore conjointement les resources. En vain. Le moderne est prisonnier du pittoresque. Et l'antique est tributaire de la convention. D'ou l'abandon du sujet); Michel in Paris 1991–92, p. 98. Abigail Solomon-Godeau, following Michel, sees it as an example of "the break with generic codes" whereby "the exalted rationale for the subject of a history painting is nowhere in evidence and, more to the point, the combination of the local event (as represented in prints) and heroic syntax is fundamentally contradictory"; Solomon-Godeau in Vancouver 1997, pp. 105–6.

PROVENANCE: Alexandre Colin; his sale, Delbergue-Cormont, Paris, December 22, 1859, no. 59; (?) Leloir; Marie Joseph François Mahérault; his sale, Hôtel Drouot, Paris, May 27–29, 1880, part of no. 74 (Fr 160); purchased at that sale by Jean Dollfus; his sale, Hôtel Drouot, Paris, March 4, 1912, part of no. 54 (Fr 175 for three drawings); Pierre-Olivier Dubaut; acquired through Martin Birnbaum by Grenville L. Winthrop, December 1932; his bequest to the Fogg Art Museum, 1943.

EXHIBITION: Cambridge, Mass., 1946a, p. 15.

REFERENCES: Clément 1867, no. 58; Clément (1868) 1879, p. 339, no. 60; Berger 1946, no. 17, pl. 17; Bouchet 1946, illus. facing p. 146; Clément (1879) 1973, suppl., p. 464, no. 60; Zerner 1978, pp. 481, 484, fig. 3; Eitner 1983, pp. 128–29, fig. 114; Grunchec in New York–San Diego–Houston 1985–86, p. 83, fig. 33a; Bazin 1987–97, vol. 4 (1990), pp. 70, 196, no. 1355; Mongan 1996, pp. 169–70, no. 170; Whitney 1997, pp. 136–39, fig. 176.

36. *Cattle Market*, 1817

Oil on paper mounted on canvas
24¼ x 19 in. (56.5 x 48.2 cm)
1943.242

Gericault's brief stay in Italy, from
September or October 1816 until the fol-
lowing autumn, was a period of intense
study and experimentation in which he
attempted—ambitiously, and with vary-
ing degrees of success—to fuse the mon-
umental spirit of the antique and High
Renaissance with his direct observations of
modern life. He divided his time in Rome
between the galleries and churches, where
he made copies after earlier works of art,
and the streets, where he found inspiration
in the activities and incidents of everyday
life. The result of this dual focus was a
series of paintings and drawings that can be
considered works of heroic genre, a hybrid
form without precedent.

Though painted in France after
Gericault's return (according to Charles
Clément, his reliable early biographer, it
was inspired by his visits to a slaughter-
house in the rue de la Pépinière in Paris),[1]
the Winthrop *Cattle Market* can be consid-
ered the last of Gericault's Italian composi-
tions. Its action and setting, while essentially
timeless, are intended to evoke Italy—an
imagined Italy, neither fully antique nor
fully modern, the Italy of the *Race of the
Barberi Horses* (see cat. no. 35), the main
project of his Italian year.

As usual in his works of heroic genre,
Gericault found inspiration for the *Cattle
Market* in both low life and high art. While
in Rome he had witnessed the herding and
slaughter of cattle in the public markets and
abattoirs near the Porta del Popolo on the
edge of the city. Two drawings by him in
the École des Beaux-Arts, Paris, show a
Roman butcher carrying a slaughtered calf

Fig. 83. Théodore Gericault, *Ancient Sacrifice*, 1817. Brown ink and white gouache,
9½ x 11¾ in. (28.5 x 42 cm). Musée du Louvre, Paris, RF 417 (photo: Réunion des
Musées Nationaux / Art Resource, NY—J. G. Berizzi)

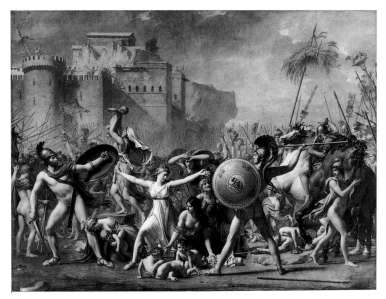

Fig. 84. Jacques-Louis David, *Battle of the Romans and the Sabines*, 1799. Oil on can-
vas, 12 ft. 7¼ in. x 17 ft. ½ in. (386 x 520 cm). Musée du Louvre, Paris, 3691 (photo:
Réunion des Musées Nationaux / Art Resource, NY—R. G. Ojeda)

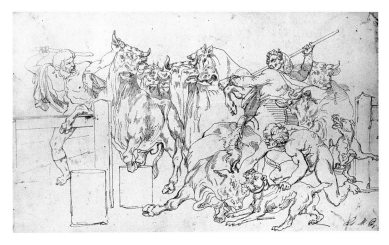

Fig. 85. Théodore Gericault, *Cattle Market*, 1817. Brown ink, 11¾ x 21¼ in. (29.8 x 54
cm). Private collection, Paris (photo: Réunion des Musées Nationaux / Art Resource,
NY—R. G. Ojeda)

on his shoulders. He was probably working alongside his friend and exact contemporary the artist Antoine-Jean-Baptiste Thomas, who depicts and vividly describes these activities in his volume of lithographs of popular Roman life entitled *Un an à Rome et dans ses environs*,[2] a copy of which Gericault owned. Another source for the subject was the Roman spectacle known as the *giostra a Corea*, a form of bullfight that took place every August in a public arena, pitting men, and sometimes dogs, against bulls; Thomas also depicted the bullfight, as did the popular Roman artist Bartolomeo Pinelli.

Gericault also turned for inspiration to his own Italian oeuvre, itself heavily influenced by Michelangelo and by the antique sculpture he studied in Rome and Naples. Among his works that most clearly foreshadow the *Cattle Market* are the monumental drawing in pen and ink known as the *Bull Tamer* (Louvre, Paris), based in part on generic Roman sculptures of Mithraic sacrifices; and the complex ink and gouache of an *Ancient Sacrifice* (fig. 83). The latter can be dated after his excursion to Naples in the spring of 1817, since it was evidently executed under the spell of the Farnese Bull, the colossal Hellenistic marble group on view in that city. In these two works, as later in the *Cattle Market*, Gericault abstracts the scene from any identifiable narrative or context, distilling it into an image of violent, elemental struggle between man and beast.

Compositionally, the *Cattle Market* owes a significant debt to Jacques-Louis David's *Battle of the Romans and the Sabines* of 1799 (fig. 84), whose principal foreground combatants are closely echoed in the poses of Gericault's two main butchers. At the time of his return from Italy, the celebrated

painting was on view in David's Paris studio in the Église de Cluny, which Gericault visited. The fresh, vivid colors of the *Cattle Market*, which mark a departure from Gericault's more subdued Italian palette, may also reflect the influence of David.

According to his friend Dedreux-Dorcy, Gericault painted eighteen or twenty oil sketches (*esquisses*) for the *Cattle Market*.[3] Only one preparatory work for the painting survives: a pen-and-ink study for the bottom half of the composition (fig. 85). Drawn on tracing paper at full scale, it differs in only a few details from the final painting, for which it presumably served as the definitive study. Gericault's working method at this time involved the extensive use of tracings to alter and rework his composition as it developed; the Paris drawing is the sole vestige of this process for the *Cattle Market*.

As he did with the *Race of the Barberi Horses*, Gericault may have intended to paint a version of the *Cattle Market* on a large scale. If so, the idea was pushed aside by other, more contemporary subjects, among them the *Raft of the Medusa* (see cat. nos. 38, 39), with which he began experimenting over the winter of 1817–18. Gericault's motivation in choosing the theme of the *Cattle Market* is obscure. In its sheer gruesomeness it is an alarming image, and it may reflect his unsettled emotional state at the end of his Italian stay, as expressed in his letters of the period. The ominous sense of danger that pervades the scene and its tangled mass of confined, struggling, strangely anthropomorphic creatures facing death give it a strong affinity with the *Raft*, which it in a sense prefigures.

Wheelock Whitney

1. Clément (1868) 1879, p. 300.
2. Thomas 1823, pp. 42–43, pl. 67.

3. Clément (1868) 1879, p. 300. None of these survives, and the accuracy of Dedreux-Dorcy's recollection on this point may be open to question.

PROVENANCE: (?) Couvreur; vicomte de Lamoignon; duchesse de Galliéra; Pierre-Olivier Dubaut; Édouard Mortier, duc de Trévise; his sale, Galerie Charpentier, Paris, May 19, 1938, no. 26 (Fr 235,000); acquired at that sale through Martin Birnbaum by Grenville L. Winthrop; his bequest to the Fogg Art Museum, 1943.

EXHIBITIONS: Paris 1874a, no. 179; Paris 1924b, no. 115; Paris 1927a, no. 1269; Paris 1936a, no. 271; Paris 1937, no. 40, illus.; Cambridge, Mass., 1946a, p. 13; Cambridge, Mass., 1977a; Tokyo 2002, no. 6.

REFERENCES: Clément (1868) 1879, pp. 105, 299–300, no. 95; Anon., January 1, 1874, p. 74; Houssaye 1879, p. 390; Rosenthal [1900], pp. 137–38; Rosenthal [1905], pp. 75–76; Rosenthal 1924a, p. 12; Grautoff 1924, p. 136; La Sizeranne 1924, p. 204; Rosenthal 1924b, p. 205; Vauxcelles 1924, p. 31; Régamey 1926, p. 26; Focillon 1927, p. 186; Magnin 1927, p. 186; Oprescu [1927], pp. 22, 82–85, 87, 193; Trévise 1927, pp. 192 (illus.), 198; Goldschmidt 1914–53, vol. 6 (1936), pp. 83 (illus.), 84; Laprade 1937, p. 8; Trévise 1938a, p. 7; Trévise 1938b, p. 22; Courthion 1939, p. 24; Antal 1940, p. 79, pl. 1d; Pach 1945, p. 238; Boyé 1946, p. 58; Courthion 1947, p. 191, illus. facing p. 128; Berger 1952, pp. 17. 69, no. 32, illus.; Friedlaender 1952, p. 98, fig. 54; Seligman 1953, pp. 323–24; Anon. 1954, illus. p. 40; Gaudibert 1954, p. 80; Aimé-Azam 1956, pp. 160, 179, 342; Florisoone 1957, pp. 302 fig. 20, 307–8 n. 18; Dubaut 1958, p. 87; Eitner 1960, pp. 3, 14, 19; Lebel 1960, pp. 334, 336, 341 n. 26, 342 n. 36, fig. 13; Leymarie 1962, pp. 61 (illus.), 63; Del Guercio 1963, pp. 42, 136, pl. 14 (detail); Prokoviev 1963, p. 120, illus.; Antal 1966, p. 32, fig. 28b; Jullian 1966, p. 900; Busch 1967, p. 184; Del Guercio 1967, unpag., pl. 4; Aimé-Azam 1970, pp. 174, 193, 363; Lüthy 1971, p. 35; Eitner in Los Angeles–Detroit–Philadelphia 1971–72, p. 21; Eitner 1972, p. 18, n. 17; Inoue and Takashina 1972–74, vol. 3, *Ingres and Delacroix* (1972), pl. 10; Clément (1879) 1973, pp. 105, 299–300 no. 95, 452; Forge 1973, p. 50; Szczepinska-Tramer 1973, p. 303; Huyghe 1976, pp. 156 (fig. 172), 158, 171; Grunchec 1978, pp. 104–5, no. 119, pl. 25; Zerner 1978, pp. 481–82, pl. 16; Grunchec in Rome 1979–80, pp. 54, 294; Matteson 1980, p. 76, fig. 7; Eitner 1983, pp. 117, 139–42, 304–5, pl. 24; Mortimer 1985, p. 178, no. 202, illus.; Grunchec in New York–San Diego–Houston 1985–86, p. 31; Kamakura–Kyōto–Fukuoka 1987–88, pp. 48, 75; San Francisco 1989, p. 2372; Bazin 1987–97, vol. 4 (1990), pp. 22–23, 144–45, no. 1219, illus.; Bowron 1990, fig. 272; Noël 1991, pp. 28, 91; Sagne 1991, pp. 123–24, illus.; Thuillant 1991, illus. p. 22; Paris 1991–92, pp. 88, 358; Michel 1992, pp. 46 (illus.), 47; Stafford 1994, p. 87, fig. 68; *Studies in Romanticism* 33, no. 24 (summer 1994), cover illus.; Boime 1996, vol. 2, pp. 579, 589; Fried 1996a, pp. 653, 706, fig. 307; De Paz 1997, pp. 92–94, 251, pl. 29; Michel 1997, pp. 212 fig. 86, 220; Whitney 1997, pp. 54, 70, 71, 76, 80, 82, 83–87, 155, 198, 200, fig. 115; Paris–Cambridge 1997–98, p. 75, n. 35; Whitney 2001, pp. 208 fig. 19, 209.

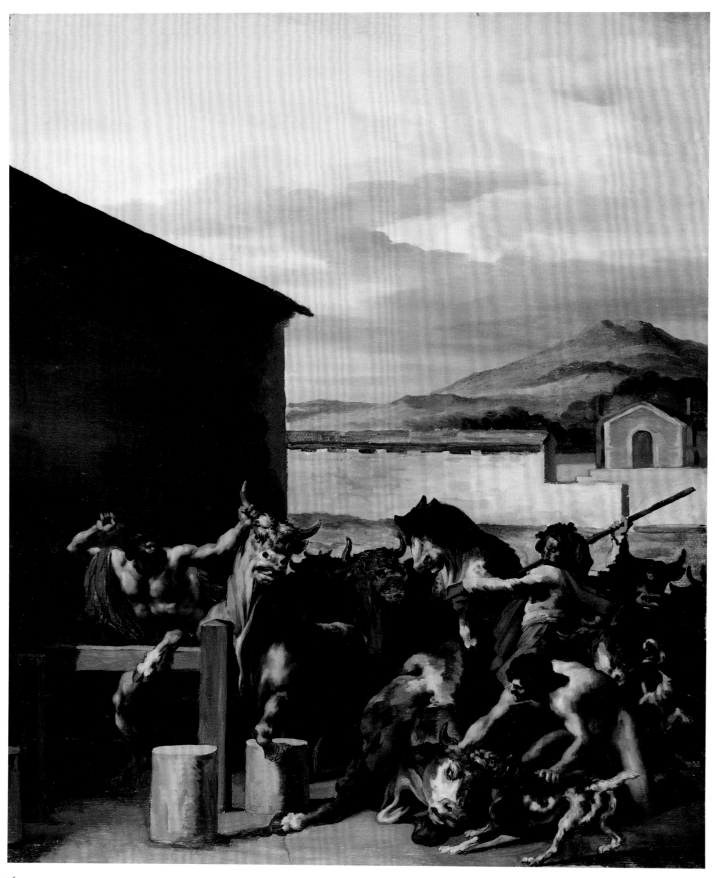

36

37. *Figure Study: Subject Unknown,* ca. 1817–18

Brown ink over graphite on heavy tan wove paper
11¼ x 9⅜ in. (28.7 x 23.9 cm)
Inscribed with monogram in brown ink, upper left:
MT *(?)*
1943.828

This powerful pen-and-ink study does not appear to relate to any other project, and its subject is uncertain. Martin Birnbaum sent it to Grenville Winthrop in 1929 as "a magnificent Roman period drawing à la Michael Ange. (Ink)," and it was among the first three Gericault drawings to enter Winthrop's collection.[1] Various classical themes have been suggested—such as the Death of Hector, or Hercules and Lychas.[2] The motif could have been remotely derived from an antique statue in Naples of a warrior with a wounded youth thrown over his shoulder and grasped by one leg, which may represent Athamas and Learchus.[3]

However, none of these possible iconographic sources explains Gericault's image of a muscular nude hauling a lifeless body up a slope, which seems above all to embody the contrast between life and death—the vigorous physical force of one figure juxtaposed with the dead weight of a body drained of all energy. The straining figure is shown from the back, gripping one leg of the frontally exposed limp torso, which falls back, its arms and head trailing, its face obliterated in shadow. The positions of the flexed muscular limbs, and the spatial relations between the weight-bearing feet and the dragging hands and arms, are underlined by the vigorously penned hatchings and impulses of line,[4] which both represent cast shadows on the sloping ground and emphasize the directions of movement. Further, the drapery has a life of its own—as if a shroud has burst open.

The physical weight and movements of

37

the anonymous figures seem to find formal expression in the deliberate heavy and dense lines, which appear to have been applied with both pressure and speed using a hatching system reminiscent of works by Michelangelo. However, the pen strokes of various thickness and direction that define the firm contours and model the figures also have their own momentum and convey an almost palpable sense of Gericault's hand and gesture.

Along the left edge of the page, seemingly unconnected with the central dramatic image and in a different graphic register, are various fluently drawn casual sketches: two of a Roman shepherd, two nudes (possibly derived from Michelangelo's *Last Judgment*), and a small hunched-over figure. These confirm that this drawing must date from during or after his Italian visit.[5]

Frances Suzman Jowell

1. Birnbaum, letter to Winthrop, Paris, April 30, 1929, Harvard University Art Museums Archives. See also cat. no. 40 for Birnbaum's letter.
2. Berger 1946, p. 26, no. 18 (with an incorrect provenance). Klaus Berger's suggestion that this drawing was "once thought to represent the death of Hector" was probably due to his mistaken assumption that

Winthrop purchased the drawing by that name which Birnbaum recommended in 1931 (letter, Paris, August 4, 1931, Harvard University Art Museums Archives). However, the drawing in question was evidently not acquired by Winthrop and was subsequently identified as depicting the death of Paris (see Eitner 1963 and Bazin 1987–97, vol. 4 [1990], p. 83, no. 1027). Berger further supported his suggestion of Hercules and Lychas by reference to an oil study of *Hercules and Lychas* (Smith College Museum of Art, Northampton, Mass.; see Bazin 1987–97, vol. 4 [1990], no. 1138) then attributed to Gericault. A more persuasive iconographic comparison might be Antonio Canova's well-known statue of the subject, which Gericault might have known while in Rome (see Praz and Pavanello 1976, no. 131, pl. 29).

3. *Group of a Warrior with a Child*, from the Baths of Caracalla, Rome (Museo Archeologico Nazionale, Naples, 5999). It was taken from the Palazzo Farnese to Naples in 1787 and initially placed on the Real Passeggio di Chiaia (present-day Villa Comunale) before being moved to the museum in 1826. It was copied in profile by Jacques-Louis David; see Guiffrey and Marcel 1907–38, vol. 4 (1909), illus. p. 86, no. 3239. (I am grateful to Paul Joannides for calling my attention to David's drawing.) Another drawn copy after the statue (but viewed from the back), attributed to Pirro Ligorio (1500–1583), was sold at Succession Henri Baderou, Hôtel Drouot, Paris, June 3, 1996, no. 37, illus.

4. For a discussion of the "apparent impulse of line" that can "fill out our sense of movement" and convey the "tension and torsion" of a figure in a way unique to the medium of drawing, see Podro 1998, pp. 9–10.

5. The dating is confirmed by various other pen-and-ink drawings that date from 1817–18 and are characterized by emphatic contours and firm, concentrated hatchings and cross-hatchings—such as *Hercules Taming the Cretan Bull* (Musée du Louvre, Paris) and several studies for the *Raft of the Medusa*.

PROVENANCE: Pierre-Olivier Dubaut; acquired from him through Martin Birnbaum by Grenville L. Winthrop, 1929; his bequest to the Fogg Art Museum, 1943.

REFERENCES: Berger 1946, illus. no. 18; Cambridge, Mass., 1946a, p. 15; Knowlton 1947, p. 217; Grunchec 1979, pp. 49, 50, fig. 36; Bazin 1987–97, vol. 4 (1990), pp. 17, 19, 117, no. 1137; Mongan 1996, p. 170, no. 171.

38. *The Mutiny on the Raft of the Medusa*, 1818

Black chalk, black crayon, white chalk, brown and blue-green watercolor, and white gouache on brown modern laid paper
16 x 20 in. (40.5 x 51 cm)
1943.824

This drawing derives its effect from tonal contrasts rather than linear outline of form.[1] It is an essential stage in the development of the *Raft of the Medusa*, the monumental painting with which Gericault, then twenty-eight, made his appearance at the Salon of 1819 (fig. 86).[2] The preparatory works for this project, which are numerous and varied in character, document Gericault's aligning himself with Renaissance and Baroque pictorial traditions. But at the same time, they define the beginnings of a new history painting. This new form of history painting is no longer affirmative but instead adopts a harshly critical stance toward contemporary events. As a corollary, the very process of making a major painting was transformed.

In this case, Gericault refers to a major shipwreck, in which the French frigate *Medusa* ran aground off the west coast of Africa in 1816. In Paris, horror and indignation at the scale of the catastrophe grew, as it became apparent that the ineptitude and recklessness of the *Medusa*'s captain, a royalist favorite, were responsible for the disaster. He escaped to safety with his entourage in lifeboats, abandoning the remaining one hundred fifty passengers to their fate on a primitively carpentered raft. Only fifteen of them survived, under gruesome circumstances.

Gericault was aware of all the details, first by reading reports in the newspapers, then from the accounts of witnesses, especially a book written by two survivors, the ship's engineer, the biographer Alexandre Corréard, and the ship's surgeon, Henri Savigny. Gericault approached his subject on two levels, the human and emotional level but also the political. The critique of the government inherent in the subject gives the painting a subversive character. It is precisely this double-layered quality that has determined the painting's reception up to the present.

Lorenz Eitner and Germain Bazin have assembled complete documentation of the final painting.[3] From this material, it becomes apparent that two preliminary works emphasized dramatically different episodes: the *Mutiny* being discussed here; and a *Scene of Cannibalism*, both themes of extreme violence and psychological release. Each of these in turn differs from the final painting, which is characterized by a high level of formal autonomy.

Gericault's approach to this complicated material was novel. Rather than beginning with a notion of what he wanted the work to look like, he started with different aspects of the event and articulated them in unusually compressed scenes, such as can be seen in the *Mutiny*.[4] Whereas in earlier times preparatory works had been generated for the individual who commissioned the painting, drawings made by an independent artist such as Gericault, not working on commission, could be autonomous. This *Mutiny*, which was executed in the summer or autumn of 1818, is just such an intellectual, rather than formal, part of the

Fig. 86. Théodore Gericault, *The Raft of the Medusa*, 1819. Oil on canvas, 16 ft. 1¼ in. x 23 ft. 5⅞ in. (491 x 716 cm). Musée du Louvre, Paris, 4884 (photo: Réunion des Musées Nationaux / Art Resource, NY)

Fig. 87. Théodore Gericault, *The Mutiny on the Raft*, 1818. Brown ink, 6⅜ x 8⅜ in. (16.2 x 21.2 cm). Musée des Beaux-Arts, Rouen, 890.52.1

creative process. Its significance is convincingly demonstrated when compared with two preparatory pen drawings in Rouen and Amsterdam (figs. 87, 88). The drawing in the Winthrop collection has the appearance of a completed image, thanks to the rich combination of materials, including chalk, watercolor, and gouache.[5]

The *Mutiny*'s complex intertwining of form and content gives graphic evidence of Gericault's bringing to bear his previous artistic experiences. These include the independent painterly drawings made in Rome; the method of working with phases of the event as in the *Barberi Horses;*[6] the visualization of the gruesome, as he did in the *Fualdès Affair,* made shortly before the *Raft of the Medusa;* and not least the engagement with nature, a dramatic key, as in the landscapes he did in the summer of 1818 (especially the *Deluge,* Louvre).[7]

The compositional structure of the *Mutiny* runs counter to convention. Gericault does not lead the gaze in the direction of the event's action. Rather, he lets it bounce off the wall of humanity to be drawn into the whirlpool of energy on all sides.[8] Accordingly, Gericault does not

accentuate the main figures, with the exception of the man at the central mast, and reduces the distinction between clothed and naked bodies, thus equalizing the struggle among the people on the raft.

Instead of organizing the figures around an event, Gericault developed a strategy of the fragment.[9] The meaning of the event is constituted by the observer's active participation through the act of viewing. Because the viewer must piece together the story,

the passage of time is reinterpreted. By this means, the catastrophe in its full implications becomes experientially perceivable as being equally historical and always reiterable.

Margret Stuffmann

1. This drawing has been thoroughly discussed in Mongan 1996, no. 174.
2. Eitner 1972, p. 24, no. 8, pl. 7 (still the most complete presentation of the project and its historical background); Eitner 1983, pp. 158, 166–67; Paris 1991–92, p. 136.

Fig. 88. Théodore Gericault, *The Mutiny on the Raft of the Medusa*, 1818. Graphite and brown ink, 16 x 23⅜ in. (40.6 x 59.3 cm). Amsterdams Historisch Museum, TA 10959

38

3. In addition to Eitner 1972 and Eitner 1983, see Bazin 1987–97, vol. 6 (1994), pp. 14–15, no. 1928, and Paris 1991–92, p. 136.

4. The most comprehensive and inspiring approach to this subject is Zerner 1993, p. 569.

5. Eitner 1972, nos. 6, 7, pls. 5, 6.

6. For the most complete presentation of this theme, see Whitney 1997, chap. 4, p. 89.

7. See Tinterow in New York 1990–91, pp. 57, 71, no. 13, illus.

8. The nonnarrative of the composition refers already to Eugène Delacroix's paintings *The Barque of Dante* and *Massacre of Chios*.

9. Recent research has emphasized the meaningful importance of the fragment; see Knoch 1996, p. 143, and Knoch 1992.

10. Tinterow (in New York 1990–91, p. 19) has noted the likelihood that Scheffer purchased the sheet at Gericault's atelier sale, Hôtel Bouillon, Paris, November 2–3, 1824. More recently, in his catalogue raisonné of the artist's oeuvre, Bazin (1987–97, vol. 6 [1994], no. 1928) suggests that it may be iden- tical with the drawing included in the Musigny sale, 16 rue des Jeûneurs, Paris, March 7–8, 1845, no. 54.

PROVENANCE: Ary Scheffer, Paris;[10] his sale, Hôtel Drouot, Paris, March 15–16, 1859, no. 12 (Fr 1,050); Anatole-Auguste Hulot, Paris; his sale, Galerie Georges Petit, Paris, May 9–10, 1892, no. 202 (Fr 720); Baron Joseph Vitta, Paris; acquired from him through Martin Birnbaum by Grenville L. Winthrop, 1935 (Fr 66,000); his bequest to the Fogg Art Museum, 1943.

REFERENCES: Anon. 1859, p. 95; Burty 1859, p. 48; Blanc 1862–63, vol. 3, "Théodore Géricault," p. 12; Clément (1868) 1879, pp. 122–23 n. 2, 127 n. 1, 351 no. 110, pl. 15 facing p. 120; Rosenthal [1905], pp. 88– 90; Oprescu [1927], p. 98; Kolb 1937, p. 62; Knowlton 1942, p. 135, pl. 48, fig. 22; Benesch 1944, p. 21; Cambridge, Mass., 1946a, p. 14; Wichmann 1954, p. 109; Berger 1955, pp. 53–54, 79, no. 47, pl. 47; Aimé- Azam 1956, p. 175; Lem 1962, p. 26; Prokofiev 1963, p. 124, illus.; Eitner 1967, p. 132 n. 16; Aimé-Azam 1970, p. 189; Eitner 1971, p. 53 n. 10; Eitner 1972, pp. 23 (pl. 7), 154–55 (under no. 37), 169 (under no. 95); Clément (1879) 1973, pp. 122–23 n. 2, 351 (no. 110), 466 (no. 110), pl. 16; Levitine 1973, pp. 422–23; Huyghe 1976, pp. 160, 170 (fig. 187); Stolte 1978, pp. 264, 404, pl. 104 (I A2); Zerner 1978, pp. 481, 483, 486, fig. 7; Eitner 1983, pp. 165–66, 167, 168, fig. 155; Mortimer 1985, p. 240, no. 281, illus.; Hamilton– New York–Amsterdam 1985–86, pp. 122–23, under no. 45, fig. 24; New York–San Diego–Houston 1985– 86, p. 137, under no. 70, fig. 70b; Rennes 1988, pp. 78–79, under no. 51, fig. 1; Tinterow in New York 1990–91, p. 19; Aimé-Azam 1991, p. 205; Noël 1991, pp. 47, 52 (illus.); Schneider 1991a, pp. 54 (illus.), 55; Schneider 1991b, pp. 76–77 (illus.), 135 (detail illus.), 178 (detail illus.); Paris 1991–92, p. 379, under nos. 190, 191; Zerner 1993, vol. 2, p. 577, fig. 6; Bazin 1987–97, vol. 6 (1994), pp. 14, 15 (illus.), 98 (under no. 1925), 100–101, no. 1928, illus.; Barret 1996, pp. 172 (illus.), 173–74; Jowell in Mongan 1996, pp. 172–74, no. 174, fig. 174; Nochlin 1996, vol. 1, pp. 406, 468, fig. 203.

39. *Family Group from "The Mutiny on the Raft of the Medusa,"* 1818

Brown ink over graphite on white modern laid paper
8¼ x 12⅛ in. (20.3 x 29.9 cm)
Signed in brown ink, lower right: T. Gericault
1943.833

This tragic scene depicts a woman almost exhausted to death lying on the ground propped on a barrel. Sitting behind her a distraught man gazes into the distance, grasping a sturdy little boy who is kneeling on his mother's lap. The scenario stems from the immediate context of Gericault's *Raft of the Medusa* project.[1]

Its inclusion in Grenville L. Winthrop's collection is particularly apt, because this scene is directly related to the *Mutiny* drawing (cat. no. 38). However, as the completed composition was finally carried out, this group of three was replaced by a group of two. The sexes of the two figures can barely be distinguished, and the emotionalism inherent in the original incident is reinterpreted: now an older man pulls a younger one from the water onto the planks of the raft. According to accounts of the shipwreck and its aftermath, there was only one woman on the raft of the *Medusa*. The *cantinière*, the waitress in the bar of the ship's crew, was pulled from the water twice but then finally abandoned.[2] The child and the man, in their unique pairing, struggling against one another as seen evident here, are Gericault's own invention.

However peripheral this group may at first appear within the many different episodes of the *Medusa*'s story, Gericault was apparently greatly preoccupied with it. It appears, only sketchily indicated, in the first complete sketch of the *Mutiny* (Musée des Beaux-Arts, Rouen; fig. 87) and then again, in a form comparable to the present work and clearly reminiscent of a Pietà, in a large compositional drawing now in the

Amsterdams Historisch Museum (fig. 88). Gericault also removed this "family" from its larger context and repeated it in two drawings clearly differing from one another, one in a private collection in Paris (fig. 89), the other Winthrop's drawing now at the Fogg Art Museum.[3] The Winthrop drawing—with its compact, more finished form and large format with a distinct signature—is to be regarded as the later of the two. Striking is the discrepancy in the relative strength of the man, woman, and child, who are united, however tenuously, by their triangular composition. The comparison of these two drawings shows how the relationship between the man and woman increasingly dissipates, and how the boy—at first seen frontally and comparable to a young Hercules figure—turns away from his father and mother, to become an independent entity. This juxtaposition of exterior and interior struggle is reminiscent of the Laocoön.

This final version of the three-figure group is proof of Gericault's conscious search for a solution that was adequate in terms of formal content. Drawing with energetic and repeatedly reinforced lines, he creates volumes, groups masses, and generates movement, simultaneously bringing the forms back into the overall enclosing outline. The combination of the lightly indicated horizontal plane and the intimation of landscape at the right directs the gaze upward and reinforces the effect of a powerful monumentality of virtually classical proportions. This compositional manner demonstrates Gericault's having been influenced by the art of Michelangelo, above all his frescoes of Christ's ancestors on the Sistine Chapel ceiling, with their muscular offspring in the spandrels.

The energy with which Gericault worked on this group, and his apparently having regarded the drawing at the Fogg as autonomous, may have had a deeper cause. We should remember that in June 1818—that is, precisely at the time of his most intensive preparations for the *Raft of the Medusa*—Gericault's son was born, the

Fig. 89. Théodore Gericault, *Family Group from "The Mutiny on the Raft of the Medusa,"* 1818. Pen on blue paper, 7¼ x 10¾ in. (18.5 x 27.3 cm). Private collection, Paris

39

result of a tragic love affair with the young wife of his uncle. What in terms of morality must have been regarded as scandalous was for the artist (coinciding with his *Medusa* project) a crucial event, the apex and turning point of his short life. He projected this situation from his life onto his drawing: we might thus explain the dramatic dualism of this familial scene and its suppression in the painting's final version. This interpretation is not intended to contradict but rather to extend Linda Nochlin's analysis of the elimination of women from Gericault's *Raft of the Medusa* painting. Nochlin understands the absence of women in the context of the artist's social and political views in conjunc-

tion with, but not as the least important factor of, his homosexual propensities.[4]

Thus the autonomy of the Winthrop drawing, as a formal entity, has to do not just with its external appearance but also with the fact that—in contrast to the painting—it alone could reflect the artist's heightened psychological state at this time.

Margret Stuffmann

1. This drawing is extensively discussed in Mongan 1996, no. 75. It also figures in Bazin 1987–97, vol. 6 (1994), no. 1931.
2. Eitner 1972, p. 153.
3. Ibid., nos. 34, 35, pls. 26, 28.
4. Nochlin 1996, p. 403.

PROVENANCE: Possibly Alexandre Colin sale, Hôtel Drouot, Paris, December 22, 1859, no. 42 ("Groupe de

trois figures, études pour la Méduse, à la plume"; Fr 42); possibly Pierre-Olivier Dubaut, Paris; Claude Roger-Marx, Paris; acquired from him through Martin Birnbaum by Grenville L. Winthrop, 1929; his bequest to the Fogg Art Museum, 1943.

EXHIBITION: Paris 1935, no. 40, illus.

REFERENCES: Martine 1928, pl. 54 (as coll. Roger-Marx); Berger 1946, p. 28, no. 26, pl. 26 (confuses the present sheet with the variant in the Marillier Collection, Paris); Cambridge, Mass., 1946a, p. 15; Mongan 1949, pp. 142–43, illus.; Moskowitz 1962, vol. 3, pl. 728; Del Guercio 1963, p. 147, pl. 58; Eitner 1972, p. 154, no. 35, pl. 28; Jowell 1974, p. 383; Zerner 1978, pp. 481, 483, 486, fig. 8; Hamilton–New York–Amsterdam 1985–86, p. 123 n. 15, fig. 26 under no. 45; Schneider 1991, p. 141, illus.; Bazin 1987–97, vol. 6 (1994), pp. 15–16, 101 under no. 1930, 102 no. 1931 (illus.) and under no. 1932; Jowell in Mongan 1996, pp. 174–75, no. 175, fig. 175; Nochlin 1996, pp. 406, 468, fig. 202; Nochlin 1999, p. 59, fig. 31.

40. *Death of a Young Mason,* 1819

Brown ink, brown wash, and blue-green watercolor
over graphite on white wove paper
6 ½ x 4⅞ in. (16.5 x 12.4 cm)
1943.367

This small but monumental work was among the first group of Gericault drawings acquired for Grenville Winthrop by his agent Martin Birnbaum in 1929. The previous year it had been exhibited in Paris and reproduced in facsimile in a lavish publication devoted to Gericault.[1] At that time the subject of the drawing was unknown; it was simply entitled "Scène dramatique (sujet inconnu)." It was not until 1955 that the precise circumstances, date, and subject of this "dramatic scene" were established, based on evidence of a published correspondence that shed new light on a little-known episode in Gericault's life.[2]

During the month after the completion of the *Raft of the Medusa,* Gericault, exhausted and despondent, retreated to Féricy (a village near Fontainebleau) with his friend Auguste Brunet. One of their frequent visitors was René-Richard Castel, a botanist and poet, who several years earlier had taught literature to both Gericault and Brunet at the Lycée Impérial.[3] In a letter of September 17, 1819, to another of his ex-pupils, Castel described how he had read Gericault an account from *La Quotidienne* about the fatal fall of a young worker whose grieving parents sat watch over his body through the night. Castel added that Gericault made a wash drawing of the subject, which in its poses, characterization, and expression was a "small masterpiece."[4]

The article in question (September 13, 1819) provides further details about the mason's seventy-foot fall from a building project for the Ministry of Finance: the "unfortunate young man aged twenty was of worthy parents; on hearing about the

fatal event, the mother and father came to spend the night next to their son's corpse. Seated on a stone, they both remained in this position from nightfall until the following morning, with the calm of a concentrated and reflective grief. This touching sight was lit by two candles. The mother covered her head with a black veil. The father wanted to attend the funeral paid for by the contractor."[5]

Gericault's response to this brief but vivid newspaper report was to create an uncaptioned image that far transcends the specific topicality of the episode. It is a superb example of Gericault's persistent search for meaningful subject matter from random newsworthy events—the *fait divers* of contemporary life.[6] In this case it involved a tragic anecdote concerning an anonymous Parisian worker and his family. While faithful to some details in the article (such as the parents seated on a stone, the mother's veil, the candlelight), this imagined scene of grieving parents watching over the corpse of their son recalls Gericault's other depicted images of despair, grief, and inconsolable suffering. The father is reminiscent of the grieving "father" in the *Raft of the Medusa,* particularly in the earlier studies,[7] and the naked son recalls studies of a dead youth, most of which relate to the dead

"son" in the *Raft.*[8] The theme of family tragedy also recalls Gericault's preoccupation with the *Family Group* for the early versions of the *Raft* (cat. no. 39). The figure of the entreating mother may be compared to the figure of Mary in Gericault's *Entombment,* also in the Winthrop collection (fig. 90).[9] However, although the general configuration and emotional intensity may resemble a Lamentation, this image of death and grief is utterly devoid of the consolation of any promise of redemption.

Gericault executed his "small masterpiece" with skillful use of his chosen media. Except for the blue-green watercolor of the sky beneath the somber clouds, the scene is conveyed entirely in monochromatic chiaroscuro. The graphite drawing is overlaid with fluently penned contours and brown washes of varying intensity, while areas of stark white paper represent the dramatic illumination of the flaming torch held by the seated father. Although the figures constitute a compositionally united pyramidal group, the dramatic pathos is emphasized by the isolation of each figure: the outstretched naked corpse across the foreground; the seated, bowed-down father absorbed in his own ponderous grief; the imploring mother, who prays upward, her anguish profiled against the dark sky.

Fig. 90. Théodore Gericault, *The Entombment,* 1816–17. Graphite, black chalk, gray wash, and white gouache on brown wove paper, 6⅜ x 8¾ in. (16.2 x 22.2 cm). Fogg Art Museum; Bequest of Grenville L. Winthrop, 1943.826

40

tioned, including my commission, will cost you 86,650 francs. . . . I hope they will please you as it is the nature of a triumph for me after so many failures."[12]

Frances Suzman Jowell

1. See Paris 1928a and Martine 1928, no. 55, where it was reproduced in facsimile.
2. Castel 1833, pp. 366–67. The relevance of Castel's correspondence to this period of Gericault's life was first discovered by Denise Aimé-Azam (1954 and 1956, pp. 233–41). However, the connection between this particular letter and the drawing in question was made by Johnson 1955, pp. 80–81.
3. On Castel, see Chenique 1996, pp. 339–44.
4. "Du reste, je lui [Gericault] avais lu l'autre jour un article de la Quotidienne qui rapporte qu'un jeune compagnon est tombé de 60 pieds dans la rue de Rivoli, c'était à la chute du jour; son père et sa mere sont venus s'asseoir près du corps et y ont passé la nuit: Jéricault [*sic*] en a fait un dessin au lavis, qui, pour la pose, les caractères de tête et l'expression, est un petit chef-d'oeuvre"; Castel 1833, vol. 1, p. 367.
5. "Un malheureux maçon est tombé de 70 pieds d'élévation, en travaillant au batiment projetté pour le ministère des finances rue de Rivoli. Cet infortuné jeune homme agé de 20 ans appartenait à des parents estimables; instruits du funeste événement, le père et la mère sont venus passer la nuit près du cadavre de leur fils. Assis tous deux sur une pierre ils sont restés dans cette position depuis la nuit tombante jusqu'au lendemain matin, avec le calme d'une douleur concentrée et réflechie. Deux chandelles éclairaient ce spectacle touchant. La mère avait la tête couverte d'un voile noir. Le père a voulu suivre le convoi dont les entrepreneurs ont fait le frais"; *La quotidienne*, September 13, 1819.
6. On the importance of the *fait divers* as "contemporary, bizarre, violent, anecdotal, and journalistic subjects" in Gericault's work, see the interesting account in Simon 1996, p. 257.
7. Eitner 1972, nos. 39–43.
8. Ibid., nos. 49, 80, 84.
9. Mongan 1996, no. 169.
10. On the importance of Dubaut and other early-20th-century collectors, see cat. no. 42, note 10.
11. Mongan 1996, no. 184 (1942.30).
12. Birnbaum, letter to Winthrop, April 30, 1929, Harvard University Art Museums Archives.

PROVENANCE: Pierre-Olivier Dubaut, Paris; acquired from him through Martin Birnbaum by Grenville L. Winthrop, 1929; his bequest to the Fogg Art Museum, 1943.

EXHIBITION: Paris 1928a.

REFERENCES: Castel 1833, pp. 366–67; Martine 1928, no. 55, illus.; Berger 1946, no. 28, illus.; Knowlton 1947, p. 217; Johnson 1955, pp. 80 (fig. 22), 81 nn. 9–11; Aimé-Azam 1956, pp. 218, 343; Del Guercio 1963, p. 147, fig. 61; Lem 1963a, p. 9, illus.; Zerner 1978, p. 483; Eitner 1983, pp. 201, 347 n. 199; Tinterow in New York 1990–91, p. 30, illus.; Aimé-Azam 1991, p. 249; Eitner 1991, pp. 277, 430 n.199; Bazin 1987–97, vol. 6 (1994), pp. 72, 176–77, no. 2106; Mongan 1996, no. 176, illus.

When this drawing first came to Birnbaum's attention, it belonged to one of the most influential early-twentieth-century collectors of works by Gericault, Pierre Dubaut,[10] from whom Birnbaum successfully negotiated two other Gericault drawings at the same time, as described by Birnbaum's enthusiastic letter to his client: "I again went to see [Dubaut] and he at once began to lament the fact that very important sales would take place soon, but prices were now prohibitive for an artist. There was my chance! If he would sell me some of his Gericaults he could bid at the coming sales. I tempted and struggled and fenced, all day— morning and afternoon—and I can now truthfully say, that Gericault is represented in your collection! First there is a fine 'Dramatic Group' (about 1818) reproduced in facsimile in said portfolio; ink, sepia, and greenish water colour sky. 2nd A Mameluk (sketched in pencil) holding a fine horse with trappings (in strong water colours)[11] 3rd a magnificent Roman period drawing à la Michael Ange (Ink) [cat. no. 37]. The three items with the portfolio above men-

41. *Studies of a Cat,* ca. 1820–21

Graphite with touches of black chalk on tan wove paper
12¾ x 15⅞ in. (32.2 x 40.2 cm)
Verso: sketch of a horse's hoof, graphite
1943.825

Among the various paintings, drawings, and lithographs that attest to Gericault's fascination with feline animals are several sheets of studies of cats.[1] The best known is the sheet of nine studies in the Louvre, Paris, first catalogued by Charles Clément in 1867.[2] When the Winthrop drawing was offered to Martin Birnbaum by its then owner, Baron Joseph Vitta, in 1937, Birnbaum could confidently assure the col-

lector that it was of "the greatest quality and the companion piece is in the Louvre."[3] Although Clément dated the Louvre drawing before Gericault's departure to Italy in 1816, the Winthrop sheet and related ones of studies of cats are now believed to date from during or after his English visits of 1820–21.[4]

In this drawing, ten sketches of carefully selected views of a striped domestic cat are superimposed over the faintly outlined figures of two harnessed draft horses— also a subject that dated from the English visit. Drawn in pencil, the carefully scrutinized animal is depicted in varying positions, in whole or in part. The model for

these various studies is generally assumed to have been a dead stuffed cat that Gericault could manipulate and position for his own viewing.[5] This was not the first time Gericault represented fragmentary lifelike images from a lifeless model: these isolated studies, in their intensely observed and carefully descriptive detail, are reminiscent of some of his graphite studies of severed heads related to the *Raft of the Medusa.*

Each of these studies of cats is independently scaled and in its own space, separate and with its own intense specificity. The feline qualities range from ferocious to kittenish, and the body is variously distorted, foreshortened, or detached into

parts. There are two studies of hindquarters in the lower left corner: one in profile and the other frontal with legs splayed apart. Three sketches represent the whole body with the head twisted to the right: two are of foreshortened views from behind and from the front, and one is in profile; two display the head with open mouth and bared teeth. Three studies concentrate on the head and forequarters, with the head bent down toward the ground or seemingly resting on its paws. Most striking are the two detailed studies of the head with open mouth and ferociously bared teeth—one sinking its fangs into an unidentified object, the other (for which there is a diminutive rough sketch) with its head pulled back, as if emitting a cry.

This example of focused perceptual, observational drawing from nature reveals Gericault's versatile and resourceful use of his medium. By varying the pressure and using both hard and soft graphite, Gericault achieves sharply defined contours, subtle tonal effects, varied textures, and descriptive detail. This sheet of studies is an exploratory study not only of the observed subject, but also of the wide range of expressive and descriptive possibilities of the medium.

Frances Suzman Jowell

1. Musée Bonnat, Bayonne, 794–796; Musée des Beaux-Arts, Besançon, D.2156; Musée des Beaux-Arts, Rouen, 880.15. A hitherto unpublished drawing recently on the market may have been the original model for various copies and tracings now at Bayonne (Bazin 1987–97, vol. 7 [1997], nos. 2368, 2368A, 2368B, 2369). See Christie's, New York, sale cat., January 24, 2001, no. 133, illus.

2. Clément 1867, no. 54; see Bazin 1987–97, vol. 7 (1997), p. 1578, no. 2366.
3. Birnbaum, letter to Winthrop, Paris, July 27, 1937, Harvard University Art Museums Archives.
4. A dating that is supported by a sheet of studies in Bayonne that combines copies of Gericault's cats with motifs from two of his English lithographs; see Bazin 1987–97, vol. 7 (1997), p. 90, no. 2188.
5. A study of a dead cat drawn from nature is listed in the inventory made immediately after Gericault's death; see ibid., vol. 1 (1987), p. 88, no. 21, doc. 299.

PROVENANCE: (?) Reiset; his (anonymous) sale, Hôtel Drouot, Paris, April 16, 1894, no. 42 (Fr 360); Baron Joseph Vitta; acquired from him through Martin Birnbaum by Grenville L. Winthrop, 1937 ($550); his bequest to the Fogg Art Museum, 1943.

EXHIBITION: Cambridge, Mass., 1964, no. 18.

REFERENCES: Berger 1946, no. 23, pl. 23; Cambridge, Mass., 1946a, p. 14; Rostrup 1964, pp. 34, 40 n. 12, fig. 41; Mendelowitz 1967, fig. 16-10; Malins 1981, no. 144, illus.; Goldstein 1982, pl. 53; Eitner 1983, p. 352, n. 98; Kamakura–Kyōto–Fukuoka 1987–88, p. 157, under D-25; Mongan 1996, pp. 170–71, no. 172; Bazin 1987–97, vol. 7 (1997), pp. 33, 158–59, no. 2367.

42. *Groom Exercising Two Horses,* ca. 1821–22

Watercolor over graphite on cream wove paper, darkened to buff
11½ x 14¾ in. (29.3 x 37.4 cm)
1943.363

The subject of this watercolor is associated with Gericault's visits to England,[1] although it may date from after his return to France at the end of 1821. It was probably made as the model for a lithograph entitled "Domestique conduisant deux chevaux anglais couverts de tapis d'écurie" (Groom exercising two English horses covered with stable rugs), published in 1823 (fig. 91).[2] The lithograph was executed by Joseph Volmar who, together with Léon Cogniet, collaborated with Gericault during 1822–23 in the production of a lithographic series of studies of horses, *Études de chevaux*.[3] These twelve plates were based in part on the famous English series of 1821, six of

which were simply repeated in reverse.[4] According to Charles Clément, who knew Cogniet, Gericault provided watercolor models for the remaining six lithographs.[5]

The choice of subject may be seen as part of contemporary French interest in the English tradition of sporting art and horse portraiture. However, it also reflects Gericault's lifelong passion for the horse, both in life and in art: "the beloved creature he superbly mastered as a sportsman, but to which his artist's imagination remained in lifelong, troubled bondage."[6] Throughout his career he depicted the horse—whether in epic classical or historical themes, in modern military dramas, in scenes from everyday life, in its stable life, or in anatomical studies.[7] Compared stylistically to his earlier Italian drawings, such as the *Study for "The Start of the Race of the*

Barberi Horses" (cat. no. 35) and the *Roman Herdsmen* (cat. no. 34), both of which reflect Gericault's responses to classical and Renaissance art, this watercolor of two high-strung thoroughbreds, typical of fashionable equestrian life in London, shows his awareness of an alternative tradition of art, both in subject matter and style.[8]

The impassive groom in a blue riding coat lined in red, green scarf, gray pants, and black hat is mounted on the light roan and leads the dark dapple gray—both meticulously groomed horses covered with stable rugs of cream, red, and yellow. The ridden horse is controlled by the carefully delineated double bridle as both move in front of a wall of red brick and gray stone pier, beyond which trees and foliage of a park are suggested. Color is applied as transparent washes and in deeper tones (the

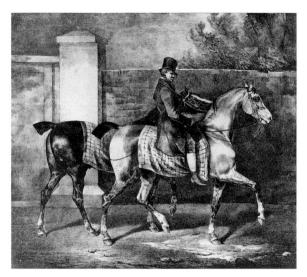

Fig. 91. Théodore Gericault, in collaboration with Joseph Volmar, *Groom Exercising Two Horses*, June 23, 1823. Crayon lithograph, 12¾ x 15 in. (32.5 x 38.2 cm). Fogg Art Museum, Bequest of Grenville L. Winthrop, M10348

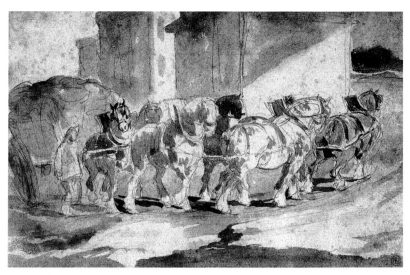

Fig. 92. Théodore Gericault, *Coal Wagon Hauled by Seven Horses*, 1821–23. Graphite and gray-blue and brown watercolor on cream modern laid paper, 6¾ x 10⅝ in. (17 x 27 cm). Fogg Art Museum, Bequest of Grenville L. Winthrop, 1943.364

general warmth of which may be the result of the paper's discoloration). The tonal subtleties and color washes have replaced the chiaroscuro and sculptural graphic manner of Gericault's earlier works. However, it is a carefully contrived composition: rider and horses are organized in shallow friezelike space, creating a subtle interplay between the main figures and background by repetition or echoing of outlines, as well as skillful alignment of contours. The cast shadows clarify positions, emphasize the ground, and measure and coordinate the strides.

The careful compositional control can be seen as the formal equivalent to the mastery of the rider over the carefully paced horses. These refined horses with cropped tails are no longer the powerful military chargers or wildly stampeding rebellious horses of some of Gericault's earlier works. They are compliant, obedient, trained—their restrained energy and vitality are conveyed only by their nervous eyes. These "aristocratic" elegant thoroughbreds are usually contrasted with Gericault's alternative images of heavy blinkered draft horses, the "proletarians of

their species,"[9] such as the remarkable watercolor from the Winthrop collection of a *Coal Wagon Hauled by Seven Horses* (fig. 92). This and other scenes of lumbering workhorses, tethered together in teams as beasts of burden, have been interpreted as evidence of Gericault's "democritising" purpose.[10] In both these alternative images, however, animal energies are depicted as bridled, harnessed, and controlled.[11]

It is unlikely that such considerations concerned the collectors of Gericault's works. The *Groom Exercising Two Horses*, which was exhibited in Paris at the commemorative exhibition in 1924[12] and again in 1937,[13] first came to Martin Birnbaum's attention in July 1939, and he immediately informed Winthrop of this "very fine Gericault water color—a stable man in uniform riding a horse and leading a second (larger than your water colours). The owner wants $2500 for it (American currency). It is a notable English period example . . . and is not exorbitantly priced."[14] He subsequently informed Winthrop, "It would be an important addition to a group of the painter's works, second only to the Louvre possessions. The owner is a

wealthy man who will sell it only to buy a Picasso drawing."[15] Winthrop cabled Birnbaum to go ahead, and the drawing was acquired for $2,200.[16]

Frances Suzman Jowell

1. The correct dates of Gericault's two visits to England (April to June 1820 and the end of 1820 to December 1821) were first established in Sells 1986. For an account of Gericault's impressions of English art and his responses to English art in his own work, see Eitner 1983, pp. 217–37.
2. In the week ending June 28, 1823; Joannides 1973, p. 668.
3. Delteil 1924, nos. 80–92.
4. French publishers commissioned the repeat of the English series, but wanted only the subjects of horses: "les frères Gihaut lui demandèrent une repetition de sa grande suite anglaise; mais on ne voulait que des chevaux"; Clément (1868) 1879, p. 220.
5. Ibid.
6. Eitner 1983, p. 38.
7. See, for example, the handsome publication on Gericault's watercolors and drawings of horses, Grunchec 1982.
8. On the importance of Gericault's early familiarity with English sporting art from his time in Carle Vernet's studio, see Eitner 1983, pp. 14–16.
9. Ibid., p. 225.
10. Antal 1966, p. 41. This is also evident in Gericault's extraordinary depictions of themes of urban desolation and poverty; see Eitner 1983, pp. 229–30, and Michel 1991, p. 202 ("Londres prolétaire").
11. For a suggestion of Gericault's awareness of the contemporary didactic texts condemning cruelty toward animals, horses in particular, and his sympathetic depiction of the Arabian horse in its native habitat, see Jowell 1993, p. 292.

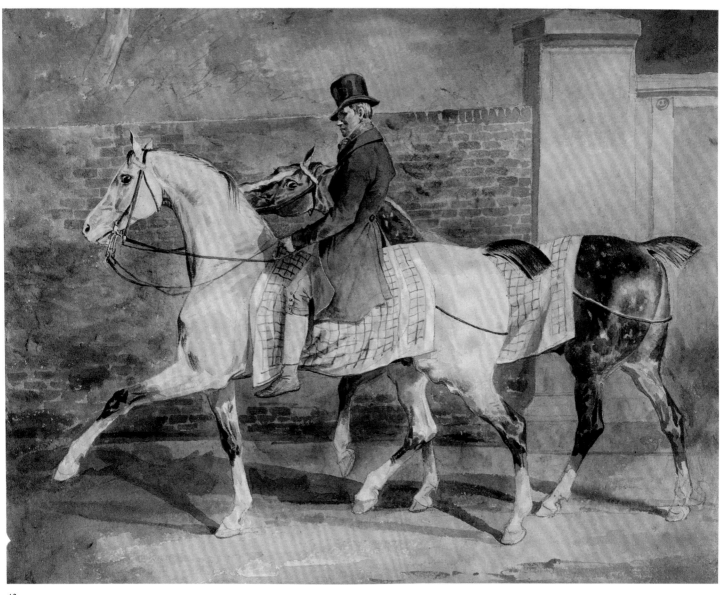

42

12. Paris 1924a, p. 79, no. 207: "Deux chevaux promenés par un jockey monté sur l'un d'eux. Ils marchent l'un au pas, l'autre au trot." On the importance of this exhibition and early collectors to Gericault's posthumous critical fortunes, see Eitner in Los Angeles–Detroit–Philadelphia 1971–72, pp. 10–11, and Grunchec in New York–San Diego–Houston 1985–86, pp. 11–20.
13. Paris 1937, no. 141.
14. Birnbaum, letter to Winthrop, Paris, July 20, 1939, Harvard University Art Museums Archives.
15. Birnbaum, letter to Winthrop, Hendaye, July 23, 1939, Harvard University Art Museums Archives.
16. "I succeeded in reducing the price of the Gericault

from $2500 to $2200 which with commission amounted to $2420 (They are paying the packing charges in Paris as well.)"; Birnbaum, letter to Winthrop, Paris, August 4, 1939, Harvard University Art Museums Archives.

PROVENANCE: Possibly sale of Cabinet de M****, 16 rue des Jeuneurs, Paris, March 11–12, 1846, no. 89 ("Jockey anglais promenant des chevaux"); Maurice Coutot; anonymous sale, Galerie Georges Petit, Paris, December 16–17, 1919, no. 129 (Fr 4,600); purchased at that sale by Édouard Henriquet; acquired through Martin Birnbaum by Grenville L. Winthrop, 1939 ($2,200); his bequest to the Fogg Art Museum, 1943.

EXHIBITIONS: Paris 1924, no. 207; Paris 1937, no. 141; Cambridge, Mass., 1943, no. 28; Cambridge, Mass., 1943–44, p. 10.

REFERENCES: Berger 1946, p. 29, no. 30, pl. 30; Cambridge, Mass., 1946a, pl. 14; Cetto 1949, pp. 29–30, pl. 54; Rouen 1981–82, p. 97 under no. 84 (unlocated); Grunchec 1982, pp. 162, 163, illus.; Jowell 1982, p. 256; Eitner 1983, p. 224, fig. 192; Christie's, London, November 15, 1985, under no. 149; New York–San Diego–Houston 1985–86, under no. 83; Jowell 1993, pp. 288–90, fig. 2; Mongan 1996, no. 181, illus.; Bazin 1987–97, vol. 7 (1997), pp. 15, 24, 117, no. 2260.

43. *English Cavalryman* (formerly *Horse Guard*), ca. 1821–22

*Watercolor and gouache over graphite on brown
wove paper; parts of the background have been
varnished*
9¼ x 11¾ in. (23.6 x 29.8 cm)
1943.365

This striking drawing was known to
Gericault's first biographer, Charles
Clément, who catalogued it in 1867 as of
"very fine quality, belonging to M. James
Nathaniel de Rothschild."[1] It was inherited
by Baron Henri de Rothschild, from whom
Martin Birnbaum gleefully acquired it in
1931 on behalf of Grenville Winthrop.[2] He
enthused to Winthrop about the "English
Horse Guard (in red) on a spirited black or
dark brown horse. . . . This water color is
only to be described in superlatives.
Nowhere have I seen anything comparable
to this Gericault. You will recall that I made
an offer of almost $3000 to [Pierre Olivier]
Dubaut for one of his. This picture is
worth more than a group of Dubaut's best.
I did not know that Gericault could create a
watercolour like this. Anything up to
$5,000 would be cheap."[3]

Since Clément catalogued this work as
"Horse-guard en petite tenue," it has been
assumed that the subject originates from
Gericault's visits to England in 1820–21
and represents a member of a regiment of
the Household Cavalry. However, the uni-
form and saddlery do not, in fact, accord
with the dress codes relating to any of these
regiments.[4] The elaborate uniform was
probably devised by Gericault himself to
create his own notion of a cavalry soldier,
possibly British, here engaged in a peaceful
equitation exercise. The rider is in undress
uniform: scarlet stable jacket with gold
trimming, and high Prussian collar of black
and gold, over blue-gray overalls with red
stripes, an unidentifiable type of gray cap
with red band, and white gloves, possibly

buckskin. The unusual pose of the left arm
and the position of the right hand on the
left of the horse's neck may indicate an
exercise of dressage. The stiff pose of the
elaborately uniformed rider contrasts with
his small mount, whose tense energy is con-
veyed by twitching ears, nervous eye,
foaming mouth, and rippling muscles—all
carefully accentuated by gouache high-
lights. The care with which Gericault com-
posed this work is evident in the pentimenti
of the underdrawing, as in the visibly
changed position of the back leg.

Gericault's careful depiction of the lone
cavalryman and his horse against a broadly
brushed background of light and dark
clouds and a subtly suggested horizontal
ground skillfully combines English water-
color technique with his native tradition of
opaque white.[5] The dyed paper, which pro-
vides the allover dominant middle tone, is
modulated by the washes of transparent
watercolor and highlighted by white
gouache, which creates general background
effects as well as accents details of the
figures. The slight lack of opacity gives the
gouache a bluish character when applied in
thin layers, as in the translucent white
reflections on the shiny coat of the horse.

This drawing served as a model in the
studios of Gericault's younger contempo-
raries; Clément listed two lithographs after
the painting, one of which is conserved in
the Bibliothèque Nationale, Paris (fig. 93).[6]
Two further versions of the painting—an
unfinished oil sketch and a pen outline
drawing on yellow tracing paper—hitherto
presumed to be by Léon Cogniet, are con-
served in the Musée des Beaux-Arts,
Orléans.[7]

Frances Suzman Jowell

1. Clément 1867, no. 155: "*Horse-guard en petite tenue,
monté sur un cheval bai-cerise marchant à gauche.*

Aquarelle gouachée d'une très belle qualité."
2. According to Birnbaum, the drawing was among
several works that Rothschild intended to sell at
public auction, in order to raise funds for a Rothschild
museum. However, Birnbaum persuaded him to sell
some items privately. Birnbaum, letter to Winthrop,
Paris, June 3, 1931, Harvard University Museums
Archives.
3. Ibid.
4. Germain Bazin, for example, insists that the scarlet
uniform and blue trousers with scarlet stripes identify
him as a Life Guard (Bazin 1987–97, vol. 7 [1997],
p. 28). However, a spokesman from the Household
Cavalry Museum, Windsor, considers identification
with a member of any of these regiments to be
implausible, as several details are incompatible with
conventional horse equipment and regimental dress
codes: there should be a double snaffle with two sets
of reins; the saddle lacks a shabrack, or cavalry sad-
dlecloth; stirrups seem absent; the rider lacks spurs
and a sword and scabbard; the double red stripe of
the overalls do not accord with the Life Guard's
double black stripe with red in the center; boots
should be pulled over the bottom of the overall pants;
the forage cap (?) is atypical; and the knotted tail of
the horse is unusual. Since cavalry headquarters at the
time were at Horseguard, Whitehall, it is likely that
"Horse Guard" was mistakenly applied by Clément
to any member of the British cavalry. (I am grateful
to the staff of the Household Cavalry Museum for
their advice.)
5. I am indebted to Marjorie Cohn (in Cambridge,
Mass., 1977b, p. 49) for the technical analysis of
Gericault's use of media.
6. "Le cheval est bai brun et marche à droite. Fond
chargé.—Sans nom d'auteur.—*Lith. de Villain.*—
Il existe une autre pièce du même sujet avec fond de
paysage et ciel en blanc. À gauche Jayler [Frederick
Tayler] *d'aprés Géricault*"; Clément (1868) 1879,
p. 414.
7. Published in Bazin 1987–97, vol. 7 (1997), pp. 28–
29, figs. 16, 17. These have recently been reattrib-
uted to Gericault by Bruno Chenique; see "Repertoire
des peintures romantiques des musées d'Orléans,"
in Orléans 1997–98, pp. 257–58, no. 236. Chenique
is planning an exhibition of this and other works
previously attributed to Cogniet that he believes to
be by Gericault.

PROVENANCE: James Nathaniel de Rothschild; his
son Baron Henri de Rothschild; acquired from him
through Martin Birnbaum by Grenville L. Winthrop,
1931; his bequest to the Fogg Art Museum, 1943.

EXHIBITIONS: Cambridge, Mass., 1943–44, p. 11;
Cambridge, Mass., 1977b, no. 19.

REFERENCES: Clément 1867, no. 138; Clément (1868)
1879, p. 362, no. 155; Berger 1946, no. 35, pl. 35; Clément
(1879) 1973, p. 468, no. 155; Zerner 1978, pp. 483, 484,
pl. 18; Eitner 1983, pp. 51 n. 62, 225, 312, pl. 35; Grunchec
1984, p. 142, illus.; Eitner 1991, pp. 303, 304 fig. 141,
432 n. 65; Jowell 1993, p. 287, fig. 1; Mongan 1996,
p. 178, no. 180; Bazin 1987–97, vol. 7 (1997), pp. 28–
29, 130–31, no. 2295; Orléans 1997–98, pp. 257–58.

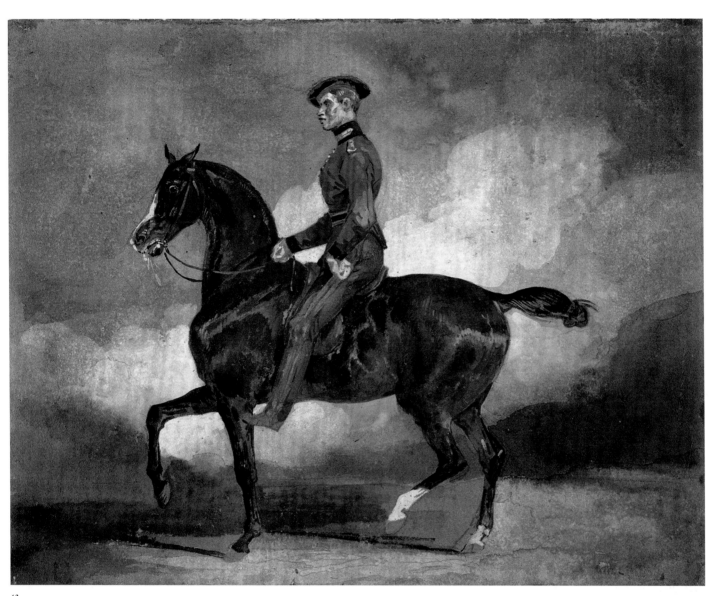

43

Fig. 93. Frederick Tayler, after Gericault, *Officier anglais à cheval*,
ca. 1825. Crayon lithograph published by Villain, 9¼ x 10⅛ in. (23.5 x
27 cm). Bibliothèque Nationale de France, Paris

44. *Postillion at the Door of an Inn,* 1822–23

Oil on canvas
21 x 17¾ in.(53.3 x 45 cm)
1943.244

"I am forsaking the buskin and the Scripture to lock myself in the stables, which I shall only leave covered in gold."[1] So wrote Gericault from London on February 12, 1821, to his friend Dedreux-Dorcy in Paris, in a statement that reveals much about his abrupt artistic change of course at the end of his career. In the period between his departure for London in April 1820 to arrange for the exhibition of the *Raft of the Medusa* and the gradual onset three years later of the painful physical deterioration—the result of a spinal injury suffered in a riding accident—that ended his activity as an artist, the influence of British art and British life on Gericault's work was paramount. Ever alive to the currents of taste, he was in the vanguard of the young French artists of the 1820s who turned to English culture for fresh inspiration. As he implied to Dedreux-Dorcy, this amounted to a conscious and willful rejection of the French artistic establishment, whose conservative reaction to the *Raft* at the Salon of 1819 had stung him. This shift also held the potential of increasing the market for his work and bolstering his increasingly precarious finances.

Gericault made three trips to England: the first, a barely documented excursion in March 1819 in the company of fellow artist Horace Vernet; the second, from April to June 1820, for the exhibition of the *Raft* in Bullock's Egyptian Hall in Piccadilly; and the third, lasting almost a year, from January to December 1821. Even more than Italy, where he had spent a productive year in 1816–17 studying both classical art and popular life, England nourished Gericault's

perpetually restless creative spirit, providing an array of lively and novel subjects to paint, draw, and lithograph. His English work reveals a sincere interest in the life and travails of the London poor, which he records with a bittersweet objectivity. More than ever before, the English Gericault gives free rein to his passion for horses of all types, from elegant racing thoroughbreds to the massive draft horses he observed laboring in the streets and fields. In the last years of his career, thanks to his English experience, Gericault became essentially a genre artist.

This change also reflects the liberating influence, openly acknowledged in his letters from London, of the local school of artists, among them Thomas Lawrence, John Constable, David Wilkie, James Ward, and Edwin Landseer, with whose work he had ample contact. Another inspiration was the venerable national tradition of sporting art. The freshness of color and informal naturalism of English painting left a distinct mark on his style, and a new interest in landscape and atmosphere permeates his work of the period. Watercolor became his preferred medium, enabling him to achieve the ease, spontaneity, and refinement of touch that characterize his English manner in works of a small, salable format appropriate to their decidedly unheroic subject matter.

The Winthrop *Postillion at the Door of an Inn,* or *White Horse Tavern,* is one of the relative handful of oil paintings Gericault produced in the last few years of his life. Though quintessentially English in inspiration, it was most likely painted in his Paris studio in 1822 or early 1823, following his return from London in December 1821. The scene shows a uniformed courier astride a sturdy bay horse, his spare mount

beside him, accepting a glass of wine from a shirtsleeved waiter outside a roadside tavern before resuming his ride. The hanging sign places the scene in some imaginary French countryside outside a large city (Paris?) glimpsed on the horizon beyond an imposing bluff. The distant sky is ominous, threatening rain, but the men and horses in the foreground are bathed in afternoon sunlight.

The figures stand out sharply from their broadly rendered setting, like characters on a stage, as forms, colors, and degrees of finish are carefully manipulated and juxtaposed to create an image of almost surreal intensity, suggesting a miniature enlarged or, conversely, a monumental scene reduced to domestic scale. The two men lock eyes as the waiter, his features indistinct but his stance jaunty and foursquare, extends the glass to the rider, whose expression and body language suggest weariness. In Gericault's hands this fleeting encounter, though devoid of narrative or sentiment, emits a subdued psychological resonance.

Technically, the Winthrop painting is complex and meticulous. For a convincing account of its development from a pencil sketch on a white ground, followed by loose underpainting in a brownish monochrome, and then, in certain areas—above all the postillion and his horses—by a careful build-up of small, precise brushstrokes that brings them into sharp visual focus, see Lorenz Eitner's description of the painting in his incomparable monograph on the artist.[2] The *Postillion* is the most finely wrought of Gericault's late cabinet pictures, and the most highly colored. Its heightened naturalism is more akin to his finished English watercolors than to comparable oil paintings of the period, such as the Louvre *Lime Kiln* or *The Village Forge*

44

at the Wadsworth Atheneum, Hartford. It seems unlikely, given its stiffness and the nature of Gericault's working method at the time, that the drawing of the composition formerly in the Gobin collection, Paris, is a preparatory study.[3] The painting was lithographed by Joseph Volmar in 1824.[4]

Wheelock Whitney

1. Clément 1879, p. 194.
2. Eitner 1983, pp. 252–53.

3. Bazin 1987–97, vol. 7 (1997), pp. 225–26, no. 2553, illus.
4. Ibid., p. 225, no. 2552A, illus.

PROVENANCE: Probably sold by the artist to (?) Duchesne, autumn 1823 (Fr 600); if so, anonymous sale, Hôtel Drouot, Paris, March 11–12, 1846, no. 11; if so, A[chille] B[oucher] sale, Hôtel Drouot, Paris, April 19–20, 1850, no. 23 (Fr 450); if so, purchased at that sale by (?) Bouchet; Mme X . . . sale, Galerie Georges Petit, Paris, December 6–7, 1926, no. 103 (Fr 60,000); purchased at that sale by Paul Rosenberg; Baron Joseph Vitta, Paris; acquired from him through Martin Birnbaum by Grenville L. Winthrop, June 1930 (Fr 240,000); his bequest to the Fogg Art Museum, 1943.

EXHIBITIONS: Cambridge, Mass., 1943–44, p. 7; Cambridge, Mass., 1946a, p. 13; Cambridge, Mass., 1969, no. 87; Cambridge, Mass., 1977a; Cambridge, Mass., 1978.

REFERENCES: Clément (1868) 1879, p. 411; Tietze 1939, pp. 264 (illus.), 327; *Fogg Art Museum Bulletin* 10, no. 3 (March 1945), illus. p. 100; *The Chronicle: A Sporting Journal* (Middleburg, Va.), May 4, 1956, p. 35, cover illus.; Gobin 1958, under no. 37; Clément (1879) 1973, p. 411; Grunchec 1978, pp. 120–21, no. 216, illus.; Zerner 1978, pp. 484–85, pl. 17; Eitner 1983, pp. 252–53, 278, 319 pl. 42, 356, no. 72; Mortimer 1985, p. 179, no. 204, illus.; Bazin 1987–97, vol. 2 (1987), pp. 233, 237, fig. 191, vol. 7 (1997), pp. 47, 224–25, no. 2552, illus.; Bowron 1990, fig. 273; Michel 1992, illus. p. 144; De Paz 1997, pp. 194, 397, fig. 175.

Circle of Théodore Gericault

45. *Portrait of a Young Man*, ca. 1820–25

Oil on canvas
23¼ x 18¾ in. (59 x 47.6 cm)
1943.243

The work of Gericault poses questions of attribution that are rarely encountered in the study of other French artists of his period. He never signed his paintings and rarely sold them; indeed, his limited output consisted largely of undocumented studies of various sizes, types, and degrees of finish, most of which were in his possession at his death and were widely and haphazardly dispersed in his posthumous studio sale. That he had numerous contemporary imitators, some of them quite talented, compounds the uncertainty of attribution. The Winthrop portrait of a young man exemplifies these connoisseurship problems.

At the time Grenville Winthrop bought the painting in 1936 from the German refugee *marchand amateur* Otto Ackermann, it was generally considered to be a youthful self-portrait.[1] Writing to Winthrop, Martin Birnbaum called it "one of the most important items I have ever been able to offer to you, and the *rarest*. . . ."[2] He claimed knowledge that the Amis du Louvre was also negotiating to acquire the picture, insisting that he could provide Winthrop with written evidence to that effect.[3] It should be noted, however, that the portrait had not been included in the comprehensive Gericault centenary exhibition held in Paris in 1924, which was organized by the preeminent Gericault authorities of the day, the scholars-collectors Pierre Dubaut and the duc de Trévise—a sign that the attribution was then already in doubt.

Notwithstanding Walter Pach's assertion in 1945 that it was "a work worthy of being placed beside the classics of all time,"[4] the portrait has fared poorly with critics and scholars, and in particular with Gericault specialists, since its arrival in America. The attribution to Gericault has been rejected by Eitner (1960),[5] Grunchec (1978),[6] and Bazin (1987).[7]

Gericault's portraits have traditionally received far less scholarly attention than the rest of his work, and their attributions tend to be more controversial. He occasionally painted his close friends and their children, notably members of the Bro, Dedreux, and Vernet families, and some of these documented portraits have survived. There is also a group of portrait studies that can be connected with the *Raft of the Medusa* project in 1818–19, as well as a handful of studies of young men, such as an unfinished head at the Kimball Art Museum, Fort Worth, that have attained critical consensus in their favor. Finally, the masterly series of five portraits of mental patients (Paris, Lyon, Ghent, Winterthur, and Springfield, Mass.) that he painted about 1822 gives a clear sense of Gericault's late portrait style.

Judged against these undisputed works, the Winthrop portrait falls short. Despite certain impressive qualities—the sitter's head is carefully modeled, his gaze firm and penetrating, all giving the impression of an assured, elegant youth—the brushwork lacks the confidence and vivacity of Gericault's flickering, often summary

45

touch. Anatomically, too, it is unconvincing: the ill-defined, flatly rendered neck fails to support the weight of the head. The overall palette and the handling in certain areas, such as the hair, are similar enough to Gericault's work to suggest that this quintessentially Romantic portrait is by an artist in his circle.

Wheelock Whitney

1. For an account of Otto Ackermann's life and his role in the promotion of French art in Germany in the early years of the 20th century, see Lüthy 2000.
2. Birnbaum, letter to Winthrop, May 16, 1936,

Harvard University Art Museums Archives.
3. Birnbaum, letter to Winthrop, May 21, 1936, Harvard University Art Museums Archives. There is in fact a letter dated June 17, 1936, among the Birnbaum papers at the Archives of American Art from the *expert* André Schoeller informing Birnbaum that the Société des Amis du Louvre seemed interested in purchasing the portrait for the Louvre.
4. Pach 1945, p. 238.
5. Eitner 1960, p. 45, n. 9.
6. Grunchec 1978, p. 143, no. A157, illus.
7. Bazin 1987–97, vol. 1 (1987), p. 214, vol. 2 (1987), p. 329, no. 11, illus.

PROVENANCE: (?) Laurent; his sale, Château d'Argentan, Orne, May 14, 1905; purchased at that sale by Otto Ackermann, Paris; acquired from him through

Martin Birnbaum by Grenville L. Winthrop, June 1936 (Fr 187,000); his bequest to the Fogg Art Museum, 1943.

EXHIBITIONS: Munich 1906, no. 28; Berlin 1907; Rouen 1911; Frankfurt 1912, no. 59; Munich 1913, no. 88; Cambridge, Mass., 1943–44, p. 7; Cambridge, Mass., 1946a; Cambridge, Mass., 1969, no. 86; Cambridge, Mass., 1977a.

REFERENCES: Scheffler 1907, p. 86; Hancke 1912, p. 60; Thieme and Becker 1907–50, vol. 13 (1920), p. 460; Grautoff 1924, illus. p. 129; Benesch 1944, pp. 9–10, illus.; Pach 1945, p. 238; Canaday 1959, illus. p. 42; Lem 1963, p. 70; MacDonald 1965; Aymar 1970, illus. p. 143; Grunchec 1978, p. 144, no. A157, illus.; Zerner 1978, pp. 485–86, fig. 5; Mortimer 1985, p. 178, no. 203, illus.; Bazin 1987–97, vol. 1 (1987), p. 214, vol. 2 (1987), p. 329, no. 11, illus.; Bowron 1990, fig. 270.

Vincent van Gogh

Zundert, The Netherlands, 1853–Auvers-sur-Oise, France, 1890

46. *The Blue Cart (Harvest at La Crau)*, June 1888

Graphite, black chalk, oil pastel (?), brown ink, watercolor, and gouache on tan laid paper
15 1/2 x 20 5/8 in. (39.4 x 52.3 cm)
Inscribed in graphite, middle ground field at right: vert clair *(illegible)*
Watermark: Glaslan (fragment)[1]
1943.279

This drawing shows the broad, flat plain of La Crau, about three miles northeast of Arles, stretching back to the range of the Alpilles. Watching over the middle distance with its fields and farmhouses are, on a hilltop at left, the ruins of the medieval abbey of Montmajour, and at right, nestling in front of the more distant peaks, the rather unimpressive Mont des Cordes.[2] In the foreground, a large stack of wheat, two waiting carts, and a mown field indicate that the harvest is already under way. The season is midsummer.

On June 12, 1888, in the fifth month of his sojourn at Arles, Vincent van Gogh wrote to his brother Theo: "I am working

on a new subject, fields green and yellow as far as the eye can reach. I have already drawn it twice, and I am starting it again as a painting."[3] The two drawings are the Winthrop sheet, which was van Gogh's first attempt, and a larger drawing (fig. 94). The latter is a more detailed study for the painting (Van Gogh Museum, Amsterdam; fig. 95), which he completed in mid-June. Van Gogh also made two small drawings after the painting so his friends could get some sense of it, one for the Australian painter and collector John Russell (private collection, Virginia) and one for the painter and critic Émile Bernard (Staatliche Museen, Berlin).[4]

For all its rapid execution, the Winthrop drawing establishes the elements of landscape and architecture that persist throughout the series. What distinguishes the Winthrop scene from the others is the absence of human activity. Except for a tiny couple strolling along a road near the cen-

ter of the composition, the Winthrop drawing is unpopulated. The larger drawing introduces three more figural groups that will remain in the next three works:[5] a reaper at left, glimpsed just behind the rick of wheat, a horse-drawn cart pulling toward the center of the composition, and a similar cart stopped at right. Together, these three incidents, which seem to move from left to right along a line across the upper middle of the scene, show a sequence of tasks that justifies van Gogh's own title, "The Harvest." Without these workers, the couple in the Winthrop drawing is free to attain a kind of pastoral poetry: their tiny aloneness in the landscape is reminiscent of the equally small and isolated figures that can be found in Rembrandt's landscape etchings.

The Winthrop drawing inaugurated not just this series of five works but a larger burst of activity—as many as nine other paintings and five drawings of wheat fields

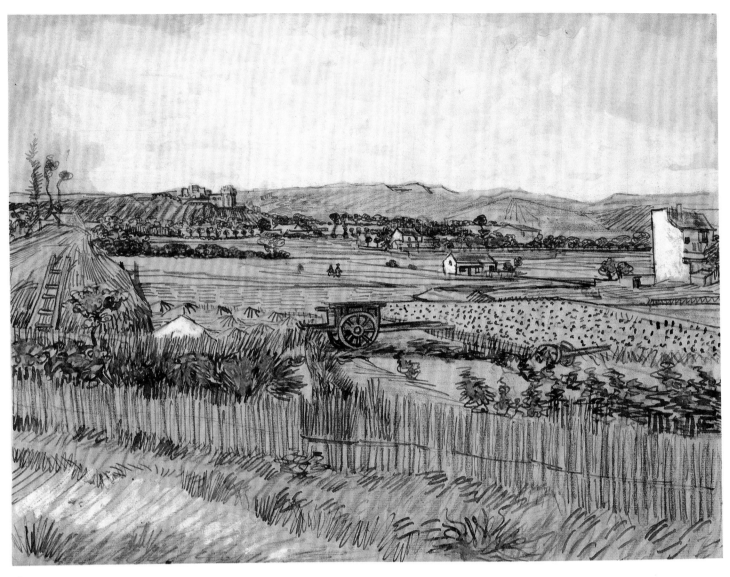

46

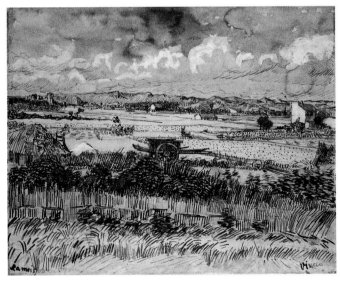

Fig. 94. Vincent van Gogh, *La moisson en Provence*, 1888. Graphite, brown ink, watercolor, and gouache, 18⅞ x 23⅛ in. (48 x 60 cm). Sotheby's Picture Library, London

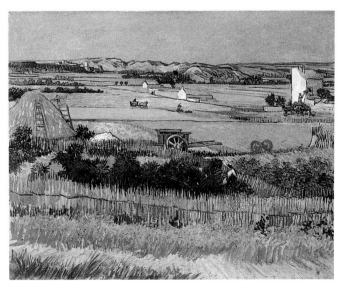

Fig. 95. Vincent van Gogh, *Harvest at La Crau*, 1888. Oil on canvas, 28¼ x 36¼ in. (73 x 92 cm). Van Gogh Museum, Amsterdam

that van Gogh completed between June 13 and June 20. The drawing can also be located chronologically between two campaigns relating to the abbey of Montmajour, seven drawings done in May and five done in July.[6]

The plain of La Crau called up two powerful sets of pictorial associations for van Gogh: one, his native Dutch landscape and its painters, and the other, the spirit of Jean-François Millet, in particular "Millet's own attempts to join allegory and reality in a picture of the land."[7] In addition, van Gogh was strongly aware that Paul Cézanne had been at work painting the same Provençal landscape for many years. What seems Cézannian about the painting, and the series as a whole, is not any specific feature but rather the energy with which van Gogh projected himself into the scene at once receding before and rushing toward him.[8] Mark Roskill convincingly defined this struggle with perspective as the story of the series: "The whole upper half of the picture seems to tilt or bend with [an] . . . excess of springiness, and the foreground to shelve away all too sharply down towards one's feet. In these respects, then, the will of nature seems to be that it should buckle up towards the observer and slide its contents down on top of him." Against this threat Roskill proposed that the human and man-made elements of the scene perform "anchoring roles" as van Gogh gradually stabilized it and balanced its play of human and natural elements by adjusting composition and handling through the series.[9]

The clearest evidence of van Gogh's search for balance, however, concerns an element to which Roskill paid little attention: the blue cart. Simple measurement reveals that the cart rises steadily through the series, so that its wheel, which is entirely below the midpoint of the page in the Winthrop drawing, ends up entirely above it in the Berlin sheet. Significantly, it is only in the painting that the exact midpoint of the composition falls within the wheel of the cart, locking the circle of the wheel into the rectangle of the whole, so that the scene seems to radiate from its spokes and revolve around it.

This bold geometric invention has at least two, quite different, effects. First, it gives the unhitched cart a powerful, almost symbolic significance, poised as it is between the stacked wheat at left and its destination, the storehouse at right. The rather counterintuitive message seems to be that a harvest is all about potential rather than realization (the cart is empty), or, to put it more darkly, that it is all about human absence rather than presence (the cart is unattended, and it dwarfs the figures at work in the background). Second, the exact centering of the cart's wheel subtly returns our gaze from the strong sweep of depicted recessions to the flat shape of the canvas itself. Here van Gogh shows himself to be a true modernist. By centering the cart, he seems to be balancing his deep investment in the problems of perspective—in the transcription of nature's spread—with an equal attention to the spread of the canvas.

Harry Cooper

1. Identified by Elizabeth Heenk 1995, pp. 173–74.
2. The distinctive tall farmhouse at the far right appears at the left of a painting by van Gogh of an overlapping scene, the *Wheat Field* (private collection, Amsterdam).
3. Quoted from New York 1984, p. 93.
4. The most detailed consideration of this series is Mark Roskill's 1966 article "Van Gogh's 'Blue Cart' and His Creative Process." He dated the Mellon drawing to late July and the Berlin drawing to early August. All five works are also discussed and reproduced in the auction catalogue entry for the largest drawing, Sotheby's, London, June 24, 1997, no. 7.
5. Yet another figure, a gardener, is added to the foreground of the painting and the succeeding drawings.
6. See Pickvance in New York 1984, pp. 77–82 (on the first series of Montmajour drawings), 93–103 (on the harvest works of June), and 109–17 (on the second series of Montmajour drawings). Also see Amsterdam 1990, pp. 122–31 (on the harvest works of June); and the companion volume Otterlo 1990, pp. 221–22 (on the first Montmajour series) and 225–28 (on the Winthrop drawing and the second Montmajour series). On the dating of all these works, see Millard 1974, pp. 156–65.
7. On this topic, see Amsterdam 1988–89. The quotation is from the drawing's label (Fogg Art Museum files) when it was displayed in the 1990 exhibition "The Harvest of 1830: The Barbizon Legacy" at Harvard's Arthur M. Sackler Museum.
8. Van Gogh identified intensely with what Cézanne would famously call, in a 1904 letter to Bernard on the subject of perspective, "the Spectacle which the Pater Omnipotens, Aeterne Deus, spreads out before our eyes"; see Cézanne 1995, p. 301 (translation slightly modified from Rewald's). In this same letter Cézanne instructed Bernard to "treat nature by means of the cylinder, the sphere, the cone, everything brought into proper perspective so that each side of an object or a plane is directed towards a central point." Ironically, Cézanne closed the letter by saying: "You have the understanding of what must be done and you will soon turn your back on the Gauguins and [van] Goghs!"
9. See Roskill 1966, pp. 8–14. The adjustments that Roskill noted across the series of drawings (p. 13) include the diminishing role of contour in defining boundaries, a greater balance among the receding diagonals, and a more systematic use of dots and dashes across the page.

PROVENANCE: Wilhelmina van Gogh, sister of the artist; Artz en De Bois, The Hague, July–September 1912; Erich Schall, Berlin; P. Seligmann, Cologne; F. Haniel, Wistinghausen; Wildenstein and Co., New York; acquired from them by Grenville L. Winthrop, November 30, 1931 ($12,500); his bequest to the Fogg Art Museum, 1943.

EXHIBITIONS: Berlin 1909–10, no. 218; Cambridge, Mass., 1943–44, p. 11; Cambridge, Mass., 1969, no. 124, illus.

REFERENCES: Meier-Graefe 1921, vol. 2, pl. 44; de la Faille 1928, vol. 3, no. 1484, vol. 4, pl. 166; Meier-Graefe 1928, pl. 20; Uhde 1936, no. 45, illus.; Huyghe 1937, pl. 15; Cooper 1955, no. 22; Van Gogh 1958, vol. 2, no. 496; Roskill 1966, pp. 3–20, pl. 2; de la Faille 1970, no. F1484, illus.; Schapiro n.d., p. 80; Lecaldano 1971, p. 209, no. 523B, illus.; Millard 1974, p. 159, pl. 26; Pollock and Orton 1978, p. 45, fig. 34; Hulsker 1980, p. 324, no. 1438, illus.; Tilborgh 1989, p. 68, n. 1; Amsterdam 1990, p. 122, fig. 46a; Hulsker 1990, fig. 76; Otterlo 1990, p. 225, fig. 33; Heijbroek and Wouthuysen 1993, pp. 40 (illus.), 205; Mühlberger 1993, illus. pp. 24, 25; Heenk 1995, pp. 173–74; Hulsker 1996, no. 1438, illus.; Orton and Pollock 1996, fig. 15; Sotheby's, London, June 24, 1997, fig. 1 under no. 7; Washington–Los Angeles 1998–99, fig. 27.

47. *Peasant of the Camargue (Portrait of Patience Escalier)*, 1888

Brown ink over graphite on white wove paper
19½ x 15 in. (49.4 x 38 cm)
Signed in brown ink, lower left: Vincent
1943.515

Taking up Jean-François Millet's banner, Vincent van Gogh wanted to place the subject of the peasant at the center of a truly modern art. He turned to this project some months after he moved from Paris to the provincial town of Arles in February 1888. On August 8, he wrote to his brother Theo: "I wanted to paint a poor old peasant, whose features bear a very strong resemblance to Father, only he is coarser, bordering on caricature. Nevertheless, I should have been very keen to do him exactly like the poor peasant that he is." On August 11, again to Theo: "You are shortly to make the acquaintance of Master Patience Escalier, a sort of 'man with a hoe,' formerly cowherd of the Camargue, now gardener at a house in the Crau." He continued, describing the setting and palette of the painting now in the collection of the Norton Simon Museum (fig. 96): "terrible in the furnace of the height of harvesttime, as surrounded by the whole Midi. Hence the orange colors flashing like lightning, vivid as red-hot iron, and hence the luminous tones of old gold in the shadows."[1]

The Winthrop drawing sticks close to the painting in its main outlines and must have been done from it. About August 11, judging from that letter, Vincent sent the drawing to Theo to give him a better idea of the painting and also as part of an effort to provide him with more drawings in order to increase sales.[2] Yet the work transcends its practical occasion. With its vigorous and inventive use of the reed pen, it has been recognized as one of the triumphs of van Gogh's graphic art. "The spectacular invention of his repertoire of spikes, dots, plumes, arabesques and brutal hatching was at its height in the Arles months," wrote Nicholas Wadley.[3] Fritz Novotny, after a breathtaking analysis of the quality and arrangement of marks in the Winthrop drawing, concluded: "It is one of the secrets of Van Gogh's genius that in a portrait such as this drawing, the wealth and splendor of the massed graphic forms should not outweigh the simplicity of the human expression."[4]

The issue of human expression is worth considering. "Millet gave the synthesis of the peasant," van Gogh wrote in the August 8 letter, implying that he had short-changed the particularities of character in his quest for a type. The problem, he continued, which no one had yet solved, was "to see the peasant now." Van Gogh himself was prey to stereotypes, as his letters amply reveal. Yet the stubbornly observed and particularized face in the Norton Simon painting partakes far less of received typologies than van Gogh's previous attempt at peasant portraiture, the ambitious *Potato Eaters* of 1885 (Van Gogh Museum, Amsterdam). In a second painting of Escalier (private collection, London), however, done about two weeks after the first, van Gogh relapsed: the sloping shoulders, the hoe, the gnarled hands, and the resigned expression around the corners of eyes and mouth all point to that virtue suggested by the man's given name, Patience.[5] In the Norton Simon version, by contrast, Escalier has an intensity that seems to return the fierceness of the artist's gaze.

This hint of self-portraiture is taken farther in the Winthrop drawing, perhaps because now the artist is a step removed from his model. Escalier's face has been shortened and widened. The features are not exactly moving in the direction of van Gogh's own, but they do anticipate those van Gogh would give himself the following month in his *Self-Portrait* (Fogg Art Museum) as "a simple bronze worshipping the eternal Buddha,"[6] especially the

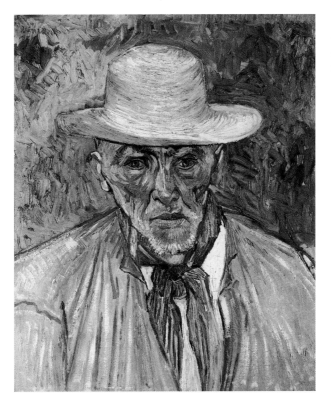

Fig. 96. Vincent van Gogh, *Portrait of a Peasant (Patience Escalier)*, 1888. Oil on canvas, 25⅜ x 21½ in. (64.5 x 54.6 cm). Norton Simon Museum, Pasadena, Calif. M.1975.06.P

exaggerated bones around the eyes, and even the eyes' slant. Thus the Winthrop drawing enacts a conflation not so much of van Gogh's features with Escalier's as of the two heroic types that informed all of the artist's work of this period: the French peasant and the Japanese monk.

If the content of the Winthrop drawing hints at the enthusiasm for Japan that overtook van Gogh in Arles, the form declares it. Wadley saw "a characteristically thorough emulation of the Japanese draughtsmen" in van Gogh's use of the reed pen. Novotny suggested that "conscious stimulus [for van Gogh's mature graphic form] was probably mainly received from two sources, Japanese woodcuts and the drawings of Delacroix."[7] What is original in van Gogh's technique, and demonstrated in the Winthrop drawing perhaps better than any other, is the variety of marks in simultaneous, sometimes dissonant play. This play reaches its climax in Escalier's cheeks, whose sunburned color and furrowed structure, clearly visible in the Norton Simon painting, van Gogh transcribed in the drawing by jamming together all the kinds of marks present in the rest of the sheet. One might say that the cheeks in the drawing are hectic in both senses of the word—"red, flushed" at the level of depiction or transcription, and "filled with excitement or confusion" at the level of pure form. Novotny acknowledged that the marks in this area are meant to convey the topography and color of the face but insisted that they far exceed that function, becoming autonomous "lines of force of a material structure" in which the dots are "the cross-sections of lines." In effect, Novotny imagined van Gogh as a diamond cutter, selectively rotating his longer

strokes in virtual space and then letting the page slice them in order to produce the dots and dashes.[8]

Wadley did not accord van Gogh's drawings quite that measure of formal autonomy. He found a tighter coordination of line and color, of drawing and painting, in the work of 1888: "The evolution of this rich sign language coincided exactly with the dazzling extension of his palette. . . . The subtle relationship of colour sequences that holds his paintings together is paralleled in the drawings by a complex network of contrasts and analogies of form and texture."[9] One might push this thesis farther still, seeing the different combinations of marks in the Winthrop drawing as van Gogh's attempt to convey to Theo, and by extension to every viewer, the particular colors of the painting, or at least the fact that what distinguishes colors from one another is their particular vibration.

This notion of vivid color and active mark as parallel kinds of vibration puts one in mind of Fauvism, and with good reason. One of several van Gogh drawings that Henri Matisse acquired around the turn of the century was a much smaller ink drawing of Escalier (private collection, Switzerland), a rather whimsical version of the second painting, which van Gogh probably enclosed in a letter (now lost) to Émile Bernard on September 5, 1888.[10] It is the last of the four extant images of Escalier by van Gogh. Several commentators have noted "the remarkable similarity between the Dutchman's drawings and Matisse's graphic work of 1905."[11] Through Matisse, the aftershocks of van Gogh's encounter with Escalier were felt throughout the art of the twentieth century.

Harry Cooper

1. The letters cited in this paragraph are excerpted and explicated more fully by Ronald Pickvance in New York 1984, p. 166.
2. See the entry for the drawing by Karyn Esielonis in Cuno et al. 1996, p. 236.
3. Wadley 1969, p. 16.
4. Novotny 1953, p. 40.
5. Naturally opinions differ on the relative merits of these two paintings. Meyer Schapiro, in the entry on the later version in his *Vincent van Gogh* (1950, p. 64), called it "perhaps the only great portrait of a peasant" in Western painting.
6. Van Gogh's letter to Gauguin of late September 1888, cited in O'Brian 1988, p. 92.
7. Wadley 1969, p. 16; Novotny 1953, pp. 40–41.
8. Novotny 1953, p. 40.
9. Wadley 1969, p. 16.
10. On Matisse's purchase of the drawing, see Flam 1986, p. 151; on the drawing itself, see Pickvance in New York 1984, p. 167.
11. Bois (1990, p. 34) goes on to argue that "Matisse's indebtedness to Van Gogh should not be exaggerated. . . . Matisse seems to use the procedure against the grain."

PROVENANCE: Mrs. J. van Gogh-Bonger, sister-in-law of the artist, Amsterdam; Klas Fåhraeus, Lidingö-Brevik, 1911; Thorsten Laurin, Stockholm; acquired in Paris through Martin Birnbaum by Grenville L. Winthrop, March 1931 (Fr 250,000); his bequest to the Fogg Art Museum, 1943.

EXHIBITIONS: Rotterdam 1900–1901, no. 54; Berlin 1927–28, no. 102; Cambridge, Mass., 1943–44, p. 11; Cambridge, Mass., 1969, no. 125.

REFERENCES: Van Gogh 1893, p. 313; Waldemar George 1927, illus. [unpag.]; de la Faille 1928, vol. 3, no. 1460, vol. 4, pl. 159; Meier-Graefe 1928, pl. 25; Uhde 1936, no. 24, illus.; Huyghe 1937, pl. 19, also cover illus.; Mongan 1943, illus. p. 55; Nordenfalk 1946a, p. 94; Nordenfalk 1946b, fig. 39; Mongan 1949, p. 192, illus.; de Gruyter and Andriesse 1953, illus. p. 70; Nordenfalk 1953, p. 146, pl. 39; Novotny 1953, pp. 39–41, figs. 3, 5; van Gogh 1958, vol. 3, no. 520; Feist 1966, p. 275, illus.; Novotny 1968, pp. 44, 157, no. 25; de la Faille 1970, no. F1460, illus.; Schapiro n.d., p. 98; Lecaldano 1971, p. 211, no. 543A, illus.; Millard 1974, p. 161, pl. 31; van Uitert 1977, pl. 71; van Uitert 1978, no. 71, illus.; Hulsker 1980, pp. 349–50, no. 1549, illus.; Bernard 1985, illus. p. 238; Jones in Cambridge, Mass., 1985, fig. 42; Mortimer 1985, no. 297, illus.; Wolk 1987, fig. 302; Norton Simon Museum 1990, fig. 15; Otterlo 1990, pp. 233, 235–36, fig. 42; Wadley 1991, p. 272, pl. 95; Heenk 1995, p. 177; Karyn Esielonis in Cuno et al. 1996, p. 236, illus.; Hulsker 1996, pp. 346, 349, no. 1549, illus.; Saywell 1998, p. 36 (under "Reed pen").

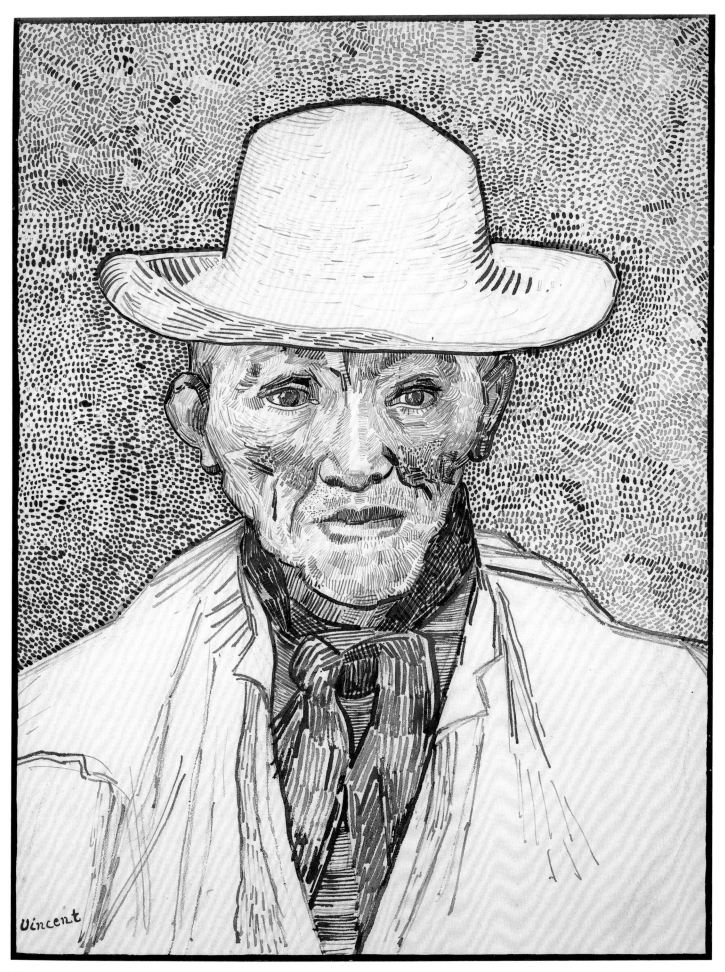

Vincent

47

François-Joseph Heim

Belfort, France, 1787–Paris, 1865

48. *Defeat of the Cimbri and the Teutons by Marius*, ca. 1853

Oil on canvas
23 ⅜ x 28 ⅜ in. (59.4 x 72 cm)
1942.189

This canvas, which was acquired by Grenville L. Winthrop as a work by Théodore Chassériau and entered the Fogg Art Museum under that name, is in reality one of the fine achievements of François-Joseph Heim. Heim was a French history painter from the first half of the nineteenth century, still little known, whose originality and talent are now being rediscovered. In 1974 Arnaud Brejon de Lavergnée and Jacques Foucart identified this work as Heim's:[1] it is a complete, elaborate study by the painter for one of his most ambitious canvases, *Defeat of the Cimbri*, which he exhibited at the Salon of 1853 (where it was poorly received by the public and the critics). The enormous canvas (16 ft. x 19 ft. 6 in. [488 x 594 cm]) is at the Musée des Beaux-Arts in Lyon; for a long time it was kept in the storeroom but has recently been on display. The painting depicts a particularly dramatic episode in Marius's victory over the Cimbri and the Teutons: the Roman troops are pushing the barbarian soldiers back to their rear lines and throwing the barbarians' women and children into the sea.

In addition to a large drawing, also at the Fogg,[2] and the present work, four other paintings by Heim related to his large *Defeat of the Cimbri* in Lyon still exist. A first, small one,[3] which is schematic, spirited, and rough, establishes the essential features of the composition. The order in which the other canvases were painted is not easy to determine, since they are very much like the final canvas and, in the freedom of their execution, fairly similar to one another; they are, moreover, close to the same dimensions. The second painting chronologically may be the one that only recently reappeared.[4] The paint was applied thickly throughout, and the painting displays a few variants (the child in the water in the foreground) in relation to the definitive work. The third in the series to be elaborated may have been the canvas of slightly larger dimensions that was exhibited at the Musée d'Art et d'Histoire, Belfort, in 1965.[5] The contrasts of light and shadow, particularly in the horsemen against the sky, are replicated in the definitive canvas. Although each of those three paintings seems to be a preliminary study for the large painting now in Lyon, Heim may have executed the other two paintings of the same composition after the fact, as souvenirs of his large undertaking. The canvas displayed by the Colnaghi Gallery in London and New York in 1996 has a vigorous and firm execution and strong contrasts of values, no notable variants in relation to the Lyon painting, but the addition, on a strip of canvas added on the right, of a male figure fleeing in the middle ground.[6] We may likewise wonder whether the Fogg canvas is a *ricordo*, perhaps executed for an art lover: consider the almost total absence of variants in relation to the large canvas (except, upper center, a horseman sketched behind the arcing horse, which does not appear elsewhere), and the spectacular but rather controlled execution, done somewhat for effect and with precisely delimited outlines.

As Heim was particularly appreciated for this type of work, it would hardly be surprising if he had replicated his large painting several times, perhaps for his personal pleasure, perhaps for collectors, perhaps for painter friends. In 1867, Philippe de Chennevières asserted: "[O]ne must say that M. Heim made admirable sketches; his fury as a colorist and his nerve as a draftsman were overabundant, as if intoxicated."[7] But we present this idea only as a hypothesis: we cannot rule out the possibility that, during the execution of his enormous canvas, the painter created a series of "snapshots" to judge the effect of the whole.

Heim had many sources of inspiration, from Raphael's *Battle of Constantine* in the Vatican to Charles Le Brun's *Battles of Alexander* in the Louvre, but one may also think of Peter Paul Rubens's *Battle of the Amazons* at the Alte Pinakothek in Munich. More than the art of his juniors Eugène Delacroix or Ary Scheffer (though there are clear similarities with the latter), Heim's work echoes that of certain brilliant sketch painters from the second half of the eighteenth century, such as Gabriel-François Doyen or François-André Vincent. Between 1803 and 1807, Heim was Vincent's student, and there may be something of Vincent here in the strong contrasts of light and shade and the very clear, sharp, and jerky strokes. At a fairly late date, Heim in this work provided his version of an elegant and somewhat illustrative romanticism, brilliant but nostalgic, attempting a kind of synthesis of all the examples museums offered history painters at the time.

Jean-Pierre Cuzin

1. Paris–Detroit–New York 1974–75 (French ed.), p. 484.
2. Black chalk, black wash, white gouache, white chalk, and graphite, squared in graphite, on pieced

48

tan laid paper; 29¾ x 34 in. (75.5 x 86.2 cm); 1945.15. See Mongan 1996, no. 203.

3. 8½ x 11⅛ in. (21.5 x 28 cm); Bonnat Museum, Bayonne, inv. 83.

4. 21¼ x 26⅜ in. (54 x 67 cm), Rouen sale, November 28, 1999, no. 19; London 2000c, no. 26.

5. Belfort 1965, no. 6, 30¾ x 37 in. (78 x 94 cm), collection of Michel Jobin.

6. New York–London 1998, no. 28, 24 x 32½ in. (61 x 82.5 cm).

7. See Cuzin 1992, p. 212.

PROVENANCE: Jacques Simon, Paris; his (anonymous) sale, Hôtel Drouot, Paris, June 26, 1937, no. 3 (as by Chassériau); possibly Dr. A. C. de Frey, Paris; Louis Lion, New York, 1938; Arnold Seligmann, New York, and Trevor and Co. Ltd., London; acquired from them by Grenville L. Winthrop, May 1939; his gift to the Fogg Art Museum, 1942.

EXHIBITIONS: Cambridge, Mass., 1942, p. 6 (as Chassériau); Cambridge, Mass., 1943–44, p. 7 (as Chassériau).

REFERENCES: Brejon de Lavergnée and Foucart in Paris–Detroit–New York 1974–75, (English ed.) p. 489, (French ed.) p. 484; Bowron 1990, fig. 294; Cuzin 1992, pp. 214, 215 (fig. 33), 217 nn. 40–43.

Jean-Auguste-Dominique Ingres

Montauban, France, 1780–Paris, 1867

49. *Portrait of a Young Woman*, 1804

Black chalk with extensive stumping on cream
wove paper
15 ⅝ x 12 ⅝ in. (39.8 x 32 cm)
Inscribed in brown ink, lower left: Ingres à
Calamatta
Partially erased inscription in graphite (?), lower
right: 44 x 84 (?)
1943.844

In the years immediately preceding his
delayed departure for Rome in 1806, Jean-
Auguste-Dominique Ingres's skills as a por-
traitist developed rapidly as he expanded his
expressive range and technical abilities and
experimented with media and styles. This
portrait of a young woman, her head in a
turban, is one of a small group of drawings
dating from those years in which the artist
experimented with a larger figure scale than
was customary for him. This drawing and
others, such as the *Portrait of Jean-Charles-
Auguste Simon* of 1802–3 (Musée des Beaux-
Arts, Orléans),[1] are bust-length, the sitters'
heads loom large on the picture plane, their
features are vividly rendered, and their eyes
are given a particular prominence. The fac-
ture is evident, as here where Ingres has
employed considerable stumping in render-
ing the cheek, neck, and shoulders of the
woman. There is often a remarkable sense of
immediacy in these works, and it seems that
many of the sitters were friends of the artist.
Ingres did not long continue in this direction,
ultimately preferring the small-scale, finely
detailed linear style of portrait drawing on
which his renown as a draftsman rests. In
later years in Rome and Florence, however,
he sometimes adapted a similar format when
he made painted portraits of friends and
loved ones, such as his *Portrait of Madame*

Ingres of about 1814 (Foundation E. G.
Bührle Collection, Zurich).[2] In such works
both the immediacy of address between
sitter and painter and the evident working
of the painted surface function as signs of
the intimate regard in which Ingres held
the sitter.

The identity of the young woman here
is not known. Hans Naef, who dated the
sheet to about 1803, suggested that she
might have been a female colleague of
Ingres's in Jacques-Louis David's studio,
and that she is dressed in studio garb.[3] She
has also been identified as the maid of
Ingres's painter friends Henrietta Harvey
and Elizabeth Norton, half sisters known as
the Harvey sisters.[4] Her strong features do
indeed bear a resemblance to those of the
woman drawn on the reverse of Ingres's
1804 portrait sketch of the sisters; that
drawing bears the partially effaced inscrip-
tion *La Bonne des demoi[selles Harvey]* (the
Harvey girls' maid).[5] The head in that
drawing is also done to a large scale similar
to the present sheet. More recently, Agnes
Mongan has proposed that the sitter here is
perhaps Elizabeth Norton herself.[6] Again, a
resemblance can be detected between her
and the presumed *Self-Portrait* of Elizabeth
Norton that has descended in her family.[7]
Finally, in 1994, Hélène Toussaint proposed
that the sitter might be Mme Jean-Pierre
Granger.[8] Ingres did indeed make a portrait
drawing of Mme Granger, the wife of an
old friend from David's studio, in 1811 in
Rome (private collection, New York).[9]
There, her round face and large, dark eyes
are like those of the sitter in the drawing.
The resemblance is even more striking in

Granger's undated, though contemporane-
ous, portrait of his wife, in which, more-
over, she wears a turban similar to the one
seen in the present drawing (Louvre,
Paris).[10] In the absence of documentary
evidence, however, such suggestions must
remain conjecture.

The outer lines around the turban of
kerchiefs that the woman wears may have
been added at a later date. Also at a later
date, Ingres signed and inscribed the
drawing to his friend Luigi Calamatta.
Following the death of the latter, the draw-
ing was acquired in 1871 by that passionate
admirer of Ingres, Edgar Degas.

Christopher Riopelle

1. Naef 1977–80, vol. 4 (1977), no. 30.
2. Wildenstein 1954, no. 107.
3. Naef 1977–80, vol. 4 (1977), no. 29.
4. Cambridge, Mass., 1980b, no. 2.
5. Naef 1977–80, vol. 4 (1977), nos. 32 (Harvey sis-
ters' maid), 33 (Harvey sisters, dated 1804).
6. Mongan 1996, no. 207.
7. Naef 1971, p. 87, fig. 20.
8. Fogg Art Museum files.
9. Naef 1977–80, vol. 4 (1977), no. 63.
10. RF 1704.
11. Naef (1977–80, vol. 4 [1977], p. 52) identifies three
possibilities for this lot: no. 129, sold for 55 francs;
no. 134, sold for 160 francs (together with another
sheet); and no. 135, sold for 200 francs. The Fogg
literature has traditionally accepted the last.

PROVENANCE: Given by the artist to Luigi
Calamatta; his sale, Hôtel Drouot, Paris, December
18–19, 1871 (Lugt 1921, no. 1717);[11] Hilaire-Germain-
Edgar Degas, Paris; his sale, Galerie Georges Petit,
Paris, March 26–27, 1918, no. 214, illus. (Fr 2,600);
purchased at that sale by (?) Vauchin; Galerie Férault,
Paris, by 1930; acquired from them through Martin
Birnbaum by Grenville L. Winthrop, April 1936 (Fr
15,000); his bequest to the Fogg Art Museum, 1943.

EXHIBITIONS: Paris 1930c, no. 60; Cambridge,
Mass., 1943–44, p. 4; Cambridge, Mass., 1961, no. 4;
Cambridge, Mass., 1967a, no. 4; Cambridge, Mass.,
1980b, no. 2.

REFERENCES: Cortissoz 1918, p. 3; Mongan 1944,
p. 403; Birnbaum 1960, p. 189; *Harvard Alumni Bulletin,*

49

March 11, 1967, p. 22, illus.; Mongan 1967b, pp. 24 (fig. 1), 27; Naef 1967b, p. 9; Mongan 1969, pp. [138] (fig. 3), 139; Naef 1972, p. 5; Cambridge, Mass., 1973b, pp. 22, 23 (fig. 13), 24; Naef 1977–80, vol. 4 (1977), pp. 52–53, no. 29, illus.; Picon 1980, p. 34, illus.; Ternois 1980, p. 18; Spike 1981, p. 190; Mongan 1996, pp. 197–98 no. 207, 199 fig. 207; New York 1997–98, vol. 1, pp. 16, 305, 306, fig. 390, vol. 2, p. 76, no. 668, illus.

50. *The Bather*, ca. 1809 or ca. 1824–33

Watercolor and white gouache over graphite,
squared in graphite, on white wove paper
13⅜ x 9 in. (34 x 22.8 cm)
1943.377

The absence of signature and inscription has provoked much speculation over the author and date of this watercolor, an almost identical replica, at much reduced scale, of Ingres's celebrated *Bather* of 1808 at the Louvre, often called *La Baigneuse Valpinçon*, but titled *Étude* when it was first exhibited at the Salon of 1808. The present watercolor so accurately reproduces the Valpinçon bather that one could suspect that Ingres relied on some sort of mechanical aid in its creation. There is a tracing at the Musée Ingres, Montauban,[1] that may have been taken from this work (all internal measurements are identical). That tracing may have served the artist in the creation of the related work of 1826 now at the Phillips collection, as well as the 1864 version now at the Musée Bonnat in Bayonne.

The first record of the Winthrop watercolor seems to be the recollection of Ingres's student Amaury-Duval. He recalled seeing in 1833 on the walls of his master's apartment in the Institut de France "a small repetition of the odalisque seen from the back, seated on the corner of a bed—the most beautiful of his odalisques—and, to my surprise, the engraving of van Loo's *Woman Climbing into Bed* [Musée des Beaux-Arts, Lyon]."[2] (Although the pose is different, the van Loo has a very similar erotic effect.) The Winthrop *Bather* is the only known work that fits this description. Absent any other source, Amaury-Duval's story is sufficiently credible to support an attribution to Ingres: it is unlikely that the artist would have hung a student copy in his quarters.[3] But there is other evidence supporting the authenticity: the celebrated photographer Charles Marville, Ingres's "official" photographer, made a photograph of the watercolor in 1861 and a print was given by Ingres's collaborator Édouard Gatteaux to the Bibliothèque Nationale on June 14, 1861, which is to say while the artist was still very much alive. Gatteaux then reproduced this work in his 1873 monograph. It is almost inconceivable that Ingres would have allowed a student copy to be reproduced and distributed in this way. Finally, and perhaps most persuasive, is the quality of the work itself: it is almost faultless, both in the drawing and in the infinitesimal gradations of watercolor washes.

The date of this work remains in question. Cohn and Siegfried make a strong case for 1808, citing the high quality and clarity of execution as well as a possible motivation, the creation of a record for his own enjoyment of a work reluctantly sent to Paris to satisfy a requirement of his scholarship at the French Academy in Rome.[4] Nevertheless, Ingres was extremely parsimonious in any expenditure of time and effort and almost never made finished works for himself. The portraits he made of his friends in Rome are markedly less finished than commissioned works, and this ravishing watercolor has all the hallmarks of a commissioned work. Perhaps Condon was right when she suggested that this watercolor was meant to be one of the replicas ordered by Mme Coutan in 1828, only to be substituted by the *Petite Baigneuse* at the Louvre. If not, it may have been originally destined for another collector, yet unknown, in the mid-1820s.

Gary Tinterow

1. Inv. 867.1180; Vigne 1995b, no. 2279.
2. Translated from Amaury-Duval (1878) 1924, pp. 81–82.
3. Ternois (in Paris 1967–68, p. 58, under no. 34) suggested that this work could have been created by one of Ingres's students; he reaffirmed this notion in Ternois and Camesasca 1971, p. 91, under no. 50.
4. Cohn and Siegfried in Cambridge, Mass., 1980b, no. 5.

PROVENANCE: Mme Delphine Ingres, née Ramel, the artist's widow; her nephew Albert Ramel; his widow, Mme Ramel (d. 1928); her heirs; acquired from them through Martin Birnbaum by Grenville L. Winthrop, January 3, 1929 ($57,000 for cat. nos. 50 and 81); his bequest to the Fogg Art Museum, 1943.

EXHIBITIONS: Cambridge, Mass., 1943–44, p. 4; Cambridge, Mass., 1961, no. 16; Cambridge, Mass., 1967a, no. 114; Cambridge, Mass., 1980b, no. 5.

REFERENCES: Gatteaux [1873] (1st ser.), pl. 9; Amaury-Duval (1878) 1924, p. 81; Pach 1939, p. 136; Mongan 1944a, p. 403; Schlenoff 1956, pp. 57–58, n. 8; Birnbaum 1960, p. 190; Paris 1967–68, p. 58, under no. 34; Radius and Camesasca 1968, p. 91, under no. 49; Ternois and Camesasca 1971, p. 91, under no. 50; Boggs 1978, p. 488; Louisville–Fort Worth 1983–84, pp. 120–22, fig. 2; Amaury-Duval (1878) 1993, pp. 212–13, fig. 192; Condon 1995, p. 55, no. 63, fig. 49; Mongan 1996, pp. 216–17, no. 230, illus.

51. *Study for the Head of Octavia in "Virgil Reading the 'Aeneid' to Augustus,"* ca. 1814

Graphite and white chalk on brown wove paper
6 x 8⅝ in. (15.4 x 21.8 cm)
Signed in graphite, lower right: Ing
1942.44A

52. *Study for "Virgil Reading the 'Aeneid' to Augustus,"* ca. 1814

Graphite and white chalk, squared in graphite, on brown wove paper
12½ x 9⅞ in. (31.6 x 25 cm)
Signed lower right: Ing.
Inscribed in graphite, lower left: noirs; *on Livia's shoulder:* Livia; *under elbow of Augustus's raised arm:* reflet; *behind Augustus's neck:* moins de demi-teinte *(?)*
1942.44B

Ingres met one of his most important Roman patrons, the French governor of the city, General Sextius-Alexandre-François Miollis, when the governor and Joachim Murat, the king of Naples, admired the artist's works at an exhibition on the Campidoglio in 1809. The meeting bore fruit two years later when Miollis commissioned two important history paintings from Ingres to decorate the imperial residence in Rome. At about the same time he gave the artist the use of a large studio in the church of Trinità dei Monti to execute the paintings. Not least, Miollis, an admirer of Virgil, also commissioned Ingres to execute a large painting for the bedroom of his private residence, the Villa Aldobrandini, on the theme of Virgil reading the *Aeneid* to Augustus. The moment was auspicious for the artist; at last, it seemed, he might be able to give up his reliance on portrait commissions and devote himself entirely to history painting.

The painting for Miollis depicts the Roman poet reading from his great epic, the *Aeneid,* to the emperor Augustus, his wife, Livia, and his sister Octavia. While Livia remains impassive, Octavia faints the moment Virgil mentions her dead son Marcellus. The adopted son of Augustus, Marcellus might one day have become emperor himself had he not been assassinated—probably at the behest of Livia. Indeed, Ingres's painting and its replicas and variants are often referred to by the words Virgil utters that cause Octavia to lose consciousness: "tu Marcellus eris . . ." (*Aeneid* 6.883). Daniel Ternois's invaluable recent research on the Virgil paintings, prompted by his wide-ranging study of Ingres's correspondence with Charles Marcotte d'Argenteuil, has helped to clarify the complicated history of this composition.[1]

The painting for Miollis was completed in 1812 and installed in the governor's bedroom early the following year. Today it is generally agreed that this painting is the one now in the Musée des Augustins, Toulouse. As always when he undertook an ambitious history painting, and often when he undertook replicas and variants as well, Ingres began by making preparatory studies of individual figures and of the composition as a whole. The Musée Ingres, Montauban,

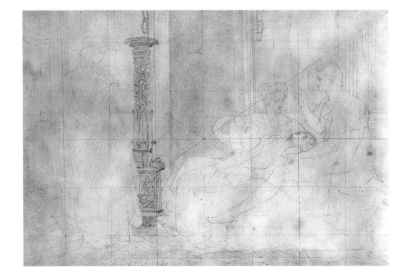

Fig. 97. Jean-Auguste-Dominique Ingres, *Study for "Virgil Reading the 'Aeneid' to Augustus,"* ca. 1811–12. Graphite and gray wash, squared in graphite, on white wove paper, 11½ x 16⅝ in. (29.1 x 42.2 cm). Fogg Art Museum; Bequest of Meta and Paul J. Sachs, 1965.299

51

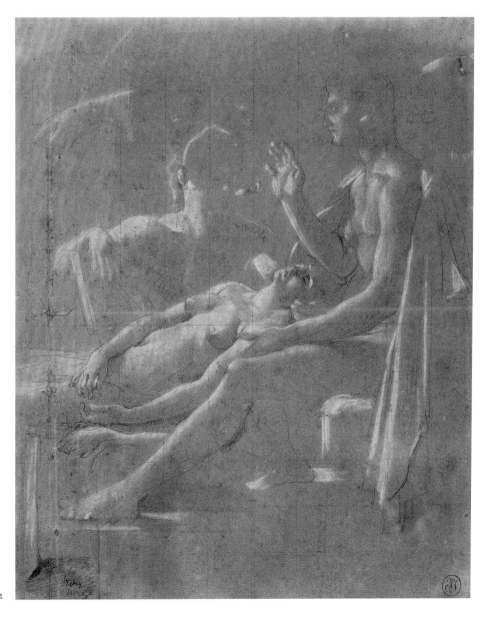

52

contains more than ninety drawings for the various versions of *Virgil Reading*. According to Georges Vigne, fifteen of those drawings are preparatory to the Toulouse painting. They include two composition drawings which, like the Toulouse painting, show Livia wearing a diadem and separated from Augustus and Octavia; she is seated near the feet of the latter.[2]

Once the painting was installed in the bedroom of Miollis in 1813, it became largely inaccessible to Ingres. He spoke of it as being "en prison."[3] If, as he told Marcotte as early as July 1813, he wished to exhibit the work at the Salon of 1814, then he had no choice but to paint a replica.[4] The replica he seems to have begun in about 1814 is almost certainly the version— actually a fragment of a once larger painting, as Virgil has disappeared from it— now in the Musées Royaux des Beaux-Arts, Brussels. This painting did not appear in the 1814 Salon, and it seems not to have been completed until 1819. Nor was it a simple replica of the earlier work. Rather, Ingres returned to making preparatory sketches; Vigne identifies ten drawings in Montauban as studies for the Brussels painting.[5] He used these drawings to work out an important compositional change in the Brussels painting, grouping the three members of the imperial family more closely together. Livia now sits directly above Octavia's shoulder, and she wears a distinctive fan-shaped hairstyle.

The Fogg Art Museum contains three preparatory drawings for *Virgil Reading*, including a line drawing of the entire composition (fig. 97) and these two sheets from the Winthrop collection, one a study for the head of Octavia, the other a composition drawing focusing on the three members of the imperial family. The two latter sheets are evidently closely related, both in the artist's delicate touch and in the similar use of white chalk highlights to suggest the fall of light from the upper left. Thus, they probably were done at about the same time. But as the position and hairstyle of Livia show, all three Fogg drawings are preparatory to the Brussels painting, not to the one in Toulouse. They must have been made in about 1814 as Ingres worked on the variant that he hoped to send to the Salon.[6]

Right from the moment he received the original commission from Miollis for *Virgil Reading*, light was an important consideration for Ingres. As he told his friend François Gérard, he conceived the painting as "un effet de nuit; la scène est éclairée par un candélabre" (a night piece; the scene is illuminated by a candelabrum).[7] As Marjorie Cohn and Susan Siegfried point out, such nocturnal effects are particularly appropriate for a painting destined to hang in a bedchamber.[8] As Ingres worked on the variant for the Salon, light remained a major consideration. Ternois notes that Ingres derived the pose of Octavia from an illustration by Anne-Louis Girodet-Trioson showing the dead Phaedra.[9] In his powerful, restrained study of the head of Octavia, he made sparing use of white chalk to suggest the fall of candlelight from the upper left onto the eyelids, nose, chin, and throat of the woman. A thin, horizontal white stripe moves from the bridge of Octavia's nose onto her forehead. Again, in the drawing showing the three members of the imperial family he made abundant though subtle use of white chalk to suggest the fall of light from the upper left. Of the three figures, the features of Livia are the least fully delineated. Nonetheless, Ingres carefully studied the fall of light on her left shoulder, the crown of her extravagant coiffure, and the very tip of her nose. Ingres also annotated the drawing with three inscriptions having to do with the play of light and shadow on the figures. In both drawings, the figures appear to be drawn from life, as they are nude, and in the three-figure drawing, he studied the limp right hand of Octavia a second time, at the upper left of the sheet.

Christopher Riopelle

1. Ternois 2001, pp. 233–36.
2. Vigne 1995b, nos. 152–239. The fifteen drawings relating to the Toulouse painting are nos. 152–66; the two composition drawings are nos. 152 and 153.
3. Ingres to Marcotte, May 26, 1814, quoted in Ternois 2001, p. 233, letter 3.
4. Ingres to Marcotte, July 18, 1813, quoted in Ternois 2001, p. 233, letter 2.
5. Vigne 1995b, nos. 167–76.
6. Cohn and Siegfried (in Cambridge, Mass., 1980b, nos. 9, 10) date the present two drawings to 1811. Mongan (1996, nos. 213, 214) dates them to ca. 1812.
7. Ingres, letter to François Gérard, February 2, 1813, quoted in Ternois 2001, p. 234.
8. Cambridge, Mass., 1980b, no. 10.
9. Ternois 2001, p. 234.

PROVENANCE FOR CAT. NOS. 51 AND 52: Sold by the artist to Étienne-François Haro; consigned by him to the Ingres sale, Hôtel Drouot, Paris, May 6–7, 1867 (Lugt 1921, no. 1477), not in catalogue; Reginald Davis, Paris; acquired from him through Martin Birnbaum by Grenville L. Winthrop, 1927; his gift to the Fogg Art Museum, 1942.

EXHIBITIONS: Cambridge, Mass., 1942, p. 9 (cat. nos. 51, 52); Cambridge, Mass., 1943–44, p. 10 (cat. nos. 51, 52); Cambridge, Mass., 1967a, nos. 21 (cat. no. 52), 22 (cat. no. 51); Cambridge, Mass., 1980b, nos. 9 (cat. no. 52), 10 (cat. no. 51).

REFERENCES: Mongan 1944a, p. 406; Paris 1967–68, p. 161, under no. 111; Mesuret 1969, p. 131 n. 26 (cat. no. 52); Mongan 1980, p. 14; Mongan 1996, pp. 202–3, nos. 213, 214, illus.; Ternois 2001, p. 236 n. 18.

53. *Raphael and the Fornarina*, 1814

Oil on canvas
25 ½ x 21 in. (64.8 x 53.3 cm)
Signed lower left: Ingres
1943.252

Raphael and the Fornarina is a subject and a composition to which Ingres kept returning for most of his life, resulting in five successive painted versions and a finished and signed drawing, not to mention numerous preparatory studies. *Raphael and the Fornarina* is Ingres's *ars pingendi,* the pictorial expression of his theory of art.

Raphael had always been widely considered the ultimate painter. Far from turning against him, the early Romantic period developed a new kind of veneration, of his life as well as his work. The ground had been prepared by his first biographer, Giorgio Vasari, who reports Raphael's deep attachment to an unnamed woman and claims the painter's premature death resulted from excessive lovemaking—thus opening the door to later elaborations, both literary and pictorial, at a time when the lives of artists became a fashionable topic.[1]

In 1800 Fulchran-Jean Harriet (1778–1805), a pupil of Jacques-Louis David, exhibited at the Paris Salon *The Death of Raphaël,* an amazing drawing that shows the painter expiring on top of his mistress's body. In 1807 the brothers Riepenhausen, who had moved to Rome, proposed a series of twelve outline drawings on the life of Raphael.[2] The Nuremberg publisher Frauenholz turned them down and their compositions, probably revised, did not appear until 1816 in Frankfurt. Whether or not Ingres, who had arrived in Rome in 1806, was aware of that project, he apparently planned a cycle of paintings on the life of the artist and made some quick sketches. A list of eight subjects published

by Henri Delaborde does not mention the romantic episodes Ingres actually painted,[3] but other episodes appear in the painter's notebooks as well.[4]

It was always thought that the painting in the Winthrop collection was the second version Ingres painted in 1814, until Hélène Toussaint argued for an earlier date.[5] This is based on the fact that in the chronological list Ingres drew up of his work, it is placed immediately after *Jupiter and Thetis* of 1811 and before *Romulus Victorious over Acron* of 1812. Achille Réveil, in his album of 1851, supervised by Ingres, places the Fogg painting first.[6] Toussaint considers this sufficient evidence to date the present painting to 1811–12. However, there are reasons, decisive in my opinion, not to follow her argument. Delaborde, generally well informed despite some mistakes in his book—as Toussaint is quick to point out—dates the Winthrop version to 1814.[7] The engraving of that version made in 1827 by C. S. Pradier under Ingres's supervision bears the inscription "J. A. Ingres pinxit Rom. 1814." More important, the painting, which never made it into the catalogue of the 1814 Salon, reached the exhibition only very late, in its last months; if the painting had been finished by 1812, there would be no reason for this delay. It must also be pointed out that Ingres did not paint anything remotely comparable at such an early date. The earlier so-called Riga version,[8] now lost, is in some ways the most radical and at the same time the least elaborate, with no window view of the loggias, no armchair, no painting in the background— all motifs that consistently appear or are replaced by others in later versions. For all these reasons we must, I believe, conclude that the traditional dating and order of the variants are correct.

Scenario of the present version: the time is 1:30 in the afternoon, as one can read on the clock, and the place is the Roman studio of the painter Raphael. The painter has stopped working. His lover, wearing a sumptuous green dress and an exotic turban, has moved to his lap from the chair in which she was posing for her portrait. The painter still has a red chalk holder in his hand, for he was only blocking in the preliminary drawing, and while he embraces his mistress, he stares at the picture, still entirely absorbed in his work. Beyond the window are the Vatican loggias—decorated by the artist—and under the window a volume propped up on a ledge is inscribed BIBLIA SACRA in reference to "Raphael's Bible," the title popularly applied to the decoration of the loggias.

Ingres's painting is replete with pictorial references. The heads in particular are subtly constructed out of a variety of Raphaelesque or pseudo-Raphaelesque models. The painter's portrait has been variously considered to be based on the self-portrait in the Vatican *School of Athens* (or its repetition in the Uffizi, Florence, which Ingres copied); the *Portrait of Bindo Altoviti* (National Gallery of Art, Washington), thought to be a self-portrait in Ingres's day; or the Muzeum Czartoryskich *Portrait of a Young Man* (disappeared from the Kraków museum during World War II), once also thought to be Raphael's self-portrait. But Jean-Pierre Cuzin must be right that Ingres's image is a "learned compromise," or synthesis, of all these pictures.[9] Similarly, while the face of the Fornarina is reminiscent of the famous painting (now at the Palazzo Barberini, Rome) that Raphael has just sketched on the easel, it also resembles the face of the *Madonna della Seggiola* (Galleria Palatina,

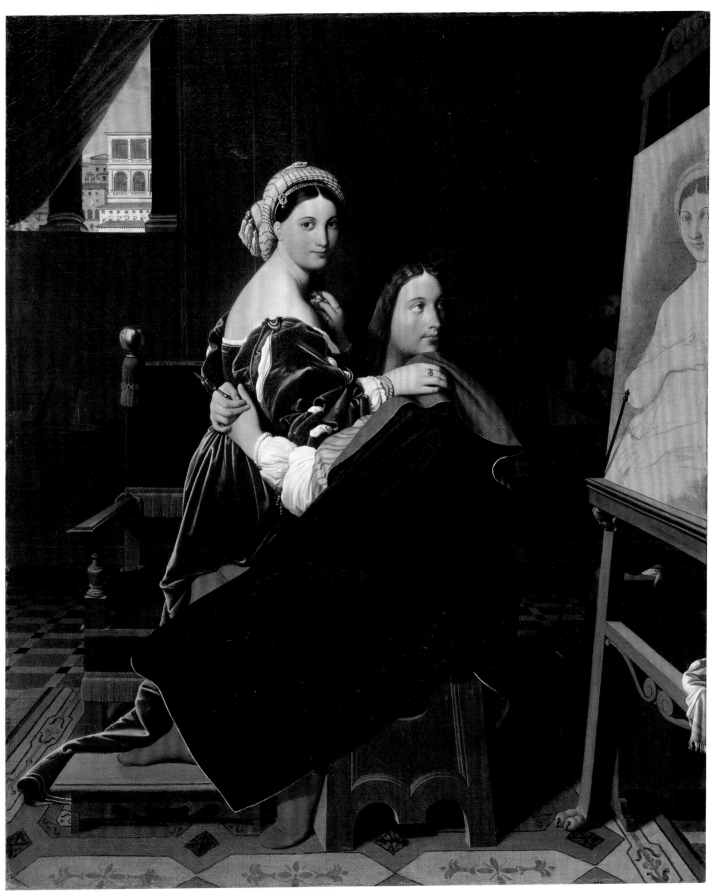

53

Palazzo Pitti, Florence) seen propped at the right.

This last synthesis is particularly significant to understand the aesthetics embodied in Ingres's painting. Desire plays a crucial role in Ingres's pictorial economy and his understanding of the relation between art and life. The play is not simply between the palpable woman and the painting in progress on the easel; the presence of the religious work in the background is part of a more complex equation. The Riga version is more condensed: the religious work is not present, but the face of the Fornarina is much more explicitly based on that of the Madonna. It would be tempting to understand the painting as an allegory of how art sublimates desire into religious spirituality. But what we know of Ingres's concerns and beliefs, as well as the strangeness and unconventionality of the painting, forces us to understand it as a more troubling statement. While Ingres was Catholic out of tradition and habit, his true devotion was to art and he literally worshiped Raphael as a superior being of divine essence, a kind of godhead or prophet of an aesthetic religion in which sensuality and spirituality are inseparable.

Henri Zerner

1. Vasari (1906) 1973, vol. 4, p. 209. For the lives of artists as a pictorial subject, see Haskell 1987, pp. 90–115.
2. On the Riepenhausen brothers, see Börsch-Supan 1996. According to her, there would be an engraved series as early as 1816.
3. The list probably refers to an earlier, more conservative project; Delaborde 1870, pp. 327–28.
4. The only other scene actually painted by Ingres was *Les Fiançailles de Raphael (The Betrothal of Raphael)*, now at the Walters Art Museum, Baltimore (fig. 106).
5. Toussaint 1986. Sarah B. Kianovsky (in Cuno et al. 1996, p. 182) accepts Toussaint's chronology and her understanding of the development of the composition.
6. Magimel 1851, no. 20.
7. Delaborde 1870, p. 226.
8. Wildenstein 1954, no. 86.
9. Cuzin in Paris 1983–84, p. 132.

PROVENANCE: Count de Pourtalès-Gorgier; his sale, Charles Pillet, Paris, March 27–April 1, 1865, no. 271 (Fr 9,500); purchased at that sale by Baron Nathaniel de Rothschild; his daughter-in-law Baroness James de Rothschild; her son Baron Henri de Rothschild; acquired through Martin Birnbaum by Grenville L. Winthrop, July 1931 (Fr 300,000); his bequest to the Fogg Art Museum, 1943.

EXHIBITIONS: Paris (Salon), 1814, not in catalogue; Paris 1867a, no. 62; Paris 1911, no. 61; Cambridge, Mass., 1967b, no. 1; Cambridge, Mass., 1977a; Cambridge, Mass., 1980b, no. 15; Tokyo 2002, no. 55.

REFERENCES: Boutard 1814; Delpech 1814, pp. 210–11; *Registre d'inscription des productions* 1814; Anon., January 14, 1815; Anon., February 13, 1815; Miel 1815; DuBois 1841, no. 208; Lagenevais 1846, p. 528; Magimel 1851, no. 20; Lacroix 1855–56, p. 209; Silvestre 1856, p. 34; Saglio 1857, p. 77; Gautier 1858a, p. 21; Galichon 1861a, p. 349; Anon. 1867, p. 137; Anon., April 7, 1867, p. 109; Bellier de la Chavignerie 1867, p. 51; Lagrange 1867, pp. 51, 72; Merson and Bellier de la Chavignerie 1867, pp. 17, 18 (no. 30), 137; Thoré 1868, p. 241; Blanc 1870, pp. 46–47; Delaborde 1870, p. 334, no. 53; Petroz 1875, p. 88; Fournel 1884, p. 52; Lapauze 1901, pp. 235, 248; Boyer d'Agen 1909, pp. 101, 106, 128; Dreyfus 1911, p. 128; Lapauze 1911a, pp. 137 (illus.), 146, 148–50, 247; Paris 1911; Hourticq 1928, pp. iv, 116, illus. p. 36; Springfield New York 1939–40, under no. 22; Mongan 1944b, p. 388, no. 1; Roger-Marx 1949, pl. 19; Scheffler 1949, p. 19; Alazard 1950, pp. 54, 146 no. 30, pl. 27; Elgar 1951, p. 6; Wildenstein 1954, no. 88, pl. 36; Parker 1955, no. 10; Grate 1959, p. 164; Birnbaum 1960, p. 191; *Kindlers Malerei Lexikon* 1964–71, vol. 3 (1966), p. 384; Cambridge, Mass., 1967a, p. x; Rosenblum 1967, pp. 62, 98–99, pl. 22 (frontis.); Paris 1967–68, under no. 190; Radius and Camesasca 1968, no. 72b; Angrand and Naef 1970, p. 13 n. 79; Ternois and Camesasca 1971, no. 73b; Paris–Hamburg 1974, p. 13; College Park 1975, p. 40, 89; Barousse 1977, p. 166, n. 14; Whiteley 1977, pp. 11–12, no. 33; Naef 1977–80, vol. 2 (1978), p. 470; Honour 1979, p. 303; Picon 1980, pp. 48, 49 (illus.); Basel 1981, p. 18, fig. 7; *Twenty-five Great Masters* 1981, no. 24, illus.; Van Liere 1981, p. 108–15, illus.; Ebert 1982, no. 22, illus.; Schiff 1983, pp. 49–50, illus.; Thompson 1983, p. 237, fig. 141; Louisville–Fort Worth 1983–84, illus. p. 24; Florence 1984, pp. 182 (illus.), 183; Shiff 1984, pp. 333–63, illus. p. 339; Mortimer 1985, p. 174, no. 198, illus.; Düsseldorf 1986, pl. 8; Krauss 1986, illus. p. 39; Toussaint 1986; Raleigh–Birmingham 1986–87, p. 33, fig. 19; Georgel and Lecoq 1987, pl. 10; Haskell 1987, pp. 96–98, illus. p. 97; McVaugh 1987, pp. 365–98, p. 381, fig. 5; Krauss 1989, pp. 9, 153–58, cover illus., fig. 6; Barasch 1990, illus.; Borel 1990, p. 112, illus. p. 33; Bowron 1990, fig. 266; Heimann 1990, pp. 10–13, illus. 5; Zanni 1990, no. 44, illus. p. 61; Castelnuovo 1991, vol. 2, illus. p. 35; Pauwels 1991, p. 252, fig. 15; Picon 1991, illus. p. 35; Paris 1991–92, fig. 107; Amaury-Duval (1878) 1993, p. 105, fig. 75; Huet 1993, vol. 2, illus. p. 164; *Urban Utopia* 1993, p. 27, fig. 1-22; Westheimer 1993, illus. p. 58; Stafford 1994, p. 112, fig. 85; Ribeiro 1995, pp. 179–80, fig. 187; Ternois 1995, p. 219, fig. 4; Vigne 1995a, pp. 168–73, illus. p. 169; Vigne 1995b, p. 122, 124 (illus.); Cuno et al. 1996, pp. 182–83; London–New York 1996, p. 51, illus. p. 162; Woodall 1997, cover illus.; Munich 1998, pp. 122–23; Bajou 1999, pp. 143–46, fig. 96; London–Washington–New York 1999–2000, pp. 12, 13, 150–53, fig. 127.

54. *Joseph-Antoine de Nogent*, 1815

Oil on mahogany panel
18½ x 13 in. (47 x 33 cm)
*Signed, dated, and inscribed in black oil paint,
lower left:* Ingres / Rom 1815
1943.254

According to a now lost note from Ingres, the artist traveled from Rome to Naples in the spring of 1814 with Joseph-Antoine de Nogent, a "négociant" (merchant), and Jean-Joseph Fournier, also a merchant and mutual friend.[1] Ingres hoped to secure further patronage from the king and queen of Naples, Joachim Murat and his wife, Caroline, Napoleon Bonaparte's sister. In 1813 Caroline had commissioned the *Grande Odalisque* as the pendant to a painting now known as the *Dormeuse de Naples*, which Joachim had purchased from Ingres four years earlier.[2] Ingres hoped to paint portraits of Caroline and her family; he would also produce for the Murats two small genre paintings.[3]

The French empire was in chaos;

Napoleon abdicated within days after Paris fell on March 31. By this time the Murats had already switched their allegiance to the Allies, but in 1815 they too would be forced from the throne. Ingres was unable to deliver the *Odalisque,* and the royal collection in Naples was looted. The *Dormeuse* disappeared, apparently forever; the genre paintings and the portrait of the queen reappeared only in the 1850s, although the portrait remained sequestered in private collections and was presumed lost until 1987.[4]

This tale of fluctuating politics and patronage is the essential background for the portrait of Nogent. The painting is Ingres's smallest figural portrait painting and the only full-length example apart from those of royalty; also exceptionally among his portraits, it is painted on wood.[5] Before the painting of the queen resurfaced, speculation arose that it might have been similar to *Nogent,* because Ingres, writing to his friend Charles Marcotte on July 7, 1814, reported that he had just finished "un petit portrait en pied d'elle" (a little full-length portrait of her).[6] That portrait turned out to be on canvas and twice the height of *Nogent,* however, and thus not an exact counterpart. Yet despite a vista through a window toward Mount Vesuvius, *Queen Caroline Murat* shares with *Nogent* the sense of a claustrophobic interior, and figures and accoutrements are executed with the same miniaturizing touch. The same sensibility for space, style, and technique is seen in Ingres's genre paintings of the period, both those made for the Murats and two others, which like *Nogent* were painted in 1815 and are on panels exactly the same width.[7] One wonders if they were cut from the same board.

Ingres's miniaturist style was not appreciated by Salon critics, who habitually accused him of imitating Netherlandish primitives, and it even seems not to have pleased Marcotte. A self-justifying response from the artist referring to a now lost genre painting gives us our best view of his commitment to the technique we see in *Nogent:* "It is painted very exquisitely and subtly, carefully done in every one of its details but not with the finish of a Gerard Dou, the tiresome finish valued not at all by painters of the Italian school, or even the excellent Flemish [painters] whose works you have quite rightly cited to me, the most skilled of which are the Teniers which are barely touched [by the brush], and are beautiful because the brushstroke is exact in its placement and made with sensibility, after these I would refer you to Metsu, above all, who is firm and gentle in his stroke. . . . I am very far, to be sure, from equaling those great painters whom I always take as my model, but I believe that in its execution my painting has some resemblance to them. . . ."[8]

Latter-day critics have associated the technique and also the subjects of the genre paintings with Ingres's expedient reorientation of his art toward the anticipated restoration of the Bourbon monarchy.[9] If one refers strictly to Ingres's portraits, one must instead relate *Nogent* to the marvelously finished and ever larger drawings that would be the artist's recourse in the lean years to come before he received any significant commissions from official Restoration France.

We have no idea what Nogent himself thought of his portrait; the date on the panel is the last record of the man's existence. He was reported to have been tall and elegant, with a lively personality, and these characteristics supposedly settled Ingres on painting him.[10] Yet the artist regularized the face of this spritely twenty-five-year-old into a mask. As a singular exception to Ingres's usual penetration into a sitter's character, *Nogent* can be contrasted to the frank sensuality of Ingres's drawn portrait of Fournier, his other companion in Naples in 1814. It was Fournier's portrait that was inscribed "A L'amitié."[11]

Marjorie B. Cohn

1. Guiffrey in Vitta sale 1935, p. 6. Naef (1977–80, vol. 1 [1977], pp. 486–87), reproduces the paraphrased text of the note.
2. *Grande Odalisque,* 1814 (Musée du Louvre, Paris; Wildenstein 1954, no. 93); *Dormeuse de Naples,* 1808 (lost; ibid., no. 54).
3. *Queen Caroline Murat,* 1814 (private collection; ibid., no. 90); *The Murat Family* (unlocated and probably never completed; ibid., no. 99); *Betrothal of Raphael,* 1813–14 (Walters Art Gallery, Baltimore; ibid., no. 85); *Paolo and Francesca,* 1814 (Musée Condé, Chantilly; ibid., no. 100).
4. Naef 1990.
5. Three head and bust-length portraits on panel are smaller in size but not in scale than *Nogent: Comtesse de la Rue,* 1804 (Bührle Collection, Zurich; Wildenstein 1954, no. 13); *Portrait of a Man,* 1804 (private collection; ibid., no. 19); *Head of Benoit-Joseph Labre,* ca. 1816 (private collection; ibid., no. 110).
6. Ingres 1999, p. 62.
7. *Aretino and the Envoy from Charles V,* 1815 (private collection; Wildenstein 1954, no. 103); *Aretino in the Studio of Tintoretto,* 1815 (private collection; ibid., no. 104).
8. "Il est peint très précieusement et finement soigné dans tous ses détails mais non d'un fini à la Gerard Dou, fini ennuyeux et point estimé des peintres de l'école italienne, et même des excellents flamands dont vous me cites avec juste raison les ouvrages, les plus habiles dont les Teniers qui ne sont que touchés, et beaux en raison de ce que la touche est juste à sa place et mise avec sentiment, je vous citerai après cela Metzu par excellence qui est fort et doux dans sa touché . . . je suis bien loin d'égaler certes ces grands peintres que je prendrai toujours pour modelle, mais je crois pour l'exécution mon tableau a quelque mine de les rappeler . . ."; Ingres, letter to Marcotte, May 26, 1814; Ingres 1999, p. 58. The painting was *Don Pedro of Toledo, the Spanish Ambassador, Kisses the Sword of Henry IV* (Wildenstein 1954, no. 101), exhibited at the 1814 Salon and now lost.
9. Ternois 2001, pp. 168–69.
10. Guiffrey in Vitta sale 1935, p. 6.
11. See Naef 1977–80, vol. 1 (1977), pp. 486–90, for what little more we know about Nogent and Fournier and their association with Ingres.

PROVENANCE: Ingres to Joseph-Antoine de Nogent (d. 1815 or later); bequeathed by him to Jean-Joseph Fournier (d. after 1861 but before 1878); his son Fiorillo-del Florido-Henri-Edmond Fournier (d. December 1895); bequeathed by him to Baron Joseph Vitta; his sale, Galerie Charpentier, Paris, March 15, 1935, no. 8 (bought in); acquired from him through Martin Birnbaum by Grenville L. Winthrop, May 13, 1935 (with cat. no. 71, Fr 200,000); his bequest to the Fogg Art Museum, 1943.

EXHIBITIONS: Paris 1867a, no. 434; Nice 1931, no. 3; Cambridge, Mass., 1943–44, p. 4; Cambridge, Mass., 1967b, no. 2; Cambridge, Mass., 1980b, no. 18.

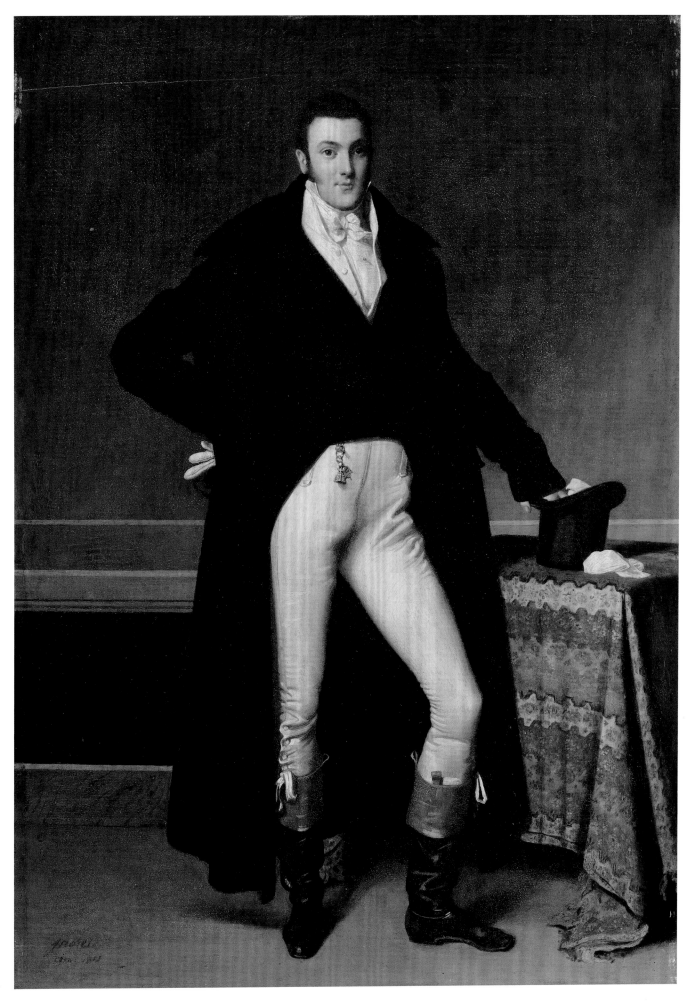

REFERENCES: Saglio 1857, p. 77; Delaborde 1870, nos. 98, 147; Lapauze 1901, pp. 235, 248; Momméja 1904, p. 69; Lapauze 1911a, p. 103; Anon., April 1935, p. 175; Guiffrey in Vitta sale 1935, p. 6; Fogg Museum of Art 1945, illus. p. 102; Wildenstein 1954, no. 106; Naef 1957, pp. 183–84; Ternois 1959, above no. 158; Cambridge, Mass., 1967a, p. x, under no. 29; Paris 1967–68, under no. 80; Florence 1968, under no. 13; Radius and Camesasca 1968, no. 86; Mongan 1969, p. 144; Ternois and Camesasca 1971, no. 87; Hüttinger and Lüthy 1974, pp. 61–66, 70, fig. 3; Naef 1977–80, vol. 1 (1977), pp. 486–90, vol. 2 (1978), p. 457; Paris 1989, illus. p. 26; Bowron 1990, fig. 262; Vigne 1995a, p. 134, fig. 106; Vigne 1995b, p. 498, illus.

55. *Portrait of the Family of Lucien Bonaparte*, 1815

Graphite on white wove paper
16¼ x 21 in. (41.2 x 53.2 cm)
Signed and dated in graphite, lower right:
J. Ingres / Del /Rom, *erased]* / Rome 1815.
Watermark: J. Whatman / 1813
1943.837

By the time Ingres arrived in Rome late in 1806, one of its most ostentatious residents was Lucien Bonaparte (1775–1840), the younger brother by six years of Emperor Napoleon. Relations between the brothers had ended in 1802. An ardent republican, Lucien disapproved of Napoleon's increasing dynastic ambitions and had taken up with a woman, Alexandrine Jouberthon, of whom Napoleon in turn could not approve. She was of uncertain origins, and by this time Napoleon's aspirations were such that he demanded his siblings marry no less than royalty. Lucien and Alexandrine had a son early in 1803, married secretly later the same year, and immediately went into exile in Rome, where they arrived in May 1804. They lived in splendor in the Palazzo Nunez surrounded by a distinguished art collection, courtiers, and a rapidly growing family, which would ultimately include twelve children, three of them from Lucien's and Alexandrine's previous marriages.

Ingres had been introduced to Lucien by early 1807 but declined his commission to draw copies of antiquities. At about the same time Ingres produced a splendid portrait drawing of Lucien, seated in the Roman Forum on an ancient cinerarium of the kind he loved (private collection).[1] The latter was rendered in meticulous, indeed archaeological, detail; even though Ingres felt it beneath him to copy antiquities, as Lucien had requested, he no doubt wanted his patron to know that when it served the purposes of his art, he was capable of doing so with consummate skill. Ingres may also have made a portrait drawing of Alexandrine about this time, but that portrait failed to meet Lucien's exacting standards. Years later she remembered that Lucien had tossed it on the fire—adding, however, that Ingres was far from the only portraitist whose work did not impress her haughty and intolerant husband.[2]

Lucien and his family failed in an attempt to escape to America and ended up spending four years in internment in England. By 1815, however, they were back in Rome, ennobled by the pope. At the start of the Hundred Days, Lucien rushed to Paris to reconcile with his brother—amazingly back on the throne after exile on Elba—and by extension to gain an imperial role for his family at last. In his absence Alexandrine commissioned Ingres to make two portrait drawings. One, a portrait of the woman herself, shows her heavily pregnant with the son she would deliver in October 1815 (Musée Bonnat, Bayonne). The other, the present work, must predate that sheet by several months as it shows her surrounded by children but not yet visibly pregnant. Hans Naef is succinct in his assessment of the drawing: it is "the richest of all Ingres's portrait compositions and unquestionably one of the supreme achievements of his career."[3]

It is the largest portrait drawing Ingres ever made, full of linear grace and acute observation, as well as an unapologetic display of opulence. Alexandrine is enthroned at its center in an armchair of flamboyant Neoclassical design. Her dress is elegant and complicated and she turns her turbaned head to give her portraitist a Mona Lisa–like smile. Perfectly at ease, she attends to the well-being of the eight children who cluster around her, including Lucien's daughters Charlotte (b. 1795) and Christine (b. 1798) and her own daughter Anna (b. 1799), all in their late teens.[4] The two eldest girls, at far right and left, accomplished and eminently marriageable, have momentarily paused in their music-making. The younger children, the fruit of Lucien and Alexandrine's union—Charles Lucien (b. 1803), Laetizia (b. 1804), Jeanne (b. 1807), Paul Marie (b. 1809), and Louis Lucien (b. 1813)—press around their mother, dutifully turning their attention to the artist she has summoned to sketch them. (The fact that Charlotte was not actually in Rome at the time suggests that Ingres drew the figures individually, assembling them into a coherent compositional group back in his studio.) With their toys and sketches and basket of flowers, the children are evidently self-assured young aristocrats, confident in the aura of love and domesticity their mother exudes. Lucien himself is not absent; his bust, by Joseph-Charles

55

Marin, showing him in the mode of a
Roman emperor, stands on a pedestal near
the center of the sheet.

All of Ingres's greatest portraits were
acts of collaboration between the artist and
his sitter, and in this case it is possible to
suggest what Alexandrine and he hoped to
achieve. Lucien was in Paris attempting to
effect a reconciliation with the emperor.
Here, Alexandrine presents herself as the
perfect Bonaparte wife and mother: ele-
gant, fertile, and regal. The allusion is pow-
erfully reinforced by the bust that Ingres
includes at the far right. It is Antonio
Canova's depiction of the archetypical
maternal figure of the Napoleonic era,

Lucien and the emperor's own mother, the
revered Madame-Mère, here shown in the
guise of Agrippina. Alexandrine herself
can be compared to another Roman matron,
Cornelia, the mother of the Gracchi, sur-
rounded by her greatest treasure: her chil-
dren. By implication Alexandrine is fit for
comparison with the matriarch of the
Bonaparte clan herself and is eminently
ready and able to assume an imperial role.

Ingres was aware that this was one of his
most important portrait drawings. Years
later, his fame established, he attempted to
borrow it back from the widow Alexandrine
to have it engraved for the Magimel album.
She airily refused. *Christopher Riopelle*

1. Naef 1977–80, vol. 4 (1977), no. 45; London–
 Washington–New York 1999–2000, no. 38.
2. See Naef 1977–80, vol. 1 (1977), p. 536.
3. Naef in London–Washington–New York 1999–
 2000, p. 159.
4. Several attempts have been made to correctly iden-
 tify the children in the drawing. Here I follow
 Mongan (1996, no. 220), in naming them and giving
 their years of birth.
5. As this group portrait was commissioned by Mme
 Bonaparte in Rome while her husband was with his
 brother Napoleon during the Hundred Days, that
 is, between March 20 and June 28, 1815, his name
 does not appear here as original owner, as in earlier
 references.

PROVENANCE:[5] Commissioned by Mme Lucien
Bonaparte; stolen from her prior to 1841; unidentified
Paris auction, 1841 or 1842; purchased at that sale by
Charles de Chatillon and returned by him to Mme
Bonaparte, September 10, 1842; her granddaughter and
sole heir, Countess Zeffirino Faina, Perugia; acquired
from her by Count Giuseppe Napoleone Primoli,
Rome and Paris, 1903; purchased from him by Galerie

Georges Bernheim, Paris, by August 10, 1918; Herman Heilbuth, Copenhagen; Dansk Landmansbank, Copenhagen; Gorm Rasmussen, Sølyst; purchased from him by Jacques Seligmann and Co., New York, March 11, 1936; acquired from them by Grenville L. Winthrop, March 13, 1936 ($20,000); his bequest to the Fogg Art Museum, 1943.

EXHIBITIONS: Cambridge, Mass., 1943–44, p. 3; Cambridge, Mass., 1967a, no. 33; Cambridge, Mass., 1969, no. 103; Cambridge, Mass., 1980b, no. 16.

REFERENCES: Saglio 1857, p. 77; Delaborde 1870, p. 292, no. 264; Scotti 1878, p. 97; Lapauze 1901, p. 248, under Cahier X; Lapauze 1903, p. 17 n. 1; Lapauze 1911a, pp. 180–82 (as coll. Joseph-Napoléon Primoli); Lapauze 1918b, pp. 12–15, illus. p. 14; Fröhlich-Bum 1924 (mistakenly as Primoli coll.); Fröhlich-Bum 1926, pp. 12–13 (mistakenly as Primoli coll.); Fleuriot de Langle 1939a, pp. 34–43; Fleuriot de Langle 1939b, p. 155 n. 1, illus. facing p. 296; Pach 1939, pp. 41–42, 248–49, 251, illus. facing p. 103; Benesch 1944, p. 32; Mongan 1944a, pp. 393–95, fig. 4; Mongan 1947, no. 10, illus.; Mongan 1949, pp. 132–33, illus.; Alazard 1950, pp. 64, 147 n. 21, pl. 29; Pietrangeli 1950, p. 101, under no. 15 (mistakenly as in the Musée Bonnat, Bayonne); Shoolman and Slatkin 1950, pp. 120–21, pl. 67; New York and other cities 1952–53, intro. (unpag.); Pietrangeli 1955, pp. 49, 50 (illus.); Thompson 1955, p. 305, illus.; Ternois 1959, above and under no. 19; Birnbaum 1960, p. 191; Naef 1960, pp. 35, 36, illus.; Pietrangeli 1960, p. 115; Sass 1960, pp. 19–21, fig. 26; Seligman 1961, p. 149, pl. 44; Gimpel 1963, p. 64; Naef 1963, p. 66; Sass 1963–65, vol. 1, pp. 399 (illus.), 400, 406, vol. 3, p. 170 n. 741; Fogg 1964, illus.; White 1964, unpag.; Angrand 1967, pp. 230–31 n. 1; Berezina 1967, pl. 38; González-Palacios 1967, p. 94, illus.; Mongan 1967, pp. 23 (fig. 2 [detail]), 29; *Time Magazine* 89 (February 17, 1967), p. 73, illus.; Waldemar George 1967, pp. 37 (illus.), 38; Paris 1967–68, p. 56, under no. 33; Radius and Camesasca 1968, p. 123, illus.; Bonaparte-Wyse 1969, illus. on endpapers; Cohn 1969, p. 15; Fleuriot de Langle 1969, pp. 47–52, fig. 1; Mongan 1969, p. 260; Lindemann 1970, pp. 285 (illus.), 288–89; Ternois and Camesasca 1971, p. 123, illus.; London 1972a, p. 373, under no. 662; Naef 1972, pp. 787–91, fig. 68; Haskell 1976, p. 33, n. 49; Rizzoni and Minervino 1976, p. 105, illus.; Pansu 1977a, no. 33, illus.; Whiteley 1977, p. 42, no. 25, illus.; Naef 1977–80, vol. 1 (1977), pp. 504–38 (figs. 5, 7–15), 543, 564, vol. 2 (1978), pp. 234, 424, vol. 4 (1977), pp. 266–69, no. 146, illus.; Borowitz 1979, pp. 258, 260 (fig. 15), 267 n. 66; Ternois 1980, pp. 18, 58, 86 (illus.), 87; Ellis 1982, p. 129; Mortimer 1985, p. 239, no. 280, illus., p. 247 under no. 289; Tübingen–Brussels 1986 (French ed.), pp. 27, 28, fig. 4; Amaury-Duval 1993, p. 31, fig. 19; McCullagh 1994, p. 30, illus.; Fleckner 1995, pp. 150, 151 (fig. 55), 157, 159, 168, 170, 180–81; Lang, Stoll, and Becker 1995, p. 32 (fig. 34), 36 n. 60; Natoli 1995, p. 251 n. 12; Vigne 1995a, p. 468, above no. 2616; Vigne 1995b, pp. 91, [94], fig. 64; Mongan 1996, pp. 206–8, no. 220, illus.; Edelein-Badie 1997, pp. [20]–21, 126, 127 (fig. 9), 128, 135 (nn. 162–63, 175–77), 365; Irwin 1997, p. 304, fig. 173; Bajou 1999, pp. 142–43, fig. 95; London–Washington–New York 1999–2000, pp. 103 (fig. 91), 147, 159; Ternois 2001, p. 140 n. 15.

56. *Portrait of Madame Charles Hayard and Her Daughter Caroline*, 1815

Graphite on white wove paper
11½ x 8⅝ in. (29.2 x 22 cm)
Signed, inscribed, and dated in graphite, lower left: Ingres / a / Monsieur Hayard / rome 1815
1943.843

In the early years of the nineteenth century, Charles Hayard (1768–1839), a transplanted Parisian, owned the best art-supply shop in Rome. Located in the vicinity of the Piazza di Spagna, it attracted the pensioners of the nearby Académie de France, relocated as recently as 1803 to the Villa Medici on the Pincio. From about 1810 the business seems to have been run by Hayard's wife, Jeanne-Susanne Alliou (1775–1854), her husband having received a minor papal appointment that kept him otherwise occupied. She was known as "the artists' mother," a sign of the affection in which she seems to have been held by her clients.[1]

Ingres arrived in Rome at the end of 1806 and must soon have met the Hayards. He made his first portrait drawing of Mme Hayard in about 1812 (fig. 98). By that time he would have been acquainted with the couple's four daughters as well, including the youngest, Caroline, born in 1810. Only a few years later Ingres's life had changed. Hans Naef has called 1815 "the artist's most difficult year in Rome."[2] The fall of Napoleon and the end of French control in the Eternal City meant that the clientele on which Ingres had relied for painting and drawing commissions, the administrators of the French occupation, had dispersed. He himself had not yet executed the major history painting that would establish his reputation in Paris and so did not feel free to follow them back to France. His circumstances, never prosperous, were further reduced. In an act of kindness at this moment, Hayard seems to have commissioned the impecunious artist to make at least three portrait drawings of himself and members of his family.

Ingres depicted Hayard himself with his daughter Marguerite, dedicating the drawing to Mme Hayard (fig. 99). He sketched an older daughter, the beautiful sloe-eyed Jeanne, on her own (private collection).[3] In the Winthrop drawing, he depicted Mme Hayard with five-year-old Caroline and dedicated it to M. Hayard, thus suggesting that the London and Winthrop sheets were specifically intended as pendants. So too does the symmetrical disposition of figures on the two sheets, with the father throwing a protective arm around his daughter at his left and the mother doing the same to Caroline at her right. Mme Hayard confronts Ingres with a steady, sympathetic look, while Caroline's direct gaze is guileless. Although Ingres never enjoyed depicting hands, here the delicate gesture with which Mme Hayard takes a finger of Caroline's right hand into her own is a key to the psychological intimacy of the drawing. Ingres may well have known little Caroline from her birth, and he remained close to her. Years later, in 1838, he served as a witness at her first wedding, and he executed a second portrait

Fig. 98. Jean-Auguste-Dominique Ingres, *Portrait of Madame Charles Hayard*, ca. 1812. Graphite on white wove paper, 10½ x 7⅛ in. (26.6 x 18 cm). Fogg Art Museum; Bequest of Paul J. Sachs, Class of 1900, "a testimonial to my friend Grenville L. Winthrop," 1965.298

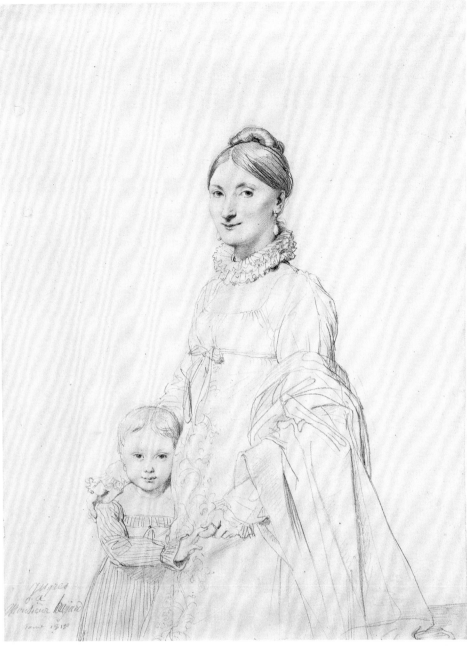

56

Fig. 99. Jean-Auguste-Dominique Ingres, *Charles Hayard and His Daughter Marguerite*, 1815. Graphite on paper, 12⅛ x 9 in. (30.8 x 22.9 cm). The British Museum, London, 1968-2-10-19

drawing of her as a mature woman in 1841 (private collection).

Christopher Riopelle

1. London–Washington–New York 1999–2000, no. 47.
2. Ibid., p. 174.
3. For the two drawings, see ibid., nos. 50, 51.
4. In his catalogue of the Musée Ingres, Momméja (1905, under no. 319) identified inv. no. 867.265 as identical with no. 321 in Delaborde's 1870 catalogue. In fact, Delaborde no. 321 is the present sheet, not the drawing in Montauban; see Vigne 1995a, p. 480, no. 2671.

PROVENANCE: Ingres to Charles-Roch Hayard; his widow, Mme Hayard, by 1839; her daughter Mme Félix Duban, née Marguerite-Françoise Hayard, by 1854; her sister Mme Frédéric Flachéron (formerly Mme Edmond Duvivier), née Caroline-Julie-Antoinette Hayard, by 1881; her son Félix-Raphaël-Alexandre Flachéron, by 1894; Scott and Fowles, New York, by or in October 1922; acquired from them by Grenville L. Winthrop, October 1922 ($2,500); his bequest to the Fogg Art Museum, 1943.

EXHIBITIONS: Paris 1861 (2nd series), no. 61; Paris 1867a, no. 353 (as coll. M. Duban); Cambridge, Mass., 1943–44, p. 4; Cambridge, Mass., 1967a, no. 28; Cambridge, Mass., 1980b, no. 17.

REFERENCES:[4] Galichon 1861a, p. 359; Blanc 1870, p. 237 (as coll. M. Duban); Delaborde 1870, p. 300, no. 322; Duplessis 1896, p. 11, no. 13 (mistakenly as coll. Mme Flachéron), pl. 13; Lapauze 1901, p. 266; Lapauze 1911a, p. 155, illus. (as coll. M. Flachéron); Hourticq 1928, p. 45, illus.; Benesch 1944, p. 32; Mongan 1944a, pp. 391, 393 (fig. 3); Ternois 1959, above no. 72; Naef 1966, pp. 40, 45 (fig. 6), 46; Schlenoff 1967, p. 379; Waldemar George 1967, pp. 41–42, illus.; Rowlands 1968, p. 44; Cohn 1969, p. 21; London 1972a, p. 933, under no. 663; Berezina 1974, pp. 7, 10; Naef 1977–80, vol. 1 (1977), pp. 451–69, fig. 3, vol. 4 (1977), pp. 240–41, no. 132, illus.; Newman 1980, p. 42, fig. 9; Ternois 1980, p. 60; Vigne 1995a, pp. 480, 508, under no. 2811, illus. above no. 2671; Mongan 1996, p. 206, no. 219, illus.; Ribeiro 1999, pp. 54–55, pl. 27; London–Washington–New York 1999–2000, p. 174, under no. 47.

57. *Portrait of Mrs. George Vesey and Her Daughter Elizabeth Vesey, later Lady Colthurst,* 1816

Graphite and white gouache on white wove paper
11¾ x 8⅞ in. (29.9 x 22.4 cm)
Signed and dated in graphite, lower right: Ingres Del. / Rome / 1816
1943.854

After the Napoleonic era ended in 1815, European travel again became possible and Italy, Rome in particular, quickly reemerged as a favored destination for visitors from across the continent. Having lost his original clientele when the French departed, Ingres now found new customers for his deft portrait drawings among the wealthy tourists who flooded into the city, many from Great Britain. Mrs. Vesey and her daughter Elizabeth, members of a distinguished Irish family, were among them, visiting Rome and sitting for Ingres in 1816.[1] The mother, born Emily La Touche, was the wife of Colonel George Vesey; it is not known whether the colonel accompanied his family on the trip. Three years after the portrait was made, in 1819, their daughter married Sir Nicholas Conway, fourth Baronet Colthurst. The drawing descended in her family and decades later

57

provoked the enthusiasm of Edgar Degas when a descendant showed him a photograph of it.

The two women sit hand in hand, Mrs. Vesey in an armchair, her tiny feet propped on a pillow, Elizabeth on the pillow by her feet. Ingres used the same pose in another, more or less contemporary drawing of unknown sitters.[2] Mrs. Vesey gazes at Ingres while her daughter glances away. Here, as in many of his portrait drawings, the artist uses the device of a touch of white gouache in the eyes to add subtle ani-

mation to them. He also lavishes attention on the women's dress, masterfully evoking rustling silk and lace in the mother's costume, feathers and complicated ruching in the daughter's. As the costume historian Aileen Ribeiro has noted, Mrs. Vesey is "a solidly corseted woman in a silk dress with a somewhat fussy arrangement of headwear—a lace veil over a frilled hat." Her daughter, on the other hand, "looks more relaxed in her simpler costume," while her hat is "strikingly modern."[3]

This emphasis on costume, common to

Ingres's portraits of British sitters, points to a change in the dynamics of the artistic exchange between him and his clients about 1815.[4] Ingres had known many of his French sitters for years, indeed sometimes considered them as friends. His portrait drawings are informed by long acquaintance and careful observation, and often they can suggest a lively sympathy between artist and sitter. Indeed, in the case of his friend Mme Charles Hayard and her daughter Caroline, of whom he made a simple and direct drawing in 1815 (cat. no. 56), Ingres suggests that affection reigns among them. On the other hand, British sitters such as the Veseys were unknown to him, they probably did not speak his language, and he certainly did not speak theirs. He engaged with them only briefly, in some cases only for a few hours on a single day.

Such drawings were primarily financial transactions between a poor artist who wished to be doing other things and wealthy tourists acquiring luxurious souvenirs of their travels. Thus, in the absence of personal knowledge of and sympathy for his sitters, Ingres seems to have lavished attention on external details such as clothing as a means to arrive quickly at a characterization. There is no diminution in the technical skill he brought to bear in such works, but a colder, more distant note enters his portrait art.

Christopher Riopelle

1. Naef 1977–80, vol. 2 (1978), chap. 72, vol. 4 (1977), no. 176.
2. Ibid., vol. 4 (1977), no. 244.
3. Ribeiro 1999, pp. 61, 62.
4. Cohn and Siegfried (in Cambridge, Mass., 1980b, no. 19) also drew attention to this shift.

PROVENANCE: Col. and Mrs. George Vesey, Dublin; their daughter Lady Nicholas Conway Colthurst; her son Sir George Conway Colthurst (d. 1878); his widow, Lady George Conway Colthurst (d. 1915); her daughter Lady Annie C. Colthurst, London, until 1930; purchased from her by Wildenstein and Co., Paris; acquired from them by Grenville L. Winthrop, New York, January 1932 ($12,500); his bequest to the Fogg Art Museum, 1943.

EXHIBITIONS: London 1907, no. 242; London 1917, no. 18 (as coll. Miss A. C. Colthurst); Cambridge, Mass., 1943–44, p. 4; Cambridge, Mass., 1967a, no. 36; Cambridge, Mass., 1980b, no. 19.

REFERENCES: Rothenstein 1931–32, vol. 1, p. 103; Anon. 1934, p. 2, illus.; Ford 1939, pp. 6, 9–10, pl. 2B; Benesch 1944, p. 32; Mongan 1944a, pp. 395, 397 (fig. 5); Mathey 1945, p. 12 and unnumbered pl.; Mongan 1947, no. 11, illus.; Davenport 1948, vol. 2, pp. 826–27, no. 2324, illus.; Alazard 1950, pp. 63, 147 n. 12; New York and other cities 1952–53, intro. (unpag.); Paris 1967–68, p. 140, under no. 100; Cohn 1969, p. 17; Mongan 1969, pp. 144, 146, [153] fig. 19; Pansu 1977a, no. 37, illus.; Naef 1977–80, vol. 2 (1978), pp. 100–103, fig. 1, vol. 4 (1977), pp. 324–25, no. 176, illus.; Ternois 1980, pp. 55, 82, illus.; Houston–New York 1986, pp. 5–6; Arikha 1991, p. 159; Hollander 1993, pp. 122, 123, fig. II.39; Arikha 1995, pp. 162, 163, illus.; Mongan 1996, pp. 208–9, no. 221, fig. 221; Bajou 1999, pp. 165 (fig. 116), 169; Ribeiro 1999, pp. 61, 62, pl. 38.

58. *Portrait of Augustin Jordan and His Daughter Adrienne,* 1817

Graphite on white wove paper
16⅞ x 12¾ in. (43 x 32.3 cm)
Signed and dated in graphite, lower right: Ingres Del. Rome 1817
1943.840

59. *Portrait of Madame Augustin Jordan and Her Son Gabriel,* 1817

Graphite on white wove paper
17⅜ x 12⅞ in. (44.3 x 32.6 cm)
Signed and dated in graphite, lower right: Ingres Del. Rome 1817
1943.841

With the restoration of the Bourbon monarchy, a wave of French officials went to Rome to restaff the embassy there. The first ambassador of the new regime, Gabriel Cortois de Pressigny, arrived in 1814. He was followed by his first secretary, Gabriel de Fontenay, and both soon sat to Ingres for portrait drawings.[1] Either official might have recommended the artist's skills to another secretary at the embassy, Augustin Jordan (1773–1849), when he arrived in 1815. Originally from Lyon, Jordan had left France during the Revolution, living in England and Geneva. He returned only after the Hundred Days and was immediately appointed to his position by François-René de Chateaubriand, a family friend. Jordan was accompanied to Rome by his wife, Augustine-Louise-Euphrasie de Mauduit Du Plessis (1789–1847), whom he had married in 1809, and by their two children. In 1817 he commissioned Ingres to make these pendant portrait drawings.[2] They show Jordan with his daughter Adrienne, six years old, and Mme Jordan with their three-year-old son, Gabriel. They remained in Rome until 1820, the same year Ingres left, but the drawings are the only evidence of what was most likely a brief, formal, and businesslike relationship between the artist and the Jordan family.

The Jordan portrait drawings are among the largest and most magisterial of Ingres's career. The artist maintains a careful compositional balance between the two sheets. The principal figures incline toward each other, although all four family members gaze outward, toward the artist. The protective gesture of the father toward his

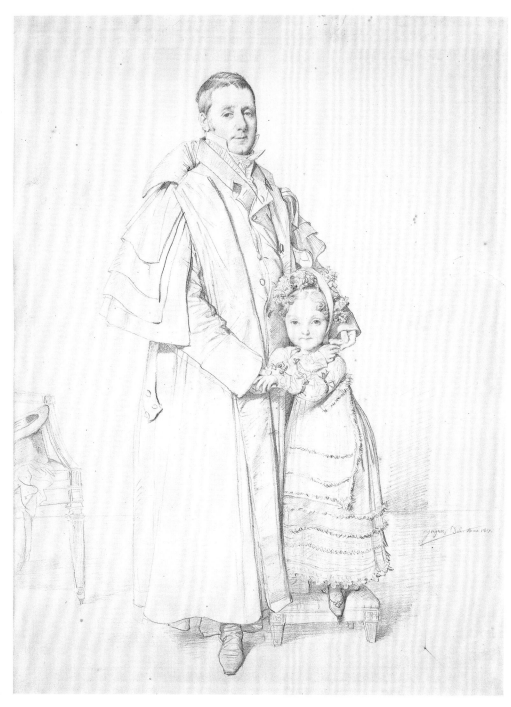

58

daughter, whom he shelters on his left side, is mirrored by that of the mother toward her son. As Marjorie Cohn and Susan Siegfried point out, one of the pleasures of the drawings is the way in which, on both sheets, Ingres places the "accent on toe-tips as the delicate yet stable balance points for all four figures."[3] The family is depicted in an interior; elegant Louis XVI–style chairs stand nearby and Mme Jordan leans her right elbow on a marble mantelpiece.

Nonetheless, M. Jordan is dressed for the outdoors in a complicated greatcoat known as a carrick, a heavy overcoat with a short cape attached. (Similar coats are worn in Ingres's painted portraits of *François-Marius Granet* [Musée Granet, Aix-en-Provence] and *Charles Marcotte d'Argenteuil* [National Gallery of Art, Washington].) The weightiness of the coat is in striking contrast to his wife's light dress of checked cotton, embellished with lace veil and cash-

mere shawl. Whether Jordan has just arrived or is preparing to leave, his carrick functions as the sign of his work in the wider world, away from family and domestic hearth, to which his position calls him.

At the same time Ingres takes evident delight in the contrast of cloth stuffs from the heaviest to the most gossamer, and the drawings are a bravura display of his skill in evoking tactile qualities with a pencil. As in his finest portrait drawings, however,

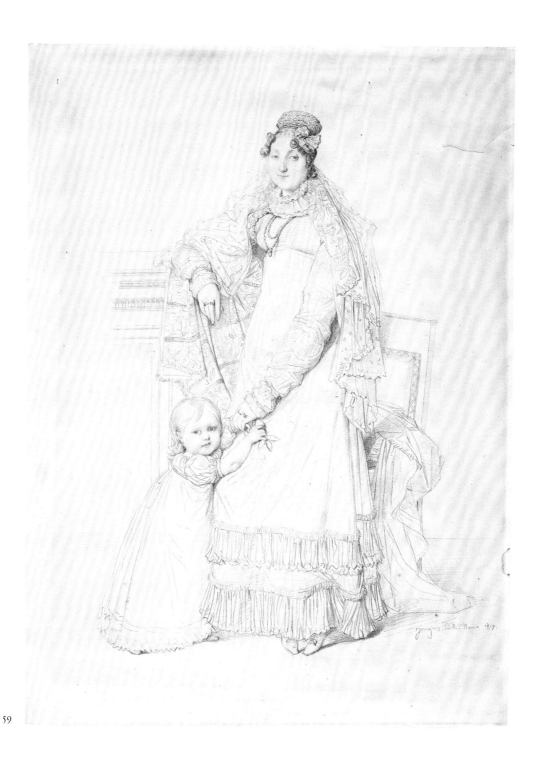

59

the viewer's eye is subtly drawn to the faces of his subjects and their personalities. Here, we admire earnest M. Jordan, weighed down by his duties to king and family, and his pretty, frivolous wife, a lover of position and of fine, expensive things, both of them united in the love of their defenseless children. *Christopher Riopelle*

1. Naef 1977–80, vol. 4 (1977), nos. 170 and 160, respectively.
2. Ibid., vol. 2 (1978), chap. 87, vol. 4 (1977), nos. 210, 211.
3. Cohn and Siegfried in Cambridge, Mass., 1980b, nos. 20, 21.

PROVENANCE FOR CAT. NOS. 58 AND 59: Augustin Jordan, Lyon; his daughter baronne Octave Despatys de Courteilles; her son Pierre-Camille-Augustin-Omer Despatys; his son Pierre-Jérôme Despatys; Wildenstein and Co., Paris, 1922; acquired from them by Grenville L. Winthrop, March 1923 (Fr 140,000 for both); his bequest to the Fogg Art Museum, 1943.

EXHIBITIONS: Paris 1922c, nos. 49, 50; Cambridge, Mass., 1943–44, p. 4; Cambridge, Mass., 1967a, nos. 40, 41; Cambridge, Mass., 1980b, nos. 20, 21.

REFERENCES: Lapauze 1922, pp. 649, 650–52, illus.; Zabel 1930, illus. pp. 378, 381; Benesch 1944, p. 32; Mongan 1944a, pp. 396 (fig. 6), 398 (fig. 7); Mongan 1947, nos. 12, 13 (illus.); Naef 1957, p. 244, n. 6; Mongan 1967, pp. 28, 29, figs. 1, 2; Radius and Camesasca 1968, p. 124, illus.; Mongan 1969, pp. 146, figs. 22, 23; Ternois and Camesasca 1971, p. 124, illus.; Pansu 1977a, no. 39, illus. (cat. no. 58); Naef 1977–80, vol. 2 (1978), pp. 201–5 (figs. 1, 2), 482, vol. 4 (1977), pp. 392–93, nos. 210, 211 (illus.); Ternois 1980, p. 60; Jordan 1983, p. 152, pls. 12, 13; Mongan 1996, p. 209, nos. 222, 223; Ribeiro 1999, pp. 48, 54, 55 pl. 28 (cat. no. 59), 179 pl. 144 (detail of cat. no. 59).

60. *Study for "Roger Freeing Angelica,"* 1818

Oil on canvas
18 x 14⅝ in. (45.8 x 37 cm)
1943.248

On July 31, 1817, the director of the Musées Royaux, Comte Auguste de Forbin, launched a project to decorate various rooms of the château of Versailles with paintings by contemporary French artists. Although Forbin was an old friend from their days together in Jacques-Louis David's studio, he did not include Ingres's name on the original list of nineteen artists to whom he offered commissions. Not long afterward, however, following the intervention of supporters in Paris, Ingres was officially informed in Rome that he was to paint an overdoor for the throne room at Versailles. No subject was named but as his contribution was to be a pendant to Pierre-Nolasque Bergeret's *Rinaldo and Armida,* a theme from Italian literature was clearly called for. Ingres may have begun work on a depiction of *Roger Freeing Angelica,* based on Ludovico Ariosto's epic poem *Orlando Furioso,* as early as 1815.[1] If so, he returned to it now and it became the subject of what he called his "tableau pour le gouvernement" (picture for the government). Ingres sent the large finished painting (Louvre, Paris) to Paris in time for the Salon of 1819, opening in late August, where it proved no more successful with the critics than any of his earlier submissions had been. He was paid 2,000 francs for the work in November of the same year. Whether the picture was ever installed at Versailles is not clear, but it entered the Musée du Luxembourg, Paris, no later than 1824.[2]

The present painting is a preparatory study for the figure of the heroine, Angelica, chained to a rock as she awaits

rescue by Roger. It is obviously based on a live model, so immediate and intimate is the depiction of the nude figure, so delicate the rendering of flesh tones. Ingres depicted her twice, first as a freestanding nude, head and eyes downcast, right arm reaching behind to delicately touch her left arm. The figure is completely surrounded by shading to create a sense of ambient space on the otherwise blank canvas. Immediately behind and above her, Ingres depicted the figure once more, restricting his attention to the torso, hands, and left arm, as well as to the head, which is now raised with eyes looking outward to her left. The position of the hands is the same, although the tilt of the head is more exaggerated, in a composition drawing for the painting, also in the Winthrop collection (cat. no. 61).

Neither pose studied in the oil sketch corresponds closely to the highly artificial figure of Angelica in the finished painting or in two replicas Ingres later made, including one dating from about 1839 in the National Gallery, London (fig. 100). There, the bizarrely mannered figure twists dramatically to her left, her right arm is drawn

across the front of her body, and her head is tossed back to a painful degree impossible to sustain in reality. Such an exaggerated pose was no doubt thought necessary for a painting meant to serve as an overdoor and therefore to be seen from below and afar. In the sketch, however, the beautiful and vulnerable figure Ingres depicts relates much more closely to the deeply sensual and highly naturalistic nudes he painted during his early Roman years, such as the *Dormeuse de Naples* and the *Reclining Nude (Madame Ingres),* both now lost. It also anticipates such paintings as the *Venus Anadyomene,* which he had begun in 1808 but finished only forty years later (Musée Condé, Chantilly), and *La Source* of 1856 (Louvre), both full-length nude figures of cool sensuality.

In 1831 Ingres gave this sketch as a gift to the painter Paul Delaroche, of whom he seems always to have been wary, perhaps as a subtle demonstration that he too was capable of the naturalism for which the younger artist himself was rapidly making a name.

Christopher Riopelle

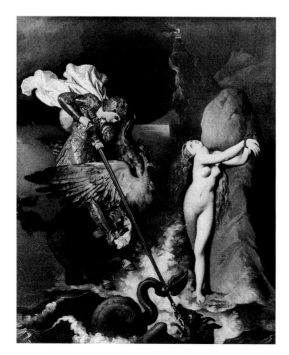

Fig. 100. Jean-Auguste-Dominique Ingres, *Roger Freeing Angelica,* 1839. Oil on canvas, 18¾ x 15½ in. (47.6 x 39.4 cm). National Gallery, London, NG3292

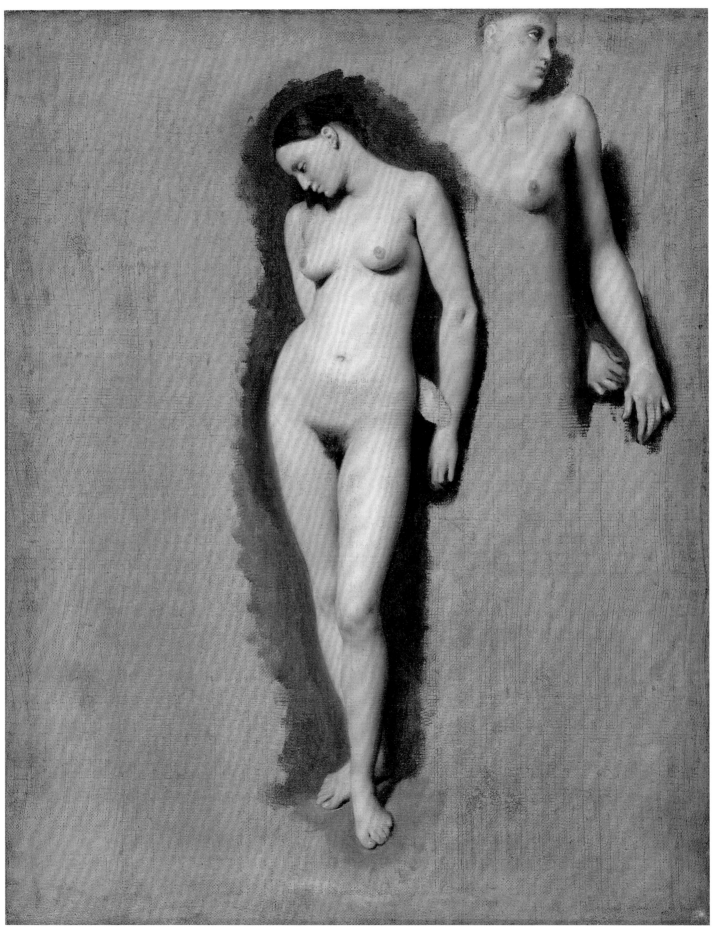

1. Vigne 1995b, p. 140.
2. The details of the commission are clarified in Ternois 2001, pp. 201–2.

PROVENANCE: Given by the artist to Hippolyte-Paul Delaroche, 1831; his son Joseph-Carle-Paul-Horace Delaroche; Wildenstein and Co., New York; acquired from them by Grenville L. Winthrop, November 1940 ($21,500); his bequest to the Fogg Art Museum, 1943.

EXHIBITIONS: Cambridge, Mass., 1943–44, p. 3; Cambridge, Mass., 1961, no. 12; Cambridge, Mass., 1967a, no. 50; Cambridge, Mass., 1977a; Cambridge, Mass., 1980b, no. 23.

REFERENCES: Delaborde 1870, pp. 208–9, under no. 32; Schlenoff 1956, pl. 16 facing p. 129; Wildenstein 1956a, p. 188, no. 126, pl. 17; Ternois 1965a, under no. 180; Paris 1967–68, pp. 152 (under no. 107), 154 (under no. 108); Radius and Camesasca 1968, p. 99, no. 996, pl. 64; Davies 1970, p. 79 n. 9, under no. 3292; Ternois and Camesasca 1971, p. 99, no. 100b, pl. 64; Rizzoni and Minervino 1976, p. 16, fig. 9; Ziff 1977, p. 117 n. 103; Boggs 1978, p. 488; Picon 1980, p. 22, illus.; Ternois 1980, p. 178, no. 137, illus.; Louisville–Fort Worth 1983–84, pp. 94, 243, 246, 248; Brown 1985, p. 46, illus.; Cavendish 1985a, p. 553, illus.; Bowron 1990, fig. 263; Haddad 1990, pp. 16 (illus.), 18; Zanni 1990, p. 84, under no. 64; Richardson 1991– , vol. 2, p. 339, illus. (as "Study for Andromeda"); Amaury-Duval (1878) 1993, p. 162, fig. 127; Vigne 1995b, pp. 144 (fig. 119), 192; Pauwels 1996, pp. 335 n. 25, 336, fig. 5; Roux 1996, pp. 56–57, pl. 14; Bajou 1999, pp. 156–57, fig. 110; Ternois 2001, p. 202 n. 4.

61. *Roger Freeing Angelica*, 1818

Graphite on white wove paper, squared
6¾ x 7¾ in. (17.1 x 19.7 cm)
Signed in graphite, lower left: Ingres
1943.859

In 1818 Ingres was hard at work in Rome on the commission he had received from the French government for a large overdoor painting in the throne room at Versailles. The subject was *Roger Freeing Angelica*, based on Ariosto's epic poem *Orlando Furioso*. As was his lifelong custom when embarking on multifigure compositions, early on Ingres devoted drawings, and sometimes oil sketches as well, to studies of individual figures. In this way he could begin to define their poses. Most often, these sketches were based on the living model, and this accounts, for example, for the delicate naturalism that characterizes the painted study for Angelica (cat. no. 60), so different from her exaggeratedly mannered pose in the finished painting. Similarly, he executed a subtle pencil sketch of a nude youth in the pose of Roger that can only have been drawn from life (Musée Ingres, Montauban, 1305). He also studied the armor with which he would clothe his hero (Musée Ingres, 1302); it is based on a fifteenth-century marble relief on the tomb of Antonio de Rido in San Francesco Romano, Rome.[1] In another sketch he worked out Roger's precarious position on the fantastical hippogriff that is his steed (Musée Ingres, 1303). Either before or after he made such studies, Ingres also made rapid and tentative composition drawings, exploring the positions of the figures in relation to one another, their place in the surrounding landscape, and the spatial intervals between figures. (These drawings include Musée Ingres, 1300 and 1301.) As his ideas gelled, such sketches became increasingly confident in execution, until Ingres was ready to set to work on the large-scale canvas itself.

This drawing is a composition study for the painting that Ingres, upon completion, sent to the Paris Salon of 1819 (Louvre, Paris) and is close to it in detail. The protagonists are arrayed in a friezelike composition. Roger's spear, about to plunge into the mouth of the dragon, cuts a sharp diagonal line across the surface of the sheet from upper left to lower right. At upper right, Angelica's head twists back unnaturally, her eyes cast heavenward; this violent movement almost imperceptibly suggests a contrasting diagonal running from upper right to lower left. (The sheet is lined for transfer but it is likely that the transfer was made from earlier drawings of individual figures to this sheet, rather than from this sheet to the finished painting.)[2] In two places, Ingres has reinforced graphite lines. These areas of greater density indicate the pictorial problems that particularly exercised Ingres at this point late in the development of the composition. He has reinforced the undulating line down the right side of Angelica's body, particularly her neck. Perhaps he was attempting to give greater relief to the figure and to emphasize that Angelica stands in front of the large rock to which she is chained. He also reinforced the armor on Roger's shoulders and, more dramatically, the hero's profile. Thus he called attention to the confrontation of Roger's head and eye with the fiercely eaglelike head and eye of the hippogriff, two beings united in a single act of bravery. The flourish with which Ingres completed his signature, at lower left, suggests that the artist, eternally insecure about his art, was, on this occasion at least, pleased with his work. So too was another great artist, and one of Ingres's most fervent admirers, Edgar Degas, who acquired this drawing later in the nineteenth century.

Christopher Riopelle

1. Cohn and Siegfried in Cambridge, Mass., 1980b, no. 24.
2. Ibid.

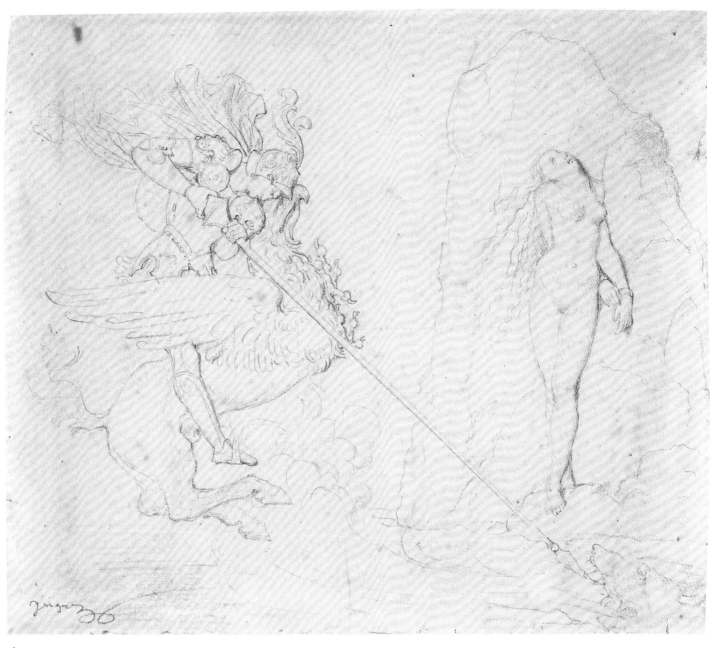

61

PROVENANCE: Fernand Guille, nephew of the artist; purchased from him by Edgar Degas; his sale, Galerie Georges Petit, Paris, March 26–27, 1918, no. 213 (Fr 3,200); purchased at that sale by Bernheim Jeune, Paris; Scott and Fowles, New York; acquired from them by Grenville L. Winthrop, December 23, 1924 ($1,200); his bequest to the Fogg Art Museum, 1943.

EXHIBITIONS: Cambridge, Mass., 1943–44, p. 3; Cambridge, Mass., 1961, no. 15; Cambridge, Mass., 1967a, no. 52, illus., p. 247; Cambridge, Mass., 1980b, no. 24.

REFERENCES: Mongan 1944a, p. 404; Mongan 1947, no. 14, illus.; Shipp 1956, p. 38; Davies 1957, p. 119; Ternois 1965, under no. 160; Waldemar George 1967, p. 49, illus.; Paris 1967–68, p. 152, under no. 107; Radius and Camesasca 1968, p. 99, under no. 99a; Ternois and Camesasca 1971, p. 99, under no. 100a; Pansu 1977a, no. 44, illus.; London and other cities 1979, p. 37; Picon 1980, p. 52, illus.; Louisville–Fort Worth 1983–84, pp. 94 (fig. 2), 243, 246, 248–50, 252, 254; Dumas 1996, pp. 23, 24 (fig. 20), 66 n. 153; Mongan 1996, pp. 212–13, no. 225, illus.; New York 1997–98, vol. 1, pp. 17, 147, 149 (fig. 192), 277, vol. 2, p. 76, no. 667, illus.

62. *Portrait of Countess Antoine Apponyi,* 1823

Graphite and white chalk on off-white wove paper
17 ¾ x 13 ¾ in. (45 x 34.9 cm)
Signed and dated in graphite, lower left: Ingres
Del. / Flor 1823.
1943.848

63. *Portrait of Count Rodolphe (?) Apponyi,* 1823

Graphite and white chalk on off-white wove paper
17 ⅞ x 13 ⅝ in. (45.3 x 34.6 cm)
Signed and dated in graphite, lower left: Ingres d /
florence 1823
1943.847

Ingres left Rome in 1820 for Florence, where he painted the monumental *Vow of Louis XIII* (Cathedral, Montauban). That painting established his artistic reputation in Paris when, at long last, he returned there with it late in 1824. While the *Vow* was the focus of Ingres's artistic attentions during his Florentine years, he was not yet in a financial position to give up making the portrait paintings and drawings that continued to put food on his table. These two elegant drawings were executed in Florence in 1823, probably for visitors wishing for a souvenir of their stay. In the distance, to the left of the male figure, who stands at the Forte Belvedere above the city, can be seen the dome of the Duomo and the tower of the Palazzo Vecchio; the same tower can be seen to the right of the woman.

Although the two drawings were not shown as a pair when first exhibited in 1867, and although Grenville Winthrop acquired them separately (the male portrait in 1925, the female portrait in 1932), there is now wide agreement that they are indeed pendants, fortuitously reunited. The identity of

62

the sitters, however, is debated. During his years in Florence between 1820 and 1824, Ingres made portrait paintings and drawings of several fellow expatriates living there, mostly Swiss and French, in whose comfortable bourgeois circle he and his wife found friendship. Hans Naef sees these sheets as part of that group of *portraits d'amitié* (friendship portraits). Back in Paris

in 1825, Naef notes, the artist wrote at length to the man who had been his closest friend in Florence, Jacques-Louis Leblanc. In closing, he asked Leblanc to give his warm greeting to a certain M. and Mme de Loqueyssie, describing them as "si bons pour moi et si intéressés à notre bonheur" (so good to me and so interested in our happiness). Naef tentatively proposed that

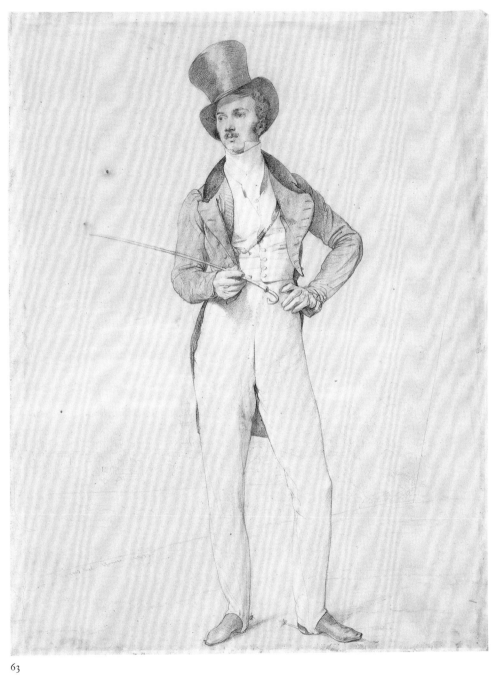

63

formal pendant portraits of M. and Mme Leblanc, which Ingres painted in 1823 (Metropolitan Museum, New York), have a quality of candor and intimacy as the couple turn bemused smiles on their friend.[3] The pendant full-length portrait drawings of M. and Mme Leblanc of 1822 and 1823 (Louvre, Paris), which formally and in degree of finish most closely resemble these two sheets, are also intimate and personal in tone and are inscribed to the sitters by Ingres.[4]

The present couple seems to inhabit a different sphere of existence. While the woman gazes confidently at her portraitist, there is little warmth in her expression. For his part the man does not deign to look at Ingres but, left arm akimbo, riding crop insolently in his right hand, he turns his head away to gaze into the distance. Tellingly, in order to draw him Ingres situates himself below, looking up at his subject, thus imbuing him with a sense of aristocratic hauteur and detachment. Ingres had adopted a similar convention in a contemporary painted portrait, that of the grand Russian aristocrat, Count Gouriev (State Hermitage, Saint Petersburg), executed on commission when the diplomat passed through Florence in 1821.[5] Like Gouriev, this couple occupies a station in life different from Ingres, and the artist acknowledges as much in the manner in which he chooses to depict them. Finally, while the drawings are signed, there is no personal inscription suggesting warmth of feeling on Ingres's part. These are not *portraits d'amitié* as the artist conceived them.

This observation suggests that a second proposal for the identification of the sitters is more likely to be correct. In 1967 Agnes Mongan first proposed that the drawings were portraits of Count and Countess

these sitters may be that same M. and Mme de Loqueyssie, about whom little is known.[1] However, comparison of the drawings with the known portraits of Florentine friends suggests otherwise.

Ingres's portraits of the early 1820s of members of the Leblanc, Thomegeux, Gonin, and Lazzarini families in Florence are marked by a warmth, immediacy, and directness that had not been seen in his art since his portraits of French friends in Rome a decade before.[2] They are mostly half-length figures and confront the artist with a steady, amused gaze, as if a conversation has been interrupted but will soon resume. Usually the drawings are affectionately inscribed by the artist to the sitter or a member of his or her family. Even the grandly

Antoine Apponyi, the Austrian minister to Florence and, in 1823, ambassador to the Holy See.[6] In 1980 Marjorie Cohn and Susan Siegfried modified this proposal, suggesting that the man, who is clearly younger than his female companion, is the ambassador's twenty-one-year-old cousin and secretary, Count Rodolphe Apponyi.[7] Both sitters resemble known portraits of these figures, and it is known that the countess was particularly close to the young man. They might well have commissioned pendant portrait drawings to commemorate a visit to Florence in 1823. Cohn and Siegfried expressed hesitation about advancing identifications of the sitters based solely on likeness. All that can be added here in support of their suggestion is the somewhat circular argument that these are indeed the kinds of impressively distant and elegant portrait drawings Ingres would be most likely to make when commissioned by visiting grandees.

Christopher Riopelle

1. Naef 1977–80, vol. 2 (1978), chap. 119, vol. 5 (1980), nos. 274 (as "Kavalier mit Gerte"), 275 (as "Dame mit Sonnenschirm").
2. On Ingres's circle of friends in Florence, see most recently Riopelle in London–Washington–New York 1999–2000, pp. 235–49.
3. Ibid., nos. 88, 89.
4. Ibid., nos. 92, 93.
5. Ibid., no. 86.
6. Mongan in Cambridge, Mass., 1967a, no. 56.
7. Cohn and Siegfried in Cambridge, Mass., 1980b, nos. 27, 28; Mongan (1996, nos. 228, 229) accepts Cohn and Siegfried's suggestion.

PROVENANCE FOR CAT. NO. 62: Albert Goupil, Paris; purchased from him by Charles-François Jalabert (1819–1901), Paris; bequeathed by him to Jean-Léon Gérôme (1824–1904), Paris; his widow, Mme Gérôme, née Marie Goupil (1841–1912; Albert Goupil's sister); her daughter Mme Aimé-Nicolas Morot; acquired from her through Martin Birnbaum by Grenville L. Winthrop, April 1932 (Fr 192,500); his bequest to the Fogg Art Museum, 1943.

EXHIBITIONS FOR CAT. NO. 62: Paris 1867a, no. 540 (as "Portrait de femme en pied, tenant une ombrelle à la main," coll. Albert Goupil); Paris 1884a, no. 393 (as "Portrait de M^me ***," coll. Albert Goupil); Paris 1911, no. 118 (as "La Femme à l'ombrelle"); Cambridge, Mass., 1943–44, p. 4 (as "Lady with parasol"); Cambridge, Mass., 1967a, no. 55; Cambridge, Mass., 1980b, no. 27.

REFERENCES FOR CAT. NO. 62: Blanc 1870, p. 240 (as "Portrait de femme en pied, tenant une ombrelle à la main," coll. Albert Goupil); Delaborde 1870, p. 289, no. 247; Molinier 1885, pp. 388–89; Lapauze 1903, no. 97, illus.; Gonse 1904, p. 92; Miller 1938, pp. 13, 14, n. 25; Fogg Art Museum 1944, p. 210, illus.; Mongan 1944a, pp. 398, 399, fig. 8 (as "Lady with a Parasol"); Cassou 1947, pl. 36; Mongan 1947, no. 16, illus. (as "Lady with Parasol"); Birnbaum 1960, p. 189 (as "Femme à l'ombrelle"); Boucher 1965, pp. 352–53, fig. 902; Mongan 1967, p. 29; Naef 1967a, p. 6 n. 1; Schlenoff 1967, p. 379, fig. 62; Radius and

Camesasca 1968, p. 124; Cohn 1969, p. 19; Mongan 1969, pp. 146, [157], fig. 26; Naef 1970, pp. 183, 184 (under "Notes"); Ternois and Camesasca 1971, p. 124; Naef 1977–80, vol. 2 (1978), pp. 449–54, fig. 1, vol. 5 (1980), pp. 50–52, no. 275, illus.; Picon 1980, p. 81, illus.; Russell 1983, pp. 340–41, fig. 19-9; Tübingen–Brussels 1986 (French ed.), pp. 31, 32, fig. 9; Mongan 1996, pp. 215–16, no. 229, illus.; Ribeiro 1999, pp. 68–70, fig. 48.

PROVENANCE FOR CAT. NO. 63: Albert Goupil, Paris, by 1867; Baron Joseph Vitta, Paris, by 1911; Scott and Fowles, New York; acquired from them by Grenville L. Winthrop, September 1925 ($3,500); his bequest to the Fogg Art Museum, 1943.

EXHIBITIONS FOR CAT. NO. 63: Paris 1867a, no. 584 (as "Portrait d'homme en pied," coll. Albert Goupil); Paris 1911, no. 11 (as coll. Vitta); Paris 1921a, no. 222; Cambridge, Mass., 1943–44, p. 4 (as "Florentine cavalier"); Cambridge, Mass., 1967a, no. 56; Cambridge, Mass., 1980b, no. 28.

REFERENCES FOR CAT. NO. 63: Blanc 1870, p. 240 (as "Portrait d'homme en pied," coll. Albert Goupil); Fogg Art Museum 1944, p. 210, illus.; Mongan 1944a, pp. 398, 399, fig. 9 (as "Young Man in a Top Hat"); Cassou 1947, pl. 37; Mongan 1947, no. 17, illus. (as "Florentine Cavalier"); Labrouche 1950, pl. 6; Birnbaum 1960, p. 189 (as "Gentleman in a silk hat"); Mongan 1967, pp. 25 (fig. 3), 29; Naef 1967a, p. 6 n. 1; Schlenoff 1967, p. 379, fig. 63; Radius and Camesasca 1968, p. 124, illus.; Mongan 1969, pp. 146, [156] fig. 25; Naef 1970, pp. 183, 184 (under "Notes"); Ternois and Camesasca 1971, p. 124, illus.; Pansu 1977a, no. 48, illus.; Naef 1977–80, vol. 2 (1978), pp. 449–54, fig. 2, vol. 5 (1980), pp. 48–49, no. 274, illus.; Picon 1980, p. 81, illus.; Van Witsen 1981, p. 122, illus.; Tübingen–Brussels 1986 (French ed.), pp. 31, 33, fig. 10; Van Witsen 1994, vol. 1, p. 122, illus.; Mongan 1996, pp. 214–15, no. 228, illus.

64. *Portrait of the Forestier Family*, ca. 1828 (?)

Graphite and white chalk on tracing paper
11 3/4 x 14 5/8 in. (30 x 37.2 cm)
Signed and dated in graphite, lower left: Ingres f. 1804.
Inscribed in graphite, lower center: famille de Mr forestier ancien juge de S. Nicolas à Paris
1943.842

Julie Forestier, standing in the center here, her left hand resting on a piano keyboard, was briefly Ingres's fiancée. She was a painter in her own right and from 1804 an irregular contributor to the Paris Salon.

Ingres seems to have met her in that same year, and soon afterward he made the acquaintance of her family as well. In the summer of 1806 the two young people became engaged; he was twenty-six and she twenty-four years of age. At about the same time, in July 1806, Ingres was directed to report to the Académie de France in Rome to take up his long-delayed position as a Prix de Rome pensioner there. It was then that he made the first of three closely related versions of this group portrait of

Julie and her family (Louvre, Paris), perhaps in recognition of their engagement or his imminent departure for Rome, or both. For Georges Vigne it is Ingres's "first mature portrait drawing."[1] Hans Naef calls it "incomparable."[2]

Julie's father, Charles-Pierre-Michel Forestier, a jurist, is seated at the right and turns an admiring gaze on his talented daughter. Seated to the left, hands clasped on lap in a matronly manner, her mother, Marie-Jeanne-Julie, gazes affectionately

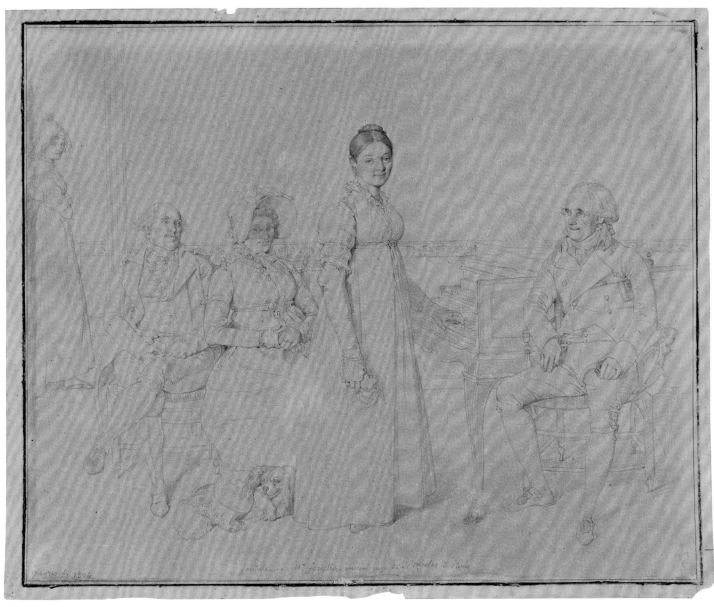

64

toward Ingres. Beside her is her brother—
and Julie's uncle—M. Salé. The family ser-
vant, Clothilde, is about to leave the room
but pauses in the doorway at the far left to
cast what might be described as a conspira-
torial glance at Ingres.

The drawing bespeaks prosperity, famil-
ial affection, and a charming domesticity of
which the artist had known little since he
left his own family home in 1791 at age
eleven. Ingres here creates an elegantly
syncopated rhythm of glances that unites

the figures and their portraitist as well. He
shows off a technical virtuosity in which he
was growing ever more confident, drawing
subtle attention to Julie by giving her face
and features slightly more definition than
other family members. Clothilde, farthest
away and about to disappear through the
door, is little more than a highly expressive
outline. Ingres is also masterful in depicting
the shadow that Mme Forestier's bonnet
causes to fall across her face. M. Salé,
cross-legged, head turned abruptly to his

left, is a remarkably complicated figure spa-
tially, but Ingres's depiction is entirely con-
vincing.

A small spaniel lies curled on the floor
between Mme Forestier and Julie. Often in
portraiture such pets are symbols of marital
fidelity, and here the dog may allude to the
longevity of the Forestier union or to the
future marital happiness of Ingres and Julie
themselves. If the latter, it was not to be.
Although Ingres had promised to return
quickly to Paris and his first months in Italy

were deeply unhappy ones, he soon realized that he must stay in Rome. Not only was his art advancing as he studied the masterpieces of the Eternal City but, following the disastrous reception his paintings had received at the Salon of 1806, he became convinced he could not return to Paris until he had completed a monumental history painting that would establish his reputation there. In August 1807 Ingres wrote to M. Forestier requesting his freedom. No answer was received. The following year Julie returned to Ingres the drawing of herself and her family that is today in the Louvre and which Ingres had given her on his departure. She never married.

The Louvre drawing is universally recognized as the primary version of the *Forestier Family*. The quality of a second version in the Musée Ingres, Montauban, is not as high. While Vigne accepts its authenticity,[3] Marjorie Cohn has suggested that it may be a copy of the Louvre sheet made by Julie Forestier herself.[4] The Louvre sheet was of course in her possession between 1806 and 1808, and in 1807, at Ingres's request, she had copied a painted portrait of her fiancé that was also in her keeping.[5] The status of the Winthrop sheet is more complicated. It is on tracing paper, and Naef describes it as a tracing of the Louvre drawing.[6] That drawing was in Ingres's possession between the time Julie returned it to him and about 1830, when he gave it to a friend, and afterward conceivably it remained accessible to him. As Agnes

Mongan notes, however, the Winthrop sheet is larger than the Louvre version, which measures 9⅛ by 12½ inches (23.3 x 31.9 cm), while the figures are not precisely to the same scale.[7] Moreover, the artist has introduced changes; Julie's left arm, for example, is visible in the Winthrop sheet while only her hand is depicted in the Louvre drawing. The Winthrop sheet is the evident source for an engraving by Achille Réveil that appeared in 1851, as it too shows Julie's left arm.[8] Finally, a pattern of thin vertical lines in pencil, approximately one-half inch (1.4 cm) apart, can be detected on the sheet; these might have been used to transfer the composition while allowing the artist to introduce alterations as he saw fit. Mongan's conclusion, that the Winthrop drawing is an autograph replica probably made by Ingres in anticipation of an engraving, is convincing.[9] Cohn and Siegfried date the drawing to about 1828, after Ingres had returned to Paris, though it might also have been made many years later.[10] Although Ingres signed the drawing and dated it to 1804, by the time he did so he misremembered by two years a period of mingled happiness and anxiety in his youth.

Christopher Riopelle

1. Vigne 1995b, p. 62.
2. London–Washington–New York 1999–2000, no. 23.
3. Vigne 1995b, p. 62.
4. Cohn and Siegfried in Cambridge, Mass., 1980b, under no. 33.
5. London–Washington–New York 1999–2000, no. 11.
6. Ibid., under no. 23.
7. Mongan 1996, no. 235.
8. Magimel 1851, no. 5.
9. Mongan 1996, p. 220.
10. Cohn and Siegfried in Cambridge, Mass., 1980b, no. 23.
11. Earlier scholars, e.g., Lapauze (1910, p. 112, n. 1), who believed that the present sheet was executed as an early copy of the original version in the Louvre, cited the artist's father, Jean-Marie-Joseph Ingres (1755–1814), as its first owner.

PROVENANCE:[11] Presumably Mme Delphine Ingres, née Ramel, the artist's widow; sold by M. M . . . , Hôtel Drouot, Paris, February 18, 1884, no. 29 (Fr 8,000); Fernand Guille, nephew of the artist; purchased from him by Edgar Degas, December 28, 1896 (Fr 5,000); his sale, Galerie Georges Petit, Paris, March 26–27, 1918, no. 208 (Fr 18,100); purchased at that sale by Bernheim Jeune, Paris; Scott and Fowles, New York; acquired from them by Grenville L. Winthrop, January 1922 ($4,500); his bequest to the Fogg Art Museum, 1943.

EXHIBITIONS: Cambridge, Mass., 1943–44, p. 4; Cambridge, Mass., 1961, no. 1; Cambridge, Mass., 1967a, no. 5; Cambridge, Mass., 1980b, no. 33.

REFERENCES: Magimel 1851, pl. 5; Silvestre 1856, pp. 6–7 (possibly referring to Louvre version); Blanc 1870, p. 8; Delaborde 1870, p. 297, under no. 301; Lapauze 1901, p. 92 n. 1; Lapauze 1903, p. 48, under no. 20; Lapauze 1910, p. 112 n. 1; Lapauze 1911a, p. 60; Lapauze 1918a, p. 350; Martine 1926, under no. 14; Benesch 1944, p. 32; Mongan 1944a, pp. pp. 388–91, fig. 1; Mongan 1947, no. 1, illus.; Alazard 1950, p. 144 n. 19; Montauban 1951, under no. 9; New York and other cities 1952–53, intro. (unpag.), under no. 20; Toulouse–Montauban 1955, under no. 103; Ternois 1959, above no. 54; Birnbaum 1960, pp. 188–89; Boggs 1962, pp. 13, 88 n. 71; Montauban 1967, p. 43, under no. 17; Paris 1967–68, p. 36, under no. 19; Delpierre 1977, p. 154; Naef 1977–80, vol. 1 (1977), pp. 124–43, fig. 3, vol. 4, pp. 66–67, no. 35, illus.; London and other cities 1979, p. 19, under no. 18; Ternois 1980, p. 27; Tübingen–Brussels 1986 (French ed.), pp. 25, 26 (fig. 2), 30; Fleckner 1995, pp. 145, 147 (fig. 54), 161, 208–9; Vigne 1995a, p. 474, above no. 2653; Dumas 1996, pp. 24, 26 (fig. 23), 71; Mongan 1996, pp. 220–22, no. 235, illus.; New York 1997–98, vol. 1, pp. 26, 29 (fig. 29), 136 (fig. 170, detail), 144, vol. 2, p. 75, no. 662, illus.; London–Washington–New York 1999–2000, pp. 72 (fig. 76), 75, 94.

65. Study of the Right Hand of Monsieur Louis Bertin, 1832

Graphite on tracing paper, laid down
6⅞ x 8⅛ in. (17.6 x 20.6 cm)
Signed in graphite, lower center: Ing.
Inscribed in graphite, lower left: Main de
M. Bertin
1943.853

66. Study for the Left Hand of Comte Louis-Mathieu Molé, 1834

Graphite and white chalk on tracing paper, laid down
7 x 8½ in. (17.8 x 21.5 cm)
Signed in graphite, lower right: Ing.
Inscribed in graphite, upper left: main de
M le Cᵗᵉ Molé
1943.850

67. Study for the Right Hand of Comte Louis-Mathieu Molé, 1834

Graphite and white chalk on tracing paper, laid down
7⅜ x 8⅜ in. (18.6 x 21.4 cm)
Signed in graphite, lower right: Ing.
Inscribed in graphite, upper left: main de
M. Molé; *lower right:* Iᵈ de Cᵗᵉ Molé
1943.851

68. Study for the Right Hand of the Duc d'Orléans, 1842

Graphite, charcoal, and white chalk on tracing paper, laid down
7½ x 9⅜ in. (18.9 x 23.9 cm)
Signed in graphite, lower right: Ing.
Inscribed in graphite, lower left: Main de Mᵍⁿᵉᵘʳ
le Duc d'Orleans.
1943.852

Although these four drawings are called studies, in fact they were produced by Ingres when he was far along in the process of painting portraits of Louis-François Bertin, an archetypal bourgeois and the publisher of the influential *Journal des débats;* comte Louis-Mathieu Molé, the aristocratic first minister of King Louis-Philippe; and duc Ferdinand-Philippe d'Orléans, the king's eldest son and heir to the throne.[1] Ingres traced the outlines of their hands from the canvases and then laid the translucent paper on a more conventional drawing surface to finish the drawings with tonal shading. As evidence, for instance, the distinctive texture of laid paper, which must have lain beneath the tracing paper of Bertin's *Hand*, shows in the fleshy area between thumb and forefinger but is absent elsewhere. The second thumb in this drawing of the right hand is not a variation in pose. Rather, it is a tracing of Bertin's painted left thumb, which is so sharply flexed that it protrudes from the placket of his cuff rather than the opening for the wrist, and appears in the portrait as dismembered as the isolated thumb of this drawing.

Because originally the two hands of Molé were traced on a single sheet of paper left over right, the opposite of their final arrangement, and then cut apart, they too have been construed as studies for an alternate pose.[2] In fact, however, a study drawing that has Molé leaning on a mantel rather than on the settee of the finished portrait also shows the hands right over left;[3] if one considers the perspective of our view of the hands, in which the left is seen from above and the right from the front, it is obvious that they were conceived in that pose, and that the artist reversed them by

repositioning his tracing in the course of recording his design.

The position of the glove in the drawing of the hand of Orléans differs somewhat from that of the painting, yet several studies now at Montauban exhibit such a miscellany of poses for the hands that by comparison the Winthrop drawing seems virtually identical to the painting.[4] Yet another drawing of the right hand, now in the collection of the École des Beaux-Arts, Paris,[5] is in the same pose, and a comparison shows clearly the difference in technique and style between a true study by Ingres and a record drawing.

Why, then, did Ingres create and keep these traced "studies"? They are not his only actual-size drawn replicas of painted-portrait hands; two of the right hands of women also survive.[6] Yet the hands of the three men were not relegated to Montauban as "studio contents." They are isolated as a group by the conformity of their inscriptions, as if Ingres had retrospectively labeled them, and also by their presentation in exhibitions during his lifetime and on sale after his death as if they were a single item. To Ingres and to his public, the drawings must have offered themselves as a visual metonymy of his increasingly distinguished portraiture of men, which attained, and ended with, royalty.

Marjorie B. Cohn

1. *Louis-François Bertin*, 1832, Musée du Louvre, Paris (Wildenstein 1954, no. 208); *Comte Louis-Mathieu Molé*, 1834, private collection (ibid., no. 225); *Duc Ferdinand-Philippe d'Orléans*, 1842, private collection (ibid., no. 239).
2. Cambridge, Mass., 1967a, nos. 74, 75.
3. Musée Ingres, Montauban, 867.324 (Vigne 1995a, no. 2729). Only the figure and the inscriptions are by Ingres.
4. Musée Ingres, Montauban, 867.358 (Vigne 1995a, no. 2759r, v), 867.359 (ibid., no. 2760), 867.360

65

68

66

67

(ibid., no. 2761), 867.361 (ibid., no. 2763), 867.362
(ibid., no. 2762v).
5. École des Beaux-Arts, Paris, 1122.
6. Musée Ingres, Montauban, 867.376 (Vigne 1995a,
no. 2775), 867.304 bis (ibid., no. 2712); the latter is
thought perhaps to be the work of a student.

PROVENANCE FOR CAT. NOS. 65–68: Sold by
the artist to Étienne-François Haro; consigned by him
to the Ingres sale, Hôtel Drouot, Paris, May 6–7, 1867
(Lugt 1921, no. 1241), no. 84 (Fr 790); (?) Thibaudeau
(or Thibaudot); Henri Lehmann; his sale, Hôtel
Drouot, Paris, March 2–3, 1883, no. 201; comtesse de
Béhague, Paris; her daughter, comtesse de Béarn;
acquired from her through Martin Birnbaum by
Grenville L. Winthrop, May–June 1931 (Fr 27,500);
his bequest to the Fogg Art Museum, 1943.

EXHIBITIONS FOR CAT. NO. 65: Paris 1861;
Paris 1867a, no. 234; Cambridge, Mass., 1964, no. 22;
Cambridge, Mass., 1967a, no. 68; Cambridge, Mass.,
1980b, no. 34.

REFERENCES FOR CAT. NO. 65: Galichon 1861a,
p. 356; Anon. 1867, p. 147, no. 84; Lapauze 1911a, illus.
p. 284; Mongan 1944a, pp. 402–3, fig. 13; "Focus on
Drawing" 1946, p. 26, illus.; Schwabe 1948, p. [8], fig. 5;
Mongan 1949, p. 138, illus.; Mathey 1955, no. 38, illus.
p. 17; Millier 1955, pl. 35; Ternois 1959, above no. 14;
Birnbaum 1960, p. 191; Paris 1962, pp. 81–82; Mongan
1967, p. 29; Montauban 1967, under no. 105; Paris 1967–
68, under no. 156; Radius and Camesasca 1968, illus.
p. 120; Ternois and Camesasca 1971, illus. p. 120; Picon
1980, illus. p. 54; Ternois 1980, p. 76; Toussaint 1985,
no. XIII.5, illus.; Ferrier 1991, illus. p. 280; Picon 1991,
illus. p. 40; Mongan 1996, no. 238, illus.; London–
Washington–New York 1999–2000, p. 303, fig. 179.

EXHIBITIONS FOR CAT. NO. 66: Paris 1861; Paris
1867a, no. 234; Cambridge, Mass., 1943–44, p. 10;
Cambridge, Mass., 1964, no. 23; Cambridge, Mass.,
1967a, no. 74; Cambridge, Mass., 1980b, no. 38.

REFERENCES FOR CAT. NO. 66: Galichon 1861a,
p. 356; Anon. 1867, p. 147, no. 84; Lapauze 1911a, illus.

p. 315; Mongan 1944a, pp. 402–3; Mathey 1955, p. 17; Millier 1955, pl. 35; Ternois 1959, above no. 129; Birnbaum 1960, p. 191; Moskowitz 1962, pl. 722; Mongan 1996, no. 238, illus.

EXHIBITIONS FOR CAT. NO. 67: Paris 1861; Paris 1867a, no. 234; Cambridge, Mass., 1943–44, p. 10; Cambridge, Mass., 1967a, no. 75, illus., p. 247; Cambridge, Mass., 1980b, no. 39.

REFERENCES FOR CAT. NO. 67: Galichon 1861a, p. 356; Anon. 1867, p. 147, no. 84; Lapauze 1911a, illus. p. 312; Mongan 1944a, pp. 402–3; Mathey 1955, p. 17; Millier 1955, pl. 35; Ternois 1959, above no. 129; Birnbaum 1960, p. 191; Moskowitz 1962, pl. 721; Mongan 1996, no. 239, illus.

EXHIBITIONS FOR CAT. NO. 68: Paris 1861; Paris 1867a, no. 234; Cambridge, Mass., 1967a, no. 84, illus., p. 247; Cambridge, Mass., 1980b, no. 43.

REFERENCES FOR CAT. NO. 68: Galichon 1861a, p. 356; Anon. 1867, p. 147, no. 84; Lapauze 1911a, illus. p. 382; Mongan 1944a, pp. 402–3; Millier 1955, pl. 35; Wildenstein 1956b, p. 77, n. 4; Davies 1957, pp. 113–14, no. 17; Ternois 1959, above no. 160; Birnbaum 1960, p. 191; Mongan 1967, pp. 27, 29, fig. 3; Toussaint 1985, no. XVI.8, illus.; Mongan 1996, no. 241, illus.

69. *The Dream of Ossian,* ca. 1832–34

Watercolor, white gouache, and brown ink over graphite and partial stylus outlining on white wove paper, backed
9¾ x 7⅜ in. (24.7 x 18.7 cm)
Signed and dated in blue watercolor, lower right:
Ingres in E Pinx Roma 1809
1943.376

In February 1810, Napoleon declared Rome the "second capital" of the French Empire. In 1811, General Miollis, military governor of French-occupied Rome, ordered several large-scale works from Ingres as part of an ambitious scheme to redecorate the Palazzo del Quirinale. The building, a summer residence of the popes (and now the residence of the president of Italy), was to serve Napoleon, the self-styled king of Italy, on a stay in the capital that in fact never occurred. Miollis had ordered *Virgil Reading the "Aeneid"* (1812; Musée des Augustins, Toulouse) for his own palace, the Villa Aldobrandini; for the apartment destined for Josephine at the Quirinale he ordered *Romulus, Conqueror of Acron* (1812; Louvre, Paris). Napoleon's bedroom was to be decorated with works on the theme of Night, Sleep, and Dreams by contemporary Italian artists.[1] Evidently, the emperor disliked a proposal for the ceiling, and *The Dream of Ossian* (1813; Musée Ingres, Montauban)

69

was commissioned from Ingres as a last-minute substitute.[2]

The subject was already closely associated with Napoleon: Percier and Fontaine had commissioned for Malmaison large works by Gérard, *Le barde Ossian évoquant les fantômes sur le bord du Lora*, 1801, and Girodet, *Les ombres des héros français morts pour la patrie, conduites par la Victoire, viennent visiter dans leurs nuages les ombres d'Ossian et de ses guerriers, qui leur donnent la fête de l'amitié*, 1802. Ingres owned prints (Musée Ingres) after both works, which exhibit the ghostly palette and dreamy mood that he had chosen for his ceiling.

The tales of Ossian first appeared as Gaelic songs published by Alexander MacDonald in 1751; they were fraudulently republished in 1762–63 by James MacPherson as the work of the third-century Ossian, son of Fingal. Didot's French edition of 1801 was immediately popular; it inspired the opera by Jean-François Le Sueur (1760–1837), *Ossian, ou Les bardes*, dedicated in 1803 to the first consul and first performed in Paris on July 10, 1804. Agnes Mongan recognized that Ingres's composition follows the stage directions in act 4, scene 3 of the libretto, when the exhausted, dispirited Ossian falls asleep and dreams of the heroes and bards whose deeds he had described: "'While Ossian sleeps, the things he has just described and of which he has been singing reappear in his mind. The ethereal palace opens and we see, first, the lesser heroes and bards. They are dressed the same as they were in life. On their heads are wreaths of immortality. At the sound of their heavenly harps the voices of the heroes' young women join in.' Chorus . . . 'The tableau opens up, the light becomes brighter, and

we see heroes and bards of higher rank. The heroes, seated on thrones of mist, are armed with spears and shields.' Chorus . . . 'Young virgins gather around the famous warriors and hold over their heads the wreaths they had won for their labors. Others descend toward Ossian and indicate the vision that is appearing to him.'"[3]

According to Cohn and Siegfried, Ingres based this watercolor on a pencil tracing, now at the Musée Ingres (867.2173), which itself may have been traced from another drawing, also at the Musée Ingres (867.2174). A wash drawing now at the Louvre (RF 1446) was probably traced from the Winthrop sheet. It is not clear, however, when the Winthrop sheet was made. The 1809 date that Ingres inscribed is without doubt apocryphal and points to a later date. Cohn and Siegfried saw it as a work executed in Paris about 1832–34, when Ingres was preoccupied with having his principal compositions reproduced through engraving.[4] Pradier engraved the *Virgil Reading the "Aeneid"* at this time, and the project to reproduce *Ossian*, which did not occur until Réveil's engravings of 1851, could have been interrupted by Ingres's departure for Rome in 1834. Ternois believes that the Winthrop sheet could be even later, perhaps after 1841.[5] Cohn and Siegfried speculate that Ingres might have inscribed the false date of 1809 on the Winthrop watercolor in connection with Réveil's 1851 engraving project,[6] although in all likelihood, this is the work that appears among other works of the 1830s in the lists that Ingres made of his cumulative output.

An impressive pen-and-ink and watercolor drawing, recently sold in London,[7] probably was made at the time of Ingres's work on the ceiling in 1813. Another draw-

ing, acquired by the National Gallery of Scotland, Edinburgh,[8] more likely was made around the same time as the Winthrop sheet, which, in every respect, is the most perfect of all Ingres's variants of the composition.

Gary Tinterow

1. Cohn and Siegfried in Cambridge, Mass., 1980b, no. 35.
2. No documentation of the commission has come to light. As Cohn and Siegfried (in ibid.) note, Ingres did not mention the Ossian commission in a letter of February 2, 1813, to Gérard, the author of an Ossian picture for Malmaison, though he did brag about Miollis's commissions of *Virgil* and *Romulus*. Hence, it is unlikely that Ingres knew about it before February 1813.
3. English translation based on quotation in Mongan 1947a, p. 12; see also Cambridge, Mass., 1967a, no. 17.
4. Cohn and Siegfried in Cambridge, Mass., 1980b, no. 35.
5. Ternois 1965b, p. 190.
6. Cohn and Siegfried in Cambridge, Mass., 1980b, no. 35.
7. Sotheby's, London, June 6, 2001, no. 109; 27.7 x 23.6 cm (image), 35 x 30.2 cm (sheet). This work was given by Ingres to Gilibert, probably in 1821.
8. Christie's, New York, January 11, 1994, no. 343; 26 x 20.5 cm, inscribed (later) 1811.

PROVENANCE: Ingres to the de Beaumont family; acquired through Martin Birnbaum by Grenville L. Winthrop, May 4, 1935 ($1,650); his bequest to the Fogg Art Museum, 1943.

EXHIBITIONS: Cambridge, Mass., 1943–44, p. 4; Cambridge, Mass., 1967a, no. 17; Cambridge, Mass., 1980b, no. 35.

REFERENCES: Saglio 1857, p. 78; Delaborde 1870, no. 201; Lapauze 1901, pp. 235, 249; Mongan 1944a, pp. 404, 405 (fig. 14); Mongan 1947a, p. 12, pl. 8b; Alazard 1950, p. 146, n. 36; Schlenoff 1956, pp. 79 n. 2, 85; Birnbaum 1960, p. 191; Ternois 1962, p. 214, n. 14; Ternois 1965b, pp. 186, 189–91, pl. 43, fig. 5; Montauban 1967, p. 96, under no. 157; Okun 1967, p. 352; Paris 1967–68, p. 92, under no. 61; Radius and Camesasca 1968, p. 95, under no. 75, illus.; Ternois 1969, p. 211; Ternois and Camesasca 1971, p. 95, under no. 76; Paris–Hamburg 1974, pp. 100 under no. 94, 102 under nos. 95–99/11, 104 under no. 96, 107 under no. 102; Ternois 1980, p. 108; Gross 1981, pp. 47, 49 (fig. 4), 52; Spike 1981, p. 190; Louisville–Fort Worth 1983–84, pp. 48, 50 (fig. 7); Paris 1989, p. 81; Zanni 1990, p. 62, under no. 45; Christie's, New York, sale cat., January 11, 1994, p. 192, under no. 343; Condon 1995, p. 54, no. 62, fig. 48; Condon 1996a, pp. 10 (no. 62), 34, 35; Mongan 1996, no. 237, illus.; Zamoyski 1999, fig. 16, facing p. 242.

70. *Studies for "The Martyrdom of Saint Symphorien" (Saint, Mother, and Proconsul)*, 1833

Oil paint over graphite and red chalk (stylus transfer), squared in graphite, on canvas laid down on wood panel
24½ x 19⅜ in. (61.3 x 49.3 cm)
Signed lower right: Ingres
1943.245

71. *Studies for "The Martyrdom of Saint Symphorien" (Lictors, Stone-Thrower, and Spectator)*, 1833

Oil paint over graphite, squared in graphite, on canvas mounted on modern aluminum support
24⅛ x 19¾ in. (61.8 x 50.1 cm)
Signed lower left: Ingres
Inscribed lower left, below left standing figure's left foot: plus haut; *below stone-thrower's left foot:* p[lus] fin
1943.246

Ingres was forty-four years old when, at the Salon of 1824, he belatedly established his artistic reputation in Paris with the exhibition of his monumental altarpiece, *The Vow of Louis XIII* (Cathedral, Montauban). For the next decade he was acclaimed as the leader of the classical school of French painting. Students flocked to his studio and official honors and commissions came his way. Exactly ten years later, at the Salon of 1834, the tables were turned when Ingres's no-less-monumental altarpiece, *The Martyrdom of Saint Symphorien* (Cathedral, Autun; fig. 101), gave rise to unexpectedly harsh criticism in some sectors of the press. More troubling still, the general public largely ignored the painting, beguiled instead by melodramatic canvases such as Paul Delaroche's *Execution of Lady Jane Grey* (National Gallery, London), the sen-

sation of that year's Salon.[1] It was the most galling defeat of Ingres's artistic career since the Salon of 1806, when his paintings also had been severely attacked. Then he was an unknown, however, but now he was the most esteemed artist in France, at least in certain influential quarters, and his students had been promoting the long-awaited painting as his masterpiece. Always undone by criticism, Ingres's reaction to the *Saint Symphorien* debacle was to retreat from Paris; soon after, he accepted the directorship of the Académie de France in Rome and departed for Italy.

Ingres had received his commission for the *Saint Symphorien* in the year of his triumph, 1824. The bishop of Autun required a vast altarpiece for his cathedral on a subject of local import, and the State awarded the prize to Ingres. Symphorien, a native of second-century Augustodunum (present-day Autun), was a young Christian sen-

tenced to death for refusing to honor the Roman gods. As he was led to martyrdom, his mother, Augusta, shouted encouragement to her son from atop the city walls. Ingres worked on the painting off and on but allowed other commissions to intervene, notably one to paint *The Apotheosis of Homer* (Louvre, Paris). Even though he announced that *Saint Symphorien* would be exhibited as early as 1827, by that time he had produced numerous preparatory drawings but only a rather staid painted maquette (private collection). Ingres was still at work on the painting in 1830 when, with the July Revolution and the fall of the Bourbon regime that had originally awarded him the commission, he laid it aside. Only in the early 1830s did the artist devote a final burst of creativity to the altarpiece, completing it in time for the 1834 Salon.

In this instance Ingres had set two novel

Fig. 101. Jean-Auguste-Dominique Ingres, *The Martyrdom of Saint Symphorien*, 1834. Oil on canvas, 13 ft. 4¾ in. x 11 ft. 10½ in. (407 x 339 cm). Cathedral of Saint-Lazare, Autun

70

71

problems for himself. Whereas both the *Vow of Louis XIII* and the *Apotheosis of Homer* were essentially static compositions, he conceived this picture as one full of violent movement. Because he chose to depict the saint on his way to martyrdom, it was full of the implication of violence to come as well. Whereas those earlier monumental paintings involved classically idealized figures shown at moments of spiritual transcendence, this altarpiece contrasted the heroic and impassioned Christians with the ugly and brutish figures of their tormentors, Symphorien's sanctity with Roman thuggery. Never before had Ingres asked himself to reconcile such opposites. Moreover, although chaos was not an artistic subject to which he was naturally disposed, here Ingres chose to place his principal figures amid a milling and unruly throng that pours haphazardly through the city gates. He had a reason for attempting so much that was new and perhaps uncongenial to him. As Georges Vigne has suggested, Ingres painted the picture "with the sole aim of reviving the unanimity [of praise] reaped by the *Vow of Louis XIII*, eclipsed by the recent successes of the Romantics."[2] It is perhaps not surprising that some critics in 1834 found the results confusing. One called the painting a macaroni of serpents. To this day it remains one of Ingres's least admired monumental paintings, although part of the problem also lies in its inaccessibility high on the wall of the cathedral in a little-visited provincial town.

As Ingres worked on *Saint Symphorien* he went through a painstaking process of testing and refining individual figures, compositional groupings, and spatial intervals between figures. This involved the production of preparatory drawings; the Musée Ingres, Montauban, alone contains 180 drawings for the altarpiece.[3] Late in the process, after the poses of individual

figures had been largely determined, Ingres painted the present two studies, as well as a third, related study now in the Musée Ingres.[4] (There may have been more.)

All three paintings are closely related to individual drawings. Graphite squaring lines, visible on the canvases, were used to transfer individual figures. Thus, the mounted proconsul at the center of catalogue number 70 exactly repeats a drawing in Montauban.[5] In these remarkable canvases, Ingres grouped together several figures while largely ignoring the spatial relationships they would share in the final painting. Thus, also in catalogue number 70, Symphorien, arms upraised, and Augusta, reaching out to him from atop the city walls, are only inches apart. The proconsul, directly behind Symphorien and far beneath Augusta in the altarpiece, is here even higher up the picture plane than she is. The rest of the canvas is full of hands and legs and expressive heads forming a kind of collage of incidents from the altarpiece. The second painting, catalogue number 71, concentrates on the brutish Roman executioners, although in the end Ingres seems to have been dissatisfied with some of their poses. Thus, the monumental nude lictor at the right—perhaps the most powerful male nude Ingres ever painted—almost disappears from the final painting. Similarly, the stone-throwing figure, studied in several drawings as well, is compressed in the final work into a small space behind and below Symphorien.

Ingres seems to have followed this unusual procedure—Vigne calls it "patchwork"—in the preparation of other monumental canvases as well, notably the *Apotheosis of Homer*. In that case, however, individual figures were later cut up and sold as separate paintings. Perhaps, as Vigne suggests, the purpose in painting such unexpected canvases was to establish correct color relationships among figures; by

suppressing spatial intervals between them the artist was better able to study color effects.[6] The Winthrop paintings were never exhibited during Ingres's lifetime and became known only when they were exhibited at the artist's posthumous retrospective exhibition in 1867. There they were praised as extravagantly as the altarpiece itself had been denounced in 1834. Théophile Gautier spoke of them as "marvelous debris" that bear comparison with the ruins of ancient Greece.[7]

Christopher Riopelle

1. On the reception of the altarpiece, see Shelton 2001.
2. "[D]ans le seul but de renouveler l'unanimité recueillie autour du *Voeu de Louis XIII*, rendue éphémère par les récents succès romantiques"; Vigne 1995b, p. 189.
3. Vigne 1995a, nos. 500–679.
4. Ternois 1965a, no. 170, illus.
5. Vigne 1995a, no. 521.
6. Vigne 1995b, p. 189.
7. Quoted by Cohn and Siegfried in Cambridge, Mass., 1980b, no. 37.

PROVENANCE FOR CAT. NO. 70: Sold by the artist to Étienne-François Haro, October 13, 1866; consigned by him to the Ingres sale, Hôtel Drouot, Paris, May 6–7, 1867, no. 7 (Fr 7,050); purchased at that sale by Eugène Lecomte; his sale, Hôtel Drouot, Paris, June 11–13, 1906, no. 49 (Fr 9,800); comtesse de Béhague, Paris; acquired from her through Martin Birnbaum by Grenville L. Winthrop, June 1934 (Fr 66,000); his bequest to the Fogg Art Museum, 1943.

EXHIBITIONS FOR CAT. NO. 70: Paris 1867a, no. 12 (as coll. M. Lecomte); Cambridge, Mass., 1943–44, p. 3; Cambridge, Mass., 1977a; Cambridge, Mass., 1980b, no. 36.

REFERENCES FOR CAT. NO. 70: Anon., May 12, 1867, p. 145, no. 7; Delaborde 1870, p. 184, under no. 16; Wyzewa 1907, pl. 27, p. iv, no. 27 (mistakenly as in the Musée de Montauban); Lapauze 1911a, pp. 303, 552 (as coll. comtesse René de Béarn); Mongan 1944a, p. 388 n. 1; Wildenstein 1956a, pp. 208–9, no. 213, pl. 74; Grate 1959, p. 147; Birnbaum 1960, p. 188; Berezina 1967, no. 52; Cambridge, Mass., 1967a, under no. 60; Paris 1967–68, p. 228, under no. 161; Radius and Camesasca 1968, p. 107, no. 127d, illus.; Ternois and Camesasca 1971, p. 107, no. 128d, illus.; Picon 1980, p. 64, illus.; Ternois 1980, p. 182, no. 227, illus.; *Twenty-five Great Masters* 1981, no. 63, illus.; Brown 1985, pp. 52 (illus.), 93 n. 27; Mortimer 1985, pp. 175 no. 199, 176 under no. 200, illus.; Bowron 1990, fig. 276; Zanni 1990, p. 108, under no. 85; Amaury-Duval 1993, p. 246, fig. 210; Stafford 1994, p. 214, fig. 151; *Harvard Review of Philosophy* 5 (spring 1995), cover illus.; Vigne 1995a, pp. 106 above no. 518, 114 under no. 568; Vigne 1995b (English ed.), pp. 189, 192, fig. 159; Bajou 1999, pp. 237, 239, fig. 165; London–Washington–New York 1999–2000, pp. 275, 282, 284,

286–87; Shelton 2001, pp. 711–39, fig. 4; Ternois 2001, p. 149 n. 25.

PROVENANCE FOR CAT. NO. 71: Sold by the artist to Étienne-François Haro, October 13, 1866; consigned by him to the Ingres sale, Hôtel Drouot, Paris, May 6–7, 1867, no. 8 (presumably bought in for Fr 4,000); Étienne-François Haro and his son Henri Haro; their sale, Galerie Sedelmeyer, Paris, May 30–31, 1892, no. 100 (Fr 3,6000); Baron Joseph Vitta, Paris; his sale, Galerie Jean Charpentier, Paris, March 15, 1935, no. 5 (bought in for Fr 13,500); acquired from him through Martin Birnbaum by Grenville L. Winthrop, March 15,

1935 (with cat. no. 54, Fr 200,000); his bequest to the Fogg Art Museum, 1943.

EXHIBITIONS FOR CAT. NO. 71: Paris 1867a, no. 13 (as coll. M. Haro); Nice 1931, no. 9; Cambridge, Mass., 1943–44, p. 3; Cambridge, Mass., 1980b, no. 37.

REFERENCES FOR CAT. NO. 71: Anon., May 12, 1867, p. 145, no. 8; Delaborde 1870, pp. 184–85, under no. 16; Lapauze 1911a, p. 552; Mongan 1944a, p. 388, n. 1; Wildenstein 1956a, pp. 208–9, no. 214, fig. 137; Birnbaum 1960, p. 188 (as purchased from the Countess Béhague); Cambridge, Mass., 1967a, under no. 60;

Paris 1967–68, p. 228, under no. 161; Radius and Camesasca 1968, p. 107, no. 127f, illus.; Ternois and Camesasca 1971, p. 107, no. 128f, illus.; Ternois 1980, p. 182, no. 229, illus.; Louisville–Fort Worth 1983–84, p. 242; Mortimer 1985, p. 175, under no. 199; Bowron 1990, fig. 277; Zanni 1990, p. 108, under no. 85; Amaury-Duval 1993, p. 115, fig. 86; Vigne 1995a, p. 106, above no. 518; Vigne 1995b (English ed.), pp. 189, [191] (fig. 160), 192; London–Washington–New York 1999–2000, pp. 275, 282, 284, 286–87; Shelton 2001, pp. 711–39, fig. 5; Ternois 2001, p. 149 n. 25.

72. *Odalisque with the Slave*, ca. 1837–40

Oil on canvas (mounted on plywood panel in 1875, according to an inscription on the reverse)
28³⁄₈ x 39½ in. (72 x 100 cm)
Signed and dated in black paint, lower left:
J. INGRES / ROM. 1839 *(repainted by Ingres over a partially legible signature and the date 1840)*
1943.251

Ingres's acolyte Henri Lehmann, in a letter to his lover the writer and socialite Marie d'Agoult, neatly summed up why this picture was made and what Ingres thought about it. "Today [Ingres] sent another painting, which was an old obligation to [Marcotte] who had lent him money or had made possible the production of an engraving (I believe of the [Vow of] Louis XIII) by advancing money [to the engraver Calamatta]. The painting is a half-lifesize odalisque, for whom a female slave plays a melody, with a eunuch standing in the background. It is as Turkish as the [*Stratonice*, painted for the duc d'Orléans] is Greek (except for the color). [Ingres] has an astonishing instinct for discovering the smallest details that give definition to the time and the place and an infinite talent for subordinating them to his flawless and exalted taste. Since this painting is not, in its subject, up to M. I[ngres]'s present ambitions, which weigh upon him beyond words, he has complained of everything about it and also that

this gentleman would be finding himself owning, for a very minimal sum, a valuable masterpiece, especially considering that the duc d'O[rléans] had sent 18,000 francs for the *Stratonice*."[1]

Charles Marcotte d'Argenteuil (1773–1864), a friend from Ingres's days as a pensionnaire at the Villa Medici in Rome, a man whom Ingres loved "with all my heart,"[2] went to Rome as one of the hundreds of bureaucrats who administered the French occupation of the Italian peninsula. He was introduced to Ingres by their mutual friend Jacques-Édouard Gatteaux in 1810. Marcotte commissioned his portrait that year and thereafter acquired Ingres's exquisite troubadour genre scene of 1814 *The Sistine Chapel* (both paintings, National Gallery of Art, Washington). When Ingres, proud but almost penniless, returned to Paris from Italy in 1824, Marcotte lent him 800 francs, against a future picture that would serve as a pendant to his *Sistine Chapel*.[3] Two years later Ingres turned to Marcotte for 15,000 francs to finance the engraving of his great success at the 1824 Salon, *The Vow of Louis XIII* (Cathedral, Montauban), and when Ingres made the final repayment of capital in 1834, Marcotte forgave the interest, about 3,700 francs, in return for a painting. Ingres sketched the *Odalisque*

with the Slave (*Odalisque à l'esclave*) on canvas prior to leaving Paris for Rome.

The ébauche, presumably with the sketch for his other unfinished commission *Stratonice*, did not arrive in Rome until spring 1835, four months after Ingres, and it appears that he did not make much progress on these two pictures before summer 1840, when he wrote of completing them as well as *Cherubini avec sa muse*, another holdover from his last days in Paris. The *Odalisque* left Rome on September 18, 1840. The artist wrote Marcotte to inform him that it required a wide but not a deep frame, and he excused "the little bit of eroticism in our painting, I did everything I could to be considerate of the modest, beautiful [?] eyes [of Mme Marcotte]."[4]

Marcotte was, of course, delighted with his picture, and he recognized that its value was far greater than Ingres's debt to him. Ingres's Parisian friends and former students were quick to write congratulations upon seeing it in Marcotte's apartment. To one, Gatteaux, Ingres revealed his surprise at the success for a singular reason: "in this painting many things, if not almost all, are based on drawings, in the absence of a living model (this is just between us), who, in keeping with what you think—and it is also my view—essentially gives life to a work

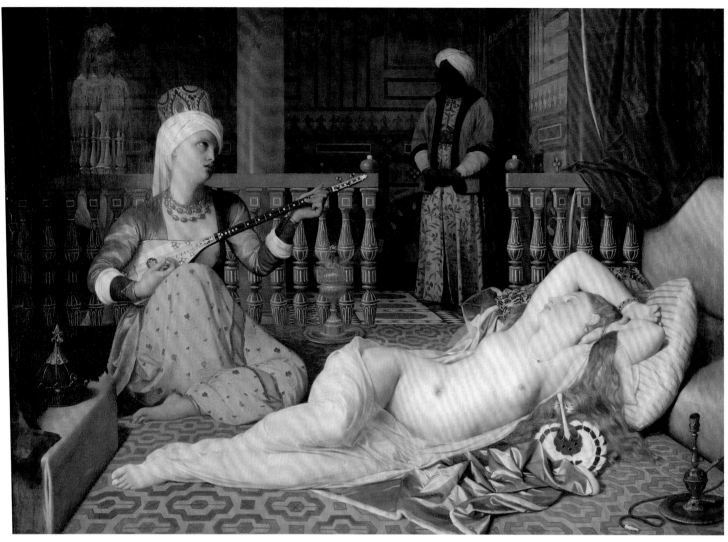

72

Fig. 102. Jean-Auguste-Dominique Ingres, *Sleeping Odalisque*, after 1808. Oil on paper, 11¾ x 18⅞ in. (180 x 229 cm). Victoria and Albert Museum, London (photo: V & A Picture Library)

Fig. 103. Eugène Delacroix, *Femmes d'Alger dans leur appartement*, 1834. Oil on canvas, 70⅞ x 90⅛ in. (180 x 229 cm). Musée du Louvre, Paris, RF 3824 (photo: Réunion des Musées Nationaux)

and makes it pulse."[5] In fact, as all modern scholars have understood, Ingres used drawings that he had made in 1808 or 1809 for the so-called *Dormeuse de Naples* (see fig. 102),[6] the recumbent nude, exhibited in Rome in 1809, that was bought by Joachim Murat, king of Naples. To provide a pendant for that work, Caroline Murat commissioned the *Grande Odalisque* (Louvre, Paris), completed in 1814 but not delivered because of the fall of French occupation. The *Dormeuse* was lost during the same upheaval, and the *Grande Odalisque* was bought by James-Alexandre, comte de Portalès-Gorgier, in 1816. Until the *Odalisque with the Slave* was shown in Paris in the 1840s, only Portalès's guests could have appreciated the erotic aspect of Ingres's aesthetic. All others knew Ingres for his sober altarpieces—*Vow of Louis XIII*, *Martyrdom of Saint Symphorien*—his ceiling at the Louvre, *The Apotheosis of Homer*, his portraits, and his small genre scenes. Hence, the marquis de Custine's perception of Ingres's icy eroticism is fascinating: "A painting by Ingres has restored my spirits after so many false works; it is conscientiously correct; it is an odalisque in the seraglio; you breathe the air of the harem, but this perfumed air is cold, and the sun is absent. The execution is irreproachable, the conception poetic: yet the viewer remains unmoved before the form of a nude woman of Grecian beauty. Another, swarthy woman plays the lute at the feet of the recumbent odalisque, and she plays with an indifference which captures the life of the seraglio; a black eunuch watches the two women from the depths of the room. All this is poetically conceived; it really is the interior of a palace of the East, it lacks only life and color. The painter has depicted his dream; he has painted neither that which he has seen, nor seen that which he thought. This painting is none the less his masterpiece and what is more, a masterpiece. It is privately owned, by one whose name I have forgotten but who lives at 11 rue St. Lazare. Recommend it to the art lovers going to Paris."[7]

The *Odalisque with the Slave* and the *Grande Odalisque* were both exhibited publicly in 1846 and again in the retrospective that Ingres organized for the 1855 Exposition Universelle. Critics naturally compared them to each other.[8] But Théophile Thoré properly recognized that there was one important precedent to the *Odalisque with the Slave*, one that no friend of Ingres could mention without inflaming the master of Montauban—Delacroix's *Femmes d'Alger* (fig. 103).[9] Thoré even suggested that the *Odalisque* and the *Femmes d'Alger* be hung side by side.

With Marcotte's permission, in 1842 Ingres traced the *Odalisque* to create a variant with a landscape background, largely painted by Paul Flandrin, for the king of Bavaria (Walters Art Museum, Baltimore). It is perhaps at this point that Ingres enlarged the Marcotte picture by 30 millimeters on all sides, since this work was carried out in Paris, sometime between Ingres's return in 1842 and the exhibition of 1846. One of Ingres's pupils in Rome, J.-Ch. Thévenin, executed an elaborate grisaille copy of the Marcotte picture for an unrealized engraving. Thévenin's drawing was so esteemed that it was the only replica not by the master to be included in Ingres's 1867 posthumous retrospective. This may be the grisaille now in the Thaw collection at the Morgan Library, New York, where it is attributed to Ingres.

Gary Tinterow

1. Lehmann, letter to Marie d'Agoult, September 18, 1840; English translation based on quotation in Ternois 2001, p. 162.
2. Ingres, letter to Flandrin, December 8, 1840; English translation based on quotation in Ternois 1962, p. 22.
3. The subject discussed at the time was an event in the Borghese Chapel. In September 1825 Marcotte was exploring the idea of the pendant with Léopold Robert (see Ternois 2001, p. 76), and in February 1829 Marcotte wrote Robert that "Ingres m'a

depuis fermé la porte de son atelier, parce que, dit-il, il travaille pour moi un tableau promis lorsqu'il était encore à Rome [crossed out] Florence" (ibid., p. 61, n. 4). I think it unlikely, however, that the *Odalisque* was yet under way. The history of the financial arrangements between Ingres and Marcotte are recorded in a letter from Marcotte to Gatteaux, n.d. (between September 18, 1840, and May 6, 1841), quoted in Ingres 1999, pp. 205–6; English translation by Marjorie B. Cohn in Naef 1969, pp. 82–83.
4. Ingres, letter to Marcotte, September 19, 1840; English translation from quotation in Ingres 1999, no. 40.
5. Ingres, letter to Gatteaux, December 17, 1840; English translation from quotation in Ternois 1986, no. 30.
6. The best indication of the composition of the *Dormeuse* is found in the replica of unknown date at the Victoria and Albert Museum, London (fig. 102). A related pencil drawing, 124 x 226 cm, was sold at Christie's, Monaco, June 16, 1989, no. 68. Other drawings that Ingres must have consulted include Musée Ingres, Montauban, 867.230 (Vigne 1995a, no. 2290); Petit Palais, Paris, 1157; and private collection (formerly Aberconway, London; reproduced in Cooper 1954, no. 134; and Paris 1967–68, no. 182).

The following are known studies from the 1830s for *Odalisque with the Slave*. Compositional studies: Musée Ingres, Montauban, 867.2029, 867.2033. Studies for the sleeping nude: Musée Ingres, 867.2030; possibly Musée Ingres, 867.1209; the drawing sold in 1999 by W. M. Brady and Co., New York. Studies for the slave: British Museum, London (acquired 1886); Musée Ingres, 867.2031, 867.2032. Studies for the eunuch: Musée Ingres, 867.4189. Studies for details: Musée Ingres, 867.1185, 867.1193, 867.1196, 867.2033b, 867.4119, 867.4130, 867.4131, 867.4135, 867.4137.
7. *Lettres du Marquis A. de Custine à Varnhagen d'Ense et à Rachel Varnhagen d'Ense* (Brussels, 1870), pp. 391f.; quoted in Naef 1969 p. 93, n. 11, and in English translation by Marjorie B. Cohn in ibid., p. 84.
8. For example, Amaury-Duval ([1846] in Foucart et al. 1995, p. 271): "Combien la première odalisque est pure, noble et pleine d'une dignité chaste! Combien la seconde a un caractère de sensualisme poétique qui fait contraste!" And Baudelaire ([1846a] 1992, pp. 65–66): "La place nous manque, et peut-être la langue pour louer dignement la *Stratonice*, qui eût étonné Poussin, la *grande Odalisque*, dont Raphaël eût tourmenté, la *petite Odalisque*, cette délicieuse et bizarre fantaisie qui n'a point de précédents dans l'art ancien. . . ."
9. Thoré 1844, p. 298.

Philadelphia; Wildenstein and Co., New York; acquired from them by Grenville L. Winthrop, April 1935 ($75,000); his bequest to the Fogg Art Museum, 1943.

EXHIBITIONS: Paris 1840; Paris 1842 (?); Paris 1846, no. 46; Paris 1855b, no. 3351; Paris 1864a; Paris 1867a, no. 423; Paris 1913, no. 187; Paris 1930b, no. 285; Paris 1931b, no. 48; Cambridge, Mass., 1943–44, p. 4; Cambridge, Mass., 1961, no. 17; Cambridge, Mass., 1967b, no. 3; Cambridge, Mass., 1969, no. 85; Cambridge, Mass., 1980b, no. 41; Tokyo 2002, no. 13.

REFERENCES: Anon. 1840, pp. 343–45; Breton 1840, pp. 67–68; *Le moniteur universel*, November 18, 1840, unpag.; *Nouvelles à la main*, December 20, 1840, p. 104; Anon., March 14, 1841; Varnier 1841, p. 308; Damay 1843, pp. 449–54; Thoré 1843, p. 284; Thoré 1844, p. 298; Amaury-Duval 1846, pp. 88–89; Anon. 1846, p. 96; Baudelaire (1846a) 1992, pp. 65–66; Baudelaire (1846b) 1992, pp. 101, 117; Delécluze 1846 (1995), p. 241; La Fizelière 1846, unpag.; Lagenevais 1846, p. 526; Lenormant 1846, p. 673; Mantz 1846, p. 200; Thoré 1846, p. 56; Anon., February 11, 1846, unpag.; *Journal des artistes*, February 15, 1846, p. 50; Anon., March 8, 1846, p. 42; Magimel 1851, no. 64 (engraving after the painting); de Cormenin 1852, p. 97; Mirecourt 1853, p. 82; Baudelaire (1855) 1976, vol. 2, p. 588; Du Camp 1855, p. 76; Mantz 1855, p. 222; Perrier 1855, pp. 57–58; Petroz 1855; Gautier 1855–56, vol. 1, pp. 157–60; Lacroix 1855–56, p. 206; Amaury-Duval 1856, pp. 247 n. 1, 248 (illus.); Anon. 1856, pp. 113–14, under n. 1; Arnould de Vienne 1856, p. 102; Silvestre 1856, pp. 22–23, 37, 39; Saglio 1857, p. 78; Delaborde 1865, p. 337, under no. 40; Bellier de la Chavignerie 1867, p. 59; Beulé 1867, pp. 22–23; Merson and Bellier de la Chavignerie 1867, pp. 22, 45, 114; *La chronique des arts et de la curiosité*, April 28, 1867, p. 138; Delphis de la Cour 1868, pp. 327, 336; Thoré 1868, pp. 246–47, 250–51; Blanc 1870, pp. 106–7, 119, 233; Delaborde 1870, pp. 99–100, 237–39 no. 78 and under no. 79, 255 under no. 139, 284 under no. 228; Montrosier 1882, p. 16; Fournel 1884, p. 55; Lapauze 1901, pp. 59, 121–22, 235, 249; Mommèja 1904, pp. 94–96; Doucet 1905, p. 128; Lapauze 1905, p. 386; Mommèja 1905, p. 107, above nos. 1253–61; Mommèja 1906, pp. 185–87; Uzanne 1906a, pp. 274, 275 (illus.); Wyzewa 1907, p. iv, no. 29, pl. 29; Finberg 1908, pp. 66–67; Boyer d'Agen 1909, pp. 21, 298–300, 350; Lapauze 1909, pp. 364–65, 373; Dreyfus 1911a, p. 136; Lapauze 1911a, pp. 335–36, [337] (illus.), 344, 350–52; Lecomte 1911, p. 350; Lapauze 1913,

part 2, pp. 90, 92–94, 97, 99, 102–5; Pauli 1913, pp. 549 (illus.), 550; Rosenthal 1914, p. 180; Alexandre 1921, pp. 195–96; Amaury-Duval 1921, pp. 247 n. 1, 248, illus.; Fröhlich-Bum 1924, pp. 25, 62, pl. 49; Fröhlich-Bum 1926, pp. vii, 28, pl. 49; Hourticq 1928, pp. vii, 81, illus.; Bouyer 1931, p. 265, illus.; Underwood 1931, pp. 184–85, illus. facing p. 177; Cassou 1934, pp. 158, 163 (illus.); Cassou 1935, pp. 3, 5; Cassou 1936, pp. 169–70, illus.; Pach (1939) 1973, pp. 71, 95, 99–102, illus. facing p. 179; Christoffel 1940, p. 117, illus.; King 1942, pp. 78–81; Fogg Museum of Art 1943, p. 58; Mongan 1944a, p. 388 n. 1; Cassou 1947, pp. 75–76, pl. 28; Alain 1949, no. 34, illus.; Roger-Marx 1949, no. 39; Scheffler 1949, pl. 39; Alazard 1950, pp. 94, 113–14, 119, 139; Friedlaender 1952, pp. 87, 89–90; New York and other cities 1952–53, under no. 33; Cooper 1954, pp. 140–41, under no. 134; Wildenstein 1954, no. 228, illus.; Clark 1956a, pp. 158, 159 (note), 393; Clark 1956b, pp. 217–19, 498 (note, under p. 219); Schlenoff 1956, p. 252 n. 5, pl. 47; Ternois 1956, pp. 163, 175; Wildenstein 1956a, pp. 210 no. 228, 213, fig. 149; Faison 1958, p. 118, fig. 16; Grate 1959, pp. 240–41; Waroquier 1959, p. 12; Huyghe 1961, vol. 3, no. 930; Ternois 1962, p. 22; Brookner 1964, pp. [272] fig. 23, 276; Angrand 1967, pp. 187, 222; Berezina 1967, pls. 54, 58 (detail); Cambridge, Mass., 1967a, p. x; Cottin 1967, p. 307; Montauban 1967, p. 79 under no. 114; Rosenblum 1967b, pp. 82, 142–45, pl. 38, dust jacket illus.; Paris 1967–68, under nos. 176–82, 198, 255; Florence 1968, pp. 115 under no. 106, 131–33 under nos. 119–21; Rome 1968, pp. 158 under nos. 119–21, 160 under no. 122; Radius and Camesasca 1968, pp. 106–7 (no. 128a, illus.), 117 under no. 167a; Fromont 1969, no. 15, detail illus.; McKim 1969, pp. 190, 191 (illus.), 192; Naef 1969, pp. 80–99, illus.; Peters 1969, pp. 100, 101, illus.; Angrand and Naef 1970, p. 19; Ternois and Camesasca 1971, pp. 106–7 (no. 129a, illus.), 117 under no. 168a; Toussaint 1971, pp. 6 no. 5, 19–20, 21 under no. 21, 32 under no. 52; Connolly 1972, pp. 21, 23 (illus.), 25, 31 nn. 8, 9; Hélène Toussaint in London 1972a, pp. 931–32, under no. 660; Connolly 1974, pp. 45–52; Paris–Hamburg 1974, p. 99; Huyghe 1976, pp. 208 fig. 223, 224; Rizzoni and Minervino 1976, pp. 60–61 fig. 4; Wight 1976, p. 229, illus.; Barousse 1977, p. 162; Hauptman 1977, pp. 124–25, 128, fig. 15; Pansu 1977a, pp. 18–19, 31; Whiteley 1977, pp. 11–15, 70 (no. 52, illus.); Naef 1977–80, vol. 2 (1978), pp. 519, 566, vol. 3 (1979), pp. 230, 371, 436 (fig. 3); Boggs 1978, pp. 487 fig. 1, 488–89; *Grand Collection of World Art* 1978, pl. 18; Philadelphia–Detroit–Paris 1978–79, p. 392, under no. VII-41; London and

other cities 1979, p. 44; Picon 1980, illus. p. 68; Johnston 1982, p. 37, under no. 6; Denny 1983, fig. 7, p. 267; Bryson 1984, pp. 137, 138 (fig. 72), 139–42, 144; Kamboureli 1984, p. 158, illus.; Finn 1985, pp. 126–27, illus.; Mortimer 1985, p. 176, no. 200, illus.; Flam 1986, pp. 158, 191, 194, fig. 190; Ternois 1986, pp. 19, 21, 22, 41–42; Feldman 1987, illus. p. 304; Chase-Riboud 1988, dust jacket illus.; Paris 1989, pp. 46, 47, illus. above no. 49; Christie's, Monaco, June 16, 1989, p. 105, under no. 68; Bowron 1990, fig. 278; Haddad 1990, pp. 102, 114–15 (illus.), 116–17, 170; Kasson 1990, p. 53, fig. 18; Zanni 1990, pp. 110–11, under no. 86, illus.; Innsbruck–Vienna 1991, pp. 157–58, illus.; Ockman 1991, pp. 527, 529, fig. 26; Picon 1991, pp. 44 (illus.), 54, 74–75, 117; Feldman 1992, p. 320, illus.; Westheimer 1993, pp. 16–17, illus.; Helfgott 1994, p. 99, fig. 5; Madrid 1994–95, p. 218, under no. 30, illus.; New York 1994–95, pp. 96–97, under no. 66; Bertin 1995, pp. 106, 108; Foucart et al. 1995, pp. 34, 84 (fig. 59), 112, 123, 195–97, 222, 225, 228, 241, 257, 271, 281, 285; Ockman 1995, pp. 53, 73, 74 (fig. 34), 97, 121, 165 n. 33; Vigne 1995a, pp. 406–8, 440; Vigne 1995b, pp. 201 (detail illus.), 218–23 (fig. 178), 226, 228, 272, 299; Bertin 1996, pp. 60–62; Condon 1996a, pp. 15, 36; Condon 1996b, pp. 841, 844; Galassi 1996, p. 141, fig. 5-11; Leppert 1996, pp. 234 (fig. 9.6), 235–36, pl. 16, 307 nn. 39, 40; Newman 1996, pp. 186 (illus.), 187–88; Roux 1996, pp. 53, 68–69; London 1996–97, p. 118 under no. 58, illus.; New York–Paris 1996–97, p. 360, illus.; Shelton 1997, [vol. 1], pp. x, 159, 175, 216 n. 159, [vol. 2], pp. 246, 247, 302–3 n. 40, 313–14 n.124, 349, 367–74, 376, 419–21 (nn. 124, 126–28, 132–38, 142–43), 438–40, 484, 518, 524, 537 (nn. 42–47), 559–60 (nn. 254–55), 586, 602, 695 fig. 53; Ternois 1997, p. 43; Bajou 1999, pp. 14 (illus.), 246 (detail), 249, 258–63 (fig. 173), 267–68, 271, 310, 313–15; Ingres 1999, pp. 22, 25, 30–32, 35–36, 42, 45–46, 114–19, 166–68, 184, 205–12, 224, 226–28, 240, 242, 247–48, 250; New York 1999, under no. 33, fig. 22; Ribeiro 1999, pp. 179, 205, 208 (detail illus.), 211, 231–36 (fig. 186); Riopelle 1999, pp. 228, 229, illus.; London–Washington–New York 1999–2000, pp. 306 n. 30, 329 fig. 190, 410, 518 n. 79, 531, 551, 552, 555, 556; Brookner 2000, pp. 107–8, fig. 36; Rifkin 2000, pp. 28, 30 (fig. 14, detail), 44, 71; Paris 2001c, pp. 5, 7, 30 under no. 26, 37 under no. 36, 38 under no. 37 (cf. fig. 26), 39 under no. 38 (cf. fig. 27), 45 under no. 50, 48 under no. 55; Powell 2001, pp. 137, 138 (fig. 68); Ternois 2001, pp. 49, 50, 57, 76, 78, 83, 90, 99, 103, 118, 143, 161–66 (entry), 167, 179, 188, 191, 201, 221, 229, 230, 274, fig. 34; Miller 2003, p. 73.

73. *Studies of a Man and a Woman for "The Golden Age,"* ca. 1842

Graphite, squared, on cream wove paper, laid down, traced with a stylus after mounting
16⅜ x 12⅜ in. (41.6 x 31.5 cm)
Signed in graphite, lower left: Ingres
Inscribed in graphite to the right of the woman's knee: cuisses un peu longues
*Watermark: LA * F & G*
1943.861

This drawing belongs to a sequence of studies for a couple destined to be the principal figures in the right-hand foreground of Ingres's initial composition for *The Golden Age* (see fig. 105). As the artist indicated on another sheet, "A young husband introduces his wife into the circle after

their wedding night. She is accompanied by her mother, who arranges her hair and encourages her to overcome her (decent) sense of modesty."[1] Stylus marks suggest that Ingres transferred the outlines from previous studies, although it is also possible that once he was satisfied with the figures

73

identical to Ingres's Adam. Ingres gave Eve the features of Marie-Élizabeth Blavot, wife of his student Clément Boulanger and later the wife of Edmond Cavé, who was in charge of fine arts at the French Ministry of the Interior, and therefore someone with whom Ingres cared to be on the best terms.

The strongly reinforced contours and elegant poses of these two nudes have made this celebrated sheet a favorite of studio art textbooks. Ingres must have understood the particular success of the drawing, since he stopped his habitual process of continual revision in order to finish it. It was one of a group of works that Ingres sold as a lot to the dealer Haro in 1866 to raise a large sum to provide for his wife's eventual widowhood. *Gary Tinterow*

1. Inscribed on the drawing at the Musée Ingres, Montauban, 867.753; English translation from quotation by Vigne in Rome–Paris 1993–94, p. 168.
2. Musée Ingres, 867.756.

PROVENANCE: Sold by the artist to Étienne-François Haro, October 13, 1866; consigned by him to the Ingres sale, Hôtel Drouot, Paris, May 6–7, 1867, no. 45 (Fr 800); purchased by comte Louis-Alexandre Foucher de Careil; with Haro again by 1870; acquired through Martin Birnbaum by Grenville L. Winthrop, January 1936 (Fr 18,000); his bequest to the Fogg Art Museum, 1943.

EXHIBITIONS: Paris 1867a, no. 137; Cambridge, Mass., 1943–44, p. 4; Cambridge, Mass., 1961, no. 10; Cambridge, Mass., 1967a, no. 87; Cambridge, Mass., 1980b, no. 44.

REFERENCES: Anon., May 12, 1867, p. 146, no. 45; Blanc 1870, p. 242; Mongan 1944a, pp. 405, 406 fig. 15; Mongan 1947, no. 20, illus.; Alazard 1950, pl. 85; Shoolman and Slatkin 1950, pp. 122–23, pl. 68; Elgar 1951, p. 11, fig. 69; Sachs 1951, pl. 56; Mathey 1955, p. 20, no. 47, fig. 47; Clark 1956a, pp. 159–60, illus.; Clark 1956b, pp. 218 (fig. 116), 219; Moskowitz 1962, vol. 3, no. 723, illus.; Mendelowitz 1967a, pp. 152 (fig. 7-1), 155; Mendelowitz 1967b, detail illus. on pp. 37, 113; Radius and Camesasca 1968, p. 113, illus. under no. 143; Aymar 1970, pp. 140, 141, illus.; Ottawa 1971, p. 12, pl. 6; Ternois and Camesasca 1971, p. 113, under no. 144, illus.; Mendelowitz 1976, p. 150, fig. 205; Pansu 1977a, no. 75, illus.; Picon 1980, p. 111, illus.; Ternois 1980, p. 101; Ebert 1982, illus. under no. 27; Pignatti 1982, illus. p. 297; Winner 1982, pp. 73, 74, fig. 2.4; Mríz 1983, p. 52, no. 61, illus.; Rawson 1984, fig. 45; Paris 1986a, p. 87, under no. 94; Vigne 1995b, pp. 258 (fig. 210), 259; Alvin L. Clark Jr. in Cuno et al. 1996, pp. 228–29, illus.; Mongan 1996, pp. 228–29, no. 244, illus.; London–Washington–New York 1999–2000, pp. 361 (fig. 205), 397 n. 15.

on this sheet, he traced them for transfer to another sheet. Because a related drawing bears the annotation "un agneau auprès d'eux,"[2] modern scholars have surmised that this couple, representing fecundity, was transformed into a different group, with a lamb, that appears at the left of the final composition, adjacent to the goddess Astarte. But as Georges Vigne remarked, these two figures in fact simply disappeared when Ingres revised his composition, as represented in the drawing of 1843 at the Musée des Beaux-Arts in Lyon. This means

that this drawing was made before the 1843 sheet in Lyon.

In composing his couple, Ingres recalled any number of famous depictions of Adam and Eve, but ultimately this sheet resembles Dürer's celebrated engraving more than any other. Scholars have also cited various sources for the poses in Greco-Roman statuary, but more likely than not Ingres used the book of engravings published in 1832–34 by the comte F. de Clarac, *Musée de Sculpture Antique et Moderne,* in which the Louvre's *Apollon Pythien* is shown in a pose

74. *Madame Frédéric Reiset, née Augustine-Modeste-Hortense Reiset,* 1846

Oil on canvas
23¼ x 18½ in. (59.2 x 47 cm)
Signed and dated, lower right:
J. Ingres P[it] / Enghien 1846.
1943.249

In 1846 Ingres executed one of the most direct, unaffected portraits of his later career—that of Hortense Reiset, whose husband, Frédéric, was an important collector of the artist's work.[1] At the Reisets' Enghien house, Ingres and his first wife, Madeleine, had enjoyed peaceful country pursuits, and at some point in the early 1840s, Ingres had promised to paint Hortense: in August 1845, Ingres wrote Frédéric Reiset from Dampierre to excuse his absence from "your paradise at Enghien." "Alas! Yes, dear sir, it is impossible this year for me to realize so agreeable a plan, not only of seeing you, but also of causing pleasure, a promise that is truly only postponed. But which I am heart set on realizing."[2] With neither the time nor the inclination to attempt one of his extravagant productions, like the portrait of the comtesse d'Haussonville or of Mme Moitessier (fig. 21), he chose a modestly sized canvas and an informal pose to fulfill his "promise," and the likeness he produced was so startlingly realistic that it has been likened to a daguerreotype.[3] Yet the direction of influence is likely reversed, for it is early photography that was made to resemble contemporary portraiture in paint. The steely tonality of Hortense's portrait is closer to that of the comtesse d'Haussonville than to a daguerreotype, and the oval frame, which Ingres had used some forty years before, is simply a flattering shape that photographers, almost all of whom had been trained as painters, had co-opted for their own frames.

Hortense Reiset (née Reiset) was born around 1813 and died in 1893. On November 4, 1835, she married her cousin (her father's brother's son) Marie-Eugène-Frédéric Reiset. Frédéric was the son of Colette Godefroy and Jacques-Louis-Étienne Reizet, Receveur Général des Finances du Département de la Seine-Inférieure and Régent de la Banque de France. In the 1840s, Frédéric emerged as an important collector of Ingres's work, acquiring the portrait of Mme Devaucey, *Venus Anadyomene,* and Ingres's repainted self-portrait of 1804 (all three now at the Musée Condé, Chantilly), as well as several hundred old master drawings. In 1849 he abandoned his life of moneyed leisure to assume the post of curator of drawings at the Louvre. That same year, Reiset comforted and cared for the aged Ingres when he was decimated by the death of his wife. Though the Reisets were intimately associated with the high-ranking bureaucrats loyal to the Bourbon and Orléans regimes, Hortense was named a lady-in-waiting to Princess Mathilde after Louis-Napoléon seized power in his 1848 electoral coup d'état. In 1859 Reiset once again helped the artist when Count Demidov refused *The Turkish Bath,* effecting an exchange for the reworked self-portrait of 1804. In 1861 Reiset was named curator of paintings at the Louvre and in 1874, director of the national museums.

Gary Tinterow

1. This entry is adapted from my remarks in London–Washington–New York 1999–2000, pp. 362, 468–70.
2. Ingres, letter to Reiset, August 22, 1845; quoted from Naef 1977–80, vol. 3 (1979), p. 351.
3. See Scharf 1969, pp. 26–29, and Hauptman 1977.

PROVENANCE: Marie-Eugène-Frédéric Reiset and his wife, Hortense Reiset; their daughter comtesse Adolphe-Louis-Edgar de Ségur-Lamoignon, Méry-sur-Oise; her son comte Louis-Marie-Frédéric-Guillaume de Ségur-Lamoignon, until 1932; acquired through Martin Birnbaum via André Weill by Grenville L. Winthrop, May 19, 1935 (approximately $29,000); his bequest to the Fogg Art Museum, 1943.

EXHIBITIONS: Paris 1855b, under "Supplément: Peinture," no. 5048 (p. 580, as "Portrait de Mme R . . ."); Paris 1911, no. 48; Paris 1921a, no. 40; Amsterdam 1926, no. 61; London 1932, no. 277; Cambridge, Mass., 1943–44, p. 3; Cambridge, Mass., 1967b, no. 4; Cambridge, Mass., 1969, no. 84; Cambridge, Mass., 1977a; Cambridge, Mass., 1980b, no. 47.

REFERENCES: Vignon 1855, p. 192; Lacroix 1855–56, p. 208; Silvestre 1856, pp. 38–39; Saglio 1857, p. 78; Bellier de la Chavignerie 1867, p. 60; Merson and Bellier de la Chavignerie 1867, pp. 23, 117; Blanc 1870, p. 233; Delaborde 1870, no. 151, p. 239; Montrosier 1882, p. 19; Lapauze 1901, pp. 115, 236, 249; Momméja 1904, p. 103; Momméja 1905, p. 139, above no. 1832; Lapauze 1911a, pp. 384–85, 397 (illus.), 442; Lecomte 1911, pp. 337, 350; Gowans & Gray 1913, pl. 29; Rosenthal 1914, p. 180; Amaury-Duval 1921, illus. p. 252; Baker 1921, p. 41, pl. 2C; Zabel 1929, p. 115; Blanche 1932, p. 85, fig. 9; Miller 1938, p. 13, n. 22; Pach 1939, p. 103; King 1942, p. 103, n. 8; Mongan 1944a, pp. 388 n. 1, 406; Bertram 1949, p. XXXI; Alazard 1950, p. 106; Elgar 1951, p. 12, fig. 73; Washington and other cities 1952–53, p. 47, under no. 117; Ford 1953, p. 356 nn. 3, 4; Wildenstein 1954, p. 216, no. 250, pl. 96; Wildenstein 1956a, p. 216, no. 250, pl. 96; Mongan 1957, p. 4; Ternois 1959, above no. 169; Birnbaum 1960, p. 194; Cambridge, Mass., 1967a, p. x, under nos. 88, 94; Paris 1967–68, p. 300, under no. 232; Radius and Camesasca 1968, pp. 112 (illus.), 113, no. 142; Ternois and Camesasca 1971, pp. 112 (illus.), 113, no. 143; Clark 1973, pp. 136, 138 (fig. 99); Whiteley 1977, p. 77, no. 58, illus.; Naef 1977–80, vol. 2 (1978), p. 179, vol. 3 (1979), p. 350, fig. 4; Mortimer 1985, p. 177, no. 201, illus.; Jedding-Gesterling 1988, pp. 185–86, fig. 339; Bowron 1990, fig. 281; Zanni 1990, p. 122, no. 94; Amaury-Duval 1993, p. 336, n. 12; Madrid 1994–95, pp. 26 (illus.), 27; Fleckner 1995, pp. 214, 218–19, fig. 79; Vigne 1995b, pp. 250, 252, fig. 206; Christie's, New York, May 22, 1996, p. 58, under no. 48; Bajou 1999, pp. 308–9, fig. 208; Ingres 1999, p. 248; Ribeiro 1999, pp. 141, 142 fig. 115, 143; London–Washington–New York 1999–2000, pp. 362 (fig. 207), 364, 421, 469 under no. 151, 519 n. 106, 554 under "May 15, 1855."

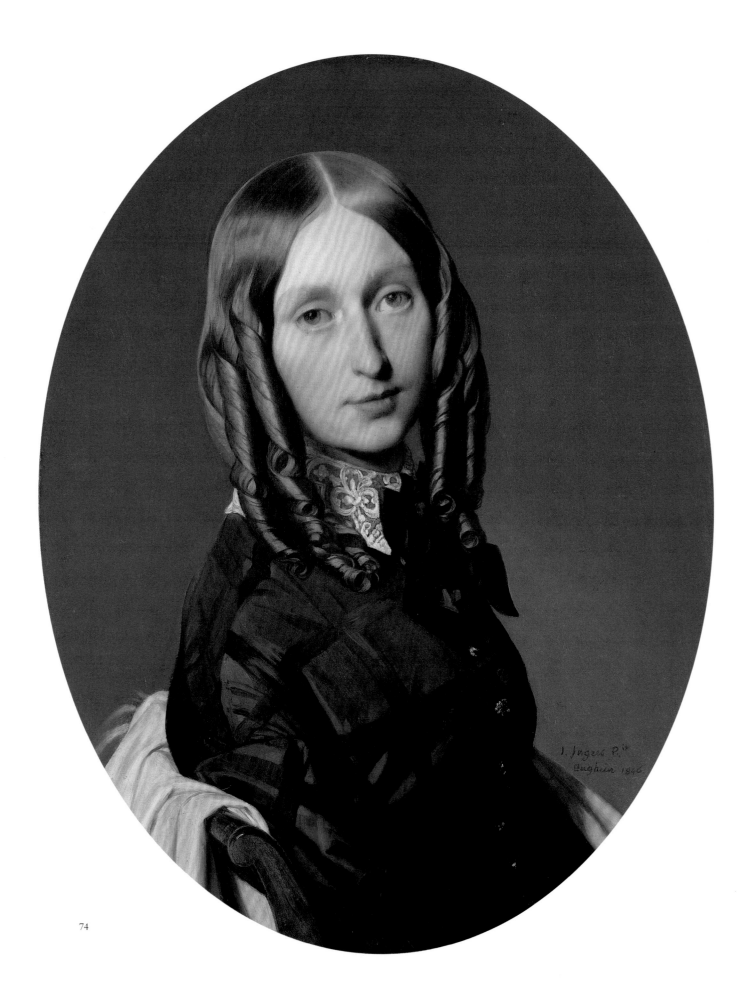

74

75. *Virgil Reading the "Aeneid" to Augustus,* 1850

Watercolor and white gouache over graphite and black crayon, partially varnished with gum, on tracing paper, patched with tracing paper and reworked, laid down
15 1/8 x 13 in. (38.5 x 33 cm)
Signed and inscribed in graphite, lower left:
J. Ingres. inv Del.; *lower right:* Paris 1850.
1943.373

Throughout his career Ingres returned to his favorite history paintings again and again to make replicas and variants in various media and sizes. These were not, for the artist, simple repetitions but rather reconsiderations of his earlier inventions, often marked by subtle modifications. In this watercolor, dated 1850, he took up a subject he had first broached in about 1811 when he received an important commission for a painting from General Sextius-Alexandre-François Miollis, the French governor of Rome. It shows Virgil reading the *Aeneid* to the emperor Augustus, his wife Livia, and his sister Octavia. The latter swoons into unconsciousness as the poet mentions her late son Marcellus, whose marble statue presides over the candlelit room in which they gather. Marcus Agrippa and Gaius Maecenas stand in the shadows at the right. Ingres completed the painting, now much altered, for Miollis in 1812 (Musée des Augustins, Toulouse). Soon afterward he began a second, rather different, version, now cut down, which he intended to send to a future Paris Salon (Musées Royaux des Beaux-Arts, Brussels). (On the history of these two paintings, see cat. nos. 51, 52.) That Miollis's painting held a particular interest for Ingres is evident from the fact that he purchased it back in about 1835, had it restored and enlarged, and kept it for the rest of his life, bequeathing it to Toulouse, the city where he had studied as a young artist decades earlier.

Over the years Ingres continued to work on the theme. In 1822 he made a drawing that he dedicated to his friend Charles Marcotte (private collection). In 1825 he gave the engraver Charles-Simon Pradier permission to make a print after the painting; Ingres was proud of the composition, and this was intended to introduce it to a wider public. The engraving project involved Ingres in further preparatory studies, as he introduced modifications, and in 1830 he executed a detailed drawing, almost identical to the later engraving, from which Pradier seems to have worked (Louvre, Paris, RF 1444). Here, for example, he introduced the pilasters that flank the statue of Marcellus.[1] The engraving was completed in 1832 and shown with some success at the 1833 Salon.

Ingres returned to the composition yet again in 1850 when he signed and dated the present watercolor version, which is very similar to both the Louvre drawing and the engraving. Indeed, it may well be a tracing of the Louvre drawing. It is on tracing paper, and where patched paper had lifted, Cohn and Siegfried noted a pure contour drawing underneath, which may have been made as early as 1830.[2] In 1850 Ingres would have returned to it, mounted it on its present support and completed the picture with the delicate watercolor washes that subtly accentuate the nighttime, candlelit setting. Here, Ingres introduced slight modifications from the Louvre drawing, such as a change in the placement of Virgil's right foot, but this, as Cohn and Siegfried note, was already indicated on a retouched proof of the Pradier engraving. Thus, they are surely correct in concluding that the present watercolor "incorporates many of Ingres's reconsiderations of the extensive changes he had already made to

transform the image of the 1812 painting in the Pradier engraving."[3] Ingres made the watercolor for a friend, Frédéric Reiset, the distinguished collector and curator of drawings, and future director of the Musée du Louvre. (For Ingres's painted portrait of Reiset's wife of 1846, see cat. no. 74.) Near the end of his life, in 1865, Ingres executed one last version of *Virgil Reading,* but this time, perhaps as a sign of satisfaction with the composition he had slowly evolved, he painted it over a proof of the print itself (LaSalle College Art Museum, Philadelphia). *Christopher Riopelle*

1. The pilasters are first seen in this version of the composition of 1830 and not, as Mongan (1996, no. 246) implies, in the present watercolor version of 1850.
2. Cohn and Siegfried in Cambridge, Mass., 1980b, no. 49.
3. Ibid.

REFERENCES: Saglio 1857, p. 78; Delaborde 1861, p. 263; Galichon 1861a, p. 348; Galichon 1861b, p. 41 n. 1; Bellier de la Chavignerie 1867, p. 51; Blanc 1867-68, part 3, p. 199; Merson and Bellier de la Chavignerie 1867, pp. 106–7; Blanc 1870, p. 55; Chennevières (1883–89) 1979, vol. 3 [1886], p. 94; Mongan 1944a, pp. 406–7; Mongan 1947, pp. 9–10, pl. 4a; New York and other cities 1952–53, [p. 3]; Paris 1967–68, p. 160, under no. 111; Radius and Camesasca 1968, p. 93, under no. 69; Mesuret 1969, p. 131 n. 35a; Ternois and Camesasca 1971, p. 93, under no. 70; Naef 1977–80, vol. 3 (1979), p. 357; Mongan 1980, p. 14; Newman 1980, p. 32, fig. 6; Picon 1980, p. 61, illus.; Spike 1981, p. 190; Louisville–Fort Worth 1983–84, pp. 54, 56, 59, fig. 16; Tübingen–Brussels 1986, p. 37; Condon 1995, pp. 60 (fig. 52), 61, no. 67; Mongan 1996, pp. 230–31, no. 246, illus.; Rifkin 2000, pp. [30]–34, fig. 15.

75

76. *The Virgin and Child Appearing to Saints Anthony of Padua and Leopold of Carinthia*, 1855

Graphite, brown ink, watercolor, and white gouache on tracing paper, laid down 10⅜ x 7⅜ in. (26.4 x 18.7 cm) Signed, dated, and inscribed in graphite, lower center: J Ingres. fec. / 1855. / à Madame Ingres *Inscribed in graphite, lower left:* Sᵀ ANTOINE DI PAD.; *lower right:* Sᵀ LEOPOLDUS 1943.375

This exquisitely executed watercolor derives from two of Ingres's key commissions: the 1824 *Vow of Louis XIII* (Cathedral, Montauban) and the 1841 *Virgin with the Host* (State Pushkin Museum of Fine Arts, Moscow). The success of the *Vow* at the Salon of 1824 transformed Ingres's status in Paris from that of a misunderstood outsider to that of celebrated artist. The 1841 commission from the czar of Russia for the *Virgin with the Host* represented international recognition of Ingres's subsequent stature. Since both pictures were sent far from Paris, Ingres thought of them as lost children. It is thus not surprising that when he sought to create small devotional pictures for family and friends toward the end of his life, he turned to these two compositions for inspiration.

In 1852 Ingres painted a small, jewel-like version of the *Virgin with the Host* for the wife of his lifelong best friend, Charles Marcotte, possibly as thanks for having introduced the aged artist to Delphine Ramel, whom he married that year. In it, he repeated the central motif of the czar's *Virgin*, while substituting the czar's saints (Alexander and Nicholas) with those meaningful to Mme Marcotte (Helen and Louis). In the present work, Ingres reproduced the Virgin and Child from his altarpiece in Montauban and placed two saints, Anthony of Padua and Leopold, in the foreground. The arch that frames the altar may derive

from a sketch that Ingres sent to the architect of the Cathedral of Montauban as a proposal for the placement of his altarpiece (private collection, Montauban).[1] The conception of the Virgin and Child in Ingres's *Vow of Louis XIII* depends on Raphael's *Sistine Madonna* in Dresden; the general arrangement of the present watercolor recalls Raphael's *Madonna di Foligno* at the Vatican.

In 1980, Cohn and Siegfried discovered through infrared reflectography the remains of a very different initial composition:[2] the host and ciborium stood on a low parapet, behind which stretched an idealized view of Florence, recalling again Raphael's *Madonna di Foligno*. This scene can now barely be detected through the altar cloth. A tracing of the Virgin with the landscape—and a counterproof—exist at the Musée Ingres, Montauban, though the saints differ on these two sheets (Anthony and Nicholas in the former; Anthony and Alexander in the latter). After this composition was rejected, Ingres inserted the altar and finished the saints on either side.

Ingres's logic in selecting the two saints, Anthony of Padua and Leopold, remains obscure. No relation has been found between these saints or their name days to days or names important to Delphine Ramel or indeed to Ingres. Little explanation is needed for Saint Anthony, patron of lost causes. He was a well-loved figure who in the nineteenth-century represented a myriad of meanings. Saint Leopold, however, is another matter. Leopold of Carinthia (ca. 1080–1136), margrave of Hungary, is revered in Bavaria and Austria as a kindly leader, not as a military man clad in Roman armor. Schlenoff proposed that Ingres intended to portray Saint

Leopard, often referred to as Saint Leopold, a Roman martyr whose story accords better with Ingres's representation;[3] Cohn and Siegfried agree.[4] However, Agnes Mongan proposed intriguingly that Ingres might have been thinking of Saint Léopaire (also known as Léofaire and Nauphary).[5] Saint Nauphary is the name of a small village just outside of Montauban and may thus refer to the artist's birthplace. Perhaps this artist from Montauban, represented by Saint Nauphary, considered himself, after the death of his beloved first wife, Madeleine, a lost cause (Saint Anthony) saved, through the intermediation of the Virgin, by his second wife, Delphine, to whom this rebus is dedicated.

Gary Tinterow

1. Reproduced in Ternois 1967, fig. 2.
2. Cohn and Siegfried in Cambridge, Mass., 1980b, no. 54.
3. Schlenoff 1967, p. 379.
4. Cohn and Siegfried in Cambridge, Mass., 1980b, no. 54.
5. Mongan 1996, no. 251.

PROVENANCE: Given by the artist to his wife, Mme Delphine Ingres, 1855; her sale, Hôtel Drouot, Paris, April 10, 1894, no. 97; (?) Max; his sale, Galerie Georges Petit, Paris, May 11, 1917, no. 64 (Fr 7,600); acquired through Martin Birnbaum by Grenville L. Winthrop, October 1927 ($1,000); his bequest to the Fogg Art Museum, 1943.

EXHIBITIONS: Paris 1867a, no. 109; Cambridge, Mass., 1943–44, p. 4; Cambridge, Mass., 1961, no. 14; Cambridge, Mass., 1967a, no. 106; Cambridge, Mass., 1980b, no. 54, illus.; Tokyo 2002, no. 23.

REFERENCES: Blanc 1870, p. 241; Delaborde 1870, no. 166; *Gazette des beaux-arts* 15 (1877), illus. facing p. 323; Maynard 1877, illus. facing p. 450; Lapauze 1901, p. 149, cf. p. 261; Momméja 1905, p. 148, above nos. 1982–83; Mongan 1944a, p. 411; Schlenoff 1956, pl. 39; Schlenoff 1967, p. 379, fig. 65; Paris 1967–68, under no. 249; Radius and Camesasca 1968, no. 115h, illus.; Ternois and Camesasca 1971, p. 102, no. 116h, illus.; Louisville–Fort Worth 1983–84, pp. 134–35, fig. 4; Condon 1995, p. 65, illus.; Vigne 1995b, illus. p. 295; Condon 1996a, p. 11; Mongan 1996, pp. 235 (illus.), 236, no. 251.

76

FRENCH SCHOOL 197

77. *Portrait of Étienne-Jean Delécluze*, 1856

Graphite and white chalk on cream wove paper
13⅛ x 9⅞ in. (33.2 x 25.1 cm)
Inscribed, signed, and dated in graphite, lower
right: Son ami et ╱ condisciple Del.ᵛⁱᵗ ╱
J. Ingres ╱ 1856
Inscribed in graphite, upper right:
M.ᴿ J. DELECLUSE.
1943.849

Delécluze entered the studio of Jacques-
Louis David in late 1796, not quite one year
before Ingres. Along with Granet and
Gros, Ingres and Delécluze worked in
provisional ateliers set up in the disused
Capuchin convent in the rue de la Paix
between 1801 and 1805. Although friendly,

they did not remain close, and Ingres's
friendships with other colleagues from
his student days—Bartolini, Gatteaux,
Granet—were much more significant over
the next two decades. However, when
Ingres returned to Paris from Italy in 1824,
Delécluze must have loomed larger in

Ingres's life, since he was then the principal art critic for the *Journal des débats*, perhaps the most important intellectual paper in Paris. Until 1863 Delécluze continued to write for the *Journal*, which was run by Louis-François Bertin. Ingres's 1832 portrait of Bertin is perhaps the most famous of his works in the genre, epitomizing in its almost savage realism the ascendancy of bourgeois power in a society still rocked by revolution. It has never been established how Ingres came by this commission, but it is not unlikely that Delécluze was the intermediary.[1]

Just as Ingres's portrait of Bertin is a kind of projected self-portrait of uncompromising probity, so too is Ingres's late portrait of Delécluze invested with a strong dose of self-regard. In 1856 both Delécluze and Ingres were now lonely survivors of the glorious school of David, whose authority had been strongly challenged by the rise of Romanticism and, now, Realism. One of Ingres's recent projects had been to ensure that the display of fine arts exhibited at the 1855 Exposition Universelle privileged the Davidians, whereas Delacroix and his supporters (principally the duc de Morny) proposed to limit the display to living (and hence more modern) artists. A compromise was reached, but there can be no doubt that Delécluze was at Ingres's side on this issue: his *Louis David, son école et son temps* was published in 1855 to coincide with the fair. In this history of David and his heritage, Delécluze sketched a warm and flattering portrait of his old school chum: "[A]nother student David accepted into his school at that time, and who not only distinguished himself by the guilelessness of his nature and his tendency toward solitude, but who also, as soon as he arrived, showed evidence of real talent . . . was M. Ingres. Like Granet, Ingres has changed neither in his physiognomy nor in his conduct since his adolescence. . . . What

is true of his person is no less so of his character, which has retained a fundamental quality of simple goodness that never makes concessions to anything unjust and wrong; and of his mind, which has stayed in the same realm. . . . When he entered David's studio, Ingres had just arrived from Montauban, his native city, where, from childhood, he had studied the art of painting under his father's direction. . . . At the school, he was one of the most studious, and that temperament, combined with the seriousness of his character and the absence of the lively instinct that in France is called esprit, was the reason he took very little part in all the unruly mischief that went on around him; thus he studied with more consistency and perseverance than most of his schoolmates [*condisciples*]. . . . Everything that today characterizes this artist's talent—the subtlety of line, the accurate and profound sense of form, and an extraordinary soundness and strength in the modeling—all these qualities were visible even in his first efforts."[2]

In his portrait of Delécluze, Ingres refers back to this passage, not only through the inscription on the book at the writer's elbow (the other book is Delécluze's 1856 *Les beaux Arts dans les deux mondes*), but also through the inscription: the unusual word "condisciple" appears in the passage cited above.

Gary Tinterow

1. As far as I know, it has never previously been proposed that Delécluze made this introduction. I thank Asher Miller, research assistant at the Metropolitan Museum, for this suggestion.
2. Translated from Delécluze (1855) 1983, pp. 84–85.

PROVENANCE: Given by the artist to Étienne-Jean Delécluze, 1856; his nephew Adolphe-Étienne Viollet-le-Duc, 1861; his widow, Mme Viollet-le-Duc, née Louise-Stéphanie Girard; her son-in-law Alfred Vaudoyer; his son Léon-Jean-Georges Vaudoyer, by 1911; acquired through Martin Birnbaum by Grenville L. Winthrop, December 1934 (Fr 82,500); his bequest to the Fogg Art Museum, 1943.

EXHIBITIONS: Paris 1861, no. 49; Paris 1893, no. 256; Paris 1911, no. 176; Paris 1921a, no. 126; Paris 1934,

no. 43; Cambridge, Mass., 1943–44, p. 10; Cambridge, Mass., 1967a, no. 107; Cambridge, Mass., 1980b, no. 56.

REFERENCES: Saglio 1857, p. 79; Blanc 1861, p. 191; Delaborde 1861, p. 267; Galichon 1861a, p. 357; *L'intermédiaire des chercheurs et curieux*, 1ère année, no. 5 (May 1, 1864), p. 68; *L'intermédiaire des chercheurs et curieux*, 1ère année, no. 6 (June 1, 1864), pp. 93–94; Delaborde 1870, p. 294, no. 280; Jouin 1888, p. 49; Centenaire du *Journal des débats* 1889, illus. facing p. 472; Bouchot 1893, pp. 208–10, illus. facing p. 310; Duplessis 1896, p. 11, pl. 7; Lapauze 1901, p. 250, cf. p. 265; Pereire 1914, p. 110; Waldemar George 1934, illus. p. 199; Baschet 1942, pp. 61, 414, 439, illus. facing p. 40; Mongan 1944a, pp. 401–3, fig. 12; Alazard 1950, p. 107, pl. 99; Schlenoff 1956, pp. 295 n. 2, 301 n. 4, pl. 5; Del Litto 1966, p. 198, illus.; Holt 1966, pl. 6; Cohn 1969, pp. [16] (fig. 1), 17; Feinblatt 1969, pp. 262, 265, fig. 6; Mongan 1969, pp. 148, [162], fig. 35; Naef 1977–80, vol. 1 (1977), p. 22, vol. 3 (1979), pp. 506, 512–13, vol. 5 (1980), pp. 362–64, no. 440, illus.; Ternois 1980, p. 104; Dijon 1981, p. 11; Delécluze 1983, illus. facing p. 265; Arikha in Houston–New York 1986, p. 5; Tübingen–Brussels 1986, p. 35, illus. p. 36; Taylor 1987, illus. facing p. 209; Arikha 1991, p. 159; Amaury-Duval 1993, p. 241 n. 5, fig. 207; Arikha 1995, p. 162; Vigne 1995b, p. 321, n. 4; Mongan 1996, no. 252, illus.; Ternois 1998, pp. 8, 10 (fig. 4), 63 n. 5; Bajou 1999, p. 328; London–Washington–New York 1999–2000, p. 515, n. 8.

78. *Portrait of Alfred-Émilien O'Hara, Comte de Nieuwerkerke, 1856*

*Graphite and white chalk, with stumping around
beard and left hand, on cream wove paper,
darkened*
13 x 9⅝ in. (33 x 24.3 cm)
*Inscribed, signed, and dated in graphite,
lower right:* hommage du / plus affèctueux /
dévouement / Ingres – / 1856.
1943.855

The relationship between Ingres and the
comte de Nieuwerkerke, which bore its
greatest fruit in this magnificent portrait
drawing, is revelatory of the character of
both artist and subject. In 1856 each occu-
pied an exalted position: Ingres had just
been given an honor greater than that of
any other artist at the 1855 Exposition Uni-
verselle, and Nieuwerkerke was de facto
minister of fine arts (though such a minis-
try did not yet exist) for the government
of Napoleon III. Yet while Nieuwerkerke
and Ingres often assisted one another, they
were more often in opposition, and they
never were friends.

They first met when Alfred-Émilien
O'Hara (1811–1892), comte de Nieu-
werkerke, an aspiring but mediocre sculptor
living in Paris, appeared, unsolicited, to
defend Ingres against a foolhardy challenge
to a duel in 1846.[1] Ingres was surprised but
delighted to learn that a perfect stranger had
delivered him from disaster.[2] Nieuwerkerke
must have seen Ingres, who had been an
intimate of the duc d'Orléans, eldest son of
King Louis Philippe, as a vehicle to social
as well as artistic advancement. He was
mistaken, but he had already made a much
more important alliance, starting an extra-
marital affair with Mathilde Bonaparte
(1820–1904), a niece of Napoleon I and a
cousin of the future Napoleon III, at the
house of her husband, Count Anatoly
Demidov, prince of San Donato. In 1846
she divorced and took up residence in Paris.

Upon the election of Louis-Napoléon as
prince-president after the Revolution of
1848, Princess Mathilde had Nieuwerkerke
named director of the national museums.

Ingres was already suspicious of Nieu-
werkerke, who lost no time in gathering
power at the expense of old institutions to
which Ingres belonged, such as the Institut
de France and the Académie des Beaux-
Arts. Nevertheless, in January 1852 Ingres
invited Nieuwerkerke to his studio, and in
March 1853 the count provided Ingres with
working space at the Louvre. It was after
Ingres's promotion to grand officer in the
Legion of Honor at the 1855 Exposition
Universelle that the artist made Nieu-
werkerke's portrait.

Here, Ingres shows us the "successful
Goliath, elegant, polished and polite, the
eye full of sweetness," as the Goncourts
described him.[3] Ingres gave him the pose of
Titian's *Man with a Glove* at the Louvre.[4]
Like several presentation portraits that
Ingres made after his return from Rome

in 1842, this work is heightened with white
chalk. If the drawing of the drapery and
hands lacks the incisive vigor of Ingres's
portraits of the 1810s, the rendering of the
face is delicate and fine. A number of small
pentimenti are visible; typically Ingres
adjusts the costume, and here one sees that
he raised the left shoulder by adding an
extra fold of fabric, just as a tailor might
install an extra pad to flatter the client.
Ingres impresses the viewer with the count's
noble bearing; the haughty stare implies
discernment. Nieuwerkerke is in the formal
attire with decorations that he would wear
to a state dinner or a soiree at the house of
Princess Mathilde or a ball at the opera.

The portrait was immediately engraved
and published in *L'Artiste*, the principal
trade publication in Paris.[5] It is difficult to
discern whether there is irony in the caption:
"[T]he portrait engraved by M. Riffaut is
one of the most confident works of the
fertile old age of M. Ingres."[6] Théophile
Gautier's enthusiasm was equally unalloyed:

Fig. 104. Jean-Auguste-
Dominique Ingres, *Le roi
Midas et son barbier*, 1863–
64. Graphite and wash,
19½ x 17¾ in. (49.5 x 45 cm).
Département des Arts
Graphiques, Musée du
Louvre, Paris, RF 30574
(photo: Réunion des
Musées Nationaux)

hommage du
plus affectueux
dévouement
Ingres
1856

78

"One knows that the pencil of M. Ingres, in its sureness and majestic perfection, gives to the most rapid sketch the value of an antique cameo. It seems that painting can add nothing to this line so pure, so knowing, so confident. We will not speak of the merit of the resemblance, since on this M. Ingres is without rival; he represents at the same time the exterior of the man and the interior, the form and the spirit."[7] By 1863, however, the Goncourts—who could not have been nastier about Ingres— noted that "Nieuwerkerke himself, who knows absolutely, but absolutely nothing about this [drawing and another he had by Ingres], finds them less beautiful since he has argued with M. Ingres over the terrible Campana affair."[8]

The Goncourts allude to one of a series of Nieuwerkerke's initiatives that displeased the aged artist. First, Ingres and other artists fueled violent opposition in the press to the cleaning of paintings at the Louvre, including works by Raphael; as a result, the curator of paintings, Frédéric Villot, resigned.[9] A year later, in 1861, Napoleon III purchased in Italy, at great expense, the Campana collection of Greek vases and Italian primitive paintings, some twelve thousand objects in all. Ingres's student Sébastien Cornu was named curator of the collection, but in 1862 Nieuwerkerke and Frédéric Reiset, the current curator of paintings at the Louvre and a close friend of Ingres, proposed distributing the majority of the collection among provincial museums. When the Institut de France objected, Nieuwerkerke responded "The Institut is [just] a coterie and incapable of judging art."[10] Ingres sent letters of protest that eventually reached the desk of the emperor, prompting Nieuwerkerke to publish an open letter contradicting Ingres.[11]

Then Nieuwerkerke signed a decree on November 13, 1863, to restrict the prerogatives of the Académie des Beaux-Arts, which controlled the École Impériale des Beaux-Arts, the Prix de Rome, the Académie de France in Rome, and naming the jury of the annual or biannual Paris Salon. As director of museums, superintendent of fine arts, and vice president of the Commission des Monuments Historiques, Nieuwerkerke had taken control of all the fine-arts institutions in France. Ingres was again in the forefront of opposition.[12] But the eighty-three-year-old artist was essentially powerless. Nieuwerkerke responded by rehanging Ingres's paintings at the

Musée du Luxembourg in a dark corner.[13] In turn, Ingres made a drawing showing Nieuwerkerke as King Midas with the ears of a jackass; in Ingres's day, a Midas was "an ignorant man stripped of all artistic feeling."[14] This elaborate drawing, with an inscription dedicating it to "all Midases, Past, Present, and Future" (fig. 104), looks as if it was conceived to be engraved and published, although the imperial censors would have prohibited it. Edgar Degas owned a dozen studies for it.[15]

It is ironic, though not surprising, that Nieuwerkerke was an officer of the memorial committee that organized Ingres's posthumous exhibition in 1867. Needless to say, the drawing of Nieuwerkerke as Midas was not exhibited until 1900.

Gary Tinterow

1. See Naef 1969. It appears that Ingres's beloved disciple Henri Lehmann may have been the intermediary who brought Nieuwerkerke into this affair; Compiègne 2000–2001, p. 13.
2. Chennevières (1883–89) 1979, vol. 2 [1885], p. 84.
3. Translated from Goncourt and Goncourt 1989, vol. 1, p. 917, under entry for January 3, 1863.
4. Although traditionally this pose has been identified with the painting by Titian (Musée du Louvre, Paris, 757), the reference (Compiègne 2000–2001, p. 81) is inexact. Titian's portrait is, by Renaissance standards, informal and accessible; Ingres's Nieuwerkerke is quite the opposite. Among the paintings at the Louvre, the closest match to Ingres's

Nieuwerkerke is Hyacinthe Rigaud's *Louis XIV* (Louvre, 7492), and if this was Ingres's intention, the message is unmistakable.
5. Another engraved copy was made in 1857 by François Dien (1787–1865); the plate was deposited at the Chalcographie du Louvre.
6. Translated from *L'artiste*, ser. 6, 2 (August 3, 1856), p. 70.
7. Translated from Gautier 1858.
8. "He showed us next to his bed two pencil drawings by Ingres: his portrait and *Philémon et Baucis* [now at the Musée Bonnat, Bayonne]. I am always afraid of destruction, when I see such things of the most miserable of all of our painters: to think that if nothing remained of him, M. Ingres might still be left! But many other things—and this I hope for—happily will remain: two unfortunate schoolgirl drawings, labored, dry, maimed, and stupid—worse than stupid, inane!" Translated from Goncourt and Goncourt 1989, vol. 1, p. 917, under entry for January 3, 1863.
9. Ingres reputedly informed the emperor that "the future will know how to judge this assassin severely"; translated from quotation in Amaury-Duval (1878) 1924, p. 223.
10. Translated from quotation in Ternois 2001, p. 63.
11. He wrote, "I regret, Sir and dear colleague, that I do not always find myself in accord with your opinion on works of art, and, respecting individual opinions, I cannot prevent myself from expressing mine, since I believe them to be well founded"; letter by Nieuwerkerke, published by Piot, reprinted by Naef 1977–80, vol. 3 (1979), pp. 536–37. This public contradiction irritated Ingres enormously, and his friends wrote to one another to express their concern for Ingres's well-being; see Ternois 2001, p. 63.
12. Uncharacteristically, Ingres published a point-by-point refutation of the proposal; reprinted in Naef 1977–80, vol. 3 (1979), pp. 538–41.
13. *Roger Freeing Angelica* and *Cherubini and the Muse of Lyric Poetry*. Hippolyte Flandrin wrote Ingres in September 1863 to convey his dismay at the hanging; Bertin 1998, p. 28.

14. Translated from Larousse 1866–90, vol. 11, pp. 232–33.
15. New York 1997–98, vol. 2, p. 77, nos. 670–81.

PROVENANCE: Comte Émilien de Nieuwerkerke, 1856; presumably his sole heir, Countess Lorenzo Altieri; Count Alessandro Contini Bonacossi, Rome; Jacques Seligmann and Co., New York, June 1928; acquired by Grenville L. Winthrop, November 1928 ($6,000); his bequest to the Fogg Art Museum, 1943.

EXHIBITIONS: Paris 1861; London 1862, no. 236; Paris 1867a, no. 381; Cambridge, Mass., 1967a, no. 108; Cambridge, Mass., 1980b, no. 57.

REFERENCES: Arnould de Vienne 1856, p. 102; *L'artiste*, ser. 6, 2 (August 3, 1856), p. 70 (Adolph-Pierre Riffaut, reproductive lithograph [1856] after the portrait drawing of Nieuwerkerke by Ingres); François Dien, reproductive engraving (1856 or 1857) after the portrait drawing of Nieuwerkerke by Ingres published in 1857; Saglio 1857, p. 79; Gautier 1858, p. 69; Galichon 1861b, p. 47; Merson and Bellier de la Chavignerie 1867, p. 120; Blanc 1870, p. 239; Delaborde 1870, p. 308, no. 384; Chennevières (1883–89) 1979, vol. 2 [1885], pp. 84–85; Henriet 1893, p. 1; *Le journal des arts*, January 25, 1893, p. 2; Henriet 1894, pp. 227, 235 (detail illus.), 237; Lapauze 1901, pp. 250, 267; Lemoisne 1920, p. 293; Miller 1938, p. 14; Mongan 1944a, pp. 400–401; Rewald 1961, p. 142, illus.; Angrand 1967, pp. 248–49 n. 2; Mongan 1969, pp. 148, [161], fig. 34; Naef 1977–80, vol. 3 (1979), pp. 514, 516, 543–44, vol. 5 (1980), pp. 360–61, no. 439, illus.; Picon 1980, illus. p. 87; Ternois 1980, pp. 104, 157, illus.; Ternois 1986, p. 60 n. 1; Tübingen–Brussels 1986, pp. 35–36, illus.; Paris 1986a, p. 29, under no. 25; Goncourt and Goncourt 1989, vol. 1, p. 917, under entry for January 3, 1863; Vigne 1995b, pp. 309–10, fig. 267; Mongan 1996, pp. 238–39, no. 253, illus.; Bajou 1999, p. 328, fig. 218; London–Washington–New York 1999–2000, p. 371, fig. 218; Compiègne 2000–2001, pp. 15, 81, under no. 23; Ternois 2001, p. 158.

79. *The Martyrdom of Saint Symphorien,* 1858

Graphite, gray wash, and white gouache over partial stylus outlining on white modern laid paper
18¾ x 16 in. (47.9 x 40.5 cm)
Inscribed in graphite, lower left: J. Ingres f^t
Delineavit; *lower left of margin:* J. Ingres inv.^it.
Pinxit et Del.; *right margin:* 1858
Verso: inscribed with a statement by Henry
Lapauze
Watermark: S^te Anne
1943.845

79

In an affectionate letter written in August 1858 to his old friend Charles Marcotte, Ingres described how he was filling his days during his summer vacation outside of Paris at Meung-sur-Loire, at the family home of his second wife, Delphine Ramel. "To fill all the intervening gaps I work 4 5 6 hours during the day amusing myself there making drawings, trying to perfect my own works. I did the Saint Symphorien, the Romulus, a colored one of Charles X in coronation robes, and others."[1] It was typical of Ingres to want to perfect his compositions, and characteristic to make copies, especially in his old age, when he increasingly viewed his career retrospectively, with an eye to leaving the most succinct statements of his aesthetic philosophy. However, his choice of subjects in summer 1858 seems particularly strange, ranging from the severely Davidian *Romulus* to the medievalizing *Charles X* to the strongly Raphaelesque *Saint Symphorien,* indicating perhaps that these compositions represented milestones in his career more than artistic triumphs.

The large altarpiece depicting the martyrdom of Saint Symphorien (whose saint's day is August 22) was robustly criticized when it was finally exhibited at the Salon of 1834, and this was the source of great unhappiness for its author. Commissioned in 1824 for the cathedral of the Burgundian town of Autun, where Symphorien was decapitated in the third century for refusing to worship idols, Ingres's picture was understood as a manifesto for his sect of the cult of Raphael, and as a countermanifesto to Romanticism (see fig. 101). Ingres had always been sensitive to any criticism but the fervor with which writers attacked his picture provided him with a pretext to accept the offer of the directorship of the French Academy in Rome in order to leave Paris and its critics behind.

In this drawing of 1858, Ingres followed the intricate and interlocking forms of the finished picture quite closely, but scholars agree that he probably based it on an 1838 lithograph by Trichot-Garneri:[2] there are marks of stylus tracing. It is not certain, however, why the drawing is squared. If, as it is assumed, Ingres intended this drawing to be a presentation piece, then the squaring mars its beauty, and any scaffold necessary for the creation of the drawing would have been less insistent. (Perhaps Ingres intended to color the drawing and thereby obscure the squaring.) Some writers have

speculated that the drawing was subsequently squared for transfer for a reproductive work, either in lithography or etching. This is possible, and it is noteworthy that the drawing appeared in a sale in Paris only two years after it was made: Ingres rarely sold sheets like this; it lacks the dedication that all of his gifts carry, so it may well have been used by an engraver and subsequently sold. It quickly became well known through the 1861 exhibition at the Salon des Arts Unis, Ingres's 1867 posthumous retrospective, and the 1875 album of photographs of works by Ingres assembled by the artist's friend Édouard Gatteaux. Nevertheless, when the drawing first appeared at sale in 1860, one critic remarked that the price was only half of that achieved by a pastel by Decamps.[3]

Martin Birnbaum recalled in his memoirs that the purchase of this drawing was one of the early triumphs of his career.[4] He asked the famous expert Henry Lapauze to inscribe a certificate of authenticity on the back, and he then took it to John Singer Sargent, who was known to hold Ingres in high regard. "The masterly Ingres drawing

put him into his gayest mood, and there was a sort of rapture to his narrative. . . . Sargent pointed out the virtues of the French master, and recalled the legends woven around him and his models, adding that 'When the Saint Symphorien was first exhibited, a critic noted that the arms of the mother holding the frightened child were too large. "That had to be so," replied Ingres, "in order to show how passionately she loved her child." Degas,' continued Sargent, 'although a disciple of Ingres, would not have felt the same way, for Degas had a cold scientific vision and intellect.'"[5] In 1855, Degas stopped in Autun and sketched a detail of Ingres's altarpiece in his notebook.[6]

Gary Tinterow

1. Ingres, letter to Marcotte, August 20, 1858; English translation from quotation in Ternois 2001, p. 174.
2. This lithograph is rare. An example with retouching by Ingres is known to have belonged to the artist's widow and then to L. Duval-Destan in 1870; its present whereabouts are unknown.
3. Speaking of the sale of the Decamps pastel *Josué* for Fr 25,000, Emile Perrin said, "on demandait à peine la moitié de cette somme du dessin de M. Ingres . . . je ne sais pas même si cette oeuvre magistrale a trouvé un acquéreur"; quoted in Mosby 1977, p. 10.

4. Birnbaum 1960, p. 187.
5. Birnbaum 1941, p. 15.
6. Theodore Reff, *The Notebooks of Edgar Degas* (London, 1976), p. 20, no. 10, Bibliothèque Nationale, carnet 3.

PROVENANCE: Unidentified sale, Paris, 1860; Galerie Francis Petit, Paris; Isaac Pereire, Paris, by 1864; Galerie [Emile and Isaac] Pereire sale, Paris, March 6–9, 1872, no. 27 (Fr 9,100); a "French collector"; his sale, Hôtel Drouot, Paris, March 31, 1914, no. 14 (Fr 4,010); (?) Schoeller; Scott and Fowles, New York; acquired through Martin Birnbaum by Grenville L. Winthrop, October 15, 1920 ($7,500); his bequest to the Fogg Art Museum, 1943.

EXHIBITIONS: Paris 1860, no. 52; Paris 1861; Paris 1867a, no. 118; Cambridge, Mass., 1943–44, p. 3; Cambridge, Mass., 1961, no. 18; Cambridge, Mass., 1980b, no. 58.

REFERENCES: Gautier 1860, pp. 323–24; Perrin 1860, pp. 860–61; Galichon 1861a, p. 346; Bürger 1864, p. 199; Blanc 1870, p. 241; Delaborde 1870, p. 268, no. 171; Gatteaux [1873] (1st ser.), pl. 1; Gatteaux 1875, pl. 41; Lapauze 1901, p. 250; Lapauze 1905, p. 388; Lapauze 1911a, p. 512; Birnbaum 1941, pp. 14–15; Mongan 1944a, p. 411; Schlenoff 1956, pl. 30 facing p. 225; Birnbaum 1960, pp. 187–88; Durbe 1965, fig. 2; Paris 1967–68, p. 226, under no. 161; Cambridge, Mass.–New York 1965–67, under no. 44; Radius and Camesasca 1968, p. 106, under no. 127; Ternois and Camesasca 1971, p. 106, under no. 128; Mosby 1977, vol. 1, pp. 10, 282, nn. 41, 42; Ternois 1980, p. 79; Louisville–Fort Worth 1983–84, pp. 25 (illus.), 248–49, 251; Houston–New York 1986, p. 73; Sotheby's, New York, May 22, 1986, under no. 5; Condon 1995, pp. 70 (fig. 61), 71, no. 80, fig. 61; Mongan 1996, pp. 238–40, no. 254, fig. 254; Tulsa–Jacksonville–Hanover 1996–97, pp. 192–93, under no. 61, fig. 6; Ingres 1999, pp. 174–76, under no. 105 (cf. pp. 153 [no. 1], 254, 258).

80. *Self-Portrait*, 1859

Oil on paper mounted on canvas
25 ⅝ x 20½ in. (65 x 52 cm)
Signed in black paint, lower left: JA / Ingres
1943.253

The authenticity of this work, one of three related self-portraits executed between 1859 and 1865, has been doubted by scholars throughout the twentieth century, begin-

ning with Lapauze in 1911 and continuing with Daniel Ternois as recently as 2001. At issue is the thin scumbling of the face, in contrast with the highly finished details of the decorations and clothing. Lapauze's doubts and concern about some flaking of the painted surface provoked sufficient misgivings with Winthrop's agent Martin Birnbaum that he declined to purchase the

painting from Ingres's heir, Emmanuel Riant, when the opportunity presented itself in May 1929. Yet Birnbaum, whose judgment has often been confirmed by history, felt strongly about the quality of the work and he believed it to be authentic. "[N]ow I have had time to investigate & study and I know he [Lapauze] was wrong. It seems that he never saw the portrait until

80

years after his book was published. . . . ”[1] Birnbaum wrote that he had found a holograph copy of Ingres's will in which this portrait and the pendant portrait of the artist's wife Delphine Ramel are identified as having been "painted in my own hand."[2] Wildenstein and Company later bought the painting from Riant and sold it to Winthrop.

In 1980 Cohn and Siegfried advanced an explanation for the discrepancy between the execution of the head and accessories: they proposed that the Winthrop picture had been painted on paper by Ingres as the ébauche for the portrait completed in 1858 for the Uffizi in Florence and that it was subsequently cut out and mounted onto a larger canvas to show the gloved hand at right and the cape at left.[3] The Winthrop picture then served as the model for the similar portrait sent by Ingres to the Academy in Antwerp in 1864. According to Ingres's list of autograph works in Notebook X, the Winthrop picture, a pendant to the worldly portrait of his wife Delphine, would have been completed in 1859. It was his gift to her.

At The Metropolitan Museum of Art in 2000, during the exhibition "Portraits by Ingres," it was possible to examine the Winthrop, Uffizi, and Antwerp portraits together for the first time. Comparison revealed that the internal dimensions of all three are nearly identical. Infrared reflectography of the three pictures showed faint but confident underdrawing in the Winthrop portrait, more extensive but equally assured underdrawing in the Uffizi portrait, and a rather hard, traced underdrawing in the Antwerp portrait.[4] These previously unknown facts confirm the hypothesis of Cohn and Siegfried and suggest that the Winthrop portrait did indeed begin as a sketch painted by Ingres. The image was then transferred in pencil (by Ingres or an assistant) to the blank canvas of the Uffizi portrait, which Ingres then revised

before the picture was painted (probably by an assistant, with some retouches by Ingres). To make the Antwerp portrait, an assistant traced the Winthrop picture, which remained in the artist's possession, and transferred the image to a fresh canvas. This last work was probably painted by an assistant, although the glazes of the face are applied with a freedom that imitates that sketchlike quality of the Winthrop picture, leading the present writer to think that Ingres himself painted the face.

The Winthrop portrait, and hence the other two as well, was based on a photograph taken about 1855 by the studio of Gerothwohl and Tanner.[5] Despite some speculation to the contrary, it would seem to be the only known instance of a direct photographic source for one of Ingres's portraits. In finished form, the Winthrop portrait appears closest to the photograph: the face of the Uffizi picture is more youthful; but Ingres flattered himself nonetheless in the portrait he gave to his wife, giving himself brown hair when it had gone gray, slimming his figure, and adding all the decorations he had earned over the course of his career. The cape that falls nonchalantly from his shoulders represents a memory of the dashing self-portrait that Ingres painted in 1804, when he was twenty-four, and repainted about 1850.

Gary Tinterow

1. Birnbaum, letter to Winthrop, May 24, 1929, Harvard University Art Museums Archives.
2. Birnbaum, letter to Winthrop, May 24, 1929, Harvard University Art Museums Archives. It is not certain which document Birnbaum refers to. Ingres's will does not list the individual works that the artist left to his wife, "ma bien-aimée épouse à laquelle je donne et lègue tous mes biens meubles et immeubles, créance, argenterie et bijoux et le surplus de mes tableaux, dessins, gravures, etc." When this painting was sold to Winthrop in 1937, Wildenstein and Co. furnished information from Ingres's estate, as provided by Maître Marcel Paillat, notaire, 87 rue de Rennes, Paris. In the posthumous inventory, no. 34 is "Un portrait de M. Ingres par lui-même." The same portrait reappears in Mme Ingres's posthumous inventory, but the characterization "par lui-même" was made by someone other than the artist.

However, in Notebook X, Ingres's autograph list of works compiled at various moments from 1850 until December 31, 1866 (some two weeks before his death), this work appears as "deux portraits buste. Peints. moi et Delphine."
3. Cohn and Siegfried in Cambridge, Mass., 1980b, no. 59.
4. See Hale 2000, pp. 206–7.
5. Illustrated in London–Washington–New York 1999–2000, p. 462.

PROVENANCE: Mme Delphine Ingres, née Ramel, the artist's widow; her nephew Albert Ramel; his widow, Mme Ramel, by 1887; her son-in-law Emmanuel Riant; Wildenstein and Co., New York; acquired from them by Grenville L. Winthrop, May 25, 1936 ($45,000); his bequest to the Fogg Art Museum, 1943.

EXHIBITIONS: Montauban 1862, no. 542; Paris 1867a, no. 96; Paris 1911, no. 65; Paris 1921a, no. 51; Cambridge, Mass., 1943–44, p. 4; Cambridge, Mass., 1961, no. 3; Cambridge, Mass., 1967a, no. 5; Cambridge, Mass., 1980b, no. 59.

REFERENCES: Anon., April 26, 1862; Debia 1862; D'Arpentigny 1864, p. 11; Bellier de la Chavignerie 1867, p. 60; Merson and Bellier de la Chavignerie 1867, p. 122; Delaborde 1870, p. 253, no. 131; Gatteaux [1873] (2nd ser.), pl. 57; Gatteaux 1875, pl. 65; Lapauze 1901, pp. 10, 250, under Cahier X; Boyer d'Agen 1909, p. 445, under no. LXXXI; Lapauze 1911a, p. 532; Bénédite 1921, illus. p. 325; *La renaissance de l'art français* 1921, illus. p. 270; Pach 1939, p. 130, illus. facing p. 274; Adlow 1943, p. 5; Fogg Museum of Art 1943, p. 59, illus.; Fogg Museum of Art 1944, cover illus.; Mongan 1944a, p. 388, n. 1; Richardson 1944, pp. 66–67, illus.; New York and other cities 1952–53, [p. 6]; Wildenstein 1954, pp. 223 (fig. 172), 224–25 (no. 292), 231, under no. 316; Wildenstein 1956a, pp. 223 fig. 172, 224 no. 292; Birnbaum 1960, pp. 190–91; Ternois 1965, under nos. 25, 191; Cambridge, Mass., 1967a, pp. x–xi; Schlenoff 1967, p. 376; Paris 1967–68, p. 330, under no. 254; Florence 1968, pp. 8 under no. 7 bis, 39 under no. 36; Radius and Camesasca 1968, p. 116, no. 160b, pl. 57; Scharf 1969, pp. 27–29; Ternois and Camesasca 1971, p. 116, no. 161b, pl. 57; Huyghe 1976, p. 182, illus.; Whiteley 1977, frontis.; Marcia 1978, pl. 54 (detail); Naef 1977–80, vol. 3 (1979), pp. 21 n. 2, 203 n. 2; Spike 1981, p. 190; Zanni 1990, p. 140, under no. 108; Mexico City 1994, p. 166; Vigne 1995b, pp. 295–96, fig. 251; Bajou 1999, p. 328; Ingres 1999, pp. 173 n. 4, 177 n. 8, 250; London–Washington–New York 1999–2000, pp. 366 (fig. 212), 368, 462–64 (fig. 285), under nos. 148–49; Hale 2000, pp. 206–7; Ternois 2001, pp. 47, 48 n. 16, 182.

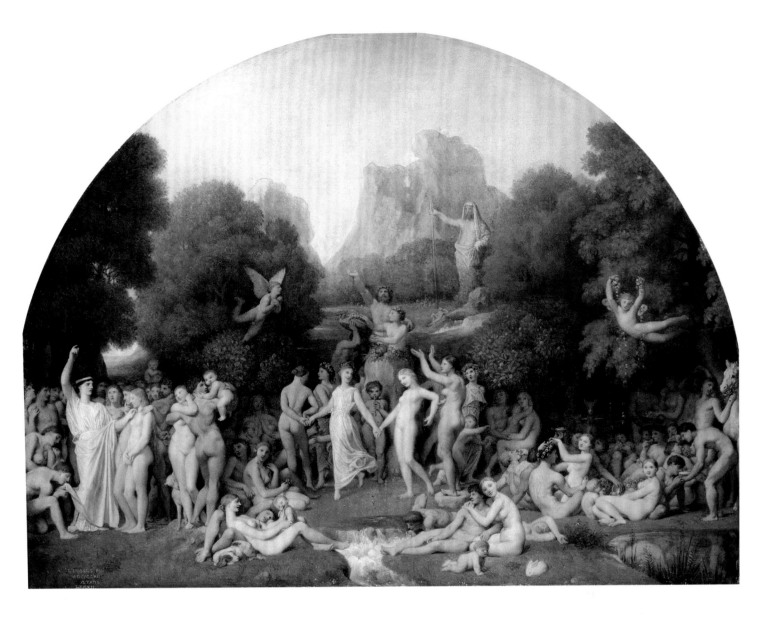

81. *The Golden Age,* 1862

Oil on paper (graphite underdrawing visible in spandrels at right), laid down on panel 18¼ x 24⅜ in. (46.4 x 61.9 cm)
Signed, dated, and inscribed in white paint, lower left: I. INGRES PIN^T/ MDCCCLXII/ AETATIS/ LXXXII
1943.247

In September 1839, Honoré-Théodore-Paul-Joseph d'Albert, duc de Luynes, commissioned two murals from Ingres for the great hall of his castle Dampierre, then being rebuilt and redecorated under the supervision of the talented architect Félix Duban.¹ The hall was to be dedicated to Minerva, and an enormous reconstruction by Charles Simart of an ancient statue of the goddess was to be placed before one

of the murals. Ingres wanted nothing more than to paint large murals, professing disgust with portraiture, so it was with great excitement that he embarked on the commission. After thinking about it for some thirty months, he wrote of his plan to Gilibert in the summer of 1843: "I have taken the Golden Age decidedly as the ancient poets imagined it. *The people of that generation . . . lived long lives and were . . . good, just, and loved one other . . . and Saturn contemplated their happiness from Heaven.* I needed a little activity to bring all these people onto the stage. I found it in a religious sensibility. They are all united in an elevated clearing, where there is a trellis

and trees heavy with fruit. A man, accompanied by a young boy and girl, voices a noble prayer. . . . Then groups of happy lovers and happy families with their children are scattered about. . . . All this in a very varied nature, à la Raphael. A young girl crowns her lover with flowers, others kiss their children. Such are the principal ideas. I have a little model in wax [to study] the effect of the shadows, and I count more than sixty figures."²

Although the arched format of *The Golden Age* (fig. 105) was borrowed from Raphael's Vatican *Stanze,* its conception was loosely based on works by Antoine Watteau, whom Ingres regarded highly.

Fig. 105. Jean-Auguste-Dominique Ingres, *The Golden Age*, 1842–47. Oil on plaster, 15 ft. 9 in. x 21 ft. 8 in. (480 x 660 cm). Château de Dampierre, Yvelines

Modern scholars have found a closer resemblance to neoclassical compositions by Anton Rafael Mengs, Étienne Delécluze, Ingres's colleague in David's studio, and a recent painting by Dominique Papety, *Un rêve de bonheur* (Musée Antoine Vivenel, Compiègne); a variety of sources in works by Giulio Romano, Agostino Carracci, and Poussin have also been cited. Ingres spent part of each year during 1843–47 at Dampierre, working with assistants such as Alexandre Desgoffe and Amédée Pichot, who executed, respectively, the landscape of *The Golden Age* and the architecture of its companion piece, *The Iron Age*, which was never completed. He himself made some five hundred drawings of the individual figures,[3] including some, such as the sheet of lovers also in the Winthrop collection (cat. no. 73), that are of extraordinary quality. Seeking to rival Raphael, Ingres had decided to execute the murals in oil on plaster, a medium akin to fresco, with which he was not familiar. It required a quick and decisive technique, with almost no possibility of reworking, and was vastly different from his customary oil-on-canvas technique, which involved laying in, scraping down, revising, and correcting. He made great progress in the summers of 1843 and 1844, but when the duc de Luynes saw *The Golden Age* for the first time at the end of

Ingres's stay during the latter year, he was shocked both by the nudity and the profusion of figures and by the slow rate of completion. Work progressed further, but the campaign of 1847 would be the last for, demoralized by the 1848 revolution and the death of his beloved wife in 1849, he never completed the project.

Much later, in 1862, Ingres preserved the fruits of his labor in this small but exquisite reduction. It was made at a time when the artist, happily remarried, was interested in organizing his artistic legacy. As he wrote to Marcotte in September 1862, "the little painting of the Golden Age . . . is a grand and new composition and . . . will enhance my artistic stock left to this world."[4] The composition was not entirely new, but instead based on a tracing, now in Lyon (Musée des Beaux-Arts), that shows all of the figures of the Dampierre mural nude, though at the scale of the Winthrop reduction. There are differences, however, between that tracing and both the large mural and the Winthrop picture, indicating that the composition was constantly changing, though Ingres continued to refer to the numerous drawings that he had made for the mural. Here the allegorical figures representing the three seasons (of antiquity) that dance around the altar are carefully identified by their wreaths, and Saturn has

been given a prominent position at the center of the scene.

Ingres finished the painting in November 1862,[5] had it photographed,[6] and exhibited it in his studio in 1864 alongside the portrait of his second wife, Delphine (Oskar Reinhart Collection, Wintherthur), the self-portrait now in Antwerp (Koninklijk Museum voor Schone Kunsten), the replica of *Homer Deified*, and *The Turkish Bath* (Louvre, Paris).[7] Every new work by Ingres was an object of curiosity among influential circles in Paris; the event was duly noted in the press. Philippe Burty wrote admiringly in the *Chronique des arts*: "[There is n]othing as chaste as all this nudity, as innocent as these activities, as childlike as these poses. This is truly the youth of the world. No violent emotion has furrowed the brows, no work has wearied the muscles. The fluttering breezes only caress bodies young, fresh, and pure."[8] In the list of works he recorded in Notebook X, Ingres included this picture among the "paintings to show if I wish at the Exposition, 1867."[9] Death intervened, but it was included in his 1867 memorial exhibition.

Gary Tinterow

1. This text has been adapted from remarks in London–Washington–New York 1999–2000, pp. 360–61, 365.
2. Ingres, letter to Gilibert, July 20, 1843, in Boyer d'Agen 1909, pp. 364–66; English translation from London–Washington–New York 1999–2000, pp. 360–61.
3. The number represents a count made by Henry Lapauze (1911a, p. 408), who identified some 400 at Montauban and stated that others were burned in the fire that destroyed Gatteaux's house in 1871.
4. Ingres, letter to Marcotte, September 10, 1862; Ingres 1999, p. 185.
5. Ingres, letter to Marcotte, November 3, 1862; ibid., p. 186.
6. Ternois 1980, pp. 47, 50 n. 20.
7. Lapauze 1905, p. 387.
8. Translation from quotation in Blanc 1870, p. 206.
9. Translation from quotation in Lapauze 1905, pp. 395–96.

PROVENANCE: Ingres sale, Hôtel Drouot, Paris, April 27, 1867, no. 1 (bought in); Mme Delphine Ingres, née Ramel, the artist's widow, 1867; her

nephew Albert Ramel, by 1887; his widow, Mme Ramel (d. 1928); her heirs; acquired from them through Martin Birnbaum by Grenville L. Winthrop, January 29, 1929 ($57,000 for cat. nos. 50 and 81); his bequest to the Fogg Art Museum, 1943.

EXHIBITIONS: Paris 1864b; Paris 1867a, no. 421; Paris 1911, no. 63; Paris 1921a, no. 49; Cambridge, Mass., 1943–44, p. 3; Cambridge, Mass., 1961, no. 11; Cambridge, Mass., 1967b; Cambridge, Mass., 1977a; Cambridge, Mass., 1980b, no. 60; Tokyo 2002, no. 1.

REFERENCES: D'Arpentigny 1864, p. 11; Burty 1864, p. 204; Anon. 1867, p. 137, under no. 1; Lagrange 1867, p. 75; Blanc 1870, pp. 205–6; Delaborde 1870, pp. 199–200, no. 27; Gatteaux [1873] (1st ser.), pl. 6; Lapauze 1901, pp. 146, 250; Momméja 1904, p. 107; Lapauze 1905, pp. 387, 395; Momméja 1905, p. 114 n. 1; Uzanne 1906b, illus. p. 279; Wyzewa 1907, p. v, pl. 33; Boyer d'Agen 1909, pl. 73 (as "Château de Dampierre"); Lapauze 1911a, pp. 527 (illus.), 540; Lapauze 1911b, pp. 304–7, illus.; Lecomte 1911, pp. 337, 351; Saunier 1911, pp. 8, 32 (illus.); Gowans & Gray 1913, pl. 40; Fröhlich-Bum 1924, pl. 74; Fröhlich-Bum 1926, p. viii, pl. 74; Pach 1939, pp. 106–7, 136, [258], illus.; King 1942, p. 101, illus.; Mongan 1944a, p. 388 n. 1; Richardson 1944, p. 67; Alazard 1949, pp. 248, 249 n. 6; Alazard 1950, pp. 103, 151 n. 12; Sachs 1951, p. 94; Friedlaender 1952, p. 88, fig. 48; New York and other cities 1952–53, [p. 6]; Wildenstein 1954, p. 227, no. 301, pl. 87; Schlenoff 1956, p. 278, pl. 35 facing p. 256; Wildenstein 1956b, p. 227, no. 301, pl. 87; Schlenoff 1959, pp. 23–[24], fig. 7; Birnbaum 1960, p. 190; Elsen 1965, pp. [291] (fig. 5), 294; Cambridge, Mass., 1967a, p. x, under no. 87; Rosenblum 1967b, pp. [167]–69, pl. 47; Viguié 1967, p. 542; Paris 1967–68, p. 286, under no. 218; Radius and Camesasca 1968, p. 113, no. 143b, illus.; Ternois and Camesasca 1971, p. 113, no. 144b, illus.; Méras 1972, p. 22; London 1975, under no. 108; Huyghe 1976, p. 231, fig. 249; Prat 1976, p. 31; Rizzoni and Minervino 1976, p. 74, fig. 1; Hardouin-Fugier 1977, fig. 3; Pansu 1977a, pp. 19, 27, illus.; Pansu 1977b, p. 102; Whiteley 1977, p. 81, no. 62, illus.; London and other cities 1979, pp. 46–47, under no. 68; Naef 1977–80, vol. 3 (1979), p. 423; Giry 1980, pp. 56–57, fig. 2; Picon 1980, pp. 114–15, illus.; Ternois 1980, pp. 108, 141, illus.; Giry 1981, pp. 23, 111, fig. 43; Nakayama and Takashina 1981, no. 41, illus.; Pressly 1981, pp. 203–4, pl. 140; Spike 1981, p. 190; Twenty-five Great Masters 1981, no. 58; Ebert 1982, no. 27; Louisville–Fort Worth 1983–84, pp. 18, 19, illus.; Flam 1986, pp. 158–59, fig. 152; Houston–New York 1986, p. 87, illus.; Ockman 1986, pp. 26–27, fig. 12; Ternois 1986, pp. 22, 58–61; Germer 1988, p. 508, fig. 22; Dardel 1989, pp. 64–65, illus.; Geller 1989, no. 11; Nochlin 1989, pp. 135–37, fig. 3; Paris 1989, pp. 56–57, illus.; Bowron 1990, fig. 312; Zanni 1990, pp. 123–24, no. 95, illus.; Innsbruck–Vienna 1991, pp. 263–64, fig. 109; Picon 1991, p. 86, illus.; Whitfield 1991, pp. 150–51, fig. 127; Canvas Seeks the Light 1992, p. 88, fig. 4-37; Herbert 1992, p. 121, fig. 63; New York 1992–93, pp. 54–55, fig. 32; Neoclassic Art 1993, no. 82; Vigne 1995a, p. 304; Vigne 1995b (Eng. ed.), pp. 307–8, fig. 263; Condon 1996a, pp. 15, 36; Ternois 1997, pp. 47, 50 n. 19; Bajou 1999, pp. 294–95, fig. 197; Ingres 1999, p. 185, n. 3, under no. 116; London–Washington–New York 1999–2000, p. 361, fig. 206; Flam 2000, pp. 20–21, fig. 3; Quimper–Angers 2000–2001, p. 133, under no. 69, fig. 50; Ternois 2001, pp. 31–32, 35 n. 41, 36–37 (entry), 46, 47 n. 22, 98.

82. *The Betrothal of Raphael and the Niece of Cardinal Bibbiena*, 1864

Graphite, watercolor, and white gouache on tracing paper, laid down
7⅞ x 6¼ in. (19.9 x 16 cm)
Inscribed in graphite in margin, lower left:
J. Ingres P.IT.; *center:* LE CARDINAL DA BIBIENA
FIANCE SA NIECE A RAPHAEL; *right:* 1864
1943.374

Joachim Murat, one of Napoleon Bonaparte's most talented associates, met Napoleon's sister Caroline in 1787 and married her in 1800. Eight years later, the French emperor installed the couple as king and queen of Naples. Ingres was already in Italy and had been introduced to Lucien Bonaparte, who was then living in Rome to escape his overbearing brother. In 1809, Joachim Murat made his first purchase from Ingres: the large, nearly lifesize female nude later known as *La Dormeuse de Naples* (lost). Soon the Murats commissioned a pendant to their nude, the

Grande Odalisque of 1814 (Louvre, Paris), a portrait of Caroline (1814; private collection), and two genre pictures, *Paolo and Francesca* (Musée Condé, Chantilly) and the *Betrothal of Raphael* (fig. 106).

The *Betrothal* was one in a series of small, exquisite pictures in the troubadour style that depicted celebrated lovers (Paolo and Francesca, Roger and Angelica) or moments in the lives of Renaissance monarchs (Charles V, Francis I, Henri IV) or artists (Tintoretto, Leonardo, and most especially, Raphael). Ingres was particularly attached to his "Life of Raphael" and continued to paint and draw variants throughout his life (see cat. no. 53): his self-identification with Raphael is legendary. It is no surprise then that he conceived the *Betrothal* in autumn 1813, at the time when his mail-order bride, Madeleine Chapelle, arrived in Rome. (They married on

December 4, 1813.) In May 1814, Ingres bragged to his friend Marcotte, "I have made a good job of a Picture showing the Cardinal of Bibiena who is giving his niece to Raphael in marriage. This work will strike you—if I don't betray great delight since I polished and finished it in twenty days, which I tell you because when one does well it is even more Glorious to be quick."[1]

In his notebooks, Ingres listed Vasari, Baglione, Passeri, Baldinucci, and Comolli as his literary sources for his life of Raphael.[2] However, the *Betrothal* does not appear on his initial list of subjects[3] or on the original 1812 commission of eight pictures from Caroline Murat.[4] For the composition, Ingres relied on an amalgam of visual sources: Raphael's *Marriage of the Virgin* (Brera, Milan) for the central group;[5] Raphael's *Portrait of Bibbiena*

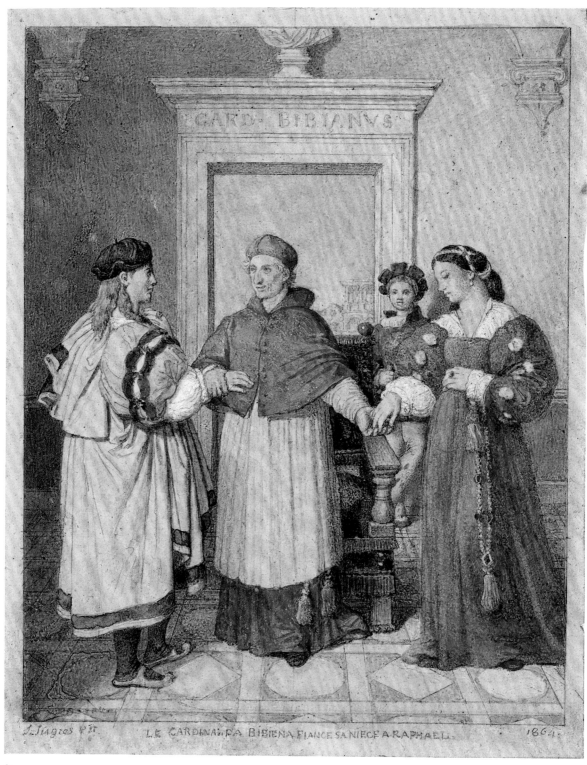

82

Fig. 106. Jean-Auguste-Dominique Ingres, *The Betrothal of Raphael and the Niece of Cardinal Bibbiena*, 1813–14. Oil on canvas, 23¼ x 18⅛ in. (59 x 46 cm). Walters Art Museum, Baltimore, 37.13

(Palazzo Pitti, Florence),[6] of which Ingres made a watercolor copy (Musée Ingres, Montauban, 867.3755), for the cardinal; Raphael's *Portrait of Bindo Altoviti* (National Gallery of Art, Washington) for the figure of Raphael. He may have used a tracing, now at Montauban (867.1390), in order to think through adjustments for the figure of the Fornarina: in the tracing her hand was

at first extended to touch the cardinal's skirt; Ingres then revised the tracing to show her hand retracted as it was in the Murat painting. The Murat painting was delivered, but Ingres was not paid: the fall of Murat and the abdication of Napoleon had as immediate an effect on Ingres as it did on western Europe. As far as the artist was concerned, the painting was lost until it reappeared in Naples in 1852, but he managed nonetheless to reconstruct the composition in a drawing of about 1825 (Louvre, RF 1449), which he mistakenly inscribed with the date 1812. In that drawing, Ingres corrected his earlier version by having Raphael's fiancée extend her hand to meet the cardinal's palm. An 1851 engraving by Réveil, made with Ingres's participation, was based on the 1825 drawing.

In 1864, the eighty-two-year-old Ingres, happily married to his second wife, Delphine Ramel, decided to make a final watercolor of his composition. The present watercolor was based on a tracing of the 1825 drawing, but it shows all the details of all the preceding versions: the Fornarina's hand was at first extended to the cardinal's skirt; then moved to rest in his hand; the cardinal's chair, missing in the Réveil

engraving, is back; and the page, barely visible in the Murat painting, is back to the proportions he has in the Réveil engraving.

Gary Tinterow

1. Translated from quotation in Ternois 2001, p. 59.
2. Schlenoff 1956, pp. 137–38.
3. Delaborde 1870, pp. 327–28.
4. Ibid., p. 280.
5. It is also possible, as Asher Miller has suggested to me, that a memory of Dürer's woodcut *The Marriage of the Virgin*, which Ingres copied, is lurking here as well.
6. This was one of the paintings sequestered by Napoleon from Florence. It was exhibited at the Louvre from 1799 to 1815. Ingres's depiction of Bibbiena also resembles another picture by Raphael, *Portrait of a Cardinal*, which Ingres may have known from an engraving.

PROVENANCE: Possibly Mme Delphine Ingres, née Ramel, the artist's widow; Louis Kronberg, Paris; acquired from him through Martin Birnbaum by Grenville L. Winthrop, June 4, 1928 ($2,500); his bequest to the Fogg Art Museum, 1943.

EXHIBITIONS: Cambridge, Mass., 1943–44, p. 4; Cambridge, Mass., 1967a, no. 115; Cambridge, Mass., 1980b, no. 62.

REFERENCES: Lapauze 1901, p. 250; King 1942, p. 105, n. 52; Mongan 1944a, p. 411; Schlenoff 1956, pl. 18; Paris 1967–68, p. 96, under no. 63; Radius and Camesasca 1968, p. 95, under no. 76; Ternois and Camesasca 1971, p. 95, under no. 77; Ternois 1980, p. 108; Louisville–Fort Worth 1983–84, illus. p. 19; Paris 1983–84, p. 133, under no. 135; Amaury-Duval 1993, p. 105, n. 9; Condon 1995, pp. 76 (fig. 66), 77 no. 86; Vigne 1995b, illus. p. 115; Condon 1996a, pp. 11 no. 86, 17; Mongan 1996, no. 255, illus.; Ternois 2001, p. 102.

83. *The Rape of Europa*, 1865

Watercolor, gouache, and graphite, with gum varnish, on tracing paper, laid down
11⅞ x 16¾ in. (30.1 x 42.5 cm)
Inscribed in graphite, lower left: J. Ingres E.[it] sur un Trait de vase grec. 1865.; *above the erased inscription:* [?] d'un Dauphin, / chargé peutêtre d'un amour ou de quelque Divinité marine / moschus dit que les Néréides portées sur des Dauphins accompagnerent / jupiter en chantant l'hymenée.; *lower center:* ENLEVEMENT

D'EUROPE. / Pline parle d'un tableau d'Antyphile qui reprsente [sic] Europe / Peut etre cette composition est elle une imitation de cet ouvrage celebre / ou une autre de Pythagoras Peintre et Sculpteur., *over an erased inscription of the same text; lower right:* NEPTUNE couronné d'une feuille de pin / il ordonne à la mer d'etre Calme., *over an erased inscription of the same text*
1943.378

As Marjorie Cohn and Susan Siegfried have remarked, this is Ingres's last original composition, made at a time when the aged artist preferred to rework compositions that he had previously elaborated.[1] However, this charming watercolor, with its deliberate and archaic naiveté, was traced by Ingres directly from an engraving in an 1813 album of Greek vases published by

James V. Millingen (fig. 107).[2] That, of course, renders the composition unoriginal, although it conforms to Ingres's preference to base almost all of his late work on tracings or transfers from existing pictures. Until recently, it was assumed that Ingres had copied the group from plate 27 in volume 1 of Charles Lenormant and Baron J. de Witte's *Élite des monuments céramographiques* (Paris, 1844), since the artist's personal copy of that work is now in the Musée Ingres, Montauban. However, Michael Perlmutter, a Harvard student, discovered the source in Millingen in 1980.[3] Both prints reproduce a third-century B.C. Greek red-figure vase that entered the collection of the British Museum, London, in 1846.[4] Although the internal dimensions of all the principal elements in Ingres's watercolor match those of the engraving in Millingen's album, some changes, such as the slimming of the figure of Eros, or the placement and contours of Europa's feet and drapery, suggest that Ingres may have also consulted the illustration in Lenormant and de Witte while working on this sheet, making a marriage of the two illustrations. Throughout, Ingres appears to have delighted in working on the sheet, whether using washes of yellow and blue to create depth in the sea, lavishing attention on the sea creatures, or inventing the playful Galatea and her retinue. The source for that little group in the upper left corner of the sheet has not been identified, though the style of drawing and the ghostly technique

suggest engraving on antique gems. (Similar figures may be seen in the background of Ingres's *Venus Anadyomene* [Musée Condé, Chantilly].) The inscription at the bottom of the sheet, partially erased, represents Ingres's understanding of the comments in Millingen, while the colors correspond to Ovid's description of the event.[5]

Hans Naef noticed the similarity of the figure of Poseidon to that of Perseus in a print by Francesco Garzoli (after a drawing by Gaetano Bianchi) that was found among Ingres's papers and is now at Montauban. Naef saw the Garzoli *Perseus* reflected in both the figure of Saturn in *The Golden Age* at Dampierre (see fig. 105) and in the figure of Poseidon in the Winthrop watercolor.[6] There is evidence that Ingres had, in fact, integrated elements of the Poseidon figure in that of Saturn in *The Golden Age*. On a sheet of notes and sketches among the studies for Saturn at Montauban, Ingres wrote, ". . . galerie mythologique / de Millin / –nouvelle galerie / mythologique. . . ."[7] The length of Saturn's right forearm and the position of the right hand, which rests on a staff, confirms the connection to Millingen—as opposed to Garzoli, where Perseus's right forearm is longer and his hand is extended palm up in order to assist the descending Andromeda. It seems that Ingres looked to the Garzoli for a solution as to the position of Saturn's legs, since these are only suggested beneath the drapery in the Millingen.[8]

Gary Tinterow

1. Cohn and Siegfried in Cambridge, Mass., 1980b, p. 168.
2. James V. Millingen, *Peintures antiques et inédites de vases grecs, tirées de diverses collections, avec des explications* (Rome, 1813).
3. Paper, Fogg Art Museum files.
4. Inv. F.184; H. B. Walters, *Catalogue of the Greek and Etruscan Vases in the British Museum* (London, 1896), vol. 4, p. 95, no. F184a.
5. *Metamorphoses* 2.1065–97, cited by Cohn and Siegfried in Cambridge, Mass., 1980b, p. 168.
6. Naef 1965, p. 6.
7. Musée Ingres, Montauban, 867.707; Vigne 1995b, no. 1857.
8. I thank Asher Miller for this observation.

PROVENANCE: Sold by the artist to Étienne-François Haro, October 13, 1866; consigned by him to the Ingres sale, Hôtel Drouot, Paris, April 27, 1867, no. 15 (Fr 1,700); purchased at that sale by Victor Baltard, Paris; his daughter Paule Arnould, Reims; her son P. Arnould, Paris; Arthur Bowen Davies, New York, possibly in 1897; Ferargil Gallery, New York, by February 1926; Stephen Carlton Clark, New York, not before February 1926; Edouard Jonas of Paris, Inc., not before December 1928; acquired from him by Grenville L. Winthrop, April 1930; his bequest to the Fogg Art Museum, 1943.

EXHIBITIONS: The Metropolitan Museum of Art, New York, on general loan, November 24, 1927–December 5, 1928; Cambridge, Mass., 1943–44, p. 4; Cambridge, Mass., 1961, no. 9; Cambridge, Mass., 1967a, no. 116; Cambridge, Mass., 1980b, no. 63.

REFERENCES: *La chronique des arts et de la curiosité* 5 (April 28, 1867), p. 137, no. 15; Delaborde 1870, p. 268, no. 173; Lapauze 1901, p. 250; Momméja 1905, p. 160 above no. 2188; Déonna 1921, p. 315; Cortissoz 1926, p. 10, illus.; *Bulletin of the Metropolitan Museum of Art* 22, no. 12 (December 1927), p. 318 (under "List of Accessions and Loans"); Cortissoz 1930, pp. 193–96; Mongan 1944a, pp. 410–12, fig. 21; Rosenblum (1956) 1976, p. 168 n. 6; Schlenoff 1956, pl. 35; Birnbaum 1960, p. 167; Naef 1965, p. 6; Radius and Camesasca 1968, pp. 118–19, no. 168, illus.; Ternois and Camesasca 1971, pp. 118–19, no. 169, illus.; Whiteley 1977, p. 87, no. 69, illus.; Symmons 1984, p. 179 n. 61; Bremen–Bonn 1988, pp. 206–7, illus.; Innsbruck–Vienna 1991, p. 266, under no. 16.1, fig. 113; Condon 1995, p. 84, no. 94, fig. 74; Vigne 1995a, p. 165, illus.; Vigne 1995b, p. 319, fig. 280; Condon 1996a, pp. 11 no. 94, 15; Mongan 1996, no. 257, illus.

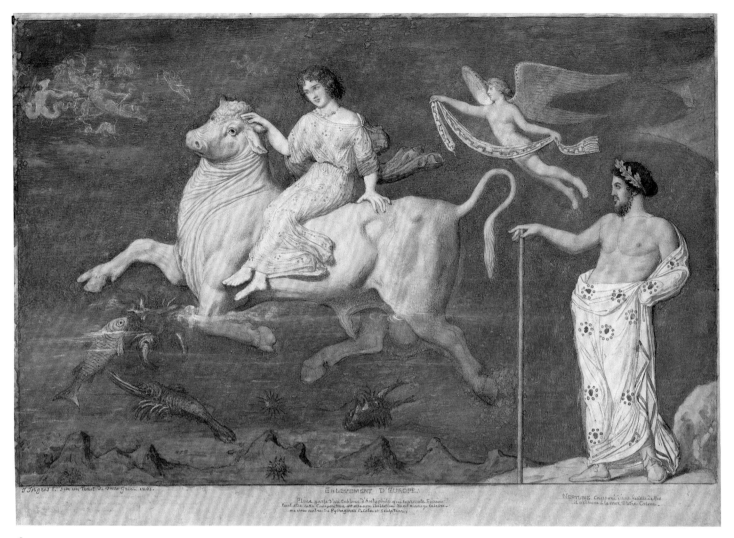

83

Fig. 107. *The Rape of Europa by Jupiter*. Plate 25 in James V. Millingen, *Peintures antiques et inédites de vases grecs, tirées de diverses collections, avec des explications* (Rome, 1813). Thomas J. Watson Library, The Metropolitan Museum of Art, New York

Adelaïde Labille-Guiard

Paris, 1749–Paris, 1803

84. *Portrait of Tournelle, called Dublin, Actor at the Théâtre Français,* ca. 1799

Oil on canvas
28½ x 22½ in. (72.4 x 57.2 cm)
Inscribed lower right: L : David; *on the paper scroll, lower left:* Acte, *followed by a now-illegible text*[1]
1943.230

Convincingly attributed to Adelaïde Labille-Guiard by Andrew A. Kagan in 1971, and identified by him as the "Portrait du Citoyen Dublin, artiste du Théâtre Français" exhibited at the Salon of year VII (1799), the painting is part of a large number of portraits once considered to have been painted by David but now removed from his body of work. In the case of this canvas, there is even a very old inscription in a hand completely different from that of David's authentic signatures. It appears to date from the time the painting was relined and several centimeters on the right edge were repainted, including the signature. The inscription on the back, which identifies the model, was probably also made at that time. However, Kagan's reading of the signature *Labille* on the paper scroll, traces of which are said to remain, is a matter of dispute; it is placed in doubt by Anne-Marie Passez in her monograph on Labille-Guiard.[2]

The subject is not well known, and certain of the details repeated here are not absolutely certain. The actor Tournelle, nicknamed Dublin, born in 1761,[3] appeared at the Théâtre des Italiens in 1791, then joined Talma's troupe in 1794, later moving with Talma to the Théâtre de la République. He seems to have been a member of the Théâtre Français from its opening in 1799

until 1814. He appears to have specialized in comic roles, particularly secondary characters such as impudent valets, which at the time were called "Frontin" roles. A critic remarked of him: "A great deal of intelligence, a great deal of ease onstage, an excellent mask, sometimes even a very good comic sense. . . . He tries too hard to attract the audience's attention. . . . He fusses too much over the details at the expense of the whole."[4] Early on, Dublin-Tournelle seems to have combined acting with the job of costume designer for the Théâtre Français. After a serious accident, which occurred onstage while he was playing Pédrille in Beaumarchais's *Marriage of Figaro* in 1800 (Fructidor, year VIII), he was obliged to devote himself more exclusively to costume design. He also worked in that capacity for the Opéra, becoming head designer for the Opéra between 1815 and his death in 1820.[5]

Although any hope of reading the text on the scroll of paper that Dublin-Tournelle holds in his left hand is futile, the word *Acte* at the top, the only legible word, and the red ribbons used to bind the sheets, seen on many contemporary documents still housed at the Comédie Française, indicate that it is the script of the play the actor is rehearsing.

The latest extant work by Labille-Guiard, this painting invites comparison to her portrait *Lawyer Delamalle* (private collection), also displayed at the Salon of 1799, which has in common the neutral background, the position of the arms, the written document in the subject's hand that

indicates his profession, and the animated facial expression with eyes gazing out at the viewer. We must also make the comparison so often advanced, even by critics of the time, to the portraits of François-André Vincent, Labille-Guiard's longtime companion, whom she married in July 1800. The conception and style are so similar that some hesitation about which artist is responsible for the work is possible. For example, in Vincent's *Actor Albouis Dazincourt* (1792; Musée des Beaux-Arts, Marseille), which predates this one, the warm sincerity of the portrait is comparable, and the close and attentive execution very similar in the two cases. But we cannot accept the accusations of the time that Labille-Guiard was aided by Vincent, since her style is very consistent from the beginning of her career until the end. The accuracy of the pose and the somewhat determined expression of emotional veracity in this portrait of Dublin-Tournelle are a long way from David's portraits, which are more relaxed and simply and supremely authoritarian in their greater economy of means.

Jean-Pierre Cuzin

1. The canvas is inscribed on the back, over an old, barely legible inscription: "peint . . . L. David / Portrait de [?] Monsieur Dublin-Tornelle / artiste du Théâtre Français, et dessinateur / du grande [?] . . . auteur des costume [*sic*] des / . . . couronnement [?] Napoléon—ami-intime Talma."
2. Passez 1973, pp. 289–91.
3. Ibid., p. 289.
4. "Beaucoup d'intelligence, une grande habitude de la scène, un excellent masque, quelquefois même un très-bon comique . . . il cherche trop à attirer l'attention du public . . . il soigne trop les détails aux dépens de l'ensemble"; Pillet et al. 1801, p. 83.
5. See Lyonnet 1902–8, vol. 1. My thanks to Claude Lesné for his kind help with the actor's biography.

84

Guillaume Guillon Lethière

Sainte-Anne, Guadeloupe, 1760–Paris, 1832 (?)

85. *The Death of Virginia*, 1828

Black chalk, brown and gray wash, white gouache, and traces of graphite on cream wove paper
Image 22⅜ x 38⅜ in. (56.8 x 97.4 cm)
Signed and dated in black ink, lower center:
G^{ME} G^{LON} LETHIERE—1828
1943.867

This drawing records Guillaume Guillon Lethière's 1828 painting *The Death of Virginia* (fig. 108), exhibited in the Salon of 1831. The story of Virginia, first told by Livy, gained currency in the eighteenth century through Charles Rollin's *Histoire romaine* (1738–48), which served as a sourcebook for artists such as Gabriel-François Doyen, who exhibited a painting on the subject in the Salon of 1759 (Galleria Nazionale, Parma).[1] Lethière, a pupil of Doyen, paid homage to his master's composition in his own version of the subject. However, he departs from Doyen's model by representing the moment after Virginia chose death to preserve her honor, rather than submit to the Roman decemvir Appius Claudius, who had claimed her as his slave. Virginia's father wields the bloodied knife that he used to kill his daughter, proclaiming, "With this innocent blood, Appius, I devote thy head to the infernal Gods."[2] Lethière envisioned his dramatic representation of Virginia's sacrifice as one of a series of four monumental paintings of episodes from Roman history; only one other work, *Brutus Condemning His Sons to Death* (Louvre, Paris), was completed in 1811.[3]

The gestation of *The Death of Virginia* spanned more than three decades. Lethière's first drawings have been assigned to his years in Rome as a pensionaire of the Académie Française from 1786 to 1791.[4] The earliest dated work is a drawing of 1795 (Musée Tavet, Pontoise), which closely resembles the composition of the painting; in addition, Lethière executed several oil sketches before completing the painting in 1828.[5] An engraving (fig. 109),

Fig. 108. Guillaume Guillon Lethière, *The Death of Virginia*, 1828. Oil on canvas, 15 ft. 2½ in. x 25 ft. 6¼ in. (458 x 783 cm). Musée du Louvre, Paris (photo: RMN—Arnaudet / Jean)

85

Fig. 109. Charles-Jérôme Becoeur and Melchior Péronard, after Guillaume Guillon Lethière, *The Death of Virginia*, 1828. Engraving, 7⅛ x 12⅜ in. (18 x 31.5 cm). Huntington Library, San Marino

executed by students of Lethière, was published in 1828, coinciding with the painting's exhibition in London that same year.[6] The high degree of finish and carefully rendered tonal gradations of the present work, as well as its close correspondence to the painting, suggest that it was intended as a model for a reproductive print.[7] However, it could not have served as the basis for the 1828 engraving, which, among other discrepancies, incorrectly renders the pose of Virginia. Significantly, the engraving was accompanied by a printed apology from the publisher for not "convey[ing] the accurate outline of the Picture as faithfully as could have been desired."[8]

It is conceivable, then, that Lethière sought a more accurate reproduction of his painting before its exhibition in the Salon of 1831, and that the Winthrop drawing was produced for that purpose.[9] Its authorship

is complicated by the documentation in the catalogue of the Salon of 1831 of a drawing of the same subject by Lethière's pupil Paul Jourdy (1805–1856); the catalogue entry specifies that Jourdy's work was "for the execution of the engraving of M. Lethière's painting," raising the possibility that the present drawing is by Jourdy rather than Lethière.[10]

The Death of Virginia belongs to a current of moralizing themes that flourished in the art of the last decades of the eighteenth century, mirroring the stoicism advocated in revolutionary and republican rhetoric.[11] However, such severe moral exemplars had lost their political and artistic relevance by 1831. Salon reviewers derided Lethière's subject and neoclassical style as passé; the painting was called an "anachronism" and Lethière a "martyr for David's cause."[12] The verdict of the critic Gustave Planche—that Lethière was destined "to die in impenitence" for clinging to a mori-bund neoclassicism—proved prescient, as this Salon would be his last.[13] The painting's unfavorable reception in 1831 might well have led Lethière to abandon plans for a second engraving, leaving only this drawing as a record of those plans.

Kathryn Calley Galitz

1. On the influence of Rollin's text and its illustrations on neoclassical art, see Walch 1967, pp. 123–26.
2. Ibid., p. 124.
3. The other two paintings planned for the series were *The Death of Caesar* and *The Defeat of Maxentius by Constantine*, according to Vauchelet 1894, p. 67.
4. Debret 1832, p. 2. A drawing at the École des Beaux-Arts, Paris (EBA 1213), might be a *première pensée* of the subject, while two others there, also identified as related works, appear, rather, to be preliminary studies for *Brutus* (EBA 1211; EBA 1212).
5. Four *esquisses* have been identified; the compositions of two undated oil sketches (Musée des Beaux-Arts, Lille; private collection, England) suggest that they were executed before the drawing of 1795. A sketch dated 1828 (Musée des Beaux-Arts, Orléans, 607) closely resembles the finished painting of 1828, as does a work on the Paris art market in 1999 (sale, PIASA, Paris, June 25, 1999, no. 79). I am grateful to Perrin Stein, associate curator in the Department of Drawings and Prints at The Metropolitan Museum of Art, for sharing her expertise in this field.
6. The engraving, drawn by Charles-Jérôme Becoeur (1807–1832) and engraved by Melchior Péronard, was published as the frontispiece to *Description of a Grand Picture now Exhibiting in the Roman Gallery of the Egyptian Hall, Piccadilly, Representing that Pathetic Incident in Roman History, The Death of Virginia, Painted by Monsieur Le Thiere* (London, 1828).
7. I am grateful to Marjorie B. Cohn, Carl A. Weyerhaeuser Curator of Prints at the Fogg Art Museum, for her assessment of the drawing.
8. *Description of a Grand Picture* 1828, facing p. 3.
9. Although the work bears no physical evidence of transfer, it does not preclude its use by an engraver. My thanks to Anne Driesse, paper conservator, Straus Center for Conservation, Harvard University Art Museums, for examining the drawing.
10. See no. 1138 in Paris (Salon) 1831. The present location of Jourdy's drawing is unknown, and there is no record in the Bibliothèque Nationale de France of an engraving made after his drawing, according to Maxime Préaud, conservateur en chef, Cabinet des Estampes. Citing Jourdy's drawing, Dewey F. Mosby first questioned the attribution of the Fogg drawing to Lethière in a letter to Agnes Mongan, February 18, 1976, files of the Drawing Department, Fogg Art Museum.
11. See Rosenblum 1967a.
12. Leaves de Conches 1831, p. 200.
13. Planche 1831, p. 185.

PROVENANCE: Grenville L. Winthrop; his bequest to the Fogg Art Museum, 1943.

REFERENCES: Lacambre and Vilain 1976, pp. 70–71; Mongan 1996, pp. 252–54, no. 280, illus.

Édouard Manet

Paris, 1832–Paris, 1883

86. *Race Course at Longchamp*, 1864

Watercolor and gouache over graphite on two joined sheets of white wove paper
8¾ x 22¼ in. (22.1 x 56.4 cm)
Signed and dated in black watercolor, lower left: Manet 1864.
Verso of left sheet: Study of Reviewing Stands at Longchamp
Graphite, 8¾ x 8⅞ in. (22.1 x 22.5 cm)
1943.387

Second Empire Paris entered a period of racing fervor with the 1857 inauguration of Longchamp racetrack, located just west of Paris in the newly created Bois de Boulogne. In May 1863 interest in the sport intensified when the first Grand Prix de Paris—with an extravagant purse of 100,000 francs—was run at the course. The craze for "les courses" was felt by all levels of society and insinuated itself into many aspects of daily life, as was delightfully captured by social satirists and cartoonists at the time (fig. 110). Paintings and sculpture of racehorses, once a specialty of the British, began to appear in the annual Parisian Salons. The theme was also taken up by such non-academic artists as Edgar Degas and Édouard Manet. As the composition of Manet's watercolor clearly attests, the lure of Longchamp was twofold: the race itself

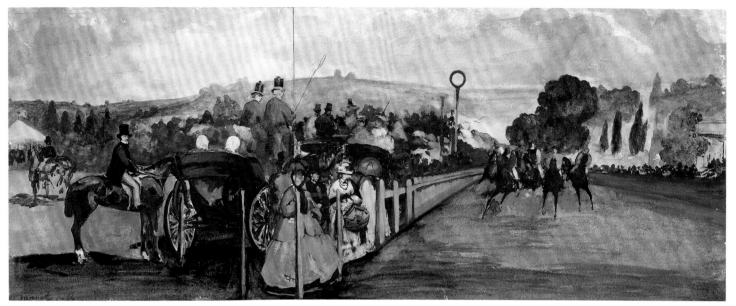

86

— Cela t'amuse de venir aux courses ?
— Oh oui! Je peux y dire zut, devant maman, sans qu'elle me dise rien.

Fig. 110. Cham,—*Cela t'amuse de venir aux courses?—Oh oui! Je peux y dire zut, devant maman, sans qu'elle me dise rien.*, ca. 1870. From Cham, *Les folies parisiennes, quinze années comiques, 1864–1879* (Paris, 1883), p. 139

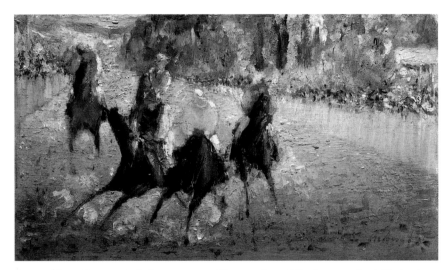

Fig. 111. Édouard Manet, *At the Races*, ca. 1875. Oil on wood, 5 x 8½ in. (12.7 x 21.6 cm). National Gallery of Art, Washington, D.C.; Widener Collection, 1942.9.41

and the spectacle of the crowd that flocked to watch it.

In 1864 Manet created a large oil painting depicting a race at Longchamp. Most art historians believe this work was similar in composition to the Winthrop watercolor. Within a year or two of its creation, the oil painting was cut down into smaller sections, one of which may have been exhibited at the 1867 Exposition Universelle as *Les courses au Bois de Boulogne*.[1] Fragments of the original canvas can today be found at the Cincinnati Art Museum and in a private collection.[2] A debate revolves around the Winthrop watercolor's relation to this larger oil. Both Jean Harris and Theodore Reff have examined the issue in some detail.[3] Harris concludes that the gouache "must be considered as a reproduction or reworking of the original oil painting, perhaps for the purpose of recording the whole composition before it was cut up."[4] Reff, on the other hand, believes that the watercolor must have been a preparatory color study for the painting; he further argues that the fact that it is painted on two sheets of paper attests to the artist's evolving ideas.[5] Gary Tinterow, one of the curators of the present exhibition, recently reexamined the watercolor, and, like

Harris, concludes that it must be a study after the final painting. The two pieces of paper are carefully joined, and the strokes of paint appear to pass from one sheet to the next without hesitation. Also, in his opinion, there is little in the composition that would suggest that Manet had at any time considered the edge of either sheet to be a boundary.

There is general consensus that the most novel aspect of Manet's watercolor is the composition. Although each half has its own focus, the combination of the two pieces provides a panoramic sense of the Longchamp experience. The right half of the picture is devoted to the horserace, which the artist represents as if standing in the middle of the track, with the horses dashing toward him. Because most nineteenth-century French racing scenes are based on British prototypes, they tend to depict the race from the grandstands, with the horses parallel or at a slight diagonal to the picture plane. It has been argued on several occasions that Manet is the first Western artist to paint speeding horses from such a distinctive viewpoint.

The left half of the composition is devoted to the spectators gathered in the middle of the grass oval, watching both the race and each other. The crowds at Longchamp garnered much attention in the mid-1860s, and important spectacles such as the Prix de Paris served as the setting for "the great dress battles." The grandstands were transformed into "a whirlwind of the most vivid colors, a chaos of the brightest shades, cherry-red and purple, sea-green and emerald, azure and Sèvres blue. Ribbons flutter, jet streams, taffeta trembles."[6] Throughout the season (races were held at Longchamp in the spring and fall),

women's fashions were avidly reported.[7] So great was the emphasis on couture and millinery, that one commentator mused, "Actually, I am not sure if love of horses has anything to do with [the lure of Longchamp], but definitely love of the latest fashions is fully satisfied there."[8]

As Manet returned to the theme of Longchamp over the next few years, he gradually de-emphasized the spectators to focus attention on the horses. A painting close in composition to the Winthrop watercolor (1866; Art Institute of Chicago) omits the carriages and many of the spectators visible in the left third of the watercolor. In a painting thought to date to about a decade later (fig. 111), Manet has almost entirely eliminated the crowds in order to focus on the racing steeds (which have been reduced in number from six to five). Although a corner of the public grandstands is visible at the far right—just as it is in the Winthrop watercolor[9]—the artist has curiously edited out the circle suspended on the post (the "poteau") which marks the finish line. In all of these pictures, Manet represents the flurry and clamor associated with the race's conclusion, without making any effort to indicate which horse has actually won.

Rebecca A. Rabinow

1. Harris 1966, pp. 78–80.
2. Ibid.; also Rouart and Wildenstein 1975, nos. 94, 95. It should be noted that Richard Brettell (in London–Amsterdam–Williamstown 2000–2001, p. 74) posits that no fragments from this original painting survive.
3. Harris 1966, pp. 78–82; Reff in Washington 1982–83, p. 132.
4. Harris 1966, p. 81.
5. Reff in Washington 1982–83, p. 132.
6. "[L]a grande bataille des robes" "c'est un tourbillon des plus vives couleurs, un chaos des nuances les plus éclatantes, le cerise et le pourpre, le vert d'eau et le vert émeraude, le bleu d'azur et le bleu de Sèvres. Les rubans voltigent, le jais ruisselle, le

taffetas frissonne"; Amédée Achard in *Paris Guide* 1867, vol. 2, p. 1236; English translation by R. Rabinow.
7. See, for example, *Le moniteur de la mode*, no. 742 (May 1864), pp. 51, 56.
8. "Je ne sais pas, à vrai dire, si l'amour des chevaux y entre pour quelque chose, mais, à coup sûr, l'amour des toilettes neuves y trouve une complète satisfaction"; Achard in *Paris Guide* 1867, vol. 2, p. 1235; English translation by R. Rabinow.
9. A faint graphite sketch of the public grandstands and the surrounding trees appears on the verso of the left-hand piece of paper of the Winthrop watercolor. The image is reproduced in Rouart and Wildenstein 1975, no. 548 (verso).

REFERENCES: Duret 1902, p. 134; Henriot 1922, p. 97, illus.; Moreau-Nélaton 1926, vol. 1, p. 64, fig. 73, vol. 2, appendix, p. 130, no. 120; Tabarant 1931, pp. 133–34; Colin 1932, p. 27; Jamot and Wildenstein 1932, vol. 1, p. 127, under no. 86; Guérin 1944, under no. 72; Mongan 1944b, p. 23, illus.; Florisoone 1947, p. 101, pl. 52; Tabarant 1947, pp. 100, 605, fig. 101; Richards 1957, p. 190; Martin 1958, no. 7, illus.; Richardson 1958, p. 121, under no. 25; Leiris 1961, pp. 59–60, 62, n. 6; Mathey 1961, p. 32, no. 119, detail illus.; Harris 1966, pp. 78–82, fig. 5; Philadelphia–Chicago 1966–67, p. 87, under no. 68, fig. 5; Bodelson 1968, p. 343; Guérin 1969, under no. 72; Leiris 1969, p. 110, no. 203, fig. 233; Rouart and Wildenstein 1975, vol. 2, pp. 194–95, no. 548, fig. 548 (recto and verso); Washington 1982–83, pp. 132–33, under no. 42, figs. 69 (recto), 70 (verso); Paris–New York 1983, p. 263, under no. 99, fig. a; Mortimer 1985, p. 245, no. 287, illus.; Detroit and other cities 1985–86, p. 96, under no. 56, fig. 11; Wollheim 1987, p. 232; Herbert 1988, p. 155 fig. 153, 158; Ives 1988, p. 8, illus.; Harris 1990, p. 202, under no. 66; Darragon 1991, p. 386, fig. 287; Finch 1991, pp. 233–34, fig. 313; Spencer 1991, pp. 231 (fig. 3), 232–33, 235 (fig. 7 [detail]); Wadley 1991, p. 86, under no. 6, pl. 2a; Wilson-Bareau 1991, pp. 132–33, fig. 92; Kendall 1993, pp. 70, 71 (fig. 56), 281 n. 41; Elias 1994, p. 12, illus.; Fairley 1995, pp. 91 (fig. 59), 92; Fried 1996b, pp. 321–23, pl. 15; Washington 1998, p. 154, fig. 87; London–Amsterdam–Williamstown 2000–2001, pp. 74, 76 (fig. 35), 77.

Attributed to Édouard Manet

87. *Emmanuel Chabrier*, 1881

Oil on canvas
25 ⅝ x 21 in. (65.1 x 53.3 cm)
1943.259

In 1873 the composer Alexis-Emmanuel Chabrier (1841–1894) and his new wife, Alice Dejean, moved into 23 rue Mosnier (now rue de Berne) in Paris, becoming neighbors of Édouard and Suzanne Manet.[1] That same year Chabrier published his Impromptu for piano with a dedication to Mme Manet, herself a fine pianist, and posed for Manet's *Masked Ball at the Opera* (National Gallery of Art, Washington). Before the *Masked Ball*, Chabrier had already appeared in at least two works of art: James Tissot's early red-chalk portrait (private collection), and Edgar Degas's *Orchestra at the Opera* (Musée d'Orsay, Paris; Chabrier is seated in the box at the upper left). Thus the Winthrop portrait is a testament to a remarkable friendship between a painter and a composer and, more broadly, to Chabrier's lifelong ties to avant-garde visual artists.

Arriving in Paris as a young man,[2] Chabrier first gravitated to writers and poets, notably Paul Verlaine and the Parnassians.[3] If it seems remarkable that a rough-mannered Auvergnat found his way into the most sophisticated Parisian artistic circles, even more paradoxical is that such a hearty bohemian worked days as a civil servant. After law studies in Paris, Chabrier accepted an Interior Ministry post in 1861 and held it for nearly twenty years. But in 1880 he obtained leave to see a production of *Tristan und Isolde* in Munich and, like so many other artistic souls in France in those years, experienced a Wagnerian conversion. Forthwith he resigned his government job in order to devote himself to composing.[4]

Fresh from that transforming experience, Chabrier wrote his *Dix pièces pittoresques* for piano, some of his most visually evocative music. (They were published in 1881, the year of the Winthrop portrait.) In autumn 1882 another significant journey—this time to Spain—inspired the symphonic rhapsody *España*, Chabrier's best-loved work.[5] Poulenc said of it, "I have always liked to think of this great visual piece having been evoked by a Spain seen through the paintings of Manet."[6] The year after that, Manet died. Legend has it that he died in Chabrier's arms and that Chabrier expressed a wish to be buried near him, at Passy.[7]

How fitting that Manet's great friend should have acquired his last great painting, *A Bar at the Folies-Bergère* (Courtauld Institute Galleries, London). Occupying a place of honor over Chabrier's piano, it was the star of his collection, which contained works by Monet, Renoir, Sisley, and Cézanne, among many others. What the collection reveals above all, beyond a sure eye or even investment savvy, is Chabrier's close links with the advanced visual artists of his day.[8] Like them, he profoundly influenced aesthetic developments in the next generation: the debts of Debussy, Ravel, Satie, Poulenc, and other giants of early-twentieth-century French music to Chabrier are undisputed.

Even if one considers this likeness of Chabrier as a private token of friendship rather than a publicly ambitious work, it still lacks a certain éclat. The painting—a sketchy swirl of grays and browns—is sufficiently weak that some scholars have questioned its attribution on the basis of style.[9] It is true that Manet's pastel of the previous year (fig. 112) portrays Chabrier quite differently: the face is much rounder, the eyebrows far thicker, the entire demeanor stiffer and warier. The Winthrop portrait's thin paint layer, especially at the edges, and the visible contour lines around the hand and head suggest that it is unfinished. Nevertheless, at least one owner thought it deserved a wider viewing: in August 1923 Mme Chabrier-Bretton, the composer's daughter-in-law, voiced an intention to bequeath it to the Musée de l'Opéra (though she changed her mind in favor of Georges Bernheim).[10]

Moreover, if the portrait lacks the power of so many of Manet's mature works, it nevertheless illuminates a thoughtful or doubting side of Chabrier's personality that few apparently saw. Cupping his brow in his hand, he looks out somewhat diffidently, while the illegible music score on the table makes only a tenuous reference to his profession. The summary technique manages to persuade us of a character more complex than the one that appears in the composer's more public images.[11] Still, one can't help but wonder how finishing touches would have altered the portrait. Perhaps, in Chabrier's words from around this time, the artist viewed it as an étude, "un chic tableau pour plus tard!"[12]—and *plus tard* came too late.

Anne Leonard

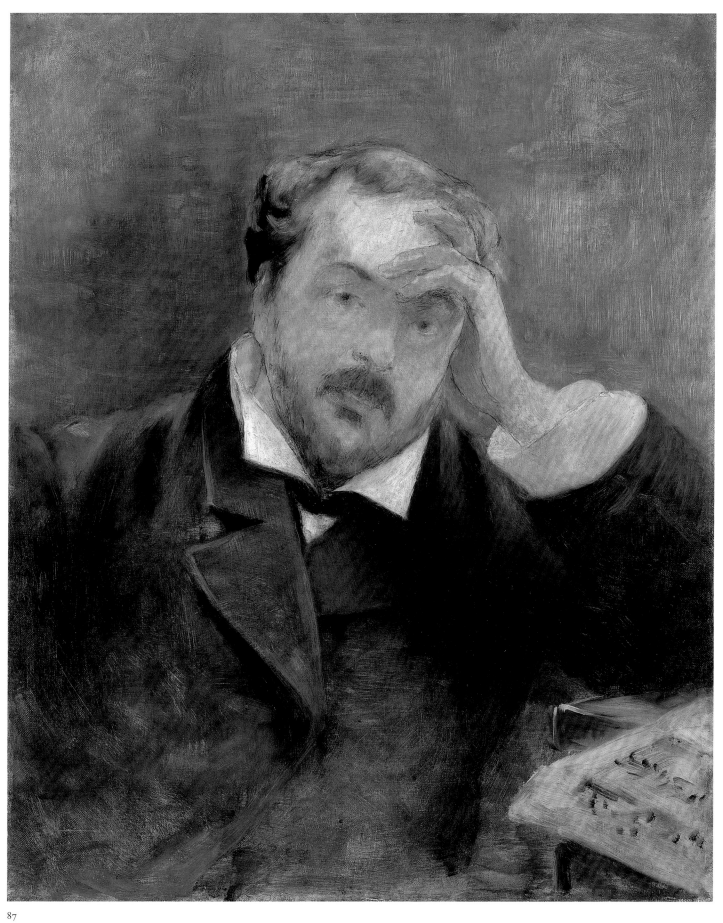

87

Fig. 112. Édouard Manet, *Emmanuel Chabrier*, 1880. Pastel, 21¾ x 13¾ in. (55 x 35 cm). Ordrupgaard, Charlottenlund

1. The Manets were steps away on rue de Saint-Petersbourg. According to Léon Leenhoff, "Les relations de Manet avec Chabrier ont commencé en 1873 à son atelier du no 4 rue de St Petersbourg. . . . Son jeu exubérant [au piano] animait nos soirées et surprenait nos invités" (Manet's relations with Chabrier began in 1873 at his studio at 4 rue de Saint-Petersbourg. . . . His exuberant piano-playing animated our evenings and surprised our guests); quoted in Delage 1999, p. 137. Their first meeting is not attested, but it could easily have been at the salon of Nina de Villard; see Tabarant 1947, p. 228; Bersaucourt 1921, pp. 8, 19; and Darragon 1991, p. 236.

2. He arrived with his family from Clermont-Ferrand, where they had moved in 1853 from Ambert (Puy-de-Dôme), the small town in the Auvergne where Chabrier was born.

3. Among them, Catulle Mendès supplied the libretti for two of Chabrier's operas, *Gwendoline* and *Briséïs*, and texts for many other works.

4. Until then he had been a composer only in his spare time, and in the opinion of Poulenc (1981, p. 27), it showed: "Few of Chabrier's works from 1860 to 1877 need to hold our attention." He would have a mere fifteen-year career as a full-time composer; already in 1879 he may have been experiencing twinges of the paralysis that would overcome him. Indeed, it seems that Chabrier's reasons for quitting the civil service could have been as much medical as musical; see ibid., p. 34, and Delage 1999, pp. 245–47.

5. As James F. Penrose (2001, p. 30) points out, it is now the *only* Chabrier composition that is standard in the orchestral repertory.

6. Poulenc 1981, p. 41.

7. He would not succeed in this; he was buried instead in the Montparnasse cemetery. The source for both claims is André Maurel, writing in the catalogue of the Chabrier sale, Hôtel Drouot, Paris, March 26, 1896.

8. He was one of the first collectors of Monet, whom he met through Manet when all three were neighbors—Monet on the rue d'Edimbourg (Delage 1999, p. 150). Of the several canvases that Chabrier bought in 1878, when Monet was in penury, he lent two to the Fourth Impressionist Exhibition of the following year (*Fête Nationale, Rue St-Denis, Paris* and *Banks of the Seine*). See Distel 1990, p. 218.

9. The painting is listed in the most recent Fogg catalogue (Bowron 1990, fig. 353) as "Attributed to" Manet. No writer after Julius Meier-Graefe seems to have taken up the assertion that the Chabrier portrait remained unsold and was finally destroyed before being finished; Jamot and Wildenstein say that assertion is false (1932, no. 453).

10. Tabarant 1947, p. 421.

11. Such as Henri Fantin-Latour's *Autour du piano* (Musée d'Orsay, Paris) or Édouard Detaille's ingenious caricature, a color drawing of 1873 that served as the cover of the *Revue illustrée* for June 15, 1887. See Delage 1982, pls. 41, 96, respectively.

12. Quoted in Delage 1999, p. 162.

PROVENANCE: Emmanuel Chabrier, Paris; his son André Chabrier; his widow, Mme Chabrier-Bretton, Avignon, until 1923; Georges Bernheim, Paris, by 1923; (?) Allard, Paris; Chester Dale, New York, by 1932; Wildenstein and Co., New York; acquired from them by Grenville L. Winthrop, January 13, 1933; his bequest to the Fogg Art Museum, 1943.

EXHIBITIONS: New York 1937, no. 35; Cambridge, Mass., 1943–44, p. 11.

REFERENCES: *Emmanuel Chabrier* 1912, illus.; Meier-Graefe 1912b, pp. 250, 252; Tabarant 1931, p. 407, no. 366; Jamot and Wildenstein 1932, no. 453; Paris 1941, p. 25, frontis.; Tabarant 1947, pp. 421–22, no. 392; Delage 1963, p. 21, illus. p. 17; Tiénot 1965, illus. facing p. 64; Lockspeiser 1966, pp. 10–11, illus.; Orienti 1967, no. 354; Myers 1969, pp. 5–6, 154, pl. 6; Orienti and Rouart 1970, no. 358; Rouart and Wildenstein 1975, no. 364; Poulenc 1981, illus. tipped in between pp. 28 and 29; Delage 1982, pp. 10–11, pl. 33; Delage 1983, p. 65, fig. 4; Traubner 1985, illus. p. 25; Adler 1986, p. 159, fig. 144; Bowron 1990, fig. 353; Distel 1990, p. 217, fig. 195; Darragon 1991, fig. 254; Buettner and Pauly 1992, pp. 104, 105 (illus.); Delage 1999, p. 138; Huebner 2001, illus. p. 404.

Henri Matisse

Cateau-Cambresis, France, 1869–Nice, France, 1954

88. *The Plumed Hat*, 1919

Graphite on off-white wove paper
21¼ x 14⅜ in. (54 x 36.5 cm)
Signed and dated in graphite, lower right: Henri Matisse 1919
1943.874

The Plumed Hat belongs to a series of at least sixteen drawings by Henri Matisse, all realized in Nice during the winter and spring of 1919, in conjunction with four canvases representing the same sitter, a young woman known as Antoinette who posed for the painter for about a year.[1]

Viewed by several Matisse scholars as "the first great achievement of the Nice period,"[2] the group is extraordinarily diverse, even though the paintings and half of the drawings (those done in pencil, as is the Winthrop sheet) partake of the same return to traditional modeling that charac-

terizes the early Nice period. More than any other ensemble, these works declare Matisse's temporary farewell to the modernist experimentation he had been carrying on since the heyday of Fauvism—an interruption that would last a decade. Matisse was manifestly proud of the drawing suite and selected eleven, including the one that Grenville Winthrop would acquire, in his *Cinquante dessins*, an album he published in 1920. Indeed he was particularly fond of the Winthrop version, which he selected for the monograph published the same year by his friend George Besson in the "Cahiers d'Aujourdhui" series, consisting of a collection of black-and-white reproductions with short essays by Elie Faure, Jules Romains, Charles Vildrac, and Leon Werth.[3]

In 1932, in what is still the only study devoted solely to the series, Margaretta Salinger perceived that the drawings were no mere preparatory studies for the paintings.[4] Salinger begins by refuting the assertion Vildrac had made in his foreword to *Cinquante dessins*, according to which such drawings "were nothing but preparatory studies for a painted portrait in which Matisse attempted, step by step, to express their synthesis."[5] First, the drawings and paintings have very little in common; second, the pencil and ink drawings are very different; and finally, even within the group of pencil drawings each sheet is independent. Comparing the Winthrop drawing to one of the same format in the Museum of Modern Art in New York,[6] Salinger noted: "Very similar in technique, and practically identical in pose, they are, however, absolutely diverse in mood. Not only the facial expression, but all the general lines of the figure are in the one more strained [presumably the New York drawing], and in the other more relaxed."[7]

Even though in *Cinquante dessins* Matisse took obvious pain *not* to organize the draw-

ings in a sequence of progressive distillation, he was probably the direct source for the notion of "synthesis" proposed by Vildrac. In June 1919, speaking to Swedish connoisseur Ragnar Hoppe about one of the Plumed Hat canvases he had just finished, Matisse declared: "You may think, as so many others do, that my paintings are improvised, put together accidentally and hastily. I am going to show you . . . a whole series of drawings I did after a single detail: the lace collar around the young woman's neck. The first ones are meticulously rendered, each network, almost each thread, then I simplified more and more; in [the] last one, where I so to speak know the lace by heart, I use only a few rapid strokes to make it look like an ornament, an arabesque, without losing its character of being lace and this particular lace. . . . I did just the same with the face, the hands, and all the other details, and I have naturally also made a number of sketches for the movements and the composition. There is a lot of work, but also much pleasure, behind such a painting. You can see for yourself how beautifully and firmly the hands rest in her lap. You may rest assured that I did not solve the problem so well at once. But the hands have to be held just so in order to be in harmony with the carriage of the body and the expression of the face. It was only little by little that it became clear to me, but once I was fully conscious of it I could express my impression with the speed of lightning."[8] Exactly when Matisse began to establish this two-tier system—painstaking analysis in drawing, then rapid synthesis in paint—in his work process is open to question, but it seems to have resulted from his forays in the genre of portraiture, perhaps after the dramatic resolution of *Mlle Yvonne Landsberg* (1914; Philadelphia Museum of Art), for which he drew countless sketches that bear no resemblance to the final painting.

Are the Plumed Hat works portraits? Matisse thought so: he included both the painting *White Plumes* at the Minneapolis Institute of Arts and the drawing closest to it (see note 4) in *Portraits*, his book of 1954. In looking at faces, he wrote, he did not "perform any psychological interpretation" and that his interest in them was "entirely of a plastic nature."[9] Yet one of the most striking aspects of all commentaries on the Plumed Hat series is their reliance on psychology. The model is depicted in all kinds of poses, with all kinds of facial expressions, and from all kinds of angles throughout the series. But what if the different facial expressions had nothing to do with the interior life of the model but were instead a way of telling us that Antoinette's visage was just an instrument, or rather its features the varying notes of a scale?[10] What if Antoinette's face attracted Matisse precisely for its impassiveness? In the Winthrop drawing Antoinette, looking much older than her alleged nineteen years, is empty-headed, her eyes hypnotized, lifeless—a dullness of the gaze that pervades the entire series.

Perhaps this psychological blandness is Matisse's reminder that the real subject of the series is not the young woman but her hat, which he made himself with great care and pride. The hat is, after all, besides Antoinette's face in all its guises, the only common denominator of the series.[11] Of all the drawings, however, the Winthrop sheet is the one in which the elaborate headgear is the least conspicuous: much more attention has been devoted to the multiple folds of the ample dress. While Pablo Picasso had followed the example of the hierarchical disjunction between face (exquisitely detailed) and garment (far more summarily sketched) in Jean-Auguste-Dominique Ingres's drawn portraits, Matisse almost reversed the polarity. Indeed, although most lines are traditional parallel hatchings,

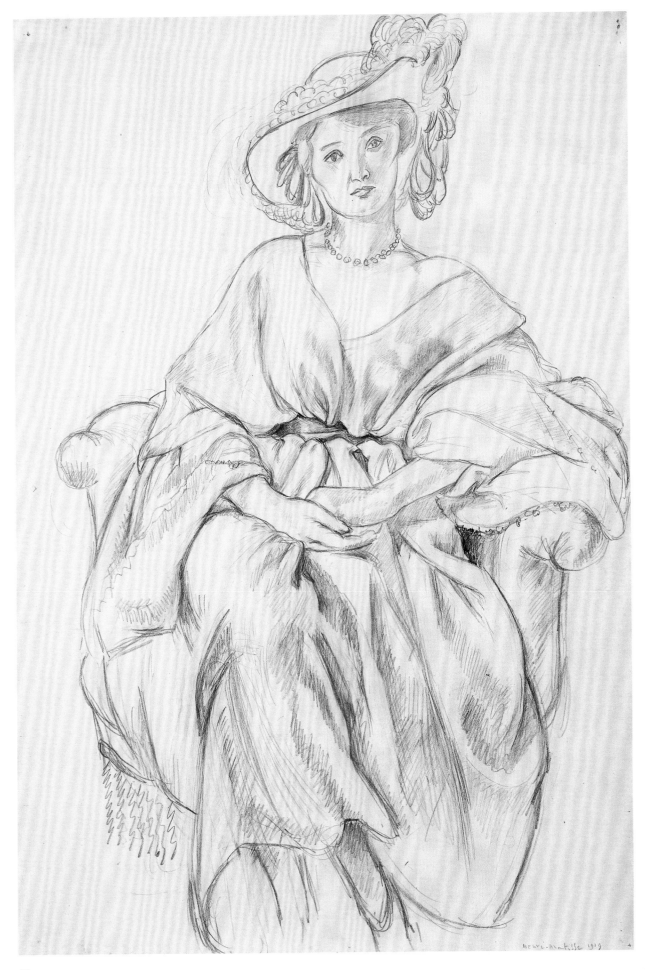

it is in the depiction of the cloth that Matisse displayed the full range of his technical prowess, just as it is from the dark knot of the belt, from which the folds emerge like ripples, that the only tension is bestowed on this undulating fabric.

Finally, the most intriguing part of Matisse's 1919 discussion about the Plumed Hat works concerns the care he took to "solve the problem" of the hands in drawing before undertaking a painted version.[12] In the vast majority of figures Matisse painted or drew throughout his entire career, the hands tend to be anatomically incorrect, mere terminations of a movement, carelessly and quickly daubed as if he had run out of steam. And the point is that he always got away with it: not even his most staunch enemies seem ever to have noticed. In the Winthrop drawing the stump that softly rests on Antoinette's right hand would be repulsive if seen in isolation. But we do *not* see it in isolation, and as a result we do not see it at all. Matisse's capacity to plant an incongruous element in the middle of his composition without rousing the awareness of the beholder was an important component of the aesthetic of subliminal distraction, of decentered expansion, that he had developed from 1906 to 1917.[13] What the Winthrop drawing reveals is that, even though the Nice period marks a return to a much more illusionistic pictorial mode, Matisse had not lost all the magic tricks of his early years. His ungainly hands are hidden in full view. Appropriating during his Nice period the code of Ingres's classicism, Matisse had not forgotten the liberties that the nineteenth-century painter had taken with anatomy and the barrage of criticism he had to endure for it. He found a way to be even

more disrespectful of the canonical body but without our noticing it.

Yve-Alain Bois

1. The most celebrated of the paintings is *The White Plumes* at the Minneapolis Institute of Arts. A version depicting Antoinette at close range is in the National Gallery of Art, Washington, D.C., and an oil sketch of the nude Antoinette wearing the hat is in a private collection; all three paintings are illustrated in color in Washington 1986–87, pp. 139–41. Finally, the most labored version—which Alfred Barr considered "the best of the paintings"—showed Antoinette in full view; see Barr 1951, p. 206. Previously in the collection of the Göteborg Konstmuseum, Sweden, it is now lost; see Aragon 1971, vol. 2, pl. 18.
2. Elderfield in London–New York 1984–85, p. 75.
3. The Winthrop drawing is pl. 17 in Matisse 1920, and pl. 42 in Faure et al. 1920. Only one other Plumed Hat drawing receives the same attention, pl. 15 of Matisse 1920, and pl. 41 of Faure et al. 1920 (reproduced in Schneider 1984, p. 499, top right). Two of the sheets reproduced in Faure et al. 1920 (p. 39 and pl. 43) were Plumed Hat drawings that had not been included in *Cinquante dessins*. Oddly, Matisse did not select for these early publications the remarkable ink drawing in the Art Institute of Chicago; see London–New York 1984–85, no. 49. Another drawing, much closer to the Winthrop sheet (same pose, same medium), was also not included; see ibid., no. 51.
4. Salinger 1932, pp. 9–10. However, two drawings are close enough to a canvas in scale and pose to be considered studies—Matisse himself did so publicly for one of them—but even in these exceptional cases so many changes were made by the painter when he switched to oil that the link only reveals how radically distinct the demands of the two media were in the artist's mind. In *Portraits*, Matisse reproduced the Minneapolis painting in color (Matisse 1954, pl. 125) and, among the drawings, one of the most finished of the series (ibid., pl. 32), which he captioned "Etude pour 'Les Plumes Blanches.'" For that drawing, see Paris 1975, no. 58; London–New York 1984–85, no. 52; and Schneider 1984, p. 498, bottom right. The now-lost painting (ex-Göteborg) could be similarly paired to Paris 1975, no. 60 (Schneider 1984, p. 499, bottom left). No drawing can be directly linked to either the Washington painting or the oil sketch of the nude Antoinette.
5. Matisse 1920, p. 8.
6. See New York 1978, p. 121.
7. Salinger 1932, pp. 9–10.
8. Quoted in New York 1978, pp. 121–22.
9. Flam 1973, p. 151.
10. Matisse's concept of expression never had much to do with expressivity—in most of his statements it is quasi-synonymous with decoration, and earlier in his career he had made a point of upsetting the old academic practice of *têtes d'expression*. He sent

The Red Madras Headdress of 1907 (Barnes Foundation, Merion, Pa.) to the Salon d'Automne of that year under the title "Tête d'expression." The attacks against the violent colors of the Fauve artist were perfunctory by then, but the press was particularly enraged by the false promise given by the title of the work. As Alastair Wright remarked, "this only served to underline the disjunction between apparently expressive signifiers and an absence of expression"; Wright 1997, p. 396. On this issue, see also Klein 2001, p. 82.
11. Margaret Scolari, Alfred Barr's wife, reported: "I asked [Matisse] where in creation he'd got that hat, so he laughed welcoming the question and said he'd made it himself. He bought the straw foundation and the feathers and the black ribbon and put it together with pins on the model's head. He said he had too much black ribbon so that he had to stuff it into the crown with dozens of pins"; Barr 1951, p. 206. Commenting upon Matisse's accomplishment as a modiste and noting that his wife had opened a millinery shop in order to support the family during the early years of their marriage, Elderfield (in New York 1978, p. 121) quoted a letter from the artist to Barr that adds: "I worked very hard on that hat which I made myself with an ostrich plume, an Italian straw, and a multitude of black and blue ribbons called by milliners *la comète*. The hat was done in such a way that one could wear it either by turning the back to the front or the front to the back. The latter as in my painting on a red background [the Minneapolis picture]." The orientation of the hat is opposite in the Winthrop drawing.
12. It is not entirely clear that Matisse is still speaking about the Plumed Hat ensemble at this point of the interview. But if indeed he is still referring to the Plumed Hat series, the only canvas to which this could apply is the now-lost painting—not because of any particular treatment of Antoinette's hands but because it is the only one in which they are visible. In the end, however, it does not matter exactly which work Matisse is signaling to his visitor.
13. On this issue, see Bois 1994, passim, and John Elderfield, "Describing Matisse," in New York 1992–93, p. 38.

PROVENANCE: E. Weyhe and Co., New York; acquired from them by Grenville L. Winthrop, May 15, 1925 ($550); his bequest to the Fogg Art Museum, 1943.

REFERENCES: Matisse 1920, pl. 17; Salinger 1932, pp. 9–10 (for series); Barr 1951, pp. 206, 427–29 (for series); Aragon 1971, vol. 2, pp. 103–9, fig. 100; Flam 1973, p. 152 (for series); Fourcade and Monod-Fontaine in Paris 1975, pp. 101–8 (for series); Elderfield in New York 1978, pp. 120–21 (for series); Elderfield in London–New York 1984–85, pp. 171–75 (for series); Washington 1986–87, pp. 24–25, 139–41 (for series); Elderfield in New York 1992–93, p. 289 and nos. 233–38 (for series); Flam in Stuttgart 1993, pp. 107, 121–32 (for series); Klein 2001, pp. 225–26, 251–52 (for series).

Jean-François Millet

Gruchy, France, 1814–Barbizon, France, 1875

89. *Head of a Boy*, ca. 1845–48

Black conté crayon heightened with white conté crayon on beige laid paper, darkened
18⅛ x 11⅝ in. (46.2 x 29.6 cm)
Signed in black crayon, lower left: J. F. Millet
1943.877

The format of *Head of a Boy* and the assured balance between bold, loose crayon strokes that suggest the sitter's jacket and cravat and softer, more restrained hatching that shapes his features connect this portrait of a pensive adolescent to several drawings of friends and colleagues that Jean-François Millet created between 1846 and 1849, as he moved away from the prettified Romanticism that had characterized his art during the mid-1840s and toward the quiet realism that would define his mature work.[1] Portraits of children, whether painted or drawn, are very rare in Millet's oeuvre, and this sympathetic glimpse of a youth warily appraising his audience must certainly represent a member of Millet's own circle, probably his youngest brother, Pierre.

From 1840, when Millet left the École des Beaux-Arts and the studio of Paul Delaroche in Paris to return to Cherbourg in his native Normandy, until the end of 1845, when he moved back to the Paris region permanently, portraiture consumed the greater part of his efforts. By the time he painted his first wife, *Pauline Ono en déshabillé* (Musée Thomas Henry, Cherbourg), in 1843 or a friend's young daughter, *Antoinette Hébert devant le miroir* (Murauchi Museum of Art, Hachioji) in 1844, Millet had become the most creative French portraitist working outside the capital, moving easily between Ingresque classicism and insouciant informality as the

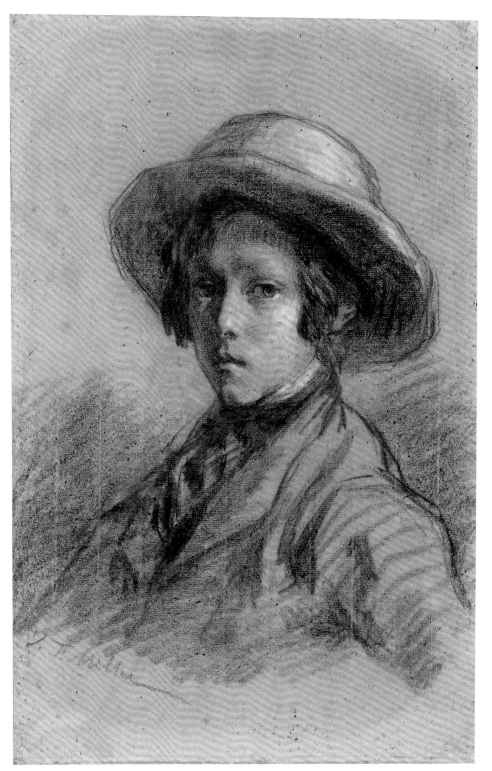

89

occasion warranted. Nonetheless, after he reestablished himself in Paris, Millet virtually abandoned portrait painting. Only the small group of black crayon portraits executed about 1846–49 to which *Head of a Boy* belongs and the occasional incorporation of a family member into a genre painting bridge the first phase of Millet's career with the better-known drawings and paintings of his Barbizon years.

Although *Head of a Boy* is signed (generally an indication that Millet was prepared to part with a work of art), the drawing remained within the artist's family and was sold as part of his widow's estate in 1894, when it was identified as "Portrait de M. P. M." The only significant "P. M." in Millet's life during the mid-1840s was his younger brother Pierre, who would have been thirteen in 1846, a suitable age for the sitter in the present work. If that identification is correct, *Head of a Boy* would be the earliest in Millet's series of crayon portraits, since it would have to predate the artist's return to Paris in late 1845. (Pierre lived with Millet's family in Gruchy, outside Cherbourg.) Conceivably, the Winthrop portrait may have been worked up soon after Millet's return to Paris on the basis of a smaller, freer life study that appears to represent the same sitter in simpler costume, *Portrait of a Young Boy* (Museum of Fine Arts, Boston).[2]

Alexandra R. Murphy

1. For portraits of Diaz, Barye, etc., see Moreau-Nelaton 1921, vol. 1, figs. 55–58.
2. For the Boston drawing, see Murphy in Boston 1984, p. 8.

PROVENANCE: Mme Millet, the artist's widow; her estate sale, Hôtel Drouot, Paris, April 24–25, 1894, no. 86; purchased at that sale by Albert Cahen d'Anvers, Paris (d. 1903); Mme Albert Cahen d'Anvers, Paris (d. 1918); Scott and Fowles, New York, by 1922; acquired from them by Grenville L. Winthrop, October 1922 ($1,000); his bequest to the Fogg Art Museum, 1943.

EXHIBITION: Cambridge, Mass., 1969, no. 108.

REFERENCES: Young 1969, p. 237, fig. 4; Lepoittevin 1971, no. 95, illus.; Murphy in Boston 1984, p. 8.

90. *Peasant Mother at the Hearth (Le Pot au Feu)*, ca. 1857–59

Black conté crayon with pastel and white crayon or chalk on buff laid paper
15⅝ x 12⅝ in. (39.7 x 32.2 cm)
Signed in black crayon, lower right: J. F. Millet
1943.880

Millet came into his own as an artist during the 1850s, as the realm of peasant subject matter opened up by his move to Barbizon profoundly engaged his natural sympathies and challenged his skills as an intently observant draftsman and quiet colorist. He drew *Peasant Mother at the Hearth* during the latter part of that decade, when he began to invest more and more of his time in producing salable drawings celebrating the simplest events of village life—an effort made necessary by the public's rejection of the more overtly critical content of his contemporary Salon paintings such as the 1857 *Gleaners* (Musée d'Orsay, Paris).

Whether drawing a woman stirring soup or a laborer cutting into unbroken soil, Millet prided himself on depicting the precise gestures that characterized a particular activity. The ungainly bracing of his housewife's feet along the hearth captures her effort to reach into a steaming pot while simultaneously stepping back to swing her skirts away from the flames and the dripping pot lid that she holds off to her side. In counterpoint to the apparent simplicity of his subjects and compositions, Millet developed a complex technique that used the broken textures of black crayons drawn across thick paper to suggest the rough surfaces of his country scenes. Interwoven into the hatchings that shape the peasant mother's heavy clothing are faint touches of mustard, mauve, and green pastels that capture the elusive colors of well-worn fabrics glimpsed across a dark interior.

Three preparatory drawings (all Cabinet des Dessins, Louvre, Paris) for *Peasant Mother at the Hearth* reflect the care Millet took in developing his figures: RF 5828 records an early stage in Millet's conception of the housewife, while RF 5679 refines her final pose and RF 5678 establishes the perspective of the fireplace relative to the figure. A finished, closely focused drawing of a deep-set window (British Museum, London) is concurrent with *Peasant Mother at the Hearth*, but whether it preceded or followed the use of a similar motif in the background of the Winthrop drawing is not clear.

Alexandra R. Murphy

PROVENANCE: Cottier and Co., New York and London, 1902; Galerie Georges Petit, Paris, 1917; acquired from them by M. Knoedler, New York and Paris, 1917; acquired from them by Scott and Fowles, New York, 1919; acquired from them by Grenville L. Winthrop, February 2, 1920; his bequest to the Fogg Art Museum, 1943

REFERENCES: Alexandre 1902–3, pl. M15; Moreau-Nelaton 1921, vol. 2, p. 37, fig. 119; Herbert 1962, p. 378.

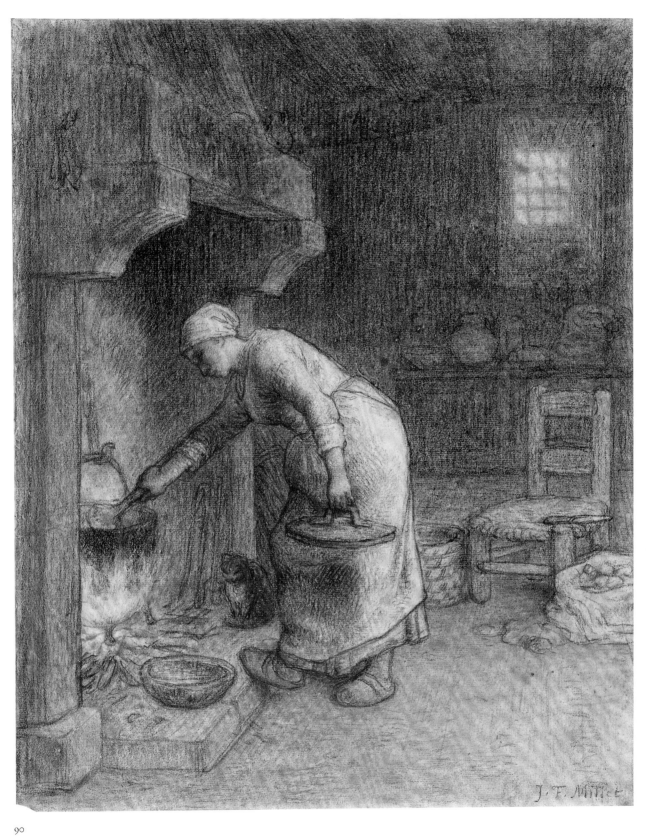

90

Claude Monet

Paris, 1840–Giverny, France, 1926

91. *Road toward the Farm Saint-Siméon, Honfleur,* 1867

Oil on canvas
21½ x 31¼ in. (54.6 x 79. 4 cm)
Signed lower right: Claude Monet
1943.260

In the late spring of 1864, Monet and Frédéric Bazille spent a few weeks painting together in northern France.[1] Among the sites they frequented was an eighteenth-century inn, the Farm Saint-Siméon, located on a bluff about a mile west of Honfleur. The property was famous for its views across the Seine estuary to Le Havre, where Monet had spent his childhood.

Monet's mentor Eugène Boudin was among the many artists who frequented Saint-Siméon in the mid-nineteenth century, and it may have been he who introduced Monet to the place.[2] Visitors to the inn could dine on local specialties such as sole and shellfish or spend the night in the ten-room cottage.[3] It was especially appealing during the summer and fall: "A hedge as tall as a man protects the grounds. . . . One enters through a Norman courtyard . . .

apple trees here, chickens there. . . . Tables anchored to the ground are scattered about with a profusion that becomes a scarcity on beautiful summer days, when the fishermen merrily come running to down pitchers of sparkling cider [fig. 113]."[4]

Between 1864 and 1867, Monet painted at least ten views of the road outside the Farm Saint-Siméon.[5] The road originates at Honfleur, passes the Côte de Grâce (a scenic overlook and site of one of the region's oldest chapels), and wends through the countryside, "bordered, at right, by small rustic homes . . . and at left, by grassy courtyards, planted with apple trees."[6] In the winter of 1866–67, probably during February, Monet painted at least three views of the road covered in snow (fig. 114).[7] It was possibly while working on these pictures—which some art historians consider the artist's first painted series[8]—that he was spotted by a critic out for a stroll: "We glimpsed a little heater, then an easel, then a gentleman swathed in three overcoats, with gloved hands, his face half-

frozen. It was M. Monet, studying an aspect of the snow."[9]

The Winthrop picture is the most springlike of the three paintings. A pale blue sky seems about to break through the haze, and the melting snow on the ground reveals vegetation on either side of the road and mud in the wagon-wheel ruts.

The composition of *Road toward the Farm Saint-Siméon, Honfleur* is one with which the artist felt particularly comfortable. The wide road, which engulfs the lower foreground, recedes into the distance, finally curving out of view. This same compositional device appears in some of Monet's earliest paintings—views of the Fontainebleau forest, the boat-yard at Honfleur, and the town of Honfleur itself—and would have been familiar to Monet from the Japanese prints he so loved, as well as from the art of Camille Corot.[10]

Monet applied his paint unevenly, so that the grain of the canvas is visible in the center, while thick impasto dominates the snowy areas in the lower sections. The two

Fig. 113. Charles-François Daubigny, *The Toutain Farm at Honfleur.* Oil on canvas, 31⅛ x 57⅛ in. (79 x 145 cm). Musée d'Orsay, Paris (photo: RMN—G. Ojeda)

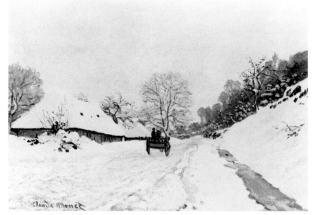

Fig. 114. Claude Monet, *The Cart, Snowy Road at Honfleur, with the Farm Saint-Siméon,* ca. 1867. Oil on canvas, 25⅝ x 36⅜ in. (65 x 92.5 cm). Musée d'Orsay, Paris (photo: RMN—H. Lewandowski)

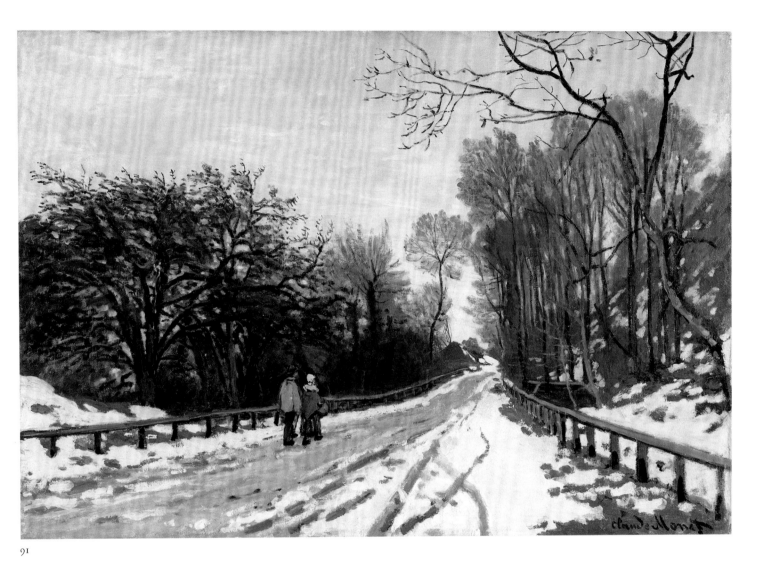

91

Fig. 115. View of the second-floor hall of Grenville Winthrop's New York house

figures walking down the road may have been an afterthought, as they were simply painted over the fence and snowbank. Monet's tactile approach is likely indebted to the snow scenes that his friend Gustave Courbet had painted earlier in the decade. The two artists socialized in Normandy during the fall of 1866 and may have remained in contact through the winter, when the Winthrop picture was made and when Courbet himself painted some twenty snow scenes at Ornans.[11]

The Farm Saint-Siméon remained associated with Monet during his rise to fame. In 1900 a critic described Saint-Siméon as "an informal academy from which has come . . . the modern school of the Impressionists."[12] When Camille Pissarro visited Honfleur three years later, he specifically booked a room at the inn, knowing of its "glorious past." He was disappointed to find that it had been "tidied up for the English who flock there."[13] Meanwhile Monet's depiction of this snowy road was taken to Paris, where it changed hands several times before Winthrop acquired it from the New York gallery of Wildenstein and Company. Photographs of Winthrop's

home reveal that the painting was displayed in a corner of his second-floor hallway, flanked by two nineteenth-century portraits on one side and an early-sixth-century Chinese head of the Buddha on the other (fig. 115).[14]

Rebecca A. Rabinow

1. See Bazille 1992, pp. 81 no. 43, 88 no. 49, 91–92 no. 52.
2. Visitors to the farm included the artists Cals, Corot, Courbet, Daubigny, Diaz, Dupré, Flers, Isabey, Jongkind, Millet, Renouf, and Troyen. For more information, see Cunningham 1976.
3. For more information on the farm, see ibid., esp. pp. 15–19.
4. "Une haie à hauteur d'homme en protége les abords. On entre dans une cour normande . . . pommiers de ci, poules de là. . . . Quelques tables, rivées au sol, sont semées avec une profusion qui devient de la parcimonie aux beaux jours d'été, quand les pêcheurs en frairie accourent pour vider de pétillants pichets de cidre"; Delvau 1865, p. 2.
5. Wildenstein 1996, nos. 24, 25, 28–30, 50, 79–82.
6. "[B]ordé, à droite, de maisonnettes rustiques . . . et, à gauche, de cours herbues, plantées de pommiers . . ."; Delvau 1865, p. 2. Monet painted the chapel of Nôtre-Dame-de-Grace in 1864 (Wildenstein 1996, no. 35).
7. Ibid., nos. 79–81. That winter he also painted a view of the same road near its entrance into Honfleur (ibid., no. 82).
8. Wildenstein 1996, nos. 79–81; Seitz 1960, p. 76; also, Elizabeth Easton in Washington–San Francisco 1998–99, p. 82.
9. "Exposition des Beaux-Arts," *Journal du Havre*, October 9, 1868, quoted in translation in Stuckey 1985, p. 192.

10. Tinterow in Paris–New York 1994–95, p. 248.
11. Courbet, letter to Boudin, ca. September–October 1866, in Courbet 1992, p. 300, no. 66-25. See also Tinterow in Paris–New York 1994–95, p. 249.
12. Jehan Soudan de Pierrefitte, *Le petit Normand*, July 8, 1900, quoted in translation in Cunningham 1976, p. 137. See also a passing mention in Joanne 1883, pp. 324–35.
13. "[C]e passé glorieux . . . c'est arrangé pour les Anglaises qui affluent"; Camille Pissarro, letter to his son Lucien, July 10, 1903, in Pissarro 1980–91, vol. 5 (1991), p. 356. Today the Farm Saint-Siméon is a luxury hotel.
14. Antonio Mancini, *Self-Portrait* (1943.120); attributed to Manet, *Emmanuel Chabrier* (cat. no. 87); *Head of Buddha*, sandstone, Northern Wei dynasty (386–534), from a niche outside of Yungang Cave 16, Shanxi Province (1943.53.46).

PROVENANCE: L. LeBrun; his sale, Galerie Georges Petit, Paris, February 23, 1918, no. 21 (Fr 30,200); purchased at that sale by Martel (possibly Édouard Martell [1834–1920]; possibly to his wife (née Caroline Estelle Elisabeth Mallet [d. 1928]); their (anonymous) sale, Hôtel Drouot, Paris, June 26, 1928, no. 14 (Fr 146,000); purchased at that sale by Wildenstein and Co. (possibly in partnership with Paul Rosenberg); acquired from them by Grenville L. Winthrop, February 18, 1935 ($12,000); his bequest to the Fogg Art Museum, 1943.

EXHIBITIONS: Cambridge, Mass., 1943–44, p. 7; Cambridge, Mass., 1974, no. 26; Cambridge, Mass., 1977a; Cambridge, Mass., 1990, p. 20.

REFERENCES: Malingue 1943, pp. 36, 145, illus.; Reutersvärd 1948, p. 29, illus.; Seitz 1960, no. 17, illus.; Hamilton 1970, no. 87, illus.; Wildenstein 1974–91, vol. 1 (1974), pp. 156–57, no. 80, illus.; Gordon and Forge 1983, p. 40, illus.; Mortimer 1985, p. 192, fig. 218; Stuckey 1985, p. 40, illus.; Bowron 1990, fig. 344; Wildenstein 1996, vol. 2, pp. 43–44, no. 80, illus.; Washington–San Francisco 1998–99, pp. 17 (fig. 5), 82.

Gustave Moreau

Paris, 1826–Paris, 1898

92. *The Young Man and Death in Memory of Théodore Chassériau*, 1856–65

Oil on canvas
85 x 48⅞ in. (215.9 x 123.9 cm)
Signed, dated, and inscribed lower left: – A LA MEMOIRE – / DE THEODORE CHASSERIAU – / – GUSTAVE MOREAU – 1865
1942.186

Gustave Moreau and Théodore Chassériau were neighbors for a brief while in the early 1850s near the place Pigalle.[1] In this short time, until July 1853, when Moreau moved to 14 rue de La Rochefoucauld, he benefited from the advice of the older artist[2] while

preparing two paintings for the Salon of 1853, *The Song of Songs* (Musée des Beaux-Arts, Dijon) and *Darius Fleeing after the Battle of Arbela*.[3] Both were so marked by Chassériau's influence that critics commented on the dependence. Chassériau's

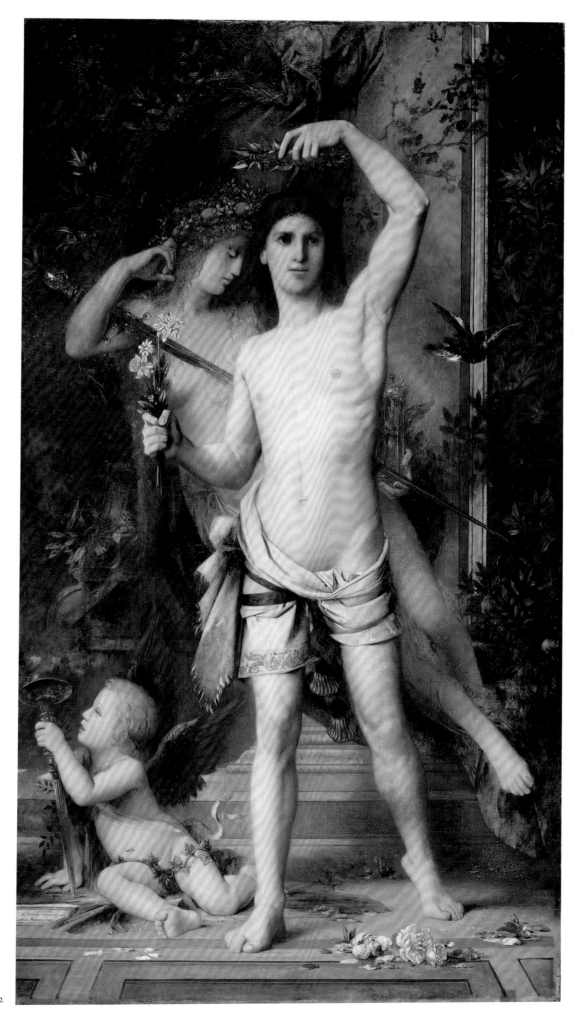

92

death on October 8, 1856, deeply affected Moreau, who attended his funeral.[4]

It seems Moreau immediately thought of paying tribute to the late artist, of whom he would always speak with emotion. On December 4, 1856, Eugène Fromentin wrote him on the subject: "Could you instead be busy starting your painting of the young man?"[5] On December 8, 1856, Moreau replied: "Nevertheless, I have begun to draw my figure of the young conqueror. . . . I got a model again, I've redone pieces of it without altering the whole or the effect, and I am expecting a fairly good result from this supreme effort. . . . But today I am tackling in earnest that sad figure of death, even if my painting has to remain on my hands, as my father predicts. The figure of the young man is completely drawn today, and I've never done better; it's very natural in its proportions, without losing too much of its style, which I've never managed before. That progress delights me. The photograph is of very little use; it didn't turn out very well and there's a stiffness, like a doll. Nevertheless, the proportions will be of use to me. I am adding a child in the empty left corner. That child has his head lifted toward the sky, he's sitting on his little behind, very naturally, and holding a torch in his hand."[6] The Musée Gustave Moreau houses several drawings, painted sketches, and cartoons that seem to predate the painting in the Winthrop collection, which Moreau exhibited at the Salon of 1865, and others that are of later date and related to versions or variants of the composition. A beautiful, particularly vigorous drawing[7] shows the young man full face, head lowered, and in motion, whereas Death is a terrifying image, a skeleton with one leg shown on the right, the other placed in the center, on a ball behind the young man's feet; a seated child is rapidly sketched in on the lower

right, in a different pose than that finally chosen. Two painted sketches[8] without the child show a winged Death, and the ball—Fortune?—once more at lower center. This was undoubtedly the state of the work in 1856. Death, who seems to have one foot on the ball, does not yet have the diagonal position that would be adopted after 1860.

An early idea for that position can be found in a sketch in the margin of page 373 of the 1660 edition of Ovid's *Metamorphoses* housed at the Musée Gustave Moreau,[9] which proved very useful to the artist. That sketch can be interpreted as a first idea for *Hercules and Omphale*,[10] on which Moreau was working in 1856–57. In that sketch, the female figure is half-lying on what appears to be a draped bed, in a pose similar to that of the classical sculpture *Ariadne Sleeping* at the Vatican. In the painting, still housed at the Musée Gustave Moreau, Omphale is standing, in a pose similar to that of the young man. To use that recumbent pose for Death in flight, Moreau had only to reverse it and eliminate the bed drapery.

The definitive choice of the poses for the three figures seems to have been made only after the artist returned from his study trip to Italy—October 1857 to September 1859—as attested in a squared drawing dated 1860.[11] In it, the man has a very young face and is depicted nude. Partial and complete studies[12] also exist, including a rapidly painted sketch of the young man alone, wearing a draped loincloth.[13] As often in Moreau's works, significant poses were sought in art of the past: the profile of Death with closed eyes is reminiscent of Michelangelo's *Night*, part of the tomb for Guiliano II de' Medici (New Sacristy, San Lorenzo, Florence).[14]

Julius Kaplan has indicated that the gesture of the arm raised above the young man's head is borrowed, but reversed, from Jean-Antoine Houdon's famous *Écorché*.[15]

Moreau may have seen a large copy of the *Écorché* at the École des Beaux-Arts, where it was well known to students.

The Young Man and Death was displayed at the Salon of 1865 along with *Jason* (Musée d'Orsay, Paris). In his review of the Salon, Maxime Du Camp praised the work. Du Camp knew Moreau well, at least as of 1864. He wrote to him several times beginning on February 25, 1865, for permission to see the paintings intended for the next Salon. During his visit, Du Camp must have had the iconography of the painting explained to him. In his review he included a piece of information that could only have come from the artist, on the source for the figure of Death: "M. Moreau gave her the charming physiognomy that Hindu theogony has established for Vishnu Narayana when, lying in the coils of the serpent Ananta in calm waters, he dreams while contemplating the Brahmanic lotus that rises from his sacred navel."[16]

The painting found a buyer only in 1870. We may wonder whether, after being sold to the art dealer Faivre,[17] it did not go to the Galerie Durand-Ruel, which in 1868 had been charged with selling *Oedipus and the Sphinx*. Indeed, in 1873, an engraved reproduction of *The Young Man and Death* was in an album of prints published by that gallery. We do not know when it entered the collection of Albert Cahen d'Anvers (1846–1903), who, according to the list drawn up by Moreau in 1885, owned three of his works, including this painting.[18] The artist had known him at least since 1881, and Cahen d'Anvers, though living on the Left Bank, was part of the same Jewish milieu as the Fould and Koenigswarter families, whom Moreau frequented in his youth.

Geneviève Lacambre

1. Chassériau lived at 26 avenue Frochot; Moreau, at rue de Laval, 28 avenue Frochot, according to the *livret* of the Salon of 1852.

2. The Musée Gustave Moreau, Paris, houses several drawings by Chassériau (including a portrait, *Rachel,* exhibited in the corridor of the second-floor apartment and annotated by Moreau: "Croquis fait sur mon portefeuille par Th. Chassériau avenue Frochot—1853"), as well as a lithograph, *Apollo and Daphne,* which appeared in *L'artiste* in 1844, photogravure reproductions of drawings, and Braun photographs surrounded by paintings. A batch of drawings that recently appeared on the Paris art market seems to point to a collaboration on the paintings Moreau exhibited in 1853.

3. Musée Gustave Moreau, Inv. 223. A small sketch (Inv. 604) shows the composition before the later—never completed—changes were made to the large canvas.

4. Eugène Delacroix remarked in his journal: "10 octobre [1856], Convoi du pauvre Chassériau. J'y trouve Dauzats, Diaz et le jeune Moreau le peintre. Il me plait assez. Je rentre de l'église avec Emile Lassalle"; Delacroix 1996, p. 594.

5. Fromentin 1995, vol. 1, pp. 1013–14.

6. Translated from ibid., pp. 1015–16.

7. Musée Gustave Moreau, Des. 1941; Kaplan 1974, fig. 1, p. 19. See also Bittler and Mathieu 1983, no. 1941 (this catalogue of drawings lists them to no. 4831).

8. Musée Gustave Moreau, Cat. 855 (22⅛ x 13⅜ in. [56 x 34 cm]; Dorra 1973, p. 132, illus.) and Cat. 642 (11⅛ x 7⅞ in. [28 x 20 cm]); Kaplan 1974, p. 79, no. 15, illus.).

9. Musée Gustave Moreau, Inv. 14698.

10. Musée Gustave Moreau, Inv. 13989 (oil on canvas, 41⅛ x 25⅜ in. [104.5 x 65 cm]).

11. Musée Gustave Moreau, Des. 92. Same composition in Des. 2941, using the same wash technique. The title "le jeune et la mort" appears on a list of subjects compiled in about 1860 in his "Livre de notes (rouge)"; Musée Gustave Moreau, Arch. GM 500, p. 3, no. 42.

12. Musée Gustave Moreau, Des. 850.

13. Musée Gustave Moreau, Cat. 1163 (10⅝ x 13⅞ in.

[27 x 35 cm]): the young man is sketched in on the right part of the canvas; on the left, an unrelated profile.

14. A plaster in miniature of it is housed in the Musée Gustave Moreau, Inv. 16191. Oval metal stamp on the front, lower left: *J. F.*; see Rome 1996–97, no. 14, illus. The same type of bowed head in profile is found again in the large *Léda* (Musée Gustave Moreau, Cat. 43) and in the corresponding water-color dated 1865 (Cat. 530).

15. Kaplan 1974, p. 18, fig. 9. In fact, among the drawings in storage at the Musée Gustave Moreau (Des. 8513), there is a sketch done in the same direction as the plaster (i.e., with the right arm raised). Kaplan notes that a plaster in miniature of Houdon's work is at the Musée Gustave Moreau (Inv. 16227; 19⅞ in. [50.5 cm] high). However, that miniature could not have served as Moreau's model since it dates from after 1871. A rectangular metal stamp on the base, *Thoquet et Marchon 27 rue Guénégaud,* indicates the Parisian caster who took over the Micheli company and who does not appear in the Didot-Bottin business registry until 1871 to 1885.

16. Du Camp 1865, p. 664. All these elements are found again in pl. 7 of Edward Moor's *The Hindu Pantheon* (see Dorra 1973, p. 134, fig. 5), though there Vishnu is horizontal. Moreau consulted this lavishly illustrated book, published in London in 1810, at the Bibliothèque Impériale (now the Bibliothèque Nationale de France), as attested in two sheets of sketches of other plates from the same work: Musée Gustave Moreau, Des. 9548 after pl. 81, and Des. 9730 after seven other plates; see Paris–Lorient 1997, no. 74, illus., and p. 234.

17. Musée Gustave Moreau, Arch. GM 501. The price is noted in an account book belonging to Mme Moreau, the artist's mother, on June 1, 1870, without the buyer's name.

18. Musée Gustave Moreau, Arch. GM 500, p. 74: "chez M. Cahen d'Anvers (Albert) / 1 Le Jeune homme et la mort. Peinture / 2 le christ au oliviers aquarell / 3 et Salomé entrant dans la salle du fest in aquarelle / Paris rue de l'Université n° [*sic*]." In fact, he lived at 118 rue de Grenelle (in the Faubourg Saint-Germain, parallel to rue de

l'Université). His widow lent the three works to the exhibition at the Galerie Georges Petit in 1906, which proves he did not purchase any others.

PROVENANCE: Sold by the artist to the dealer Faivre, May 1, 1870 (Fr 6,000); Albert Cahen d'Anvers; Mme Cahen d'Anvers; her sale, May 14, 1920, no. 20 (Fr 81,000); comte Roederer, Paris; acquired from him through Martin Birnbaum by Grenville L. Winthrop, 1935 (Fr 180,000, along with Moreau's *Moses Exposed,* 1943.262); his gift to the Fogg Art Museum, 1942.

EXHIBITIONS: Paris (Salon) 1865, no. 1540 (as "Le Jeune Homme et la Mort à la mémoire de Théodore Chassériau"); Paris 1867c, no. 484 (as "Le Jeune Homme et la Mort. A la mémoire de Théodore Chassériau"); Amiens 1868, no. 386 (as "Le Jeune Homme et la Mort. Allégorie à la mémoire de Théodore Chassériau"); Bordeaux 1868, no. 456 (as "Le Jeune Homme et la Mort"); Paris 1889b, no. 531 (as "Le Jeune Homme et la Mort"); Paris 1906b, no. 22 (collection of Mme A[lbert] Cahen d'Anvers); Tokyo 2002, no. 53.

REFERENCES: Galerie Durand-Ruel 1873, part 12, no. 119 (engraved by Le Rat); Baignières 1886, p. 218; Renan 1886 (May), p. 378, (July), pp. 42–44; Leprieur 1889, pp. 19, 41, 43, 46; Renan 1900, p. 28, illus. facing p. 54 (engraved by Patricot); Schuré 1904; Deshairs and Laran [1913], pp. 31–32; *Art et décoration,* June 1920, illus.; Romanet 1926, p. 313; Dorra 1973, pp. 129–32, fig. 4; Kaplan 1974, pp. 12, 19 (fig. 11), 21; Mathieu 1976, pp. 92–94, no. 67, illus.; Bowron 1990, fig. 318; Mathieu 1991, pl. 9, fig. 106; Mathieu 1994, pp. 83, 85 (illus.), 86; Lacambre 1996, p. 8, illus.; Dussol 1997, pp. 10 (illus.), 159; Lacambre 1997, p. 49; Mathieu 1998a, no. 80, illus.; Capodieci in Lacambre, Cooke, and Capodieci 1998, p. 34; Mathieu 1998b, p. 70, illus. p. 73; Sanchez and Seydoux 1998, p. 135, no. 1899-13; Lacambre in Paris–Chicago–New York 1998–99, pp. 177, 264–65, 271; Peltre 2001, p. 22, illus. pp. 216–18 and no. 243; Peltre 2002, pp. 48 (detail illus.), 50, 53, fig. 2.

93. *The Chimera*, 1867

Oil on wood
13 x 10¾ in. (33 x 27.3 cm)
Signed and dated lower left: Gustave Moreau
GM *[monogram]* 1867
Inscribed on back: Chimere / à Monsieur
Bocquet
1943.269

The subject of the chimera in Moreau's oeuvre appeared first in a drawing dated 1856,[1] in which the wings of the centaur, half horse, half man, are small and curved, and the horse's coat is composed of scales. His pose can be compared with that of Nessus in an engraving illustrating the rape of Deianira in the 1660 edition of Ovid's *Metamorphoses*, a copy of which Moreau owned.[2] Moreau used it for the leaping centaur in *The Springs*, which remained in the state of a large cartoon,[3] and in a drawing entitled *The Centaur*.[4] The pose of the woman, who is grasping the chimera's neck, is already fixed, her left leg outstretched, the right leg bent, in an attitude taken from a classical sarcophagus in the Palazzo Lancellotti in Rome.

On an alphabetical list of his drawings made before 1870, there appears a "femme enlevée par un centaure" (woman ravished by a centaur), which is no doubt connected to this theme.[5] A circular watercolor composition,[6] explicitly titled "La Chimère" and whose date, 1858, indicates it was made in Italy, shows the wings deployed behind the centaur to the outer limit of the circle and a flying bird below right. The centaur's coat is speckled, whereas in the later versions, short feathers appear on the horse's flank and the left wing stands almost straight up. In his "Livre de notes (rouge)," Moreau noted two versions of *The Chimera*, painted on wood and practically the same size, sold in October 1867: the first, undated, to

M. Wertheimber; the second, dated 1867, to M. Bocquet, the painting in the Winthrop collection. Moreau sometimes called that second version a "variante. reprod."[7] and sometimes a "reproduction de cette Chimère sans variante peinture" (reproduction of that Chimera without painting variant),[8] despite slight differences in the iconography and color scheme. Hence M. Bocquet's version reproduces the bird in the 1858 watercolor, which is absent from the Wertheimber version.

These two valuable paintings, carefully finished, in the small format Moreau was producing for connoisseurs (in contrast to the large-format Salon paintings), were nevertheless not the last incarnations of the theme. The round format reappeared in an enamel by Frédéric de Courcy, exhibited at the Salon of 1869,[9] and in the watercolor in the Charles Hayem collection.[10] This uses the same color scheme, especially the red veil in the lower portion, that is found in an enamel dated 1889, rectangular this time, done by Paul Grandhomme and Alfred Garnier after the Hayem watercolor.[11] At the Salon des Artistes Français of 1891, Gaston Manchon showed an etching, *The Chimera: After Gustave Moreau*.[12] Finally, an enamel on this subject, which belonged to Roger Marx, is dated 1897 and signed by Paul Grandhomme.[13]

In fact, it seems that Charles Hayem, a passionate art lover, wished to have a watercolor of *The Chimera* in 1879, when that composition—with the bird at lower right as in M. Bocquet's version—appeared as the frontispiece to *The Chimera*, a novel by Ernest Chesneau, published by Charpentier. The author, a friend of the artist ever since he praised Moreau's paintings at the Salon of 1864, dedicated the work to the painter.

Nevertheless, Hayem had to wait for his watercolor. He had obtained the loan of a photograph of the painted version and sent it back on September 7, 1879.[14] He again asked for a photograph to offer to one of his women friends, on December 25, 1880. He must have received the watercolor in 1881 or 1882.[15] The poet Jean Lorrain admired it at the collector's home in the spring of 1883; it inspired a sonnet he addressed to Moreau in June 1883. In his letter, Lorrain wrote: "I am in love, irremediably so, with the Sirens, the Sphinx, and the Chimera, chimerically in love myself with riddles and mysteries; I send you these awkward flights of fancy and beg you to be very forgiving toward someone with a real mania for your art."[16]

The beautiful description by Ary Renan reveals the fascination exerted by the original image on the artist's admirers and explains why it was diffused in every medium possible: "With one last step, it is suspended over the pit, and, in its androgynous face, its blue eyes gaze at the zenith. But a frantic creature, a mortal virgin—a soul in tears—leaps onto the neck of the chimera whom she loves, abandoning behind her her earthly veils, throwing her head back so as not to see the gaping abyss; the same north wind lashes their flesh, and their passionate fervor joins them for an instant into a group wholly drawn against the sky. . . . In the history of art, I know no clearer or more sublime symbol of it."[17]

Geneviève Lacambre

1. It has recently reappeared and undoubtedly comes from the collection of Gustave Duruflé. It was sold, Hôtel Drouot, Paris, April 7, 1995, no. 21; it was exhibited in Paris–Chicago–New York 1998–99, no. 13 (see the entry in the Eng. ed., pp. 55–56).
2. Musée Gustave Moreau, Paris, Inv. 14698 (translation and commentary by Pierre du Ryer); see Rome 1996–97, p. 59, no. 2, illus.

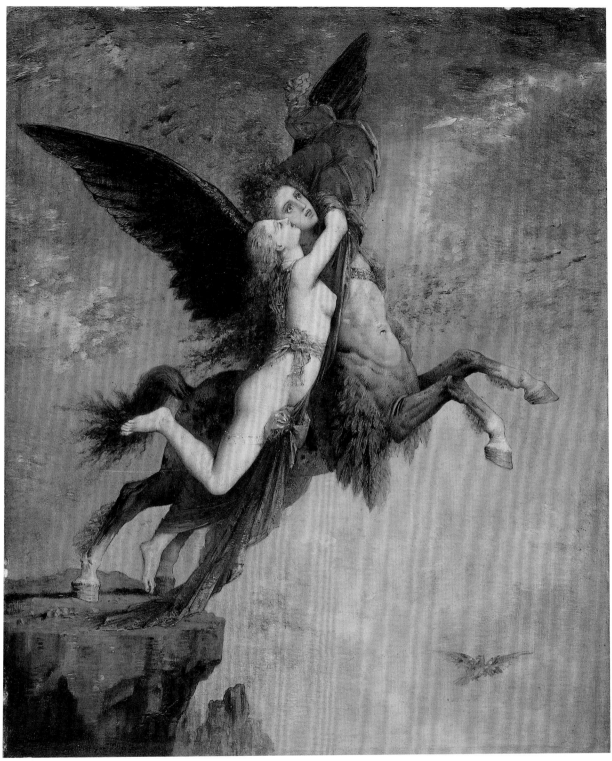

93

3. Musée Gustave Moreau, Cat. 40. Musée Gustave
Moreau, Des. 2283 and 2292, bearing the inscription
Études pour les Sources, are dated 1856.

4. Musée Gustave Moreau, Des. 5067, on tracing
paper: the centaur with a cupid is reversed, as is the
title "Le Centaure"; see Spoleto 1992, no. 88, illus.

5. Musée Gustave Moreau, Arch. GM 500, p. 218.

6. Musée Gustave Moreau, Cat. 457.

7. Musée Gustave Moreau, Arch. GM 500, p. 261.

8. Ibid., p. 77. On the list of collectors dating from
1885, Moreau indicated that M. Bocquet was
deceased.

9. Paris (Salon) 1869, no. 2636. That enamel, dated
1869 with a diameter of 13⅞ in. (35 cm), in a square
black and gold frame, is in a private collection in
Paris. The veils are red below, olive green above; the
wings and feathers are blue.

10. Mathieu 1998a, no. 217, illus. It is also reproduced

by Deshairs and Laran [1913], pl. 4, facing p. 24,
with its location incorrectly indicated as the Musée
Gustave Moreau. In a letter from Cannes on
January 9, 1880, Hayem wrote Moreau that he
thought the paintings for the Salon were completed
and that "[v]ous pourriez alors vous occuper de
l'OEdipe, de la Chimère, du St Georges, etc. . . .
Je tâcherai d'être patient."

11. That 1889 enamel was acquired by the famous

Russian collector Sergei Shchukin; it is now at the Gosudarstvennyj Istoričeskij Muzej, Moscow, GIM 23826; see Lacambre 1999a, pp. 89–91, illus. The veil is red below, as in the Courcy enamel, and yellow above, whereas it is olive green in the Courcy.

12. Salon des Artistes Français, Paris, 1891, no. 3504 (16⅛ x 13⅜ in. [42 x 34 cm]; see Mathieu 1998a, no. 482), after the Bocquet version. There is a framed copy of it in the dining room on the second floor of the Musée Gustave Moreau.

13. Ibid., no. 513.

14. There are two framed photographs in the dining room on the second floor of the Musée Gustave Moreau, no doubt done by the photographer Bingham.

15. It does not appear clearly in the accounts or letters. Payments without precise indication of the work concerned took place during those years.

16. Translated from quotation in Lorrain and Moreau 1998, p. 26. The sonnet is found on p. 30. It was published in *La jeune France* in October 1883, and reprinted in *L'ombre ardente* in 1897.

17. Translated from quotation in Deshairs and Laran [1913], p. 24.

PROVENANCE: Sold by the artist to (?) Bocquet, October 9, 1867 (Fr 2,000); (?) Drouin; Willy Blumenthal; acquired from him through Martin Birnbaum by Grenville L. Winthrop, 1935 (Fr 38,500); his bequest to the Fogg Art Museum, 1943.

EXHIBITIONS: Paris 1906b, no. 21 (collection of Willy Blumenthal); Tokyo 2002, no. 43.

REFERENCES: Renan 1900, pp. 105–6, illus.; Mathieu 1976, no. 89, illus.; Selz 1978, p. 29, illus.; Bowron 1990, fig. 316; Mathieu 1991, no. 121, illus.; Mathieu 1994, pp. 98–99, illus. p. 101; Mathieu 1998a, no. 104, illus.; Lacambre in Paris–Chicago–New York 1998–99, p. 264 (with a confusion between the two versions).

94. *Aphrodite,* or *Birth of Venus,* 1871

Watercolor and white gouache over graphite on cream wove paper
9⅝ x 5⅞ in. (24.4 x 14.7 cm)
Signed and inscribed along bottom, in black ink over graphite, left: GM [monogram]; in black ink and white gouache over graphite, center:
APHRODITE; *in black ink, right:* Gustave Moreau
1943.388

During his second stay in Florence in late December 1858, Moreau had copied Botticelli's *Birth of Venus.*[1] That subject, the pretext for a depiction of a female nude, was a favorite of academic painters such as Alexandre Cabanel and Eugène-Emmanuel Amaury-Duval. Moreau took up the theme in 1866 and before 1870 painted several variants of it, in which he attempted to set himself apart from the traditional schema with Venus seated, lying, or standing in front of rocks and stalactites or with the supplementary figures, the fishermen or the men who first found her like that.

A sheet that can be dated to 1871 contains three lists of subjects—Venuses, genre paintings, history paintings—and, among the Venuses, seven descriptions.[2] The sixth of these, "Vénus naissant dont un dessin dans un album: ligne diagonale.

composition singulière" (Venus being born, including a drawing in an album: diagonal line, unique composition), may be the bright watercolor studied here. The diagonal is marked by the forward thrust of the figure's hip and the lock of her hair at left. The quasi-vertical position of her feet, seen frontally, almost gives her the look of a flying figure, like Sappho falling from the rock of Leucas, another subject dear to Moreau. Of course, she is rising up from the sea foam, as in Ingres's *Venus Anadyomene,*[3] her feet barely touching a sheer rock on which a cupid or winged genie is squatting behind her—the tip of his wing is visible to the left of Venus's right leg. The cupid holds a lit torch, an attribute that can be connected to the one that appears in *The Young Man and Death* (cat. no. 92).

In the face of the sea's immensity, Venus holds back her long hair, flying in the wind, with her left hand, and modestly lowers her eyes. The frontal presentation of the body with the head in profile is extremely common in Moreau's works and no doubt stems from his familiarity with classical intaglios, of which he possessed molds and photographs.

Fig. 116. Gustave Moreau, *Venus Anadyomene.* Chalk and India ink, 5¼ x 3¼ in. (13.2 x 8.3 cm). Musée Gustave Moreau, Paris, Des. 1951 (photo: Réunion des Musées Nationaux)

A small drawing (fig. 116) constitutes one stage in the elaboration of the composition; the India ink highlights show how the iconography was simplified. As in the watercolor, the horizon line falls at mid-thigh. The artist had first intended to paint the

94

continuing to designate her by the name "Venus."

This watercolor was owned by a succession of collectors passionate about Moreau's art. It was given to Félix de Romilly as a New Year's present by his wife.[6] De Romilly must have parted with the work, for, according to the list Moreau drew up in 1885 in his "Livre de notes (rouge)," it no longer was in de Romilly's home.

Indeed, the watercolor had been bought in 1881 by Alfred Hartmann, an industrialist from Mulhouse. Under the date June 9, 1881, Pauline Moreau, the artist's mother, notes in her account book payment of one thousand francs for "Venus watercolor" by "M. A. Hartmann." Hartmann sent Moreau twice that amount. Moreau often did not declare the entire sum he received to his mother. It is not known whether he kept some money for a margin of unacknowledged financial freedom or set a sum aside for professional costs.

Hartmann's letter enclosing the money describes the mounting the watercolor had at the time, which seems to be what still exists today: "The framer has wrongly kept the black lines and his gold beveled edge is too wide, which makes the mounting heavy, when it needs rather to be very light."[7]

The artist concurred with Hartmann's desire for lightness. He wrote to Antony Roux in December 1881: "I remember that, for that fable [of La Fontaine], you wanted to have something from me reminiscent of the composition of mine that M. Hartmann has, that is, a white, wholly ideal, milky figure with Olympian light rising on the light sky of Greece, the whole thing very bright, very limpid, and handled as a drawing rather than a true painting."[8]

Geneviève Lacambre

shell—as in Botticelli—and a flying cupid holding a bow. Venus, her face in profile, holds back her hair with a decided gesture of both hands, a memory perhaps of Théodore Chassériau's *Sea Venus*.[4] Appearing in the lower portion of that drawing is Venus's last name, Anadyomene, which literally means, "comes out of the depths."

On another drawing with a different iconography, "Anadyomene" is inscribed in the lower portion in Greek capital letters,[5] a good indication of the artist's familiarity with the Greek language. On the watercolor in the Winthrop collection, Moreau inscribed in Latin capital letters the Greek form of the goddess's name, even while

1. Musée Gustave Moreau, Paris, Inv. 13622; see Rome 1996–97, p. 32, no. 64, illus.
2. Musée Gustave Moreau, Arch. GM 507. Among the genre paintings is *The Crusader*, for which a drawing

exists, dated 1871 (Musée Gustave Moreau, Des. 1784), and among the history paintings, *France, Large Allegorical Composition* (Des. 5871), inspired by the war of 1870–71 and never executed in large format.

3. The version in the Musée Condé, Chantilly, was exhibited at the Universal Exposition of 1855 in Paris; a small replica was bequeathed to the Louvre in 1867 by Marcotte Genlis.

4. Chassériau exhibited a painting at the Salon of 1839 under the title "Venus Anadyomene" (Musée du Louvre, Paris), and he made a lithograph of the subject. Moreau owned a copy of it.

5. Musée Gustave Moreau, Des. 3431; in it, Venus leans on a rock.

6. Alfred de Sourdeval, letter to Moreau, December 26, 1871, Archives, Musée Gustave Moreau.

7. Translated from Hartmann, letter to Moreau, June 8, 1881, Archives, Musée Gustave Moreau.

8. Translated from Moreau, letter to Roux, December 1881, Archives, Musée Gustave Moreau.

PROVENANCE: Félix de Romilly, Paris, 1871 (Fr 600); returned to the artist; purchased from the artist through the dealer Beugniet by Alfred Hartmann, Mulhouse, June 1881 (Fr 2,000); his sale, Hôtel Drouot, Paris, April 12–15, 1899, no. 311 (as "Aphrodite"; Fr 3,500); acquired at that sale by Louis Sarlin; his sale, Galerie Georges Petit, Paris, March 2, 1918, no. 79 (as "Naissance de Vénus"); (Alfred?) Beurdeley; Scott and Fowles, New York; acquired from them by by Grenville L. Winthrop, January 2, 1922 ($400); his bequest to the Fogg Art Museum, 1943.

EXHIBITIONS: Paris 1906, no. 190 (as "Venus"); Tokyo 2002, no. 59.

REFERENCES: Mathieu 1976, no. 121, illus.; Mathieu 1994, p. 96, illus.; Lacambre 1996, p. 31, illus.; Lacambre 1997, p. 65, illus.; Lacambre, Cooke, and Capodieci 1998, p. 100, fig. 1; Mathieu 1998a, no. 138, illus.; Lacambre in Paris–Chicago–New York 1998–99, pp. 266, 269; Lacambre 1999b, p. 65, illus.

95. *The Apparition*, 1877

Oil on canvas
21³⁄₈ x 17¹⁄₂ in. (54.2 x 44.5 cm)
Signed lower left: Gustave Moreau
1943.268

Gustave Duruflé (1834–1909), who lived in the same neighborhood as Moreau, was introduced to the artist through a letter dated March 18, 1870, from Maxime Du Camp, requesting an interview. Duruflé also knew Armand Du Mesnil, an intimate of the painter Eugène Fromentin, a faithful friend of Moreau, and became in turn a regular visitor, as attested in the vast correspondence housed in the archives of the Musée Gustave Moreau. From this source, we also know that Duruflé received visits from various critics—Paul Leprieur, Ary Renan, Gustave Larroumet—to whom he willingly showed his "little canvases."[1] He commissioned from Moreau particularly refined miniature versions, painted or drawn, of the artist's most famous compositions.[2] Duruflé also collected coins and medals; his posthumous sale, on May 9–11, 1910, contained 710 such items. It is therefore not surprising that, shortly after the Salon of 1876 where Moreau made a name

for himself, particularly with the painting *Salome* and the large watercolor *The Apparition*,[3] Duruflé should have wished to enrich his collection with the latter subject. Bloody themes did not put him off, since in February 1877 he also obtained a painting depicting Diomedes devoured by his horses[4] and, in November of the same year, a cameo of the *Head of Orpheus*.[5]

The Apparition is a medium-size variation on a theme already treated in the Salon watercolor, with which it bears many similarities, though it is at the same time less complex. The seated musician has disappeared, and a black panther has been added at Salome's feet. Herod and Herodias, on the left, and the executioner on the right, are rapidly sketched in. The architecture and lighting are different, though certain details are used, such as the capitals inspired by the Alhambra in Grenada, Spain, and the haloed statue in the center, which, barely visible in the watercolor, in the painting stands out against a bright background. The architecture, marked by solid columns and massive architraves, can be compared with that Moreau used for the large painting *David,* presented at the

Exposition Universelle of 1878. Particularly forceful is the evocation of temple caves in India, especially those at Elephanta, photographs of which he had studied at the Palais de l'Industrie in 1873.[6] Salome's attitude is the same as that in the watercolor. She is slightly less covered in jewels, and the details of her costume, easily rendered in watercolor, are rapidly sketched in oil. The head of John the Baptist appears to her more tinged with blood than in other versions, surrounded by an enormous luminous halo, similar to the one in the large painting *The Apparition,* which the artist kept in his studio.[7]

Hence the painting is far from simply a miniature of one or another version; it has its own originality, its particular, glowing-red sumptuousness.

The lugubrious iconography corresponds to the general idea of decadence that haunted the artist after the Franco-Prussian War of 1870–71 and its aftermath, the Commune. Might it not be a symbolic transposition of that cataclysm recklessly triggered by Napoleon III at the instigation of the empress, which led to so many violent deaths? But the prophet's bloody head,

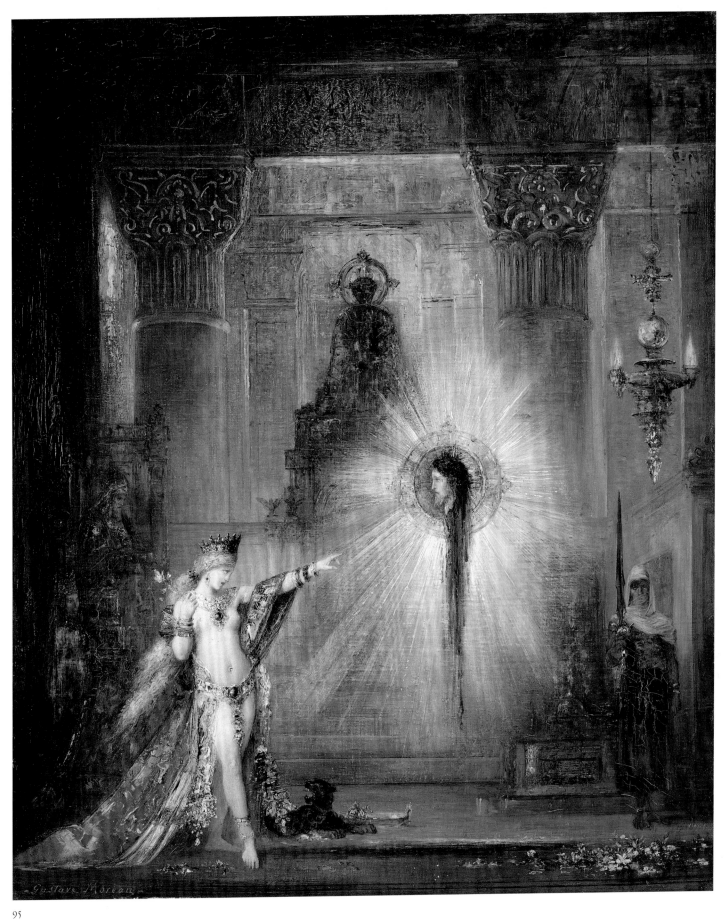

95

which Salome will demand from the weak sovereign Herod at the end of her voluptuous dance, is also like the head of Orpheus, which bears within it a certain hope: the thoughts of the poet, of the prophet, persist beyond physical death. In this series of troubling compositions, Moreau proves to be the painter of dreams adorned with the splendors of the entire Orient.

Geneviève Lacambre

1. "Ce sera pour moi une fête de montrer mes petites toiles à Monsieur Renan"; Musée Gustave Moreau, Paris, Duruflé correspondence, letter dated "Tuesday evening," Arch GM.
2. On this subject, see Rouen 2000, p. 48. In 1885 Moreau made note of ten works in Duruflé's collection (Musée Gustave Moreau, Arch GM 500, p. 74), including: "3. L'apparition peinture."
3. Musée du Louvre, Paris, Département des Arts Graphiques, fonds du Musée d'Orsay (formerly Charles Hayem collection).
4. For Fr 2,000 (18⅛ x 15 in. [46 x 38 cm]), collection of M. Zimet, French and Co., New York.
5. For Fr 2,000 (11⅞ x 6½ in. [30 x 16.5 cm]); Christie's, Monaco, June 30, 1995, no. 149, illus.; see Mathieu 1998a, fig. 90.
6. See Paris–Lorient 1997, nos. 70, 72.
7. Musée Gustave Moreau, Cat. 222. That version, the same size as the *Salome* at the Salon of 1876, was left unfinished. In the last months of his life, the artist added decorative motifs.

PROVENANCE: Sold by the artist to Gustave Duruflé, February 1877 (Fr 4,000; according to Mme Moreau's account book, listed in the annual summary as "Salome and Apparition," then "Salome"); G. Bernheim; purchased by (?) Tauber, Paris, ca. 1912 (Fr 35,000; according to Alfred Baillehache's manuscript catalogue, at the Galerie Brame et Lorenceau, Paris, no. 38, as "L'Apparition [Salomé dansant]"); acquired from him through Martin Birnbaum by Grenville L. Winthrop, October 1930 (Fr 165,000); his bequest to the Fogg Art Museum, 1943.

EXHIBITIONS: Cambridge, Mass., 1960; Cambridge, Mass., 1969, no. 90; Cambridge, Mass., 1973a; Cambridge, Mass., 1977a; Tokyo 2002, no. 26.

REFERENCES: Mathieu 1976, fig. 160; Bowron 1990, fig. 320; Mathieu 1991, fig. 187; Mathieu 1998a, fig. 187; Lacambre in Paris–Chicago–New York 1998–99, p. 267.

96. *Jacob and the Angel*, 1874–78

Oil on canvas
102 x 58½ in. (259.2 x 148.6 cm)
Signed lower left: Gustave Moreau
1943.266

"By a singular coincidence stemming, in short, from the fact that the true artist does no more than translate the movements of his soul, my subjects could be symbolic of current events and aspirations, as well as current cataclysms."[1] These words of Moreau help us to understand the meaning of his large compositions.

The idea of using the biblical theme of Jacob wrestling the angel (Genesis 32:22–32) must have germinated in Moreau's mind shortly after the events of 1870–71, which marked the fall of the Second Empire, the Commune, and the beginnings of the Third Republic. The artist had been greatly shocked by these happenings and situated himself more on the side of the reactionaries in politics, the side of the clerics against the republicans.

The painting is cited in the artist's "Notes des choses à faire pendant le mois jusqu'au 15 9bre" (Notes of things to do during the month up to Sept. 15), which dates from 1874.[2] In particular, we read: "recalquer les figures du Moïse pour en prendre la toile pour le Jacob: mesurer cette toile avec celle du Jacob" (retrace the figures of Moses to use the canvas for Jacob: measure that canvas against the Jacob one). We must see this as a desire to make an antithetical companion piece for the painting *Moses in Sight of the Promised Land, Removing His Sandals*,[3] which, he explains, is a "gesture of humility and respect, of submission to God's commands."[4] By contrast, *Jacob* expresses the struggle between matter and spirit.[5]

The "Notes of things to do" also indicates that the artist must have made life studies from a female model in October–November 1874: "4 ange de Jacob" (4 angel of Jacob) and 'rechercher mes photos de Géricault" (look for my photos of Géricault).[6] These were photographs by Paul Berthier of drawings from the Marcille collection, especially the one depicting the *Horserace on the Corso in Rome: La Mossa*,[7] from which Moreau borrowed the pose—if reversing it—of Jacob with legs spread and arms extended.

Moreau's method of working was based on making many studies of significant poses in rapid sketches, reinforced with references to art of the past. Once the pose had been found, however, he studied a living model, in accordance with the academic tradition. For example, to capture Jacob's hair being lifted by the wind, he referred to the movement—also reversed—of the angel's hair in Raphael's fresco in the Vatican, *Heliodorus Chased from the Temple*, of which he had made beautiful copies.[8]

Moreau was satisfied with the way he interpreted his subject: "What is admirably rendered & what Delacroix rendered in a vulgar manner & did not even understand at all [in the Chapel of the Holy Angels, Saint-Sulpice], is that this combat is a com-

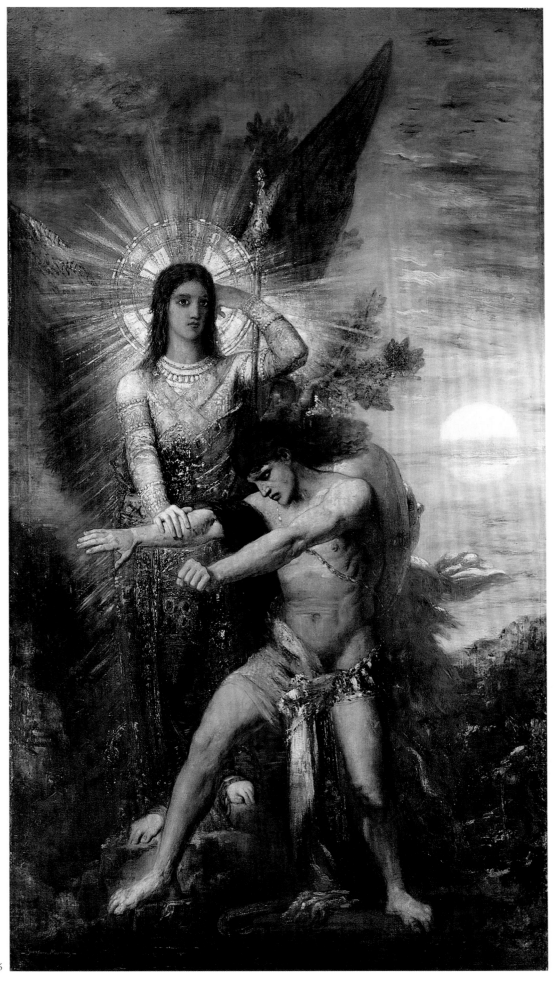

96

bat that is the symbol of physical might against superior moral might and that in that struggle it is said that Jacob did not see his antagonist & sought him, exhausting all his strength."[9] (This is no doubt the reason why, as he did for about ten other compositions, he translated *Jacob and the Angel* into a wax statuette.)[10] He then opened the possibility of redemption: "He wrestles, he seeks to discern through the veil of impending night the mysterious and sacred enigma of life, and his powerless might cannot grasp anything. But the angel sent by God, who has pity on man, smiling on his fruitless efforts, softens his heart out of Love, subjugates him, and soon inundates him with splendor, eternal brightness."[11]

The finished canvas was presented at the Exposition Universelle of 1878, at the same time as *The Infant Moses* in the Winthrop collection (fig. 30) and *David* (UCLA Hammer Museum, Los Angeles); the three together symbolize the three ages of man. For the first time in his career (with the exception of the three state commissions he received between 1852 and 1855), the work found a buyer before it was shown at the Exposition Universelle.

The painting was purchased by Marie Raffalovich for her husband. Marie was a great admirer of Moreau as early as 1872.[12] She had considered compiling a catalogue of the artist's works and is said to have sent art criticism to a Saint Petersburg review (these remain unidentified; perhaps she used a pseudonym).

The *Jacob* sold for a large sum.[13] Up to that time, Moreau had not sold any work for such a high price. It marks the beginning of a period of financial success with a limited, but dedicated, number of already established or new art lovers.

Moreau had suggested that Mme Raffalovich purchase a specific kind of lighting for the painting. The lamp was not easy to find, and when it was installed, Mme Raffalovich

asked Moreau to come adjust it. "Dear Sir, Would you be generous enough to come give me your opinion on the lighting of *Jacob*. I have the stand from Barbedienne's and the reflector from Gagneau, but the height from which the light ought to shine must be found, and you are the only one who knows the secret of the mysteries of light and who could determine the quantity and quality of brightness necessary. Today at five o'clock, or tomorrow at five, will it be possible for you to come by for a moment?"[14]

Sometime later, Mme Raffalovich wrote again: "I write you with a heavy heart, but it is in your power to dissipate the cloud that obscures my sight and conceals from me the treasure of colors that you captured in the painting in which you inscribed the angel and Jacob wrestling. For some time, the colors have been fading and seems [*sic*] to have become faint on the part where Jacob's hair appears; his hand looks speckled, and the angel's robe is vanishing. What to do? Might it be merely an error in perception, an optical illusion? Perhaps a look from you will be enough to illuminate the dying brilliance of those parts? You are my only confidant in this discovery and I await a word from you to reassure me."[15]

Moreau retrieved the painting and, after apologizing for the delay (she had written in 1881; he replied seven years later, in 1888), reported "that the touch-up operation is a success and it seems to me it has improved many parts of the canvas."[16]

The next year, Paul Leprieur, in his major study of Gustave Moreau, described the painting at length: "How much better [than Delacroix] M. Moreau has distinguished between the essences: the man agitated and restless, making the most violent efforts; the angel motionless and stiff, one of those great Byzantine angels whose bearing has so much dignity, the feminine head surrounded by a halo, dressed in a

long flowing robe and who, in a single gesture, overpowers the enemy with the might of a sovereign will! How much more meaning that mysterious battle of body against spirit has, conducted by moonlight in that way!"[17]

Geneviève Lacambre

1. Translated from Moreau 1984, p. 125.
2. Musée Gustave Moreau, Paris, Arch. GM 541. In this document, we also read: "terminer mes 2 petites toiles pour Tesse," which were paid for—hence completed—in March–April 1875.
3. Musée Gustave Moreau, Cat. 21 (96½ x 59½ in. [245 x 151 cm]).
4. Translated from Moreau 1984, p. 55.
5. Moreau hung the two watercolors of these compositions as pendants in the gallery on the second floor of his museum: Inv. 13985 (*Moses*) and Inv. 13988 (*Jacob and the Angel*); Paris–Chicago–New York 1998–99, nos. 7, 76, illus.
6. Musée Gustave Moreau, Arch. GM 541.
7. Musée Gustave Moreau, Inv. 14598-3; Rome 1996-97, no. 22, illus. Géricault's drawing is now housed in the Louvre.
8. Musée Gustave Moreau, Des. 1188, dated 1848, and probably made after the copy of the Balze brothers exhibited at the time at the Panthéon in Paris; and Des. 4243, probably made in Rome.
9. Translated from Musée Gustave Moreau, Des. 12807, fol. 58.
10. Musée Gustave Moreau, Inv. 14134 and Des. 8501; see Nice 1991, no. 11. In a note of November 10, 1874, Moreau mentions the following project: "modeler en terre ou en cire les compositions à une ou deux figures qui, fondues en bronze, donneraient mieux qu'en peinture la mesure de mes qualités et de ma science dans le rythme et l'arabesque des lignes"; Moreau 1984, p. 128. The statuettes were never produced in bronze.
11. Translated from Moreau 1984, p. 82.
12. Marie Raffalovich acquired a small watercolor of Sappho (Victoria and Albert Museum, London) in 1872.
13. A letter from Moreau to Raffalovich indicated a price of Fr 20,000 (Bibliothèque de l'Institut, Paris, Raffalovich collection, MS 3694/35, transcribed by Marie Josée Loverini). Mme Moreau's account book indicates, in March 1878, a payment of Fr 15,000, but there is frequently a discrepancy between the real price and that which Moreau declared to his mother. Alfred Baillehache, for his part, notes Fr 20,000 (manuscript catalogue by Alfred Baillehache, Galerie Brame et Lorenceau, Paris, no. 2, which indicates the successive prices for the work, as noted in the provenance), but a draft of a letter from Moreau indicates Fr 18,000 (Musée Gustave Moreau, Moreau's drafts to unnamed correspondents).
14. Letters concerning the special lighting, undated but from late November 1878, are in the Musée Gustave Moreau, Raffalovich correspondence.
15. Ibid. The mention, later in the letter, of the exhibition of watercolors (illustrating the *Fables* of La Fontaine) on rue Laffite allows us to confirm that it was written in 1881.
16. Bibliothèque de l'Institut, Raffalovich collection, MS 3694/55.
17. Leprieur 1889, p. 37.

PROVENANCE: Sold by the artist to Marie Raffalovich, March 1878; purchased from her by the Galerie Georges Petit, Paris (Fr 28,000); purchased from them by the vicomte of Curel (Fr 50,000); repurchased from him by the Galerie Georges Petit (Fr 60,000); purchased from them by Charles Guasco (Fr 85,000); his sale, Galerie Georges Petit, June 11, 1900, no. 58 (Fr 53,000); purchased at that sale by Paul Gillibert; his niece Mme de Saint-Péreux; Baron de T——; his sale, Galerie Lambert, Nice, February 15, 1934; purchased at that sale by Jacques Seligmann and Co., New York (Fr 19,500); acquired from them by Grenville L. Winthrop, March 27, 1934 ($18,000); his bequest to the Fogg Art Museum, 1943.

EXHIBITIONS: Paris 1878b, class 1, no. 658 (belonging to M. H. Raffalovich); Paris 1906b, no. 62 (Paul Gillibert collection); Cambridge, Mass., 1960; Cambridge, Mass., 1973a; Tokyo 2002, no. 54.

REFERENCES: Renan 1886 (May), pp. 378–79, (July), p. 42; Leprieur 1889, p. 37; Renan 1900, illus. p. 75 (engraving by Waltner); Deshairs and Laran [1913], pp. 81–82, fig. 33; Romanet 1926, p. 324; Holten 1960, fig. 66; Seligman 1961, p. 149; Mathieu 1976, pp. 131–32, no. 170, illus. p. 134; Kaplan 1982, fig. 55; Bowron 1990, fig. 322; Mathieu 1991, fig. 197; Mathieu 1994, pp. 137–38, illus.; Lacambre 1997, illus. p. 59; Mathieu 1998a, fig. 199; Mathieu 1998b, p. 102, illus. p. 104; Lacambre in Paris–Chicago–New York 1998–99, p. 268; Lacambre 1999b, illus. p. 59.

97. *The Sirens,* 1882

Watercolor, brown ink, and black chalk on cream wove paper
13 x 8¼ in. (32.8 x 20.9 cm)
Signed in brown ink, lower left: Gustave Moreau
Inscribed in brown ink, lower right: Sirènes
1943.392

Moreau's compositions depicting three sirens are numerous and varied. The sirens appear by themselves,[1] tempting Ulysses and his companions on their return from the Trojan War,[2] or, in a first notion about the Argonauts, illustrating the episode when Orpheus saves his companions by singing louder than the sirens.[3] This watercolor was first owned by Édouard Saisset, who bought it in 1881. The artist's mother noted the sale, on November 9, 1881, of two watercolors, *Eve* and *Sirens*, to M. Sessai [*sic*],[4] spelling the name of the connoisseur in an idiosyncratic manner, as she often did. In addition, a drawing, in the same format and on the same subject as the watercolor, bears the inscription, "—à Mr Saisset—Sirènes—Syrènes—,"[5] with the designation "Les Syrènes" repeated by Moreau on his list of the Hayem collection in 1885,[6] Charles Hayem being the next person to own the work.

Hayem (1839–1902), an indefatigable collector, sometimes grew tired of having to wait months for the works promised him by the artist and did not hesitate to look

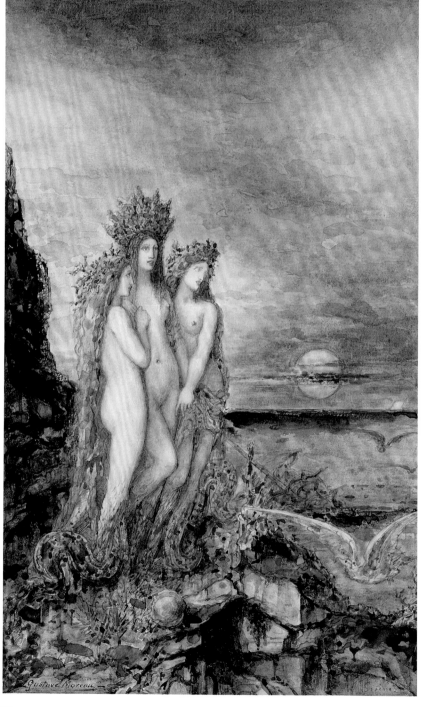

97

elsewhere for them. Thus he wrote the artist, in a postscript to a letter of May 13, 1882: "As of yesterday, your Sirens belong to me." He wanted to have the presentation modified by his usual framer in the near future and sent the work to the artist to be dismantled. He wrote him on September 1, 1882: "I summoned Mr. Guay and gave him the order to bring you the Sirens tomorrow."

It was during that summer of 1882 that Hayem moved into a "large and beautiful apartment" in Paris, at 84 boulevard Malesherbes, where, every Thursday, from one to five in the afternoon, he welcomed art lovers, including the poet Jean Lorrain and the art critics Ary Renan and Paul Leprieur.[7] After his visits to Hayem, in May 1883, Lorrain dedicated a ten-tercet poem to Moreau—"The Sirens," devoted to the "three terrible sisters" and fraught with hatred and death. The manuscript sent to Moreau in June 1883 was subsequently reworked.[8]

In his 1889 study on the artist, Paul Leprieur considered *The Sirens* "an exquisite watercolor in the Hayem collection," one of the many examples of the theme of

woman's omnipotence in Moreau's iconography: "Who better than the Sirens represent the perfidious voluptuousness and the troubling power of women?"[9]

It should be noted that the algae and coral setting can be compared to that of *Galatea* (Musée d'Orsay, Paris), exhibited at the Salon of 1880 and taken up again the next year, when the artist was also working on his Sirens.

Geneviève Lacambre

1. For example, standing at left in the painting Musée Gustave Moreau, Paris, Cat. 103, and the watercolor Cat. 356, standing at right in the painting Cat. 107, lying on a central rock in the paintings Cats. 207 and 790 (enlacing a victim in their tails), standing in an axial composition of 1896 in Des. 86.
2. In the watercolors Musée Gustave Moreau, Cats. 407 and 584, and in the painting Inv. 13957.
3. They appear on the right in the painted sketch Musée Gustave Moreau, Cat. 266, one of the three sketches referred to by Moreau in 1885 for the monumental painting (Cat. 20) executed in about 1891 and enlarged in 1897 (they do not appear in the large painting).
4. Archives, Musée Gustave Moreau. In his 1885 list of collectors, Gustave Moreau indicated only *Eve* with M. Saisset (Musée Gustave Moreau, Arch. GM 500, p. 78). Alfred Baillehache (manuscript catalogue, Galerie Brame et Lorenceau, Paris) cited two Eves, again ignoring the Saisset collection. It seems there was only one (signed) watercolor on this subject, with the same dimensions as *The Sirens*, to which it may have been a companion piece (Mathieu 1998a, no. 376, illus.—13 x 7¾ in. [33 x 19.5 cm]—and no. 377).

5. Musée Gustave Moreau, Des. 742 (crayon on tracing paper, 14⅛ x 8⅛ in. [35.7 x 20.4 cm]); see Bittler and Mathieu 1983, p. 44.
6. Musée Gustave Moreau, Arch. GM 500, p. 73, no. 12.
7. Hayem, letters to Moreau, May 13 and July 4, 1882 (Hayem chose a Pompeiian rose fabric for the walls and sent a sample to the artist). He had previously lived at 47 rue Le Peletier.
8. Lorrain and Moreau 1998, pp. 26, 28–29. The poem is published with variants, without the dedication to Moreau, in *L'ombre ardente* in 1897, then in the 1926 catalogue of the Musée Gustave Moreau, pp. 33–34, under the painting Cat. 103, where the same group of "sirens" is to the left of a "seascape with crypts," according to the description given by Moreau on June 4, 1885, of the contents of the "storeroom near the studio" (Arch. GM 500, p. 75). See cat. no. 93 for Lorrain's letter to Moreau when he sent the poem.
9. Leprieur 1889, p. 32.

PROVENANCE: Sold by the artist to Édouard Saisset, November 9, 1881 (Fr 2,000; with *Eve*); purchased from him by Charles Hayem, May 12, 1882; purchased from him by Alfred Baillehache (Fr 4,000); Galerie Brame, Paris; purchased from them by (?) Gillet, Lyon, 1913 (Fr 7,000); bought back by Brame, 1914; acquired from Scott and Fowles, New York, by Grenville L. Winthrop, October 1923 ($1,350); his bequest to the Fogg Art Museum, 1943.

EXHIBITIONS: Paris 1906b, no. 6 (collection of Alfred Baillehache); Tokyo 2002, no. 44.

REFERENCES: Renan 1886 (May), p. 378; Leprieur 1889, p. 32, tipped in pl. facing p. 32; Renan 1900, p. 102, illus.; Mathieu 1976, no. 276, illus.; Selz 1978, p. 60, illus.; Selz 1979, p. 60, illus.; Lorrain and Moreau 1998, pp. 26, 28–29; Mathieu 1998a, no. 308, illus.; Mathieu 1998b, p. 123, illus.; Lacambre in Paris–Chicago–New York 1998–99, p. 269.

Camille Pissarro

Charlotte Amalie, Saint Thomas, Danish West Indies, 1830–Paris, 1903

98. *Banks of the Oise River*, 1874

Oil on canvas, mounted on modern aluminum support
18⅛ x 15 in. (46 x 38 cm)
Signed and dated lower left: C. Pissarro 1874
1942.204

In the late 1860s and 1870s Camille Pissarro and his peers began including industrial imagery in their landscapes: the train bridge at Argenteuil, the smokestacks along the Bay of Marseille, the factories at Gennevilliers, Ivry, Marly, and other towns within commuting distance of Paris. Pissarro resided

in one of these towns, Pontoise, from 1866 to 1869 and again after the Franco-Prussian War, from 1872 to 1883. During those years he painted hundreds of landscapes, many of which contain glimpses of the local factories. Occasionally they are featured as the primary subjects of his canvases, while

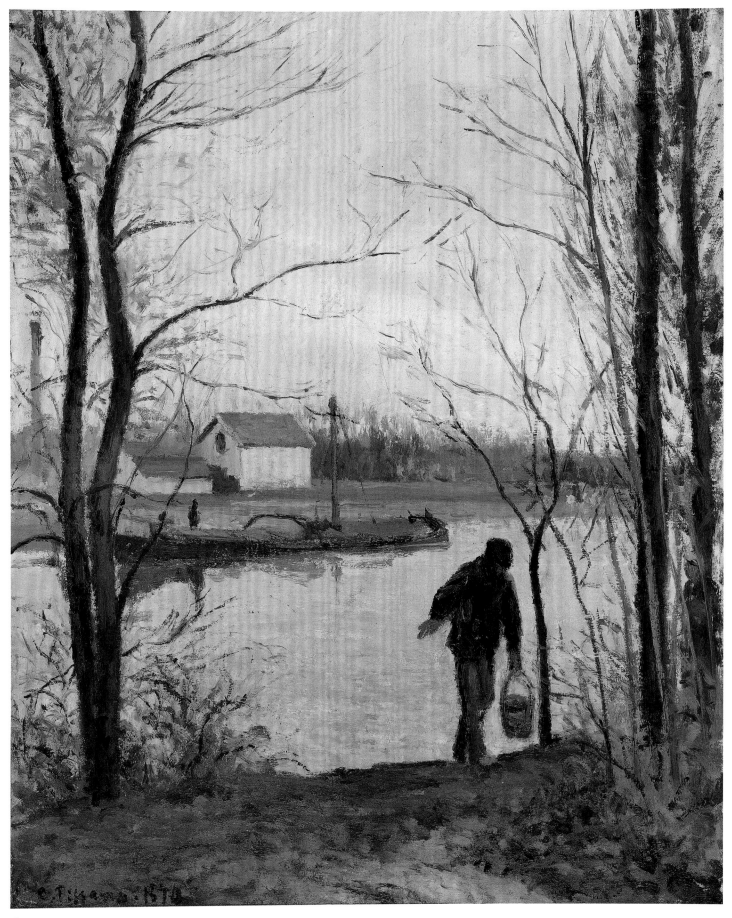

98

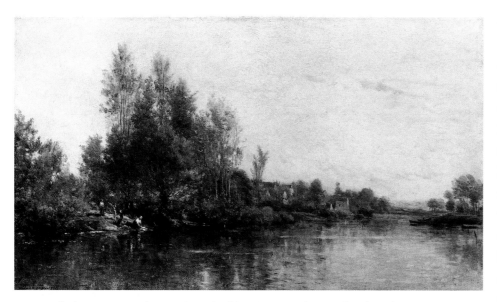

Fig. 117. Charles-François Daubigny, *The Banks of the Oise*, 1863. Oil on wood, 14¾ x 26⅜ in. (37.5 x 67 cm). The Metropolitan Museum of Art, New York; Bequest of Benjamin Altman, 1913 14.40.815

similarities with those that were, such as *Gelée blanche* (Musée d'Orsay, Paris), in its depiction of a laborer within a larger landscape setting. To compare Pissarro's *Banks of the Oise River* with Charles-François Daubigny's work of the same title, painted a decade earlier, reveals just how modern Pissarro's approach must have seemed, both in the application of paint and in the chosen view (fig. 117). The local population's dependence on the Oise River is stressed in both: Daubigny depicts a woman washing clothes and Pissarro shows a man fetching a pail of water. But where Daubigny's wideangle panorama is lyrical and timeless, the inclusion of the passing barge and factory dates Pissarro's scene to his day. For Pissarro and the Impressionists, the modern landscape had its own aesthetic, one that they believed merited a place in fine art.

Rebecca A. Rabinow

other times, as in the Winthrop picture, they are seen in the distance beyond a screen of trees.

A native of Saint Thomas in the Danish West Indies (now one of the Virgin Islands), Pissarro was twenty-five years old when he moved to France. For much of his adult life he resided in the somewhat rural areas to the north and west of Paris. He explained the lure of Pontoise in a letter to his friend Claude Monet: "The countryside is very wholesome, especially halfway up and on the hills; lower, along the Oise, fog prevails. . . . It is cold in the hills, the air is quite bracing, which I do not consider a drawback. . . . The countryside is very beautiful."[1] Long an agricultural region, the valley of the Oise River—which flows southwestward from the Ardennes Mountains in Belgium to the Seine River—was increasingly industrialized during the

second half of the nineteenth century. By the 1870s the town of Pontoise, for example, boasted at least two factories, one that distilled alcohol from potatoes and sugar beets and another that manufactured paint.[2]

Pissarro's *Banks of the Oise River* was painted in 1874, the year of the first Impressionist exhibition. Pissarro had been instrumental in organizing the public debut of the Société Anonyme des Artistes Peintres, Sculpteurs, Graveurs. It was immediately recognized that Pissarro's landscapes—along with those by Monet and Alfred Sisley—broke with tradition. "Nothing, I believe, would offend them more than to compare them, even favourably, with Théodore Rousseau or Corot, or to anybody, for nobody exists for them," wrote a critic.[3]

Although the Winthrop picture was not included in the exhibition, it shares

1. "Le pays est très sain, à mi-côte surtout et sur les côtes; dans le bas, le long de l'Oise, il y règne des brouillards. . . . Il fait froid sur les côtes, l'air très vif, je pense que ce n'est pas un inconvénient . . . le pays est très beau"; Pissarro, letter to Monet, September 18, 188; Pissarro 1980–91, vol. 1 (1980), pp. 165–66.
2. Brettell 1990, pp. 80–81; see also "The Industrial Landscape: Pissarro and the Factory," chap. 3 in ibid., pp. 73–97.
3. Burty 1874, p. 616, quoted in translation in Berson 1996, p. 10.

PROVENANCE: Louis Cazalens (Cayalens?); Étienne Bignou; sale, Hôtel Drouot, Paris, June 15, 1927, no. 51 (Fr 31,500); purchased at that sale by Gérard Frères; Sam Salz, New York; Wildenstein and Co., New York; acquired from them by Grenville L. Winthrop, January 3, 1940 ($6,500); his gift to the Fogg Art Museum, 1942.

EXHIBITIONS: Cambridge, Mass., 1985, p. 52, fig. 43; Cambridge, Mass., 1990, p. 21.

REFERENCES: Pissarro and Venturi 1939, no. 245, illus. (as "Bords de l'Oise"); Bowron 1990, fig. 329; Brettell 1990, p. 168.

99. *The Market Place*, 1889

Watercolor, gouache, black and brown ink, and
black chalk on off-white wove paper
11⅝ x 9 in. (29.5 x 22.8 cm)
Signed, dated, and inscribed in black ink, lower
left: un coin des Halles. C. Pissarro. 1889.
1943.394

In the early 1880s Pissarro gradually turned his attention away from landscape painting toward scenes of peasants laboring in the fields and selling their produce. He focused on the outdoor markets in Gisors, Pontoise, and Rouen, where commodities such as beef, poultry, cabbage, grain, and potatoes were bought and sold. The Winthrop water-color—a view of the fish market at Les Halles—is one of the artist's rare examples of a covered (indoor) market, and a Parisian one at that.

Designed in the mid-nineteenth century by the architects Victor Baltard and Félix-Emmanuel Callet, Les Halles Centrales consisted of ten large, well-lit, amply venti-lated, iron-and-glass pavilions connected by covered walkways (figs. 118, 119).[1] Hundreds of thirty-three-foot cast-iron columns supported the zinc roof of the structure. Completed in 1866, the market

soon was touted in tourist guides and fea-tured in novels such as Émile Zola's *Le Ventre de Paris* (1873).[2]

Judging from his letters, Pissarro con-sidered the aesthetic qualities of his local markets critical to his quotidian life. During an initial house-hunting trip at Meaux, for example, he rejected the town (located just east of Paris) after finding the market "frightful": "an immense modern shed, built like a railway station, less interesting than the Halles in Paris, whose proportions give it character. True, there were no trades-men, from whom it, of course, derives its qualities. . . ."[3]

Ultimately the appeal of the market for Pissarro was the people who worked and shopped there. Because the artist often depicted both the vendors and their clien-tele, some art historians have interpreted these pictures as social commentaries. On a more fundamental level, Pissarro was inter-ested in the movement of the figures as they bend, stretch, and stand.

The poses in the Winthrop watercolor echo the surrounding architecture. The rounded shape of the bending figure at left,

for example, recalls the arches in the dis-tance. Similarly, the rigid verticality of the standing woman at center is underscored by the cast-iron column to her right. The care-ful arrangement suggests that this water-color may have been painted in Pissarro's studio after sketches from nature, a com-mon practice for the artist.[4] There are at least two related studies at the Ashmolean Museum, Oxford. One is a detail of the standing vendor's hand holding a fish.[5] The second—a black chalk drawing—depicts a man seated at the left end of an obliquely placed table, with the market's arches and columns visible behind him (fig. 120).

Like other Pissarro watercolors of the period, the Winthrop picture is signed, dated, and inscribed with the location depicted.[6] In certain areas the washes of color are so thin that the underdrawing is visible; in others, the gouache is heavily worked. Awkward areas such as the fist of the woman at right or the strange perspec-tive of the table may have been of little concern to the artist. As he explained to his son, "a drawing does not have to be 'correct' to convey what the artist wishes to convey,

Fig. 118. Paul Géniaux, *Les Halles, Paris: Snail and Fish Sellers*, ca. 1900. Photograph, 5 x 7 in. (12.7 x 17.7 cm). Musée d'Orsay, Paris (photo: RMN—Pascale Néri)

Fig. 119. Unknown photographer, *Covered Market, Les Halles Centrales, rue Solferino*. Musée des Beaux-Arts, Lille (photo: RMN—Quecq d'Henripret)

99

but it must have the sensation of movement and form that nature inspires. . . ."[7]

It has been suggested that the Winthrop watercolor is part of a series on urban markets planned by Pissarro.[8] Only one other is known to exist: *The Marché St. Honoré* (private collection). It is of the same dimensions and, like the Winthrop picture, is dated 1889. Pissarro had many reasons to visit the French capital that year, among them the much-touted Exposition Universelle (for which the Eiffel Tower was constructed). In May he came to consult an optometrist about an eye problem that would plague him for the rest of his life. His doctor recommended that he avoid dust and wind, which may have added to the lure of the sheltered market as a subject.[9]

Fig. 120. Camille Pissarro, *Study of a Man Seated in an Interior*. Black chalk, 7½ x 4¾ in. (18.9 x 11.2 cm). Ashmolean Museum, Oxford

It is not known whether Pissarro ever completed his series on urban markets, but it is evident that the artist was still toying with the concept of a market series in 1891. He wrote to his son, "When painting tires me, I shall work at watercolors and engraving. I hope to do a series of *Markets. . . .*"[10]

Rebecca A. Rabinow

1. The first pavilion of Les Halles was built in 1851–53 and then destroyed at the order of Napoleon III. With the support of Baron Haussmann, Baltard and Callet were retained as architects. Of the fourteen revised pavilions—the first was begun in 1854 (the year of Callet's death)—only ten were completed. Two more were erected in 1936.
2. "The great markets of Paris have been called the finest in the world and likened to Crystal Palaces. 'Built entirely of iron and glass, these edifices will astonish the visitor, who should by all means go through them'" (Graefe 1889, p. 34). "The cellars underground are worth seeing, and may be visited for a small fee . . ." (*Galignani's New Paris Guide for 1867*, p. 244).
3. Pissarro, letter to his son Lucien, June 4, 1883; Pissarro 1980, p. 34.
4. Lloyd 1985, p. 20.
5. Note from Richard R. Brettell, Fogg Art Museum Drawing Department files.
6. Brettell and Lloyd 1980, p. 32.
7. "Un dessin n'a pas besoin d'être correct pour dire ce que l'artiste veut dire, mais doit avoir les sensations du mouvement et de forme que la nature nous inspire"; Pissarro, letter to his son Georges, January 9, 1890; Pissarro 1980–91, vol. 2 (1986), p. 323.
8. Thomson in Birmingham–Glasgow 1990, p. 73.
9. Pissarro, letter to his niece Esther, May 7, 1889; Pissarro 1980–91, vol. 2 (1986), pp. 270–71.
10. Pissarro, letter to his son Lucien, June 23, 1891; Pissarro 1980, p. 177.

PROVENANCE: Scott and Fowles, New York; acquired from them by Grenville L. Winthrop, December 1923 ($630); his bequest to the Fogg Art Museum, 1943.

EXHIBITION: Cambridge, Mass., 1969, no. 116.

REFERENCES: London–Paris–Boston 1980–81, p. 180, under no. 132; Lloyd 1985, p. 31, n. 20; Thomson in Birmingham–Glasgow 1990, p. 73, fig. 85; Pissarro 1993, pp. 202, 206, fig. 241.

Pierre-Paul Prud'hon

Cluny, France, 1758–Paris, 1823

100. *Love and Wisdom (L'Amour et la Sagesse)*, 1791

Black crayon, white gouache, and graphite[1] *on a prepared tablet (off-white paper stretched over cardboard)*[2]
12⅝ x 6¾ in. (32 x 17 cm)
1943.890

"Un Jeune-Homme, appuyé sur le Dieu Termes" (A Young Man Leaning on the God Terminus): the title of this work as it appeared in the *livret* of the Salon of 1791, whether given by Pierre-Paul Prud'hon or invented by the compiler of the handbook, is not accurate. Far from representing the god Terminus, who presided over boundaries in fields and gave his name to that type

of monument, the sculpture is in fact a bust of Minerva atop a terminus. In addition, the young man, with wings and a torch, is identical with Cupid as Prud'hon represented him in 1793 in *The Union of Love and Friendship* (Minneapolis Institute of Arts; fig. 121). This drawing came to be known as *Le Génie de la Liberté et la Sagesse* (The Genius of Liberty and Wisdom)[3] only after it was linked to an engraving by Jacques-Louis Pérée (fig. 122) that was derived from it. The legend of that engraving reads: "L'aurore de la raison commence à Luire / et le Génie de la Liberté / établit

l'Empire de la Sagesse sur la terre" (The Dawn of Reason begins to break / and the Spirit of Liberty / establishes the Empire of Wisdom on earth). The slight curve of the ground, in both the drawing and the print, represents the curvature of the earth. Although some have given the drawing the beginning of that title,[4] others have clung to the evidence of the figures, Minerva and Cupid.[5] *L'Amour et la Sagesse* (Love and Wisdom) may be the most accurate title.

Pérée's undated engraving bears his name as engraver (he was a student of Regnault; born in 1769) and the long title

Fig. 121. Pierre-Paul Prud'hon, *The Union of Love and Friendship*, 1793. Oil on canvas, 57⅞ x 45 in. (146.5 x 114.3 cm). The Minneapolis Institute of Arts, John R. Van Derlip and William Hood Dunwoody Fund, 64.50

Fig. 122. Jacques-Louis Pérée, after Prud'hon, *L'aurore de la raison commence à Luire / et le Génie de la Liberté / établit l'Empire de la Sagesse sur la terre*, ca. 1793. Engraving, plate 13⅜ x 8¾ in. (34 x 22 cm). Département des Estampes et de la Photographie, Bibliothèque Nationale de France, Paris

cited above but not Prud'hon's name. Reversing the drawing (even the Greek word *Sophia* is backward), the print introduces elements that make the subject decidedly republican: the young man wears a Phrygian cap and the shaft of the terminus is engraved with three symbols, another Phrygian cap for Liberty, a triangular mason's level for Equality, and scales for Justice. Prud'hon may well have been responsible for these alterations, for he modified his allegory *The French Constitution* in the same way, in response to the changing political climate.[6]

The artist had been in Rome from 1784 to 1788, as the winner of a competition similar to the Prix de Rome, but administered by his native province of Burgundy. On his return to Paris, he undertook a painting for admission to the Académie Royale de Peinture et de Sculpture. On October 20, 1789, he wrote in a letter to his master François Devosge that he had begun a composition with four figures (which we identify as *Love Seduces Innocence*, *Pleasure Entraps*, *Remorse Follows*, known through many drawings [see cat. no. 104] and a painting done twenty years later [private collection]), and that the need to earn his living impelled him to replace it with a less important one.

In our view, the latter composition was *The Union of Love and Friendship*, a painting with only two main figures, which was exhibited at the Salon of 1793 (fig. 121). In it, Love, his arm around the neck of a seated Friendship, is represented by the same ephebe who, in the Winthrop drawing, similarly embraces a bust of Minerva. It is likely that the drawing represents the union of Love and Wisdom and is a variant of the subject that occupied Prud'hon in the early years of the Revolution.

As in other works from the 1790s (see cat. nos. 101–103), Prud'hon used what he had learned from his experience in Rome.

The figure of Love (or the Genius of Liberty) replicates the figure in a drawing in the Louvre depicting a young man next to a drapery (fig. 123), certainly executed in Rome after a statue or classical relief, as yet unidentified and surely of Praxitelian derivation, such as *Apollo Sauroctonus*. The technique and style (graphite, partly redone in ink stippling) suggest that the sheet may have been removed from a notebook used in Rome.

The Winthrop drawing, very carefully finished in a dense play of black and white hatching, shows signs of retouching in the outline of the body on the side of the statue: according to Slayman,[7] the aim was to broaden the slender, androgynous body. Conversely, some other retouching seems to have reduced the volume of the figure. It may be that these changes, perceptible around the head in a halo of stumped white chalk, on the arms and shoulders, and in the

Fig. 123. Pierre-Paul Prud'hon, *Study of a Young Man*, ca. 1790. Graphite, partially redrawn in gray ink, on white paper, 7⅜ x 4¾ in. (18.8 x 12.1 cm). Département des Arts Graphiques, Musée du Louvre, Paris, RF 4635 (photo: RMN—Michèle Bellot)

σοφία

external outline of the legs, were prompted by criticism of the drawing when it was shown at the Salon: "A young man with a big head, by M. Prud'hon";[8] "Drawing of a young man, by M. Prud'hon. The legs are too fat."[9]

Prud'hon made few revolutionary artworks: the principal work, and the only painted one, is a large painting, 140 inches (355 cm) square, executed in 1798–99 (Louvre, Paris).[10] The title of that composition is *La Sagesse et la Vérité descendent sur la terre, et les ténèbres qui la couvrent se dissipent à leur approche* (Darkness Dissipates as Wisdom and Truth Descend to the Earth). The curve of the earth at the bottom of the composition (on a drawing at the Städelsches Kunstinstitut in Frankfurt there is even the word "France") links Minerva to Truth, who is also nude. The Minerva is no longer a bust but a full-length, severely draped figure. It appears that Prud'hon followed the same plan in both compositions. The allegory is rooted in the spirit of the Enlightenment, whose tenets he had absorbed from his master Devosge, his mentor Baron de Joursanvault, and his Masonic membership. The allegory asserts that the reign of Reason is inseparable from both Liberty and Truth, which itself appeals to Nature. Prud'hon, an atypical history painter, almost never treated the ancient subjects dear to neoclassicism. From the start, he devoted himself to the lofty and perilous genre of allegory, which, from Charles-Alphonse Dufresnoy to Anton Raphael Mengs, was considered the pinnacle of painting, the genre in which the painter equaled the poet in giving shape to new ideas.

Sylvain Laveissière

1. Guiffrey's mention (1924, p. 139) of pen and ink is inaccurate.
2. The label of the art supplier and framer Adolphe Beugniet, 1 and 10 rue Lafitte, Paris, was affixed to the back of the tablet when the work was framed in the 19th century.

100

3. Clément 1872, p. 124; Paris 1874b, no. 251.

4. Paris 1922a, no. 95 ("L'Aurore de la Raison commence à luire").

5. Sale of the duc de Rivoli, Paris, April 18–19, 1834, no. 60 ("L'Amour admirant le buste de la Sagesse"), and Paris 1884a, no. 518 ("L'Amour et la Sagesse").

6. Paris–New York 1997–98, pp. 161–64, nos. 110–12. Perhaps Prud'hon replicated his composition on another sheet, modifying it expressly for the engraver. Elizabeth Menon (1997, p. 159) asserts that it was after the exhibition of *The Union of Love and Friendship* at the Salon of 1793 that Prud'hon "transformed a drawing containing a figure similar to that of Love (which he had exhibited two years earlier under the title *Le Génie de la Liberté* [*sic*; inaccurate], into a print promoting the government." That is possible, but there is nothing to confirm it.

7. Slayman 1970, p. 20.

8. "Un jeune homme à grosse tête, par M. Prud'hon"; Anon. (*La béquille de Voltaire*) 1791, p. 25.

9. "Dessin d'un jeune homme, par M. Prud'hon. Les jambes sont trop grosses"; Anon. 1791, p. 54.

10. Paris–New York 1997–98, no. 116.

PROVENANCE: Duc de Rivoli; his sale, Me Petit, Laneuville, *expert*, Paris, April 18–19, 1834, no. 60 (as "L'Amour admirant le buste de la Sagesse"); M. G . . . (per illegible inscription on back of cardboard support); Pierre-Jules Mène, by 1872; his son-in-law Auguste Nicolas Cain, by 1884; his son Georges Cain, Paris, by 1900; Mme Georges Cain, by 1922; Cain sale, Hôtel Drouot, Paris, March 9–10, 1939, no. 68 (as "Le Génie de la Liberté ou La Sagesse"); acquired through Martin Birnbaum by Grenville L. Winthrop, April 1939 (Fr 20,000); his bequest to the Fogg Art Museum, 1943.

EXHIBITIONS: Paris (Salon) 1791, no. 540 (as "Un Dessin à la Pierre noire, représentant un Jeune-Homme, appuyé sur le Dieu Termes"); Paris 1874b, no. 251 (as "Le Génie de la Liberté et la Sagesse"); Paris 1884a, no. 518 (as "L'Amour et la Sagesse"); Paris 1900a, no. 1253 (as "Sophia"); Paris 1922a, no. 95 (as "L'Aurore de la Raison commence à luire").

REFERENCES: Anon. 1791, p. 54 (wrongly attributed to the painter Chéry); Anon. (*La béquille de Voltaire*) 1791, p. 25; Renouvier 1863, pp. 11, 98; Clément 1872, pp. 206, 209 n. 1, 214–15; Goncourt 1876, pp. 151–52; *Les maîtres du dessin* 1900–1902, vol. 2 (1901), pl. 87 (photogravure by J. Chauvet, "Sophia"); Guiffrey 1924, p. 139, no. 378; Sachs 1965, p. 13, fig. 1 facing p. 5; Slayman 1970, pp. 18–21, 283, pl. 10; Lévis-Godechot 1985, pp. 92–94, illus.; Heim, Béraud, and Heim 1989, pp. 314–15, illus.; Elderfield and Gordon 1996 (and 1997 ed.), pp. 17, 21, illus. p. 14; Eunice Williams in Mongan 1996, pp. 264–66, no. 294, illus.; Laveissière 1997b, pp. 22–23, illus.; Lévis-Godechot (1982) 1997, pp. 223, 228–30; Menon 1997, pp. 158–59, fig. 3; Paris–New York 1997–98, p. 67, fig. 23a; Clark (1997) 2001, pp. 182, 189, 198, fig. 8; Guffey (1997) 2001, pp. 87, 90, 107, fig. 15; Guffey 2001, pp. 59, 131, 191, fig. 35.

101. *Cruelty Laughs at the Tears He Has Caused to Flow (Le Cruel rit des pleurs qu'il fait verser)*, 1793–94

Black chalk on off-white antique laid paper
9¾ x 12¾ in. (24.5 x 32.3 cm)
Signed and dated in black ink, lower right:
P. P. Prud'hon D/elineavit, an/ 2
Watermark: Fleur-de-lis atop a plain shield
with a bend
1943.889

In 1792 the Convention abolished the Académie Royale de Peinture et de Sculpture, depriving Prud'hon of the institutional support for which he had been preparing himself since his return from Rome in 1788 (see cat. no. 100). Since both public and private commissions had disappeared, Prud'hon, who was not well-off and had family responsibilities, turned to the only two activities possible for his survival: portraits and prints.

According to Prud'hon's first biographer, Jacques-Philippe Voïart, Prud'hon made "the drawing of *Ceres*, which he executed in pen, *Love Reduced to Reason*, and its companion piece, which were all engraved by Jacques-Louis Copia: these pieces established his reputation and made him well known." Voïart says that the drawings were made for "the comte d'Harlai,"[1] who was, in fact, Auguste-Louis-César-Hippolyte-Théodose de Lespinasse de Langeac (1759–1814), who bore the title comte d'Arlet. A cavalry captain, he was also a passionate collector and was apparently very involved in the art market.

Three compositions by Prud'hon were engraved by Copia under the following titles: *L'Amour réduit à la Raison* (Love Reduced to Reason), *Le Cruel rit des Pleurs qu'il fait verser* (Cruelty Laughs at the Tears He Has Caused to Flow), and *La Vengeance de Cérès* (The Revenge of Ceres).[2] The first plate bears the words "Prudon del[ineavit]" (Prud'hon drew it) and the others "Prudhon inv[enit]" and "PP Prudhon inv[enit]" (Prud'hon invented it; PP Prud'hon invented it) but never "pinxit" (painted it). Thus it is wrong to speak of "paintings" of these subjects. The first and last plates are inscribed "Tiré du cabinet du Citoyen d'Arlet" (From the cabinet of Citizen d'Arlet), and, in fact, the two corresponding drawings are the only ones by Prud'hon that appeared at the sale of Lespinasse de Langeac, comte d'Arlet (an anonymous sale taking place at the Mont-de-Piété) on July 11–19, 1803. Number 329, *Love Reduced to Reason*,[3] a drawing in pen heightened with white gouache, exhibited at the Salon of 1793 (no. 680), was last seen at the J. Tabourier sale on December 1, 1933,[4] and number 330, *Céres changeant en lézard le jeune Stellio, qui se moquait d'elle* (*La Vengeance de Cérès* [Ceres Changing the Young Stellio, Who Was Making Fun of Her, into a Lizard; The Revenge of Ceres]), whose fate and even existence

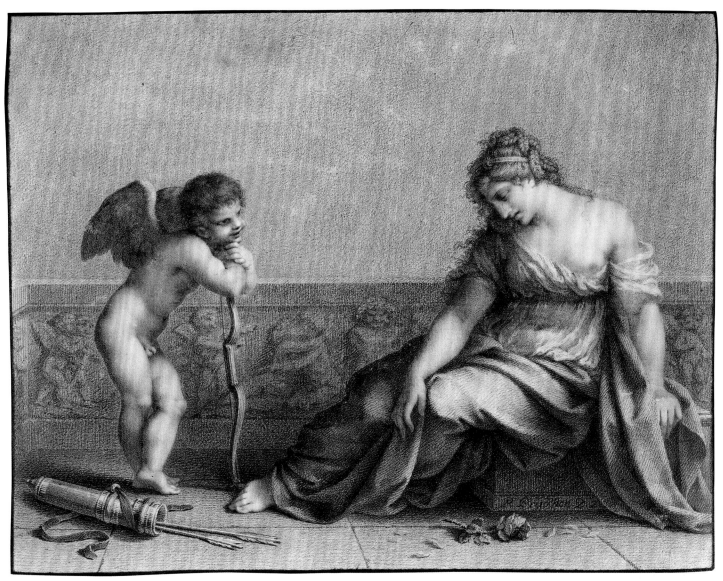

101

D'aprés l'Antique

Fig. 124. Jean Barbault, *D'après l'Antique*. Engraving, 4½ x 7¼ in. (11.5 x 18.4 cm). Private collection

Fig. 125. Pierre-Paul Prud'hon, *Woman Holding a Fawn Suckled by a Doe*, 1785–88. Graphite, black chalk, and brown ink on white paper, 6⅝ x 4½ in. (11.3 x 16.8 cm). Département des Arts Graphiques, Musée du Louvre, Paris (photo: Réunion des Musées Nationaux)

(Guiffrey does not catalogue it) were unknown, was discovered in 1980 in the Albertina, Vienna.[5] Thus the Winthrop drawing never belonged to the comte d'Arlet, despite what has been repeatedly claimed. Instead, it belonged to the architect Poulain, at whose sale it appeared in 1803.[6]

The print after *Love Reduced to Reason* appeared in December 1793; a companion piece to it was drawn at the same time, in year II (1793–94), and was entitled *Cruelty Laughs at the Tears He Has Caused to Flow*. The compositions and the subjects correspond exactly.

Cruelty Laughs at the Tears He Has Caused to Flow offers an eloquent example of the use Prud'hon made of his memories of the stay in Rome (1784–88). Although the title *Love Reduced to Reason* appears in one of his Roman notebooks,[7] it may have been inscribed later. But the other notebook, housed in the Louvre,[8] shows a sketch done after a sarcophagus in the Vatican,[9] in which a nude man, leaning on a stick (fig. 125), provides the adult prototype for the mocking Cupid in *Cruelty Laughs*. In addition, Helen Weston recognized the classical source of the figure of the weeping woman in a print by Jean Barbault, titled *D'après l'Antique* (After the Classics; fig. 124): it is a detail from the famous Medici Vase, at the Uffizi in Florence, the decoration of which is often interpreted as a Sacrifice of Iphigenia.[10]

It is a truly classical antique spirit that presides over all these works, which, while belonging to the revolutionary age, are more generally encompassed by the tradi-

tion of the purest Neoclassicism. Although their compositions are clearly derived from Pompeiian frescoes and the famous interpretation Joseph-Marie Vien gave them in his *Cupid Seller* (Salon of 1763; Musée National du Château, Fontainebleau), the huge formal repertoire of Greco-Roman sculpture provided schemes for works of art, which were likely to be adapted to fit poetic ideas, also inspired by classical literature, such as the poems of Anacreon or fragments from the *Palatine Anthology*.

Prud'hon's world is the world of love. In ways that Jean-Baptiste Greuze, one of his great models, explored at length shortly before him, he depicts the pleasures and woes of passion, whose risks he had experienced from an early age (like Greuze, he had a hellish marriage). The two compositions stand in contrast to each other. *Love Reduced to Reason* shows the young girl in a state of Innocence, making fun of ravaging Love, whom she has bound to a bust of Minerva, goddess of Reason, who recommends Hymen and the joys of motherhood, which are in bas-relief in the middle ground. Conversely, *Cruelty Laughs* depicts the woman who has let herself be swept away by passion, once more illustrated in the bas-relief, surrounded by symbols of defloration: a rose that has lost its petals and an almost empty quiver on the ground. She grieves for her lost innocence in front of a Cupid, whose diabolical laugh cruelly bears witness to his triumph.

Sylvain Laveissière

1. ". . . le dessin de la *Cérès*, qu'il exécuta à la plume; *L'Amour réduit à la Raison*, et son *pendant*, qui

furent tous gravés par Copia: ces morceaux préparaient sa réputation et le firent connaître"; Voïart 1824, p. 13.
2. Paris–New York 1997–98, nos. 30, 32, 34.
3. Guiffrey 1924, no. 24.
4. Tabourier sale 1933, no. 15; Paris–New York 1997–98, fig. 30b.
5. Paris–New York 1997–98, no. 33.
6. Goncourt (1876, p. 138) was unaware of that sale, even though it had been noted by Charles Blanc (1857–58, p. 217) and Théodore Lejeune (1864–65, vol. 1, p. 315); and Guiffrey (1924, no. 19) also forgot it, despite its being mentioned by Tailhades in 1877 as one of Goncourt's omissions.
7. Paris–New York 1997–98, no. 14.
8. Ibid., no. 13, fig. 13g.
9. Engraved by Ennio Quirino Visconti (1782–1807, vol. 4, *Bassirilievi* [1788], pl. 25). See Guffey (1997) 2001, p. 86.
10. Helen Weston, conversation with the author, 1999.

PROVENANCE: Jean-Baptiste Martial Poulain; his sale, G. J. Constantin, Paris, December 19, 1803, no. 145 (as "Le cruel rit des pleurs qu'il fait verser; dessin précieux, à la pierre noire"; Fr 281); Barthélemy Roger; his sale, Mannheim, Paris, December 23–28, 1841, no. 139 (Fr 360); Constantini, by 1874 at least until 1879; anonymous sale (Constantini's, according to Guiffrey 1924, no. 19), Hôtel Drouot, Paris, room 3, April 15, 1882, no. 71 (as "L'Amour vainqueur"); purchased at that sale by Mme Poiret (Fr 1,000); Robert Hoe; his sale, American Art Association, New York, February 15–March 3, 1911, no. 3228; Richard Ederheimer Print Cabinet, New York, December 1913; anonymous sale, Paris, Hôtel Drouot, April 1, 1914, no. 89 (Fr 1,000); Lilly Lawlor, Paris, 1927; acquired from her through Martin Birnbaum by Grenville L. Winthrop, July 1927 ($2,700); his bequest to the Fogg Art Museum, 1943.

EXHIBITIONS: Paris 1874b, no. 252; Paris 1879, no. 662.

REFERENCES: Voïart 1824, p. 13; Blanc 1857–58, p. 217; Lejeune 1864–65, vol. 1, p. 315; Clément 1872, pp. 199, 206, 376; Goncourt 1876, p. 138; Tailhades 1877, p. 329; Ederheimer Print Cabinet 1913, p. 48, no. 93, illus.; Guiffrey 1924, pp. 9–10, no. 19 (and p. 21, following no. 52, for the 1882 sale); Birnbaum 1960, p. 199; Slayman 1970, pp. 25–27, 256, pl. 15; Eunice Williams in Mongan 1996, pp. ii, 265–66, no. 295, illus.; Laveissière 1997b, pp. 28–29, illus.; Laveissière in Paris–New York 1997–98, pp. 77–78, fig. 32a; Bordes (1997) 2001, p. 113; Clark (1997) 2001, pp. 179, 189, 195, fig. 1; Laveissière (1997) 2001, p. 211; Guffey 2001, pp. 81 (fig. 53, caption error: reproduction of Fogg drawing, not engraving after it), 89–91.

102. *Reason Speaks, Pleasure Entraps (La Raison parle, le Plaisir entraîne)*, 1796

Black and white chalk on faded blue antique laid paper
8⅝ x 7 in. (21.7 x 17.7 cm)
1943.888

103. *Virtue Struggling with Vice (La Vertu aux prises avec le Vice)*, 1796

Black and white chalk on faded blue antique laid paper
8⅝ x 7 in. (21.7 x 17.7 cm)
1943.884

These two drawings, very freely executed, have never been separated.[1] For the first subject only, *Reason Speaks, Pleasure Entraps*, there is a polished drawing (fig. 126),[2] but, even though Guiffrey catalogues a similar sheet that may show *Virtue Struggling with Vice*[3] using the same technique, it cannot be traced, and we may wonder whether it ever existed. We know Prud'hon worked a very long time on his finished drawings and often did not complete them. Nevertheless, the two compositions were engraved, in reverse, under these titles, by Barthélemy Roger (1770–1841). From 1795 on, Roger gradually replaced his master Jacques-Louis Copia as

Prud'hon's major collaborator, and he indicated that *Reason Speaks, Pleasure Entraps* was the first print he engraved after Prud'hon. He certainly executed it after the very finished drawing,[4] and he may have done the pendant after Winthrop's less detailed drawing. The success of these prints is attested by the existence of color prints, and even reproductions on porcelain plates from Paris.[5]

The two drawings are companion pieces. They correspond to each other by developing oppositions: masculine/feminine in the central figures, calm/agitation in the actions, and temptation/repulsion in the feelings expressed. But an ambivalence

in these feelings also brings them closer together. The young man, positioned between Reason and Pleasure—represented by two women with contrasting expressions, one severe and veiled, the other cajoling and bareheaded—hesitates like Hercules at the crossroads, but we discern that his choice is enticing him (as the title says) toward pleasure. The young woman, assaulted by the libidinous brutality of a satyr, is resisting, but for how long? Her face expresses both fear and a surrender to pleasure, in accordance with a subtle rhetoric of feelings that had passionately interested artists not just since Charles Le Brun, but since Leonardo da Vinci,

Fig. 126. Pierre-Paul Prud'hon, *Reason Speaks, Pleasure Entraps*, ca. 1796? Black and brown chalk heightened with white on white paper, 8½ x 6¾ in. (21.5 x 17 cm). Private collection

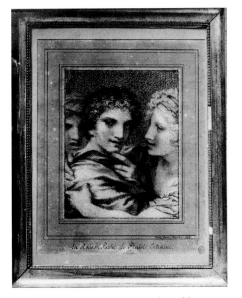

Fig. 127. Cat. nos. 102 and 103 in their old mounts inscribed *La Raison Parle, Le Plaisir Entraîne* and *La Vertu aux prises avec le Vice*, as well as *Pierre Paul Prud'hon 1796*. Photograph, 1924, Jean Guiffrey archives, private collection

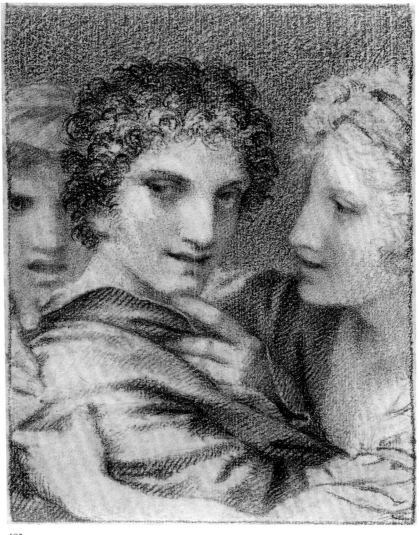

102

Prud'hon's idol. The moral dialogue of the images, in short, leads the beholder toward the conclusion that love is all-powerful, Reason and Virtue, fragile.

The idea of depicting allegorical figures, presented at half-length, one in front of the other and framed by the subordinate figures in an almost square space, is not a invention of Prud'hon's. The source can be found in the Renaissance Venice of Giovanni Bellini (*Pietà*, Accademia Carrara, Bergamo) or of Sebastiano del Piombo (*Triple Portrait* [previously attributed to Giorgione and Titian], Detroit Institute of Arts).[6]

The date of 1796, which once appeared on

Fig. 128. Detail of fig. 129

Fig. 129. Pierre-Paul Prud'hon, *Head of a Man with Short Hair, Seen in Left Profile*, 1785–88? Brown ink on white paper, 3½ x 2⅞ in. (8.3 x 7.2 cm). Private collection

103

the old mounts (lost) of the two Winthrop drawings (fig. 127), is our only chronological indicator regarding these compositions, which Prud'hon obviously undertook with the idea of publishing the pair of prints by Roger. In similar undertakings, especially the pair engraved by Copia under the titles: *Cruelty Laughs at the Tears He Has Caused to Flow* and *Love Reduced to Reason* (see cat. no. 101), Prud'hon used drawings done in Italy after ancient reliefs, whose figures he combined in various ways. In this case, a minuscule sketch (figs. 128, 129), drawn at the edge of a study for *Head of a Man with Short Hair* (*Tête d'homme aux cheveux courts*),[7] shows the starting point for *Virtue Struggling with Vice:* in it we see a man's face pressing against a young girl's cheek. There may be a classical model behind that sketch of an erotic composition. The vio-

lent temperament of the main subject on that sheet, a study with an expression similar to certain drawings by Leonardo, is represented in features resembling those of the amorous satyr in the Winthrop drawing. Prud'hon would repeat that expression of desire in a drawing, *Innocence and Love*,[8] executed in 1795–1800 and not engraved until 1817.

Sylvain Laveissière

1. There was another, more polished, pair of drawings, stippled in black chalk on white paper, at the sale of Poterlet the elder, December 7–9, 1840, no. 150, then at the Ponce-Blanc sale, February 11, 1887, nos. 28 and 27 (with the dimensions 8⅞ x 7⅜ in. [22.5 x 18.5 cm]). These appear to be copies, like most of the Ponce-Blanc drawings.
2. Guiffrey 1924, p. 127, no. 351; Paris–New York 1997–98, pp. 80–81, no. 36.
3. Guiffrey 1924, no. 352.
4. Ibid., no. 351.
5. One example was at the Galerie Michel Descours in Lyon in 1993.

6. Dominique Cordellier (in Paris 2001b, pp. 97–98, no. 28) defined that type of composition.
7. Paris–New York 1997–98, no. 16.
8. Musée Condé, Chantilly; Chantilly 1997–98, no. 18.

PROVENANCE FOR CAT. NOS. 102 AND 103: L. Lapeyrière; his sale, Me. Lacoste, Paris, April 14, 1817, no. 98 (as "la Vertu aux prises avec le Vice" and "la Raison parle, le Plaisir entraîne"; Fr 261); purchased at that sale by (?) Sallé; Senator Justynian Karnicki, Warsaw (d. before 1881; his mark, Lugt 1921, no. 1562, on old mounts; see fig. 128); Galerie Adolphe Le Goupy, Paris, 1924; acquired through Martin Birnbaum by Grenville L. Winthrop, June 1928 (Fr 40,000); his bequest to the Fogg Art Museum, 1943.

REFERENCES: Guiffrey 1924, pp. 127 under no. 351, 484 nos. 351 bis, 352 bis; Slayman 1970, pp. 33–34, 260, pls. 20, 21; Eunice Williams in Mongan 1996, pp. 267–68, nos. 298, 297, illus.; Laveissière 1997b, pp. 30–31, illus. (cat. no. 103); Laveissière in Paris–New York 1997–98, pp. 80–81, fig. 36a (cat. no. 103); Clark (1997) 2001, pp. 180, 195, fig. 3.

104. *Love Seduces Innocence, Pleasure Entraps, Remorse Follows* (*L'Amour séduit l'Innocence, le Plaisir l'entraîne, le Repentir suit*), ca. 1805

Black ink, gray wash, and graphite on cream antique laid paper
19¾ x 15½ in. (50.3 x 39.5 cm)
Watermark: D & C BLAUW / IV
1943.891

As an ephebic Love leads an enraptured Innocence away from her virtue, Pleasure, in the form of a delighted putto, sprays the path before them with flowers and urges them forward by pulling on the drapery of Innocence. Visibly distraught, Remorse follows behind in the shadow of the wings of Love. Delicately balanced between the seduction of temptation and the pain of regret, this gently erotic composition typifies the art of Prud'hon, who countered the cerebral and linear classicism of Jacques-Louis David and his circle with sensual allegories imbued with both the sfumato of Leonardo and the sweetness of Correggio.[1]

The Winthrop drawing is one of ten extant figure and composition studies executed over nearly three decades (see fig. 130) that relate to Prud'hon's painting of this subject of about 1809 (fig. 131) and to the engraved version of about 1812 by Barthélemy Roger (fig. 132).[2] It has always been noted that the pen work in the Winthrop drawing was left "unfinished"; however, this study is by no means incomplete. The generous, fluid, and unbroken contours, subtly nuanced with wash, reveal Prud'hon's thorough command of the medium and provide a completed grisaille. The task that remained, given the artist's preference for tight control over his commissions and collaborations, was to communicate the manner in which he wished to direct Roger's interpretation of his design. Prud'hon meticulously delineated the tonal and textural variety he wished to see in the

print by carefully hatching and stippling two faces and the top third of the sheet. He may have considered his work complete, for to continue beyond this indication of direction might have seemed like an insult to the very capable Roger.

The near uniqueness of this drawing— with its visible blend of Prud'hon's early tight hatching and his later and more vigorously drawn grisaille—makes it a particularly difficult one to date. Rather than abandoning the detailed pen technique for the less permanent and laborious medium of black and white chalk with which his draftsmanship is usually associated, Prud'hon may have returned to pen and ink just for this particular exercise. In this case, it is the grisaille to which one should turn for dating. Here, at what I propose to be about 1805, we seem midway between the approximations of Sylvain Laveissière

Fig. 130. Pierre-Paul Prud'hon, *Love*. White and black chalk with touches of pink chalk on blue paper, 23 x 16⅛ in. (58.4 x 41 cm). Collection of Jeffrey E. Horvitz, Boston, D-F-252

Fig. 131. Pierre-Paul Prud'hon, *L'Amour séduit l'Innocence, le Plaisir l'entraîne, le Repentir suit*, ca. 1809. Oil on canvas, 38⅜ x 32⅛ in. (97.5 x 81.5 cm). Private collection (photo: Photographie Bulloz)

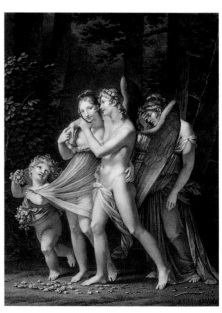

Fig. 132. Barthélemy Roger, after Pierre-Paul Prud'hon, *L'Amour séduit l'Innocence, le Plaisir l'entraîne, le Repentir suit*, ca. 1812. Etching and engraving, second state, plate 18 x 13¾ in. (45.6 x 35 cm). Département des Estampes, Bibliothèque Nationale de France, Paris, DC 37, vol. 1, p. 13

104

(1800) and Eunice Williams (1810). Of course, the mystery concerning the precise date of this step during Prud'hon's thirty-year preoccupation with this theme only adds to the ineffable charm of this beguiling allegory.

Alvin L. Clark Jr.

1. See Laveissière 1994.
2. For the other drawings related to the composition, see Sylvain Laveissière in Paris–New York 1997–98, pp. 81–89.

PROVENANCE: Prud'hon to Baron Barthélemy Roger; given by him to Théodore Charpentier; Mme Charpentier; (?) Delestre; his sale, Hôtel Drouot, Paris, May 14, 1936, no. 88 (Fr 25,000); acquired at that sale through Martin Birnbaum by Grenville L. Winthrop, 1936 ($2,100); his bequest to the Fogg Art Museum, 1943.

EXHIBITIONS: Paris 1874, no. 219; Tokyo 2002, no. 49.

REFERENCES: Clément 1872, pp. 408–11; Goncourt 1876, p. 143; Guiffrey 1924, no. 8; Bjurström 1986, under no. 1664; Eunice Williams in Mongan 1996, pp. 270–71; Laveissière 1997a, p. 560, under no. 2061; Laveissière 1997b, p. 26, illus.; Laveissière in Paris–New York 1997–98, pp. 83–84, under no. 38, fig. 38b; Clark (1997) 2001, p. 181, fig. 7; Guffey 2001, pp. 122–30, fig. 84.

105. *Study of a Seated Man, Half Reclining, Leaning on His Right Hand*

Black and white chalk on blue antique laid paper 18⅜ x 22⅛ in. (46.6 x 56.2 cm), including strips added at top and right edges
1943.886

This sheet—the original blue color of which has been preserved, which is rare—is one of the most accomplished in the impressive series of academic drawings by Prud'hon.[1] The artist did this sort of exercise at various times in his career. He must have done some when he was a student at François Devosge's École de Dessin in Dijon from 1774 to 1776, but none of them is known today. A student of the Académie Royale de Peinture et de Sculpture in Paris from 1780 to 1783, he is mentioned as having won an award for a study after a living model on June 28, 1783. The same year, he returned to Dijon to prepare for the competition for the Prix de Rome from the province of Burgundy, which he won in June 1784. Either in Paris or in Dijon he executed a series of academic drawings of men, now housed in the Musée des Beaux-Arts in Dijon, several of which bear the date 1783.[2] The fierce modeling and angular forms of these studies allow the personality of the great draftsman to show through the school exercise.

Nothing is known of life drawings Prud'hon made while in Rome, where in the evenings, although not resident at the Académie de France, he drew there in front of the model. Later, beginning in the 1790s, preparation for his allegorical compositions also involved studying the model: we know of youthful figures for *Love Seduces*

Innocence (see fig. 130), and later for *Psyche* and *Justice and Divine Vengeance Pursuing Crime* (1808), *Venus and Adonis* (1812), and *A Young Zephyr* (1814).

But there are also academic drawings of men and women, and sometimes of children, independent of any painting project. We know through an article Delacroix devoted to Prud'hon that the artist, in his final years, "spent every evening in the studio of his student, M. Trézel, drawing from life, as if he had himself been a student."[3] Trézel's studio was at the Sorbonne, the old Parisian university where Napoleon had found new lodgings for the artists evicted from the Louvre, and where Prud'hon had lived since 1802 and Trézel from 1810 to 1821. Trézel's occupancy gives an idea of the period when the majority of these academic drawings were likely produced.[4] We know the names of Prud'hon's favorite models—Marguerite, Julien, and Léna—whom he drew in diverse poses on large sheets of blue paper (about 24 x 14 in. [60 x 35 cm]). He began with a play of rapid and vigorous cross-hatching that was then stumped, before beginning the more delicate work of modeling and fine parallel hatching, always executed in black and white chalk. The extremities (the hands and feet, and sometimes the arms and legs) were often left unfinished, which tends to give these figures, though modeled with extremely firm precision, a wholly spontaneous and lively character.

Many academic drawings, eloquent witnesses to these posing sessions, where the model was shared by several draftsmen dis-

persed around him or her, show us the same nudes from slightly different angles: the artists who drew them were sitting close to Prud'hon, to whom it was then easy to attribute these artworks, especially since the draftsmen (today unknown) naturally took their example from the master's style. We thus know of a drawing (private collection) by an artist who was sitting very close to Prud'hon—just behind him perhaps, on a higher tier, and who captured the model with the head and left shoulder slightly more elevated—as he was working on this sheet (fig. 133).

Sylvain Laveissière

1. A fine selection of these, chosen by Robert Gordon, was published in Elderfield and Gordon 1996.
2. See Paris–New York 1997–98, nos. 9, 10.
3. Delacroix 1846, p. 447.
4. Paris–New York 1997–98, nos. 183–98.

PROVENANCE: Charles-Pompée Le Boulanger de Boisfremont (Lugt 1921, no. 353); his son Oscar; his sale, Hôtel Drouot, Paris, April 9, 1870, no. 53 (Fr 110); purchased at that sale by (?) Du Boys; anonymous sale (Du Boys?), Hôtel Drouot, Paris, May 26–27, 1879, no. 133 (Fr 1,205); purchased at that sale by (?) Lefè [. . .]; Jean Dollfus; his sale, Galerie Georges Petit, Paris, May 20–21, 1912, no. 111 (Fr 1,650); purchased at that sale by (?) Strauss; Reginald Davis; acquired through Martin Birnbaum by Grenville L. Winthrop, May 1928 (Fr 46,000); his bequest to the Fogg Art Museum, 1943.

EXHIBITION: Cambridge, Mass., 1994–95, no. 41.

REFERENCES: Guiffrey 1924, p. 456, no. 1237 (also erroneously cited on p. 35, in the provenance for no. 102, which is a study—now in the Louvre—for *The Dream of Happiness*); Birnbaum 1960, p. 199; Elderfield and Gordon 1996, pl. 51; Eunice Williams in Mongan 1996, p. 275, no. 304, illus. ("ca. 1815–20"); Laveissière in Paris–New York 1997–98, cited p. 304 (bibliography of no. 214); Clark (1997) 2001, pp. 180–81, 189, 198, fig. 4; Guffey 2001, pp. 120–21, fig. 78.

105

Fig. 133. Unknown artist near Prud'hon, *Study of a Seated Man*, *Half Reclining*, *Leaning on His Right Hand*. Black and white chalk, stumped, on blue paper, 16⅞ x 16⅝ in. (43 x 42.1 cm). Private collection

106. *Portrait of Dr. Thomas Dagoumer,* 1819

Oil on canvas
24⅛ x 20¼ in. (61.2 x 51.3 cm)
Signed and dated lower left: P. P. Prud'hon /
1819[1]

1943.273

Thomas Dagoumer (1762–1833/1835) first trained as an architect. Born in Louviers, he went to Paris in 1779 to learn drawing from the architect Auguste Hubert. After Hubert won the Prix de Rome in architecture from the Académie Royale, he lived in Rome as a scholarship student at the Académie de France from 1784 to 1788, and Dagoumer accompanied him. Dagoumer's name is among those of the competitors in the contest of the academy of Parma, where, in the architecture division, submissions "from Mr. Thomas Dagoumer of Louvier in Normandy, student of the Academy of Paris" appeared in 1785 and 1786.[2]

Returning to Paris in 1787, Dagoumer began studying medicine in 1792 and was a student at the Saint-Louis hospital in 1794, before receiving his medical degree from the Faculté in Paris. His publications

appeared between 1816 and 1831. His death is reported in the dictionaries as occurring in about 1835, but his sale—it is not known whether it was posthumous or not—took place in October 1833. In fact, the sale itself (its catalogue has not been located) is known only through the catalogue for another sale, which included the famous *Self-Portrait* drawn by Prud'hon (fig. 134).[3]

Dagoumer was Prud'hon's physician and friend until his death and also treated his companion, Constance Mayer, in 1821. They had known each other at least since they were in Italy (Prud'hon was a student in Rome from Christmas 1784 to spring 1788), they may have been companions earlier, in Paris, where Dagoumer and Prud'hon (from October 1780 to autumn 1783) had been students.

In addition to the self-portrait drawing, Dagoumer reportedly possessed the copperplate of an etching called *The Rape of Europa*[4] and a small painting on slate representing Law (Musée d'Art et d'Archéologie, Cluny).[5] All three works date

between 1785 and 1794, from the beginning of Prud'hon's career. According to the *Journal spécial des lettres et des beaux-arts,* which published *The Rape of Europa,* Prud'hon gave Dagoumer the copperplate, which was purchased at his sale by the painter Raverat.[6]

It is possible that, while in Rome, Prud'hon executed a portrait of Dagoumer. A small portrait of a young man in a wig (fig. 135), which family tradition claims is a depiction of "Prud'hon's physician," has been on the art market.[7] The work may be the same as the "portrait d'un ancien docteur-médecin par Prud'hon" (portrait by Prud'hon of a former physician), which was offered at an anonymous sale on March 12, 1852, as number 29.[8]

Winthrop's painting, in an excellent state of preservation, is one of the most beautiful portraits of men that Prud'hon left behind. Dagoumer is not a celebrity, but that is also the case of most of the other half-length portraits: the student David Johnston (fig. 136);[9] Louvre curator Louis-

Fig. 134. Pierre-Paul Prud'hon, *Self-Portrait.* Brown ink, 6 x 4⅞ in. (15.1 x 12.5 cm). Département des Arts Graphiques, Musée du Louvre, Paris, RF 1580; formerly Dagoumer collection (photo: Réunion des Musées Nationaux)

Fig. 135. Pierre-Paul Prud'hon (?), *So-called Portrait of Prud'hon's Physician,* ca. 1784–88 (?). Oil on canvas, 5⅛ x 4 in. (13 x 10 cm). Whereabouts unknown

Fig. 136. Pierre-Paul Prud'hon, *David Johnston,* 1808. Oil on canvas, 21⅝ x 18⅛ in. (55 x 46 cm). National Gallery of Art, Washington, D.C.; Samuel H. Kress Collection, 1961.9.84

Antoine Lavallée (Musée des Beaux-Arts, Orléans); and the chief treasurer and paymaster Louis-Auguste-Claude Vallet de Villeneuve (Louvre).[10]

The date of this painting, 1819, four years before Prud'hon's death, corresponds to that of the Salon where the portrait was hung under his *Assumption of the Virgin* (no. 922),[11] a prestigious commission for the royal chapel of the Tuileries, and accompanied by the *Portrait of the Son of M. Baron de C[ourval]* (no. 924). A *Portrait of a Woman* (baronesse de Courval?) was added by the artist two days before the Salon closed.[12] The critics, harsh toward the *Assumption,* praised the portraits' firmness, suavity, and resemblance to the sitters.

On September 4, ten days after the Salon opened, Prud'hon's only daughter, Émilie, was married and her dowry caused money problems for the painter for the rest of his life. Along with public commissions, portraits were for him an indispensable source of revenue. It is not known, however, whether the Dagoumer portrait was a commission from the model (perhaps to help out Prud'hon), as thanks from the painter for care he or Mayer received at no cost, or as a gift of pure friendship. In any case, the friendship shows through in the rendering of the face, at once grave and alert; and although, unlike a number of Prud'hon's models, Dagoumer is not smiling, his expression shows an attention marked by sympathy. His left eye with a gray iris is fixed on the beholder, hence first on the painter, and we cannot forget that the latter was also his patient. The face, framed by graying hair, modeled with bristly strokes as powerful as they are delicate, is sharply sculpted by the light, which explodes on the white collar and is reflected on the sheet of paper, itself an admirable "bit of paint" worthy of Chardin. The effect of light and shadow on the hands, moreover, is reminiscent of the backlighting found in *The Dream of Happiness,* a painting Mayer exhibited at the same Salon of 1819 (no. 809),[13] but to which Prud'hon, who had made sketches and drawings of it, also added some touches. *Sylvain Laveissière*

1. The date is difficult to read because it is obscured by the varnish.
2. "Del signore Tommaso Dagoumer di Louvier in Normandia, allievo dell'Accademia Parignia"; "Atti della Reale Accademia di Pittura, Scultura ed Architettura instituita in Parma," Parma MS, Accademia Nazionale di Belle Arti, archivio, vol. 1 (1770–93), pp. 229, 252.
3. Sale of P.-E. Dromont, December 4–5, 1871, in which Prud'hon's self-portrait drawing was no. 45 and was described as having sold with Dagoumer's collection in 1833; the drawing has been at the Louvre since 1887 (Paris–New York 1997–98, no. 47).
4. Actually, a *Naiad and Sea Bull* after an ancient sarcophagus, the drawing for which has been preserved; see Paris–New York 1997–98, no. 20.
5. Ibid., no. 113.
6. Anon. 1835, p. 35. The *Journal des artistes* (1847, p. 81), which published the same etching, indicated more precisely that, at the Dagoumer sale, Raverat also acquired several drawings, which are believed to have entered the collection of M. Marcille.
7. Sotheby's Monaco, June 23, 1985, no. 335, illus. (as by Prud'hon); Hôtel Drouot, Paris, salle 5, October 14, 1992, no. 6, illus. (as attributed to Prud'hon).
8. Guiffrey 1924, p. 186, following no. 496.
9. Birnbaum first advised Winthrop to acquire that painting, also at the duc de Trévise sale of 1938, no. 36, then changed his mind, finding it "entirely repainted," which is inaccurate.
10. The portrait of the famous Vivant Denon, now in the Louvre, is a fragment of a full-length portrait.
11. Louvre; Paris–New York 1997–98, no. 210.
12. Anon. 1819, p. 533.
13. Paris–New York 1997–98, no. 215.

PROVENANCE: Dr. Thomas Dagoumer; his bequest to his servant ("governess") "Mlle Elisabeth," 1833/35; purchased from her by the dealer Roehn the elder "in exchange for a life annuity paid for many years" (Goncourt 1876, pp. 49–50); purchased from him by Laurent Laperlier, before 1860 (Fr 2,000); his sale, Hôtel Drouot, Paris, April 11–13, 1867, no. 46 (Fr 440); purchased at that sale by Dugléré; Galerie Trotti et Cie, Paris, by 1923; Édouard Mortier, duc de Trévise; his sale, Galerie Charpentier, Paris, May 19, 1938, no. 37 (Fr 61,000); acquired at that sale through Martin Birnbaum by Grenville L. Winthrop; his bequest to the Fogg Art Museum, 1943.

EXHIBITIONS: Paris (Salon) 1819, no. 923; Paris 1860, no. 235; Paris 1922a, no. 50.

REFERENCES: Anon. 1819, p. 532; Emeric-David 1819, p. 1324; Pillet 1819 (September), p. 3; Anon. 1835, p. 35; Goncourt 1876, pp. 49–50; Burty 1879, p. 148; Clouzot 1923, p. 362, illus.; Guiffrey 1924, pp. 185–86, no. 496, and p. 484 (add.); Bowron 1990, fig. 268; Laveissière in Paris–New York 1997–98, p. 280, fig. 200c; Clark (1997) 2001, p. 191, n. 3; Laveissière 2001, p. 252.

Pierre Puvis de Chavannes

Lyon, France, 1824–Paris, 1898

107. *Saint Genevieve as a Child at Prayer,*[1] ca. 1879

Oil on canvas
52⅞ x 30 in. (134.3 x 76.2 cm)
Signed lower left: P. Puvis de Ch
Inscribed bottom center (in cartouche): DÈS SON
ÂGE LE PLUS TENDRE, SAINTE GENEVIÈVE /
DONNA LES MARQVES D'VNE PIÉTÉ ARDENTE. /
SANS CESSE EN PRIÈRE, ELLE FRAPPAIT DE
SVRPRISE / ET D'ADMIRATION TOVS CEVX QVI
LA VOYAIENT (From the tenderest age Saint
Genevieve showed the signs of an ardent piety; con-
tinually in prayer, she struck surprise and admira-
tion in all those who caught sight of her)
1942.188

Pierre Puvis de Chavannes's depiction of the devout young Genevieve kneeling in rapt prayer before a crudely made cross is a reduced version after his monumental mural *Sainte Geneviève enfant en prière* (fig. 137)[2] from his cycle L'Éducation de Sainte Geneviève (The Education of Saint Genevieve)[3] for the immense church dedicated to the patron saint of Paris, a building secularized in 1885 and now known as the Panthéon.[4] It is in the context of his 1874 commission, with its mandate to represent France's intertwined religious and national history,[5] and his practices as a painter that *Saint Genevieve as a Child in Prayer* is best understood.

Saint Genevieve was revitalized in the French imagination during the 1870–71 Franco-Prussian War, when many citizens appealed to her to deliver Paris from enemy siege and starvation[6] as she had miracu-lously intervened to save the imperiled country from the invasion of the Huns in the fifth century.

Believing for much of his career that his reputation would rest on his murals and keenly aware that their dispersal would pre-vent their being readily accessible and bet-ter known, Puvis executed "réductions" after his major programs; beginning with the Exposition Universelle of 1867, he made them available for exhibition and came to call them his testamentary task.[7] Following the critical acclaim in 1877–78 for his Saint Genevieve complex, his important first Paris project,[8] he produced reduced versions of these wall paintings. The 1879 date of the triptych after the com-position adjacent to the praying Genevieve, *La vie pastorale de sainte Geneviève* (*The Pastoral Life of Saint Geneviève;* Norton Simon Art Foundation, Pasadena),[9] itself a triad of murals, must stand for the ensemble of which the Winthrop painting is evidently a part. Yet, contrary to previous informa-tion,[10] their provenance and exhibition history are not the same.[11]

In the later nineteenth century, mural *décorations* and easel paintings or *tableaux* were considered distinctly different endeavors, and that the Winthrop canvas is a reduced version after a mural explains much about its uncommon appearance. Its vertically oriented, tall and narrow format was dictated by the architecture the mural embellishes. Its flatness, the overall even-ness of pictorial interest, compositional weight, color tonalities, and surface texture reinforce architectural planarity. Legibility demanded staunch delineations and simplifications. Therefore, the flattened landscape tilts forward to reinforce the pic-torial surface and ranges upward in distinct, stacked color zones. Genevieve, in the mid-dle distance, is bracketed in the foreground by a rustic couple with a baby, who turn to observe her, and in the background (at the composition's top) by a watching plowman.

Puvis's pastoral image emphasizes an idyllic, prelapsarian world of earnest faith and innocence underscored by an archaiz-ing style that mediates the image and ren-ders it unreal, furthers its expressive meaning by suggesting an epoch closer to that of the pictured events, and thus also tends to authenticate it. Puvis sought to make the girl angel-like, appearing like a vision to the onlookers.[12] Indeed, his slight, white-clad Genevieve recalls angels and innocents by such so-called Italian primi-tives as Sassetta and Fra Angelico, admired by Puvis as they were by his aesthetic men-tor Théodore Chassériau, who included a similar kneeling figure in an 1843 mural (Church of Saint-Merri, Paris).[13]

Although the Winthrop canvas follows the mural closely, the difference in scale seriously compromises their similarities. Insofar as its composition, perspectival sys-tem, opaque colors, roughly scumbled fres-colike painting technique, matte surfaces, and borders were dictated by a mural aes-thetic, its appearance is all the more unex-pected in an easel painting, which is thus that much more original. The broad tech-niques developed for the *grands traits* of murals viewed at a distance are visibly ruder in a work of smaller dimensions and images. The figures are less substantial, there is a lighter touch, and there are more abbreviated forms. The deleted halo—in this independent work—eliminates the supernatural. Editing enhances clarity: an eradicated cloth exposes the woman's strong arm; the pink furrowed field is more

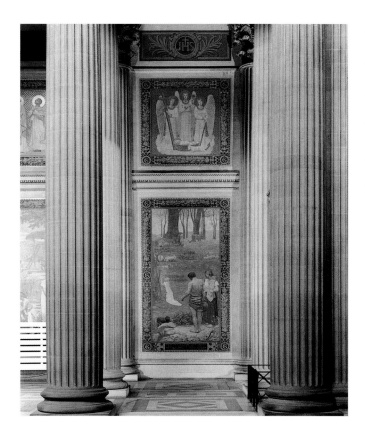

Fig. 137. Pierre Puvis de Chavannes, *Sainte Geneviève enfant en prière (Saint Genevieve as a Child in Prayer)*, 1876 (dated 1877). Oil on canvas with possible wax additives, 15 ft. 1⅞ in. x 7 ft. 4 in. (462 x 221 cm). Panthéon, Paris (photo: C. Rose © Centre des Monuments Nationaux)

steeply angled; a plow is eliminated; trees are simplified. The composition, perceived as unusually terse, was described by Henry James as "simplicity at any price."[14]

Puvis considered borders indispensable to his murals[15] and pressed to design them himself, as in his oil sketch (fig. 138).[16] The Winthrop canvas (of the same dimensions) reproduces Pierre-Victor Galland's Panthéon borders, with their SG monogram, devised to unify the murals by the various artists there.

In 1896 Puvis's praying Genevieve became the subject of a large lithographic poster[17] published for the "Union pour l'action morale," which promoted "affiches morales" (moral posters)[18] to combat what it viewed as the overly frivolous, licentious, and commercial posters[19] that proliferated in Paris in the 1890s.[20]

Puvis's vision proved formative to a host of younger painters.[21] Maurice Denis, Pablo Picasso, and Edwin Blashfield produced work specifically indebted to *Sainte Geneviève enfant en prière*.[22]

Aimée Brown Price

1. Alternative titles include *Saint Genevieve as a Child in Prayer* and the designation "reduced replica" or "reduced version" (*Sainte Geneviève enfant en prière [réduction]*) (this work was previously erroneously called an *esquisse*, or sketch). Whether Genevieve should be called in translation "in" or "at" prayer has been disputed (the latter may suggest a more institutionalized act within a formal setting); Henri Zerner and others have proposed the latter; the title of an oil sketch (Van Gogh Museum, Amsterdam; fig. 138) is rendered into English by Aimée Brown Price as "in prayer."
2. The definitive mural (fig. 137) is dated 1877, the year of its installation, but it was actually completed the year before and exhibited at the Paris Salon of 1876 (no. 1694). Puvis customarily exhibited his murals, painted on canvas as they were, before sending them off to their various destinations to be fixed into place (through a method using white lead called *marouflage*).
3. This was the first of his two campaigns for the Panthéon; for more on this commission, the program, other works in this cycle, and other variant versions, see Paris–Ottawa 1976–77, pp. 132–44; Amsterdam 1994, pp. 146–57; and particularly Price 1995.
4. Designed by Jacques Germain Soufflot in the 18th century, the building had a change in designation at several junctures in its history; for a succinct account, see Roos 1986, pp. 633–36; see also Chevallier and Rabreau 1977.
5. As stipulated in his contract of May 14, 1874, Archives Nationales, Paris (hereafter AN); Décoration de l'Église patronale de Sainte Geneviève; Programme des peintures et sculptures, F²¹4403.
 For other unpublished sources concerning this commission, see AN F²¹248; AN F²¹487. See also the contract of May 15, 1874, and unpublished correspondence of May 15, 1874; July 7, August 10,

November 11, 1877; July 28, 1879; June 6, 1888, private collection, France.
6. Brogan 1944, p. 38.
7. Pierre Puvis de Chavannes, undated letter to Henri Daras, private collection, France.
8. The murals consist of the praying Genevieve, an adjoining tripartite composition *L'Enfance de Sainte Geneviève (The Childhood of Saint Genevieve)* or *The Meeting of Saint Genevieve and Saint Germain;* and surmounting the former, *La Naissance de Sainte Geneviève (The Birth of Saint Genevieve)* or *The Three Theological Virtues Watching the Saint in Her Cradle;* and above the latter, a so-called frieze of saints; see Amsterdam 1994, pp. 147–50.
9. Also known as *L'Enfance de Sainte Geneviève (The Childhood of Saint Genevieve)* or *The Meeting of Saint Genevieve and Saint Germain*, the sections measure 52⅞ x 32¼ in., 52⅞ x 35¼ in., 52¾ x 31⅞ in. (134.2 x 81.8 cm, 134.2 x 89.5 cm, 134 x 81 cm), respectively; inv. no. M. 1968.49.P. In addition, there is a reduced version of the tripartite frieze *Saints légendaires de la France (Legendary Saints of France;* Philadelphia Museum of Art, 1969-167-001); but to date no reduced version after *The Birth of Saint Genevieve* has been located nor is one documented, though one would seem to have been painted to complete the ensemble.
10. As indicated in Cambridge, Mass., 1942, p. 11; and Paris–Ottawa 1976–77, pp. 133, 134, 137.

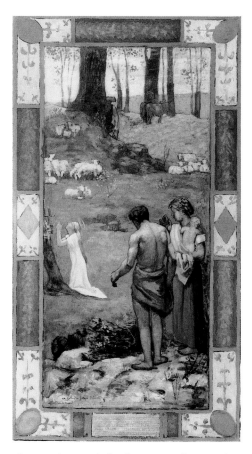

Fig. 138. Pierre Puvis de Chavannes, *Sainte Geneviève enfant en prière (Saint Genevieve as a Child in Prayer)*, ca. 1875–76. Oil on paper, laid on canvas, 53¾ x 30 in. (136.5 x 76.2 cm). Van Gogh Museum, Amsterdam

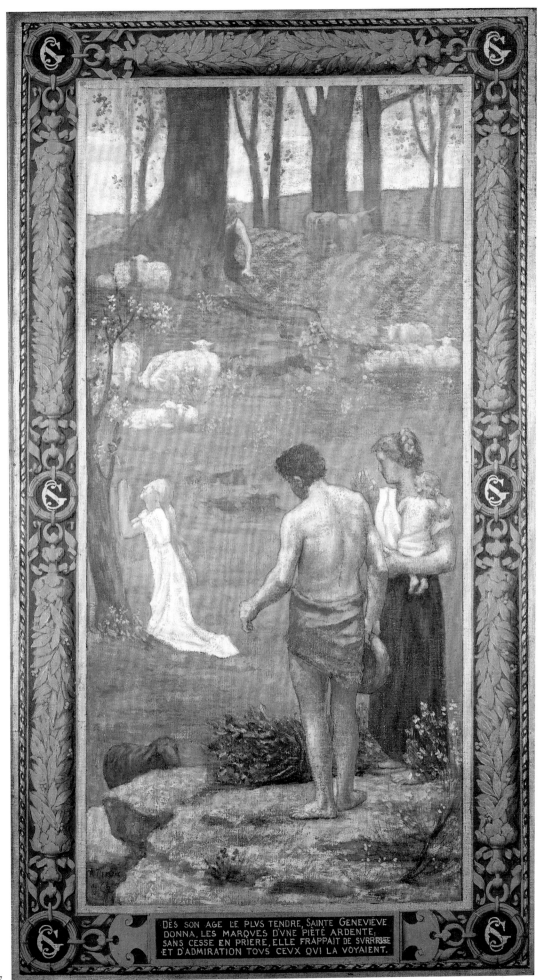

DES SON AGE LE PLVS TENDRE, SAINTE GENEVIÈVE
DONNA, LES MARQVES D'VNE PIÉTÉ ARDENTE;
SANS CESSE EN PRIERE, ELLE FRAPPAIT DE SVRPRISE
ET D'ADMIRATION TOVS CEVX QVI LA VOYAIENT.

107

11. For the provenance and exhibition history of the triptych, see Amsterdam 1994, no. 74.

12. Chennevières 1884–85 (October 1884), p. 266; also published in Chennevières 1885, p. 88.

13. In the upper tier of *Communion de Marie l'Égyptienne (Conversion of Saint Mary the Egyptian)*; Sandoz 1974, no. 94B, pl. 77; an analogous figure is in François-Joseph Heim's *Presentation of the Virgin in the Temple* (Église Saint-Séverin, Paris) of 1849.

14. James 1876, p. 415.

15. Puvis, letter to Charles Dufour (in conjunction with his Amiens murals), September 3, 1863, Commission du Musée Napoléon, 1863, Bibliothèque de la Société des Antiquaires de Picardie, Musée d'Amiens.

16. See Amsterdam 1994, pp. 147–49, no. 70, illus.; Price 1995, pp. 118–21, 124–29.

17. *Sainte Geneviève en prière*, color lithograph after Puvis de Chavannes by Alexandre Lauzet, printed by the firm of Lemercier; its measurements given variously as 59 x 39¼ in. (149.9 x 99.6 cm), 55½ x 31 in. (141 x 78.5 cm), and, by Jumeau-Lafond 1995, p. 63, as 59 x 44¼ in. (150 x 112.5 cm), the disparities partly due to the inclusion or exclusion of the borders. The edition of this rare print is uncertain;

examples are in the private collections of the artist's collateral descendants in Rives and Nançay and the Nelson-Atkins Museum of Art, Kansas City, Missouri. For the other three poster panels, see Price 1995, p. 130.

18. See Geffroy 1892–1903, vol. 5 (1897), p. 10.

19. Jumeau-Lafond 1995, pp. 63–68, 71–72, illus. p. 63.

20. The four panels, *Saint Genevieve in Prayer* and three contiguous panels (Saint Genevieve recognized by Saint Germain and Saint Loup or *The Pastoral Life of Saint Genevieve*), were also republished at reduced size, approximately 15⅜ in. (38.9 cm) high, printed by Imprimerie Chaix (Encres Lorilleux et Cie) in a series issued by Roger-Marx, *Les Maîtres de l'affiche*, 1897, pl. 54 (example at the Nelson-Atkins Museum of Art); see Price 1995, pp. 129–31.

21. This is recognized in monographs on many individual artists; also see Toronto 1975 and Amsterdam 1994, pp. 237–51.

22. See Price 1995, pp. 131–32, figs. 14, 15; Toronto 1975, p. 173, proposes possible additional influence.

PROVENANCE: Durand-Ruel, New York; Hannah Edwards, Boston, 1924; acquired in Connecticut through Martin Birnbaum by Grenville L. Winthrop, April 1941; his gift to the Fogg Art Museum, 1942.

EXHIBITIONS: New York, Durand-Ruel Gallery, November–December 1887, no. 53 (presumably included with *Reduction of the Paintings at the Pantheon*); Paris 1887a, no. 1 (presumably included with *Peintures murales du Panthéon Réduction*); Cambridge, Mass., 1942, p. 11; Tokyo 2002, no. 11.

REFERENCES: Ballu 1877, p. 212; Chennevières 1884–85 (October 1884), pp. 257–76; Vachon 1895, pp. 107–20; Bazin 1896, pp. 28–29; Geffroy 1892–1903, vol. 5 (1897), p. 10; Desjardins 1898, pp. 68–72; Puvis de Chavannes 1899, pp. 1080–82; Vachon [1900], pp. 185–97; Puvis de Chavannes 1910, pp. 688–92; Anon. 1916, p. 134; Sertillanges 1917, pp. 10–15; Anon. 1924, pp. 117–20; Price 1972, pp. 430–57, 460–68; Toronto 1975 (1976 ed.), pp. 162–77; Paris–Ottawa 1976–77, pp. 132–39; Paris 1979, p. 64; Bergdoll 1989, pp. 229–30; Bowron 1990, fig. 352; Burkom 1993, pp. 15–19; Amiens 1994, pp. 48–49; Amsterdam 1994, pp. 18, 26, 147–49, illus.; Jumeau-Lafond 1995, pp. 63–68, 71; Price 1995, 118–21, 124–33.

108. *Head of a Woman,* ca. 1884–89

Black chalk (possibly with charcoal), touches of oil paint, with stumping and possible traces of fixative, on tracing paper laid down on wove card[1]
14⅛ x 10⅛ in. (36. x 25.8 cm)
Estate stamp lower right: P.P.C.
1943.899

This magnificent drawing of a firmly delineated, supremely subtle, classicizing female head represents several principal aspects of Puvis de Chavannes's mature idiom: an impulse toward Hellenizing imagery; the seeking after essentialist form as its apt vehicle; and a proclivity for undisturbed structural integrity, clear pictorial rhythms, and steadfast calm.

Classicizing imagery from Nicolas Poussin through Jacques-Louis David and beyond was a French tradition, and Puvis turned to this ennobling legacy for his first monumental mural paintings for French civic buildings in the 1860s. Its significance as a national expression was underscored

after the 1870–71 Franco-Prussian War, when the defeated country reasserted its historical and cultural filiations with Greco-Roman antiquity (in contradistinction to Germanic Northern Kultur).[2] Classicizing images served an integrative function,[3] useful at a time of change, as they reiterated certain fundamental historico-intellectual precepts.

A preponderant number of the thousands of drawings that Puvis de Chavannes produced were in conjunction with specific paintings.[4] Yet he was also interested in drawing for its own sake. Indeed, many of the heads that he executed throughout his career, including the Winthrop head, were done independently of his paintings.

Although this head cannot be identified with a particular painting, its style accords with work of the mid- to late 1880s and such generalized heads as those of the muses in Puvis's quintessentially Arcadian

Le Bois sacré cher aux arts et aux muses of 1884 (Musée des Beaux-Arts, Lyon); or *The Sacred Grove, Beloved of the Arts and Muses* of about 1884–89 (fig. 139), a reduced version after his mural; or the personifying figures in his 1889 mural for the main lecture hall of the Sorbonne.

Puvis drew heads in pencil, charcoal, and colored chalk, most frequently black chalk with, on occasion, white highlights. In the 1880s he also experimented with fixative to vary his surfaces, and after the mid-1880s he often used pastel.[5] His heads range from veristic portraiture, caricature, and other individualized depictions to generalized, idealized abstractions, as here. His early heads occasionally repeat types associated with Théodore Chassériau and Thomas Couture. Many heads of the 1850s display a graphic fervor that in the 1860s and 1870s gives way to carefully calibrated tonal values. This rare and beautiful head

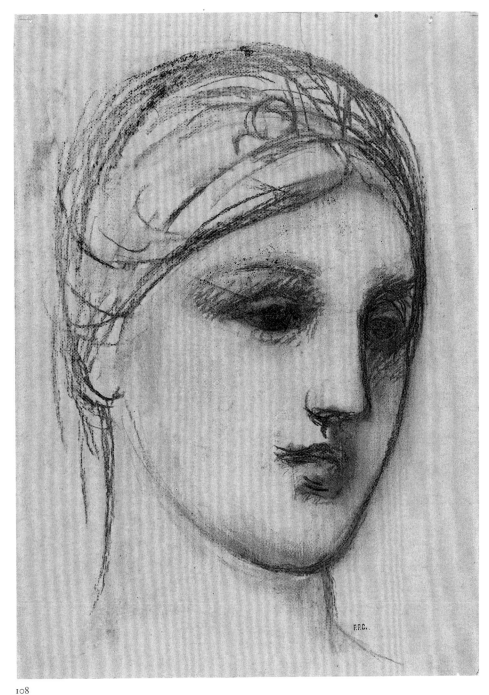

108

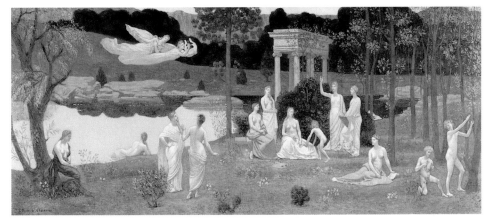

Fig. 139. Pierre Puvis de Chavannes, *The Sacred Grove, Beloved of the Arts and Muses*, ca. 1884–89. Oil on canvas, 36⅝ x 91 in. (93 x 231 cm). Art Institute of Chicago; Potter Palmer Collection, 1922.445 (photo: © 2001 Art Institute of Chicago)

shows Puvis in command of a gamut of techniques. It is delineated in several tonalities of black and orders of definition, with granulated lines and halftones (comparable to mezzotint) achieved by drawing on thin paper against a textured surface—a method Puvis also favored in transfer lithographs.[6] These muted blacks cushion sharper, darker, ever stronger and more succinct lines. With elegant economy of means, a darkened zone both indicates a shadow against which the head more fully emerges and casts its right side in shade, modeling the facial features while accenting their vertical profilelike continuity (a mapping dear to Chassériau, Puvis, and Pablo Picasso). The touch of color introduces a whisper of naturalism, drawing attention to the activity of the making of art itself, as do the array of markings—from stumping to intense reworkings (around the eyes)— that abrade the paper. Puvis exposes these pictorial elements as such and his process of invention, notation, adjustments, and pentimenti for their intrinsic aesthetic appeal.

The proportions, serene features, and rhythms are those associated with Periclean sculpture—a smooth forehead and brow, straight nose, and small, full lips defined by the simplest means. Head and hair are constructed to emphasize pure, spare forms, largely unbroken by extraneous embellishments except an ornamental curlicue and the masterful sweep of a few sure lines to indicate wisps of hair curved up and around a filletlike headdress. It was through developing an aesthetic proper to his murals that Puvis learned to reduce pictorial components and eliminate superfluous detail.

Acutely aware of style as such, Puvis used it to expressive purpose.[7] A classicizing image was enriched through association, making radical simplifications reassuringly acceptable. The terse Greek paradigm paradoxically epitomized the "natural" but was tantamount to mod-

ernism. In so elegantly translating the oval head from three to two dimensions, Puvis presages the graphic negotiations of such artists as the early Henri Matisse or Picasso.

Puvis gave drawings to family and friends (as is testified to by dedications); others were acquired by connoisseurs. An inventory made after his 1898 death lists almost two thousand drawings. Many were tallied by location, numbered, and initialed "D" (for the notary, Delapalme). These received an estate stamp with the initials P.P.C., as here.[8] Most went to Puvis's heirs and, at his behest, some 949 were donated to museums in cities that had commissioned or otherwise shown special interest in his work during his lifetime (with an effort made to distribute pertinent works to each venue).[9]

Aimée Brown Price

1. My thanks to Craigen Bowen, Straus Conservator of Works of Art on Paper, Straus Center for Conservation, Harvard University Art Museums, for reviewing the materials of this drawing with me.
2. Jacques Foucart notes (in Paris–Ottawa 1976–77, p. 133) that to call a style "French" and classical was "one of the favorite clichés of the art criticism of this period."
3. See Lears 1985, pp. 570, 573.
4. A superb summation is in Boucher 1979.
5. For example, see Paris–Ottawa 1976–77, nos. 15, 17, 57, 126, 170–72, 183, 213; Paris 1979, nos. 35, 53, 82, 103, 158–67, 170, 172; Amsterdam 1994, nos. 16, 17, 40, 55, 73, 132, 133, fig. 16.
6. For example, *The Toilette*, ca. 1882–83, transfer lithograph of black chalk drawing with stumping, signed on the stone, 12 x 9⅞ in. (30.5 x 25 cm), published in *L'Épreuve* (1895), no. 1, pl. 1; see Druick in Paris–Ottawa 1976–77, no. 166; Ivins 1930, p. 175; Ivins 1958, p. 21, illus.
7. His earliest references to making choices among stylistic conventions are in his caricatural drawings; see Price 1991, pp. 121–30, and Price 1995, pp. 16–19, and passim.
8. Lugt 1921, no. 2104. In the determination of authenticity the stamped letters bear close examination, as at least two false stamps exist.
9. These are detailed in Paris 1979, unpag.

PROVENANCE: Acquired from Scott and Fowles, New York, by Grenville L. Winthrop, March 1925 ($750); his bequest to the Fogg Art Museum, 1943.

Odilon Redon

Bordeaux, France, 1840–Paris, 1916

109. *Saint Sebastian*, ca. 1912

Watercolor and black chalk on off-white wove paper
9¼ x 6 in. (23.4 x 15.3 cm)
Signed in red watercolor, lower right: ODILON REDON
1943.396

In its technique and style, this watercolor is characteristic of many works on paper created by Odilon Redon during the last decade of his life. Using a light touch with brilliant colors and leaving the support in reserve, the artist combined broad strokes with fine lines and hatching similar to a pen drawing, consistent with the advice he once received from Corot: "Next to an uncertainty, place a certainty."[1] With a spontaneity comparable to that in his sketchbooks and a penchant for ornament, he returned to themes that were dear to him and freely appropriated traditional subjects.

Redon devoted about fifteen works, executed in watercolor, pen and wash, pastel, or oil, to the martyrdom of Saint Sebastian.[2] Over its long pictorial history, this theme was favored by, among others, Gustave Moreau, the inspiration of Redon's youth (Redon would critically reassess that artist's works at the opening of the Moreau museum in 1900).[3] Other biographical and cultural events may have contributed to Redon's late interest in Saint Sebastian. In 1910–11, Redon decorated the library of the abbey of Fontfroide, near Narbonne, the saint's native city, according to Jacobus de Voragine's *Golden Legend*. On May 22, 1911, Gabriele D'Annunzio's drama *The Martyrdom of Saint Sebastian* was performed at the Théâtre du Châtelet, with music by Claude Debussy and sets by Léon Bakst; Redon had been in contact

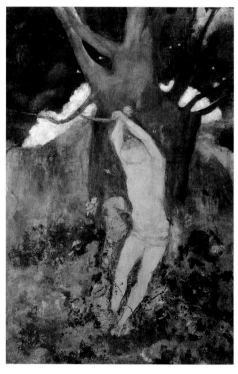

Fig. 140. Odilon Redon, *Saint Sebastian*, ca. 1910. Oil on canvas, 36⅜ x 23⅜ in. (92.5 x 59.5 cm). Öffentliche Kunstsammlung Basel, 2325 (photo: Öffentliche Kunstsammlung Basel, Martin Bühler)

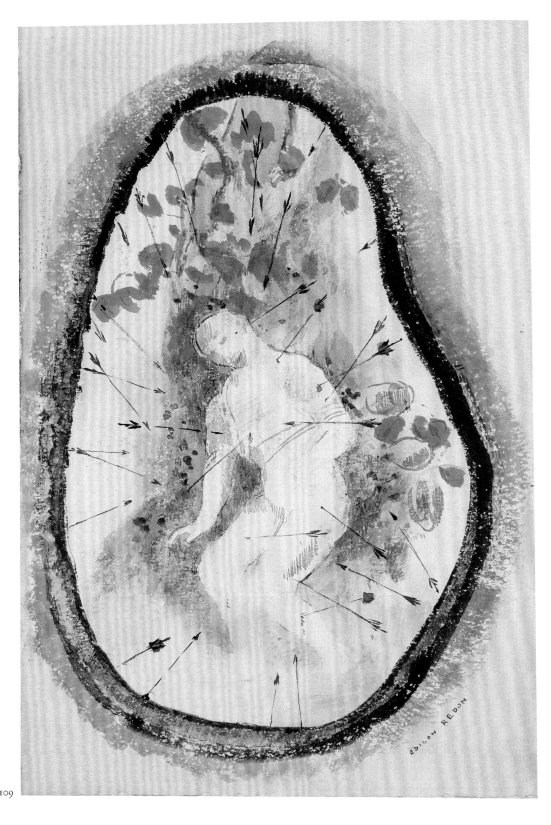

109

with Debussy since 1893, and Diaghilev reportedly asked Redon to design the sets for Debussy's ballet *Afternoon of a Faun*, which premiered at the Théâtre du Châtelet in 1912.[4] The archbishop of Paris issued an interdict of D'Annunzio's "mystery play" because the title role was given to a woman, Ida Rubinstein. The indeterminate gender of the saint in Redon's work may reflect that casting choice.

Redon chose to depict the moment when Sebastian is assaulted by the arrows, but he eliminated all narrative elements and, by way of setting, retained only a tree, to which the saint is attached (fig. 140), signifying the union of man and nature.[5] The watercolor in the Winthrop collection shows the saint in a curiously restful pose that further distinguishes him from the usual iconography.[6] The pose is remarkable for its two-dimensional and abstract char-

acter. The lack of depth is indicated by the trajectory of the arrows, which seem to be coming from every direction, and by the outline surrounding the composition. Lacking any determinate iconographic or iconic identity, the outline motif is richly suggestive. It may bring to mind the mandorla in medieval Christian art and the auras portrayed by the theosophists of Redon's time, especially Charles W. Leadbeater in *Man Visible and Invisible* (1902). But it is especially reminiscent of the organic world and evokes by turns a cell, a microscopic animal, an egg, a shell, or even a uterus.

In any case, Redon introduces a contradiction by juxtaposing the protective enclosure and the body exposed to the arrow attack. The red of the wounds, however, reappears in the kidney-shaped outline. The martyrdom, metaphorical or symbolic rather than historical or religious, thus appears to be a conception or a birth, which the saint's closed eyes place on an internal and spiritual plane. That interpretation of the torment, luminous and peaceful at least in appearance, echoes a text written more than thirty years earlier, in which Redon sought to make sense of the isolation he felt as a man and as an artist: "He who suffers is he who rises up. Strike. Always strike. The wound is fertile."[7]

Dario Gamboni

1. Redon (1961) 1979, p. 36.
2. See Wildenstein 1992–98, vol. 1, *Portraits et figures* (1992), nos. 524–38.
3. Redon 1923, pp. 38–39.
4. Paris 1983–84a, pp. 156–59; Bacou 1960, p. 228.
5. See Groom 1994, pp. 349–50.
6. The same pose is found again in a small oil on wood housed at the Musée d'Orsay, Paris; Wildenstein 1992–98, vol. 1 (1992), no. 527.
7. Text dated August 10, 1877; Redon (1961) 1979, p. 60.

PROVENANCE: (?) Bauchy (Wildenstein 1992–98, vol. 1 [1992], no. 534); his sale, Hôtel Drouot, Paris, March 20, 1923, no. 52; acquired at that sale through Martin Birnbaum by Grenville L. Winthrop, April 1930; his bequest to the Fogg Art Museum, 1943.

EXHIBITION: Paris 1917, no. 32.

REFERENCES: Berger 1965, no. 534, pl. 24; Wildenstein 1992–98, vol. 1 (1992), no. 534, illus.; Chicago–Amsterdam–London 1994–95, pp. 349 (fig. 116), 350.

Pierre-Auguste Renoir

Limoges, France, 1841–Cagnes-sur-Mer, France, 1919

110. *Spring Bouquet*, 1866

Oil on canvas
41¼ x 31⅝ in. (104 x 80.5 cm)
Signed and dated lower right: A. RENOIR 1866
1943.277

Pierre-Auguste Renoir was not alone in the mid-1860s in painting flower still lifes. He knew that admired older artists such as Gustave Courbet and friends such as Claude Monet were also painting flower pieces regularly, while contemporaries like Henri Fantin-Latour were beginning to make a very good living at it. Moreover, flowers were always among the cheapest and most reliable of models. During this youthful period, however, flower painting seems to have played a unique role in Renoir's personal artistic development.

Flowers made him less nervous than other subjects, he confessed, and he could apply the lessons he learned there to more complicated compositions. As he told the critic Albert André, "I just let my mind rest when I paint flowers. . . . I establish the tones, I study the values carefully, without worrying about losing the picture. . . . The experience which I gain in these works, I eventually apply to my [figure] pictures."[1]

This exuberant still life of spring flowers in a blue-and-white Chinese vase was painted in early summer 1866. Douglas Cooper has related it to a letter of spring 1866 in which the artist told a friend, the painter Jules Le Coeur, that he had discovered *la vraie peinture*, true painting.[2] The announcement coincided with Renoir's

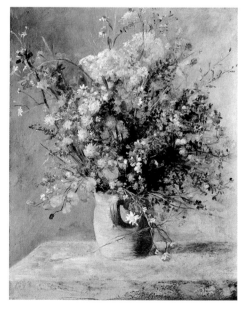

Fig. 141. Pierre-Auguste Renoir, *Flowers in a Vase*, ca. 1866. Oil on canvas, 32 x 25⅝ in. (81.3 x 65.1 cm). National Gallery of Art, Washington, D.C.; Collection of Mr. and Mrs. Paul Mellon, 1983.1.32 (PA)

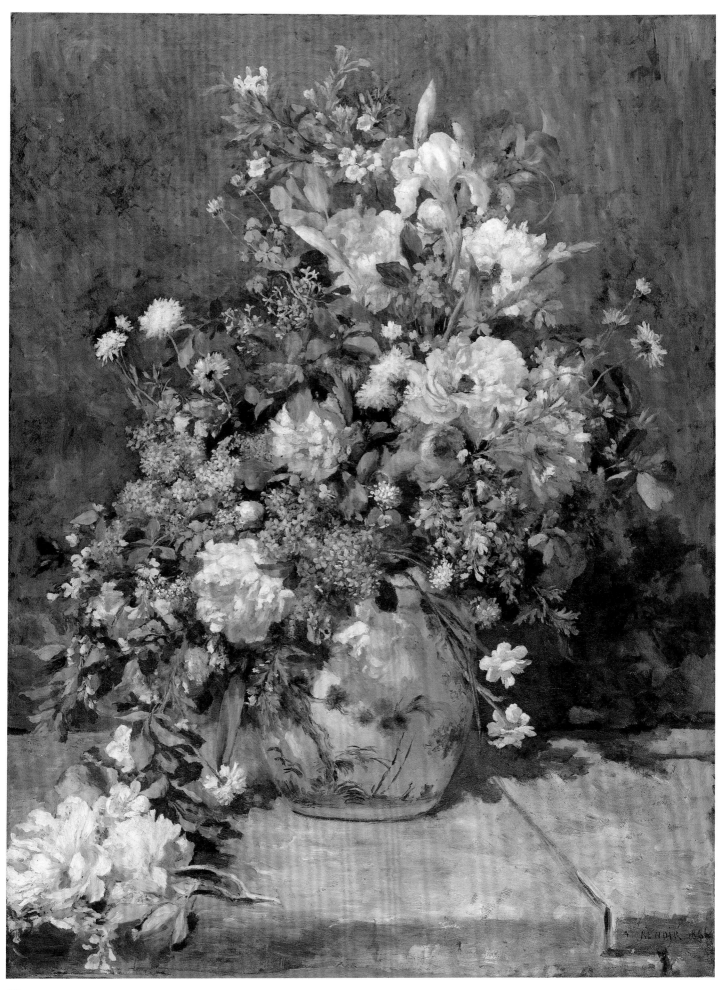

adoption of a freer, more confident approach to his art, using thinner paints applied with the brush alone, rather than with the palette knife he had often employed before this date. These are characteristics of the present work, as they are of a second still life, *Flowers in a Vase* (fig. 141), which, although undated, must have been painted at about the same time. Both paintings were made for Jules Le Coeur's older brother, Charles, Renoir's earliest and most loyal patron. An architect, Charles Le Coeur (1830–1906) worked for wealthy and noble clients such as the prince George Bibescu, and he also had a distinguished official career under the Third Republic, particularly as a designer of schools.[3] Over the years, he commissioned or purchased a number of paintings from Renoir, including, in 1874, a portrait of himself (Musée d'Orsay, Paris). The Renoirs remained in the Le Coeur family until the mid-1920s.

The artist had made the acquaintance of the family in about May 1865. Early the following year he was at work, in their elegant Paris home on the rue Humboldt (now rue Jean Dolent), on a portrait of the Le Coeur family matriarch, never finished (Musée d'Orsay). By March and April he was painting with Jules, as well as Alfred Sisley, at the family's country home at Marlotte, in the Forest of Fontainebleau. For several years, before they broke with him in 1874, the Le Coeur family received the artist frequently at both residences.

The Winthrop painting, with its porcelain vase set on a stone ledge, suggests the elegance and refinement of sophisticated city life. A photograph from the early twentieth century shows that the painting did indeed hang in the family's Paris home.[4] It was set directly into the *boiserie*, or wood paneling, of a sitting room furnished in elegant eighteenth-century style. Flanking it on wall brackets were Chinese vases not unlike the one depicted in the painting itself. Years later, in the early 1920s, Paul Dumas saw the painting in the same house. A family member informed him, he reported, that the picture had been painted "in the very garden that lay before us."[5] The Washington painting, on the other hand, shows wildflowers more haphazardly displayed in a simple earthenware pot standing on another stone ledge. The mood is rustic and informal. A railway label from the town of Melun, near the Le Coeur country home at Marlotte, is found on the back of the picture, and it suggested to Cooper that the painting was perhaps executed there.[6] Although the picture is smaller than the present work, it is as if the two canvases were conceived as pendants contrasting urban refinement with the greater simplicity of the countryside, the two poles of life for the convivial Le Coeur family around the time that Renoir first came to know them.

Christopher Riopelle

1. Quoted in Gaunt 1982, p. 31.
2. Cooper 1959, p. 164.
3. On Charles Le Coeur, see most recently Paris 1996–97.
4. The photograph is reproduced in Distel 1990, p. 16, fig. 9.
5. Dumas 1924, p. 364.
6. Cooper 1959, p. 167, n. 23.

PROVENANCE: Charles Le Coeur, Paris, 1866; private collector, Detroit; purchased from him by Wildenstein and Co., New York; acquired from them by Grenville L. Winthrop, June 11, 1942 ($27,500); his bequest to the Fogg Art Museum, 1943.

EXHIBITIONS: Cambridge, Mass., 1943–44, p. 7; Cambridge, Mass., 1969, no. 91; Cambridge, Mass., 1974, no. 45; Cambridge, Mass., 1977a.

REFERENCES: Dumas 1924, illus. p. 364 ("Collection Le Coeur"); Fogg Art Museum 1943, illus. p. 59; Rewald 1946, pp. 144, 145 (illus.), 147; Pach 1950, illus. facing p. 34; Cassou 1953, pl. 33; Fox 1953, illus. p. 9; Bazin 1960, illus.; Gaunt 1962, fig. 1; Nichols 1967, illus. p. 111; Cabanne 1970, illus. p. 46; Mongan 1970, illus. p. 21; Fezzi 1972, pp. 89–90, pl. 12; Yamazaki, Tomiyama, and Takashina 1972, p. 112, pl. 17; Kelder 1980, illus. p. 227; White 1984, illus. p. 12; Mortimer 1985, p. 188, no. 214, illus.; Bernard 1986, pp. 171 (illus.), 258; Nakayama 1986, illus. p. 6; Keller 1987, p. 21, pl. 14; Wadley 1987, p. 20, pl. 4; Distel 1989, no. 10, illus. p. 17; Bowron 1990, fig. 378; Renoir 1990, pp. 22–23, illus.; Abe 1991, illus. p. 40; de Mazia 1991, pl. 2; Denvir 1991, pl. 64; Distel 1993, illus. p. 12.

111. *Portrait of Madame Pierre-Henri Renoir,* 1870

Oil on canvas
32 x 25½ in. (81.28 x 64.77 cm)
Signed and dated lower right: A. Renoir. 70
1943.275

A young woman is seated in a plush chair in an interior decorated with ornate wall hangings. She wears a silk gown trimmed with black lace at the bodice and holds a closed fan in her right hand. Her eyes are averted from the viewer toward her right and her head is tilted. Light falls from the upper right onto the side of her face, her bare shoulder, and her plump arm. She raises her left hand to her breast in a modest gesture that recalls the pose of the Medici Venus; at the same time it allows her to display the simple gold wedding band on her finger. The saturated autumn tonality of the painting is animated here and there by bright highlights, quickly applied, as on her skirt, and a rather formal intimacy is deftly suggested.

For many years the subject of Renoir's portrait was identified as Countess Edmond de Pourtalès (1836–1914), a grand and aloof figure in Parisian society of the 1860s and 1870s.[1] In 1995, however, Colin B. Bailey pointed out that when the portrait was signed and dated in 1870, Renoir as yet had no access to the *haut bourgeois* circles in which the countess moved.[2] He would paint her eventually, but not until 1877.[3] Around 1870 Renoir's portrait subjects tended to be drawn from members of his own family and friends, and it was in that humbler and, for the young Renoir, more accessible milieu that Bailey found the actual subject of the painting. The sitter is the artist's sister-in-law, Blanche-Marie Blanc (1841–1910?), wife of his elder brother Pierre-Henri Renoir (1832–1909).

No portrait of Blanche-Marie had previously been recorded. Early in the twentieth century, when this picture was on the art market in Berlin, it was known simply as *Portrait of a Woman.* It is not clear when the Pourtalès name came to be associated with it, although it was before Winthrop acquired the painting in 1937.[4] By chance, however, in the first volume of his catalogue raisonné of Renoir's paintings, published in 1971, the late François Daulte reproduced the so-called Pourtalès portrait beside the artist's sober portrait of Pierre-Henri Renoir (fig. 142).[5] Here, a plump, satisfied-looking seated man fingers a gold watch fob in his left hand. It was Bailey's insight to recognize that in fact the two paintings function very well as pendant images. The canvases are almost identical in size and their russet tonalities are the same, as is the scale of the figures. The figures inhabit domestic interiors that are similar in decor, and, as in traditional portraits *en regard,* the two incline slightly toward each other. Indeed, when the paintings are seen side by side, it is clear that Blanche-Marie's reticent gesture and the angle of her head show that wifely deferral to the husband that had long been a tradition in pendant portraits of spouses.

Blanche-Marie was the illegitimate daughter of a seamstress, Joséphine Blanche, and the medalist and gem engraver Samuel Daniel (1808–after 1864), with whom she lived. It was in their home that Pierre-Henri Renoir met his future wife when he came to study medal and gem engraving under Daniel. He would go on to establish a considerable reputation and to publish manuals in the field.[6] He and Blanche-Marie were married on July 18, 1861.[7] By the time Renoir painted their portraits they had arrived at the success and financial ease that the fine clothes and jewels Blanche-Marie wears suggest. Indeed, Pierre-Henri may well have commissioned the pendants to celebrate this prosperity. After his retirement in 1877, the couple, childless, moved to a villa at Poissy. The future filmmaker Jean Renoir remembered with pleasure his youthful visits to the café-concert with his aunt and uncle.[8]

Both portraits are signed and dated 1870. As Bailey shows, they must have been completed before October of that year, when Renoir departed for Bordeaux and his military service in the Franco-Prussian War.[9] The pendants went their separate ways early, however, before the death of either sitter, though at a time when the artist had already achieved considerable renown. The portrait of Blanche-Marie was with the dealer Gaston-Alexandre Camentron by 1896, as he sold it to Durand-Ruel on April 23 of that year.[10] The portrait of Pierre-Henri went to Ambroise Vollard at an unknown date. Camentron, like Vollard a dealer in the rue Lafitte, sometimes collaborated

Fig. 142. Pierre-Auguste Renoir, *Portrait of Pierre-Henri Renoir,* 1870. Oil on canvas, 31⅞ x 25¼ in. (81 x 64.1 cm). Private collection

III

with him.[11] Perhaps the pendant portraits were split between them at that time. If so, Camentron got the more salable of the two paintings. In the absence of the stolid male figure it is perhaps not surprising that a grand aristocratic name should have come to be attached to this refined and elegant lady.

Christopher Riopelle

1. Most recently in Bowron 1990, p. 127.
2. Bailey 1995, p. 685.
3. The portrait is in the Museu de Arte, São Paulo; Daulte 1971, no. 256.
4. Bailey (1995, p. 684) is mistaken when he says that the Pourtalès name was applied only after Winthrop acquired the painting from Wildenstein, New York, in May 1937. The portrait had previously been in the collection of Oskar Schmitz, Dresden. The French-language edition of the Schmitz collection catalogue, published by Wildenstein, Paris, in 1936 identifies the painting as *Portrait de femme (Mme de Pourtalès)* (Paris 1936b, p. 108).
5. Daulte 1971, nos. 61 (Pierre-Henri Renoir), 62 (Mme de Pourtalès).
6. Further information on Pierre-Henri Renoir's career can now be found in Ottawa–Chicago–Fort Worth 1997–98, no. 7.
7. Bailey 1995, p. 687, publishes their wedding certificate.
8. Renoir 1962, p. 409; cited by Bailey 1995, p. 686.
9. Bailey 1995, p. 685.
10. Camentron seems to have sold Renoirs to Durand-Ruel regularly; see Daulte 1971, nos. 15, 158, 414.
11. In 1897 they jointly organized an exhibition of Eugène Murer; see Distel 1990, p. 215.

PROVENANCE: Gaston-Alexandre Camentron, Paris; purchased from him by Durand-Ruel, Paris, April 23, 1896; purchased from them by Adrien Hébrard, Paris, February 3, 1906; purchased back from him by Durand-Ruel, October 24, 1906; purchased from them by Galerie Thannhauser, August 5, 1912; Oskar Schmitz, Dresden; his son, Édouard Schmitz; Wildenstein and Co., New York; acquired from them by Grenville L. Winthrop, May 28, 1937 ($17,500); his bequest to the Fogg Art Museum, 1943.

EXHIBITIONS: Paris 1912; Zürich 1932, no. 46; Paris 1936b, no. 49; Cambridge, Mass., 1969, no. 92; Cambridge, Mass., 1977a.

REFERENCES: Pica 1908, illus. p. 82; Meier-Graefe 1911, illus. p. 36; Meier-Graefe 1912a, illus. p. 33; Biermann 1913, p. 326, no. 22; Scheffler 1920–21, p. 186; Dormoy 1926, p. 342; Meier-Graefe 1929, p. 41, no. 23, illus.; Pach 1950, illus. p. 39; Huyghe 1960, pl. 5; Daulte 1971, no. 62, illus.; Fezzi 1972, p. 92, pl. 56; Yamazaki, Tomiyama, and Takashina 1972, p. 113, pl. 21; Lucie-Smith 1989, pp. 80 (fig. 67), 83–85; Bowron 1990, fig. 376; Bailey 1995; Ottawa–Chicago–Fort Worth 1997–98, p. 272, fig. 115.

112. *Portrait of Victor Chocquet,* ca. 1875

Oil on canvas
20⅞ x 17⅛ in. (53.02 x 43.5 cm)
Signed lower left: Renoir
1943.274

Victor Guillaume Chocquet (1821–1891), originally from Lille, was an indefatigable collector of works of art. He was a low-paid customs officer in the Ministry of Finance, one, moreover, who resisted career advancement if it meant leaving Paris. Nonetheless, he used what resources he could to assemble a superb collection of paintings, objets d'art, and fine furniture. He filled the modest apartment on the rue de Rivoli, overlooking the Tuileries Gardens, that he shared with his wife, Caroline. Only late in life did Chocquet enjoy financial ease, when an inheritance came his wife's way in 1882. At that point, oddly, his passion for collecting seems to have abated. During the 1860s and 1870s, however, he haunted dealers' shops, auction houses, and artists' exhibitions, where he acquired works by the artists who most excited him. First among them was Eugène Delacroix, whose works he began to acquire in the 1860s; some twenty-three paintings and more than sixty drawings and watercolors by the artist were included in the posthumous auction of Chocquet's estate in 1899. In the mid-1870s, he was smitten in turn by the works of the young Impressionists and became one of their most assiduous early champions and collectors.[1]

Chocquet missed the first Impressionist exhibition of 1874. He did attend the disastrous sale of their works at auction the following year, although he did not buy. It was there, however, that he seems to have met Renoir, and soon afterward Chocquet commissioned a portrait of his wife from the artist (Staatsgalerie, Stuttgart). Chocquet also began to acquire the young painter's works, and by the time of the second Impressionist exhibition, in 1876, he was in a position to lend no fewer than six Renoir paintings; ten works by the artist were included in the posthumous sale of 1899. Renoir later spoke in exaggeratedly glowing terms of Chocquet's patronage. He was "le plus grand collectionneur français depuis les rois, peut-être du monde depuis les papes" (the greatest French collector since the kings, perhaps in the world since the popes).[2] Chocquet also quickly became enthusiastic about Paul Cézanne, to whom Renoir introduced him. Indeed, he was Cézanne's first real collector, accumulating some thirty-one works. More than that, he became a friend and confidant to the young artists; Renoir called him *le père* Chocquet in acknowledgment of the warmth of his admiration and support.

Sometime soon after their initial meeting, Renoir painted this portrait of his new

friend. Chocquet confronts his limner with an even gaze, tiny dots of white in the pupils of his eyes suggesting a natural vivacity. Similarly, the portrait as a whole is painted with small, quick touches of color that also hint at the sitter's quickness and spontaneity. His long, meditative face, accentuated by a beard, is centered in the top half of the canvas. His right arm is languidly draped across the back of a chair, the long fingers of both hands weaving together to animate the lower quadrant of the painting, their asymmetrical placement contrasting with the frontality of the sitter's face. Chocquet is dressed casually, without a tie, and it is clear that we are meeting him in the domestic realm. Behind his head, its semicircular frame echoing the sitter's halo of hair, swept back from a high forehead, is a painting by the artist he most admired. Chocquet identified Renoir as a follower of Delacroix, the natural inheritor of his coloristic art, and here Renoir acknowledges the compliment by including Delacroix's *Hercules Rescues Hesione* of 1852 into the

portrait. The painting is a preparatory study, today at Ordrupgaard, Charlottenlund (Copenhagen), for a lunette in the Salon de la Paix in the Hôtel de Ville, Paris, destroyed in 1871. In the 1875 portrait of Chocquet's wife in Stuttgart, Renoir included, hanging on the wall in the background, a second painting by Delacroix from the Chocquet collection. In 1876 Renoir painted a second portrait of his patron (Sammlung Oskar Reinhart am Römerholz, Winterthur). If anything, it is even more pensive. Years later, when Renoir again saw one of his portraits of Chocquet in an exhibition, he remarked that it was "Portrait d'un fou . . . par un fou. . . . Quel délicieux toqué!" (A portrait of a nut . . . by a nut. What a charming crackpot!).[3] *Christopher Riopelle*

1. On Chocquet, see Distel 1990, pp. 125–39; and Rewald 1969, pp. 33–96.
2. Quoted in Distel 1990, p. 125.
3. Quoted in Distel 1993, p. 47.

PROVENANCE: Victor Chocquet, 1875; his sale, Galerie Georges Petit, Paris, July 1–4, 1899; purchased

at that sale by Durand-Ruel, Paris; purchased from them by Adrien Hébrard, Paris, February 3, 1906; Alexandre Berthier, prince de Wagram, Paris; Jacques Seligmann and Co.; acquired from them by Grenville L. Winthrop, March 1930 ($65,000); his bequest to the Fogg Art Museum, 1943.

EXHIBITIONS: Paris 1876, no. 211; Paris 1904, no. 21; Cambridge, Mass., 1943–44, p. 11; Cambridge, Mass., 1977a; Cambridge, Mass., 1985, no. 8.

REFERENCES: Rivière 1921, illus. facing p. 36; André 1928, p. 7; Manson 1929, pp. 256–60, illus.; McBride 1937, p. 69, illus.; Frost 1944, illus. p. 20; Mongan 1944b, illus. p. 22; "Sixteen Reproductions" 1944, illus.; Rewald 1946, illus. p. 291; Drucker 1955, pl. 27; "Businessman and the Artist" 1958, illus. p. 31; Bosman 1961, no. 47, illus.; *Enciclopedia universale dell'arte* Rome 1958–67, vol. 11 (1961), p. 318, pl. 209; Seligman 1961, p. 149, pl. 47; Gaunt 1962, no. 23, illus.; Hanson 1968, illus. following p. 110; Murphy 1968, illus. p. 70; Rewald 1969, p. 53, fig. 13; Cabanne 1970, illus. p. 71; Daulte 1971, no. 176, illus.; Fezzi 1972, p. 99, pl. 255; Bellony-Rewald 1976, pp. 82–83, illus.; "Treasures from New England" 1976, p. 10, fig. 3; White 1984, illus. p. 60; Feldman 1985, p. 63, fig. 2-48; Bernard 1986, illus. p. 65; McQuillan 1986, p. 140, illus.; Nakayama 1986, illus. p. 20; Wadley 1987, p. 99, pl. 35; Distel 1989, p. 126, no. 107; Grada 1989, p. 47, no. 26, illus.; Bowron 1990, fig. 379; Abe 1991, illus. p. 74; Plazy 1991, p. 82, fig. 2; Walther 1992, detail illus. p. 655; Adriani 1993, illus. p. 85; Distel 1993, illus. p. 47; *Geijutsu Shincho* (Tokyo), no. 8 (1993), illus. p. 35; Brisbane–Melbourne–Sydney 1994–95, p. 30, fig. 8; Paris–London–Philadelphia 1995–96, p. 167, fig. 1; Sotheby's, New York, November 13, 1997, p. 25; Ottawa–Chicago–Fort Worth 1997–98, p. 33, fig. 45.

Auguste Rodin

Paris, 1840–Meudon, France, 1917

113. *Saint John the Baptist*, 1880

Black ink with touches of graphite on light tan wove paper
12⅞ x 9⅜ in. (32.8 x 23.9 cm)
Signed and inscribed in black ink, lower center: Rodin; lower right: salon de 1880 / A. Rodin
1943.910

The catalogue of the sale of Baron Joseph Vitta's collection describes this preaching *Saint John the Baptist* as "an admirable drawing done by the master, after the plas-

ter statue that appeared at the Salon of 1880, number 6641, which was but the culmination of a piece on which Rodin had worked since 1877 under the strong influence of Michelangelo, and which first bore the title Walking Man. In the 1880 statue, Saint John the Baptist is seen standing on the base, his right arm extended, his hand making a gesture to accompany his words, his left arm falling the length of his

body and with the end of a cross in his left hand. The main beam of the cross rests on his shoulder and has a long banderole at the top. The cross disappeared from the model that was cast in bronze, because Rodin found that this accessory broke the line of movement."[1]

Baron Vitta had a villa, La Sapinière, in Evian, on the south bank of Lake Leman, and in 1893–1900 he asked Auguste Rodin,

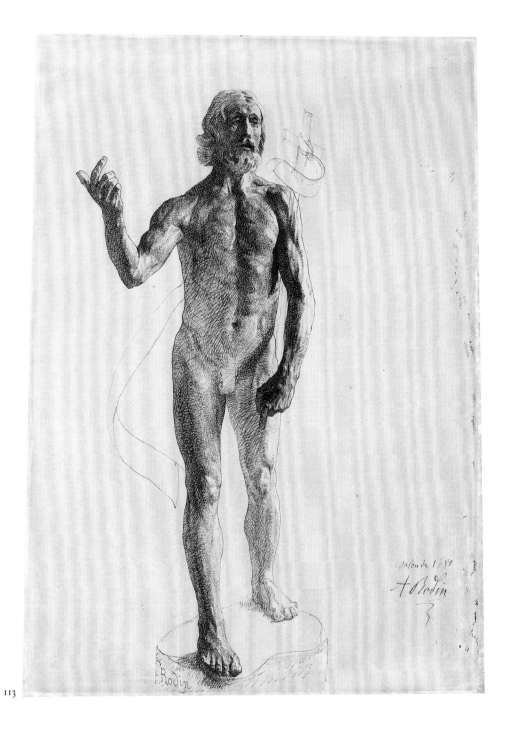

113

along with Alexandre Falguière, Jules Chéret, Alexandre Charpentier, Félix Bracquemond, and Albert Besnard, to participate in decorating it. Pediments and planters completed by Rodin in 1904 evoked the seasons. This drawing of Saint John the Baptist may have been given by Rodin to Baron Vitta on that occasion.

Another drawing of the same pose, but without the cross or banderole, was published in *L'artiste* in January 1889. It bears a dedication to the writer and politician Étienne Arago.[2] A drawing of Saint John the Baptist in profile, in pen and ink and on a wash background, served as an illustration to an 1898 article by Camille Mauclair.[3] There is also a drawing after Rodin's bust of Saint John the Baptist that was exhibited at the Salon of 1883.

Since all these drawings were intended to show sculptures as exhibited, for example, at a Salon, they share a very particular style. They are precisely rendered in pen and ink, with modeling accomplished by cross-hatching similar to that in engravings.

Claudie Judrin

1. Translated from Vitta sale 1935, no. 12.
2. Département des Arts Graphiques, Musée du Louvre, Paris, RF 16079.
3. Mauclair 1898, p. 603.

PROVENANCE: Baron Joseph Vitta, Paris; his sale, Galerie Charpentier, Paris, March 15, 1935, no. 12; acquired at that sale through Jacques Seligmann and Co., New York, by Grenville L. Winthrop (Fr 25,000); his bequest to the Fogg Art Museum, 1943.

REFERENCES: Leroi 1880, p. 124; *Revue de l'art*, April 1935, p. 181; Geldzahler 1962, p. 499; San Francisco 1975, p. 14, fig. i; Schmoll gen. Eisenwerth 1983, p. 124, fig. 72; Vilain et al. 1996, p. 24.

114. *Vase Clodion (Lovers)*, ca. 1880

Black ink and gouache, with traces of graphite on tan wove paper
7½ x 5¾ in. (18.9 x 14.5 cm)
Inscribed in gray ink, upper left: Vase Clodion /
pour
1943.914

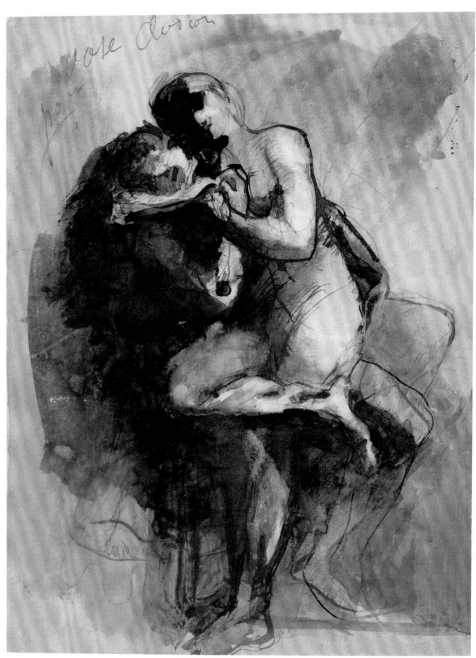

114

In inscribing "Vase Clodion" on this drawing, Rodin was alluding both to the eighteenth-century French sculptor Claude Michel, called Clodion, and to work Rodin did for the Sèvres Manufactory. Regarding Clodion's work, Rodin said that "his modeling was a little facile, but supple, and with such pretty decorative harmonies, such seductive charm!"[1] The manufactory was between 1879 and 1882 directed by Albert-Ernest Carrier-Belleuse, with whom Rodin had collaborated in Belgium in 1871. At Carrier-Belleuse's request Rodin designed figures to decorate the bellies of porcelain vases. A vase ornamented with the entwined lovers in this drawing was probably not executed, since it does not appear in the only work published on Rodin the ceramist.[2]

However, between 1882 and 1886, the drawing was photographed twice by Charles Bodmer and retouched in graphite.[3] The retouching was done to the woman's left knee, seen in a twist of legs in the style of Michelangelo.

The drawing entered the collection of the American artist John Singer Sargent, who painted Rodin's portrait in 1884.[4] When he was posing for the portrait, Rodin may have given Sargent several drawings by way of thanks. In a letter, Sargent wrote: "What a nice surprise it was just now for me to find your beautiful gift. I cannot thank you enough for these drawings, which I find extremely interesting."[5]

Claudie Judrin

1. Translated from Dujardin-Beaumetz (1913) 1992, p. 107.
2. Marx 1907.
3. Musée Rodin, Paris, D.7741, fols. 28r, 29v.
4. Rodin gave the Sargent portrait to the French government in 1916; Musée Rodin, P.7341.
5. Sargent, undated letter to Rodin, Musée Rodin Archives.

PROVENANCE: John Singer Sargent; his sale, Christie's, London, July 24–25, 1925, part of no. 269 (£58 16s.); purchased at that sale by Scott and Fowles, New York; acquired from them by Grenville L. Winthrop, January 1926 ($550); his bequest to the Fogg Art Museum, 1943.

REFERENCES: Paras-Perez 1967, p. 136; Judrin 1984–92, vol. 5 (1992), p. 373.

115. *Study for "The Gates of Hell": Shades Speaking to Dante,* ca. 1883

Black ink, gray wash, and white gouache over graphite on tan wove paper with ruled lines; drawing is irregularly shaped and laid down on tan paper, itself laid down on blue mount
7⅝ x 4¾ in. (19.4 x 11.8 cm)
Inscribed in graphite, upper right: ombres parlant / au dante / ou à un/ / damné / regardant / la transformation / de Bose; *in red ink, upper left, sideways:* faire une esquisse avec / des bas reliefs à 3 ou 2 personnages (la porte)
1943.916

Rodin spent a full year occupied with Dante, "living only on him and with him, drawing the eight circles of his Inferno."[1] The drawings he would do are much more faithful to the text of the *Divine Comedy* than are the sculptures of *The Gates of Hell.* In this drawing two shades from canto 25 of the Inferno look with dread at the torment to which the corrupt official Buoso Donati (Rodin referred to him as "Bose" in the inscription at the upper right of the sheet) is condemned to change into a serpent—metamorphosis of both body and mind. The inscription at upper left, "do a sketch with bas-reliefs . . .," demonstrates that the sculptor, contrary to his habits, considered making a bas-relief of the figures. These two damned men have a musculature worthy of Michelangelo's pencil.

This very beautiful drawing was reproduced as a photogravure in the *Album Goupil* and as a wood engraving by Auguste Lepère in *L'Image.*[2] Charles Bodmer also made a photograph of it. Sometime between 1882 and 1886, Rodin retouched the legs of the damned men in the photograph with graphite.[3]

Claudie Judrin

1. Translated from Basset 1900.
2. *Album Goupil* 1897, pl. 42; Marx 1897, pp. 294–95.
3. Musée Rodin, Paris, D.7741, fol. 65r.

PROVENANCE: Scott and Fowles, New York; acquired by Grenville L. Winthrop, January 1926 ($450); his bequest to the Fogg Art Museum, 1943.

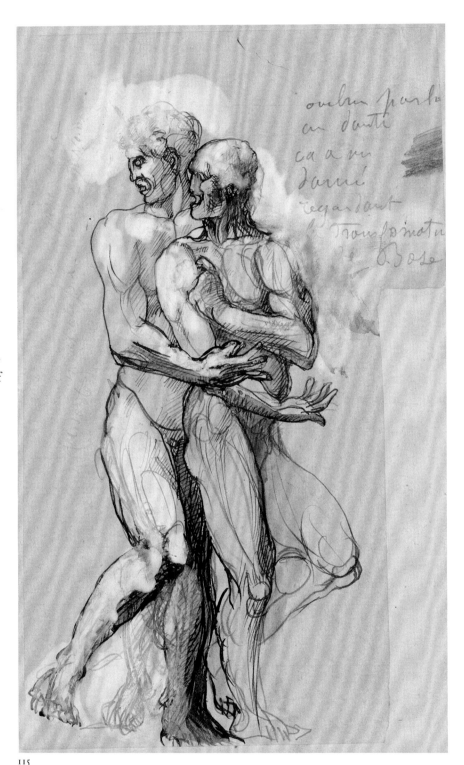

115

REFERENCES: Dargenty 1883, illus. p. 33; *Album Goupil* 1897, pl. 42 (as "Ombres parlant à Dante"); Marx 1897, pp. 294–95; Adams 1945, pl. 1; Birnbaum 1946, pp. 70–71, 95, pl. 28; Elsen 1960, p. 16, pl. 15; Elsen and Varnedoe 1972, pp. 61–62, fig. 42; Judrin 1984–92, vol. 5 (1992), p. 375.

116. *Eternal Spring*, 1884

Bronze, Griffoul and Lorge cast, April 1888
25 x 26¾ x 15⅜ in. (63.5 x 67.9 x 39.1 cm)
1943.1137

No one knew better than Rodin how to make bodies speak, but their message is often tragic. Even the groups that radiate passion, such as *The Kiss*, rarely express joie de vivre. In the artist's oeuvre, then, *Eternal Spring* occupies a place apart, which may confirm the date of 1884 granted by Georges Grappe:[1] the passion Camille Claudel inspired in Rodin at that time may have propelled him toward this radiantly lyrical image. In full possession of his craft, aided by the youth and freedom of the models who posed for him, he translated his exaltation into the very skillful composition of this group, constructed in the form of an X. Its elegant forms, enhanced by the languorous bodies and the delicacy of the embrace, made it one of his most popular works, even among the succeeding generation: Raymond Duchamp-Villon did not hesitate to transpose it into a cubist bas-relief in *The Lovers* (1913; plaster, Musée des Beaux-Arts, Rouen).

The importance given to the front view suggests that the group was modeled for *The Gates of Hell*, and in fact, a photograph by Charles Bodmer shows the original clay model in Rodin's studio, in front of the framework for the *Gates* (fig. 143). But, as with *The Kiss*, there was too great a dissonance between these happy lovers and the tragic universe for which *The Gates of Hell* serves as stage. Rodin therefore decided not to include the group there, except via the torso of the young woman, the *Torso of Adèle*, which connects the architectural frame to the tympanum.

Left out of *The Gates of Hell*, the group

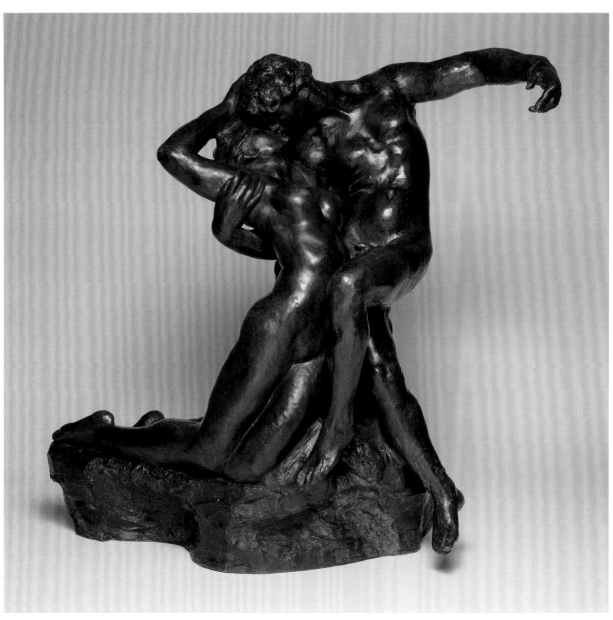

116

Fig. 143. Charles Bodmer, photograph of *Eternal Spring* in Rodin's studio, before 1893. Silver gelatin print, 7½ x 9⅝ in. (19 x 24.3 cm). Musée Rodin, Paris, Ph 312

began an autonomous existence. Probably in 1886 Rodin gave a plaster cast (Rodin Museum, Philadelphia) to Robert Louis Stevenson as thanks for defending him in the *Times* on September 6, 1886, after he had been called the "Zola of sculpture, too realist and brutal even for French stomachs." *Eternal Spring* filled the author of *Treasure Island* with joy; he took it with him when he left Europe in 1888 and kept it close to him until his death. Shortly after the gift to Stevenson, Rodin received a large canvas from Alfred Roll entitled *Little Mary and Her Cows* or *Peasant Girl Keeping Her Cows* (Musée Rodin, Meudon), in exchange for two bronzes, *The Kiss* and *Eternal Spring*. Rodin, who had just executed a marble portrait of Mme Roll (Musée Rodin, Paris), felt a "deep-rooted"[2] friendship for her husband and admired his paintings. He was therefore "very happy but very embarrassed" to receive a "masterpiece" from Roll; "I am startled by it, and hope to make up for it [by offering a work in exchange]."[3] Roll knew Rodin's works well and probably did not take long to make his choice, with the understanding that he would pay for the cost of casting.[4] When Roll parted with the two bronzes near the end of his life, in an exchange with an intermediary,[5] he dated the original exchange with Rodin to "about 1885"; in

reality it can be dated to spring 1888. Roll recalled that Rodin had told him that "*The Kiss* was the second copy in bronze and *Spring* the first cast after his models," and we know by the bill for the casting that the second *Kiss* was cast by Griffoul and Lorge in March 1888 and the first *Eternal Spring* executed a month later at the same foundry.

The group was probably shown for the first time in 1889 in the Monet–Rodin exhibition at the Galerie Georges Petit in Paris. It appears in the catalogue simply as "Groupe, plâtre" (Group, plaster; no. 18 or 19), even though it had already been baptized "Le Printemps" (Spring), a title it still bore at the traveling Rodin exhibition in Belgium and the Netherlands in 1899.[6] The complete title, "L'Éternel Printemps" (Eternal Spring), appeared at the Rodin exhibition in 1900, in reference to the marble version of it belonging to Albert Kahn (no. 122), which had been shown for the first time at the Salon de la Société Nationale des Beaux-Arts in 1897 (no. 127) with the title "Amour et Psyché" (Cupid and Psyche; this explains the small wings on the young man's back). The praise given to the first marble led Rodin to very quickly execute a second one (location unknown), which was completed in early 1898 and was the point of departure for bronze reproductions. On July 6, 1898, Gustave Leblanc-

Barbedienne obtained from Rodin exclusive rights for twenty years to reduce and reproduce *The Kiss* and *Spring* in metal.[7] The scale models of the two works (in four sizes) were an enormous success and eclipsed the original bronze versions. The first bronzes differ from the Barbedienne ones in the young man's extended arm, which in the marbles is supported by a plant, and in the smaller base. About ten casts were executed by Griffoul and Lorge before 1900 but were then supplanted by the scale models, and it was not until after Rodin's death that this version reappeared. As for the marbles, as many as ten were made between 1896 and 1910.

Antoinette Le Normand-Romain

1. Grappe 1944, no. 113.
2. Rodin, letter to Alfred Roll, July 1883; translated from Rodin 1985–92, vol. 1 (1985), no. 43.
3. Rodin, letter to Roll, late 1887 or early 1888?; translated from Rodin 1985–92, vol. 1 (1985), no. 90.
4. Rodin, three letters to Roll, early 1888; Rodin 1985–92, vol. 1 (1985), nos. 99–101.
5. Roll, letter to an unidentified intermediary, December 1, 1913, Houghton Library, Harvard College Library.
6. Reprinted by J. de Meester, "Rodin," *Elsevier's geillustreerd maandshrift*, September 1899, p. 208; see Paris 1996, no. 10.
7. Vassalo 1992, pp. 187–90.

PROVENANCE: Sold by the artist to the painter Alfred Roll in exchange for the cost of casting (Fr 400) and a large canvas, *Little Mary and Her Cows*, 1888; Scott and Fowles, New York; acquired from them through Martin Birnbaum by Grenville L. Winthrop, March 2, 1922 ($5,000); his bequest to the Fogg Art Museum, 1943.

EXHIBITION: Cambridge, Mass., 1943–44, p. 11.

REFERENCES: Maillard 1899, pp. 121–22; Cladel 1936, pp. 34–35; Grappe 1944, no. 113; Steinberg 1972, pp. 363–65; Tancock 1976, pp. 241–47; Elsen 1980, fig. 48; Rodin 1985–92, vol. 1 (1985), passim; Beausire 1988, passim; Fonsmark in Copenhagen 1988, pp. 100–102; Le Normand-Romain 1999, pp. 62–63; Le Normand-Romain in Paris 2001a, pp. 66, 427.

117. *Antonin Proust,* 1884

Bronze, lost-wax cast by Pierre Bingen, August 1884
20⅜ x 9¾ x 9¾ in. (51.7 x 24.7 x 24.7 cm)
Signed on back: Rodin
Foundry mark on back: Bingen fondeur
1943.1141

Antonin Proust (1832–1905), like his childhood friend Édouard Manet, who did a portrait of him (Toledo Museum of Art), studied with the painter Thomas Couture. He then turned to journalism, art criticism, and administration. He was elected deputy from Deux-Sèvres, his native region, in 1876. In 1879 he became a member of the Conseil Supérieur des Beaux-Arts. He was minister of fine arts in Léon-Michel Gambetta's cabinet between November 1881 and February 1882 and, finally, president of the Union Centrale des Arts Décoratifs.

Rodin made Proust's acquaintance in December 1883. At the time, Rodin was preparing to have the estimate done for casting *The Gates of Hell.* To get into the good graces of that high official of the Direction des Beaux-Arts, he offered to make a bust of him. The sittings began in early 1884 and ended in July.¹ The bust was cast in August by Pierre Bingen, who used the lost-wax method.² Rodin was interested in this casting process, since, for previous works, he had called on the man who had revived it, Eugène Gonon, and the two estimates he requested for *The Gates of Hell* in June and July 1884 were from Gonon and Bingen for lost-wax casting. He may have contacted Bingen at the suggestion of the sculptor Jean Carriès, who had met Bingen in October 1883 and found him capable of achieving perfection in the surface of bronzes and the color of the patina. The casts Bingen did for Carriès stand as masterpieces, and the same is true for the

Proust bust. If Rodin entrusted it to Bingen to ascertain his skill before ordering *The Gates of Hell* to be cast by him, he was certainly reassured.

The bust of Proust, exhibited at the Salon of 1885 in Paris,³ belonged to a series of portraits from the early 1880s. The precise modeling in the details of the face and the refined cascade of curls at the back relied on a meticulous observation of nature. The modeling was admirably served in the case of *Proust* by the quality of the casting. "The eyes speak, the nostrils quiver. It is life itself, nature caught in the act," said one critic.⁴ Said another, "A personal labor can be seen in the broad contours, the hollows of the folds, the puckering of the flesh, the accentuation of lines. The bronze was treated forcefully and with a sure hand, and the antithetical words 'unpolished skillfulness' and 'bold delicacy' come to mind to characterize the sculptor's talent."⁵

Rodin's portraits of that period were mostly of close friends, from whom he asked only reimbursement for the costs of execution. He therefore carried them out as he pleased, attempting to bring to light the deep personality of his models, not always to their liking. Proust was treated like the others, in spite of his official status, and did not care for his portrait, according to Gustave Coquiot.⁶ Mme de Rute, one of Proust's friends, called it "a libel in bronze, because [it] is sincere."⁷ However, the work elicited an enthusiastic appraisal from Octave Mirbeau: "What mastery in that head, detailed, raw, full of a magnificent ruggedness! . . . What is particular about this bust is that the model is reproduced exactly, but simultaneously ennobled by a skillful curve of lines and a powerful modeling that give it something grander, loftier."⁸

Probably at the same time, Rodin rendered the bust in drypoint, of which several

Fig. 144. Auguste Rodin, *Portrait of Antonin Proust,* ca. 1885–88. Brown ink over drypoint, 5½ x 4⅜ in. (14 x 11 cm). Musée Rodin, Paris, D.5305

Fig. 145. Jacques-Ernest Bulloz, photograph of Rodin's bust of Antonin Proust, ca. 1907? Silver gelatin print, 13⅝ x 10 in. (34.6 x 25.4 cm). Musée Rodin, Paris, Ph.313

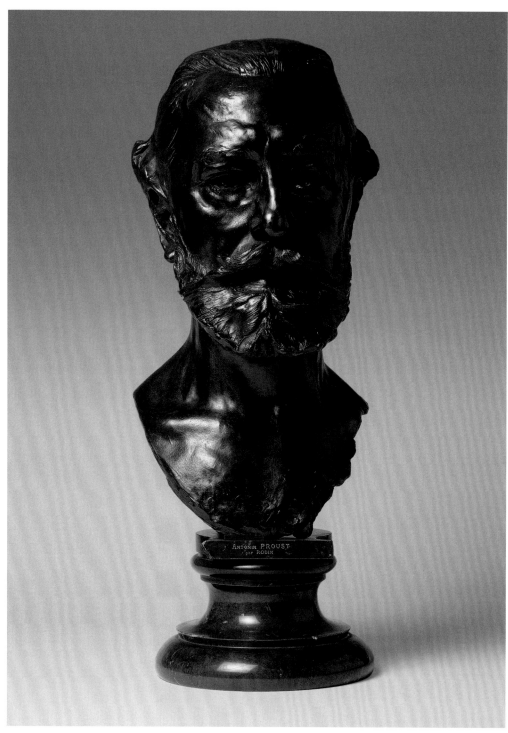

117

states exist. One of them was reworked in pen (fig. 144), as if to further detail the subtlety of the modeling.

The Winthrop bronze—the only known cast of this work since the plaster at the Musée Rodin disappeared—corresponds to the first casting, which was given to Proust and still belonged to him when it was exhibited in Düsseldorf in 1904. Proust committed suicide the following year; the

bust probably became part of the Rikoff collection and was sold with the collection as a whole in 1907. It was acquired by Haro, one of the appraisers at the sale, acting on behalf of Baron Joseph Vitta, who owned Manet's portrait of Proust.[9] Martin Birnbaum acquired the bust for Grenville Winthrop directly from Baron Vitta in November 1935.[10]

Two other bronze casts may have been

made (both now lost). On November 2, 1907, a month before the Rikoff sale, Rodin reimbursed the German collector Emil Heilbut for three works, including a Proust bust, which Heilbut had purchased "a few years" earlier and which had never been delivered to him.[11] This could only have been a second cast, no doubt the one for which Jacques-Ernest Bulloz, who worked for Rodin beginning in 1903, photographed

the wax prepared for the casting (fig. 145) and which in 1907 was in Limet's workshop for patination.[12] The third cast is more a matter of hypothesis: in 1912, Raymond Koechlin, vice president of the Union Centrale des Arts Décoratifs, expressed to Rodin his wish to have a cast made in order to be able to exhibit "the series of busts of presidents of our society."[13] However, that bust is not found in the Musée des Arts Décoratifs and was most likely never executed.

Antoinette Le Normand-Romain

1. "Quand voulez-vous que je vienne pour une dernière séance?"; Proust, letter to Rodin, July 16, 1884, Musée Rodin, Paris, Archives.
2. Bingen billed Rodin Fr 300 for it on August 23, 1884; Musée Rodin Archives.
3. The plaster cast had been shown at the Salon of Brussels the previous autumn, September–November 1884, no. 1360.
4. Translated from Léon Lequime, *Revue générale*, Brussels, October 1884?; Musée Rodin Archives.
5. Translated from Gustave Geffroy, *La Justice*, May 9, 1885?; Musée Rodin Archives.
6. Coquiot 1913b, p. 96.
7. Translated from Champsaur 1886, p. 105.
8. Octave Mirbeau, "Le Salon (V)," *La France*, June 3, 1885; reprinted in Mirbeau 1993, vol. 1, p. 188. Mirbeau's description served as the entry (no. 80) in Paris 1900; see Le Normand-Romain in Paris 2001a, p. 423.
9. Haro prevailed without difficulty over the Direction des Beaux-Arts, which had budgeted Fr 1,200, much lower than the sale price of Fr 8,900; press clipping, Musée Rodin Archives.
10. Birnbaum, letter to Winthrop, November 2, 1935, Harvard University Art Museums Archives.
11. Correspondence between Heilbut and Rodin, Musée Rodin Archives.
12. Two different views are reproduced in Elsen 1980, pl. 46, and Paris 1986b, no. 9.
13. Koechlin, letter to Rodin, June 5, 1912. On February 4, 1911, Gaston Migeon had asked Rodin if he could procure a cast of the bust and, if so, at what price. Both communications, Musée Rodin Archives.

PROVENANCE: Antonin Proust, until 1905; (?) Rikoff; his sale, Galerie Georges Petit, Paris, December 4–7, 1907, no. 231 (Fr 8,900); purchased at that sale by Baron Joseph Vitta; acquired from him through Martin Birnbaum by Grenville L. Winthrop, November 1935 (Fr 60,500); his bequest to the Fogg Art Museum, 1943.

EXHIBITIONS: Paris (Salon) 1885, no. 4168; Paris 1889b, no. 2124; Paris 1900b, no. 80; Düsseldorf 1904, no. 1731b/1758b.

REFERENCES: Grautoff 1908, p. 18; Coquiot 1913b, p. 96; Grappe 1944, nos. 114, 115; Descharnes and Chabrun 1967, pp. 71, 144; Elsen 1980, pl. 46; Rodin 1985–92, vol. 1 (1985), passim; Paris 1986b, no. 9; Beausire 1988, passim; Grunfeld 1988, pp. 148, 187, 188, 313; Goldscheider 1989, pp. 178, 179; Butler 1993, passim; Mirbeau 1993, passim; Tahinci 1995, p. 211; Le Normand-Romain 1997, p. 69.

118. *Marianna Russell (Mrs. John Russell)*, 1888

Bronze with red-brown patina, cast ca. 1916
18¼ x 9¾ x 11 in. (46.4 x 24.8 x 28.2 cm)
Signed left side of base: Rodin; in interior in relief: A. Rodin
Inscribed left side of base: a Rosa Benedite / Rodin
Foundry mark left side of base: ALEXIS RUDIER. FONDEUR. / PARIS
1943.1153

Rodin met Anna Maria Antonietta Mattiocco (1865–1908), the Italian wife of the Australian painter John Russell, and produced her portrait in 1888. Her classical features appealed to the sculptor, who used her as a model for a number of works of mythological inspiration, such as *Minerva Wearing a Helmet*, *Minerva without a Helmet*, *Pallas with the Parthenon*, *Pallas Wearing a Helmet*, and *Ceres*.

The Winthrop version of Mrs. Russell's portrait differs from other casts in the style of its base and in the integration of the plaquette showing an embracing couple, known as "Protection" or "Vaine tendresse" (Protection or Vain Tenderness), on the front of the base. This relief was inspired by the group of figures in the lower-right decorative pilaster of Rodin's *Gates of Hell*, and in 1916 it was cast as separate plaquettes in gold, silver, and bronze to benefit the Society of Theatrical Artists and Workers of Paris. Rodin's artistic procedure included assembling existing works to create new ones, which may provide the explanation for his integrating the relief into the portrait.

This portrait is dedicated to Rosa Bénédite, daughter of Léonce Bénédite, first director of the Musée Rodin in Paris and Rodin's executor. Martin Birnbaum bought the sculpture from Rosa Bénédite's daughter, Eva Bénédite-Ungemach, in May 1928. He had brought the work to Grenville Winthrop's attention for the first time in August 1927: "Miss Benedite, the daughter of the deceased director, has a *superb* bronze bust of 'Mrs. Russell (?)' by Rodin, *with a dedication*, and a lovely bas relief on the base, which is also bronze. It is *absolutely unique*, and a fine item."[1] Birnbaum stayed in touch with the Bénédite family. In December 1927, Rosa Bénédite wrote to Birnbaum: "I prefer to sell the Rodin to your friend as I know he is to give them to museums later on according to your statement."[2]

The following year Birnbaum suggested that Winthrop buy the bronze, along with a companion piece:[3] "It would be wise to acquire those busts. . . . Though both are

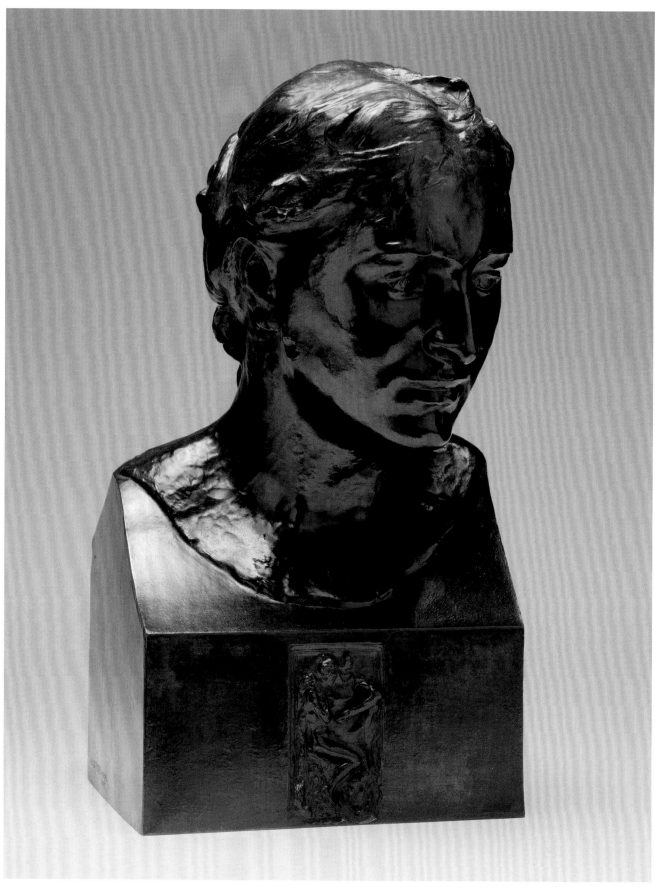

118

portraits of women, they are wholly different in type, style, period etc. I would like you to have the costlier of the two, if you don't take both. Nothing like them is on the market. . . . The bronzes were offered as gifts to the daughters of Benedite, but the latter, as a Museum director, would not permit the girls to accept them. So Rodin, before his death inscribed them and left them as legacies. They are unique in condition though not in subject matter. . . ."[4]

Winthrop decided to acquire only one of the two bronzes, and Birnbaum negotiated the price to 115,000 francs: "On the receipt of your cable to 'Buy one' I saw Madame Benedite & her married daughter and after further bargaining I secured the bronze for a further reduction of 25000 francs. . . . I have not done my closest bargaining for any items except Madame Benedite's Rodin."[5]

Anna Tahinci

1. Birnbaum, letter to Winthrop, August 4, 1927, Harvard University Art Museums Archives.
2. Rosa Bénédite-Maynard, letter to Birnbaum, December 28, 1927, Martin Birnbaum Papers, Archives of American Art, Smithsonian Institution, Washington, D.C.
3. A bronze cast of *Mrs. Vicuña*.
4. Birnbaum, letter to Winthrop, April 22, 1928, Harvard University Art Museums Archives.
5. Ibid., May 8, 1928.

PROVENANCE: Bequeathed by the artist to Rosa Bénédite, 1916; acquired from her through Martin Birnbaum and Eva Bénédite-Ungemach by Grenville L. Winthrop, May 1928 (Fr 115,000); his bequest to the Fogg Art Museum, 1943.

REFERENCE: Tancock 1976, pp. 595–96.

119. *The Eternal Idol,* 1893

Marble, first version executed by Jean Escoula
28½ x 25 x 31½ in. (72.4 x 63.5 x 80 cm)
1943.1034

In its original size (6¾ in. [17 cm] high), *The Eternal Idol* was associated with *The Gates of Hell*. In fact, the two figures, executed during the great creative period of the *Gates* (1880–90), were integrated separately into the right panel of the door at an unknown date. Both were then used in various compositions. In 1890, at the latest, they were joined together to form an independent group, which attracted the attention of Willem Geertrudus Cornelis Byvanck[1] and of Jules Renard: "From Rodin comes a revelation, an enchantment, those *Gates of Hell*, that little thing the size of a hand, which is called *The Eternal Idol:* a man, arms behind his back, vanquished, is embracing a woman below her breasts, fixes his lips to her skin, and the woman looks very sad. I had trouble tearing myself away from it."[2]

In February 1891 a bronze cast (Musée Rodin, Paris) was delivered to the collector Antoni Roux, who was surprised by its small size: "In my memory, I saw *The Eternal Idol* as much larger. It is a little small for the composition; I am very sorry about that and will ask you someday for the enlarged group; it seems to me that it ought to be double the size. What do you think?"[3] A few days later, likely in response to a letter from Rodin, Roux confirmed: "It is agreed, 600 francs for enlargement to double the size, since you find that acceptable."[4]

Roux's reaction may have led Rodin to enlarge the original group and to have it carved in marble by one of his best assistants, Jean Escoula,[5] for the painter Eugène Carrière (1849–1906). The two artists, whose friendship was based on similar ideals and objectives, had undoubtedly met at the Sèvres Manufactory in the early 1880s, and they remained close until Carrière's death. *The Eternal Idol*, after having been molded by Rodin,[6] was returned to Carrière in 1893. Carrière agreed to part with it only once, for the 1900 Rodin retrospective,[7] for which he designed the poster. But the enthusiasm of those who had seen the work impelled Rodin to have a second marble made, again by Escoula. It differed from the first primarily in the shape of the base, which was more rounded.[8]

The Carrière heirs had to part with the painter's marble after his death on March 27, 1906, and it seems then to have been returned to Rodin in Meudon[9] before being acquired by Edmund Davis. After Davis's death and the announcement that his collection would be sold, Martin Birnbaum went to Davis's Chilham Castle, near Canterbury, "to study everything and make a tentative report. . . . There are so many fine things,—drawings and sculptures—including a great Rodin marble, one of his very best."[10] In keeping with Davis's wishes, the marble did not appear at the sale that took place at Christie's, London, July 7, 1939,[11] but in the months that followed Birnbaum negotiated its sale directly with Lady Davis. The marble arrived undamaged in New York in October, after passing through a storm during the Atlantic crossing.

The title "Éternelle Idole" (Eternal Idol)—suggested, it is said, by a remark made by a "French deputy"[12]—appeared in

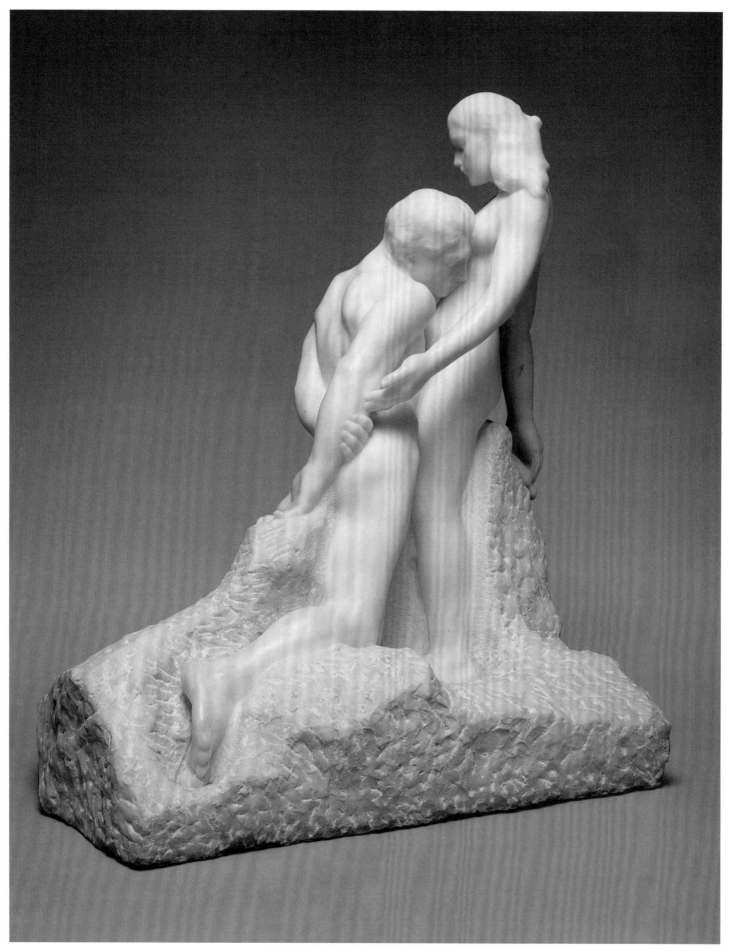

1891. It was replaced by "Hostie" (Host) in 1896, as if to emphasize the adoration man feels for woman, who appears to him in the shape of an inaccessible deity. Although the group was interpreted in various ways (Byvanck saw it as "the ecstasy of passion"),[13] it is generally understood in negative terms, linked as it is to the universe of *The Gates of Hell*. The man humiliates himself, his arms behind his back, before the woman, who stands arrogantly erect and, above all, curiously detached.

What, then, is the relation between the two figures? Does the woman dominate the man, or is she a source of renewal, offering him "her bosom where he will drink, her belly where he will sleep"?[14] Are the man's arms crossed behind his back in a sign of slavery or of the respect he feels? For an admirer of Rodin such as Paul Margueritte, it is the image of man's "divine weakness" before woman who, for her part, feels both kindness and disdain: "She triumphs without pride, a placid but invincible sovereign. And he, nude, kneeling, humble, weary, in human distress, in passionate fervor, hands behind his back to mark clearly that he is the slave and not the master, rests his head on the lower part of her bosom, on the woman's hip, which he kisses like a child worshiping the Madonna, like a devout man receiving the Host."[15] Is it a reflection of Rodin's feelings for Camille Claudel? At

the time, their affair was reaching its peak, and this group must certainly be compared to works such as Rodin's *The Kiss* and especially Claudel's *Sakuntala*, or *Abandonment*, both slightly earlier. In those two works, however, the figures are closely united, whereas in *The Eternal Idol* they seem separated by a gulf; and it is that gulf, so difficult to define, that gives the group the intriguing character that certainly accounts for some of its success. As Rainer Maria Rilke put it, "A mysterious greatness emanates from this group. As so often with Rodin, one doesn't dare assign a meaning to it. It has thousands. . . . Something of the atmosphere of a Purgatorio lives in this work. A heaven is near, but is not yet attained; a hell is near, and not yet forgotten."[16]

Antoinette Le Normand-Romain

1. Byvanck 1892, p. 10.
2. Translated from Renard 1990, p. 68, journal entry for March 8, 1891.
3. Translated from Roux, letter to Rodin, February 26, 1891, Musée Rodin, Paris, Archives.
4. Translated from Roux, letter to Rodin, March 5, 1891, Musée Rodin Archives.
5. For the price of Fr 3,000, the job included supplying the marble, rough-hewing, modeling, carving, and retouching.
6. This allowed the Musée Rodin to have bronze casts made by Alexis and then by Georges Rudier.
7. It was picked up on May 24, 1900, by the carrier Autin and returned to Carrière on December 5; Autin's bill and Carrière's receipt, Musée Rodin Archives.
8. Signed, 31½ x 22⅛ x 14¼ in. (80 x 56 x 36 cm), private collection, South America? Completed in time

to be exhibited as an unlisted entry at the Salon de la Société Nationale des Beaux-Arts in 1896, the marble was acquired before 1900 by Alexandre Blanc, and resold in Paris with the Blanc collection, December 3 and 4, 1906. Rodin may have considered buying it back with the help of a banker friend, Joanny Peytel; but the latter's offer arrived too late and the marble was acquired by a German banker, Julius Stern. It was exhibited at the twelfth Berlin Secession, 1907, no. 306.
9. See Freedman 1996, p. 349, quoting a letter of May 6, 1906, from Rilke to Sidonie Nadherny.
10. Birnbaum, letter to Grenville Winthrop, May 26, 1939, Harvard University Art Museums Archives.
11. "The Great Rodin 'Eternelle Idylle' will *not* be sold at the sale (and I am glad of that) for Sir Edmund left written instructions that it must not be sold to a dealer"; Birnbaum, letter to Winthrop, June 2, 1939, Harvard University Art Museums Archives. Davis had undoubtedly made that arrangement out of respect for the wish, expressed by Rodin after Carrière's death, "de ne pas voir ce beau marbre tomber aux mains des marchands"; L. Delvolvé, letter to Rodin, January 10, 1907, Musée Rodin Archives.
12. See Lawton 1908, p. 154. A certain Rivet?
13. Translated from Byvanck 1892, p. 10.
14. Translated from Riotor 1899, p. 211.
15. Translated from Paul Margueritte, in *L'écho de Paris*, May 21, 1896.
16. Rilke 1979, p. 38.

PROVENANCE: Commissioned by Eugène Carrière through Léopold Blondin, 1893; purchased from Carrière's heirs through Jean Delvolvé, Carrière's son-in-law, by Edmund Davis, Kent, ca. 1906–7 (Fr 15,000); his widow, Mrs. Davis; acquired from her through Martin Birnbaum by Grenville L. Winthrop, 1939 (£1,500); his bequest to the Fogg Art Museum, 1943.

EXHIBITION: Paris 1900b, no. 95.

REFERENCES: Byvanck 1892, p. 10; Maillard 1899, pp. 129 (illus.), 132–33, 147; Rilke (1903) 1928, pp. 58–61, illus. facing p. 64; Lawton 1908, pp. 146, 154, 174, 180; Mauclair 1909, pp. 40–41; Hoffman 1939, p. 123; Caso and Sanders 1977, pp. 63–67; Beausire 1988, passim; Kausch in Vienna 1996, pp. 53–54, no. 22; Le Normand-Romain in Paris 2001a, pp. 66, 425.

120. *Walking Man,* 1899–1900

Bronze
33⅛ x 23 x 11⅛ in. (84.1 x 58.4 x 28.3 cm)
Signed and inscribed on base: à J. Sargent /
affectueux admirateur Rodin
1943.1148

Walking Man was probably created in the months before the opening of the 1900 retrospective exhibition of Rodin's work in Paris. In 1900 the small plaster model was presented as a "powerful study [for] Saint John the Baptist,"[1] that is for the large *Saint John the Baptist*, the plaster model of which had been exhibited at the Salon of 1880. However, this was actually a new work, the result of assembling old studies for the *Saint John the Baptist* of a torso and a pair of legs. The torso study, created some twenty-five years earlier and rediscovered by the artist in 1887 at the latest, had cracks and fissures caused by drying.[2] The legs had survived the years without damage. The work pleased Rodin just as it was; it was in perfect harmony with his approach during 1895–1900, which was inspired by a reflection on the partial figure. The new figure was exhibited on top of a tall column in Paris in 1900. Although it was barely noticed, it was shown that way again in Vienna and Venice in 1901, in Prague in 1902, and in Düsseldorf in 1904.[3] The work also presided over the banquet held on June 30, 1903, in Vélizy, outside Paris, at which the artist was bestowed with the insignia of commander of the Legion of Honor. Probably about that time Rodin gave a copy of it to John Singer Sargent, with whom he had long been on friendly terms. Sargent had painted Rodin's portrait in 1884 (Musée Rodin, Paris), and he was among those who set up a fund to offer the large *Saint John the Baptist* to England in 1902 (Victoria and Albert Museum, London). It was likely by way of thanks that Rodin sent him "that

enigmatic study for Saint John,"[4] probably in the form of a plaster cast, which Sargent later had cast in bronze. The work's interest did not escape Martin Birnbaum, who used all his influence to convince Grenville Winthrop to acquire it after Sargent's death.

However, not until the figure was enlarged—by Henri Lebossé in 1905–6—did its true expressive power become clear. The large plaster cast was exhibited in Paris at the Salon de la Société Nationale des Beaux-Arts in 1907, where it was universally admired as a revival of classical antiquity. The first large bronze, cast in 1910, was given to the French government and was placed in the courtyard of the Palazzo Farnese, the French embassy in Rome. Surely nothing could have pleased Rodin more than to see his *Walking Man* there, side by side with sculpture both from classical antiquity and by Michelangelo. But in 1923 the statue was sent to Lyon; from there, in 1986, this "masterpiece of pure plasticity," as Carl Burckhardt described it in 1921, joined the collections of the new Musée d'Orsay in Paris and was set up "like a beacon, at the entryway to the history of twentieth-century sculpture."[5]

The title *Walking Man*—suggested, it is said, by the mold makers—appeared in 1907. It no longer referred to the original subject of *Saint John the Baptist Preaching* but rather to a simple description of fact. By leaving off the head and arms, Rodin focused the interest of the sculpture on the figure's stride, which, combined with the tilt of the torso, produces a clear sense of movement. Nevertheless, as some have pointed out, compared with chronophotography *Walking Man* does not literally reproduce a moment in the act of walking. Leo Steinberg remarked that "it was the pose of a man 'determined' and 'planting

himself' which inspired the image of a man walking 'copied from nature.'" And "to hold both feet down on the ground, Rodin made the left thigh (measured from groin to patella) one-fifth as long again as its right counterpart."[6] In 1907 Paul Gsell reported that according to Rodin, "My *Walking Man* . . . is interesting not in himself but rather in the idea of the stops he has already made and of those he has yet to make." Gsell went on to comment: "That art, which deliberately moves beyond the sculpted figure through suggestion and binds it to the whole, which the imagination recomposes step by step, is, I believe, a fertile innovation."[7] In its evocation of the unfolding of an action, this figure, slightly earlier than the works of František Kupka, Marcel Duchamp, and the Italian Futurists, paved the way for the appearance in art of a fourth dimension, time.

Antoinette Le Normand-Romain

1. Translated from Paris 1900b, no. 63.
2. Reproduced in *L'art français*, September 4, 1888.
3. As indexed in Beausire 1988.
4. Translated from Sargent, letter to Rodin, undated but after August 1900 since it bears the address 31 Tite Street, London, a residence Sargent rented after that date; Musée Rodin Archives.
5. Krahmer 1986, p. 68, n. 27, quoting Burckhardt 1921, pp. 61ff.: "one of the finest analyses of the plastic qualities of Rodin's work."
6. Steinberg 1972, p. 349.
7. Translated from Gsell 1907, p. 100.

PROVENANCE: John Singer Sargent; his sale, Christie's, London, July 28, 1925, no. 66 (£336); purchased at that sale by Croal Thomson, London; acquired through Martin Birnbaum by Grenville L. Winthrop, July 1927 (£472 10s.); his bequest to the Fogg Art Museum, 1943.

REFERENCES: Geffroy 1900, illus. p. 93; Gsell 1907, p. 100; Rodin 1911, pp. 71–89; Cladel 1936, pp. 132–33, 257, 280, 310; Steinberg 1972, passim; Elsen 1974, pp. 12, 29–35, 80; Tancock 1976, pp. 357–69; Elsen 1980, pls. 132–34; Schnell 1980, pp. 176 no. 7, 180 nos. 46–47; Schmoll gen. Eisenwerth 1983, pp. 131–42; Krahmer 1986, p. 68; Beausire 1988, passim; Pingeot in Paris–Frankfurt 1990, pp. 123–26; Le Normand-Romain in Paris 2001a, no. 47.

120

121. *The Man with the Key, Jean d'Aire*

Bronze, greenish brown patina
18½ x 6½ x 6¼ in. (47 x 16.5 x 15.9 cm)
Signed on top of base and stamped in interior:
A. Rodin
Foundry mark incised on side of base: Alexis
Rudier / Fondeur. Paris
1943.1154

122. *Eustache de Saint-Pierre*

Bronze, dark reddish brown patina
18¾ x 9⅝ x 6 in. (47.6 x 24.5 x 15.2 cm)
Signed on top left of base and stamped in interior:
A. Rodin
Inscribed on base: A. Mr. Emile Chouanard
Foundry mark incised on rear of base, proper right:
ALEXIS RUDIER / Fondeur PARIS
1943.1155

123. *Jean de Fiennes*

Bronze, greenish black patina
18 x 10¾ x 6½ in. (45.7 x 27.3 x 16.5 cm)
Signed left side of base: A. Rodin
Foundry mark incised on rear right side of base:
ALEXIS RUDIER / Fondeur PARIS
1943.1156

124. *Pierre de Wiessant*

Bronze, brown patina
17½ x 8¼ x 8⅞ in. (44.5 x 21 x 22.5 cm)
Signed on top of base, left front, and cachet
impressed in interior: A. Rodin
Foundry mark incised on side, rear center of base:
ALEXIS RUDIER. / FONDEUR. PARIS.
1943.1157

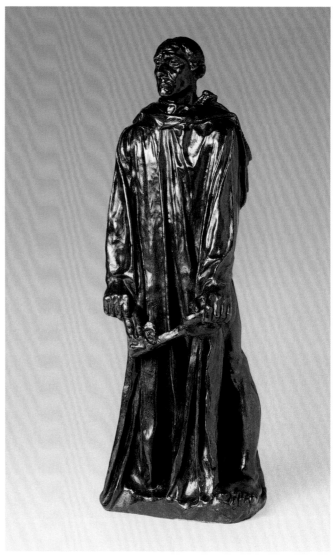

121

125. *The Weeping Burgher, Andrieu d'Andres*

Bronze, brown patina
17 x 8⅜ x 9¼ in. (43.2 x 21.3 x 23.5 cm)
Signed on left side of base and cachet impressed in
interior: A. Rodin
Foundry mark incised on base: ALEXIS RUDIER. /
FONDEUR. PARIS.
1943.1158

In 1884 the city of Calais commissioned Rodin to create a monument illustrating an important episode from the annals of its medieval history. In 1347, early in the Hundred Years' War, six burghers of the city had offered themselves to England's King Edward III, who had agreed to lift the siege of Calais if six prominent citizens volunteered as sacrificial hostages. Edward's wife, Queen Philippa, impressed by the burghers' courage, requested that their liberty be restored. Rodin studied the medieval chronicle of this event by Jean Froissart.

Dissatisfied with the academic conventions of epitomizing a historical episode in a single hero or rhetorical gesture, Rodin decided to render the concept of a collective

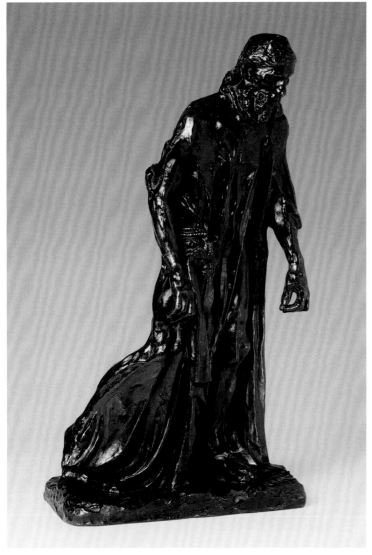

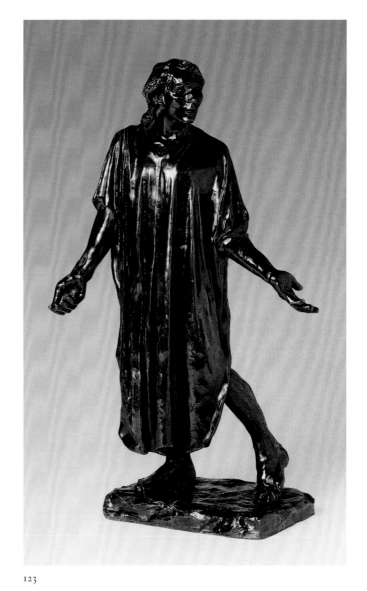

sacrifice by treating all six of the Calaisian heroes individually and equally. As a result he depicted the moment of commitment when the victims prepared to march out to what seemed certain death. Rodin worked on the individual figures, both nude and clothed, and modeled the arms, heads, and feet separately before adjusting the figures for the final composition.

In each figure Rodin depicted a character study of a particular physical type, each with a different emotion and posture. Jean d'Aire, the burgher holding the key and dressed in a monkish robe, stands immo-

bile, bravely facing his inevitable fate. Eustache de Saint-Pierre, the oldest burgher, walks steadily, his bearded head downcast. Jean de Fiennes, the youngest, is represented as a longhaired adolescent, arms outstretched in a gesture of uncertain yielding. Pierre de Wiessant raises his right arm in a suspended and tentative movement of affliction. Andrieu d'Andres clutches his head in his hands in a gesture of despair.

After numerous financial difficulties and repeated delays the monument was finally unveiled in June 1895. The popularity of the group and the desire of private collec-

tors to own copies were such that about the turn of the century, Rodin decided to cast reductions of the Burghers. Between 1895 and 1906, with the help of his collaborator Victor-Henri Lebossé, the sculptor had the monumental figures reduced mechanically, then cast in bronze. The first set of reduced Burghers was commissioned by Rodin's friend and banker Joanny Peytel, director of the Crédit Algérien and one of the sponsors of Rodin's retrospective exhibition in 1900 in a pavilion on the place de l'Alma.

Grenville Winthrop gathered his set of figures almost one by one from Scott and

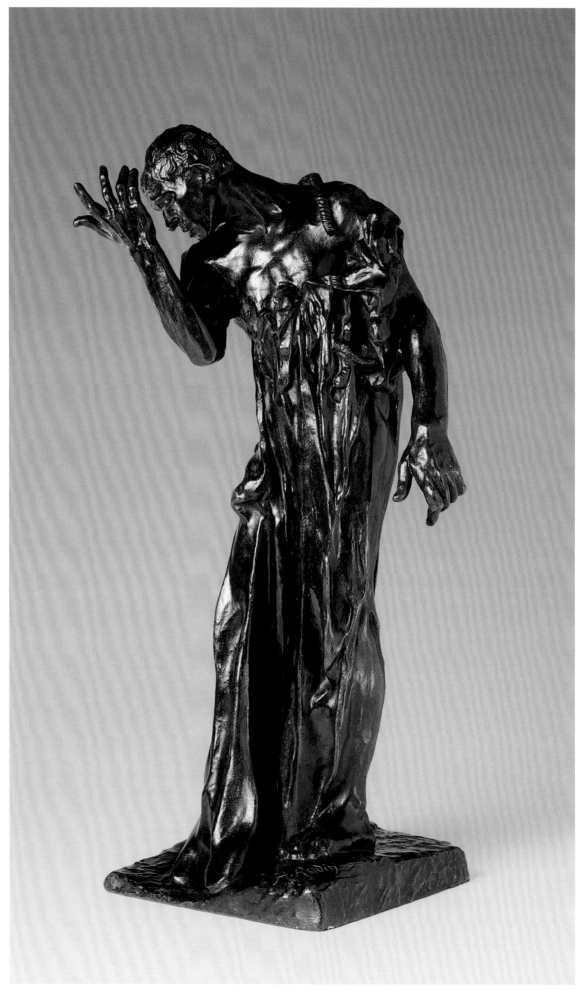

124

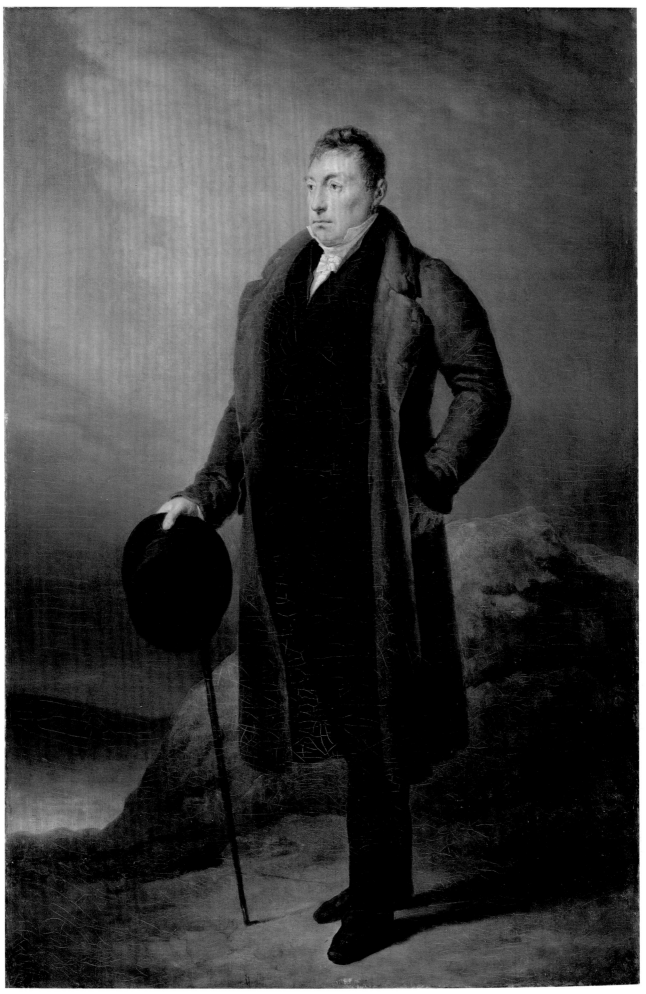

127

newly acquired Louisiana, and on the occasion of his visit Congress voted to compensate him further with the sum of $200,000 for the personal fortune he had expended on the American cause. In return, Lafayette presented a portrait of himself to Congress.

Scheffer had completed a full-length portrait of Lafayette in 1819 (last recorded, Otis Mygatt collection), which he exhibited at the Salon of that year.[3] A second full-length portrait was in all likelihood exhibited at the Salon of 1822.[4] This portrait exists in two autograph versions: one remained in the possession of the Lafayette family and in 1859 was recorded as belonging to his grandson Jules de Lasteyrie; the other was the portrait presented by Lafayette to Congress.[5] This large-scale canvas— 94½ by 66⅞ inches (240 x 170 cm)—still hangs in the House of Representatives. The present work is an autograph reduction and was most likely made to serve as the pattern for the edition of prints by Jean-Marie Leroux (1788–1870). *Ivan Gaskell*

1. His full name was Marie-Joseph-Paul-Yves-Roch-Gilbert du Motier, marquis de Lafayette.
2. The literature on Lafayette is immense. Among recent works, see, in particular, Kramer 1996.
3. Ewals 1987, pp. 58–59, 399–400.
4. Paris (Salon) 1822, no. 1173, "Portrait en pied du général L." This is probably Lafayette rather than General Georges Mouton, comte de Lobau, because the former's aide-de-camp, Ferdinand de Lasteyrie, noted in his 1858 obituary of Ary Scheffer that the engraving by Leroux was after the portrait of Lafayette exhibited at the Salon of 1822 (Ewals 1987, p. 61).
5. Ewals 1987, p. 400.
6. The Bonaventure Art Galleries invoice (in Fogg Art Museum curatorial object file for 1943.278 [cat. no. 127]) states: "Full length portrait of Marquis de Lafayette painted by Ary Scheffer in 1822, exposed in the Paris expositions of 1889 [Exposition universelle?] and 1900 [Exposition universelle et internationale?] and the worlds Fair Chicago 1893. Loaned by Colonel F. Connolly and purchased from his widow." I have not found mention of the painting in the publications relating to the two Paris expositions.

PROVENANCE: Colonel T. Connolly, by 1893; his widow, Mrs. Connolly; purchased from her by E. F. Bonaventure Art Galleries, New York; acquired from them by Grenville L. Winthrop, July 26, 1918; his bequest to the Fogg Art Museum, 1943.

EXHIBITIONS:[6] Chicago 1893, French Pavilion; Cambridge, Mass., 1944d, no. 104; Cambridge, Mass., 1975–76a, no. 43.

REFERENCES: Ewals 1987, pp. 59, 400; Bowron 1990, fig. 196.

Georges Pierre Seurat

Paris, 1859–Paris, 1891

128. *Woman Sewing*, 1882

Black crayon with metallic silver paint and black chalk on tan laid paper
12⅝ x 9⅝ in. (32.2 x 24.5 cm)
Dated in black crayon, lower right: 18 Juillet 82
Inscribed in black ink, at bottom of verso, not in the artist's hand: 3 pareils / bristol [?] gris foncé / et sous verre 47.38 / ne pas mettre en verre[1]
1943.919

Seemingly determined to leave behind him a "whole chapter of efforts shackled by deadening practices and routines,"[2] Georges Seurat did not return to the École des Beaux-Arts after completing his compulsory service in the military. Instead, in late 1880 he took a studio in Paris and set to work. At a prodigious, almost intractable pace, he succeeded not only in asserting his youthful independence from the strictures of the academy, with its insistence on the purity of line and classical paradigms, but also in coming into his own as a mature draftsman. By the time he was twenty-two, as this drawing reveals, he had fully mastered an original tenebrist style, in which line is diffused by gossamer veils of conté crayon, and the everyday is invested with a timeless, magical, grandeur.

One of the only dated drawings in Seurat's inimitable technique and unique for its precise inscription, the present work of "July 18, 1882," has long been regarded a compelling gauge of Seurat's precocious maturity. Robert Herbert, in his definitive study of the artist's drawings, highlighted its documentary value (and guaranteed its present renown) when he established that Seurat's mature graphic style was "formulated probably by 1881" and, on the basis of this sheet, "for a certainty by 1882."[3] Notwithstanding the evidence of drawings dated 1881, which have since allowed Herbert to confirm his suspicions, the Winthrop work has retained its distinction, if not as the earliest record of Seurat's prodigious achievement, as the most authoritative example. Indeed, as Erich Franz and Bernd Growe have observed, it marks a significant plateau, or triumph, in Seurat's graphic development. More unified in surface texture than Seurat's previous efforts and no longer dependent on contour lines—which still cling to forms in drawings dated 1881—here enveloping passages of light and shade model the figure that seamlessly emerges from the tenebrous background in a "single weave of grays."[4]

Once Seurat had found his distinctive voice as a draftsman—in velvety tones, subtly modulated with a rich vibrato tenor—he succeeded in engaging his

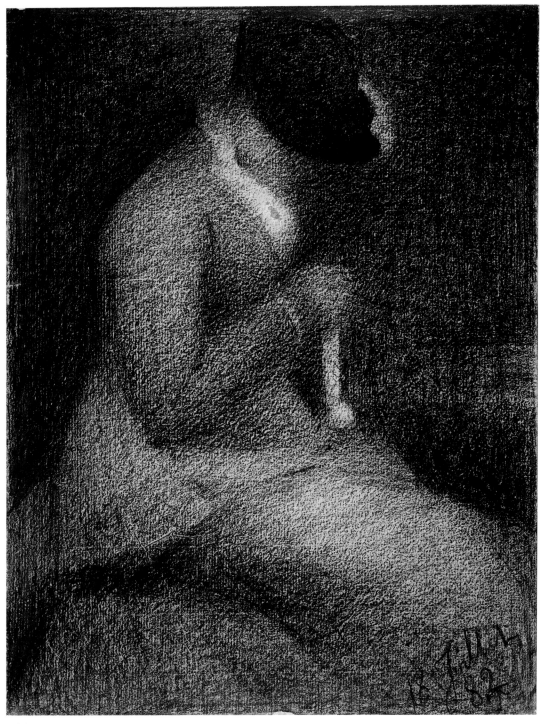

128

method and means in essentially the same dialogue, composing some 230 conté crayon drawings on Michallet paper, which, seen individually or as a whole, give currency to his artistic credo "Art is Harmony."[5] These works are as dependent on his "sound, fertile theory of contrast," to quote Paul Signac,[6] as they are on his imagery for their particular timbre. The present piece is one of a number of early drawings that show solitary females occupied with quiet domestic activities, such as sewing or reading; some depict the artist's mother, others, such as the faceless figure shown here, are insistently anonymous. All are suffused with a gentle melancholy. The subject, with its links to the artist's upbringing in a matriarchal household and with its ties to the cast of characters seated on the lawn of *A Sunday Afternoon on the Island of the Grande Jatte* of 1886 (Art Institute of Chicago), echoes the past and anticipates the future, not unlike Seurat's approach, which draws upon an art historical tradition—for which such masters of shadowy chiaroscuro as Rembrandt and Millet were guideposts— while it heralds abstraction.[7]

Inevitably, the evocative rather than descriptive character of Seurat's graphic art—with its suppression of the incidental

and anecdotal in favor of the *effet*—presents certain challenges in interpreting and, in turn, cataloguing drawings for which the artist's title is not known. That the subject of the present work is somewhat ambiguous is keenly betrayed by the alternative titles provided in César M. de Hauke's catalogue raisonné, which describe the sitter as knitting, sewing, or embroidering. While the drawing was originally shown in 1892 as *Woman Sewing*, the title *Woman Knitting* (as it was first called in the 1908–9 Bernheim-Jeune retrospective, and until recently by the Fogg Art Museum) has tended to hold sway in the literature. However, the sitter does not hold knitting needles, nor is there a loose ball of yarn that would freely unravel as her work progressed. The position of her hands, gently cupped over a small slice of material that falls limply to her lap and curls up at the end, suggests that she is sewing—perhaps darning a sock, in light of the bulbous shape—if not tatting lace. Other clues left by the master of elegant understatement slowly come into focus. The hat she wears, in tandem with the slight articulation of the background, suffice to tell us that she is seated out-of-doors and that her activity is leisurely and not that of "A Seamstress," as she is sometimes called. Not unlike the characters that emerge little by little as the story unfolds in novels by the Naturalist writers he admired, Seurat's visual counterparts disclose their secrets gradually, and only partially. By means of a few incisive and guiding details, Seurat succeeded in preserving a sense of the integrity of his

figures, while at the same time, and more profoundly, maintaining what Meyer Schapiro described as the "mystery of the coming-into-being for the eye."[8]

Susan Alyson Stein

1. The presence of this inscription—which denotes "3 the same / dark, gray bristol [?] and under glass"—was flagged in Cambridge, Mass., 1969, p. 186: "The framing instructions on the verso mention two other works of the same size; they may refer to any number of drawings which also belonged to Mme Seurat mère or to Léon or Maurice Appert." Surprisingly, however, there seem to be only two drawings that share the identical provenance and exhibition history of the present work that may be described as "pareils": *Embroidery: The Artist's Mother* (H 582; The Metropolitan Museum of Art, New York) and *Woman Reading: The Artist's Mother* (H 584; location unknown). They are similar in terms of subject and presumably of size. (In the case of *Embroidery* the dimensions are identical; those for *Woman Reading*, horizontal in format, are not known, but Seurat routinely drew on sheets of the same scale.) All three drawings were included in exhibitions held in Paris in 1892 (lent by the artist's mother, as nos. 1117 [H 584], 1118 [H 582], and 1120 [the present work]) and 1900 (lent anonymously from the Seurat family collection, as nos. 43, 40, and 47 respectively). The titles assigned to the drawings at the time of these shows did not make a great distinction among these works; it was only later that scholarship, filling in the blanks that discretion left bare, identified the artist's mother as the sitter for two of the works. After the turn of the century, the drawings went their separate ways, with no record, save the inscription on the back of this sheet, of the early relationship—if not kinship—among them.
2. Emile Verhaeren, "Georges Seurat," *La société nouvelle* 7 (1891), recording the sentiments Seurat expressed to him in an 1887 conversation, quoted in Herbert 1962b, p. 59.
3. Herbert 1962b, p. 44, and see p. 36. While scholars, beginning with Herbert, have appreciated the documentary value of the dated drawings as stylistic anchors for charting Seurat's progressive realization of an original style, they have hesitated to consider—even in the case of the Winthrop inscription, with its specificity as to month, day, and year—the possibility that Seurat may have marked these successes himself. This artist, who left nothing to chance, most especially the recognition he felt due him, disbanded the practice of dating his drawings early on—one may argue, once he had established his early mastery of an innovative technique and his

authoritative command. (The last work with a date, albeit visible only under ultraviolet light, was apparently his virtuoso demonstration piece, *Aman-Jean* [The Metropolitan Museum of Art, New York], shown in the Salon of 1883.)

4. Franz and Growe in Bielefeld–Baden-Baden 1983–84, pp. 59–60.
5. For Seurat's famous "Esthétique," drafted in 1890, see Paris–New York 1991–92, p. 282.
6. Paul Signac, *D'Eugène Delacroix au néo-impressionnisme* (1899), reprinted and translated from the 1921 edition, in Ratliff 1992, p. 252.
7. On the nature of this subject within Seurat's graphic oeuvre and in relationship to his upbringing, see Herbert in Paris–New York 1991–92, pp. 34, 47.
8. Schapiro 1978, p. 101.

The date of "July 18, 1882," seems not to be a family birthday, anniversary, notable Saint's day, or French holiday. No clues as to what the date may commemorate are offered by the subject (which is without temporal or historical bearing) or provenance (it belonged to the artist's mother by 1892 until her death in 1899).

PROVENANCE: Mme Seurat *mère* (d. 1899); the artist's brother-in-law, Léon Appert (d. 1925); his son, Maurice Appert, Paris; Étienne Bignou, Paris, 1927; Knoedler and Co., New York; acquired from them through Martin Birnbaum by Grenville L. Winthrop, December 19, 1933 ($2,200); his bequest to the Fogg Art Museum, 1943.

EXHIBITIONS: Paris 1892, no. 1120 (as "Femme cousant," lent by Mme Seurat); Paris 1900c, no. 46 (as "Femme cousant"); Paris 1908–9, no. 161 (as "Tricotant," lent by M. L. A. [Léon Appert]); Paris 1926, no. 146 (as "Tricotant"; not in catalogue); London 1926, no. 12 (as "Femme Tricotant, From Seurat's family"); New York 1929, no. 71 (private collection, New York); Cambridge, Mass., 1969, no. 120 (as "The Seamstress").

REFERENCES: Cousturier 1926, pl. 51 (as "Tricotant"); Zervos 1927, illus. p. 278 (as "collection particulière Etienne Bignou"); Kahn 1928, vol. 2, pl. 125; Roger-Marx 1931, pl. 26 (as "Woman Knitting"); Rich 1935, p. 59, no. 2; Seligman 1947, pp. 16, 23, 72, no. 40, pl. 29; Jedding [1957], p. 6; Hauke 1961, vol. 2, fig. 512; Herbert 1962b, pp. 41, 178, fig. 40; Courthion 1968, p. 51 (as "Knitting"), illus.; Chastel and Minervino 1972, no. D109, p. 112; Broude (1974) 1978, p. 170, illus. facing p. 102, fig. 2; Broude 1976, pp. 158–59, fig. 6; Alexandrian 1980, p. 21; Bielefeld–Baden-Baden 1983–84, (German ed.) illus. p. 59, fig. 11, (Eng. ed.) pp. 59 (fig. 11), 60, 63; Thomson 1985, p. 24, illus. p. 25, pl. 17; Madeleine-Perdrillat 1990, illus. p. 32 (as "Woman Knitting"); Zimmermann 1991, p. 63, fig. 88.

129. *Café-Concert (À la Gaîté Rochechouart)*, 1887–88

Conté crayon and white gouache on buff laid paper
12⅛ x 9¼ in. (30.7 x 23.4 cm)
Signed in black ink, black crayon, and white
gouache, top center: G. Seurat
Inscribed in graphite, on verso: Mo *[?]* 13711 *[?]*
Watermark: MICHALLET
1943.918

Not long after his move to Montmartre, Seurat undertook a series of drawings in 1887–88 dedicated to café-concerts, choosing as his subjects local haunts—like the *La Gaîté Rochechouart* (at 15 boulevard Rochechouart)—which had recently become as much a staple of the neighborhood as its artists' studios. Then at the height of their popularity, these establishments, which offered food and drink along with lively entertainment (albeit "never of a high class," as one guidebook warned),[1] had grown in number to more than two hundred by the late 1880s, encouraging a spate of illustrations and articles in the press, some of them controversial. While conservative factions eyed the cabarets as a breeding ground for debauchery and political dissent, liberals celebrated the progressive nature of the venues: from the democratic mix of clientele from all strata of society to the invention of gaslight, which extended the hours of operation well into the night. The café-concert, as the latest cause célèbre, had an irresistible draw for writers and artists of modern-life subjects eager to position themselves as the next Zola or Degas.[2]

In the late 1880s greater and lesser talents, from Toulouse-Lautrec to Émile Bernard, tackled the subject, which had been given memorable form in the works of Daumier and Degas and a contemporary edge by commercial illustrators and poster artists, such as Jules Chéret. Degas, whose preeminence in the genre had gone unri-

valed for nearly a decade, was prompted around 1885 to rework several of his earlier black-and-white prints with pastel. These richly inventive prints exerted a decisive influence on the efforts of younger artists, not least of all Seurat, who was inspired to produce a formidable suite of drawings that—with their kindred emphasis on dramatic lighting effects, provocative viewpoints, nuanced graphic touch, and technical mastery—effectively met Degas on his own ground.

Distinctive for their unity of conception and for their high degree of finish, the eight drawings that Seurat dedicated to the café-concert represent his most conscientious undertaking as a draftsman. He brought to this subject, which was the sustained focus of his aloof, ironic gaze and refined vision, the full weight of his talent and ambition, and he saw to it that these works became known. Seurat featured drawings from this group in four exhibitions held between 1887 and 1889 and published one café-concert in the avant-garde journal *La vie moderne*.[3] He seems to have shown the present drawing twice, and he may have intended to publish it as well.

Seurat made two almost identical versions of *À la Gaîté Rochechouart*: a unique occurrence in his oeuvre, which has intrigued and puzzled scholars. "Why should any artist of Seurat's gifts have copied himself so precisely?" asked Agnes Mongan in 1946, as she examined the Winthrop drawing side by side with the version at the Rhode Island School of Design (fig. 147). She noted "only minor differences between the two," including the scale of the figures, the depth of light and shadow, and the fact that whereas this drawing is signed at top, the other lacks a signature. She attributed the "chief differ-

ence in appearance" to the slightly yellow cast caused by the fixative applied to the Rhode Island School of Design drawing.[4] Germain Seligman, writing a year later, found the most "striking" variation to be "the difference in angle of observation," which, as a result, had "presented new lighting problems for the artist to ponder."[5] Alternatively, James Rubin, in his thoroughgoing analysis of the geometric relationship between the two works, deduced that it was Seurat's search for "an ideal aesthetic simplicity or legibility" that led him to "perfect" his original composition, by relying, in the case of the Winthrop drawing ("the superior" and "more accurately composed of the two") on the golden section ratio.[6] (This presumption was predicated on the myth, since debunked, that Seurat had applied it to painting.)

Rubin, however faulty the crux of his argument, did convincingly establish that the present work, as the more fully resolved of the two sheets by virtue of its signature (a hallmark of the drawings that Seurat exhibited during his lifetime) and its provenance, was almost certainly the version Seurat chose to exhibit with the Indépendants in Paris in 1888 and with Les XX in Brussels in 1889. In turn, Gary Tinterow sensibly reasoned that "it is possible that the artist, already satisfied with the composition [now in Rhode Island] made the Fogg drawing as the stronger, more legible work for exhibition purposes."[7] Yet the exercise of laboring over a second version for this purpose does not seem entirely persuasive: Seurat's subtle tweaks to the composition would have escaped the eye of even the most attentive viewer. On the other hand, the nature of the changes Seurat made, which were largely geared to strengthening tonal contrasts and tightening formal

relationships, would have made a significant difference in reproduction. Indeed, it was precisely for this reason that Seurat's closest colleague, Paul Signac, undertook a second—somewhat bolder and more emphatic—version of one of his drawings, namely the *Passage du Puits Bertin*, for publication in the February 12, 1887, issue of *La vie moderne*.[8] At the time there was considerable interest among the Neo-Impressionists, as we glean from Pissarro's correspondence, in the exciting prospect of contributing illustrations to *La vogue* and other revues that would "make our work known."[9] Seurat did publish several of his works during the period 1887–90, even though hopes pinned on certain opportunities, for example, *La vogue*, as an exclusive forum for their works never came to pass. Perhaps destined for one of its issues, the present drawing, which has unfailingly captivated the eye and imagination of writers, has since enjoyed the renown, if not the promise, guaranteed by the printed page.

Susan Alyson Stein

1. Baedeker's *Paris and Environs*, 1881, p. 37; 1891, p. 33; 1904, p. 38. The 1904 edition mentioned La Gaîté Rochechouart, which by this date, had become one of the more established cafés-concerts. Toulouse-Lautrec depicted it in an 1893 lithograph, and Walter Sickert in a 1906 oil painting and a 1920 etching.
2. Among the writers was Seurat's friend and the original owner of the present drawing, the Belgian symbolist Émile Verhaeren, who dedicated a prose poem

to the subject, "Au café-concert," which was published in the March 16, 1889, issue of *La cravache*.
3. A wood engraving after Seurat's *Eden Concert* (Van Gogh Museum, Amsterdam) was reproduced in Gustave Kahn's April 9, 1887, review of the Indépendants exhibition (p. 230).
4. Agnes Mongan, letters to Heinrich Schwarz (of the Rhode Island School of Design), January 2 and 7, 1946, Fogg Art Museum curatorial files.
5. Seligman 1947, p. 25.
6. Rubin 1970, pp. 242–43.
7. Tinterow in Paris–New York 1991–92, p. 301.
8. On this subject, see Robert Herbert in New York 1968, no. 91, and Susan Stein and Anne Distel in Paris–Amsterdam–New York 2001, pp. 118–19, nos. 18, 19.
9. Camille Pissarro, letter to his son Lucien, n.d. [January 9, 1887]; Pissarro 1980, p. 91, and see also letters dated to December 10, 1886 (p. 85), January 7, 1887 (p. 89), and January 12, 1887 (p. 92).

PROVENANCE: Émile Verhaeren, Brussels, by 1892 (d. 1916); M. and Mme Émile Laffon, Paris; their sale, Savoy Hotel, Zürich, April 8, 1938, no. 74 (bought in; CHF 14,100); acquired from Mme Laffon through Martin Birnbaum by Grenville L. Winthrop, April 1939 (Fr 150,000); his bequest to the Fogg Art Museum, 1943.

EXHIBITIONS: Paris 1888, no. 616; Brussels 1889, no. 12; Brussels 1892, no. 24 (lent by É. Verhaeren).

REFERENCES: Cousturier 1914, pp. 97–106; Alexandre 1933, illus. p. 194; Anon. 1938, illus. p. 5; Seligman 1947, pp. 24–25, 85; Mongan 1949, illus. p. 186; Hauke 1961, vol. 2, no. 686, illus. pp. 270, 271; Herbert 1962b, p. 144, no. 126, frontis.; Russell 1965, p. 237, fig. 204; Rubin 1970, pp. 237–43, illus. p. 238, fig. 1; Jirat-Wasiutynski and Jirat-Wasiutynski 1980, p. 133, fig. 17; Bielefeld–Baden-Baden 1983–84, (German ed.) pp. 87 (fig. 23), 88, 193, (English ed.) pp. 87, 193; Thomson 1985, p. 197, illus. p. 201; Barthelmess 1987, pp. 102–6; Lebensztejn 1989, p. 17, illus. p. 19; Rewald 1990, illus. p. 185; Tilston 1991, p. 129, illus.; Wadley 1991, p. 297, pl. 105; Zimmermann 1991, p. 366, fig. 508; Tinterow in Paris–New York 1991–92, (French ed.) under no. 195, fig. 66, (English ed.) pp. 296, 300–301, illus.; Herbert 2001, pp. 116 fig. 97, 182, n. 4.

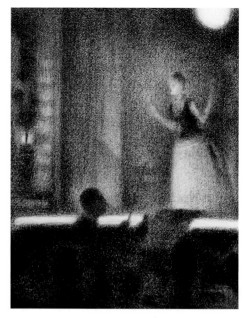

Fig. 147. Georges Pierre Seurat, *À la Gaîté Rochechouart*, 1887–88. Conté crayon and white chalk, 12 x 9¼ in. (30.5 x 23.5 cm). Museum of Art, Rhode Island School of Design, Providence; Gift of Mrs. Murray S. Danforth, 42.210

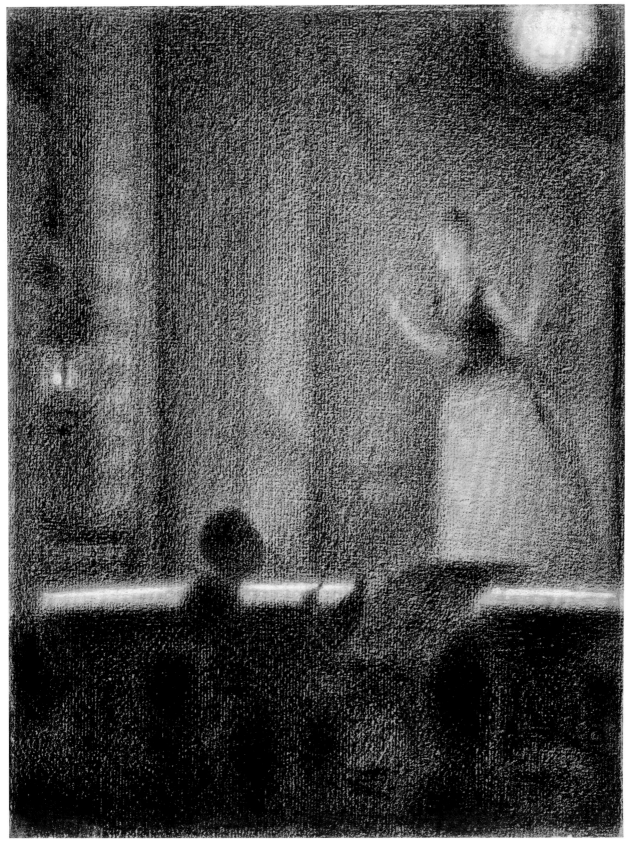

129

Alfred Sisley

Paris, 1839–Moret-sur-Loing, France, 1899

130. *The Bridge at Villeneuve-la-Garenne*, 1872

Oil on canvas
20⅜ x 24 in. (51.8 cm. x 61 cm)
Signed lower left: Sisley
1942.206

In the early 1870s Alfred Sisley painted several series of landscapes, mostly depicting the villages and countryside along the River Seine immediately to the northwest of Paris. They constitute an essential component in the development of Impressionism, and their culmination is found in his miraculous depictions of the flooded Seine at Port-Marly in 1876. In order to achieve this exceptional recording of fleeting weather and receding waters, Sisley had evolved in the previous years a personal style and range of subject matter in rapid Seine-side campaigns—at Bougival, Argenteuil, Villeneuve-la-Garenne, and Louveciennes. He moved between exhilarating innovation in composition and handling of paint and, as if recovering his breath, more traditional landscapes particularly indebted to the example of Camille Corot. In sensibility, however, he did not vary.

Unlike his contemporaries in the Impressionist group, especially Claude Monet and Camille Pissarro, Sisley had a less voracious appetite for contemporary life. He seems more remote from us than his colleagues partly because we know less about him, partly because of the extreme reticence of his reactions in front of the landscape. He never pushes his emotional responses into our consciousness in the way Monet can do; he has none of the caressing immediacy of Pierre-Auguste Renoir or Pissarro's more social inquisitiveness. Unlike them, Sisley rarely painted cityscapes and did no large-scale figures or portraits. By birth an Englishman, he was first drawn to landscape as a young man in London in the late 1850s in front of the works of John Constable and J.M.W. Turner. A little later, often in the company of Monet, Renoir, and Frédéric Bazille, his fellow students from the academy of Charles Gleyre in Paris, he worked in the Forest of Fontainebleau, beloved of an earlier generation of French landscapists such as Théodore Rousseau.

By 1872, the year of this painting, Sisley was working with confidence; he hardly seems to put a foot wrong in the unfolding development of his gifts. He set up his easel in several neighboring locations along the Seine, generally seeking out the still placid riverbanks and untouched villages and omitting the increasingly industrialized aspects of the river. The village of Villeneuve-la-Garenne had recently been made more accessible to Paris by the building of an uncompromisingly modern suspension bridge, seen in the present work busy with people crossing between Villeneuve, on the right, and the Île Saint-Denis at left. Sisley has nothing to "say" about this scene, an early summer morning with skiffs still moored along the riverbank, along which walks a local woman of the type found throughout Sisley's work. Villas withdraw behind the new foliage of their walled gardens; two figures stand to talk by the water's edge. Will it rain? Will it stay dry? they might be saying. But nothing distracts Sisley from his absorption in the scene itself, with its classic divisions of sky, water, and earth, its temperate tonality and soft light. Its modest perfection heralds Sisley's finest period of painting.

Richard Shone

PROVENANCE: Sold by the artist to Durand-Ruel, Paris, June 25, 1872; purchased from them by Alexander Reid, Glasgow, December 1, 1928; sold by Reid and Lefèvre, London, to Étienne Bignou, Paris, February 22, 1929; Émile Laffon, Paris; Wildenstein and Co., New York; acquired from them by Grenville L. Winthrop, June 1, 1939 ($12,500); his gift to the Fogg Art Museum, 1942.

EXHIBITIONS: Paris 1921b, no. 14; Paris 1927b, no. 2; Paris 1930d, no. 4; Cambridge, Mass., 1943–44, p. 7; Cambridge, Mass., 1974, no. 28; Cambridge, Mass., 1977a; Cambridge, Mass., 1990, pp. 20–21.

REFERENCES: Alexandre 1933, pp. 182, 190, illus.; Daulte 1957, no. 60, illus. p. 49; Daulte 1959, no. 38, illus.; Bowron 1990, fig. 338.

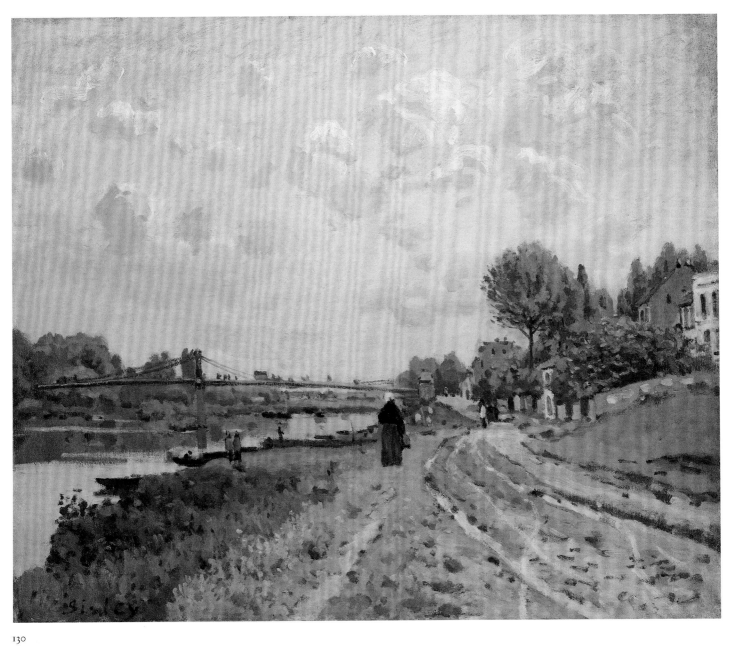

130

Henri de Toulouse-Lautrec

Albi, France, 1864–Malromé, France, 1901

131. *Jeanne Granier*,[1] 1897

Red chalk on blue modern laid paper
18⅞ x 12⅞ in. (47.8 x 32.6 cm)
Signed and dated in red chalk, lower right:
HTLautrec 97
1943.920

Although he is now known primarily for his posters and other works chronicling fin-de-siècle high life, among his contemporaries Henri de Toulouse-Lautrec was also known as a portrait painter. His subjects included café-concert performers such as Jane Avril and Yvette Guilbert, as well as actors in the traditional theater. Lautrec was an inveterate theatergoer; his letters to friends and family are replete with references to actors and actresses, tickets acquired, and performances attended. In

1896 he began a collaboration with W.H.B. Sands to create a portfolio of twenty-five portraits of actors and actresses of the contemporary theater, to be accompanied by brief biographical notes by Arthur Byl. Sands was unable to complete the project, and it was not published until late 1898 or early 1899, much reduced in scope, under the title *Treize lithographies*. Two unpublished lithographic portraits of Jeanne Granier, which appear to be studies for *Treize lithographies*, also date to this period.[2] Both of these are similar to the published version in their uplifted profile pose and features enlivened by expression (fig. 150).

In 1897, Jeanne Granier was an established star in the Parisian musical theater,

having played leading roles since her 1874 debut in Jacques Offenbach's *La jolie parfumeuse* (fig. 148).[3] In 1894 Lautrec had borrowed some of her features, as she appeared in her youthful performances, for the figure in *Confetti*, a poster advertising paper confetti, a new product manufactured by J. and E. Bella (fig. 149).

In contrast to the theatrical nature of the lithographic portraits and *Confetti*, the drawing in the Winthrop collection is a serious portrait, depicting Granier as an elegant, mature woman rather than as an ingenue. In its simple composition and placid expression, this drawing has more in common with Lautrec's early portraits of friends and family members than it does with the extravagantly costumed and posed

Fig. 148. *Jeanne Granier*. Cabinet photograph, 6½ x 4¼ in. (16.5 x 10.6 cm). The Harvard Theatre Collection, The Houghton Library

Fig. 149. Henri de Toulouse-Lautrec, *Confetti*, 1894. Poster, color lithograph, 22⅜ x 17½ in. (56.8 x 44.5 cm). The Metropolitan Museum of Art, New York; Gift of Bessie Potter Vonnoh, 1941 41.12.42

Fig. 150. Henri de Toulouse-Lautrec, *Jeanne Granier*, 1898, from *Treize lithographies*. Lithograph, 11¾ x 9½ in. (29.8 x 24.2 cm). Boston Public Library, Print Department, Albert H. Wiggin Collection

131

figures of his mature career. The drawing bears a strong resemblance to a cabinet card photo of similar date (fig. 151). This more sober mien corresponds to a change in Granier's public persona as well. While she had made her fame as a star of the operetta, by the late 1880s her popularity had begun to wane and in 1895 she began a new career in straight comedy.

Sarah B. Kianovsky

1. Winthrop purchased this drawing as a portrait of Jane Avril, one of Lautrec's most frequent subjects and a patron as well. In 1979 Colles Baxter (pp. 41–44) corrected the identification of the sitter, pointing out the strong resemblance to Granier and the lack of resemblance to Avril.
2. Correspondence between Lautrec and Sands suggests that the artist was unhappy with his initial attempts; see Toulouse-Lautrec 1983, pp. 44 no. 6, 49 no. 11.

3. Such was her fame that Auguste Escoffier named a dish of eggs, asparagus, and truffles in her honor.

PROVENANCE: Maurice Joyant; Jacques Seligmann and Co.; acquired from them by Grenville L. Winthrop, May 1935 ($3,000, as a portrait of Jane Avril); his bequest to the Fogg Art Museum, 1943.

REFERENCES: Tietze 1947, no. 147; Dortu 1971, vol. 6, pp. 780–81, no. D.4.374, illus.; Baxter 1979, pp. 41–44.

132. *At the Circus: In the Wings (Au cirque: Dans les coulisses)*, 1899

Black and colored chalks and graphite on thin cream wove paper
12¼ x 8 in. (31.1 x 20.2 cm)
Inscribed, signed, and dated in black chalk, lower right: à la colombe / de l'arche / HTLautrec / à Madrid les / bains 1899 / Jeudi 9 mars
1943.922

In 1899 Lautrec's physical and mental condition was in a steep decline, the result of his congenital physical weakness, tertiary syphilis, and years of alcohol abuse. While his family and friends debated the wisdom of hospitalizing him for his own protection, nature took events into her own hands. Collapsing with a bout of delirium tremens, he was taken by the authorities to the sanitarium known as La Folie Saint-James, supervised by Dr. Sémelaigne, where he convalesced for several weeks. The enforced

abstinence from alcohol resulted in a rapid stabilization of his condition, but he remained hospitalized for some time afterward, perhaps as long as two months.

Much as she had when he was bedridden as a child, his mother provided him with drawing materials, and as soon as possible he began to work again. This drawing, one of the first that Lautrec completed while hospitalized, is dedicated to Misia Natanson, his first visitor. She was the wife of Thadée Natanson, who was one of the publishers of *La revue blanche* and a biographer of Lautrec. In his inscription Lautrec refers to Misia as "la colombe d'arche," the dove of the ark, suggesting that like the dove that bore an olive branch to Noah, Misia brought to Lautrec evidence that the world outside still existed and that he might someday

Fig. 152. Henri de Toulouse-Lautrec, *At the Circus: The Curtain Call (Au cirque: Le rappel)*, 1899. As reproduced in *Au cirque: Vingt-deux dessins aux crayons de couleur* (Paris, 1905), pl. 22

132

return to it. The inscription jokingly refers to his temporary home as Madrid-les-Bains, alluding both to its address at 16 rue Madrid in Neuilly and to its luxurious location, the Château de Saint-James. This was an eighteenth-century château with decor recalling Antoine Watteau and Jean-Honoré Fragonard, set amid beautifully landscaped grounds that could be seen through the locked doors and barred windows.[1]

This drawing depicts two individuals in the wings at the circus. Maurice Joyant, Lautrec's biographer and executor of his estate, referred to the female figure in the foreground as an "écuyère en panneau," a rider who performed her acrobatic tricks on a platform saddle.[2] She wears the same black shoulder bows and neck ribbon as the performer in the drawing *Au cirque: Le rappel* (fig. 152; in *Au cirque: Écuyère de panneau* this performer is depicted riding in just such a saddle). The identity of the figure in the background is unclear. Joyant described him as the fireman on duty, yet his profile also recalls that of the clown Footit who appears in several of the drawings Lautrec made subsequent to *Dans les coulisses*.[3]

Although it is similar to the subsequent works of the artist's confinement in its treatment of a circus subject, *Dans les coulisses* predates Lautrec's decision to complete a group of drawings to demonstrate his recovery.[4] One of the first drawings made during this period, it signals his desire to return to life. Like the *écuyère* in the wings, he awaits his cue.

Sarah B. Kianovsky

1. Simon 1990, pp. 354–55.
2. Joyant 1926–27, vol. 1, p. 225.
3. Ibid., vol. 2, p. 237.
4. Of the thirty-nine circus-theme drawings made by Lautrec during this period, only twenty-two were included in the initial publication of *Au cirque* in 1905. *Dans les coulisses* was published in 1902, in *Le figaro illustré*.

PROVENANCE: Maurice Joyant; acquired through Martin Birnbaum by Grenville L. Winthrop, April 1940; his bequest to the Fogg Art Museum, 1943.

EXHIBITION: Paris 1931a, no. 270.

REFERENCES: *Le figaro illustré*, no. 145 (April 1902), p. 13; Dortu 1971, vol. 6, pp. 862–63, no. D.4.549, illus.

133. *At the Circus: Jockey (Au cirque: Jockey)*, 1899

Black and colored chalk, graphite on off-white wove paper
13 x 19¾ in. (33 x 50.2 cm)
Signed in black chalk, lower left: HTL [monogram in circle]
1943.923

Although Lautrec's mother had provided basic art supplies early in his confinement to the sanitarium of Dr. Sémelaigne in 1899, in a letter dated March 17 Lautrec requested that his friend Maurice Joyant bring him additional drawing materials and lithography tools.[1] Fearing that continued imprisonment would drive him mad, he proposed a plan to Joyant by which he would make a certain number of drawings to prove to his doctors that he had recovered.[2] He soon began a series of drawings depicting circus subjects, which he intended to publish as a portfolio after his release.[3] He would complete thirty-nine circus-theme drawings during his convalescence, twenty-two of which were published as *Au cirque* in 1905.

The subject of the circus was one that Lautrec had explored at great length earlier in his career, most notably in *Au cirque Fernando* of 1888. Yet while the earlier works were the fruit of careful observation, these thirty-nine drawings were of necessity made entirely from memory. Despite this fact, Lautrec's ability to recall precise details makes it possible, in some cases, to determine the identity of performers and the particular performance being depicted.

Many of the circus drawings represent equestrian subjects. The nineteenth-century circus relied heavily on a variety of equestrian acts, but the subject may have had a more personal meaning to Lautrec. In his aristocratic family riding, especially to the hunt, was an important part of the culture, but one that was increasingly denied to Lautrec as he grew older and his physical fragility became apparent. In this drawing he depicted a rider performing a feat known as "voltige à la casaque" or "voltige indienne." The performer uses athletic skills to achieve a gracefulness that Lautrec himself could never hope to emulate except through his art.

Sarah B. Kianovsky

1. Toulouse-Lautrec 1991, p. 349, letter 564.
2. There is no evidence that his doctors were aware of or agreed to this plan, or that it had the desired result. In the final analysis, his release from the clinic was as much a response to public attention as it was to his improved condition. To counter reports

133

in the press that described the artist's illness as inevitable and incurable, Joyant convinced Arsène Alexandre to interview Lautrec for *Le figaro*. The article, "Un Guérison," appeared on March 30, 1899, and described the artist as fully recovered and in full command of his faculties. This public declaration of health precipitated a reevaluation by his doctors. After a transitional period of several weeks Lautrec was allowed to return home.

3. In a letter of April 12, 1899, to Joseph Albert, Lautrec referred to the group as an album; Toulouse-Lautrec 1991, p. 350, no. 566.

PROVENANCE: Maurice Joyant; possibly M. G. Dortu; possibly Otto Gerstenberg, Berlin; M. Knoedler and Co., New York, by 1931; Philip Hofer, Cambridge, Mass.; Grenville L. Winthrop; his bequest to the Fogg Art Museum, 1943.

EXHIBITIONS: New York 1931, no. 1; Paris 1931a, no. 242.

REFERENCES: *Le figaro illustré*, no. 145 (April 1902), p. 13; Toulouse-Lautrec 1905, pl. 1; Coquiot 1913a, p. 206; Joyant 1926–27, vol. 1, pp. 223–26, vol. 2, p. 234; Dortu 1971, vol. 6, pp. 814–15, no. D.4.522, illus.

Adolph Menzel

Breslau, Silesia (now Wrocław, Poland), 1815–Berlin, 1905

134. *The Statue*, 1852

Watercolor, white watercolor, and white gouache on gray wove paper
11⅛ x 8¾ in. (28.2 x 22.2 cm)
Signed and dated in brown ink, right edge: A.M. 7te Febr.1852.
Inscribed in brown ink, at bottom: Interessent: Sie! Drehen Sie Sich doch mal um! der Monsieur Lafontaine da sagt: / der Knebelbart hänge Ihnen bis— / Ach Sie haben gar keinen?! / Auch nie einen gehabt? / Statue: Nie. Keinen.— Scher er sich.—
1943.288

The most renowned German artist during the second half of the nineteenth century, Adolph Menzel is best known today for his paintings and drawings illustrating the life of the eighteenth-century Prussian king Frederick II (the Great), for plein air landscapes (*The Berlin-Potsdam Railway*, 1847), informal interior scenes (*The Balcony Room*, 1845), and for *The Iron-Rolling Mill* (1872–75), the realist masterpiece that captured the awesome scale and working conditions of contemporary industrial production.[1] More than 10,000 of his drawings, most executed in his favorite medium of graphite pencil, have survived, and they rank among the most impressive by any nineteenth-century artist.

Winthrop's 1943 bequest to the Fogg Art Museum included nine works on paper by Menzel. He purchased five of them—three in 1923, and two in 1926—from Scott and Fowles, New York. Three were acquired in 1927 through Martin Birnbaum from German galleries and one in 1935 through Birnbaum from the London trade. Ranging in date from 1852 to 1894, they include two gouaches (cat. nos. 135 and 136), a pen sketch, and the present mixed media work

in addition to graphite drawings. Their subjects comprise head studies, landscapes, scenes of everyday life, an imaginary meeting of four Enlightenment intellectuals (fig. 153),[2] and *The Statue*, a satirical composition that pokes fun at Menzel's friend the realist author Theodore Fontane.[3]

Dated 1852, *The Statue* is the earliest of Menzel's drawings in the Winthrop collection. The playful jab at Fontane must be understood in the context of Menzel's intense, lifelong interest in eighteenth-century Prussian history and visual culture, which informed much of his work, especially during the period from the late 1830s through the 1850s. Menzel established his reputation with his designs for some 400 wood-engraved illustrations to Franz Kugler's *Geschichte Friedrichs des Grossen* (History of Frederick the Great; 1839–42). Their success led in 1842 to two additional commissions for illustrations to "Frederician" publications: 200 vignettes for a thirty-volume edition of Frederick's writings; and 436 pen lithographs ordered by the publisher Sachse for a three-volume monograph on Frederick's army and the uniforms of its soldiers. In the late 1840s Menzel painted the first of what would become a cycle of eleven canvasses depicting events in Frederick's life.

In 1850 Menzel joined *Tunnel über der Spree* (Tunnel over the [River] Spree), a literary sodality whose members included authors, academics, lawyers, and officers, among them some of the leading lights in the Berlin cultural firmament. The art historian Kugler, whose book on Frederick the Great Menzel had illustrated, probably

introduced the artist to this elite discussion group. A member of the Tunnel and a fellow student of Prussia's past, Fontane published *Männer und Helden. Acht Preussen-Lieder* (Men and Heroes. Eight Prussian Songs) early in 1850, and these poems were doubtless discussed in Tunnel meetings. A minor factual error in one of Fontane's Prussian Songs provoked Menzel's comic response in the form of *The Statue*.

A man has clambered up the pedestal to address Johann Gottfried Schadow's marble statue of 1800 commemorating one of the ablest eighteenth-century Prussian generals, Prince Leopold von Anhalt-Dessau, known as *Der Alte Dessauer* (the Old Dessauer; fig. 154).[4] In the drawing the statue turns his head toward his interlocutor, while in the original monument the general inclines his head only slightly in this direction. Beneath this curious scene Menzel wrote a dialogue between the statue and the man. Fontane's Prussian Song *Der Alte Dessauer* referred to Leopold's waxed mustache that drooped to his shoulders. Thanks to his knowledge of the statue, which Schadow had based on exhaustive research and which Menzel himself had used as a source for the general's appearance in several illustrations, the artist knew that he in fact wore a short mustache. "You! Turn around!" says the man to the statue. Using Fontane's Tunnel nickname, he continues, "A certain Monsieur Lafontaine says that your waxed mustache hangs down to . . . Oh, you don't have a mustache like that at all?! You've never had one like that?" The statue answers, "Never. None. Tell

134

Fig. 154. Johann Gottfried Schadow, *Prince Leopold I von Anhalt-Dessau*, 1800. Marble, 7 ft. 4⅛ in. (215 cm). Staatliche Museen zu Berlin—Preussischer Kulturbesitz, Skulpturensammlung, 2830

Fig. 153. Adolph Menzel, *Portrait Group: Jean Paul, Schiller, Goethe, and Herder*, 1855. Black chalk on dark cream paper, heavily fixed, 17½ x 22½ in. (44.6 x 57.1 cm). Fogg Art Museum, Bequest of Grenville L. Winthrop, 1943.531

him to get lost."[5] In later editions of the poem Fontane deleted the passages referring to the mustache.

The date 7 February 1852, which Menzel inscribed on the drawing, must be the day he completed the work or the day he presented it to Fontane, whose term as secretary of the Tunnel ended on 15 February. As Annette Schlagenhauff suggested, Menzel's gift might have been in gratitude for his service.[6] It remained in the author's possession until his death.

William W. Robinson

1. Keisch in Paris–Washington–Berlin 1996–97, nos. 18, 35, 160.
2. *Portrait Group: Jean Paul, Schiller, Goethe, and Herder*, 1855; black chalk on dark cream paper, heavily fixed; 44.6 x 57.1 cm; 1943.531; Schlagenhauff 1991, pp. 10–11.
3. Winthrop's Menzel drawings are thoroughly catalogued in Schlagenhauff 1991, pp. 8–17, 20–23, 28–31. I am indebted to this publication for much of the information presented here and in the following entries.
4. Johann Gottfried Schadow, *Prince Leopold I von Anhalt-Dessau*, 1800; marble, 2.15 m; Staatliche Museen zu Berlin—Preussischer Kulturbesitz, Skulpturensammlung, 2830.
5. Translation quoted from Schlagenhauff 1991, p. 9.
6. Ibid.

PROVENANCE: Theodore Fontane, Berlin, 1906; Leo Lewin, Breslau; his sale, Paul Cassirer, Berlin, April 12, 1928, no. 123; Galerie Caspari, Munich; acquired from them through Martin Birnbaum by Grenville L. Winthrop, November 1927; his bequest to the Fogg Art Museum, 1943.

EXHIBITIONS: Berlin 1905, no. 236; Cambridge, Mass., 1998, no. 22.

REFERENCES: Tschudi 1906, no. 311; Schlagenhauff 1991, pp. 8–9; Lammel 1993, p. 74; Keisch in Berlin 1998, p. 153.

135. *Before Confession,* 1875

Gouache on cream wove paper adhered to cream card
Paper 9 x 6¼ in. (22.9 x 16 cm); card 9⅜ x 6¾ in. (23.9 x 17.2 cm)
Signed and dated in brown gouache, lower right: Ad. Menzel / 75.
1943.90

From the 1850s on, Menzel increasingly favored gouache (opaque watercolor), often combined with transparent watercolor, for finished works on paper. Most of his gouaches are fully resolved compositions executed in a technique that combines exactingly precise description with painterly flair. While many exhibit the scale and ambition of small paintings, Menzel believed that certain subjects did not lend themselves to treatment in oil, and he clearly preferred the relative freedom afforded by the water-based medium.[1] His most familiar gouaches are probably those that constitute the so-called *Children's Album,* a group of forty-four sheets produced from the 1860s to the 1880s, which the artist preserved, and eventually sold, for the benefit of his niece and nephew,[2] but there are dozens of others not in this series. *Before Confession* and *In the Park* (cat. no. 136), both dated 1875, are characteristic of his mature work in gouache.

Starting in 1852, Menzel regularly traveled during the summer holidays to southern Germany, Austria, and Switzerland. He sketched the local people and the scenery as well as vacationers at spas and resorts, and he delighted especially in drawing Baroque churches and palaces in Munich, Würzburg, Salzburg, Vienna, Innsbruck, Sankt Gallen, and elsewhere, further cultivating the interest in eighteenth-century architecture and interior decoration that originated with his studies of Prussian buildings from the time of Frederick the Great.[3]

The present gouache depicts an everyday scene that Menzel might have observed in a Bavarian church during one of his summer excursions. Its title, *Before Confession (Vor der Beichte),* was sanctioned by the artist himself, since it appears in an 1890 catalogue of his oeuvre prepared under his direct supervision.[4] As Annette Schlagenhauff noted, the title fully clarifies the anecdotal situation that provided the pretext for this profoundly pondered composition.[5] A woman kneels at a prie-dieu, a dark form against the light pier, and covers her face with her hands as she interrogates her conscience prior to making confession. Viewed from the side, immobile and totally absorbed in her spiritual concerns, her figure contrasts with those of the man who jerks a rosary from his pocket as he hurries into the church and the two boys, one making a cursory sign of the cross, who hasten toward the nave. The diagonal formed by the kneeling woman's back and bowed head is aligned with the man's face, which, depicted frontally and illuminated against the shadowed columns behind him, is a focal point of the design. As he moves from the secular world outside into the sacred realm of the church, he wears a momentarily vacant, absentminded expression that seems to reflect a process of mental adjustment between the everyday preoccupations he leaves behind and the religious obligation he is about to fulfill.

William W. Robinson

135

1. See Keisch in New York and other cities 1990–91,
 p. 134; and Keisch in Paris–Washington–Berlin
 1996–97, p. 442.
2. Keisch in New York and other cities 1990–91,
 pp. 134–59.
3. For Menzel's travels in southern Germany and
 Austria, see Wirth 1974, passim.

4. Schlagenhauff 1991, p. 13.
5. Ibid.

PROVENANCE: Frau Schwabe, Berlin, by 1890; B.
Lippert, Magdeburg, by 1906; Galerien Thannhauser,
Berlin; acquired from them through Martin Birnbaum
by Grenville L. Winthrop (DM 10,600); his bequest to
the Fogg Art Museum, 1943.

EXHIBITIONS: Berlin 1927, no. 239; Berlin 1928,
no. 111.

REFERENCES: Jordan and Dohme 1890, pl. 83;
Tschudi 1906, no. 611; Kiel and other cities 1981–82,
p. 146; Schlagenhauff 1991, pp. 12–13.

136. *In the Park*, 1875

Gouache on cream cardboard
7⅝ x 5¾ in. (19.5 x 14.7 cm)
Signed and dated in red gouache, lower right:
Menzel / 75.
1943.91

This intimate masterpiece might depict a scene remembered from one of Menzel's summer trips—see *Before Confession* (cat. no. 135), also dated 1875—but the setting of the present work cannot be identified and could just as well be a park in Berlin as the grounds of one of the southern German or Austrian resorts where the artist vacationed. As Marie Ursula Riemann-Reyher noted in correspondence, one element of the composition, the poses of the couple seated on the bench, originated in a quick study in a sketchbook Menzel used in 1872 (fig. 155).[1]

In the Park has been compared to another gouache of 1875, *Travel Plans* (Reisepläne), which also features two bour-geois couples on holiday (fig. 156).[2] In *Travel Plans*, which is set on the terrace of a private house or hotel, the men smoke and converse jovially over a map spread out on a table, while the women gaze out at the landscape, seemingly in anticipation of their journey together.[3] Annette Schlagenhauff, who first associated the two works, maintained that the men and the woman in the white hat in Winthrop's gouache reappear as protagonists in *Travel Plans*, and she suggested that Menzel might have produced the two works as part of a series.[4] However that may be, there is no question that they are closely related in their subject matter and holiday mood.

The design of *In the Park*—the strong horizontal and vertical accents of the bench and the tree framing the figures against the loosely brushed backdrop of foliage and sky—lends the image an impressive scale that belies it small size. Menzel's versatile technique, at once broad and exact, com-bines freely executed passages, such as the reflective highlights on the standing woman's white dress, with precise description in, for example, the women's faces and the floral decoration of their hats.

William W. Robinson

1. Correspondence dated April 1991 preserved in the curatorial file in the Drawing Department, Fogg Art Museum.
2. See Riemann-Reyher in Paris–Washington–Berlin 1996–97, pp. 389–90.
3. See Riemann-Reyher (in ibid., p. 389), who writes that while the men make travel plans, "the women are in a state of dreamy, hopeful expectation."
4. Schlagenhauff 1991, p. 15.

PROVENANCE: Private collection, Smolensk, by 1906; Galerie Caspari, Munich; acquired from them through Martin Birnbaum by Grenville L. Winthrop, November 1927; his bequest to the Fogg Art Museum, 1943.

EXHIBITION: Cambridge, Mass., 1998, no. 24.

REFERENCES: Tschudi 1906, no. 616; Mortimer 1985, no. 291; Schlagenhauff 1991, pp. 14–15; Riemann-Reyher in Paris–Washington–Berlin 1996–97, pp. 389–90.

Fig. 155. Adolph Menzel, *Couple on a Bench*, 1872. Graphite, 3¼ x 5½ in. (8.3 x 13.9 cm). Staatliche Museen zu Berlin—Preussischer Kulturbesitz, Kupferstichkabinett, SZ Menzel, Skizzenbuch 40, p. 33.

136

Fig. 156. Adolph Menzel, *Travel Plans*, 1875. Gouache, 5⅞ x 12¼ in. (15 x 31 cm). Folkwang Museum, Essen, G 117

137. *Head of a Bearded Man Facing Right,* 1893

Graphite and black and white chalk, stumped,
on cream wove paper
7¼ x 4⅝ in. (18.3 x 11.6 cm)
Signed and dated in graphite, lower right: A.M. /
93
1943.534

As first noted by Werner Schmidt, Menzel adapted this study for the head of the man entering from the left in the 1894 gouache *Frühstunde im Café* (Early Morning in the Café) in the Kunsthalle, Hamburg (fig. 157).[1] In the gouache the patron smokes a cigar, which is not included in the drawing, and, carrying an umbrella and unbuttoning his heavy coat with a gloved hand, strides

Fig. 157. Adolph Menzel, *Early Morning in the Café,* 1894. Gouache, 7¼ x 4⅝ in. (18.3 x 11.7 cm). Hamburger Kunsthalle, 2460

purposefully into the café, his alert eyes evidently fixed on his favorite table. He sweeps past an employee, who has left his keys and dust broom on the table while he wipes the windows. The title Menzel originally gave to this composition—*Morgenstimmung / Café—München* (Morning Atmosphere / Café—Munich)—attests that he must have conceived the work in the Bavarian city, which he visited in the summer of 1892.[2] Four studies for the figure of the window washer that, like the present work, are dated 1893, and additional detail studies in sketchbooks Menzel used in 1892–93 and 1893–94 record the long gestation period of this small, but hardly minor, gouache.

Annette Schlagenhauff noted a resemblance between the model who posed for this drawing and Edwin Emerson, an American clergyman and professor who sat in 1893–94 to the Munich portraitist Franz von Lenbach.[3] In my view the resemblance is not compelling. The man in the Winthrop drawing, especially as reincarnated in the ruddy-faced, red-bearded café patron of the gouache, seems younger and more vigorous than the wizened graybeard portrayed in Lenbach's picture. The head in the drawing more likely belonged to one of the many models who appeared daily at the door of Menzel's Berlin studio.[4]

Completed in his seventy-ninth year, *Frühstunde im Café* is one of Menzel's last colored compositions. During the course of the 1890s he gradually limited his production to pencil drawings,[5] and studies of

heads constitute a significant category of his late work in graphite. In many of them, including *Head of a Bearded Man Facing Right*, he made impressive use of stumping, the technique of smudging the graphite or chalk lines to create areas of tone. Thus, as he abandoned color, the aged Menzel developed an increasingly painterly approach to drawing in monochrome. The richly modulated grays achieved through stumping evoke texture, color, and shadow in the face, hat, and jacket. The only linear marks in the drawing are the granular strokes of the soft carpenter's pencil that render the beard and mustache. There, the realism of the technique is such that, as Michael Fried has observed about the representation of hair in Menzel's late drawings, "depiction and mark-making have been brought into a new relation of something like material identity with one another."[6]

William W. Robinson

1. Schmidt associated the Fogg's drawing with the Hamburg gouache during a visit to the Fogg in 1988. See Schlagenhauff 1991, pp. 28–29. On the Hamburg gouache, see Hofmann in Hamburg 1982, pp. 286–87, and Riemann-Reyher in Paris–Washington–Berlin 1996–97, p. 450.
2. Hofmann in Hamburg 1982, p. 286.
3. Schlagenhauff 1991, p. 29.
4. Riemann-Reyher in Paris–Washington–Berlin 1996–97, p. 452; Fried 2002, p. 224.
5. Riemann-Reyher in Paris–Washington–Berlin 1996–97, p. 450.
6. Fried 2002, p. 224.

PROVENANCE: Scott and Fowles, New York; acquired from them by Grenville L. Winthrop, April 1923 ($350); his bequest to the Fogg Art Museum, 1943.

REFERENCE: Schlagenhauff 1991, pp. 28–29.

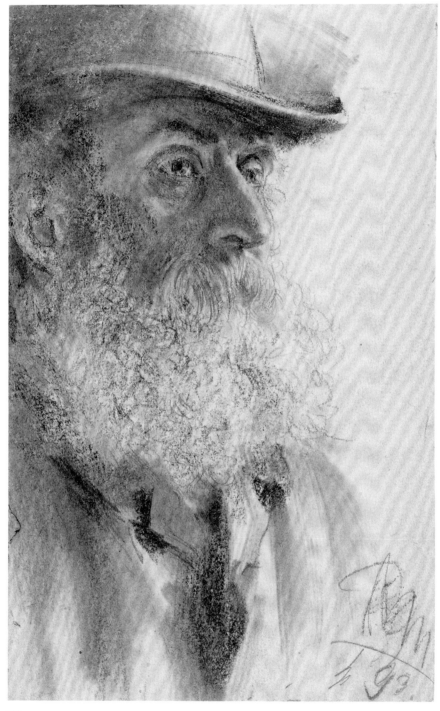

137

138. *Head of a Woman*, 1894

Graphite, stumped, on off-white wove paper
8¼ x 5⅛ in. (20.9 x 12.9 cm)
Signed and dated in graphite, lower right: A. M. / 94.
1943.532

Menzel remained a productive draftsman
until his death, at the age of eighty-nine, in
1905. During the final phase of his career
he worked primarily in pencil, producing
private works characterized by their techni-
cal virtuosity, especially in the use of
stumping,[1] and by profoundly introspective
emotional expression. His effort to probe
the model's thoughts and feelings, if not an
entirely new element in the artist's work,
became the primary intention of many of
the late head studies, and his portrayal of
the psychological dimension took on an
urgency and an enigmatic quality that did
not inform his earlier work. Menzel height-
ened the subjective element in these works
by drawing the models in arresting, often
disconcerting poses, depicting their heads
uncomfortably close up, oddly foreshort-
ened, and from unexpected angles, includ-
ing from above and from the back.[2] Head
studies rather than portraits, these drawings
depict anonymous subjects—people he
encountered by chance on his summer trav-
els and in the streets and restaurants of
Berlin or models chosen from among the
many who presented themselves at his stu-
dio each morning.[3]

The present sheet of 1894, like *Head of a*
Bearded Man Facing Right (cat. no. 137),
belongs to this large group of heads that
Menzel drew in graphite from about 1893
until the end of his life. It relates to a
larger, but less formally composed and
finished sheet in Berlin, which shows two
studies of the same woman running a small
comb through her hair (fig. 158).[4] The steep
foreshortening and tight cropping of the

head in the Winthrop drawing—the trun-
cation of the forearm and elbow have the
effect of bringing the hand holding the
comb dramatically forward—are charac-
teristic devices Menzel used in these later
drawings.

Michael Fried has underscored the
nearly obsessive conspicuousness of hair in
some of these studies. Not only did Menzel
develop a graphite technique of such
extraordinary verisimilitude that it sug-
gested to Fried a "material equivalence
between hair and the mark,"[5] but in several
drawings he posed the models to emphasize
the abundance or texture of the hair or he
focused specifically on a coiffure, hair orna-
ment or, as in the present work and that
reproduced in figure 158, the act of comb-
ing.[6] The Winthrop study incorporates
both what Fried calls the "thematization of
the materiality of the graphic, or rather
graphite, mark as such"[7] in the rendering of
the hair and the portrayal of an enigmatic
inwardness in the face that are characteris-
tic of the head studies from Menzel's final
years. *William W. Robinson*

Fig. 158. Adolph Menzel, *Woman Combing Her Hair.*
Graphite, 12¼ x 9 in. (31 x 22.9 cm). Staatliche
Museen zu Berlin—Preussischer Kulturbesitz,
Kupferstichkabinett, SZ Menzel N 4433

1. See text on *Head of a Bearded Man Facing Right* (cat.
no. 137).
2. Schlagenhauff 1991, p. 31; Fried 2002, pp. 224–25.
3. Riemann-Reyher in Paris–Washington–Berlin
1996–97, p. 452.
4. See Riemann-Reyher in Paris–Washington–Berlin
1996–97, p. 451, and Fried 2002, pp. 226–27. Fried
was the first to notice that the woman in the
Winthrop drawing holds a comb, which is more
clearly discernible in the Berlin sheet.
5. Fried 2002, p. 226.
6. Ibid., pp. 224–28.
7. Ibid., p. 224.

PROVENANCE: Scott and Fowles, New York;
acquired from them by Grenville L. Winthrop, April
1923 ($350); his bequest to the Fogg Art Museum,
1943.

REFERENCES: Watrous 1957, p. 145; Schlagenhauff
1991, pp. 30–31; Riemann-Reyher in Paris–
Washington–Berlin 1996–97, p. 451; Fried 2002,
pp. 226, 292 n. 23.

138

Aubrey Vincent Beardsley

Brighton, England, 1872–Menton, France, 1898

139. *The Peacock Skirt,* for *Salome,* summer 1893

Black ink and graphite on white wove paper
9⅛ x 6⅝ in. (23 x 16.8 cm)
Signed with Beardsley's Japanese monogram in
black ink, upper right corner
Inscribed on verso, in graphite: The Peacock Skirt /
from 'Salome' / 2 /⑫; in blue crayon:③
1943.649

Aubrey Beardsley had made approximately 1,125 black-and-white drawings in various styles by the time he died of tuberculosis.[1] His work decisively shaped Art Nouveau, changed the look of English illustration and page design, brought reasonably priced art to the public, and improved the status of drawings and prints. While working on his first two book-illustration commissions, Sir Thomas Malory's *Morte d'Arthur* (1893–94) and the Bon-Mots series (1893–94), or possibly before, Beardsley made a startling

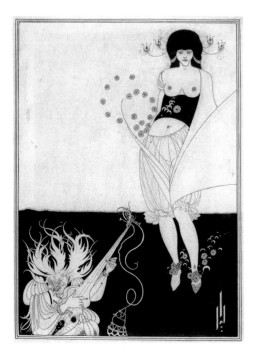

Fig. 159. Aubrey Beardsley, *Stomach Dance*, 1893. Black ink and graphite on white wove paper, 8⅞ x 6½ in. (22.6 x 16.6 cm). Fogg Art Museum, Bequest of Grenville L. Winthrop, 1943.634

drawing of Salome holding the head of John the Baptist. A few months later, on June 8, 1893, at Oscar Wilde's request, the publisher John Lane offered the twenty-one-year-old artist a contract to illustrate the English version of Wilde's play *Salome*, which was published on February 24, 1894.[2] Beardsley's work for these books constitutes almost 500 double-page, full-page, and smaller drawings and reveals the astoundingly quick development of his style from stiltedly imitative Pre-Raphaelite scenes to the flowering of succinctly ornamented and deftly balanced compositions.

The *Salome* contract required a cover and ten drawings; Beardsley made nineteen.[3] *The Peacock Skirt* was published facing page 2. A border of three narrow lines and the play's major motifs, including the moon, peacocks, and Princess Salome herself, link the illustrations. Before Beardsley, pictures were not linked either to one another or by symbols in a text, nor did they rivet attention through the dramatic tension created by judiciously arranged areas of blacks on white paper. On the publication of *Salome*, many critics registered disgust with the drawings; the *Times*, for example, declared that they were "grotesque, unintelligible [and] repulsive."[4]

This drawing links Salome with two of Wilde's major motifs: peacocks and the moon. The peacock at the left formally balances the drawing and also refers to a later event in the play. Desirous of seeing Salome dance for him, Herod offers in exchange fifty of his "beautiful white peacocks" with gilded beaks and purple feet, which will follow her wherever she goes.[5]

Herod imagines his exquisite peacocks as a "great white cloud" that will surround Salome, making her like "the moon."[6] Encircling one peacock with a cloudlike nimbus, Beardsley links plumage, Salome's feathered headpiece, and the moon, subtly articulating Wilde's verbal text.

Salome's beauty hypnotizes the young Syrian captain shown next to her, who repeatedly sighs, "How beautiful is the Princess Salome to-night!"[7] He faces Salome, his legs deliberately and firmly planted, his right hand hooked into a low fold of his pleated, togalike costume. The cincture and his exaggerated shoulders anchor the material, which ends in wisps flying left and right, suggesting that he is turning toward her. The attire of the two contrasts in bulk, but their hairstyles match, although pearls adorn Salome's. The Syrian gestures with his left hand, perhaps to silence the unseen page of Herodias, who predicts that "something terrible will happen" if the captain looks "too much" at Salome.[8] The line formed by his hand and Beardsley's emblem above it suggests a wall that halts movement and isolates the two figures.

Beguilingly and, because of her relative size, almost threateningly, Salome leans toward the young Syrian in three-quarter profile, encased in the robe that gives its name to the picture. The bottom of her kimono bears the Japanese decoration that Beardsley adapted in late 1892, while her tulle-and-peacock-feather headdress—blending Roman and modern styles—sways.[9] Her skirt is in fact adorned not with peacocks but with slivers of moon and

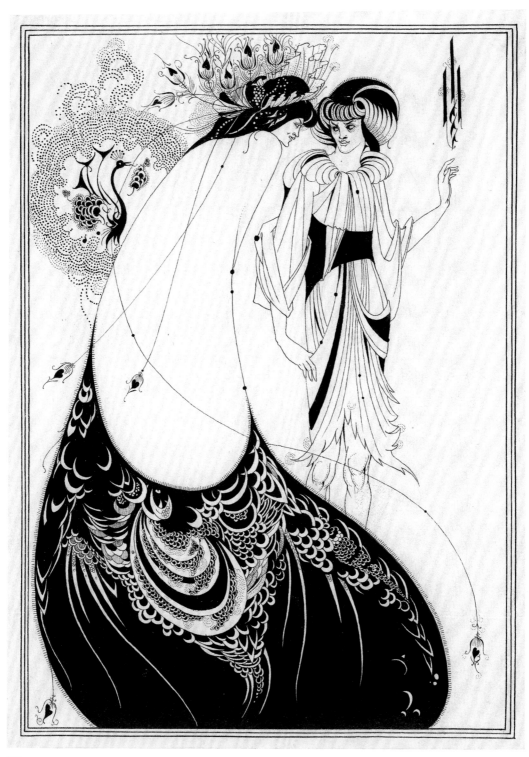

139

adaptations of Japanese fish-scale patterns. The dense patterning, some of which is repeated in the peacock's body, lends the skirt a bejeweled appearance. Beardsley effects Salome's movement in two ways: he drapes her full skirt to the viewer's right, suggesting that she has just stepped to her left. And he positions the feathers on her head with the two drifting to the left and

down along her back, leading the eye to the fantastically long feathers that fly around her gown, emphasizing the sense of her movement. Without visible hands or feet, Salome's shape resembles a phallus. Both physically and symbolically, she dominates the scene.

Two characteristics help to date this work to summer 1893. First, the black dots

that punctuate the lines defining the figures and the shafts of the peacock feathers are also found in sketches for the Bon-Mots, which Beardsley began illustrating in autumn 1892 and completed a year later. Second, the tiny hairs used to mediate between large black and white masses in this drawing also turn up in *The Climax, John and Salome* (also in the Winthrop

collection, 1943.651) and *The Stomach Dance* (fig. 159). Their appearance in these drawings suggests that Beardsley made them before the others in *Salome*. In *The Peacock Skirt*, Salome's gown bears these lines, and in *The Stomach Dance* they can be seen between the floor or fringed rug and the blank backdrop. A few months later, in *John and Salome*, Beardsley can be seen moving away from this technique, and in *The Dancer's Reward* (cat. no. 140) the fringe becomes hair on the executioner's arm, with powerful effect.

Linda Gertner Zatlin

1. Biographical details may be found in Beardsley 1949, pp. 75–83; Brophy 1969; Weintraub 1976; and Sturgis 1998.
2. John Lane, letter to Oscar Wilde, June 8, 1893, Harry Ransom Humanities Research Center, University of Texas at Austin.
3. Ibid. Lane wrote, "I have this day seen Beardsley and arranged for 10 plates and a cover for 50 guineas!" Lane monitored the drawings closely for (supposed) erotic details: among the nineteen were replacements for the three he suppressed (though he missed or ignored such details in other drawings); see May 1936, pp. 78–79. Beardsley first mentions a drawing for the English version in a June letter to his friend Robert Ross, directing him to go to the publisher "Elkin Mathews *today*[;] they have a drawing (Salomé) to show you"; Beardsley 1970, pp. 49–50.
4. "Books of the Week," *Times* (London), March 8, 1894, p. 12.
5. Wilde 1894, p. 58.
6. Ibid., p. 59.
7. Ibid., p. 2.
8. Ibid., p. 3; for the influence of Japanese art on this drawing, see Zatlin 1997, pp. 199, 200.
9. Beardsley 1970, pp. 33–36.

PROVENANCE: John Lane, London; his widow, Annie Lane; their sale, Anderson Galleries, New York, November 22, 1926, no. 46d; purchased at that sale by Scott and Fowles, New York; acquired from them by Grenville L. Winthrop, May 6, 1927 ($1,600); his bequest to the Fogg Art Museum, 1943.

EXHIBITIONS: Brussels 1894, no. 72; London 1904, no. 21; Paris 1907, no. 26; Rome 1911, no. 696; Leipzig 1914–17, no. 11; Brooklyn 1923–24, no. 25; Milwaukee–Cincinnati–Rochester 1924–25; Tokyo 2002, no. 48-4.

REFERENCES: Vallance 1897, p. 207, no. 21, illus.; Vallance 1909, no. 86.II; Gallatin 1945, no. 880; Reade 1967, no. 277, illus.; Clark 1979, no. 18, illus.; Zatlin 1990, pp. 119 (illus.), 121.

140. *The Dancer's Reward*, for *Salome*, summer 1893

Black ink and graphite on white wove paper
9 x 6½ in. (23 x 16.5 cm)
Signed with Beardsley's Japanese monogram in black ink, lower left corner
Inscribed on verso, in graphite: The / Dancer's / Reward / from / Salome / ② [crossed out] / 5 [crossed out] / Elkins [sic] Mathews / Wed.; in blue crayon: ⑩
1943.652

For *Salome*, the volume's title page tells us, Beardsley "pictured" the text, but his drawings also interpret Wilde's words. In this drawing, published facing page 56, Salome receives the head of John the Baptist as indicated in the stage directions: "A huge black arm, the arm of the Executioner, comes forth from the cistern [in which Iokannan has been imprisoned] bearing on a silver shield the head of Iokanaan. Salome seizes it."[1] She addresses the head triumphantly, saying with satisfaction, "Ah! Thou wouldst not suffer me to kiss thy mouth, Iokanaan. Well! I will kiss it now. I will bite it with my teeth as one bites a ripe fruit. Yes, I will kiss thy mouth, Iokanaan. . . . Ah! I will kiss it now."

Beardsley captures Salome as she seizes Iokanaan's head, grasping it by the hair with her right hand and fingering his blood with her left. She examines her reward, exulting that his eyes, formerly "so full of rage and scorn," are shut and his tongue, "that scarlet viper that spat its venom upon me . . . stirs no longer." Quickly, victory yields to adoration and longing as she describes her passion, awakened by his body and his voice. Salome's expression matches her words of victory and dismay.

Her figure and the muscled, hairy arm of Naaman the executioner, both dramatically lengthened, pulsate with Salome's thwarted sexuality. She has stepped out of her slippers as if she were going to bed. The opening of her cloak can be seen as a vagina that opens to receive the phallus, shaped by Naaman's arm and Iokanaan's head on the shield. Beardsley uses full-blown roses throughout his work to signal passion. Here, reinforcing the sexual symbolism, they line her cloak and clasp Salome's neck pendant, which is suggestive of a clitoris. The roses, the executioner's armlet, Salome's slippers, her hair, and Beardsley's emblem set off the principal stark black masses. Paralleling the phallic arm, Beardsley's emblem, composed of lines and dots of ink, suggests both male and female genitalia. (The emblem and Salome's discarded slippers anchor and balance the black masses.) Reflecting sexuality thwarted, the faces of Iokanaan and Salome, both with open mouths, are equally white and look equally dead; the blood flowing from John's head and strands of his hair and the widening gap in her cloak imply the only movement in an otherwise static scene. The moon, too, is white, and it links male and female in sex denied. Behind Salome seemingly hangs a crescent moon, and she declares that Iokanaan is "chaste, as the moon is" and "like a moonbeam . . . a shaft of silver." Her perception leads to the final pairing of the two: immediately before Herod orders Salome's death, the stage directions state, a "ray of moonlight falls on Salome and illumines her."

Linda Gertner Zatlin

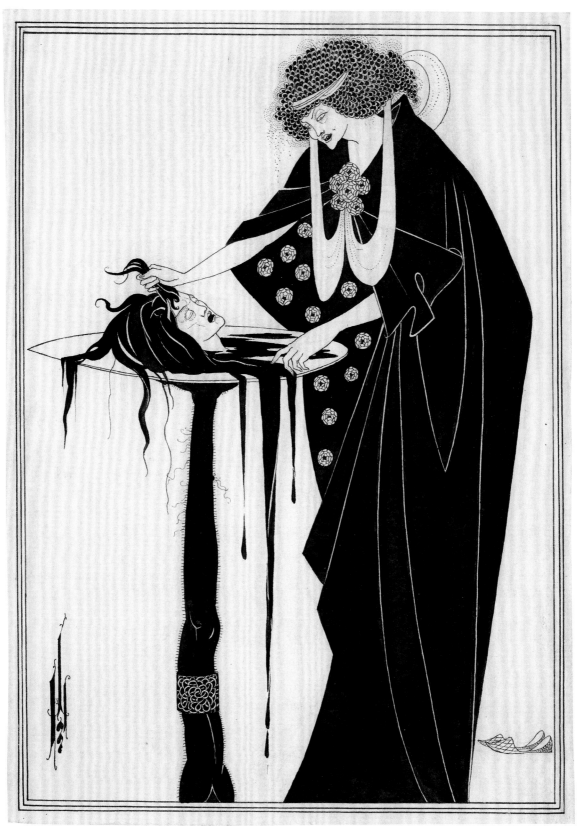

140

1. All quotations in this paragraph are from Wilde 1894, p. 64; in the last paragraph, they are from ibid., pp. 19, 67.

PROVENANCE: John Lane, London; his widow, Annie Lane; their sale, Anderson Galleries, New York, November 22, 1926, no. 46i; purchased at that sale by Scott and Fowles, New York; acquired from them by Grenville L. Winthrop, November 23, 1926 ($1,100); his bequest to the Fogg Art Museum, 1943.

EXHIBITIONS: Brussels 1894; Berlin 1903–4, no. 74; London 1904a, no. 28; Paris 1907a, no. 35; London 1909a, no. 20; Rome 1911, no. 697; Leipzig 1914–17, no. 17; Brooklyn 1923–24, no. 30; Milwaukee–Cincinnati–Rochester 1924–25; Cambridge, Mass., 1944a, no. 3; Tokyo 2002, no. 48-8.

REFERENCES: Vallance 1897, p. 207, no. 22, illus.; Beardsley 1899a, no. 36, illus.; Vallance 1909, no. 86.IX; Gallatin 1945, no. 887; Reade 1967, no. 282, illus.; Clark 1979, no. 22, illus.; Wilson 1983, no. 21, illus.; Zatlin 1990, no. 50, illus.

141. *Isolde,* summer 1895

Black and gray ink and red and green watercolor
on cream wove paper
11⁵/₁₆ x 7 in. (28.6 x 18 cm)
Inscribed in black ink and green watercolor, lower
right: ISOLDE
Inscribed on verso in graphite: Aubrey Beardsley
[crossed out] with instructions to block maker,
difficult to decipher
1943.656

Beardsley was entranced with Richard Wagner's operas, particularly *Tannhäuser, Tristan und Isolde,* and *Das Rheingold,* and he continued through 1896 to make drawings of the major characters at decisive points in their stories. In 1892 he drew the figures of Tannhäuser, perhaps after seeing the opera at Covent Garden during spring or autumn 1891, and of two Wagnerian singers who appeared in *Tristan und Isolde* during June or July 1892. He owned an 1893 copy of the composer's *Quatre Poèmes d'opéras: Le Vaisseau fantôme, Tannhäuser, Lohengrin, Tristan et Iseult* and developed decided opinions about performances, saying, for example, that he would go anywhere to hear "Wagner's music decently rendered."[1]

When Beardsley illustrated J. M. Dent's edition of *Le Morte d'Arthur* (1893–94), he began portraying the story of Tristan and Isolde, together from the time King Mark of Ireland sends his knight to England to bring home Mark's bride, Isolde. One full-page drawing shows the young couple immediately before they unknowingly drink the love potion that binds them together until they die. Another illustration portrays Isolde nursing the wounded Tristan. Two others depict Isolde writing to Tristan and walking in the garden at Tristan's home, Joyous Garde, surrounded by a border of symbols of her adultery. Beardsley intended

to reproduce this drawing in a volume of his collected work, *A Book of Fifty Drawings,* but Charles Holme, editor of *The Studio* magazine, which had published it as a color lithograph, did not release it.[2]

By the summer of 1895 Beardsley had become practiced at stripping away backgrounds and focusing on a figure, adroitly capturing personality through posture and gaze. Such minimalism did not endear Beardsley to the late Victorians, who preferred their art to express a clear narrative and an equally distinct moral. In divorcing art from story and moral, Beardsley followed James Abbott McNeill Whistler, who frequently drew his titles from musical forms and painted his subjects to reflect mood, and he was also influenced by Wilde's paradoxical dictum that art should be, not mean. Revealing both influences in this hand-colored drawing of Isolde, Beardsley places her before a red (theater) curtain, about to drink from the cup that she believes holds poison but in fact contains a love potion. Her name inscribed on the drawing and the chalice identify her as Wagner's tragic heroine, while the tulip-shaped flowers with their vibrant green leaves and the butterfly-wing-like form of her hat suggest the transience of her life. Her clothing calls to mind other Beardsley women. Her hat is reminiscent of Salome's in *The Peacock Skirt* (cat. no. 139) and *The Eyes of Herod* (also in the Winthrop collection, 1943.631) and that of the woman on the right in *Black Coffee* (fig. 160). While the style of Isolde's gown also links her with the modern woman of the 1890s, the suggestively buttoned overskirt, its frilled side panel opening like labia, and the gray of her gown, which is repeated on the bright red curtain, symbolize her adulterous passion. The braided

Fig. 160. Aubrey Beardsley, *Black Coffee,* 1895. Black ink, gray wash, and graphite on white wove paper, 6⅛ x 6¼ in. (15.7 x 15.9 cm). Fogg Art Museum, Bequest of Scofield Thayer, 1986.673

green counterweight of her necklace hangs down her back; a similarly patterned thick bracelet coils around her right wrist. Like the curl of hair on her right shoulder, both pieces of jewelry end in tassels, another Beardsleyesque sexual symbol, but they are also reminiscent of hair jewelry, a customary Victorian memento mori.

Linda Gertner Zatlin

1. Beardsley's copy of the 1893 edition is listed for sale in C[hristopher] S. Millard, bookseller, *Catalogue,* no. 1 (London, 1919); Lawrence 1897, p. 196.
2. Beardsley 1970, p. 159.

PROVENANCE: Charles Holme; Scott and Fowles, New York; acquired from them by Grenville L. Winthrop, February 16, 1924 ($1,400); his bequest to the Fogg Art Museum, 1943.

REFERENCES: "Herkomer School" 1895, illus.; Vallance 1897, p. 205; Beardsley 1899a, no. 24, illus.; Vallance 1909, no. 119; Gallatin 1945, no. 987; Walker 1950, p. 251; Reade 1967, p. 391, illus.; Wilson 1983, no. 39, illus.

ISOLDE

141

142. *Design for Frontispiece of "The Wonderful Mission of Earl Lavender," 1894*

Black ink with traces of graphite on white wove paper
10¼ x 6⅛ in. (25.9 x 15.6 cm)
Signed in black ink, lower right: AUBREY / BEARDSLEY
Inscribed on verso, in graphite: Design for frontispiece / of Earl Lavender; *with instructions to the block maker:* Reduce to 3½ inches; *numbered:* 13 *(in black crayon) and* 58 *(in blue crayon)*
1943.641

Following the immense succès de scandale of his illustrated edition of Wilde's *Salome* in February 1894, and the publication of the first number of *The Yellow Book* in the middle of April, Beardsley found himself not only notorious but also much in demand. Besides designing covers and illustrations for John Lane and Elkin Mathews of the Bodley Head publishing company, he was approached by a number of other publishers anxious to cash in on the "Beardsley boom." As a result, in this annus mirabilis he carried out a considerable number of commissions for posters, theater programs, and other miscellaneous graphic items as well as producing illustrations or cover designs for quite a few books that—were it not for Beardsley's distinctive contribution—would now be forgotten.

One such commission came from Ward and Downey, a small London publishing house with which Beardsley seemingly had no previous connection, to provide the frontispiece for a curious book, *Earl Lavender* by John Davidson. Davidson (1857–1909) was a somewhat difficult and cantankerous Scot who earned a hard living by his pen. Although by no means an aesthete or a decadent by temperament, he moved in their circles. By the early 1890s he was intimate with a number of the leading

142

London publishers and literary journalists, and for a while he was a member of the Rhymers' Club, attending their convivial gatherings at the Cheshire Cheese, the celebrated Fleet Street tavern.[1] He also seems to have moved on the fringes of the Cenacle, the coterie of literary and artistic young men that formed around Wilde, an association attested by the survival of copies of two of his books with presentation inscriptions to Wilde.[2]

Lane, the publisher of Wilde, of Beardsley, and of much of the best avant-garde poetry of the 1890s, issued Davidson's *Fleet Street Eclogues* in 1893 and followed it up with a handsome edition of his undoubtedly erudite but largely unactable plays, embellished with a frontispiece and cover by Beardsley.[3] Shortly afterward Davidson was a guest at the dinner held to celebrate the launch of *The Yellow Book*, at the Hôtel d'Italie, Old Compton Street, on April 16, 1894. He sat next to the wife of the Celtic poet Ernest Rhys; she found him, for once, amiable and talkative.

When his "Ballad of a Nun" appeared in the third number of *The Yellow Book*, Davidson found himself arraigned by the popular newspaper critics as a typical example of the moral decline and depravity of the Bodley Head writers. Ironically, by this time his new work, *Earl Lavender*, was already well advanced at the press. Bearing in full the preposterous title: *A full and true account of the wonderful mission of Earl Lavender, which lasted one night and one day: with a history of the pursuit of Earl Lavender and Lord Brumm by Mrs Scamler and Maud Emblem*, the book must have been conceived by Davidson as an attempt to write a modern philosophical and moral romance in the manner of Voltaire.

Only partially successful, the tale concerns the attempts of an elegant young man to pass himself off—under the title "Earl Lavender," a pun on "Earl de l'Avenir" (Lord of the Future)—as the "fittest of all men" and therefore destined to triumph in the Darwinian evolutionary process. He and his companion, "Lord Brumm," having spent all their remaining money, throw themselves upon chance and engage in several adventures, most of which involve eating dinners at the expense of others. A funny episode involves their intrusion into a meeting of the "Guild of Prosemen," a parody of the Rhymers. One of the longest (and, it must be said, least amusing) set pieces relates, with Davidson's usual uneasy mix of satire and puritanical distaste, their involvement with a "Veiled Lady" who introduces them to a sect of flagellants in a basement temple beneath a dubious hotel near Piccadilly Circus.

Perhaps not entirely surprisingly, Beardsley chose this most sensational episode as the subject for his frontispiece. Aware of both the long tradition of books celebrating the "English vice" in the lurid world of pornographic gutter publishing and more elevated treatments of the theme in the works of writers such as Algernon Charles Swinburne, Beardsley depicted the scene with a carefully studied elegance and emotional neutrality. In fact, he captures precisely the tone of Davidson's text and the curiously bourgeois banality of the setting: "Although, while in her company before, the Veiled Lady had not uncovered her face for an instant, Earl Lavender had no difficulty in recognising her as the robed beauty with whom he had just exchanged whippings. It was the individuality of her carriage, along with her unusual height, which betrayed her. All her motions were rapid, graceful and full of precision without being precise; and when she was at rest her stillness was like that of a statue—of Galatea waking into life."[4]

With a further twist of irony, *Earl Lavender* appeared early in 1895 just as the fateful sequence of events that led to Wilde's downfall began to unfold.[5] Artists and writers who were perceived to belong to the decadent camp found themselves obliged to make their positions clear. Davidson distanced himself rapidly from his former acquaintances; he was among those who signed the ultimatum instigated by William Watson demanding that Lane dismiss Beardsley from *The Yellow Book* and remove all his and Wilde's works from the Bodley Head list.

Stephen Calloway

1. Davidson later broke with the Rhymers. W. B. Yeats recalled that he came to believe that they "lacked blood and guts" and "saw in delicate, laborious discriminating taste an effeminate pedantry." Finally he burst out that "if a man must be a connoisseur, let him be a connoisseur in women." See Yeats 1955, p. 317.
2. See Wilde 2000, p. 1114 n.
3. Davidson 1894. Lasner (1995, no. 58) notes that it was published on February 12, 1894; *Salome* was published on February 24, 1894.
4. Davidson 1895, p. 129.
5. Lasner (1995, no. 82) notes that it was published in February 1895. The marquess of Queensberry left his defamatory card at Wilde's club on February 28.

PROVENANCE: Commissioned from the artist by Messrs. Ward and Downey, publishers, London, 1894; John Lane, London, before 1903; his widow, Annie Lane; their sale, Anderson Galleries, New York, November 22, 1926, no. 50 ($650); purchased at that sale by Scott and Fowles, New York; acquired from them by Grenville L. Winthrop, September 9, 1927 ($1,000); his bequest to the Fogg Art Museum, 1943.

EXHIBITIONS: Chicago 1911, no. 55; Cambridge, Mass., 1969, no. 113.

REFERENCES: Beardsley 1899a, pl. 87; Gallatin 1903, p. 33; Vallance 1909, p. 99, no. 124; Gallatin 1945, no. 971, p. 56; Reade 1967, no. 383, pl. 381; Lasner 1995, no. 82.

143. *Ali Baba* (design for the cover of a projected edition of *The Forty Thieves*), 1897

Black ink touched with white gouache, with traces of graphite, on white wove paper
9½ x 7¾ *in. (24 x 19.8 cm)*
Signed lower left: AB.
Inscribed on verso with instructions to the block maker and the address of the publisher: 4½ x 6½ mount; same size / reduce to / 9½ inches / in length *[crossed out]* / Leonard Smithers / 4 Royal Arcade / Old Bond St / London W
1943.647

This boldly conceived design was intended for the cover of a projected, but ultimately abandoned, volume of tales drawn from the *Arabian Nights*. It is one of the finest drawings Beardsley made between the late summer of 1896 and the last months of 1897, when his worsening state of health and financial problems conspired to make it ever more difficult for him to fix upon a definite project and carry it through. He flitted from one idea to the next, exasperating even Leonard Smithers, his indulgent publisher and by now virtually his sole employer. Paradoxically, Beardsley drew at this moment with a greater assurance than ever before. Although he still occasionally employed the large bold areas of solid black characteristic of his *Yellow Book* designs, many of his drawings of this period reveal a richer use of dense ornament, while his draftsmanship is more taut and muscular, and his sense of design is imbued with a new and powerful spareness.

Despite grand premises and an opulent lifestyle, Smithers, whose business methods were always erratic, now was also in somewhat precarious financial circumstances, his resources stretched in particular by the rash decision to bring out *The Savoy* as a monthly rather than a quarterly publication.[1] As a result, and no doubt adding to his own personal worries, Beardsley became aware that even if Smithers were

able to pay for drawings (and his remittances were slow to arrive and his checks all too often postdated), the publisher might lack the resources to pay block makers, printers, and binders and thus actually complete and bring out the books. Nevertheless, the two remained firm friends, writing every few days and, to judge from Beardsley's letters that have been preserved, peppering their discussion of practicalities with teasing wit and flashes of scurrilous humor.

The richer survival of letters from this period of Beardsley's life than from any other allows us to trace the whole trajectory of this project from the characteristically enthusiastic beginnings to the point at which it finally languished. Beardsley's first mention of the idea of illustrating the Ali Baba stories is found in a letter to Smithers on July 3, 1896: "I shall have finished *Lysistrata* in a week from now. . . . What about the Christmas book. Is it to be *Amlet* or the *40 Thieves*? The latter I think judging from your account would give me plenty of chance."[2] On July 6 he wrote: "I think the *forty thieves* will be my best choice," adding that "I fancy that I shall do the pictures in a very superior *Morte Darthurian* manner."[3] Four days later he thanked Smithers for the loan of his copy of the "*Nights*," promising to take great care of it and enthusing that "*Ali Baba* will make a scrumptious book."[4]

On July 13, Beardsley wrote again, clearly having given it some thought: "The book I take it will be the same size as the *Rape* [*of the Lock*]."[5] Just two days after that he wrote to his friend and patron André Raffalovich: "The *Forty Thieves* will be my Christmas book. It's great fun illustrating it. . . ."[6] Yet it was not until May 1897, by which time he was listlessly moving from

hotel to hotel in and around Paris, that he seems to have taken up the project again.

We first hear of the present sheet in a letter of May 7, 1897, to Raffalovich: "I have just finished the cover for *Ali Baba*, quite a sumptuous design."[7] He posted the original drawing to Smithers in London on May 17. Unusually, he had made a considerable number of corrections and small additions to the ink drawing using white body color; his accompanying note contained an urgent injunction to be passed on to the block makers: "The cover has a good deal of chinese white on it, so beg them *not* to *rub* or *touch* the drawing at Naumanns."[8] The following week, perhaps in response to a suggestion by Smithers to cut costs in blocking the cover, Beardsley wrote, "Certainly I think the *Ali Baba* should be printed in gold."[9]

Clearly pleased, Beardsley wrote to a new Parisian acquaintance, the influential writer Octave Uzanne, that he had asked Smithers to send him a proof copy of the design.[10] However, in a note a few days later to his friend Herbert Pollitt, he admitted, "I haven't done a stroke of work since I left England save a couverture for *Ali Baba*."[11] After this there is no mention of the *Arabian Nights* for months until, pressed by the evidently impatient Smithers regarding several possibilities, Beardsley wrote in November, "All right, *Ali Baba* be it."[12]

By this time he had conceived a second, more purely ornamental cover design for the book. It was "within an ace" of being finished, he reported, and he promised to send it "in twenty-four hours or so."[13] Perhaps not wishing the original design to be wasted, he asked Smithers: "Have you had a block made of the other? If so, will you send me a proof? I should like to see if it is at all suitable for the prospectus, but

143

I recollect that there is too much black in it. . . . I should advise you undoubtedly to print it in black or red upon yellow, as a *posterette* card for shops."[14]

Smithers must have sent a proof by return, for on November 14 Beardsley replied: "The proof is *capital* and after all will make the best cover."[15] He immediately decided to put the second design to use for another project, changing the small panel of lettering at the center of the swirling design to read *Volpone*. From this point we hear no more of *Ali Baba*. A few days later, with tuberculosis consuming his lungs, Beardsley boarded the train to Mentone, on the Riviera. In the few months that

remained to him he struggled to complete the handful of designs that ornament his last book, the posthumously published edition of Ben Jonson's dark masterpiece.[16]

Stephen Calloway

1. Edited by Arthur Symons and financed entirely by Smithers, *The Savoy* commenced as a quarterly, the first number appearing in January 1896. From no. 3, July 1896, it was issued monthly until publication ceased with no. 8 in December. See Lasner 1995, no. 103.
2. Beardsley 1970, p. 141.
3. Ibid., p. 142.
4. Ibid., p. 143.
5. Ibid., p. 144.
6. Ibid.
7. Ibid., p. 315.
8. Ibid., p. 319.
9. Ibid., p. 324.
10. Ibid., p. 327.
11. Ibid., p. 329.
12. Ibid., p. 389.
13. Ibid.
14. Ibid.
15. Ibid., pp. 390–91.
16. Lasner 1995, no. 129.

PROVENANCE: Commissioned from the artist by Leonard Smithers, 1897; Messrs. Robson and Co., by 1909; Fitzroy Carrington, New York, by 1911; Scott and Fowles, New York; acquired from them by Grenville L. Winthrop, September 20, 1921 ($1,200); his bequest to the Fogg Art Museum, 1943.

EXHIBITION: Chicago 1911, no. 79.

REFERENCES: Beardsley 1899b, p. 175, no. 41; Gallatin 1900, p. 4; Beardsley 1901, pl. 153; Gallatin 1903, p. 43; Vallance 1909, p. 109, no. 157 (i); Gallatin 1945, p. 66, no. 1057; Reade 1967, no. 458, pl. 458; Beardsley 1970, pp. 96, 141 n., 142–45 passim, 147, 315, 319, 324, 327, 329, 389 and n., 390, 391.

William Blake

London, 1757–London, 1827

144. *Christ Blessing*, ca. 1810

Tempera on canvas
30⅛ x 25 in. (76.5 x 63.5 cm)
1943.180

This is one of a set of four paintings in "Fresco" that were made for William Blake's great patron Thomas Butts about 1810 and are unusual for Blake in the scale of their figures. The works, perhaps along with others that Butts owned, formed an iconographic scheme in his house, though their precise arrangement is not known. The others are *Adam Naming the Beasts*, signed "Fresco by Willm Blake 1810" (fig. 161); *Eve Naming the Birds* (fig. 162); and *The Virgin and Child in Egypt*, signed "Fresco by Willm Blake 1810" (fig. 163).¹ The sequence of the paintings expresses the idea of Christ and the Virgin Mary as the "Second Adam" and "Second Eve." Adam and Christ, and Eve and the Virgin, are united by the beautiful interplay of the hands; Adam's naming of the serpent is alluded to in Christ's gesture of blessing, as is Eve's naming of the birds in Mary's presentation of the Savior. Yet, in accordance with the mundane perceptions of fallen humanity, Adam treats the serpent merely as a beast and not as Satan, while Eve's gaze does not follow the birds heavenward. Christ and Mary, by contrast, represent exultant humanity freed from the world, the latter represented in both images by the setting in an "Egyptian" landscape with pyramids, symbolic for Blake of the material world.

Blake called the medium of the four paintings "Fresco," though in reality it was far from that used in early Italian wall paintings. It was in fact a form of tempera, involving watercolor within layers of a glue medium, and it had first been used in a series of biblical paintings for Butts in 1799–1800.² Blake's exhibition of 1809 was largely devoted to his "rediscovery" of fresco, the medium of "All the little old Pictures, called cabinet Pictures." Fresco, he claimed, had been unfortunately superseded by oil painting, which "will not drink or absorb Colour enough to stand the test of very little Time and of the Air." Blake's fresco, by contrast, is "properly Miniature, or Enamel Painting; every thing in Fresco is as high finished as Miniature or Enamel, although in Works larger than Life. The Art has been lost: I have recovered it."³ Blake's claims are far-fetched, but it is true that his tempera paintings of this period have generally survived in much better condition than those of 1799–1800, in many of which the paint has come away from the support. This suggests that by 1809–10 he had found ways to stabilize his pigments, with the consequence that the *Christ Blessing* is in relatively fine condition.

David Bindman

Fig. 161. William Blake, *Adam Naming the Beasts*, 1810. Tempera on canvas, 29½ x 24¼ in. (75 x 62.2 cm). Pollok House, Glasgow; Stirling Maxwell Collection

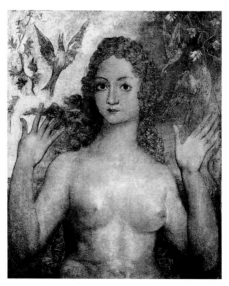

Fig. 162. William Blake, *Eve Naming the Birds*, 1810. Tempera on canvas, 28¾ x 24¼ in. (73 x 61.5 cm). Pollok House, Glasgow; Stirling Maxwell Collection

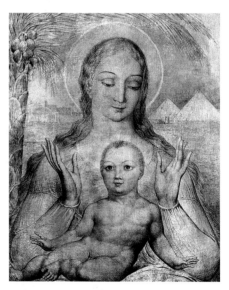

Fig. 163. William Blake, *The Virgin and Child in Egypt*, 1810. Tempera on canvas, 30 x 25 in. (76.2 x 63.5 cm). Victoria and Albert Museum, London

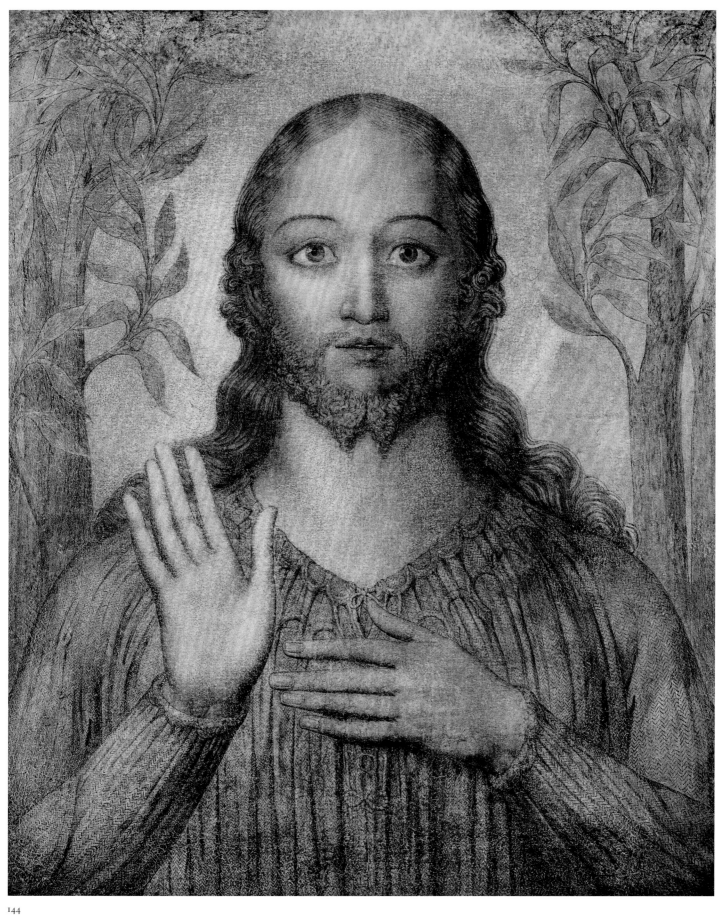

144

BRITISH SCHOOL 339

1. Butlin 1981, nos. 667–69. *Christ Blessing* is no. 670.
2. See Bindman 1977, pp. 115–31.
3. Advertisement for Blake's "Exhibition of Paintings in Fresco, Poetical and Historical Inventions," London, 1809; Erdman 1965, p. 518.

PROVENANCE: Thomas Butts; Thomas Butts Jr.; his sale, Foster's, June 29, 1853, no. 74 (as "The Saviour"); purchased at that sale by J. C. Strange; Francis Harvey, London; James Jackson Jarves, by 1876; his daughter Mrs. Annabel Kerr; anonymous sale (Kerr's?), Christie's, London, July 17, 1925, no. 51 (£189; bought in); purchased from her by Scott and Fowles, New York; acquired from them by Grenville L. Winthrop, January 4, 1930 ($25,000); his bequest to the Fogg Art Museum, 1943.

EXHIBITIONS: London 1876, no 127 ("Head of Our Saviour"); Boston 1891, no. 14; on loan to the Tate Gallery, London, January 1, 1927–December 31, 1928; Tokyo 2002, no. 22.

REFERENCES: Gilchrist 1863, vol. 2, p. 231, no. 201; Wilson 1927, p. 316, pl. 18; Keynes 1957, p. 34, no. 122; Keynes 1971, p. 156; Bindman in Hamburg 1975, no. 113, fig. 76; Bindman 1977, p. 171; Butlin in London–Manchester 1978, no. 214, fig. 18; Butlin 1981, no. 670; Lister 1986, no. 50, illus.; Essick 1989, pl. 8; Bowron 1990, fig. 29; Eaves 1992, p. 198, fig. 4.13; Stafford 1994, p. 207, fig. 145.

145. *The Body of Abel Found by Adam and Eve; Cain, Who Was about to Bury It, Fleeing from the Face of His Parents,* ca. 1809–21

Watercolor, black ink, and graphite on cream wove paper
11⅞ x 12⅞ in. (30.3 x 32.6 cm)
1943.401

One of Blake's most dramatic watercolors, this is taken by Martin Butlin, Geoffrey Keynes, and Robert N. Essick and Joseph Viscomi[1] to be the "drawing" exhibited in Blake's famous exhibition of 1809 as "The body of Abel found by Adam and Eve; Cain, who was about to bury it, fleeing from the face of his Parents."[2] It is one of a group of four watercolor drawings—and the only one of the four, all of which have survived,[3] not to have belonged to Thomas Butts—that "the Artist wishes were in Fresco, on an enlarged scale to ornament the altars of churches, and to make England like Italy, respected by respectable men of other countries on account of Art."[4] Whether or not it can be identified with the work in the 1809 exhibition, it is beyond doubt the one John Linnell mentioned in his journal for September 11, 1821: "Mr Blake Brought Drawing of Cain & Abel."[5] Linnell began copying it the next day, and at some point it entered his collection, remaining with the family until 1918. Given the absence of other candidates it is more likely than not to have been the version in the 1809 exhibition, but the intensely expressive use of light and atmosphere points more to a date in the early 1820s. Whatever its date it is one of Blake's most convincing exercises in the sublime, and its relationship to the work of Fuseli, particularly in the figure of Eve, was remarked upon by Anthony Blunt.[6] There is also a late version of the composition in tempera, of about 1826, in the Tate Gallery, London.[7]

The inclusion of Adam and Eve, as William Vaughan has pointed out, must derive from Solomon Gessner's poem *The Death of Abel*[8]—and the watercolor drawing's theme may be understood by reference to the brief dramatic work, entitled *The Ghost of Abel* and dated 1822, executed in Blake's illuminated printing.[9] Although the action of that drama begins after Abel's parents have found his body and Cain has already fled, it opens with a scene reminiscent of the watercolor drawing: "Eve fainted over the dead body of Abel which lays near a Grave. . . . Adam kneels by her." *The Ghost of Abel*, "A Revelation in the Visions of Jehovah," is addressed "To Lord Byron in the Wilderness," presumably in response to the latter's *Cain: A Mystery* of 1821.[10] The theme of Blake's brief dramatic work is, like much of his late writing, the necessity of forgiveness, even of such a horrific crime as murder. "The Voice of Abel's Blood," invoking the "Elohim of the Heathen [who] Swore Vengeance for Sin," calls out for vengeance but in doing so calls up Satan. The last word, however, is given to the "Elohim Jehovah . . . All Clothed in Thy Covenant of the Forgiveness of Sins," for he is the Christ who will come to redeem the progeny of Adam and Eve.

David Bindman

1. Butlin 1981, no. 664; Keynes 1976, p. 60; Blake 1993, p. 222.
2. Erdman 1965, p. 539.
3. *The Soldiers Casting Lots for Christ's Garment*, 1800 (Fitzwilliam Museum, Cambridge), Butlin 1981, no. 494; *Jacob's Ladder*, ca. 1805 (British Museum, London), ibid., no. 438; *The Angels Hovering over the Body of Jesus in the Sepulchre*, ca. 1805 (Victoria and Albert Museum, London), ibid., no. 500.
4. Erdman 1965, p. 538.
5. Quoted in Butlin 1981, p. 481.
6. Blunt 1959, pp. 40–41.
7. Butlin 1981, no. 806.
8. Vaughan 1979, pp. 107–9.
9. Blake 1993, pp. 220–27, illus. pp. 244–45.
10. See Tannenbaum 1975, pp. 350–64.

PROVENANCE: Acquired from the artist by John Linnell; his sale, Christie's, London, March 15, 1918, no. 157 (£105); purchased at that sale by Frank T. Sabin; Gabriel Wells, New York; acquired from him by Grenville L. Winthrop, 1922 ($1,275); his bequest to the Fogg Art Museum, 1943.

EXHIBITIONS: London 1809, no. 11 (?); Cambridge, Mass., 1947, p. 13; Cambridge, Mass., 1977b, no. 4; Tokyo 2002, no. 38.

REFERENCES: Keynes 1957, p. 2, no. 15b; Blunt 1959, pp. 40–41; Bentley 1969, p. 274; Keynes 1971, pp. 145–46; Todd 1971, pp. 122–25; Schiff 1973, pp. 289, 605; Keynes 1976, pp. 39–45, 60–61, pl. 9; Bindman 1977, p. 237, n. 17; Butlin in London–Manchester 1978, no. 312; Butlin 1981, no. 664, pl. 596; Maheux 1984, pp. 124, 128; Lister 1986, no. 73; Butlin 1990, p. 168; Blake 1993, p. 222.

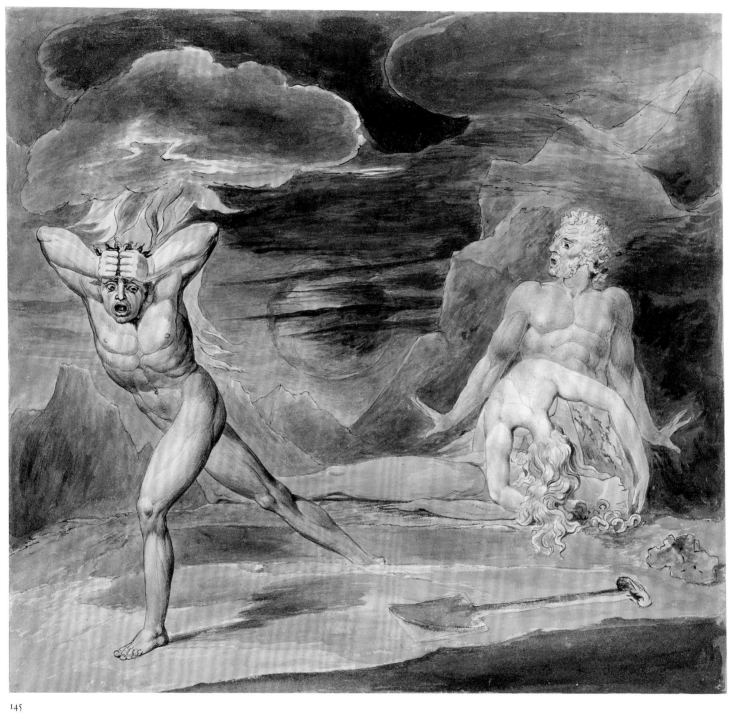

145

Two Watercolors from *The Book of Job*

These watercolors have been selected from the Linnell, or second set of twenty-one images, of which nineteen are in the Winthrop collection, the other two having been sold separately by Gabriel Wells. The Linnell set is known to have been made in 1821 and is based on the earlier Butts set of about 1805 (Pierpont Morgan Library, New York), which also contains two designs that probably date from after the 1821 set.[1] The circumstances behind the production of the Linnell set are precisely documented. John Linnell (1792–1882), a young landscape and portrait painter who befriended and supported Blake in his last years,[2] commissioned the set from Blake in 1821, tracing the outlines himself from the first set, lent by Thomas Butts, and leaving them for Blake to color. In his journal Linnell notes under September 7, 1821, "Traced outlines &c.

from Mr Blakes drawings of Job—all day—Mr Blake and Mr Read[3] with me all day," and on Monday, September 10, he "traced outlines &c from Mr Blakes drawing of Job—all day— . . . Mr Blake took home the drawing of Job."[4] In fact they are substantially freer and more dramatic in color than the Morgan Library set, and differences between them suggest that Blake did not confine himself rigorously to Linnell's traced lines. The designs received their final major incarnation in the celebrated set of engravings *Illustrations of the Book of Job*, which Blake published with Linnell early in 1826.[5]

Blake's interpretation of the biblical Book of Job in his watercolors and engravings has given rise to a number of rich and detailed interpretations since Joseph Wicksteed's *Blake's Vision of the Book of Job*, first published in 1910. In brief Blake

transforms Job, in defiance of the Old Testament account, into an archetypal man who falls from spiritual complacency into despair until he is redeemed through Christ. The tormented visions of destruction and suffering (nos. 2–11) are pictured as the consequence of his own spiritual distress. But he achieves sufficient self-knowledge to pass from acceptance of the vengefulness of the Old Testament Jehovah, who releases Satan upon him, to an understanding that the merciful Christ is the true Savior. Christ leads him, in a series of three visionary enactments of human history (nos. 14–16), to an understanding of the world, and in the final images to redemption in the spirit. Of the two watercolors exhibited, one represents the phase of Job's fall and the other of his redemption.

David Bindman

146. *Thy Sons and Thy Daughters Were Eating and Drinking Wine*, number 3 of *The Book of Job*, 1821

Watercolor, black ink, and graphite on cream antique laid paper
11½ x 8⅞ in. (29.2 x 22.4 cm)
1943.419

In the third design, God has unleashed Satan upon Job's family in his eldest son's house, killing all the latter's brothers and sisters. Satan occupies the place of Jehovah's throne, for Job's despair makes him imagine a world in which Satan is in the ascendant. The outlines follow those of the version in the Morgan Library set, but in the final engraved version Satan appears to be grinning mischievously (fig. 164).

David Bindman

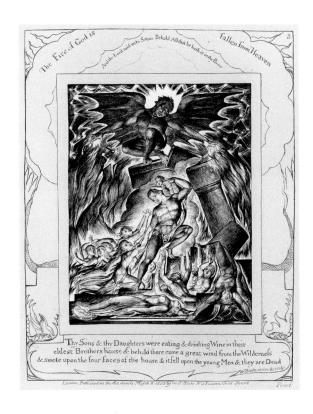

Fig. 164. William Blake, *Thy Sons & thy Daughters were eating and drinking Wine*. Plate 3 of *Illustrations of the Book of Job*, 1826. Engraving, plate 8⅝ x 6¾ in. (22 x 17.2 cm). Yale Center for British Art, New Haven; Paul Mellon Collection (photo: Joseph Szaszfai, Yale Center for British Art)

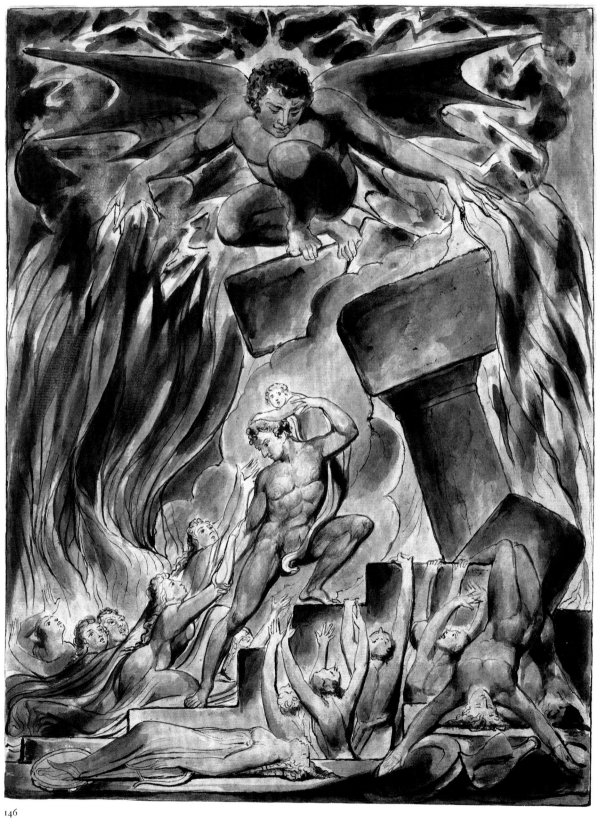

146

147. *Behold Now Behemoth Which I Made with Thee,* number 15 of *The Book of Job,* 1821

Watercolor, black ink, and graphite on cream antique laid paper
10⅞ x 7⅞ in. (27.5 x 20 cm)
Watermark: GM
1943.415

The fifteenth image belongs with the phase of Job's redemption when, having recognized the mercy of Christ, he is guided by the latter through the spiritual history of mankind. In the previous plate, number 14, Job, his wife, and the three Comforters are given a vision of the creation of the Earth. In the present design Behemoth and Leviathan, the warlike and brutal rulers of land and sea, represent a materialist vision of the fallen world, the one in which Job lived until he saw Christ, and in which

Blake's contemporaries still live. Design number 16 shows the final demon to be cast out before redemption: Satan himself. In the Linnell version of number 15, Blake for the first time adds a profusion of stars in the sky, which remain prominent in the engraved version (fig. 165).

David Bindman

1. Nos. 17 and 20; Butlin 1981, pp. 410–11, no. 550.
2. For a documentary account of Linnell's lifelong contribution to the publication and sales of the *Illustrations of the Book of Job* engravings, see Bindman 1987.
3. David Charles Read (1790–1851) was a watercolorist and drawing master in Salisbury, who fell out with Linnell soon after. Read's chief claim to fame is that he corresponded with Goethe, who mistakenly thought that Read was a leading light in the English school of watercolor painting.
4. Bindman 1987, p. 104.
5. Reproduced in facsimile, ibid., vol. 2.

PROVENANCE FOR CAT. NOS. 146 AND 147: Commissioned from the artist by John Linnell, 1821; his sale, Christie's, London, March 15, 1918, part of no. 149; purchased at that sale by Frank T. Sabin; Gabriel Wells, New York, by 1921; acquired from him by Grenville L. Winthrop, July 10, 1922 (cat. no. 146), and January 4, 1923 (cat. no. 147); his bequest to the Fogg Art Museum, 1943.

EXHIBITIONS: London 1876, nos. 40, 57; Cambridge, Mass., 1947, pp. 3, 5.

REFERENCES: Binyon and Keynes 1935, vol. 1, pp. 24, 37, vol. 3, whole series reproduced; Bentley 1969, pp. 273–74; Lindberg 1973, pp. 212, 299, nos. 3C, 15C; Bindman 1977, p. 208; Butlin 1981, nos. 551, 3 and 15; Maheux 1984, p. 128, fig. 3; Bindman 1987, whole series reproduced in relation to other versions.

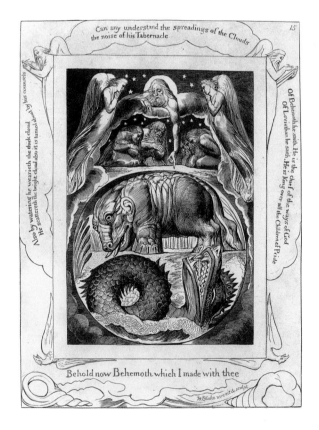

Fig. 165. William Blake, *Behold now Behemoth which I made with thee.* Plate 15 of *Illustrations of the Book of Job,* 1826. Engraving, 8 x 6 in. (20.2 x 15.3 cm). Yale Center for British Art, New Haven; Paul Mellon Collection (photo: Joseph Szaszfai, Yale Center for British Art)

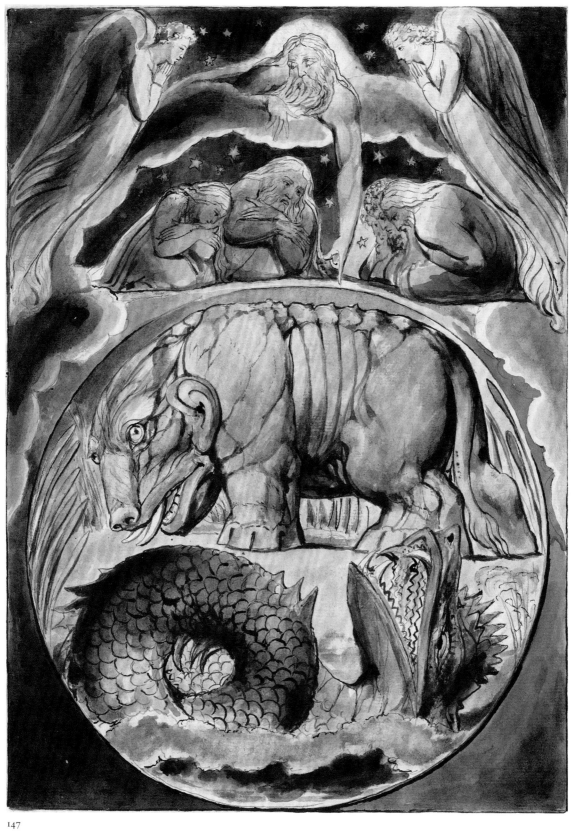

147

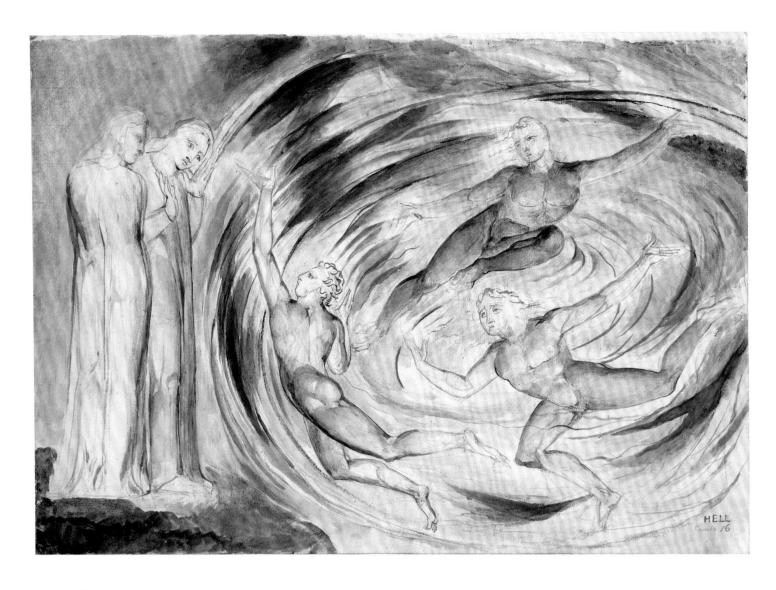

148. *The Punishment of Jacopo Rusticucci and His Companions*, 1824–27

Watercolor, black ink (with scratchwork),
graphite, and black chalk on off-white antique
laid paper
14⅝ x 20⅝ in. (37 x 52.3 cm)
Inscribed in black ink over graphite, lower right:
HELL; *in graphite, lower right:* Canto 16; *in*
graphite, upper right, along edge: 87
Inscribed on verso in graphite, upper left, along
edge: 88; *upper left, upside down:* Paradise
Canto 27 / v25
Watermark: W ELGAR / 1796
1943. 447

In Blake's 102 illustrations to the *Divine Comedy* by the Italian poet Dante Alighieri (1265–1321), Dante the Pilgrim is identifiable by his red robe and his guide Virgil by his blue robe. In this illustration the two travelers are shown having descended into the Circle of the Violent, the seventh of the nine circles of Hell. They have arrived at the third and last of the rings into which this circle is divided and which is described in canto 16 of "Hell" (*Inferno*), which forms the first part of the *Divine Comedy*. It consists of a plain of burning sand; "Dilated flakes of fire" (14.26) continually fall on it as part of the punishment for the three types of sinners confined to this ring, those who are guilty of violence against God—the blasphemers, sodomites, and usurers. Dante sees "Three spirits, running swift" (16.6) who "issu'd from a troop, / That pass'd beneath the fierce tormenting storm" (16.4–5). As they call out to catch Dante's and Virgil's attention Dante notices the "wounds . . . upon their limbs, / . . . inflicted by the flames" (16.10–11). They "whirl'd round together in one restless wheel. / . . . / . . . each one, as he wheel'd, his countenance / At me directed, so that opposite / The neck mov'd ever to the twinkling feet" (16.21–27). These three are identified as Guido Guerra, Tegghiaio Aldobrandi, and Jacopo Rusticucci, all thirteenth-century Florentine Guelphs. They are just a few of the "naked spirits" (14.18) being punished for the sin of sodomy; from an earlier description of Hell's seventh circle we learn that its "inmost round marks with its seal / Sodom . . ." (11.53–54).

Blake shows Dante and Virgil standing on what looks like a grassy bank rather than

on the "stone-built" (14.79) margin of a river of boiling blood, the Phlegethon, which provides them with the only way of crossing the ring without having to tread on the scorching sand or endure the fiery rain. Nor does he show the burns that Dante describes as "mark'd" (16.11) on the sinners' limbs. Otherwise Blake follows and interprets Dante's text closely as he mostly does in all his illustrations. The expression on Dante's face and his raised hands convey a sense of his grief and sympathy for the sinners followed by his recognition of fellow Florentines whose "deeds and names" (16.60) were known to him. The grouping of the three sinners forms the "restless wheel" of Dante's description, while the vortex in which they are contained suggests their restlessness or, as in the description in canto 14 when they are first seen by Dante, their pacing "Incessantly around" (14.22). It is only Rusticucci who speaks to Dante, and he is thus shown closest to him. Ahead of him is Guerra, "in whose track thou see'st /

My steps pursuing" (16.34–35), and behind is Aldobrandi, "next to me that beats the sand" (16.41); as Dante describes, all three gaze at Dante. The circular motif created out of the reds, yellows, dark blues, and blacks of the fiery rain reinforces the idea of the unceasingness of the sinners' torture and perhaps even suggests the sound of the River Phlegethon heard by Dante and Virgil "Resounding like the hum of swarming bees" (16.3) as it plunges over the precipice that forms the far edge of this ring.

Canto 16 of "Hell" finishes with Dante and Virgil about to be carried on the back of the monster Geryon farther down into the pit of Hell to the next, or eighth, circle at the bottom of the precipice, where in a series of ten ditches or gulfs the fraudulent are punished. This circle is described in cantos 18–30 of "Hell," and Blake illustrated twenty-nine episodes from this part of the *Divine Comedy;* six are among the Winthrop Blakes, two of which are included here (cat. nos. 149, 150).

On the back of this drawing Blake inscribed a canto and line number from "Paradise," the third part of the *Divine Comedy*, presumably thinking of it as a source for an illustration. Such an illustration, which would have shown Saint Peter denouncing the corrupt church, does not appear to have survived if it was even made.

Robin Hamlyn

PROVENANCE: Commissioned from the artist by John Linnell; with Linnell, by 1830; his sale, Christie's, London, March 15, 1918, part of no. 148; purchased at that sale by Alec Martin for the National Art-Collections Fund, London; Scott and Fowles, New York, by 1921; acquired from them by Grenville L. Winthrop, February 5, 1921; his bequest to the Fogg Art Museum, 1943.

EXHIBITIONS: New York 1921, no. 9; Cambridge, Mass., 1947, p. 10; Cambridge, Mass., 1969, no. 98.

REFERENCES: Cary 1819, vol. 1, pp. 136–39 ("Hell" 16.1–53); Gilchrist 1863, vol. 2, p. 218, no. 101 (b¹); Blake 1922, no. 29, illus.; Roe 1953, pp. 84–85, no. 29, illus.; Willard 1953, illus.; Klonsky 1980, pp. 55, 144, illus.; Butlin 1981, no. 812.29; Gizzi in Pescara 1983, p. 109, no. 31, illus.; Maheux 1984, p.128; Cieszkowski 1989–90, p. 170; Nassar 1994, pp. 201, 208, illus.; Hamlyn 1998, illus. facing p. 63; Bindman 2000, pp. 80–81, no. 31, illus.

149. *Virgil Rescuing Dante from the Evil Demons*, 1824–27

Watercolor, black ink, graphite, and black chalk on off-white antique laid paper
20⅝ x 14⅝ in. (52.3 x 36.9 cm)
Inscribed in black ink, lower right: HELL *Canto 23*
Verso: black chalk offset from The Laborious Passage along the Rocks
Inscribed on verso in graphite, upper left: 70; *lower left, along edge:* Hell Canto 24 / v 30
Watermark: W ELGAR / 1796

1943.443

In his reading of the *Divine Comedy* Blake would have quickly noticed that, as described in cantos 21 and 22 of "Hell,"

Dante the Pilgrim is more terrified by the demons in the fifth *bolgia*, or gulf, of the eighth circle than by any other characters he encounters. Canto 23 opens with Dante and Virgil moving in "silence" and "solitude" down toward the sixth *bolgia*. The silently fearful mood heightens the suddenness and physicality of Dante's shock as the demons reappear (he "from far beheld them with spread wings / Approach to take us" [23.37–38]) and then of Virgil's snatching him up to save him "ev'n as a mother that from sleep / Is by the noise arous'd, and

near her sees / The climbing fires, . . . / And flies ne'er pausing" (23.39–42). In the original Italian the demons are called "malebranche," meaning "evil claws," because of their talonlike hands and the hooks, shown by Blake, that they use to attack their victims.

By introducing in the lower left-hand corner a procession of friars, Blake shows his sensitivity to Dante's dramatic and narrative technique: the emotional link between experiences with the demons and, in a simultaneous view into the sixth *bolgia*,

a look at those hypocrites whom they are about to encounter being punished there. These are monks "with hoods, that fell low down / Before their eyes. . . . / . . . Their outside / Was overlaid with gold . . . But leaden all within . . ." (23.61–65). Such compression of different parts of the narrative into a single image echoes what Blake would have seen in woodcut illustrations in the sixteenth-century Italian edition of the *Divine Comedy* that, along with a nineteenth-century English translation by H. F. Cary, he is known to have used when working on his illustrations.

Blake's treatment of these monks is almost certainly a direct borrowing from plate 25 of the series of illustrations for the *Divine Comedy* by his friend John Flaxman. Flaxman made the first of these drawings in Italy in 1792, and a volume of the finished drawings is now in the Houghton Library, Harvard University (see cat. no. 171). Thomas Piroli made outline engravings after these in 1793, and Blake would probably have known them through the first London edition of the series, which appeared in 1807. From a reference in his illuminated book *The Marriage of Heaven and Hell* we know that Blake was aware of Dante's work by the early 1790s; he may have had thoughts of illustrating it even before then since he later accused Flaxman, who was in Italy between 1787 and 1794, of taking his ideas on Dante as his own. So, in Blake's eyes, borrowing from Flaxman might have been entirely legitimate.

As mentioned in catalogue number 148, Blake usually followed Dante's text closely, albeit largely through Cary's translation. For example, in the illustrations for the eighth circle of Hell his rendering of its landscape was fairly consistently guided by Dante's description of the ironlike (that is, gray) color of the rocks ("tutto di pietra di color ferrigno") as opposed to Cary's translation of "ferrigno" as "hue ferruginous" (18.3), or an iron-rust

color. However, in exceptions such as *Virgil Rescuing* and *Agnello Brunelleschi* (cat. no. 150), the artist seems more inclined to follow Cary than Dante in this detail.

Blake's decision to illustrate this rescue scene highlights just how his treatment of subjects from the *Divine Comedy* shows an understanding of the poem that could come only from someone who was both poet and artist and felt some affinity with the autobiographical and visionary nature of the relationship between Dante as Poet and as Pilgrim, which is central to the poem's conception. This sets Blake apart from his only rival as a great Dante illustrator, Sandro Botticelli (1444/45–1510). His affinity emerges most powerfully in the parallel between Blake's stated "fear and trembling"[1] as he embarked on the Dante project and the "fear" (1.18) that assails Dante the Pilgrim as he sets out on his journey at the beginning of "Hell" before meeting his guide, Virgil.

Further, Dante the Poet writing of Dante the Pilgrim also mirrors the role Blake took in his own epic poetry, for example, in the image *Los as He Entered the Door of Death*, which is the frontispiece to his illuminated book *Jerusalem* and which anticipates the illustration *The Inscription over the Gate* (Tate, London) showing Dante and Virgil entering Hell. In Blake's mythology Los stands for the creative imagination, represents Blake himself, and, as the rescuer of Albion (that is, Britain), is seen "in all the terrors of friendship, entering the caves / Of despair & death" (*Jerusalem*, pl. 45 [31], ll. 4–5). Even in real life he locates certain acts of friendship in a visionary dimension and identifies a relationship between himself and fellow artists as that of guide and rescuer. Thus Flaxman is "a Sublime Archangel My Friend & Companion from Eternity" and the painter George Romney (1734–1802) is one "whose spiritual aid has not

a little conduced to my restoration to the light of Art."[2]

Some of Blake's inscriptions on the backs of the Dante drawings provide clues as to how he might have set about working up the series as a whole. The "Hell Canto 24 / v 30" on the verso of *Virgil Rescuing Dante* refers to the subject of two illustrations for *The Laborious Passage along the Rocks*, one of which he had drawn on the next leaf of the sketchbook (Tate). The offset from this on the back of *Virgil Rescuing Dante* would have happened when Blake added watercolor to the recto, with the dampened sheet then absorbing parts of the graphite outline. This offset, together with the fact that the Tate's *Laborious Passage* has "69" inscribed on the back of it and *Virgil Rescuing Dante* has "70" in the same position, identifies these numbers as marking their order in the bound volume in which Blake drew them, though not necessarily the order in which they were executed or in which the subjects are found in Dante's poem.

Robin Hamlyn

1. Samuel Palmer, quoted in Palmer 1892, p. 10.
2. Blake to Flaxman, September 21, 1800, in Blake 1982, p. 710; and Blake to William Hayley, October 23, 1804, in ibid., p. 756.

PROVENANCE: Commissioned from the artist by John Linnell; with Linnell, by 1830; his sale, Christie's, London, March 15, 1918, part of no. 148; purchased at that sale by Alec Martin for the National Art-Collections Fund, London; Scott and Fowles, New York; acquired from them by Grenville L. Winthrop, February 5, 1921; his bequest to the Fogg Art Museum, 1943.

EXHIBITIONS: London 1893, no. 11; New York 1921, no. 13 (as "Virgil rescues Dante from the Evil Demons"); Cambridge, Mass., 1947, p. 11 (as "Dante and Virgil Escaping from the Devils").

REFERENCES: Cary 1819, vol. 1, p. 198 ("Hell" 23.36–57); Gilchrist 1863, vol. 2, p. 219, no. 101 (p¹); Blake 1922, no. 43, illus.; Roe 1953, p. 98, no. 43, illus.; Willard 1953, illus.; Bentley 1969, p. 291; Klonsky 1980, pp. 69, 147, illus.; Butlin 1981, no. 812.43, illus. (verso); Gizzi in Pescara 1983, p. 123, no. 45, illus.; Cieszkowski 1989–90, p. 170; Taylor and Finley 1997, pp. 80–81, no. 76, illus.; Bindman 2000, pp. 108–9, no. 45, illus.

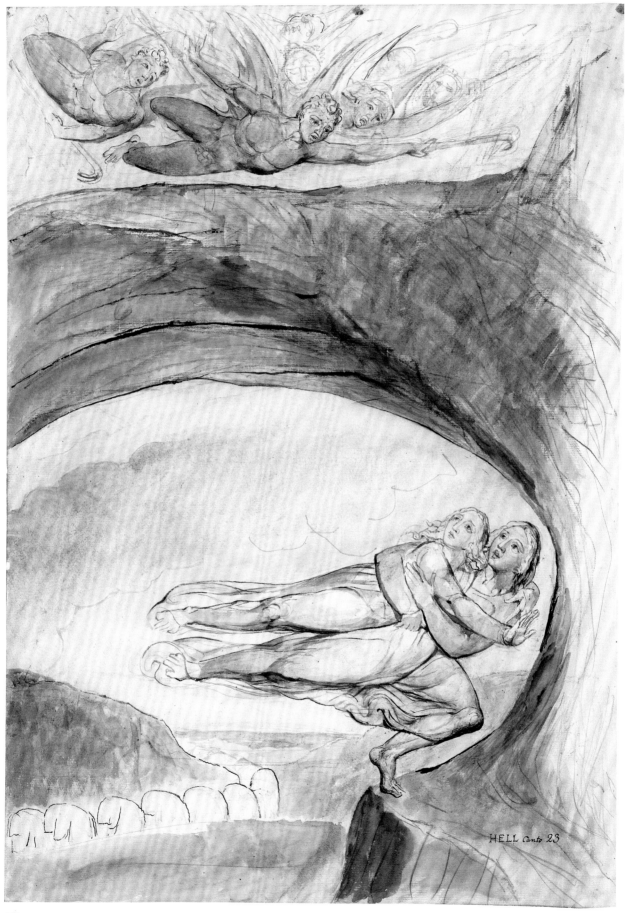

HELL Canto 23

149

150. *Agnello Brunelleschi Half Transformed by the Serpent*, 1824–27

*Watercolor, black ink, graphite, and black chalk
on off-white antique laid paper
14⅝ x 20⅝ in. (37 x 52.3 cm)
Inscribed in black ink, lower right:* HELL *Canto 25
Inscribed on verso in graphite, along right edge:
73 N 48 next at p 57; at center: N 48 next at p 57;
upper left (partly erased):* HELL *Canto 25
Watermark: fleur-de-lis on a shield, crowned, with
monogram* WE *(doubled in mirror image) below
1943.432*

Dante and Virgil leave the hypocrites in the sixth *bolgia*, or gulf, of the eighth circle of Hell and reach the seventh *bolgia* by moving "from crag to crag" (24.33), as Blake illustrates in *The Laborious Passage along the Rocks* (Tate, London [see cat. no. 149], and British Museum, London). Here the thieves are punished by "serpents terrible, so strange of shape / And hideous" (24.80–81). Two cantos (24 and 25) of "Hell" are devoted to Dante's and Virgil's journey toward and through the seventh *bolgia*, and Blake illustrates eleven episodes from it, more than for any other section of the *Divine Comedy*. *Agnello Brunelleschi* is one of the two illustrations from this group that are in the Winthrop collection, the other being *Buoso Donati Transformed into a Serpent* (1943.434).

Agnello Brunelleschi, one of the three shades Dante and Virgil meet in the seventh *bolgia*, is attacked by a six-footed serpent into which the Florentine thief Cianfa Donati had been transformed. The attack, when ". . . Ivy ne'er clasped / A dodder'd oak, as round the other's limbs / The hideous monster intertwin'd his" (25.51–53), is watched by Dante and Virgil and the two other shades, those of the thieves Buoso Donati and Puccio Sciancato (de' Galigai). Blake also illustrated this subject in a watercolor now in the National Gallery of Victoria, Melbourne. *Agnello Brunelleschi Half Transformed* depicts the aftermath of the attack: Buoso and Puccio

exclaim, "Ah! how dost thou change, / Agnello. See! Thou art nor double now, / Nor only one" as human and serpent heads, bodies, and limbs gradually fuse until "Of former shape / All trace was vanish'd." Blake shows the mutated figure, both "Two, yet neither" (25.60–68), as it slowly moves away. The serpent's tail and wings grow out of the new creature's back; its nose, upper lip, and teeth are serpentlike; it has partly human and partly scaled skin and its hands and feet taper into claws.

Dante would have seen this punishment of thieves, when their bodies and minds are stolen from them by serpents in a process of metamorphosis, as an apt and just retribution for their sins: most obviously it looks back to the Temptation and Fall of Man in Eden, when the crafty serpent instigated the stealing of the fruit of the Tree of Knowledge, but a thief's movements were also comparable to those of a serpent's silent creeping. Blake was certainly critical of Dante's scheme of punishments in "Hell"—he said the poet "saw devils where I see none"[1]—but he drew eight illustrations of the serpents at work, two of which he went on to engrave. His concentration on such subject matter reflects the dramatic and pictorial potential found in Dante's descriptions in cantos 24 and 25 but also Blake's own interest in serpent imagery, which can be seen in his work as variously symbolizing evil, hypocrisy, materialism, sexuality, reason, and nature. An image quite close to those inspired by cantos 24 and 25 is his engraving of about 1820, after an antique statue, of the Trojan priest Laocoön and his sons being killed by snakes. Far more comparable with Dante in energy and imagery is the transformation Blake wrought on his own mythological figure of Orc, described at some

length in the vast poem *The Four Zoas* as becoming "a Serpent form augmenting times on times."[2]

The rapidity of Blake's drawing technique evident in many of the 102 Dante watercolors lends some support to the contemporary account that the artist designed them "during a fortnight's illness in bed!"[3] This process must have included a small number of preliminary sketches, some for subjects that he took no further. A few have survived, among them a preparatory drawing for the figure of Agnello showing his head more or less upright and joined to a serpent's body at the back of the skull (Art Institute of Chicago). But as a way of taking us back to the moment of this creature's creation, as seen in the Melbourne watercolor, for the finished transformation scene Blake tilted Agnello's head backward in a calculated allusion to the angle of the serpent's head when it first strikes.

Among the inscriptions found on the backs of many of Blake's Dante drawings the function of those such as "N 48 next at p 57" on *Agnello Brunelleschi* (see also *Lucia*, cat. no. 151) has always been puzzling. The "N" stands for "number" while the "p" for "page" seems to refer to the separate single- or double-digit number also found on the backs of the illustrations. It is important to note that Blake lived long enough to finish or nearly finish seven engravings after the Dante illustrations, and there can be little doubt that he intended to engrave all of them. The optimistic scale of Blake's Dante project was remarkable given the artist's age (he was sixty-seven when he started) and poor health. Indeed it remained unrealized in this form, cut short by his death in August 1827, and the engravings were first published in 1838 by John Linnell. At the time Blake embarked

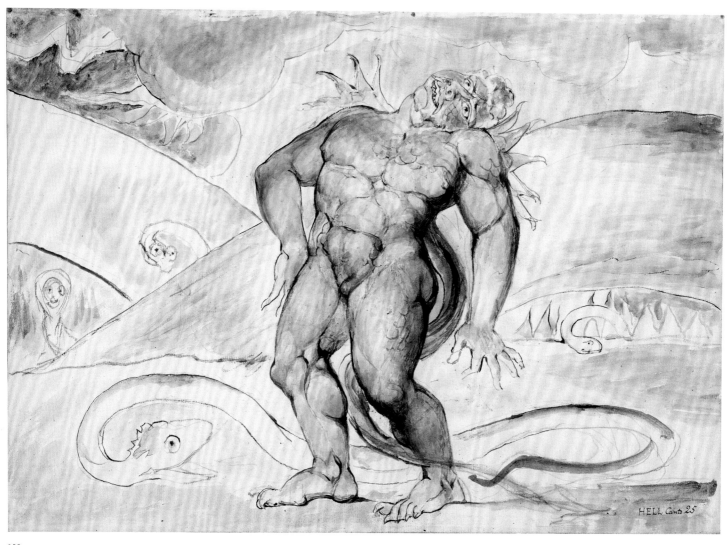

150

on his Dante it was not uncommon for groups of engraved illustrations to literary works to be issued by subscription in a number of "parts" over a period of time. The prints contained in each part did not need to form a single group based on strictly consecutive episodes in the text but rather, as a marketing ploy, could be taken from widely separate episodes as a way of maintaining subscribers' interest until the publication of the final part. Such a pattern is found in the posthumously published Dante plates, which cover cantos 5, 22, 25, 29, and 32 from "Hell." It seems quite pos-

sible, therefore, that Blake's sequence of "N" numbers, imposing as they do a similar episodic variety on the grouping of illustrations, indicates an overall order for the entire set of proposed engravings before its subdivision into separate "parts."

Robin Hamlyn

1. Henry Crabb Robinson, *Diary*, December 10, 1825, quoted in Bentley 1969, p. 313.
2. Blake 1982, p. 373.
3. Samuel Palmer, quoted in Palmer 1892, p. 10.

PROVENANCE: Commissioned from the artist by John Linnell; with Linnell, by 1830; his sale, Christie's, London, March 15, 1918, part of no. 148; purchased at that sale by Alec Martin for the National Art-

Collections Fund, London; Scott and Fowles, New York; acquired from them by Grenville L. Winthrop, February 5, 1921; his bequest to the Fogg Art Museum, 1943.

EXHIBITIONS: New York 1921, no. 14; Cambridge, Mass., 1947, p. 11.

REFERENCES: Cary 1819, vol. 1, pp. 218–19 ("Hell" 25.59–70); Gilchrist 1863, vol. 2, p. 219, no. 101 (y'); Blake 1922, no. 52, illus.; Roe 1953, pp. 108–9, no. 52, illus.; Bentley 1969, pp. 291, 313; Klonsky 1980, pp. 79, 149, illus.; Butlin 1981, p. 555 and nos. 812.52, 823, illus.; Gizzi in Pescara 1983, p. 133, no. 55, illus.; Maheux 1984, pp. 125, 127, 128, illus. (details); Fuller 1988, pp. 369–70; Cieszkowski 1989–90, p. 170; Nassar 1994, p. 289, illus.; Bindman 2000, pp. 128–29, no. 55, illus.

151. *Lucia Carrying Dante in His Sleep*, 1824–27

Watercolor, black ink, graphite, and black chalk on off-white antique laid paper
14¾ x 20⅝ in. (37.2 x 52.2 cm)
Inscribed in black ink over graphite, bottom center:
P-g Canto 9
Inscribed on verso in graphite, center (erased):
N 20 [or 25 or 23]; *upper left (upside down):*
Capaneus / Hell Canto 14; *along left edge:*
N 23 next at p 53; *upper left: 42*
Watermark: fleur-de-lis on a shield, crowned, with monogram WE *(doubled in mirror image) below*
1943.438

Having descended through the nine circles of Hell, Dante and Virgil have emerged at the foot of the Mountain of Purgatory and started climbing it. This stage of their journey is described in the second part of the *Divine Comedy*, which is called "Purgatory." The first eight cantos of "Purgatory" are concerned with their progress through Ante-Purgatory, where they meet the excommunicated and the late repentant. In canto 7, by now accompanied by the poet and courtier Sordello, they look down into the valley of the negligent rulers—those who put worldly duties above the spiritual. The valley is filled with vegetation in brilliant colors that outshine those of "Refulgent gold, and silver thrice refin'd, / And scarlet grain and ceruse, Indian wood / Of lucid dye serene, fresh emeralds / But newly broken" (7.70–73). This valley in all its lushness, with Dante, Virgil, and Sordello about to step down into it to encounter its inhabitants (as they do in canto 8), is illustrated in the Blake watercolor that immediately precedes *Lucia Carrying Dante* in the Blake series, *The Lawn with the Kings and Angels* (National Gallery of Victoria, Melbourne). Eventually, as night falls and the moon rises over the valley of the negligent rulers, Dante the Pilgrim "sank down upon the grass, o'ercome with sleep" (9.10).

Blake illustrates lines in canto 9 describing how, during that sleep, Saint Lucia, followed by Virgil, carries Dante the Pilgrim up toward the entrance to Purgatory. Virgil tells Dante what has actually happened to him, something Dante senses only through a dream in which he is "snatch'd" (9.28) up by a "golden-feather'd eagle" (9.18) toward that sphere of fire lying beyond the air surrounding the earth, the heat of which awakens him: ". . . Ere the dawn / Usher'd the day-light, when thy wearied soul / Slept in thee, o'er the flowery vale beneath / A lady came, and thus bespake me: 'I / Am, Lucia. Suffer me to take this man, / Who slumbers. Easier so his way shall speed'" (9.46–51).

The treatment of this Saint Lucia subject and its highly finished state epitomize Blake's thoughtful approach to illustrating the *Divine Comedy*. Here it has resulted in one of the most beautiful of all the Dante drawings. The power and the richness of the landscape setting are particularly striking. The sky, with its full moon "lucent with jewels" (9.4), the stars of the constellation of Scorpio, and with the aurora of the rising sun, which "Look'd palely o'er the eastern cliff" (9.3), suggests the time span of Dante's deep slumber from evening to the moment of his dream just before first light. These same motifs also signify the role of Saint Lucia (her name alludes to light and daybreak) as the instrument of enlightenment as she bears him toward Paradise. Furthermore Blake, who takes his cue from the "flowery vale" of Virgil's description of events, then looks back to the canto 7 description of this vale as well as to his own rendering of it in the Melbourne watercolor already mentioned. The most dramatic heightening of effect now when compared with the latter is seen in his use of green, produced by mixing gamboge yellow and Prussian blue, in order to truly capture the idea of "fresh emeralds . . . newly broken."

Thus Blake further harmonizes his illustrative narrative with Dante's text but, equally significantly, in doing so shows his understanding of this landscape's symbolic importance in the *Divine Comedy*. Despite its exoticness as described in canto 7 it is still a landscape recognizably of this world and the last such landscape Dante sees before he faces the precipitous climb up the Mountain of Purgatory with its "riven rock" (10.6) of "sullen hue" (13.8). The dramatic effect created by introducing such a contrast between Ante-Purgatory and Purgatory at this point in the poem is obvious. But Blake through his illustrations, as does Dante the Poet for the reader through his verse, also involves the viewer further in Dante the Pilgrim's progress toward redemption as recounted across the entire breadth of the *Divine Comedy*. In particular *Lucia* recalls Blake's equally beautiful illustration of the very beginning of Dante's journey in canto 1 of "Hell" as he emerges from the gloomy wood, now tinted by the beams of the rising sun, and first meets Virgil (National Gallery of Victoria).

And then *Lucia* anticipates the "glimm'ring dawn" ("Purgatory" 27.110) and ". . . the herb / The arborets and flowers, which of itself / This land pours forth profuse" (27.133–35) of the Earthly Paradise at the top of the Mountain of Purgatory. Dante finally reaches this too after a sleep and a dream, an episode

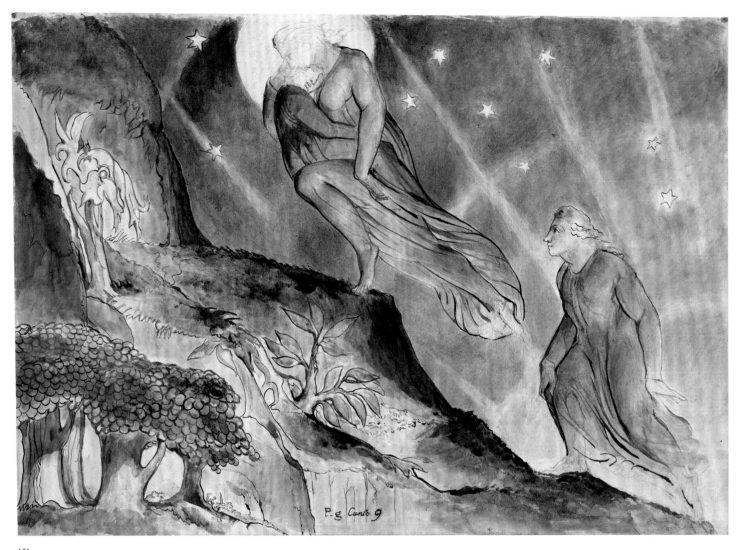

151

Blake illustrated as part of the Dante series (Ashmolean Museum, Oxford). Blake's especially glorious handling of color and light in *Lucia* can of course be seen as having yet another function, for it directly implicates viewers in the action in a way that is comparable to Dante the Pilgrim's own experience at this moment: it is a purely visual means of reminding us that Lucia is the saint invoked as the protector of eyesight, a sense that actually and symbolically can lead us all toward

enlightenment. The "Capaneus" noted on the back of *Lucia* refers to an illustration (National Gallery of Victoria) numbered 43 and thus the next work after *Lucia* in Blake's sketchbook.

Robin Hamlyn

PROVENANCE: Commissioned from the artist by John Linnell; with Linnell, by 1830; his sale, Christie's, London, March 15, 1918, part of no. 148; purchased at that sale by Alec Martin for the National Art-Collections Fund, London; with Charles Ricketts and Charles Shannon, by 1927; acquired from them through Martin Birnbaum by Grenville L. Winthrop, February 1929; his bequest to the Fogg Art Museum, 1943.

EXHIBITIONS: London 1893, no. 21; London 1927, no. 43, illus.; Cambridge, Mass., 1944a, no. 20; Cambridge, Mass., 1947, p. 11; Cambridge, Mass., 1969, no. 99, illus.; Cambridge, Mass., 1977b, no. 6.

REFERENCES: Cary 1819, vol. 2, pp. 78–80 ("Purgatory" 9.17–54); Gilchrist 1863, vol. 2, p. 221, no. 102(h); Binyon 1922, p. 28, illus.; Blake 1922, no. 77, illus.; Roe 1953, pp. 146–48, no. 77, illus.; Willard 1953, illus.; Blunt 1959, p. 91, illus.; Bindman 1977, p. 218; Klonsky 1980, pp. 104, 155, illus.; Butlin 1981, no. 812.77; Gizzi in Pescara 1983, p. 158, no. 80, illus.; Maheux 1984, p. 128; Cieszkowski 1989–90, p. 170; Taylor and Finley 1997, pp. 133–35, no. 136, illus.; Bindman 2000, pp. 178–79, no. 80, illus.

Richard Parkes Bonington

Arnold, England, 1802–London, 1828

152. *Evening in Venice,* ca. 1828

Oil on canvas
22¼ x 18⅜ in. (56.5 x 46.6 cm)
1943.182

Few British artists exercised as enduring an influence on French painting as Richard Parkes Bonington. In 1817 he moved with his parents from Nottingham to Calais, where he studied informally with the watercolorist Louis Francia. The following year he was in Paris, enrolled in the atelier of Baron Antoine-Jean Gros. His fellow pupils included Paul Delaroche, Eugene Lami, and Paul Huet. While making watercolor copies in the Louvre he met Eugène Delacroix, into whose circle of artists and literati he was eventually drawn. Having little patience with French academic method, he abandoned Gros to pursue a course of self-tuition in topographical and antiquarian illustration. The first of his annual tours of Normandy occurred in 1821. From landscape painting in watercolor, Bonington rapidly progressed to oils. At the 1824 Salon, he stunned the Paris art world with a series of exquisite marine views that garnered him, together with John Constable and Sir Thomas Lawrence, a gold medal. The last four years of Bonington's professional career were frenetic. Commissions generated by his celebrity in France were matched by a comparable appreciation in England after 1826. A brief tour of northern Italy in that year furnished him with a repertoire of new material, while his close association with Delacroix between 1826 and 1828 inspired a number of important historical and literary subjects.

A contemporary watercolor version of this oil differs chiefly in the poses of the foremost female figure and in minor details of drapery and architecture.[1] Both versions are more informed elaborations of an earlier Bonington watercolor illustration to Shakespeare's *Merchant of Venice* (act 3, scene 2).[2] The setting is Portia's palace at Belmont. Bassanio, anxious to win her hand in marriage, has submitted successfully to the test of the caskets, as Portia's maid, Nerissa, and Bassanio's friend, Gratiano, consort in the background. In response to Bassanio's request for a token of assurance, Portia pledges her fortune by giving him a ring. In both of Bonington's later interpretations, Portia pointedly touches Bassanio's ring finger.

The Venetian sensibility in coloring and costume confirms a date for both versions after Bonington's 1826 trip to Venice. Furthermore, the technical sophistication of the watercolor and the scale of the oil, which is one of Bonington's largest figure subjects, argue for a date of execution near the end of the artist's life.[3] A Paris production of *The Merchant of Venice,* performed by English actors under the aegis of the duc d'Orléans at the Théâtre-Français, commenced in April 1828 and Edmund Kean played the role of Shylock in May, a momentous event that Bonington recorded in a pen-and-ink sketch.[4] It was perhaps the promise or the presence of the English troupe in Paris that prompted Bonington to revisit the theme.

Bonington's figure subjects are primarily illustrations of the works of his favorite authors, Shakespeare, Cervantes, Goethe,

and Scott. The earliest oils date to 1825–26 and were undoubtedly undertaken with the encouragement of Delacroix, with whom he shared a studio. From the beginning Bonington's unorthodox practice was first to render the idea in watercolor or sepia wash and then to paint the oil version without further preparatory stages. In developing an oil version, he researched his subject thoroughly, seeking historical models for costumes and portraits in works of art contemporary in date and parallel in theme with his subject. This process of appropriation infused his illustrations with "local color," the sense of authenticity so much admired by his contemporaries. For the Winthrop oil, Bonington borrowed picturesque details from a remarkable range of available sources. The brocade dress and hair fillet worn by Portia and the doublet of the young page appear to derive from figures in Gerard David's *Marriage at Cana.*[5] Nerissa's conspicuous diamond fillet relates to Leonardo's *La Belle Ferronnière.*[6] Bassanio's dress incorporates features from several sources, including the costume of an Italian warrior in the famed armor collection of Samuel Meyrick, copied in London by both Bonington and Delacroix,[7] and Raphael's *Self-Portrait with a Friend,* which Bonington also sketched.[8] His features were borrowed, with significant alterations to the face, either from Cariani's *Portrait of Gentile and Jacopo Bellini*[9] or from Delacroix's lifesize oil replica of this particular head.[10]

Within months of completing this picture, Bonington's premature death from tuberculosis would deprive international

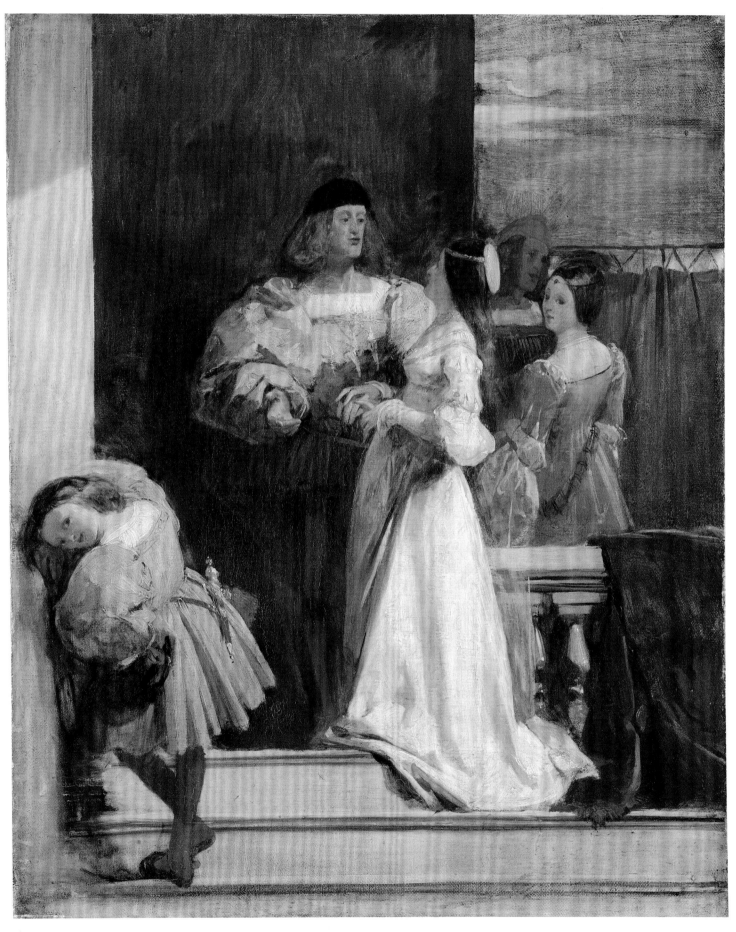

Romanticism of a prodigious talent. As Delacroix aptly expressed it, "no one in this modern school, and perhaps even before, has possessed that lightness of touch which makes Bonington's work a type of diamond that flatters and ravishes the eye."[11]

Patrick Noon

1. Musée Fabre, Montpellier (836.4.182); see Noon 1991, p. 248.
2. Yale Center for British Art, New Haven; see ibid., no. 109. The ultimate source for all three Bonington compositions was the engraving after Richard Westall's 1795 illustration to the scene for John Boydell's *Shakespeare Gallery*.
3. Delacroix observed of Bonington's last pictures that "those in which the figures are the largest date to this period, notably the Henri III"; Delacroix 1935–38, vol. 4, pp. 287–88.
4. Yale Center for British Art; see Noon 1991, no. 158.
5. Musée du Louvre, Paris.
6. Louvre (778), also titled *Portrait of a Woman of the Court of Milan*.
7. For the Bonington drawing, see Noon 1991, no. 38; for the Delacroix drawing, see Sérullaz et al. 1984, no. 1468.
8. The Raphael is in the Louvre (614); Bonington's graphite sketch is in the Nottingham Museum and Art Gallery.
9. Louvre (RF 1156); when it was copied it was thought to be by Giovanni Bellini.
10. For Delacroix's copy, see Johnson 1981–89, no. 13, where it is argued that the oil study antedates graphite sketches of the same heads that Delacroix drew in a sketchbook (Louvre, RF 9143) in use during his trip to England in 1825 and the

following autumn, when he shared his studio with Bonington.
11. Delacroix 1935–38, vol. 4, p. 288.

PROVENANCE: Commissioned or purchased from the artist by Henry Labouchère, Baron Taunton, Somersetshire; his son Edward James Stanley, Somersetshire; his son Edward Arthur Vestey Stanley, Somersetshire; his sale, Sotheby's, London, July 15, 1920, no. 113 (£42); purchased at that sale by (?) Buxford; Scott and Fowles, New York; acquired from them by Grenville L. Winthrop, March 14, 1934 ($3,500); his bequest to the Fogg Art Museum, 1943.

EXHIBITION: Cambridge, Mass., 1943–44, p. 9.

REFERENCES: Dubuisson and Hughes 1924, p. 203, illus. facing p. 78; Shirley 1940, p. 151; Bowron 1990, fig. 50; Noon 1991, pp. 79, 230, 244, 247, 248, fig. 66.

Ford Madox Brown

Calais, France, 1821–London, 1893

153. *Self-Portrait*, 1877

Oil on canvas
29⅜ x 24 in. (74.6 x 61 cm)
Signed and dated upper left: FMB [monogram]—77
1943.185

Ford Madox Brown produced only two self-portraits in oils, a youthful work of 1844[1] and this painting, completed in 1877 when the artist was fifty-six years old. His grandson and first biographer, Ford Madox Hueffer, saw in the *Self-Portrait* "a man of great handsomeness of a masculine cast— Roman nosed, broad of forehead, with rather long, almond-shaped eyes; the face rather oval and broad at the cheeks. The profuse grey hair, carefully parted in the middle, and falling mane-like on each side, and the sweeping grey beard, beginning to grow white, impart an almost patriarchal air to a face otherwise vigorous enough."[2] Brown's character, earlier prickly and

pugnacious, had mellowed somewhat with age. Arthur Hughes, a lifelong friend, recalled Brown's "rather severe face"[3] at their first meeting in 1851, and photographs of Brown from the 1860s revealed to Hueffer a "species of frown—one betokening, it is true, almost as much the hard thinker, who is resolving a knotty point, as the hater of all mankind."[4] A man who "lived in his eyes and for his eyesight,"[5] Brown's gaze in the portrait is world-weary, perhaps in response to the death in 1874 of his son, Oliver, whose precocious literary and artistic talents Brown believed to betoken genius. Dressed for painting, Brown holds an oval palette typical of the period; his use of a rag, held in the left hand with palette and brushes, is also documented in an accomplished portrait of him at work outside, painted by his daughter Catherine.[6]

Art history has characterized Brown as a Pre-Raphaelite,[7] and though he was

not a member of the Brotherhood his contribution as an "aider and abettor"[8] was undoubtedly profound. "Friendship portraits" of him by Dante Gabriel Rossetti and John Everett Millais survive.[9] Nonetheless, Brown's work from after 1860 has been unjustly neglected. Only recently has his significance in the development of the Aesthetic Movement in Britain been recognized.[10] Yet the 1877 *Self-Portrait* stands alongside works of Frederic Leighton and James Abbott McNeill Whistler as a consummate Aesthetic portrait.[11] The subtle harmonies of the burnished golds, browns, and blacks of the color scheme and a new sensitivity to texture have replaced the fierce, interrogatory realism of Brown's earlier work. Typical of Aesthetic taste is the tooled and painted leather screen bearing decorative motifs of Eastern origin, parallel to the picture plane. This unusual hybrid seems to reinterpret the form of a

153

Coromandel screen, a lacquered or painted wooden Chinese object popular with Victorian collectors. The use of leather and the hinge—typical of an English screen—indicate a European, rather than an Oriental, origin.[12] The screen formed a part of Brown's home or studio furnishings, which like those of Whistler and Rossetti were notably eclectic.[13]

In 1861 Brown had been a founding member of Morris, Marshall, Faulkener and Company, designers of furniture, textiles, and stained glass and headed by William Morris. Brown contributed innovative designs, though the extent of his involvement remains questionable. He was deeply angered when Morris reorganized the firm in 1874–75, ejecting Brown, Rossetti, and others.[14] Brown gave this self-portrait to his friend Theodore Watts-Dunton, a lawyer and confidant of Rossetti who had represented Brown ("one of his principal clients")[15] in the legal wrangling about Morris and Company. Kenneth Bendiner suggests that the chair in the self-portrait is from Morris and Company's Sussex range, the design for which Brown may have been responsible. Perhaps by this device in a painting given to a friend so closely involved, Brown, ever the ironist, was making a sly reference to Morris's alleged unfairness.[16]

Tim Barringer

1. *Self-Portrait*, 1844, oil on board, 8¾ x 5¾ in. (22.2 x 14.6 cm), private collection; see Liverpool 1964, p. 12, no. 7. A significant addition to these oil portraits is the superb pencil drawing inscribed "Ford Madox Brown aetat 29 / Sept. 1850 / retouched Oct 1853" (private collection; reproduced in ibid., p. 30).
2. Hueffer 1896, pp. 313–14. This is clearly evident in Brown's self-portrayal as an emigrant in his major work *The Last of England*, 1852–55, Birmingham Museum and Art Gallery.
3. Arthur Hughes, letter to Ford Madox Hueffer, ca. 1895, quoted in Hueffer 1896, pp. 69–70.
4. Ibid., p. 70.
5. Hueffer in London 1909, p. 12.
6. Catherine Madox Brown, *Ford Madox Brown at the Easel*, 1870, private collection; see Manchester 1997, pp. 39, 130.
7. Mary Bennett wrote in the introduction to the 1964 exhibition of Madox Brown's work: "The most important and prolific period of his career undoubtedly dates from the decade after 1848 when he was most intimately connected with Dante Gabriel Rossetti and his circle" (Liverpool 1964, p. 4). The Liverpool exhibition included only a small selection of the later work. Even fewer examples of Brown's work from after 1860 appeared in "The Pre-Raphaelites" at the Tate Gallery, London, in 1984. The survey literature has tended to replicate this pattern. See, for example, Hilton 1970; Barringer 1999; and Prettejohn 2000. A reappraisal of Brown's later work is overdue.
8. Ford Madox Brown, letter to Lowes Dickinson, May 14, 1851, quoted in Hueffer 1896, p. 73.
9. Dante Gabriel Rossetti, *Ford Madox Brown*, pencil on paper, 1852, National Portrait Gallery, London; see Surtees 1971, vol.1, p. 158, no. 269, vol. 2, pl. 397. John Everett Millais, *Ford Madox Brown*, watercolor over pencil, 1853, Ashmolean Museum, Oxford; see Whiteley 1989, no. 2, pp. 12–13.
10. See Bendiner 1998, chap. 4, pp. 61–86.
11. See, for comparison, Frederic Leighton, *Self-Portrait*, 1880, Galleria degli Uffizi, Florence; James Abbott McNeill Whistler, *Arrangement in Grey and Black No.1: Portrait of the Artist's Mother*, 1871–72, Musée d'Orsay, Paris.
12. I am grateful to Dr. David Sensebaugh, curator of Asian Art at Yale University Art Gallery, for his assessment of this curious object.
13. The screen also appears, somewhat incongruously, in *Cromwell, Protector of the Vaudois*, 1877–78, Castle Museum and Art Gallery, Nottingham.
14. On the breakup and reconstitution of Morris and Co., see Newman and Watkinson 1991, p. 169. See also Harvey and Press 1996, pp. 49–57, esp. p. 51.
15. Madox Brown's friendship with Theodore Watts-Dunton (1832–1914) is extensively discussed in Hake and Compton-Rickett 1916, esp. vol. 2, p. 269. Watts-Dunton was a prolific contributor to the *Athenaeum* and also published verse. His novel *Aylwin* (1898) was highly successful. He earned Madox Brown's lifelong gratitude by securing publication for a story by the artist's son, Oliver.
16. Bendiner 1998, p. 78. On the Sussex chair, see also Collard 1996, in which the design is tentatively attributed to Philip Webb. Collard gives credit to Brown for the Sussex chair with a round seat (ibid., p. 176, no. J.25); but the chair that appears in the portrait is closer to the armchair from the Sussex range (ibid., p. 168, no. J.11). However, E. M. Tait argued in 1898 that Brown "persuaded the 'firm' to manufacture the Sussex chairs which are probably the most popular products of Morris & Co even at this day"; see Tait 1900, pp. 61–63, quoted in Bendiner 1998, p. 81.

PROVENANCE: Given by the artist to Theodore Watts-Dunton, 1877; his widow, Clara Watts-Dunton, Putney, 1914; her sale, Sotheby's, London, March 23, 1939, no. 43 (£520); purchased at that sale by Barbizon House; acquired through Martin Birnbaum by Grenville L. Winthrop, March 1939 (£629); his bequest to the Fogg Art Museum, 1943.

EXHIBITIONS: Bradford 1904, no. 97; London 1909, no. 17; Manchester 1911, no. 17; Venice 1934, no. 234; Cambridge, Mass., 1946b, no. 1; Cambridge, Mass., 1950, p. 5; Cambridge, Mass., 1973a; Cambridge, Mass., 1977a; Cambridge, Mass., 1980a; Cambridge, Mass., 1982.

REFERENCES: Hueffer 1896, frontis., pp. 311–13; Hake and Compton-Rickett 1916, vol. 2, p. 269; Liverpool 1964, p. 12; Newman and Watkinson 1991, frontis., p. 175; Bendiner 1998, p. 78, fig. 65.

Edward Burne-Jones

Birmingham, England, 1833–London, 1898

154. *Sir Galahad,* 1858

Black ink on vellum
6⅛ x 7½ in. (15.6 x 19.2 cm)
1943.672

Sir Galahad is one of several highly finished pen-and-ink drawings of medieval subjects, mostly on vellum, that were among the young Edward Burne-Jones's first completed works as an artist. The origins of the group lay in the enthusiasm for medieval literature, history, and art that he and his close friend William Morris had developed as students at Oxford University in 1853–56. Burne-Jones and Morris were devoted to the Arthurian legends and in particular to Sir Galahad, the knight of immaculate purity whose destiny was to achieve the Holy Grail and die in ecstasy. This was a hero with whom, as youthful idealists at odds with the times, they felt they could identify. When they fantasized about founding a monastic order—they had both come to Oxford intending to enter the Church—they spoke of naming it the Order of Sir Galahad. Burne-Jones wrote to another friend: "Remember, I have set my heart on founding a Brotherhood. Learn Sir Galahad by heart. He is to be the patron of our Order. I have enlisted *one* in the project up here, heart and soul. You shall have a copy of the canons some day. General of the Order of Sir Galahad."[1] He greatly admired the poems on Arthurian themes by Alfred Tennyson, the poet laureate, and the "Sir Galahad" that he recommended learning by heart was Tennyson's poem of that title, published in 1842. This was also the inspiration for the present drawing.

In the poem Tennyson describes how Sir Galahad's purity and self-denial as the "maiden knight" make him mighty in combat: "My strength is as the strength of ten, /

154

Because my heart is pure." After the tournament is over, the other Knights of the Round Table enjoy the accolades of beautiful women and the promise of love: "They reel, they roll in clanging lists, / And when the tide of combat stands, / Perfume and flowers fall in showers, / That lightly rain from ladies' hands." But Sir Galahad in his "virgin heart" desires only spiritual consummation, through finding the Grail and passing on to glory in Christ. Burne-Jones seems to have taken this contrast as the starting point for his drawing. Sir Galahad rides past a garden of delights in which musicians perform, lovers embrace, and others play cards, eat, and drink. The scene is conceived as an allegory of duty versus pleasure. As the Christian knight, Sir Galahad takes duty's difficult path, which, in contrast to the garden behind, sprouts only thistles and brambles; judging by his horse's breath, the very air around him is colder than that in the garden. The lantern he carries, with its design of stars, recalls the one carried by Christ himself in William Holman Hunt's painting *The Light of the World*, which thrilled Burne-Jones when he saw it at the Royal Academy in 1854.[2] The theme of duty versus pleasure was to recur in Burne-Jones's later work, and echoes of *Sir Galahad* can be traced, for instance, in the great *Laus Veneris* of 1873–78.[3]

The meticulously worked, allover detail and feeling of dense compression about the drawing owe much to Dante Gabriel Rossetti, who was the artistic mentor of Burne-Jones's early career. In particular Burne-Jones seems to have been imitating the wood-engraved illustrations that Rossetti contributed to the Moxon edition of Tennyson's poems, published in 1857. His allegorizing approach to the poem may also show the influence of Rossetti, who, along with other contributors to the Moxon edition, had much annoyed Tennyson by taking creative liberties with his texts. In composing his drawing Burne-Jones may have recalled the mounted knight in John Everett Millais's principal venture into the painting of medieval subjects, *A Dream of the Past: Sir Isumbras at the Ford*, exhibited at the Royal Academy in 1857.[4] Both compositionally and stylistically he certainly drew on his knowledge of the engravings of Albrecht Dürer. Dürer was an artistic hero among the whole Pre-Raphaelite circle, and his engraving *The Knight, Death, and the Devil* clearly played a large part in Burne-Jones's conception of his subject.[5]

Burne-Jones began the drawing at 17 Red Lion Square in London, where he shared rooms with Morris for a period after leaving Oxford, and in June 1858 he took it with him to Summertown, near Oxford, on a visit to his friend Archibald Maclaren. He came with his future wife, Georgiana Macdonald, who recalled his working on the drawing and reading aloud to the party from Thomas Malory's *Morte d'Arthur*, the canonical account of the Arthurian legends.[6] "I can't look at Galahad yet to finish it," he later wrote to her; "every stroke in it reminds me of some dear little word or incident that happened as the pen was marking."[7]

Sir Galahad was probably one of the group of early pen-and-ink drawings that Burne-Jones exhibited in 1859 at the Hogarth Club, a short-lived, semiprivate exhibiting institution for members of the Pre-Raphaelite circle.[8] It seems originally to have been mounted in an oak frame inscribed with the title.[9] This was probably one of the gilt oak, butt-jointed frames that Burne-Jones favored from about 1860.[10] It is now lost, having been replaced by a modern frame after the drawing entered the Winthrop collection.

Malcolm Warner

1. Burne-Jones 1904, vol. 1, p. 77.
2. *The Light of the World* is now at Keble College, Oxford.
3. Laing Art Gallery, Newcastle upon Tyne; see Christian in New York–Birmingham–Paris 1998–99, pp. 166–69, no. 63.
4. Lady Lever Art Gallery, Port Sunlight.
5. For a discussion of the Pre-Raphaelites' interest in Dürer, see Christian 1973b.
6. Burne-Jones 1904, vol. 1, p. 181.
7. Ibid., pp. 181–82.
8. See Cherry 1980, p. 241.
9. See London 1899a.
10. See Mitchell and Roberts 2000, pp. 362–63.

PROVENANCE: Colonel William Gillum, by 1892; Juliet M. (Mrs. Sydney) Morse, by 1899; acquired through Martin Birnbaum by Grenville L. Winthrop, 1937 (£50); his bequest to the Fogg Art Museum, 1943.

EXHIBITIONS: probably Hogarth Club, London, January 1859; London 1899a, no. 12; London 1933, no. 47; Cambridge, Mass., 1946b, no. 5.

REFERENCES: Bell 1894, pp. 26–27, 101; Burne-Jones 1904, vol. 1, pp. 181–82; Harrison and Waters 1989, pp. 37–40; Mancoff 1990, pp. 164–65; Mancoff 1995, pp. 121–22; New York–Birmingham–Paris 1998–99, p. 59.

155. *Day*, 1870

Watercolor, gouache, and metallic paint on white
paper mounted on very fine canvas formerly
attached to wooden panel
47⅞ x 17⅞ in. (121.7 x 45.5 cm)
Signed and dated in watercolor, lower right:
E. BURNE-JONES / MDCCCLXX
1943.460

156. *Night*, 1870

Watercolor, gouache, and metallic paint on white
paper mounted on very fine canvas formerly
attached to stretcher
48⅛ x 18 in. (122.2 x 45.7 cm)
Signed and dated in watercolor, lower right: HAS
IMAGINES PINXIT *E.* BURNE-JONES / MDCCCLXX
1943.461

Two figures personify Day and Night, wel-
coming the coming day and bringing it to
its close. In the first the young man opens
the door to the east, a lighted torch in his
hand and the mists of the morning swirling
around his body. His face looks longingly
out at the viewer. On the plinth a painted
label bears the following verses written by
William Morris: "I am Day I bring again /
Life and Glory Love and Pain / Awake
arise from death to death / Through me
the worlds tale quickeneth." The figure of
Night, dressed in a deep blue gown, reaches
to close the door while with the other hand
she extinguishes the torch. Of weary
aspect, she looks down, her eyes closed.
Her hand gently resting on the doorframe
mirrors that of Day. The verses on her
plinth read: "I am Night & bring again /
Hope of pleasure rest from pain /
Thoughts unsaid twixt life and death / My
fruitful silence quickeneth."

These two watercolors, together with
the set of the four Seasons, were painted
for Frederick Richards Leyland, the impor-
tant patron of the Pre-Raphaelites and
shipowner in Liverpool.[1] He purchased
a house at Queen's Gate in London for
which he bought or commissioned pieces
from artists such as Burne-Jones, Albert
Joseph Moore, Dante Gabriel Rossetti, and
James Abbott McNeill Whistler to create a
complete artistic environment.[2] In 1868
Burne-Jones wrote to Leyland about the
commission: "Here comes the Spring at
last, I've been seedy and out of town, so
that I couldn't send it you when I meant.
I intend doing four more to complete the
set—a Summer nearly naked, a Winter
heavily draped, and a Day and Night—by
degrees. Of course I should like them all
to go together, but you needn't feel tied
by that, for it is not of vast importance,
but I think they would make a nice set of
decorative pictures for one room." Burne-
Jones also went into detail about the colors:
"This is to be the plan of them all: first
Day, naked, with a blue sky at the back of
him and yellow marble to stand on . . . and
last, Night in grey, shutting a door after
her, standing on blue marble, with a torch
held down and her eyes closed. There is a
plan throughout, of colour and expression
and everything."[3] Completed in 1871, the
panels hung in the dining room at Queen's
Gate until they were moved to Leyland's
new house at 49 Prince's Gate in 1874.[4]

These figures owe much to the Renais-
sance tradition, with which Burne-Jones
was familiar, of single figures symbolizing
the abstract concepts of virtues, times of
the day, or seasons.[5] In addition, Day's con-
trapposto pose with one knee bent forward
and heel raised is very typical of Renais-
sance types, particularly figures of saints.[6]
It appears throughout the work of Sandro
Botticelli and Andrea Mantegna, artists
whom Burne-Jones much admired.[7] Botti-
celli's *Saint Sebastian* (Gemäldegalerie,
Berlin), with which Day invites comparison
as a single figure, holds this pose as does
a *Saint Sebastian* by Mantegna (Galleria
Giorgio Franchetti alla Ca' d'Oro, Ven-
ice).[8] The manner in which Day's fingers
lightly encircle the torch is also probably
derived from Renaissance painting. In
Mantegna's *Virgin and Child with Saint John
the Baptist and the Magdalen* (National
Gallery, London), for example, a slender
cross almost appears to slip through the
fingers of the Baptist.[9] Burne-Jones's figure
is different in the hand resting on the door-
frame and the longing hungry look of the
youth, the direct engagement with the spec-
tator, unlike Renaissance saints, who look
heavenward or demurely downward.

The watercolors were exhibited at the
Grosvenor Gallery, London, in 1878,
according to Malcolm Bell to "a storm of
ridicule."[10] In fact the critical reaction
appears to have been very mixed, and some
critics passed over these works in favor
of the larger exhibits.[11] It is perhaps the
reviewer of the *Daily Telegraph* who most
objected to what he saw as Burne-Jones's
rejection of Renaissance ideals and con-
scious move away from advances made in
French art of the period: "[T]hey are all
essentially and exclusively medieval in
conception, arrangement and execution,
and they utterly and contemptuously
ignore all that has been done in art, either
in the Renaissance, by the Classic Revival,
or by the Romantic movement which we
owe to Ary Scheffer, to Eugène Delacroix
and to Paul Delaroche, painters whom
Mr. E. Burne-Jones holds, no doubt, in
the supremest scorn."[12]

They were sold with the rest of
Leyland's collection in May 1892 and

subsequently entered the collection of Joseph Rushton, a manufacturer of agricultural machinery.[13] The next owner was James Ross, a councillor in Montreal and one of the most important Canadian art collectors of his time.

Sarah Herring

1. See Duval 1986, pp. 110–15. The set of the Seasons is in a private collection.
2. This led to some adverse comment, as this letter of March 4, 1873, from Charles Howell to Ford Madox Brown demonstrates: "As long as he keeps to Queen's Gate he will not buy much more, for he really is not a collector, and only buys a thing when he wants it for a certain place. He is never taken with the beauty of a certain pot or anything, he only sees that such and such a corner requires a pot and then he orders one." Rossetti 1965–67, no. 1313, quoted in Duval 1986, p. 110.
3. Burne-Jones 1904, vol. 2, pp. 9–10.
4. Child (1892, p. 313) lists the pictures hanging in the first of the salons on the second floor, including Burne-Jones's six panels.
5. Two early commentators remark on the artist's debt to the Renaissance tradition. Julia Cartwright (1894, p. 16) wrote, "The same love of allegory led the painter to revert to a practise common among Renaissance masters and to represent the Virtues, the Seasons and other abstractions in a succession of single figures." Claude Phillips (1894, p. 98) compared them to the tradition of Florentine art.
6. The figure of Day is based on one of the painted panels in the Green Dining Room in the Victoria and Albert Museum, London, painted in 1866–67; New York–Birmingham–Paris 1998–99, p. 116. The panel is one of those representing the months, in this case September.
7. There are several studies on the influence of Italian Renaissance art on Burne-Jones. See, for example, Christian 1992 and Weinberg 1995.
8. Claude Phillips (1894, p. 98) wrote of the figure of Day as "Mantegnesque, however, without the grimness or the strength of the Paduan master."
9. Other aspects that derive from Renaissance painting include the rays of light and clouds emanating from around the figure's feet, which are reminiscent of those surrounding the dove, or Holy Spirit, in Annunciation scenes. The seaport in the background could have come straight out of a Sienese painting.
10. "The six water-colour idealizations, 'Day' and 'Night', 'Spring', 'Summer', 'Autumn', and 'Winter', painted in 1869, 1870, and 1871, were lent by Mr. Leyland and encountered from many quarters a storm of ridicule"; Bell 1892, p. 5.
11. The *Art Journal* (1878, p. 155) was complimentary in general about Burne-Jones's exhibits, but not about these works in particular or the Seasons, stating that they would not enhance his reputation. F. G. Stephens in the *Athenaeum* (May 18, 1878) hardly mentions them, preferring to concentrate on exhibits such as *Laus Veneris* (now Laing Art Gallery, Newcastle upon Tyne). The reviewer in the *Magazine of Art* did not mention them at all.

155

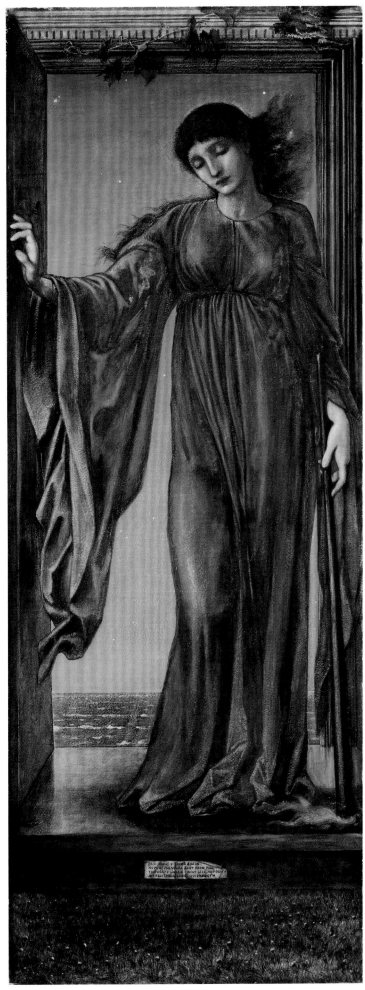

12. *Daily Telegraph*, May 1, 1878. The opinion is
 echoed by Claude Phillips (1894, p. 98) regarding
 the figure of Night: "The long classical draperies
 wholly cover, yet they too much reveal a shape
 which in its characteristic, and, as we may assume,
 wilful deficiencies, carries us back to the fifteenth
 century, and rather to the meagre, attenuated grace
 of Botticelli than to the force of the Pollajuoli or
 the vigorous realism of Signorelli."
13. See Phillips 1894 and Sachko MacLeod 1996a, p. 20.
14. One of five drawings sent by the artist, as noted in
 the *Art Journal*, 1870, p. 173. Ash (1993, pl. 6)
 draws attention to this.

PROVENANCE: Commissioned from the artist by
Frederick R. Leyland, London; his sale, Christie's,
London, May 28, 1892, no. 43 (£1,415); purchased at
that sale by Thomas Agnew and Sons, London; Joseph
Rushton; his sale, Christie's, London, May 21–23,
1898, no. 26 (£1,050); purchased at that sale by Thomas
Agnew and Sons, London; James Ross, Montreal, by
1901; his sale, Christie's, London, July 8, 1927, no. 1
(£231); purchased at that sale by Leggatt Brothers;
Scott and Fowles, New York, 1927; acquired from
them by Grenville L. Winthrop, October 18, 1927
($3,000); his bequest to the Fogg Art Museum, 1943.

EXHIBITIONS: London 1870, no. 136 (cat. no. 156);[14]
London 1878; Liverpool 1886, nos. 1165, 1170; Lon-
don 1892–93, nos. 61, 63; Montreal 1901, nos. 4, 5;
Montreal 1914, nos. 26, 27; Montreal 1915, nos. 406,
451; Cambridge, Mass., 1946b, nos. 16, 17; Tokyo
2002, nos. 52-1, 52-2.

REFERENCES: *Art Journal*, 1878, p. 155; *Daily
Telegraph*, May 2, 1878; *Times*, May 2, 1878;
Wedmore 1878, pp. 336, 339; Bell n.d., pp. 29–30;
Bell 1892, pp. 5, 22, 30, 42, 63, 97, 109; Leprieur
1892, p. 386; Robinson 1892, p. 138; Cartwright 1894,
p. 17; Phillips 1894, pp. 97–98; Schleinitz 1901, p. 26;
Burne-Jones 1904, vol. 2, pp. 9–10; de Lisle 1906,
pp. 105–6, 182; "Ross Residence" 1926, pp. 29–32;
Gianelli 1927, pp. 34–35; "Pre-Raphaelites" 1943,
p. 26; London–Southampton–Birmingham 1975–76,
p. 44; Montreal 1989–90, pp. 132, 177; Ash 1993, pl. 6;
Toronto and other cities 1993–94, p. 22; London–
Munich–Amsterdam 1997–98, p. 130; Wood 1998,
pp. 70–71; New York–Birmingham–Paris 1998–99,
pp. 116, 214.

157. *Venus Epithalamia*, 1871

Watercolor, gouache, metallic gold paint, and varnish on linen prepared with Chinese white
14 ¾ x 20 ⅝ in. (37.5 x 26.9 cm)
Signed and dated in watercolor on pedestal, lower left: E. B. J. MDCCCLXXI
Inscribed in watercolor on scroll, lower right: VENUS EPITHALAMIA
1943.453

As the goddess of beauty and love, which are the dominant themes of Burne-Jones's art, Venus in her various guises held a special place among his favorite subjects. In 1871, the year in which he painted *Venus Epithalamia*, he also made graphite drawings of *Venus Concordia* and *Venus Discordia*, showing the goddess contemplating scenes of the good and the evil that come of love; he began both compositions as large oil paintings in the following year but finished neither.[1] In the present watercolor she appears in her role as the origin of marriage, the "Venus of the Nuptials."

Burne-Jones shows the goddess standing at a doorway, her physique and pose deliberately recalling the famous ancient Greek sculpture of the Venus de Milo (Louvre, Paris). She holds a mysterious torch, a traditional attribute with which she sets the fires of love burning. She leans against a statue of her son Cupid pulling back his bow to shoot an arrow of love at his next victim, his eyes covered because love is blind; the artist was to use variations on this same figure in several later works, including the large watercolor *Cupid's Hunting Fields* of 1885.[2] The plant behind Venus and on the floor is myrtle, which is sacred to her and, as an evergreen, symbolic of everlasting love, especially marital fidelity. In the background we see the preparations for a wedding: a boy—perhaps the mortal representative of Cupid—decorating a

chamber and, through another doorway, a veiled bride and her bridal procession, their tall candles the earthly counterparts to Venus's torch.

Venus Epithalamia was commissioned by Burne-Jones's friend and patron of some years Euphrosyne Cassavetti, member of a prosperous Anglo-Greek merchant family; her brother Alexander Ionides was also an important patron of contemporary British painting. Nicknamed "the Duchess" in the family, Cassavetti was a wealthy, slightly eccentric widow who greatly enjoyed the company of artists. She commissioned the watercolor as a wedding present for Marie Spartali, who was also part of the Anglo-Greek community in London, and whom she had known since she was a girl. A celebrated beauty who sat for Burne-Jones as a model, and an accomplished artist in her own right, Spartali was to be married to the American journalist W. J. Stillman. Whether following any specific wishes of Cassavetti as to the content of the work, Burne-Jones presumably devised its nuptial subject as appropriate for the occasion.

What gave the commission an intense personal significance and piquancy was that Burne-Jones had recently had a tempestuous extramarital affair with Maria Zambaco, who was Cassavetti's daughter and Marie Spartali's intimate friend. Zambaco had come to live in London with her two children after the failure of her marriage to a Greek doctor in Paris. In the later 1860s she became Burne-Jones's model, his pupil, and eventually his lover. She seems to have hoped he would leave his wife—the loyal, long-suffering Georgiana Burne-Jones—but he was unwilling to do so. Zambaco was distraught at his first attempt to break off the affair and attempted suicide, but by

1870 she appears to have accepted his decision. They continued to see each other, and Zambaco's exotic features continued to haunt Burne-Jones's paintings. Of particular interest in relation to the *Venus Epithalamia* is the portrait of her that he painted as a birthday present for her mother in 1870, in which the presence of Cupid drawing back a curtain in the background implicitly likens Zambaco to Venus.[3] Burne-Jones thought of her as his own classical goddess of beauty and love, and the facial features of his *Venus Epithalamia* are unmistakably an idealized version of hers.

All this may help explain the cool, melancholy mood of what was supposedly a celebratory work. *Venus Epithalamia* hardly seems to wholeheartedly support the idea of marriage. The bridal procession moves somewhat mournfully along a dark passage, its confinement within the doorframe suggesting the idea of marriage itself as a form of confinement—and the heavily clothed bride certainly cuts a puritanical figure in comparison to the unabashed Venus. We remember that Venus's own marriage to the lame blacksmith god, Vulcan, was an unhappy one, and that she too had an extramarital love affair—with Mars, the god of war. It seems possible that Burne-Jones may have thought of Venus and the bride in *Venus Epithalamia* as representing Zambaco in two aspects: the beautiful goddess and the unhappy wife. Consciously or unconsciously—and inappropriately, given the nature of the commission—he seems to have infused the work with some of his own ambivalent feelings about love and marriage at this time, emphasizing not so much the natural connection between them as the tension.

Burne-Jones painted *Venus Epithalamia* on a piece of linen prepared with Chinese white and wrapped around a wooden panel. The linen has been removed from the panel, which remains as the backboard in the frame.[4]

Euphrosyne Cassavetti was so pleased with *Venus Epithalamia* that she commissioned Charles Fairfax Murray, who had been Burne-Jones's studio assistant, to paint a copy of the work for her own collection. After her death the copy passed to Maria Zambaco, who kept it until her own death in Paris in 1914.[5]

Ironically, when Marie Spartali Stillman sold the original *Venus Epithalamia* in 1905, it was to pay the expenses of a wedding, that of her daughter Effie.[6]

Malcolm Warner

1. The drawings are in the Whitworth Art Gallery, Manchester; see New York–Birmingham–Paris 1998–99, p. 157.
2. Art Institute of Chicago; see ibid., pp. 256–59, no. 115.
3. Clemens-Sels-Museum, Neuss, Germany; see ibid., pp. 138–40, no. 49.
4. The panel is inscribed in graphite by the artist: "This to be covered / with cloth prepared with / Chinese white for / water colour" and "panel / same length / half width covered / with vellum." There are also graphite sketches of an unidentified triptych composition with a single figure in each section, and a larger graphite study for the figure in the right section, who appears to be listening at a door or wall.
 The frame is gilt oak and butt jointed and may be the original or a copy. It follows a design developed by Dante Gabriel Rossetti and Ford Madox Brown in the 1850s and much used by Burne-Jones. With its outer frame of slender bay leaf tori set close together, it is almost identical to that of the watercolor *Sidonia von Bork* of 1860 (Tate, London); see Mitchell and Roberts 2000, p. 362, fig. 26.
5. See Christian 1973a, p. 102, fig. 46, and p. 106, n. 35, and London 1993, p. 45, no. 5.
6. See the copy of a letter from Marie Spartali Stillman to Grace Norton, December 9, 1912, Harvard University Art Museums Archives.

PROVENANCE: Commissioned from the artist by Euphrosyne Cassavetti as a wedding gift for Marie Spartali (Stillman), 1871; Marie Spartali Stillman,

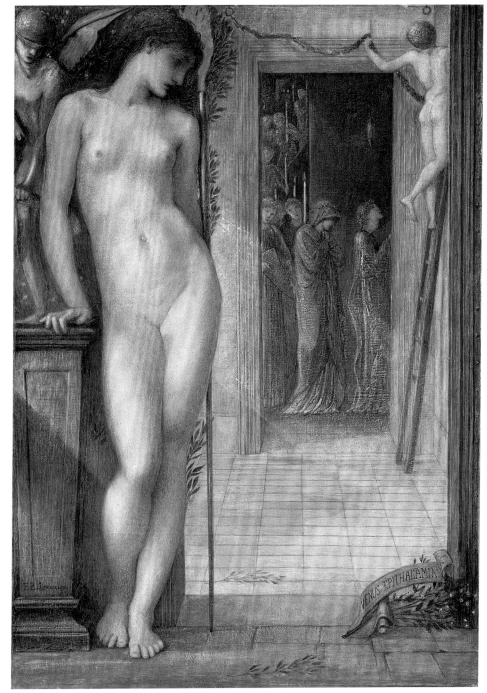

157

until 1905; Thomas Agnew and Sons, London, 1905; purchased from them by Baron de Turckheim; his sale, Christie's, London, June 9, 1911, no. 87 (£304 10s.); purchased at that sale by Charles Fairfax Murray; acquired from him by Grenville L. Winthrop, July 29, 1912 (£500); his bequest to the Fogg Art Museum, 1943.

EXHIBITIONS: London 1898–99, no. 134; Cambridge, Mass., 1946b, no. 18; Tokyo 2002, no. 60.

REFERENCES: Bell 1894, pp. 42, 102; Harrison and Waters 1973, p. 97; Cassavetti 1989, pp. 42, 44.

158. *Danaë Watching the Building of the Brazen Tower* (or *Danaë and the Brazen Tower*), 1872

Oil on wood panel
7 x 10¼ in. (18 x 26 cm)
Signed lower right: EBJ
1943.189

During the period from 1870 to 1877, between Burne-Jones's resignation from the Old Water-Colour Society, following objections to the male nude in *Phyllis and Demophoön*, and his sensational reappearance at the inaugural exhibition of the Grosvenor Gallery, a period the artist described as his "seven blissfullest years of work," he remained busy painting for private patrons. By far the most sympathetic of these patrons was William Graham (1816–1885), a Glasgow merchant and

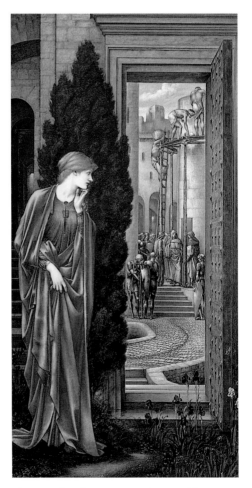

Fig. 166. Edward Burne-Jones, *Danaë* or *The Tower of Brass*, 1888. Oil on canvas, 91 x 44½ in. (231 x 113 cm). Glasgow Museums: Art Gallery and Museum, Kelvingrove; Gift of William Connal, 1901, 936

member of Parliament, who was appointed a trustee of the National Gallery, London, a year before his death. According to Georgiana Burne-Jones: "Keen man of business though he was, simplicity and devotion of soul were as evident in him as in a cloistered monk. His face was that of a saint and at times like one transfigured. He had an inborn perception about painting, and an instinct for old pictures that was marvellous."[1] Once when Burne-Jones showed him a picture, "it had a part of it painted so much to his mind that he went up to it and kissed the panel."[2] *Danaë Watching the Building of the Brazen Tower* is one of a number of important Pre-Raphaelite paintings in the Winthrop collection that had belonged to Graham, including Burne-Jones's *Days of Creation* (cat. nos. 161–65); Dante Gabriel Rossetti's *Beata Beatrix* (cat. no. 186), *The Blessed Damozel* (cat. no. 188), and *Il Ramoscello* (cat. no. 184); and John Everett Millais's *Six Parables* (Fogg Art Museum, 1943.481).[3] "So many thanks for the Danaë which is charming," Graham wrote Burne-Jones in February 1873.[4]

Graham's Pre-Raphaelite paintings hung in proximity to his splendid collection of old masters: "He was a passionate lover of beauty and was one of the first and largest collectors of the Italian Primitive, and the Pre-Raphaelite Schools; he bought pictures so largely," his daughter Frances Horner recalled, "that our house in Grosvenor Place was literally lined with them in every room from floor to ceiling; old and modern, sacred and profane; they stood in heaps on the floor and on the chairs and tables."[5] Appropriately Graham's *Danaë* passed into the collection of R. H. Benson, who, like Graham, was a notable collector of old masters. Benson's collection of Italian paintings passed into the hands of Sir Joseph Duveen in 1927 and

subsequently into the possession of numerous American collectors and museums.

The subject of Danaë represents a prelude to the Perseus cycle which was to occupy so much of Burne-Jones's career. The painting illustrates the fable, treated by William Morris in *The Earthly Paradise*, published between 1868 and 1870, of "The Doom of King Acrisius": "Acrisius, King of Argos, being warned by an oracle that the son of his daughter Danaë should slay him, shut her up in a brazen tower built for that end beside the sea: there, though no man could come near her she nevertheless bore a son to Jove. . . . her son, grown to manhood, set out to win the Gorgon's Head and accomplished the prophecy by unwittingly slaying Acrisius."[6] The most notable use of the Danaë legend had been the glowing horizontal vision of fulfillment incarnated by the reclining figure of Danaë in her tower, receiving the god in a shower of gold, a scene treated most iconically by Titian.

In contrast, the Burne-Jones in the Winthrop collection depicts the moment when Danaë stares unknowingly at the brazen tower being built for her imprisonment, an embodiment of Walter Pater's description, applying both to the poetry of the Middle Ages and to that of Morris and Rossetti, as "a passion of which the outlets are sealed."[7] A series of rectangular units imprisons Danaë, and even the central door opens only onto a walled courtyard and the menacing bulk of the tower. These verticals and their constraining horizontals are repeated in the patterns of the floor, the armature of the flowerpot, and the fountain, whose meager vertical streams fall into a pool that is barely large enough to receive them. The obscured profile of Danaë's glance is repeated by the posture and gaze of the bird, which perches on the wall like Danaë's spirit double.

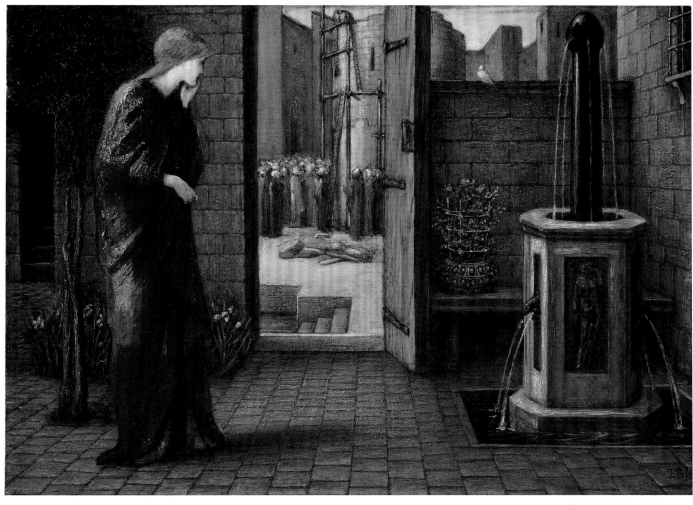

158

An earlier version of *Danaë*, painted in watercolor for John Ruskin, seems to have been destroyed in a fire, or perhaps stolen by Ruskin's notorious secretary Charles Augustus Howell.[8] A version of *Danaë*, also in oil on panel, now in the collection of the Ashmolean Museum, Oxford, shows the left-hand portion of the Winthrop painting: Danaë in the opened door beyond which stands the tower.[9] Although Danaë's pose and robes in the Ashmolean painting correspond to the Winthrop version, in the Oxford painting she stands posed against the dark vertical of a cypress, a motif that distinguishes the last and largest version of the *Danaë*, exhibited in the New Gallery in 1888 and now in the Glasgow Art Gallery (fig. 166).[10] In this final version, every ele-

ment of the Winthrop *Danaë*, from the ladder and scaffolding of the tower to the paving of the inner courtyard, has been elaborated and rationalized, but it conveys no greater impression of pathos, longing, and loss than the simpler means employed in the earlier version.

Gail S. Weinberg

1. Burne-Jones 1904, vol. 1, pp. 295–96.
2. Ibid.
3. For William Graham, see Sachko Macleod 1996. See also Garnett 2000.
4. Garnett 2000, letter B14, p. 257.
5. Horner 1933, p. 5.
6. Cambridge, Mass., 1946, p. 32.
7. Walter Pater, "Aesthetic Poetry," in Pater 1948, p. 79. For the publication history of this essay, see Wright 1975, pp. 3–5, no. 6.
8. Fitzgerald 1975, p. 110.
9. Whiteley 1989, p. 66, illus. p. 67. I am indebted to Dr. Jon Whiteley for this reference.
10. Christian in London–Southhampton–Birmingham

1975–76, pp. 62–63. See also Wood 1997, p. 106, illus. p. 107.

PROVENANCE: Purchased from the artist by William Graham (£150); his sale, Christie's, London, April 3, 1886, no. 155 (£220 10s.); purchased at that sale by Thomas Agnew and Sons, London, for Robert Henry Benson, Sussex; his sale, Christie's, London, June 21, 1929, no. 95 (£68 10s.); purchased at that sale by Scott and Fowles, New York; acquired from them by Grenville L. Winthrop, January 6, 1930 ($1,200); his bequest to the Fogg Art Museum, 1943.

EXHIBITIONS: London 1898–99, no. 31; Cambridge, Mass., 1946b, no. 20; Cambridge, Mass., 1973a; Cambridge, Mass., 1980a; Tokyo 2002, no. 41.

REFERENCES: Morris 1869, p. 218; Bell 1892, chronology, p. 109; Leprieur 1893, p. 468; Morris 1902, p. 2; Burne-Jones 1904, vol. 2, p. 30; de Lisle 1906, pp. 134–36, 182, 184; Huyghe 1957–61, vol. 3, fig. 1008; Brion 1966, illus. no. 79; Fitzgerald 1975, pp. 147–48; Christian in London–Southampton–Birmingham 1975–76, pp. 62–63; Bowron 1990, fig. 67; Waters in London 1993, p. 58, under no. 26 (a Study for Danaë); New York–Birmingham–Paris 1998–99, p. 267; Garnett 2000, pp. 287–88.

159. *Pan and Psyche*, 1872–74

Oil on canvas
27⅛ x 20⅞ in. (68.8 x 53 cm)
Signed lower right: *EBJ*
1943.187

Like many works throughout Burne-Jones's career, *Pan and Psyche* has its origins in his and William Morris's great unrealized project of the 1860s: to publish Morris's voluminous poem *The Earthly Paradise* in a lavishly illustrated edition for which Burne-Jones would supply hundreds of woodcuts—an eventual precursor to the products of the Kelmscott Press.[1] When the poet William Allingham visited Burne-Jones and Morris in August 1866 he found them hard at work on this project: "Ned . . . occupies himself, when in the mood, with designs for the Big Book of Stories in Verse by Morris, and has done several from Cupid and Psyche. . . . He founds his style in these on old woodcuts, especially those in *Hypnerotomachia*, of which he has a fine copy. His work in general, and that of Morris too, might perhaps be called a kind of *New Renaissance*."[2] Evidence of Burne-Jones's and Morris's mutual fascination

with the lavishly illustrated 1499 edition of Francesco Colonna's *Hypnerotomachia Poliphili*, published by Aldus Manutius in Venice, is afforded by the copy presented by Morris to Burne-Jones that is now in the Houghton Library at Harvard University (Typ Inc 5574F).

Pan and Psyche depicts the moment in Morris's poem when Psyche, in despair over her loss of Cupid, has attempted suicide by throwing herself into a river, to be saved and comforted by the god Pan. The composition of Burne-Jones's painting has often been compared to Piero di Cosimo's *Death of Procris* (fig. 167), which had entered the collection of the National Gallery, London, in 1862.[3] Georgiana Burne-Jones has described the National Gallery as "a hallowed place" to which the artist's "mind and soul constantly turned."[4] The museum's function as a source of inspiration for Burne-Jones can only have been heightened by the increasing number of early Italian paintings that Sir Charles Eastlake, the gallery's director between 1855 and 1865, added to the small selection available to the original Pre-Raphaelite Brotherhood.[5]

Giorgio Vasari's life of Piero di Cosimo had given the late-fifteenth-century painter a memorable identity as an eccentric and recluse. By the 1860s Piero's notoriety was heightened by his appearance as a character in George Eliot's novel *Romola* (1863)[6] and his mention by Burne-Jones's friend Algernon Charles Swinburne in his "Notes on Designs of the Old Masters in Florence." In this essay, which originally appeared in the *Fortnightly Review* of July 1868, not only does Swinburne allude to Piero di Cosimo's "strong romantic invention" and "subtle questionable grace,"[7] but he singles out *The Death of Procris*, along with Sandro Botticelli's *Birth of Venus*, as the "two great samples" of the "romantic school" of late-fifteenth-century Florentine art.[8]

The elongated and, to Victorian eyes, androgynous figures of Burne-Jones's Pan and Psyche also show the overwhelming influence of the figure types of late-fifteenth-century Florentine painting, especially those of Botticelli and Andrea Mantegna, on Burne-Jones's art in the 1870s. Although Pan is described as "goat-

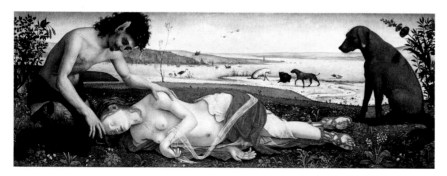

Fig. 167. Piero di Cosimo, *The Death of Procris*, ca. 1495. Oil on poplar, 25¾ x 72¼ in. (65.4 x 184.2 cm). National Gallery, London, 698

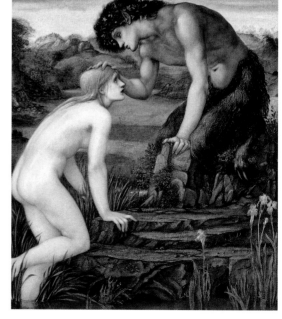

Fig. 168. Edward Burne-Jones, *Pan and Psyche*, ca. 1872–74. Oil on canvas, 24 x 21½ in. (61 x 54.6 cm). Private collection, London (photo: Prudence Cuming Associates Ltd., London)

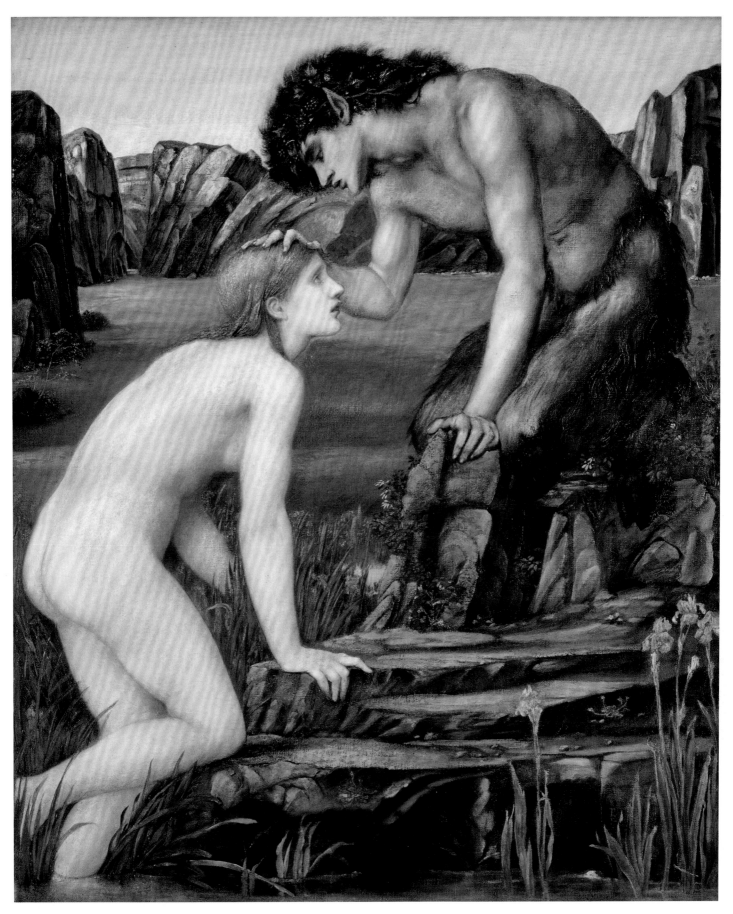

159

legged and merry" in Morris's text and refers to himself as "old," the young god shown in Burne-Jones's painting is lithe and svelte. Like Piero's satyr, Burne-Jones's Pan is hirsute from the waist down and hoofed, but this evidence of his half-animal nature is minimized by his kneeling posture and concealed by his supporting arm. At first glance, only the elongated tips of his ears proclaim his satyric origins. Psyche is an incarnation of the Botticellian figure types that characterize Burne-Jones's work of the period, most conspicuously, the *Venus Epithalamia* in the Winthrop collection (cat. no. 157).[9]

George Hamilton, the patron for whom Burne-Jones painted this *Pan and Psyche*, was a business associate of Burne-Jones's chief patron, William Graham,[10] and like Graham one of a small circle of avant-garde Victorian patrons who would tolerate paintings of the nude figure.[11] Graham even wrote to Burne-Jones evincing his eagerness to take on the commission of *Pan and Psyche* if Hamilton did not wish to keep the picture.[12]

Correspondence between Burne-Jones and Hamilton (Houghton Library, Harvard University) shows Burne-Jones's care to complete the commission and mentions his continued retouchings and modifications to the painting.[13] A conservation study by Mark Aronson, *Trial and Error: Further Notes in the Materials and Techniques of the Pre-Raphaelite Painters*, has found evidence of overpainting on the figure of Psyche, which leads him to conclude that Burne-Jones "drew, painted, and then repainted" this figure.[14]

Nor did Burne-Jones's reworkings of the figure of Psyche represent the full extent of his attempts to modify this composition. A contemporary variation of the *Pan and Psyche* now in a private collection (fig. 168), undertaken for another Aesthetic patron of Burne-Jones, Alexander Ionides, repeats the position of the figures and the naturalistic irises before the foreground rocky ledge, but substitutes for the bare theater of rocks in the background of Hamilton's painting a gentle landscape of leafy trees. Perhaps, John Christian has suggested, this was an attempt to make Ionides' version harmonize with the Aesthetic interior of his home in Holland Park.[15]

Subsequently Ionides's version entered the collection of R. H. Benson, a great collector of Italian Renaissance art and works by the Pre-Raphaelites, who also owned Burne-Jones's *Danaë Watching the Building of the Brazen Tower* (cat. no. 158). Both versions of *Pan and Psyche* seem internally harmonious, but the bare lunar rocks of the background of the Winthrop painting repeat the forms of the rocky ledge in the foreground and provide a strikingly effective backdrop for the naked figures of the maiden and the god.[16]

Gail S. Weinberg

1. Burne-Jones 1904, vol. 1, p. 294. See also New York–Birmingham–Paris 1998–99, pp. 116–17; Dunlap 1971; and Peterson 1991.
2. Allingham 1967, p. 140.

3. New York–Birmingham–Paris 1998–99, p. 238. See also Davies 1961, pp. 420–22.
4. Lago 1981, p. 120.
5. Warner 1992. See also Weinberg 1997.
6. Witemeyer 1979.
7. Swinburne 1875, p. 336.
8. Ibid., p. 331.
9. For the rediscovery of Botticelli in 19th-century England, see Levey 1960. See also Weinberg 1987, pp. 25–27.
10. New York–Birmingham–Paris 1998–99, p. 238.
11. Smith 1996, p. 146.
12. Garnett 2000, letter B13, p. 256.
13. Excerpts from this correspondence are included in Cambridge, Mass., 1946b, pp. 35–36.
14. Files of the Conservation Department, Fogg Art Museum.
15. Christian in New York–Birmingham–Paris 1998–99, pp. 239–40, where he cites White 1897, pp. 111–12.
16. For a note by Burne-Jones on the effectiveness of a background of "grey, doleful rock" in a version of his *Perseus and Andromeda*, see Cambridge, Mass., 1946b, pp. 36–37.

PROVENANCE: Commissioned from the artist by George Hamilton, 1874; his widow, Mrs. Hamilton, Skene; Scott and Fowles, New York; acquired from them by Grenville L. Winthrop, August 1923 ($6,190.50); his bequest to the Fogg Art Museum, 1943.

EXHIBITIONS: London 1878, no. 109; Birmingham 1885, no. 86; Manchester 1887, no. 188; Glasgow 1888, no. 371; London 1892–93, no. 37; London 1898–99, no. 90; Cambridge, Mass., 1946b, no. 23; Cambridge, Mass., 1973a; Cambridge, Mass., 1977a; Cambridge, Mass., 1980a; Tokyo 2002, no. 3.

REFERENCES: Blackburn 1878, pp. 37–38; Henley 1889, pp. xxvi, 18; Bell 1892, pp. 5, 24, 43, 49, 51, 63, illus. facing p. 48, list on p. 109; Cartwright 1894, p. 14, illus.; Carrington 1901, illus. p. 5; Bate 1899, p. 106; Schleinitz 1901, pp. 50, 80, 153; Burne-Jones 1904, vol. 2, p. 30; de Lisle 1906, pp. 86, 105, 110, 182; Bell 1910, fig. 1; Graves 1913–15, vol. 1 (1913), pp. 119ff.; Fell 1937, illus. p. 12; Whitley 1939, pp. 77, 81, 84; Cecil 1969, pl. 84; Hilton 1970, illus. p. 197; Johnston 1971, p. 70; Harrison and Waters 1973, illus. p. 106; Christian in London–Southampton–Birmingham 1975–76, pp. 62–63; Saski 1980, pl. 66; Bowron 1990, fig. 66; Haddad 1990, illus. p. 105; New York–Birmingham–Paris 1998–99, p. 266.

160. *Perseus and Andromeda,* 1875

Watercolor, white gouache, shell gold and
coloured chalks on off-white card
13½ x 12¾ in. (34.3 x 32.3 cm)
Signed and dated in blue chalk, lower right: EB-J /
1875
Inscribed in shell gold, at left (vertically):
ANDROMEDA; right edge (vertically): PERSEUS
Verso: Graphite sketch of organ-pipe cluster and
console (?); inscribed: 18 x 20
1943.674

The recto is an important study for *The Doom Fulfilled* from the Perseus cycle, a series of paintings that occupied Burne-Jones from 1875 to 1892. To appease Poseidon, Andromeda has been chained to a rock to be sacrificed to a sea monster by her father, the king of Joppa, after his wife, Cassiopeia, upset the sea nymphs by boasting of her beauty. Perseus sees her, falls in love, and frees her, and then uses her as bait for the monster, killing it when it reveals itself.

Burne-Jones's series was commissioned by the Conservative politician Arthur James, first earl of Balfour, for his drawing room at 4 Carlton Gardens.[1] Using as his source "The Doom of King Acrisius" from William Morris's *Earthly Paradise,* Burne-Jones initially devised a sequence of ten subjects mapped out in three large designs with decorative borders of Morris's acanthus wallpaper pattern.[2] These designs consist of three panels with three scenes each except the third panel, which has four, with *The Rock of Doom,* showing Andromeda chained to her rock, and *The Doom Fulfilled* combined in a single scene (fig. 169).[3] Reducing the number of subjects to eight, he then produced full-scale cartoons in watercolor and body color.[4] In 1885 he began to work on the oils but completed only four designs.[5] Those of *The Rock of Doom* and *The Doom Fulfilled* (figs. 170, 171) were exhibited at the New Gallery in 1888.[6] Reception was mixed, but critics seemed to agree about a certain coldness in the characters. F. G. Stephens in the *Athenaeum* wrote of Andromeda that "her action in either picture is less marked by emotion than other great pictures of the subject prepare us to expect."[7]

In the finished oils, the Andromeda of the second scene is a mirror image of herself in the first; each stands in contrapposto with one heel delicately raised, her hip jutting out toward Perseus, as she looks decidedly unconcerned at him. Her cool demeanor was achieved only through a large number of studies for the figure in both scenes.[8] Burne-Jones combined the two episodes in a single scene not only in the watercolor design of 1875–76 but also in an unfinished painting of 1876, *Perseus and Andromeda* (fig. 172), in the Art Gallery of South Australia, Adelaide.[9] In the for-

mer she is shown in the second scene from the front, and in another early design for the combined scenes she is shown fully clothed.[10] He was also producing many figure and composition studies for the scenes, most of which he abandoned.[11] In these Andromeda appears waiflike, her body recoiling and her head bowed with a combination of distress and modesty.[12] These drawings reflect more properly the lines from Morris's poem in which she first sees Perseus and "Stared at him, dumb with fear and misery, / shrunk closer yet unto the rocky place / And writhed her bound hands as to hide her face," and later "sank down shivering in her every limb, / Silent despite herself for fear and woe."[13]

In the Adelaide painting she has been turned around in the second scene, so that she is viewed from the back and has much more in common with the finished painting (fig. 171). Burne-Jones was already experimenting with this pose in three related drawings: the Fogg drawing, dated 1875; a second in the Art Institute of Chicago, also dated 1875 (fig. 173); and a third, undated, of unknown location.[14] Though without backgrounds, they can be described as compositional sketches, as they include all the elements in a scheme that is very close to the final layout. There are small differences from the final cartoon and oil, including the

Fig. 169. Edward Burne-Jones, *From Designs for "The Story of Perseus": Atlas Turned to Stone; The Rock of Doom and the Doom Fulfilled; The Court of Phineas; The Baleful Head,* 1875–76. Gouache, gold paint, pencil, and chalk on paper, 14½ x 58½ in. (36.7 x 148.7 cm). Tate Gallery, London, N03458

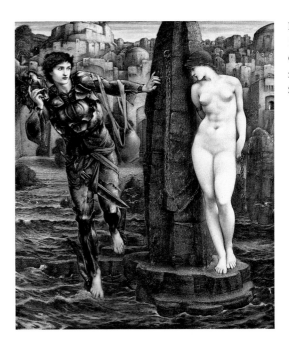

Fig. 170. Edward Burne-Jones, *The Rock of Doom*, 1885–88. Oil on canvas, 61 x 51⅛ in. (155 x 130 cm). Staatsgalerie, Stuttgart

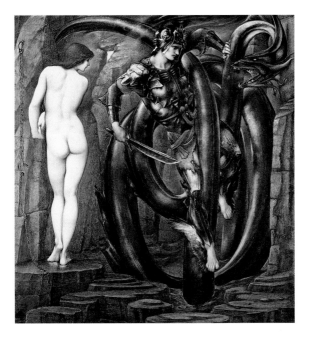

Fig. 171. Edward Burne-Jones, *The Doom Fulfilled*, 1888. Oil on canvas, 61 x 55¼ in. (155 x 140.5 cm). Staatsgalerie, Stuttgart

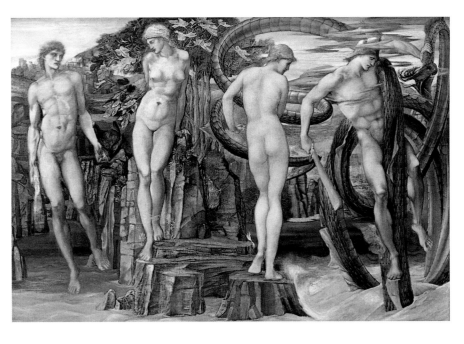

Fig. 172. Edward Burne-Jones, *Perseus and Andromeda*, 1876. Oil on canvas, 60 x 90 in. (152.2 x 229 cm). Art Gallery of South Australia, Adelaide; Elder Bequest Fund, 1902

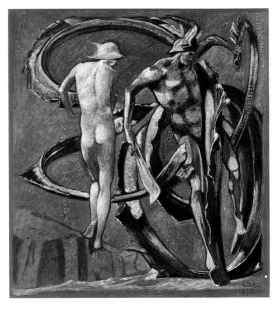

Fig. 173. Edward Burne-Jones, *Perseus and Andromeda*, 1875. Gouache with gold paint on board. Art Institute of Chicago; Gift of James Viles, 1922.5522

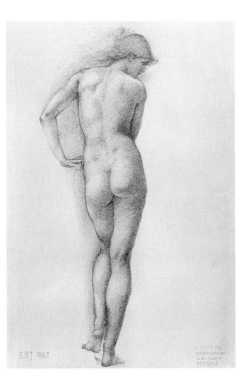

Fig. 174. Edward Burne-Jones, *Study of Andromeda Viewed from the Back*, 1885. Pencil on paper, 10¾ x 7⅛ in. (27.2 x 18.2 cm). British Museum, London, 1967-10-14-48 (photo: © British Museum)

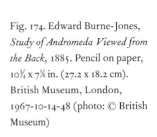

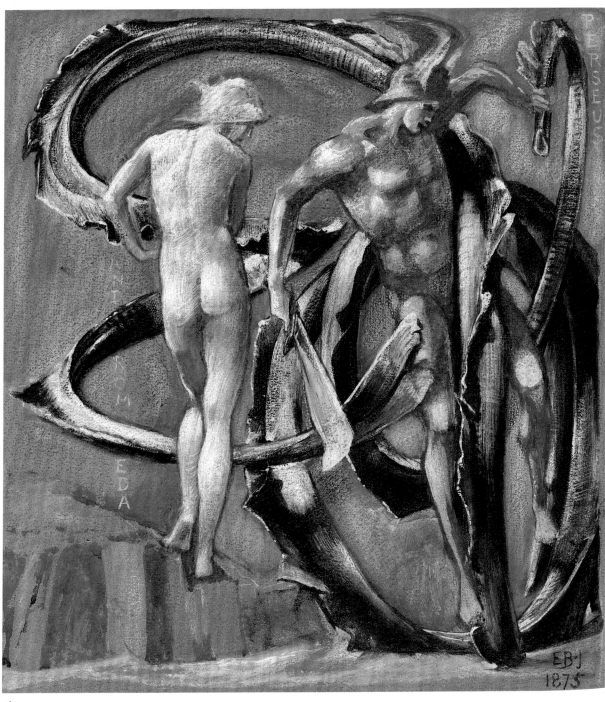

160

positions of Andromeda's arms, hands, and head; instead of gazing directly at Perseus, in all three drawings and the Adelaide painting she looks down, her chin sunk into her shoulder.[15]

Originally Burne-Jones had planned that both figures of Andromeda would face front with a stance indicating the distress described by Morris. This is still evident in *The Rock of Doom* scene of the Adelaide painting, even though the figure in the sec-ond scene of *The Doom Fulfilled* has been resolved according to these compositional drawings. Since equivalents for these com-positional drawings do not seem to exist for *The Rock of Doom*, he may have resolved the figure in the latter scene first, turning her into the calm maiden of the final car-toon and oil, and then matched her in the earlier scene with a figure in reverse to cre-ate a mirror image, a convention used in the Renaissance with which he would have been familiar.[16] In *Study of Andromeda Viewed from the Back*, signed and dated 1885 (fig. 174), Burne-Jones returned to the figure of these compositional drawings and the Adelaide painting and reworked the hands slightly, bringing the pose closer still to the final version.[17] It has been sug-gested that this drawing was done from life.[18] It is more likely that he reworked the pose explored in the earlier drawings. The intent gaze and sense of movement in the

flying hair, as if she has just turned her head to stare at Perseus, lends it a sense of determination that is even stronger than in the Winthrop drawing.[19]

By contrast the figure of Perseus, apart from added armor, changes less throughout the evolution of the scene.[20] As for the serpent, its coils become less elaborate, and the two that encircle Andromeda in the compositional drawings have disappeared. Burne-Jones also reinstates the monster's head in the final versions, whereas in the Winthrop drawing Perseus already seems to have cut it off and is holding onto the neck. In the final oil and cartoon he presses his hand against the monster's neck to ward off its open mouth.

This drawing, together with the closely related Chicago and lost sketches, represents an important step in the evolution of *The Doom Fulfilled*, particularly with regard to Andromeda, and may have helped to resolve the same figure in *The Rock of Doom*, creating companion scenes in which the figures complement each other in stance and demeanor.

Sarah Herring

1. He decided to ask Burne-Jones to carry out the decoration after Lady Airlie took him on a visit to the artist's studio in 1875. "It so happens that the principal drawing room was, as London drawing-rooms go, long and well-lit, and the happy thought occurred to me to ask my new friend to design for it a series of pictures characteristic of his art." Balfour 1930, pp. 233–34. Burne-Jones visited the house in March of that year but decided the lighting in that room was too harsh and asked for the windows to be reglazed, the walls to be repaneled in oak, and an oak ceiling to be added. Lady Burne-Jones states that it was the music room; Burne-Jones 1904, vol. 2, p. 60.

2. The list of subjects is in the Fitzwilliam Museum, Cambridge, sketchbook 1070, fol. 77v.

3. Tate Gallery, London (No3456-8). The first design illustrates *The Call of Perseus, Perseus and the Graiae*, and *Perseus and the Nereids;* the second, *The Finding of Medusa, The Death of Medusa (The Birth of Pegasus and Chrysador)*, and *Perseus Pursued by the Gorgons;* and the final, in addition to the combined scenes of Andromeda and Perseus, *Atlas Turned to Stone, The Court of Phineas*, and *The Baleful Head*. See London–Munich–Amsterdam 1997–98, pp. 227–28, nos. 93–95.

4. Southampton City Art Gallery. They were begun in 1877 and completed in 1885. See Southampton 1998.

5. These are in the Staatsgalerie, Stuttgart, together with two unfinished canvases and two duplicate cartoons.

6. Burne-Jones mentions these canvases in "List of my designs, drawings and pictures from 1856 when I began to draw": "This year I finished two pictures of the Perseus story. The Rock of Doom and the Doom's fulfillment." Manuscript, 1888, fol. 35, Fitzwilliam Museum, Cambridge.

7. *Athenaeum*, May 19, 1888, p. 635. *Art Journal* (1888), p. 221, also complains about the lack of emotion or "human interest," and the sentiment is repeated by Cosmo Monkhouse in the *Academy*, June 2, 1888, p. 383: "Finally, we know what human nature is, and it is difficult to believe in the terror of a scene which can be regarded by Andromeda with such *sang-froid*."

8. For a detailed examination of the studies and development of these scenes and the others in the series, see Löcher 1973. Other examinations of the series include Wildman and Christian in New York–Birmingham–Paris 1998–99, pp. 221–34.

9. See Menz in Adelaide 1994, p. 67, no. 18.

10. Private collection, Paris; see Löcher 1973, no. 8a. According to Löcher the first appearance of *The Rock of Doom* as a single scene is in a drawing in Fitzwilliam Museum sketchbook 1085, fols. 22r and 19v.

11. A series of studies for the figure in *The Doom Fulfilled* in sketchbooks E.9-1955 and E.442-1943, Victoria and Albert Museum, London, also shows her from the front and in movement and, as Löcher points out (1973, p. 30 and nos. 9q and 9r), have very little relation to the final work.

12. The studies for the figure of Andromeda in *The Rock of Doom* are also in Victoria and Albert Museum sketchbook E.9-1955. They are Löcher 1973, nos. 8g, h, i, k, l, o. Löcher no. 8e is a study for the Adelaide painting in the Birmingham Museum and Art Gallery, sketchbook P 5'52.

13. William Morris, "The Doom of Acrisius," quoted in Löcher 1973, p. 45.

14. The Chicago drawing is no. 9f in Löcher 1973, and the third drawing, with the figures sketched in outline, is his no. 6g. He does not cite the Winthrop drawing. There is a further drawing that explores the figure of Andromeda, dated 1875–76, not cited by Löcher; it is in the University of Michigan Museum of Art, Ann Arbor.

15. In the Chicago drawing her head is also turned so that she is seen in lost profile. The raised heel in all three drawings actually makes more sense than in the final versions, as in these she is shown poised on a precipitous cliff, the toes of her left foot balancing on the uneven rock. In the Adelaide painting and the final cartoon and oil this rock has become the smooth surface of many flat-topped pillars, removing any justification for the raised heel and emphasizing the Mannerist, rather artificial nature of the pose.

16. A drawing for Andromeda in *The Rock of Doom* exhibited at Peter Nahum, London, 1989, no. 57, represents an intermediate stage between the Tate watercolor and the Adelaide painting and the final cartoon and oil.

17. British Museum, London, 1967-10-14-48; Löcher 1973, no. 9v. The right arm is still visible, however, as in the Winthrop and its related drawings and unlike the final versions, where it is drawn right across her front and invisible from the back. The chin is still sunk into the shoulder. Interestingly the positioning of the arms has been taken from his earlier conception of the figure in *The Rock of Doom*, for instance in the Tate design, where one is hooked behind the rock and the other is drawn across the body. There is a related study of the back of Andromeda in Fitzwilliam Museum sketchbook 1991 B, fol. 23r (Löcher 1973, no. 9f), two studies of her head in the same sketchbook, fols. 23v and 24r (ibid., nos. 9w and 9x), a further back study in the Tate Gallery, No3980 (ibid., no. 9u), and a study of her arm and hand at the Yale University Art Gallery, New Haven (ibid., no. 9y).

18. London–Southampton–Birmingham 1975–76, p. 62, no. 172.

19. Löcher (1973, p. 37, n. 51) reproduces a drawing by Frederic Leighton in a sheet of studies of 1872 for *Summer Moon* (private collection) of a nude in almost exactly the same pose as Andromeda. The drawing is in Leighton House, London, L.H. no. 520. It is difficult to state with any certainty, however, if there was any mutual influence. He states that Burne-Jones also used the figure in his *Masque of Cupid*, ca. 1898. It appears on the extreme left of one of the studies of 1872 (National Museum and Gallery, Cardiff) but not in the final watercolor of ca. 1898 (private collection).

20. Studies of the figure of Perseus are in Birmingham Museum and Art Gallery sketchbook P5'52 (dated July 1875), which also contains studies related to *The Rock of Doom* (Löcher 1973, nos. 9l, m, n); Fitzwilliam Museum sketchbook 962, fol. 14r (ibid., no. 9i); and the Reitlinger Collection, London (ibid., no. 9 0). A head of Perseus is in the Courtauld Institute, London (ibid., no. 9p).

PROVENANCE: Charles Fairfax Murray, London; Francis Bullard, Boston; his bequest to Grenville L. Winthrop, 1913; his bequest to the Fogg Art Museum, 1943.

EXHIBITION: Cambridge, Mass., 1946b, no. 24.

REFERENCES: Sutton 1978a, p. 450; Cohn 1993, p. 38, no. 55.

161–165. *The Days of Creation*, 1875–76

Watercolor, gouache, shell gold, and platinum paint, on linen-covered panels prepared with zinc white ground
Five panels, each approx. 40³/₁₆ x 14⅛ in. (102.1 x 36 cm)
Signed and dated in gold paint, lower left of cat. no. 161: E B J 1876
1943.454–56, 1943.458–59[1]

Burne-Jones painted *The Days of Creation* during what he later described as "the seven blissfullest years of work that I ever had,"[2] the years leading up to the first exhibition of the Grosvenor Gallery, London, in 1877. The series was part of the spectacular array of paintings that he showed at that exhibition, which made him famous overnight and established him as the leading artist of the Aesthetic Movement in British art.

Within Burne-Jones's work the *Days* belongs to a family of serial compositions in which he used figures to represent times; elsewhere the subjects are the seasons or the hours.[3] Here he addresses the grand narrative of the creation of the universe, each panel in the series showing God's acts on one of the days of creation as described in the first chapter of the Book of Genesis. The days are personified by angels, whose complicated wings and feathered costumes are the decorative theme of the series: in the words of Henry James, the angels' faces seem to rise out of a "feathery wall."[4] Much of the extraordinary beauty of the series lies in the effects of color that Burne-Jones achieves in his treatment of this dominant feature. The colors of the feathers seem to defy being named, such is the subtlety with which they shift and blend—the gradual warming of color through the series suggesting the progress of creation as it becomes more and more hospitable to mankind.

All but one of the angels holds a glassy sphere in which a stage of creation is represented.[5] The spheres suggest at once the earth and the universe as a whole; the divine acts of creation seem to unfold within strange and indefinable spaces appropriate to the mysteriousness of the events. Having presented their spheres—their heads marked by a flame of spiritual energy as they do so—the first five angels continue to appear in the compositions that follow, standing behind or alongside the successive newcomers to the group. This makes for an effect of crescendo, like that of a piece of music played first on a single instrument and then by two together, then three, and so on. The six sphere-holding angels are joined in the final composition by the angel of the seventh day, the day of rest, who plays on a medieval psaltery.

The events symbolized in the spheres are as follows: *The First Day*—the creation of light and the division of light from darkness, day from night, shown by separate, smaller spheres within the larger one (Genesis 1:1–5); *The Second Day*—the creation of the firmament, or Heaven, dividing the waters above from those below, again shown by a pair of spheres within the larger one (1:6–8); *The Third Day*—the division of the seas from the dry land and the creation of plants and trees, represented by olives and vines (1:9–13); *The Fourth Day*—the creation of the sun, moon, and stars (1:14–19); *The Fifth Day*—the bringing forth of creatures from the sea, the fish and the birds (1:20–23); *The Sixth Day*—the creation of the rest of the animals, as well as mankind in the form of Adam and Eve, behind whom are the tree of knowledge of good and evil, and the serpent (1:24–31).

As Dorothy Mercer has pointed out, the days of creation were a most unusual and

original theme for a modern artist to undertake, and Burne-Jones may have been the first since medieval times to treat the whole sequence in a single work.[6] The most familiar images from the creation narrative place the emphasis on the Creator—the dynamic and heroic figure of the Almighty in Michelangelo's Sistine Chapel ceiling, for instance. It is typical of Burne-Jones, and indeed of the whole Aesthetic Movement, that he should offer such a static, passive, and feminine alternative with his sphere-holding angels, devoid of action and expression alike. For him the paramount good in a work of art lay in its beauty and in its broad, universal meaning—to which drama and emotion, beyond a dreamy melancholy, were inimical. When Henry James saw *The Days of Creation* at the Grosvenor Gallery, he was fascinated above all by the angels' faces and "that vague, morbid pathos, that appealing desire for an indefinite object, which seems among these artists an essential part of the conception of human loveliness."[7] Burne-Jones avoided expression because he wanted his figures to be "types, symbols, suggestions," rather than individuals with whom we might identify. "The moment you give what people call expression, you destroy the typical character of heads and degrade them into portraits which stand for nothing," he once remarked.[8]

According to an inscription on the reverse of *The First Day*, probably by the artist himself though possibly by an assistant, the series was "designed 1870 / painted 1875–6." It is typical of the cross-fertilization that took place between Burne-Jones's activities as a fine artist on the one hand and a designer on the other that he first developed the idea of the series under the auspices of the decorative-arts firm that

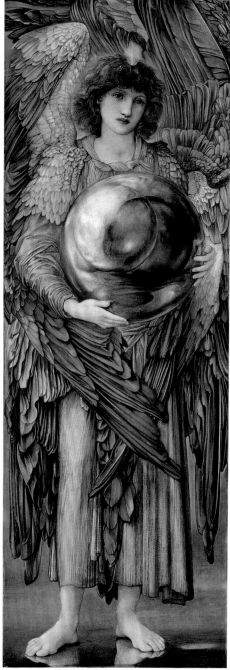

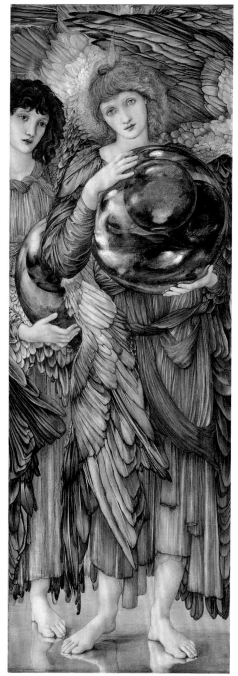

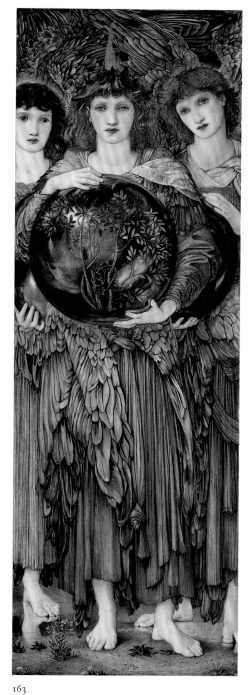

161

162

163

he had helped found with his friend William Morris. Its origin was a stained-glass window that he designed in 1870 for All Saints Parish Church, Middleton Cheney, Northamptonshire; the six small *Days of Creation* lights form the middle tier of the window, above three much larger lights showing Shadrach, Meschach, and Abednego.[9] The present series of watercolors, which follows the basic designs of the Middleton Cheney windows fairly closely,

seems to have been planned in 1872 and executed in 1875–76 over a ten-month period.[10] The idiosyncratic technique Burne-Jones used in carrying out the work is far removed from that of a typical British watercolorist of his own or any other period. His object seems to have been to make watercolor look like anything but itself: the matte surface recalls fresco or tempera; the small brushstrokes and cross-hatching also recall tempera; the fine weave

of the linen support shows through like canvas through oil paint; and the many touches of gold and silver (in fact platinum) throughout the panels would, for most of Burne-Jones's contemporaries, have suggested a decorator's work rather than that of the fine artist.

The *Days* were originally displayed in a frame of Burne-Jones's own design (see fig. 176). Clearly it was important to him that the series should be seen together and

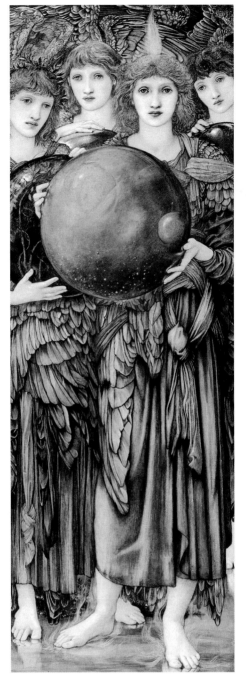
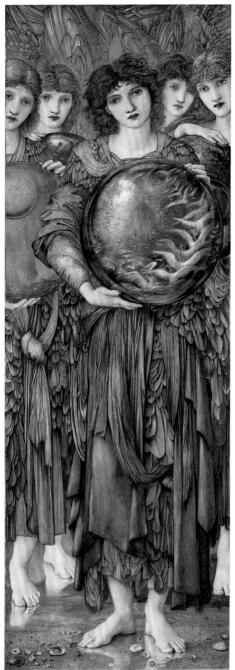
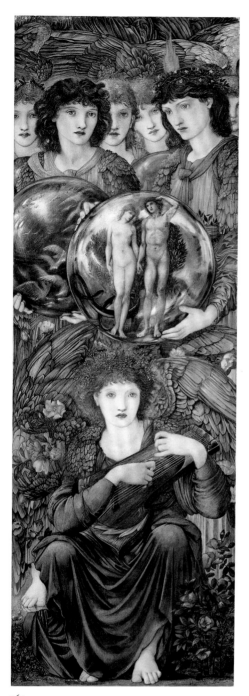

164

165

Fig. 175. Edward Burne-Jones, *The Fourth Day*, 1875–76. Watercolor, gouache, shell gold, and platinum paint, on linen-covered panel prepared with zinc white ground, approx. 40 3/16 x 14 1/8 in. (102.1 x 36 cm). Stolen; formerly Fogg Art Museum, Bequest of Grenville L. Winthrop, 1943.457; present whereabouts unknown

in this setting. The reverse of the first panel is inscribed (again, either by the artist or by an assistant): "This picture is not complete by / itself, but is No. 1 of a series of / six water color pictures representing / the Days of Creation, which are / placed in a frame designed by / the Painter, from which he / desires they may not be removed," and there are similar inscriptions on the reverse of all the other panels. Burne-Jones designed many of the frames

for his works, and this was a landmark in being the first of his elaborate, aedicular (or altarpiece-like) designs to be carried out.[11] The Latin inscription on the frieze, chosen presumably for its references to time, darkness, and light—all ideas represented in the *Days*—is from the Book of Daniel: "Blessed be the name of God for ever and ever: for wisdom and might are his. And he changeth the times and the seasons: he knoweth what is in the darkness,

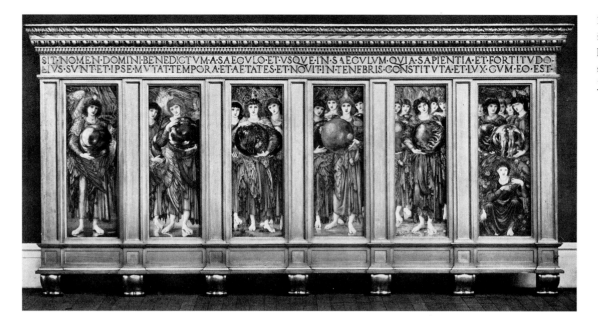

and the light dwelleth with him."[12] Despite the artist's wishes, the original frame seems to have been destroyed after the watercolors were acquired by Grenville Winthrop, who reframed them singly in plain gilt moldings.[13]

The photographer Frederick Hollyer made platinotype reproductions of all six of the *Days*, probably about the time of their first exhibition at the Grosvenor Gallery in 1877.[14] These were available in various types of frame including an aedicular design in oak that was a simplified version of the frame the artist designed for the watercolors themselves.[15] Oscar Wilde had a set in his rooms at Magdalen College, Oxford.[16] In 1892 Margaret, Lady Brooke obtained a set from Burne-Jones to send to the French Symbolist painter Gustave Moreau, who was effusively grateful for them.[17]

Malcolm Warner

1. *The Fourth Day* (fig. 175) is not in the present exhibition, having been stolen from a dining room in Dunster House, Harvard University, in 1970. The whole *Days of Creation* series was hanging there at the time, on loan from the Fogg Art Museum through the University Loans Program.
2. Burne-Jones 1904, vol. 2, p. 13.
3. In 1869–70, for instance, he painted a series of four paintings of *The Seasons* (private collection) and in 1870–83 the six-figure composition *The Hours* (Sheffield Art Gallery).
4. From an essay first published in the *Galaxy*, August 1877; reprinted in James 1956, p. 146.
5. Dorothy Mercer (1989) cites an array of possible sources for the idea of angels holding symbolic globes, from medieval manuscripts to William Blake. Perhaps the most likely to have been in Burne-Jones's mind was the 15th-century set of engraved cards known as the "Tarocchi of Mantegna," of which his friend John Ruskin owned a set.
6. Mercer's dissertation (ibid.) deals in some detail with the tradition of the creation in art and literature, and the stylistic and iconographic evolution of the theme in Burne-Jones's work.
7. James 1956, p. 146.
8. Burne-Jones 1904, vol. 2, pp. 140–41.
9. See Sewter 1974–75, vol. 1, fig. 322, vol. 2, p. 134. Apparently the earliest finished designs for the series (graphite, each 19½ x 7 in. [49.5 x 17.8 cm], contained in a single frame) are in a private collection in England. Further *Days of Creation* stained-glass windows were made by Morris for Saint Editha's Church, Tamworth, Staffordshire (1874), and Manchester College Chapel, Oxford (1895); and the Della Robbia Pottery in Birkenhead made some ceramic panels (1895–1904).
10. Preparatory drawings dating from 1872–76 include fourteen sheets of studies at the Fitzwilliam Museum, Cambridge (1995, 2002.1–4, 2011A and B, 2013.1–7), and one sheet at Birmingham Museum and Art Gallery (464'27); a pair of studies for the main figures in *The Second Day* and *The Sixth Day* was exhibited at the Royal Society of British Artists in 1944 (no. 55).
11. See Mitchell and Roberts 2000, p. 365.
12. Daniel 2:20–22 (abbreviated).
13. The problem seems to have been the sheer amount of space the work occupied in the original frame, which was six feet tall and twelve feet wide. On June 14, 1934, Winthrop's agent Martin Birnbaum wrote to him: "The question of the frame is a rather difficult one. It was designed by the artist, but it is a vast affair. I have decided to send it on, in spite of the expense, for it might be used, if my suggestion of making an additional room for the English division can be carried out or realized," and on June 27: "You may decide to reframe the six panels, and store the large frame, on which the letters need regilding. A place might be built for this great work in the new English Room!!" (from letters in the Harvard University Art Museums Archives).
14. The Photograph Department at the Fogg Art Museum contains a set (P1994.8–13).
15. See Mitchell and Roberts 2000, pp. 365–66, 368, fig. 35.
16. See London 2000, p. 17, fig. 11.
17. See des Cars 1998, pp. 29–30.

PROVENANCE: Purchased from the artist by William Graham, London, 1877 (£2,000); his sale, Christie's, London, April 2–4, 1886, no. 161 (£1,732 10s.); purchased at that sale by Thomas Agnew and Sons, London; purchased from them by Alexander Henderson, later first Lord Faringdon, 1886; his sale, Sotheby's, London, June 13, 1934, no. 99 (£860); acquired at that sale through Martin Birnbaum by Grenville L. Winthrop; his bequest to the Fogg Art Museum, 1943.

EXHIBITIONS: London 1877, no. 60; Birmingham 1885; London 1892–93, no. 23; London 1898–99, no. 29; Cambridge, Mass., 1946b, no. 25; Cambridge, Mass., 1977b, no. 9; Tokyo 2002, nos. 27-1 (cat. no. 164), 27-2 (cat. no. 165).

REFERENCES: Stephens 1885, pp. 229–30; Bell 1894, pp. 49–51, 102; Cartwright 1894, p. 19; Bayliss 1902, pp. 79–81, frontis.; James (1877) 1956, pp. 145–46; Birnbaum 1960, pp. 204–5; Mortimer 1985, no. 295, illus. (cat. no. 161); Harrison and Waters 1989, pp. 110–13; Mercer 1989; des Cars 1998, pp. 29–30, 143; Mancoff 1998, pp. 71–73; Garnett 2000, pp. 258, 260, 262, 288; Mitchell and Roberts 2000, p. 365.

Four Sketchbooks

The four sketchbooks by Burne-Jones in the Winthrop collection are little known and have rarely been published. Winthrop must have been intrigued by the private "pocketbooks" of such artists as Burne-Jones and Jacques-Louis David (see cat. nos. 19, 20), although he usually preferred more finished works. Following a tip from Charles Ricketts, Martin Birnbaum acquired these sketchbooks from a "Miss Gray" in London in 1928 and noted that they were from the collection of the artist's son, Philip Burne-Jones.[1] He wrote to Winthrop that "they would add an interesting note to your fine group and would be of immense interest to students. . . . [T]hey would be kept in the library or in the tables in the Pre Raphaelite rooms."[2]

After Burne-Jones was roundly criticized in the 1860s for his unschooled drawing—the *Times* chastised him for "anatomical eccentricities"—he was determined to atone for his lack of academic training.[3] He never ceased to do the work of an artist: keeping up with his drawing and the training of his hand. He admonished his wife's sister, who had artistic intentions: "Keep up drawing the whole time through, say at the least half the day, and let it be from nature—faces, best of all, because hardest. Practise at anything that will reveal its mistakes most glaringly; not at foliage, because a hundred errors may be concealed in the general confusion, nor even drapery, but bare arms, necks, noses, tops of heads, &c. wherein one faltering step turns everything to ridicule."[4]

Philip Burne-Jones remembered that "before starting upon the actual painting of a large composition it was my father's custom to make innumerable careful studies of limbs, drapery, etc. in chalk or pencil—and from these he worked upon the picture."[5]

His nude studies in preparation for paintings were a conscious adoption of the academic tradition. Later in his life, Burne-Jones said about his picture *The Sleep of Arthur in Avalon* (1881–98; Museo de Arte de Ponce, Puerto Rico): "It won't do to begin painting heads or much detail in this picture till it's all settled. I do so believe in getting in the bones of a picture properly first, then putting on the flesh and afterwards the skin, and then another skin; last of all combing its hair and sending it forth to the world. If you begin with the flesh and the skin and trust to getting the bones right afterwards, it's such a very slippery process."[6] The traditional academic preparation of a painting, with its carefully delineated steps, had become second nature.

Dozens of Burne-Jones's sketchbooks are known, and no doubt large numbers of pages were removed from them by the artist himself, as well as by family and collectors.[7] Many of the drawings, including most of those in the Winthrop sketchbooks, are signed with the artist's initials. Burne-Jones paid special attention to the drawings he selected for an exhibition at the Fine Art Society, London, in 1896, "looking them out, touching, arranging, naming, and dating." He found it overwhelming and vowed that "in future I'll sign every single drawing as I do it and put all the writing on it that it will ever need at once, and never have such a business as this over again. I am so dazed and tired as to have forgotten how to spell."[8] Clearly some of the drawings removed from sketchbooks were included in exhibitions such as the Fine Art Society's.

Because Burne-Jones labored on many of his paintings for decades, it is difficult to date the sketchbooks exactly based on studies for particular works. Many of the drawings in the Winthrop sketchbooks are connected with his paintings of the 1870s and 1880s, and more will surely be identified with further research. The repetition of motifs from one picture to another complicates the task. While some of his sketchbooks include rapid composition studies, others, like the Winthrop sketchbooks, reveal an artist of some caution and deliberation, painstaking in his preparation for finished works. Once the composition was established Burne-Jones concentrated on individual elements within the whole. The sketchbooks are replete with careful studies of nudes and hands, limbs, and feet in the attitudes they would assume in the final paintings. The precision of many of the studies suggests that the artist may have used some of his sketchbooks as a kind of record of satisfactory elements. Many of the studies are artfully situated on the page in a graceful rhythm of hands, feet, and heads. The traditional intimacy of the sketchbook format—with hurried sketches, doodles, and laundry lists—is here tempered by the degree of finish and the artist's self-consciousness. The sketchbooks suggest a hope for a public, rather than a private, posterity.

Miriam Stewart

1. Only two of the sketchbooks, cat. nos. 166 and 167, appear in Philip Burne-Jones's sale, Sotheby's, London, November 10, 1926.
2. Birnbaum, letter to Winthrop, June 29, 1928, Harvard University Art Museums Archives.
3. "His figures are queerly drawn, stand in contorted attitudes, show neither bone, muscle, nor curvature of flesh under their robes"; "The Water-Colour Exhibition—Old Society," *Times* (London), April 25, 1864, p. 14.
4. Burne-Jones 1904, vol. 1, p. 255.
5. Rogers 1970, p. 67, n. 3.
6. Burne-Jones 1904, vol. 2, pp. 322–23.
7. New York–Birmingham–Paris 1998–99, p. 150. This catalogue has been an invaluable resource.
8. Burne-Jones 1904, vol. 2, p. 281.

166. *Sketchbook,* ca. 1870–78

Tan cloth covers, remains of cloth ties
11¹⁄₁₆ x 7⅞ in. (28 x 20 cm)
Inscribed on front cover in brown ink, upper right
corner: *V.;* in graphite on label: 49
Inside front cover: Burne-Jones's bookplate, FROM
THE LIBRARY OF / EDWARD BURNE-JONES /
THE GRANGE NORTH / END ROAD FULHAM
Graphite on 14 pages of heavy cream wove paper;
remaining pages in uncut drawing block; most
pages removed before sketchbook came to Fogg
10¾ x 7⅛ in. (27.2 x 18.1 cm)
Nearly all drawings signed with the artist's ini-
tials; many inscribed by the artist's son, Philip
1943.1815.18

Burne-Jones devoted several decades to the Perseus cycle, begun in 1875 and taken from William Morris's story of King Acrisius in *The Earthly Paradise* (see cat. no. 160), for which a large number of studies exist.[1] This sketchbook includes studies for several compositions in the series: *Perseus and the Graiae* (fol. 10r), *Perseus and the Sea Nymphs (The Arming of Perseus)* (fol. 12r), and *The Finding of Medusa* (fol. 2r); doubtless more drawings

for the project were removed before Winthrop purchased the sketchbook.[2] There is also a portrait identified as Mrs. Drummond (Margaret Benson), who was one of the models for the Perseus cycle (fol. 11r); according to Georgiana Burne-Jones, "many were the studies he made from her."[3]

Philip Burne-Jones identified several drawings in this sketchbook as studies for the figures of Fortune, the Slave, and the King in *The Wheel of Fortune* (1875–83, Musée d'Orsay, Paris; fols. 4r, 5r, 6r, 7r), in which Burne-Jones's debt to Michelangelo is particularly evident. A study of a harnessed man (fol. 9r, illus.) for the unfinished *Car of Love* (also known as *Love's Wayfaring*), begun in 1870 (Victoria and Albert Museum, London), recalls the *Dying Slave* (Louvre, Paris).[4]

A study of Venus in a curious caged chariot (fol. 1r) for *The Passing of Venus* was probably based on a wood-and-wax model.[5] There are also several drawings for the Angel of Suffering (1878; fols. 13r, 14r) in the east window of the Regimental Chapel at Christ Church Cathedral, Oxford.[6]

Miriam Stewart

166, fol. 9r

1. For the cycle, see New York–Birmingham–Paris 1998–99, pp. 221–34, and Löcher 1973.
2. Although beyond the scope of this entry, it would be a rewarding task to find some of the pages missing from the sketchbooks. It is possible that the following drawings, for example, were removed from Fogg sketchbook 1943.1815.18 or another of the same size: *Study for "The Wheel of Fortune,"* 27.1 x 18 cm, signed and dated EBJ 1879, British Museum, London, 1967-10-14-47 (see "Studies of Sir Edward Burne-Jones," *The Studio* 7 [May 1896], p. 200; London–Southampton–Birmingham 1975–76, no. 126); and *Study of Andromeda Viewed from the Back,* 27.2 x 18.2 cm, signed and dated EBJ 1885, British Museum, 1967-10-14-48 (see fig. 174).
3. Burne-Jones 1904, vol. 2, p. 81.
4. Burne-Jones owned a replica of the *Dying Slave;* New York–Birmingham–Paris 1998–99, p. 155, under no. 52.
5. See Burne-Jones 1900, p. 162.

6. Sewter 1974–75, vol. 2, p. 146, fig. 530; for cartoons
 in graphite, see London–Southampton–Birmingham
 1975–76, no. 200, illus.

PROVENANCE: Philip Burne-Jones, the artist's son,
London; his sale, Sotheby's, London, November 10,
1926, no. 97 (£20); purchased at that sale by (?)
Spencer; Miss Gray; acquired from her through Martin
Birnbaum by Grenville L. Winthrop, August 1, 1928
(£126 10s. for cat. nos. 166–169); his bequest to the
Fogg Art Museum, 1943.

EXHIBITIONS: Cambridge, Mass., 1946b, no. 47;
Cambridge, Mass., 1969, no. 112c.

REFERENCES: Löcher 1973, no. 2k, fig. 39 (fol. 10),
no. 3h (fol. 12), no. 4s (fol. 2); Saywell 1998, p. 36
under "Sketchbook."

167. *Sketchbook*, 1870s–1880s

Tan cloth covers, pencil sleeve, remains of cloth ties
5½ x 4 in. (14 x 10 cm)
Inscribed on front cover in graphite on label, top: 33
Inside front cover: Burne-Jones's bookplate, FROM
THE LIBRARY OF / EDWARD BURNE-JONES /
THE GRANGE NORTH / END ROAD FULHAM;
fragment of Roberson label
Graphite on 44 pages of heavy cream wove paper;
remaining pages are in uncut drawing block
5¼ x 3¾ in. (13.4 x 9.4 cm)
Most drawings signed with artist's initials
1943.1815.15

167, fol. 10r

This sketchbook contains a large number of drapery studies, in which the fabric is intricately tied in often improbable knots (e.g., fol. 10r, illus.). In some of the drawings the drapery takes on a life of its own, floating freely, with little or no reference to the physical body (as seen, for example, in the painting *The Tree of Forgiveness*, 1881–82; Lady Lever Art Gallery, Port Sunlight); in others, it is bound around the waist or loins, sometimes serving as an elaborate sling for a sword (e.g., in *The Rock of Doom*, fig. 170). T. Martin Wood noted that the artist's "arrangement of drapery is always beautiful, and he owes less to the Parthenon than to his own fancy for the rhythm of the folds."[1]

Several studies of female heads in turbans and draped female figures may relate to *The Wheel of Fortune* (1875–83; Musée d'Orsay, Paris), although the contrapposto stance of the figure of Fortune, with the right knee forward, can be found in many of Burne-Jones's works. Other drawings in the sketchbook include studies of a cloaked male figure with a staff (fols. 38r–39v), and a series of heads of a youth with curly hair (fols. 24v–26v).

Miriam Stewart

1. Wood 1907, p. 5.

PROVENANCE: Philip Burne-Jones, the artist's son,
London; his sale, Sotheby's, London, November 10,
1926, no. 96 (£11); purchased at that sale by (?)
Spencer; Miss Gray; acquired from her through Martin
Birnbaum by Grenville L. Winthrop, August 1, 1928
(£126 10s. for cat. nos. 166–169); his bequest to the
Fogg Art Museum, 1943.

EXHIBITIONS: Cambridge, Mass., 1946b, no. 44;
Cambridge, Mass., 1994–95, no. 9.

168, fols. 24v–25r

168, fol. 6r

168. *Sketchbook*, 1880s (?)

Tan cloth covers
9⅞ x 6¼ in. (25 x 16 cm)
Inscribed on front cover in graphite, top: BANNERS;
in graphite on label: 67
Inside front cover: Burne-Jones's bookplate, FROM
THE LIBRARY OF / EDWARD BURNE-JONES /
THE GRANGE NORTH / END ROAD FULHAM
Variously black and purple chalk, graphite, and
dark brown ink on 92 pages of cream modern laid
paper
9½ x 6⅛ in. (24.1 x 15.6 cm), bound irregularly
Some drawings signed with artist's initials; several
pages inscribed in graphite with letters of the
alphabet
Watermark: MICHALLET
1943.1815.16

Burne-Jones's devotion to drapery is here
expressed in lovingly rendered studies of
banners of all sorts, some stretching across
the sketchbook openings (e.g., fols. 24v–
25r, illus.). There are stately flags and
sprightly pennants with forked tails. Some
swell in the breeze or curl in on themselves
like birch-bark fragments, others hang
mute and limp. They may relate to the
stylized banners in the late painting *The
Fall of Lucifer* (1894; collection of Lord
Lloyd-Webber), or another of Burne-
Jones's battle subjects, such as *Flodden
Field* (1882; Musée d'Orsay, Paris).[1]

Burne-Jones's admiration for Michel-
angelo was heightened by a visit to the
Sistine Chapel in 1871: "[H]e bought the
best opera-glass he could find, folded his
railway rug thickly, and, lying down on his
back, read the ceiling from beginning to
end, peering into every corner and revel-
ling in its execution."[2] In the same year
Burne-Jones implored his friend Charles
Eliot Norton to continue to send him repro-
ductions of works by the old masters:
"Select some for me, will you—I can't
judge of them, can I, and you know what I
like—the more finished the better. I love
Da Vinci and Michael Angelo most of all."[3]

Michelangelo's influence is demon-
strated in this sketchbook by the diligent
studies in purple chalk after the tomb
figures *Dawn* and *Night* from the Medici
Chapel (fols. 3r, 4r, 5r, 6r [illus.], 7v).
Graham Robertson, on his first visit to
Burne-Jones's studio, noted that "the only
ornaments were pale casts; the Night and
Morning of Michelangelo brooded over
the hearth."[4] A cast of *Dawn* is visible in a
watercolor of the drawing room at Burne-
Jones's house, the Grange, by his studio
assistant Thomas Matthews Rooke.[5] The
drawings in this sketchbook are executed
from different vantage points, suggesting
that the artist worked from these small
replicas, which could easily be turned.[6] As
Burne-Jones's draftsmanship became more
assured his figures began to swell with a
Michelangelesque vigor, borne out in the
studies (for example, fols. 88v, 89v, 90v,
91r, 92v) for Demophoön's legs in *The Tree
of Forgiveness* (1881–82; Lady Lever Art
Gallery), a later, more robust version of
Phyllis and Demophoön (1870; Birmingham
Museum and Art Gallery).

Although Burne-Jones was seemingly indifferent to landscape studies from nature—Graham Robertson could not "remember once to have heard him express pleasure at a natural effect"[7]—there are a number of dutiful sketches of trees presumably drawn out of doors. One of the studies of birch trees (fol. 41r) is inscribed: "stripes on the birch trees / of terra verte—as if / streaked on white plaister [sic]." *Miriam Stewart*

1. New York–Birmingham–Paris 1998–99, p. 283, under no. 132.
2. Burne-Jones 1904, vol. 2, p. 26.
3. Ibid., p. 20.
4. Robertson 1931, p. 74.
5. London–Southampton–Birmingham 1975–76, no. 376.
6. There may be some confusion in the identification of the replicas of the tomb figures in Burne-Jones's possession. It is not clear whether he owned all four—*Dawn, Day, Evening,* and *Night*—or just the female figures, *Dawn* and *Night.*
7. Robertson 1931, p. 82.

PROVENANCE: Philip Burne-Jones, the artist's son, London; Miss Gray; acquired from her through Martin Birnbaum by Grenville L. Winthrop, August 1, 1928 (£126 10s. for cat. nos. 166–169); his bequest to the Fogg Art Museum, 1943.

EXHIBITIONS: Cambridge, Mass., 1946b, no. 45; Cambridge, Mass., 1969, no. 112a; Cambridge, Mass., 1994–95, no. 11.

169, fol. 5r

169. *Sketchbook,* ca. 1880–86

Tan cloth covers, remains of cloth ties
10⅝ x 6¾ in. (27 x 17 cm)
Inscribed on front cover in brown ink, upper right corner: XVI 18 / 80;[1] in graphite on label: 41
Inside front cover: Burne-Jones's bookplate, FROM THE LIBRARY OF / EDWARD BURNE-JONES / THE GRANGE NORTH / END ROAD FULHAM; *label,* ROBERSON & CO. / 99, LONG ACRE, / LONDON
Variously graphite and black crayon on 12 pages of heavy cream wove paper; remaining pages are in uncut drawing block; most pages removed before sketchbook came to Fogg
10⅜ x 5⅞ in. (26.3 x 15 cm)
Nearly all drawings signed with artist's initials; a few inscribed by the artist's son, Philip; several pages inscribed in graphite with series of numbers 1943.1815.17

Many of the drawings in this sketchbook can be connected to specific compositions. Refined, elegant studies of hands, some plucking psalteries or fingering panpipes, are related to *The Bath of Venus* (1873–88, Museu Calouste Gulbenkian, Lisbon; fols. 5r [illus.], 7r). Other hand studies can be linked to *The Hours* (1870–83, Sheffield City Museum and Mappin Art Gallery; fols. 1r–2r, 3r). In two studies, identified by Philip Burne-Jones, for *Flamma Vestalis* (1886, private collection, Switzerland; fols. 7v, 8r), the subject, said to be Burne-Jones's daughter Margaret, wears a peasant frock with full sleeves, and holds a sprig of flowers instead of the rosary she clasps in the painting.[2]

There are also drawings for *Hill Fairies*, a pair of panels originally intended to flank *The Sleep of Arthur in Avalon* (1881–98, Museo de Arte de Ponce; fols. 9v, 10r).

Miriam Stewart

1. Many of Burne-Jones's sketchbooks are numbered on the cover, presumably by the artist. See London–Southampton–Birmingham 1975–76, no. 125.
2. A half-length version of the painting from the Winthrop collection is now in the Fogg Art Museum (1943.190).

PROVENANCE: Philip Burne-Jones, the artist's son, London; Miss Gray; acquired from her through Martin Birnbaum by Grenville L. Winthrop, August 1, 1928 (£126 10s. for cat. nos. 166–169); his bequest to the Fogg Art Museum, 1943.

EXHIBITIONS: Cambridge, Mass., 1946b, no. 46; Cambridge, Mass., 1969, no. 112b; Cambridge, Mass., 1994–95, no. 10.

170. *The Depths of the Sea*, 1887

Watercolor and gouache on wove paper mounted on panel
77½ x 29⅞ in. (197 x 76 cm)
Signed and dated in gouache, lower left: EBJ /
1887
1943.462

On June 5, 1885, Burne-Jones received a letter from his friend, the current president of the Royal Academy, Frederic Leighton: "Dear Ned, an event has just occurred which has filled me with the deepest satisfaction and with real joy. A spontaneous act of justice has been done at Burlington

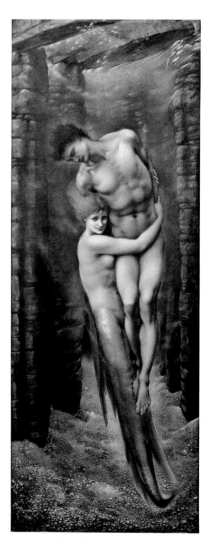

Fig. 177. Edward Burne-Jones, *The Depths of the Sea*, 1886. Oil on canvas, 77½ x 29½ in. (197 x 75 cm). Private collection, courtesy of Julian Hartnoll

House—the largest meeting of members that I ever saw has by a majority elected you an Associate of the Royal Academy. I am not aware that any other case exists of an Artist being elected who has never exhibited, nay has pointedly abstained from exhibiting on our walls. It is a pure tribute to your genius and therefore a true rejoicing to your affectionate old friend Fred Leighton."[1] Characteristically, Burne-Jones was torn in his decision to accept this unexpected honor between his personal friendship with Leighton and his affiliation with the academy's rival, the Grosvenor Gallery.

Conflicted as he was, Burne-Jones accepted the associateship but exhibited nothing in 1885. In 1886 he exhibited the only painting he was to show at the Royal Academy, the version of *The Depths of the Sea* in oil on canvas (no. 314; fig. 177), of which Winthrop's painting, initialed by the artist and dated 1887, is a copy in watercolor and gouache.

It has been suggested that Burne-Jones's interest in the subject of mermaids was linked to his purchase of a house in Rottingdean, a village on the Sussex coast, in 1880.[2] *The Depths of the Sea* depicts a mermaid dragging the body of a sailor down to her subterranean depths without realizing that the water, which is her natural environment, has already caused his death. To embody this eerie vision, Burne-Jones borrowed a studio property that Henry Holiday had used when painting a picture of the Rhine maidens in Richard Wagner's *Das Rheingold:* "a large tank with a plate glass front, filled with water coloured transparent blue-green. I also modeled rocks and the effect was curiously natural."[3] A structure of rocks like undersea pillars surrounds the two figures, and a shoal of small fishes floats at the top right-hand

corner of the painting, an invention that Burne-Jones had toyed with omitting, but which Leighton urged him to include: "I like the idea of the fish up there *hugely*," he wrote; "they would emphasise the fanciful character which is the charm of the picture, and would bring home to the vulgar eye . . . the *underwateriness* which you have indicated by the delightful green swirls in the background."[4]

Leighton himself had exhibited at the Royal Academy in 1858 (no. 501) a similar subject, *The Fisherman and the Syren* (now Bristol Art Gallery), in which a voluptuous mermaid, her blond hair decked with coral and braided with pearls, emerges from the water to clasp the neck of a beautiful young Italianate fisherman, immobilized against a rock.[5] Leighton's painting was inspired by a poem by Johann Wolfgang von Goethe, *Der Fischer:* "Half drew she him, / Half sank he in, / And never more was seen."[6]

In contrast, the fate foretold in Leighton's painting is embodied in Burne-Jones's, in which the willowy mermaid clasps the lithe fisherman about his loins to spirit him to her realm. A beautiful Aesthetic young woman, Laura Tennant Lyttleton, the daughter of Sir Charles Tennant, had been nicknamed "the Siren," and the painter and his wife "always associated 'The Depths of the Sea' with our dear 'Siren,' for the face of the mermaid had some likeness to her strange charm of expression."[7]

While Burne-Jones was painting the Royal Academy *Depths of the Sea*, Laura Lyttleton died in childbirth, on Easter 1886. John Christian, however, has noted that "a fine study for the mermaid's head (Lady Lever Art Gallery, Port Sunlight) has all the appearance of having been made from a professional model."[8] A drawing, *Head of a Girl*, which has been identified with Laura

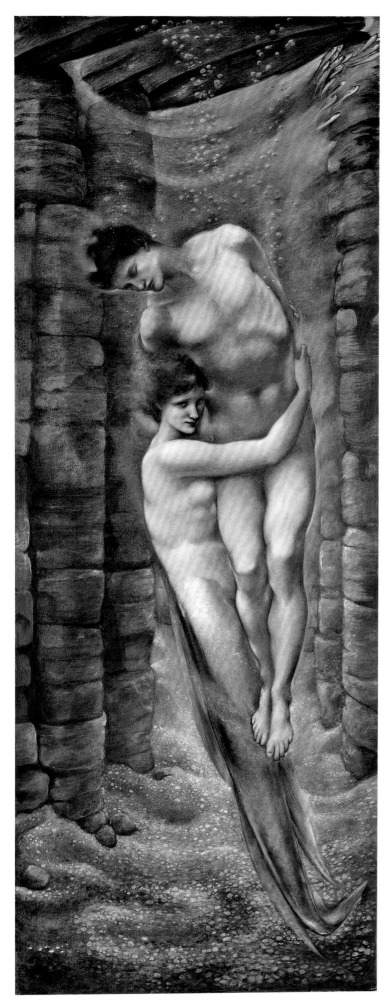

Tennant, was recently exhibited by Peter Nahum in London and New York,[9] but the features and expression bear little resemblance to the glittering eyes and mocking smile of the Royal Academy mermaid, although they are closer to the Winthrop version, in which Burne-Jones has softened and sweetened the visage of the mermaid.

Unfortunately, the Royal Academy *Depths of the Sea* was the only painting Burne-Jones would exhibit there, and he resigned from the academy in 1893. He predicted to another of his young lady devotees, Frances Horner, William Graham's daughter, that the painting would be "lost entirely in the Academy."[10] Its monochromatic tints were overwhelmed when the Royal Academy hanging committee insisted on "flanking her with two portraits of modern ladies in red,"[11] a situation that only J. M. W. Turner on Varnishing Day could have rectified.

Although the dimensions of the oil and watercolor versions are almost identical, Burne-Jones made several subtle changes to the Winthrop replica. There are small differences between the number and placement of the fish and the formation of the rocks, but the most significant ones are the modifications that he made to the mermaid. As well as the changes noted to her expression, the artist altered the position of her neck and face, nestling her head into the fisherman's body and lessening the torsion of her neck. In addition, he modified the contours of her tail fins, so that they look less like the tail fins of a fish and more like the drapery of a nymph. Combined with the calmer, gentler eyes and smile of the mermaid in the Winthrop picture, these changes in position and contour bestow on her less of the animal glee of a predator clasping its prey and more of the gentle embrace of a maiden clasping her beloved.

Gail S. Weinberg

1. Burne-Jones 1904, vol. 2, p. 150.
2. New York–Birmingham–Paris 1998–99, p. 264.
3. Holiday 1914, p. 267, quoted in New York–Birmingham–Paris 1998–99, p. 264.
4. Burne-Jones 1904, vol. 2, p. 165, quoted in New York–Birmingham–Paris 1998–99, p. 265.
5. Ormond and Ormond 1975, p. 39. See also London 1996a, p. 110, no. 12.
6. Ibid.
7. Burne-Jones 1904, vol. 2, p. 166; cited in New York–Birmingham–Paris 1998–99, p. 265.
8. Christian in New York–Birmingham–Paris 1998–99, p. 265.
9. New York–London 2001, no. 11.
10. Burne-Jones 1904, vol. 2, p. 165, quoted in New York–Birmingham–Paris 1998–99, pp. 265–66.
11. Exhibition reviews, *Times* (London), May 1, 1886, p. 10, and May 8, 1886, p. 8, quoted in New York–Birmingham–Paris 1998–99, p. 266.
12. I am grateful to Christopher Newall, who identified the owner as Lord Lawrence of Kingsgate, whose collection was sold at Christie's, London, on March 15, 1935. *The Depths of the Sea* does not appear in this sale and therefore must have been sold or bequeathed separately.
13. Although there is a label on the back of the work from the Inter-Colonial Exhibition, Christopher Newall has found no record of an exhibition by this name either at the Grosvenor Gallery during 1877–90 or in the period after 1912 when the name was reused.

PROVENANCE: Lord Lawrence (the Honorable Charles Napier Lawrence, created first Baron Lawrence of Kingsgate, 1923);[12] Jacques Seligmann and Co., New York; acquired from them by Grenville L. Winthrop, October 3, 1935 ($3,500); his bequest to the Fogg Art Museum, 1943.

EXHIBITIONS: London 1889;[13] Liverpool 1897, no. 1014 (as oil painting); Cambridge, Mass., 1946b, no. 32; Tokyo 2002, no. 46.

REFERENCES: Bell 1892, pp. 62, 110; Burne-Jones 1904, vol. 2, p. 30; de Lisle 1906, p. 186, note; Harrison and Waters 1973, fig. 207; London–Southampton–Birmingham 1975–76, pp. 62–63; Auerbach 1982, p. 94, fig. 23; Allen 1983, no. 45; Cooper 1986b, p. 10, fig. 6; Young 1987, fig. 3; Kestner 1989, pp. 97–98, fig. 2.27; Ash 1993, pl. 26 and facing text; Binion 1993, p. 41, fig. 23; Cullingford 1993, fig. 7, p. 175; Hamilton 1993, p. 147, fig. 71; Gediman 1995, p. 59, fig. 4; Kestner 1995, p. 245, fig. 6.5; Kern 1996, p. 444, fig. 311; Mancoff 1998, pp. 88, 91, pl. 38; New York–Birmingham–Paris 1998–99, pp. 264–66, under no. 119.

John Flaxman

York, England, 1755–London, 1826

171. *Album of Drawings for the "Divine Comedy,"* 1792

Dark yellow morocco leather binding
14¼ x 17⅞ in. (36.1 x 45.5 cm)
Album cover stamped with arms and motto of Thomas Hope, AT SPES NON FRACTA; Hope's stamp (T.H.) in black ink on inside page
111 drawings pasted on album pages; gray ink on off-white wove paper, sizes vary slightly. Each drawing surrounded by a gray ink border, with a quotation from the Divine Comedy *inscribed beneath*
Department of Printing and Graphic Arts, Houghton Library, Harvard College Library,
**42.1353F*

John Flaxman's drawings were the first complete set of illustrations of Dante's *Divine Comedy* in the eighteenth century. As such they helped launch and inspire the nineteenth-century rediscovery of Dante. They were known throughout the European continent in engravings by Tommaso Piroli and spoken of as early as 1799 by both Johann Wolfgang von Goethe and August Wilhelm von Schlegel. Although Flaxman was primarily a sculptor, his outline drawings sealed his reputation, particularly on the Continent. They were widely copied and influenced artists as diverse as Jean-Auguste-Dominique Ingres, Francisco de Goya, William Blake, Joseph Anton Koch, and Aubrey Beardsley.[1]

Flaxman spent seven years in Italy (1787–94) and received the commission for the Dante drawings in Rome from Thomas Hope (1769–1831), an Anglo-Dutch banker and important Neoclassical patron and collector. Hope was probably influenced by the recommendation in 1757 of the antiquarian the comte de Caylus that Dante would be a good source for modern painters.[2] In the 1770s Henry Fuseli had begun to work on scenes from Dante, and in 1773 Joshua Reynolds created a startling and influential painting of Ugolino and his sons, from the *Inferno*, that was shown at the Royal Academy.[3] Hope requested 109 drawings, for payment of a guinea each. The poem's one hundred cantos are each represented by at least one drawing; in all, Flaxman made thirty-eight drawings for the *Inferno*, thirty-eight for the *Purgatorio*, and thirty-three for the *Paradiso*. Piroli's engravings based on the drawings were published in a small private edition that Hope planned to give only to a few friends—to Flaxman's distress. Some engravings did circulate, however, and a pirated French edition appeared in 1802. Hope eventually sold a set of the Piroli

171, *Inferno* 5

171, *Inferno* 13

171, *Inferno* 14

171, *Inferno* 31

171, *Inferno* 33

171, *Inferno* 34 171, *Paradiso* 12

plates to Longman's for 200 pounds, and they were published in England in 1807 and frequently reproduced thereafter.

The drawings reflect a variety of influences: medieval tomb sculpture, Greek vases, Roman bas-reliefs, and trecento and quattrocento painting and sculpture. While in Italy Flaxman studied not only classical art but also medieval and early Renaissance Italian painting and sculpture, and his interest in trecento and quattrocento art was unusual at the time. He also made drawings from life, and these too find echoes in the Dante drawings.[4] The drawings are characterized by clarity of construction and purity of line. Schlegel was the first to praise their economy of form: "Everything is done with minimal means: his outlines combine the briskness of the first thought with the care and delicacy of the most consummate finish."[5] Flaxman's designs erase the difference between figure and ground by articulating "the surfaces in such a way that they are defined equally by the interior forms and the space which surrounds them. Thus the space in which the objects are set is not a void, but is part of the overall formal interplay in the picture."[6] Later artists whose own styles were very different from

Flaxman's nonetheless found the drawings a remarkable visual catalyst.[7]

The bond between Dante and Virgil is one of the themes of the drawings for the *Inferno* and the *Purgatorio*; the two poets are usually seen side by side and dressed similarly in draped togalike garments with laurel wreaths. When the poet Statius enters the poem in the *Purgatorio*, he is similarly clothed. Dante and Virgil are also imagined as if they were of the same age and status rather than in a filial relationship as they are frequently represented by other artists.

Flaxman's drawings for the *Inferno* attempt to deal with the dramatic qualities of the text. For both Paolo and Francesca (canto 5) and Ugolino (canto 33) he made two drawings to represent two moments in each narrative. For canto 5 he drew the lovers as they are about to kiss, with their murderer in the background spying on them, and then the scene of Dante's swoon after hearing their story, with the poet stretched out on the ground, the lovers in gestures of grief, and faintly drawn shades in the background. This subject fascinated artists throughout the nineteenth century. Another popular subject was Ugolino, the

Pisan traitor imprisoned with his young children and starved to death. Flaxman's version is more understated than many others. His drawing of Antaeus, one of the few vertically oriented drawings, contrasts the size of the giant with that of the two poets whom he has just carried down to the last circle of Hell. There a hideous and symmetrical Lucifer reproduces Dante's description and suggests both the terror and the sterility of Satan; David Irwin calls it "the most awesome of all images" in Flaxman's work.[8] Although Flaxman rarely included landscape in his drawings, Dante led him to do so occasionally. His representation of the wood of the suicides (canto 13) is beautifully eerie and rhythmically inventive, and the Old Man of Crete (canto 14) is placed in a heavily wooded landscape.

It is in the drawings for the *Paradiso* that Flaxman is most inventive. His fluidity and delicacy recall Sandro Botticelli's ethereal versions at times. Flaxman's shades are dematerialized but frequently appear individualized and clothed, while in Dante's poem they are all merely effulgences of light. Flaxman's drawing for the Circle of the Sun (canto 12) does attempt to picture the souls as circling lights, but this is

171, *Paradiso* 28 171, *Paradiso* 33

unusual. His version of Dante's abstract vision of God and the angelic hierarchies as a point of light encircled by nine concentric circles (canto 28) is very suggestive, while the geometric abstraction of the last drawing captures something of Dante's final epiphany.

Martin Birnbaum connected Grenville Winthrop's interest in Flaxman's drawings with the artist's importance to Ingres: "Since Flaxman, who was among the first to follow Winckelmann's lead in the classical revival, had encouraged the youthful Ingres and was admired by Mr. Winthrop for his exquisite musical line and composition, it was natural that he should be represented by a large number of drawings."[9] In a catalogue written for an exhibition of Flaxman drawings at Scott and Fowles in 1918, Birnbaum speaks of the drawings as Flaxman's most important works, an exemplar of the art of the beautiful in a turbulent time: "We need something to liberate us from the tyranny of our more or less ugly mode in art, and these superb drawings, incisive, suave, tender or voluptuous, vigorous and yet serene, aerial in their delicacy, quiet in their loveliness and elegant in execution, like the playing of Heifetz and Casals, or the singing of Galli-Curci, will again exercise their imperishable influence and help to carry us back to a time when the highest form of civilised life was a manifestation of noble beauty."[10]

Rachel Jacoff

1. Symmons 1984 explores their influence in England, Italy, France, Germany, and Spain.
2. Watkin 1968, p. 32.
3. On Dante in the 18th century, see Irwin 1966, pp. 125–27.
4. Relevant work from the Italian sketchbooks is reproduced in London 1979, pp. 70–84, with sketches for the Dante drawings on pp. 98–99. On Flaxman's use of drapery, see Irwin 1979, pp. 97–100.
5. Quoted in London 1979, p. 17. On Schlegel's response to Flaxman, see Symmons 1984, pp. 202–6.
6. Hofmann 1979, p. 17.
7. Symmons 1984, p. 275.
8. Irwin 1979, p. 96.
9. Birnbaum 1960, p. 213.
10. Birnbaum 1918, p. 28.

PROVENANCE: Thomas Hope, Deepdene; by descent to Lord Francis Pelham Clinton Hope; his sale, Christie's, London, July 25, 1917, no. 362; Scott and Fowles, New York; acquired from them by Grenville L. Winthrop, September 19, 1921 ($8,000); his bequest to the Fogg Art Museum, 1943; transferred to the Houghton Library, Harvard University.

EXHIBITION: New York 1921, no. 21.

REFERENCES: Birnbaum 1946, p. 73, pls. 25–27; Bentley 1964, p. 53.

Drawings for Works by Homer and Aeschylus

These three works by Flaxman are studies for the series of drawings he made to illustrate Dante's *Divine Comedy*, Homer's *Iliad* and *Odyssey* (cat. no. 172), and the plays of Aeschylus (cat. nos. 173, 174). While living in Rome, Flaxman noted in a letter to George Romney of September 12, 1792, that after working on a large sculpture of *The Fury of Athemas* (National Trust, Ickworth) and a restoration of the *Torso Belvedere* (University College London; on loan to Petworth House), he passed his "Evenings making a Series of drawings from Homer & Dante which are engraving."[1] The volumes of drawings in the outline style were made initially for a small group of English patrons in Rome, but the designs became unexpectedly famous after they were engraved by Tommaso Piroli, the Dante (see cat. no. 171) and Homer engravings appearing in Rome in 1793 and the Aeschylus in 1795 in London and Rome.[2]

Despite their subsequent fame Flaxman regarded the drawings as work for the evenings, not to be compared in prestige and importance with the monumental sculpture to which he devoted his career.

The appeal to the classically educated of the unusually spare outlines of the engravings was signaled by Romney's enthusiastic response, in a letter of July 18, 1793: "They are outlines without shadow, but in the style of antient art. They are simple, grand, and pure; I may say with truth very fine. They look as if they had been made in the age when Homer wrote."[3] The engraved outlines were copied and adapted by many of the best artists of the time—Francisco de Goya, Jean-Auguste-Dominique Ingres, and Théodore Gericault were particularly affected by them[4]—and they were especially fashionable in Germany. August Wilhelm von Schlegel wrote a celebrated analysis as early as 1799 in which he claimed that by not going beyond the "hieroglyph" (*Hieroglyphe*), or the primary stage of representing forms (*ersten leichten Andeutungen*), the outlines brought the figurative arts close to the ways of pure poetry.[5] It is a sign of the breadth of Flaxman's reputation that he attracted a certain cynicism from Johann Wolfgang von Goethe, who described him as "der Abgott aller Dilettanten" (the idol of all the dilettantes).[6]

Flaxman's own claims for the outline engravings were, however, modest. He wrote to the poet William Hayley on October 26, 1793, that "my intention is to shew how any story may be represented in a series of compositions on principles of the Antients, of which as soon as I return to England I intend to give specimens in Sculpture of different kinds, in groups of basreliefs, suited to all the purposes of Sacred and Civil Architecture."[7]

He was irritated in later life that the fame of the outline engravings surpassed that of his sculpture; he claimed he had done them only because his sculptural work did not pay, and he even suggested that artists would be better off copying nature rather than his outlines.[8]

David Bindman

1. Quoted in London 1979, p. 86; see also Irwin 1979, pp. 67–90.
2. For a full account of their printing history, see Bentley 1964.
3. Ibid., p. 18.
4. See Sarah Symmons, in London 1979, pp. 152–55, and Symmons 1984.
5. Schlegel 1799; see also Hofmann, in Hamburg 1979, pp. 205–6.
6. Peter-Klaus Schuster, in Hamburg 1979, pp. 32–35.
7. Quoted in London 1979, p. 86.
8. In an interview with the German critic Ludwig Schorn (London 1979, p. 31).

172. *The King of the Lestrigens Seizing One of the Companions of Ulysses,* from Homer's *Odyssey*, ca. 1792

Gray ink and graphite on off-white wove paper
8½ x 10⅛ in. (21.5 x 25.6 cm)
Inscribed in gray ink, lower center: One for his food the raging glutton slew / B[ook]10—133; *upper right:* 10. 116
1943.695

The subject is taken from book 10 of the *Odyssey* in Alexander Pope's translation, and the drawing is a study for plate 15 of *The Odyssey of Homer Engraved from the Compositions of John Flaxman R.A. Sculptor*, London, 1805[1] (fig. 178), which was

engraved by Thomas Parker. Odysseus and his companions, after escaping from the giant Polyphemus, arrive in the seemingly hospitable kingdom of the Lestrigens. They are dismayed to find themselves confronted by the ferocious queen, "of size

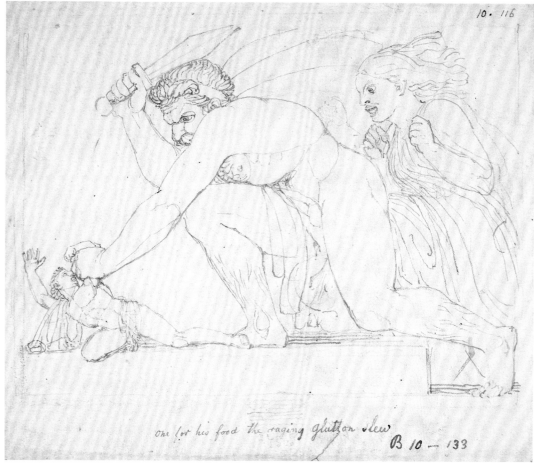

one for his food the raging glutton slew

172

enormous, and terrific mien, not yielding to some bulky mountain's height," and her even more ferocious husband, Antiphates, who immediately falls on some of the sailors with the intention of eating them, while the others rush back to the boat in terror. Flaxman's design is an exercise in

Fig. 178. Plate 15 of *The Odyssey of Homer Engraved from the Compositions of John Flaxman R.A. Sculptor, London* (London, 1805)

the mode of sublime terror associated with his Royal Academy contemporary Henry Fuseli and with William Blake (see cat. no. 145).

Flaxman's wife, Nancy, wrote on December 15, 1792, that he was working on "a set of drawings from Homer's Iliad & Oddyssey [*sic*]—consisting of 60 most beautiful Subjects & as beautifully treated— these are for Mr Udney[2] an Englishman— of which also he makes duplicates for Mr Naylor[3] (Husband of the late Bishop of St Asaph's Daughter)."[4] There are substantial groups of drawings for the *Iliad* and *Odyssey* in the Royal Academy, British Museum, and University College London. Some of these may have originally belonged to the Udny or Hare-Naylor set but many, like the present one, are working drawings. This is clear from the numerous pentimenti; the right arm of both the king and

queen were substantially changed in the final engraving, and the square shape of the drawing suggests that at this point the horizontal format of the volume had not yet been established.

David Bindman

1. The edition of 1793 was small, since the plates were lost when they were sent back to England. A new edition was produced in London in 1805, to which this plate was added; see Bentley 1964, pp. 22–23. See also Essick and LaBelle 1977, pl. 15.
2. Probably John Udny (1727–1800), a dealer and collector; see Ingamells 1997, pp. 961–63.
3. Francis Hare-Naylor (1753–1815; Ingamells 1997, p. 465), but actually his wife, Giorgiana, a close friend of Flaxman, was the real patron (ibid., p. 466).
4. Bentley 1964, p. 17.

PROVENANCE: Grenville L. Winthrop; his bequest to the Fogg Art Museum, 1943.

REFERENCE: Essick and LaBelle 1977, pl. 15 (where it is suggested that cat. no. 172 may be a copy).

173. *The Ghost of Clytemnestra*, from Aeschylus's *The Furies (Eumenides)*, ca. 1792

Gray ink on cream laid paper
8⅝ x 13⅜ in. (22 x 34 cm)
1943.703

This is a study for plate 25 of *Compositions from the Tragedies of Aeschylus Designed by John Flaxman Engraved by Thomas Piroli,* 1795 (fig. 179). The scene is taken from Aeschylus's play *The Furies* or *Eumenides,* the last of the trilogy of the Oresteia, first produced about 458 B.C. In Aeschylus's account, Clytemnestra murders her husband, Agamemnon, the chief commander of the Greeks in the Trojan Wars. She in turn, with her lover Aegisthus, is killed by her own son, Orestes. The Ghost of Clytemnestra seeks here to rouse the Furies, the "grim-visaged hags," to avenge her: "Meanwhile Orestes flies; shall he escape, The murderer of his mother?"[1]

This is clearly a working drawing, so it is unlikely to have belonged to the set commissioned by Countess Spencer.[2] It represents an early stage of composition and a slightly different moment from that of the engraving[3]. In the drawing the Ghost of Clytemnestra is actively declaiming as the

Furies begin to rouse one another, while in the engraving she has finished her speech, thus placing the emphasis more on the activity of the Furies, who in the next plate catch up with Orestes. In the engraving the curtain, or possibly columns, have been eliminated, leaving the space indeterminate. In neither drawing nor engraving has Flaxman been able to suggest the horrifying ugliness of the Furies as described by Aeschylus.

The Aeschylus drawings may have been begun in late 1792 and were certainly finished by 1794, but they were not published in engraved form until 1795. They were commissioned by, and dedicated to, the Countess Dowager Spencer (Margaret Georgiana, Viscountess Spencer, 1737–1814), a cousin of Mrs. Hare-Naylor (see cat. no. 172) and mother of Georgiana, duchess of Devonshire.

David Bindman

1. Robert Potter's translation. The drawing is reproduced in Irwin 1979, pl. 112.
2. According to the title page, "The original drawings [are] in the possession of the Countess Dowager Spencer."
3. It is close in composition to another drawing in the Castle Museum and Art Gallery, Nottingham (04-130), reproduced in Symmons 1984, pl. 11. Symmons (ibid., p. 54) suggests the influence of Romney on the composition.

PROVENANCE: Grenville L. Winthrop; his bequest to the Fogg Art Museum, 1943.

REFERENCE: Irwin 1979, p. 88, pl. 112.

Fig. 179. Plate 25 of *Compositions from the Tragedies of Aeschylus Designed by John Flaxman Engraved by Thomas Piroli* (London, 1795)

174. *The Dream of Atossa*, from Aeschylus's *The Persians*, ca. 1792

Gray ink and graphite on cream wove paper
8⅞ x 13⅝ in. (22.6 x 34.5 cm)
1943.699

A drawing for plate 29 of the Aeschylus engravings (fig. 180), this represents a scene from the play *The Persians*: the dream of Atossa, mother of Xerxes, the Persian king and invader of Greece. Atossa's dream is an allegory of Xerxes' future defeat. He is pulled along by two maidens, one Persian and the other Greek, until the latter breaks the harness, causing him to fall. The ghostly figure of his aged father, Darius, laments in the background. This drawing, though unfinished and tentative in parts, belongs nonetheless to the last phase of the composition. In an earlier but more finished drawing in the Royal Academy (fig. 181), Xerxes, like Darius, wears a "Persian" hat, while in this drawing and the final engraving he is hatless and now conforms to the heroic typology of the canonical Hellenistic sculpture the *Laocoön*. The squaring around the present drawing suggests that Flaxman was working on the format of the final page and the placing of the

Fig. 180. Plate 29 of *Compositions from the Tragedies of Aeschylus Designed by John Flaxman Engraved by Thomas Piroli* (London, 1795)

Fig. 181. John Flaxman, *The Dream of Atossa*, ca. 1792. Pen, 9 x 13½ in. (23.2 x 33.3 cm). Royal Academy of Arts, London

figures in relation to the margins. This caused him to alter the position of Xerxes' left arm, bringing it alongside his body, allowing the image to be cropped closer on the right. *David Bindman*

William Holman Hunt

London, 1827–London, 1910

175. *The Triumph of the Innocents*, 1870–1903

Oil on canvas
28¾ x 48½ in. (73 x 123.2 cm)
Inscribed lower left: 18 Whh [monogram] 70-6
1943.195

This first and smallest of three versions of *The Triumph of the Innocents* was begun in Palestine in early 1870. The main version (fig. 182) was begun in 1876 and was followed in 1883–85 by a slightly larger replica (Tate Gallery, London).

William Holman Hunt conceived the idea of painting the Holy Family on the Flight into Egypt in connection with a proposed wall decoration in the Church of Saint Michael and All Angels, Cambridge.[1] The death of the incumbent led to the cancellation of the commission, but in Jerusalem in early 1870 Hunt "sometimes reflected upon the relinquished subject of the 'Flight into Egypt'; and pondering on the history given by St. Matthew, the notion came to me that since the little playmates of Jesus had been a vicarious sacrifice, they would in their spiritual life be still constant in their love for the forlorn but Heaven-defended family."[2] Both the Flight into Egypt and the Massacre of the Innocents derive from chapter 2 of the Gospel of Saint Matthew: Hunt's originality lay in transforming the traditional iconography of angels attending the flight into those of the infants Herod has condemned to death in Bethlehem. Their halos reflect their transfigured state as spiritualist manifestations, and the main reason for the contemporary popularity of the image was its consoling message of the reality of the Resurrection.

Despite the picture's mystical aspects,

Hunt was concerned to paint the landscape background with his usual Pre-Raphaelite attention to truth to nature. At Gaza in February 1870, he "at last . . . found the group of trees over the water-wheel which is the central part of the picture," and, by the light of the full moon, "unpacked a portable canvas about 4 ft. in length, and sat throughout the nights painting this in complete form."[3]

The work was then set aside and not resumed until Hunt's third visit to Jerusalem. By March 3, 1876, he was able to report that he had completed "the composition of a picture which I have had in hand for some years."[4] Later that month he began the second version of *The Triumph of the Innocents* (fig. 182), and catalogue number 175 was then used not only as a preliminary oil sketch but also as a testing ground for ideas. According to the label on the reverse of the blind stretcher, after 1876 the Winthrop picture was abandoned, with

parts of the background left unfinished.[5] It was completed in 1903 at the request of Juliet Morse, who then purchased it.[6]

The most obvious difference between Winthrop's painting 175 and the two larger versions of *The Triumph of the Innocents* is in the treatment of the Virgin and child. In the first version the mother's head is protectively inclined toward the infant, who stares mournfully out at the viewer and is much less realistically portrayed than in the subsequent versions of the subject. His vertical pose and outstretched left arm prefigure the Crucifixion, and he is placed almost directly above the martyred Innocent examining a rent in his dress, a reference to the stigmata. The way in which the limbs of Mary and Jesus are disposed to suggest a tondo format is extremely Italianate. In contrast to this, Mary and Joseph are attired in accurately rendered Palestinian costume, which Hunt had carefully studied on his 1870 trip to Gaza.[7]

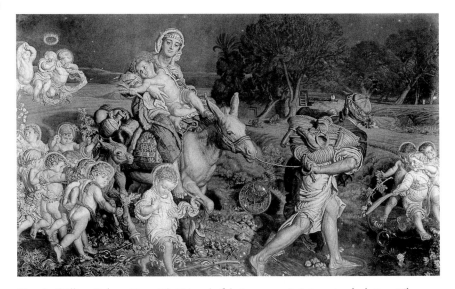

Fig. 182. William Holman Hunt, *The Triumph of the Innocents*, 1876–87, retouched 1890. Oil on canvas backed by panel, 62 x 97½ in. (157.5 x 247.7 cm). National Museums and Galleries on Merseyside, Walker Art Gallery, Liverpool, 2115 (photo: John Mills [Photography] Ltd.)

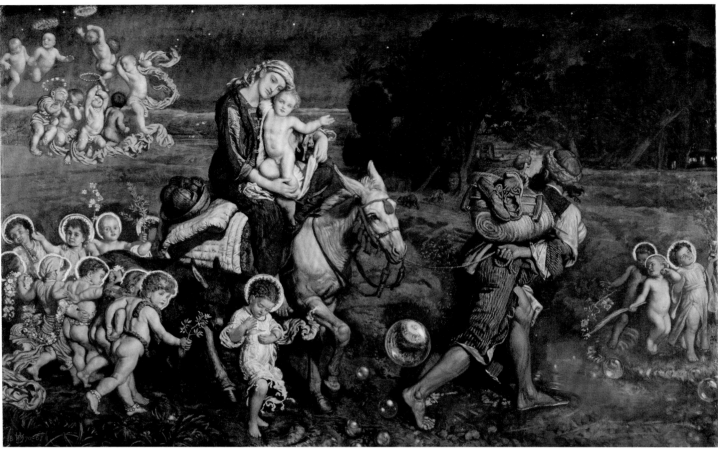

175

In *The Triumph of the Innocents* Hunt has incorporated complex philosophical ideas that cannot be understood without a literary gloss. The Innocents at the far right of the picture are buoyed up by a mystical stream, inspired by Revelation 22:1: "And he shewed me a pure river of water of life, clear as crystal, proceeding out of the throne of God and of the Lamb." This river of life engenders two symbolic globes. The larger (behind Joseph's right calf) includes a vision of heaven in the form of the worship of the Lamb (an emblem of Christ).[8] The globe beneath the trio of Innocents at the far right shows a woman pursued by a dragon. This imagery is inspired by an earlier passage in Revelation that Hunt interpreted as symbolic of the persecution of the Christian church, whom the woman represents.[9]

In his memoirs Hunt noted that the effect in this painting is "that of uncheckered moonlight,"[10] reflecting the conditions under which the canvas was begun and differentiating the small version from the large ones, in which supernatural light envelops the massacred Innocents.

Judith Bronkhurst

1. Hunt 1905, vol. 2, p. 257.
2. Ibid., p. 298.
3. Hunt, letter to a friend in Liverpool, published in the *Liverpool Daily Post*, January 15, 1891, p. 6.
4. Hunt, letter to John Lucas Tupper, March 3, 1876, Henry E. Huntington Library, San Marino, HM 54617; published in Coombs et al. 1986, p. 204.
5. The relevant part of the label reads: "This picture was practically completed 1870/1876, it was the original sketch of the two larger rather different versions. In places the background was left unfinished. It was completed in 1903, purchased direct by Juliet M. Morse from Holman Hunt."
6. Gladys Joseph, "History of the Pre-Raphaelite Movement," typescript, n.d., private collection, p. 587.

Juliet (d. 1937) and her solicitor husband, Sydney (d. 1929), were Kensington friends of the Hunts.
7. Hunt, letter to a friend in Liverpool, published in the *Liverpool Daily Post*, January 15, 1891, p. 6.
8. Hunt 1885, p. 11.
9. The relevant passage, Revelation 12:3–17, is discussed in Hunt 1905, vol. 2, p. 109.
10. Hunt 1905, vol. 2, p. 324.

PROVENANCE: Acquired from the artist by Juliet M. (Mrs. Sydney) Morse, London, 1903; her sale, Christie's, London, March 9, 1937, part of no. 63 (bought in); her son Esmond Morse; purchased from him by Agnew's, London, June 11, 1937 (£630); acquired from them through Martin Birnbaum by Grenville L. Winthrop, June 11, 1937 (£800); his bequest to the Fogg Art Museum, 1943.

EXHIBITIONS: London 1906, no. 11; Manchester 1906, no. 7; Liverpool 1907, no. 47; Cambridge, Mass., 1946b, no. 48; Tokyo 2002, no. 28

REFERENCES: *Liverpool Daily Post*, January 15, 1891, p. 6; Hunt 1905, vol. 2, pp. 298, 317, 324, illus. facing p. 327; Hunt 1913, vol. 2, pp. 235–36, 253, 254 illus.; Holman-Hunt 1969, p. 14; Coombs et al. 1986, pp. 150, 204; Bennett 1988, fig. 36, pp. 87–88, 89.

176. *The Miracle of Sacred Fire in the Church of the Holy Sepulchre, Jerusalem,* ca. 1892–99

Oil on canvas
36¼ x 49½ in. (92 x 125.7 cm)
1942.198

Hunt's last major original composition depicts the moment after the apparently spontaneous rekindling, on (the Greek) Easter Saturday, of the extinguished light that usually burns over the Tomb of Christ. The church, located on the traditional sites of the Crucifixion, burial, and Resurrection of the Savior, is the focal point for the Orthodox, Roman Catholic, and Protestant branches of the Christian church. Hunt had first viewed the ceremony on April 7, 1855, and was deeply disturbed by the sharp contrast between the holiness of the site and the scenes of hysteria that the ceremony always generated. He confided in his diary: "I am disgusted yet must stay."[1] The miracle had for centuries had been denounced by Roman Catholics as well as Protestants as a fraud perpetrated by the Greek Orthodox Patriarch of Jerusalem, leading to wild fanaticism and often violence among the pilgrim onlookers. In the belief that it would purify their sins, they rushed to light candles from the flame carried by the Greek priest (in the right middle ground of the picture) before its distribution to churches in Syria and Russia.[2]

Muslim troops were required to keep the peace, and they are shown on the right of the picture. This was a significant aspect of the ceremony for the artist, since it displayed Christian sectarianism in such a poor light. Hunt, a committed Protestant, had been dismayed by the behavior of vying Christian sects since his first visit to the Holy Land (1854–55). Indeed he had already dealt pictorially with this issue—albeit symbolically—in *The Hireling Shepherd* of 1851–52 (Manchester Art Gallery). His fourth and final visit to

Jerusalem, in March 1892, coincided with the Greek Easter and gave him "the opportunity of perpetuating for future generations the astounding scene which many writers have so vividly described."[3] Nine preparatory sketches were executed at this period,[4] but the fact that Hunt "was drawing at the design all the way home"[5] suggests that the oil painting was not begun in Jerusalem. It was definitely on hand in London by March 14, 1893.[6]

Thereafter progress was sporadic,[7] partly because the challenge of depicting more than two hundred figures in an enclosed space had an appalling effect on Hunt's deteriorating eyesight.[8]

The Miracle of Sacred Fire was first shown at the New Gallery, Regent Street, London, in the annual exhibition of 1899. Hunt needed a substantial entry in the catalogue to explain the ceremony. In addition, a sixpenny pamphlet was on sale that elucidated the

1 Egyptian, who treats the ceremony with contempt.
2 Woman from over Jordan, with child suspended from her head.
3 Husband of above.
4 Abyssinian Priest.
5 Turkish Trumpeter.
6 & 7 Youthful Greek Priests.
8 Bethlehem Family.
9 English Mother and Children.
10 Ayah of the same.
11 Arab boy in flight from soldiers.
12 "Sherif" descendant of the Prophet, who is present at the ceremony in courtesy to Christian authorities.
13 Armenian Patriarch.
14 Two Franciscans, the only Latins present in the interest of their church.
15 Pasha.
16 Bim Pasha.
17 Syrian Patriarch.
18 Dervish, present by courtesy.
19 Patriarch.
20 Syrian Bishop.
21 Russian Priest.
22 Pilgrim personifying the Crucifixion.
23 Woman of Jerusalem.
24 Woman from Nazareth.
25 Woman from Bethlehem.
26 Egyptian.
27 "Kavass."
28 Pilgrim personifying "Jesus dead," carried by companions.

29 People from beyond Jordan, survivors of the early Christians.
30 Armenian Pilgrims.
31 Pilgrims personifying "Jesus risen."
32 The same.
33 Young Bethlehemite who has been seized by Turkish soldiers and accused as one of the rioters.
34 His Bride, desire for whose silver ornaments may have been the sole cause of the husband's apprehension by the "Zuptich."
35 His young Sister, in desperation for his release.
36 His Mother, shaking her fist at her son's arrest.
37 A Group of friends combining with intention to rescue the prisoner.
38 A Pilgrim being hoisted on companion's shoulder to personify "Jesus risen."
39 Opening in North of Shrine from which Holy Fire is distributed to Greeks; on South side is another opening from which it is distributed to Armenians.
40 Greek Priest carrying light, and guarded by half a dozen strong men, to secure the flame for the Russian Church. He is carried in the arms of one of these attendants, and shelters the light with his hand, subsequently he guards it in a lantern to the city gate, where a horseman is waiting to carry it to Jaffa; from thence it is taken to Odessa, the centre of distribution to all Russian Churches. The flame is also distributed to Bethlehem and other Syrian Churches.
41 A mass of Pilgrims, Russian, Circasian, and others who have made the pilgrimage on foot. In the galleries are ecstatic devotees.

Fig. 183. Key plate to *The Miracle of Sacred Fire in the Church of the Sepulchre, Jerusalem.* First published in the 1899 pamphlet accompanying the exhibition of the picture at the New Gallery, London. Reprinted from Hunt 1913, vol. 2, p. 433

176

subject and included a key plate (fig. 183) identifying the participants.[9] But paintings dependent for their meaning on a literary gloss were no longer fashionable, and consequently the reviews were mixed. Nevertheless, this painting attracted the most attention of all the works in the exhibition.[10]

None of the critics addressed the central issue, which is Hunt's attempt to convey his attitude toward the miracle through the composition itself. The crowded confusion demonstrates the chaotic nature of the ceremony, and the kindled fire is presumably relegated to the right middle ground because the miracle is spurious. What really interested the artist happens elsewhere, and it is disillusioning. First, there are the strug-

gles precipitated by a so-called holy event: hence the prominence given to the fleeing Arab boy just to the left of the center of the composition and the Bethlehemite arrested by Muslim soldiers at the right. Second, there are the pilgrims who reenact scenes from the Passion: the figure leaning on the wall of the rotunda, with arms upraised and dilated pupils suggesting a state of trance, simulates the Crucifixion (fig. 183, no. 22), while at the far left a pilgrim personifying Jesus dead is carried on the shoulders of his companions (fig. 183, no. 28).[11] In general, mass hysteria reigns and the senior spiritual leaders—the crowned and white-bearded Syrian patriarch, seated at the entrance to the sepulchre, and the bishop, relatively iso-

lated at the left, holding a crosier and dressed in deep pink (fig. 183, nos. 17, 20)—appear lacking in authority.

In the lower corners of the composition Hunt included hostile observers. At the left is an Egyptian who, according to the key plate (fig. 183, no. 1), "treats the ceremony with contempt"—the gesture of his left hand suggests his detachment. At the far right an English woman is shielding her offspring to prevent them from witnessing the fire at all. This group, based on Hunt's wife, Edith, and their children,[12] provides a point of identification for the Western viewer.

The Miracle of Sacred Fire can be viewed as the culmination of Hunt's mission as

artist/ethnographer—his attention to the details of the church architecture and the costumes of the different races is as acute as ever. But critical reaction to the work seems to have brought him to the realization that the ceremony was unsuited to pictorial treatment, and he "determined to retain" the picture "in my own house as being of a subject understood in its importance only by the few."[13]

Judith Bronkhurst

1. Entry of April 7, 1855, John Rylands Library of the University of Manchester, Ryl. Eng. MS 1211, fol. 12, published in Pointon 1989, p. 26.
2. See fig. 183, no. 40. At the end of the 19th century, the Holy Land was known as Syria.
3. Hunt 1905, vol. 2, p. 381.
4. Five studies in silverpoint (private collection, England) appear to have been executed during the actual ceremony.
5. Hunt, letter to Frederic James Shields, ca. late May 1892, John Rylands Library of the University of Manchester, Eng. MS 1239/17.
6. Edith Holman Hunt, letter to William Michael Rossetti, March 14, 1893, University of British Columbia, Special Collections Division, Angeli-Dennis Papers.
7. Hunt 1905, vol. 2, p. 381.
8. Gissing 1936, p. 216.
9. *Times* (London), April 22, 1899, p. 4.
10. *Athenaeum*, May 6, 1899, p. 568.
11. This is based on an incident Hunt witnessed during the ceremony on April 7, 1855; John Rylands Library of the University of Manchester, Ryl. Eng. MS 1211, fols. 11v–12.
12. The trio was identified in a letter of August 19, 1957 from the artist's daughter-in-law Gwendolen Norah Holman-Hunt to John Coolidge of the Fogg Art Museum, Fogg Art Museum curatorial files.
13. Hunt 1905, vol. 2, p. 386.

PROVENANCE: Given by the artist to his wife, Edith Holman Hunt, London, September 10, 1901; bequeathed to their son Hilary Holman Hunt, 1931; acquired from him through Martin Birnbaum by Grenville L. Winthrop, September 1936 (£2,625); his gift to the Fogg Art Museum, 1942.

EXHIBITIONS: London 1899, no. 80; Liverpool 1899, no. 1076; London 1906, no. 10; Manchester 1906, no. 11; Liverpool 1907, no. 36; Liverpool 1923, no. 1022; Cambridge, Mass., 1946b, no. 52; Cambridge, Mass., 1973a; Cambridge, Mass., 1977a; Cambridge, Mass., 1980a; Tokyo 2002, no. 17

REFERENCES: Hunt 1899, pp. 1–12; *Times* (London), April 22, 1899, p. 4; *Saturday Review* 87 (April 29, 1899), p. 523; *Spectator*, April 29, 1899, p. 611; *Academy* 66 (May 6, 1899), p. 510; *Athenaeum*, May 6, 1899, p. 568; *Illustrated London News* 114 (May 6, 1899), p. 649; *Magazine of Art*, June 1899, p. 344; *Journal of the Society of Arts* 47 (June 2, 1899), pp. 597–98; Hunt 1905, vol. 2, pp. 5–6, 380–82, 385–86, illus. facing p. 385; Hunt 1913, vol. 2, pp. 5–6, 316–17 (illus.), 318, 322–23, 421–33; Gissing 1936, pp. 207–16, illus.; Landow 1979, pp. 54–59, illus.; Landow 1983, pp. 477–78, illus.; Pointon 1989, pp. 26–27, 39–40, illus. pp. 28–29; Bronkhurst 1996, p. 237; Katz 1998, pp. 423–24 (illus.), 442 n. 5.

Sir Edwin Landseer

London, 1802–London, 1873

177. *The Falcon* (also called *Study for Scene in the Olden Time at Bolton Abbey*), ca. 1834

Oil on wood panel
26 x 19½ in. (66 x 49.5 cm)
1943.1815.1

A young falconer with a dead heron slung over his back is showing off his falcon to a young woman, who has just removed its guard. They stand on a low flight of steps leading to a darkened interior space. Although painted sketchily, with lots of medium, the picture is rich in texture and color, contrasting the red jacket of the falconer with the deep green fur-lined overgarment of the woman and the beautifully painted gray feathers of the bird. The dog's ribbon and the hawk's guard provide bright accents of red standing out from the brown tones of the background. Both figures are

Fig. 184. Sir Edwin Landseer, *Scene in the Olden Time at Bolton Abbey*, ca. 1834. Oil on canvas, 61 x 76 in. (155 x 193 cm). Devonshire Collection, Chatsworth; reproduced by permission of the Duke of Devonshire and the Chatsworth Settlement Trustees

177

dressed in period costume loosely in the style of the sixteenth century. Fashionably dressed and attended by a King Charles spaniel, the woman appears to be of a superior class to the falconer, who may be a retainer; no self-respecting gentleman would carry his own game. However, the youth and proximity of this handsome couple hint at a romantic attachment; they might well be characters from a novel by Sir Walter Scott. Sir Edwin Landseer was a friend and illustrator of Scott, who inspired many of the Highland scenes that made the artist's name.

The figure of the falconer relates quite closely to the figure on the right of Landseer's picture of *Bolton Abbey in the Olden Time* (fig. 184), which was commissioned by the sixth duke of Devonshire in 1831 and exhibited three years later at the Royal Academy exhibition of 1834. It hangs today in the front hall of Chatsworth, the principal residence of the Duke of Devonshire. Instead of painting the picturesque ruins of Bolton Abbey on the Devonshire estate in Yorkshire, as he had been asked to do, Landseer chose to depict the abbey as it had been in earlier times. A forester, accompanied by his son and daughter, lays at the feet of the abbot the trophies of the chase: a dead stag, a whooper swan, duck, grouse, partridge, heron, bittern, and trout. The portly abbot, in the white order of an Augustinian, stands at the gateway of the abbey checking off the items from a list, while a second aged monk looks on. Monasteries did not receive a particularly good press in the nineteenth century. Scott's novels on the subject, *The Monastery* and *The Abbot* (both

published in 1820), paint a robust and unflattering picture of a border abbey in the mid-sixteenth century. Landseer could be pointing the finger at a greedy and profligate Church despoiling the poor, but this does not seem to be his intention. Rather the theme of the painting is nostalgia for the good old times, when the rivers and forests teemed with game, when the monastery was a source of benevolence and protection, and when people accepted and enjoyed their lot.

Bolton Abbey in the Olden Time scored a big success when it was exhibited at the Royal Academy, and it was widely reviewed and generally praised for its masterly rendering of dead animals and its romantic atmosphere. It was to be engraved on no fewer than three occasions, in 1837, 1856, and 1858, gaining currency as one of Landseer's best-known works. The two figures of the young falconer and the fishergirl were particularly admired, and they were later engraved as single figures in a pair of prints. They were modeled respectively by Landseer's great friend the collector and chemist Jacob Bell and by the artist's sister Jessica, and their youth and beauty shine out from the gloomy monastery and its elderly inhabitants. The pose of the falconer in the Winthrop sketch anticipates that of the falconer in the finished picture, but it does not seem to have been painted from the same model and differs in several of its details. The young woman in this work is quite unlike the fishergirl in *Bolton Abbey,* and the setting itself is different. The panel appears, therefore, to be an independent sketch on which Landseer drew for the figure of the falconer.

A number of other sketches relating to *Bolton Abbey* are recorded, including an oil study for the composition (artist's sale, Christie's, London, May 8–15, 1874, lot 110, now in a private collection), a variant study for the falconer and the fishergirl (artist's sale, lot 58 or 87, private collection), and an oil sketch of the painter Sir Augustus Wall Callcot for the head of the abbot (National Portrait Gallery, London).

Details of the payment to Landseer by Alfred Harris were given in an autograph account formerly on the reverse of the picture (recorded in the catalogue entry for the American Art Association auction in 1920). Harris was a minor collector of British paintings and watercolors. His sale in 1900 resulted from a change of residence from Kirkby Lonsdale in Lancashire to Frimley Green in Surrey; it included three other oil sketches by Landseer (lots 49, 50, and 52). Following Harris's death in 1906, his executors sold further pictures at Christie's on March 24, 1906, and April 22, 1927.

Richard Ormond

PROVENANCE: Sold by the artist to Alfred Harris (£110); his sale, Christie's, London, March 17, 1900, no. 51; purchased at that sale by Wallis and Co. (£31 10s.); Frank Bulkeley Smith, Worcester, Mass.; his sale, American Art Association, New York, April 22–23, 1920, no. 20 ($200); purchased at that sale by W. W. Seaman; Scott and Fowles, New York; acquired from them by Grenville L. Winthrop, July 13, 1923 ($1,142.86); his bequest to the Fogg Art Museum, 1943.

REFERENCES: *Art Journal* (London), 1876, p. 2 (reproduced as a woodcut); Monkhouse 1879, vol. 1, pp. 74, 76 (reproduced as a woodcut), pl. 16; Bowron 1990, fig. 45.

Sir Thomas Lawrence

Bristol, England, 1769–London, 1830

178. *Napoléon-François-Charles-Joseph Bonaparte (1811–1832), duc de Reichstadt, Styled King of Rome,* 1818–19

Oil on canvas
23⅝ x 19 in. (57.6 x 48.2 cm)
1943.197

Sir Thomas Lawrence, the foremost British portrait painter after the death of Sir Joshua Reynolds in 1792, had a career of uninterrupted success. He was knighted in 1815 and was sent by the prince regent on a mission to Aix-la-Chapelle, Vienna, and Rome in 1818 to paint portraits of the heads of state and military leaders involved in the wars against Napoleon. All of these are now in the Waterloo Chamber, Windsor

178

Castle. The regent, who succeeded as King George IV in 1820, did not accept the portrait of Napoleon's young son, not wishing to have his likeness in the royal collection, and it remained in Lawrence's studio. Lawrence was in Vienna from December 1818 to May 1819. In a letter to Joseph Farington from Rome, May 19, 1819, he lists his Viennese sitters;[1] somewhat surprisingly he does not mention the duc de Reichstadt. It must have been a very private commission. H. Wade White points out that Lawrence probably overemphasized the resemblance of the young Napoleon to his father.[2] A full-length portrait, by an unidentified hand, of Reichstadt as a youth wearing a greatcoat, the head based on the Winthrop portrait, passed through Christie's, London, on April 24, 1987 (lot 101). Lawrence also made a drawing of him, now in a private collection, which was engraved by W. Bromley, 1830.

Napoléon-François-Charles-Joseph, the son of the emperor Napoleon and his second wife, Marie-Louise, daughter of Emperor Francis II of Austria, was born at the Tuileries on March 20, 1811. He was styled king of Rome. After the defeat at Waterloo his father proclaimed him Napoleon II, emperor of the French, but the title was ineffectual. After Napoleon's exile to Elba the boy was taken to Vienna, where his grandfather the Austrian emperor conferred on him the title of duc de Reichstadt; he had already been declared prince of Parma. He died of consumption in Vienna on July 21, 1832, and was buried in the Hapsburg vault. He was reburied in the Invalides, Paris, in 1940.

Kenneth Garlick

1. Williams 1831, vol. 2, pp. 143–55.
2. White 1964, p. [3].

PROVENANCE: Samuel Woodburn; duc de Bassano, Paris; acquired from his heirs by Grenville L. Winthrop, 1937; his bequest to the Fogg Art Museum, 1943.

EXHIBITIONS: London 1833, no. 9; Paris 1883, no. 150; Paris 1897, no. 120; Amsterdam 1936, no. 92; Cambridge, Mass., 1969, no. 82; Cambridge, Mass., 1977a, no. 33.

REFERENCES: Passavant 1836, p. 251; Tarbell 1895, pl. 177; Gower 1900, p. 151, illus. facing p. 42; Armstrong 1913, pp. 66–67, pl. 29; Garlick 1954, p. 13, no. 84; Garlick 1962–64, p. 149; White 1964; Garlick 1989, p. 243, no. 591; Bowron 1990, fig. 40.

Albert Joseph Moore

York, England, 1841–London, 1893

179. *Companions*, ca. 1885

Watercolor, gouache, and graphite on off-white wove paper
17⅛ x 8¾ in. (43.4 x 22.3 cm)
Signed with anthemion device in watercolor, lower left
1943.485

The pursuit of ideal beauty provided the focus of Albert Moore's career. Essentially self-taught, he went on to become a leading figure in the English Aesthetic Movement. Moore's early work as an architectural draftsman and designer led him to develop a geometric system of proportion that he used in formulating his pictorial compositions. All his works are underpinned by meticulously refined linear armatures, which dictate the placement of every element. In *Companions*, the result is an extremely complex arrangement of contrasting patterns in which the strict orthogonal linearity of the architecture contrasts with the flowing folds and floral motifs of the fabrics and wallpaper. Moore conceived of such pictures as perfected arrangements of line, form, and color, without conventional subject matter or thematic significance.

The idealized features of the two women in *Companions* and the elegant arrangement of their drapery attest to Moore's analysis of classical Greek sculpture, while the picture's flat, allover surface patterning reflects his study of Japanese prints. This stylistic eclecticism is consistent with Moore's belief in the essential formal unity of all beautiful things—a central tenet of the Aesthetic Movement. The anthemion device with which he generally signed his works (and which appears on the architectural molding at lower left in *Companions*) alludes to this principle of unity, as the motif occurs in the art of diverse civilizations. Analysis of natural forms also provided Moore with many decorative devices. He claimed that the idea of laying a tracery of white lace over dark drapery in *Companions* was inspired by the filigree patterns of sunlight created by dark foliage against a pale sky. He repeated the motif in several subsequent paintings of the late 1880s (see cat. no. 180).[1]

Companions further develops a composition that Moore had first adopted in *Topaz* (private collection), a painting exhibited at the Grosvenor Gallery, London, in 1879. At least two other works are closely related to *Companions*: an oil painting, exhibited in

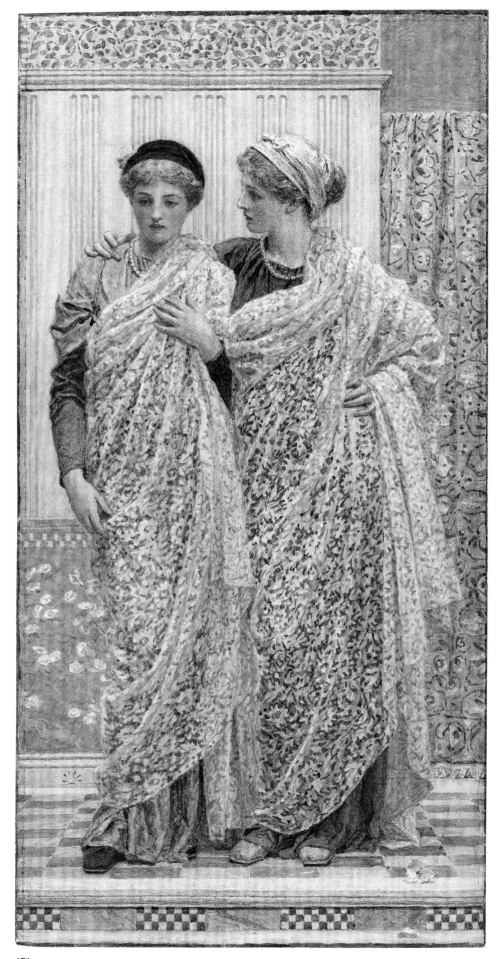

1883 at the Dowdeswell Gallery of New Bond Street and published that year as a photogravure (private collection), and *Ivory Beads* (unlocated), a smaller oil focusing on a single figure.[2] Such apparent repetition led some to complain of the monotony of Moore's work. However, through subtle refinements made in successive versions he was actually striving to bring his pictures closer to a personal ideal of perfection. In the present work he experimented with a cooler color scheme and softer, more lyrical background patterns than those employed in the larger oil version.

Known for his unconventional art, outspoken opinions, and disregard for social proprieties, Moore was blackballed from membership in the prestigious Royal Academy of Arts, although he regularly exhibited his paintings there. It was as a watercolorist that he achieved official recognition, elected an associate of the Royal Society of Painters in Water-Colours in March 1884. *Companions* was exhibited the following year under the auspices of a rival group of watercolorists, the Royal Institute of Painters in Watercolours. In its review of the exhibition, the *Pall Mall Budget* praised Moore's contribution as "an unusually beautiful specimen."[3]

Robyn Asleson

1. Asleson 2000, p. 226, n. 173.
2. Baldry 1894, p. 54; Asleson 2000, p. 224, n. 99.
3. Anon. 1885, p. 15.

PROVENANCE: William Newall; his widow, Mrs. Newall; her sale, Christie's, London, June 8, 1934, no. 62 (£60 18s., as "Comrades"); acquired at that sale through Martin Birnbaum by Grenville L. Winthrop (£105); his bequest to the Fogg Art Museum, 1943.

EXHIBITIONS: London 1885, no. 605; Cambridge, Mass., 1946b, no. 61; Tokyo 2002, no. 67.

REFERENCES: Anon. 1885, p. 15; Baldry 1894, p. 105; Holme 1905, pl. 25; Asleson 2000, pp. 224 n. 99, 226 n. 173.

179

180. *Myrtle,* ca. 1886

Watercolor and gouache over graphite and graphite squaring on cream wove paper
13⅛ x 7⅝ in. (33.2 x 19.5 cm)
Signed with anthemion device in watercolor, upper left
1943.909

From the mid-1860s to the end of his life, Moore consistently used the classically idealized female form to embody abstract systems of beauty that he discerned in the finest examples of art and nature. Each of his paintings evolved through a painstaking preparatory process in which the figure, setting, color scheme, and all other elements were gradually accommodated to an underlying geometric armature developed specifically for the picture in hand.

Myrtle is one of a number of pictures that Moore developed while working on *A Summer Night,* an ambitious painting of four seminude female figures that occupied him from 1884 until 1890, when it was exhibited at the Royal Academy (Walker Art Gallery, Liverpool).[1] He often financed his preparatory work on such large, time-consuming canvases by completing the oil studies as finished pictures that he could sell to a loyal coterie of patrons. There are at least two finished oil versions similar to the present composition: *Silver,* exhibited at the Royal Academy in 1886 (private collection), and *The Toilette* (Tate, London).[2] *Myrtle* differs from these other versions in numerous respects, most notably in its bold color scheme and in the presentation of the figure as nude from the waist up, rather than lightly draped in transparent silk. It may have been produced at the specific request of a patron, for watercolor studies do not seem to have played a role in Moore's preparatory process.

Misinterpreting Moore's paintings as illustrations of classical history, many crit-

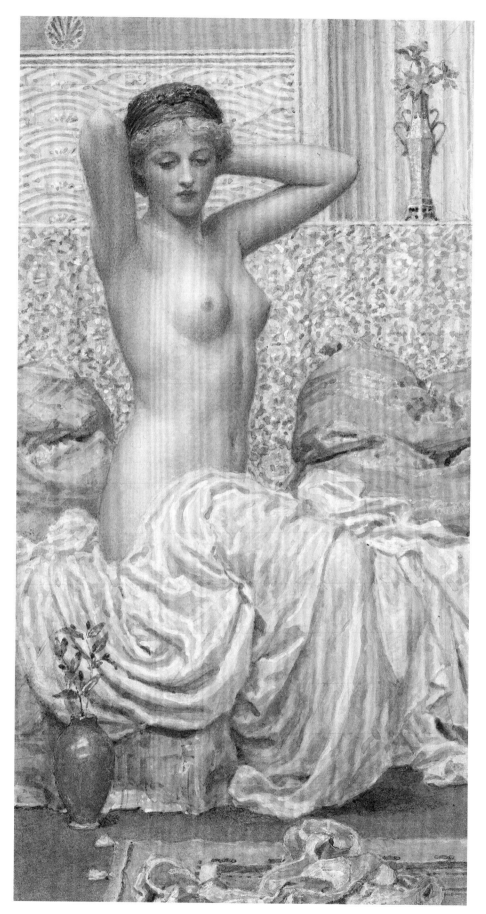

180

ics were dumbfounded by such seemingly anachronistic details as the Liberty of London fabrics and wall treatments that he introduced into *Myrtle* and other works of the 1870s and 1880s. Moore included such materials simply because he considered them beautiful, and they underscore the point that his intentions were fundamentally aesthetic, rather than narrative or historical. As a further frustration to conventional interpretation, Moore often titled his pictures after seemingly insignificant details within the composition. The present work derives its name from the sprig of myrtle in the vase at lower left.

Although Moore's advanced aesthetic experiments were lost on the majority of his contemporaries (who saw in his art only an endless parade of classically draped— or undraped—maidens), *Myrtle* was enthusiastically and perceptively received when exhibited at the Royal Society of Painters in Water-Colours in 1886. Several journals commented on the exquisitely rendered flesh and the convincing modeling of the torso, difficult feats to achieve in watercolor.[3] The influential critic F. G. Stephenson went so far as to call *Myrtle* "the finest work that has been wrought in water-colour" by Moore.[4] Delicate and pristine, it is indeed an exceptionally fine example of the artist's mastery of the medium.

Robyn Asleson

1. See Asleson 2000, pl. 179.
2. Ibid., pp. 185–86, 228 n. 36.
3. Anon. 1886, p. 385; Anon., May 1886, p. xxx; Anon., May 22, 1886, p. 683; Wedmore 1886, p. 404.
4. Stephens 1886, p. 623.

PROVENANCE: John Postle Heseltine; his sale, Sotheby's, London, May 27–29, 1935, no. 437 (£19); acquired at that sale through Martin Birnbaum by Grenville L. Winthrop; his bequest to the Fogg Art Museum, 1943.

EXHIBITIONS: London 1886, no. 238; Cambridge, Mass., 1946b, no. 62; Tokyo 2002, no. 66.

REFERENCES: Anon. 1886, p. 385; Anon., May 1886, p. xxx; Anon., May 22, 1886, p. 683; Stephens 1886, p. 623; Wedmore 1886, p. 404; Baldry 1894, p. 60; Cohn in Cambridge, Mass., 1977b, pp. 9, 52, 103, no. 41; Newall 1987, p. 106, pl. 75; Asleson 2000, pp. 185–86, 226 n. 173, 228 n. 36.

Dante Gabriel Rossetti[1]

London, 1828–Birchington-on-Sea, England, 1882

181. *The Salutation of Beatrice,* or *Il Saluto di Beatrice,* 1849 and 1850

Black ink, black wash, and graphite on cream wove paper[2]
15 1/2 x 26 5/8 in. (39.5 x 67.7 cm)
Left and right panels signed and dated in brown ink, lower right: DGR [monogram] / 1849 (left), DGR [monogram] / 1850 (right)
Inscribed in black ink over graphite, above central figure: ITA N'È BEATRICE IN ALTO CIELO; over head of central figure: 9 GIUGNO 1290; below central figure: ED HA LASCIATO AMOR MECO DOLENTE; below left panel: E CUÎ SALUTA, FA TREMAR LO CORE; below right panel: GUARDAMI BEN; BEN SON, BEN SON BEATRICE; lower center: IL SALUTO DI BEATRICE
1943.739

Although Rossetti was three-quarters Italian and his father was a famous Dante scholar, he seems to have shown little interest in Italy's national poet until 1848, the year the Pre-Raphaelite Brotherhood was probably founded. It was not until the following spring that he started to sign himself Dante Gabriel Rossetti, placing first what was in fact his third baptismal name, but in October 1848 he completed his own translation of the *Vita nuova* and began a series of illustrations of it. His list of them in an 1848 letter[3] includes the *Second Meeting of Dante and Beatrice,* also known as *The Salutation in Florence,* the subject of the left panel of the Winthrop diptych. This panel is dated 1849, which likely is correct, although the date and the monogram were probably added some ten years later.

The panel illustrates a passage in the *Vita nuova* in which Dante describes a meeting with Beatrice in Florence when he was eighteen: "[I]t happened that the same wonderful lady appeared to me dressed all in pure white, between two gentle ladies elder than she. And passing through a street, she turned her eyes thither where I stood sorely abashed: and by her unspeakable courtesy, which is now guerdoned in the Great Cycle, she saluted me with so virtuous a bearing that I seemed then and there to behold the very limits of blessedness."[4] Beneath the drawing is inscribed a line from a sonnet in the *Vita nuova* describing the effect of Beatrice's salutation: E CUÎ SALUTA, FA TREMAR LO CORE (He whom she greeteth feels his heart to rise).[5]

E CUI SALUTA, FA TREMAR LO CORE

IL SALUTO DI BEATRICE

GUARDAMI BEN; BEN SON, BEN SON BEATRICE

Rossetti has selected a moment of drama between two people, the kind of crucial meeting that fascinated him and is the central focus in many of his other important works.

Rossetti moves the meeting to the entrance to a cloister and places Dante at the opening to a chapel. The vaulted arcade and many details of dress are taken from plates in the costume historian Camille Bonnard's book of medieval and Renaissance dress, which Rossetti purchased in September 1849.[6] Behind Dante is a wall frescoed with angels, a reference to the realm of his future work *La divina commedia*. He holds a volume of Virgil, his guide in the *Commedia*. Dante's head and headpiece are adapted from a supposed portrait of the poet in a Florentine fresco then attributed to Giotto (see cat. no. 183). At Dante's feet is a slab incised with the image of a mounted knight, perhaps a ref-

erence to his service with the Florentine cavalry at the battle of Campaldino.[7] An arch in the background frames a view of the river Arno and the statue of a partially draped maenad clashing cymbals, perhaps a reference to the loose life Dante led for a time after Beatrice's death. Among several incidental details, Beatrice holds a lily and wears a dress patterned with lilies, the emblem of Florence. Such details do not detract from her salutation to Dante and the intensity of their exchanged gazes—a hallmark of Pre-Raphaelite art, of which this drawing is a moving example.

Another salutation, that of Beatrice in Purgatory, is shown in the right-hand panel. In his *Purgatorio*, Dante describes his longed-for meeting with Beatrice after her death: accompanied by female companions, she descends from a triumphal car drawn by a griffin and unveils to him. Rossetti illustrates the moment of unveiling when

Beatrice castigates Dante for his tardiness in seeking her out: "Observe me well. I am, in sooth, I am / Beatrice. What! and hast thou deign'd at last / Approach the mountain? Knewest not, O man! / Thy happiness is here?"[8] The key line is inscribed below: GUARDAMI BEN; BEN SON, BEN SON BEATRICE.

Beatrice wears the veil and olive wreath described in the text, and the Garden of Eden is suggested by the lily hedge and minute angel in the background. Appropriately the figures appear more mature than in the scene at left. Dante is crowned with a laurel wreath and his face is perhaps suggested by a death mask.[9] The gravity of the figures recalls Hippolyte Flandrin's frieze in Saint-Germain-des-Prés, Paris, which Rossetti admired extravagantly in October 1849, while the folds of Beatrice's costume are taken from a fifteenth-century Sienese painting repro-

duced in Bonnard's book.[10] The bold division of space, dispensing with any middle ground and pushing the horizon and its miniature detail to the top of the picture, is much more radically "primitive" than in the left panel.

Although perhaps Rossetti conceived the two panels for an engraving, he also hoped to paint an important picture of the dual subject on a canvas more than seven feet long. In the autumn of 1850 he took the design with him from London to Sevenoaks to paint the background of *The Salutation of Beatrice in Heaven* from nature.[11] He abandoned this canvas but many years later used a fragment that he painted for the background of *The Bower Meadow*.[12] The landscape above the lily hedge in the present drawing is similar and so was probably drawn at Sevenoaks.

Beatrice's death, occurring between the two salutations, is symbolized by the figure of Love with downturned torch on the thin strip between the scenes. Above and below are inscribed lines from the *Vita nuova* referring to Beatrice's death and Dante's sorrow: "Beatrice is gone up into high Heaven"; "And hath left Love below, to mourn with me."[13] Love holds a sundial with its shadow falling on the hour of Beatrice's death; this mystical number nine

recurs at key points in the *Vita nuova*. The date of her death, 9 GIUGNO 1290, is inscribed above his head. The head is an insert, on a patch, but on purely stylistic grounds it must be one of the earliest parts drawn. It resembles the child angel in Rossetti's first major oil painting, *The Girlhood of Mary Virgin*, of 1848–49.

The theme of lovers separated by death is found repeatedly in Rossetti's art and writing (see cat. no. 189) but here, unusually, the lovers are reunited (in Dante's vision) after one has died. Rossetti returned to the subject of Beatrice's salutation several times, most notably in a watercolor finished in 1854[14] and three large cupboard door panels of 1859.[15]

Alastair Ian Grieve

1. In compiling the entries for cat. nos. 181–83, 185–87, and 189, I have drawn heavily on Surtees 1971. The staff at the Fogg Art Museum has helped me in every way. I should particularly like to thank Miriam Stewart for her assistance at Harvard.
2. Some of the highlights were executed by scraping away the paper surface. The whole composition is on one sheet of paper, but there has been an attempt to separate the left compartment with a cut along part of its right edge.
3. Rossetti, letter to Charles Lyell, November 14, 1848; see Rossetti 1965–67, vol. 1, p. 49. Lyell, Rossetti's godfather, was another Dante scholar, who completed the first English translation of Dante's *Canzoniere* in 1835.
4. Rossetti's translation, section 3 of the *Vita nuova*; see Rossetti 1911, p. 312.
5. Ibid., p. 326.

6. Bonnard, *Costumes des XIIIe, XIVe et XVe siècles* (1829–30). The setting is the Basilica of Sant'Ambrogio, Milan; see Yamaguchi 2000, pp. 6, 11. See also Weinberg 1999, pp. 622–23.
7. See Rossetti 1911, p. 297.
8. Cary n.d., p. 367 ("Purgatory" 30.71–74).
9. Seymour Kirkup had obtained the mask for Rossetti's father and Rossetti himself came to own it; see Boyce 1980, p. 17. The mask was probably a cast from the Torrigiani monument, which in turn was supposed to be made from a death mask; see Lyell 1842, p. xv, n.
10. See Weinberg 1999, pp. 622–23, and Yamaguchi 2000, pp. 6, 11.
11. Rossetti 1965–67, vol. 1, p. 94.
12. Surtees 1971, no. 229.
13. Rossetti's translation; see Rossetti 1911, p. 337.
14. Surtees 1971, no. 116D.
15. Ibid., nos. 116, 117.

PROVENANCE: George Rae, Birkenhead; Viscount Leverhulme, 1917; his sale, Anderson Galleries, New York, March 4, 1926, no. 272; Scott and Fowles, New York; acquired from them by Grenville L. Winthrop; his bequest to the Fogg Art Museum, 1943.

EXHIBITIONS: London 1883a, no. 33; Cambridge, Mass., 1944a, no. 69; Cambridge, Mass., 1946b, no. 63; Cambridge, Mass., 1969, no. 110.

REFERENCES: Sharp 1882, pp. 136, 182, 226, chronology, no. 5; Stephens 1883, part 1, p. 87 n. 1, part 2, p. 118; Destrée 1894, chronology, no. 13; Ortensi 1896, illus. p. 7; Marillier 1899a, pp. 25, 87, chronology no. 15, illus. p. 24; Marillier 1899b, pp. 353–57; Cary 1900, chronology, no. 217; Toynbee 1912, no. 6; Dupré 1921, pp. 66, 67; Sweeney 1944, illus. p. 18; Ironside and Gere 1948, pp. 34, 37; Rogers 1963, pp. 180–81; Rossetti 1965–67, vol. 1, pp. 48, 49, vol. 2, pp. 490, 491; Surtees 1971, p. 71, no. 116A, pl. 173; Henderson 1973, illus. p. 54; Grieve 1978, pp. 9–11, fig. 7; Sutton 1978a, p. 449, fig. 9; Sussman 1979, pp. 121–23, pl. 33; Ainsworth 1980, facing p. 72, fig. 6; Benedetti 1982, fig. 7; Benedetti 1984, p. 168, no. 22, illus.; Bennett 1988, p. 199; Faxon 1989, p. 59, pl. 41; London–Munich–Amsterdam 1997–98, p. 136, under no. 31; Weinberg 1999, pp. 622–23, fig. 38; Yamaguchi 2000, p. 11.

182. *A Christmas Carol*, 1857–58

Watercolor and gouache on cream wove paper mounted on another sheet of paper, mounted on linen, and stretched on a stretcher
13½ x 11¾ in. (34.3 x 29.7 cm)
Signed and dated in gouache, upper left: DGR [monogram] Xmas / 1857–8
1943.490

In November 1857 Rossetti was called away from Oxford—where he and his friends, among them William Morris and Edward Jones (later Burne-Jones), were painting an Arthurian mural cycle—by the illness of Elizabeth Siddal at Matlock in Derbyshire.[1] He spent Christmas with her there and

probably painted *A Christmas Carol* then, for it is dated "Xmas 1857–8" and the woman in the center and the one on the right both resemble Siddal, who became Rossetti's wife in 1860 until her death in 1862.

The subject of people making music had long occupied Rossetti, occurring perhaps

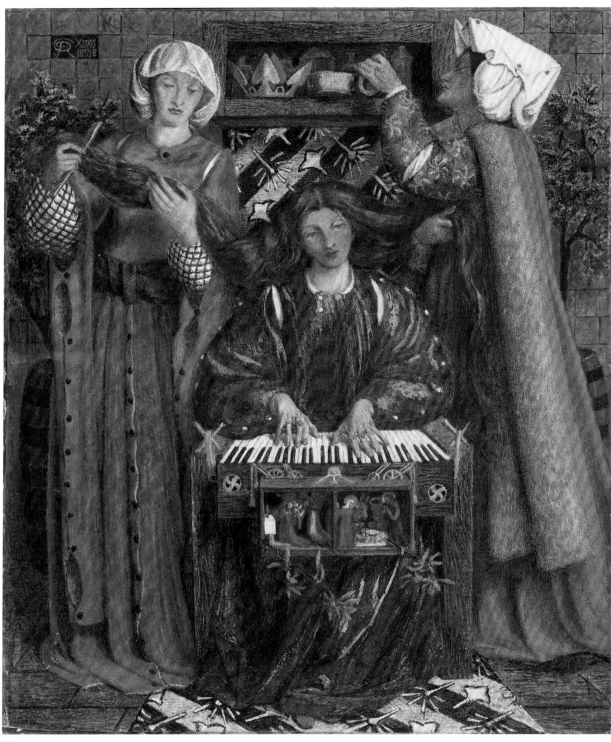

182

first in the drawing *Genevieve* of 1848,[2] while the subject of a medieval queen having her hair dressed by attendant maids is already found in his sketch of 1850 for an ambitious oil, *"Hist"—said Kate the queen,*[3] from Browning's *Pippa Passes*. In *A Christmas Carol* a queen is having her immensely long red-gold hair dressed as she plays a Christmas carol on a clavichord

slung between the heavy wooden arms of her chair. Attached to the front of the clavichord is a strange rectangular box, which may be some kind of acoustical device. It has slots at the top with cogs and tasseled levers and is decorated with painted scenes of the Annunciation and the Nativity. Sprigs of mistletoe hang from it.

The rectangular form of the clavichord

is echoed in the butt-jointed locker above the queen's head, which is built of the same grained wood as her throne. The locker holds her crown, ornamented with hearts, and bottles of scent in brilliant primary colors of red, gold, and blue. Indeed, the color of this entire work is astonishing, fused as it is with the geometry of heraldic shapes and the contrasting soft, rounded forms of

the costumes of the women contained in the shallow space. An orthogonal grid of blue tiles extends over the back wall, incorporating a small rectangle of red and gold bearing Rossetti's monogram and the date. Holly bushes with berries stand in red-and-black-striped tubs on either side. Hanging behind the queen is a heraldic patterned cloth with black and gold stripes that change direction on the flagged or boarded floor in the foreground. The staccato rhythm of the black and white keys of the clavichord contrasts with the full, rounded sleeves of the queen's scarlet dress and the flowing rivulets of her hair.

Rossetti repainted her hair in the summer of 1859, and *A Christmas Carol* is in some ways a transitional work between his intensely medieval and mysterious watercolors of 1856–57 and the more relaxed and avowedly sensual pictures of the next decade.[4] Although a fascination with women's hair can be found early in his work, from even before 1848, it becomes a positive fetish in the early 1860s in pictures such as *Fazio's Mistress*.[5] Yet in its symmetry and subject *A Christmas Carol* has much in common with the watercolor *The Blue Closet* of late 1856.[6] The symmetry of these compositions probably derives from medieval scenes such as *sacre conversazioni*, Flagellations, or, specifically, a Florentine fourteenth-century fragment of four paired musical angels in the collection of Christ Church College, Oxford.[7] A more prosaic possible source for the medieval setting of *A Christmas Carol* is the actor Charles Kean's antiquarian production of Shakespeare's *Richard II,* in 1857, which drew on medieval illuminated manuscripts and included a throne backed with a striking diagonal striped hanging.[8]

Though probably executed at Matlock, *A Christmas Carol* is redolent of the interests of the circle of friends Rossetti had left at Oxford, where, one of them recalled, "Mediaevalism was our *beau idéal*" and "in all art there was to be an abundance of pattern."[9] Rossetti himself was notoriously unmusical but both Morris and Jones had belonged to a plainsong society while at Oxford.[10] Morris's contemporary short stories and poems, many of them published in 1858 in his first volume of verse, *The Defence of Guenevere*, which was dedicated to Rossetti, contain references to medieval Christmases, to ancient carols, to heraldic pattern, and also to the tactile delight of women's hair. The heavy "medieval" furniture that Morris had made for the rooms he shared with Jones in Red Lion Square, London, in the winter of 1856, and which he, Rossetti, and Jones decorated with painted scenes, no doubt influenced the furniture in *A Christmas Carol*. The young poet Algernon Charles Swinburne, who came into their circle at Oxford in 1857, shared their interests and wrote what he later described as an "undergraduate imitation of an old carol" inspired by Rossetti's *A Christmas Carol*.[11]

Rossetti was extremely short of money in the winter and spring of 1857–58; his work on his Oxford mural had been unpaid, and his lodging at Matlock with Siddal was a drain on his slim resources. To raise cash he took an extremely unusual step for him and submitted *A Christmas Carol* for exhibition and sale, priced at 80 guineas, at the Liverpool Academy in 1858. It failed to sell then but in August 1859 he sold it privately for 60 guineas to the Newcastle lead manufacturer and important Pre-Raphaelite patron James Leathart, to

whom he had been introduced by the poet and painter William Bell Scott.[12]

Alastair Ian Grieve

1. Burne-Jones 1904, vol. 1, p. 168.
2. Surtees 1971, no. 38.
3. Ibid., no. 49.
4. Ibid., p. 56, no. 98.
5. Ibid., no. 164.
6. Ibid., no. 90.
7. Fox Stangways Gift, 1828.
8. See Riding and Riding 2000, p. 94.
9. Prinsep 1904, p. 169; Burne-Jones 1904, vol. 1, p. 164.
10. Mackail 1899, vol. 1, p. 66.
11. Letter of January 19, 1885. See Swinburne 1959–62, vol. 5, p. 96. I am grateful to Gail Weinberg for this information. She suggests that Swinburne based his "carol" on medieval poems from a manuscript in the British Museum reprinted in a pamphlet he owned that was published by the Warton Club: Thomas Wright, ed., *Songs and Carols Printed from a Manuscript in the Sloane Collection in the British Museum* (London, 1856). It is likely that by 1856 the Oxford group also knew the architect Edmund Sedding, who avidly collected old carols and included one of Morris's pseudo-antique ones in his book *A Collection of Ancient Christmas Carols* (London, 1860).
12. Surtees 1971, no. 98, pp. 55, 56.

PROVENANCE: Sold by the artist to James Leathart, Bracken Dene, Gateshead-on-Tyne, 1859 (£63); purchased from his estate by Charles Fairfax Murray, 1897; acquired from him by Grenville L. Winthrop, July 1913 (£1,000); his bequest to the Fogg Art Museum, 1943.

EXHIBITIONS: Liverpool 1858, no. 301; London 1883b, no. 366; Leeds 1889, no. 144 (lent by James Leathart); London 1901a, no. 142; Manchester 1904, no. 15; London 1906a, no. 92; Cambridge, Mass., 1946b, no. 65; Tokyo 2002, no. 10.

REFERENCES: Sharp 1882, pp. 122, 152, chronology, no. 61; Rossetti 1896, p. 132; Marillier 1899a, pp. 50, 82, 145, chronology, no. 76, illus. p. 84; Cary 1900, chronology, no. 49; Rossetti 1900a, p. 343; Rossetti 1902, p. 21, frontis.; Symons 1910, illus. facing p. 28; Bennett 1963, pp. 491–92, fig. 28; Staley 1967, illus. p. 85; Buckley 1968, illus. p. 338; Sonstroem 1970, p. 161, illus. p. 70; Surtees 1971, pp. 55, 56, no. 98, pl. 134; Henderson 1973, illus. p. 47; Nicoll 1975, p. 113, pl. 68; Boyce 1980, p. 22; Benedetti 1984, no. 115, illus. p. 206; Faxon 1989, pl. 129; Rossetti 1992, illus. p. 41; Powell 1993, pp. 16, 17; New York–Washington–Provo 1994–95, p. 52, fig. 50; Rodgers 1996, pp. 58–59, illus. p. 59; Yamaguchi 2000, pp. 17, 18.

183. *Giotto Painting Dante's Portrait*, ca. 1859

*Watercolor, gouache, and graphite on cream wove
paper mounted to paper-backed canvas
18¾ x 22¼ in. (47.6 x 56.4 cm)
1943.488*

Rossetti first drew the subject of *Giotto Painting Dante's Portrait* in December 1849.[1] This work is untraced, but there survives a watercolor of the same subject, evidently differently composed, which was completed in September 1852 and exhibited later that year (fig. 185).[2] That work shows an extraordinarily bold and unconventional treatment of space. In the center, raised on a scaffold that recedes into the composition, Dante sits facing Giotto. At the left stands Guido Cavalcanti, a fellow poet, leaning familiarly on the side of Dante's chair. In the background Cimabue, Giotto's predecessor, climbs a ladder to peer in wonder at Dante's portrait, which Giotto is painting in fresco. Beneath the scaffold, low in the

right corner, a line of girls moves in procession toward us. The most prominent one, Beatrice, has red hair. Dante, cutting a pomegranate, looks down at her as she passes.

Winthrop's version of the scene, dating from about 1859, is incomplete, probably cut a little along the base and at the right-hand side so that neither the procession of girls nor Cimabue is included. As well as truncating the subject, the reduction of the composition has also made the space comparatively conventional.

The subject was of great importance to Rossetti. He entitled the 1852 work *The Youth of Dante* and composed it so as to bring together what he believed to be all the important influences on Dante's early life—art, friendship, love. As with his contemporary scenes of the Virgin's life, it was momentous change through time that he wanted to portray. He described

the subject in a letter of January 8, 1853, to his fellow Pre-Raphaelite Thomas Woolner: "The main incident is that old one of mine, of Giotto painting Dante, but treated quite differently from anything you have seen, and with the figures of Cimabue, Cavalcante, Beatrice, and some other ladies. It illustrates a passage in the *Purgatory* which perhaps you know, where Dante speaks of Cimabue, Giotto, the two Guidos (Guinicelli and Cavalcante, the latter of whom I have made reading aloud the poems of the former who was then dead) and, by implication, of himself. For the introduction of Beatrice, who with the other women (their heads only being seen below the scaffolding) are making a procession through the church, I quote a passage from the *Vita Nuova*. I have thus all the influence of Dante's youth—Art, Friendship and Love—with a real incident embodying them."[3]

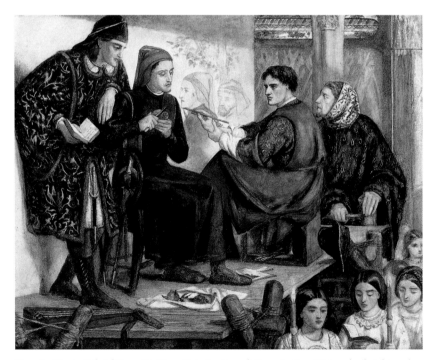

Fig. 185. Dante Gabriel Rossetti, *Giotto Painting Dante's Portrait*, 1852. Watercolor heightened with gum arabic over pencil, 14¾ x 18½ in. (37.5 x 47 cm). Collection of Lord Lloyd-Webber.

Fig. 186. *"Giotto's" Portrait of Dante*, chromolithograph, 17¼ x 12½ in. (43.8 x 31.8 cm). From a tracing by Seymour Kirkup. Occasional publication of the Arundel Society, 1859. Reproduced from Holbrook 1921, facing p. 76

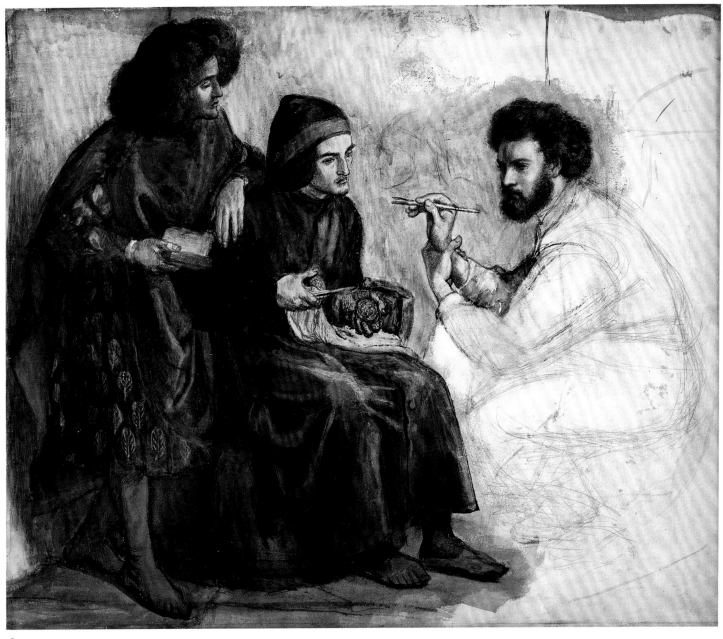

183

The lines from the *Purgatorio* to which Rossetti refers are these: "Cimabue thought / To lord it over painting's field; and now / The cry is Giotto's, and his name eclipsed. / Thus hath one Guido from the other snatch'd / The letter'd prize: and he, perhaps, is born, / Who shall drive either from their nest."[4] And the lines from the *Vita nuova:* "For certain he hath seen all perfectness / Who among other ladies hath seen mine."[5] Both passages were quoted (in the original Italian) in the catalogue of the 1852 exhibition and are also inscribed on a contemporary drawing in pen and ink of the subject.[6]

Rossetti's concern with momentous change in Dante's life would have been even more apparent if he had been able to add other scenes to the central incident of Giotto painting Dante's portrait, as he had intended to do. His brother tells us that Rossetti planned a triptych with the scene of Giotto painting Dante's portrait flanked by wings showing contrasting episodes in the poet's life.[7] One wing was to show Dante as a prior in Florence banishing the leaders of the contending Black and White factions. The other wing was to show him as an exile himself, being taunted by a jester at the court of Can Grande della Scala in Verona. Among the leaders of the Whites banished by Dante in 1300 was his poet friend Cavalcanti. Dante was exiled in the following year and spent much of his later life in Verona.

The main incident and intended central subject, of Giotto painting the portrait of his friend Dante in fresco, is mentioned in passing by Giorgio Vasari but had become

famous in the mid-nineteenth century when interest in the so-called Primitives and the cult of the national hero developed. For Rossetti it had a profound personal importance for he himself was a medievalizing artist and poet who had been named after the great medieval Italian.

The supposed Giotto portrait itself, showing Dante with a banded headpiece, a branch of pomegranates, and a book under his arm, had been discovered in the chapel of the Palazzo del Podestà in Florence on July 21, 1840. Among those present at the discovery was Seymour Kirkup, an acquaintance of Rossetti's father, Gabriele. The following year, Kirkup sent Gabriele three copies of the portrait (see fig. 186).[8] After these copies were made the portrait was drastically restored, and Kirkup stressed to Gabriele that the copies retained essential characteristics lost forever as a result of the restoration. He also emphasized that the portrait showed Dante as a young man: "[I]t is not the mask of a corpse of fifty-six—a ruin—but a fine, noble image of the Hero of Campaldino, the lover of Beatrice."[9] By at least December 1852 one of these copies, together with a cast of the poet's death mask, was in Rossetti's studio and by that date both items were well known—the fresco portrait especially so—among a wider circle of British scholars of Italian medieval art and literature.[10]

Rossetti, always keen to bring poets and artists together and drawn to subjects concerned with the creation of art, seizes on the supposed historic link between Giotto and Dante and makes their alliance live through his imagination. In Winthrop's version of the subject, the cut pomegranate in Dante's hand, symbol of immortality, is the central focus. Dante's friend and fellow poet Cavalcanti leans on his shoulder while holding a book of verse by Guinicelli. Dante stares ahead and down to where Beatrice should be proceeding below the scaffold at the bottom right.

Although Rossetti evidently did not use models for the 1852 watercolor,[11] it seems that he did for this version. It has been suggested that the model for Giotto was Val Prinsep, who had painted murals with Rossetti in the Oxford Union in 1857, while Cavalcanti's red hair was perhaps suggested by the notorious head of the poet Swinburne, who also came into Rossetti's circle then.[12] Whereas in the earlier versions of the scene Rossetti had shown Dante sitting in an anachronistic wooden chair with curved arms, in Winthrop's work he is sitting in a simple basket chair of the kind Rossetti himself used in his London rooms and adopted for medieval scenes. This unfinished work provides an insight into Rossetti's technique. Working from left to right with a dry brush, he carefully finished parts such as the heads and

hands, while leaving other parts, Giotto's body for example, only roughly sketched.

Alastair Ian Grieve

1. Rossetti 1900b, p. 238.
2. Surtees 1971, no. 54; in "The Winter Exhibition of Sketches and Drawings," the Gallery, 121 Pall Mall, removed from the gallery of the Old Water-Color Society, London, 1852, no. 7, as "Sketch for a Picture"; sold at Sotheby's, London, June 19, 1991, no. 230, to Lord Lloyd-Webber (fig. 185).
3. Rossetti 1965–67, vol. 1, pp. 122, 123.
4. Cary n.d., p. 367 ("Purgatory" 11.93–98).
5. Rossetti 1911, p. 334.
6. Surtees 1971, no. 54A.
7. Rossetti 1895, vol. 1, p. 163.
8. Rossetti 1901, pp. 147, 148.
9. Ibid., p. 146.
10. See Lyell 1842, frontis. and facing p. xvii; Merrifield 1844, pl. 6; Lindsay 1847, vol. 2, p. 174; and Ruskin 1854, p. 30 n. For the reproduction of the portrait produced by the Arundel Society in 1859 (fig. 186), see Toynbee 1910, pp. 133, 134.
11. Holman Hunt informed Thomas Combe in a letter of December 30, 1852, that models were not used, Bodleian Library, Oxford, MS Eng. Lett. C.296. I am grateful to Dr. Deborah Cherry for this information.
12. Surtees 1971, p. 20, no. 54R.1.

PROVENANCE: Fanny Cornforth; Charles Fairfax Murray; Scott and Fowles, New York; acquired from them by Grenville L. Winthrop, 1924 ($2,400); his bequest to the Fogg Art Museum, 1943.

EXHIBITIONS: London 1883a, no. 17; London 1923, no. 43; Cambridge, Mass., 1946b, no. 66.

REFERENCES: Sharp 1882, p. 406; Marillier 1899a, p. 101, n. 1, no. 84; Cary 1900, chronology, no. 55; Toynbee 1912, no. 25; Rossetti 1965–67, vol. 1, pp. 122–23; Surtees 1971, p. 20, no. 54R.1, pl. 48; Susan B. Bandelin in New Haven 1976, pp. 37–38; Grieve 1978, pp. 13–16; Benedetti 1982, no. 32, illus.; Benedetti 1984, no. 144, illus. p. 219; Faxon 1989, p. 63, pl. 46; McGann 1997– ; McGann 2000, illus. following p. 44 (Frederick Hollyer photographic reproduction); Dietrich 2000, pp. 61–69, fig. 1; Yamaguchi 2000, p. 14.

184. *Il Ramoscello (Bella e Buona)*, 1865

Oil on canvas
18 3/4 x 15 1/2 in. (47.6 x 39.4 cm)
Signed and dated top left: DGR [monogram] 1865
Inscribed top right: IL RAMOSCELLO
1943.201

Programmatically, *Il Ramoscello* fits into a series of similarly composed allegorical pictures of women that Rossetti began with *Bocca Baciata* (1859; Museum of Fine Arts, Boston). All have at their heart the subject

of the compelling nature of feminine beauty, and they suppress any narrative content in favor of suggestion, mood, allegory, and symbolism. Their shortened foregrounds, bringing the figure into close

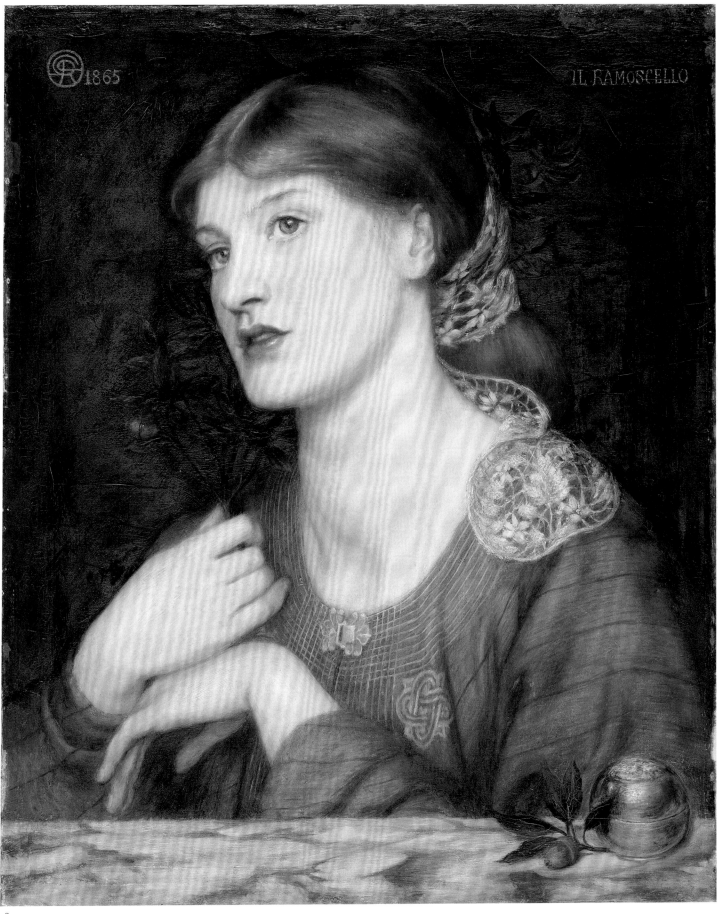

1865 IL RAMOSCELLO

184

proximity, and their decorative backgrounds, rich painting, and sumptuous coloring all derive from Venetian Renaissance painting, for which there was newfound enthusiasm as a result of John Ruskin's critical writings. Rossetti, too, admired the sensuous opulence of painters such as Titian and Giorgione, whose contrast to the austerity and seriousness of Roman and Florentine Renaissance art perhaps mirrored his own progression away from the rigors of true Pre-Raphaelite practice and subject matter. Rossetti painted *Il Ramoscello* for William Graham, the Scottish Presbyterian jute manufacturer and member of Parliament who was one of the great collectors of Rossetti's work and who also later commissioned *The Blessed Damozel* (cat. no. 188). The picture's original title was *Bella e Buona* (Beautiful and Good), but in 1873 Rossetti changed it to *Il Ramoscello* (The Twig).

The characterization of the figure is more restrained and less sensual than in other similar pictures. Nevertheless, Rossetti portrays his subject with rich decorations such as the elaborate lace hair tie and a dress of gold-shot silk fastened with a golden clasp. The design on her breast is Celtic, and perhaps this is connected with the prominent branch of ilex that she grasps. The species of ilex illustrated is the evergreen oak, and the oak was specifically held as sacred by the druids, who venerated evergreen trees as magical symbols of fertility and regeneration. Druidism was the religion of pre-Roman Britain, but in the early nineteenth century its rites were

revived by Iolo Morgannwg as part of the Corwen Eisteddfod, a celebration in Wales of Celtic culture. Rossetti's inclusion of ilex in the picture may be purely decorative, but he might also be placing his epitome of female beauty in a setting relating to fertility and to pagan belief in its centrality. The acorn on the marble ledge might support this, and the sphere could symbolize the globe, although in traditional iconography it is also a symbol of truth, as Rossetti would have been aware.

Red-haired and with lips parted, in common with many of his pictures of women Rossetti's model appears as if looking in a mirror, in a moment of narcissistic contemplation of herself, or else staring into the distance but really lost in thought, her gaze directed inward upon herself. The sitter has some resemblance to Alexa Wilding, the professional model Rossetti started to use in 1865, the year the picture was begun, but conclusive identification remains elusive. William Michael Rossetti, the artist's brother, claimed it was a portrait of William Graham's daughter Amy;[1] however, this was specifically refuted by H. C. Marillier.[2] In her memoirs, Graham's daughter Frances made no mention of it being a depiction of her sister, supporting Marillier's assertion; she also provides an interesting account of the proprietorial changes Rossetti made to the picture and how Graham responded to them: "In his last years Rossetti took to repainting his pictures, and making them all with exaggerated throats and hair, which were characteristic of his later work. My father had a

lovely little early picture of his, a girl standing against a background of ilex. . . . Rossetti said he wanted it back to revarnish, or some excuse, my father was very reluctant to part with it, but he did ultimately consent to let it go. It came back quite altered, and we were all very sad. There was a picture cleaner and restorer named Merrett, whom my father trusted and employed with all his Italian pictures, so he sent Bella e Buona to him. Merrett took off all the super-imposed paint, and returned her to us as she was at first; but we never dared let Gabriel see her again, for it would have offended him deeply."[3]

A pencil-and-sepia drawing entitled *Il Ramoscello* and dated 1865, presumably a study for the painting, was exhibited at Nottingham Art Gallery in 1892 but is now untraced.[4]

Robert Upstone

1. Rossetti 1895, vol. 2, p. 243.
2. Marillier 1899a, p. 139.
3. Horner 1933, pp. 8–9.
4. Surtees 1971, no. 181a.

PROVENANCE: William Graham, by 1872 (£350); his sale, Christie's, London, April 3, 1886, no. 111 (£378); purchased at that sale by Major Vipan; his widow, Mrs. Vipan; her sale, Christie's, London, March 13, 1925, no. 155 (£378); Scott and Fowles, New York; acquired from them by Grenville L. Winthrop, January 22, 1926 ($3,500); his bequest to the Fogg Art Museum, 1943.

EXHIBITIONS: London 1883b, no. 310; Cambridge, Mass., 1946b, no. 69; Cambridge, Mass., 1973a; Cambridge, Mass., 1980a; Cambridge, Mass., 1987; Tokyo 2002, no. 63.

REFERENCES: Stephens 1883, pp. 87, 89; Rossetti 1889, p. 71; Rossetti 1895, vol. 2, p.243; Marillier 1899a, p.139, no. 167; Horner 1933, pp. 8–9; Surtees 1971, no. 181, pl. 261.

185. *Portrait Head of Jane Morris*, 1865

*Charcoal with touches of black chalk on cream
wove paper
16 3/4 x 13 7/8 in. (42.7 x 35.3 cm)
Signed and dated in charcoal, lower right: DGR
[monogram] / 1865
1943.745*

Rossetti first met Jane Morris (1839–1914),
the wife of his friend William Morris, at
Oxford in 1857, when she was Jane Burden,
the daughter of a groom. She modeled for
him then as Guenevere, for a mural he was
painting and for another he was intending
to paint in the Union building.[1] In the fol-
lowing year he made a careful portrait
drawing of her,[2] and from then until about
1876 he regularly continued to make fine
drawings of her, both as preliminaries for
his subject pictures and as portrait studies
in their own right. In 1865 he hired a pro-
fessional photographer to make a series of
posed photographs of her, and from the
same year dates a group of beautiful black-
chalk-and-charcoal studies of her head, of
which two or three, including catalogue
number 185, are in the Winthrop collection
at the Fogg Art Museum.[3]

Although Rossetti had drawn Elizabeth
Siddal repeatedly in the previous decade,
these 1865 drawings of Jane Morris have
more the appearance of a unified series
since they are about the same size, in the
same media, and focused on the sitter's
face, neck, and hair. When Charles Fairfax
Murray, who sold the drawings to Grenville
Winthrop, first saw them in Rossetti's studio
in 1866, they were together in one frame.[4]

Jane Morris was tall, her frame angular,
her neck slim and long, her face pale, her
jaw pronounced, her eyes large and
gray, and her hair very dark and rippled.
She resembled Ligeia, the fantasy of Edgar
Allan Poe, a writer Rossetti greatly

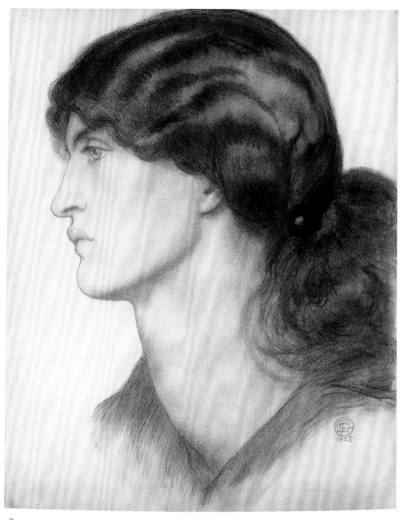

185

admired: "In beauty of face no maiden ever
equalled her. It was the radiance of an
opium dream— . . . Yet her features were
not of that regular mould which we have
been falsely taught to worship in classical
labors of the heathen. 'There is no exqui-
site beauty,' says Bacon, Lord Verulam,
speaking truly of all the forms and *genera*
of beauty, 'without some *strangeness* in the
proportion.'"[5] Her peculiar beauty inspired
Rossetti, and from 1868 until his death in
1882 she was his dominant muse.

Alastair Ian Grieve

1. Surtees 1971, nos. 363, 95A.
2. Ibid., no. 364.
3. The Winthrop bequest includes, in addition to cat.
 no. 185, a black chalk drawing dated 1865 (1943.749;
 Surtees 1971, no. 369) and another dated 1861
 (1943.747; ibid., no. 371). This cataloguer thinks
 that the drawing dated 1861 may not be by Rossetti,
 although all three drawings were bought from
 Charles Fairfax Murray, who was a reliable source
 and who informed Winthrop that he had seen them
 in one frame in Rossetti's studio in 1866; see note 4
 below. Virginia Surtees (ibid., no. 371) accepts the
 drawing dated 1861 as being by Rossetti, but she
 dates it to ca. 1865–70.
4. Murray, letter to Winthrop, May 31, 1909, Harvard
 University Art Museums Archives.
5. *Collected Works of Edgar Allan Poe: Tales and
 Sketches, 1831–42*, edited by Thomas O. Mabbott
 (Cambridge, Mass., 1978), vol. 2, pp. 311–12.

PROVENANCE: Charles Fairfax Murray; acquired
from him by Grenville L. Winthrop, 1909; his bequest
to the Fogg Art Museum, 1943.

EXHIBITION: Cambridge, Mass., 1946b, no. 70.

REFERENCES: Sharp 1882, probably either no. 137 or
138, illus.; Symons 1910, illus. facing p. 23; Surtees 1971,
p. 175, no. 368; Allen 1983, fig. 2; Faxon 1989, pl. 259.

186. *Beata Beatrix*, 1871

*Watercolor and gouache, partially varnished, on
off-white wove paper*
28 x 21⅝ in. (71.2 x 55 cm)
Signed in watercolor, lower left: DGR [monogram]
1943.491

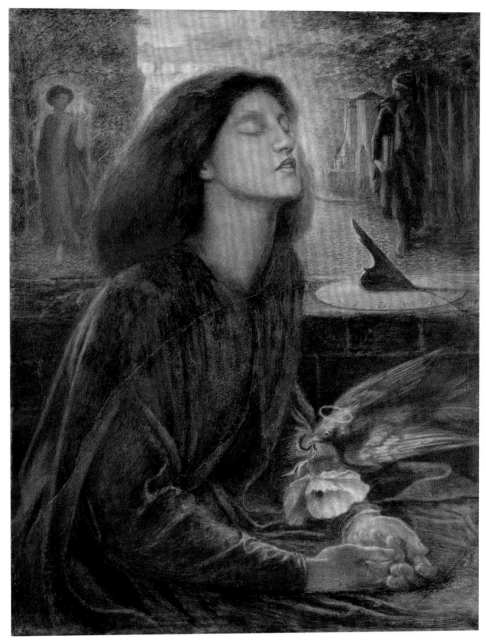

186

This watercolor of 1871 is a reduced replica
of an oil painted between about 1864 and
1870 and now in Tate Britain, London.[1]
Rossetti himself characterized *Beata
Beatrix* as "a poetic work," and it differs
markedly from his contemporary, sensuous
"Venetian" paintings.[2] Although *Beata
Beatrix* can be taken as a memorial to the
artist's wife, Elizabeth Siddal, who died
from an overdose of laudanum in 1862, it
was in fact conceived about ten years
before her death. In the winter of 1852–53
Rossetti was engaged on a diptych "sym-
bolizing in life-sized half-figures, Dante's
resolve to write the *Divina Commedia* in
memory of Beatrice."[3] This was put aside
but in the winter of 1863 Rossetti came
across the started canvas, with a lifesize
head of Siddal as Beatrice, which probably
forms the basis for the oil in Tate Britain.[4]
That picture was almost finished in 1866, by
which time it had been commissioned by
the Honorable William Cowper-Temple,
but for some reason it was not completed
until the end of 1870.

Even before its completion it became
one of Rossetti's most admired concep-
tions, and in 1867 his assistant Henry Dunn
was engaged in creating a chalk replica,
which is also in the Winthrop Collection.[5]
In 1871 Rossetti was busy on an oil replica
with a predella, which he told his brother
was "a beastly job, but lucre was the lure."[6]
At the same time he painted Winthrop's
reduced watercolor replica to satisfy the
insistent demands of Frederick Craven,
who had commissioned it "long ago" for
the large sum of 300 guineas.[7] Three more

replicas were to follow, one in chalk and
two in oil.[8] Since 1867 Rossetti had experi-
enced trouble with his eyes.[9] He found
working in watercolor more trying than
chalks or oils and, in fact, this watercolor
replica of *Beata Beatrix* is one of his last
works in that medium. Unfortunately, it has
been badly damaged, with a large curved
tear across it.

Rossetti emphasized that the picture did
not represent the death of Beatrice. On

March 11, 1873, he described its subject to
the purchaser of the first oil replica: "The
picture must of course be viewed not as a
representation of the incident of the death
of Beatrice, but as an ideal of the subject,
symbolized by a trance or sudden spiritual
transfiguration. Beatrice is rapt visibly into
Heaven, seeing as it were through her shut
lids (as Dante says at the close of the Vita
Nuova): 'Him who is Blessed throughout
all ages'; and in sign of the supreme

change, the radiant bird, a messenger of death, drops the white poppy between her open hands. In the background is the City which, as Dante says: 'sat solitary' in mourning for her death; and through whose street Dante himself is seen to pass gazing towards the figure of Love opposite, in whose hand the waning life of his lady flickers as a flame. On the sundial at her side the shadow falls on the hour of nine, which number Dante connects mystically in many ways with her and with her death."[10] In this description Rossetti makes no mention that his wife's death was in any way connected with the subject, yet she was the model for it and the white poppy hints at the way she died. A recent commentator, Robert Upstone, has seen in the picture a fusion of sexual and religious ecstasy which he suggests derives from Emanuel Swedenborg's idea of conjugal love.[11]

There are other symbols. Rossetti's old friend Frederic G. Stephens noted that the colors of Beatrice's drapery—a green

tunic, resembling wilting petals, over a dress of purple-gray—are "the colours of hope and sorrow as well as of life and death."[12] These colors are the same as those worn by the female apparition of the soul who appears to the artist Chiaro in Rossetti's story *Hand and Soul,* written in December 1849. On the frame (not shown), which is original and follows a design by Rossetti of about 1870, roundels representing the sun, the stars, the moon, and the earth (the last bearing the date of Beatrice's death, 9 GIUGNO 1290) further elaborate the meaning as they suggest the last line of the *Divina commedia*: "Love that moves the sun in heaven and all the stars."

Alastair Ian Grieve

1. 34 x 26 in. (86.4 x 66 cm); Surtees 1971, no. 168.
2. Rossetti 1965–67, vol. 2, p. 603.
3. Fredeman 1975, p. 98.
4. Surtees 1971, vol. 1, p. 94, no. 168.
5. 1943.743; ibid., p. 95, no. 168R.1.
6. Ibid., no. 168R.3; Rossetti 1965–67, vol. 3, p. 1003, no. 1165.
7. Mills 1912, p. 151.
8. Surtees 1971, nos. 168R.4, R.5, R.6.

9. Allingham 1907, p. 159.
10. Horner 1933, p. 25.
11. London–Munich–Amsterdam 1997–98, p. 156, no. 44.
12. Stephens 1891, p. 46.

PROVENANCE: Commissioned from the artist by Frederick W. Craven; his sale, Christie's, London, May 18, 1895, no. 50 (£173); purchased at that sale by Major Vipan; his widow, Mrs. Vipan; her sale, Christie's, London, March 13, 1925, no. 143 (£346 10s.); Russell, Cooke and Co.; Henry Beecham; acquired by Grenville L. Winthrop; his bequest to the Fogg Art Museum, 1943.

EXHIBITIONS: London 1883a, no. 150 (lent by Craven); Manchester 1887, no. 706; Cambridge, Mass., 1946b, no. 75; Cambridge, Mass., 1993; Tokyo 2002, no. 32.

REFERENCES: Sharp 1882, pp. 183, 226, chronology, no. 216; Rossetti 1889, p. 75; Destrée 1894, chronology, no. 296; Knight n.d., chronology, no. 163; Marillier 1899a, chronology, no. 242; Cary 1900, chronology, no. 157; Mills 1912, pp. 150–52; Toynbee 1912, no. 63; Rossetti 1965–67, vol. 3, p. 971; Surtees 1971, p. 95, no. 168R.2; Nicoll 1975, pp. 143, 144, 153; Johnson 1975, pp. 548–58; Allen 1983, pp. 130–31, 144–45, fig. 30; London 1984, under no. 131 (Tate Britain version); Benedetti 1984, no. 398, illus. p. 298; Faxon 1995, p. 18, fig. 5; London–Munich–Amsterdam 1997–98, under no. 44 (Tate Britain version); McGann 1997– ; Thomas 2000, pp. 73–74, fig. 2.

187. *Lucrezia Borgia,* 1871

Watercolor and gouache with heavy gum varnish on cream wove paper
25 1/4 x 15 3/8 in. (64.2 x 39.2 cm)
Signed and dated in gouache, lower right corner:
DGR [monogram] / 1871
1943.489

About 1860 Rossetti painted a watercolor of *Lucrezia Borgia,* showing her standing stiffly, crowned with a mass of dark hair, her arms covered.[1] In 1868 he regained this work and made considerable alterations to the figure, giving her blond hair, a turning pose, and a sumptuous white-and-gold dress based partly on a plate in Camille Bonnard's *Costumes* and partly on drapery

that he must have owned and had used before in his "Venetian" pictures *Monna Vanna* and *Monna Rosa* of 1866–67.[2] The Winthrop picture is an enlarged replica of the 1868 version.

The notorious Renaissance duchess Lucrezia Borgia is shown washing her hands after having administered poison to her second husband, Alfonso of Aragon, duke of Bisceglie, with the aid of her father, Pope Alexander VI. As she washes her hands she looks toward her husband, who is being walked around the room by her father "to settle the poison well into his system," as Rossetti said;[3] that scene is reflected in the circular mirror in the back-

ground. On the cabinet in front are a goblet, a flask of wine, and a red poppy, suggesting death by poisoning. At Lucrezia's right is an orange tree in a pot, perhaps an ironic reference to marriage. The pot is decorated with a writhing Chinese dragon, and other Chinese motifs pattern the black walls of the chamber. These exotic elements, no doubt included to suggest strange dissipation, were probably part of the furnishings of Rossetti's home at 16 Cheyne Walk, Chelsea, which was remarkable for its exotic decor.[4]

Rossetti had first used the motif of the ewer and basin, derived from a print by Albrecht Dürer, in his watercolor *Dante*

Drawing an Angel on the Anniversary of Beatrice's Death of 1853.[5] There it was introduced as a detail of everyday medieval life, but in *Lucrezia Borgia* it has become a sensually erotic, feminine accoutrement. Lucrezia has placed her many rings on the lip of the basin and our attention is focused on her intertwined fingers, bare arms and shoulders, and turned head. Her features have some resemblance to those of Fanny Cornforth, Rossetti's mistress and principal model between about 1858 and 1868.

Rossetti shared with Algernon Charles Swinburne and Edward (Burne-)Jones his fascination with beautiful, amoral, and evil women. Already at Oxford in 1857, when this group of friends came together, they are recorded arguing that a contemporary murderess should be excused the death penalty because she was beautiful.[6] In 1860 Jones painted *Sidonia von Bork* (Tate Britain, London), whose character is similar to that of Lucrezia Borgia, and they were also attracted to Potiphar's wife Phraxanor and to Nimue, Merlin's seducer, among many other femmes fatales. Swinburne, especially, venerated Lucrezia Borgia and may have been responsible for kindling Rossetti's enthusiam for her. Although Rossetti would probably have known Victor Hugo's play *Lucrèce Borgia* and is reported to have greatly admired Giulia Grisi's performance as Lucrezia in Gaetano Donizetti's opera based on Hugo's play, these sources dramatize episodes later in her career than the assassination of her second husband who, according to Hugo, was stabbed to death rather than poisoned.[7] The source for Rossetti's subject probably lies in one of the more esoteric historical records with which Swinburne was familiar.

Like the first, repainted version of the subject, the Winthrop watercolor is executed in gouache with gum coating, an opaque technique closer in some respects to oils than to the traditional watercolor

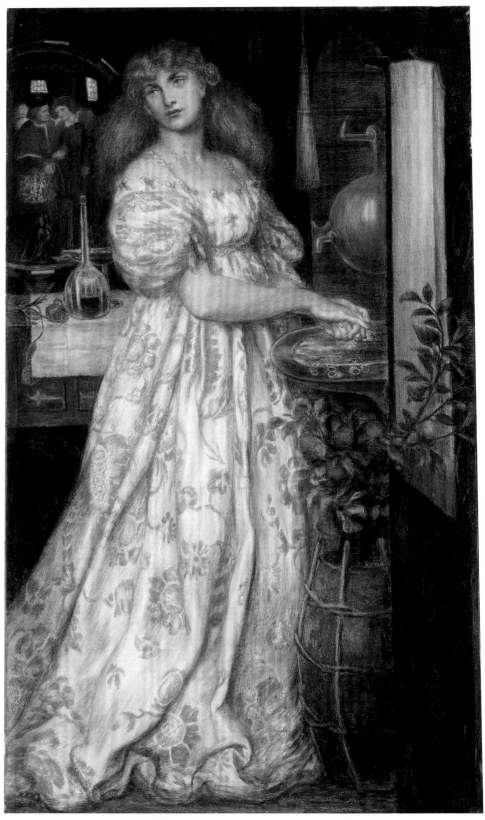

187

washes of the earlier English school. In fact, Rossetti had turned increasingly to oils from about 1859, thus becoming financially more successful than he had been in the previous decade, with a widening circle of patrons who demanded replicas of his successful works. He employed assistants to help him with the laborious process, first Walter Knewstub and then, from 1867, Henry Treffry Dunn. The extent of Dunn's involvement in Rossetti's work from that date has not been properly inves-

tigated; it would be an extremely difficult task as Dunn emulated his master's style with skill. The Winthrop version of *Lucrezia Borgia,* though a replica, is of high quality and remains in its original frame designed by Rossetti.[8]

Alastair Ian Grieve

1. Tate Britain, London; Surtees 1971, no. 124. For a reproduction of this work before its alteration in 1868, see Marillier 1899a, p. 105.
2. Surtees 1971, nos. 191, 198.
3. Marillier 1899a, p. 105.
4. Several Chinese and Dutch Chinese pieces of furniture were listed in the sale of his belongings after his death in 1882.
5. Surtees 1971, no. 58.
6. Hill 1897, p. 144.
7. Prinsep 1904, p. 282. Hugo has it mentioned in an aside that Alfonso of Aragon was stabbed to death, not poisoned; see Hugo 1964, *Lucrèce Borgia,* 2.1, p. 357.
8. The frame, of gilded oak, follows a design by Rossetti of September 1867, which developed a pattern he and Ford Madox Brown invented in 1863–64; see Rossetti 1965–67, vol. 2, pp. 631–33, nos. 734, 738.

PROVENANCE: Mrs. Tong, by 1878; William Coltart, by 1886; Mr. and Mrs. Joseph Beausire, by 1902; his sale, Christie's, London, April 13, 1934, no. 21 (£173 5s.); purchased at that sale by Barbizon House; Cecil French; acquired through Martin Birnbaum by Grenville L. Winthrop, 1938; his bequest to the Fogg Art Museum, 1943.

EXHIBITIONS: Manchester 1878, no. 245 (lent by Mrs. Tong); Liverpool 1886, no. 846 (lent by William Coltart); Southport 1892; London 1897–98, no. 28 (lent by William Coltart); Glasgow 1901, no. 323; Wolverhampton 1902 (lent by Joseph Beausire); London 1908, no. 432; Rome 1911, no. 557; Liverpool 1922, no. 44; Cambridge, Mass., 1946b, no. 78; Cambridge, Mass., 1977b, no. 51.

REFERENCES: Temple 1896, pp. 99–100; Marillier 1899a, pp. 105, 106, under no. 240; Radford 1899, pl. 40; Cary 1900, chronology, no. 155; Rossetti 1903, p. 301 (on reworking of first version); Jessen 1905, p. 43, fig. 30; Pica 1913, illus. p. 303; Graves 1913–15, vol. 3 (1914), pp. 1152, 1153, 1155; Tate Gallery 1924, p. 269; Rossetti 1965–67, vol. 3, illus. facing p. 1112; *Dictionnaire universel de l'art et des artistes* 1967–68, vol. 3, illus. in article on Rossetti; Surtees 1971, p. 78, no. 124R.1; Fennell 1978, pp. 10, 11, 35 (Tate Britain version); Benedetti 1984, p. 291, no. 377, illus. p. 292; Faxon 1989, pp. 151, 153, pl. 160; Finch 1991, p. 215 (Tate Britain version, pl. 287); Yamaguchi 2000, p. 20.

188. *The Blessed Damozel,* 1871–78

Oil on canvas
83½ x 52⅜ in. (212.1 x 133 cm), including original gilt frame with inscribed verse
1943.202

Even as a young man Rossetti was fascinated by the theme of lovers separated by death. In February 1850 his poem "The Blessed Damozel" appeared in the short-lived Pre-Raphaelite journal *The Germ,* although it underwent continuous adaptation until the final version appeared in 1881. In this the damozel (damsel) leans out over "the gold bar of Heaven" to gaze down with longing upon her still-living lover on earth; parted for ten years she yearns for their heavenly reunion, praying for his release by death. This extraordinary work was partly inspired by two verse narratives, Edgar Allan Poe's "The Raven" (1845) and Philip James Bailey's "Festus" (1839), dealing with the grief of earthly partners; it was a theme Rossetti explored further in his picture and poem "Dante at Verona"

(1870), and it was the central subject of Dante's *Vita nuova,* which Rossetti translated in 1861. This fascination with deathly separation took an eerily personal turn in the year after his translation of Dante appeared, when Rossetti's wife, Elizabeth, died from a laudanum overdose. Rossetti was filled with self-recrimination and guilt, exacerbated in 1869 when he ordered her exhumation to recover his manuscript poems from her coffin. It is against this background of guilt, separation, and belief in after-death existence that his painting *The Blessed Damozel* must be seen.

It was commissioned by William Graham in 1871, and Rossetti took until 1878 to complete and deliver it. Although several poems derived from his paintings or were worked on concurrently, this is his only picture based on an already completed poem, which appears on the artist-designed frame. The picture is full of symbolic references that have deep personal resonance. The damozel looks down mournfully while

holding three lilies, emblems of purity and innocence that suggest both the Trinity and the Annunciation and perhaps are self-referential to Rossetti's *Ecce Acilla Domini* (1849–50). The stars in the damozel's hair "were seven," a reference to the daughters of Atlas and Pleione who were transformed into seven stars. But one of them, Merope, shines invisibly out of shame for loving the mortal Sisyphus, and Rossetti has painted in only six stars to take account of this. It may be that Rossetti, thinking about his separation from his wife and his life as a widower, saw himself as being like Sisyphus, who was condemned to labor endlessly. He continued to venerate Lizzie, even though toward the end of their life together his once pure love for her had grown stale and he had turned toward decadent pleasures of the flesh. These characterized his bohemian life as a widower, but perhaps Rossetti looked back ruefully to his innocent, all-consuming love for Lizzie and the self that he had lost.

One unusual inspiration for the painting was apparently the book *Conjugial Love* (1768) by the Swedish theologian and mystic Emanuel Swedenborg.[1] In this work Swedenborg describes how the conjunction of two souls in heaven is necessary to create a single angel. The two souls must be "conjugial partners," that is single ideal partners; each human has only one conjugial partner, his or her true love, who must be met in the mortal world to create perfect, sanctified love. By the mid-nineteenth century Swedenborg's ideas were well known in London circles, with most of his books published in that city and large numbers of people attending the Church of the New Jerusalem based on his doctrines. Rossetti's friends Robert and Elizabeth Browning, for instance, held Swedenborg in favor and owned a copy of *Conjugial Love*. In the background of *The Blessed Damozel*, for which Winthrop also owned a chalk study (cat. no. 189), Rossetti shows the reunion of earthly lovers: "Around her, lovers, newly met / 'Mid deathless love's acclaims, / Spoke evermore among themselves / Their heart-remembered names." The formal design of this background was partly inspired by Sandro Botticelli's *Mystic Nativity* (see fig. 187), in which pairs of angels clasp each other. Rossetti saw it at an exhibition in Leeds in 1868 and described it as "most glorious";[2] in 1878 it was purchased by the National Gallery, London.

In front of the damozel are three angels, creatures who have made the transition into new beings; below them, in a separate pre-della suggested by William Graham, the lover turns his eyes toward heaven. Rossetti used Alexa Wilding as the model for the damozel, perhaps at the request of Graham, who favored her. Rossetti might have been expected to show Lizzie, but he always found it difficult to compose without a live model. An additional layer of complexity is created, however, by his use of Jane Morris for each of the women in the background. Swedenborg issued dire warnings about spending the earthly life with anyone other than one's conjugial partner, but the 1870s saw Rossetti obsessed by his compulsive love for the unattainable Janey, his friend William Morris's wife. He may well have been questioning just who was his one true love, and what was their spiritual fate.

Rossetti made a second, smaller version of *The Blessed Damozel* (1875–79; Lady Lever Art Gallery, Port Sunlight), which omits the embracing lovers. Grenville Winthrop and his agent Martin Birnbaum had identified the prime version as the most desirable of Rossetti's works for the collection, but Birnbaum believed it was this work that had entered the Lady Lever Art Gallery. When he realized his mistake Birnbaum traced the owner, C. W. Dyson Perrins. "I was frank," Birnbaum wrote to Winthrop, "and told him I was acting for a gentleman whose collection would in all probability be bequeathed . . . to Harvard.—This interested him for he would not sell anything . . . to a dealer."[3] What convinced Perrins to part with it was that "the Rossetti was always a source of irritation to his wife, because they could find no proper place to show it. . . . [W]e found Mrs Perrins would bless me if I would take the picture away, and she urgently advised its sale."[4]

Robert Upstone

1. See London–Munich–Amsterdam 1997–98, nos. 70, 71.
2. Rossetti 1965–67, pp. 664–65.
3. Birnbaum, letter to Winthrop, July 18, 1934, Harvard University Art Museums Archives.
4. Birnbaum 1960, p. 209.

PROVENANCE: Commissioned by William Graham, February 1871, finished 1878; (possibly purchased from him by) J. Dyson Perrins; his son C. W. Dyson Perrins, Malvern; acquired from him through Martin Birnbaum by Grenville L. Winthrop, 1934; his bequest to the Fogg Art Museum, 1943.

EXHIBITIONS: London 1883b, no. 313; Manchester 1887, no. 698; Cambridge, Mass., 1946b, no. 83; Cambridge, Mass., 1973a; Cambridge, Mass.,1977a; Cambridge, Mass., 1980a; Cambridge, Mass., 1982; Tokyo 2002, no. 31.

REFERENCES: Compton n.d.; Sharp 1882, pp. 117, 202, 244, 248–53, chronology no. 274; Carrington 1899, frontis.; Rossetti 1889, chronology, no. 323; Ortensi 1896, pp. 10, 13, illus. facing p. 3; Marillier 1899, pp. 175, 180, chronology, no. 27; Cary 1900, p. 194, chronology, no. 1784; Radford 1908, pl. 47; Ross 1908, p. 123; Mourey 1909, pp. 40, 69; Rossetti 1965–67, p. 1371; Buckley 1968, illus. p. 7; Fleming 1971, illus. facing p. 140; Surtees 1971, no. 244, pl. 355; Henderson 1973, p. 65, poem p. 64; Roberts 1974, p. 382, no. 4, pl. 3; Brandell and Kreuzer 1976, p. 381, illus.; Bryson and Troxell 1976, p. 51, no. 25, illus.; Spalding 1978, pp. 50, 51, pl. 38; Sutton 1978a, p. 448, fig. 7; Wood 1981, illus. p. 103; Kemp 1983, fig. 21; Fletcher 1983, pl. 12; Benedetti 1984, pp. 318–19, no. 464, pl. 23; Mortimer 1985, pl. 187, no. 213; Bloom 1986, frontis.; Schulte 1986, fig. 45; *World of Art Nouveau* 1987, illus. p. 56; Shefer 1987, p. 9, fig. 5; McDannell and Lang 1988, p. 254, fig. 50; Faxon 1989, p. 208, illus. pp. 198, 209; *Spirit Summonings* 1989, illus. p. 97; Bowron 1990, fig. 70; Wheeler 1990, pl. 11; McManners 1990, illus. p. 7; Veith 1991, p. 74, fig. 4.9; *Rossetti* 1992, illus. p. 77; Takahashi and Takahashi 1993, illus. p. 263; Dumont 1994, p. 82, pl. 11; Cuno et al. 1996, pp. 188–89; Rodgers 1996, pp. 45–46; Garnett 2000, pp. 199–203, 208, 211–12, 215, 226–39, 241–42, 245–46, 283, fig. 97.

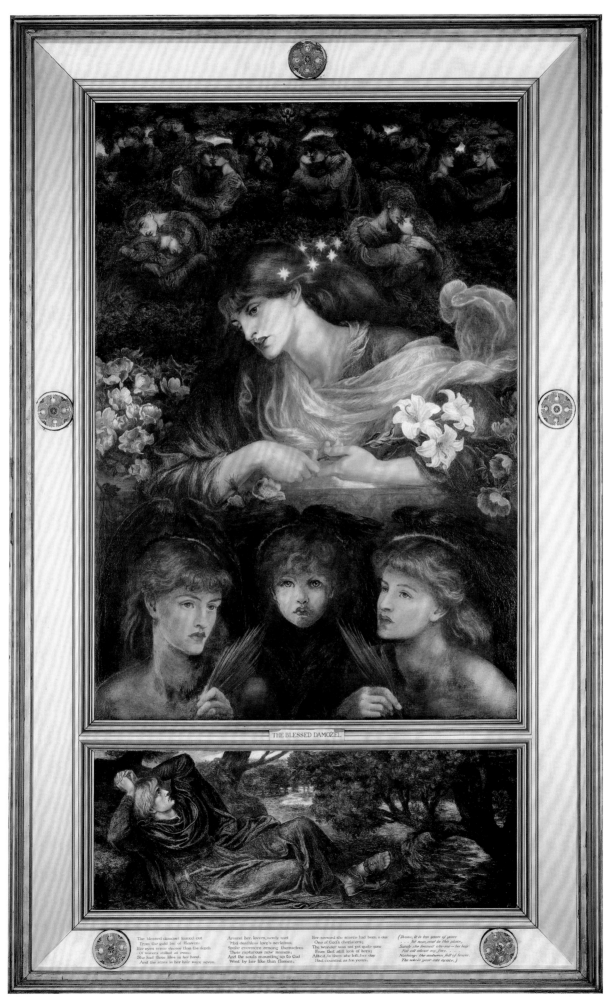

THE BLESSED DAMOZEL

The blessed damozel leaned out
From the gold bar of Heaven;
Her eyes were deeper than the depth
Of waters stilled at even;
She had three lilies in her hand,
And the stars in her hair were seven.

Around her, lovers, newly met
'Mid deathless love's acclaims,
Spoke evermore among themselves
Their rapturous new names;
And the souls mounting up to God
Went by her like thin flames.

Her seemed she scarce had been a day
One of God's choristers;
The wonder was not yet quite gone
From that still look of hers;
Albeit, to them she left, her stay
Had counted as ten years.

(Brave, it is ten years of years
... Yet now, and in this place,
Surely she leaned o'er me—her hair
Fell all about my face...
Nothing: the autumn-fall of leaves.
The whole year sets apace.)

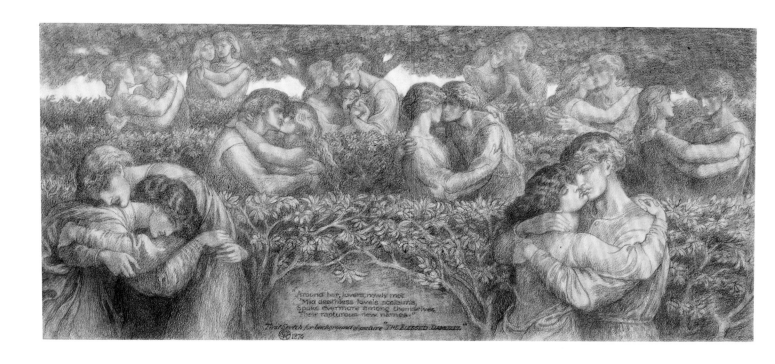

189. *Study for "The Blessed Damozel" (First Sketch for Background)*, 1876

*Black, red, and white chalk on green wove paper,
two sheets joined*
15¾ x 36½ in. (39.9 x 93 cm)
*Signed and dated in black chalk, bottom center:
DGR [monogram] 1876*
*Inscribed in black chalk, lower center: "Around
her, lovers, newly met / 'Mid deathless love's
acclaims, / Spoke evermore among themselves /
Their rapturous new names."¹ / First Sketch for
background of picture "THE BLESSED DAMOZEL."*
1943.750

This fine drawing was made in 1876 for the
background of the painting *The Blessed
Damozel* (cat. no. 188), which occupied
Rossetti between 1875 and 1878. Although
the painting is a late work, the subject is
from Rossetti's early poem "The Blessed
Damozel," written in 1847 and first pub-
lished in the Pre-Raphaelite magazine
The Germ in February 1850. The poem
describes the longing of a woman in
heaven for her lover on earth. Toward the
end of his life Rossetti reminisced to his
secretary Hall Caine: "I saw that Poe [in
'The Raven'] had done the utmost it was
possible to do with the grief of the lover on
earth and I determined to reverse the con-
ditions and give utterance to the yearnings
of the loved one in heaven."² A variation
of lines from verse seven of the poem,
describing the joy of lovers who have met
again after long separation, is inscribed on
the drawing. The theme of lovers meeting
occurs often in Rossetti's work and can be
seen, for example, in *Found* and the many
versions of *The Salutation of Beatrice* (see
cat. no. 181). In this drawing ten pairs of
lovers, rhythmically grouped amid laurel
hedges, express emotions of joy, concern,
rapture, or thankful rest.

From about 1868 the influence of
Florentine and Roman High Renaissance
artists can be seen in Rossetti's work. The
composition of the painting *The Blessed
Damozel* resembles that of an Italian
Renaissance altarpiece and the *mouvementé*
style of this drawing perhaps emulates
the graphic technique of Leonardo or
Michelangelo, while the motif of meeting
lovers may have been suggested by the
angels embracing resurrected mortals in
Botticelli's *Mystic Nativity* (fig. 187), which
Rossetti greatly admired when he saw it
in 1868.³

Although the model Alexa Wilding sat
for the principal figure in the painting, the

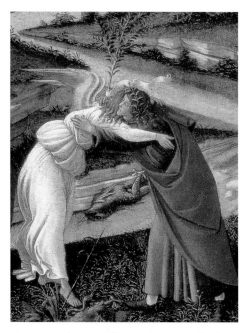

Fig. 187. Sandro Botticelli, *Mystic Nativity* (detail),
1501. Oil on canvas, 42¾ x 29½ in. (108.5 x 75 cm).
National Gallery, London

women in the foreground of the drawing are recognizable as Jane Morris, with whom Rossetti had established an intimate relationship by 1869 and to whom he wrote in July of that year that "no absence can ever make me so far from you again as your presence did for years. For this long inconceivable change, you know now what my thanks must be."[4] Rossetti gave the drawing to her and she hung it in her bedroom in her home, Kelmscott House, Hammersmith.[5]

Alastair Ian Grieve

1. A variant of verse seven of "The Blessed Damozel"; see Rossetti 1911, p. 4
2. Rossetti 1895, vol. 1, p. 107.
3. See Rossetti 1965–67, vol. 2, pp. 664–65, no. 786.
4. Bryson and Troxell 1976, p. 11.
5. Ibid., p. 205.

PROVENANCE: Gift of the artist to Mrs. William Morris; her daughter May Morris; her sale, Hobbs and Chambers, at Kelmscott Manor, July 19, 1939, no. 309; acquired at that sale through Martin Birnbaum by Grenville L. Winthrop, July 1939; his bequest to the Fogg Art Museum, 1943.

EXHIBITION: Cambridge, Mass., 1946b, no. 82.

REFERENCES: Hodgson 1887, pp. 45–46; Marillier 1899a, no. 270 (dated incorrectly); Lang 1968, pl. 5; Sonstroem 1970, pp. 23, 24, 63, 175, 178–79, 196, illus. p. 24; Surtees 1971, p. 143, no. 244G, pl. 360; Henderson 1973, illus. p. 63; Bryson and Troxell 1976, p. 205; Wight 1976, p. 299; Sussman 1979, p. 131, pl. 38; Benedetti 1982, pp. 21, 41, 42, no. 59; Benedetti 1984, p. 320, no. 470, pl. 72; Marsh 1987, p. 57, fig. 45; Faxon 1989, p. 209, pl. 233 (detail illus.); White 1993, p. 25, illus. p. 33; McGann 1997– ; New York–Birmingham–Paris 1998–99, under no. 101.

190. *La Donna della Finestra*, 1879

Oil on canvas
39 x 28⅝ in. (99.1 x 72.7 cm)
Signed and dated lower right: D.G.Rossetti.1879
1943.200

After the death of Beatrice, Dante is so overcome with grief that while walking in the street "it became manifest in mine altered countenance. Whereupon, feeling this and being in dread lest any should see me, I lifted mine eyes to look; and then perceived a young and very beautiful lady, who was gazing upon me from a window with a gaze full of pity, so that the very sum of pity appeared gathered in her."[1] Rossetti believed her to be Gemma Donati, whom Dante later married. In *La Donna della Finestra* he shows the moment Dante describes when their eyes first meet. On the frame, which Rossetti designed, are Dante's sonnet inspired by the incident and Rossetti's own translation of it from the *Vita nuova*. William Michael Rossetti believed it an important picture in his brother's late work and explained: "Humanly she is the lady at the Window; mentally she is the Lady of Pity. This interpretation of soul and body—this sense of an equal

and indefeasible reality of the thing symbolized and of the form which conveys the symbol—this externalism—are constantly to be understood as the keynote of Rossetti's aim and performance in art."[2] The artist was fascinated by the *Vita nuova* and evidently saw parallels in his own life with the Italian poet's love and loss. For the model he used Jane Morris, the subject of so much of his art in the 1870s. Rossetti was passionately in love with her, and while her marriage to William Morris made her ultimately unattainable, her husband appears to have given tacit, albeit disapproving, consent to their liaison. In Janey, Rossetti apparently found relief from his troubles, and by casting her as The Lady of the Window he was undoubtedly suggesting this was comparable to the comfort Dante found. In the picture Jane's fingers hover lightly over a rose, emblematic of love, and behind her more roses form a decorative, allusive background. The format of the picture owes its composition to half-length portraits of the Venetian Renaissance. The golden gown that Jane Morris wears was a studio prop, as it appears in another picture of her of 1868–81, *La Pia de' Tolomei* (Spencer Museum

of Art, University of Kansas, Lawrence), and Rossetti possessed a collection of such rich fabrics.[3]

He planned *La Donna della Finestra* as early as 1870, when he made several preparatory drawings, and in the year before his death he started a replica in oils that remained unfinished (Birmingham Museum and Art Gallery). Evidently he was pleased with the first version, which brought him newfound optimism. He wrote to Theodore Watts-Dunton in May 1879: "Today I have got on the background of the *Lady of Window*, and really the picture is quite transfigured and ought to sell. It looks as if I were not dead yet."[4]

Robert Upstone

1. Dante, *Vita nuova*; Rossetti 1999, p. 121.
2. Rossetti 1889, p. 108.
3. Gail S. Weinberg, in a note in the Harvard University Art Museums curatorial files, shows that Leonée Ormond (1974, p. 28) has written that "For this picture [*La Pia de' Tolomei*], Rossetti copied the costume from a portrait in his own collection, . . . a Botticelli of Smeralda Bandinelli [Victoria and Albert Museum, London, CAI:100]. He himself hunted for 'Indian muslin of a peculiar yellowish tinge' for an overdress like that in his portrait [see Rossetti 1965–67, pp. 658–59]. . . . Jane Morris made up the dress for him." Dr. Weinberg furthermore suggests that not only the costume of *La Donna della Finestra* but also the composition and architec-

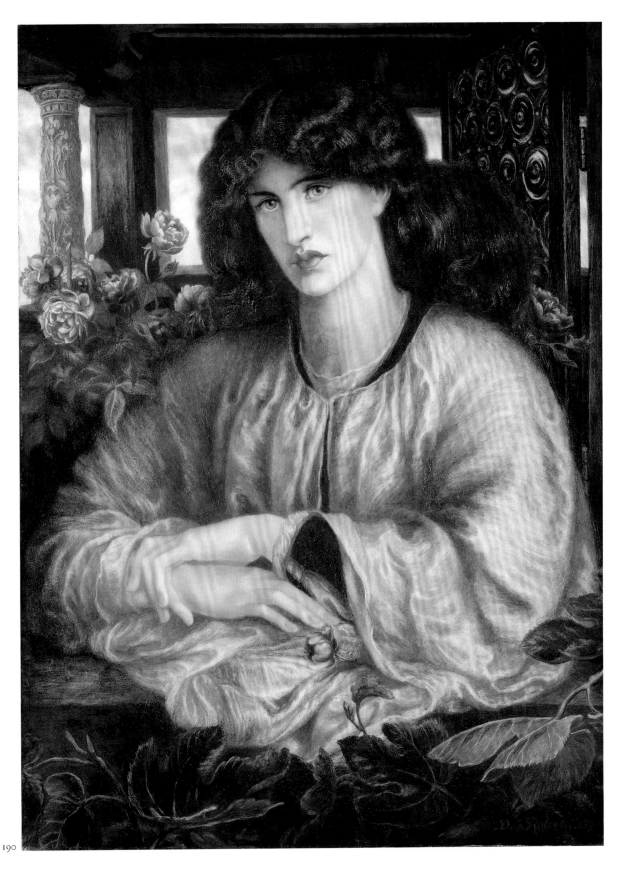

190

tural background of this picture are indebted to Rossetti's Botticelli. She will be examining his ownership of this painting in a forthcoming article.

4. Rossetti 1965–67, p. 1636.

PROVENANCE: Sold by the artist to Frederick S. Ellis, 1879 (£420); sold, Christie's, London, May 16, 1885, no. 91 (£538 10s.); purchased at that sale by C. Flower?; W. R. Moss, Bolton, England; Colonel W. E. Moss, Sonning-on-Thames; his sale, Sotheby's, London, February 24, 1937, no. 39 (£300); Scott and Fowles, New York; acquired from them by Grenville L. Winthrop, November 21, 1938 ($4,000); his bequest to the Fogg Art Museum, 1943.

EXHIBITIONS: London 1883b, no. 321; Southport 1892; London 1897–98 no. 26; Wolverhampton 1902; Manchester 1911; Cambridge, Mass., 1946b, no. 85; Cambridge, Mass., 1973a; Cambridge, Mass., 1980a; Cambridge, Mass., 1982; Tokyo 2002, no. 57.

REFERENCES: Sharp 1882, pp. 256–59, 263; Marillier 1899a, p. 197, no. 289; Rossetti 1889, pp. 107–9; Rossetti 1965–67, pp. 1643–44; Surtees 1971, no. 255, pl. 383; Faxon 1989, p. 197, pl. 10; Seattle and other cities 1995–96, pp. 312–14; Marsh 1999, pp. 503, 505, 510.

Thomas Rowlandson

London, 1756–London, 1827

191. *Comparative Anatomy: Resemblances between the Countenances of Men and Beasts,* ca. 1822–26

Bound album: quarter leather, marble paper covered boards
9⅛ x 7¾ in. (23.3 x 19.6 cm)
Album assembled from individual drawings, some bound directly into the album, others attached to blank album pages
Drawings: variously gray, red, and brown ink, watercolor, and graphite on 57 pages of cream wove paper

8⅞ x 7⅜ in. (22.5 x 18.6 cm)
Pages inscribed in English and in Latin
Watermarks include: SMITH & ALLNUT / 1821; BATH / 1822; J. GREEN & SON / 1825; WD WELLS / 1822; and [Plumed Crown] / J&M / 1824
Department of Printing and Graphic Arts, Houghton Library, Harvard College Library, MS Typ 100.1

Endowed with a deft hand, a biting wit, and a wickedly observant eye, Thomas Rowlandson became one of the most popular artists of his age and one of the great caricaturists and social satirists of all time. He trained at the Royal Academy in London, but instead of the history subjects

191, p. 36

Amongst the numerous Religions! in the World, there is one which teaches us that the souls of human beings pass into the bodies of other Animals — Pythagoreans

191, p. 57

191, p. 27

favored in official circles he chose to make drawing after drawing of the world around him. Most of these lampooned society of all ranks and politicians of all persuasions with humor that ranged from gentle to bawdy to raucous, from mildly comic to knee-slappingly funny.

Around 1821–22, near the end of his career, Rowlandson began work on a book of comparative anatomy, which he never completed. Two drawing albums bear witness to his explorations of the physical and psychological resemblances between humans and animals: this one in the Winthrop collection and another in the British Museum, London (pressmark 201.a.13).[1] In spite of the apparent weightiness of the subject, however, Rowlandson's purpose was entirely humorous, as the deliciously evocative pairs of studies in the Winthrop album clearly demonstrate.

The inspiration for these highly amusing studies undoubtedly came from the famous lectures on physiognomy delivered by Charles Le Brun (1619–1690) at the French Academy in Paris in the fall of 1668.[2] To illustrate his ideas, Le Brun made numerous drawings comparing human and animal heads, many of which were engraved.[3] Rowlandson was surely familiar with Le Brun's theories and images, which were well published,[4] but his explorations of the subject could not have been more different. While Le Brun's comparisons, no matter how ludicrous, were drawn with perfect sincerity and seriousness, Rowlandson delighted in the comical aspects of his pairings. Ironically, though, while the features of Le Brun's men were exaggerated in such a manner as to make many of them overly bestial in appearance, Rowlandson maintained the essential human character of his people, however much he distorted their features. Here still, as was so often the case throughout his career, the *human* comedy remained the central focus of his art.

Margaret Morgan Grasselli

1. A drawing in the collection of Courtauld Institute of Art, Witt Collection, may also be related to this project. See Hayes 1972, p. 58, fig. 59.
2. Theories of comparative physiognomy of this type originated with Giovanni Battista della Porta, who first published and illustrated his ideas in *De humana physiognomonia* in 1586.
3. All the physiognomic studies by Le Brun are in the collection of the Département des Arts Graphiques, Musée du Louvre, Paris. See Guiffrey and Marcel 1913, nos. 6623–6762. See also Montagu 1994, figs. 18, 21, 22, 23, 35, 36, 38, 44, 134.
4. Montagu 1994, app. 4, pp. 175–87, lists many of the publications in which Le Brun's physiognomic studies were reproduced.

PROVENANCE: E. Gilbertson; sold, Christie's, London, July 25, 1938, no. 43 (£73 10s.); acquired at that sale through Martin Birnbaum by Grenville L. Winthrop; his bequest to the Fogg Art Museum, 1943; transferred to the Houghton Library of Harvard University.

REFERENCES: Hayes 1972, p. 62, n. 53; Wark 1975, p. 116, under no. 464.

Alfred George Stevens

Blanford Forum, England, 1817–London, 1875

192. *Valour and Cowardice*, ca. 1863, cast before 1929

Bronze with brown patina
25 ⅜ x 13 ½ x 13 ¾ in. (64.4 x 34.4 x 35 cm)
Inscribed on proper left side of plinth:
ALFRED STEVENS. NO. 5
1943.1122

193. *Truth and Falsehood*, ca. 1863, cast before 1929

Bronze with brown patina
22 ¾ x 11 ⅜ x 16 in. (58 x 28.8 x 40.6 cm)
Inscribed on proper right side of plinth: ALFRED
STEVENS. NO. 5
1943.1123

These bronzes derive from Alfred Stevens's clay sketches for the allegorical groups on the Wellington Monument in Saint Paul's Cathedral, London. Stevens submitted a design to the international competition for the commission of a memorial in honor of the duke of Wellington (d. 1852) that the British government advertised in 1856. Although Stevens was a relatively unknown artist, his concept was ultimately selected because it seemed best suited to the location, one of the lateral arches in Saint Paul's. He labored for seventeen years over the project in increasing conflict with the Office of Public Works and died destitute before he could see the monument fully erected. In 1892 Frederic Leighton persuaded the authorities to place the monument in the originally intended location, and later the sculptor John Tweed, Stevens's student, cast the equestrian figure, finally completing the memorial in 1912 (fig. 189).[1]

Stevens designed the monument in the form of a triumphal arch, using sculpture as an integral part of an architectural ensemble, a paramount concept in the Italian Renaissance art he had studied in Italy during 1833–42.[2] The figure of Wellington appeared both on an ornamental sarcophagus and as the crowning equestrian statue. Two allegorical groups representing attributes of Wellington's character were placed on either side of the arch above the frieze.

In one group Valour is portrayed as a seated female warrior who subjugates the male figure of Cowardice crouching under his large oval shield at her feet. Draped with a lion skin and crowned by the lion's head, this Virtue holds Hercules' club in her right hand and secures her own upright shield with her left arm. In the other group Truth is also represented as a draped seated female figure, who tears out the forked tongue of the recoiling male figure of Falsehood. His mask pulled back from his face, he struggles to hold on to his tongue as his split serpentlike tail writhes below his conqueror. The depiction of Virtues as female figures triumphant over male adversaries has its root in medieval iconography, and Stevens's Valour opposing Cowardice picks up a theme he knew well from Salisbury Cathedral.[3] Falsehood may have been based on Cesare Ripa's *Iconologia*.[4] Stevens's studies of Renaissance masters in Italy are reflected in several ways; for example, Michelangelo's influence comes through in the raw, sketchy quality of Stevens's allegories, and Raphael's frescoes in the Vatican seem to have provided Stevens with particular formal solutions to his composition.[5]

Although the model for both Virtues is still recognizable in these small bronzes as

Fig. 188. Alfred Stevens, *Truth and Falsehood* and *Valour and Cowardice* installed in the Gill-Beardsley-Bonington Room in Grenville Winthrop's New York house, 1943

Florence Morris Moore, daughter of Stevens's friend John Morris Moore, in the finished work she evolved into an idealized woman.[6] Conversely the face of Falsehood is merely sketched out in the working model, but in the full-scale work Stevens took revenge on Acton Smee Ayrton, first commissioner of the Office of Public Works, by giving the face of Falsehood his features.[7]

Comparison of the competition model with these bronze statuettes and the full-scale plaster models shows that Stevens had already worked out the themes and composition of the groups at the earliest stages.[8] He altered many details in the full-size models, however, to further enhance the dynamic tension between the figures and the subtle meaning of the groups.[9]

The bronze statuettes, all posthumous, were produced by the lost-wax process from molds taken of lifetime plaster casts of Stevens's clay sketches.[10] They preserve the working models' spontaneity as well as the traces of seam lines from the piece mold that was used to produce the plaster replicas. No doubt Stevens would have appreci-

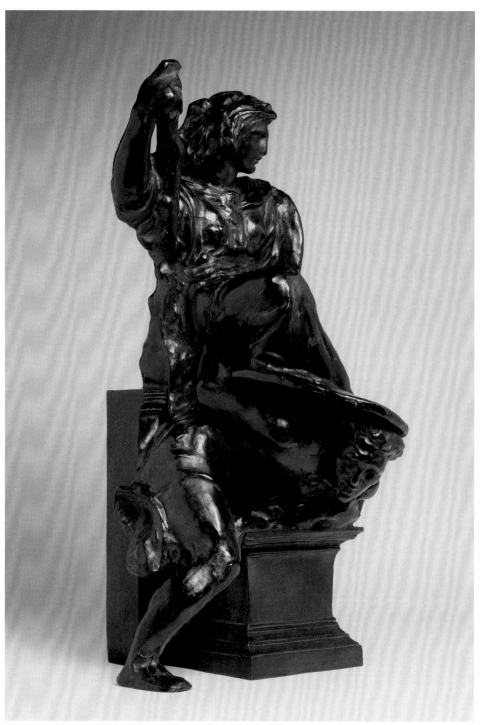

192

Fig. 189. Dugald S. MacColl, photograph of the Wellington Monument by Alfred Stevens in Saint Paul's Cathedral, London, March 31, 1908. Photograph no. 69, in D. S. MacColl, Correspondence and Papers Concerning Alfred Stevens, 1837–1934. V&A Picture Library, London

ated the sketchy quality of these bronzes, as he professed a dislike for chased finish in metalwork.[11] Of the fifteen known pairs of bronze casts, three are signed and numbered; the highest number identified is on the Winthrop casts, inscribed "No. 5."[12] The earliest documented pair was cast in 1896 by the J. W. Singer and Sons foundry of Frome, Somerset, the most prominent among the fine-art foundries that had

emerged in the latter half of the nineteenth century; several other pairs were also cast at Singer.[13] Other sets are likely to have been cast at different foundries.[14] In addition to the fact that no casts are marked except the signed and numbered ones, the casts show noticeable variations in execution—the back of the cast is open in some and closed in others, and the patina varies from cast to cast.

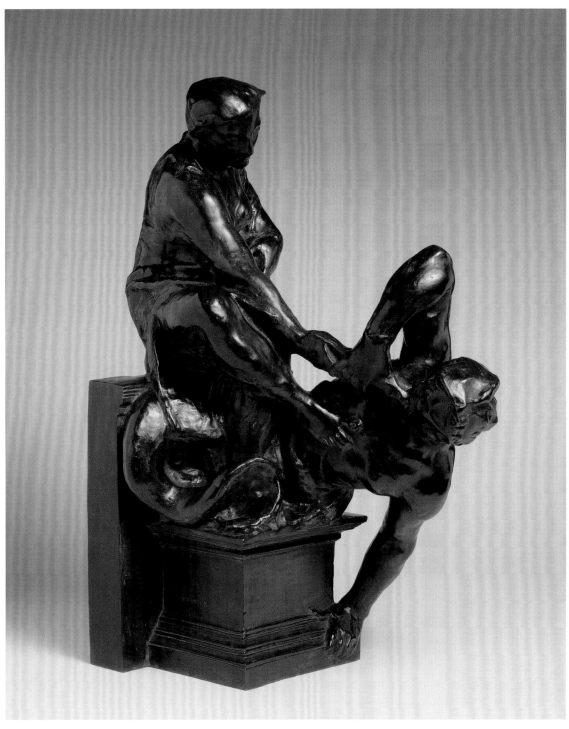

193

Edmund Davis, the financier and art patron, who was advised in his collecting by Charles Ricketts, owned at least one set of the plaster casts and several pairs of bronzes.[15] Since the first of the signed and numbered bronzes was the one Davis gave to his sister-in-law and aspects of the casting process are the same as the Winthrop bronzes, it seems likely that they are from the same edition.[16] Winthrop's agent Martin Birnbaum acquired catalogue numbers 192 and 193 from Ricketts in 1929.[17] During the period of negotiation with Ricketts, Birnbaum received a letter from the Russell Gallery, London, offering a pair, which may or may not have been Ricketts's set.[18] However, that the Russell Gallery letter referred to "not more than . . . 5 sets [having] been sold" does provide coincidence with the number on the Winthrop bronzes.

The allegorical groups joined works by Stevens in other mediums in Winthrop's collection.[19] Birnbaum suggested that Winthrop give them a prime place among his important pre-Raphaelite works.[20] The bronzes were eventually installed in the Gill-Beardsley-Bonington Room in Grenville Winthrop's New York City house with work by the other renowned British artists (fig. 188).

Stevens's allegorical figures herald the New Sculpture movement, which revitalized sculpture in late-nineteenth-century Britain.[21] The Victoria and Albert Museum and the Tate Galleries collected his work from the end of the century, and casts started entering public collections in the second decade of the twentieth century as gifts from some of the more insightful collectors of the period. Although by the late 1920s Stevens was well represented in British collections, Winthrop's were unique examples of the sculptor's work in the United States.

Francesca G. Bewer

1. The fullest account of the saga of the commission can be found in Physick 1970.
2. Stevens sought, through his entire career as a designer, to break down the perceived barriers between "high" and "decorative" art; see Beattie 1983, p. 3. This leveling of all creative activities into "one art" without hierarchy echoes Michelangelo's "V'é un'Arte sola"; see Towndrow 1939, p. xxvii.
3. See D. S. MacColl's preface to Towndrow 1939, p. xx.
4. See Yarker 2000, p. 66, n. 19.
5. The source for the right leg of Cowardice, which strains, flat-footed, to the side of the plinth, may be found in those of the foreground figures in Raphael's *Solomon Building the Temple in Jerusalem*. Stevens must have known this fresco well from copying sections of Raphael's wall paintings in the Vatican; see Towndrow 1939, p. 264.
6. Stevens's assistant James Gamble identified her; see Yarker 2000, p. 58.
7. The politician Acton Smee Ayrton (1816–1886) replaced the more kindly disposed Lord John Manners as first commissioner of works in 1869 and held the post until 1873; see Physick 1970, pp. 74, 95.
8. The competition model (Victoria and Albert Museum, London, 44.1878) and the original clay sketch for *Valour and Cowardice* (Victoria and Albert Museum, A.7-1912) show the same overall composition. The full-scale plasters are also preserved in the Victoria and Albert Museum (321a-1878, 321b-1878).
9. For example, in the full-size model the club of Valour was brought up onto the shield and her legs rearranged. Falsehood, who at first held the hand of Truth that was pulling his tongue, now grabs the tongue itself; his other hand rests on an orb, introduced in part to make up for the elongation of the pediments. The entire monument was originally designed to be made of bronze, but it was later decided to fashion the architectural elements in marble, which brought about some design changes. In the original design the two groups were placed directly on the frieze, while in the final design they sit on thrones above pediments. See Towndrow 1939, p. 141.

10. Four sets of plaster casts were listed in the catalogue of contents of Stevens's studio that were sold after his death, July 19–20, 1877, at 9 Eaton Villas, Haverstock Hill; see Towndrow 1939, p. 261. One was purchased at that sale by John R. Clayton. Clayton lent his plasters to the Singer foundry for a small number of reproductions in bronze; see Clayton, letter to Major General Sir J.F.D. Donnelly, February 21, 1894, Victoria and Albert Museum Archive. According to this letter, Clayton allowed the foundry to cast several other plasters as well, one for "my friend James Knowles of the 'XIX Century' and one for [Singer] himself." To date I have been able to locate only two and a half sets of plasters: a pair given by Edmund Davis in 1914 to the Manchester City Art Gallery (1914.60, 1914.61); a *Truth and Falsehood* at the Tate (2270), which, according to photographic records in the Conway Library, Courtauld Institute, London, was originally paired with a cast of the other group (2269) that is no longer accessioned; and a pair in the Dorset County Museum, Dorchester, which are owned by the Dorset Natural History and Archaeological Society (ART 564, 565). The Dorset plasters were sold by Morris Singer to Patrick Synge-Hutchinson in 1937. Synge-Hutchinson's papers record them as lot 46 from the first day of sale at Stevens's studio. Many thanks to Gwen Yarker for this information.
11. Towndrow 1939, p. 73.
12. The pair inscribed no. 1 is in the Fitzwilliam Museum, Cambridge (M/1A/1953, M/1B/1953), the gift of Constance Rea, who received them from Edmund Davis, her brother-in-law; "I know [he] bought the casts, & had them cast in bronze & gave them to me" (Rea, letter to Carl Winter, September 27, 1946, Fitzwilliam Museum curatorial files). I have not been able to locate pairs numbered 2 and 3. Pair no. 4 was sold at Sotheby's, London, June 20, 1989, no. 34; its current location is unknown.
13. The 1896 casts are at the Victoria and Albert Museum (264-1896, 265-1896); see London 1972b, pp. 58–59. The following pairs are also documented as having been cast by the J. W. Singer and Sons foundry: South African National Gallery, Cape Town (611, 612), given in 1935 by Edmund Davis (Proud 1999, p. 144); Birmingham Museum and Art Gallery (P.15.73, P.16.73), ex coll. Mr. and Mrs. Charles Handley-Read (Birmingham 1987, nos. 264, 265); and National Gallery of Victoria, Melbourne (1896-D3, 1895-D3), commissioned in 1919 by Frank Rinder for the Felton bequest (National Gallery of Victoria curatorial files; with thanks to Professor John Poynter for providing this information). A pair was sold with the property of J. W. Singer and Sons Ltd. at Sotheby's, London, May 20, 1994, no. 121; its whereabouts are unknown.
14. Pairs of bronzes not known to be signed and numbered, or to have been cast by the Singer Foundry, or to have been owned by Davis (see notes 12, 13, 15) are in the National Gallery of Ireland, Dublin, bequest of Sir Hugh Lane, 1915 (8075, 8076); Ashmolean Museum, Oxford (571, 572), ex coll. Frank Rinder; National Gallery of Scotland, Edinburgh (2057, 2058); Huntington Art Gallery, Pasadena, Calif. (77.12a, 77.12b). Nicolas Penny

(1992, p. 161) mentions a pair in the City Museum and Art Gallery, Leicester.
15. In addition to the set of plaster casts he gave to the Manchester City Art Gallery (see note 10), the pair of bronze casts he gave to his sister-in-law (now at the Fitzwilliam Museum; see note 12), and the pair of bronzes he gave to the South African National Gallery (see note 13), one pair of bronze casts appears to have been sold by Davis through the Leicester Galleries to the Whitworth Art Gallery, Manchester (S.1914.1, S.1914.2); another set may have been similarly sold by him to the Walker Art Gallery, Liverpool (1943/14, 1943/15), in 1943, though Lady Cunard's collection was also suggested as a provenance for this pair, according to Walker Art Gallery curatorial files.
16. The bronzes at the Fitzwilliam Museum and the Fogg are hollow. Flanges for mounting are cast in an identical fashion inside the base of each. The rear of all the plinths is sealed with a crudely modeled, integrally cast backing. Stevens did not develop this area, which would have been concealed by the architectural elements of the monument. The treatment of the back of these two bronze casts of *Truth and Falsehood* is very similar to that of the plaster model in the Tate. The inscription and number were added at the wax stage, i.e., before the bronzes were cast.
17. The difficulty of this task, given Ricketts's reluctance to part with them, is documented in letters Birnbaum wrote to Winthrop: Paris, February 17, 1929; Taormina, March 28, 1929; Paris, May 18, and July 19, 1929, Harvard University Art Museums Archives.
18. The manager of the Russell Gallery told Birnbaum that its pair was cast from the original plaster models and not more than five such sets had been sold; letter to Birnbaum, May 28, 1929, Martin Birnbaum Papers, Archives of American Art, Smithsonian Institution, Washington, D.C. Birnbaum penciled "Ricketts" in the margin of this letter.
19. This included several drawings, a watercolor, an original plaster model for a door knocker (1943.1299), and an oil portrait of Leonard Collman (1943.928), all acquired between 1928 and 1929. To these he added a bronze statuette of *David* (1943.1124) in January 1932.
20. Birnbaum, letter to Winthrop, London, July 28, 1934, Harvard University Art Museums Archives.
21. As Susan Beattie has pointed out (1983, p. 3), the posthumous exhibition of Stevens's full-size plaster model of *Truth and Falsehood* at the Royal Academy in 1876 influenced Frederic Leighton's *Athlete Wrestling with a Python* (1877), which was long credited as the starting point of the New Sculpture movement.

PROVENANCE: Charles Ricketts and Charles Hazelwood Shannon, until 1929; acquired from Ricketts through Martin Birnbaum by Grenville L. Winthrop, 1929 (£150); his bequest to the Fogg Art Museum, 1943.

EXHIBITIONS: The pair was informally exhibited in the courtyard of the Fogg Art Museum at the opening of "Pre-Raphaelite and Early French Symbolist Art in the Fogg Collection," January 14, 1973, and remained on display for approximately two weeks.

George Frederic Watts

London, 1817–London, 1904

194. *Sir Galahad*, 1860–62

Oil on canvas
78⅛ x 42¼ in. (198.5 x 107.3 cm)
1943.209

Sir Galahad, exhibited at the Royal Academy of Arts in London in 1862, is one of George Frederic Watts's most important and fully realized works of the 1860s. It marked his return to the Royal Academy with a major subject picture after a gap of twelve years, showing the value he placed on it. *Sir Galahad* has indeed become one of Watts's best-known works through engravings and reproductions since the late nineteenth century.

The subject shows the character originally derived from Sir Thomas Malory's *Morte d'Arthur*, the late-fifteenth-century cycle of Arthurian legends. Galahad was one of the Knights of the Round Table, distinguished by his pure spirit as he sought the Holy Grail, a symbol of perfection in the legends. In the early 1840s Alfred Tennyson published the "Morte d'Arthur," later to form one of the *Idylls of the King*, composed by the Poet Laureate from the mid-1850s onward. Watts's great friendship with Tennyson has led to an inevitable association between the poem and *Sir Galahad*, but the painting is not an illustration though it partakes of the same spirit.

Arthurian legends attracted artists from the 1850s onward, most notably the Pre-Raphaelite Dante Gabriel Rossetti and his disciples Edward Burne-Jones and William Morris, fresh from Oxford.[1] The painting is often cited as an indication that Watts had come under the influence

Fig. 190. Installation view of George Frederic Watts, *Sir Galahad*, ca. 1860 and 1897. Watercolor and oil on canvas, 78 x 42 in. (198.1 x 106.7 cm). Reproduced by permission of the Provost and Fellows of Eton College, Windsor

Fig. 191. Watts's *Sir Galahad* hanging in the Pre-Raphaelite Room in Winthrop's house at 15 East 81st Street, New York

of the Pre-Raphaelites. Indeed he came to know these young men well during the 1850s and was undoubtedly familiar with the recent abundance of visual references to Sir Galahad as a leading personality in the Arthurian legends,[2] yet his own interpretation could not be more different from the Pre-Raphaelites' intense, highly worked, essentially miniaturist versions of the subject. Watts's *Galahad* is by contrast a large oil treating the subject as a character on the scale of a grand-manner portrait.[3]

For Watts the enduring appeal of figures in armor had a personal meaning

as well. He had already painted a self-portrait in armor (private collection) in the mid-1840s while falling under the spell of Italian Renaissance art during several years in Florence. Later Watts painted a self-portrait as a middle-aged knight gazing downward in reflection in *The Eve of Peace* (1863–76; Dunedin Public Art Gallery, New Zealand).[4] Watts's identification with the knight as a man of action also capable of pensive contemplation links these two later paintings, with *Sir Galahad* presenting what might almost be considered the artist's view of himself as a thoughtful youth and *The Eve of*

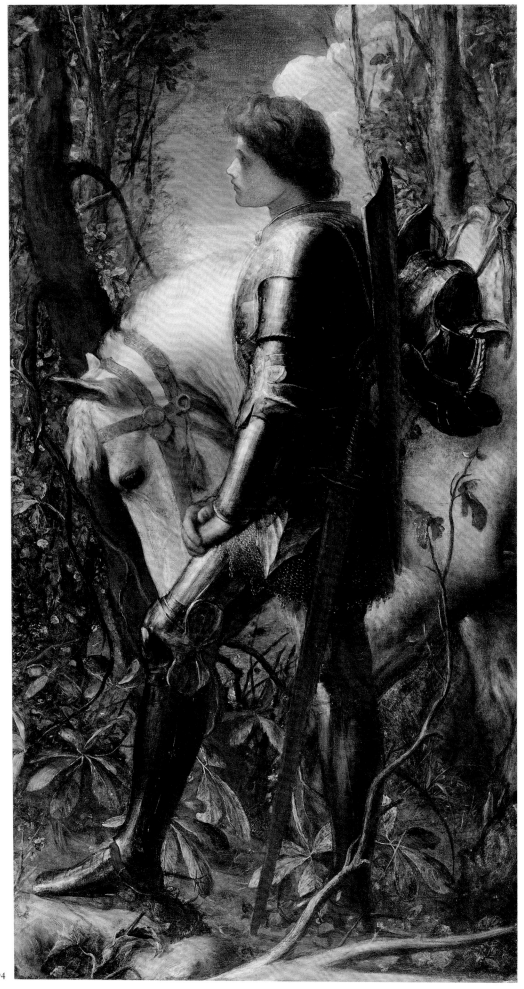

194

Peace showing him as an older, wiser man reflecting on lost dreams.

A small version of *Sir Galahad* (formerly the Forbes Collection) that the artist apparently completed before 1862[5] is often confused with the Royal Academy painting.[6] Painted on panel, it differs slightly in the details of the armor and the disposition of the tree branches and almost certainly preceded the larger picture. Given the impressive scale of Winthrop's *Sir Galahad,* Watts no doubt worked on it for a year or so before sending it to be exhibited in 1862.

Watts's poetical interpretation, suggestive rather than narrative in appeal, forecasts changes in art in the 1860s. Art criticism enjoyed a new role, with writers casting off the mantle of anonymity. William Michael Rossetti, brother of Dante Gabriel, took the Pre-Raphaelite stance, writing that *Sir Galahad* belonged to the "poetical class" and that "there is fine style in 'Sir Galahad' . . . yet Mr. Watts's tendency to idealism interferes, to our judgement, with his success in subjects of this kind, where an ideal of character has to be presented in the person of an individual man. We would ask for more of the individual and less of the impersonal ideal."[7] Frederic G. Stephens, a former Pre-Raphaelite known to be the *Athenaeum*'s art reviewer, likened the painting of the armor to the "true warm fashion of the early Venetian school" but also commented that the treatment was thin and overly glazed.[8] The richness of the color is a hallmark of the painting, with the auburn-haired Galahad standing within a dark, thick wood. The white horse, harnessed in red, is set against this background. Through glazing Watts deepened the aquamarine blue and verdant green, characteristic colors in his work at this time. Tiny blue flowers scattered in the foreground may be a nod to

the Pre-Raphaelites, who were more preoccupied with the treatment of nature than Watts.

It was left to Watts's friend Tom Taylor in the *Times* to praise in unqualified manner the pure knight: "but for stateliness, solemnity, and imaginative suggestion the picture stands apart from everything in the exhibition." According to Taylor, in stylistic terms Watts ventured into new territory with handling of color that "recalls the Venetian masters—above all, Giorgione."[9] The alliance of the poetical subject with a style evoking the old masters showed Watts to be an absolute technician at the height of his powers.

The painting remained with the artist until 1872 or 1873, when Mary and Thomas Eustace Smith purchased it.[10] The couple lent it to the International Exhibition in London in 1873; then it joined their noted collection of contemporary English painting.[11] It later appeared at retrospectives of the artist's work in 1881 and 1896–97.[12] When the painting was on view in these exhibitions, H. E. Luxmoore, a master at Eton College, wrote to Watts that the message of *Sir Galahad* might influence the students at Eton, and he inquired about obtaining a version of the painting. At the time of the latter showing, Watts rallied to the cause. Using the large canvas on which he had prepared the original design in watercolor, he quickly worked up the painting, presenting it himself to Eton College in June 1897 (it remains in the Ante-Chapel to this day; fig. 190).[13]

Sir Galahad belonged to Alexander Henderson (Lord Faringdon from 1913) from 1887 until his death. When the sale of the Faringdon collection took place in 1934, Martin Birnbaum leaped at the opportunity to acquire in particular "the celebrated Watts *Sir Galahad*" for Grenville Winthrop. Birnbaum had

already purchased two works directly from Mrs. Watts (cat. no. 195 and a version of *The Genius of Greek Poetry* [Fogg Art Museum, 1943.207]). In fact, at the Faringdon sale, Birnbaum lost *Sir Galahad* to an anonymous buyer, but he managed to secure the work immediately afterward when it emerged that the wealthy purchaser could not fit the painting into its designated location. *Sir Galahad* became a highlight of Winthrop's collection (fig. 191).

Barbara Bryant

1. On the background to the treatment of such subjects including the Pre-Raphaelites, see Mancoff 1990.
2. In 1857 Rossetti headed the project—only partially completed—for decorating the walls of the Debating Room (now the Library) in the new Oxford Union building at the university, and he chose as his subject "Sir Galahad receiving the Sanc Grael" (known by drawings). Rossetti also produced the design for a wood engraving of *Sir Galahad at the Ruined Chapel,* an illustration for Tennyson's poem published in the Moxon edition of 1857. In another example, Burne-Jones made a tiny pen-and-ink drawing of *Sir Galahad* in 1885 (cat. no. 154).
3. Watts used a portrait head study (Watts Gallery) of Arthur Prinsep (1840–1915) for Galahad. The fifteen-year-old son of Watts's friends Sara and Thoby Prinsep had accompanied the artist to Paris in the winter of 1855–56, and Watts made two studies of him. The profile in soft chalks is certainly directly related to *Sir Galahad,* but it is not obvious that the artist intended it as a study for a painting of the Arthurian knight when he drew it; he may simply have selected it, when he decided to paint *Sir Galahad* some five or six years later, as representative of the type of youthful manhood extolled in this painting and others (see Blunt 1975, pl. 12a).
4. See West and Pantini 1904, pl. 27.
5. According to Mrs. Watts and discussed by Allen Staley in the entry on this painting in Manchester–Minneapolis–Brooklyn 1978–79, no. 12. This work, along with the painting of another Arthurian knight, Sir Perceval, appeared in Manchester 1984, nos. 116, 117.
6. Frederic G. Stephens's review in the *Athenaeum* (1862, p. 602) refers to Watts's *Sir Galahad* as "life-size"; therefore, the Winthrop painting is the work exhibited at the Royal Academy in 1862. Confusion has arisen since Mrs. Watts misidentified the smaller painting as the Royal Academy work ("Watts Catalogue," ca. 1910, vol. 1, p. 61); it is also discussed as such in Manchester–Minneapolis–Brooklyn 1978–79, no. 12, and in the catalogue of the Forbes Collection sale, Christie's, London, February 19, 2003, no. 34.
7. Rossetti 1862, p. 71.
8. Stephens 1862, p. 602.
9. Taylor 1862, p. 14.

10. Mrs. Smith recalled that the price was "such a small sum for such a wonderful picture"; quoted in the "Watts Catalogue," ca. 1910, vol. 1, p. 61—where, however, the exhibition histories of the various versions are much confused.

11. Wilcox 1993, pp. 43–57. See also Newcastle upon Tyne 1979–80, pp. 27–28, 129–30; and Sachko Macleod 1996, pp. 474–75.

12. For a discussion of Watts's reputation from the late 1870s onward, see Bryant 1996.

13. Watts painted yet another smaller version of the subject in 1903; and there are several other versions and variants on small scale.

PROVENANCE: Eustace Smith, M.P., by 1873; purchased from him by Alexander Henderson (created Baron Faringdon, 1913), 1887; his sale, Sotheby's, London, June 13, 1934, no. 133 (£820); purchased at that sale by the Fine Art Society; acquired from it through Frost and Reed by Grenville L. Winthrop through Martin Birnbaum, July 1934 (£770); Winthrop's bequest to the Fogg Art Museum, 1943.

EXHIBITIONS: London 1862, no. 141; London 1873, no. 1061; London 1881–82, no. 49; London 1887, no. 22; London 1896–97, no. 97; London 1905b, no. 182; London 1906–7, no. 97; Cambridge, Mass.,

1943–44, p. 6; Cambridge, Mass., 1946b, no. 95; Cambridge, Mass., 1973; Cambridge, Mass., 1980a; Tokyo 2002, no. 12.

REFERENCES: Rossetti 1862, p. 71; Stephens 1862, p. 602; Taylor 1862, p. 14; Spielmann 1886, p. 30; Temple 1897, p. 170; "Watts Catalogue," ca. 1910, vol. 1, pp. 61–62; Watts 1912, vol. 1, pp. 158, 161, 188, 228, 328; vol. 2, pp. 262–64; Luxmoore 1929, p. 55; Loshak 1968, p. 484; Allen Staley in Manchester–Minneapolis–Brooklyn 1978–79, no. 12; Girouard 1981, p. 150 and passim; Bowron 1990, fig. 82.

195. *Orpheus and Eurydice*, 1870–80

Oil on canvas
28 x 36 in. (71.1 x 91.4 cm)
1943.205

Watts painted many versions of this subject, testifying to his continual fascination with its inherent themes of love and death. Ovid (among others) retold the Greek myth of Orpheus, the poet and musician enamored of the nymph Eurydice. After her death he braved the underworld and played his lyre to Pluto and Proserpine, who restored Eurydice to him on the condition that he not gaze at her until they reached the farthest point of Hades. When finally in sight of the upper world, however, Orpheus forgot his vow and turned—only to see Eurydice vanish forever. This tale of tragic loss struck a chord with Watts, who when he found such a subject returned to it repeatedly, almost obsessively.

The idea of both half-length and full-length versions of the subject evolved in parallel. The first exhibited version (fig. 192),[1] a small scale oil of great delicacy showing the figures in half-length, appeared at the Royal Academy of Arts, London, in 1869 and was immediately purchased. Watts next painted a small full-length version (fig. 193), which he called a

design, exhibiting it at the Dudley Gallery, London, in 1872. The artist often painted several versions concurrently, testing variations in composition, pose, color, tonal range, and details.[2] As Watts moved from the smaller, closer view to the full-length one, he had to rework the relationship between the two figures. In the painting completed in 1869, Orpheus reaches out as Eurydice falls backward, but his gesture, a mere touching of her breast, fails to arrest her movement. In mood this version is both lyrical and sad. The small full-length version of 1872 required a more energetic relationship; Orpheus lunges with an emphatic twisting motion, grasping Eurydice around her waist. The emotions are cast at a higher pitch, with background details lending dramatic force to this small but potent image.

It seems that Watts executed Winthrop's *Orpheus and Eurydice* as he worked through a range of variations on the two-figure composition, culminating in the grand full-length version (Salar Jung Museum, Hyderabad, India) exhibited at the Grosvenor Gallery, London, in 1878.[3] Winthrop's painting, a work left unfinished, is an intermediary step; Watts was rethinking both the composition and the mood. The scale of the figures increases in a

close-up view, as Orpheus reaches over Eurydice's shoulder. With more focus on the two lovers, the painting has a greater intensity of feeling. Eurydice's deathlike swoon testifies to the tragedy; she is clearly destined for Hades with no further salvation. Orpheus's mouth opens in shock. His hand, incomplete in detail, merges into the long blond waves of her hair, linking them. Meanwhile, the painterly qualities of broad handling and softly focused light contrast with the tighter definition of the first version. In the 1870s Watts experimented more with glazes to achieve surface effects. The massive sculptural quality of the work is also removed from the graceful movement of the earlier painting. Watts's famed exemplars the Elgin Marbles fed into his work in a variety of ways, not least here as the colossal forms fill the picture space and squeeze out any distracting ancillary details.

According to Mary Watts, who compiled the manuscript catalogue of her husband's works, this painting remained unfinished because Watts thought the scale of the figures too large,[4] but this view is unnecessarily limiting. An essential part of the artist's working process by the 1860s was a constant rethinking of compositions, with

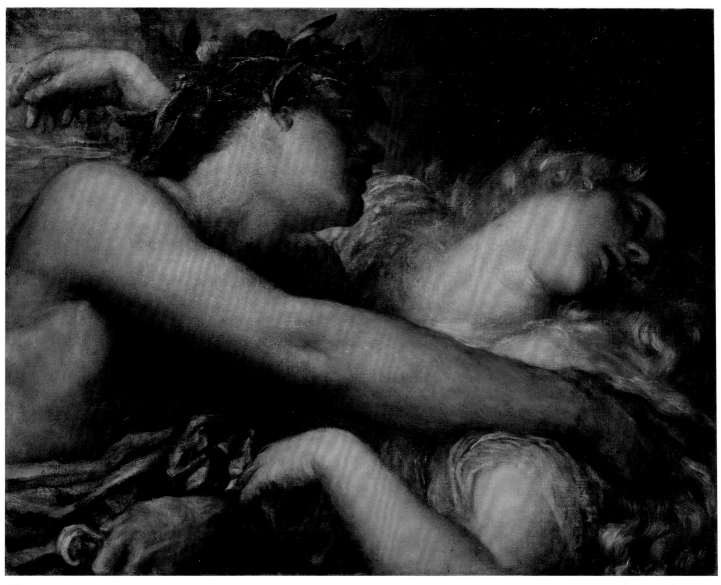

195

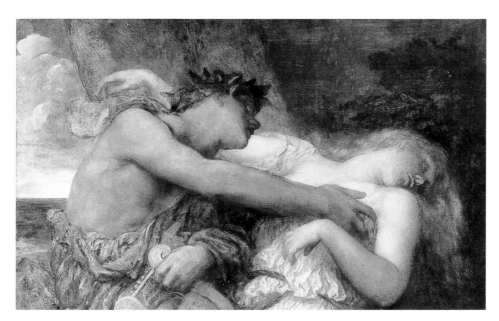

Fig. 192. George Frederic Watts, *Orpheus and Eurydice*, ca. 1868–69. Oil on canvas, 12¾ x 21 in. (32.4 x 53.3 cm). Formerly © the Forbes Collection, New York

each stage valuable for its own sake. Watts simply moved on to an entirely different, more Symbolist treatment of the subject, encompassing a nude and more vulnerable Eurydice as well as a landscape setting of sheer rock edges; however, the painting in the Winthrop collection formed a key stage in the evolution of Watts's depiction of this story of lost love and unavoidable death.

The artist apparently gave this work to Mary, his second wife, as a wedding gift,[5] and it hung in their home rather than the nearby Watts Gallery, in the village of Compton in Surrey. Grenville Winthrop already had an established interest in Watts's work, having acquired an oil painting, *Escaped*, showing cupids at play,[6] as well as several portraits, but it seems that Martin Birnbaum, by then a freelance dealer, stimulated or reinforced a decision to acquire major subject pictures.

The artists Charles Ricketts and Charles Shannon,[7] Birnbaum's friends and keen admirers of Watts's art, knew Mrs. Watts and indicated that she was unlikely to sell anything. Therefore, it was a purely speculative venture when Birnbaum motored down to Compton to visit "the charming octogenarian widow" in the summer of 1928. Birnbaum later recalled pointing out to her that "she was not serving the reputation of her distinguished husband by holding the majority of his works in a secluded English village. His artistic message, such as it was, would be far better served if good original examples of his work were seen by students in foreign countries."[8] Rowland Alston, curator of the Watts Gallery, concurred. Birnbaum selected a painting hanging over the mantelpiece—this *Orpheus and Eurydice*. Mrs. Watts protested that she could not part with this work since it was "the wedding gift I received from my husband." After hard bargaining, however, Birnbaum triumphantly cabled Winthrop,

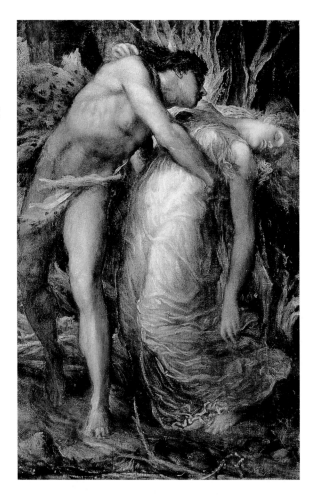

Fig. 193. George Frederic Watts, *Orpheus and Eurydice*, ca. 1868–72. Oil on canvas, 27½ x 18 in. (71.8 x 48.1 cm). Aberdeen Art Gallery and Museums

"Persuaded widow of distinguished painter Watts to sell any or all of the following five paintings," among which he recommended *Orpheus and Eurydice* as a "glorious masterpiece rich colour noble design finest quality and beauty." Winthrop responded positively.

Mrs. Watts took a fancy to Birnbaum and added a version of *The Genius of Greek Poetry* to the purchase price. Birnbaum's recollection of his departure from the Watts Gallery may be fictionalized, but it is richly evocative: "I left for London with the two pictures securely attached to the top of an automobile, from the window of which I caught a glimpse of Mrs. Watts standing in her doorway, weeping like a child."[9]

Barbara Bryant

1. See Allen Staley, in Manchester–Minneapolis–Brooklyn 1978–79, no. 19. An unfinished study for this version, at the Walker Art Gallery, Liverpool,

differs in the position of Eurydice's arm; see Morris 1996, vol. 2, pp. 471–72.
2. For Watts's use of this procedure, see Bryant 1987–88, pp. 52–59.
3. For a discussion of another small full-length version in relation to the main one, especially concerning its impact in Paris, see Bryant in London–Munich–Amsterdam 1997–98, pp. 65ff., 142–43, no. 37.
4. "Watts Catalogue," ca. 1910, vol. 1, p. 111.
5. Mrs. Watts told this to Martin Birnbaum; see Birnbaum 1960, p. 207.
6. Fogg Art Museum, 1943.212; see Cambridge, Mass., 1946b, no. 104.
7. Birnbaum discusses their work based on his friendship with them in his book *Introductions* (1919), pp. 24–28).
8. Birnbaum 1960, p. 206.
9. Ibid., p. 208.

PROVENANCE: Mary Watts, the artist's widow; acquired from her through Martin Birnbaum by Grenville L. Winthrop, July 1928; his bequest to the Fogg Art Museum, 1943.

EXHIBITIONS: Cambridge, Mass., 1946b, no. 97; Cambridge, Mass., 1973a; Cambridge, Mass., 1980a; Tokyo 2002, no. 40.

REFERENCES: Spielmann 1886, p. 31; "Watts Catalogue," ca. 1910, vol. 1, p. 111; Barrington 1905, pp. 126–27; Staley in Manchester–Minneapolis–Brooklyn 1978–79, pp. 75–76, no. 19; Bowron 1990, fig. 83; Bryant in London–Munich–Amsterdam 1997–98, pp. 65ff., 142–43, no. 37.

196. *Ariadne*, 1888–90

Oil on canvas
49⅞ x 40½ in. (126.8 x 103 cm)
Signed and dated bottom center: G. F. Watts 1890
1943.213

Like *Sir Galahad* and *Orpheus and Eurydice* (cat. nos. 194, 195), the tale of Ariadne from Greek mythology attracted Watts over a period of forty years. The artist depicted an invented moment in the story of King Minos's daughter, abandoned by her husband, Theseus, and stranded on the island of Naxos. Bacchus, the free-spirited god of wine, found her, but what we see in the painting is a moment of poetic longing after the revels of the previous night: she gazes at the horizon in mourning for Theseus, while still holding the red ball of wool he used to escape from her father's labyrinth.

Watts first turned to the subject when he executed a copy (unlocated) of Titian's *Bacchus and Ariadne* in the National Gallery, London. About 1860 he began to paint a large upright canvas showing Ariadne as a massive draped figure inspired by antique sculpture, particularly the prime exemplars, the Elgin Marbles at the British Museum, London. Several seated female figures in the marbles' pedimental group fed into Watts's conception of his Ariadne, but another stimulus should also be mentioned. In 1855–56 he had traveled throughout the eastern Mediterranean around the Greek islands, prompting landscape studies and several specific subjects drawing on that setting. From the late 1850s on, Watts increasingly treated classical subject matter. His choice of such a subject in about 1860 with the first *Ariadne* placed him in the forefront of new ideas in contemporary English art and indeed preceded the outpouring of such subjects beginning in

the early 1860s. This early version of *Ariadne* (private collection, England), exhibited at the Royal Academy of Arts, London, in 1863, had considerable reverberations in the work of Frederic Leighton and Albert Moore, among others, although it soon went into a private collection.

The essentially poetic spirit of the story remained a potent source of ideas for Watts, whose next version on a much smaller scale showed Ariadne with several companions watching for the return of Theseus. In the early 1870s he returned to the idea of the single figure, but in a horizontal format with more action, including a subsidiary figure enhancing the strong diagonal thrust of the composition. The most fully realized version of this idea is the well-known *Ariadne in Naxos* (fig. 194), completed in 1875 and much exhibited.

Watts's wife noted that he began Winthrop's painting in 1888.[1] It reprised the

version exhibited in 1863 on a somewhat smaller scale and in a less upright composition, with changes in handling and detail. His return to the subject was no doubt prompted by his recent honeymoon trip to Greece and the Mediterranean, exposing him again to the linked stimuli of classical sculpture and the terrain and light of the Mediterranean region. Indeed the setting in the painting is particularly beautiful, with yellow glazes near the horizon warming the essentially cool tones of the landscape. Unlike the earlier version, this one shows a handmaiden washing in the lower corner rather than the playful panthers of Bacchus. Ariadne's hair is here entwined with vine leaves, referring to Bacchic revels. The essential difference is in the handling, especially in the virtuoso passages of drapery painted with a wide range of suggestive white tones. This work is a prime example of the artist's late style, with strong,

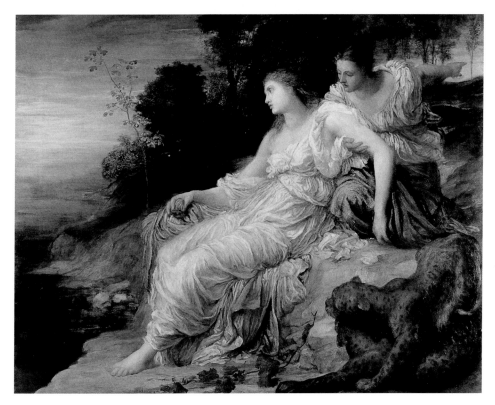

Fig. 194. George Frederic Watts, *Ariadne in Naxos*, ca. 1868–75. Oil on canvas, 29½ x 37 in. (75 x 94 cm). Guildhall Art Gallery, Corporation of London

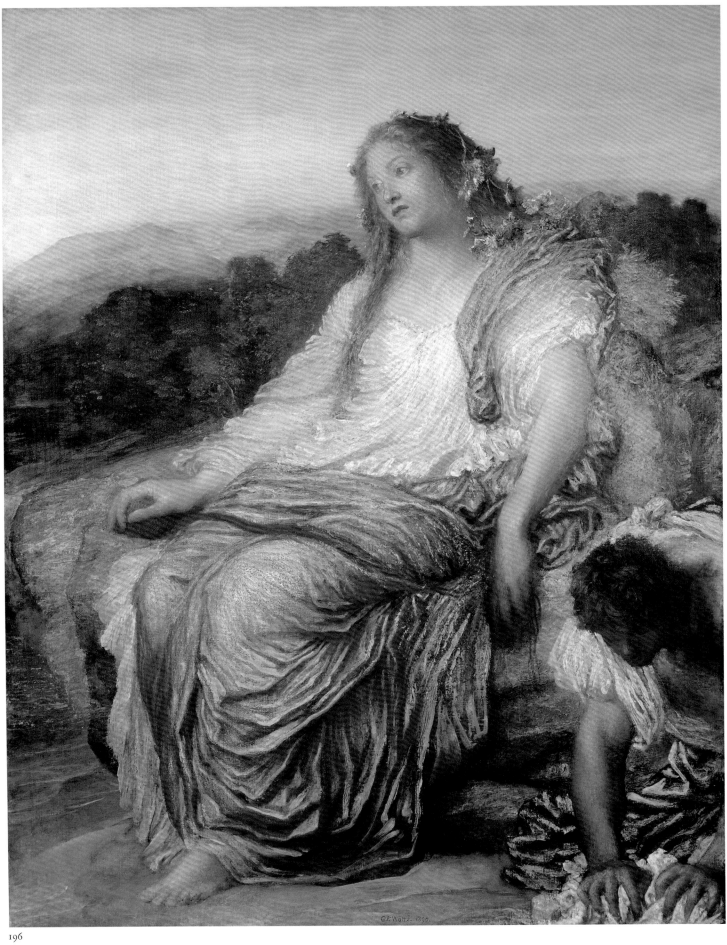

196

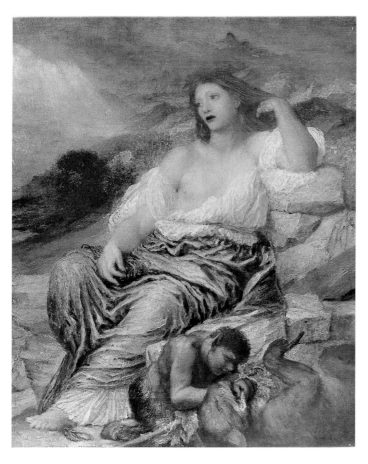

Fig. 195. George Frederic Watts, *Ariadne in Naxos*, 1894. Oil on canvas, 24 x 20 in. (61 x 50.8 cm). The Metropolitan Museum of Art, New York; Rogers Fund, 1905 05.39.1

second rate sketch."[5] They succeeded in acquiring not only *Ariadne* but also the *Creation of Eve* and the *Expulsion of Adam and Eve* (Fogg Art Museum, 1943.210 and 1943.211), making Winthrop's holdings of works by Watts "unrivalled outside" the main British collection of the artist's work at the Tate Gallery in London.

Barbara Bryant

1. "Watts Catalogue," ca. 1910, vol. 1, p. 7.
2. "The New Gallery, Regent Street," *Athenaeum*, May 3, 1890, p. 577.
3. Buck in Cambridge, Mass., 1946b, p. 15 and no. 101.
4. This is the artist's authorized photograph by his trusted photographer Frederick Hollyer, who took these images in different stages of work.
5. Birnbaum, letter to Winthrop, June 2, 1939, Harvard University Art Museums Archives.

PROVENANCE: Leopold Hirsch, after 1890; his sale, Christie's, London, May 11, 1934, no. 80 (£68 5s.); purchased at that sale by the Fine Art Society; Sir Edmund Davis; his sale, Christie's, London, July 7, 1939, no. 94 (£168); acquired at that sale through Martin Birnbaum by Grenville L. Winthrop; his bequest to the Fogg Art Museum, 1943.

EXHIBITIONS: London 1890, no. 31; London 1905b, no. 56; London 1911, no. 33; London 1921, no. 6; Cambridge, Mass., 1946b, no. 101; Cambridge, Mass., 1973a; Cambridge, Mass., 1979–80; Tokyo 2002, no. 4.

REFERENCES: "The New Gallery, Regent Street," *Athenaeum*, May 3, 1890, p. 577; Temple 1897, p. 169; West and Pantini 1904, pl. 17 (illus. of Hollyer photograph); "Watts Catalogue," ca. 1910, vol. 1, p. 7; Watts 1912, vol. 1, pp. 236, 283; London 1954–55, under nos. 62 and 133; Bowron 1990, fig. 77.

confident lines of paint defining the complications of the flowing drapery over the solid sculptural form of the figure.

The painting did not, however, come easily to the artist. At its first exhibition in 1890 a reviewer, while praising the areas of white, "the tonality and local colour of which is a triumph of art," and applauding "the sentiment of the attitude and pathos of the whole," noted that it was incomplete, needing additional attention particularly to the arm of Ariadne.[2] Later examination at the Fogg by Richard Buck in the 1940s revealed that "the painting had been relined after it had been begun, but before it was finished," with evidence of overpainting by the artist himself.[3] It was entirely typical of Watts's working method to exhibit a painting, assess it, and then carry on with further work, and this indeed happened with *Ariadne*. A look at the photograph of the painting in the New Gallery's catalogue of 1890[4] confirms that Watts revised the position of the left arm, removing the flower she held and adjusting passages of drapery, and made many other slight changes, resulting in a work more in the spirit of his late style with broken, painterly surfaces.

The *Ariadne* of 1890 is a handsome, important late reworking of a favored subject. It is not known when Leopold Hirsch purchased the painting, possibly about 1894 when the artist exhibited yet another, much smaller, version of the subject (fig. 195) at the Royal Academy, a work perhaps intended as a recollection of the big picture. After leaving the Hirsch collection in 1934, *Ariadne* went into the famed collection of Sir Edmund Davis. He owned an important group of works by Watts, of which seven appeared at the sale following his death in 1939. A series of urgently worded communications from Martin Birnbaum in London to Grenville Winthrop in New York discussed their strategy for acquisition, with the dealer recommending the "noble Ariadne," mischievously adding "for which the Metropolitan owns a small

Daniel Chester French

Exeter, New Hampshire, 1850–Glendale, Massachusetts, 1931

197. *Abraham Lincoln Seated,* 1916

Bronze with black-brown over bottle green patina
32¼ x 26¾ x 28 in. (82 x 68 x 71 cm)
Signed and dated in wax model, proper left side of
base: D C French / March 1916; inscribed beneath
Lincoln's feet, front of platform: ©[1]
Foundry mark in wax model, back of base: ROMAN
BRONZE WORKS, N.Y.
1943.1108

In 1917 Daniel Chester French wrote to
Winthrop: "I am indeed glad that you like
my Lincoln, for Washington, even to the
extent of wishing to have the study of it in
bronze. That is a real tribute. I shall be
more than willing to let you have it, but I
fear it cannot be very soon."[2] Winthrop
must have seen the working model for the
statue French was designing for the Lincoln
Memorial during a visit to the sculptor's
studio. The two men were neighbors in
the Berkshires,[3] and Winthrop's daughter
Emily—also a sculptor—studied with
French, who was perhaps the country's
most popular sculptor at the time.[4] By 1917
the collector was already an established
admirer of his work. Indeed, he owned two
other bronzes by French: a fountain figure,
Spirit of the Waters (bought in 1914), and
the first bronze cast from the original study
for the *Standing Lincoln* that had been
erected in Lincoln, Nebraska, in 1912.[5]

In December 1914 the Lincoln Com-
mission for the monument approved the
selection of French to create the statue for
the Lincoln Memorial in Washington, D.C.,
designed by the architect Henry Bacon.
French resolved the basic composition of
the work in a series of small clay sketch
models in a few months during the summer
of 1915, and in March 1916 he finished the
working model.[6] The sculptor portrayed

Lincoln sitting back in a deep armchair,
arms extending along the armrests, eyes
focused intently on the ground ahead.
From the inception, French planned to
concentrate the intensity of the man in his
portrayal of the face and hands. In his own
words, he sought "to convey . . . the mental
and physical strength of the great President
and his confidence in his ability to carry
the thing through to a successful finish. If
any of this 'gets over', I think it is probably

as much due to the whole pose of the
figure and particularly to the action of the
hands as to the expression of the face."[7]
According to Michael Richman, "In the
maquette, French grasped the essence of
his heroic statue. It was this talent for
creative conception in small scale from
the very start that enabled French success-
fully to address matters of pure sculpture:
design, movement, silhouette, and
composition."[8]

Fig. 196. Daniel Chester French, *Abraham Lincoln,* 1911–22. Marble; H. 20 ft. 3¼ in. (617.7 cm).
Lincoln Memorial, Washington, D.C. (photo: © Bernie Cleff, courtesy Chesterwood, a National
Trust Historic Site, Stockbridge, Mass.)

197

While Bacon had conceived of the seated figure as being in marble, French initially planned to execute it in bronze, and the wording of the contract remained vague regarding both material and size. In order better to fit the space he increased the figure to nineteen feet rather than the originally contracted ten feet, and in 1917 he decided it would be more appropriate to carve it in white marble. One can only wonder how much of the fluid quality of the model French would have preserved had he cast the monument in bronze. Although the figure was finished in 1920 and dedicated in 1922, French was not satisfied with it until 1926, when the portrait was lit to its best advantage.[9] The *Seated Lincoln* (fig. 196) soon came to be considered his masterpiece.

This bronze statuette reproduces the plaster cast obtained from the clay working model and was the first such replica in metal.[10] It preserves some of the sketchy quality of the early stages of the design, as can be seen in the outlines of the stars, in the hatching created by a toothed modeling tool on the trousers, and in the few ridges that denote the taut tendons in Lincoln's hands. The bronze sculpture reflects the changes that French had effected since his earliest surviving sketch models.[11] He brought the right foot forward and the left back, changed the position of the hands, reversed the direction of the folds in the coat, and rounded the back of the armchair. The most noticeable change between the latest sketch model and the working model was the addition of the American flag draped over the back of the chair. Then, in the almost lifesize plasticine model that French made, he eliminated the eagle reliefs from the corners of the base and concentrated on the president's hands and face. Like his friend Augustus Saint-Gaudens, he studied photographs of the president as well as casts of Lincoln's face and hands and of his own.[12]

Winthrop acquired the *Seated Lincoln* directly from the artist in 1920, paying $1,500 despite French's own concern that the price was "more than it is worth."[13] Winthrop had paid the same amount eight years earlier for a bronze reduction of Saint-Gaudens's *Standing Lincoln*.[14] His impressive collection of bronze representations of the president reflected not only an appreciation for contemporary sculpture, but also a fascination with the man. His library included several books on Lincoln, one of which dealt with his personal traits.[15] It is clear that the sculptures in all of their glorious detail were for him a source of contemplation and connection not only with the sculptors but also with the great historical figure.

Francesca G. Bewer

1. The design was copyrighted after the plaster working model had been approved by the Lincoln Commission for the monument. See Richman in New York and other cities 1976–77, p. 178.
2. French, letter to Winthrop, November 16, 1917, Winthrop Archive, Harvard University Art Museums Archives.
3. French had established a summer home and studio, Chesterwood, in Stockbridge, Mass., in 1896.
4. See Manchester 1964, copy in the Grenville Winthrop file, Archives, The Metropolitan Museum of Art.
5. In 1909 French collaborated with architect Henry Bacon to produce a standing bronze figure of the sixteenth president in front of a granite wall inscribed with the Gettysburg Address. This tribute was dedicated in 1912. See Richman in New York and other cities 1976–77, p. 123. Winthrop paid $1,000 for the bronze reduction of the statue. See copy of transcription of letter from French to Winthrop, September 26, 1912, curatorial file of 1943.1107, Fogg Art Museum. The *Standing Lincoln* marked the beginning of French's interest in the replication in reduced size of his larger works, for which he detected a potential market; see Shapiro 1985, p. 89.
6. French would cast the small clay sketch modes in plaster from waste molds in order to better preserve them. Several of the plaster sketch models for the *Seated Lincoln* are preserved at Chesterwood. The differences among them reveal some of his thinking through the composition. See Richman 1975, p. 220.
7. French, letter to Charles Moore, May 13, 1922, Box 5, Charles Moore Papers, Library of Congress, Washington, D.C., quoted by Richman in New York and other cities 1976–77, p. 184.
8. Richman 1977, p. 51, quoted in Williamstown 1985–86, p. 41.
9. The Piccirilli Brothers of New York carved it in a year from twenty-eight identical blocks of Georgian marble, and French carried out some of the final carving. See Richman in New York and other cities 1976–77, pp. 182–84.
10. This study is traditionally two to three times larger than the sketch model and about one-quarter of the size of the final sculpture. The working model of the *Seated Lincoln* included a separate base with eagles at the corners, as can be seen in the plaster model at Chesterwood. See New York and other cities 1976–77, p. 176, fig. 9. The base was not reproduced in the bronze versions. The bronze was cast by the lost-wax process. A second casting, ordered in 1924, belongs to the Heckscher Museum, Huntington, N.Y. There may have been as many as seven more replicas cast during the artist's lifetime. In the 1950s Margaret French Cresson, his daughter, had several casts of the working model executed. See Richman 1975, p. 186, n. 48.
11. Preserved at Chesterwood. First sketch model (incomplete), NT 97.6; reproduction of the first version made by Alva Studios, ca. 1960, NT 69.38.561; sketch model, NT 87.3.2; working model, NT 69.38.186.
12. Saint-Gaudens's two sculpted versions of Lincoln also served as references for French; White 1970, p. 366. French and Saint-Gaudens both worked from casts in the Smithsonian Institution; Cambridge, Mass., 1972, no. 125.
13. French, letter to Winthrop, April 30, 1920, Winthrop Archive, Harvard University Art Museums Archives. French selected foundries primarily on the basis of estimates. For more on French's use of foundries, see Shapiro 1985, pp. 78–91.
14. The model had been mechanically reduced directly from the full-scale plaster model for Saint-Gaudens's statue of Abraham Lincoln in Lincoln Park, Chicago, that was still preserved in his studio. See Mrs. Saint-Gaudens, letter to Winthrop, November 10, 1912, curatorial files of 1943.1116, Fogg Art Museum. It was the third of these posthumous casts. See copy of extract of letter dated 1912 from Mrs. Saint-Gaudens to F. S. Turner of Doll and Richards, Boston, from whom Winthrop bought the bronze, curatorial files of 1943.1116, Fogg Art Museum.
15. For example, he owned Helen Nicolay, *Personal Traits of Abraham Lincoln* (New York, 1912), and John T. Morse Jr., *Abraham Lincoln*, 2 vols. (Cambridge, Mass., 1893). See List of Winthrop's Library Holdings, p. 28, Harvard University Art Museums Archives. Winthrop went so far as to inquire about the accuracy of Saint-Gaudens's representation of Lincoln's stance in his *Standing Lincoln*. See copy of letter from Edward Robinson to Winthrop, November 4, 1912, curatorial files of 1943.1116, Fogg Art Museum.

PROVENANCE: Acquired from the artist by Grenville L. Winthrop, 1920 ($1,500); his bequest to the Fogg Art Museum, 1943.

EXHIBITIONS: Cambridge, Mass., 1972, no. 125; New York and other cities 1976–77 (Cambridge venue only), pp. 184, 185.

REFERENCES: Cresson 1947, pp. 270–81; White 1970, p. 365; Laurel, Miss., 1985–86, p. 7, fig. 8.

William Michael Harnett

Clonakilty, Ireland, 1848–New York City, 1892

198. *Still Life with Bric-a-Brac,* 1878

Oil on canvas
32 x 42¾ in. (81.28 x 108.59 cm)
Signed and dated lower left: W M Harnett / 1878
1942.220

The artistic chronology of William M. Harnett seems as orderly and balanced as his still-life paintings. His career evenly divides into three six-year periods: primarily in Philadelphia from 1874 to 1880, then in Munich until 1886, and finally in New York from then until his relatively early death in 1892. Born in County Cork, Ireland, in 1848, Harnett was taken the next year by his family to Philadelphia, where he was reared and schooled. During the 1870s he received training in drawing,

modeling, and design at the Pennsylvania Academy of the Fine Arts in Philadelphia and at the Cooper Union and the National Academy of Design in New York. He also found early employment as a silver engraver for a couple of years at the New York firms of Wood and Hughes and Tiffany and Company.[1] These formative experiences are clearly evident in *Still Life with Bric-a-Brac*. As a student in Thomas Eakins's night class on still life, he could have seen examples of recent work by

the older master, whose influence seems apparent in the precision of drawing and polished modeling of forms in Harnett's painting.[2] Likewise, the generally planar organization and the intricate delicate linework on so many of the objects, not least the prominent ones in metal, must in part reflect Harnett's experience working in relief and decorative silver engraving.

This picture was painted on commission for William Hazelton Folwell (1840–1900), a Philadelphia dry-goods merchant and decorative arts collector. The subjects we see here of old books and decorated bric-a-brac speak to the rise of Victorian materialism in the decades after the Civil War, the new passions for travel and collecting, and the emergence of enterprising businesses and rapid accumulations of wealth. The recent Centennial Exhibition of 1876 in Philadelphia had greatly stimulated the collecting of decorative arts from various world cultures, and Folwell's acquisitions were typical in their embrace of pieces from across Europe and the Mediterranean.[3] It is easy to see why this array would appeal to the collecting instincts of Grenville Winthrop.

During the year preceding this picture Harnett completed a number of smaller, less complicated tabletop paintings devoted to various businessmen and bankers, often juxtaposing books and ledgers on one side with stacks of coins or currency on the other, visually joined by an inkwell and pen. In a sense these were crafty surrogate portraits of their patrons, engaged respectively in their spheres of public commerce and private communication.[4] So too may we see this ambitious bric-a-brac assemblage as a symbolic still-life "portrait" of Folwell. Stylistically, Harnett had moved during the 1870s from rather simple austere gatherings of a few objects to larger-scaled, denser clusterings, a rhythmic sequence he was to repeat the following decade, culminating with his famed *After the Hunt* series, and again in his last years concluding with his summary *Old Models* of 1892 (Museum of Fine Arts, Boston). The Winthrop painting at once anticipates the next phase of his career in Germany as well as the complex and beautiful major works of his maturity.

John Wilmerding

1. On his early work as an artisan, see Provost 1992, pp. 131–35.
2. Noteworthy relevant examples by Eakins with prominent still-life elements in them include *Portrait of Samuel Gross*, 1875 (Thomas Jefferson University, Philadelphia), *The Chess Players*, 1876 (The Metropolitan Museum of Art, New York), *Professor Benjamin Howard Rand*, 1874 (Thomas Jefferson University), and *Baby at Play*, 1876 (National Gallery of Art, Washington, D.C.).
3. Many of the objects owned by Folwell and depicted here by Harnett were later purchased by the Fogg Art Museum (1955.92a–f) from the owner's daughter, Mrs. H. Allen Barton of Rye, New York. She and others were quick to note that the plate shown in the right center of the composition actually displayed the head of a young girl, which Harnett intentionally depersonalized by painting a blue design of birds in its place. For fuller discussion of William Folwell and his brother Nathan as Harnett patrons, see Bolger 1992.
4. The larger context of Harnett's stylistic development and works related to the Winthrop painting are discussed in Wilmerding 1992.

PROVENANCE: Commissioned by William Hazelton Folwell, Philadelphia, 1878; acquired through Martin Birnbaum by Grenville L. Winthrop, 1942 ($1,200); his gift to the Fogg Art Museum, 1942.

EXHIBITIONS: Cambridge, Mass., 1972a, no. 89; Cambridge, Mass., 1977a; Cambridge, Mass., 1994.

REFERENCES: Frankenstein 1953, p. 183, pl. 35; Gerdts 1971, pp. 745, 747, illus.; Gerdts and Burke 1971, pp. 135, 138, fig. 10-5; Gerdts 1972, p. 68, illus.; Groseclose 1987, p. 59; Bolger 1990, p. 13, fig. 9; New York and other cities 1992–93, pp. 36 (fig. 9), 246 (fig. 112).

Winslow Homer

Boston, Massachusetts, 1836–Prout's Neck, Maine, 1910

199. *Sailboat and Fourth of July Fireworks*, 1880

Watercolor and white gouache on white wove paper
9½ x 13⅝ in. (24.5 x 34.7 cm)
Inscribed in watercolor, lower left: July 4 1880;
lower right: W.H.
1943.305

In the late 1870s Winslow Homer seriously and openly flirted with overtly modernist newness, most seriously and openly in the watercolors he painted at Gloucester, Massachusetts, in the summer of 1880; and among them, almost flagrantly, in *Sailboat and Fourth of July Fireworks*. It was not only that these watercolors were suddenly

different from what Homer himself had done before, though they were, but that it was the nature of their difference to embrace things that in their time and place—about 1880 in America—were suddenly and radically new to art.

One of them was Impressionism. Some people recognized its presence in the "frank

199

and hasty impressions of striking effects," as one critic wrote; another saw it in Homer's strong interest "in effects of light, and . . . recording his impressions."[1] Many others, who sensed the novelty of Homer's Gloucester watercolors without naming its source, called them, in language that regularly greeted modernist innovation—that had greeted French Impressionism itself a few years earlier—"incoherent," "meaningless," "eccentric," "exaggerated," and "arbitrary." When Homer sent his Gloucester watercolors to the Water Color Society exhibition in 1881 his innovations "had severe justice meted out to them by the Spartans of the hanging committee"[2] by being "skied," or hung high on the wall where they could barely be seen.

Gloucester celebrated the Fourth of July in a big way in 1880, with a band concert, boat and yacht races, a footrace, a baseball game, a two-ring circus, and, finally, fireworks, "a fine display of rockets, mines,

bengolas, and candles" that lasted half an hour.[3] Homer, living that summer in a lighthouse in Gloucester Harbor, had an excellent view of them over the water.

He painted the fireworks not just because they were there, however, or because they were an important part of the summer at Gloucester. Fireworks—even more than sunsets, which he also painted at Gloucester—were an intensely transient and quintessentially momentary experience, one that attracted him precisely because they afforded "hasty impressions of striking effects"; that is, they constituted a canonical Impressionist subject.

There is another aspect of novelty in *Sailboat and Fourth of July Fireworks:* there is about it the unmistakable aroma of James McNeill Whistler, Homer's expatriate contemporary. The nighttime subject and close and subdued tonal range of *Sailboat and Fourth of July Fireworks* are squarely in the vein of Whistler's notorious nocturnes;

what is more, in its depiction of fireworks it resembles the most notorious nocturne of all, the *Nocturne in Black and Gold: The Falling Rocket* (1875; Detroit Institute of Arts), the one that John Ruskin said in print was "a pot of paint" flung in the public's face, and for which, in 1877, Whistler sued him for libel.[4] Homer could not have seen *The Falling Rocket* itself when he painted *Sailboat and Fourth of July Fireworks* in 1880, and he never spoke of Whistler at this time (although he spoke very little at any time about anything). But the Whistler-Ruskin trial was widely reported in America, and during the 1870s, furthermore, Homer was part of the cultivated circle around Richard Watson Gilder, editor of *Scribner's Monthly;* his wife, Helena de Kay; and her brother the critic Charles de Kay, and within this circle Whistler was certainly known. Charles de Kay's novel *The Bohemian* contains one of the earliest references to Whistler in the United States,

particularly to "his nocturnes in black";[5] the first serious study of Whistler in America appeared in *Scribner's Monthly* in 1879, and Homer's portrait of Helena de Kay (1871–72; Fundación Colección Thyssen-Bornemisza, Madrid) is astonishingly like Whistler's famous *Arrangement in Grey and Black: Portrait of the Painter's Mother* (1871; Musée d'Orsay, Paris).

Setting possibilities of Whistler's pictorial influence aside, Homer's *Sailboat and Fourth of July Fireworks* also echoed and argued Whistler's ideas about finish and artifice. What was most disturbing about Homer's watercolor, as Whistler's *Falling Rocket* was to Ruskin, was what one of the witnesses for the defense in the Whistler-Ruskin trial, the painter Edward Burne-Jones, called "the question of completion,"

that is, the huge distance by which Homer's watercolor and Whistler's painting fell short of proper finish, in favor of suggestive expressiveness and to claim attention for pigment and color—for the "pot of paint"—equal to what they might be deployed to represent in nature.

By including the crescent moon in the upper left of his watercolor, Homer agrees with another Whistlerian principle. The moon, arguably the chief emblem of romantic nature, is outshone and its position as the center of pictorial attention usurped by something else that claims for itself the same or even greater attention: the noisy man-made fireworks that are the emblem of art and artifice.

Nicolai Cikovsky Jr.

1. "Fine Arts. American Water-Color Society," *New York Tribune*, January 29, 1881.
2. "The American Water Color Society," *New York Sun*, January 23, 1881.
3. "Fourth of July Celebration.—Large Crowds and Lots of Fun.—Processions, Races, Circus and Fireworks," *Cape Ann Bulletin*, July 7, 1880.
4. See Merrill 1992.
5. De Kay 1878, p. 29.

PROVENANCE: Jacob Otis Wardwell, Haverhill, Mass., after 1892; his bequest to his son Sheldon Eaton Wardwell, Brookline, Mass., 1940; consigned to Macbeth Gallery, New York, January 1941; acquired from them through Martin Birnbaum by Grenville L. Winthrop, November 1941 ($450); his bequest to the Fogg Art Museum, 1943.

EXHIBITIONS: Boston 1880; Cambridge, Mass., 1944c; Cambridge, Mass., 1962, no. 70; Cambridge, Mass., 1972a, no. 102; Cambridge, Mass., 1977b, no. 22.

BIBLIOGRAPHY: Hendricks 1979, p. 297, no. CL-270, fig. 226; Plimpton 1984, illus. facing p. 145; Washington–Fort Worth–New Haven 1986, pp. 73, 112, fig. 49; Youngstown 1986, illus. p. [5]; Cikovsky 1990, illus. p. 69; Jennings 1990, p. 51; Cikovsky 1991, pl. 29; Washington–Boston–New York 1995–96, pp. 286–87, fig. 189; Cuno et al. 1996, illus. p. 232; Tatham 1996, p. 83, fig. 27; Saywell 1998, pp. 37–38, under "Watercolor."

200. *Schooner at Sunset,* 1880

*Watercolor over graphite on off-white wove paper
9⅞ x 13⅞ in. (25 x 35 cm)
Inscribed in black ink, lower right:* Homer 1880
1943.298

For a year or two preceding Homer's summer in Gloucester in 1880 people began to notice a change in his behavior. "What has come over this artist of late years that he sulks in his tent?" the critic Clarence Cook asked in 1878.[1] He became gruff and surly— "*posé* in the extreme," with "eccentricities of manner that border upon gross rudeness"[2]—and by 1881, someone said, had "retired wholly within himself" into "grim and misanthropic seclusion."[3]

A particularly clear sign of Homer's altered behavior and state of mind is that when he visited Gloucester in 1880 he did not stay on shore, as he had during an ear-

lier visit seven years before (when he painted his first watercolors), but boarded at the lighthouse on Ten Pound Island, in the middle of Gloucester Harbor and a good rowboat ride away from the society of the town. Even clearer indications, perhaps, are the watercolors he painted during that summer of misanthropic withdrawal, most especially *Schooner at Sunset* and several others like it. They were, as was disturbingly apparent to his contemporaries, highly charged with feeling. "One critic said they "appear almost morbid in their intensity."[4] Another described their effect as "fervid, half internal poetry."[5] The anxious, nearly disruptive tensions that inhabit them and shape their outward form—the discordant intensity of their coloration and vigorous, even violent, brushwork ("artis-

tic brutality," someone was overheard to say at their exhibition)[6]—were induced by a powerful emotional perturbation that was recorded, almost seismically, in their appearance. "How queer they are," someone said, hinting at their abnormality and irrationality, and adding that "they seem to lack common sense."[7] The nature of Homer's emotional or mental state can only be guessed at—he was deeply reserved and pathologically private, which of course makes the expressive outburst of these Gloucester watercolors all the more surprising and disturbing—but of its powerful shaping presence there can be little question.

But the effect of such watercolors was not generated entirely from within Homer's inner emotional life. They were also touched by other art. In a way sanctioned by the

200

impressionism (at first more German in its origin than French) that entered American artistic experience in the late 1870s, they were Homer's response to a particularly and even definitively transient natural event, a summer sunset, with a brevity of style that matched the briefly visible existence of his subject. And they may be Homer's response as well to one of the most famous paintings of the late nineteenth century, Joseph M. W. Turner's *Slave Ship* (1840; Museum of Fine Arts, Boston). John Ruskin, who once owned *The Slave Ship* and to whom it owed much of its fame, said it was the noblest sea "ever painted by man."[8] When first exhibited at the Royal Academy, it was described as "the most tremendous piece of color that ever was seen."[9] Homer knew the picture. The New York collector John Taylor Johnston, its second owner, sold it in 1876 in a well-publicized sale that also included something certain to attract Homer's attention to it: one of his own paintings, *Prisoners from the Front* (1866; The Metropolitan Museum of Art, New York). It must have been an experience of that picture that Homer reckoned with a few years later in the lurid and incarnadined (Ruskin's splendid word) coloration of this and other Gloucester sunset watercolors.

Nicolai Cikovsky Jr.

1. Cook 1878.
2. "Exhibition of the Academy of Design," *Art Amateur* 2 (May 1880), p. 112.
3. "The American Water Color Society," *New York Sun*, January 23, 1881.
4. "The Fine Arts. Winslow Homer's Water-Color Studies," *Boston Adventurer*, December 11, 1880.
5. [M. G. Van Rensselaer], "The Water-Color Exhibition," *New York World*, January 27, 1883.
6. Van Rensselaer 1881, p. 135.
7. Edward E. Hale, letter to "Margaret," Roxbury, Mass., December 2, 1880, Archives of American Art, Smithsonian Institution, Washington, D.C.
8. Ruskin 1903, p. 571.
9. *Fraser's Magazine* (London, 1840), quoted in Butlin and Joll 1984, p. 237.

PROVENANCE: Bequeathed by the artist to Charles S. Homer Jr., New York, 1910; his bequest to his wife, 1917; her bequest to Arthur P. Homer, Townsend, Mass., and Charles L. Homer, 1937 ; acquired from Macbeth Gallery, New York, by Grenville L. Winthrop, 1940 ($1,100); his bequest to the Fogg Art Museum, 1943.

EXHIBITIONS: Prout's Neck 1936; Cambridge, Mass., 1944c; Cambridge, Mass., 1972a, no. 101.

REFERENCES: Gardner 1961, pp. 29 (illus.), 249; Hannaway 1973, pp. 142–43, pl. 1; Hendricks 1979, p. 298, no. CL-271; Washington–Fort Worth–New Haven 1986, pp. 73, 74, 247, fig. 61.

201. *Watching the Tempest*, 1881

Watercolor over graphite on off-white wove paper
14 x 19⅞ in. (35.4 x 50.5 cm)
Inscribed in brown watercolor, lower left: Winslow
Homer 1881
1943.296

Homer sailed in March 1881 to England, where he settled in the fishing village of Cullercoats, on the northeast coast near Newcastle. He lived there alone for a year and a half. He lived in seclusion in England, as he had lived earlier in Gloucester (and as he would live later at Prout's Neck, Maine), to salve emotional wounds. He went to England, it is not too strong to say, to remake his life, but also, perhaps as part of that restorative therapy, to remake his art.

Works like *Watching the Tempest* were the result. All in watercolor, all large in size, often intensely dramatic in subject and complex in composition, they were wholly and deliberately different from all of Homer's work that preceded them. "Winslow Homer, instead of the original and spirited [Gloucester] studies he showed last year," a critic wrote of work he showed in New York in 1882, "exhibited . . . large figure-pieces done in England and quite foreign to any of the styles he has hitherto affected."[1] For those who found his previous work "rather too impressionist,"[2] "things of shreds and patches,"[3] and "mere studies or sketches,"[4] his English watercolors touched "a far higher plane" and were

"pictures in the fullest sense," "works"—as no one had said of Homer's work before—of "High Art."[5] Some found them conventional, too much in the manner of English watercolors. And they were. But that was their point and purpose. Having smarted for years from unrelenting criticism of his work as incomplete and unfinished, this was precisely what Homer—seeking the comfort in convention that he never found in innovation—intended them to be.

This was a matter not only of conventional style, but of conventional subject matter as well. The dramatic subjects of shipwreck and rescue that first attracted Homer in England were new to him. But they were common along the perilous

stretch of coast at Cullercoats. One of the town's most prominent (and still standing) buildings is the lifesaving station, visible in the middle distance of *Watching the Tempest*. To that extent the subject forced itself upon him. But depictions of the lives of fishermen and their wives, including events of shipwreck and rescue that were a tragic part of them, were hugely popular in the years around 1880. No Paris Salon, for example, was without its complement of them. It was such a subject, *Oyster Gatherers of Cancale* (1878; Corcoran Gallery of Art, Washington, D.C.), by which Homer's ambitious younger contemporary John Singer Sargent launched his career at the Salon of 1878. And it was by such a subject that Homer announced his renovated style.

Nicolai Cikovsky Jr.

1. Van Rensselaer 1882, p. 160.
2. "Water Colors," *Brooklyn Daily Eagle*, March 16, 1882.
3. "Art Exhibitions. The Water-Color Society," *New York Sun*, January 28, 1883.
4. Van Rensselaer 1883, p. 17.
5. [M. G. Van Rensselaer], "The Water-Color Exhibition," *New York World*, January 27, 1883.

PROVENANCE: Purchased from the artist by Thomas B. Clarke, 1881?; purchased at his sale, American Art Galleries, New York, February 14–18, 1899, by Burton Mansfield, New Haven, Conn.; purchased at his sale, American Art Association/Anderson Galleries, April 7, 1933, no. 67, by Scott and Fowles, New York; acquired from them by Grenville L. Winthrop, February 1934 ($3,600); his bequest to the Fogg Art Museum, 1943.

EXHIBITIONS: Chicago 1889, no. 245; New York 1889a, no. 40; New York 1889b, no. 24; Philadelphia 1891, no. 91; New York 1898, no. 48; New York 1911, no. 30; Hartford 1920; Cambridge, Mass., 1969, no. 114.

REFERENCES: Downes 1911, pp. 100, 101, 103, 259, illus. facing p. 88; Van Dyck 1919, p. 100; Beam 1966, p. 22, fig. 2; Flexner 1966, p. 104, illus.; Wilmerding 1972, p. 157, pl. 4-8; Clarke 1976, p. 76; Hendricks 1979, p. 298, no. CL-276, fig. 246; Washington–Fort Worth–New Haven 1986, pp. 96, 101, 216, 248, fig. 86; Mertens 1987, pp. 122, 207 (illus.); Jennings 1990, pp. 54–55; Berg 1992, pp. 92–99, illus.; Washington–Boston–New York 1995–96, pp. 179, 180, fig. 143.

202. *Mink Pond*, 1891

Watercolor over graphite on white wove paper
13⅞ x 20 in. (35.2 x 50.8 cm)
Inscribed in red gouache, lower right: Mink Pond 1891 / Winslow Homer
1943.304

Homer visited the Adirondack Mountains of New York State eighteen times between 1870 and 1910, the year of his death, on most of his visits staying at the North Woods Club (of which he was a member), in Minerva. He went to the Adirondacks to fish, but often, at the same time, to paint. He painted chiefly—and beginning in 1889, exclusively—in the portable medium of watercolor. His Adirondack watercolors are some of his most numerous, and some of his finest.

Mink Pond, located a quarter of a mile or so from the North Woods Club, was the place in the Adirondacks that Homer painted most often. In a broad view, he painted it in his first Adirondack oil,

Adirondack Lake of 1870 (Henry Gallery, University of Washington, Seattle). And with almost microscopic closeness he painted it about twenty years later in *Mink Pond*.

In certain respects *Mink Pond* seems to look to the past. Its close and intimate view of nature has something about it of Ruskinian meticulousness and morally truthful exactitude of style, and its kind of still life in situ was one that John Ruskin, through his followers, disseminated in America.[1] And in a different form of retrospection the almost speaking encounter between the sunfish and the frog in *Mink Pond* verges on being a comedy of manners in the vein of Victorian narrative paintings of humanized animals (usually dogs), such as those by Sir Edwin Landseer and others. The title of one of Landseer's most famous paintings, *Dignity and Impudence* (ca. 1840; Tate, London), might be applied as well to Homer's dignified frog and impudent sunfish.

The ruling characteristic of *Mink Pond*, however, may be less a throwback to Ruskinian stylistic moralism and Victorian narrative painting than a reflection of a vision determined by objective scientific investigation and lodged, consequently, squarely in the present.

The microscope was one of the great scientific instruments of the nineteenth century, and one of the chief emblems of scientific enterprise. Looking back at the century in the 1890s, the French Symbolist critic Albert Aurier pointed to microscopes ("lenses") as the symbol of what he and many others had come to regard with disdain as the nineteenth century's "childlike enthusiasm" for "scientific observation and deduction."[2] The nineteenth century did not invent the microscope, of course, but it perfected and disseminated it. The main

202

character in Ivan Turgenev's *Fathers and Sons* (1862), the positivist (or nihilist, as Turgenev calls him) scientist Bazarov, carries his microscope with him on his travels almost as his talisman and uses it (interestingly, perhaps, in view of the subject of *Mink Pond*) to study the frogs he dissects whenever he can. (The other tool of scientific investigation, Aurier wrote, was the scalpel.) The unusual closeness and minuteness of *Mink Pond*, therefore, can be said to have in those respects the quality of microscopic vision, mimicking it, perhaps with a touch of humor, but nevertheless invoking at the same time a kind of vision possible only to microscopy and thereby stamped with modernity.

That is involved with what the microscope allowed one newly to see, for "the general use of the microscope had the wider effect of bringing before people's vision an unsuspected realm of delicate forms and brilliant colorings." The singularly delicate forms and colors of *Mink Pond* suggest otherwise unseen beauties of nature that microscopic examination revealed, such as ferns, which under the microscope became "objects of exquisite elegance" for one observer and "vegetable jewelry" for another.[3]

Nicolai Cikovsky Jr.

1. See Gerdts 1985.
2. Aurier 1892, quoted in Chipp 1968, p. 93.
3. Quoted in Allen (1976) 1994, p. 115.

PROVENANCE: Given by the artist to Charles S. Homer Jr., New York, ca. 1891; his bequest to his wife, 1917; her bequest to Arthur P. Homer, Townsend, Mass., 1937; his bequest to his wife, 1940; sold by her to Macbeth Gallery, New York, 1941; acquired from them by Grenville L. Winthrop, 1941 ($4,500); his bequest to the Fogg Art Museum, 1943.

EXHIBITIONS: New York 1892–1900, no. 26; Prout's Neck 1936, no. 8; New York 1936–37, no. 70; Cambridge, Mass., 1944c; Cambridge, Mass., 1962, no. 71; Cambridge, Mass., 1969, no. 115; Cambridge, Mass., 1972a, no. 104; Cambridge, Mass., 1978.

REFERENCES: Goodrich 1944, p. 117, pl. 35; Gardner 1961, pp. 231 (illus.), 248; Beam 1966, p. 164, fig. 64; Flexner 1966, p. 129, illus.; Haverstock 1970, pp. 60, 61, illus.; Lindemann 1970, pp. 277 (illus.), 279; Wilmerding 1972, p. 199, pl. 35; Stebbins 1976, p. 245, fig. 203; Hoopes 1977, p. 104, pl. 8; Wilmerding 1978, p. 492, pl. 23; Hendricks 1979, p. 297, no. CL-265, pl. 45; Haverstock 1979, pp. 111–13, illus.; Eisenberg and Taylor 1981, p. 94, illus.; Verner 1985, p. 33; Mortimer 1985, no. 294, illus.; Washington–Fort Worth–New Haven 1986, pp. 174, 252, fig. 160; Jennings 1990, pp. 84–85; Tatham 1990, p. 124, fig. 10; Wilkinson 1990, pp. 64–71, illus. p. 66; Cikovsky 1991, pl. 54; *Discovering Literature* 1991, illus. p. 236; Jennings 1995, pp. 60–61; Washington–Boston–New York 1995–96, pp. 292, 293, fig. 198; Tatham 1996, pp. 84 (illus.), 92, 122, 141, pl. 17.

203. *Adirondack Lake*, 1892

Watercolor on white wove paper
11⅞ x 21¹/₁₆ in. (30.1 x 53.5 cm)
Inscribed in watercolor, lower right: Winslow
Homer 1892
1943.302

"Wherever that singularly original and gifted painter Winslow Homer wanders in search of pictorial subjects, he is sure to fetch home records of his impressions which are revelations of the intimate character of the places visited," a special correspondent to the *Boston Evening Transcript* wrote from New York.[1] He or she went on, "We have looked over a portfolio of his watercolor sketches in the Adirondacks, where he has lately been hunting armed with a box of water colors and those big brushes he wields with such bewildering skill, and we are more than ever impressed by his superb breadth and mastery." The portfolio the correspondent looked through

may well have contained this watercolor. It is an especially good example of Homer's bewildering skill in wielding a big watercolor brush, for it is painted directly, without the armature of drawing that, though it diminished as Homer's proficiency in watercolor grew, seldom disappeared altogether.

Homer's Adirondack watercolors were greatly esteemed for capturing what the writer called "the wonderfully vivid idea of the immense scale of things, the wildness, the grandeur, the rudeness, and almost oppressive solitude of the great Northern forest," and the life of its denizens: "the hunters, guides and fishermen of the wilderness," as here, as "they play the agile trout in his beautiful black pool under the dense shadows of the huge pines overhead." For Americans who by the late nineteenth century had lost touch with wilderness, as the wilderness itself was

being lost to tourism and logging, and whose lives had become increasingly sedentary and afflicted by nervous disease, "It is like inhaling a breath of balsamic air from the big woods, full of stimulating and expansive life, to look at these robust and powerful sketches of the Adirondacks."

Nicolai Cikovsky Jr.

1. "The Fine Arts. Third Annual Exhibition of the New York Watercolor Club," *Boston Evening Transcript*, December 23, 1892.

PROVENANCE: Purchased from M. Knoedler and Co., New York, by Goelet Gallatin, Big Horn, Wyo., ca. 1905; acquired from Frederick Keppel and Co., New York, by Grenville L. Winthrop, 1932; his bequest to the Fogg Art Museum, 1943.

EXHIBITIONS: Cambridge, Mass., 1944c; Cambridge, Mass., 1962, no. 69; Cambridge, Mass., 1972a, no. 106.

REFERENCES: "Sixteen Reproductions" 1944, illus.; Blue Mountain Lake 1959, p. 75, fig. 47; Hendricks 1979, p. 296, no. CL-252; Tatham 1996, p. 141.

203

George Inness

Newburgh, New York, 1825–Bridge of Allan, Scotland, 1894

204. *October Noon*, 1891

Oil on canvas
30⅝ x 44⅝ in. (77.79 x 113.35 cm)
Inscribed lower left: G. Inness 1891
1943.137

As early as 1864, the critic James Jackson Jarves recognized the difference between the landscapes of the then-dominant Hudson River School, with their "realism, vigor, enterprise," and the "subtle and delicate" views of George Inness.[1] Inness deviated from the mainstream of American landscape painting in his early admiration for the French painters of the Barbizon school, especially Jean-Baptiste-Camille Corot and Jean-François Millet, his extensive travels in France and Italy, and his deep Swedenborgian faith, as well as his practice of working not from nature but from his imagination.[2] Despite constant bouts of ill health and emotional distress, he was enormously productive, producing more than 1,500 landscapes, many of considerable size, during his fifty-year career.

October Noon, 1891, is one of the late works that Nicolai Cikovsky speaks of as representing Inness's "highest level of sustained . . . achievement," and as "the most perfectly religious of his works."[3] These paintings, of scenery near the artist's home in Montclair, New Jersey, or at Tarpon Springs, Florida, where he vacationed, depict the typical elements of pastoral landscape—pastures, ponds, trees, figures, and distant houses—laid out in nearly geometric patterns and muted with an unnatural atmospheric veil through which one strains to see.

The simple composition of *October Noon* approaches abstraction. Three nearly equal horizontal bands dominate: in the foreground lies a green pasture, which itself is bisected by a path leading into the distance; above it is a band of trees composed of an orchard, and, farther to the right, a copse of tall trees, through which one sees a few houses; while the top third comprises a muted blue sky with clouds. A woman in red, perhaps going home, walks away from us down the path, while a tall, spindly white birch, already half-bare of autumn leaves, leans to the left, balancing the rightward course of the walking figure. Inness's varied brushwork and his occasional use of subtractive, calligraphic markings, incised with the blunt wooden end of the brush, emphasize his emotional involvement with the painting. The quiet stillness of the scene and the muted colors of a late, wet autumn suggest the "overflow of sadness" Jarves found in Inness's work, or what Wanda Corn described a century later as its "pervasive though understated melancholy."[4] Inness here may well have been ruminating on departure and death, given his emphasis on the late autumn coloring, the end-of-day mood, and the single receding figure in his composition.

Such late works as *October Noon* have caused Corn and other writers to see Inness as one of the major American "tonalists."[5] A more recent scholar suggests a correlation between Inness's blurred landscapes and the English philosopher Herbert Spencer's theories, commenting that the painter's renderings of "the amorphous natural world . . . had much in common with Spencer's verbal description of an unknowable, vaporous universe."[6] Finally, it may be equally useful to point out the relationship between the painter's late work, along with that of such American contemporaries as Albert Ryder and Elihu Vedder—with their subjectivity and deliberate ambiguity—and much international Symbolist art of the fin de siècle.[7]

Theodore E. Stebbins Jr.

1. Jarves (1864) 1960, pp. 194–95.
2. See Cikovsky in New York and other cities 1985, p. 11; speaking of *October Noon*, Cikovsky wrote of "its nearly arbitrary coloration and suggestive form (very like Rothko, I might say now), its reduction of natural objects to pictorial shapes and their reconstitution into a virtually abstract design."
3. Cikovsky 1993, p. 113.
4. Jarves (1864) 1960, p. 196; Corn in San Francisco 1972, p. 2.
5. Corn in San Francisco 1972, p. 2; see also Gerdts in Phoenix–Huntington–New Britain 1982.
6. Mazow in Annville 1999, pp. 13–14.
7. See New York–Lawrence 1979–80.

PROVENANCE: Walter D. Blair, Tarrytown, N.Y.; purchased from him by M. Knoedler and Co., New York, May 1919; Charles M. Schwab, New York, May 1920; his sale, Tobias, Fischer and Co., New York, April 24, 1940, no. 4; M. Knoedler and Co., New York, 1940; John Levy Galleries, New York, 1942; acquired through Martin Birnbaum by Grenville L. Winthrop, 1942 ($300); his bequest to the Fogg Art Museum, 1943.

EXHIBITIONS: Montclair Art Museum, Montclair, N.J., 1935, no. 18; Cambridge, Mass., 1972a, no. 98; Cambridge, Mass., 1990, p. 24; Cambridge, Mass., 1995.

REFERENCES: Cikovsky (1965) 1977, p. 332, fig. 112; Ireland 1965, p. 346, no. 1359, illus.; Cikovsky 1971, text p. 55, pl. 9; Ambler and Bolton 1972, pp. 877 (fig. 8), 879; New York and other cities 1985, p. 11, fig. 1; Cikovsky 1993, p. 109, illus.; Taylor 1997, nos. 1, 2:7.

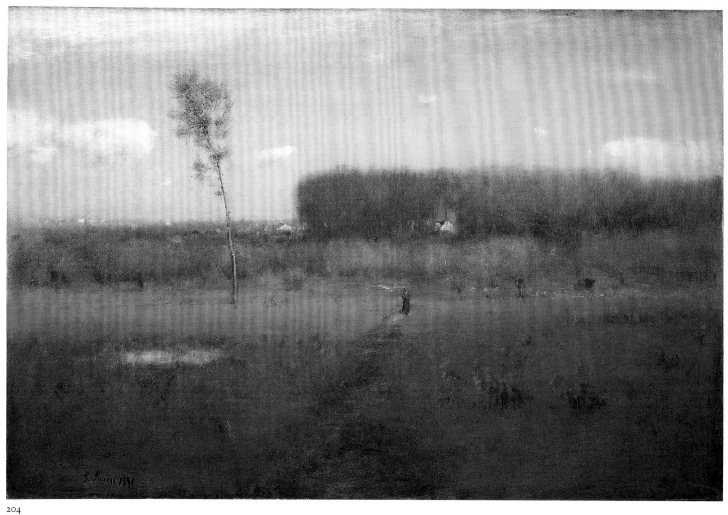

204

Charles Bird King

Newport, Rhode Island, 1785–Washington, D.C., 1862

205. *The Vanity of the Artist's Dream (The Anatomy of Art Appreciation, Poor Artist's Study)*, 1830

Oil on canvas
35⅞ x 30 in. (91.3 x 76.1 cm)
Inscribed on edge of book, lower center: C.B. KING
1830[1]
1942.193

Charles Bird King studied painting in New York for five years (1800–1805) before spending six years in London, where he enjoyed the tutelage of Benjamin West and the company of such other young American artists as Thomas Sully, Washington Allston, and Samuel F. B. Morse. On King's return to the United States, he settled by 1819 in Washington, D.C., and became a specialist in rendering likenesses of statesmen and visiting Indian chiefs. William Dunlap judged that it was King's "industry in painting that has served him instead of genius," and posterity has generally agreed.[2]

Thus, it is difficult to imagine how King came in 1830 to execute *The Vanity of the Artist's Dream*, one of the most important American still lifes of the antebellum period.[3] Still life was not taught in West's studio, was not practiced by King's closest compatriots there, and was not a popular genre in the United States in these years apart from the work of Raphaelle and James Peale and other members of their Philadelphia family.

King painted only a handful of still lifes, including a small game piece in London in 1806 and then, more significantly, the *Poor Artist's Cupboard* (fig. 197), about 1815, a direct precedent for *Vanity of the Artist's Dream*.[4] The Corcoran picture depicts in an arched niche more than a dozen books,

some bread on a plate, and a conch shell, with the volumes at the bottom of the composition protruding toward the viewer in trompe l'oeil fashion. One sees such titles as "Advantages of Poverty: Third Part" and "Pleasures of Hope." That the work is an ironic commentary on the difficult life of a painter is confirmed by the notice, tacked at upper left, of a Sheriff's Sale: The Property of an Artist.[5]

Vanity of the Artist's Dream takes up the same theme fifteen years later, making use of many of the same books and other materials, but now the rather elegant conception of the earlier work has become a pseudo-autobiographical horror vacui.[6] If the

Corcoran picture expresses disillusionment, then the Winthrop painting speaks of despair. The painter has apparently put away in this broken cupboard his most essential supplies: his books, penknife, sewing kit, a bottle of blacking, packets of prints and letters, a set of drafting tools, a truncated cast of the head of the *Apollo Belvedere* (Vatican Museums)—perhaps the most revered work of art in the world at the time—an extinguished lamp, a top hat, a small painting representing a cornucopia figure, a half-eaten loaf of bread, his sketchbook, and his own brushes and palette. At the lower left one sees "The Pleasures of Hope," with ripped and tat-

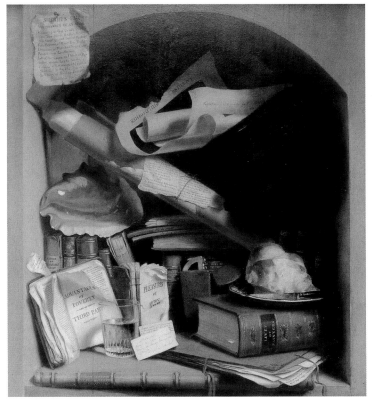

Fig. 197. Charles Bird King, *Poor Artist's Cupboard*, ca. 1815. Oil on panel, 29¾ x 27¾ in. (75.57 x 70.49 cm). Corcoran Gallery of Art, Washington, D.C.; Museum Purchase, Gallery Fund and Exchange, 55.93

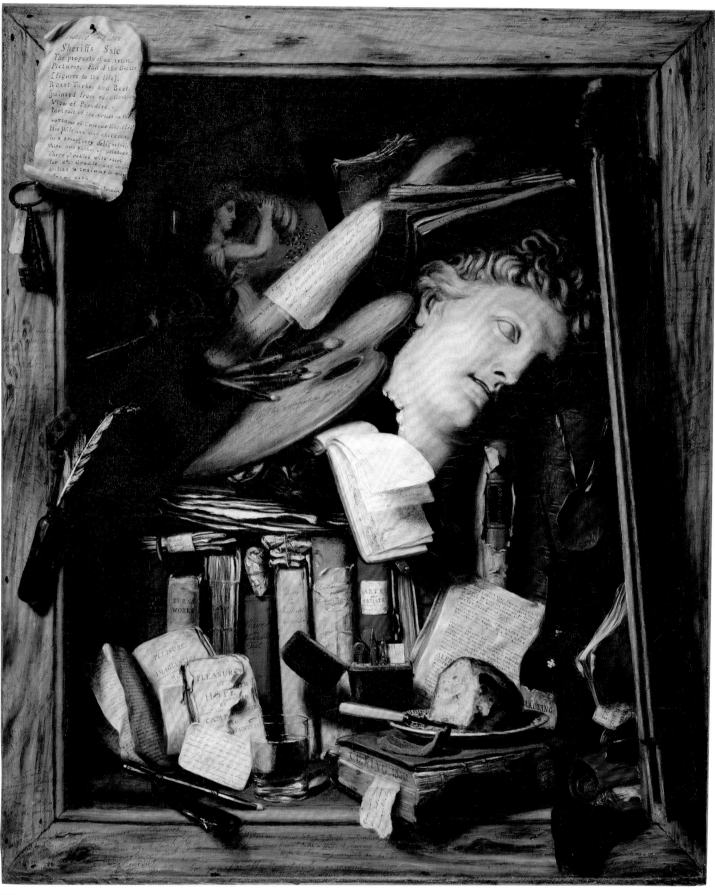

Within the painting, on the paper at upper left:

Sheriff's Sale
The property of an Artist.
Pictures. Fall of the Giants
[figures to the life].
Roast Turkey and Beef
painted from recollection
View of Paradise.
Portrait of the Artist in the
costume of Croesus King of Lid
His Wife and nine children
in a group very delightfull.
Also one bushel of potatoes.
Three p' ruffles with shirt
for d°. Cruel, and trifles
trifles to tedious to me

205

tered pages, apparently having aged fifteen years since the time of the Corcoran picture. At the upper left one sees, as before, notice of a Sheriff's Sale, now bearing an "ink" inscription, "Mento Mori" (for "memento mori"); King thus clearly identifies his work with the Dutch seventeenth-century tradition of vanitas pictures. The Sheriff's Sale list specifies: "The property of an Artist. Pictures. Fall of the Giants [figures to the life]: Roast Turkey and Beef [painted from recollection]. . . ."

One of the most remarkable aspects of *Vanity of the Artist's Dream* is the extensive "pencil" script with which King has virtually covered the whole of the cupboard's painted trompe l'oeil frame. Included are some twenty different quotations, memoranda, and other notes, including "Advantages of Poverty . . . Never Married for Money," "Sweeter to me is my own crust of bread / than rich viands at the expense of others . . . ," and the notation of fifty cents that he "gave to a beggar (Better off than self)." There is even more printing and handwriting on the objects inside the closet, including the titles of some fifteen books on art, antiquities, poetry, and philosophy, and a host of letters, notes, and invitations. Several items are addressed to "Mr. C. Palette," the artist/owner—one infers—of this motley collection. One item reads: "I regret to inform you that the picture you *lent* to the Boston Athenaeum for their exhibition is sold (*by mistake at half-price*) to Mr. Fullerton who refuses to relinquish it or pay your price." This apparently refers to *Vanity of the Artist's Dream* itself, which was exhibited at the Athenaeum in 1832 as number 39, "Poor Artist's Study," owned by "J. Fullerton." Another notice makes it clear that the painting laments not only the fate of one obviously well-schooled, ambitious painter, but the plight of the arts in America. It reads: "The exhibitions of a Cats Skin in Philadelphia pro-

duced THREE HUNDRED DOLLARS, totally eclipsing its rival the splendid portrait of WEST by Sir T. LAWRENCE, the later [*sic*] we regret to state, did not produce enough to PAY ITS EXPENSES. OH' ATHENS OF AMERICA."

Vanity of the Artist's Dream speaks to the aspirations and disillusion of King's generation of London-trained American painters, in the manner of such contemporary works as Morse's *Gallery of the Louvre*, 1831–33 (Terra Museum of Art, Chicago), or Allston's *Belshazzar's Feast*, 1817–43 (Detroit Institute of Arts). But King alone made his statement within the European trompe l'oeil tradition, in this work imaginatively drawing on several different currents of Dutch and Flemish painting. Vanitas still lifes set in trompe l'oeil niches were well known in Netherlandish art of the sixteenth century, and cupboard and cabinet interiors were frequently represented through the seventeenth and eighteenth centuries.[7] The Amsterdam artist Simon Luttichuys (1610–1661) in 1646 created his *Allegory of the Arts*, a painter's vanitas whose theme is the fragility of life and the risk of relying on one's worldly goods and accomplishments.[8] Luttichuys replaced the typical skull with a classic bust, as King would later; other objects found in both their works include the palette and brushes, frayed books, drafting tools, and a small painting, along with drawings and prints. However, perhaps the most important precedent for King was the work of Cornelis Gijsbrechts (ca. 1610–after 1675), who during the 1660s executed several trompe l'oeil/artist's vanitas pictures that depict in highly illusionistic style such typical vanitas elements as a skull and a snuffed candle, along with documents, drafting materials, and the painter's palette and brushes.[9] King's painting may also refer ironically to the Northern European tradition of the *kunstkammer* (depicting the rare and luxuriant objects of a collection) or the

kunstschranken (curio cabinets containing precious objects): *Vanity of the Artist's Dream* is a rarity in portraying the "collection" of a poor person. Thus, though King drew on a number of precedents with doubtless pride, the accomplishment of *Vanity of the Artist's Dream* was extraordinary, and there are few works of any period which have examined the plight of the artist more obsessively or more plaintively.

Theodore E. Stebbins Jr.

1. The various inscriptions on the painting, about 975 words, have been transcribed by Professor Daniel D. Reiff of the Art Department of the State University of New York at Fredonia. A copy of his work is available in the object file, Fogg Art Museum.
2. Dunlap (1834) 1969, vol. 3, p. 27.
3. Cosentino (1977, p. 80) writes that *Vanity of the Artist's Dream* "represents King at the height of his powers."
4. *Still-Life: Game*, 1806, is in the collection of the IBM Corporation. King in 1828 executed a remarkable composition, *Still Life with Catalogue* (Redwood Library, Newport), depicting a Salvator Rosa–like landscape with an effective trompe l'oeil rendering of a catalogue of his own paintings in the lower right corner. In addition, he is known to have painted up to a dozen traditional fruit and flower subjects: see Cosentino 1977, nos. 485–96.
5. Gerdts and Burke 1971, p. 52.
6. Cosentino (1977, pp. 115–16), King's biographer, makes the case that King was both well patronized and relatively prosperous; in the years around 1832, he was purchasing house lots in Washington and was patronizing the Redwood Library with gifts. Cosentino correctly concludes (ibid., p. 28) that King in *Vanity* was probably commenting on the neglect of artists by the American public.
7. See Milman 1983, pp. 38–49.
8. See Washington–Boston 1989, pp. 114–16, fig. 23.
9. See Gijsbrechts's *Trompe l'Oeil Studio Wall with Vanitas Still Life*, 1664 (Ferens Art Gallery, Kingston upon Hull); see London 2000b.

PROVENANCE: J. Fullerton; Thomas R. Walker, Utica, N.Y.; by descent to Muriel Matthews; acquired by Grenville L. Winthrop; his gift to the Fogg Art Museum, 1942.

EXHIBITIONS: Cambridge, Mass., 1948; New Haven 1967; Cambridge, Mass., 1972a, no. 39; Cambridge, Mass., 1977a; Cambridge, Mass., 1995.

REFERENCES: Dunlap (1934) 1969, vol. 2, pl. 228; Born 1946, illus.; Born 1947, pl. 69; Frankenstein 1953, p. 88; Flexner 1970, p. 194; Gerdts and Burke 1971, pp. 52–53; Cosentino 1974, pp. 58–59, note; d'Otrange Mastai 1975, p. 275, pl. 313; Cosentino 1977, p. 188, no. 501, fig. 79; Baker 1982, illus.; Washington 1983–84, pl. 1; Rebora 1989, p. 36, figs. 13, 14; Rice 1997, cover illus.

John La Farge

New York City, 1835–Providence, Rhode Island, 1910

206. *The Dawn,* ca. 1899

Oil on canvas
31⅛ x 33½ in. (79.06 x 85.09 cm)
1939.90

John La Farge was one of many American painters drawn to Europe during the later nineteenth century to study or travel. His parents were French Caribbean émigrés who had settled in New York, where he was born. As a youth, he tried the study of law, but by his early twenties an interest in art impelled him to visit France, where he was taken with the paintings of Eugène Delacroix in the Louvre and with the landscapes of the Barbizon artists. He studied for a brief time in Paris in the studio of Thomas Couture. In 1857 he returned to the United States via England, where he

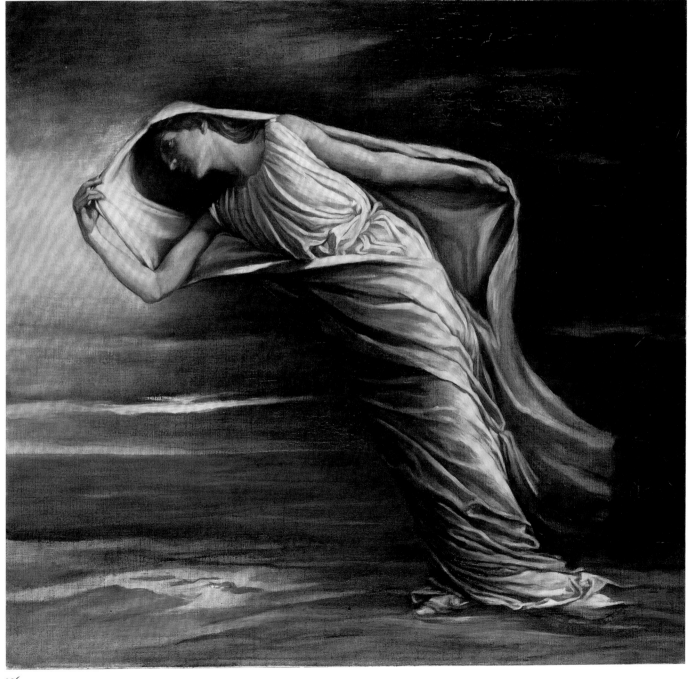

206

was impressed by the work of the Pre-Raphaelite painters. One would like to think that collectively the exposure to these various masters instilled in La Farge his visual interests in expressive color, delicate landscape effects, and classicized figures. Once home, after an unsatisfying effort at law, La Farge turned to studying around Newport with William Morris Hunt, a fellow admirer of Barbizon taste and instrumental figure in encouraging the collecting of Jean-François Millet and Jean-Baptiste-Camille Corot by Bostonians.

During the 1870s La Farge became engaged in mural painting and large-scale interior decorative projects; one of his first and most significant efforts was overseeing the collaborative decorations of the interior of H. H. Richardson's Trinity Church in Boston. The following decade he organized his own decorating company, and played a key role in the furnishing of the Japanese Room for William H. Vanderbilt's house on Fifth Avenue in New York in 1880. That year, for his relative Cornelius Vanderbilt II, La Farge conceived this image of Dawn to decorate the Water Color Room. He drew

his idea in a soft and highly refined black crayon drawing, also in the Fogg collection (1940.88), but the design was never carried out. Nearly twenty years later the artist returned to the theme, painting this large oil, which he exhibited at the Carnegie Institute, Pittsburgh, and later in 1899 sold through Doll and Richards in Boston. The image would see a third incarnation in 1903 as a stained-glass window executed for the Brooklyn residence of Frank Lusk Babbott (now in a private collection).

The large canvas thus retains something of the sinuous drawing and smooth modeling of this allegorical figure in its initial graphic form, while also anticipating the intense glowing colors subsequently realized in stained glass.[1] Here the figure is clothed in drapery of pale rose and salmon pinks, set against a sea and sky of layered light and deep blues and lavenders, with a bright streak of aqua and yellow piercing the dark night clouds in the center distance. La Farge's smooth brushwork and flowing fabrics seem to caress the figure as they suggest her attenuated torso and limbs beneath. His nearly square format creates

an artifice of pure geometry and stability, which is in turn countered by the dynamic tension and sense of motion in the powerful diagonal form moving from right to left against the visual current, as it were. The haunting beauty and sensuous touch of La Farge's monumental form make this work one of the indelible achievements of the American Renaissance.

John Wilmerding

1. The colors in the stained-glass window have been described as follows: "The deep sapphire blue sky of night shading off to paler cerulean is streaked with salmon and yellow light, while the figure stands on a brilliant green ground. This explosive color calls to mind the Fauve paintings that would soon scandalize Paris." La Farge 1987, pp. 219–20.

PROVENANCE: Consigned by the artist to Doll and Richards, Boston, 1900; purchased by Mrs. Roland C. Lincoln, Boston, 1900; her sale, American Art Association, New York, January 22, 1920, no. 57; purchased at that sale by Scott and Fowles, New York; acquired from them by Grenville L. Winthrop, ca. 1930; his gift to the Fogg Art Museum, 1939.

EXHIBITIONS: Pittsburgh 1899–1900, no. 135; Cincinnati 1921, no. 87; New York 1936, no. 24.

REFERENCES: Waern 1896, pp. 43–44; Allen 1936, p. 77; Cortissoz in *New York Herald Tribune*, March 29, 1936; Sayre 1936, p. 28; La Farge 1987, pp. 219–20.

John Singer Sargent

Florence, 1856–London, 1925

207. *The Breakfast Table,* 1883–84

Oil on canvas
21¼ x 17¾ in. (53.98 x 45.09 cm)
Signed lower right: John S. Sargent
Inscribed lower right: à mon cher ami Besnard
1943.150

During his early campaign for celebrity and wealth as a fashionable portraitist in Paris, John Singer Sargent also produced paintings that were more personal and experi-

mental. *The Breakfast Table* superbly exemplifies his regard for some of the recent innovations of the French Impressionists: it is a painter's poem addressing the ambience and comforts of a room adorned with silver and art. The picture's sophisticated, sober palette and passages of broad brushwork affirm Sargent's enthusiasm for the works of Édouard Manet. The composition's subdivisions and cropped

foreground items foster a sense of pictorial intrigue worthy of Edgar Degas. Sargent's attention to the little Japanese picture in the upper left quadrant is another indication of his modernist predilections.

The human focus of *The Breakfast Table* is a solitary young woman absorbed by her reading; she clasps a piece of fruit and a silver knife in her raised hands, but is too preoccupied to eat. Sargent draws the viewer

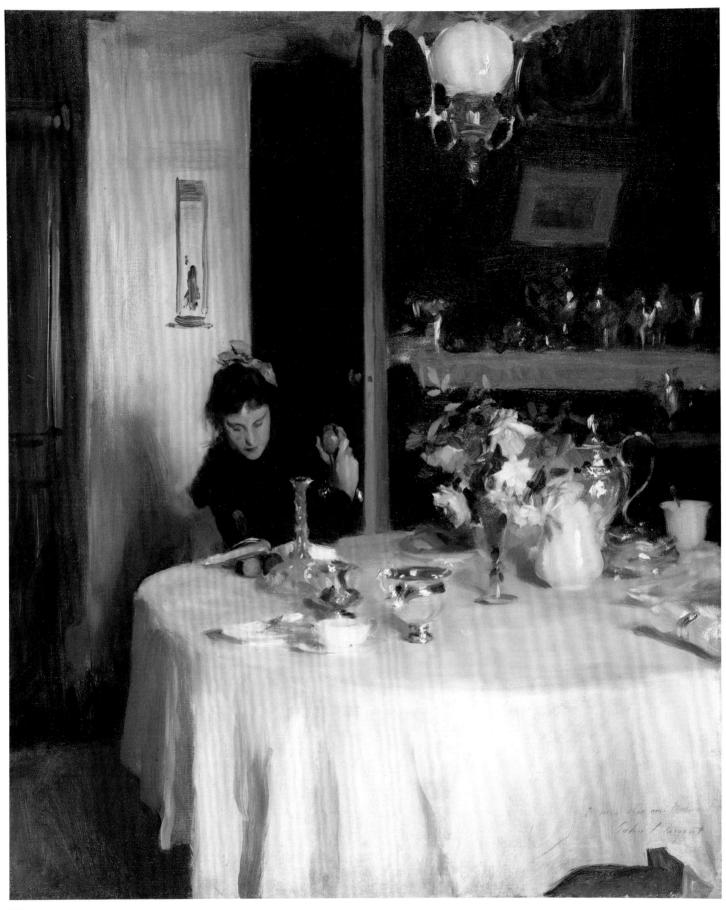

207

into this fleeting moment with additional telling details: daylight from an unseen window at the right; two oranges propping up a book; pink roses lavishly overhanging their vase; a white door standing ajar; and a doorknob silhouetted against the darkness of the adjoining room. He also makes striking use of the various rectangles of color constituting the back of the room: one-half of the young woman's body is set against the white woodwork and the other half against the vertical void of the doorway, whose blackness sets off her hands while engulfing her dark dress.

There is no evidence that this painting ever appeared in an exhibition during Sargent's lifetime, but he put it on public record in 1884–85 by posing with it in two commercial photographs. Both images show it on an easel prominently positioned amid the eclectic decor of his studio on the boulevard Berthier; in one photograph *The Breakfast Table* accompanies the final retouched version of Sargent's notorious submission to the Salon of 1884 (*Madame X*, 1883–84; The Metropolitan Museum of Art, New York).[1] The fact that Sargent inscribed the painting to Albert Besnard, a fairly progressive Parisian artist seven

years his senior, is another reflection of his desire to connect with forward-looking artists and connoisseurs.[2]

The Breakfast Table was probably the first of four informal paintings in which Sargent portrayed red rooms animated by intriguing effects of light. The other works show a wealthy English couple enjoying glasses of port by candlelight; Robert Louis Stevenson and his wife, Fanny, eccentrically positioned on either side of an open door; and a birthday party with cake and candles for the young son of Charlotte and Albert Besnard.[3] When *The Breakfast Table* entered the Winthrop collection in 1935, the young woman in the picture was thought to be a daughter of the artist Frank Millet; more recently Sargent's sister Violet has been proposed as the model.[4] The room has not yet been firmly identified; it may be in the Nice residence rented by the artist's parents or a Parisian interior inhabited by Sargent or one of his friends.[5]

Trevor Fairbrother

1. Auguste Giraudon was the photographer. Both images are illustrated in London–Washington–Boston 1998–99, figs. 8, 9.
2. Sargent and Besnard both exhibited in a group exhibition at the Galerie Georges Petit, Paris, May 1885; Claude Monet was another participant.

3. The paintings are *A Dinner Table at Night* (1884; Fine Arts Museums of San Francisco); *Robert Louis Stevenson and His Wife* (1885; Mrs. John Hay Whitney); and *Fête Familiale* (ca. 1885; Minneapolis Institute of Arts). The owners of *The Breakfast Table* were the subjects of *Fête Familiale*.
4. Frederick F. Sherman (June 1933, p. 96) identified the young woman as Miss Millet. David McKibbin (in Boston 1956, p. 113) identified her as Violet Sargent (Mrs. Francis Ormond).
5. Richard Ormond and Elaine Kilmurray (1998, p. 79) assumed Nice to be the setting. Ormond recently indicated there is no evidence to confirm that Nice was the location; personal communication with Trevor Fairbrother, April 2001.

PROVENANCE: Given by the artist to Albert Besnard, Paris, 1884 or after; purchased from him by Hector Brame, Paris, 1931; purchased from him by M. Knoedler and Co., New York, 1931; purchased from them by Mrs. John D. (Anna R.) Mills, 1933; purchased from her by M. Knoedler and Co., 1935; acquired from them through Martin Birnbaum by Grenville L. Winthrop, 1935; his bequest to the Fogg Art Museum, 1943.

EXHIBITIONS: New York 1934, no. 49; New York 1935; Cambridge, Mass., 1972a, no. 116; Cambridge, Mass., 1977a; Cambridge, Mass., 1985.

REFERENCES: Sherman 1933, facing p. 96; Birnbaum 1941, pp. 29, 50, pl. 2; Mount 1955, p. 445; Boston 1956, pp. 23 (fig. 8), 113; Ormond 1970, p. 31, fig. 32; Ambler and Bolton 1972, pp. 877, 879, fig. 9; New Haven–Philadelphia–Albany 1973–74, pp. 19 (fig. 14), 60; New York 1980, checklist; Simpson 1980, pp. 9, 10, fig. 5; Ratcliff 1982, p. 13, pl. 6; Mortimer 1985, p. 185, no. 211; Fairbrother 1986, p. 199, n. 8; Olson, Adelson, and Ormond 1986, illus. p. 36; Jennings 1991, illus. p. 19; Scott 1991, p. 360; Fairbrother 1994, pp. 54 (illus.), 56–57; Adelson et al. 1997, p. 17, fig. 7; London–Washington–Boston 1998–99, p. 29, fig. 30; Ormond and Kilmurray 1998, pp. 79–80, no. 74, illus.

208. *Man Reading*, 1904–11

Watercolor over graphite on white wove paper
13¾ x 21 in. (34.9 x 53.5 cm)
Signed in brown ink, lower right: John S. Sargent
1943.315

By 1868 the twelve-year-old Sargent was following the artistic example of his mother, who made watercolor sketches as a pastime during the family's travels in Europe. Many of his juvenile watercolors depict the crags, glaciers, and lakes of the Alps, and a few focus on architecture or picturesque local people.[1] Once he was a successful portraitist Sargent produced fewer watercolors and made little effort to exhibit them until his late forties, when he

found a fresh and enduring passion for the medium. He included five recent examples in his first British solo exhibition (Carfax Gallery, London, 1903), then sent five more to the Royal Water-Colour Society's annual show in 1904. Critics on both sides of the Atlantic hailed his watercolors as a new and casual facet of his creativity. In 1912, for example, a prominent New Yorker found himself "breathless in following the sleight-of-hand of so remarkable a virtuoso," and

208

he likened the "sure power" of Sargent's watercolor technique to "the playing of some absolute master in music."[2]

Man Reading richly manifests the technical brilliance that so many of Sargent's contemporaries admired in his watercolors. The artist shows a man slumped on a bed, his body engulfed in large, puffy pillows. A lamp directs a beam of strong light on the papers in the subject's hand; the cushions throw shadows across his head and torso. Sargent's certainty of touch and his gift for recording nuances of light and shadow imbue the scene with a tremendous sense of realism. But we are thwarted if we move closer to look for more factual details. The best reward of close scrutiny is a greater awareness of Sargent's painterly "sleight-of-hand"—his free and confident application of transparent washes and his dramatic scratches that expose the white

paper and produce sharp linear highlights (see, for example, the cushion supporting the man's head).

Throughout his career Sargent painted and drew people in reclining poses; he did this inside and out-of-doors, and he produced numerous pictures that quietly celebrate reading, napping, or resting. *Man Reading* belongs to a subgroup devoted to men resting indoors. It was probably painted during a holiday abroad, for its subject and mood recall the watercolor *In Switzerland*, which Sargent sold to the Brooklyn Museum in 1909. There is insufficient visual evidence for a conclusive identification of the model. Recent suggestions include the artist's valet, Nicola D'Inverno, and Lawrence Alexander ("Peter") Harrison, an English artist and frequent holiday companion of Sargent's.[3]

Trevor Fairbrother

1. For a good introduction to these early works, see Herdrich and Weinberg 2000.
2. Cortissoz 1912, p. 7.
3. Another watercolor (*Peter Harrison Asleep*, private collection) shows a very similar interior with the same voluminous pillows, but the person is probably not the one depicted in *Man Reading*. When Winthrop purchased his watercolor from Scott and Fowles in 1922, it bore the title *Sebastino (Man Reading)*. Since Sargent was still alive he may have given it that title. There is no conclusive evidence to connect the reading man with anyone named Sebastino; nonetheless, a few speculative proposals exist in the object file, Fogg Art Museum.

PROVENANCE: Acquired from Scott and Fowles, New York, by Grenville L. Winthrop, April 3, 1922 ($3,000); his bequest to the Fogg Art Museum, 1943.

EXHIBITIONS: Cambridge, Mass., 1972a, no. 117; Cambridge, Mass., 1977b, no. 55.

REFERENCES: Birnbaum 1941, p. 59, illus.; Boston 1956, p. 92; New York 1980, checklist; Herdrich and Weinberg 2000, pp. 308–9, under no. 283.

209. *In the Simplon Valley*, ca. 1905–11

Oil on canvas
38⅛ x 45⅝ in. (96.84 x 115.89 cm)
1943.155

The Simplon Valley is one of the main passes linking Switzerland and Italy. Sargent knew it well from his peripatetic childhood and returned there often as an adult, usually making it an early stop on his holiday trips. *In the Simplon Valley*, a moody, atmospheric canvas, captures both the rugged grandeur of the Alps and the sweet relief they promise during a hot summer. Sargent shows four brightly clad people—three women and a man—relaxing in a secluded and sheltered meadow in the foreground.[1] The ancient mountains dwarf these visitors, who are clearly as fleetingly seasonal as the blossoms on the shrubs nearby. Sargent has ascended the grassy slope and settled at some remove from his companions. His position allows him to gaze down on their diminutive figures and look up to the awe-inspiring mountain peaks. *In the Simplon Valley* celebrates the kind of day when the play of light in the immense Alpine space is changeable and very exciting. Sargent brilliantly captures the vivid highlights playing on the edges of one mountain ridge. In the upper left corner he shows clouds rolling dramatically across the sky, but for the most part he devotes himself to the more difficult task of translating the desolate topography of cliffs and immense boulders into thickly applied passages of paint.

This picture conveys Sargent's delight in remote summer places that allowed him to enjoy the company of a select circle of

211

wilderness. One wonders if Sargent, now in his fifties and no longer an advocate of innovative art, was thinking about aging when he gave Raffele such a precarious place in his composition. Photographs of Sargent at work in the Alps in this period confirm that he was just as burly as his Italian friend; it seems valid, therefore, to read *Artist in the Simplon* as a surrogate self-portrait.[2]

This is one of six Sargent watercolors purchased by Winthrop in 1922.[3] It was notoriously difficult to persuade Sargent to sell his watercolors, although he eventually made exceptions for major museums and such longtime supporters as Isabella

Stewart Gardner of Boston and Asher Wertheimer of London. Winthrop's loyal dealer, Martin Birnbaum, befriended the artist soon after World War I, and he probably deserves the credit for bringing this remarkable cache of watercolors into private hands three years before Sargent's death. Birnbaum's 1941 memoir about Sargent bears the dedication "To Grenville Lindall Winthrop."[4]

Trevor Fairbrother

1. The pictures are *Reconnoitering* (ca. 1911, oil on canvas; Palazzo Pitti, Florence) and *The Hermit* (1908, oil on canvas; The Metropolitan Museum of Art, New York).
2. For photographs of Sargent at work in the Simplon, see Adelson et al. 1997, figs. 51, 60, 88, 242.

3. Winthrop purchased the following watercolors in 1922: *Cathedral, Granada, Spain* (1942.56); *Olive Trees, Corfu* (cat. no. 210); *Man Reading*; *Garden at Florence* (1942.55); *Artist in the Simplon* (1942.54); and *Boats, Venice* (1943.317). All are now in the collection of the Fogg Art Museum.
4. Birnbaum 1941, p. [vii].

PROVENANCE: Acquired from Scott and Fowles, New York, by Grenville L. Winthrop, August 15, 1922 ($3,200); his gift to the Fogg Art Museum, 1942.

REFERENCES: Boston 1956, p. 118; New York 1980, checklist; Adelson et al. 1997, pp. 32, 48, fig. 19; Little 1998, illus. p. 74; Esten 2000, illus. p. 69; Herdrich and Weinberg 2000, p. 274, fig. 105.

James Abbott McNeill Whistler

Lowell, Massachusetts, 1834–London, 1903

212. *Nocturne in Blue and Silver*, ca. 1871–72

Oil on wood
17 ³⁄₈ x 24 in. (44.1 x 61 cm)
Signed lower right with a butterfly device
1943.176

The American expatriate artist James McNeill Whistler was a controversial figure in London, where he chose to live for nearly all his years after 1859. His most celebrated public assertion of his "art for art's sake" project occurred in 1878 through the highly publicized trial of *Whistler v. Ruskin*. This case tried Whistler's libel suit against the most prominent British art critic of his day, John Ruskin, for his criticism of the artist's works exhibited at the Grosvenor Gallery in 1877. Among these eight paintings was this *Nocturne in Blue and Silver*.

While today it may be difficult to conceive that such a lovely picture could generate outrage, its perceived lack of "finish" offended many Victorian critics and viewers besides Ruskin. Whistler's engagement with broad overall effects of color and tone registered in the 1870s as an affront to artistic standards and to middle-class morality through its rejection of a pictorial work ethic that valued the hours of labor evinced by minutely rendered details. The most famous excerpt of the passage from Ruskin's criticism at issue in the 1878 trial described another "Nocturne"—*Nocturne in Black and Gold: The Falling Rocket* (ca. 1875)—as Whistler's "flinging a pot of paint in the public's face." Yet Ruskin's critique of Whistler's paintings at the Grosvenor Gallery lambasted not only the *Nocturne in Black and Gold* but his other oils on display there as well, including this

Nocturne in Blue and Silver. Ruskin described all of these works as products of the artist's "ill-educated conceit" that "nearly approached the aspect of wilful imposture."[1] As Ruskin's words demonstrate, Whistler's daring reductions in order to promote painting as a purely formal entity could be seen at the time as verging on artistic fraudulence.

This work is among the earliest of the paintings of night that Whistler called "Nocturnes," after the term for a musical piece evoking the night. The artist presented this *Nocturne in Blue and Silver* as a gift to Frances Leyland, the wife of his patron Frederick Leyland. Whistler had initially called these night scenes "Moonlights," until Frederick Leyland proposed the term "Nocturne." Whistler wrote in thanks to Leyland for suggesting this title: "You have no idea what an irritation it proves to the critics and consequent pleasure to me—

besides it is really so charming and does so poetically say all I want to say and *no more than I wish!*"[2] This note conveys Whistler's pleasure in "irritating" the art critics of his day, as well as his concern to avoid producing works that were too explicitly representational. His preference for suggestive abstraction is apparent in this *Nocturne*'s attention to the cool tonalities of the expanse of water, while the city of London is reduced to the shadowy silhouette of a skyline.

The *Nocturne in Blue and Silver* demonstrates Whistler's capacity to combine graphic representation with formal abstraction. The painting conveys a sense of a particular view across the Thames, looking from Lindsey Row in Chelsea across to the spire of Battersea Church and the muted signs of modern industry—factory chimneys and a slag heap. Yet the concentration of color and tone into a narrow range of

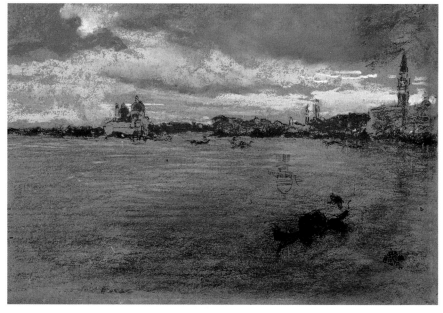

Fig. 198. James Abbott McNeill Whistler, *The Storm-Sunset*, ca. 1880. Pastel on brown wove paper, 7¼ x 11¼ in. (18.4 x 28.6 cm). Fogg Art Museum, Bequest of Grenville L. Winthrop, 1943.624

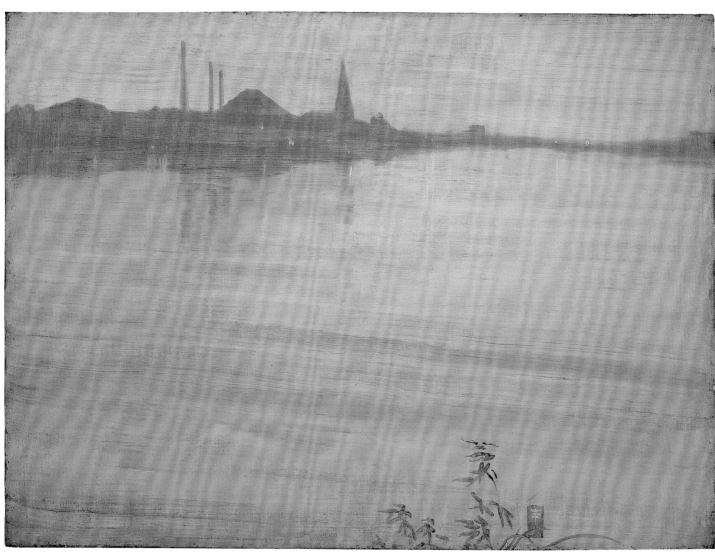

212

silvery blues yields a unified surface reminiscent of the smooth surfaces of the blue-and-white Chinese porcelains that Whistler assiduously collected. The sprays of leaves near the bottom edge of the canvas are painted thinly with a calligraphic touch that relates to the artist's well-documented admiration for East Asian art. Set within a rectangular cartouche is the golden design of a schematic butterfly, which Whistler had adopted as his signature by 1869.

The *Nocturne in Blue and Silver* includes two fainter echoes of the already attenuated London skyline: first, in the reflections in the water, and again, in a dim echo underneath the painted water at the lower left of the picture. While this phantom skyline may have become more visible through the years as the covering paint has grown more

translucent, it may also have been discernible from the start, perhaps deliberately included within the composition by an artist fond of innuendo and fascinated by the play between absence and presence. *The Storm-Sunset* (fig. 198), a pastel by Whistler in the Winthrop collection that is not included in this exhibition, likewise includes the inverted image of a building left visible in the finished work: the outlines of a dome, indicating the artist's initial foray into drawing the Santa Maria della Salute before inverting the page, floats ghostlike in the waters of this Venetian view.

Aileen Tsui

1. Ruskin's oft-quoted words from *Fors Clavigera* 79 (July 1877) can be found in Merrill 1992, p. 47.
2. Whistler's letter to F. R. Leyland, [November 1872], is quoted in Merrill 1992, p. 31.

PROVENANCE: Presented by the artist to Mrs. F. R. Leyland, London, before November 1872; Hunt Henderson, New Orleans, after 1910; his bequest to Tulane University, New Orleans, 1939; acquired from it through Martin Birnbaum by Grenville L. Winthrop, April 1941; his bequest to the Fogg Art Museum, 1943.

EXHIBITIONS: London 1877; London 1892, no. 9; Baton Rouge 1937; Cambridge, Mass., 1972a, no. 92; Cambridge, Mass., 1985, p. 54; Cambridge, Mass., 1994, no. 34.

REFERENCES: Way and Dennis 1903, illus. facing p. 60; Pennell and Pennell 1908, vol. 1, pp. 234, 236 (illus.), 239–40; Sickert 1908, p. 156, no. 45; Pennell and Pennell 1921, illus. facing p. 20; Richardson 1947, illus. p. 11; Prideaux 1970, p. 109; Weintraub 1974, p. 143; Young, MacDonald, and Spencer 1980, vol. 1, p. 69, no. 113, vol. 2, pl. 107; Spencer 1989, p. 138, pl. 41; Merrill 1992, pl. 4; Pyne 1994, p. 74, illus.; Lechien 1995, pp. 60–65, illus.; Madeline 1995, pp. 50–51, illus.; Siewert 1995, p. 38; New Haven–Denver–Newcastle upon Tyne 1996, p. 97, fig. 52; Tedeschi 1997, p. 9, no. 5; Merrill 1998, p. 126, fig. 3.9; Stratis and Tedeschi 1998, vol. 1, p. 44, fig. 8.

213. *Harmony in Grey and Peach Colour*, 1872–74

Oil on canvas
76 x 39¾ in. (193 x 101 cm)
Signed center left with a butterfly device
1943.165

Although Whistler nominally won the libel suit that he brought against Ruskin, he was granted only a farthing in damages, rather than the thousand pounds he had sought. For an artist already in a financially precarious position, the costs of the legal expenses for the trial led toward bankruptcy in 1879. When the contents of his studio had to be confiscated by bailiffs, Whistler deliberately defaced his unfinished paintings before relinquishing them to his creditors. The *Harmony in Grey and Peach Colour* is one of the works that suffered this treatment. Although the outright signs of defacement have been cleaned off, we still face a canvas that is only unevenly finished. Most notably, for instance, the figure lacks hands. When Elizabeth Pennell, one of Whistler's earliest biographers, saw the painting in 1910 she described it as "a sadly battered ghost of a Whistler."[1]

Although it is not worked up to the more consistent representational resolution and unified surface coherence characteristic of Whistler's finished canvases, the *Harmony in Grey and Peach Colour* is nevertheless a striking image. Though the sitter has not been identified for certain, her face suggests the likeness of Maud Franklin, the model who began to pose for Whistler in the early 1870s and became his mistress. This portrait is unusual in Whistler's oeuvre in its combination of overt signs of *japonisme*, more often in evidence in his figure paintings from the early to mid-1860s, together with the gray tonalities, ultra-thin facture, and geometric elements characteristic of his portraits of the 1870s. These characteristic qualities of Whistler's

portraits of the seventies are apparent in his most famous painting, the *Arrangement in Grey and Black* (1871; Musée d'Orsay, Paris) often called "Whistler's Mother." Like "Whistler's Mother," the *Harmony in Grey and Peach Colour* includes a framed work of art on the wall, cut by the edges of the canvas into a slice of geometry; the *Harmony*'s emphasis on geometric order continues in the pattern of lines and checks in the carpet, and in the young woman's stiffly upright bearing. Yet, unlike "Whistler's Mother," the severe angularity of the composition is softened by blossoms, the pouf of fabric at the young woman's waist, and the circular cartouche around Whistler's butterfly signature.

The fans pinned to the wall, the pink blossoms, and the large ceramic jar—only dimly visible in the painting today but more prominent in a preparatory drawing in the Manchester Art Gallery[2]—are signs of Whistler's enthusiastic participation in *japonisme*, the late-nineteenth-century European and American fad for Japanese objects. Besides Whistler's incorporation of Japanese and Chinese objects into such studio scenes as this, his passion for these decorative objects encouraged his move to develop paintings preoccupied with their formal design as decorative surfaces. Whistler was among the earliest of Western artists to esteem East Asian decorative objects as works of art on the same level as the fine arts of painting and sculpture in the European tradition. In this *Harmony*, for instance, two Japanese fans hang opposite the framed picture or print on the wall, as if equating the decorative

and the fine arts. Yet even though Whistler titled his painting as an arrangement of colors—*Harmony in Grey and Peach Colour*—the work also participates in the Western tradition of portraiture, the woman's face staring outward with subjective intensity even as her body in its white dress appears strangely immaterial. The dematerialized quality of the work as a whole is an effect of the artist's idiosyncratic technique, after 1870, of working with extremely thin paint.

Aileen Tsui

1. Pennell and Pennell 1921, p. 135.
2. For this study for the *Harmony in Grey and Peach Colour*, executed in chalk, pastel, and gouache, see MacDonald 1995, p. 175, no. 469.

PROVENANCE: Purchased at Whistler's bankruptcy sale by a dealer for Thomas R. Way senior, London, 1879; by descent to the Misses Way; purchased from Sotheby's, London, by Agnew, London, 1916; purchased from them by C. W. Kraushaar Galleries, New York, 1916; Mrs. Benjamin Thaw; purchased from her through Mrs. C. Lewis Hind, London, by John F. Braun, Merion, Pa., 1918; to his wife at his death; acquired from her through Ferargil Galleries, New York, by Grenville L. Winthrop, 1939; his bequest to the Fogg Art Museum, 1943.

EXHIBITIONS: London 1874, no. 7; London 1910, no. 43; Philadelphia 1930; New York 1932–34; Chicago 1934, no. 434; Cambridge, Mass., 1977a; Cambridge, Mass., 1994, no. 86; Tokyo 2002, no. 70.

REFERENCES: Rossetti 1874; Way and Denis 1903, pp. 26–27, reproduction in pastel facing p. 26; Pennell and Pennell 1908, vol. 1, p. 258; Way 1912, illus. facing p. 139; *Fine Arts Journal* (Chicago) 1917, pp. 137–39, illus. facing p. 134; Pennell and Pennell 1921, pp. 134–35, illus. facing p. 134, reproduction in pastel facing p. 275; Henri 1923, p. 275; Watts 1926, illus. p. 47; Stubbs 1948, p. 22; Sutton 1963, p. 72; Sutton 1966, pl. 63; Young, MacDonald, and Spencer 1980, vol. 1, p. 79, vol. 2, pl. 83; Washington 1984, p. 255, fig. 240.3; Heartney 1987, pp. 1–2; MacDonald 1987, pp. 13–14, fig. 1; Stratis and Tedeschi 1998, vol. 2, p. 154, n. 171.2.

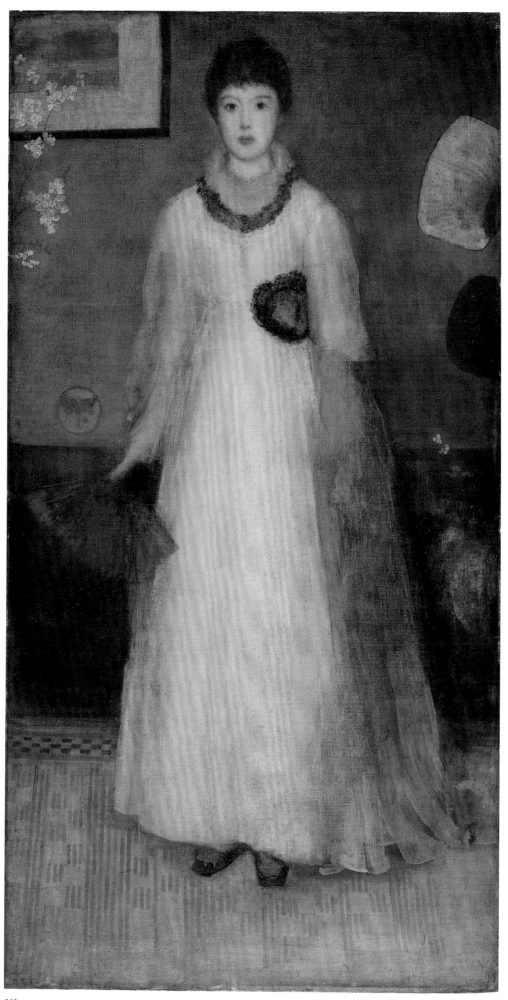

213

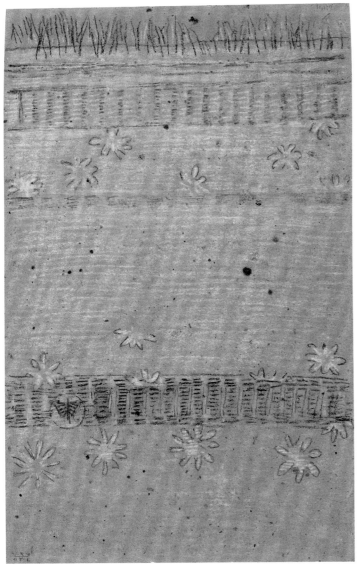

214. *Design for Matting;* verso: *Design for Paneling,* 1873–75

Pastel on brown wove paper
11⅛ x 7¼ in. (28.2 x 18.4 cm)
Signed at left of recto with a butterfly device in
black and peach pastel
1943.610

The designs for matting and for paneling on the two sides of this page are examples of several such existing designs that Whistler made for the decoration of his own homes, the homes of others, and his exhibition spaces. In planning the decoration of his exhibition spaces, the artist designed all aspects of the physical surround for his paintings, drawings, and prints: floor matting, wall colors, lighting, drapes, seating, floral appointments, banners, invitation cards, catalogue, and even the costume of the attendant. The artist was equally scrupulous in designing and selecting the decorations and furnishings of his own home. At a time when interior decoration tended toward ornate elaboration, Whistler's designs were notable for their lightness and their spare elegance, foregrounding proportion, space, and subtly harmonized colors.

Although serving as a design for the production of matting, this sketch also functions as a work of art in itself, as the careful placement of the artist's butterfly signature amid the floral elements indicates. David Park Curry has previously noted an affinity between this design for matting and Whistler's seascapes in their shared compositional concern with horizontal bands of color.[1] Whistler's involvement with the decorative arts was linked to his promotion of the purely formal components of his easel paintings: even while the near abstraction of his paintings brought them closer to decoration, the attention that he accorded to such decorative schemes as this design for floor covering suggested their elevation to a status equal to that of painting. In this design for matting, the repeated colors are

punctuated by the asymmetrical scattering of flowers and by the visible irregularities in the texture of the brown paper, producing an overall effect both unified and animated.

Aileen Tsui

1. Curry 1984, p. 1196.

PROVENANCE: Purchased from Dowdeswell Galleries, London, by Colnaghi, London, March 1917; purchased by Scott and Fowles, New York, June 1921; Hunt Henderson, New Orleans; his bequest to Tulane University, New Orleans, 1939; acquired from it by Grenville L. Winthrop, 1941; his bequest to the Fogg Art Museum, 1943.

REFERENCES: Curry 1984, fig. 9 (recto); Washington 1984, p. 185, fig. 106.1 (recto); MacDonald 1987, p. 73, fig. 10; Dorment and MacDonald 1995, p. 158, illus. under no. 73; MacDonald 1995, pp. 182–83, no. 493 (recto and verso), illus.

215. *Nocturne in Grey and Gold: Chelsea Snow*, 1876

Oil on canvas
18¼ x 24¾ in. (46.4 x 62.9 cm)
1943.172

In addition to its merits as a painting, the *Nocturne in Grey and Gold: Chelsea Snow* holds historical significance as the central example in Whistler's text "The Red Rag." In his day, the artist was celebrated not only as a painter and graphic artist but equally as a wit and the author of catalogues, pamphlets, books, and letters to newspapers. Of these varied texts, "The Red Rag" comprises the most concise summary of Whistler's artistic aims. First published as a newspaper interview in 1878 and then, in revised form, in his book *The Gentle Art of Making Enemies* (1890 and 1892), "The Red Rag" discusses this *Nocturne* as follows: "I care nothing for the past, present, or future

215

of the black figure, placed there because the black was wanted at that spot. All that I know is that my combination of grey and gold is the basis of the picture. Now this is precisely what my friends cannot grasp. They say, 'Why not call it "Trotty Veck," and sell it for a round harmony of golden guineas?'—naïvely acknowledging that, without baptism, there is no . . . market! . . . I should hold it a vulgar and meretricious trick to excite people about Trotty Veck when, if they really could care for pictorial art at all, they would know that the picture should have its own merit, and not depend upon dramatic, or legendary, or local interest."[1]

In Whistler's view, to value a painting as narrative illustration was to slight its true significance as a formal construction. Eschewing sentiment and anecdote, his works promoted pure color and form at a time when a painting's importance was most often judged according to its effective representation of a significant, instructive, or elevating subject. The title "Trotty Veck" would have signaled viewers to read

this painting as an illustration of Charles Dickens's Christmas novella *The Chimes* (1845), in which Trotty Veck is a poor but virtuous old man who walks through the cold London streets to earn his meager living as a messenger. Against such interpretation, Whistler's text insists that the figure in his painting is no more than a patch of color demanded by the work's visual balance: "the black . . . wanted at that spot."

Whistler's text describes this painting as if it hovers in its own aesthetic realm, apart from the market, and apart from the specific conditions of time and place. The dark figure is significant as a formal element, not as a character with a "past, present, or future." Indeed, the road down which the figure walks appears to end in a heap of snow, as if its access to any future destiny is blocked. The white snow and the yellow of the lamplight at the window are the most solidly painted elements of a work in which the buildings are strangely insubstantial, created through a reserved effect of exposed dark ground.

Aileen Tsui

1. Whistler (1892) 1967, pp. 126–27.

PROVENANCE: Purchased from the artist by C. A. Howell, London, 1878; purchased by Alfred Chapman, Esq., Liverpool, 1878; purchased by Whistler, 1894 or later; purchased by John James Cowan, Edinburgh, December 1898; Edwin Amsinck, Hamburg; bequeathed to his wife, Antonie; bequeathed by her to the Kunsthalle, Hamburg, 1921; sold by the Kunsthalle, Hamburg, through the Galerie G. Paffrath, Düsseldorf, May 1926; acquired from Scott and Fowles, New York, by Grenville L. Winthrop, March 1933 ($8,000); his bequest to the Fogg Art Museum, 1943.

EXHIBITIONS: London 1878, no. 57; Munich 1888, no. 57; London 1892, no. 16; Paris 1892, no. 1069; Edinburgh 1901, no. 347; London 1930; Cambridge, Mass., 1972a, no. 93; Cambridge, Mass., 1994, no. 21; Tokyo 2002, no. 69.

REFERENCES: Way and Dennis 1903, pp. 20, 60–61; Duret 1904, illus. facing p. 82; Whistler 1904, pp. 126, 307–8; *Gazette des beaux-arts*, ser. 3, 34 (1905), p. 239, illus.; Pennell and Pennell 1908, vol. 1, pp. 166–67; Sickert 1908, pp. 142, 145, 159; Bryan 1909–10, vol. 5, p. 363; Pauli 1922, p. 243, no. 2487; Laver 1930, p. 182; Boston 1939, p. 91; Sutton 1966, p. 192, pl. 80; Holden 1969, pp. 46–47, illus.; Weintraub 1974, pp. 140–41; Sutton 1978b, pp. 290–91, illus.; Young, MacDonald, and Spencer 1980, vol. 1, p. 100, no. 174, vol. 2, pl. 94; Cabanne 1985, illus. p. 57; Cavendish 1985b, illus. p. 595; Mortimer 1985, p. 185, no. 210, illus.; MacDonald 1987, p. 22; Spencer 1989, p. 162, pl. 49; Lechien 1995, pp. 84–86, illus.

216. *Nocturne in Black and Gold: Rag Shop, Chelsea*, ca. 1878

Oil on canvas
15 1/8 x 20 5/8 in. (38.4 x 52.4 cm)
1943.173

On a dark London street, a little girl stands in the open doorway of a lighted interior, while passersby stop to peer at goods in a shop window. Their heads are dimly silhouetted against the light in the window, while their bodies are swallowed up by the night.

This *Nocturne in Black and Gold* shows Whistler's attraction to subjects that allowed him to suggest formal self-reference, even while continuing painting's representational

function. While the unifying darkness of night enabled him to approach the pure color of the monochrome, the subject of a simple architectural facade aligned with the picture plane allowed him to deploy geometric forms that emphasize the two-dimensional nature of the canvas support.

Whistler's attraction to building facades, rare as the subject for a Nocturne, recurs frequently in his etchings, pastels, and in the small oils on wood—only about four by nine inches in size—that he painted in the 1880s and 1890s. The Winthrop collection includes one such oil on panel of a

building facade: *White and Grey: Courtyard, House in Dieppe* (fig. 199), not included in this exhibition. As is also the case in his small panels, this *Nocturne in Black and Gold* positions the building's facade parallel to the picture plane, so that the ordered geometry of the mullioned windowpanes begins to suggest the elements of a modernist grid. Visible through the extremely thin paint layer, the weave of the canvas produces another gridlike effect, albeit on a much finer scale.

The child in her white dress, standing in the illuminated doorway, adds to the enig-

216

Fig. 199. James Abbott McNeill Whistler, *White and Grey: Courtyard, House in Dieppe*, ca. 1885. Oil on wood panel, 8¼ x 5 in. (20.96 x 12.7 cm). Fogg Art Museum, Bequest of Grenville L. Winthrop, 1943.168

matic effect of this *Nocturne*. Whistler often represented figures standing in open doorways in his prints, especially in his Venice etchings of 1879–80. The viewer catches a glimpse of the interior space of a house or an inner courtyard, the open doorway providing the suggestion of depths beyond the flat facade of the building or wall. This motif of the open doorway may be taken as a metaphor for the operations of the painting or print itself, which provides the suggestion of something beyond the flat surface of the canvas or paper. By includ-

ing an open door in this *Nocturne in Black and Gold*, Whistler could suggest the otherworldliness of aesthetic experience even while emphasizing the fact of his painting as a flat surface through its reiteration of gridlike horizontal and vertical elements.

Aileen Tsui

PROVENANCE: Purchased from the artist by John James Cowan, Edinburgh, 1899; purchased at his sale, Christie's, London, by Mason, 1926, no. 161; acquired from Scott and Fowles, New York, by Grenville L. Winthrop, 1930 ($4,900); his bequest to the Fogg Art Museum, 1943.

EXHIBITIONS: London 1884, no. 58; London 1899c, no. 134; London 1905a, no. 90; Edinburgh 1925, no. 52.

REFERENCES: Way and Dennis 1903, illus. facing p. 64; Cary 1907, p. 221, no. 436; Sickert 1908, p. 162, no. 82; Sutton 1966, pp. 78 illus., 192; Holden 1969, p. 48, pl. 14; Young, MacDonald, and Spencer 1980, p. 118, no. 204; Spencer 1989, p. 188, pl. 59.

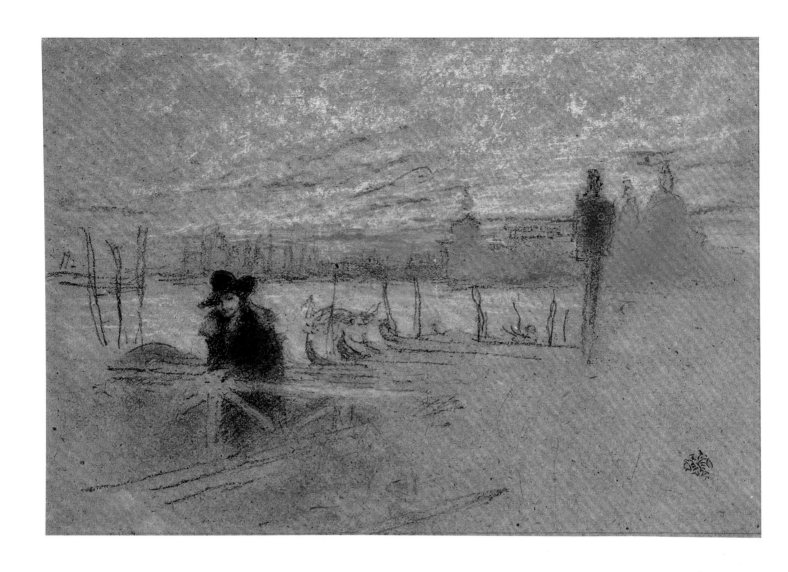

217. *Sunset; Red and Gold—The Gondolier,* 1880

Pastel on brown wove paper
7⅛ x 11 in. (18.2 x 27.8 cm) (sight)
Signed lower right with a butterfly device in black crayon and orange pastel
1943.617

In 1881 at the Fine Art Society in London, Whistler exhibited fifty-three pastels—including this one—that he had made during his 1879–80 sojourn in Venice. An article in *The Court Journal* reported, "The rooms of the Fine Art Society have become almost a battle-field for the London critics—so divided are the opinions, so impassioned the arguments for and against the Whistler style of painting."[1] This remark about Whistler's controversial style of "painting" refers to the artist's innovative manipula-tion of the pastel medium. Ordinarily, the entire surface of the paper would be cov-ered over by the pastel pigment, whereas Whistler's pastels employ the paper itself as an important component of the image, with the pigment only touching in certain fea-tures: here, the colors of the sunset, the suggestion of a skyline, the prows of gon-dolas, a shadowy figure.

In this pastel, the figure of the gondolier at the left foreground is balanced by Whistler's butterfly signature positioned in the lower right corner. The butterfly's deci-sive articulation asserts the artist's clear-sighted decision in producing an image that is deliberately vague, employing selective degrees of elaboration and focus for effects of evocative suggestion. This suggestive indefinition troubled one British critic in 1881 who voiced irritation at the work's perceived lack of "finish": "Then look at No. 46, the gondolier, with a misty and sug-gestive boatman rowing in a phantom boat. We admire the colour and tone, but we can-not help asking helplessly, Why on earth not finish the gondolier? It is this deliberate incompleteness, this purposed vagueness and want of finish that persistently puzzle and irritate us."[2]

Yet despite their daring rejection of con-ventional finish and of the conventions of the medium itself through the foreground-ing of the paper support, Whistler's Venice pastels were a great success with British

1. *Court Journal*, February 12, 1881, quoted in Getscher 1991, p. 185.
2. "Mr. Whistler's Venice Pastels," *Pan*, February 5, 1881, quoted in Getscher 1991, p. 181.

PROVENANCE: Mme Blanche Marchesi; possibly "The Salute, Sunset" purchased from J. P. Heseltine by Colnaghi, London, 1926; possibly "Salute, Sunset, Venice" acquired from Alphonse Kann through Martin Birnbaum by Grenville L. Winthrop, 1927; his bequest to the Fogg Art Museum, 1943.

EXHIBITION: London 1881, no. 46.

REFERENCES: *James's Gazette*, February 2, 1881; *Pan*, February 5, 1881; "Art: Venice Pastels," *Observer* (London), February 6, 1881, p. 1; Way and Dennis 1903, p. 93; Cary 1907, pp. 216, 397; Way 1912, illus. facing p. 52; Sutton 1966, p. 193, no. 89, pl. 89; Young, MacDonald, and Spencer 1980, p. 124; Getscher 1991, pp. 122–23, 181–82, no. 42; Wadley 1991, pl. 12; MacDonald 1995, pp. 302–3, no. 806; Grieve 2000, p. 165, fig. 213; MacDonald 2001, p. 45, fig. 47.

patrons: nearly all of the pastels shown in the 1881 exhibition sold. In the city of Venice, Whistler found a subject whose associations with exoticism, beauty, poetry, and the dream accorded nicely with his own artistic propensity for creating works that evoke an otherworldly realm of pure color and dreamlike indefinition.

Aileen Tsui

218. *Note in Black and Grey*, 1883–84

Watercolor on off-white cardboard
8⅜ x 5 in. (21.4 x 12.6 cm)
Signed in watercolor with a butterfly device, center right
1943.618

This watercolor is likely the *Note in Black and Grey* included in Whistler's *"Notes"— "Harmonies"— "Nocturnes"* exhibition at the Dowdeswell Galleries, London, in May 1886. Also called an "Arrangement in Brown and Gold," the exhibition attracted attention with its strikingly coordinated interior decoration, designed by the artist. In this exhibition, Whistler displayed together small works in different media: forty-eight watercolors, twelve oils, eight pastels, and seven drawings. The smallness of the works, the variety of media, and their display in an interior designed as a work of art in itself—as the "Arrangement in Brown and Gold" title implies—all worked together to convey Whistler's view that a true artist expressed his artistry in everything he touched, not just in the large oil paintings considered most important by conventional Victorian criteria.

Although this watercolor's title of *Note in Black and Grey* provides no clue to the sitter's identity, which remains unknown, the face that looks out at the viewer quietly communicates an expressive presence, despite the small scale of the work, its nearly monochrome palette, and its remarkable physical delicacy. The distribution of denser and more transparent dark washes on the page envelops the form of the young woman in a richly shadowy atmosphere. Whistler often posed his portrait subjects clothed in black or gray,

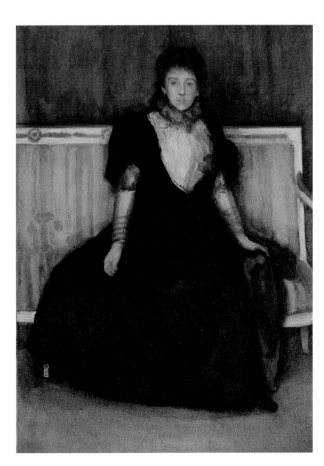

Fig. 200. James Abbott McNeill Whistler, *Green and Violet: Mrs. Walter Sickert*, 1885–86 or 1894. Oil on canvas, 34 x 24½ in. (86.4 x 62.2 cm). Fogg Art Museum, Bequest of Grenville L. Winthrop, 1943.166

standing against a black curtain in his studio with the shades drawn to filter and lower the light.

Whistler titled this work a "Note," as he did a number of other watercolors, pastels, and small oils. The term participates in the artist's idiosyncratic system of musical titling while also conveying a sense of brevity or concision of means. Yet the artist

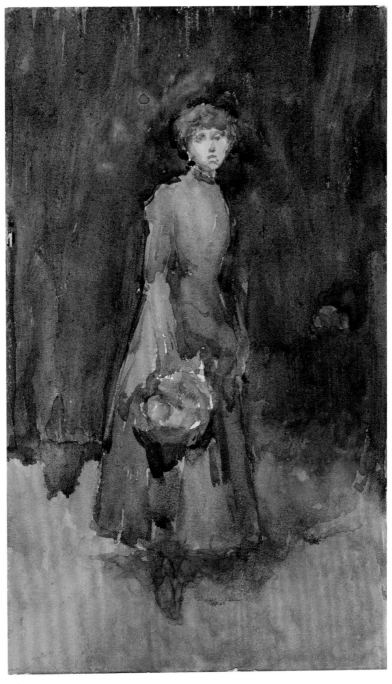

218

did not consider these smaller Notes any less important than the more complex compositions on a grander scale to which he gave such titles as "Harmony" or "Symphony." When producing full-length portraits in the last two decades of his life, Whistler tended to paint nearly lifesize images or else extremely small portraits in oil or watercolor, such as this one, in order to make the point that scale was irrelevant to the value and importance of a work of art. (In its middling size, a portrait of Mrs. Sickert in the Winthrop collection [fig. 200] is unusual in Whistler's oeuvre.) Like the low tone of this and many of his works, the small size of such portraits demands intensely focused attention from the viewer, so that a cursory glance will not be rewarded. In accordance with Whistler's conception of the elevation of art, the *Note in Black and Grey* demands a highly attuned mode of viewing.

Aileen Tsui

PROVENANCE: Probably purchased from the 1886 Dowdeswell Galleries exhibition by Mrs. Blomfield More, London; probably purchased at her sale, Christie's, London, May 5, 1900, by Boussod Valadon et Cie; Albert Rouillier, Chicago dealer, by 1904; acquired from Alphonse Kann through Martin Birnbaum by Grenville L. Winthrop, 1927; his bequest to the Fogg Art Museum, 1943.

EXHIBITIONS: Probably included in London 1886b, as no. 40; probably exhibited in London 1901, as no. 33; Boston 1904, no. 104.

REFERENCES: Wadley 1991, p. 249, pl. 83b; MacDonald 1995, pp. 354–55, no. 931, illus.

219. *Brown and Gold: Lillie "In Our Alley!"* ca. 1896

Oil on canvas
20⅛ x 12⅜ in. (51.1 x 31.2 cm)
1943.177

After three decades of campaigning against sentimental subjects in painting in order to promote the importance of form itself, in the last decade of his life Whistler showed more concern with emotional expression in his portraits. Whereas in earlier portraits he had deliberately muted the sitter's expression in order to emphasize that a painting is primarily an arrangement of colors on canvas, late in his career he appears to have relaxed his stringently formalist self-censure. This modified approach is especially seen in the portraits of children that Whistler produced in the 1890s. Lillie Pamington, who sat for this painting, was one of a number of models whom Whistler found among the lower-class children in the streets around his studio in Fitzroy Square during this decade. Lillie was a favorite of these child models; Whistler painted ten or so portraits of her.

In this work, the artist modified his previous commitment to pointedly antinarrative titles. His earlier works had employed musical titles—"Symphony," "Nocturne," "Harmony"—in order to signal the viewer to approach the painting as an abstract composition, as a listener is moved by the purely formal effects of instrumental and orchestral music. In this late work, Whistler no longer insisted that human expression be suppressed in order to foreground the expressive capacities of color and form alone, and he further permitted himself to use the kind of anecdotally suggestive title that he had vociferously opposed in earlier years. While continuing his tradition of musically allusive titles, here the musical allusion is not to the

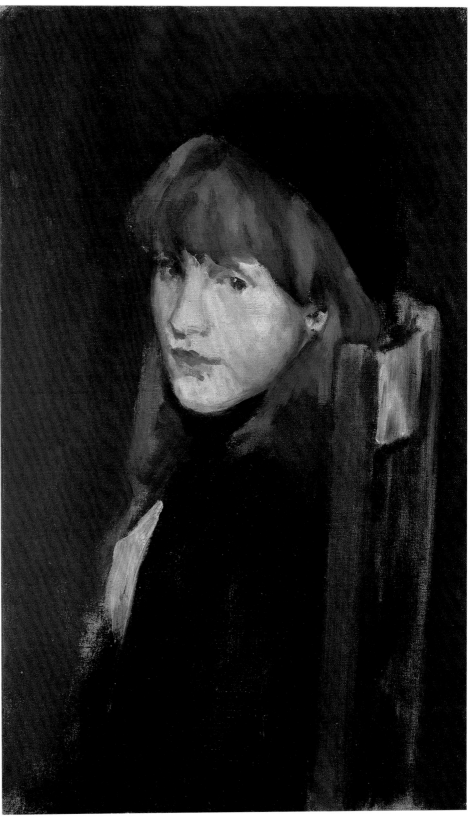

219

abstraction of symphonic music but rather to an English ballad—"Sally in Our Alley"—which would have been familiar to many of Whistler's viewers. The lyrics of this ballad, dating back to the early eighteenth century and described as "extremely popular" in 1859, concern the charms of a girl of humble birth: "Of all the girls that are so smart, / There's none like pretty Sally; / She is the darling of my heart, / And lives in our alley."[1] *Lillie "In Our Alley,"* seemingly so unexpected a title choice for the producer of "Symphonies" and "Nocturnes," nevertheless reveals a delight in wordplay consistent with Whistler's witty writings, as well as a taste for alliteration that parallels the emphasis on color repetition in his paintings.

Brown and Gold reveals another change in Whistler's productions during the last few years of his career. What had made his paintings so distinctive in the 1870s and 1880s was not just their formal rigor and repudiation of narrative but also their skillful manipulation of extremely thin paint. In 1895 Whistler wrote a letter to his wife in which he concluded that his previous methods of producing a painting in a single session had been misguided.[2] In works like *Brown and Gold,* the artist experimented with painting more thickly and building his canvas up through progressive stages. The more definite expression of the child's subjective presence through her level gaze, which carries the weight of the picture, is matched by the greater solidity of the painting itself.

Aileen Tsui

1. "Sally in Our Alley" was written and composed by Henry Carey; see Chappell (1859) 1965, pp. 645–58.
2. Whistler, letter to Beatrice Whistler, November 11, 1895, quoted in Dorment and MacDonald 1994, p. 274.

PROVENANCE: Sold by the artist to John James Cowan, Edinburgh, 1899; Hunt Henderson, New Orleans, by 1934; his bequest to Tulane University, New Orleans, 1939; acquired from it through Martin Birnbaum by Grenville L. Winthrop, April 1941; his bequest to the Fogg Art Museum, 1943.

EXHIBITIONS: London 1899c, no. 136; London 1905a, no. 18; New York 1916, no. 154; Chicago 1934, no. 427; Cambridge, Mass., 1972a, no. 94.

REFERENCES: Way and Dennis 1903, p. 50, illus. facing p. 50; Cary 1907, p. 213, no. 379; Sickert 1908, p. 167, no. 116; Pennell and Pennell 1908, vol. 2, pp. 205, 207, 224, illus. facing p. 204; Wood 1908 (?), pl. 5; Laver 1930, p. 285; Young, MacDonald, and Spencer 1980, vol. 1, p. 203, no. 464, vol. 2, pl. 298.

Concordance of Fogg Art Museum Inventory Numbers and Catalogue Numbers

Catalogue numbers 171 and 191 are in the Department of Printing and Graphic Arts, Houghton Library, Harvard College Library.

Inventory	Cat.	Inventory	Cat.	Inventory	Cat.	Inventory	Cat.
1939.90	206	1943.205	195	1943.278	127	1943.419	146
1942.44A	51	1943.209	194	1943.279	46	1943.432	150
1942.44B	52	1943.213	196	1943.288	134	1943.438	151
1942.54	211	1943.219	7	1943.296	201	1943.443	149
1942.186	92	1943.225	15	1943.298	200	1943.447	148
1942.188	107	1943.226	13	1943.302	203	1943.453	157
1942.189	48	1943.227	23	1943.304	202	1943.454	161
1942.190	8	1943.228	22	1943.305	199	1943.455	162
1942.193	205	1943.229	21	1943.314	210	1943.456	163
1942.198	176	1943.230	84	1943.315	208	1943.458	164
1942.204	98	1943.233	31	1943.338	3	1943.459	165
1942.206	130	1943.239	32	1943.340	2	1943.460	155
1942.220	198	1943.242	36	1943.347	14	1943.461	156
1943.90	135	1943.243	45	1943.349	27	1943.462	170
1943.91	136	1943.244	44	1943.351	26	1943.485	179
1943.137	204	1943.245	70	1943.352	29	1943.488	183
1943.150	207	1943.246	71	1943.354	28	1943.489	187
1943.155	209	1943.247	81	1943.363	42	1943.490	182
1943.165	213	1943.248	60	1943.365	43	1943.491	186
1943.172	215	1943.249	74	1943.367	40	1943.515	47
1943.173	216	1943.251	72	1943.373	75	1943.532	138
1943.176	212	1943.252	53	1943.374	82	1943.534	137
1943.177	219	1943.253	80	1943.375	76	1943.610	214
1943.180	144	1943.254	54	1943.376	69	1943.617	217
1943.182	152	1943.259	87	1943.377	50	1943.618	218
1943.185	153	1943.260	91	1943.378	83	1943.641	142
1943.187	159	1943.266	96	1943.387	86	1943.647	143
1943.189	158	1943.268	95	1943.388	94	1943.649	139
1943.195	175	1943.269	93	1943.392	97	1943.652	140
1943.197	178	1943.273	106	1943.394	99	1943.656	141
1943.200	190	1943.274	112	1943.396	109	1943.672	154
1943.201	184	1943.275	111	1943.401	145	1943.674	160
1943.202	188	1943.277	110	1943.415	147	1943.695	172

1943.699	174	1943.833	39	1943.877	89	1943.1123	193
1943.703	173	1943.836	4	1943.880	90	1943.1137	116
1943.739	181	1943.837	55	1943.884	103	1943.1140	126
1943.745	185	1943.840	58	1943.886	105	1943.1141	117
1943.750	189	1943.841	59	1943.888	102	1943.1148	120
1943.773	5	1943.842	64	1943.889	101	1943.1153	118
1943.780	6	1943.843	56	1943.890	100	1943.1154	121
1943.787	10	1943.844	49	1943.891	104	1943.1155	122
1943.788	9	1943.845	79	1943.899	108	1943.1156	123
1943.790	11	1943.847	63	1943.909	180	1943.1157	124
1943.796	12	1943.848	62	1943.910	113	1943.1158	125
1943.799	17	1943.849	77	1943.914	114	1943.1815.1	177
1943.805	18	1943.850	66	1943.916	115	1943.1815.12	19
1943.810	24	1943.851	67	1943.918	129	1943.1815.13	20
1943.812	25	1943.852	68	1943.919	128	1943.1815.15	167
1943.814	30	1943.853	65	1943.920	131	1943.1815.16	168
1943.820A	33	1943.854	57	1943.922	132	1943.1815.17	169
1943.824	38	1943.855	78	1943.923	133	1943.1815.18	166
1943.825	41	1943.859	61	1943.1023	1	1943.1815.19	16
1943.828	37	1943.861	73	1943.1034	119		
1943.830	35	1943.867	85	1943.1108	197		
1943.831	34	1943.874	88	1943.1122	192		

Bibliography

Abe 1991 Nobuo Abe. *Great History of Art: Koki inshoha to seikimatsu no miryoku.* [Kyōto], 1991.

Abruzzo–Milan 1986–87 *Flaxman e Dante.* Exhibition, Casa di Dante, Abruzzo, September–October 1986; Palazzo di Brera, Milan, November 22, 1986–January 14, 1987. Catalogue edited by Corrado Gizzi. Milan, 1986.

Adams 1945 Philip R. Adams. *Auguste Rodin.* New York, 1945.

Adelaide 1994 *Morris & Company: Pre-Raphaelites and the Arts and Crafts Movement in South Australia.* Exhibition, Art Gallery of South Australia, Adelaide, February 4–May 8, 1994. Catalogue by Christopher Menz. Adelaide, 1994.

Adelson et al. 1997 Warren Adelson et al. *Sargent Abroad: Figures and Landscapes.* New York, 1997.

Adhémar 1954a Jean Adhémar. *Honoré Daumier.* Paris, 1954.

Adhémar 1954b Jean Adhémar. *Honoré Daumier: Drawings and Watercolors.* New York, 1954.

Adler 1986 Kathleen Adler. *Manet.* Oxford, 1986.

Adlow 1943 Dorothy Adlow. "Winthrop Bequest Boosts Fogg Museum to Front Rank." *Christian Science Monitor,* October 18, 1943, p. 5.

Adriani 1993 Götz Adriani. *Cézanne Gemälde.* Cologne, 1993.

Aimé-Azam 1954 Denise Aimé-Azam. "Le tragique secret de Théodore Géricault." *Journal de l'amateur d'art,* February 10, March 10, 1954.

Aimé-Azam 1956 Denise Aimé-Azam. *Mazeppa, Géricault et son temps.* Paris, 1956. Republished as Aimé-Azam 1970.

Aimé-Azam 1970 Denise Aimé-Azam. *La passion de Géricault.* Paris, 1970.

Aimé-Azam 1991 Denise Aimé-Azam. *Géricault.* Paris, 1991.

Ainsworth 1980 Maryan Wynn Ainsworth. "Dante Gabriel Rossetti's *Dantis Amor.*" *Journal of Pre-Raphaelite Studies* 1, no. 1 (November 1980), pp. 69–78.

Alain 1949 Alain [Émile Chartier]. *Ingres.* Paris, 1949.

Alazard 1930 Jean Alazard. "Les peintres de l'Algérie au XIXe siècle." *Gazette des beaux-arts,* ser. 6, 3 (March 1930), pp. 370–87.

Alazard 1949 Jean Alazard. "Ingres et la peinture murale." In *Miscellanea Leo van Puyvelde,* pp. 245–48. Brussels, 1949.

Alazard 1950 Jean Alazard. *Ingres et l'ingrisme.* Paris, 1950.

Album Goupil 1897 *Les dessins d'Auguste Rodin: 129 planches comprenant 142 dessins reproduits en facsimile par la Maison Goupil.* 2 vols. Preface by Octave Mirbeau. Paris, 1897.

Alexandre 1888 Arsène Alexandre. *Honoré Daumier: L'homme et l'oeuvre.* Paris, 1888.

Alexandre 1896 Estignard Alexandre. *Courbet: Sa vie, ses oeuvres.* Besançon, 1896.

Alexandre 1899 Arsène Alexandre. "Un guérison" [interview with Lautrec]. *Le figaro,* March 30, 1899.

Alexandre 1902–3 Arsène Alexandre. "Jean-Francois Millet." In "Corot and Millet," *The Studio,* special number (winter 1902–3), pp. M.i–M.xiv.

Alexandre 1921 Arsène Alexandre. "Comprendre Ingres, c'est comprendre la Grèce et la France." *La renaissance de l'art français et des industries de luxe* 4 (May 1921), pp. 194–205.

Alexandre 1933 Arsène Alexandre. "La collection E. L." *La renaissance* 16 (October–November 1933), pp. 175–200.

Alexandrian 1980 Sarane Alexandrian. *Seurat.* Translated by Alice Sachs. New York, 1980.

Allen 1936 Josephine L. Allen. "Exhibition of the Work of John La Farge." *Bulletin of The Metropolitan Museum of Art* 31, no. 4 (April 1936), pp. 74–78.

Allen 1983 Virginia M. Allen. *The Femme Fatale: Erotic Icon.* Troy, N.Y., 1983.

Allen (1976) 1994 David Elliston Allen. *The Naturalist in Britain: A Social History.* Princeton, 1994. First published London, 1976.

Allingham 1907 William Allingham. *William Allingham: A Diary.* Edited by Helen Allingham and D. Radford. London, 1907.

Allingham 1967 William Allingham. *William Allingham's Diary.* Introduction by Geoffrey Grigson. Fontwell, Sussex, 1967.

Alston 1929 Rowland Alston. *The Mind and Work of G. F. Watts, O.M., R.A., with Introductory and Special Reference to the Watts Gallery, Compton, Guildford.* London, 1929.

Amaury-Duval 1846 Amaury-Duval [Eugène-Emmanuel Pineu-Duval]. "De M. Ingres à propos de l'exposition Bonne-Nouvelle." *La revue nouvelle* 7 (February 1, 1846), pp. 77–94.

Amaury-Duval 1856 Amaury-Duval [Eugène-Emmanuel Pineu-Duval]. "Monsieur Ingres, II." *L'artiste,* ser. 6, 1 (May 18, 1856), pp. 175–77. Reprinted in Amaury-Duval 1921, pp. 247–48.

Amaury-Duval (1878) 1924 Amaury-Duval [Eugène-Emmanuel Pineu-Duval]. *L'atelier d'Ingres.* Reprint of 1878 ed. Edited by Élie Faure. Paris, 1924.

Amaury-Duval (1878) 1993 Amaury-Duval [Eugène-Emmanuel Pineu-Duval]. *L'atelier d'Ingres; édition critique de l'ouvrage publié à Paris en 1878.* Edited by Daniel Ternois. Paris, 1993.

Amaury-Duval 1921 Amaury-Duval [Eugène-Emmanuel Pineu-Duval]. "M. Ingres." *La renaissance de l'art français et des industries de luxe* 4, no. 5 (May 1921), pp. 241–52.

Ambler and Bolton 1972 Louise Todd Ambler and Kenyon C. Bolton III. "American Painting at Harvard." *Antiques* 102 (November 1972), pp. 876–83.

Ambrosini and Facos 1987 Lynne Ambrosini and Michelle Facos. *Rodin: The Cantor Gift to the Brooklyn Museum.* Brooklyn, 1987.

Amiens 1868 *Exposition de la Société des Amis des Arts de la Somme.* Exhibition, Amiens, 1868.

Amiens 1994 *Les dessins de Puvis de Chavannes du Musée de Picardie.* Exhibition, Musée de Picardie, Amiens, March 1994. Catalogue by Marie-Christine Boucher. Amiens, 1994.

Amsterdam 1926 *Exposition retrospective d'art français.* Exhibition, Rijksmuseum, Amsterdam, July 3–October 3, 1926. Catalogue. Amsterdam, 1926.

Amsterdam 1936 *Tentoonstelling twee eeuwen Engelsche kunst / Two Centuries of British Art.* Exhibition, Stedelijk Museum, Amsterdam, July 4–October 4, 1936. Catalogue introduction by D. C. Röell; foreword by Kenneth Clark. Amsterdam, 1936.

Amsterdam 1988–89 *Van Gogh en Millet.* Exhibition, Van Gogh Museum, Amsterdam, December 9, 1988–February 26, 1989. Catalogue by Louis van Tilborgh, Sjraar van Heugten, and Philip Conisbee. Zwolle and Amsterdam, 1988.

Amsterdam 1990 *Vincent van Gogh: Paintings.* Exhibition, Van Gogh Museum, Amsterdam, March 30–July 29, 1990. Catalogue by Evert van Uitert, Louis van Tilborgh, and Sjraar van Heugten. Milan and Rome, 1990.

Amsterdam 1993–94 *Felix Bracquemond, 1833–1914.* Exhibition, Van Gogh Museum, Amsterdam, November 26, 1993–February 13, 1994. Catalogue by Charlotte van Rappard-Boon. Amsterdam, 1993.

Amsterdam 1994 *Pierre Puvis de Chavannes.* Exhibition, Van Gogh Museum, Amsterdam, February 25–May 29, 1994. Catalogue by Aimée Brown Price, with contributions by Jon Whiteley and Geneviève Lacambre. Amsterdam, Zwolle, and New York, 1994.

Amsterdam 1995–96 *Franz von Stuck, 1863–1928: Eros & Pathos.* Exhibition, Van Gogh Museum, Amsterdam, September 29, 1995–January 21, 1996. Catalogue by Edwin Becker. Amsterdam and Zwolle, 1995.

Anderson Galleries 1926 *The John Lane Collection of Original Drawings by Aubrey Beardsley.* Sale, Anderson Galleries, New York, November 22, 1926.

André 1928 Albert André. *Renoir*. Cahiers d'aujour-d'hui. Paris, 1928.

Angrand 1967 Pierre Angrand. *Monsieur Ingres et son époque*. Lausanne and Paris, 1967.

Angrand and Naef 1970 Pierre Angrand and Hans Naef. "Ingres et la famille de Pastoret: Correspondance inédite; II." *Bulletin du Musée Ingres*, no. 27 (July 1970), pp. 7–24.

Annville 1999 *George Inness: The 1880s and 1890s.* Exhibition, Suzanne H. Arnold Art Gallery, Lebanon Valley College, Annville, Pa., March 11–April 11, 1999. Catalogue by Leo G. Mazow and Rachael Ziady DeLue. Annville, Pa., 1999.

Anon. 1791 Anonymous; signed M. D. *Explication et critique impartiale de toutes les peintures, sculptures, gravures, dessins, etc. . . . exposés au Louvre, d'après le décret de l'Assemblée Nationale, au mois de Septembre 1791, l'an IIIe de la Liberté*. Paris, 1791.

Anon. (*La béquille de Voltaire*) 1791 Anonymous. *La béquille de Voltaire au Salon, seconde et dernière promenade*. Paris, year III [1791].

Anon., January 14, 1815 Anonymous. "Salon de 1814." *Journal royal*, January 14, 1815.

Anon., February 13, 1815 Anonymous; signed A. V. "[Lettres] sur le Salon de 1814." *Le moniteur universel* 51–52 (February 13, 1815).

Anon., February 14, 1815 Anonymous; signed M. "Salon de 1814." *Journal général de France*, February 14, 1815.

Anon. 1819 Anonymous; signed P. A. "Notice sur l'exposition des tableaux en 1819. Second article." *Revue encyclopédique*, 1819, pp. 532–33.

Anon. 1824 Anonymous. *Notice sur la vie et les ouvrages de M. J.-L. David: Avec portrait*. Paris, 1824.

Anon. 1835 Anonymous. "Un souvenir de Prud'hon. *L'enlèvement d'Europe*. Gravé par Prud'hon, d'après l'antique." *Journal spécial des lettres et des beaux-arts* (Paris) 1, no. 2 (January 11, 1835), p. 35.

Anon. 1840 Anonymous. "De la nouvelle odalisque envoyée de Rome par M. Ingres." *L'artiste*, ser. 2, 6 (1840), pp. 343–45.

Anon. 1841 Anonymous. "Salon de 1841. M. Ingres." *Le charivari*, March 14, 1841.

Anon. 1846 Anonymous. "Exposition des ouvrages de peinture dans la galerie Beaux-Arts Boulevard Bonne-Nouvelle, 22." *L'illustration* 6 (1846), p. 96.

Anon., February 11, 1846 Anonymous; signed C. A. D. "Exposition dans les galeries du boulevard Bonne-Nouvelle, no. 22, en faveur des artistes malheureux." *La France*, February 11, 1846, unpag.

Anon., March 8, 1846 Anonymous; signed F. C. A. "Exposition des Galeries Bonne-Nouvelle. M. Ingres." *Moniteur des arts* 3, no. 6 (March 8, 1846), p. 42.

Anon. 1856 Anonymous. *Visites et études de S.A.I. Le Prince Napoléon au Palais des Beaux-Arts*. Paris, 1856.

Anon. 1859 Anonymous. "Chronique, documents, faits divers." *Revue universelle des arts* 9 (1859), p. 95.

Anon. 1862 Anonymous. "Chronique locale." *Le courrier de Tarn-et-Garonne*, April 26, 1862.

Anon. 1867 Anonymous. "Mouvement des arts et de la curiosité. Tableaux et dessins d'Ingres." *La chronique des arts et de la curiosité* 5 (May 5 and 12, 1867), pp. 137–38, 145–47.

Anon., April 7, 1867 Anonymous. "Exposition des oeuvres d'Ingres." *La chronique des arts et de la curiosité* 5 (April 7, 1867), p. 109.

Anon. 1874 Anonymous. "Les dessins de Géricault." *Gazette des beaux-arts*, ser. 2, 9 (January 1, 1874), pp. 72–78.

Anon. 1885 Anonymous. "The Royal Institute of Painters in Water-colours." *Pall Mall Budget*, May 1, 1885, p. 15.

Anon. 1886 Anonymous. "Summer Exhibitions." *Art Journal* 48 (1886), p. 385.

Anon., May 1886 Anonymous. "Art in May." *Magazine of Art* 9 (May 1886), p. xxx.

Anon., May 22, 1886 Anonymous. "The Royal Academy. (Third Notice.)" *Athenaeum*, no. 3056 (May 22, 1886), p. 683.

Anon. 1909 Anonymous. "Chronique." *Art et décoration* 25 (May 1909), unpag.

Anon. 1916 Anonymous. "Loan of Paintings by Puvis de Chavannes." *Bulletin of The Metropolitan Museum of Art* 11 (June 1916), pp. 134–35.

Anon. 1924 Anonymous; signed L. C. "Studies for the Childhood of St. Geneviève, Puvis de Chavannes." *Bulletin of the Art Institute of Chicago* 18 (January 1924), pp. 117–20.

Anon. 1934 Anonymous. "Monsieur Ingres et ses élèves." *Beaux-arts* 73, no. 65 (March 30, 1934), p. 2.

Anon., April 1935 Anonymous. "La curiosité." *Le bulletin de l'art ancienne et moderne* (supplement to *Revue de l'art*) 67 (April 1935), p. 175.

Anon. 1938 Anonymous. "À Zurich: La collection de Mr. [sic] et Mme Émile Laffon." *Beaux-arts*, no. 270 (March 4, 1938), p. 5.

Anon. 1954 Anonymous. "Géricault." *Sele arte* 3, no. 15 (November–December 1954), pp. 37–45.

Antal 1940–41 Frederick Antal. "Reflections on Classicism and Romanticism—III–V." *Burlington Magazine* 77 (September 1940), pp. 72–80; (December 1940), pp. 188–92; (January 1941), pp. 14–22. Reprinted in Antal 1966, pp. 30–44.

Antal 1966 Frederick Antal. *Classicism and Romanticism, with Other Studies in Art History*. London and New York, 1966.

Aragon 1952 Louis Aragon. *L'exemple de Courbet*. Paris, 1952.

Aragon 1971 [Louis] Aragon. *Henri Matisse, roman*. 2 vols. Paris, 1971.

Arikha 1991 Avigdor Arikha. *Peinture et regard: Écrits sur l'art, 1965–1990*. Paris, 1991.

Arikha 1995 Avigdor Arikha. *On Depiction: Selected Writings on Art, 1965–94*. London, 1995.

Armstrong 1913 Walter Armstrong. *Lawrence*. New York, 1913.

Arnason 1968 H. Harvard Arnason. *History of Modern Art: Painting, Sculpture, Architecture*. New York, 1968.

Arnason 1977 H. Harvard Arnason. *History of Modern Art: Painting, Sculpture, Architecture*. Englewood Cliffs, N.J., 1977.

Arnould de Vienne 1856 Arnould de Vienne. "Galerie de M. Marcotte." *L'artiste*, ser. 6, 2 (August 24, 1856), p. 102.

D'Arpentigny 1864 D'Arpentigny. "Exposition intime dans l'atelier de M. Ingres." *Le courrier artistique*, June 19, 1864, p. 11.

Ash 1993 Russell Ash. *Sir Edward Burne-Jones*. New York, 1993.

Asleson 2000 Robyn Asleson. *Albert Moore*. London, 2000.

Asnières 1909 *Exposition de gravures exécutées par M. Félix Bracquemond et Sir F. Seymour Haden*. Exhibition, Les Arts, Asnières, February 1909. Catalogue preface by Gustave Geffroy. Asnières, 1909.

Auerbach 1982 Nina Auerbach. *Woman and the Demon: The Life of a Victorian Myth*. Cambridge, Mass., 1982.

Aurier 1892 G.-Albert Aurier. "Les peintres symbolistes." *Révue encyclopédique* (Paris), April 1892. Translated in Chipp 1968, pp. 93–94.

Auxentios 1993 Auxentios of Photiki. *The Paschal Fire in Jerusalem*. Berkeley, 1993.

Aymar 1967 Gordon C. Aymar. *The Art of Portrait Painting: Portraits through the Centuries as Seen through the Eyes of a Practicing Portrait Painter*. Philadelphia, 1967.

Aymar 1970 Brandt Aymar. *The Young Male Figure*. New York, 1970.

Bacou 1960 Roseline Bacou. *Lettres de Gauguin, Gide, Huysmans, Jammes, Mallarmé, Verhaeren . . . à Odilon Redon*. Introduction by Arï Redon. Paris, 1960.

Baignières 1886 Arthur Baignières. "Théodore Chassériau." *Gazette des beaux-arts*, ser. 2, 31 (March 1, 1886), pp. 209–18.

Bailey 1995 Colin B. Bailey. "Renoir's Portrait of His Sister-in-Law." *Burlington Magazine* 137 (October 1995), pp. 684–87.

Bajou 1999 Valérie Bajou. *Monsieur Ingres*. Paris, 1999.

Baker 1921 C. H. Collins Baker. "Reflections on the Ingres Exhibition." *Burlington Magazine* 39 (July 1921), pp. 36–42.

Baker 1982 Kenneth Baker. "Things and Things to Come." *Christian Science Monitor*, July 8, 1982.

Baldry 1894 Alfred Lys Baldry. *Albert Moore: His Life and Works*. London, 1894.

Baldry 1895 Alfred Lys Baldry. "The Herkomer School." *The Studio* 6, no. 31 (October 1895), pp. 2–17.

Balfour 1930 Arthur James, first earl of Balfour. *Chapters of Autobiography*. Edited by Blanche E. C. Dugdale. London, 1930.

Ballu 1877 Roger Ballu. "Les peintures de M. Puvis de Chavannes au Panthéon." *La chronique des arts et de la curiosité*, no. 22 (June 9, 1877), p. 212.

"Band of Brothers" 1973 "Band of Brothers." *Christian Science Monitor*, November 30, 1973.

Barasch 1990 Moshe Barasch. *Modern Theories of Art*. Vol. 1, *From Winckelmann to Baudelaire*. New York, 1990.

Barbedienne 1893 F[erdinand] Barbedienne. *Oeuvres de A.-L. Barye*. Paris, 1893.

Barbedienne sale 1892 *Catalogue de tableaux, aquarelles et dessins modernes, oeuvres importantes de Barye, Cogniet, Decamps, E. Delacroix . . . composant la collection de m. Barbedienne*. Sale, Galerie Durand-Ruel, Paris, June 2–3, 1892.

Barère 1791 Bertrand Barère de Vieuzac. In *La feuille du jour*, June 3, 1791, p. 528.

Barousse 1977 Pierre Barousse. "L''idée' chez Monsieur Ingres." In Ingres colloque (1975) 1977, pp. 157–67.

Barr 1951 Alfred H. Barr. *Matisse: His Art and His Public*. New York, 1951.

Barret 1996 André Barret. *Les peintres du fantastique*. Paris, 1996.

Barringer 1999 Tim Barringer. *Reading the Pre-Raphaelites*. New Haven, 1999.

Barrington 1905 Mrs. Russell Barrington. *G. F. Watts: Reminiscences*. London, 1905.

Barthelmess 1987 Wieland Barthelmess. "Das Café-Concert als Thema der französischen Malerei und Graphik des ausgehenden 19. Jahrhunderts." Doctoral thesis, Freien Universität Berlin, 1987.

Barye sale 1876 *Oeuvres de feu Barye*. Sale, Hôtel Drouot, Paris, February 7, 1876.

Barzini and Mandel 1971 Luigi Barzini and Gabriele Mandel. *L'opera pittorica completa di Daumier*. Milan, 1971.

Baschet 1854a Armand Baschet. *Chassériau*. N.p., 1854.

Baschet 1854b Armand Baschet. "Les ateliers de Paris en 1854. Lettres à M. Arsène Houssaye. VII. M. Théodore Chassériau," parts 1, 2. *L'artiste*, ser. 5, 12 (June 1 and 15, 1854), pp. 134–35, 150–51.

Baschet 1942 Robert Baschet. *E.-J. Delécluze, témoin de son temps*. Paris, 1942.

Basel 1921 *Exposition de peinture française: Catalogue*. Exhibition, Kunsthalle, Basel, May 30–June 1921. Catalogue by the Société des Beaux-Arts de Bâle. Basel, 1921.

Basel 1981 *Pablo Picasso: Das Spätwerk. Themen, 1964–1972*. Exhibition, Kunstmuseum, Basel, September 6–November 8, 1981. Catalogue by Christian Geelhaar et al. Basel, 1981.

Basset 1900 Serge Basset. "La Porte de l'Enfer." *Le matin*, March 19, 1900.

Bate 1899 Percy Bate. *The English Pre-Raphaelite Painters*. London, 1899.

Baton Rouge 1937 *Loan Exhibition of Paintings and Prints by James McNeill Whistler. . . .* Exhibition, Louisiana State University Art Gallery, Baton Rouge, 1937.

Baudelaire (1846a) 1992 Baudelaire-Dufays [Charles Baudelaire]. "Le musée classique du Bazar Bonne-Nouvelle." *Le Corsaire-Satan*, January 21, 1846. Reprinted in Baudelaire, *Écrits sur l'art*, pp. 65–66. Paris, 1992.

Baudelaire (1846b) 1992 Baudelaire-Dufays [Charles Baudelaire]. *Salon de 1846*. Paris, 1846. Reprinted in Baudelaire, *Écrits sur l'art*. Paris, 1992.

Baudelaire (1855) 1976 Charles Baudelaire. "Exposition universelle" (1855). Reprinted in *Oeuvres complètes*, vol. 2, p. 588. Paris, 1976.

Baudelaire 1868 Charles Baudelaire. *Curiosités esthétiques*. Paris, 1868.

Baudelaire 1945 Charles Baudelaire. *Au temps de Baudelaire, Guys et Nadar*. Introduction by François Boucher. Paris, 1945.

Baxter 1979 Colles Baxter. "Mistaken Identities: Three Portraits by Toulouse-Lautrec." *Print Collector's Newsletter* 10, no. 2 (May–June 1979), pp. 41–44.

Bayliss 1902 Wyke Bayliss. *Five Great Painters of the Victorian Era: Leighton, Millais, Burne-Jones, Watts, Holman Hunt*. London, 1902.

Bazille 1992 *Frédéric Bazille: Correspondance*. Compiled and edited by Didier Vatuone; transcrip-

tions and documentation by Guy Barral and Didier Vatuone. Montpellier, 1992.

Bazin 1896 Germain Bazin. "Puvis de Chavannes et l'action morale." *Bulletin de l'Union pour l'action morale*, December 1, 1896, pp. 28–29.

Bazin 1960 Germain Bazin. *Das Blumenbouquet: Gemälde grosser Meister*. Translated by Paul Baudisch. Munich, 1960.

Bazin 1987–97 Germain Bazin. *Théodore Géricault: Étude critique, documents et catalogue raisonné*. 7 vols. Paris, 1987–97.

Beam 1966 Philip C. Beam. *Winslow Homer at Prout's Neck*. Boston, 1966.

Beardsley 1897 Aubrey Beardsley. *A Book of Fifty Drawings*. London, 1897.

Beardsley 1899a Aubrey Beardsley. *The Early Work of Aubrey Beardsley*. Prefatory note by H[enry] C[urrie] Marillier. London, 1899.

Beardsley 1899b Aubrey Beardsley. *A Second Book of Fifty Drawings*. Preface by Leonard Smithers. New York, 1899.

Beardsley 1901 Aubrey Beardsley. *The Later Work of Aubrey Beardsley*. London, 1901.

Beardsley 1949 Ellen Beardsley. "Aubrey Beardsley." In *A Beardsley Miscellany*, by Georges Derry, edited by R. A. Walker. London, 1949.

Beardsley 1970 Aubrey Beardsley. *The Letters of Aubrey Beardsley*. Edited by Henry Maas, J. L. Duncan, and W. G. Good. Rutherford, N.J., 1970.

Beattie 1983 Susan Beattie. *The New Sculpture*. New Haven, 1983.

Beausire 1988 Alain Beausire. *Quand Rodin exposait*. Paris, 1988.

Beausire and Cadouot 1987 Alain Beausire and Florence Cadouot. *Correspondance de Rodin, III: 1908–1912*. Paris, 1987.

Becker 1998–99 David P. Becker, "Rodolphe Bresdin as Book Illustrator." *Journal of the Iris and B. Gerald Cantor Center for Visual Arts at Stanford University* 1 (1998–99), pp. 20–32.

Becker 2000 David P. Becker. "Bresdin dessinateur." In Paris 2000, pp. 20–29.

Beetem 1964 Robert N. Beetem. "Delacroix's Mural Paintings, 1833–1847." Ph.D. dissertation, University of California, Berkeley, 1964.

Belfort 1965 *Exposition commémorative du centenaire de la mort de l'artiste* [François-Joseph Heim]. Exhibition, Musée d'Art et d'Histoire, Belfort, 1965.

Bell n.d. Malcolm Bell. *Sir Edward Burne-Jones: A Biographical Study*. Newnes' Art Library Series. London, n.d.

Bell 1892 Malcolm Bell. *Edward Burne-Jones: A Record and Review*. London and New York, 1892. 2nd ed., 1893.

Bell 1894 Malcolm Bell. *Sir Edward Burne-Jones: A Record and Review*. 3rd ed. London and New York, 1894.

Bell 1910 Malcolm Bell. *Sir Edward Burne-Jones*. London, 1910.

Bell 1982 Quentin Bell. *A New and Noble School: The Pre-Raphaelites*. London, 1982.

Bellier de la Chavignerie 1867 Émile Bellier de la Chavignerie. "Notes sur l'oeuvre de M. Ingres." *La chronique des arts et de la curiosité* 5 (February 24, 1867), pp. 51, 59–60.

Bellony-Rewald 1976 Alice Bellony-Rewald. *The Lost World of the Impressionists*. London, 1976.

Bendiner 1998 Kenneth Bendiner. *The Art of Ford Madox Brown*. University Park, Pa., 1998.

Benedetti 1982 Maria Teresa Benedetti. *Dante Gabriel Rossetti: Disegni*. Florence, 1982.

Benedetti 1984 Maria Teresa Benedetti. *Dante Gabriel Rossetti*. Florence, 1984.

Bénédite 1909 Léonce Bénédite. "La Légende de Sainte Geneviève." *Art et décoration* 25 (May 1909), pp. 137–52 and supplement.

Bénédite 1921 Léonce Bénédite. "Une exposition d'Ingres." *Gazette des beaux-arts*, ser. 5, 3 (June 1921), pp. 325–37.

Bénédite 1922 Léonce Bénédite. *Notre art, nos maîtres: Puvis de Chavannes, Gustave Moreau, Burne-Jones, G. F. Watts*. Paris, 1922.

Bénédite [1931] Léonce Bénédite. *Théodore Chassériau. Sa vie. Son oeuvre*. 2 vols. Paris, n.d. [1931].

Benesch 1944 Otto Benesch. "The Winthrop Collection: From Neo-Classic to Romanticism; David, Ingres, Géricault." *Art News* 42, no. 16 (January 1–14, 1944), pp. 9–10, 20–21, 32.

Benge 1969 Glenn Franklin Benge. "The Sculpture of Antoine-Louis Barye in American Collections; with a Catalogue Raisonné." Ph.D. dissertation, University of Iowa, Iowa City, 1969.

Benge 1984 Glenn Franklin Benge. *Antoine-Louis Barye: Sculptor of Romantic Realism*. University Park, Pa., 1984.

Bennett 1963 Mary Bennett. "A Check-List of Pre-Raphaelite Pictures Exhibited at Liverpool, 1846–47." *Burlington Magazine* 105 (November 1963), pp. 486–95.

Bennett 1988 Mary Bennett. *Artists of the Pre-Raphaelite Circle: The First Generation. Catalogue of Works in the Walker Art Gallery, Lady Lever Art Gallery, and Sudley Art Gallery*. London, 1988.

Benson sale 1929 *Ancient and Modern Pictures and Drawings . . . of R. H. Benson*. Sale, Christie's, London, June 21, 1929.

Bentley 1964 Gerald E. Bentley Jr. *The Early Engravings of Flaxman's Classical Designs: A Bibliographical Study*. New York, 1964. Reprinted from the *Bulletin of the New York Public Library*, May–June 1964.

Bentley 1969 Gerald E. Bentley Jr. *Blake Records*. Oxford, 1969.

Béraldi 1885–92 Henri Béraldi. *Les graveurs du XIXe siècle: Guide de l'amateur d'estampes modernes*. 12 vols. Paris, 1885–92.

Berezina 1967 Valentina N. Berezina. *Zhan Ogiust Dominik Engr* (Jean-Auguste-Dominique Ingres). Leningrad, 1967.

Berezina 1974 Valentina Berezina. "Portrait de Mme Hayard et de sa fille Caroline." *Bulletin du Musée Ingres*, no. 36 (1974), pp. 7–10.

Berg 1992 Constance Demuth Berg. "Letter from Cullercoats: Retracing Homer's English Odyssey." *American Art* 6, no. 3 (summer 1992), pp. 92–99.

Bergdoll 1989 Barry Bergdoll. "Le Panthéon. Sainte Geneviève au XIXe siècle." In *Le Panthéon: Symbole des révolutions*, pp. 229–30. Paris, 1989.

Berger 1946 Klaus Berger. *Géricault: Drawings and Watercolors*. New York, 1946.

Berger 1952 Klaus Berger. *Géricault und sein Werk.* Vienna, 1952.

Berger 1955 Klaus Berger. *Géricault and His Work.* Translated by Winslow Ames. Lawrence, Kans., 1955.

Berger 1965 Klaus Berger. *Odilon Redon: Fantasy and Colour.* New York, 1965.

Berlin 1903–4 *Secession VIII Kunstausstellung: Zeichnende Kunst.* Exhibition, Berlin, December 1903–January 1904.

Berlin 1905 *Ausstellung von Werken Adolph von Menzels.* Exhibition, Königliche National-Galerie, Berlin, 1905. Catalogue. Berlin, 1905.

Berlin 1907 *Gericault-Ausstellung.* Exhibition, Galerie Fritz Gurlitt, Berlin, October 1907. Catalogue. Berlin, 1907.

Berlin 1909–10 19th Secession. Exhibition, Paul Cassirer, Berlin, 1909–10.

Berlin 1927 *Eröffnungs-Ausstellung unseres neuen Berliner Hauses.* Exhibition, Galerien Thannhauser, Berlin, 1927. Catalogue. Berlin, 1927.

Berlin 1927–28 *Vincent van Gogh: Erste grosse Ausstellung seiner Zeichnungen und Aquarelle.* Exhibition, Otto Wacker, Berlin, 1927–28. Catalogue by J. B. de la Faille. Berlin, 1927.

Berlin 1928a *Adolph von Menzel, 1815–1905: Ausstellung von Gemälden, Gouachen, Pastellen, Zeichnungen in unserem Berliner Haus Bellevuestrasse 13.* Exhibition, Galerien Thannhauser, Berlin, April 1928. Catalogue. Berlin, 1928.

Berlin 1928b *Ausstellung Édouard Manet, 1832–1883: Gemälde, Pastelle, Aquarelle, Zeichnungen.* Exhibition, Galerie Matthiessen, Berlin, February 6–March 18, 1928. Catalogue. Berlin, 1928.

Berlin 1930 *Ausstellung Gustave Courbet.* Exhibition, Galerie Wertheim, Berlin, September 28–October 26, 1930. Catalogue by Charles B. Leger. Berlin, 1930.

Berlin 1998 *Fontane und die bildende Kunst.* Exhibition, Nationalgalerie, Staatliche Museen zu Berlin, September 4–November 29, 1998. Catalogue edited by Claude Keisch, Peter-Klaus Schuster, and Moritz Wullen, with contributions by Ulrich Finke et al. Berlin, 1998.

Berlin–Madrid–Geneva 1999–2000 *The Timeless Eye: Master Drawings from the Jan and Marie-Anne Krugier-Poniatowski Collection.* Exhibition, Kupferstichkabinett, Staatliche Museen zu Berlin–Preussischer Kulturbesitz, May 29–August 1, 1999; Peggy Guggenheim Collection, Venice, September–December 1999; Museo Thyssen-Bornemisza, Madrid, February–May 2000; Musée de l'Art et d'Histoire, Geneva, summer 2000. Catalogue by Philip Rylands, with contributions from Sigrid Achenbach et al. Berlin and Venice, 1999.

Bernard 1971 Camille Bernard. "Some Aspects of Delacroix's Orientalism." *Bulletin of the Cleveland Museum of Art Bulletin* 58 (April 1971), pp. 123–27.

Bernard 1985 Bruce Bernard, ed. *Vincent by Himself: A Selection of van Gogh's Paintings and Drawings together with Extracts from His Letters.* Boston, 1985.

Bernard 1986 Bruce Bernard, ed. *The Impressionist Revolution.* London, 1986.

Bersaucourt 1921 Albert de Bersaucourt. *Au temps des Parnassiens: Nina de Villard et ses amis.* Paris, 1921.

Berson 1996 Ruth Berson, ed. *The New Painting: Impressionism, 1874–1886. Documentation.* 2 vols. San Francisco and Seattle, 1996.

Bertin 1995 Eric Bertin. "Les peintures d'Ingres. II: Expositions et ventes publiques du vivant de l'artiste." *Bulletin du Musée Ingres,* nos. 67–68 (1995), pp. 103–11.

Bertin 1996 Eric Bertin. "Les peintures d'Ingres, III: Estampes et photographies de reproduction parues du vivant de l'artiste." *Bulletin du Musée Ingres,* no. 69 (1996), pp. 39–62.

Bertin 1998 Eric Bertin. "Ingres: D'après les lettres reçues de contemporains illustres." *Bulletin du Musée Ingres,* no. 71 (April 1998), pp. 17–50.

Bertram 1949 Anthony Bertram. *Jean-August-Dominique Ingres.* London, 1949.

Besançon 1886 *Sixième exposition Société des Amis des Beaux-Arts de Besançon.* Exhibition, Besançon, 1886.

Beulé 1867 [Charles-Ernest] Beulé. *Éloge de M. Ingres . . . prononcé dans la séance publique de l'Académie des Beaux-Arts, le 14 decembre 1867.* Paris, 1867.

Bevlin 1977 Marjorie Elliott Bevlin. *Design through Discovery.* New York, 1977.

Bickley 1932 Francis L. Bickley. *The Pre-Raphaelite Comedy.* London, 1932.

Bielefeld–Baden-Baden 1983–84 *Georges Seurat: Zeichnungen.* Exhibition, Kunsthalle Bielefeld, October 30–December 25, 1983; Staatliche Kunsthalle Baden-Baden, January 15–March 11, 1984. Catalogue edited by Erich Franz and Bernd Growe. Munich, 1983. English ed.: *Georges Seurat Drawings.* Translated by John William Gabriel. Boston, 1984.

Bielefeld–Winterthur 1987–88 *Hans von Marées und die Moderne in Deutschland.* Exhibition, Kunsthalle Bielefeld, October 25, 1987–January 10, 1988; Kunstmuseum Winterthur, January 31–April 4, 1988. Catalogue edited by Erich Franz, with contributions by Anne S. Domm et al. Bielefeld, 1987.

Biermann 1913 Georg Biermann. "Die Kunst auf dem Internationalen Markt. I. Gemälde aus dem Besitz der Modernen Galerie Thannhauser, München." *Der Cicerone* 5 (May 1913), pp. 309–26.

Bindman 1977 David Bindman. *Blake as an Artist.* Oxford, 1977.

Bindman 1987 David Bindman, ed. *William Blake's Illustrations of the Book of Job.* With contributions by Barbara Bryant, Robert Essick, Geoffrey Keynes, and Bo Lindberg. 2 vols. London, 1987.

Bindman 2000 David Bindman. *William Blake: The Divine Comedy.* Paris, 2000.

Binion 1993 Rudolph Binion. *Love Beyond Death: The Anatomy of a Myth in the Arts.* New York, 1993.

Binyon 1922 Laurence Binyon. *The Drawings and Engravings of William Blake.* London, 1922.

Binyon and Keynes 1935 Laurence Binyon and G. L. Keynes. *Illustrations of the Book of Job by William Blake.* 5 vols. Facsimile ed. New York: Pierpont Morgan Library, 1935.

Birmingham 1885 Exhibition, Royal Birmingham Society of Artists, 1885.

Birmingham 1987 *See* Silber 1987.

Birmingham–Glasgow 1990 *Camille Pissaro: Impressionism, Landscape, and Rural Labour.* Exhibition, City Museum and Art Gallery, Birmingham, March 8–April 22, 1990; Burrell Collection, Glasgow, May 4–June 17, 1990. Catalogue by Richard Thomson. London, 1990.

Birnbaum 1918 Martin Birnbaum. "An Essay on John Flaxman with Special Reference to His Drawings." *International Studio* 65 (1918). Reprinted in *Catalogue of an Exhibition of Original Drawings by John Flaxman, R.A.* New York, 1918.

Birnbaum 1919 Martin Birnbaum. *Introductions: Painters, Sculptors, and Graphic Artists.* New York, 1919.

Birnbaum 1941 Martin Birnbaum. *John Singer Sargent, January 12, 1856–April 15, 1925: A Conversation Piece.* New York, 1941.

Birnbaum 1946 Martin Birnbaum. *Jacovleff and Other Artists: Alexandre Jacovleff, William Blake and Other Illustrators of Dante, Thomas Rowlandson, Aubrey Beardsley, Marcus Behmer, Arthur Rackham, Hermann Struck, Anne Goldthwaite.* New York, 1946.

Birnbaum 1960 Martin Birnbaum. *The Last Romantic: The Story of More than a Half-Century in the World of Art.* New York, 1960.

Bittler and Mathieu 1983 Paul Bittler and Pierre-Louis Mathieu. *Musée Gustave Moreau: Catalogue des dessins de Gustave Moreau.* Paris, 1983.

Bjurström 1986 Per Bjurström. *French Drawings: Nineteenth Century.* Drawings in Swedish Public Collections, 5. Stockholm, 1986.

Blackburn 1878 Henry Blackburn, ed. *Grosvenor Notes.* No. 1. London, 1878.

Blake 1922 William Blake. *Illustrations to the Divine Comedy of Dante by William Blake.* London: Privately printed for the National Art-Collections Fund, 1922.

Blake 1982 William Blake. *The Complete Poetry and Prose of William Blake.* Edited by David V. Erdman; commentary by Harold Bloom. New ed. Berkeley and Los Angeles, 1982.

Blake 1993 William Blake. *Milton, a Poem, and the Final Illuminated Works: The Ghost of Abel; On Homer's Poetry [and] On Virgil Laocoön.* Edited and with notes by Robert N. Essick and Joseph Viscomi. Blake's Illuminated Books, vol. 5. Princeton and London, 1993.

Blanc 1857–58 Charles Blanc. *Le trésor de la curiosité, tiré des catalogues de vente de tableaux, dessins, estampes, livres, marbres, bronzes, ivoires, terres cuites, vitraux, médailles, armes, porcelaines, meubles, émaux, laques et autres objets d'art; avec diverses notes et notices historiques et biographiques. . . .* 2 vols. Paris, 1857–58.

Blanc 1861 Ch[arles] B[lanc]. "Le Salon des Arts-Unis." *Gazette des beaux-arts* 9 (February 1, 1861), pp. 189–92.

Blanc 1862–63 Charles Blanc. *École française.* 3 vols. Histoire des peintres de toutes les écoles. Paris, 1862–63.

Blanc 1867–68 Charles Blanc. "Ingres, sa vie et ses ouvrages," parts 1–9. *Gazette des beaux-arts* 22 (May 1, 1867), pp. 415–30; 23 (July 1, 1867), pp. 54–71; (September 1, 1867), pp. 193–208; (November 1, 1867), pp. 442–58; 24 (January 1, 1868), pp. 5–25; (April 1, 1868), pp. 340–67; (June 1, 1868), pp. 525–45; 25 (August 1, 1868), pp. 89–107; (September 1, 1868), pp. 228–48.

Blanc 1870 Charles Blanc. *Ingres, sa vie et ses ouvrages. Avec un portrait du maître, gravé par Flameng et douze gravures sur acier par MM. Henriquel-Dupont. . . .* Paris, 1870.

Blanch 1954 Lesley Blanch. *The Wilder Shores of Love.* London, 1954.

Blanchard 1998 Mary Warner Blanchard. *Oscar Wilde's America: Counterculture in the Gilded Age.* New Haven, 1998.

Blanche 1919 Jacques-Émile Blanche. *Propos de peintre. Série 1, De David à Degas.* Paris, 1919.

Blanche 1932 Jacques-Émile Blanche. "L'exposition française de Londres: Le XIXe siècle." *Gazette des beaux-arts,* ser. 6, 7 (September 1932), pp. 77–96.

Blanton 1965 Catherine W. Blanton. "'Scapin and Géronte' by Daumier." In *Fogg Art Museum Acquisitions* (1965), pp. 165–71. Cambridge, Mass., 1965.

Blanton 1966 Catherine W. Blanton. "An Unpublished Daumier Panel in the Fogg Art Museum: 'Scapin and Géronte.'" *Burlington Magazine* 108 (October 1966), pp. 511–16.

Bloom 1986 Harold Bloom, ed. *Pre-Raphaelite Poets: Modern Critical Views.* New York, 1986.

Blue Mountain Lake 1959 *Winslow Homer in the Adirondacks.* Exhibition, Adirondack Museum, Blue Mountain Lake, New York, August 15–September 15, 1959. Blue Mountain Lake, 1959.

Blunt 1959 Sir Anthony Blunt. *The Art of William Blake.* New York, 1959.

Blunt 1975 Wilfrid Blunt. *"England's Michelangelo": A Biography of George Frederic Watts, O.M., R.A.* London, 1975.

Board 1992 Marilynn Lincoln Board. "Art's Moral Mission: Reading G. F. Watts's 'Sir Galahad.'" In *The Arthurian Revival: Essays on Form, Tradition, and Transformation,* edited by Debra N. Mancoff. New York and London, 1992.

Bodelson 1968 Merete Bodelson. "Early Impressionist Sales, 1874–94." *Burlington Magazine* 110 (June 1968), pp. 331–48.

Boggs 1962 Jean Sutherland Boggs. *Portraits by Degas.* Berkeley, 1962.

Boggs 1978 Jean Sutherland Boggs. "Variations on the Nude." *Apollo* 107 (June 1978), pp. 487–89.

Boggs and Maheux 1992 Jean Sutherland Boggs and Anne Maheux. *Degas Pastels.* New York, 1992.

Bohn 1993 Willard Bohn. *Apollinaire, Visual Poetry, and Art Criticism.* London, 1993.

Boime 1996 Albert Boime. "Géricault's *African Slave Trade* and the Physiognomy of the Oppressed." In Michel 1996, vol. 2, pp. 561–93.

Bois 1990 Yve-Alain Bois. "Matisse and Arche-Drawing." In *Painting as Model,* by Yve-Alain Bois. Cambridge, Mass., 1990.

Bois 1994 Yve-Alain Bois. "On Matisse: The Blinding." *October,* no. 68 (spring 1994), pp. 61–121.

Bolger 1990 Doreen Bolger. "Cards and Letters from His Friends: *Mr. Hulings' Rack Picture* by William Michael Harnett." *American Art Journal* 22, no. 2 (1990), pp. 4–32.

Bolger 1992 Doreen Bolger. "The Patrons of the Artist: Emblems of Commerce and Culture." In New York and other cities 1992–93, pp. 73–85.

Bonafoux 1985 Pascal Bonafoux. *Portraits of the Artist: The Self-Portrait in Painting.* New York, 1985.

Bonaparte-Wyse 1969 Olga Bonaparte-Wyse. *The Spurious Brood—Princess Letitia Bonaparte and Her Children.* London, 1969.

Bonnard 1829–30 Camille Bonnard. *Costumes des XIIIe, XIVe et XVe siècles: Extraits des monumens les plus authentique de peinture et de sculpture, avec un texte historique et descriptif.* 2 vols. Paris, 1829–30.

Bordeaux 1851 *Explication des ouvrages . . . des artistes vivants exposés dans la Galerie de la Société des Amis des Arts le 15 novembre 1851.* Bordeaux, 1851.

Bordeaux 1868 *XVIe exposition de la Société des Amis des Arts de Bordeaux.* Exhibition, Bordeaux, 1868.

Bordeaux–Paris–Athens 1996–97 *La Grèce en révolte: Delacroix et les peintres français, 1815–1848.* Exhibition, Musée des Beaux-Arts, Bordeaux, June 14–September 8, 1996; Musée National Eugène Delacroix, Paris, October 8, 1996–January 13, 1997; Ethnikē Pinakothēkē Mouseion Alexandrou Soutsou, Athens, February 12–April 25, 1997. Catalogue edited by Claire Constans. Paris, 1996.

Bordes 1980 Philippe Bordes. "Jacques-Louis David's 'Serment du Jeu de Paume': Propaganda without a Cause?" *Oxford Art Journal* 3 (October 1980), pp. 19–25.

Bordes 1983 Philippe Bordes. *"Le Serment du Jeu de Paume" de Jacques-Louis David: Le peintre, son milieu et son temps, de 1789 à 1792.* Notes et documents des musées de France, 8. Paris, 1983.

Bordes (1997) 2001 Philippe Bordes. "Un graveur disponible, Jacques-Louis Copia." In Prud'hon colloque (1997) 2001, pp. 105–27.

Bordes and Pougetoux 1983 Philippe Bordes and Alain Pougetoux. "Les portraits de Napoléon en habits impériaux par Jacques-Louis David." *Gazette des beaux-arts,* ser. 6, 102 (July–August 1983), pp. 21–34.

Borel 1990 France Borel. *Le modèle ou l'artiste séduit.* Geneva, 1990.

Born 1946 Wolfgang Born. "Notes on Still-Life Painting in America." *Antiques* 50, no. 3 (September 1946), pp. 158–60.

Born 1947 Wolfgang Born. *Still-Life Painting in America.* New York, 1947.

Borowitz 1979 Helen Osterman Borowitz. "Two Nineteenth-Century Muse Portraits." *Bulletin of the Cleveland Museum of Art* 66, no. 6 (September 1979), pp. 246–67.

Borowitz and Borowitz 1991 Helen Osterman Borowitz and Albert Borowitz. *Pawnshop and Palaces: The Fall and Rise of the Campana Art Museum.* Washington, D.C., 1991.

Börsch-Supan 1996 Eva Börsch-Supan. "Riepenhausen." In *Dictionary of Art,* edited by Jane Turner, vol. 26, pp. 374–75. London and New York, 1996.

Bosman 1961 Anthony Bosman. *Pierre-Auguste Renoir.* London, 1961.

Boston 1880 Exhibition of Homer's Gloucester watercolors and drawings, Doll and Richards, Boston, 1880.

Boston 1891 *Exhibition of Books, Water Colors, Engravings, etc., by William Blake.* Exhibition, Museum of Fine Arts, Boston, February 7–March 15, 1891. Catalogue compiled by S. R. Koehler. Boston, 1891.

Boston 1904 *Loan Collection: Oil Paintings, Water Colors, Pastels, and Drawings: Memorial Exhibition of the Works of Mr. J. McNeill Whistler.* Exhibition, Copley Hall, Copley Society, Boston, February 1904. Catalogue. Boston, 1904.

Boston 1939 *Art in New England: Paintings, Drawings, Prints, from Private Collections in New England.* Exhibition, Museum of Fine Arts, Boston, June 9–September 10, 1939. Catalogue. Cambridge, Mass., 1939.

Boston 1956 *Sargent's Boston.* Exhibition, Museum of Fine Arts, Boston, January 3–February 7, 1956. Catalogue, *Sargent's Boston, with an Essay and a Biographical Summary and a Complete Checklist of Sargent's Portraits,* by David McKibbin. Boston, 1956.

Boston 1984 *Jean-Francois Millet.* Exhibition, Museum of Fine Arts, Boston, March 28–July 1, 1984. Catalogue by Alexandra R. Murphy, with contributions by Susan Fleming and Chantal Mahy-Park. Boston, 1984.

Boston 1996 *New Histories.* Exhibition, Institute of Contemporary Art, Boston, October 23, 1996–January 5, 1997. Catalogue by Milena Kalinovska, curator, and Lia Gangitano and Steven Nelson, eds. Boston, 1996.

Boucher 1965 François Boucher. *Histoire du costume en Occident de l'antiquité à nos jours.* Paris, 1965.

Boucher 1979 Marie-Christine Boucher. "L'oeuvre peint de Puvis de Chavannes au Musée du Petit Palais et sa place dans les collections publiques françaises." In Paris 1979, unpag.

Bouchet 1946 André du Bouchet. "The Violence of Géricault." *Foreground* 1 (1946).

Bouchot 1893 Henri Bouchot. "Exposition des portraits des écrivains et journalistes du siècle." *Gazette des beaux-arts,* ser. 3, 10 (September 1, 1893), pp. 202–22.

Bouchot-Saupique 1929 J. Bouchot-Saupique. "Quelques dessins de David au musée de Besançon." *Bulletin de la Société de l'Histoire de l'Art Français,* 1929, pp. 219–20.

Bouillon 1986 Jean-Paul Bouillon. *Klimt: Beethoven.* Geneva, 1986.

Bouillon 1987 Jean-Paul Bouillon. *Félix Bracquemond, le réalisme absolu: Oeuvre gravé, 1849–1859. Catalogue raisonné.* Geneva, 1987.

Boutard 1814 Jean-Baptiste Bon Boutard. "Beaux-Arts Salon de 1814." *Journal des débats,* December 12, 1814.

Bouvy 1933 Eugène Bouvy. *Daumier: L'oeuvre gravé du maître.* 2 vols. Paris, 1933.

Bouyer 1931 Raymond Bouyer. "Les expositions du mois." *Revue de l'art* 60 (1931), pp. 263–68.

Bowness 1965 Alan Bowness, ed. *Impressionists and Post-impressionists.* Vol. 7 of *The Book of Art: A Pictorial Encyclopedia of Painting, Drawing, and Sculpture.* New York, 1965.

Bowron 1990 Edgar Peters Bowron. *European Paintings before 1900 in the Fogg Art Museum: A Summary Catalogue Including Paintings in the Busch-Reisinger Museum.* Cambridge, Mass., 1990.

Boyce 1980 George Price Boyce. *The Diaries of George Price Boyce.* Edited by Virginia Surtees. Norwich, 1980. Originally published in the Old Water-Colour Society Club's 19th annual volume, 1941.

Boyé 1946 Maurice Pierre Boyé. *La mêlée romantique.* Paris, 1946.

Boyer 1997 Sylvain Boyer. "Les autoportraits: Journal intime du peintre." *Dossier de l'art* 39 (July 1997), pp. 34–37.

Boyer d'Agen 1909 J. A[ugustine] B. Boyer d'Agen, ed. *Ingres d'après une correspondance inédit.* Paris, 1909. Reprinted, Paris, 1926.

Bradford 1904 *Inaugural Exhibition.* Exhibition, City of Bradford Cartwright Memorial Hall, Bradford, May–October 1904. Catalogue, *Official Souvenir.* Bradford, 1904.

Brady 1999 Mark Brady. *Old Master Drawings.* New York, 1999.

Brandell and Kreuzer 1976 Gunnar Brandell and Helmut Kreuzer. *Jahrhundertende, Jahrhundertwende.* Wiesbaden, 1976.

Brattler: Intimate Landscapes 1997 *The Brattler: Intimate Landscapes.* Cambridge, Mass.: Harvard Extension School Writing Program, 1997.

Bremen–Bonn 1988 *Mythos Europa: Europa und der Stier im Zeitalter der Industriellen Zivilisation.* Exhibition, Kunsthalle Bremen; Wissenschaftszentrum Bonn, 1988. Catalogue by Siegfried Salzmann. Bremen, 1988.

Breton 1840 Ernest Breton. "M. Ingres.— L'Odalisque. La Chapelle Sixtine." *Bulletin des salons,* 1840, pp. 67–68.

Brettell 1990 Richard R. Brettell, with assistance of Joachim Pissarro. *Pissarro and Pontoise: The Painter in a Landscape.* New Haven, 1990.

Brettell and Lloyd 1980 Richard R. Brettell and Christopher Lloyd. *A Catalogue of the Drawings by Camille Pissarro in the Ashmolean Museum, Oxford.* Oxford, 1980.

Brimo 1938 René Brimo. *L'évolution du goût aux États-Unis d'après l'histoire des collections.* Paris, 1938.

Brion 1966 Marcel Brion. *Art of the Romantic Era.* New York, 1966.

Brisbane–Melbourne–Sydney 1994–95 *Renoir: Master Impressionist.* Exhibition, Queensland Art Gallery, Brisbane, July 30–September 11, 1994; National Gallery of Victoria, Melbourne, September 18–October 30; Art Gallery of New South Wales, Sydney, November 5, 1994–January 15, 1995. Catalogue by John House. Sydney, 1994.

Bristol and other cities 1991–92 *The Primacy of Drawing: An Artist's View.* Exhibition, City of Bristol Museum and Art Gallery, and circulated elsewhere by the South Bank Centre, 1991–92. Catalogue by Deanna Petherbridge. London, 1991.

Brogan 1944 Denis W. Brogan. *The Development of Modern France (1870–1939).* London, 1944.

Bronkhurst 1996 Judith Bronkhurst. "Holman Hunt's Picture Frames, Sculpture, and Applied Art." In *Re-framing the Pre-Raphaelites: Historical and Theoretical Essays,* edited by Ellen Harding, pp. 231–51. Aldershot, Hants., and Brookfield, Vt., 1996.

Brooklyn 1923–24 *An Exhibition of Original Drawings* [by Aubrey Beardsley]. Exhibition, Brooklyn Museum, December 19, 1923–January 31, 1924. Catalogue. Brooklyn, 1923.

Brooklyn–Minneapolis 1988–89 *Courbet Reconsidered.* Exhibition, Brooklyn Museum, November 4, 1988–January 16, 1989; Minneapolis Institute of Arts, February 18–April 30, 1989. Catalogue by Sarah Faunce and Linda Nochlin. Brooklyn and New Haven, 1988.

Brookner 1964 Anita Brookner. "Art Historians and Art Critics VII: Charles Baudelaire." *Burlington Magazine* 106 (June 1964), pp. 269–79.

Brookner 1980 Anita Brookner. *Jacques-Louis David.* London, 1980.

Brookner 2000 Anita Brookner. *Romanticism and Its Discontents.* New York, 2000.

Brophy 1969 Brigid Brophy. *Black and White: A Portrait of Aubrey Beardsley.* New York, 1969.

Broude (1974) 1978 Norma Broude. "Night Light on Seurat's 'Dot': Its Relation to Photo-Mechanical Color Printing in France in the 1880s." *Art Bulletin* 56 (December 1974), pp. 581–89. Reprinted in Norma Broude, ed., *Seurat in Perspective,* Englewood Cliffs, N.J., 1978.

Broude 1976 Norma Broude. "The Influence of Rembrandt Reproductions on Seurat's Drawing Style: A Methodological Note." *Gazette des beaux-arts,* ser. 6, 88 (October 1976), pp. 155–59.

Brown 1981 Ford Madox Brown. *The Diary of Ford Madox Brown.* Edited by Virginia Surtees. Studies in British Art. New Haven, 1981.

Brown 1985 Hilton Brown. "Academic Art Education and Studio Practices." *American Artist* 49 (February 1985), pp. 42–53.

Brown 1996 Eleanor Brown. *Maiden Speech.* Newcastle upon Tyne, 1996.

Browse 1949 Lillian Browse. *Degas Dancers.* New York, [1949].

Brussels 1884 *Le salon de Bruxelles.* Exhibition, Brussels, September–November 1884. Catalogue by Max Waller; preface by Camille Lemonnier. Brussels, 1884.

Brussels 1889 *VIme exposition annuelle des XX.* Exhibition, Brussels, 1889.

Brussels 1892 *IXe exposition annuelle des XX.* Exhibition, Brussels, February 1892. Catalogue by Anna Boch et al. Brussels, 1892.

Brussels 1894 *Ie salon de La Libre Esthétique.* Exhibition, National Gallery, Brussels, February 17–March 15, 1894.

Bryan 1903–5 Michael Bryan. *Bryan's Dictionary of Painters and Engravers.* 5 vols. New ed. London, 1903–5.

Bryan 1909–10 Michael Bryan. *Bryan's Dictionary of Painters and Engravers.* 5 vols. New ed. London, 1909–10.

Bryant 1987–88 Barbara Bryant. "The Origins of G. F. Watts's 'Symbolical' Paintings: A Lost Study Identified." *Porticus: Journal of the Memorial Art Gallery of the University of Rochester* 10–11 (1987–88), pp. 52–59.

Bryant 1996 Barbara Bryant. "G. F. Watts at the Grosvenor Gallery: 'Poems Painted on Canvas' and the New Internationalism." In New Haven–Denver–Newcastle upon Tyne 1996, pp. 109–28.

Bryant 1997 Barbara Bryant. "G. F. Watts and the Symbolist Vision." In London–Munich–Amsterdam 1997–98, pp. 65ff.

Bryson 1984 Norman Bryson. *Tradition and Desire: From David to Delacroix.* Cambridge and New York, 1984.

Bryson and Troxell 1976 John Bryson and Janet Camp Troxell. *Dante Gabriel Rossetti and Jane Morris, Their Correspondence.* Oxford, 1976.

Buckley 1968 Jerome H. Buckley, ed. *The Pre-Raphaelites.* New York, 1968.

Buettner and Pauly 1992 Stewart Buettner and Reinhard G. Pauly. *Great Composers, Great Artists: Portraits.* Portland, Oreg., 1992.

Bullard 1916 Francis Bullard. *A Catalogue of the Collection of Prints from the* Liber Studiorum *of Joseph Mallord William Turner, Formed by the Late Francis Bullard of Boston, Massachusetts, and Bequeathed by Him to the Museum of Fine Arts in Boston.* Boston, 1916.

Bullen 1998 J. B. Bullen. *The Pre-Raphaelite Body: Fear and Desire in Painting, Poetry, and Criticism.* Oxford, 1998.

Burckhardt 1921 Carl Burckhardt. *Rodin und das plastische Problem.* Basel, 1921.

Bürger 1864 W. Bürger [Théophile Thoré]. "Les cabinets d'amateurs à Paris: Galerie de MM. Pereire." *Gazette des beaux-arts* 16, no. 3 (March 1, 1864), pp. 193–213.

Burkom 1993 Frans von Burkom. "Puvis de Chavannes Ste. Geneviève als kind, ingebed." *Jong Holland* 14, no. 4 (1993), pp. 15–19.

Burne-Jones 1900 Philip Burne-Jones. "Notes on Some Unfinished Works of Sir Edward Burne-Jones, Bt., by His Son." *Magazine of Art* 24 (1900), pp. 159–67.

Burne-Jones 1904 G[eorgiana] B[urne-]J[ones]. *Memorials of Edward Burne-Jones.* 2 vols. London, 1904.

Burne-Jones (1904) 1993 G[eorgiana] B[urne-]J[ones]. *Memorials of Edward Burne-Jones.* 2 vols. Facsimile ed., with an introduction by John Christian. London, 1993.

Burty 1859 Philippe Burty. "Vente de la collection Ary Scheffer." *Gazette des beaux-arts* 2, no. 1 (April 1, 1859), p. 48.

Burty 1864 Philippe Burty. "Six tableaux nouveaux de M. Ingres." *La chronique des arts et de la curiosité* 2, no. 70 (July 10, 1864), pp. 204–5.

Burty 1874 Philippe Burty. "The Paris Exhibitions: *Les Impressionistes.*" *The Academy* (London), May 30, 1874, p. 616.

Burty 1878 Philippe Burty. "Silhouettes d'artistes contemporaines. VI. Le peintre et graveur Félix Bracquemond." *L'art* 12 (1878), pp. 289–98.

Burty 1879 Philippe Burty. "Profils d'amateurs. I. Laurent Laperlier." *L'art* 16 (1879), pp. 147–51.

Busch 1967 Gunter Busch. "Kopien von Théodore Gericault nach alten Meistern." *Pantheon* 25, no. 3 (May–June 1967), pp. 176–84.

"Businessman and the Artist" 1958 Charles C. Withers. "The Businessman and the Artist." *Harvard Business School Bulletin* 34, no. 1 (February 1958), pp. 23–31.

Butler 1993 Ruth Butler. *Rodin: The Shape of Genius.* New Haven, 1993.

Butler 1998 Ruth Butler. *Rodin: La solitude du génie.* Translated by Dennis Collins. Paris, 1998.

Butlin 1981 Martin Butlin. *The Paintings and Drawings of William Blake.* 2 vols. New Haven, 1981.

Butlin 1990 Martin Butlin. *William Blake, 1757–1827.* Tate Gallery Collections, vol. 5. London, 1990.

Butlin and Joll 1984 Martin Butlin and Evelyn Joll. *The Paintings of J. M. W. Turner.* Rev. ed. 2 vols. Studies in British Art. New Haven, 1984.

Byatt 1992 A. S. Byatt. *Angels and Insects.* London, 1992.

Byvanck 1892 Willem Geertrudus Cornelis Byvanck. *Un Hollandais à Paris en 1891: Sensations de littérature et d'art.* Paris, 1892.

Cabanne 1970 [Pierre Cabanne]. *Renoir.* Génies et réalités. Paris, 1970.

Cabanne 1985 Pierre Cabanne. *Whistler.* New York, 1985.

Cailles 1947 Pierre Cailles, ed. *Géricault raconté par lui-même et par ses amis.* Geneva, 1947.

Cambridge, Mass., 1942 *French Art of the Nineteenth Century: Paintings, Prints, Drawings.* Exhibition, Fogg Art Museum, Harvard University Art Museums, Cambridge, Mass., July 1–August 31, 1942. Catalogue by Agnes Mongan. Cambridge, Mass., 1942.

Cambridge, Mass., 1943 *French Romanticism of the 1830s.* Exhibition, Fogg Art Museum, Harvard University Art Museums, Cambridge, Mass., January 16–February 12, 1943. Catalogue by Agnes Mongan. Cambridge, Mass., 1943.

Cambridge, Mass., 1943–44 *Chinese Sculpture, Bronzes, Jades, Paintings and Drawings, Egyptian and Persian Sculpture, Pre-Columbian Art: Selected from the Collection of Grenville Lindall Winthrop.* Exhibition, Fogg Art Museum, Harvard University Art Museums, Cambridge, Mass., October 1943–February 1944. Catalogue. Cambridge, Mass., [1943].

Cambridge, Mass., 1944a *Blake to Beardsley: A Century of English Illustration.* Exhibition, Fogg Art Museum, Harvard University Art Museums, Cambridge, Mass., 1944. Catalogue, Cambridge, Mass., 1944.

Cambridge, Mass., 1944b *Drawing Exhibition of Recent Loans and Gifts.* Exhibition, Fogg Art Museum, Harvard University Art Museums, Cambridge, Mass., 1944.

Cambridge, Mass., 1944c *Watercolors by Winslow Homer.* Exhibition, Fogg Art Museum, Harvard University Art Museums, Cambridge, Mass., 1944.

Cambridge, Mass., 1944d *Washington, Lafayette, Franklin: Portraits, Books, Manuscripts, Prints, Memorabilia, for the Most Part from the Collections of the University.* Exhibition, Fogg Art Museum, Harvard University Art Museums, Cambridge, Mass., February 22–May 28, 1944. Catalogue preface by Agnes Mongan and Mary Wadsworth. Cambridge, Mass., 1944.

Cambridge, Mass., 1946a *Between the Empires: Géricault, Delacroix, Chassériau.* Exhibition, Fogg Art Museum, Harvard University Art Museums, Cambridge, Mass., April 30–June 1, 1946. Catalogue introduction by F[rederick] S. W[ight]. Cambridge, Mass., 1946.

Cambridge, Mass., 1946b *Paintings and Drawings of the Pre-Raphaelites and Their Circle.* Exhibition, Fogg Art Museum, Harvard University Art Museums, Cambridge, Mass., April 8–June 1, 1946. Catalogue by Mary Wadsworth et al.; introduction by Agnes Mongan. Cambridge, Mass., 1946.

Cambridge, Mass., 1946c *French Painting since 1870 Lent by Maurice Wertheim, Class of 1906.*

Exhibition, Fogg Art Museum, Harvard University Art Museums, Cambridge, Mass., June 1–September 7, 1946. Catalogue. Cambridge, Mass., 1946.

Cambridge, Mass., 1947 *Exhibition of Watercolors and Drawings by William Blake, 1757–1827.* Exhibition, Fogg Art Museum, Harvard University Art Museums, Cambridge, Mass., October–November 1947. Typescript pamphlet. Cambridge, Mass., 1947.

Cambridge, Mass., 1948 *Real and Ideal in American Art.* Exhibition, Fogg Art Museum, Harvard University Art Museums, Cambridge, Mass., summer 1948. Catalogue. Cambridge, Mass., 1948.

Cambridge, Mass., 1948–49 *Seventy Master Drawings.* Exhibition, Fogg Art Museum, Harvard University Art Museums, Cambridge, Mass., November 1948–January 1949. For catalogue, *see* Mongan 1949.

Cambridge, Mass., 1950 *The Self-Portrait, 1850–1950.* Exhibition, Fogg Art Museum, Harvard University Art Museums, Cambridge, Mass., 1950.

Cambridge, Mass., 1955 *Delacroix in New England Collections.* Exhibition, Fogg Art Museum, Harvard University Art Museums, Cambridge, Mass., October 15–November 26. 1955. Checklist. Cambridge, Mass., 1955.

Cambridge, Mass., 1959 *The Self-Portrait, 1850–1950.* Exhibition, Fogg Art Museum, Harvard University Art Museums, Cambridge, Mass., May 5–30, 1959. Catalogue. Cambridge, Mass., 1959.

Cambridge, Mass., 1960 *Gustave Moreau, 1826–1898, and Adolphe Monticelli, 1824–1886: A Museum Course Exhibition.* Exhibition, Busch-Reisinger Museum, May 13–June 8, 1960. Organized by Elizabeth Baker, Diane Russell, and Michael C. D. Macdonald; typescript catalogue. [Cambridge, Mass., 1960].

Cambridge, Mass., 1961 *Ingres and Degas: Two Classical Draughtsmen.* Exhibition prepared by the students in the Museum course, Fogg Art Museum, Harvard University Art Museums, Cambridge, Mass., April 24–May 20, 1961. Catalogue. Cambridge, Mass., 1961.

Cambridge, Mass., 1961–62 *Pictorial Reflections of Drama: Barlach to Ibsen.* Exhibition, Busch-Reisinger Museum, Harvard University Art Museums, Cambridge, Mass., November 20, 1961–January 8, 1962.

Cambridge, Mass., 1962 *Rivers and Seas: Changing Attitudes toward Landscape, 1700–1962.* Exhibition, Busch-Reisinger Museum, Harvard University Art Museums, Cambridge, Mass., April 26–June 16, 1962. Catalogue. Cambridge, Mass., 1962.

Cambridge, Mass., 1964 *Studies and Study Sheets: Master Drawings from Five Centuries.* Exhibition, Fogg Art Museum, Harvard University Art Museums, Cambridge, Mass., March 26–April 18, 1964. Catalogue. Cambridge, Mass., 1964.

Cambridge, Mass., 1967a *Ingres Centennial Exhibition, 1867–1967: Drawings, Watercolors, and Oil Sketches from American Collections.* Exhibition, Fogg Art Museum, Harvard University Art Museums, Cambridge, Mass., February 12–April 9, 1967. Catalogue by Agnes Mongan and Hans Naef, appendix by Marjorie B. Cohn. Cambridge, Mass., 1967.

Cambridge, Mass., 1967b *Paintings from the Bequest of Grenville L. Winthrop Shown in Conjunction with the Ingres Centennial Exhibition.* Exhibition, Fogg Art Museum, Harvard University Art Museums, Cambridge, Mass., February 12–April 9, 1967.

Cambridge, Mass., 1968 *Degas Monotypes: Essay, Catalogue, and Checklist.* Exhibition, Fogg Art Museum, Harvard University Art Museums, Cambridge, Mass., April 25–June 14, 1968. Catalogue by Eugenia Parry Janis. Cambridge, Mass., 1968.

Cambridge, Mass., 1969 *Grenville L. Winthrop: Retrospective for a Collector.* Exhibition, Fogg Art Museum, Harvard University Art Museums, Cambridge, Mass., January 23–March 31, 1969. Catalogue by Dorothy W. Gillerman, Gridley McKim, and Joan R. Mertens. Cambridge, Mass., 1969.

Cambridge, Mass., 1969–70 *Rodin: The Burghers of Calais.* Exhibition, Fogg Art Museum, Harvard University Art Museums, Cambridge, Mass., November 14, 1969–January 28, 1970. See Jones and Kuretsky, 1969.

Cambridge, Mass., 1970 *The Turn of a Century, 1885–1910: Art Nouveau–Jugendstil Books.* Exhibition, Houghton Library, Cambridge, Mass., May–July 1970. Catalogue by Eleanor M. Garvey, Anne B. Smith, and Peter A. Wick. Cambridge, Mass., 1970.

Cambridge, Mass., 1972a *American Art at Harvard.* Exhibition, Fogg Art Museum, Harvard University Art Museums, Cambridge, Mass., April 19–June 18, 1972. Catalogue compiled by Kenyon C. Bolton III et al. Cambridge, Mass., 1972.

Cambridge, Mass., 1972b *Beerbohm, Beardsley, and Rothenstein: A Centennial View.* Exhibition, Houghton Library, Cambridge, Mass., April–May 1972.

Cambridge, Mass., 1973a *Pre-Raphaelite and Early French Symbolist Art in the Fogg Collections.* Exhibition, Fogg Art Museum, Harvard University Art Museums, Cambridge, Mass., January 16–February 25, 1973.

Cambridge, Mass., 1973b *Ingres' Sculptural Style: A Group of Unknown Drawings.* Exhibition, Fogg Art Museum, Harvard University Art Museums, Cambridge, Mass., February 9–March 11, 1973. Catalogue by Phyllis Hattis. Cambridge, Mass., 1973.

Cambridge, Mass., 1974 *Color in Art: A Tribute to Arthur Pope.* Fogg Art Museum, Harvard University Art Museums, Cambridge Mass., April 24–June 16, 1974. Catalogue by James N. Carpenter. Cambridge, Mass., 1974.

Cambridge, Mass., 1975 *Ancient Chinese Jades from the Grenville L. Winthrop Collection in the Fogg Art Museum, Harvard University.* Exhibition, Fogg Art Museum, Harvard University Art Museums, Cambridge, Mass., January 22–March 18, 1975. Catalogue by Max Loehr, with Louisa G. Fitzgerald Huber. Cambridge, Mass., 1975.

Cambridge, Mass., 1975–76a *Harvard Honors Lafayette.* Exhibition, Fogg Art Museum, Harvard University Art Museums, Cambridge, Mass., December 3, 1975–March 12, 1976. Catalogue by Agnes Mongan, with the assistance of Louise Todd Ambler et al. Cambridge, Mass., 1975.

Cambridge, Mass., 1975–76b *Metamorphoses in Nineteenth-Century Sculpture.* Exhibition, Fogg Art Museum, Harvard University Art Museums, Cambridge, Mass., November 19, 1975–January 7, 1976. Catalogue edited by Jeanne L. Wasserman. Cambridge, Mass., 1975.

Cambridge, Mass., 1976–77 *Aubrey Beardsley: Drawings and Books.* Exhibition, Fogg Art Museum, Harvard University Art Museums, Cambridge, Mass., December 1976–January 1977.

Cambridge, Mass., 1977a *Master Paintings from the Fogg Collection.* Exhibition, Fogg Art Museum, Harvard University Art Museums, Cambridge, Mass., April 13–August 1977.

Cambridge, Mass., 1977b *Wash and Gouache.* Exhibition, Fogg Art Museum, Harvard University Art Museums, Cambridge, Mass., May 12–June 22, 1977. Catalogue, *Wash and Gouache: A Study of the Development of the Materials of Watercolor,* by Marjorie B. Cohn and Rachel Rosenfield. Cambridge, Mass., 1977.

Cambridge, Mass., 1978 *Apollo's Laurels.* Exhibition, Fogg Art Museum, Harvard University Art Museums, Cambridge, Mass., June 1–October 4, 1978.

Cambridge, Mass., 1979–80 *Dionysos and His Circle: Ancient through Modern.* Exhibition, Fogg Art Museum, Harvard University Art Museums, Cambridge, Mass., December 10, 1979–February 10, 1980. Catalogue by Caroline Houser. Cambridge, Mass., 1979.

Cambridge, Mass., 1980a *The Pre-Raphaelites: Selections from the Permanent Collection.* Exhibition, Fogg Art Museum, Harvard University Art Museums, Cambridge, Mass., 1980.

Cambridge, Mass., 1980b *Works by J.-A.-D. Ingres in the Collection of the Fogg Art Museum.* Exhibition, Fogg Art Museum, Harvard University Art Museums, Cambridge, Mass., October 19–December 7, 1980. Catalogue by Marjorie B. Cohn and Susan L[ocke] Siegfried. Fogg Art Museum Handbooks, vol. 3. Cambridge, Mass., 1980.

Cambridge, Mass., 1981 *A Bronze Menagerie and Other Works by Antoine-Louis Barye from the Fogg Museum's Collection.* Exhibition, Fogg Art Museum, Harvard University Art Museums, Cambridge, Mass., September 25–December 27, 1981. For catalogue, *see* Wasserman 1982.

Cambridge, Mass., 1982 *Dante Gabriel Rossetti: A Centennial Exhibition from the Harvard Collections.* Exhibition, Fogg Art Museum, Harvard University Art Museums, Cambridge, Mass., July 12–September 11, 1982.

Cambridge, Mass., 1985 *Modern Art at Harvard: The Formation of the Nineteenth- and Twentieth-Century Collections of the Harvard University Art Museums.* Exhibition, Arthur M. Sackler Museum, Harvard University Art Museums, Cambridge, Mass. Catalogue by Caroline A. Jones, with an essay by John Coolidge. New York and Cambridge, Mass., 1985.

Cambridge, Mass., 1987 *Paintings by Dante Gabriel Rossetti: A Technical Study.* Exhibition, Fogg Art Museum, Harvard University Art Museums, Cambridge, Mass., July 24–September 18, 1987.

Cambridge, Mass., 1990 *The Harvest of 1830: The Barbizon Legacy.* Exhibition, Arthur M. Sackler Museum, Harvard University Art Museums, Cambridge, Mass., August 25–October 21, 1990. Catalogue by Eric M. Rosenberg and Miriam Stewart. Cambridge, Mass., 1990.

Cambridge, Mass., 1991 *Théodore Géricault, 1791–1824: A Bicentennial Exhibition of His Prints and Drawings.* Exhibition, Fogg Art Museum, Harvard University Art Museums, Cambridge, Mass., June 8–August 4, 1991.

Cambridge, Mass., 1993 *Portrait, Prospect and Poetry: British Drawings from the Grenville L. Winthrop Bequest.* Exhibition, Fogg Art Museum, Harvard University Art Museums, Cambridge, Mass., September 11–November 7, 1993.

Cambridge, Mass., 1994 *American Art at Harvard: Cultures and Contents.* Exhibition, Arthur M. Sackler Museum, Harvard University Art Museums, Cambridge, Mass., October 1–December 30, 1994. Catalogue by Timothy Anglin Burgard. Harvard University Art Museums Gallery Series, no. [10]. Cambridge, Mass., 1994.

Cambridge, Mass., 1994–95 *Drawing on Tradition: The Lost Legacy of Academic Figure Studies.* Exhibition, Fogg Art Museum, Harvard University Art Museums, Cambridge, Mass., November 19, 1994–January 29, 1995. Gallery brochure by Alvin L. Clark Jr. Harvard University Art Museums Gallery Series, no. 12. Cambridge, Mass., 1994.

Cambridge, Mass., 1995 *The Persistence of Memory: Continuity and Change in American Cultures.* Exhibition, Fogg Art Museum, Harvard University Art Museums, Cambridge, Mass., 1995.

Cambridge, Mass., 1998 *Classicism, Romanticism, Realism: German Drawings from Mengs to Menzel in the Harvard University Art Museums.* Exhibition, Busch-Reisinger Museum, Harvard University Art Museums, Cambridge, Mass., April 4–June 28, 1998. Catalogue by William W. Robinson. Harvard University Art Museums Gallery Series, no. 23. Cambridge, Mass., 1998.

Cambridge, Mass., 2001 *Verso: The Flip Side of Master Drawings.* Exhibition, Fogg Art Museum, Harvard University Art Museums, Cambridge, Mass., May 19–August 12, 2001. Catalogue by James G. Harper. Cambridge, Mass., 2001.

Cambridge, Mass.–New York 1965–67 *Memorial Exhibition: Works of Art from the Collection of Paul J. Sachs, 1878–1965, Given and Bequeathed to the Fogg Art Museum.* Exhibition, Fogg Art Museum, Harvard University Art Museums, Cambridge, Mass., November 15, 1965–January 15, 1966; Museum of Modern Art, New York, December 19, 1966–February 26, 1967. Catalogue by Agnes Mongan with Mary Lee Bennett. Cambridge, Mass., 1965.

Canaday 1959 John Canaday. *Mainstreams of Modern Art.* New York, 1959.

Canaday 1981 John Canaday. *Mainstreams of Modern Art.* [2nd ed.]. New York, 1981.

Cantaloube 1860 A. Cantaloube. "Les dessins de Louis David." *Gazette des beaux-arts* 7–8 (September 1860), pp. 285–303.

Cantinelli 1930 Richard Cantinelli. *Jacques-Louis David, 1748–1825.* Paris and Brussels, 1930.

Canvas Seeks the Light 1992 *Journey into Masterpieces.* Vol. 19, *The Canvas Seeks the Light.* (In Japanese.) Tokyo, 1992.

Carnet de dessins 2000 *Carnet de dessins: La main.* Paris, 2000.

Carrington 1899 Fitzroy Carrington. *Pictures and Poems by Dante Gabriel Rossetti.* New York, 1899.

Carrington 1901 Fitzroy Carrington, ed. *Pictures of Romance and Wonder by Sir Edward Burne-Jones.* New York, 1901.

Cartwright 1894 Julia Cartwright. "The Life and Work of Sir Edward Burne-Jones." *Art Annual,* special number of the *Art Journal.* London, 1894.

Cary n.d. Henry Francis Cary, trans. *The Vision; or Hell, Purgatory, and Paradise of Dante Alighieri.* London: Newnes, n.d.

Cary 1819 Henry Francis Cary, trans. *The Vision; or Hell, Purgatory, and Paradise, of Dante Alighieri.* 3 vols. 2nd ed. London, 1819.

Cary 1900 Elisabeth Luther Cary. *The Rossettis: Dante Gabriel and Christina.* London, 1900.

Cary 1907 Elisabeth Luther Cary. *The Works of James McNeill Whistler: A Study with a Tentative List of the Artist's Work.* New York, 1907.

Caso and Sanders 1977 Jacques de Caso and Patricia B. Sanders. *Rodin's Sculpture: A Critical Study of the Spreckels Collection, California Palace of the Legion of Honor.* San Francisco, Rutland, Vt., and Tokyo, 1977.

Cassavetti 1989 Eileen Cassavetti. "The Fatal Meeting and the Fruitful Passion." *Antique Collector* 60, no. 3 (March 1989), pp. 34–45.

Cassou 1934 Jean Cassou. "Ingres et ses contradictions." *Gazette des beaux-arts,* ser. 6, 11 (March 1934), pp. 146–64.

Cassou 1935 Jean Cassou. "Ingres: Inventeur des femmes." *La renaissance* 18 (March 1935), pp. 1–8.

Cassou 1936 Jean Cassou. "Ingres." *L'art et les artistes* 31 (February 1936), pp. 145–75.

Cassou 1947 Jean Cassou. *Ingres.* Brussels, 1947.

Cassou 1953 Jean Cassou. *Die Impressionisten und ihre Zeit.* Lucerne, 1953.

Castan 1889a Auguste Castan. *Histoire et description des musées de la ville de Besançon.* Paris, 1889.

Castan 1889b Auguste Castan. *Musée de Besançon: Catalogue des peintures, dessins, sculptures et antiquités.* Besançon, 1886.

Castel 1833 René-Richard-Louis Castel. *Lettres de René-Richard-Louis Castel au comte Louis de Chevigné, son élève et son ami.* Vol. 1. Reims, 1833.

Castelnuovo 1991 Poppi Castelnuovo, ed. *La pittura in Italia: L'Ottocento.* 2 vols. Milan, 1991.

Casteras 1988 Susan P. Casteras. "Rossetti's Embowered Females in Art; or, Love Enthroned and the Lamp's Shrine." *Nineteenth Century Studies* 2 (1988), pp. 27–51.

Casteras 1998 Susan P. Casteras. "Victorian Vignettes: Daniel Maclise's Scottish Lovers and Marie Spartali Stillman's 'La Pensierosa.'" *Bulletin / Biennial Report 1995–97, Elvehjem Museum of Art* (University of Wisconsin, Madison), 1998, pp. 29–40.

Cavendish 1985a Marshall Cavendish Ltd. *The Great Artists: A Marshall Cavendish Weekly Collection. No. 18: Ingres.* Sussex, 1985.

Cavendish 1985b Marshall Cavendish Ltd. *The Great Artists: A Marshall Cavendish Weekly Collection. No. 19: Whistler.* Sussex, 1985.

Cecil 1969 David Cecil. *Visionary and Dreamer: Two Poetic Painters, Samuel Palmer and Edward Burne-Jones.* Princeton, 1969.

***Centenaire du* Journal des débats 1889** *Le livre du centenaire du* Journal des débats, *1789–1889.* Paris, 1889.

Cetto 1949 S. M. Cetto. *Tierzeichnungen aus acht Jahrhunderten.* Basel, 1949.

Cézanne 1995 Paul Cézanne. *Letters.* Edited by John Rewald; translations by Marguerite Kay. New York, 1995. An unabridged republication of the 1976 ed. with notations and the addition of 52 illus. from the 1941 ed.

Chaet 1979 Bernard Chaet. *An Artist's Notebook: Techniques and Materials.* New York, 1979.

Cham 1865 Cham [Amédée-Charles-Henri, comte de Noé]. *Le Salon de 1865, photographié par Cham.* Paris, 1865.

Cham 1883 Cham [Amédée-Charles-Henri, comte de Noé]. *Les folies parisiennes, quinze années comiques, 1864–1879.* Paris, 1883.

Champsaur 1886 Félicien Champsaur. *Le cerveau de Paris: Esquisses de la vie littéraire et artistique.* 2nd ed. Paris, 1886.

Chantilly 1997–98 *Pierre-Paul Prud'hon (1758–1823) dans les collections du Musée Condé: Dessins et peintures.* Exhibition, Musée Condé, Chantilly, September 24, 1997–January 5, 1998. Catalogue by Sylvain Laveissière. Chantilly, 1997.

Chapman 1945 Ronald Chapman. *The Laurel and the Thorn: A Study of G. F. Watts.* London, 1945.

Chappell (1859) 1965 W[illiam] Chappell. *The Ballad Literature and Popular Music of the Olden Time.* Reprint of 1859 ed. New York, 1965.

Chase-Riboud 1988 Barbara Chase-Riboud. *De Macht van een Sultane.* The Netherlands, 1988.

Chassériau sale 1857 *Catalogue de tableaux, études, esquisses, dessins, armes et costumes laissés par M. Théodore Chassériau, dont la vente aura lieu par suite de son décès, rue Drouot, 5 . . . les lundi 16 et mardi 17 mars 1857 à deux heures.* Sale, Hôtel Drouot, Paris, March 16–17, 1857.

Chastel and Minervino 1972 André Chastel and Fiorella Minervino. *L'opera completa di Seurat.* Classici dell'arte, no. 55. Milan, 1972.

Cheatham and Cheatham 1983 Jane Hart Cheatham and Frank R. Cheatham. *Design Concepts and Applications.* Englewood Cliffs, N.J., 1983.

Cheney 1992 Liana de Girolami Cheney, ed. *Pre-Raphaelitism and Medievalism in the Arts.* Lewiston, N.Y., 1992.

Chenique 1996 Bruno Chenique. "Pour une étude de *milieu*: Le cercle amical de Géricault." In Michel 1996, vol. 1, pp. 337–52.

Chennevières 1851 Philippe de Chennevières. *Lettres sur l'art français en 1850.* Paris, 1851.

Chennevières 1883–89 Philippe de Chennevières. *Souvenirs d'un directeur des Beaux-Arts.* 5 vols. Paris, 1883–89. Originally published as articles in *L'artiste.*

Chennevières 1884–85 Philippe de Chennevières. "Souvenirs d'un directeur des beaux-arts: Les décorations du Panthéon." *L'artiste* (July 1884), pp. 1–28; (August 1884), pp. 92–119; (September 1884), pp. 180–204; (October 1884), pp. 257–76; (December 1884), pp. 413–33; (January 1885), pp. 7–27; (February 1885), pp. 97–106.

Chennevières 1885 Philippe de Chennevières. *Les décorations du Panthéon; extrait de* L'artiste. Paris, 1885.

Chennevières 1889 Philippe de Chennevières. "Le Panthéon." In *Inventaire général des richesses d'art de la France. Paris: Monuments civils (église Sainte-Geneviève),* vol. 2, pp. 335, 340–41. Paris, 1889.

Chennevières (1883–89) 1979 Philippe de Chennevières. *Souvenirs d'un directeur des Beaux-Arts.* 5 vols. Reprint. Paris, 1979. Extracted from *L'artiste,* 1883, 1885, 1886, 1888, 1889.

Cherry 1980 Deborah Cherry. "The Hogarth Club, 1858–1861." *Burlington Magazine* 122 (April 1980), pp. 237–44.

Chesneau 1879 Ernest Chesneau. *La chimère.* Paris, 1879.

Chevallier and Rabreau 1977 Pierre Chevallier and Daniel Rabreau. *Le Panthéon.* Paris, 1977.

Chevillard 1893 Valbert Chevillard. *Un peintre romantique: Théodore Chassériau.* Paris, 1893.

Chicago 1889 *Seventeenth Annual Exhibition.* Inter-State Industrial Exhibition of Chicago, 1889. *Catalogue of the Paintings Exhibited.* Chicago, 1889.

Chicago 1893 *World's Columbian Exposition.* Exhibition, Chicago, May 1–October 26, 1893. Catalogue. Chicago, 1893.

Chicago 1911 *The First American Exhibition of Original Drawings by Aubrey Vincent Beardsley.* Exhibition, Art Institute of Chicago, 1911. Catalogue by Martin Birnbaum. Chicago, 1911.

Chicago 1931 *Exhibition of Etchings Lithographs and Drawings by Rodolphe Bresdin (Chien-Caillou) 1822–1885.* Exhibition, The Art Institute of Chicago, 1931. Catalogue edited by Mildred J. Prentiss. Cambridge, Mass., 1931.

Chicago 1933 *Century of Progress Exhibition of Paintings and Sculpture Lent from American Collections.* Exhibition, Art Institute of Chicago, June 1–November 1, 1933. *Catalogue of a Century of Progress . . . ,* edited by Daniel Catton Rich. Chicago, 1933.

Chicago 1934 *Century of Progress Exhibition of Paintings and Sculpture, 1934.* Exhibition, Art Institute of Chicago, June 1–November 1, 1934. *Catalogue of a Century of Progress . . . ,* edited by Daniel Catton Rich. Chicago, 1934.

Chicago 1995 *Claude Monet, 1840–1926.* Exhibition, Art Institute of Chicago, July 22–November 26, 1995. Catalogue by Charles F. Stuckey, with Sophia Shaw. London, 1995.

Chicago–Amsterdam–London 1994–95 *Odilon Redon: Prince of Dreams, 1840–1916.* Exhibition, Art Institute of Chicago, July 2–September 18, 1994; Van Gogh Museum, Amsterdam, October 20, 1994–January 15, 1995; Royal Academy of Arts, London, February 16–May 21, 1995. Catalogue by Douglas W. Druick et al. Chicago and New York, 1994.

Child 1892 Theodore Child. "A Pre-Raphaelite Mansion." In *Art and Criticism: Monographs and Studies,* by Theodore Child. London, 1892.

Chipp 1968 Herschel B. Chipp. *Theories of Modern Art: A Source Book by Artists and Critics.* Berkeley and Los Angeles, 1968.

Christian 1973a John Christian. "Burne-Jones Studies." *Burlington Magazine* 115 (February 1973), pp. 93–107.

Christian 1973b John Christian. "Early German Sources for Pre-Raphaelite Designs." *Art Quarterly* 36 (spring–summer 1973), pp. 56–83.

Christian 1992 John Christian. "Burne-Jones et l'art italien." In Nantes–Charleroi–Nancy 1992, pp. 33–57.

Christoffel 1940 Ulrich Christoffel. *Klassizismus in Frankreich um 1800.* Munich, 1940.

Chu 1980 Petra ten-Doesschate Chu. "Into the Modern Era: The Evolution of Realist and Naturalist Drawing." In *The Realist Tradition: French Painting and Drawing, 1830–1900,* by Gabriel Paul Weisberg and Petra ten-Doesschate Chu. Catalogue. Cleveland: Cleveland Museum of Art, 1980.

Cieszkowski 1989–90 Krzysztof Z. Cieszkowski. "'They murmuring divide; while the wind sleeps beneath, and the numbers are counted in silence': The Dispersal of the Illustrations to Dante's 'Divine Comedy.'" *Blake: An Illustrated Quarterly* 23, no. 3 (winter 1989–90), pp. 166–71.

Cikovsky 1971 Nicolai Cikovsky Jr. *George Inness.* New York, 1971.

Cikovsky (1965) 1977 Nicolai Cikovsky Jr. *The Life and Work of George Inness.* New York, 1977. Ph.D. dissertation, Harvard University, Cambridge, Mass., 1965.

Cikovsky 1990 Nicolai Cikovsky Jr. *Winslow Homer.* New York, 1990.

Cikovsky 1991 Nicolai Cikovsky Jr. *Winslow Homer Watercolors.* New York, 1991.

Cikovsky 1993 Nicolai Cikovsky Jr. *George Inness.* New York and Washington, D.C., 1993.

Cincinnati 1921 *The Twenty-Eighth Annual Exhibition of American Art.* Exhibition, Cincinnati Art Museum, May 28–July 31, 1921.

Cladel 1936 Judith Cladel. *Rodin: Sa vie gloreuse, sa vie inconnue.* 4th ed. Paris, 1936.

Cladel 1950 Judith Cladel. *Rodin: Sa vie gloreuse, sa vie inconnue.* New ed. Paris, 1950.

Clark 1956a Kenneth Clark. *The Nude: A Study in Ideal Form.* The A.W. Mellon Lectures in the Fine Arts, Bollingen Series XXXV.2. Princeton, 1956.

Clark 1956b Kenneth Clark. *The Nude: A Study in Ideal Form.* Garden City, N.Y., 1956.

Clark 1973 Kenneth Clark. *The Romantic Rebellion: Romantic versus Classic Art.* New York, 1973.

Clark 1979 Kenneth Clark. *The Best of Aubrey Beardsley.* London, 1979.

Clark (1997) 2001 Alvin L. Clark Jr. "Un grand collectionneur américain de dessins français: Grenville L. Winthrop et les oeuvres de Pierre-Paul Prud'hon au Fogg Art Museum." In Prud'hon colloque (1997) 2001, pp. 177–202.

Clarke 1976 Thomas B. Clarke. "Checklist of Paintings Owned by Thomas B. Clarke, 1872–1899." *American Art Journal* 8, no. 1 (May 1976), pp. 71–83.

***Classics in Art* 1968** *Classics in Art Series: Ingres.* New York, 1968.

Clément 1867 Charles Clément. "Catalogue de l'oeuvre de Géricault (suite et fin). Dessins." *Gazette des beaux-arts* 23, no. 138 (October 1867), pp. 351–72.

Clément 1872 Charles Clément. *Prud'hon: Sa vie, ses oeuvres et sa correspondance.* Paris, 1872.

Clément (1868) 1879 Charles Clément. *Géricault: Étude biographique et critique, avec le catalogue*

raisonné de l'oeuvre du maître. 3rd ed., with added suppl. Paris, 1879. First published Paris, 1868.

Clément (1879) 1973 Charles Clément. *Géricault: Étude biographique et critique, avec le catalogue raisonné de l'oeuvre du maître.* Reprint of 3rd ed. of 1879, with intro. and suppl. by Lorenz Eitner. Paris, 1973.

Clément (1879) 1974 Charles Clément. *Géricault: A Biographical and Critical Study, with a Catalogue Raisonné of the Master's Works.* Reprint of 3rd ed. of 1879, with intro. and suppl. by Lorenz Eitner; translated by Régis Annequin. New York, 1974.

Clouzot 1923 Henri Clouzot. "Le quartier de la Paix, hier et aujourd'hui." *La renaissance de l'art français et des industries de luxe* 6, no. 6 (June 1923), pp. 290–313.

Coggins 1968 Clemency Coggins. "Tracings in the Work of Jacques-Louis David." *Gazette des beaux-arts,* ser. 6, 72 (November 1968), pp. 260–64.

Cohn 1969 Marjorie B. Cohn. "The Original Format of Ingres Portrait Drawings." In *Colloque Ingres [1967],* pp. 15–26. [Montauban, 1969].

Cohn 1993 Marjorie B. Cohn. "Turner, Ruskin, Norton, Winthrop." *Harvard University Art Museums Bulletin* 2, no. 1 (1993), pp. 9–77. Published on the occasion of the exhibition at the Fogg Art Museum, November 27, 1993–February 20, 1994.

Cole 1990 Mark Cole. "A Haunting Portrait by William Holman Hunt [*Triumph of the Innocents*]." *Bulletin of the Cleveland Museum of Art* 77, no. 10 (December 1990), p. 355.

Colin 1932 Paul Colin. *Édouard Manet.* Paris, 1932.

Collard 1996 Frances Collard. "Furniture." In London 1996b, pp. 155–79.

College Park 1975 *Search for Innocence: Primitive and Primitivistic Art of the 19th Century.* Exhibition, Department of Art, University of Maryland Art Gallery, College Park, October 29–December 10, 1975. Catalogue essay by George Levitine; entries by Melinda Curtis. College Park, Md., 1975.

Cologne–Frankfurt 1972–73 *Die schwarze Sonne des Traums: Radierungen, Lithographien und Zeichnungen von Rodolphe Bresdin (1822–1885).* Exhibition, Wallraf-Richartz-Museum, Cologne, September 10–November 19, 1972; Städelsches Kunstinstitut, Frankfurt am Main, December 2, 1972–January 21, 1973. Catalogue by Hans Albert Peters. Cologne, 1972.

Compiègne 2000–2001 *Le comte de Nieuwerkerke: Art et pouvoir sous Napoléon III.* Exhibition, Musée National du Château de Compiègne, October 6, 2000–January 8, 2001. Catalogue by Fernande Goldschmidt, Suzanne Higgott, Philippe Luez, Françoise Maison, Raphaël Masson, and Robert Wenley. Paris, 2000.

Compton n.d. Walter A. Compton. "Dante Gabriel Rossetti: *The Blessed Damozel.*" M.A. thesis, Harvard University, Cambridge, Mass., n.d. [ca. 1965]. Fogg Art Museum files.

Condon 1995 Patricia Condon. "J. A. D. Ingres: Les dessins historiques achévés." *Bulletin du Musée Ingres,* no. 67–68 (1995), pp. 3–86.

Condon 1996a Patricia Condon. "J. A. D. Ingres: Les dessins historiques achévés (deuxième partie)." *Bulletin du Musée Ingres,* no. 69 (1996), pp. 3–38.

Condon 1996b Patricia Condon. "Ingres, Jean-Auguste-Dominique." In *The Dictionary of Art,* edited by Jane Turner, vol. 15, pp. 835–46. London and New York, 1996.

Connolly 1972 John L. Connolly Jr. "Ingres and the Erotic Intellect." In *Woman as Sex Object: Studies in Erotic Art, 1730–1970,* edited by Thomas B. Hess and Linda Nochlin, pp. 16–31. *Art News Annual* 38. New York, 1972.

Connolly 1974 John L. Connolly Jr. "Ingres Studies. Antiochus and Stratonice: The Bather and Odalisque Themes." Ph.D. dissertation, Graduate School of Arts and Sciences, University of Pennsylvania, Philadelphia, 1974.

Cook 1878 Clarence Cook. "Fine Arts. National Academy of Design. Fifty-Third Annual Exhibition. V." *New York Tribune,* May 11, 1878.

Cooke 1998 Peter Cooke. "La pensée esthétique." *Dossier de l'art,* no. 51 (October 1998), pp. 16–26.

Coolidge 1953 John Coolidge. "Do You Know What You Like in Art?" *Harvard Alumni Bulletin,* January 10, 1953, pp. 307–12.

Coombs et al. 1986 James H. Coombs et al., eds. *A Pre-Raphaelite Friendship: The Correspondence of William Holman Hunt and John Lucas Tupper.* Ann Arbor, 1986.

Cooper 1954 Douglas Cooper. *The Courtauld Collection: A Catalogue and Introduction.* London, 1954.

Cooper 1955 Douglas Cooper. *Vincent van Gogh: Drawings and Watercolours.* New York, 1955.

Cooper 1959 Douglas Cooper. "Renoir, Lise and the Le Coeur Family: A Study of Renoir's Early Development—I, Lise." *Burlington Magazine* 101 (May 1959), pp 162–71.

Cooper 1986a Helen A. Cooper. "Winslow Homer's Watercolors." *Antiques* 129, no. 4 (April 1986), pp. 824–33.

Cooper 1986b Robyn Cooper. "Arthur Hughes's 'La Belle Dame Sans Merci' and the Femme Fatale." *Art Bulletin of Victoria,* no. 27 (1986), pp. 6–25.

Copenhagen 1988 *Rodin. La Collection du brasseur Carl Jacobsen à la Glyptothèque, et oeuvres apparen-tées.* Exhibition, Ny Carlsberg Glyptotek, Copenhagen, May 20–September 1, 1988. Catalogue by Anne-Birgitte Fonsmark. Copenhagen, 1988.

Copenhagen–Stockholm–Oslo 1928 *Udstillingen af Fransk malerkunst fra den første halvdel af det 19. aarhundrede.* Exhibition, Ny Carlsberg Glyptotek, Copenhagen, March 31–April 21, 1928; Nationalmuseum, Stockholm, May 12–June 16, 1928; Nasjonalgalleriet, Oslo, July–August. Catalogue. Copenhagen, 1928. Swedish ed., *Fransk måleri från David till Courbet.* Stockholm, 1928. Norwegian ed., *Fransk Malerkunst fra David til Courbet.* Oslo, 1928.

Coquiot 1913a Gustave Coquiot. *H. de Toulouse-Lautrec.* Paris, 1913.

Coquiot 1913b Gustave Coquiot. *Le vrai Rodin.* 5th ed. Paris, 1913.

de Cormenin 1852 Louis de Cormenin. "Oeuvres de M. Ingres." *La revue de Paris,* February 1852, p. 97.

Cortissoz 1912 R[oyal] C[ortissoz]. "Mr. Sargent and Some Others." *New York Tribune,* March 20, 1912, p. 7.

Cortissoz 1918 Royal Cortissoz. "Degas as a Collector of the Art of Other Men: A First View of His Treasures, Presently to Be Sold in Paris—Ingres, Delacroix and the Impressionists." *New York Tribune,* February 24, 1918, section 3, p. 3.

Cortissoz 1926 Royal Cortissoz. "Ingres: A Fascinating Souvenir of His Last Phase." *New York Herald Tribune,* February 21, 1926, p. 10.

Cortissoz 1930 Royal Cortissoz. *The Painter's Craft.* New York, 1930.

Cortissoz 1936 Royal Cortissoz. "John La Farge and His Original Traits." *New York Herald Tribune,* March 29, 1936, section 5, p. 10.

Cosentino 1974 Andrew J. Cosentino. "Charles Bird King: An Appreciation." *American Art Journal* 6, no. 1 (May 1974), pp. 54–71.

Cosentino 1977 Andrew J. Cosentino. *The Paintings of Charles Bird King (1785–1862).* Washington, D.C., 1977. Published on the occasion of the exhibition at the National Collection of Fine Arts, Smithsonian Institution, Washington, D.C.

Cottin 1967 Madeline Cottin. "Théophile Gautier: 'Le poème de la femme.'" *Gazette des beaux-arts,* ser. 6, 70 (November 1967), pp. 303–7.

Coupin 1827 Pierre-Alexandre Coupin. *Essai sur J. L. David, peintre d'histoire, ancien membre de l'Institut, officier de la Légion-d'honneur.* Paris, 1827.

Courbet 1992 Gustave Courbet. *Letters of Gustave Courbet.* Edited and translated by Petra ten-Doesschate Chu. Chicago, 1992.

Courthion 1931 Pierre Courthion. *Courbet.* Arts et artistes français. Paris, 1931.

Courthion 1939 Pierre Courthion. "Passage de Gericault." *Minotaure,* May 1939, pp. 23–24.

Courthion 1947 Pierre Courthion, ed. *Géricault raconté par lui-même et par ses amis.* Vésenaz–Geneva, 1947.

Courthion 1968 Pierre Courthion. *Georges Seurat.* New York, 1968.

Courthion 1985 Pierre Courthion. *L'opera completa di Courbet.* Classici dell'arte, 111. Milan, 1985.

Cousturier 1914 Lucie Cousturier. "Les dessins de Seurat." *L'art décoratif,* no. 201 (March 1914), pp. 97–106.

Cousturier 1926 Lucie Cousturier. *Georges Seurat.* Paris, 1926.

Cox 1975 Janet Cox. "A Collector's Collection: The Winthrop Jades." *Harvard Magazine* 77, no. 5 (1975), pp. 28–35.

Cresson 1947 Margaret French Cresson. *Journey into Fame: The Life of Daniel Chester French.* Cambridge, Mass., 1947.

Cullingford 1993 Elizabeth Butler Cullingford. *Gender and History in Yeats's Love Poetry.* Cambridge, 1993.

Cunningham 1976 Charles Cunningham. "Jongkind and the Pre-Impressionists: Painters of the École Saint-Siméon." In Northampton–Williamstown 1976–77.

Cuno et al. 1996 James Cuno et al. *Harvard's Art Museums: 100 Years of Collecting.* Cambridge, Mass., 1996.

Curry 1984 David Park Curry. "Whistler and Decoration." *Antiques* 126 (November 1984), pp. 1186–99.

Cuzin 1992 Jean-Pierre Cuzin. "François-Joseph Heim (1787–1865), peintre d'esquisses." *Bulletin de*

la Société de l'Histoire de l'Art Français, 1991 (1992), pp. 199–217.

Daguerre de Hureaux 1993 Alain Daguerre de Hureaux. *Delacroix*. Paris, 1993.

Damay 1843 Damay. "Une visite à l'atelier d'Ingres." *Mémoires de l'Académie des Sciences, Agriculture, Commerce, Belles-lettres et Arts du Département de la Somme* 5 (1843), pp. 449–54.

Dante 1998 Dante Alighieri. *Inferno*. Translated by Henri Francis Cary; illustrated by William Blake. London: The Folio Society, 1998.

Dardel 1989 Aline Dardel. "Le thème de l'Âge d'or dans la peinture." *La gazette de l'Hôtel Drouot* 98, no. 4 (January 27, 1989), pp. 64–65.

Dargenty 1883 G. Dargenty. "Le Salon national." *L'art* 4 (1883), p. 33.

Darragon 1991 Éric Darragon. *Manet*. Paris, 1991.

Daudet n.d. Alphonse Daudet. *Trente ans de Paris à travers ma vie et mes livres*. Paris, n.d.

Daulte 1957 François Daulte. "Découverte de Sisley." *Connaissance des arts* 60 (February 1957), pp. 47–53.

Daulte 1959 François Daulte. *Alfred Sisley: Catalogue raisonné de l'oeuvre peint*. Lausanne, 1959.

Daulte 1971 François Daulte. *Auguste Renoir: Catalogue raisonné de l'oeuvre peint*. Vol. 1, *Figures, 1860–1890*. Lausanne, 1971.

Davenport 1948 Millia Davenport. *The Book of Costume*. 2 vols. New York, 1948.

David 1880–82 J[acques]-L[ouis]-Jules David. *Le peintre Louis David, 1748–1825*. Vol. 1, *Souvenirs et documents inédits*. Vol. 2, *Suite d'eaux-fortes d'après ses oeuvres gravées par J.-L.-Jules David, son petit-fils*. Paris, 1880–82.

Davidson 1894 John Davidson. *Plays. Being: An Unhistorical Pastoral; A Romantic Farce; Bruce, a Chronicle Play; Smith, a Tragic Farce; and Scaramouche in Naxos, a Pantomime*. London, 1894.

Davidson 1895 John Davidson. *A Full and True Account of the Wonderful Mission of Earl Lavender, Which Lasted One Night and One Day: With a History of the Pursuit of Earl Lavender and Lord Brumm by Mrs Scamler and Maud Emblem*. London, 1895.

Davies 1957 Martin Davies. *French School*. 2nd ed. National Gallery Catalogues. London, 1957.

Davies 1961 Martin Davies. *The Earlier Italian Schools*. 2nd ed. National Gallery Catalogues. London, 1961.

Davies 1970 Martin Davies. *French School: Early 19th Century, Impressionists, Post-Impressionists, etc.* Revisions and additions by Cecil Gould. National Gallery Catalogues. London, 1970.

Davis and Bowen 2001 Whitney Davis and Craigen Bowen, eds. "On the Edge of Matrimony: On Some Early Drawings by Edward Burne-Jones." In *Dear Print Fan: A Festschrift for Marjorie B. Cohn*, pp. 99–104. Cambridge, Mass.: Harvard University Art Museums, 2001.

Debia 1862 Prosper Debia. "Feuilleton de Courrier: Exposition des Beaux-Arts à Montauban." *Le courrier de Tarn-et-Garonne*, May 17, 1862.

Debret 1832 François Debret. *Funérailles de M. Guillon Lethière. Discours de M. Debret, Président de l'Académie, prononcé aux funérailles de M. Guillon Lethière, le mardi 24 avril 1832*. Paris, 1832.

Degas 1931 Edgar Germain Hilaire Degas. *Lettres de Degas*. Edited by Marcel Guérin. Paris, 1931.

Degas 1947 Edgar Germain Hilaire Degas. *Letters*. Edited by Marcel Guérin; translated by Marguerite Kay. Oxford, 1947.

De Kay 1878 Charles De Kay. *The Bohemian: A Tragedy of Modern Life*. New York, 1878.

Delaborde 1861 Henri Delaborde. "Les dessins de M. Ingres au Salon des Arts Unis." *Gazette des beaux-arts* 9 (March 1, 1861), pp. 257–69.

Delaborde 1865 Henri Delaborde. *Lettres et pensées d'Hippolyte Flandrin*. Paris, 1865.

Delaborde 1870 Henri Delaborde. *Ingres: Sa vie, ses travaux, sa doctrine, d'après les notes manuscrites et les lettres du maître*. Paris, 1870.

Delacroix 1846 Eugène Delacroix. "Peintres et sculpteurs modernes. II. Prud'hon." *La revue des deux mondes*, n.s., 16 (November 1, 1846), pp. 432–51.

Delacroix 1930 Eugène Delacroix. *Voyage au Maroc, 1832: Lettres, aquarelles et dessins*. Edited by André Joubin. Albums des beaux-arts, 3. Paris, 1930.

Delacroix 1932 Eugène Delacroix. *Journal de Eugène Delacroix*. 3 vols. Edited by André Joubin. Paris, 1932.

Delacroix 1935–38 Eugène Delacroix. *Correspondance générale d'Eugène Delacroix*. 5 vols. Edited by André Joubin. Paris, 1935–38.

Delacroix 1981 Eugène Delacroix. *Journal, 1822–1863*. Introduction and notes by André Joubin; revised by Régis Labourdette. Paris, 1981.

Delacroix 1996 Eugène Delacroix. *Journal, 1822–1863*. Introduction and notes by André Joubin; revised by Régis Labourdette. Paris, 1996.

Delacroix 1999 Eugène Delacroix. *Souvenirs d'un voyage dans le Maroc*. Edited by Laure Beaumont-Maillet, Barthélémy Jobert, and Sophie Join-Lambert. Paris, 1999.

Delage 1963 Roger Delage. "Chabrier et ses amis Impressionistes." *L'oeil* 108, no. 17 (December 1963), pp. 16–23.

Delage 1982 Roger Delage. *Chabrier*. Iconographie musicale, [no. 6]. Geneva, 1982.

Delage 1983 Roger Delage. "Manet et Chabrier." *Revue de l'art ancien et moderne* 62 (1983), pp. 65–70.

Delage 1999 Roger Delage. *Emmanuel Chabrier*. Paris, 1999.

Delalain 1872 Édouard Delalain. *Légendes historiques de Sainte Geneviève, patronne de Paris*. Paris, 1872.

Delécluze (1846) 1995 Étienne-Jean Delécluze. "Exposition des ouvrages de peinture dans la Galerie des Beaux-Arts, boulevard Bonne Nouvelle, 22." *Journal des débats*, January 28, 1846. Reprinted in Foucart et al. 1995, p. 241.

Delécluze 1851 Étienne-Jean Delécluze. "Salon de 1850." *Journal des débats*, January–March 1851.

Delécluze 1983 Étienne-Jean Delécluze. *Louis David, son école et son temps: souvenirs* (1855). New ed., edited by Jean-Pierre Mouilleseaux. Paris, 1983.

Del Guercio 1963 Antonio Del Guercio. *Géricault*. Milan, 1963.

Del Guercio 1965 Antonio Del Guercio. *Théodore Géricault*. I maestri del colore, 46. Milan, 1965.

Del Guercio 1967 Antonio Del Guercio. "Une recherche anxieuse du thème de l'énergie." *Chefs-d'oeuvre de l'art*, October 1967, unpag.

de Lisle 1906 Fortunée de Lisle. *Burne-Jones*. London, 1906.

Della Porta 1586 Giovanni Battista Della Porta. *De humana physiognomonia, libri IIII*. Vici Aequensis: Apud Iosephum Cacchium, 1586.

Del Litto 1966 Victor Del Litto. *Album Stendhal: Iconographie réunie et commentée*. Paris, 1966.

Delpech 1814 François-Seraphin Delpech. *Examen raisonné des ouvrages de peinture, sculpture, et gravure exposés au Salon du Louvre en 1814*. Paris, 1814.

Delphis de la Cour 1868 Delphis de la Cour. "Étude sur Ingres et les peintres de son temps." *Annales de la Société d'Agriculture, Sciences, Arts et Belles-Lettres du Département d'Indre-et-Loire* 47 (October–November 1868), pp. 327–36.

Delpierre 1977 Madeleine Delpierre. "Ingres et la mode de son temps." In Ingres colloque (1975) 1977, pp. 147–56.

Delteil 1924 Loÿs Delteil. *Le peintre graveur illustré (XIXe et XXe siècles)*. Vol. 18, *Géricault*. Paris, 1924.

Delteil (1925–30) 1969 Loÿs Delteil. *Le peintre graveur illustré (XIXe et XXe siècles)*. Vols. 20–29, *Honoré Daumier*. Paris, 1925–30. Reprint ed., New York, 1969.

Delteil and Strauber (1908) 1997 Loÿs Delteil and Susan Strauber. *Delacroix: The Graphic Work: A Catalogue Raisonné*. Translated and revised by Susan Strauber from part of vol. 3 of Delteil's *Le peintre-graveur illustré* (1908). San Francisco, 1997.

Delvau 1865 Alfred Delvau. "Les châteaux des rois de Bohême." *Le figaro*, January 8, 1865, p. 2.

Denny 1983 Walter B. Denny. "Orientalism in European Art." *Muslim World* 73, no. 3 (July–October 1983), p. 267.

Denvir 1991 Bernard Denvir. *Impressionism: The Painters and the Paintings*. London, 1991.

Déonna 1921 Waldemar Déonna. "Ingres et l'imitation de l'antique." *Pages d'art*, October 1921, pp. 315–22.

De Paz 1997 Alfredo De Paz. *Géricault: La febbre dell'arte e della vita*. Naples, 1997.

des Cars 1998 Laurence des Cars. "Edward Burne-Jones and France." In New York–Birmingham–Paris 1998–99, pp. 25–39.

Descharnes and Chabrun 1967 Robert Descharnes and Jean-François Chabrun. *Auguste Rodin*. Paris, 1967.

Deshairs and Laran [1913] Léon Deshairs and Jean Laran. *Gustave Moreau*. Paris, n.d. [1913].

Desjardins 1898 [Paul Desjardins]. "Pierre Puvis de Chavannes." *Bulletin de l'union pour l'action morale*, November 15, 1898, pp. 68–72.

Destrée 1894 Oliver G. Destrée. *Les Pré-Raphaélites: Notes sur l'art décoratif*. Brussels, 1894.

Detroit and other cities 1985–86 *The Prints of Edouard Manet*. Exhibition organized and circulated by the International Exhibitions Foundation, Washington, D.C., venues as follows: Detroit Institute of Arts; University Art Museum, Berkeley; Saint Louis Art Museum; Hunstville [Alabama] Museum of Art; Art Gallery of Ontario, Toronto, 1985–86. Catalogue by Jay McKean Fisher. Washington, D.C., 1985.

Dictionnaire universel de l'art et des artistes 1967–68 *Dictionnaire universel de l'art et des artistes, où sont traités, de manière historique et critique, l'art de*

tous pays et contrées, des origines à nos jours, les écoles et mouvements, la vie et l'oeuvre des architectes, peintres, sculpteurs, dessinateurs et graveurs. Edited by Robert Maillard. 3 vols. Paris, 1967–68.

Diderot (1751–80) 1966 Denis Diderot, ed. *Encyclopédie; ou, Dictionnaire raisonné des sciences, des arts et des métiers (mise en ordre et publié par Diderot, quant à la partie mathématique, par d'Alembert).* 35 vols. Facsimile of 1751–80 ed. Stuttgart–Bad Cannstatt, 1966.

Dietrich 2000 Flavia Dietrich. "Art History Painting: The Pre-Raphaelite View of Italian Art. Some Works by Rossetti." *British Art Journal* 2 (autumn 2000), pp. 61–69.

Dijon 1981 *Ingres, dessins sur le vif: Cinquante-deux dessins du Musée Ingres de Montauban.* Exhibition, Musée des Beaux-Arts, Dijon, October 3–November 28, 1981. Catalogue by Avigdor Arikha. Dijon, 1981.

Dijon 1982–83 *La peinture dans la peinture.* Exhibition, Musée des Beaux-Arts, Dijon, December 18, 1982–February 28, 1983. Catalogue by Pierre Georgel and Anne-Marie Lecoq. Dijon, 1983.

Discovering Literature **1991** *Discovering Literature.* Macmillan Literature Series. Mission Hills, Calif., 1991.

Distel 1989 Anne Distel. *Les collectionneurs des Impressionistes: Amateurs et marchands.* [Paris], 1989.

Distel 1990 Anne Distel. *Impressionism: The First Collectors.* Translated by Barbara Perroud-Benson. New York, 1990.

Distel 1993 Anne Distel. *Renoir: "Il faut embellir."* Découvertes Gallimard, no. 177. Paris, 1993.

"Doctrine de Ingres" "La doctrine de Ingres." *La renaissance de l'art français et des industries de luxe* 4, no. 5 (May 1921), pp. 266–76.

Dorbec 1907 Prosper Dorbec. "David Portraitiste." *Gazette des beaux-arts,* ser. 3, 37 (April 1, 1907), pp. 306–30.

Dorment and MacDonald 1994 Richard Dorment and Margaret MacDonald. *James McNeill Whistler.* London, 1994.

Dorment and MacDonald 1995 Richard Dorment and Margaret MacDonald. *James McNeill Whistler.* New York, 1995.

Dormoy 1926 Marie Dormoy. "La Collection Oskar Schmitz à Dresde." *L'amour de l'art* 7 (1926), pp. 339–43.

Dorra 1973 Henri Dorra. "The Guesser Guessed: Gustave Moreau's 'Oedipus.'" *Gazette des beaux-arts,* ser. 6, 81 (March 1973), pp. 129–40.

Dortu 1971 M. G. Dortu. *Toulouse-Lautrec et son oeuvre.* 6 vols. New York, 1971.

Doucet 1905 Jérome Doucet. *Les peintres français.* Paris, [1905].

Douglas 1904 James Douglas. *Theodore Watts-Dunton: Poet, Novelist, Critic.* London, 1904.

Dowd 1948 David Lloyd Dowd. *Pageant-Master of the Republic: Jacques-Louis David and the French Revolution.* New York, 1948.

Dowd 1960 David Lloyd Dowd. "Art and the Theater during the French Revolution: The Role of Louis David." *Art Quarterly* 23, no. 1 (1960), pp. 3–22.

Downes 1911 William Howe Downes. *The Life and Works of Winslow Homer.* Boston, 1911.

Dreyfus 1911 Albert Dreyfus. "Jean Auguste Dominique Ingres, 1780–1867." *Die Kunst für Alle* 27 (December 1911), pp. 125–46.

Drucker 1955 Michel Drucker. *Renoir.* Paris, 1955.

Dubaut 1958 Pierre Dubaut. "Géricault, cet ami." *Le jardin des arts,* no. 50 (December 1958), pp. 83–89.

DuBois 1841 Léon-Jean-Joseph DuBois. *Description des tableaux faisant partie des collections de M. le Comte de Pourtalès-Gorgier.* Paris, 1841.

Dubuisson and Hughes 1924 Albert Dubuisson and Cecil E. Hughes. *Richard Parkes Bonington: His Life and Work.* London, 1924.

Du Camp 1855 Maxime Du Camp. *Les beaux-arts à l'Exposition Universelle de 1855.* Paris, 1855.

Du Camp 1865 Maxime Du Camp. Review of the 1865 Salon. *La revue des deux mondes,* June 1, 1865, p. 664.

Düchting 1999 Hajo Düchting. *Georges Seurat.* Cologne, 1999.

Dujardin-Beaumetz (1913) 1992 François Dujardin-Beaumetz. *Entretiens avec Rodin.* Reprint of 1913 ed. Paris, 1992.

Dumas 1924 Paul Dumas. "Quinze tableaux inédits de Renoir." *La renaissance de l'art français et des industries de luxe* 7 (July 1924), pp. 361–68.

Dumas 1996 Ann Dumas. *Degas as a Collector.* Published on the occasion of the exhibition at the National Gallery. London, 1996.

Dumont 1994 Jutta Stroter-Bender Dumont. *Liebesgottinnen.* Cologne, 1994.

Dumur 1988 Guy Dumur. *Delacroix et le Maroc.* Paris, 1988.

Dunlap (1834) 1969 William Dunlap. *A History of the Rise and Progress of the Arts of Design in the United States.* 3 vols. in 2 parts. Reprint with new introduction by James T. Flexner; edited by Rita Weiss. New York, 1969. First published New York, 1834.

Dunlap 1971 Joseph R. Dunlap. *The Book that Never Was.* New York, 1971.

Dupays 1857 A.-J. Dupays. "Nécrologie. Théodore Chassériau. Tableaux, études, esquisses, dessins, armes et costumes, dont la vente aura lieu par suite de son décès, rue Drouot, 5, les lundi 16 et mardi 17 mars 1857." *L'illustration, journal universel* 29, no. 733 (March 14, 1857), p. 176.

Duplessis 1896 Georges Duplessis. *Les portraits dessinés par J.-A.-D. Ingres, avec vingt photogravures par E. Charreyre.* Paris, 1896.

Dupré 1921 Henri Dupré. *Un Italien d'Angleterre: Le poète-peintre, Dante Gabriel Rossetti.* Paris, 1921.

Durbé 1965 Dario Durbé. *J. A. Dominique Ingres.* I maestri del colore, 87. Milan, 1965.

Duret 1902 Théodore Duret. *Histoire d'Edouard Manet et de son oeuvre . . . avec un catalogue des peintures et des pastels.* Paris, 1902.

Duret 1904 Théodore Duret. *Histoire de J. McN. Whistler et de son oeuvre.* Paris, 1904.

Düsseldorf 1904 *Internationale Kunstausstellung.* Exhibition, Kunstpalast, Düsseldorf, May 1–October 23, 1904. Catalogue. Düsseldorf, 1904.

Düsseldorf 1986 *James Lee Byars: The Philosophical Palace / Palast der Philosophie.* Exhibition, Städtische Kunsthalle Düsseldorf, October 18–November 30, 1986. Catalogue edited by Jürgen Harten. Düsseldorf, 1986.

Dussol 1997 Dominique Dussol. *Art et bourgeoisie: La Société des Amis des Arts de Bordeaux (1851–1939).* Toulouse, 1997.

Duval 1986 M. Susan Duval. "F. R. Leyland: A Maecenas from Liverpool." *Apollo* 124 (August 1986), pp. 110–15.

Duval 1994 Jonathan P. Duval. "Chasseriau's Juvenilia: Some Early Works by an 'Enfant du siècle.'" *Zeitschrift für Kunstgeschichte* 57, (1994), pp. 219–38.

Dwyer 2001 Michael Middleton Dwyer. *Great Houses of the Hudson River.* Boston, 2001.

Eaves 1992 Morris Eaves. *The Counter-Arts Conspiracy: Art and Industry in the Age of Blake.* Ithaca, N.Y., 1992.

Ebert 1982 Hans Ebert. *Jean-Auguste-Dominique Ingres.* Berlin, 1982.

Edelein-Badie 1997 Béatrice Edelein-Badie. *La collection de tableaux de Lucien Bonaparte, prince de Canino.* Notes et documents des musées de France, 30. Paris, 1997.

Edinburgh 1901 Exhibition, Royal Scottish Academy, Edinburgh, 1901.

Edinburgh 1925 *Inaugural Loan Exhibition.* Exhibition, Kirkcaldy Art Gallery, Edinburgh, 1925.

Eisenberg and Taylor 1981 Lee Eisenberg and DeCourcy Taylor, eds. *The Ultimate Fishing Book.* Boston, 1981.

Eitner 1960 Lorenz Eitner. *Géricault: An Album of Drawings in the Art Institute of Chicago.* Chicago, 1960.

Eitner 1963 Lorenz Eitner. "Géricault's *Dying Paris* and the Meaning of His Romantic Classicism." *Master Drawings* 1 (1963), pp. 21–34.

Eitner 1967 Lorenz Eitner. "Reversals of Direction in Géricault's Compositional Subjects." In *Stil und Überlieferung in der Kunst des Abendlandes,* vol. 3. Berlin, 1967.

Eitner 1971 Lorenz Eitner. "Dessins de Géricault d'après Rubens et la genèse du 'Radeau de la Méduse.'" *Revue de l'art* 14 (1971), pp. 51–56.

Eitner 1972 Lorenz Eitner. *Géricault's "Raft of the Medusa."* London, 1972.

Eitner 1973 Lorenz Eitner. "Géricault's *Black Standard Bearer.*" *Stanford Museum* 2 (1973), pp. 3–9.

Eitner 1983 Lorenz Eitner. *Géricault: His Life and Work.* London, 1983.

Eitner 1991 Lorenz Eitner. *Géricault: Sa vie, son oeuvre.* Translated by Jeanne Bouniort. Paris, 1991.

Eitner 1998 Lorenz Eitner. "Géricault's First Lithograph: A Hitherto Unrecorded First State of the *Bouchers de Rome.*" *Apollo* 148 (November 1998), pp. 33–36.

Elderfield and Gordon 1996 John Elderfield and Robert Gordon. *The Language of the Body: Drawings by Pierre-Paul Prud'hon.* New York, 1996.

Elderfield and Gordon 1997 John Elderfield and Robert Gordon. *La poésie du corps: Dessins de Pierre-Paul Prud'hon.* Translated by France Valentini. Paris, 1997.

Elgar 1951 Frank Elgar. *Ingres.* Paris, 1951.

Elias 1994 Daniel Elias. "Works on Paper: The New Agnes Mongan Center for the Study of Prints, Drawings, and Photographs Opens at Harvard." *Art New England,* June–July 1994, p. 12.

Ellis 1982 Margaret H. Ellis. "Watermarks and the Stories They Tell." *Drawing* 3, no. 6 (March–April 1982), pp. 128–31.

Elsen 1960 Albert E. Elsen. *Rodin's Gates of Hell*. Minneapolis, 1960.

Elsen 1965 Albert E. Elsen. "Rodin's 'La Ronde.'" *Burlington Magazine* 107 (June 1, 1965), pp. 290–99.

Elsen 1967 Albert E. Elsen. "Rodin's 'Walking Man' as Seen by Henry Moore." *Studio International*, July–August 1967, pp. 26–31.

Elsen 1974 Albert E. Elsen. *Origins of Modern Sculpture: Pioneers and Premises*. New York, 1974.

Elsen 1980 Albert E. Elsen. *In Rodin's Studio: A Photographic Record of Sculpture in the Making*. Oxford and Ithaca, 1980. Also published in French.

Elsen and Varnedoe 1972 Albert Elsen and Kirk T. Varnedoe, with contributions by Victoria Thorson and Elisabeth Chase Geissbuhler. *The Drawings of Rodin*. New York, 1972.

Emeric-David 1819 [Emeric-David]; signed T. "Beaux-Arts. Salon, Troisième article." *Le moniteur universel*, no. 285 (October 12, 1819), p. 1324.

Emmanuel Chabrier 1912 *Emmanuel Chabrier (In Memoriam)*. Paris, 1912.

Emporium 1895 G. B. "Artisti contemporanei: Sir Edward Burne-Jones." *Emporium* 2 (1895), pp. 445–65.

Enciclopedia universale dell'arte 1958–67 *Enciclopedia universale dell'arte*. 15 vols. Venice, 1958–67.

Erdman 1965 David V. Erdman. *The Poetry and Prose of William Blake*. New York, 1965.

Escholier 1921 Raymond Escholier. "L'Orientalism de Chassériau." *Gazette des beaux-arts*, ser. 5, 3 (February 1921), pp. 89–107.

Escholier 1923 Raymond Escholier. *Daumier, peintre et lithographe*. Paris, 1923.

Escholier 1926–29 Raymond Escholier. *Delacroix: Peintre, graveur, écrivain*. 3 vols. La vie et l'art romantiques. Paris, 1926–29.

Escholier 1930 Raymond Escholier. *Daumier, 1808–1879*. Paris, 1930.

Essick 1989 Robert N. Essick. *William Blake and the Language of Adam*. Oxford, 1989.

Essick and LaBelle 1977 Robert N. Essick and Jenijoy LaBelle, eds. *Flaxman's Illustrations to Homer*. New York, 1977.

Esten 2000 John Esten. *Sargent: Painting Out-of-Doors*. New York, 2000.

Ewals 1987 Leo Ewals. "Ary Scheffer: Sa vie et son oeuvre." Doctoral thesis, Katholieke Universiteit te Nijmegen, 1987.

Ewing 1904 Lucie Lee Ewing. *George Frederick Watts, Sandro Botticelli, Matthew Arnold*. New York, 1904.

de la Faille 1928 Jacob-Baart de la Faille. *L'oeuvre de Vincent van Gogh—catalogue raisonné*. 4 vols. Paris, 1928.

de la Faille 1970 Jacob-Baart de la Faille. *The Works of Vincent Van Gogh: His Paintings and Drawings*. Rev. ed. Amsterdam, 1970.

de la Faille 1992 Jacob-Baart de la Faille. *Vincent van Gogh: The Complete Works on Paper, Catalogue Raisonné*. 2 vols. Reprint of *L'oeuvre de Vincent van Gogh—catalogue raisonné* (1928) and *The Works of Vincent van Gogh* (1970). San Francisco, 1992.

Fairbrother 1986 Trevor J. Fairbrother. *John Singer Sargent and America*. New York, 1986. Ph.D. dissertation, Boston University, 1981.

Fairbrother 1994 Trevor J. Fairbrother. *John Singer Sargent*. Library of American Art. New York, 1994.

Fairley 1995 John Fairley. *The Art of the Horse*. New York, 1995.

Faison 1958 S[amson] Lane Faison Jr. *A Guide to the Art Museums of New England*. New York, 1958.

Fantin-Latour 1911 Victoria Dubourg Fantin-Latour. *Catalogue de l'oeuvre complet (1849–1904) de Fantin-Latour, établi et rédigé par madame Fantin-Latour*. Paris, 1911. Reprinted, Amsterdam and New York, 1969; Paris, 2000.

Farrington 1955 Edward I. Farrington. *Twenty-five Historic Years: How an Exhibition, a Magazine and a Library Brought New Life to a Famous Institution. The History of the Massachusetts Horticultural Society from March, 1929*. Boston, 1955.

Farwell 1958 Beatrice Farwell. "Sources for Delacroix' 'Death of Sardanapalus.'" *Art Bulletin* 40 (March 1958), pp. 66–71.

Fasanelli 1967 James A. Fasanelli. "Charles Eliot Norton and His Guides: A Study of His Sources." *Journal of Aesthetics and Art Criticism* 26 (1967), pp. 251–58.

Faure et al. 1920 Élie Faure, Jules Romains, Charles Vildrac, and Léon Werth. *Henri-Matisse*. Cahiers d'aujourdhui. Paris, 1920.

Faxon 1985 Alicia Craig Faxon. "D. G. Rossetti and His Models." *Journal of Pre-Raphaelite Studies* 5, no. 2 (May 1985), pp. 54–67.

Faxon 1989 Alicia Craig Faxon. *Dante Gabriel Rossetti*. New York, 1989.

Faxon 1995 Alicia Craig Faxon. "Introduction: A New View of Pre-Raphaelitism." In *Pre-Raphaelite Art in Its European Context*, edited by Susan P. Casteras and A. Craig Faxon. Madison, N.J., and London, 1995.

Feinblatt 1969 Ebria Feinblatt. "An Ingres Drawings for Los Angeles." *Connoisseur* 170 (April 1969), pp. 262–65.

Feist 1966 Peter H. Feist. Review of *Vincent van Gogh: Sämtliche Briefe*, translated by Eva Schuman. *Bildende Kunst*, no. 5 (1966), p. 275.

Feldman 1972 Edmund Burke Feldman. *Varieties of Visual Experience: Art as Image and Idea*. 2nd ed. New York, 1972.

Feldman 1985 Edmund Burke Feldman. *Thinking about Art*. Englewood Cliffs, N.J., 1985.

Feldman 1987 Edmund Burke Feldman. *Varieties of Visual Experience*. 3rd ed. New York, 1987.

Feldman 1992 Edmund Burke Feldman. *Varieties of Visual Experience*. 4th ed. New York, 1992.

Fell 1937 H. Granville Fell. "Of the Despised Victorians—II, A Century's Retrospect." *Connoisseur* 100 (1937), pp. 11–15.

Fennell 1978 Francis L. Fennell, ed. *The Rossetti–Leyland Letters: The Correspondence of an Artist and His Patron*. Athens, Ohio, 1978.

Fernier 1977–78 Robert Fernier. *La vie et l'oeuvre de Gustave Courbet: Catalogue raisonné*. 2 vols. Lausanne, 1977–78.

Ferrara 1998 *Thomas Gainsborough*. Exhibition, Palazzo dei Diamanti, Ferrara, June 7–August 30, 1998. Catalogue by John T. Hayes. Ferrara, 1998.

Ferrier 1991 Jean-Louis Ferrier. *L'aventure de l'art au XIXe siècle*. Paris, 1991.

Fezzi 1972 Elda Fezzi. *L'opera completa di Renoir nel periodo impressionista, 1869–1883*. Milan, 1972.

Figueiredo 1992 Maria Rosa Figueiredo. *Catálogo de escultura europeia*. Vol. 1, *A escultura francesa*. Lisbon: Museu Calouste Gulbenkian, 1992.

Finberg 1908 Alexander Joseph Finberg. *Ingres*. London, [1908].

Finch 1991 Christopher Finch. *Nineteenth-Century Watercolors*. New York, 1991.

Finn 1985 David Finn. *How to Visit a Museum*. New York, 1985.

Fitzgerald 1975 Penelope Fitzgerald. *Edward Burne-Jones: A Biography*. London, 1975.

Flam 1973 Jack Flam, ed. *Matisse on Art*. New York, 1973.

Flam 1986 Jack Flam. *Matisse: The Man and His Art, 1869–1918*. Ithaca, N.Y., 1986.

Flam 2000 Jack Flam. "Matisse and Ingres." *Apollo* 152 (October 2000), pp. 20–21.

Flandrin 1911 Louis Flandrin. "Deux disciples d'Ingres: Paul et Raymond Balze," parts 1, 2. *Gazette des beaux-arts*, ser. 4, 6 (August 1911), pp. 139–55, (October 1911), pp. 317–32.

Flaxman 1795 John Flaxman. *Compositions from the Tragedies of Aeschylus*. Engraved by Thomas Piroli. London, 1795.

Flaxman 1805 John Flaxman. *The Odyssey of Homer Engraved from the Compositions of John Flaxman R.A. Sculptor, London*. London, 1805.

Fleckner 1995 Uwe Fleckner. *Abbild und Abstraktion: Die Kunst des Porträts im Werk von Jean-Auguste-Dominique Ingres*. Mainz, 1995.

Fleming 1971 Gordon H. Fleming. *That Ne'er Shall Meet Again: Rossetti, Millais, Hunt*. London, 1971.

Fletcher 1983 Pauline Fletcher. *Gardens and Grim Ravines: The Language of Landscape in Victorian Poetry*. Princeton, 1983.

Fletcher and Desantis 1989 Shelley Fletcher and Pia Desantis. "Degas: The Search for His Technique Continues." *Burlington Magazine* 131 (April 1989), pp. 256–65.

Fleuriot de Langle 1939a Paul Fleuriot de Langle. "Monsieur Ingres et la princesse de Canino." *La revue de France*, July 1939, pp. 34–43.

Fleuriot de Langle 1939b Paul Fleuriot de Langle. *Alexandrine Lucien-Bonaparte, Princesse de Canino, 1778–1855*. Paris, 1939.

Fleuriot de Langle 1969 Paul Fleuriot de Langle. "La famille de Lucien Bonaparte." *Colloque Ingres [1967]*, pp. 47–52. [Montauban, 1969].

Flexner 1966 James Thomas Flexner. *The World of Winslow Homer, 1836–1910*. New York, 1966.

Flexner 1970 James Thomas Flexner. *Nineteenth Century American Painting*. New York, 1970.

Florence 1968 *Ingres e Firenze, con una sezione dedicata agli artisti toscani contemporanei di Ingres*. Exhibition, Orsanmichele, Florence, July 13–August 20, 1968. Catalogue by Anna Maria Ciaranfi; introduction by Mathieu Méras. Florence, 1968.

Florence 1984 *Raffaello: Elementi di un mito. Le fonti, la letteratura artistica, la pittura di genere storico*. Exhibition, Biblioteca Medicea Laurenziana, Florence, February 4–April 15, 1984. Catalogue. Florence, 1984.

Florisoone 1938 Michel Florisoone. *Eugène Delacroix*. Paris, 1938.

Florisoone 1947 Michel Florisoone. *Manet*. Monaco, 1947.

Florisoone 1957 Michel Florisoone. "Moratin, Inspirer of Géricault and Delacroix." *Burlington Magazine* 99 (September 1957), pp. 302–9.

Focillon 1927 Henri Focillon. *La peinture au XIXe siècle*. Paris, 1927.

"Focus on Drawing" 1946 "Focus on Drawing: Lines for Painting at the Metropolitan." *Art News* 45, no. 1 (March 1946), pp. 26–27.

Fogg Art Museum 1943 "A Special Number Devoted to the Grenville Lindall Winthrop Bequest." *Bulletin of the Fogg Museum of Art* 10, no. 2 (November 1943).

Fogg Art Museum 1944 "The Winthrop Art Collection." *Harvard Alumni Bulletin* 46 (January 8, 1944), pp. 210–14.

Fogg Art Museum 1945 "Paintings from the Winthrop Collection." *Bulletin of the Fogg Museum of Art* 10, no. 3 (March 1945), pp. 98–103.

Fogg Art Museum 1964 *A Survey of the Collections*. Cambridge, Mass., 1964.

Fondation Taylor 1995 *See* Foucart et al. 1995.

Fontainas 1921 André Fontainas. *Courbet*. Paris, 1921.

Fontainas 1923 André Fontainas. *La peinture de Daumier*. Paris, 1923.

Fontana 1999 Jeffrey Fontana. *Timeless Beauty: Representing the Ideal in Necoclassical Drawing*. Harvard University Art Museums Gallery Series, no. 27. Cambridge, Mass., 1999.

Forbes 1955 Edward W. Forbes. "History of the Fogg Museum of Art." 5th revision, 1955. Typescript, Harvard University Art Museums Archives.

Ford 1939 Brinsley Ford. "Ingres' Portrait Drawings of English People at Rome, 1806–1820." *Burlington Magazine* 75 (July 1939), pp. 3–13.

Ford 1953 Brinsley Ford. "Ingres' Portrait Drawing of the Reiset Family." *Burlington Magazine* 95 (November 1953), pp. 356–59.

Forge 1973 Andrew Forge. "New and Recent Art Books: Géricault's Raft of the Medusa by Lorenz Eitner." *Studio International* 186, no. 957 (July–August 1973), p. 50.

de Forges 1972 Marie-Thérèse de Forges. "Autoportraits de Courbet." *La revue du Louvre* 22, no. 6 (1972), pp. 451–56.

de Forges 1973 Marie-Thérèse de Forges. *Autoportraits de Courbet*. Étude au laboratoire de recherché des musées de France by Suzy Delbourgo and Lola Faillant. Dossiers du département des peintures, 6. Paris: Musée du Louvre, 1973.

Foucart 1977 Bruno Foucart. *Courbet*. Paris and New York, 1977.

Foucart 1995 Bruno Foucart. *Courbet*. 2nd ed. Paris, 1995.

Foucart et al. 1995 Bruno Foucart, Anne-Marie Debelfort, and Frédérique Giess. *Le Baron Taylor, l'Association des Artistes et l'exposition du Bazar Bonne-Nouvelle en 1846*. Paris, 1995.

Fournel 1884 Victor Fournel. *Les artistes français contemporains*. Tours, 1884.

Fox 1953 Milton S. Fox. *Pierre Auguste Renoir*. Pocket Library of Great Art, no. A11. New York, 1953.

Frankenstein 1953 Alfred V. Frankenstein. *After the Hunt: William Harnett and Other American Still Life Painters, 1870–1900*. Berkeley, 1953.

Frankenstein 1969 Alfred V. Frankenstein. *After the Hunt: William Harnett and Other American Still Life Painters, 1870–1900*. Rev. ed. California Studies in the History of Art, 12. Berkeley and Los Angeles, 1969.

Frankfurt 1912 *Die Klassische Malerei Frankreichs im neunzehnten Jahrhundert*. Exhibition, Frankfürter Kunstverein, 1912.

Frankfurt–New York 1992–93 *Daumier Drawings*. Exhibition, Städelsches Kunstinstitut Frankfurt am Main, November 17, 1992–January 17, 1993; The Metropolitan Museum of Art, New York, February 26–May 2, 1993. Catalogue by Colta Ives, Margret Stuffmann, and Martin Sonnabend, with contributions by Klaus Herding and Judith Wechsler. New York, 1992.

Fredeman 1975 William E. Fredeman, ed. *The P.R.B. Journal: William Michael Rossetti's Diary of the Pre-Raphaelite Brotherhood, 1849–1853, Together with Other Pre-Raphaelite Documents*. Oxford, 1975.

Freedman 1996 Ralph Freedman. *Life of a Poet: Rainer Maria Rilke*. New York, 1996.

Fried 1982 Michael Fried. "Painter into Painting: On Courbet's *After Dinner at Ornans* and *Stonebreakers*." *Critical Inquiry* 8 (summer 1982), pp. 619–49.

Fried 1990 Michael Fried. *Courbet's Realism*. Chicago, 1990.

Fried 1996a Michael Fried. "Géricault's Romanticism." In Michel 1996, vol. 2, pp. 641–59.

Fried 1996b Michael Fried. *Manet's Modernism; or, The Face of Painting in the 1860s*. Chicago, 1996.

Fried 2002 Michael Fried. *Menzel's Realism: Art and Embodiment in Nineteenth-Century Berlin*. New Haven, 2002.

Friedlaender 1952 Walter F. Friedlaender. *David to Delacroix*. Translated by Robert Goldwater. Cambridge, Mass., 1952.

Frisch and Shipley 1939 Victor Frisch and Joseph T. Shipley. *Auguste Rodin, a Biography*. New York, 1939.

Fröhlich-Bum 1924 L[ili] Fröhlich-Bum. *Ingres: Sein Leben und sein Stil*. Vienna and Leipzig, 1924.

Fröhlich-Bum 1926 Lili Fröhlich-Bum. *Ingres, His Life and Art*. Translated by Maude Valérie White. London, 1926.

Fromentin 1995 Eugène Fromentin. *Correspondance d'Eugène Fromentin*. Edited by Barbara Wright. Paris, 1995.

Fromont 1969 D. Fromont. *La peinture française du classicisme au réalisme*. Brussels, 1969.

Frost 1944 Rosamund Frost. *Pierre Auguste Renoir*. New York, 1944.

Fuchs 1927 Eduard Fuchs. *Der Maler Daumier*. New York, 1927.

Fuller 1988 David Fuller. "Blake and Dante." *Art History* 11, no. 3 (September 1988), pp. 349–73.

Furet 1988 François Furet. *La révolution de Turgot à Jules Ferry, 1770–1880*. Histoire de France Hachette. Paris, 1988.

Furet 1992 François Furet. *Revolutionary France, 1770–1880*. Translated by Antonia Nevill. Cambridge, 1992.

Furet and Ozouf 1989 François Furet and Mona Ozouf, eds. *A Critical Dictionary of the French Revolution*. Translated by Arthur Goldhammer. Cambridge, Mass., 1989.

Gaddis 2000 Eugene R. Gaddis. *Magician of the Modern: Chick Austin and the Transformation of the Arts in America*. New York, 2000.

Gage 1999 John Gage. *Colour and Meaning: Art, Science and Symbolism*. London, 1999.

Galassi 1996 Susan Grace Galassi. *Picasso's Variations on the Masters: Confrontations with the Past*. New York, 1996.

Galerie Durand-Ruel 1873 *Galerie Durand-Ruel: Recueil d'estampes gravées à l'eau forte*. Preface by Armand Silvestre. Paris and London, 1873. Issued in 30 parts of 10 plates each.

Galichon 1861a Émile Galichon. "Description des dessins de M. Ingres Ingres exposés au Salon des Arts-Unis," [part 1]. *Gazette des beaux-arts* 9 (March 15, 1861), pp. 343–62.

Galichon 1861b Émile Galichon. "[Description des] Dessins de M. Ingres [exposés au Salon des Arts-Unis], deuxième série." *Gazette des beaux-arts* 11 (July 1, 1861), pp. 38–48.

Galignani's New Paris Guide for 1867 *Galignani's New Paris Guide for 1867*. [Paris, 1867].

Gallatin 1900 Albert E . Gallatin. *List of Drawings by Aubrey Beardsley*. New York, 1900.

Gallatin 1903 Albert E. Gallatin. *Aubrey Beardsley's Drawings: A Catalogue and a List of Criticisms*. New York, 1903.

Gallatin 1945 A[lbert] E. Gallatin. *Aubrey Beardsley: Catalogue of Drawings and Bibliography*. New York, 1945.

Gardner 1961 Albert Ten Eyck Gardner. *Winslow Homer, American Artist: His World and His Work*. New York, 1961.

Garlick 1954 Kenneth Garlick. *Sir Thomas Lawrence*. London, 1954.

Garlick 1964 Kenneth Garlick, ed. *A Catalogue of the Paintings, Drawings, and Pastels of Sir Thomas Lawrence*. Volume of the Walpole Society 39 (1962–64). Glasgow, 1964.

Garlick 1989 Kenneth Garlick. *Sir Thomas Lawrence: A Complete Catalogue of the Oil Paintings*. Oxford, 1989.

Garnett 2000 Oliver Garnett. "The Letters and Collection of William Graham—Pre-Raphaelite Patron and Pre-Raphaelite Collector." In *The Sixty-Second Volume of the Walpole Society*, pp. 145–86, 287–88. Leeds, 2000.

Gatteaux [1873] (1st ser.) Édouard Gatteaux. *Collection de 120 dessins, croquis et peintures de M. Ingres classés et mis en ordre par son ami Édouard Gatteaux*. 1st ser. Paris, n.d. [1873?].

Gatteaux [1873] (2nd ser.) Édouard Gatteaux. *Dessins, croquis et peintures de M. Ingres de la Collection de Édouard Gatteaux, du Musée National du Louvre et l'École Nationale des Beaux-Arts à Paris*. 2nd ser. Paris, n.d. [1873?].

Gatteaux 1875 Édouard Gatteaux. *Collection de 120 dessins, croquis et peintures de M. Ingres classés et mis en ordre par son ami Édouard Gatteaux*. Paris, 1875.

Gaudibert 1954 Pierre Gaudibert "Géricault." *Europe*, October 1954.

Gaunt 1942 William Gaunt. *The Pre-Raphaelite Tragedy*. London, 1942.

Gaunt 1962 William Gaunt. *Renoir*. London, 1962.

Gaunt 1982 William Gaunt. *Renoir.* 3rd ed. Notes by Kathleen Adler. London, 1982.

Gautier 1851 Théophile Gautier. "Salon de 1850–1851." *La presse,* February–May 1851.

Gautier 1855–56 Théophile Gautier. *Les beaux-arts en Europe, 1855.* 2 vols. Paris, 1855–56.

Gautier 1856–57 Théophile Gautier. *Les beaux-arts en Europe, 1855.* 2 vols. Paris, 1856–57.

Gautier 1857 Théophile Gautier. "Atelier de feu Théodore Chassériau." *L'artiste,* ser. 6, 3 (March 15, 1857), pp. 209–11.

Gautier 1858 Théophile Gautier. "Les soirées du Louvre." *L'artiste,* ser. 7, 3 (January 31, 1858), pp. 69–70.

Gautier 1858a Théophile Gautier. "Louis XIV et Molière—tableau de M. Ingres." *L'artiste,* ser. 7, 3 (January 10, 1858), pp. 21–23.

Gautier 1860 Théophile Gautier. "Exposition de tableaux modernes au profit de la caisse de secours des artistes peintres, statuaires, architectes." *Gazette des beaux-arts* 5 (March 15, 1860), pp. 321–31.

Gautier 1865 Théophile Gautier. *Salon de 1865.* Paris, 1865. Offprints from *Le moniteur universel.*

Gediman 1995 Helen K. Gediman. *Fantasies of Love and Death in Life and Art: A Psychoanalytic Study of the Normal and the Pathological.* New York, 1995.

Geffroy 1892–1903 Gustave Geffroy. *La vie artistique.* 8 vols. Paris, 1892–1903.

Geffroy 1900 Gustave Geffroy. "Rodin." *Art et décoration,* no. 10 (October 1900), pp. 97–110.

van Gelder 1958 Jan Gerrit van Gelder. *Prenten en tekeningen.* De Schoonheid van ons land, 15: Beeldende kunsten. Amsterdam, 1958.

van Gelder 1976 Dirk van Gelder. *Rodolphe Bresdin.* 2 vols. Translated by J. Amiel and M. Stordiau. The Hague, 1976.

Geldzahler 1962 Henry Geldzahler. "Two Early Matisse Drawings." *Gazette des beaux-arts,* ser. 6, 60 (November 1962), pp. 497–505.

Geller 1989 Katalin Geller. *La pintura francesa del siglo XIX.* Translated by Krisztina Zilahi. Havana and Budapest, 1989.

Geller 1990 Katalin Geller. *Malarstwo Francuskie w XIX Wieku.* Budapest, 1990.

Geoffroy 1851 L. de Geoffroy. "Le Salon de 1850." *La revue des deux-mondes,* March 1851.

Georgel 1995 Pierre Georgel. *Courbet: Le poème de la nature.* Paris, 1995.

Georgel and Lecoq 1987 Pierre Georgel and Anne-Marie Lecoq. *La peinture dans la peinture.* Paris, 1987. Revised version of Dijon 1982–83.

Georgel and Mandel 1972 Pierre Georgel and Georges Mandel. *Tout l'oeuvre peint de Daumier.* Les classiques de l'art. Paris, 1972.

Gerdts 1971 William H. Gerdts. "The Bric-a-Brac Still Life." *Antiques* 100 (November 1971), pp. 744–48.

Gerdts 1972 William H. Gerdts. "On the Tabletop: Europe and America." *Art in America,* September–October 1972, pp. 62–69.

Gerdts 1985 William H. Gerdts. "Through a Glass Brightly: The American Pre-Raphaelites and Their Still Lifes and Nature Studies." In *The New Path: Ruskin and the American Pre-Raphelites.* Brooklyn: Brooklyn Museum, 1985.

Gerdts and Burke 1971 William H. Gerdts and Russell Burke. *American Still Life Painting.* New York, 1971.

Géricault 1947 Théodore Géricault. *Géricault, raconté par lui-même et par ses amis.* Les grands artistes racontés par eux-mêmes et par leurs amis, 10. Geneva, 1947.

Germer 1988 Stefan Germer. *Historizitat und Autonomie: Studien zu Wandbildern im Frankreich des 19. Jahrhunderts. Ingres, Chassériau, Chenavard, und Puvis de Chavannes.* New York and Zürich, 1988.

Getscher 1991 Robert H.Getscher. *James Abbott McNeill Whistler Pastels.* New York, 1991.

Gianelli 1927 A. M. Gianelli. "Montreal Collection Is Auctioned at Christie's." *Canadian Homes and Gardens,* September 1927, pp. 34–35.

Gilchrist 1863 Alexander Gilchrist. *The Life of William Blake: "Pictor Ignotus"; with Selections from His Poems and Other Writings.* 2 vols. London, 1863.

Gimpel 1963 René Gimpel. *Journal d'un collection-neur, marchand de tableaux.* Paris, 1963.

Girouard 1981 Mark Girouard. *The Return to Camelot: Chivalry and the English Gentleman.* New Haven, 1981.

Giry 1980 Marcel Giry. "Ingres et le Fauvisme." In *Actes du colloque international, Ingres et son influence, Montauban, septembre 1980,* pp. 55–60. Montauban, 1980.

Giry 1981 Marcel Giry. *Le Fauvisme: Ses origines, son évolutions.* Neuchâtel, 1981.

Gissing 1936 Alfred C. Gissing. *William Holman Hunt: A Biography.* London, 1936.

Glasgow 1888 International Exhibition, Glasgow Fine Art Institute, 1888.

Glasgow 1901 *International Exhibition of Industry, Science, and Art.* Exhibition, Glasgow, 1901. Catalogue. Glasgow, 1901.

Gobin 1952 Maurice Gobin. *Daumier Sculpteur, 1808–1879.* Geneva, 1952.

Gobin 1958 Maurice Gobin. *Géricault, 1791–1824, dans la collection d'un Amateur.* Paris, 1958.

van Gogh 1893 Vincent van Gogh. "Lettres de Vincent van Gogh à son frère Théodore." Introduction by Émile Bernard. *Mercure de France,* August 1893, p. 313.

van Gogh 1958 Vincent van Gogh. *The Complete Letters of Vincent van Gogh.* 3 vols. London, 1958.

Goldscheider 1989 Cécile Goldscheider. *Auguste Rodin: Catalogue raisonné de l'oeuvre sculpté.* Vol. 1. Lausanne and Paris, 1989.

Goldscheider and Jianou 1967 Cécile Goldscheider and Ionel Jianou. *Rodin.* Paris, 1967.

Goldschmidt 1914–53 Ernst Goldschmidt. *Frankrigs Malerkunst.* 9 vols. Copenhagen, 1914–53.

Goldstein 1977 Nathan Goldstein. *The Art of Responsive Drawing.* 2nd ed. Englewood Cliffs, N.J., 1977.

Goldstein 1982 Nathan Goldstein. *100 American and European Drawings.* Englewood Cliffs, N.J., 1982.

Goldstein 1984 Nathan Goldstein. *The Art of Responsive Drawing.* 3rd ed. Englewood Cliffs, N.J., 1992.

Goldstein 1992 Nathan Goldstein, *The Art of Responsive Drawing.* 4th ed. Englewood Cliffs, N.J., 1992.

Goncourt 1876 Edmond de Goncourt. *Catalogue raisonné de l'oeuvre peint, dessiné et gravé de P. P. Prud'hon.* Paris, 1876.

Goncourt and Goncourt 1956 Edmond de Goncourt and Jules de Goncourt. *Journal: Mémoires de la vie littéraire.* Edited and annotated by Robert Ricatte. 4 vols. Paris, 1956.

Goncourt and Goncourt 1989 Edmond de Goncourt and Jules de Goncourt. *Journal: Mémoires de la vie littéraire.* Edited and annotated by Robert Ricatte; preface and chronology by Robert Kopp. 3 vols. Paris, 1989.

Gonse 1904 Louis Gonse. *Les chefs-d'oeuvre des musées de France.* Paris, 1904.

Gonzalez-Palacios 1967 Alvar Gonzalez-Palacios. *David e la pittura napoleonica.* Milan, 1967.

Goodrich 1928 Lloyd Goodrich. "Théodore Chassériau." *The Arts* 14, no. 2 (August 1928), pp. 60–100.

Goodrich 1944 Lloyd Goodrich. *Winslow Homer.* New York, 1944.

Gordon and Forge 1983 Robert Gordon and Andrew Forge. *Monet.* New York, 1983.

Gorely and Schwartz 1965 Jean Gorely and Marvin D. Schwartz. *The Emily Winthrop Miles Collection: The Work of Wedgwood and Tassie.* Brooklyn: Brooklyn Museum, 1965.

Gowans & Gray 1913 [Gowans & Gray, Ltd., London]. *The Masterpieces of Ingres (1780–1867): Sixty Reproductions of Photographs from the Original Paintings . . . Gowan's Art Books, No. 47.* London, 1913.

Gower 1900 Ronald Sutherland Gower. *Sir Thomas Lawrence, with a Catalogue of the Artist's Exhibited and Engraved Works, Compiled by Algernon Graves.* London and New York, 1900.

Grada 1989 Raffaele de Grada. *Renoir.* New York, 1989.

Graefe 1889 R. H. Graefe, ed. *Special Official Guide to Paris.* Liverpool, 1889.

Grand Collection of World Art 1978 *Gurando sekai bijutsu / Grand Collection of World Art.* Tokyo, 1978.

Grappe 1929 Georges Grappe. *Catalogue du Musée Rodin: Essai de classement chronologique des oeuvres d'Auguste Rodin.* 2nd ed. Paris, 1929.

Grappe 1939 Georges Grappe. *Rodin.* New York, 1939.

Grappe 1944 Georges Grappe. *Catalogue du Musée Rodin.* 5th ed. Paris, 1944.

Grate 1959 Pontus Grate. *Deux critiques d'art de l'époque romantique: Gustave Planche et Théophile Thoré.* Stockholm, 1959.

Grautoff 1908 Otto Grautoff. *Auguste Rodin.* Künstler-Monographien, no. 93. Bielefeld and Leipzig, 1908.

Grautoff 1924 Otto Grautoff. "Théodore Géricault, zum 100. Todestag." *Die Kunst für Alle* 39 (February 1924), pp. 129–42.

Graves 1913–15 Algernon Graves. *Century of Loan Exhibitions, 1813–1912.* 5 vols. London, 1913–15.

Grieve 1978 Alastair Grieve. *The Art of Dante Gabriel Rossetti: The Watercolours and Drawings of 1850–1855.* Norwich, 1978.

Grieve 2000 Alastair Grieve. *Whistler's Venice.* New Haven, 2000.

Groom 1994 Gloria Groom. "The Late Work [of Odilon Redon]." In Chicago–Amsterdam–London 1994–95, pp. 305–52.

Groseclose 1987 Barbara S. Groseclose. "Vanity and the Artist: Some Still-Life Paintings by William Michael Harnett." *American Art Journal* 19, no. 1 (1987), pp. 51–59.

Gross 1981 Robert Allen Gross. "Ingres' Celtic Fantasy: *The Dream of Ossian.*" *Rutgers Art Review* 2 (1981), pp. 47–52.

Grunchec 1976 Philippe Grunchec. *All the Paintings of Théodore Géricault.* New York, 1976.

Grunchec 1978 Philippe Grunchec. *Tout l'oeuvre peint de Géricault.* Paris, 1978. Also published in Italian.

Grunchec 1979 Philippe Grunchec. "Géricault: Problèmes de méthode." *La revue de l'art,* no. 43 (1979), pp. 37–58.

Grunchec 1982 Philippe Grunchec. *Gericault: Dessins et aquarelles de chevaux.* Lausanne and Paris, 1982.

Grunchec 1984 Philippe Grunchec. *Géricault's Horses: Drawings and Watercolours.* New York, 1984.

Grunchec 1991 Philippe Grunchec. *Tout l'oeuvre peint de Géricault.* Paris, 1991.

Grunfeld 1987 Frederic V. Grunfeld. *Rodin: A Biography.* New York, 1987.

Grunfeld 1988 Frederic V. Grunfeld. *Rodin.* Translated by Denise Meunier. Paris, 1988.

de Gruyter and Andriesse 1953 W. Jos de Gruyter and Emmy Andriesse. *De wereld van Van Gogh.* The Hague, 1953.

Gsell 1907 Paul Gsell. "Propos de Rodin sur l'art et les artistes." *La revue,* no. 21 (November 1, 1907), pp. 95–107.

Guégan 1994 Stéphane Guégan. *Delacroix et les Orientales.* Paris, 1994.

Guérin 1872 Paul Guérin. "Sainte Geneviève, vierge." In *Vie des saints de l'ancien et du nouveau testament* [d'après le père Giry. . . les Grands Bollandistes . . .], vol. 1, pp. 92–104. Paris, 1872.

Guérin 1944 Marcel Guérin. *L'oeuvre gravé de Manet.* Paris, 1944.

Guérin 1969 Marcel Guérin. *L'oeuvre gravé de Manet; avec un supplément nouvellement ajouté.* New York, 1969.

Guffey (1997) 2001 Elizabeth E. Guffey. "Prud'hon et le cercle bourguignon à Rome." In Prud'hon colloque (1997) 2001, pp. 77–103.

Guffey 2001 Elizabeth E. Guffey. *Drawing an Elusive Line: The Art of Pierre-Paul Prud'hon.* Newark, Del., 2001.

Guiffrey 1924 Jean Guiffrey. *L'oeuvre de P. P. Prud'hon.* Archives de l'art français, vol. 13. Paris, 1924.

Guiffrey and Marcel 1907–38 Jean Guiffrey and Pierre Marcel. *Inventaire général des dessins du Musée du Louvre et du Musée de Versailles: École française.* 11 vols. Paris, 1907–38.

Guiffrey and Marcel 1913 Jean Guiffrey and Pierre Marcel. *Inventaire général des dessins du Musée du Louvre et du Musée de Versailles.* Paris, 1913.

Gustave Moreau **1991** *Gustave Moreau.* Tokyo, 1991.

Haddad 1990 Michèle Haddad. *La divine et l'impure: Le nu au XIXe.* Paris, 1990.

Haddad 2000 Michèle Haddad. *Khalil-Bey: Un homme, une collection.* Paris, 2000. Includes text of the Khalil-Bey sale, 1868.

Hake and Compton-Rickett 1916 Thomas Hake and Arthur Compton-Rickett. *The Life and Letters of Theodore Watts-Dunton.* London, 1916.

Hale 2000 Charlotte Hale. "['Portraits by Ingres: Image of an Epoch':] Technical Observations." *Metropolitan Museum Journal* 35 (2000), pp. 198–207.

Hamburg 1975 *William Blake, 1757–1827.* Exhibition, Hamburger Kunsthalle, March 6–April 27, 1975; sponsored by the British Council, London. Catalogue by David Bindman; edited by Werner Hofmann. Munich, 1975.

Hamburg 1979 *John Flaxman: Mythologie und Industrie. Kunst um 1800.* Exhibition, Hamburger Kunsthalle, April 20–May 30, 1979. Catalogue edited by Werner Hofmann; translated by Detlef W. Dörrbecker. Munich, 1979.

Hamburg 1982 *Menzel, der Beobachter.* Exhibition, Hamburger Kunsthalle, May 22–July 25, 1982. Catalogue edited by Werner Hofmann, with contributions by Gisela Hopp, Eckhard Schaar, et al. Munich, 1982.

Hamburg–Frankfurt 1978–79 *Courbet und Deutschland.* Exhibition, Hamburger Kunsthalle, October 19–December 17, 1978; Stadtische Galerie, Frankfurt, January 17–March 18, 1979. Catalogue by Werner Hofmann and Klaus Herding. Cologne, 1978.

Hamilton 1970 George Heard Hamilton. *19th and 20th Century Art: Painting, Sculpture, Architecture.* New York, 1970.

Hamilton 1993 George Heard Hamilton. *Painting and Sculpture in Europe, 1880–1940.* New Haven, 1993.

Hamilton–New York–Amsterdam 1985–86 *The Fodor Collection: Nineteenth-Century French Drawings and Watercolors from Amsterdams Historisch Museum.* Exhibition, Picker Art Gallery, Colgate University, Hamilton, N.Y., February–April 1985; Baruch College Art Gallery, New York, September–October 1985; Amsterdams Historisch Museum, December 1985–January 1986. Catalogue by Wiepke Loos. Hamilton, N.Y., 1985.

Hamlyn 1998 Robin Hamlyn. Introduction. In *Dante Alighieri: Inferno.* Translated by Henry Francis Cary. London, 1998.

Hammacher 1981 A. M. Hammacher. *Phantoms of the Imagination: Fantasy in Art and Literature from Blake to Dali.* Harry N. Abrams, New York, 1981.

Hancke 1912 Erich Hancke. "Die klassische Malerei Frankreichs im neunzehnten Jahrhundert." *Kunst und Kunstler* 11 (October 1912), pp. 60–64.

Hannaway 1973 Patti Hannaway. *Winslow Homer in the Tropics.* Richmond, Va., 1973.

Hanson 1968 Lawrence Hanson. *Renoir, the Man, the Painter, and His World.* New York, 1968.

Hardouin-Fugier 1977 Elisabeth Hardouin-Fugier. "Louis Janmot, élève d'Ingres, ami de Delacroix." In Ingres colloque (1975) 1977, pp. 135–46.

Harpham 1982 Geoffrey Galt Harpham. *On the Grotesque: Strategies of Contradiction in Art and Literature.* Princeton, 1982.

Harrington 1994 Henry R. Harrington. "English Travelers and the Oriental Crowd: Kinglake, Curzon, and the Miracle of the Holy Fire." *Harvard Library Bulletin* 5, no. 2 (summer 1994), pp. 73–86.

Harris 1966 Jean C. Harris. "Manet's Race-Track Paintings." *Art Bulletin* 48 (March 1966), pp. 78–82.

Harris 1990 Jean C. Harris. *Edouard Manet, the Graphic Work: A Catalogue Raisonné.* Rev. ed. Edited by Joel M. Smith. San Francisco, 1990.

Harrison and Waters 1973 Martin Harrison and Bill Waters. *Burne-Jones.* New York and London, 1973.

Harrison and Waters 1989 Martin Harrison and Bill Waters. *Burne-Jones.* Rev. ed. London, 1989.

Hartford 1920 *Exhibition of Paintings, Pottery and Glass Loaned by the Honorable Burton Mansfield of New Haven.* Exhibition, Wadsworth Atheneum, Hartford, Conn., 1920.

Harvard Alumni Bulletin, **March 11, 1967** "Ingres, a Gala Opening at the Fogg." *Harvard Alumni Bulletin,* March 11, 1967, pp. 20–27.

Harvard University 2001 *Harvard University Art Museums Annual Report, 1999–2000.* Cambridge, Mass., 2001.

Harvey and Press 1996 Charles Harvey and Jon Press. "The Businessman." In London 1996b, pp. 49–57.

Haskell 1976 Francis Haskell. *Rediscoveries in Art: Some Aspects of Taste, Fashion, and Collecting in England and France.* Ithaca, N.Y., 1976.

Haskell 1982 Francis Haskell. "A Turk and His Pictures in Nineteenth-Century Paris." *Oxford Art Journal* 5, no. 1 (1982), pp. 40–47.

Haskell 1987 Francis Haskell. *Past and Present in Art and Taste.* New Haven, 1987.

Hauke 1961 César M. de Hauke. *Seurat et son oeuvre.* 2 vols. Paris, 1961.

Hauptman 1977 William Hauptman. "Ingres and Photographic Vision." *History of Photography* 1 (April 1977), pp. 117–28.

Hautecoeur 1954 Louis Hautecoeur. *Louis David.* Paris, 1954.

Haverstock 1970 Mary Sayre Haverstock. "An American Bestiary." *Art in America* 58, no. 4 (July–August 1970), pp. 38–71.

Haverstock 1979 Mary Sayre Haverstock. *An American Bestiary.* New York, 1979.

Hayes 1972 John Hayes. *Rowlandson, Watercolours and Drawings.* New York and London, 1972.

Hayum 1989 Andrée Hayum. *The Isenheim Altarpiece: God's Medicine and the Painter's Vision.* Princeton, 1989.

Heartney 1987 Eleanor Heartney. "What's Wrong with Beauty?" *Independent Curators Inc.* 2, no. 1 (winter 1987).

Heenk 1995 Elizabeth Nicoline Heenk. "Vincent Van Gogh's Drawings: An Analysis of Their Production and Uses." Ph.D. dissertation, Courtauld Institute of Art, University of London, 1995.

Heijbroek and Wouthuysen 1993 Jan Frederik Heijbroek and Ester L. Wouthuysen. *Kunst, kennis en commercie: De kunsthandelaar J. H. de Bois (1878–1946).* Amsterdam and Antwerp, 1993.

Heim, Béraud, and Heim 1989 Jean-François Heim, Claire Béraud, and Philippe Heim. *Les salons de peinture de la Révolution française (1789–1799).* Paris, 1989.

Heimann 1990 Nora M. Heimann. "The Road to Thebes: A Consideration of Ingres' 'Antiochus and Stratonice.'" *Rutgers Art Review* 11 (1990), pp. 1–20.

Helfgott 1994 Leonard M. Helfgott. *Ties that Bind: A Social History of the Iranian Carpet.* Washington, D.C., and London, 1994.

Henderson 1973 Marina Henderson. *D. G. Rossetti.* London and New York, 1973.

Hendricks 1979 Gordon Hendricks. *The Life and Work of Winslow Homer.* New York, 1979.

Henley 1889 W. E. Henley. *A Century of Artists.* Glasgow, 1889.

Henri 1923 Robert Henri. *The Art Spirit.* Philadelphia, 1923.

Henriet 1893 Frédéric Henriet. "Le Comte de Nieuwerkerke." *Le journal des arts,* January 21, 1893, p. 1.

Henriet 1894 Frédéric Henriet. "Le Comte de Nieuwerkerke." *L'art* 18 (1894), pp. 227–37.

Henriot 1922 Émile Henriot. "Le décor de la vie sous le Second Empire." *Gazette des beaux-arts,* ser. 5, 64 (July–August 1922), pp. 97–110.

Herbert 1962a Robert L. Herbert. "Millet Revisited," parts 1, 2. *Burlington Magazine* 104 (July 1962), pp. 294–305; (September 1962), pp. 377–86.

Herbert 1962b Robert L. Herbert. *Seurat's Drawings.* New York, 1962.

Herbert 1988 Robert L. Herbert. *Impressionism: Art, Leisure and Parisian Society.* New Haven, 1988.

Herbert 1992 James D. Herbert. *Fauve Painting: The Making of Cultural Politics.* New Haven, 1992.

Herbert 2001 Robert L. Herbert. *Seurat: Paintings and Drawings.* New Haven, 2001.

Herdrich and Weinberg 2000 Stephanie L. Herdrich and H. Barbara Weinberg. *American Drawings and Watercolors in The Metropolitan Museum of Art: John Singer Sargent.* New York, 2000.

Hilton 1970 Timothy Hilton. *The Pre-Raphaelites.* London, 1970.

Hodgson 1887 John Evan Hodgson. *Fifty Years of British Art: As Illustrated by the Pictures and Drawings in the Manchester Royal Jubilee Exhibition.* Manchester, 1887.

Hoffman 1939 Malvina Hoffman. *Sculpture Inside and Out.* New York, 1939.

Hofmann 1979 Werner Hofmann. "The Death of the Gods." In London 1979.

Holden 1969 Donald Holden. *Whistler Landscapes and Seascapes.* New York, 1969.

Holiday 1914 Henry Holiday. *Reminiscences of My Life.* London, 1914.

Hollander 1993 Anne Hollander. *Seeing through Clothes.* Berkeley, 1993.

Holman-Hunt 1969 Diana Holman-Hunt. *My Grandfather, His Wives and Loves.* London, 1969.

Holme 1905 Charles Holme, ed. *The "Old" Water-Colour Society, 1804–1904.* London, 1905. Special spring issue of *The Studio.*

Holmes 1927 Sir Charles (C. J.) Holmes. *Old Masters and Modern Art.* Vol. 3. New York, 1927.

Holt 1966 Elizabeth Gilmore Holt. *From the Classicists to the Impressionists: A Documentary History of Art and Architecture in the 19th Century.* Garden City, N.Y., 1966.

Holten 1960 Ragnar von Holten. *L'art fantastique de Gustave Moreau.* Paris, 1960.

Homer 1958 William I. Homer. "Seurat's Formative Period: 1880–1888." *Connoisseur* 142 (September 1958), pp. 58–62.

Hönnighausen 1987 Lothar Hönnighausen. *William Faulkner: The Art of Stylization in His Early*

Graphic and Literary Work. Cambridge Studies in American Literature and Culture, 24. Cambridge, 1987.

Honour 1979 Hugh Honour. *Romanticism.* New York, 1979.

Hoog 1989 Michel Hoog. *Cézanne: "Puissant et Solitaire."* Découvertes Gallimard, no. 55. Paris, 1989.

Hoopes 1977 Donelson F. Hoopes. *American Watercolor Painting.* New York, 1977.

Horner 1933 Frances Horner. *Time Remembered.* London, 1933.

Hourticq 1928 Louis Hourticq. *Ingres: L'oeuvre du maître.* Paris, 1928.

Hourticq 1930 Louis Hourticq. *Delacroix: L'oeuvre du maître.* Paris, 1930.

Houssaye 1879 Henry Houssaye. "Un maître de l'école française: Théodore Géricault." *La revue des deux mondes,* November 15, 1879, p. 390.

Houston–New York 1986 *Ingres: Life Studies.* Exhibition, Museum of Fine Arts, Houston, February 1–March 16, 1986; Frick Collection, New York, May 6–June 15, 1986. Catalogue, *J. A. D. Ingres: Fifty Life Drawings from the Musée Ingres at Montauban,* by Avigdor Arikha. Houston, 1986.

Howard 1976 Seymour Howard. *A Classical Frieze by Jacques-Louis David: Sacrifice of the Hero. The Roman Years.* Sacramento, Calif., 1976.

Huebner 2001 Steven Huebner. "Chabrier." In *The New Grove Dictionary of Music and Musicians,* 2nd ed., edited by Stanley Sadie, vol. 5. London, 2001.

Hueffer 1896 Ford Madox Hueffer [later Ford Madox Ford]. *Ford Madox Brown: A Record of His Life and Work.* London, 1896.

Hueffer 1902 Ford Madox Hueffer [later Ford Madox Ford]. *Rossetti: A Critical Essay on His Art.* London, 1902.

Hueffer 1914 Ford Madox Hueffer [later Ford Madox Ford]. *Rossetti: A Critical Essay on His Art.* [2nd ed.]. London, 1914.

Huet 1993 Marie-Hélène Huet. *Monstrous Imagination.* Cambridge, Mass., 1993.

Hugo 1964 Victor Hugo. *Théâtre complet.* Vol. 2. Paris, 1964.

Hulsker 1980 Jan Hulsker. *The Complete Van Gogh: Paintings, Drawings, Sketches.* New York, 1980.

Hulsker 1990 Jan Hulsker. *Vincent and Theo van Gogh: A Dual Biography.* Translated and rewritten by Jan Hulsker; edited by James M. Miller. Ann Arbor, 1990.

Hulsker 1996 Jan Hulsker. *The New Complete Van Gogh: Paintings, Drawings, Sketches.* Rev. ed. Amsterdam, 1996.

Hunt 1885 William Holman Hunt. *The Triumph of the Innocents.* London, 1885.

Hunt 1899 [William Holman Hunt]. "The Miracle of the Holy Fire in the Church of the Sepulchre at Jerusalem." *Painted by W. Holman Hunt.* London, 1899.

Hunt 1905 William Holman Hunt. *Pre-Raphaelitism and the Pre-Raphaelite Brotherhood.* 2 vols. London, 1905.

Hunt 1913 William Holman Hunt. *Pre-Raphaelitism and the Pre-Raphaelite Brotherhood.* 2nd ed. 2 vols. London, 1913.

Hüttinger and Lüthy 1974 Eduard Hüttinger and Hans A. Lüthy, eds. "Vier Unbekannte Ingres-

Modelle." In *Gotthard Jedlicka: Eine Gedenkschrift.* Zürich, 1974.

Huyghe 1930 René Huyghe. "L'exposition Delacroix au Musée du Louvre." *Bulletin des musées de France* 2, no. 6 (June 1930), pp. 117–33.

Huyghe 1937 René Huyghe. *Van Gogh.* Galerie d'estampes, [4]. Paris, 1937.

Huyghe 1957–61 René Huyghe, ed. *L'art et l'homme.* 3 vols. Paris, 1957–61.

Huyghe 1960 René Huyghe. *L'art et l'âme.* Paris, 1960.

Huyghe 1976 René Huyghe. *La relève de l'imaginaire. La peinture française au XIXe siècle: Réalisme, romantisme.* Paris, 1976.

Ingamells 1997 John Ingamells, comp. *A Dictionary of British and Irish Travellers in Italy, 1701–1800.* Compiled from the Brinsley Ford Archive. New Haven, 1997.

Ingres 1999 Jean-Auguste-Dominique Ingres. *Lettres d'Ingres à Marcotte d'Argenteuil.* Edited by Daniel Ternois. Société de l'Histoire de l'Art Français, Archives de l'art français, n.s., 35. Nogent-le-Roi, 1999.

Ingres colloque (1975) 1977 *Actes du colloque international: Ingres et le Néo-Classicisme, Montauban, octobre 1975.* Montauban, [1977].

Innsbruck–Vienna 1991 *J. A. D. Ingres, 1780–1867: Zeichnungen und Ölstudien aus dem Musée Ingres, Montauban.* Exhibition, Tiroler Landesmuseum Ferdinandeum, Innsbruck, January 23–February 24, 1991; Graphische Sammlung Albertina, Vienna, March 15–April 28, 1991. Catalogue by Christine Ekelhart-Reinwetter. Vienna, 1991.

Inoue and Takashina 1972–74 Yasushi Inoue and Shūji Takashina, eds. *Sekai no meiga / Les grands maîtres de la peinture moderne.* 25 vols. Tokyo, 1972–74.

Ireland 1965 LeRoy Ireland. *The Works of George Inness: An Illustrated Catalogue Raisonné.* Austin, 1965.

Ironside and Gere 1948 Robin Ironside and John A. Gere. *Pre-Raphaelite Painters.* London, 1948.

Irwin 1966 David Irwin. *English Neoclassical Art.* London, 1966.

Irwin 1979 David Irwin. *John Flaxman, 1755–1826.* New York, 1979.

Irwin 1997 David Irwin. *Neoclassicism.* London, 1997.

Ives 1988 Colta Ives. "French Prints in the Era of Impressionism and Symbolism." *The Metropolitan Museum of Art Bulletin* 46, no. 1 (summer 1988).

Ivins 1930 William M. Ivins Jr. *Notes on Prints; Being the Text of Labels Prepared for a Special Exhibition of Prints from the Museum Collection.* New York, 1930.

Ivins 1958 William M. Ivins Jr. *How Prints Look: Photographs with a Commentary.* Reprint of 1943 ed. Boston, 1958.

Jacobus de Voragine 1993 Jacobus de Voragine. *The Golden Legend: Readings on the Saints* [ca. 1260]. Translated by William G. Ryan. 2 vols. Princeton, 1993.

James 1876 Anonymous [Henry James]. *The Nation,* June 29, 1876, p. 415.

James 1956 Henry James. *The Painter's Eye: Notes and Essays on the Pictorial Arts by Henry James.* Selected and edited by John L. Sweeney. Cambridge, Mass., 1956.

Jamot 1905 Henry Jamot. "Le 'Bain Turc' d'Ingres." *Revue de l'art ancien et moderne* 18 (1905), p. 386–87, 395.

Jamot 1920 Paul Jamot. "Le don Chassériau au Musée du Louvre." *La revue de l'art ancien et moderne* 37 (February 1920), pp. 65–78.

Jamot and Wildenstein 1932 Paul Jamot and Georges Wildenstein. *Manet.* 2 vols. Paris, 1932.

Janis 1967 Eugenia Parry Janis. "The Role of the Monotype in the Working Method of Degas," parts 1, 2. *Burlington Magazine* 109 (1967), pp. 20–27, 71–81.

Janson and Janson 1991 Anthony F. Janson and H. W. Janson. *History of Art [4th ed.].* New York, 1991.

Jarrassé 1991 Dominique Jarrassé. *Henri de Toulouse-Lautrec-Monfa: Entre le mythe et la modernité.* Marseille, 1991.

Jarrassé 1995 Dominique Jarrassé. *Les Préraphaélites.* Paris, 1995.

Jarves (1864) 1960 James Jackson Jarves. *The Art-Idea.* Edited by Benjamin Rowland Jr. Cambridge, Mass., 1960. First published 1864.

Jean-Aubry 1922 Georges Jean-Aubry. *Eugène Boudin d'après documents inédits, l'homme et l'oeuvre.* Paris, 1922.

Jean-Aubry and Schmit 1968 Georges Jean-Aubry and Robert Schmit. *Eugène Boudin: La vie et l'oeuvre d'après les lettres et les document inédits.* Neuchâtel, 1968.

Jedding [1957] Hermann Jedding. *Seurat.* Milan, n.d. [1957?].

Jedding-Gesterling 1988 Maria Jedding-Gesterling, ed. *Hairstyles: A Cultural History of Fashions in Hair from Antiquity up to the Present Day; Illustrated with Objets d'art from the Schwarzkopf Collection and International Museums.* Translated by Peter Alexander and Sarah Williams. Hamburg, 1988.

Jedlicka 1941 Gotthard Jedlicka. *Édouard Manet.* Zürich, 1941.

Jennings 1990 Kate F. Jennings. *Winslow Homer.* New York, 1990.

Jennings 1991 Kate F. Jennings. *John Singer Sargent.* New York, 1991.

Jennings 1995 Kate F. Jennings. *American Watercolors.* New York, 1995.

Jessen 1905 Jarno Jessen. *Rossetti.* Bielefeld and Leipzig, 1905.

Jirat-Wasiutynski 1990 Thea Jirat-Wasiutynski. "Tonal Drawing and the Use of Charcoal in Nineteenth Century France." *Drawing* 11, no. 6 (March–April 1990), pp. 121–24.

Jirat-Wasiutynski and Jirat-Wasiutynski 1980 Vojtech Jirat-Wasiutynski and Thea Jirat-Wasiutynski. "The Uses of Charcoal Drawing." *Arts Magazine* 55 (October 1980), pp. 128–35.

Joanne 1883 Paul Joanne. *Itinéraire général de la France: Normandie.* Paris, 1883.

Joannides 1973 Paul Joannides. "Towards the Dating of Géricault's Lithographs." *Burlington Magazine* 115 (October 1973), pp. 666–71.

Jobert 1997 Barthélémy Jobert. *Delacroix.* Paris, 1997.

Jobert 1998 Barthélémy Jobert. *Delacroix.* Translated by Terry Grabar and Alexandra Bonfante-Warren. Princeton and Chichester, 1998.

Jobert 2000 Barthélémy Jobert. "Delacroix et l'estampe: Chronologie, techniques, collaborations." *Revue de l'art* 127 (2000–2001), pp. 43–61.

Johnson 1932 Charles Johnson. *English Painting from the Seventh Century to the Present Day.* London and New York, 1932.

Johnson 1955 Lee Johnson. "Some Unknown Sketches for the 'Wounded Cuirassier' and a Subject Identified." *Burlington Magazine* 97 (March 1955), pp. 78–81.

Johnson 1975 Ronald W. Johnson. "Dante Rossetti's *Beata Beatrix* and the *New Life.*" *Art Bulletin* 57 (1975), pp. 548–58.

Johnson 1981–89 Lee Johnson. *The Paintings of Eugene Delacroix: A Critical Catalogue.* Vols. 1, 2 (1981), *1816–1831,* reprinted with corrections, 1987; vols. 3, 4 (1986), *1832–1863 (Movable Pictures and Private Decorations),* reprinted with corrections and a supplement, 1993; vols. 5, 6 (1989), *The Public Decorations and Their Sketches.* Oxford and New York, 1981–89.

Johnson 1993a Dorothy Johnson. "L'expérience de l'exil: L'art de David à Bruxelles." In *Louvre Conferences et Colloques: La documentation française.* Paris, 1993.

Johnson 1993b Dorothy Johnson. *Jacques-Louis David: Art in Metamorphosis.* Princeton, 1993.

Johnson 1995 Lee Johnson. *Delacroix Pastels.* New York, 1995.

Johnson 1997 Dorothy Johnson. *Jacques-Louis David, the Farewell of Telemachus and Eucharis.* Santa Monica, Calif., 1997.

Johnson 2003 Lee Johnson. "Towards a Reconstruction of Delacroix's Mornay Album." *Burlington Magazine* 145 (February 2003), pp. 92–95.

Johnston 1971 Diane C. Johnston. "Art Nouveau in America: Three Posters by Will H. Bradley." *Register of the Museum of Art* (University of Kansas) 4, no. 4–5 (March 1971), pp. 62–77.

Johnston 1982 William R. Johnston. *The Nineteenth Century Paintings in the Walters Art Gallery.* Baltimore, 1982.

Jones and Kuretsky 1969 Robin Jones and Robert Kuretsky. *Rodin: The Burghers of Calais.* 16 mm, 18 min. Cambridge, Mass., 1969.

Jordan 1983 Augustin Jordan. *Une lignée de Huguenots dauphinois et ses avatars: Les Jordan de Lesches-en-Diois du XVIe au XXe siècle. Étude généalogique et historique.* Clermont-Ferrand, 1983.

Jordan and Dohme 1890 Max Jordan and Robert Dohme. *Das Werk Adolph Menzels: Vom Künstler autorisierte Ausgabe.* 3 vols. Munich, 1890.

Jouin 1888 Henri Jouin. *Musée de portraits d'artistes, peintres, sculpteurs, architectes, graveurs, musiciens, artistes dramatiques, amateurs, etc., nés en France ou y ayant vécu.* Paris, 1888.

Jowell 1974 Frances S. Jowell. "'The Raft' Unravelled." *Apollo* 99 (May 1974), pp. 381–83.

Jowell 1982 Frances S. Jowell. "Rouen: Géricault at the Musée des Beaux-Arts." *Burlington Magazine* 124 (April 1982), pp. 255–56.

Jowell 1993 Frances S. Jowell. "Géricault's *Arabian Grey*: Questions of Authorship and Inspiration." *Apollo* 137 (May 1993), pp. 287–93.

Jowell 1996 Frances S. Jowell. "'Le voilà en France': Géricault According to Thoré." In Michel 1996, vol. 2, pp. 777–99.

Joyant 1926–27 Maurice Joyant. *Henri de Toulouse Lautrec, 1864–1901.* 2 vols. Paris, 1926–27.

Judrin 1984–92 Claudie Judrin. *Musée Rodin: Inventaire des dessins.* 6 vols. Paris, 1984–92.

Jullian 1924 Camille Jullian. "Sainte Geneviève à Nanterre." In *Mélanges offerts à M. Gustave Schlumberger,* vol. 2, pp. 372–75. Paris, 1924.

Jullian 1966 René Jullian. "Géricault et l'Italie." In *Arte in Europa: Scritti di storia dell'arte in onore di Edoardo Arslan,* vol. 1, pp. 897–902. Milan, 1966.

Jullien 1909 Adolphe Jullien. *Fantin Latour: Sa vie et ses amitiés: Lettres inédites et souvenirs personnels.* Paris, 1909.

Jumeau-Lafond 1995 Jean-David Jumeau-Lafond. "*L'Enfance de Sainte-Geneviève*: Une affiche de Puvis de Chavannes au service de *l'Union pour l'action morale.*" *La revue de l'art,* 1995, pp. 63–74.

Kagan 1971 Andrew A. Kagan. "A Fogg 'David' Reattributed to Madame Adelaïde Labille-Guiard." In *Fogg Art Museum, Acquisitions, 1969–1970,* pp. 31–40. Cambridge, Mass., 1971.

Kahn 1887 Gustave Kahn. "À l'exposition des Artistes indépendants." *La vie moderne,* no. 15 (April 9, 1887), pp. 229–31.

Kahn 1928 Gustave Kahn. *Les dessins de Georges Seurat.* 2 vols. Paris, 1928.

Kamakura–Kyōto–Fukuoka 1987–88 *Jerikō ten / Géricault.* Exhibition, Museum of Modern Art, Kamakura, October 31–December 20, 1987; National Museum of Modern Art, Kyōto, February 2–March 21, 1988; Fukuoka Art Museum, Fukuoka, March 24–April 24, 1988. Catalogue by François Bergot et al. Tokyo, 1987.

Kamboureli 1984 Smaro Kamboureli. "Discourse and Intercourse: Design and Desire in the Erotica of Anaïs Nin." *Journal of Modern Literature* 11, no. 1 (March 1984), pp. 143–58.

Kaplan 1974 Julius Kaplan. *Gustave Moreau.* Los Angeles and Greenwich, Conn., 1974.

Kaplan 1982 Julius Kaplan. *The Art of Gustave Moreau: Theory, Style, and Content.* Studies in the Fine Arts; the Avant-garde, no. 33. Ann Arbor, 1982.

Kasson 1990 Joy S. Kasson. *Marble Queens and Captives: Women in Nineteenth-Century American Sculpture.* New Haven, 1990.

Katz 1998 Melissa R. Katz. "Holman Hunt on Himself: Textual Evidence in Aid of Technical Analysis." In *Looking through Paintings: The Study of Painting Techniques and Materials in Support of Art Historical Research,* edited by Erma Hermens, pp. 415–33. Leiden, 1998.

Kelder 1980 Diane Kelder. *The Great Book of French Impressionism.* New York, 1980.

Keller 1987 Horst Keller. *Auguste Renoir.* Munich, 1987.

Kemp 1983 Wolfgang Kemp. *Der Anteil des Betrachters.* Munich, 1983.

Kemp 1986 Wolfgang Kemp. "Das Revolutionstheater des Jacques-Louis David: Eine neue Interpretation des Schwurs im Ballhaus." *Marburger Jahrbuch für Kunstwissenschaft* 21 (1986), pp. 165–84.

Kendall 1993 Richard Kendall. *Degas Landscapes.* New Haven, 1993.

Kennedy 1953 Robert Woods Kennedy. *The House, and the Art of Its Design*. New York, 1953.

Kern 1996 Stephen Kern. *Eyes of Love: The Gaze in English and French Paintings and Novels, 1840–1900*. London, 1996.

Kestner 1989 Joseph A. Kestner. *Mythology and Misogyny: The Social Discourse of Nineteenth Century British Classical-Subject Painting*. Madison, Wis., 1989.

Kestner 1993 Joseph A. Kestner. "The Representation of Armour and the Construction of Masculinity in Victorian Painting." *Nineteenth Century Studies* 7 (1993), pp. 1–28.

Kestner 1995 Joseph A. Kestner. *Masculinities in Victorian Painting*. Aldershot, Hants., and Brookfield, Vt., 1995.

Keynes 1957 Geoffrey Keynes. *Illustrations to the Bible*. London, 1957.

Keynes 1971 Geoffrey Keynes. *Blake Studies*. 2nd ed. Oxford, 1971.

Keynes 1976 Geoffrey Keynes. *William Blake's Laocoön, a Last Testament, with Related Works: On Homer's Poetry and On Virgil, The Ghost of Abel*. Boissia, Clairvaux, Jura, 1976.

Khalil-Bey sale 1868 *Tableaux anciens et modernes* [Khalil-Bey collection]. Sale, Hôtel Drouot, Paris, January 16, 1868. *See also* Haddad 2000.

Kiel and other cities 1981–82 *Adolph Menzel, Realist, Historist, Maler des Hofes: Gemälde, Gouachen, Aquarelle, Zeichnungen und Druckgraphik aus der Sammlung Georg Schäfer, Schweinfurt, und aus der Kunsthalle Bremen, ergänzt durch die Bestände der Kunsthalle zu Kiel, des Museums für Kunst und Kulturgeschichte in Lübeck*. Exhibition, Kunsthalle zu Kiel, April 5–June 8, 1981; and various places in Germany through January 1982. Catalogue edited by Jens Christian Jensen. [Schweinfurt], 1981.

Kimura et al. 1993 Shigenobu Kimura, Shūji Takashina, Koichi Kabayama, et al. *Ongaku o mezasu kaiga / Impressions and Illusions*. Tokyo, 1993.

Kimura et al. 1994 Shigenobu Kimura, Shūji Takashina, Koichi Kabayama, Tokiko Suzuki, Hiroko Takahashi, and Tatsushi Takashashi. *Kaiga to kakumei / Art and Revolution*. Tokyo, 1994.

Kindlers Malerei Lexikon 1964–71 *Kindlers Malerei Lexikon*. Edited by Germain Bazin et al. 6 vols. Zürich, 1964–71.

King 1942 Edward King. "Ingres as Classicist." *Journal of the Walters Art Gallery* 5 (1942), pp. 69–113.

Klein 2001 John Klein. *Matisse Portraits*. New Haven, 2001.

Kleine Museum Reise durch Amerika 1969 *See* Peters 1969.

Klingenstein 1998 Susanne Klingenstein. *Enlarging America: The Cultural Work of Jewish Literary Scholars, 1930–1990*. Syracuse, N.Y., 1998.

Klonsky 1980 Milton Klonsky. *Blake's Dante: The Complete Illustrations to the Divine Comedy*. London and New York, 1980.

Klossowski 1923 Erich Klossowski. *Honoré Daumier*. 3rd ed. Munich, 1923.

Knight n.d. Joseph Knight. *Life and Writings of D. G. Rossetti*. London, n.d.

Knoch 1992 Inken D. Knoch. "Malerei als Anatomie der Seele: Zu den 'Fragments anatomiques' von Théodore Géricault." M.A. thesis, University of Hamburg, 1992.

Knoch 1996 Inken D. Knoch. "Une peinture sans sujet?: Études sur les *Fragments anatomiques*." In Michel 1996, vol. 1, pp. 143–60.

Knowlton 1942 John Knowlton. "The Stylistic Origins of Géricault's *Raft of the Medusa*." *Marsyas* 2 (1942), pp. 125–44.

Knowlton 1947 John Knowlton. Review of Berger 1946. *Art Bulletin* 29 (September 1947), pp. 215–17.

Kolb 1937 Marthe Kolb. *Ary Scheffer et son temps, 1795–1858*. Paris, 1937.

Krahmer 1986 Catherine Krahmer. "Rodin revu." *La revue de l'art*, no. 74 (1986), pp. 64–72.

Kramer 1996 Lloyd S. Kramer. *Lafayette in Two Worlds: Public Cultures and Personal Identities in an Age of Revolutions*. Chapel Hill, N.C., 1996.

Krauss 1986 Rosalind E. Krauss. "Originality as Repetition: Introduction." *October*, no. 37 (summer 1986), pp. 35–40.

Krauss 1989 Rosalind E. Krauss. "Retaining the Original? The State of the Question." *National Gallery of Art, Studies in the History of Art* 20 (1989), pp. 7–11.

Kusano, Abe, and Takashina 1972 Shinpei Kusano, Yoshio Abe, and Shūji Takashina. *Kurube to shajitsu shugi / Courbet et le réalisme*. Sekai no meiga, 4. Tokyo, 1972.

Labrouche 1950 Pierre Labrouche. *The Drawings of Ingres*. Translated by F. A. McFarland. London, 1950.

Lacambre 1996 Geneviève Lacambre. *Moreau.* Supplément d'*Art e dossier*, no. 117 (November 1996).

Lacambre 1997 Geneviève Lacambre. *Gustave Moreau: Maître sorcier*. Découvertes Gallimard, no. 312. Paris, 1997.

Lacambre 1999a Geneviève Lacambre. "Les fruits de l'exposition Gustave Moreau; ou, Gustave Moreau et l'Europe." *48/14: La revue du musée d'Orsay*, no. 9 (autumn 1999).

Lacambre 1999b Geneviève Lacambre. *Gustave Moreau: Magic and Symbols*. Translated by Benjamin Lifson. New York, 1999.

Lacambre 2001 Geneviève Lacambre. "La diffusion de l'oeuvre de Gustave Moreau par la reproduction au XIXe siècle." *Bulletin de la Société J.-K. Huysmans*, no. 94 (2001).

Lacambre, Cooke, and Capodieci 1998 Geneviève Lacambre, Peter Cooke, and Luisa Capodieci. *Gustave Moreau: Les aquarelles*. Paris, 1998.

Lacambre and Mathieu 1997 Geneviève Lacambre and Pierre-Louis Mathieu. *The Gustave Moreau Museum*. Paris, 1997.

Lacambre and Vilain 1976 Jean Lacambre and Jacques Vilain. "Dessins néo-classiques. Bilan d'une exposition." *Revue du Louvre et des musées de France* 26 (1976), pp. 67–73.

Lacroix 1855–56 Paul Lacroix ("Bibliophile Jacob"). "M. Ingres à l'Exposition Universelle." *Revue universelle des arts* 2 (October 1855–March 1856), pp. 202–14.

Lacy 1997 Norris J. Lacy. *The Arthurian Handbook*. New York, 1997.

La Farge 1987 Henry A. La Farge. "Painting with Colored Light: The Stained Glass of John La Farge." In Pittsburgh–Washington 1987.

La Fizelière 1846 Albert de La Fizelière. "Exposition de l'Association des Artistes." *Journal du commerce*, February 1, 1846, unpag.

La Fizelière 1851 Albert de La Fizelière. *Exposition nationale. Salon de 1850–1851*. Paris, 1851.

Lafond 1918–19 Paul Lafond. *Degas*. 2 vols. Paris, 1918–19.

Lagenevais 1846 F. de Lagenevais [Frédéric Bourgeois de Mercey]. "Peintres et sculpteurs modernes. I: M. Ingres." *La revue des deux mondes*, n.s., 15 (August 1, 1846), pp. 514–41.

Lago 1981 Mary Lago, ed. *Burne-Jones Talking: His Conversations, 1895–1898, Preserved by His Studio Assistant, Thomas Rooke*. Columbia, Mo., 1981.

Lagrange 1867 Léon Lagrange. "Ingres." *Le correspondant* 71 (May 1867), pp. 34–76.

Lammel 1993 Gisold Lammel. *Adolf Menzel und seine Kreise*. Dresden, 1993.

Landow 1979 George P. Landow. *William Holman Hunt and Typological Symbolism*. New Haven, 1979.

Landow 1983 George P. Landow. "Shadows Cast by *The Light of the World*: William Holman Hunt's Religious Paintings, 1893–1905." *Art Bulletin* 65 (September 1983), pp. 471–84.

Lang 1968 Cecil Lang, ed. *The Pre-Raphaelites and Their Circle*. Boston, 1968.

Lang, Stoll, and Becker 1995 Paul Lang, Anna Stoll, and Thomas Becker. *Joseph Bonaparte et le Château de Prangins: Deux acquisitions du Musée National Suisse*. Zürich, 1995.

Langle 1939 Fleuriot de Langle. "Monsieur Ingres et la princesse de Canino." *La revue de France*, July 1, 1939, pp. 40–42.

Lapauze 1901 Henry Lapauze. *Les dessins de J.-A.-D. Ingres du Musée de Montauban*. Paris, 1901.

Lapauze 1903 Henry Lapauze. *Les portraits dessinés de J.-A.-D. Ingres*. 2 vols. Paris, 1903.

Lapauze 1905 Henry Lapauze. "Le 'Bain Turc' d'Ingres d'après des documents inédits." *La revue de l'art ancien et moderne* 18 (July–December 1905), pp. 383–96.

Lapauze 1909 Henry Lapauze. "L'Académie de France à Rome." *La nouvelle revue* 8 (1909), pp. 364–65, 373.

Lapauze 1910 Henry Lapauze. *Le roman d'amour de M. Ingres*. Paris, 1910.

Lapauze 1911a Henry Lapauze. *Ingres, sa vie et son oeuvre (1780–1867), d'après des documents inédits*. Paris, 1911.

Lapauze 1911b Henry Lapauze. "Jean Briant Paysagiste (1760–1799), maître d'Ingres, et le paysage dans l'oeuvre d'Ingres." *La revue de l'art ancien et moderne* 29 (January–June 1911), pp. 85–100, 207–218, 299–312.

Lapauze 1913 Henry Lapauze. "Lettres inédites de Ingres à son ami M. Marcotte." *Le correspondant* 252, no. 6 (September 25, 1913), pp. 1069–90; 253, no. 1 (October 10, 1913), pp. 88–107.

Lapauze 1918a Henry Lapauze. "Les Faux Ingres." *La renaissance de l'art français et des industries de luxe* 1 (November 1918), pp. 341–50.

Lapauze 1918b Henry Lapauze. "Ingres chez Degas." *La renaissance de l'art français et des industries de luxe* 1 (March 1918), pp. 9–15.

Lapauze 1922 Henry Lapauze. "Sur quelques oeuvres inédites de Ingres." *La renaissance de l'art*

français et des industries de luxe 5 (December 1922), pp. 649–53.

Laprade 1937 Jacques Victor de Laprade. "Une magnifique exposition d'oeuvres de Géricault a été organisée par la Sauvegarde de l'art français." *Beaux-Arts Magazine*, May 14, 1937, p. 8.

Laran 1911 Jean Laran. *Chassériau*. Paris, 1911.

Larousse 1866–90 Pierre Larousse, ed. *Grand dictionnaire universel du XIXe siècle.* . . . 17 vols. Paris, 1866–90.

Larsen 1990 Stephen Larsen. *The Mythic Imagination*. New York, 1990.

La Sizeranne 1911 Robert de La Sizeranne. "L'oeil et la main de M. Ingres—à la galerie Georges Petit." *La revue des deux mondes* 3 (1911), pp. 416–17. Reprinted in Bajou 1999, pp. 310–11.

La Sizeranne 1924 Robert de La Sizeranne. "Géricault et la découverte du cheval." *La revue des deux mondes*, May 1, 1924, p. 204.

Lasner 1995 Mark Samuels Lasner. *A Selective Checklist of the Published Work of Aubrey Beardsley*. Boston, 1995.

Lasner 2000 Mark Samuels Lasner. "The Pursuit of the Rare: Three Early Beardsley Collectors." *Gazette of the Grolier Club*, n.s., 51 (2000), pp. 5–22.

Lassaigne 1937 Jacques Lassaigne. *Daumier*. New York, 1937.

Lassaigne 1938 Jacques Lassaigne. *Daumier*. Paris, 1938.

Laughton 1991 Bruce Laughton. *The Drawings of Daumier and Millet*. New Haven, 1991.

Laughton 1996 Bruce Laughton. *Honoré Daumier*. New Haven, 1996.

Laurel, Miss., 1985–86 *Jean Leon Gerome Ferris, 1863–1930: American Painter Historian*. Exhibition, Lauren Rogers Museum of Art, Laurel, Miss., December 7, 1985–February 7, 1986; and other cities. Catalogue by Barbara J. Mitnick. Laurel, Miss., 1985.

Laurent 1981 Monique Laurent. "Observations on Rodin and His Founders." In Washington 1981–82.

Laurent 2000 Béatrice Laurent. "Vision and Apocryphal Re-Vision in William Holman Hunt's 'Triumph of the Innocents.'" *Journal of Pre-Raphaelite Studies*, n.s., 9 (fall 2000), pp. 37–49.

Laveissière 1994 Sylvain Laveissière. "'C'est là mon maître et mon héros': Notes sur Prud'hon et Léonard da Vinci." In *Hommage à Michel Laclotte: Études sur la peinture du Moyen Âge et de la Renaissance*, pp. 565–72. Milan and Paris, 1994.

Laveissière 1997a Sylvain Laveissière. Drawings entries. In *De Pagnest à Puvis de Chavannes*, nos. 2047–99. Inventaire générale des dessins du Musée du Louvre et du Musée d'Orsay, 13. École française. Paris, 1997.

Laveissière 1997b Sylvain Laveissière. *Prud'hon*. Le cabinet des dessins. Paris, 1997.

Laveissière (1997) 2001 Sylvain Laveissière. "À quel siècle Prud'hon appartient-il?" In Prud'hon colloque (1997) 2001, pp. 203–16.

Laveissière 2001 Sylvain Laveissière. "'Notre Saint Prud'hon': Une lettre inédite de Laurent Laperlier à Philippe Burty." In *Mélanges en hommage à Pierre Rosenberg, peintures et dessins en France et en Italie, XVIIe–XVIIIe siècles*. Paris, 2001.

Laver 1930 James Laver. *Whistler*. London, 1930.

Lawrence 1897 Arthur H. Lawrence. "Mr. Aubrey Beardsley and His Work." *The Idler* 11 (1897), pp. 189–202.

Lawton 1908 Frederick Lawton. *François-Auguste Rodin*. New York, 1908.

Lears 1985 T. J. Jackson Lears. "The Concept of Cultural Hegemony." *American Historical Review* 90 (June 1985), pp. 568–93.

Leaves de Conches 1831 Leaves de Conches [pseud.]. "Lettres sur le Salon de 1831. Première lettre." *L'artiste* 1 (1831), pp. 199–201.

Lebel 1960 Robert Lebel. "Géricault: Ses ambitions monumentales et l'inspiration italienne." *L'arte* 59 (October–November 1960), pp. 327–39.

Lebensztejn 1989 Jean-Claude Lebensztejn. *Chahut*. Paris, 1989.

Lecaldano 1967 Paolo Lecaldano, ed. *The Complete Paintings of Manet*. New York, 1967.

Lecaldano 1971 Paolo Lecaldano. *L'opera pittorica completa di Van Gogh e i suoi nessi grafici*. Milan, 1971.

Lechien 1995 Isabelle Enaud Lechien. *James Whistler: Le peintre et le polémiste*. Paris, 1995.

Lecomte 1911 Georges Lecomte. "Ingres, son oeuvre, son influence." *Le correspondant* 252, no. 6 (1911), pp. 337, 350–51.

de Leeuw 1993a Ronald de Leeuw. "*De Heilige Genevieve als Kind in Gebed*, Rijksmuseum Vincent van Gogh, Amsterdam." *Vereniging-Rembrandt-National-Fonds-Kunstbehoud* 3, no. 2 (summer 1993), pp. 25–28.

de Leeuw 1993b Ronald de Leeuw. "Pierre Puvis de Chavannes: Two Recent Acquisitions." *Van Gogh Bulletin* 2 (1993), pp. 16–18.

Le Follic and Vilain 1997 Stephanie Le Follic and Jacques Vilain. *Rodin at the Musée Rodin*. London, 1997.

Léger 1929 Charles Léger. *Courbet*. Paris, 1929.

Léger 1931 C[harles] L[éger]. "Documents inédits sur Gustave Courbet (1819–1877)." *L'amour de l'art* 10 (October 1931), pp. 382–406.

Léger 1948 Charles Léger. *Courbet et son temps: Letters et documents inédits*. Paris, 1948.

Leipzig 1914–17 *British Section of the International Exhibition of Book Industry and Graphic Arts: Illustrations for Books*. Exhibition, Internationale Ausstellung für Buchgewerbe und Graphic, Leipzig, 1914–17. Catalogue. London, 1914.

Leiris 1961 Alain de Leiris. "Manet: 'Sur la plage de Boulogne.'" *Gazette des beaux-arts*, ser. 6, 57 (January 1961), pp. 53–62.

Leiris 1969 Alain de Leiris. *The Drawings of Edouard Manet*. Berkeley and Los Angeles, 1969.

Lejeune 1864–65 Théodore Michel Lejeune. *Guide théorique et pratique de l'amateur de tableaux; études sur les imitateurs et les copistes des maîtres de toutes les écoles dont les oeuvres forment la base ordinaire des galeries*. 3 vols. Paris, 1864–65.

Lem 1962 F.-H. Lem. "Le thème du nègre dans l'oeuvre de Géricault." *L'arte* 61 (1962), pp. 19–38.

Lem 1963a F.-H. Lem. "À propos de Géricault: Les sources. B: Les motifs d'inspiration." *Le peintre*, no. 262 (April 1, 1963), pp. 7–9.

Lem 1963b F.-H. Lem. "Gericault portraitiste." *L'arte*, n.s., 28 (January–June 1963), pp. 59–118.

Lemann 1936 Bernard Lemann. "Two Daumier Drawings." *Bulletin of the Fogg Art Museum* 6, no. 1 (November 1936), pp. 13–16.

Lemoisne 1920 P[aul] A[ndré] Lemoisne. "Les Soirées du Louvre: Aquarelles d'Eugène Giraud conservées au Cabinet des Estampes." *Bulletin de la Société de l'Histoire de l'Art Français*, no. 2 (1920), p. 293.

Lemoisne 1946–49 P[aul] A[ndré] Lemoisne. *Degas et son oeuvre*. 4 vols. Paris, [1946–49].

Lenoir 1835 Alexandre Lenoir. "Mémoires. David. Souvenirs historiques." *Journal de l'Institut Historique* 3 (1835), pp. 1–13.

Le Normand-Romain 1997 Antoinette Le Normand-Romain. *Rodin*. Collection "Tout l'art." Paris, 1997.

Le Normand-Romain 1999 Antoinette Le Normand-Romain. *Rodin: La Porte de l'Enfer*. Paris, 1999. Also published in English.

Lenormant 1846 Ch[arles] Lenormant. "Exposition au profit des artistes malheureux." *Le correspondant* 13 (January–March 1846), p. 673. Reprinted in Foucart et al. 1995, p. 281.

Lepoittevin 1971 Lucien Lepoittevin. *Jean-Francois Millet, I. Portraitiste. Essai et catalogue*. Paris, 1971.

Leppert 1996 Richard D. Leppert. *Art and the Committed Eye: The Cultural Functions of Imagery*. Boulder, Colo., 1996.

Leprieur 1889 Paul Leprieur. "Gustave Moreau." *L'artiste* 59, no. 1 (March, May, June 1889), pp. 161–80, 338–59, 443–55.

Leprieur 1892 Paul Leprieur. "Burne-Jones, décorateur et ornemaniste." *Gazette des beaux-arts*, ser. 3, 8 (November 1, 1892), pp. 386–99.

Leprieur 1893 Paul Leprieur. "La légende de Persée, peinture de M. Burne-Jones." *Gazette des beaux-arts*, ser. 3, 10 (December 1, 1893), pp. 462–77.

Leroi 1880 Paul Leroi. "Salon de 1880." *L'art* 22 (1880), p. 124.

Leslie 1980 Clare Walker Leslie. *Nature Drawing: A Tool for Learning*. Englewood Cliffs, N.J., 1980.

Lévêque 1989 Jean-Jacques Lévêque. *La vie et l'oeuvre de Jacques-Louis David*. Paris, 1989.

Levey 1960 Michael Levey. "Botticelli and Nineteenth-Century England." *Journal of the Warburg and Courtauld Institutes* 23 (1960), pp. 291–306.

Levey 1978 Michael Levey. *The Case of Walter Pater*. London, 1978.

Lévis-Godechot 1985 Nicole Lévis-Godechot. "Prud'hon Jacobin." *Bulletin d'histoire de la Révolution française, années 1982–1983* (1985), pp. 87–102.

Lévis-Godechot (1982) 1997 Nicole Lévis-Godechot. *La jeunesse de Pierre-Paul Prud'hon (1758–1796): Recherches d'iconographie et de symbolique*. Paris, 1997. Doctoral thesis, Université de Paris IV (Paris-Sorbonne), 1982.

Levitine 1953 George Levitine. "David's 'Sieyès' in the Fogg Museum and Girodet's 'De Sèze Méditant la Défense du Roi.'" *Burlington Magazine* 95 (October 1953), pp. 335–36.

Levitine 1973 George Levitine. Review of Eitner 1972. *Art Quarterly* 36 (winter 1973), pp. 421–23.

***Lexicon Iconographicum* 1981–99** *Lexicon Iconographicum Mythologiae Classicae*. 8 vols. Zürich, Munich, and Düsseldorf, 1981–99.

Leymarie 1962 Jean Leymarie. *French Painting: The Nineteenth Century*. Geneva, 1962. Also published in French.

Lindberg 1973 Bo Lindberg. *William Blake's Illustrations to the Book of Job*. Acta Academiae Aboensis, ser. A, Humaniora, vol. 46. Åbo (Turku), Finland, 1973.

Lindemann 1970 Gottfried Lindemann. *Prints and Drawings: A Pictorial History*. London, 1970.

Lindsay 1847 Alexander Crawford Lindsay. *Sketches of the History of Christian Art*. 3 vols. London, 1847.

Lister 1986 Raymond Lister. *The Paintings of William Blake*. Cambridge, 1986.

Little 1998 Carl Little. *The Watercolors of John Singer Sargent*. Berkeley, 1998.

Liverpool 1858 Exhibition. Liverpool Academy, 1858.

Liverpool 1886 *Grand Loan Exhibition of Pictures from Lancashire Collections, and Exhibition of the Liverpool Society of Painters in Water-Colours and Liver Sketching Club*. Exhibition, Walker Art Gallery, Liverpool, closed at the end of July 1886. Catalogue. Liverpool, 1886.

Liverpool 1897 *Twenty-seventh Autumn Exhibition of Modern Pictures in Oil and Water-Colours*. Exhibition, Walker Art Gallery, Liverpool August 30–December 11, 1897. Catalogue. Liverpool, 1987.

Liverpool 1899 *Twenty-ninth Autumn Exhibition of Modern Pictures in Oil and Water-Colours*. Exhibition, Walker Art Gallery, Liverpool, 1899. Catalogue. Liverpool, 1899.

Liverpool 1907 *Collective Exhibition of the Art of W. Holman Hunt, O.M., D.C.L.* Exhibition, Walker Art Gallery, Liverpool 1907. Catalogue. Liverpool, 1907.

Liverpool 1922 *Jubilee Autumn Exhibition*. Exhibition, Walker Art Gallery, Liverpool, 1922.

Liverpool 1923 *Fifty-first Autumn Exhibition*. Exhibition, Walker Art Gallery, Liverpool, autumn 1923. Catalogue. Liverpool, 1923.

Liverpool 1964 *Ford Madox Brown, 1821–1893*. Exhibition, Walker Art Gallery, Liverpool, 1964.

Lloyd 1985 Christopher Lloyd. "The Market Scenes of Camille Pissarro." *Art Bulletin of Victoria* (National Gallery of Victoria, Melbourne), no. 25 (1985), pp. 16–32.

Lobstein 2000 Dominique Lobstein. "Alfred Baillehache-Lamotte et le legs de 'La chaste Suzanne,' de Gustave Moreau, au Musée des Beaux-Arts de Lyon." *Bulletin des musées et monuments lyonnais*, no. 1 (2000), pp. 26–33.

Löcher 1973 Kurt Löcher. *Der Perseus-Zyklus von Edward Burne-Jones*. Stuttgart, 1973.

Lockspeiser 1966 Edward Lockspeiser. "Music and Painting: Chabrier, Debussy and the Impressionists." *Apollo*, n.s., 83 (January 1966), pp. 10–16.

London 1809 *Exhibition of Paintings in Fresco, Poetical and Historical Inventions*. Exhibition, London, 1809. Catalogue, *A Descriptive Catalogue of Pictures: Poetical and Historical Inventions Painted by William Blake in Water Colours, Being the Ancient Method of Fresco Painting Restored; and Drawings, for Public Inspection, and for Sale by Private Contract*. London, 1809.

London 1833 *Catalogue of a Selection of the Works of Sir Joshua Reynolds, Benjamin West, Esq., and Sir Thomas Lawrence, the Three Last Presidents of the Royal Academy, with Which the Proprietors Have Favoured the Institution*. Exhibition, British Institution, 1833. Catalogue. London, 1833.

London 1862 *International Exhibition*. Exhibition, London, 1862.

London 1870 Exhibition, Old Water-Colour Society, London, 1870.

London 1873 *International Exhibition*. Exhibition, London, 1873.

London 1874 *Mr. Whistler's Exhibition*. Exhibition, Pall Mall, London, 1874.

London 1876 *Exhibition of the Works of William Blake*. Exhibition, Burlington Fine Arts Club, London, 1876. Catalogue introduction by William B. Scott. London, 1876.

London 1877 Exhibition, Grosvenor Gallery, London, 1877.

London 1878 Summer Exhibition, Grosvenor Gallery, London, 1878.

London 1881 *Venice Pastels*. Exhibition, Fine Arts Society, New Bond Street, London, 1881.

London 1881–82 *Winter Exhibition: Collection of the Works of G. F. Watts, R.A.* Exhibition, Grosvenor Gallery, London, winter 1881–82.

London 1883a *Pictures, Drawings, Designs and Studies by the Late Dante Gabriel Rossetti*. Exhibition, Burlington Fine Arts Club, London, 1883.

London 1883b *Winter Exhibition: Works by the Old Masters and by Deceased Masters of the British School, Including a Special Selection from the Works of John Linnell and Dante Gabriel Rossetti*. Exhibition, Royal Academy of Arts, London, January–February 1883.

London 1884 *"Notes"—"Harmonies"—"Nocturnes."* Exhibition, Dowdeswell, London, 1884.

London 1885 Exhibition of Royal Institute of Painters in Water-colours, London, 1885.

London 1886a *Pictures by Holman Hunt*. Exhibition, Fine Art Society, London, 1886. Catalogue, *Descriptive Catalogue of the Pictures by Holman Hunt. . . .* London, 1886.

London 1886b *"Notes"—"Harmonies"—"Nocturnes."* [2nd ser.]. Exhibition, Dowdeswell, London, 1886.

London 1887 Exhibition, Saint Jude's, Whitechapel, London, 1887.

London 1889 *Intercolonial Exhibition*. Exhibition, Grosvenor Gallery, London, 1889.

London 1890 *Annual Summer Exhibition*. Exhibition, New Gallery, Regent Street, London, 1890.

London 1892 *Nocturnes, Marines and Chevalet Pieces*. Exhibition, Goupil Gallery, London, 1892.

London 1892–93 *Exhibition of the Works of Edward Burne-Jones*. Exhibition, New Gallery, London, 1892–93.

London 1893 *Exhibition of Works by the Old Masters and by Deceased Masters of the British School; Winter Exhibition Including a Collection of Watercolour Drawings etc., by William Blake. . . .* Exhibition, Royal Academy of Arts, London, 1893.

London 1896–97 *Winter Exhibition: The Works of G. F. Watts*. Exhibition, New Gallery, London, winter 1896–97.

London 1897–98 *Pictures Ancient and Modern by Artists of the British and Continental Schools, including a Special Selection from the Works of Dante Gabriel Rossetti*. Exhibition, New Gallery, London, winter 1897–98.

London 1898–99 *Winter Exhibition of the Works of Sir Edward Burne-Jones*. Exhibition, New Gallery, London, 1898.

London 1899a *Exhibition of Drawings and Studies by Sir Edward Burne-Jones, Bart*. Exhibition, Burlington Fine Arts Club, London, 1899. Catalogue introduction by Cosmo Monkhouse. London, 1899.

London 1899b *Twelfth Summer Exhibition. MDCCCXIX*. Exhibition, New Gallery, London, 1899. Catalogue. London, 1899.

London 1899c Exhibition, International Society of Sculptors, Painters, and Gravers, London, 1899.

London 1901 *Spring Exhibition*. Exhibition, Goupil, London, 1901.

London 1901a *The Water Colour Art of the 19th Century*. Exhibition, Fine Art Society, January 1901. *Catalogue of an Exhibition of Water-Colour Art of the 19th Century by One Hundred Painters*, preface by Sir J. D. Linton. London, 1901.

London 1903 Sargent Solo Show. Exhibition, Carfax Gallery, London, 1903.

London 1904 *A Selection of Drawings by Aubrey Beardsley, 1872–98*. Exhibition, Carfax and Co., London, October 1904.

London 1905a *Memorial Exhibition of the Works of the Late James McNeill Whistler, First President of the International Society of Sculptors, Painters, and Gravers*. Exhibition, New Gallery, Regent Street, London, February 22–March 31, 1905. Catalogue. London, 1905.

London 1905b *Winter Exhibition: Works by the Late George Frederick Watts, R.A., O.M., and the Late Frederick Sandys*. Exhibition, Royal Academy of Arts, London, 1905.

London 1906 *Exhibition of the Collected Works of W. Holman Hunt, O.M., D.C.L.* Exhibition, Ernest Brown and Phillips, Leicester Galleries, London, 1906. Catalogue. London, 1906.

London 1906a Winter Exhibition, Royal Academy, London, 1906.

London 1906–7 Winter Exhibition, New Gallery, London, 1906–7.

London 1907 *Exhibition of Works by the Old Masters and Deceased Masters of the British School. . . .* Exhibition, Royal Academy of Arts, London, 1907.

London 1908 *Franco-British Exhibition*. Exhibition, London, 1908. Catalogue. Derby, 1908.

London 1909 *Collected Works of Ford Madox Brown*. Exhibition, Leicester Galleries, London, 1909. Catalogue by Ford Madox Hueffer. London, 1909.

London 1909a *Exhibition of Drawings by Aubrey Beardsley*. Exhibition, Baillie Gallery, London, August–September 1909. Catalogue. London, 1909.

London 1910 *Third Exhibition of Fair Women*. Exhibition, International Society of Sculptors, Painters, and Gravers, London, 1910.

London 1911 *Century of Art Exhibition, 1810–1910*. Exhibition, International Society of Sculptors, Painters, and Gravers, Grafton Gallery, London, 1911.

London 1917 *Catalogue of a Collection of Drawings by Deceased Masters, with Some Decorative Furniture and Other Objects of Art*. Exhibition, Burlington Fine

Arts Club, London, 1917. Catalogue introduction by H[enry] T[onls]. London, 1917.

London 1921 Exhibition, Committee of Civic Art, Kensington Town Hall, London, 1921.

London 1923 *Loan Exhbition; Paintings and Drawings of the 1860 Period.* Exhibition, Tate Gallery, London, April 27–July 29, 1923. Catalogue. London, 1923.

London 1926 *Pictures and Drawings by Georges Seurat.* Exhibition, Galerie Lefevre, London, April–May 1926.

London 1927 *Blake Centenary Exhibition.* Exhibition, Burlington Fine Arts Club, London, 1927.

London 1930 Exhibition, London Artists' Association, London, 1930.

London 1932 *Exhibition of French Art, 1200–1900.* Exhibition, Royal Academy of Arts, London, January 4–March 5, 1932. Catalogue. London, 1932.

London 1933 *Centenary Exhibition of Paintings and Drawings by Sir Edward Burne-Jones, Bart. (1833–1898).* Exhibition, Tate Gallery, London, June 14–August 31, 1933. Catalogue introduction by William Rothenstein; note by T. M. Rooke. London, 1933.

London 1938 *A Century of French Drawings, from Prud'hon to Picasso.* Exhibition, Matthiesen Gallery, London, May 3–31, 1938. Catalogue. London, 1938.

London 1954–55 *George Frederic Watts, O.M., R.A., 1817–1904.* Exhibition, Tate Gallery, London, December 9, 1954–January 16, 1955; and Arts Council of Great Britain, London, 1955. Catalogue by David Loshak. London, 1955.

London 1972a *The Age of Neo-Classicism.* Exhibition, Royal Academy and Victoria and Albert Museum, London, September 9–November 19, 1972. Catalogue. London, 1972.

London 1972b *Victorian and Edwardian Decorative Art: The Handley-Read Collection.* Exhibition, Royal Academy of Arts, London, 1972. Catalogue edited by Simon Jervis. London, 1972.

London 1972c *Exhibition of Sculpture, Antoine Louis Barye, 1796–1875.* Exhibition, Sladmore Gallery, London, June 14–July 8, 1972. Catalogue. London, 1972.

London 1975 *Exhibition of French Drawings Post Neo-Classicism.* Exhibition, P. and D. Colnaghi, London, February 20–March 27, 1975. Catalogue by Jane Low. London, 1975.

London 1979 *John Flaxman.* Exhibition, Royal Academy of Arts, London, October 26–December 9, 1979. Catalogue edited by David Bindman. London, 1979.

London 1984 *The Pre-Raphaelites.* Exhibition, Tate Gallery, London, 1984. Catalogue edited by Leslie Parris. London, 1984.

London 1986–87 *Rodin: Sculpture and Drawings.* Exhibition, Arts Council of Great Britain, London, November 1, 1986–January 25, 1987. Catalogue by Catherine Lampert. London, 1986.

London 1987 *Jacques-Louis David: Portrait of Jacobus Blauw.* Exhibition, National Gallery, London, September 16–November 15, 1987. Catalogue by John Leighton. London, 1987.

London 1989 *Burne-Jones, the Pre-Raphaelites, and Their Century.* Exhibition, Peter Nahum, London, 1989. Catalogue by Hilary Morgan, 2 vols. London, 1989.

London 1993 *Burne-Jones—A Quest for Love. Works by Sir Edward Burne-Jones Bt and Related Works by Contemporary Artists.* Exhibition, Peter Nahum, London, 1993. Catalogue by Bill Waters and Peter Nahum. London, 1993.

London 1996a *Frederic, Lord Leighton: Eminent Victorian Artist.* Exhibition, Royal Academy of Arts, London, February 16–April 21, 1996. Catalogue by Stephen Jones et al. New York and London, 1996.

London 1996b *William Morris.* Exhibition, Victoria and Albert Museum, London, May 9–September 1, 1996. Catalogue edited by Linda Parry. New York, 1996.

London 1996–97 *From Mantegna to Picasso: Drawings from the Thaw Collection at The Pierpont Morgan Library, New York.* Exhibition, Royal Academy of Arts, London, November 9, 1996–January 23, 1997. Catalogue by Cara Dufour Denison et al. New York and London, 1996.

London 1997 *Rossetti, Burne-Jones and Watts: Symbolism in Britain, 1860–1910.* Exhibition, Tate Gallery, London. Catalogue, *Rossetti and His Circle,* by Elizabeth Prettejohn. London and New York, 1997.

London 2000a *The House Beautiful: Oscar Wilde and the Aesthetic Interior.* Exhibition, Geffrye Museum, London, 2000. Catalogue by Charlotte Gere and Lesley Hoskins. London, 2000.

London 2000b *Painted Illusions: The Art of Cornelius Gijsbrechts.* Exhibition, National Gallery, London, February 2–May 1, 2000. Catalogue by Olaf Koester. London, 2000.

London 2000c *Agnew's Millennium Exhibition.* Exhibition, Thos. Agnew and Sons, June 8–July 21, 2000. Catalogue. London, 2000.

London and other cities 1979 *Ingres: Drawings from the Musée Ingres at Montauban and Other Collections.* Exhibition, Victoria and Albert Museum, London, and other English cities, 1979. Catalogue by Michael Kauffmann, Pierre Barousse, and Janet Holt. London, 1979.

London–Amsterdam–Williamstown 2000–2001 *Impression: Painting Quickly in France, 1860–1890.* Exhibition, National Gallery, London, November 1, 2000–January 28, 2001; Van Gogh Museum, Amsterdam, March 2–May 20, 2001; Sterling and Francine Clark Art Institute, Williamstown, Mass., June 16–September 9, 2001. Catalogue by Richard Brettell. New Haven, 2000.

London–Boston 1995–96 *Landscapes of France: Impressionism and Its Rivals.* Exhibition, Hayward Gallery, London, May 18–August 28, 1995; Museum of Fine Arts, Boston, October 4, 1995–January 14, 1996 (under the title *Impressions of France: Monet, Renoir, Pissarro and Their Rivals*). Catalogue by John House; contributions from Ann Dumas, Jane Mayo Roos, James F. McMillan. London, 1995.

London–Manchester 1978 *William Blake.* Exhibition, Tate Gallery, March 9–May 21, 1978; selected pieces shown Whitworth Art Gallery, Manchester, June 10–July 15, 1978. Catalogue by Martin Butlin. London, 1978.

London–Munich–Amsterdam 1997–98 *The Age of Rossetti, Burne-Jones, and Watts: Symbolism in Britain, 1860–1910.* Exhibition, Tate Gallery, London, October 16, 1997–January 4, 1998; Haus der Künst, Munich, February–April 1998; Van Gogh Museum, Amsterdam, May–July 1998. Catalogue edited by Andrew Wilton. and Robert Upstone, with contributions by Barbara Bryant et al. London, 1997.

London–New York 1984–85 *The Drawings of Henri Matisse.* Exhibition, Hayward Gallery, London, October 4, 1984–January 6, 1985; Museum of Modern Art, New York, February 27–May 14, 1985; organized by the Arts Council of Great Britain and with the collaboration of the Museum of Modern Art. Catalogue by John Elderfield and Magdalena Dabrowski. London and New York, 1984.

London–New York 1996 *Romance and Chivalry: History and Literature Reflected in Early Nineteenth-Century French Painting.* Exhibition organized by Matthiesen Fine Art, London, and Stair Sainty Matthiesen, New York; exhibited New Orleans Museum of Art; Stair Sainty Matthiesen, New York; and Taft Museum, Cincinnati. 1996. Catalogue by Guy Stair Sainty and Nadia Tscherny. London and New York, 1996.

London–Paris–Boston 1980–81 *Pissarro: Camille Pissarro, 1830–1903.* Exhibition, Hayward Gallery, London, October 30, 1980–January 11, 1981; Galeries Nationales du Grand Palais, Paris, January 30–April 27, 1981; Museum of Fine Arts, Boston, May 19–August 9, 1981. Catalogue. London, 1980; also French ed.: Paris, 1981.

London–Southampton–Birmingham 1975–76 *Burne-Jones: The Paintings, Graphic and Decorative Work of Sir Edward Burne-Jones, 1833–98.* Exhibition, Hayward Gallery, London, November 5, 1975–January 4, 1976; Southampton Art Gallery, January 24–February 22, 1976; City Museums and Art Gallery, Birmingham, March 10–April 11, 1976. Catalogue by John Christian. London, 1975.

London–Washington–Boston 1998–99 *John Singer Sargent.* Exhibition, Tate Gallery, London, October 15, 1998–January 17, 1999; National Gallery of Art, Washington, February 21–May 31, 1999; Museum of Fine Arts, Boston, June 23–September 26, 1999. Catalogue edited by Elaine Kilmurray and Richard Ormond. London, 1998.

London–Washington–New York 1999–2000 *Portraits by Ingres: Image of an Epoch.* Exhibition, National Gallery, London, January 27–April 25, 1999; National Gallery of Art, Washington, D.C., May 23–August 22, 1999; The Metropolitan Museum of Art, New York, October 5, 1999–January 2, 2000. Catalogue edited by Gary Tinterow and Philip Conisbee; drawings entries by Hans Naef; with contributions by Rebecca A. Rabinow et al. New York, 1999.

Lorrain and Moreau 1998 Jean Lorrain and Gustave Moreau. *Correspondance et poèmes.* Edited and annotated by Thalie Rapetti. Paris, 1998.

Los Angeles–Detroit–Philadelphia 1971–72 *Géricault.* Exhibition, Los Angeles County Museum of Art, October 12–December 12, 1971; Detroit Institute of Arts, January 23–March 7, 1972; Philadelphia Museum of Art, March 30–May 14, 1972. Catalogue by Lorenz Eitner. Los Angeles, 1971.

Los Angeles–San Francisco 1974 *Gustave Moreau.* Exhibition, Los Angeles County Museum of Art, July 23–September 1, 1974; California Palace of

the Legion of Honor, San Francisco, September 14–November 3, 1974. Catalogue by Julius Kaplan. Los Angeles, 1974.

Loshak 1963 David Loshak. "G. F. Watts and Ellen Terry." *Burlington Magazine* 105 (November 1963), pp. 476–85.

Lostalot 1884 Alfred de Lostalot. "Les artistes contemporains: M. Félix Bracquemond, peintre-graveur" (parts 1–3). *Gazette des beaux-arts*, ser. 2, 29, no. 6 (June 1, 1884), pp. 420–26, 517–24; 30, no. 2 (August 1, 1884), pp. 155–61.

Louisville–Fort Worth 1983–84 *In Pursuit of Perfection: The Art of J.-A.-D. Ingres.* Exhibition, J. B. Speed Art Museum, Louisville, December 6, 1983–January 29, 1984; Kimbell Art Museum, Fort Worth, March 3–May 6, 1984. Catalogue by Patricia Condon, with Marjorie B. Cohn and Agnes Mongan. Louisville, 1983.

Lozowick 1948 Louis Lozowick. *A Treasury of Drawings.* New York, 1948.

Lucie-Smith 1977 Edward Lucie-Smith. *Henri Fantin-Latour.* New York, 1977.

Lucie-Smith 1989 Edward Lucie-Smith. *Impressionist Women.* London, 1989.

Lugt 1921 Frits Lugt. *Les marques de collections de dessins et d'estampes. . . .* 2 vols. Amsterdam, 1921.

Lugt 1956 Frits Lugt. *Les marques de collections de dessins et d'estampes. . . Supplement.* The Hague, 1956.

Luoma 1984 Jon R. Luoma. "Clouds over Canoe Country." *The Scientist* 24, no. 1 (January–February 1984).

Lüthy 1971 Hans A. Lüthy. "Géricault in Los Angeles." *Neue Zurcher Zeitung*, November 20, 1971, p. 35.

Lüthy 2000 Hans A. Lüthy. "Otto Ackermann, Schweizer 'amateur-marchant' und Gericaults 'Fou au commandement militaire.'" In *Jenseits der Grenzen: Französische und deutsche Kunst vom Ancien Régime bis zur Gegenwart.* Vol. 2, *Kunst der Nationen*, pp. 481–87. 3 vols. Cologne, 2000.

Luxmoore 1929 Henry Elford Luxmoore. *The Letters of H. E. Luxmoore.* Edited by A. B. Ramsay. Cambridge, 1929.

Lyell 1842 Charles Lyell, trans. *The Poems of the Vita nuova and Convito of Dante Alighieri.* London, 1842.

Lyonnet 1902–8 Henry Lyonnet. *Dictionnaire des comédiens français.* Issued in parts. Paris and Geneva, 1902–8.

Maas 1984 Jeremy Maas. *Holman Hunt and the Light of the World.* London, 1984.

MacDonald 1965 Bruce MacDonald. "A Portrait by Gericault in the Fogg Museum." Student paper, 1965, Fogg Art Museum files.

MacDonald 1987 Margaret F. MacDonald. "Total Control: Whistler at an Exhibition." In *James McNeill Whistler: A Reexamination.* Washington, D.C.: National Gallery of Art, 1987.

MacDonald 1995 Margaret F. MacDonald. *James McNeill Whistler: Drawings, Pastels, and Watercolours: A Catalogue Raisonné.* New Haven, 1995.

MacDonald 2001 Margaret F. MacDonald. *Palaces in the Night: Whistler in Venice.* Aldershot, Hants., 2001.

MacKail 1899 J. W. Mackail. *The Life of William Morris.* 2 vols. London, 1899.

Macmillan 1903 Hugh Macmillan. *The Life-Work of George Frederick Watts, R.A.* London and New York, 1903.

Madeleine-Perdrillat 1990 Alain Madeleine-Perdrillat. *Seurat.* Translated by Jean-Marie Clarke. New York, 1990.

Madeline 1995 Laurence Madeline. "L'art de se faire des ennemis." *Beaux-Arts Magazine*, January 1995, pp. 50–51.

Madrid 1994–95 *Federico de Madrazo y Kuntz (1815–1894).* Exhibition, Museo del Prado, Madrid, November 19, 1994–January 29, 1995. Catalogue by José Luis Díez. Madrid, 1994.

Magimel 1851 Albert Magimel, ed. *Oeuvres de J. A. Ingres, membre de l'Institut, gravées au trait sur acier par A^{le} Réveil, 1800–1851.* Paris, 1851.

Magnin 1927 Jeanne Magnin. *Les débuts du romantisme a la Maison Victor Hugo.* Dijon, 1927.

Maheux 1984 Anne Maheux. "An Analysis of the Watercolor Technique and Materials of William Blake." *Blake, an Illustrated Quarterly* 17, no. 4 (spring 1984), pp. 124–29.

Maillard 1899 Léon Maillard. *Études sur quelques artistes originaux: Auguste Rodin statuaire.* Paris, 1899.

Maison 1960 Karl Eric Maison. *Daumier Drawings.* New York and London, 1960.

Maison 1968 Karl Eric Maison. *Honoré Daumier: Catalogue Raisonné of the Paintings, Watercolors and Drawings.* New York, 1968.

Maîtres du dessin 1900–1902 *Les maîtres du dessin.* Edited by Roger Marx. 3 vols. Paris, 1900–1902.

Malingue 1943 Maurice Malingue. *Claude Monet.* Monaco, 1943.

Malins 1981 Frederick Malins. *Drawing Ideas of the Masters: Artists' Techniques Compared and Contrasted.* Oxford, 1981.

Manchester 1878 Exhibition. Royal Institute, Manchester, 1878.

Manchester 1887 *Royal Jubilee Exhibition.* Exhibition, Manchester Art Gallery, Manchester, 1887.

Manchester 1904 *Ruskin Exhibition.* Exhibition. Manchester City Art Gallery, Manchester, spring 1904. Catalogue. London, 1904.

Manchester 1906 *The Collected Works of W. Holman Hunt, O.M., D.C.L.* Exhibition, Manchester City Art Gallery, Manchester, 1906. Catalogue. Manchester, 1906.

Manchester 1911 *Loan Exhibition of Works by Ford Madox Brown and the Pre-Raphaelites.* Exhibition, Manchester City Art Gallery, Manchester, autumn 1911. Catalogue. Manchester, 1911.

Manchester 1964 "Memorial Exhibition: Emily Winthrop Miles (1893–1962)." Essay in brochure of the 1964 Festival of the Arts, Southern Vermont Art Center, Manchester, Grenville Winthrop file, Archives, The Metropolitan Museum of Art, New York.

Manchester 1984 *William Morris and the Middle Ages: A Collection of Essays, together with a Catalogue of Works Exhibited.* Exhibition, Whitworth Art Gallery, Manchester, September 28–December 8, 1984. Catalogue edited by Joanna Banham and Jennifer Harris. Manchester, 1984.

Manchester 1997 *Pre-Raphaelite Women Artists.* Exhibition, Manchester City Art Gallery, 1997. Catalogue by Pamela Gerrish Nunn and Jan Marsh. Manchester, 1997.

Manchester–Minneapolis–Brooklyn 1978–79 *Victorian High Renaissance.* Exhibition, City Art Gallery, Manchester, September 1–October 15, 1978; Minneapolis Institute of Arts, November 19, 1978–January 7, 1979; Brooklyn Museum, February 10–April 8, 1979. Catalogue by Allan Staley. Minneapolis, 1978.

Mancoff 1990 Debra N. Mancoff. *The Arthurian Revival in Victorian Art.* New York, 1990.

Mancoff 1995 Debra N. Mancoff. *The Return of King Arthur: The Legend through Victorian Eyes.* London, 1995.

Mancoff 1997 Debra N. Mancoff. "Epitaph in Avalon: Edward Burne-Jones's Last Picture." In *Collecting the Pre-Raphaelites: The Anglo-American Enchantment*, edited by Margaretta Frederick Watson, pp. 163–73. Aldershot, Hants., 1997.

Mancoff 1998 Debra N. Mancoff. *Burne-Jones.* San Francisco, 1998.

Mann 1969 *See* Peters 1969.

Manson 1929 James Bolivar Manson. "The Renoir Exhibition in New York." *Apollo* 10, no. 59 (November 1929), pp. 256–60.

Mantz 1846 Paul Mantz. "Une exposition hors du Louvre: M. Ingres et son école." *L'artiste*, ser. 4, 5 (January 25, 1846), pp. 198–201. Reprinted in Foucart et al. 1995, p. 257.

Mantz 1855 Paul Mantz. "Salon de 1855." *Revue française* 2 (1855), p. 222.

Mantz 1856 Paul Mantz. "Théodore Chassériau." *L'artiste*, ser. 6, 2 (October 19, 1856), pp. 220–25.

Marcel and Laran [1911] Henry Marcel and Jean Laran. *Chassériau.* Collection "L'art de notre temps." Paris, n.d. [1911].

Marcia 1978 Viorica Guy Marcia. *Ingres.* Translated by André Bantas. London, 1978.

Marillier 1899a Henry Currie Marillier. *Dante Gabriel Rossetti: An Illustrated Memorial of His Art and Life.* London, 1899.

Marillier 1899b Henry Currie Marillier. "The Salutation of Beatrice; as Treated Pictorially by D. G. Rossetti." *Art Journal* 61 (December 1899), pp. 353–57.

Marillier 1904 Henry Currie Marillier. *Dante Gabriel Rossetti: An Illustrated Memorial of His Art and Life.* 3rd ed., abr. and rev. London, 1904.

Marquant 1970 Robert Marquant, comp. *Les Archives Sieyès: Inventaire.* Paris, 1970.

Marseille 1906 *Exposition Nationale Coloniale.* Official notice and illustrated catalogue of the exhibition of fine arts and the retrospective exhibition of the French Orientalists. Marseille, 1906.

Marsh 1987 Jan Marsh. *Pre-Raphaelite Women: Images of Feminity.* New York, 1987.

Marsh 1999 Jan Marsh. *Dante Gabriel Rossetti: Painter and Poet.* London, 1999.

Martin 1958 Kurt Martin. *Édouard Manet: Aquarelle und Pastelle.* Basel, 1958.

Martine 1926 Charles Martine. *Ingres: Soixante-cinq reproductions de Léon Marotte avec un catalogue par Charles Martine [Dessins de maîtres français V].* Paris, 1926.

Martine 1928 Charles Martine. *Théodore Géricault: Cinquante-sept aquarelles, dessins, croquis.* Dessins de maîtres français, vol. 8. Paris, 1928.

Marx 1897 Roger Marx. "Cartons d'artistes." *L'image,* September 1897, pp. 294–95.

Marx 1907 Roger Marx. *Auguste Rodin, céramiste.* Paris, 1907.

Mathey 1945 Jacques Mathey. *Ingres.* Paris, 1945.

Mathey 1955 Paul Mathey. *Ingres: Dessins.* Paris, [1955].

Mathey 1961 Jacques Mathey. *Graphisme de Manet.* Paris, 1961.

Mathieu 1976 Pierre-Louis Mathieu. *Gustave Moreau, sa vie, son oeuvre, catalogue raisonné de l'oeuvre achevé.* Fribourg, 1976. Also published in English as *Gustave Moreau: With a Catalogue of the Finished Paintings, Watercolors, and Drawings.* Boston, 1976.

Mathieu 1985 Pierre-Louis Mathieu. *Gustave Moreau: The Watercolors.* New York, 1985.

Mathieu 1986 Pierre-Louis Mathieu. *Le Musée Gustave Moreau.* Paris, 1986.

Mathieu 1991 Pierre-Louis Mathieu. *Tout l'oeuvre peint de Gustave Moreau.* Paris, 1991.

Mathieu 1994 Pierre-Louis Mathieu. *Gustave Moreau.* Paris, 1994.

Mathieu 1998a Pierre-Louis Mathieu. *Gustave Moreau: Monographie et nouveau catalogue de l'oeuvre achevé.* Paris, 1998.

Mathieu 1998b Pierre-Louis Mathieu. *Gustave Moreau: L'assembleur de rêves.* Courbevoie, 1998.

Matisse 1920 Henri Matisse. *Cinquante dessins.* Introduction by Charles Vidrac. Paris, 1920.

Matisse 1954 Henri Matisse. *Portraits.* Monte Carlo, 1954.

Matteson 1980 Lynn R. Matteson. "Observations on Géricault and Pinelli." *Pantheon* 38 (January–March 1980), pp. 74–78.

Mauclair 1898 Camille Mauclair. "L'art de M. Auguste Rodin." *La revue des revues,* June 15, 1898.

Mauclair 1909 Camille Mauclair. *Auguste Rodin: The Man, His Ideas, His Works.* Translated by Clementina Black. London, 1909. First published 1905.

Mauclair 1918 Camille Mauclair. *Auguste Rodin: L'homme et l'oeuvre.* Paris, 1918.

Mauries 1996 Patrick Mauries. *Le trompe-l'oeil de l'antiquité au XXe siècle.* Paris, 1996.

May 1936 J[ames] Lewis May. *John Lane and the Nineties.* London, 1936.

Maynard 1877 Abbé Michel-Ulysse Maynard. *La Sainte-Vièrge.* Paris, 1877.

Mayr-Oehring 1997 Erika Mayr-Oehring, ed. *The Orient: Austrian Painting between 1848 and 1914.* Salzburg, 1997.

de Mazia 1991 Violette de Mazia. "Form and Matter: The Form of Renoir's Color." *Vistas* 5, no. 2 (1991).

McBride 1937 Henry M. McBride. "Renoirs in America." *Art News* 35 (May 1, 1937), pp. 59–76, 158–60, 162.

McCullagh 1994 Suzanne Folds McCullagh. "The Extraordinary Eye, Erudition, Energy, and Example of Agnes Mongan." *Drawing* 16, no. 2 (July–August 1994), pp. 29–32.

McDannell and Lang 1988 Colleen McDannell and Bernhard Lang. *Heaven: A History.* New Haven, 1988.

McGann 1997– Jerome McGann, ed. *The Complete Writings and Pictures of Dante Gabriel Rossetti: A Hypermedia Research Archive.* Online archive presented by the Institute for Advanced Technology in the Humanities at the University of Virginia, Charlottesville, 1997– . http://jefferson.village.virginia.edu/rossetti/

McGann 2000 Jerome McGann. *Dante Gabriel Rossetti and the Game That Must Be Lost.* New Haven, 2000.

McKim 1969 Gridley McKim. "Grenville L. Winthrop: Retrospective for a Collector, 2. Grenville Winthrop's Western Art." *Connoisseur* 170 (March 1969), pp. 190–92.

McManners 1990 John McManners, ed. *The Oxford Illustrated History of Christianity.* Oxford, 1990.

McQuillan 1986 Melissa McQuillan. *Impressionist Portraits.* Boston, 1986.

McPherson 1991 Heather McPherson. "Historical Fiction: David, Marat, and Napoleon." *Eighteenth-Century Studies* 21. East Lansing, Mich., 1991.

McVaugh 1987 Robert E. McVaugh. "Turner and Rome, Raphael and the Fornarina." *Studies in Romanticism* 26, no. 3 (fall 1987), pp. 365–98.

Meier-Graefe 1911 Julius Meier-Graefe. *Auguste Renoir, mit Hundert Abbildungen.* Munich, 1911.

Meier-Graefe 1912a Julius Meier-Graefe. *Auguste Renoir.* Paris, 1912.

Meier-Graefe 1912b Julius Meier-Graefe. *Édouard Manet.* Munich, 1912.

Meier-Graefe 1921 Julius Meier-Graefe. *Vincent.* 2 vols. Munich, 1921.

Meier-Graefe 1928 Julius Meier-Graefe. *Vincent van Gogh: Der Zeichner.* Berlin, 1928.

Meier-Graefe 1929 Julius Meier-Graefe. *Renoir.* Leipzig, 1929.

Mendelowitz 1967a Daniel M. Mendelowitz. *Drawing.* New York, 1967.

Mendelowitz 1967b Daniel M. Mendelowitz. *Drawing: A Study Guide. A Supplement to Drawing.* New York, 1967.

Mendelowitz 1976 Daniel M. Mendelowitz. *A Guide to Drawing.* New York, 1976.

Menon 1997 Elizabeth Menon. "Pierre-Paul Prud'hon's *Union of Love and Friendship* Reconsidered." *Gazette des beaux-arts,* ser. 6, 130 (November 1997), pp. 155–66.

Méras 1972 Mathieu Méras. "Un lettre inédite d'Ingres à Luigi Mussini et deux études inédites pour *L'Âge d'Or.*" *Bulletin du Musée Ingres,* no. 31 (1972), pp. 19–22.

Mercer 1989 Dorothy Kimbrell Mercer. "'The Days of Creation' and Other Hexaemeral Cycles by Edward Burne-Jones." Ph.D. dissertation, University of Georgia, Athens, 1989.

Mercier 1800 Louis-Sébastien Mercier. *Le nouveau Paris.* 6 vols. Paris, 1800.

Merrifield 1844 Mrs. Merrifield, trans. and ann. *A Practical Treatise on Painting in Fresco, Oil and Distemper by Cennino Cennini.* London, 1844.

Merrill 1992 Linda Merrill. *A Pot of Paint: Aesthetics on Trial in Whistler v. Ruskin.* Washington, D.C., 1992.

Merrill 1998 Linda Merrill. *The Peacock Room: A Cultural Biography.* Washington, D.C., and New Haven, 1998.

Merson and Bellier de la Chavignerie 1867 Olivier Merson and Émile Bellier de la Chavignerie. *Ingres: Sa vie et ses oeuvres.* Paris, 1867.

Mertens 1987 Sabine Mertens. *Seesturm und Schiffbruch: Eine motivgeschichtliche Studie.* Hamburg, 1987.

Mesuret 1969 Robert Mesuret. "'Si Qua Fata Aspera Rumpas,' ou les disgraces du tableau préféré." In *Colloque Ingres [1967].* [Montauban, 1969].

Metropolitan Museum 1911 "List of Loans, April 20 to May 20, 1911." *Bulletin of The Metropolitan Museum of Art* 6 (June 1911), pp. 142–43.

Mexico City 1994 *De David a Matisse: 100 Dibujos franceses.* Escuela Nacional Superior de Bellas Artes de Paris. Centro Cultural / Arte Contemporaneo, Mexico City, July 14–September 25, 1994. Catalogue. Mexico City, 1994.

Meyers 1974 Jeffrey Meyers. "Huysmans and Gustave Moreau." *Apollo* 99 (January 1974), pp. 39–44.

Mezzatesta 1984 Michael P. Mezzatesta. *Henri Matisse Sculptor/Painter: A Formal Analysis of Selected Works.* Fort Worth: Kimbell Art Museum, 1984.

Michel 1992 Régis Michel. *Gericault: L'invention du réel.* Découvertes Gallimard, no. 154. Paris, 1992.

Michel 1996 Régis Michel, ed. *Géricault.* 2 vols. Louvre conférences et colloques. Paris, 1996.

Michel 1997 Régis Michel. "'Géricault wird geschlagen': Nachgeschichtliche Meditationen über den Trug des Subjektes." In *Bilder der Macht, Macht der Bilder: Zeitgeschichte in Darstellungen des 19. Jahrhunderts,* edited by Stefan Germer and Michael F. Zimmermann. Veröffentlichungen des Zentralinstituts für Kunstgeschichte, vol. 12. Munich, 1997.

Michel and Sahut 1988 Régis Michel and Marie-Catherine Sahut. *David: L'art et le politique.* Decouvertes Gallimard, no. 46. Paris, 1988.

Miel 1815 Edme Miel. "Beaux-Arts Salon de 1814." *Journal général de France,* February 5, 1815.

Milhau 1990 D. Milhau. "Discours d'histoire, discours d'actualité: Quelques remarques à propos de David et de la modernité." *Bulletin du Musée Ingres,* no. 61–62 (1990), pp. 87–103.

Millard 1974 Charles Millard. "A Chronology for Van Gogh's Drawings of 1888." *Master Drawings* 12, no. 2 (summer 1974), pp. 156–65.

Miller 1938 Alexandrine Miller. "Ingres' Three Methods of Drawing as Revealed by His Crayon Portraits." *Art in America* 26 (January 1938), pp. 3–15.

Miller 2003 Asher Miller. "Ingres and the Fondation Custodia: Some Recent Publications." *Master Drawings* 41, no. 1 (spring 2003), p. 73.

Millier 1955 Arthur Millier. *The Drawings of Ingres.* Master Draughtsman Series. London, 1955.

Mills 1912 Ernestine Mills, ed. *Life and Letters of Frederic Shields.* London, 1912.

Milman 1983 Miriam Milman. *Trompe-l'oeil Painting: The Illusions of Reality.* New York, 1983.

Milwaukee–Cincinnati–Rochester 1924–25 *An Exhibition of Original Drawings by Aubrey Beardsley.* Exhibition, Milwaukee Art Institute, October 1–30, 1924; Cincinnati Art Museum, November 1–30, 1924; Memorial Art Gallery, Rochester, N.Y., December 1, 1924–January 1925. Catalogue, *Paintings by Charles W. Hawthorne, N.A., John*

Noble, A.N.A., *Abram Poole and William Zorach, Etchings by William H. W. Bicknell and Drawings by Aubrey Beardsley*. Rochester, N.Y., 1924.

Mirbeau 1993 Octave Mirbeau. *Combats esthétiques, 2 (1813–1914)*. Edited by Pierre Michel and Jean-François Nivet. Paris, 1993.

Mirecourt 1853 Eugène de Mirecourt. *Ingres*. Paris, 1853.

Mirecourt 1855 Eugène de Mirecourt. *Ingres*. Les contemporains. Paris, 1855.

Mireur 1911–12 Hippolyte Mireur. *Dictionnaire des ventes d'art faites en France et à l'étranger pendant les XVIIIme et XIXme siècles*. 7 vols. Paris, 1911–12.

Mitchell 1978 W. J. T. Mitchell. *Blake's Composite Art: A Study of the Illuminated Poetry*. Princeton, 1978.

Mitchell 1983 W. J. T. Mitchell. "Metamorphoses of the Vortex: Hogarth, Turner, and Blake." In *Articulate Images: The Sister Arts from Hogarth to Tennyson*, edited by Richard Wendorf. Minneapolis, 1983.

Mitchell and Roberts 2000 Paul Mitchell and Lynn Roberts. "Burne-Jones's Picture Frames." *Burlington Magazine* 142 (June 2000), pp. 362–70.

Molinier 1885 Émile Molinier. "La Collection Albert Goupil." *Gazette des beaux-arts*, ser. 2, 31 (May 1, 1885), pp. 377–94.

Momméja 1904 J[ules] Momméja. *Ingres*. Paris, [1904].

Momméja 1905 Jules Momméja. *Collection Ingres au Musée de Montauban*. Inventaire Générale des richesses d'art de la France. Province, Monuments civils, 7. Paris, 1905.

Momméja 1906 Jules Momméja. "Le 'Bain Turc' d'Ingres." *Gazette des beaux-arts*, ser. 3, 36 (September 1, 1906), pp. 177–98.

Mongan 1943 Agnes Mongan. "Drawings and Watercolours [from the Grenville Winthrop Bequest]." *Bulletin of the Fogg Art Museum* 10, no. 2 (November 1943), pp. 53–57.

Mongan 1944a Agnes Mongan. "Drawings by Ingres in the Winthrop Collection." *Gazette des beaux-arts*, ser. 6, 26 (July–December 1944), pp. 387–412.

Mongan 1944b Agnes Mongan. "The Grenville Winthrop Collection: Before and after Impressionism." *Art News* 42, no. 16 (January 1–14, 1944), pp. 22–23, 31–32.

Mongan 1947 Agnes Mongan. *Ingres: 24 Drawings*. New York, 1947.

Mongan 1947a Agnes Mongan. "Ingres and the Antique." *Journal of the Warburg and Courtauld Institutes* 10 (1947), pp. 1–13.

Mongan 1949 Agnes Mongan, ed. *One Hundred Master Drawings*. Cambridge, Mass., 1949. Includes the 70 drawings exhibited Cambridge, Mass., 1948–49.

Mongan 1951 Agnes Mongan. "Find the Artist." *Art News* 50, no. 1 (March 1951), pp. 20–23, 61.

Mongan 1957 Agnes Mongan. "Ingres et Madame Moitessier." *Bulletin du Musée Ingres*, no. 2 (July 1957), pp. 3–8.

Mongan 1963 Agnes Mongan. "Souvenirs of Delacroix's Journey to Morocco in American Collections." *Master Drawings* 1, no. 2 (summer 1963), pp. 20–31.

Mongan 1967 Agnes Mongan. "Hommage à Ingres." *L'oeil*, nos. 151–53 (September 1967), pp. 22–29, 81.

Mongan 1969 Agnes Mongan. "Ingres as a Great Portrait Draughtsman." In *Colloque Ingres [1967]*, pp. 134–50. [Montauban, 1969].

Mongan 1970 Agnes Mongan. "Renoir's Spring Bouquet." *Nihon Keizai Shimbun* (Tokyo), September 1970.

Mongan 1975 Agnes Mongan. "Some Drawings by David from His Roman Album I." In *Études d'art français offertes à Charles Sterling*, pp. 319–26. Paris, 1975.

Mongan 1978 Agnes Mongan. "A Bracquemond Print and Drawing." In *A Portfolio Honoring Harold Hugo for His Contribution to Scholarly Printing*, quire 11. [Lunenburg, Vt.], 1978.

Mongan 1980 Agnes Mongan. "Ingres et ses jeunes compatriotes à Rome, 1806–1820." In "Actes du Colloque International: Ingres et son influence," *Bulletin du Musée Ingres*, no. 47 (1980), pp. 9–15.

Mongan 1996 Agnes Mongan. *David to Corot: French Drawings in the Fogg Art Museum*. Cambridge, Mass., 1996.

Monkhouse 1879 W. Cosmo Monkhouse. *The Works of Sir Edwin Landseer R.A., . . . with a History of His Art-Life*. 2 vols. London, 1879.

Monneret 1998 Sophie Monneret. *David et le Néoclassicisme*. Paris, 1998.

Montagu 1994 Jennifer Montagu. *The Expression of the Passions: The Origin and Influence of Charles Le Brun's "Conférence sur l'expression générale et particulière."* New Haven, 1994.

Montauban 1862 *Exposition des Beaux-Arts, ouverte à Montauban dans les salles de l'Hôtel de Ville*. Exhibition, Hôtel de Ville, Montauban, May 4–[31], 1862. Catalogue. Montauban, 1862.

Montauban 1951 *Dessins d'Ingres du Musée de Montauban*. Exhibition, Musée Ingres, Montauban, July–October 1951. Catalogue. Montauban, [1951].

Montauban 1967 *Ingres et son temps: Exposition organisé pour le centenaire de la mort d'Ingres (Montauban 1780–Paris 1867)*. Exhibition, Musée Ingres, Montauban, June 24–September 15, 1967. Catalogue by Daniel Ternois and Jean Lacambre. Montauban, 1967.

de Montebello 1961 Philippe Lannes de Montebello. "The Problem of Composition in Eugene Delacroix's Small Canvases." Senior thesis, Harvard University, Cambridge, Mass., 1961, Fogg Art Museum files.

Montreal 1901 *Second Loan Exhibition of Paintings*. Exhibition, Art Association of Montreal, February 21–26, 1901. Catalogue. Montreal, 1901.

Montreal 1914 *Thirtieth Loan Exhibition*. Exhibition, Art Association of Montreal, February 23–March 14, 1914. Catalogue, *A Catalogue of the Water Colours and Pastels on View in the Thirtieth Loan Exhibition at the Galleries*. Montreal, 1914.

Montreal 1915 *The Ross Loan Collection of Paintings, etc.* Exhibition, Art Association of Montreal, May 1915.

Montreal 1989–90 *Discerning Tastes: Montreal Collectors 1880–1920*. Exhibition, Montreal Museum of Fine Arts, December 8, 1989–February 15, 1990. Catalogue by Janet M. Brooke. Montreal, 1989.

Montrosier 1882 Eugène Montrosier. *Peintres modernes: Ingres, H. Flandrin, Robert Fleury*. Paris, 1882.

Monval 1928 Jean Monval. *Le Panthéon*. 2nd ed. Collections publiques de France: Memoranda. Paris, 1928.

Moreau 1873 Adolphe Moreau. *Eugène Delacroix et son oeuvre*. Paris, 1873.

Moreau 1984 Gustave Moreau. *L'Assembleur de rêves: Écrits complets de Gustave Moreau*. Preface by Jean Paladilhe; text edited and annotated by Pierre-Louis Mathieu. Fontfroide, 1984.

Moreau-Nélaton 1916 Étienne Moreau-Nélaton. *Delacroix raconté par lui-même: Étude biographique d'après ses lettres, son journal, etc.* 2 vols. Paris, 1916.

Moreau-Nélaton 1921 Étienne Moreau-Nélaton. *Millet raconté par lui-même*. 3 vols. Paris, 1921.

Moreau-Nélaton 1926 Étienne Moreau-Nélaton. *Manet raconté par lui-même*. 2 vols. Paris, 1926.

Morel 1996 Dominique Morel. "Ambroise Vollard et Emile Chouanard, collectionneurs de céramiques d'André Metthey." In Nice–Bruges 1996, pp. 71–75.

Morgan 1978 Fred Morgan. *Here and Now: An Approach to Writing through Perception*. New York, 1978.

Morris 1869 William Morris. *The Earthly Paradise, a Poem*. 3rd ed. Boston, 1869.

Morris 1902 William Morris. *The Doom of King Acrisius*. New York, 1902.

Morris 1996 Edward Morris. *Victorian and Edwardian Paintings in the Walker Art Gallery and at Sudley House: British Artists Born after 1810 but before 1861*. Victorian and Edwardian Paintings in the National Museums and Galleries on Merseyside, vol. 2. London, 1996.

Mortimer 1985 Kristin A. Mortimer. *Harvard University Art Museums: A Guide to the Collections, Arthur M. Sackler Museum, William Hayes Fogg Art Museum, Busch-Reisinger Museum*. Contributions by William G. Klingelhofer. Cambridge, Mass., and New York, 1985.

Mosby 1977 Dewey F. Mosby. *Alexandre-Gabriel Decamps, 1803–1860*. 2 vols. New York, 1977.

Moskowitz 1962 Ira Moskowitz, ed. *Great Drawings of All Time*. Vols. 1–4. New York, 1962. *See* Thorson 1979 for vol. 5 of this series.

Moskowitz and Sérullaz 1962 Ira Moskowitz, ed.; text by Maurice Sérullaz. *French Impressionists: A Selection of Drawings of the French 19th Century*. Drawings of the Masters. New York, 1962.

Mount 1955 Charles Merrill Mount. *John Singer Sargent, a Biography*. New York, 1955.

Mourey 1909 Gabriel Mourey. *D.–G. Rossetti et les Préraphaélites anglais*. Les grands artistes. Paris, 1909.

Mráz 1983 Bohumír Mráz. *Ingres Zeichnungen*. Honau, 1983.

Mühlberger 1993 Richard Mühlberger. *What Makes a Van Gogh a Van Gogh?* New York: The Metropolitan Museum of Art, 1993.

Munich 1888 *III Internationale Kunst—Austellung*. Exhibition, Munich, 1888.

Munich 1906 Exhibition, Kunstsalon Walter Zimmermann, Munich, 1906.

Munich 1913 Exhibition, Galerie Heinemann, Munich, 1913.

Munich 1998 *Fuseli to Menzel: Drawings and Watercolors in the Age of Goethe from a German Private Collection.* Exhibition, Munich, 1998. Catalogue by Hinrich Sieveking. Munich, 1998.

Murphy 1968 Richard Murphy. *The World of Cezanne.* New York, 1968.

Musée Gustave-Moreau 1926 *Catalogue sommaire des peintures, dessins, cartons et aquarelles, exposés dans les galeries du Musée Gustave-Moreau.* Paris, 1926.

Muther 1907 Richard Muther. *The History of Modern Painting*, vol. 3. London and New York, 1907.

Myers 1969 Rollo Myers. *Emmanuel Chabrier and His Circle.* London, 1969.

Naef 1957a Hans Naef. "Deux dessins d'Ingres: Monseigneur Cortois de Pressigny et le chevalier de Fontenay." *La revue des arts* 57 (November–December 1957), pp. 243–48.

Naef 1957b Hans Naef. "Notes on Ingres Drawings, I. The Composer Victor Dourlen." *Art Quarterly* 20 (summer 1957), pp. 180–90.

Naef 1960 Hans Naef. "Vier Ingres-Zeichnungen" (Portrait of an Unknown Girl [State Hermitage Museum, Saint Petersburg], Lucien Bonaparte, Mlle. Lorimier, F. Pouqueville). *Pantheon* 18 (1960), pp. 35–43.

Naef 1963 Hans Naef. "Ingres und die Familie Guillon Lethière." *Du* 23 (December 1963), pp. 65–78.

Naef 1965 Hans Naef. "Parmi les gravures de la collection Ingres." *Bulletin du Musée Ingres*, no. 18 (December 1965), pp. 5–10.

Naef 1966 Hans Naef. "Ingres et la famille Hayard." *Gazette des beaux-arts*, ser. 6, 67 (January 1966), pp. 37–50.

Naef 1967a Hans Naef. "L'exposition Ingres du Musée Fogg, 12 février–9 avril 1967." *Bulletin du Musée Ingres*, no. 21 (July 1967), pp. 5–7.

Naef 1967b Hans Naef. "Ingres et les demoiselles Harvey." *Bulletin du Musée Ingres*, no. 22 (December 1967), pp. 7–9.

Naef 1969 Hans Naef. "*Odalisque à l'esclave*, by J. A. D. Ingres." *Fogg Art Museum Acquisitions*, 1968, pp. 80–99. Cambridge, Mass., 1969.

Naef 1970 Hans Naef. "Ingres to M. Leblanc, an Unpublished Letter." *The Metropolitan Museum of Art Bulletin* 29 (December 1970), pp. 178–84.

Naef 1971 Hans Naef. "Henrietta Harvey and Elizabeth Norton: Two English Artists." *Burlington Magazine* 113 (February 1971), pp. 79–89.

Naef 1972 Hans Naef. "Révoil dessiné par Ingres." *Bulletin du Musée Ingres*, no. 32 (December 1972), pp. 5–10.

Naef 1974 Hans Naef. "Vier Unbekannte Ingres-Modelle." In *Gotthard Jedlicka: Eine Gedenkschrift*, edited by Eduard Hüttinger and Hans A. Lüthy, pp. 61–70. Zürich, 1974.

Naef 1977–80 Hans Naef. *Die Bildniszeichnungen von J.-A.-D. Ingres.* 5 vols. Bern, 1977–80.

Naef 1990 Hans Naef. "Un chef-d'oeuvre retrouvé: *Le Portrait de la reine Caroline Murat* par Ingres." *Revue de l'art*, no. 88 (1990), pp. 11–20.

Naef and Angrand 1970 Hans Naef and Pierre Angrand. "Ingres et la famille de Pastoret, correspondance inedite. II." *Bulletin du Musée Ingres* 28 (December 1970), pp. 7–22.

Nakayama 1986 Kimio Nakayama. *Runowaru* (Renoir). Shonen shojo meisaku kaigakan, no. 7. Tokyo, 1986.

Nakayama and Takashina 1981 Kimio Nakayama and Shūji Takashina. *Allégories et symboles, II. Nu feminin dans l'art*, vol. 8. Tokyo, 1981.

Nantes–Charleroi–Nancy 1992 *Burne-Jones, 1833–1898: Dessins du Fitzwilliam Museum de Cambridge.* Exhibition, Musée des Beaux-Arts de Nantes, May 7–July 27, 1992; Palais des Beaux-Arts de Charleroi, September 5–October 15, 1992; Musée des Beaux-Arts de Nancy, October 20–December 21, 1992. Catalogue edited by Jane Munro. Nantes, 1992.

Nanteuil 1985 Luc de Nanteuil. *Jacques-Louis David.* New York, 1985.

Nash 1973 Steven A. Nash. "The Drawings of Jacques-Louis David: Selected Problems." Ph.D. dissertation, University of Stanford, 1973.

Nassar 1994 Eugene Paul Nassar. *Illustrations to Dante's Inferno.* Rutherford, N.J., London, and Mississauga, Ont., 1994.

Natoli 1995 Marina Natoli, ed. *Luciano Bonaparte: Le sue collezioni d'arte, le sue residenze a Roma, nel Lazio, in Italia (1804–1840).* Contributions by Mina Gregori et al. Rome, 1995.

Neiswander 1984 Judith A. Neiswander. "Imaginative Beauty and Decorative Delight: Two American Collections of the Pre-Raphaelites." *Apollo* 119 (March 1984), pp. 198–205.

Neoclassic Art 1993 *New History of World Art.* Vol. 19, *Neoclassic Art, Revolutionary Epoque Art.* Tokyo, 1993.

Neumann 1929 J. B. Neumann. *Rodolphe Bresdin.* The Art Lover Library, vol. 1. New York, 1929.

Newall 1987 Christopher Newall. *Victorian Watercolours.* Oxford, 1987.

Newcastle upon Tyne 1979–80 *Pre-Raphaelites: Painters and Patrons in the North East.* Exhibition, Laing Art Gallery, Newcastle upon Tyne, 1979–80.

New Haven 1967 *Paintings, Drawings, Sculpture from the Fogg Art Museum, Harvard University.* Exhibition, Yale University Art Gallery, New Haven, October 12–December 3, 1967. Catalogue. New Haven, 1967.

New Haven 1969 *The Graphic Art of Géricault.* Exhibition, Yale University Art Gallery, February 5–March 30, 1969. Catalogue by Kate H. Spencer. New Haven, 1969.

New Haven 1976 *Dante Gabriel Rossetti and the Double Work of Art.* Exhbition, Yale University Art Gallery, New Haven, September 23–November 14, 1976. Catalogue by Maryan Wynn Ainsworth. New Haven, 1976.

New Haven–Denver–Newcastle upon Tyne 1996 *The Grosvenor Gallery: A Palace of Art in Victorian England.* Exhibition, Yale Center for British Art, March 2–April 28, 1996; Denver Art Museum, June 1–August 25, 1996; Laing Art Gallery, Newcastle upon Tyne, September 13–November 3, 1996. Catalogue edited by Susan P. Casteras and Colleen Denney. New Haven, 1996.

New Haven–Philadelphia–Albany 1973–74 *Edwin Austin Abbey (1852–1911).* Exhibition, Yale University Art Gallery, New Haven, December 6, 1973–February 17, 1974; Pennsylvania Academy of the Fine Arts, Philadelphia, March 9–April 17, 1974; Albany Institute of History and Art, September 6–October 27, 1974. Catalogue. New Haven, 1973.

Newhouse 1982–83 Gloria Newhouse. "A Newly Identified Drawing by Jacques-Louis David." *The Stanford Museum* 12–13 (1982–83), pp. 13–19.

Newman 1980 Richard Newman. "The Microtopography of Pencil Lead in Drawings: A Preliminary Report." In *Papers Presented at the Art Conservation Training Programs Conference.* Winterthur, Del., 1980.

Newman 1996 Robert Newman, ed. *Pedagogy, Praxis, Ulysses: Using Joyce's Text to Transform the Classroom.* Ann Arbor, 1996.

Newman and Watkinson 1991 Theresa Newman and Raymond Watkinson. *Ford Madox Brown and the Pre-Raphaelite Circle.* London, 1991.

New York 1889a *Annual Exhibition of Water Colors.* Exhibition, Union League Club, New York, April 11–13, 1889. Catalogue. New York, 1889.

New York 1889b *Third Annual Loan Exhibition . . . from Members' Collections.* Exhibition, New York Athletic Club, 1889.

New York 1892–1900 *Annual Loan Exhibition: American Paintings Never Before Exhibited.* Exhibition, New York Athletic Club, 1892–1900.

New York 1898 *The Paintings of Two Americans* [George Inness and Winslow Homer]. Exhibition, Union League Club, New York, March 10–12, 1898. Catalogue. New York, 1898.

New York 1911 *Loan Exhibition of Paintings by Winslow Homer.* Exhibition, The Metropolitan Museum of Art, New York, February 6–March 19, 1911. Catalogue. New York, 1911.

New York 1916 *Paintings, Etchings and Lithographs by Whistler.* Exhibition, Kennedy and Co., New York, 1916.

New York 1921 *Original Water-colour Drawings by William Blake to Illustrate Dante.* Exhibition, Scott and Fowles, New York, 1921. Catalogue by Martin Birnbaum. New York, 1921.

New York 1929 *First Loan Exhibition: Cézanne–Gauguin–Seurat–Van Gogh.* Exhibition, Museum of Modern Art, New York, November 1929. Catalogue foreword signed A[lfred] H. B[arr]. New York, 1929.

New York 1931 *The Circus by Toulouse-Lautrec.* Exhibition, M. Knoedler and Co., New York, November 30–December 12, 1931.

New York 1934 *Loan Exhibition of Interiors and Paintings of Interiors.* Exhibition, M. Knoedler and Co., New York, 1934.

New York 1935 *Paintings and Watercolors by John Singer Sargent, R.A.* Exhibition, M. Knoedler and Co., New York, 1935.

New York 1936 *An Exhibition of the Work of John La Farge.* Exhibition, The Metropolitan Museum of Art, New York, March 23–April 26, 1936. Catalogue by Royal Cortissoz. New York, 1936.

New York 1936–37 *Winslow Homer Centenary Exhibition.* Exhibition, Whitney Museum of American Art, New York, December 15, 1936–January 15, 1937. Catalogue by Lloyd Goodrich. New York, 1936.

New York 1937 *Edouard Manet: Retrospective Loan Exhibition.* Exhibition, Wildenstein and Co., New York, March 19–April 17, 1937. New York, 1937.

New York 1941 *Loan Exhibition in Honour of Royal Cortissoz and His Fifty Years of Criticism in the New York Herald Tribune.* Exhibition, M. Knoedler and Co., December 1–20, 1941. Catalogue. New York, 1941.

New York 1967 *Paintings and Watercolors by John Marin from the Phillips Collection: A Loan Exhibition for the Benefit of the Dalton School.* Exhibition, M. Knoedler and Co., May 3–26, 1967. Catalogue. New York, 1967.

New York 1968 *Neo-Impressionism.* Exhibition, Solomon R. Guggenheim Museum, New York, February–April 1968. Catalogue by Robert L. Herbert. New York, 1968.

New York 1978 *Matisse in the Collection of the Museum of Modern Art, Including Remainder-Interest and Promised Gifts.* Exhibition, Museum of Modern Art, New York, 1978. Catalogue by John Elderfield, with additional texts by William S. Lieberman and Riva Castleman. New York, 1978.

New York 1980 *John Singer Sargent: His Own Work.* Exhibition, Coe Kerr Gallery, New York, May 28–June 27, 1980. Catalogue by Warren Adelson. New York, 1980.

New York 1984 *Van Gogh in Arles.* Exhibition, The Metropolitan Museum of Art, New York, October 18–December 30, 1984. Catalogue by Ronald Pickvance. New York, 1984.

New York 1986 *Paestum and the Doric Revival, 1750–1830: Essential Outlines of an Approach.* Exhibition, National Academy of Design, New York, February 19–March 30, 1986. Catalogue edited by Joselita Raspi Serra. Florence, 1986.

New York 1990–91 *Gericault's Heroic Landscapes: The Times of Day.* Exhibition, The Metropolitan Museum of Art, New York, November 6, 1990–January 13, 1991. Catalogue by Gary Tinterow, published as *The Metropolitan Museum of Art Bulletin* 48, no. 3 (winter 1990–91). New York, 1990.

New York 1992–93 *Henri Matisse: A Retrospective.* Exhibition, Museum of Modern Art, New York, September 24, 1992–January 12, 1993. Catalogue by John Elderfield. New York, 1992.

New York 1994–95 *The Thaw Collection: Master Drawings and New Acquisitions.* Exhibition, Pierpont Morgan Library, New York, September 21, 1994–January 22, 1995. Catalogue by Cara Dufour Denison et al. New York, 1994.

New York 1996 *From Mantegna to Picasso: Drawings from the Thaw Collection at the Pierpont Morgan Library.* Exhibition, Pierpont Morgan Library, New York, 1996. Catalogue by Cara Dufour Denison. New York, 1996.

New York 1997–98 *The Private Collection of Edgar Degas.* Exhibition, The Metropolitan Museum of Art, New York, October 1, 1997–January 11, 1998. Catalogue [vol. 1], by Ann Dumas, Colta Ives, Susan Alyson Stein, and Gary Tinterow; [vol. 2], *The Private Collection of Edgar Degas: A Summary Catalogue,* compiled by Colta Ives, Susan Alyson Stein, and Julie A. Steiner, with Ann Dumas, Rebecca A. Rabinow, and Gary Tinterow. New York, 1997.

New York 1998 *Aleksandr Rodchenko.* Exhibition, Museum of Modern Art, New York, 1998. Catalogue by Leah Dickerman and Magdalena Dabrowski. New York, 1998.

New York 1999 *Old Master Drawings.* Exhibition, W. M. Brady and Co., New York, January 26–February 20, 1999. Catalogue by W. Mark Brady. New York, 1999.

New York and other cities 1952–53 *A Loan Exhibition of Paintings and Drawings by Ingres from the Ingres Museum at Montauban, Organized by the Knoedler Galleries for the Benefit of the Museum of Montauban.* Exhibition, M. Knoedler and Co., New York, November 2–29, 1952; Currier Gallery of Art, Manchester; Detroit Institute of Arts; Cincinnati Art Museum; Cleveland Museum of Art; California Palace of the Legion of Honor, San Francisco, 1952–53. Catalogue by Agnes Mongan and Daniel Ternois. [Paris], 1952.

New York and other cities 1963–65 *Auguste Rodin: An Exhibition of Sculptures and Drawings.* Exhibition, Charles E. Slatkin Galleries, New York, May 6–June 26, 1963, and at other places in the United States and Canada through January 1965. Catalogue introduction by Leo Steinberg; catalogue notes by Cécile Goldscheider; photos by Phyllis Dearborn-Massar et al. New York, 1963.

New York and other cities 1976–77 *Daniel Chester French: An American Sculptor.* Exhibition, The Metropolitan Museum of Art, New York, November 4, 1976–January 10, 1977; National Collection of Fine Arts, Smithsonian Institution, Washington, D.C., February 11–April 17, 1977; Detroit Institute of Arts, June 15–August 28, 1977; Fogg Art Museum, Cambridge, Mass., September 30–November 30, 1977. Catalogue by Michael Richman. New York, 1976.

New York and other cities 1985 *George Inness.* Exhibition, The Metropolitan Museum of Art, New York, April 1–June 9, 1985; and other museums. Catalogue by Nicolai Cikovsky Jr. and Michael Quick. Los Angeles, 1985.

New York and other cities 1990–91 *Adolph Menzel, 1815–1905: Master Drawings from East Berlin.* Exhibition, Frick Collection, New York, September 11–November 18, 1990; Museum of Fine Arts, Houston, December 1, 1990–January 27, 1991; Frick Art Museum, Pittsburgh, February 16–March 31, 1991; Harvard University Art Museums, Cambridge, Mass., April 27–June 23, 1991. Catalogue by Peter Betthausen et al. Alexandria, Va., 1990.

New York and other cities 1992–93 *William M. Harnett.* Exhibition, The Metropolitan Museum of Art, New York, March 14–June 14, 1992; Amon Carter Museum, Fort Worth, July 18–October 18; Fine Arts Museums of San Francisco, November 14, 1992–February 14, 1993; National Gallery of Art, Washington, D.C., March 14–June 13, 1993. Catalogue edited by Doreen Bolger, Marc Simpson, and John Wilmerding, with the assistance of Thayer Tolles Mickel. New York, 1992.

New York–Birmingham–Paris 1998–99 *Edward Burne-Jones: Victorian Artist-Dreamer.* Exhibition, The Metropolitan Museum of Art, New York, June 4–September 6, 1998; Birmingham Museums and Art Gallery, October 17, 1998–January 17, 1999; Musée d'Orsay, Paris, March 1–June 6, 1999. Catalogue by Stephen Wildman and John Christian, with essays by Alan Crawford and Laurence des Cars. New York, 1998.

New York–Düsseldorf–Stockholm 1998–99 *Aleksandr Rodchenko.* Exhibition, Museum of Modern Art, New York, June 25–October 6, 1998; Kunsthalle Düsseldorf, October 1998–January 1999; Moderna Museet, Stockholm, March 6–May 24, 1999. Catalogue by Magdalena Dabrowski, Leah Dickerman, and Peter Galassi, with essays by Aleksandr Lavrentev and Varvara Rodchenko. New York, 1998.

New York–Lawrence 1979–80 *American Imagination and Symbolist Painting.* Exhibition, Grey Art Gallery and Study Center, New York University, New York, October 24–December 8, 1979; Helen Foresman Spencer Museum of Art, University of Kansas, Lawrence, January 20–March 2, 1980. Catalogue by Charles C. Eldredge. New York, 1979.

New York–London 1998 *An Exhibition of Master Paintings.* Exhibition, P. and D. Colnaghi and Co., New York, May 7–30, 1998; P. and D. Colnaghi and Co., London, June 10–July 11, 1998. Catalogue by Donald Garstang; presented by Jean-Luc Baroni. London, 1998.

New York–London 2001 *Pre-Raphaelite, Symbolist, Visionary.* Exhibition, International Fine Art Fair, 7th Regiment Armory, New York, May 11–16, 2001; 5 Ryder Street, London, June 12–July 7, 2001, in conjunction with the Grosvenor House Art and Antiques Fair. Catalogue by Peter Nahum and Sally Burgess. London, 2001.

New York–Paris 1996–97 *Picasso and Portraiture: Representation and Transformation.* Exhibition, Museum of Modern Art, New York, April 28–September 17, 1996; Grand Palais, Paris, October 1996–January 1997. Catalogue edited by William Rubin, with essays by Anne Baldassari, Pierre Daix, Michael C. FitzGerald, Brigitte Léal, Marilyn McCully, Robert Rosenblum, William Rubin, Hélène Seckel, and Kirk Varnedoe. New York, 1996.

New York–San Diego–Houston 1985–86 *Master Drawings by Géricault.* Exhibition, Pierpont Morgan Library, June 7–July 31, 1985; San Diego Museum of Art, August 31–October 20, 1985; Museum of Fine Arts, Houston, November 9, 1985–January 5, 1986. Catalogue by Philippe Grunchec. Washington, D.C., 1985.

New York–Washington–Provo 1994–95 *Unfaded Pageant: Edwin Austin Abbey's Shakespearean Subjects; from the Yale University Art Gallery and Other Collections.* Exhibition, Miriam and Ira D. Wallach Art Gallery, Columbia University, New York, April 13–June 4, 1994; Folger Shakespeare Library, Washington, D.C., June 20–September 10, 1994; Museum of Art, Brigham Young University, Provo, Utah, November 12, 1994–January 31, 1995. Catalogue by Lucy Oakley. New York, 1994.

Nice 1931 *Exposition Ingres.* Exhibition, Palais des Arts, Musée Jules Chéret, Nice, March 1–28, 1931. Catalogue. Nice, 1931.

Nice 1986 *Delacroix: Peintures et dessins d'inspiration religieuse.* Exhibition, Musée National Message Biblique Marc Chagall, Nice, July 5–October 6, 1986. Catalogue. Paris, 1986.

Nice 1991 *Gustave Moreau et la Bible.* Exhibition, Musée National Message Biblique Marc Chagall,

Nice, July 6–October 7, 1991. Catalogue by Sylvie Forester, Guillaume Ambroise, Geneviève Lacambre, and Pierre-Louis Mathieu. Paris, 1991.

Nice–Bruges 1996 *La céramique fauve: André Metthey et les peintres.* Exhibition, Musée Matisse, Nice, May 17–July 21, 1996; Fondation Saint-Jean, Bruges, August 2–November 17, 1996. Catalogue. Cahiers Henri Matisse, no. 15. Nice, 1996.

Nichols 1967 Beverley Nichols. *The Art of Flower Arrangement.* London, 1967.

Nicoll 1975 John Nicoll. *Dante Gabriel Rossetti.* London, 1975.

Nishimura 1972 Toshio Nishimura, ed. *Renoir.* Tokyo, 1972.

Nochlin 1989 Linda Nochlin. "Seurat's *Grand Jatte*: An Anti-Utopian Allegory." *Museum Studies* (Art Institute of Chicago) 14, no. 2 (1989), pp. 133–53.

Nochlin 1996 Linda Nochlin. "Géricault and the Absence of Women." In Michel 1996, vol. 1, pp. 403–21.

Nochlin 1999 Linda Nochlin. *Representing Women.* London, 1999.

Nodier, Taylor, and Cailleux 1820–78 Charles Nodier, Baron Isidore-Justin-Séverin Taylor, and Achille-Alexandre-Alphonse de Cailleux. *Voyages pittoresques et romantiques dans l'ancienne France.* 18 vols. in 20 parts. Paris, 1820–78.

Noël 1989 Bernard Noël. *L. David.* New York, 1989.

Noël 1991 Bernard Noël. *Géricault.* Paris, 1991.

Noon 1991 Patrick Noon. *Richard Parkes Bonington: "On the Pleasure of Painting."* New Haven, 1991.

Nordenfalk 1946a Carl Nordenfalk, ed. "Swedish van Gogh-Studies." *Konsthistorisk Tidskrift* 15, no. 3–4, (December 1946), pp. 87–152.

Nordenfalk 1946b Carl Nordenfalk. *Vincent van Gogh.* Stockholm, 1946. Reprinted, Amsterdam, 1990.

Nordenfalk 1953 Carl Nordenfalk. *The Life and Work of Van Gogh.* New York, 1953.

Northampton–Williamstown 1976–77 *Jongkind and the Pre-Impressionists.* Exhibition, Smith College Museum of Art, Northampton, Mass., October 15–December 5, 1976; Sterling and Francine Clark Art Institute, Williamstown, Mass., December 17, 1976–February 13, 1977. Catalogue by Charles C. Cunningham, with Susan D. Peters and Kathleen Zimmerer. Williamstown, Mass., 1977.

Norton Simon Museum 1990 *Vincent van Gogh: Painter, Printmaker, Collector.* Pasadena, Calif.: Norton Simon Museum, 1990.

Novotny 1953 Fritz Novotny. "Reflections on a Drawing by Van Gogh: *Tile Factory near Arles.*" *Art Bulletin* 35 (March 1953), pp. 36–43.

Novotny 1960 Fritz Novotny. *Painting and Sculpture in Europe, 1780 to 1880.* Harmondsworth, Eng., 1960.

Novotny 1968 Fritz Novotny. *Über das "Elementare" in der Kunstgeschichte und andere Aufsätze.* Vienna, 1968.

Oberhuber 1979 Konrad Oberhuber, ed. *Old Master Drawings: Selections from the Charles A. Loeser Bequest.* Fogg Art Museum Handbooks, vol. 1. Cambridge, Mass., 1979.

O'Brian 1988 John O'Brian. *Degas to Matisse: The Maurice Wertheim Collection.* New York and Cambridge, Mass., 1988.

Ockman 1986 Carol Ockman. "Astraea Redux: A Monarchist Reading of Ingres' Unfinished Murals at Dampierre." *Arts Magazine* 61 (October 1986), pp. 21–27.

Ockman 1991 Carol Ockman. "'Two Large Eyebrows à l'Orientale': Ethnic Stereotyping in Ingres's *Baronne de Rothschild.*" *Art History* 14 (December 1991), pp. 521–39.

Ockman 1995 Carol Ockman. *Ingres's Eroticized Bodies: Retracing the Serpentine Line.* New Haven, 1995.

Okun 1967 Henry Okun. "Ossian in Painting." *Journal of the Warburg and Courtauld Institutes* 30 (1967), pp. 327–56.

Olson, Adelson, and Ormond 1986 Stanley Olson, Warren Adelson, and Richard L. Ormond. *Sargent at Broadway: The Impressionist Years.* New York, 1986.

Olson and Pasachoff 1998 Roberta J. M. Olson and Jay M. Pasachoff. *Fire in the Sky: Comets and Meteors, the Decisive Centuries, in British Art and Science.* New York, 1998.

One Hundred Saints 1993 *One Hundred Saints.* Boston and New York, 1993.

Oppenheimer 1997 Margaret A. Oppenheimer, "Four 'Davids,' a 'Regnault,' and a 'Girodet' Reattributed: Female Artists at the Paris Salon." *Apollo,* n.s., 145 (June 1997), pp. 38–44.

Oppler 1976 Ellen C. Oppler. *Fauvism Reexamined.* New York, 1976. Ph.D. dissertation, Columbia University, New York, 1969.

Oprescu [1927] Gheorghe Oprescu. *Géricault.* Paris, n.d. [1927].

Orienti 1967 Sandra Orienti. *L'opera pittorica di Édouard Manet.* Milan, 1967. Also published in English as *The Complete Paintings of Manet.* New York, 1967.

Orienti and Rouart 1970 Sandra Orienti and Denis Rouart. *Tout l'oeuvre peint d'Édouard Manet.* Paris, 1970.

Orléans 1997–98 *Le temps des passions: Collections romantiques des musées d'Orléans.* Exhibition, Musée des Beaux Arts d'Orléans, November 7, 1997–March 31, 1998. Catalogue. Orléans, 1997.

Ormond 1970 Richard Ormond. *John Singer Sargent: Paintings, Drawings, Watercolors.* New York, 1970.

Ormond 1974 Leonée Ormond. "Dress in the Painting of Dante Gabriel Rossetti." *Costume: The Journal of the Costume Society,* no. 8 (1974), pp. 26–29.

Ormond and Kilmurray 1998 Richard Ormond and Elaine Kilmurray. *John Singer Sargent: Complete Paintings.* Vol. 1, *The Early Portraits.* New Haven, 1998.

Ormond and Ormond 1975 Leonée Ormond and Richard Ormond. *Lord Leighton.* Studies in British Art. New Haven, 1975.

Ornans 1984 *L'imagerie du visage de Courbet.* Part of an exhibition, Musée Maison Natale Gustave Courbet, Ornans, June 16–October 31, 1984. Catalogue, *Visages, visages;* Musée Maison Natale Gustave Courbet, Dossier 1 (summer 1984). Ornans, 1984.

Ortensi 1896 Ulisse Ortensi. "Artisti contemporanei: Dante Gabriele Rossetti." *Emporium* 4 (July 1896), pp. 3–14.

Orton and Pollock 1996 Fred Orton and Griselda Pollock. *Avant-Gardes and Partisans Reviewed.* Manchester, 1996.

Oshima 1976 Seiji Oshima. *David.* Tokyo, 1976.

Østermark-Johansen 1998 Lene Østermark-Johansen. *Sweetness and Strength: The Reception of Michelangelo in Late Victorian England.* Aldershot, Hants., and Brookfield, Vt., 1998.

d'Otrange Mastai 1975 Marie-Louise d'Otrange Mastai. *Illusion in Art. Trompe l'oeil: A History of Pictorial Illusionism.* New York, 1975.

Ottawa 1971 *Picasso et la Suite Vollard / and the Vollard Suite.* Exhibition, National Gallery of Canada, Ottawa, 1971. Catalogue by Jean Sutherland Boggs. Ottawa, 1971.

Ottawa–Chicago–Fort Worth 1997–98 *Renoir's Portraits: Impressions of an Age.* Exhibition, National Gallery of Canada, Ottawa, June 27–September 14, 1997; Art Institute of Chicago, October 17, 1997–January 4, 1998; Kimbell Art Museum, Fort Worth, February 8–April 26, 1998. Catalogue by Colin B. Bailey and John B. Collins; essays by Colin B. Bailey, Linda Nochlin, and Anne Distel. New Haven, 1997.

Ottawa–Paris–Washington 1999–2000 *Daumier 1808–1879.* Exhibition, National Gallery of Canada, Ottawa, June 11–September 6, 1999; Galleries Nationales du Grand Palais, Paris, October 5, 1999–January 3, 2000; Phillips Collection, Washington, D.C., February 19–May 14, 2000. Exh. cat. by Henri Loyrette and Ségolène Le Men. Ottawa, 1999.

Otterlo 1990 *Vincent van Gogh: Drawings.* Exhibition, Rijksmuseum Kröller-Müller, Otterlo, March 30–July 29, 1990. Catalogue by Johannes van der Wolk, Ronald Pickvance, and E. B. F. Pey. Milan and Rome, 1990.

Ouin-la-Croix 1867 Charles Ouin-la-Croix. *Basilique de Sainte Geneviève, ancien Panthéon français: Description historique et artistique.* Paris, 1867.

Ovid 1660 *Les metamorphoses d'Ovide; en latin et françois, divisées en XV. livres.* Translation and commentary by Pierre du Ryer. Brussels, 1660.

Pach 1939 Walter Pach. *Ingres.* New York and London, 1939. Reprinted, New York, 1973.

Pach 1945 Walter Pach. "Géricault in America." *Gazette des beaux-arts,* ser. 6, 27 (April 1945), pp. 227–40.

Pach 1950 Walter Pach. *Pierre Auguste Renoir.* New York, 1950.

Paladilhe and Pierre 1971 Jean Paladilhe and José Pierre. *Gustave Moreau.* Paris, 1971.

Palmer 1892 Alfred H. Palmer. *The Life and Letters of Samuel Palmer, Painter and Etcher.* London, 1892.

Panofsky 1955 Erwin Panofsky. "*Et in Arcadia Ego*: Poussin and the Elegiac Tradition." In *Meaning in the Visual Arts,* by Erwin Panofsky, pp. 295–320. New York, 1955.

Pansu 1977a Evelyne Pansu. *Ingres dessins.* Paris, 1977.

Pansu 1977b Evelyne Pansu. "Quelques aperçus sur la thème iconographique de l'Âge d'Or avant Ingres." In Ingres colloque (1975) 1977, pp. 97–102.

Paras-Perez 1967 Rodolfo Paras-Perez. "Notes on Rodin's Drawings." *Art Quarterly* 30 (summer 1967), pp. 126–37.

Parinaud 1994 André Parinaud. *Les peintres et leur école: Barbizon, les origines de l'Impressionnisme.* Vaduz, 1994.

Paris (Salon) 1791 *Ouvrages de peinture, sculpture, et architecture, gravures, dessins, modèles, etc, exposés au Louvre par ordre de l'Assemblée nationale, au mois de septembre 1791, l'an IIIe de la Liberté.* Exhibition, Louvre, Paris, September 1791. Catalogue. Paris, 1791.

Paris (Salon) 1799 *Explication des ouvrages de peinture et dessins, sculpture, architecture et gravure des artistes vivans exposés au Muséum central des arts d'après l'Arrêté du ministre de l'intérieur le Ier fructidor, an VII de la République française.* Exhibition, Musée Central des Arts (Louvre), Paris, year VII (1799). Catalogue. Paris, 1799.

Paris (Salon) 1814 *Explication des ouvrages de peinture, sculpture, architecture et gravure des artistes vivans.* Exhibition, Musée Royal des Arts, Paris, opened November 1, 1814. Catalogue. Paris, 1815.

Paris (Salon) 1819 *Explication des ouvrages de peinture, sculpture, architecture et gravure, des artistes vivans.* Exhibition, Musée Royal des Arts, Paris, opened August 25, 1819. Catalogue. Paris, 1819.

Paris (Salon) 1822 *Explication des ouvrages de peinture, sculpture, architecture et gravure des artistes vivans.* Exhibition, Musée Royal des Arts, Paris, opened April 24, 1822. Catalogue. Paris, 1822.

Paris (Salon) 1831 *Explication des ouvrages de peinture, sculpture, gravure, lithographie et architecture des artistes vivans.* Exhibition, Musée Royal des Arts, Paris, opened May 1, 1831. Catalogue. Paris, 1831.

Paris (Salon) 1839 *Explication des ouvrages de peinture, sculpture, architecture, gravure, et lithographie des artistes vivans.* Exhibition, Musée Royal des Arts, Paris, opened March 1, 1839. Catalogue. Paris, 1839.

Paris 1840 Private exhibition at the home of Marcotte d'Argenteuil, Paris, late 1840.

Paris 1842 Private exhibition in Ingres's studio, Paris, April 1842.

Paris 1846 *Explication des ouvrages de peinture exposés dans la Galerie des Beaux-Arts, boulevard Bonne-Nouvelle, 22, au Profit de la Caisse de Secours et Pensions de la Société des Artistes.* Exhibition, Galerie des Beaux-Arts, boulevard Bonne-Nouvelle, Paris, January 11–March 15, 1846. Catalogue. Paris, 1846.

Paris (Salon) 1849 *Salon de 1849.* Exhibition, Palais des Tuileries, Paris, opened June 15, 1849. Catalogue, *Explication des ouvrages de peinture, sculpture, architecture, gravure et lithographie des artistes vivans.* Paris, 1849.

Paris (Salon) 1850–51 *Salon de 1850–1851.* Exhibition, Palais National, Paris, December 30, 1850–January 1851. Catalogue, *Explication des ouvrages de peinture, sculpture, architecture, gravure et lithographie des artistes vivans exposés au Palais National le 30 décembre 1850.* Paris, 1850.

Paris (Salon) 1853 *Salon de 1853.* Exhibition, Menus-Plaisirs, Paris, May 15–July 15, 1853. Catalogue, *Explication des ouvrages de peinture, sculpture, architecture, gravure et lithographie des artistes vivans exposés aux Menus-Plaisirs le 15 mai 1853.* Paris, 1853.

Paris 1855a *Exhibition et vente de 40 tableaux et 4 dessins de l'oeuvre de M. Gustave Courbet.* Exhibition, Pavillon du Réalisme, avenue Montaigne, 7, Champs-Elysées, Paris, 1855. Catalogue. Paris, 1855.

Paris 1855b *Exposition Universelle de Paris en 1855.* Exhibition, Palais des Beaux-Arts, avenue Montaigne, Paris, opened May 15, 1855. Catalogue, *Explication des ouvrages de peinture, sculpture, gravure, lithographie et architecture des artistes vivans étrangers et français,* by Claude Vignon. Paris, 1855.

Paris 1860 *Catalogue de tableaux et dessins de l'école française, principalement du XVIIIe siècle, tirés de collections d'amateurs et exposés au profit de la Caisse de secours des artistes peintres, sculpteurs, architectes et dessinateurs.* Exhibition, 26, boulevard des Italiens, Paris, 1860. Catalogue, 2nd ed., edited by Philippe Burty. Paris, 1860. The 1st ed., *Tableaux de l'école française ancienne tirés de collections d'amateurs,* is less complete and lacks Burty's commentaries.

Paris 1861 *Dessins [d'Ingres] tirés de collections d'amateurs.* Exhibition, Salon des Arts-Unis, Galerie Martinet, Paris. Catalogue [for 1st series]. Paris, 1861. To date, no brochure or catalogue has been identified for the 2nd series.

Paris 1864a Exhibition, Galerie Francis Petit, Paris, March 1864.

Paris 1864b Private exhibition, Ingres's studio on the quai Voltaire, Paris, July 1864.

Paris (Salon) 1865 *Explication des ouvrages de peinture, sculpture, architecture, gravure et lithographie des artistes vivans.* Exhibition, Palais des Champs-Élysées, Paris, May 1–June 20, 1865. Catalogue. Paris, 1865.

Paris 1867a *Catalogue des tableaux, études peintes, dessins et croquis de J.-A.-D. Ingres, peintre d'histoire, sénateur, membre de l'Institut.* Exhibition, École Impériale des Beaux-Arts, Paris, opened April 10, 1867. Catalogue. Paris, 1867.

Paris 1867b *Exposition des oeuvres de M. G. Courbet.* Exhibition, Rond-Point du Pont de l'Alma, Champs-Elysées, Paris, 1867. Catalogue. Paris, 1867.

Paris 1867c *Exposition Universelle de 1867.* Exhibition, Palais du Champ de Mars, Paris, 1867. Catalogue. Paris, 1867.

Paris (Salon) 1869 *Explication des ouvrages de peinture, sculpture, architecture, gravure et lithographie des artistes vivans.* Exhibition, Palais des Champs-Élysées, Paris, opened May 1, 1869. Catalogue. Paris, 1869.

Paris 1874a *Exposition au profit des Alsaciens-Lorrains.* Exhibition, Palais de la Présidence du Corps Legislatif, Paris, 1874.

Paris 1874b *Exposition des oeuvres de Prud'hon au profit de sa fille.* Exhibition, École des Beaux-Arts, Paris, May 4–July 4, 1874. Catalogue by Eudoxe Marcille and Camille Marcille. Paris, 1874.

Paris 1876 *2e exposition de peinture.* Exhibition, Société Anonyme des Artistes Peintres, Sculpteurs, Graveurs, etc., Paris, 1876.

Paris (Salon) 1876 *Explication des ouvrages de peinture, sculpture, architecture, gravure et lithographie des artistes vivans.* Exhibition, Palais des Champs-Elysées, Paris, opened May 1, 1876. Catalogue. Paris, 1876.

Paris 1878a *Exposition des peintures et dessins de H. Daumier.* Exhibition, Galerie Durand-Ruel, Paris. Catalogue with a biographical essay by Champfleury. Paris, 1878.

Paris 1878b *Exposition Universelle.* Exhibition, Palais du Trocadéro, Paris, 1878. Catalogue published in Henry Jouin, *Notice historique et analytique des peintures, sculptures, tapisseries, miniatures, émaux, dessins, etc., exposés dans les galeries des portraits nationaux au Palais du Trocadéro.* Paris, 1879.

Paris 1879 *Exposition de dessins de maîtres anciens.* Exhibition, École Nationale des Beaux-Arts, Paris, May–June 1879. Catalogue. Paris, 1879.

Paris 1882 *Exposition des oeuvres de Gustave Courbet.* Exhibition, École Nationale des Beaux-Arts, Paris, May 1882. Catalogue. Paris, 1882.

Paris (Salon) 1883 *Explication des ouvrages de peinture, sculpture, architecture, gravure et lithograhie des artistes vivans.* Exhibition, Palais des Champs-Élysées, Paris, opened May 1, 1883. Catalogue. Paris, 1883.

Paris 1883 *Exposition de portraits du siècle (1783–1883).* Exhibition, École Nationale des Beaux-Arts, Paris, opened April 25, 1883. Catalogue. Paris, 1883.

Paris 1884a *Dessins de l'école moderne exposés a l'École Nationale des Beaux-Arts au profit de la Caisse de Secours de l'Association.* Exhibition, École Nationale des Beaux-Arts, Paris, February 1884. Organized by the Association des Artistes. Catalogue. Paris, 1884.

Paris 1884b *Éxposition des œuvres de Édouard Manet.* Exhibition, École Nationale des Beaux-Arts, Paris, January 1884. Catalogue preface by Émile Zola. Paris, 1884.

Paris (Salon) 1885 *Salon des artistes français.* Exhibition, Palais des Champs-Elysées, Paris, May 1–June 30, 1885. *Catalogue illustré du Salon contenant environ 300 reproductions d'après les dessins originaux des artistes,* edited by François-Guillaume Dumas. Paris, 1885.

Paris 1887 *3e Salon des Indépendants.* Exhibition, Pavillon de la Ville de Paris, Champs-Élysées, Paris, March 26–May 3, 1887.

Paris 1887a *Exposition de tableaux, pastels, dessins [par M. Puvis de Chavannes].* Exhibition, Galerie Durand-Ruel, Paris, 1887. Catalogue preface by Roger-Ballu. Paris, 1887.

Paris 1888 *4e Salon des Indépendants.* Exhibition, Pavillon de la Ville de Paris, Champs-Élysées, Paris, March 22–May 3, 1888.

Paris 1889a *Catalogue des oeuvres de Barye.* Exhibition, École Nationale des Beaux-Arts, Paris, 1889. Catalogue by Eugène Guillaume. Paris, 1889.

Paris 1889b *Exposition Universelle Internationale de 1889.* Exhibition, Palais des Beaux-Arts, Paris, May 6–November 6, 1889. Catalogue. Paris, 1889.

Paris 1891 *Salon de 1891: Société des Artistes Français et Société Nationale des Beaux-Arts.* Exhibition, Paris, 1891. Catalogue by A. Hustin, issued in 12 parts. Paris, 1891.

Paris 1892 Société des Artistes Indépendants. 8th Exhibition, Pavillon de la Ville de Paris, Champs-Élysées, March 19–April 27, 1892. *Catalogue des oeuvres exposés.* Paris, 1892.

Paris 1893 *Portraits des écrivains et journalistes du siècle (1793–1893).* Exhibition, Galerie Georges Petit, Paris, opened June 12, 1893. Catalogue. Paris, 1893.

Paris 1897 *Catalogue des oeuvres exposées de Bracquemond. Expositions périodiques d'estampes: Première exposition.* Exhibition, Musée National de Luxembourg, Paris, February–July 1897. Catalogue by Léonce Bénédite. Paris, 1897.

Paris 1897a *Exposition des portraits de femmes et d'enfants.* Exhibition, École Nationale des Beaux-

Arts, Paris, opened April 30, 1897. Catalogue. Paris, 1897.

Paris 1900a *Exposition Universelle de 1900.* Exhibition, Grand Palais, Paris. 1900. *Catalogue official illustré de l'Exposition centennale de l'art français, 1800–1889.* Paris, 1900.

Paris 1900b *Exposition de 1900: L'oeuvre de Rodin.* Exhibition, Pavillon de l'Alma, Paris, June 1– November 27, 1900. Catalogue by Arsène Alexandre. Paris, 1900.

Paris 1900c *Seurat: Oeuvres peintes et dessinées.* Exhibition, La Revue Blanche, Paris, March 19– April 5, 1900.

Paris 1901 *Exposition Daumier.* Exhibition, Palais de l'École Nationale des Beaux-Arts, Paris, organized by the Syndicat de la Presse artistique. Catalogue preface by Gustave Geffroy. Paris, 1901.

Paris 1904 *Salon d'Automne.* Exhibition, Paris, 1904.

Paris 1906a *Exposition de l'oeuvre d Fantin-Latour.* Exhibition, Palais de l'École Nationale des Beaux-Arts, May–June 1906. Catalogue. Paris, 1906.

Paris 1906b *Exposition Gustave Moreau.* Exhibition, Galerie Georges Petit, Paris, 1906. Preface by Robert de Montesquiou. Paris, 1906.

Paris 1907 *Oeuvres de Bracquemond exposées à la Société Nationale des Beaux-Arts.* Exhibition, Société Nationale des Beaux-Arts, Salon de 1907, Paris. Catalogue by Léandre Vaillat. Paris, 1907.

Paris 1907a *Aubrey Beardsley, 1872–1898.* Exhibition, Galeries Shirley, Paris, February 1907.

Paris 1908–9 *Exposition Georges Seurat, 1859–1891.* Exhibition, Bernheim-Jeune, Paris, December 14, 1908–January 9, 1909. Catalogue. Paris, 1908.

Paris 1909 *Catalogue de l'exposition de gravures exécutées par M. Félix Bracquemond et Sir F. Seymour Haden.* Exhibition, Les Arts, Hôtel des Modes, Paris, 1909. Catalogue by Gustave Geffroy. Paris, 1909.

Paris 1910 *Exposition de chefs-d'oeuvre de l'école française: Vingt peintres du XIXe siècle.* Exhibition, Galerie Georges Petit, Paris, May 2–31, 1910. Catalogue. Paris, 1910.

Paris 1911 *Exposition Ingres . . . organisée au profit du Musée Ingres.* Exhibition, Galerie Georges Petit, Paris, April 26–May 14, 1911. Catalogue introduction by Henry Lapauze. Paris, 1911.

Paris 1912 *Portraits par Renoir.* Exhibition, Galerie Durand-Ruel, Paris, 1912.

Paris 1913 *Exposition David et ses élèves.* Exhibition, Palais des Beaux-Arts de la Ville de Paris, April 7– June 9, 1913. Catalogue. Paris, 1913.

Paris 1917 *Paysages d'après nature: Aquarelles et dessins par Odilon Redon.* Exhibition, Bernheim-Jeune, Paris, April 18–28, 1917.

Paris 1921a *Exposition Ingres.* Exhibition, Hôtel de la Chambre Syndicale de la Curiosité et des Beaux-Arts, Paris, May 8–June 5, 1921. Catalogue introduction by Henry Lapauze. Paris, 1921.

Paris 1921b *Sisley.* Exhibition, Galerie Durand-Ruel, Paris, 1921.

Paris 1922a *Exposition P.-P. Prud'hon.* Exhibition, Palais des Beaux-Arts de la Ville de Paris, May–June 1922. Catalogue by Henry Lapauze. Paris, 1922.

Paris 1922b *Oeuvres de grands maîtres du dix-neuvième siècle.* Galerie Paul Rosenberg, Paris, 1922. Catalogue. Paris, 1922.

Paris 1922c *Le décor de la vie sous le Second Empire.* Exhibition, Palais du Louvre, Pavillon de Marsan, Paris, May 27–July 10, 1922. Catalogue. Paris, 1922.

Paris 1924a *Exposition Degas au profit de la Ligue Franco-Anglo-Américaine contre le Cancer.* Exhibition, Galerie Georges Petit, Paris, April 12–May 2, 1924. Catalogue. Paris, 1924.

Paris 1924b *Exposition d'oeuvres de Géricault: Au profit de la Société "La Sauvegarde de l'art français."* Exhibition, Hôtel Jean Charpentier, Paris, April 24– May 16, 1924. Catalogue by the duc de Trévise and Pierre Dubaut. Paris, 1924.

Paris (Salon) 1924 *Exposition annuelle des Beaux-Arts: Salon de 1924.* Exhibition, Grand Palais des Champs-Elysées, Paris, opened April 30, 1924. Catalogue, *Explication des ouvrages de peinture, sculpture, architecture, gravure et lithographie des artistes vivants.* Paris, 1924.

Paris 1926 *Les dessins de Georges Seurat.* Exhibition, Bernheim-Jeune, Paris, November 29–December 24, 1926.

Paris 1927a *La jeunesse des romantiques.* Exhibition, Maison de Victor Hugo, Paris, May 18–June 30, 1927. Catalogue by Raymond Escholier. Paris, 1927.

Paris 1927b *Sisley.* Exhibition, Galerie Durand-Ruel, Paris, 1927.

Paris 1928a *Exposition des Artistes Normands: Peintres normands de Nicolas Poussin à nos jours.* Exhibition, Galerie Hodebert, Paris, January 1928.

Paris 1928b *Exposition d'œuvres de Manet au profit des "Amis du Luxembourg."* Exhibition, Bernheim-Jeune, Paris, April 14–May 4, 1928. Catalogue preface by Robert Rey. Paris, 1928.

Paris 1930a *Exposition Eugène Delacroix: Peintures, aquarelles, pastels, dessins, gravures, documents.* Exhibition, Musée du Louvre, Paris, June– September 1930. Catalogue by Paul Jamot. Paris, 1930.

Paris 1930b *Exposition du centenaire de la conquête de l'Algérie, 1830–1930.* Exhibition, Petit Palais, Paris, May–June 1930. Catalogue. Paris, 1930.

Paris 1930c *Exposition de dessins et quelques peintures du XVe au XVIIIe siècle.* Exhibition, Galerie Fèrault, Paris, December 8–20, 1930. Catalogue. Paris, 1930.

Paris 1930d *Tableaux de Sisley.* Exhibition, Galerie Durand-Ruel, Paris, February 22–March 8, 1930. Catalogue. Paris, 1930.

Paris 1931a *Exposition H. de Toulouse-Lautrec.* Exhibition, Musée des Arts Décoratifs, Paris, April 9– May 17, 1931. Catalogue. Paris, 1931.

Paris 1931b *Exposition d'oeuvres importantes de grands maîtres du dix-neuvième siècle: Prêtées au profit de la Cité Universitaire de l'Université de Paris.* Exhibition, Galerie Paul Rosenberg, Paris, May 18–June 27, 1931. Catalogue. Paris, 1931.

Paris 1933 *Chassériau, 1819–1856.* Exhibition, Musée de l'Orangerie, Paris, 1933. Catalogue by Charles Sterling; preface by Jean-Louis Vaudoyer. Paris, 1933.

Paris 1934 *Exposition de portraits par Ingres et ses élèves.* Jacques Seligmann et fils, Paris, March 23– April 21, 1934. Catalogue by Charles Sterling. Paris, 1934.

Paris 1935 *Expositions . . . de dessins, aquarelles et gouaches [par Géricault].* Exhibition, Maurice Gobin, Paris, December 5–21, 1935. Catalogue. Paris, 1935.

Paris 1936a *Gros: Ses amis, ses élèves.* Exhibition, Musée du Petit Palais, Paris, 1936. Catalogue by Germaine Barnaud and Yves Sjöberg. Paris, 1936.

Paris 1936b *La Collection Oscar [sic] Schmitz: Chefs-d'oeuvre de la peinture française du XIXe siècle.* Exhibition, Wildenstein, Paris, 1936. Catalogue [compiled by Assia Rubinstein]. Paris, 1936. Also published in English.

Paris 1937 *Géricault, peintre et dessinateur (1791–1824).* Exhibition, Bernheim-Jeune, Paris, May 10–29, 1937. Catalogue by Pierre Dubaut. Paris, 1937.

Paris 1941 *Exposition Emmanuel Chabrier en commémoration du centenaire de sa naissance.* Exhibition, Opéra-Comique, Paris, 1941. Catalogue edited by Auguste Martin. Paris, 1941.

Paris 1962 *Première exposition des plus beaux dessins du Louvre et de quelques pièces célèbres des collections de Paris.* Exhibition, Musée du Louvre, Paris, March– May 1962. Catalogue. Paris, 1962.

Paris 1967–68 *Ingres.* Exhibition, Petit Palais, Paris, October 27, 1967–January 29, 1968. Catalogue by Lise Duclaux, Jacques Foucart, Hans Naef, Maurice Sérullaz, and Daniel Ternois. Paris, 1967.

Paris 1971 *Le* Bain Turc *d'Ingres.* Exhibition, Musée du Louvre, Paris, 1971. Catalogue by Hélène Toussaint. Les dossiers du département des peintures, 1. Paris, 1971.

Paris 1974–75 *Le néo-classicisme français: Dessins des musées de province.* Exhibition, Grand Palais, Paris, December 6, 1974–February 10, 1975. [Catalogue by Arlette Sérullaz]. Paris, 1974.

Paris 1975 *Henri Matisse: Dessins et Sculpture.* Exhibition, Musée National d'Art Moderne, Paris, May 29– September 7, 1975. Catalogue edited by Dominique Fourcade and Isabelle Monod-Fontaine (drawings); and Nicole Barbier (sculpture). Paris, 1975.

Paris 1979 *Catalogue des dessins et peintures de Puvis de Chavannes.* Exhibition, Musée du Petit Palais, Paris, 1979. Catalogue by Marie-Christine Boucher. Paris, 1979.

Paris 1979a *Dessins français du XIXe siècle du Musée Bonnat à Bayonne: LXIXe exposition du Cabinet des Dessins.* Exhibition, Musée du Louvre, Paris, February 2–April 30, 1979. Catalogue by Vincent Ducourau and Arlette Sérullaz. Paris, 1979.

Paris 1983–84 *Raphaël et l'art français.* Exhibition, Grand Palais, Paris, November 15, 1983–February 13, 1984. Catalogue by Jean-Paul Boulanger and Geneviève Renisio. Paris, 1983.

Paris 1983–84a *Saint-Sébastien: Rituels et figures.* Exhibition, Musée National des Arts et Traditions Populaires, Paris, November 25, 1983–April 16, 1984. Catalogue by Sylvie Forestier and Chantal Martinet. Paris, 1983.

Paris 1985 *Les portraits d'Ingres: Peinture des musées nationaux.* Exhibition, Musée du Louvre, Paris, May 30–September 30, 1985. Catalogue by Hélène Toussaint. Paris, 1985.

Paris 1986a *Les mots dans le dessin.* 87e exposition du Cabinet des Dessins. Exhibition, Musée du Louvre, Paris, June 20–September 29, 1986. Catalogue by Régis Michel, Madeleine Pinault, and Arlette Sérullaz. Paris, 1986.

Paris 1986b *Les photographes de Rodin: Jacques-Ernest Bulloz, Eugène Druet, Stephen Haweis et Henry Coles,*

Jean-François Limet, *Eduard Steichen*. Exhibition, Musée Rodin, Paris, April 9–July 7, 1986. Catalogue by Hélène Pinet. Paris, 1986.

Paris 1989 *Dessins d'Ingres du Musée de Montauban*. Exhibition, Pavillon des Arts, Paris, June 7–September 3, 1989. Catalogue by Marie-Christine Boucher and Béatrice Riottot El-Habib. Paris, 1989.

Paris 1990 *Polyptyques: Le tableau multiple du Moyen Âge au vingtième siècle*. Exhibition, Musée du Louvre, Paris, March 27–July 23, 1990. Catalogue. Paris, 1990.

Paris 1991–92 *Géricault*. Exhibition, Grand Palais, Paris, October 10, 1991–January 6, 1992. Catalogue by Italo Rota and Jean-Thierry Bloch. Paris, 1991.

Paris 1992–93 *Rodin sculpteur: Oeuvres méconnues*. Exhibition, Musée Rodin, Paris, November 24, 1992–April 11, 1993. Catalogue. Paris, 1992.

Paris 1994–95 *Delacroix: Le voyage au Maroc*. Exhibition, Institut du Monde Arabe, Paris, September 27, 1994–January 15, 1995. Catalogue edited by Brahim Alaoui. Paris, 1994. English ed., *Delacroix in Morocco*, translated by Tamara Blondel. Paris, 1994.

Paris 1996 *Rodin et la Hollande*. Exhibition, Musée Rodin, Paris, February 6–March 31, 1996. Catalogue by Claudie Judrin. Paris, 1996.

Paris 1996–97 *Charles Le Coeur (1830–1906): Architecte et premier amateur de Renoir*. Exhibition, Musée d'Orsay, Paris, October 16, 1996–January 5, 1997. Catalogue edited by Marc Le Coeur. Paris, 1996.

Paris 1998 *Delacroix: Le trait romantique*. Exhibition, Bibliothèque Nationale de France, Paris, April 6–July 12, 1998. Catalogue edited by Barthélémy Jobert. Paris, 1998.

Paris 2000 *Rodolphe Bresdin, 1822–1885: Robinson graveur*. Exhibition, Bibliothèque Nationale de France, Galerie Mansart, Paris, May 30–August 27, 2000. Catalogue by Maxime Préaud [et al.]. Paris, 2000.

Paris 2001a *Rodin en 1900: L'exposition de l'Alma*. Exhibition, Musée du Luxembourg, Paris, March 12–July 15, 2001. Catalogue edited by Antoinette Le Normand-Romain, with contributions by Ruth Butler et al. Paris, 2001.

Paris 2001b *Un siècle de dessin à Bologne, 1480–1580: De la Renaissance à la réforme tridentine*. Exhibition, Musée du Louvre, Paris, March 30–July 2, 2001. Catalogue by Marzia Faietti and Dominique Cordellier, with Laura Aldovini, Bernadette Py, and Roberta Serra. Paris, 2001.

Paris 2001c *Ingres et Marcotte: Lettres, documents, dessins, et gravures [Exposition-dossier II]*. Exhibition, Fondation Custodia, Paris, February 22–April 1, 2001. Catalogue by Mària van Berge-Gerbaud. Paris, 2001.

Paris 2001d *Dessins romantiques français provenant de collections privées parisiennes*. Exhibition, Musée de la Vie Romantique, Paris, May 3–July 15, 2001. Catalogue edited by Louis-Antoine Prat. Paris, 2001.

Paris–Amsterdam–New York 2001 *Signac, 1863–1935*. Exhibition, Grand Palais, Paris, February 27–May 28, 2001; Van Gogh Museum, Amsterdam, June 15–September 9, 2001; The Metropolitan Museum of Art, New York, October 9–December 30, 2001. Catalogue by Marina Ferretti-Bocquillon, Anne Distel, John Leighton, and Susan Alyson Stein. Paris and New York, 2001.

Paris–Cambridge 1997–98 *Géricault: Dessins et estampes des collections de l'École des Beaux-Arts*. Exhibition, École Nationale des Beaux-Arts, Paris, November 25, 1997–January 25, 1998; Fitzwilliam Museum, Cambridge, March 26–May 24, 1998. Catalogue by Emmanuelle Brugerolles. Paris, 1997.

Paris–Chicago–New York 1998–99 *Gustave Moreau: Between Epic and Dream*. Exhibition, Grand Palais, Paris, September 29, 1998–January 4, 1999; Art Institute of Chicago, February 13–April 25, 1999; The Metropolitan Museum of Art, New York, June 1–August 22, 1999. Catalogue by Geneviève Lacambre, with contributions by Larry J. Feinberg, Marie-Laure de Contenson, and Douglas W. Druick. Chicago, 1999.

Paris–Detroit–New York 1974–75 *French Painting, 1774–1830: The Age of Revolution*. Exhibition, Grand Palais, Paris, November 16, 1974–February 3, 1975; Detroit Institute of Arts, March 5–May 4, 1975; The Metropolitan Museum of Art, New York, June 12–September 7, 1975. Catalogue by Arnaud Brejon de Lavergnée and Jacques Foucart. New York, 1975. French ed., *De David à Delacroix: La peinture française de 1774 à 1830*. Paris, 1974.

Paris–Frankfurt 1990 *Le corps en morceaux*. Exhibition, Musée d'Orsay, Paris, February 5–June 3, 1990; Schirn Kunsthalle, Frankfurt, June 23–August 26, 1990. Catalogue by Anne Pingeot et al. Paris, 1990. German ed., *Das Fragment: Der Körper in Stücken*, edited by Sabine Schulze; translated by Max Looser. Frankfurt, 1990.

Paris Guide 1867 *Paris Guide par les principaux écrivains et artistes de la France*. 2 vols. Paris, 1867.

Paris–Hamburg 1974 *Ossian*. Exhibition, Grand Palais, Paris, February 15–April 15, 1974; Hamburger Kunsthalle, May 8–June 26, 1974. Catalogue by Hélène Toussaint and Hanna Hohl. Paris, 1974. German ed., *Ossian und die Kunst um 1800*. Munich, 1974.

Paris–London–Philadelphia 1995–96 *Cézanne*. Exhibition, Grand Palais, Paris, September 25, 1995–January 7, 1996; Tate Gallery, London, February 8–April 28, 1996; Philadelphia Museum of Art, May 30–September 1, 1996. Catalogue by Françoise Cachin et al. Philadelphia, 1996.

Paris–Lorient 1997 *L'Inde de Gustave Moreau*. Exhibition, Musée Cernuschi, Paris, February 15–May 17, 1997; Musée de la Compagnie des Indes, Lorient, June 17–September 15, 1997. Catalogue. Paris, 1997.

Paris–New York 1983 *Manet, 1832–1883*. Exhibition, Grand Palais, Paris, April 22–August 8, 1983; The Metropolitan Museum of Art, New York, September 10–November 27, 1983. Catalogue by Françoise Cachin, Charles S. Moffett, Michel Melot, et al. New York, 1983.

Paris–New York 1991–92 *Georges Seurat, 1859–1891*. Exhibition, Grand Palais, Paris, April 9–August 12, 1991; The Metropolitan Museum of Art, New York, September 24, 1991–January 12, 1992. Catalogue by Robert L. Herbert, with Françoise Cachin et al. English ed., New York, 1991.

Paris–New York 1994–95 *Origins of Impressionism*. Exhibition, Grand Palais, Paris, April 19–August 8, 1994; The Metropolitan Museum of Art, New York, September 27, 1994–January 8, 1995. Catalogue by Gary Tinterow and Henri Loyrette. New York, 1994.

Paris–New York 1997–98 *Prud'hon, ou le Rêve du Bonheur*. Exhibition, Grand Palais, Paris, September 23, 1997–January 12, 1998; The Metropolitan Museum of Art, New York, March 2–June 7, 1998. Catalogue by Sylvain Laveissière. Paris, 1997. English ed., New York, 1998.

Paris–Ottawa 1976–77 *Puvis de Chavannes, 1824–1898*. Exhibition, Grand Palais, Paris, November 26, 1976–February 14, 1977; National Gallery of Canada, Ottawa, March 25–May 8, 1977. Catalogue by Louise d'Argencourt and Jacques Foucart, with contributions by Marie-Christine Boucher, Douglas Druick, and Aimée Brown Price. Ottawa, 1977.

Paris–Ottawa–New York 1988–89 *Degas*. Exhibition, Grand Palais, Paris, February 9–May 16, 1988; National Gallery of Canada, Ottawa, June 16–August 28, 1988; The Metropolitan Museum of Art, New York, September 27, 1988–January 8, 1989. Catalogue by Jean Sutherland Boggs, Douglas W. Druick, Henri Loyrette, Michael Pantazzi, and Gary Tinterow. New York, 1988.

Paris–Ottawa–San Francisco 1982–83 *Fantin-Latour*. Exhibition, Grand Palais, Paris, November 9, 1982–February 7, 1983; National Gallery of Canada, Ottawa, March 17–May 22, 1983; California Palace of the Legion of Honor, San Francisco, June 18–September 6, 1983. Catalogue by Douglas Druick and Michel Hoog. Ottawa, 1983.

Paris–Philadelphia 1998–99 *Delacroix, les dernières années*. Exhibition, Grand Palais, Paris, April 7–July 20, 1998; Philadelphia Museum of Art, September 10, 1998–January 3, 1999. Catalogue edited by Arlette Sérullaz, Vincent Pomarède, and Joseph J. Rishel. Paris, 1998.

Paris–Strasbourg–New York 2002–3 *Chassériau: Un autre romantisme*. Exhibition, Grand Palais, Paris, February 26–May 27, 2002; Musée des Beaux-Arts de Strasbourg, June 19–September 21, 2002; The Metropolitan Museum of Art, New York, October 21, 2002–January 5, 2003. Catalogue by Stéphane Guégan, Vincent Pomarède, Louis-Antoine Prat, with Bruno Chenique, Christine Peltre, and Peter Benson Miller. Paris and Strasbourg, 2002. English ed., New York, 2002.

Paris–Versailles 1989–90 *Jacques-Louis David, 1748–1825*. Exhibition, Musée du Louvre, Paris; Musée National du Château, Versailles, October 26, 1989–February 12, 1990. Catalogue edited by Antoine Schnapper and Arlette Sérullaz. Paris, 1989.

Paris–Washington–Berlin 1996–97 *Adolph Menzel, 1815–1905: Between Romanticism and Impressionism*. Exhibition, Musée d'Orsay, Paris, April 15–July 28, 1996; National Gallery of Art, Washington, D.C., September 15, 1996–January 5, 1997; Alte Nationalgalerie, Berlin, February 7–May 11, 1997. Catalogue edited by Claude Keisch and Marie Ursula Riemann-Reyher. New Haven, 1996.

Parker 1955 James Parker. *Jean Auguste Dominique Ingres, 1780–1867*. New York, 1955.

Pasadena 1990 *Vincent van Gogh: Painter, Printmaker, Collector*. Pasadena: Norton Simon Museum, 1990.

Passavant 1836 Johann David Passavant. *Tour of a German Artist in England.* 2 vols. London, 1836.

Passeron 1981 Roger Passeron. *Daumier.* Translated by Helga Harrison. New York, 1981.

Passez 1973 Anne-Marie Passez. *Adelaïde Labille-Guiard, 1749–1803: Biographie et catalogue raisonné de son oeuvre.* Paris, 1973.

Pater 1873 Walter Pater. *Studies in the History of the Renaissance.* London, 1873.

Pater 1948 Walter Pater. *Walter Pater: Selected Works.* Edited by Richard Aldington. New York, 1948.

Pauli 1913 Gustave Pauli. "David im Petit Palais." *Künst und Künstler* 11 (1913), pp. 29–33.

Pauli 1922 Gustav Pauli, ed. *Katalog der neueren Meister.* Hamburg: Hamburger Kunsthalle, 1922.

Pauwels 1991 Dirk Pauwels. "Raphael en de Fornarina (1842), een historisch genrestuk van Nicaise de Keyser (1813–1887), Kanttekeningen, theoretische en kritische reflecties bij een der 'parels' van het Antwerpse Salon van 1843." *Jaarboek van het Koninklijk Museum voor Schone Kunsten Antwerpen,* 1991, pp. 211–314.

Pauwels 1996 Dirk Pauwels. "*Roma 1817 / refait à Bruxelles 1834. De Heilige Familie* van François-Joseph Navez (1787–1869), een onuitgegeven compositieschets." *Koninklijk Museum voor Schone Kunsten Antwerpen: Jaarboek* 1996.

Pelletan 1878 Camille Pelletan. "L'exposition Daumier." *Le Rappel,* May 31, 1878.

Peltre 2001 Christine Peltre. *Théodore Chassériau.* Paris, 2001.

Peltre 2002 Christine Peltre. "Resurrection and Metamorphosis: Chassériau about 1900." In Paris–Strasbourg–New York 2002–3, pp. 48–54.

Pennell and Pennell 1908 Elizabeth Robins Pennell and Joseph Pennell. *The Life of James McNeill Whistler.* 2 vols. Philadelphia, 1908.

Pennell and Pennell 1921 Elizabeth Robins Pennell and Joseph Pennell. *The Whistler Journal.* Philadelphia, 1921.

Penny 1992 Nicolas Penny. *Catalogue of European Sculpture in the Ashmolean Museum.* Vol. 3, *British.* Oxford, 1992.

Penrose 2001 James F. Penrose, "Emmanuel Chabrier and French Musical Tradition." *New Criterion* 19, no. 5 (January 2001), pp. 29–36.

Pereire 1914 Alfred Pereire. *Le Journal des débats politiques et littéraires, 1814–1914.* Paris, 1914.

Perrier 1855a Charles Perrier. "Exposition universelle des beaux-arts, II, III: La peinture française—M. Ingres." *L'artiste,* ser. 5, 15 (May 27, 1855), pp. 43–46; (June 3, 1855), pp. 57–60.

Perrier 1855b Charles Perrier. "Exposition Universelle des Beaux-Arts, VII: La peinture française—Histoire." *L'artiste,* ser. 5, 15 (July 1, 1855), pp. 113–17.

Perrin 1860 Émile Perrin. "Raffet et Decamps." *Revue européene* 11 (1860), pp. 860–81.

Pescara 1983 *Blake e Dante.* Exhibition, Castello Gizzi di Torre de' Passeri, Pescara, September–October 1983. Catalogue edited by Corrado Gizzi. Milan, 1983.

Peters 1969 Heinz Peters, ed. *Kleine Museumsreise durch Amerika.* Berlin, 1969.

Peterson 1991 William S. Peterson. *The Kelmscott Press.* New York, 1991.

Petroz 1855 Pierre Petroz. "Exposition universelle des beaux-arts [II]." *La Presse,* May 30, 1855.

Petroz 1875 Pierre Petroz. *L'art et la critique en France depuis 1822.* Paris, 1875.

Philadelphia 1891 *Thomas B. Clarke Collection of American Pictures.* Exhibition, Pennsylvania Academy of the Fine Arts, Philadelphia, October 15–November 28, 1891. Catalogue. Philadelphia, 1891.

Philadelphia 1930 *American Painting in the Braun Collection.* Exhibition, Pennsylvania Museum of Art, Philadelphia, 1930.

Philadelphia–Chicago 1966–67 *Edouard Manet, 1832–1883.* Exhibition, Philadelphia Museum of Art, November 3–December 11, 1966; Art Institute of Chicago, January 13–February 19, 1967. Catalogue by Anne Coffin Hanson. Philadelphia, 1966.

Philadelphia–Detroit–Paris 1978–79 *The Second Empire, 1852–1870: Art in France under Napoleon III.* Exhibition, Philadelphia Museum of Art, October 1–November 26, 1978; Detroit Institute of Arts, January 15–March 18, 1979; Grand Palais, Paris, April 24–July 2, 1979. Catalogue by Victor Beyer, Kathryn B. Hiesinger, Jean-Marie Moulin, and Joseph Rishel. Philadelphia and Detroit, 1978.

Phillips 1894 Claude Phillips. "The Rushton Collection. The Modern Pictures—I, II." *Magazine of Art* 17 (1894), pp. 37–44, 97–101.

Phoenix–Huntington–New Britain 1982 *Tonalism: An American Experience.* Exhibition, Phoenix Art Museum, March 13–April 25, 1982; Heckscher Museum, Huntington, N.Y., May 8–June 6, 1982; New Britain Museum of American Art, New Britain, Conn., June 13–July 11, 1982. Catalogue by William H. Gerdts, Diana Dimondica Sweet, and Robert R. Preato. New York, 1982.

Physick 1970 John Frederick Physick. *The Wellington Monument.* London, 1970.

Pica 1908 Vittorio Pica. *Gl'Impressionisti francesi.* Bergamo, 1908.

Pica 1913 Vittorio Pica. *L'arte mondiale a Roma nel 1911.* Collezione di monografie illustrate, ser. esposizioni, 7. Bergamo, 1913.

Picon 1967 Gaëtan Picon. *Ingres: Biographical and Critical Study.* Translated by Stuart Gilbert. The Taste of Our Time, vol. 47. Geneva, 1967.

Picon 1980 Gaëtan Picon. *Jean-Auguste-Dominique Ingres.* Rev. ed. Translated by Stuart Gilbert. New York, 1980.

Picon 1991 Gaëtan Picon. *Ingres.* Translated by Stuart Gilbert. New ed. of Picon 1980. Geneva and New York, 1991.

Pietrangeli 1950 Carlo Pietrangeli. *Il Museo Napoleonico—Guida.* Rome, 1950.

Pietrangeli 1955 Carlo Pietrangeli. "Un autografo di Ingres nel museo napoleonico." *Bollettino dei musei comunali di Roma* 2, no. 3–4 (1955), pp. 47–51.

Pietrangeli 1960 Carlo Pietrangeli. *Museo Napoleonico "Primoli": Guida.* 2nd ed. Cataloghi dei musei comunali di Roma, ser. 1, no. 3. Rome, 1960.

Pignatti 1982 Terisio Pignatti. *Master Drawings: From Cave Art to Picasso.* Translated by Sylvia Mulcahy. New York, 1982.

Pillet 1819 [Fabien Pillet]; signed F. P. T. "Musée royal. Exposition des tableaux." *Journal de Paris,* September 4, 1819, pp. 2–3; October 4, 1819, pp. 2–3.

Pillet et al. 1801 Fabien Pillet et al. *La nouvelle lorgnette de spectacles.* Paris, year IX [1801].

Pinelli 1816 Bartolomeo Pinelli. *Nuova raccolta di cinquanta costumi pittoreschi incisi all'acqua forte.* Rome, 1816.

Pissarro 1980 *Camille Pissarro: Letters to His Son Lucien.* Edited by John Rewald, with the assistance of Lucien Pissarro. 4th ed. London, 1980.

Pissarro 1980–91 Camille Pissarro. *Correspondance de Camille Pissarro.* 5 vols. Edited by Janine Bailly-Herzberg. Paris, 1980–91.

Pissarro 1993 Joachim Pissarro. *Camille Pissarro.* New York, 1993.

Pissarro and Venturi 1939 Ludovic Rodo Pissarro and Lionello Venturi. *Camille Pissarro: Son art—son oeuvre.* 2 vols. Paris, 1939.

Pitman 1998 Dianne W. Pitman. *Bazille: Purity, Pose, and Painting in the 1860s.* University Park, Pa., 1998.

Pittsburgh 1899–1900 *The Fourth Annual Exhibition.* Exhibition, Carnegie Institute, Pittsburgh, November 2, 1899–January 1, 1900.

Pittsburgh–Washington 1987 *John La Farge.* Exhibition, Carnegie Museum of Art, Pittsburgh; National Museum of American Art, Smithsonian Institution, Washington, D.C. Catalogue, *John La Farge: Essays,* by Henry Adams et al. New York, 1987.

Pivar 1974 Stuart Pivar. *The Barye Bronzes.* Woodbridge, Eng., 1974.

Planche 1831 Gustave Planche. *Salon de 1831.* Paris, 1831.

Plazy 1991 Gilles Plazy. *Cezanne.* Paris, 1991.

Plimpton 1984 George Plimpton. *Fireworks.* Garden City, N.Y., 1984.

Podro 1998 Michael Podro. *Depiction.* New Haven, 1998.

Pointon 1989 Marcia Pointon. "The Artist as Ethnographer: Holman Hunt and the Holy Land." In *Pre-Raphaelites Re-viewed,* edited by Marcia Pointon, pp. 22–44. Manchester, 1989.

Pollock and Orton 1978 Griselda Pollock and Fred Orton. *Vincent van Gogh: Artist of His Time.* New York, 1978.

Pougetoux 1990 Alain Pougetoux. "David et ses portraits de Napoléon." *Société des Amis de Malmaison, Bulletin,* 1990, pp. 12–13.

Poulenc 1981 Francis Poulenc. *Emmanuel Chabrier.* Translated by Cynthia Jolly. London, 1981.

Poulson 1999 Christine Poulson. *The Quest for the Grail: Arthurian Legend in British Art, 1840–1920.* Manchester, Eng., and New York, 1999.

Powell 1993 Kirsten Hoving Powell. "Object, Symbol, and Metaphor: Rossetti's Musical Imagery." *Journal of Pre-Raphaelite Studies,* n.s., 2 (spring 1993), pp. 16–29.

Powell 2001 Kirsten Hoving Powell. "*Le Violon d'Ingres:* Man Ray's Variations on Ingres, Deformation, Desire and de Sade." In "Fingering Ingres," edited by Susan Siegfried and Adrian Rifkin, *Art History* 23, no. 5. Oxford and Malden, Mass., 2001.

Prat 1976 Louis-Antoine Prat. "Trois dessins inédits d'Ingres pour l'Âge d'Or." *Bulletin du Musée Ingres,* no. 40 (December 1976), pp. 29–33.

Prat 1988a Louis-Antoine Prat. *Musée du Louvre. Cabinet des Dessins. Inventaire général des dessins:*

École française. Dessins de Théodore Chassériau (1819–1856). 2 vols. Paris, 1988.

Prat 1988b Louis-Antoine Prat. Théodore Chassériau (1819–1856): Dessins conservés en dehors du Louvre. Paris, 1988.

Prat 2002 Louis-Antoine Prat. "The Indian and the Chinese, or the Two Byzantines." In Paris–Strasbourg–New York 2002–3, pp. 23–29.

Praz and Pavanello 1976 Mario Praz and Giuseppe Pavanello. L'opera completa del Canova. Classici dell'arte, 85. Milan, 1976.

"Pre-Raphaelites" 1943 "Pre-Raphaelites [from the Grenville Winthrop Bequest]." In Fogg Art Museum 1943, pp. 62–63.

Pressly 1981 William L. Pressly. The Life and Art of James Barry. New Haven, 1981.

Prettejohn 2000 Elizabeth Prettejohn. The Art of the Pre-Raphaelites. London, 2000.

Price 1972 Aimée Brown Price. "Puvis de Chavannes: A Study of the Easel Paintings and a Catalogue of the Painted Work." Ph.D dissertation, Yale University, New Haven, 1972.

Price 1991 Aimée Brown Price. "Puvis de Chavannes's Caricatures: Manifestoes, Commentary, Expressions." Art Bulletin 73 (March 1991), pp. 119–40.

Price 1995 Aimée Brown Price. "Pierre Puvis de Chavannes: Saint Genevieve as a Child in Prayer." Van Gogh Museum Journal 1995, pp. 118–33.

Prideaux 1970 Tom Prideaux. The World of Whistler: 1834–1903. New York, 1970.

Prinsep 1904 Valentine Prinsep. "A Chapter from a Painter's Reminiscences," 2 parts. Magazine of Art 27 (1904).

Prokoviev 1963 N. V. Prokoviev. Géricault. Moscow, 1963.

Proud 1999 Hayden Proud, ed. The Sir Edmund and Lady Davis Presentation: A Gift of British Art to South Africa in the Permanent Collections of the South African National Gallery, Cape Town. Capetown, 1999.

Prout's Neck 1936 Century Loan Exhibition as a Memorial to Winslow Homer. Exhibition, Prout's Neck Association, Prout's Neck, Maine, 1936. Catalogue. Prout's Neck, 1936.

Provost 1992 Paul Raymond Provost. "Burin to Brush: Harnett as an Artisan." In New York and other cities 1992–93, pp. 131–35.

Prud'hon colloque (1997) 2001 Pierre-Paul Prud'hon: Actes du colloque organisé au Musée du Louvre par le Service Culturel le 17 novembre 1997. Edited by Sylvain Laveissière. Paris, 2001.

Puvis de Chavannes 1899 Pierre Puvis de Chavannes. "Pensées et réflexions, extraites des lettres de Puvis de Chavannes." La revue encyclopédique, December 23, 1899, pp. 1080–82.

Puvis de Chavannes 1910 Pierre Puvis de Chavannes. "Lettres de Puvis de Chavannes," collected by Conrad de Mandach and L. Wehrlé. La revue de Paris 10 (December 15, 1910), pp. 673–92.

Pyne 1994 Kathleen Pyne. "Whistler and the Politics of the Urban Picturesque." American Art (National Museum of American Art, Washington, D.C.) 8, no. 3–4 (summer–fall 1994), pp. 60–77.

Quimper–Angers 2000–2001 Dessins d'artistes: Les plus beaux dessins français des musées d'Angers. Exhibition, Musée des Beaux-Arts de Quimper, November 22, 2000–February 26, 2001; Musée

Pincé, Angers, May–September 2001. Catalogue by André Cariou, Patrick Le Nouëne, and Sophie Bathélémy. Paris, Angers, and Quimper, 2000.

Radford 1899 Ernest Radford. Dante Gabriel Rossetti. London, 1899.

Radford 1908 Ernest Radford. Dante Gabriel Rossetti. London, 1908.

Radius and Camesasca 1968 Emilio Radius and Ettore Camesasca. L'opera completa di Ingres. Classici dell'arte, vol. 19. Milan, 1968.

Raleigh–Birmingham 1986–87 French Paintings from the Chrysler Museum. Exhibition, North Carolina Museum of Art, Raleigh, May 31–September 14, 1986; Birmingham (Ala.) Museum of Art, November 6, 1986–January 18, 1987. Catalogue by Jefferson C. Harrison. Norfolk, Va., 1986.

Ransy 1983 Jean Ransy. "Gustave Moreau." Bulletin de la classe des beaux-arts 65, no. 11 (1983), pp. 249–63.

Ratcliff 1982 Carter Ratcliff. John Singer Sargent. New York, 1982.

Ratliff 1992 Floyd Ratliff. Paul Signac and Color in Neo-Impressionism. Includes the first English translation of D'Eugène Delacroix au néo-impressionnisme, by Paul Signac; translated from the 3rd French ed. (Paris, 1921), by Willa Silverman. New York, 1992.

Raver 1998 Miki Raver. Listen to Her Voice: Women of the Hebrew Bible. San Francisco, 1998.

Rawson 1984 Philip Rawson. The Art of Drawing: An Instructional Guide. Englewood Cliffs, N.J., 1984.

Reade 1967 Brian Reade. Aubrey Beardsley. London, 1967.

Réau 1955–59 Louis Réau. Iconographie de l'art chrétien. 3 vols. in 6 parts. Paris, 1955–59.

Rebora 1989 Carrie Rebora. "Sir Thomas Lawrence's Benjamin West for the American Academy of the Fine Arts." American Art Journal 21, no. 3 (1989), pp. 19–47.

Redon 1923 Lettres d'Odilon Redon, 1878–1916, publiées par sa famille. Preface by Marius-Ary Leblond. Paris and Brussels, 1923.

Redon (1961) 1979 Odilon Redon. À soi-même: Journal (1867–1915); notes sur la vie, l'art et les artistes. Paris, 1961. New ed. Paris, 1979.

Redon 1987 Odilon Redon. Critiques d'art: Salon de 1868, Rodolphe Bresdin, Paul Gauguin. Précédées de Confidences d'artiste. Introduction and notes by Robert Coustet. Bordeaux, 1987.

Régamey 1926 Raymond Régamey. Géricault. Paris, 1926.

Registre d'inscription des productions 1814 Registre d'inscription des productions des artistes vivants présentées à l'exposition, Salon de 1814. Paris, Musée Royal, 1814.

Renaissance de l'art français 1921 Special issue: "L'Exposition Ingres." La renaissance de l'art français et des industries de luxe 4, no. 5 (May 1921).

Renan 1886 Ary Renan. "Gustave Moreau," 2 parts. Gazette des beaux-arts, ser. 2, 33 (May 1886), pp. 377–94; 34 (July 1886), pp. 35–51.

Renan 1899 Ary Renan. "Gustave Moreau." Gazette des beaux-arts, ser. 3, 22 (July 1, 1899), pp. 53–70.

Renan 1900 Ary Renan. Gustave Moreau. Paris, 1900.

Renard 1990 Jules Renard. Journal (1887–1910). Edited by Henry Bouillier. Paris, 1990.

Rennes 1988 De Poussin à Picasso: Dessins français du Musée des Beaux-Arts de Dijon. Exhibition, Musée

des Beaux-Arts de Rennes, March 19–June 5, 1988. Catalogue by Patrick Ramade. Rennes, 1988.

Renoir 1962 Jean Renoir. Pierre-Auguste Renoir, mon père. Paris, 1962.

"Renoir" 1989 "Renoir." Asahi Shinbun, Asahi Graph magazine (Tokyo), special issue on art (1989).

Renoir 1990 Auguste Renoir. Renoir by Renoir. Edited by Rachel Barnes. Exeter, 1990.

Renouvier 1863 Jules Renouvier. Histoire de l'art pendant la Révolution, considérée principalement dans les estampes. 2 vols. Paris, 1863.

Reutersvärd 1948 Oscar Reutersvärd. Monet, en konstnärshistorik. Stockholm, 1948.

Rewald 1944 John Rewald, ed. Degas: Works in Sculpture; a Complete Catalogue. Translated by John Coleman and Noel Moulton. London, 1944.

Rewald 1946 John Rewald. The History of Impressionism. New York, 1946.

Rewald 1961 John Rewald. The History of Impressionism. Rev. ed. New York, 1961.

Rewald 1969 John Rewald. "Choquet and Cézanne." Gazette des beaux-arts, ser. 6, 74 (July–August 1969), pp. 33–96.

Rewald 1990 John Rewald. Seurat: A Biography. New York, 1990.

Rey 1938–39 Robert Rey. "Les Préraphaélites." La Renaissance 21 (1938–39), pp. 15–24.

Riat 1906 Georges Riat. Gustave Courbet, Peintre. Paris, 1906.

Ribeiro 1988 Aileen Ribeiro. Fashion in the French Revolution. London, 1988.

Ribeiro 1995 Aileen Ribeiro. The Art of Dress. New Haven, 1995.

Ribeiro 1999 Aileen Ribeiro. Ingres in Fashion: Representations of Dress and Appearance in Ingres's Images of Women. New Haven, 1999.

Ribner 1994 Jonathan P. Ribner. "Chasseriau's juvenilia: Some Early Works by an 'Enfant du siècle.'" Zeitschrift für Kunstgeschichte 57, no. 2 (1994), pp. 219–38.

Rice 1997 Grantland S. Rice. The Transformation of Authorship in America. Chicago, 1997.

Rich 1935 Daniel Catton Rich. Seurat and the Evolution of "La Grande Jatte." Chicago, 1935.

Richards 1957 Louise S. Richards. "Prints of Edouard Manet." Bulletin of the Cleveland Museum of Art 44 (October 1957), pp. 187–91.

Richardson 1944 E[dgar] P[reston] Richardson. "Recent Acquisitions of American Collections: Ingres' Self-Portrait in the Fogg Museum." Art Quarterly 7 (1944), pp. 66–67.

Richardson 1947 Edgar Preston Richardson. "'Nocturne in Black and Gold: The Falling Rocket' by Whistler." Art Quarterly 10, no. 1 (winter 1947), pp. 3–12.

Richardson 1958 John Richardson. Edouard Manet: Paintings and Drawings. London, 1958.

Richardson 1991– John Richardson. A Life of Picasso. 2 vols. to date. New York, 1991– .

Richman 1975 Michael Richman. "Daniel Chester French (1850–1931)." In Cambridge, Mass., 1975–76b, pp. 219–23.

Richman 1977 Michael Richman, "The Man Who Made John Harvard." Harvard Magazine 80, no. 1 (September–October 1977), pp. 46–51.

Riding and Riding 2000 Christine Riding and Jacqueline Riding. *The Houses of Parliament: History, Art, Architecture*. London, 2000.

Rifkin 2000 Adrian Rifkin. *Ingres, Then and Now*. London and New York, 2000.

Rilke 1913 Rainer Maria Rilke. *Auguste Rodin*. Leipzig, 1913. Reprint of the 1903 ed. and "Auguste Rodin," *Kunst und Künstler* 1 (October 1907), pp. 28–39.

Rilke 1928 Rainer Maria Rilke. *Auguste Rodin*. Translated by Maurice Betz. Paris, 1928. Reprint of the 1903 ed. and "Auguste Rodin," *Kunst und Künstler* 1 (October 1907), pp. 28–39.

Rilke 1979 Rainer Maria Rilke. *Rodin*. Translated by Robert Firmage. Salt Lake City, 1979.

Riopelle 1999 Christopher Riopelle. "The Early Nineteenth Century." In *The Critics' Choice: 150 Masterpieces of Western Art*, edited by Marina Vaizey et al., chap. 7. New York, 1999.

Riotor 1899 Léon Riotor. "Auguste Rodin." *La revue populaire des beaux-arts*, April 8, 1899, p. 211.

Rivière 1921 Georges Rivière. *Renoir et ses amis*. Paris, 1921.

Rizzoni and Minervino 1976 Gianni Rizzoni and Fiorella Minervino. *Ingres*. I geni dell'arte. Milan, 1976.

Robaut 1885 Alfred Robaut. *L'oeuvre complète de Eugène Delacroix: Peintures, dessins, gravures, lithographies*. With the collaboration of Ernest Chesneau and Fernand Calmettes. Paris, 1885.

Robaut (1885) 1969 Alfred Robaut. *L'oeuvre complète de Eugène Delacroix: Peintures, dessins, gravures, lithographies*. With the collaboration of Ernest Chesneau and Fernand Calmettes. Reprint of 1885 ed. New York, 1969.

Roberts 1974 Helene E. Roberts. "The Dream World of Dante Gabriel Rossetti." *Victorian Studies* 17, no. 4 (June 1974), pp. 371–94.

Roberts 1989 Warren Roberts. *Jacques-Louis David, Revolutionary Artist: Art, Politics and the French Revolution*. Chapel Hill, N.C., 1989.

Robertson 1931 W. Graham Robertson. *Time Was: The Reminiscences of W. Graham Robertson*. London, 1931.

Robertson 1978 David Robertson. *Sir Charles Eastlake and the Victorian Art World*. Princeton, 1978.

Robinson 1892 Lionel Robinson. "The Leyland Collection." *Art Journal* 1892, pp. 134–38.

Rochester–Chicago–Washington–Williamstown 1990–91 *Winslow Homer in the 1890s: Prout's Neck Observed*. Exhibition, Memorial Art Gallery of the University of Rochester, August 18–October 21, 1990; Terra Museum of American Art, Chicago, November 17, 1990–January 13, 1991; National Museum of American Art, Smithsonian Institution, Washington, D.C., February 8–May 27, 1991; Sterling and Francine Clark Art Institute, Williamstown, Mass., June 22–September 2, 1991. Catalogue by Philip C. Beam et al. New York, 1990.

Rodgers 1996 David Rodgers. *Rossetti*. London, 1996.

Rodin 1907 Auguste Rodin. "Tolstoï et Shakespeare." *Les lettres* (Paris), January 15, 1907.

Rodin 1911 Auguste Rodin. *L'art: Entretiens réunis par Paul Gsell*. Paris, 1911. Reprinted, 1986.

Rodin 1985–92 Auguste Rodin. *Correspondance de Rodin, 1860–1917*. 4 vols. Edited and annotated by Alain Beausire, Florence Cadouot, Hélène Pinet, and Frédérique Vincent. Paris, 1985–92.

Roe 1953 Albert S. Roe. *Blake's Illustrations to the Divine Comedy*. Princeton, 1953.

Roger-Marx 1931 Claude Roger-Marx. *Seurat*. Les artistes nouveaux. Paris, 1931.

Roger-Marx 1949 Claude Roger-Marx. *Ingres*. Lausanne, 1949.

Rogers 1963 Millard F. Rogers. "The Salutation of Beatrice, by Dante Gabriel Rossetti." *Connoisseur* 153 (July 1963), pp. 180–81.

Rogers 1970 A[nn] W. R[ogers]. "An Introduction to Three Sketchbooks from the Institute's Collection." *Minneapolis Institute of Arts Bulletin* 59 (1970), pp. 59–67.

Rohan 1995 Tim Rohan. "The Picture of Grenville Winthrop." Seminar paper, FA 207, Harvard University, Cambridge, Mass., spring 1995, Harvard University Art Museums Archives.

Rolnik 1985 Marc Rolnik. "Hunt's Pictorial Unity, 1870–1905." In *Ladies of Shalott: A Victorian Masterpiece and Its Contexts*, pp. 37–49. Providence, 1985.

Romanet 1926 Fernand Romanet. "Gustave Moreau." *La revue hebdomadaire*, April 1926, p. 324.

Rome 1911 *International Fine Arts Exhibition: British Section*. Exhibition, International Society of Sculptors, Painters, and Gravers, Rome, 1911. Catalogue introduction by J. Comyns Carr. London, 1911.

Rome 1968 *Ingres in Italia: 1806–1824, 1835–1841*. Exhibition, Accademia di Francia, Villa Medici, Rome, February 26–April 28, 1968. Catalogue by Jacques Foucart, Hans Naef, and Daniel Ternois. Rome, 1968.

Rome 1979–80 *Gericault*. Exhibition, Accademia di Francia, Villa Medici, Rome, November 1979–January 1980. Catalogue by Philippe Grunchec. Rome, 1979.

Rome 1981–82 *David e Roma*. Exhibition, Accademia di Francia, Villa Medici, Rome, December 1981–February 1982. Catalogue by Régis Michel. Rome, 1981.

Rome 1996–97 *Gustave Moreau e l'Italia*. Exhibition, Accademia di Francia, Villa Medici, Rome, October 23, 1996– January 7, 1997. Catalogue by Geneviève Lacambre. Milan, 1996.

Rome–Paris 1993–94 *Le retour à Rome de Monsieur Ingres: Dessins et peintures*. Exhibition, Accademia di Francia, Villa Medici, Rome, December 14, 1993–January 30, 1994; Espace Electra, Paris, March 1–April 3, 1994. Catalogue by Georges Vigne. Rome, 1993.

Roos 1986 Jane Mayo Roos. "Rodin's *Monument to Victor Hugo*: Art and Politics in the Third Republic." *Art Bulletin* 68 (December 1986), pp. 632–56.

Roos 1996 Jane Mayo Roos. *Early Impressionism and the French State (1866–1874)*. Cambridge, 1996.

Rosenberg 1959 Jakob Rosenberg. *Great Draughtsmen from Pisanello to Picasso*. Cambridge, Mass., 1959.

Rosenberg 1974 Jakob Rosenberg. *Great Draughtsmen from Pisanello to Picasso*. Rev. ed. New York, 1974.

Rosenberg 2000 Pierre Rosenberg. *From Drawing to Painting: Poussin, Watteau, Fragonard, David, and Ingres*. Princeton, 2000.

Rosenberg 2001 Pierre Rosenberg. "David a Bologna, David e Bologna." In *L'intelligenza della passione: Scritti per Andrea Emiliani*, pp. 497–512. Bologna, 2001.

Rosenberg and Prat 2002 Pierre Rosenberg and Louis-Antoine Prat. *Jacques-Louis David: Catalogue raisonné des dessins*. 2 vols. Milan, 2002.

Rosenblum 1967a Robert Rosenblum. "The *Exemplum Virtutis*." In *Transformations in Late Eighteenth Century Art*, pp. 50–106. Princeton, 1967.

Rosenblum 1967b Robert Rosenblum. *Jean-Auguste-Dominique Ingres*. New York, 1967.

Rosenblum (1956) 1976 Robert Rosenblum. *The International Style of 1800: A Study in Linear Abstraction*. New York, 1976. Ph.D. dissertation, New York University, Institute of Fine Arts, 1956.

Rosenthal 1900 Léon Rosenthal. *La peinture romantique: Essai sur l'evolution de la peinture francaise*. Paris, 1900.

Rosenthal [1905] Léon Rosenthal. *Géricault*. Paris, n.d. [1905].

Rosenthal 1914 Léon Rosenthal. *De Romanticism au Réalisme: Essai sur l'évolution de la peinture en France de 1830 à 1848*. Paris, 1914.

Rosenthal 1924a Léon Rosenthal. "L'exposition du centenaire de Géricault." *L'amour de l'art* 5, no. 6 (June 1924), pp. 203–6.

Rosenthal 1924b Léon Rosenthal. "Géricault et notre temps." *L'amour de l'art* 5, no. 1 (January 1924), pp. 12–14.

Roskill 1966 Mark Roskill. "Van Gogh's 'Blue Cart' and His Creative Process." *Oud Holland* 81 (1966), pp. 3–19.

Ross 1908 Robert Ross. "Art in America. Rossetti: An Observation." *Burlington Magazine* 13 (1908), pp. 116–23.

Ross 1909 Robert Ross. *Aubrey Beardsley*. London, 1909.

"Ross Residence" 1926 "The Residence of Commander J. K. L. Ross, Peel Street, Montreal." *Canadian Homes and Gardens* 3 (September 1926), pp. 29–32.

Rossetti 1862 William M. Rossetti. Review. *Fraser's Magazine*, July 1862, p. 71.

Rossetti 1874 William M. Rossetti. In *The Builder*, July 9, 1874.

Rossetti 1889 William M. Rossetti. *Dante Gabriel Rossetti as Designer and Writer*. London and New York, 1889.

Rossetti 1895 Dante Gabriel Rossetti. *Dante Gabriel Rossetti, His Family Letters; with a Memoir*. 2 vols. Edited by William M. Rossetti. Boston, 1895.

Rossetti 1896 William M. Rossetti. "A Pre-Raphaelite Collection." *Art Journal* (London), n.s., 58 (May 1896), pp. 129–34. Reprinted in Rossetti 1900a.

Rossetti 1897 Dante Gabriel Rossetti. *Letters of Dante Gabriel Rossetti to William Allingham, 1854–1870*. Edited by George B. Hill. London, 1897.

Rossetti 1900a William M. Rossetti. *Fifty Years of Art, 1849–1899*. London, 1900.

Rossetti 1900b William M. Rossetti, ed. *Pre-Raphaelite Diaries and Letters*. London, 1900.

Rossetti 1901 Gabriele Rossetti. *A Versified Autobiography*. Translated by William M. Rossetti. London, 1901.

Rossetti 1902 Helen M. Rossetti. "The Life and Work of Dante Gabriel Rossetti." *Art Journal*, Easter Annual (1902).

Rossetti 1903 William M. Rossetti, comp. *Rossetti Papers, 1862–1870*. London, 1903.

Rossetti 1911 Dante Gabriel Rossetti. *The Works of Dante Gabriel Rossetti*. Rev. ed. Edited and with notes by William M. Rossetti. London, 1911.

Rossetti 1965–67 Dante Gabriel Rossetti. *Letters of Dante Gabriel Rossetti*. Edited by Oswald Doughty and John R. Wahl. 4 vols. Oxford, 1965–67.

Rossetti 1992 *Dante Gabriel Rossetti*. Edited by Tanita Hiroyuki. Tokyo, 1992.

Rossetti 1999 Dante Gabriel Rossetti. *Collected Writings*. Selected and edited by Jan Marsh. London, 1999.

Rossi Bortolatto 1978 Luigina Rossi Bortolatto, ed. *L'opera completa di Claude Monet, 1870–1889*. New ed. Milan, 1978.

Rostrup 1964 Haavard Rostrup. "Den huide kat." *Meddelelser fra Ny Carlsberg Glyptotek*, no. 21 (1964), pp. 27–41.

Rothenstein 1931–32 William Rothenstein. *Men and Memories: Recollections of William Rothenstein*. 2 vols. New York, 1931–32.

Rotterdam 1900–1901 *Van Gogh Teekeningen*. Exhibition, Rotterdamsche Kunstkring, 1900–1901.

Rouart and Wildenstein 1975 Denis Rouart and Daniel Wildenstein. *Édouard Manet: Catalogue raisonné*. 2 vols. Lausanne and Paris, 1975.

Rouen 1911 *Millenaire normand*. Exhibition, Musée des Beaux-Arts, Rouen, 1911.

Rouen 1981–82 *Géricault: Tout l'oeuvre gravé et pièces en rapport*. Exhibition, Musée des Beaux-Arts, Rouen, November 28, 1981–February 28, 1982. Catalogue. Rouen, 1981.

Rouen 2000 *Gustave Moreau: Diomède dévoré par ses chevaux*. Exhibition, Musée des Beaux-Arts, Rouen, April 2–July 3, 2000. Catalogue by Claude Pétry-Parisot and Geneviève Lacambre, with Marie-Claude Coudert. Paris, 2000.

Roux 1996 Paul de Roux. *Ingres*. Paris, 1996.

Rowlands 1968 John Rowlands. "Treasures of a Connoisseur: The César de Hauke Bequest." *Apollo* 88 (1968), pp. 42–50.

Rowley 1911 Charles Rowley. *Fifty Years of Work without Wages (Laborare est Orare)*. London and New York, 1911.

Roy 1972 Claude Roy. *Daumier. Le goût de notre temps*. Geneva, 1971.

Rubin 1970 James H. Rubin. "Seurat and Theory: The Near-Identical Drawings of the 'Café-Concert.'" *Gazette des beaux-arts*, ser. 6, 76 (October 1970), pp. 237–43.

Rubin 2000 Patricia Rubin. "Bernard Berenson, Villa I Tatti, and the Visualization of the Italian Renaissance." In *Gli Anglo-Americani a Firenze: Idea e costruzione del Rinascimento; Atti del Convegno, Georgetown University, Villa Le Balze, Fiesole, 19–20 giugno 1997*, edited by Marcello Fantoni. Florence, 2000.

Rupprecht 1992 Carol Schreier Rupprecht. "Dreams and Dismemberment: Transformation of the Female Body in Dante's Purgatorio." *Quadrant* 25, no. 2 (fall 1992), pp. 43–61.

Ruskin 1854 John Ruskin. *Giotto and His Works in Padua; Being an Explanatory Notice of the Series of Woodcuts Executed for the Arundel Society after the Frescoes in the Arena Chapel*. London, 1854.

Ruskin 1884 John Ruskin. "Realistic Schools of Painting: D. G. Rossetti and W. Holman Hunt." In *The Art of England: Lectures Given in Oxford*, lecture 1, pp. 1–36. Sunnyside, Kent, 1884.

Ruskin 1903 John Ruskin. *Modern Painters*. Vol. 1. *The Works of John Ruskin*, vol. 3, edited by E. T. Cook and Alexander Wedderburn. London, 1903.

Russell 1965 John Russell. *Seurat*. London, 1965.

Russell 1983 Douglas A. Russell. *Costume History and Style*. Englewood Cliffs, N.J., 1983.

Russell 1996 Ruth Russell. *Pastimes: The Context of Contemporary Leisure*. Madison, Wis., 1996.

Sachko MacLeod 1996 Dianne Sachko MacLeod. *Art and the Victorian Middle Class: Money and the Making of Cultural Identity*. New York, 1996.

Sachko MacLeod 1996a Dianne Sachko MacLeod. "The 'Identity' of Pre-Raphaelite Patrons." In *Re-framing the Pre-Raphaelites: Historical and Theoretical Essays*, edited by E. Harding, pp. 7–26. Aldershot, Hants., 1996.

Sachs 1951 Paul J. Sachs. *The Pocket Book of Great Drawings*. New York, 1951.

Sachs 1965 Samuel Sachs II. "Prud'hon's *L'union de l'Amour et de l'Amitié*: A Neo-Classical Allegory." *Minneapolis Institute of Art Bulletin* 54 (1965), pp. 4–18.

Saco 1957 Maria Luisa Saco. "Joyas del arte en los museos norteamericanos." *Cultura Peruana* (Lima) 17, no. 105 (1957).

Sadleir 1924 Michael Sadleir. *Daumier, the Man and the Artist*. London, 1924.

Saglio 1857 Edmond Saglio. "Un nouveau tableau de M. Ingres, liste complète de ses oeuvres." *La correspondance littéraire*, February 5, 1857, pp. 77–79.

Sagne 1991 Jean Sagne. *Géricault*. Paris, 1991.

Saint Louis–Philadelphia–Minneapolis 1967 *Drawings by Degas*. Exhibition, City Art Museum, Saint Louis, January 20–February 26, 1967; Philadelphia Museum of Art, March 10–April 30, 1967; Minneapolis Society of Fine Arts, May 18–June 25, 1967. Catalogue by Jean Sutherland Boggs. Saint Louis, 1966.

Salinger 1932 Margaretta Salinger. "White Plumes with Variations." *Parnassus* 4 (December 1932), pp. 9–10.

Salter 1976 Elizabeth Salter. *The Lost Impressionist*. London, 1976.

Samuels 1979 Ernest Samuels. *Bernard Berenson: The Making of a Connoisseur*. Cambridge, Mass., 1979.

Sanchez and Seydoux 1998 Pierre Sanchez and Xavier Seydoux. *Les estampes de* La Gazette des beaux-arts *(1859–1933)*. Paris, 1998.

Sandoz 1968 Marc Sandoz. "Théodore Chassériau et la peinture des Pays-Bas." *Bulletin des Musées Royaux des Beaux-Arts de Belgique* (Brussels) 17, no. 3–4 (1968), pp. 172–90.

Sandoz 1974 Marc Sandoz. *Théodore Chassériau. Catalogue raisonné des peintures et estampes*. Paris, 1974.

Sandoz 1986 Marc Sandoz. *Portraits et visages dessinés par Théodore Chassériau*. Paris, 1986.

Sandström 1955 Sven Sandström. *Le Monde Imaginaire d'Odilon Redon*. London, 1955.

San Francisco 1972 *The Color of Mood: American Tonalism, 1880–1910*. Exhibition, California Palace of the Legion of Honor, San Francisco, January 22–April 2, 1972. Catalogue by Wanda M. Corn. San Francisco, 1972.

San Francisco 1975 *Rodin Graphics: A Catalogue Raisonné of Drypoints and Book Illustrations*. Exhibition, California Palace of the Legion of Honor, San Francisco, June 14–August 10, 1975. Catalogue by Victoria Thorson. San Francisco, 1975.

San Francisco 1989 *Géricault, 1791–1824*. Exhibition, Fine Arts Museums of San Francisco, January 28–March 26, 1989. Catalogue by Lorenz E. A. Eitner and Steven A. Nash. San Francisco, 1989.

Sarlin sale 1918 *Catalogue des Tableaux Modernes . . . composant la Collection Louis Sarlin*. Sale, Galerie Georges Petit, Paris, March 2, 1918.

Sasaki 1980 Hideya Sasaki. *Shimwa: Ninfu to yōsei / Mythologie: Fées et nymphes*. Tokyo, 1980.

Sass 1960 Else Kai Sass. "Ingres' Drawing of the Family of Lucien Bonaparte." *Burlington Magazine* 102 (1960), pp. 18–21.

Sass 1963–65 Else Kai Sass. *Thorvaldsens Portraetbuster*. 3 vols. Copenhagen, 1963–65.

Saunier 1911 Charles Saunier. "Exposition Ingres." *Les arts* 10 (July 1911), pp. 2–32.

Saunier 1925a Charles Saunier. *Barye*. Paris, 1925.

Saunier 1925b Charles Saunier. "Les dessins de David." *L'art vivant*, no. 24 (December 15, 1925), pp. 15–16.

Saunier 1926 Charles Saunier. *Louis Barye*. Translated by Wilfrid S. Jackson. London, 1926.

Saunier 1929 C[harles] Saunier. "Le dessin de Louis David." *Le dessin*, no. 5 (September 1929), p. 413.

Sayre 1936 Ann Hamilton Sayre. "The Complete Work of John La Farge at the Metropolitan." *Art News* 34, no. 26 (March 28, 1936), pp. 5–6, 10.

Saywell 1998 Edward Saywell. "Guide to Drawing Terms and Techniques." *Harvard University Art Museums Bulletin* 6, no. 2 (fall 1998), pp. 30–39.

Schapiro n.d. Meyer Schapiro. *Vincent*. Paris, n.d.

Schapiro 1950 Meyer Schapiro. *Vincent van Gogh*. New York, 1950.

Schapiro 1978 Meyer Schapiro. "Seurat." In *Modern Art, 19th and 20th Centuries: Selected Papers*, pp. 101–9. New York, 1978.

Scharf 1968 Aaron Scharf. *Art and Photography*. London, 1968.

Scharf 1969 Aaron Scharf. *Art and Photography*. Baltimore, 1969.

Scheffler 1907 Karl Scheffler. "Chronik." *Kunst und Künstler* 6 (November 1907), pp. 86–90.

Scheffler 1920–21 Karl Scheffler. "Die Sammlung Oskar Schmitz in Dresden." *Kunst und Künstler* 19 (1920–21), pp. 178–91.

Scheffler 1949 Karl Scheffler. *Ingres*. Translated by Ervino Pocar. Bern, 1949.

Scheiwiller 1936 Giovanni Scheiwiller. *Honoré Daumier*. Milan, 1936.

Scherer 1945 Margaret R. Scherer. *About the Round Table*. New York, 1945.

Schiff 1973 Gert Schiff. *Johann Heinrich Füssli*. Zürich, 1973.

Schiff 1983 Gert Schiff. *Picasso: The Last Years, 1963–1973*. New York, 1983.

Schlagenhauff 1991 *Adolph Menzel: Works in Harvard Collections*. Cambridge, Mass.: Busch-Reisinger Museum, Harvard University Art Museums, 1991.

Schlegel 1799 August Wilhelm von Schlegel. "Über Zeichnungen zu Gedichten und John Flaxman's Umrisse." *Athenaeum: Eine Zeitschrift von August Wilhelm und Friedrich Schlegel* (Berlin) 2, part 1 (1799), pp. 193–246.

Schleinitz 1901 Otto von Schleinitz. *Burne-Jones*. Kunstler-Monographien 55. Bielefeld and Leipzig, 1901.

Schlenoff 1956 Norman Schlenoff. *Ingres: Ses sources littéraires*. Paris, 1956.

Schlenoff 1959 Norman Schlenoff. "Ingres and the Classical World." *Archaeology* 12 (March 1959), pp. 16–25.

Schlenoff 1967 Norman Schlenoff. "Ingres Centennial at the Fogg Museum." *Burlington Magazine* 109 (June 1967), pp. 376–79.

Schmoll gen. Eisenwerth 1983 J. Adolf Schmoll gen. Eisenwerth. *Rodin-Studien: Personlichkeit, Werke, Wirkung, Bibliographie*. Munich, 1983.

Schnapper 1980 Antoine Schnapper. *David, témoin de son temps*. Paris, 1980.

Schnapper 1982 Antoine Schnapper. *David*. Translated by Helga Harrison. New York, 1982.

Schnapper 1988 Antoine Schnapper. "À propos de David et des martyrs de la Révolution." In *Les images de la Révolution française: Actes du colloque des 25–27 oct. 1985 tenu en Sorbonne*, edited by Michel Vovelle, pp. 109–17. Paris, 1988.

Schnapper 1989 Antoine Schnapper. "Les portraits de Napoleon pour Gênes et pour Cassel (1805–1808)." In Paris–Versailles 1989–90, pp. 433–36.

Schneider 1984 Pierre Schneider. *Matisse*. Translated by Michael Taylor and Bridget Strevens Romer. New York, 1984.

Schneider 1991a Michel Schneider. "Géricault: La chair du tableau." *Connaissance des arts*, no. 476 (October 1991), pp. 50–59.

Schneider 1991b Michel Schneider. *Un rêve de pierre: Le Radeau de la Méduse, Gericault*. Paris, 1991.

Schnell 1980 Werner Schnell. *Der Torso als Problem der modernen Kunst*. Berlin, 1980.

Schulte 1986 Edvige Schulte. *Dante Gabriel Rossetti: Vita, arte, poesia*. Naples, 1986.

Schuré 1904 Édouard Schuré. *Précurseurs et révoltés*. Paris, 1904.

Schwabe 1948 Randolph Schwabe. *Degas: The Draughtsman*. London, 1948.

Scott 1991 Barbara Scott. "Letter from Paris: The Artist in His Studio." *Apollo* 134 (November 1991), pp. 359–60.

Scotti 1878 G. B. Rossi Scotti. *Guida illustrata di Perugia*. Perugia, 1878.

Seattle and other cities 1995–96 *Visions of Love and Life: Pre-Raphaelite Art from the Birmingham Collection*. Exhibition, Seattle Art Museum; Delaware Art Museum, Wilmington; Museum of Fine Arts, Houston; High Museum of Art, Atlanta; Birmingham Museums and Art Gallery. Catalogue edited by Stephen Wildman. Seattle, 1995.

Secrétan sale 1889 *Catalogue de 17 tableaux anciens . . . de la collection Secrétan*. Sale, Christie, Manson and Woods, London, July 13, 1889.

Seitz 1960 William Chapin Seitz. *Claude Monet*. New York, 1960.

Seligman 1947 Germain Seligman. *The Drawings of Georges Seurat*. New York, 1947. First published 1946.

Seligman 1953 Germain Seligman. Review of Berger 1952. *Art Bulletin* 35 (December 1953), pp. 320–26.

Seligman 1961 Germain Seligman. *Merchants of Art, 1880–1960: Eighty Years of Professional Collecting*. New York, 1961.

Sells 1986 Christopher Sells. "New Light on Géricault, His Travels and His Friends, 1816–23." *Apollo* 123 (June 1986), pp. 390–95.

Selz 1978 Jean Selz. *Gustave Moreau*. Paris, 1978.

Selz 1979 Jean Selz. *Gustave Moreau*. Translated by Alice Sachs. New York, 1979.

Sertillanges n.d. *See* Sertillanges 1917.

Sertillanges 1917 Abbé Antonin Gilbert Sertillanges. *Sainte Geneviève*. L'art et les saintes, 2. Paris, n.d. [1917].

Sérullaz 1963 *See* Moskowitz and Sérullaz 1962.

Sérullaz 1980 Arlette Sérullaz. "Un carnet de croquis de Jacques-Louis David." *La revue du Louvre*, no. 2 (1980), pp. 102–8.

Sérullaz 1991 Arlette Sérullaz. *Dessins de Jacques-Louis David, 1748–1825*. Musée du Louvre, Cabinet des dessins, Inventaire général des dessins: École française. Paris, 1991.

Sérullaz et al. 1984 Maurice Sérullaz, with Arlette Sérullaz, Louis-Antoine Prat, and Claudine Ganeval. *Dessins d'Eugène Delacroix*. 2 vols. Musée du Louvre, Cabinet des dessins, Inventaire général des dessins: École française. Paris, 1984.

Servières 1912 Georges Servières. *Emmanuel Chabrier, 1841–1894*. Paris, 1912.

Sevely 1987 Josephine Lowndes Sevely. *Eve's Secrets: A New Theory of Female Sexuality*. New York, 1987.

Sewell 1994 William Hamilton Sewell. *A Rhetoric of Bourgeois Revolution: The Abbé Sieyes and "What is the Third Estate?"* Durham, N.C., 1994.

Sewter 1974–75 A. Charles Sewter. *The Stained Glass of William Morris and His Circle*. 2 vols. New Haven, 1974–75.

Shapiro 1985 Michael Edward Shapiro. *Bronze Casting and American Sculpture, 1850–1900*. Newark, London, and Toronto, 1985.

Sharp 1882 William Sharp. *Dante Gabriel Rossetti*. London, 1882.

Shaw 1998 Teresa Shaw. *The Burden of the Flesh*. Minneapolis, 1998.

Shefer 1987 Elaine Shefer. "A Rossetti Portrait: Variation on a Theme." *Arts in Virginia* 27, no. 1–3 (1987), pp. 2–15.

Shelton 1997 Andrew Carrington Shelton. "From Making History to Living Legend: The Mystification of M. Ingres (1834–1855)." Ph.D. dissertation, Institute of Fine Arts, New York University, 1997.

Shelton 2001 Andrew Carrington Shelton. "Art, Politics, and the Politics of Art: Ingres's *Saint Symphorien* at the 1834 Salon." *Art Bulletin* 83 (December 2001), pp. 711–39.

Sherman 1933 Frederick Fairchild Sherman. "Some Early Paintings by John S. Sargent." *Art in America* 21 (1932–33), pp. 94–100.

Shiff 1984 Richard Shiff. "Representation, Copying and the Technique of Originality." *New Literary History* 15, no. 2 (winter 1984), pp. 333–63.

Shipp 1956 Horace Shipp. "Ingres and the Angelica Theme." *Apollo* 63 (January 1956), pp. 37–39.

Shirley 1940 Andrew Shirley. *Bonington*. London, 1940.

Shoolman and Slatkin 1950 Regina Shoolman and Charles E. Slatkin. *Six Centuries of French Master Drawings in America*. New York, 1950.

Shrewsbury 1918 H. W. Shrewsbury. *The Visions of an Artist*. London, 1918.

Sias n.d. Azariah B. Sias. "A Genealogy of the Sias Family." N.p.: Privately printed, n.d. Published as *The Sias Family in America, 1677 to 1952*. Orlando, Fla., 1953.

Sickert 1908 Bernhard Sickert. *Whistler*. London, 1908.

Siewert 1995 John Siewert. "Suspended Spectacle: Whistler's Falling Rocket and the Nocturnal Subject." *Bulletin of the Detroit Institute of Arts* 69 (1995), pp. 36–48.

Sieyès 1789 Emmanuel Joseph Sieyès. *Vues sur les moyens d'exécution dont les représentans de la France pourront disposer en 1789*. 2nd ed. N.p., 1789.

Silber 1987 Evelyn Silber. *Sculpture in the Birmingham Museums and Art Gallery: A Summary Catalog*. Birmingham, 1987.

Silvestre 1856 Théophile Silvestre. *Histoire des artistes vivants français et étrangers: Études d'après nature*. Paris, 1856.

Simmons and Winer 1977 Seymour Simmons III and Marc S. A. Winer. *Drawing: The Creative Process*. Englewood, N.J., 1977.

Simon 1990 Alfred Simon. *Toulouse-Lautrec*. Les classiques de La Manufacture. Paris, 1990.

Simon 1996 Robert Simon. "Géricault and the *fait divers*." In Michel 1996, vol. 1, pp. 255–69.

Simpson 1980 Marc A. Simpson. "Two Recently Discovered Paintings by John Singer Sargent." *Yale University Art Gallery Bulletin* 37–38 (fall 1980), pp. 6–11.

Simpson 1998 Judith W. Simpson. *Creating Meaning through Art: Teacher as Choicemaker*. Upper Saddle River, N.J., 1998.

Sinker 1962 Madge Sinker. "Sir Galahad." *The Lady*, May 17, 1962.

"Sixteen Reproductions" 1944 "Sixteen Reproductions." *Harvard Alumni Bulletin* 46 (January 8, 1944), pp. 217–20.

Skrapits 1992 Joseph C. Skrapits. "Shades of Gray: The Drawings of Georges Seurat." *American Artist* 56, no. 596 (March 1992), pp. 44–49, 71.

Slayman 1970 James H. Slayman. "The Drawings of Pierre-Paul Prud'hon: A Critical Study." Ph.D. dissertation, University of Wisconsin, Madison, 1970.

Sloane 1951 Joseph C. Sloane. *French Painting between the Past and the Present*. Princeton, 1951.

Smith 1903 H. Clifford Smith. "The Full and True Story of the Portland Vase." *The Magazine of Art* 27 (1903), pp. 309–12.

Smith 1985 Kathryn A. Smith. "The Post-Raphaelite Sources of Pre-Raphaelite Painting." *Journal of Pre-Raphaelite Studies* 5, no. 2 (May 1985), pp. 41–53.

Smith 1996 Alison Smith. *The Victorian Nude*. Manchester and New York, 1996.

Snodgrass 1995 Chris Snodgrass. *Aubrey Beardsley: Dandy of the Grotesque.* New York, 1995.

Somville 1991 Pierre Somville. "Amour et mort chez H. Baldung Grien, G. Moreau et F. Rops." *Art and Fact* 10, (1991), pp. 66–69.

Sonstroem 1970 David Sonstroem. *Rossetti and the Fair Lady.* Middletown, Conn., 1970.

Soulier-François n.d. Françoise Soulier-François, Conservateur chargée du cabinet des Dessins, Musée des Beaux-Arts et d'Archéologie, Besançon. Archival research.

Southampton 1998 *Sir Edward Coley Burne-Jones: The Perseus Series.* Exhibition, Southampton City Art Gallery, 1998. Catalogue by A. Anderson, M. Cassin, and E. Jones. Southampton, 1998.

Southport 1892 *Centenary Exhibition.* Southport, Eng., 1892.

Spalding 1978 Frances Spalding. *Magnificent Dreams: Burne-Jones and the Late Victorians.* Oxford, 1978.

Spencer 1952 Hazelton Spencer, ed. *British Literature.* Vol. 2, *From Blake to the Present Day.* Boston, 1952.

Spencer 1989 Robin Spencer, ed. *Whistler: A Retrospective.* New York, 1989.

Spencer 1991 Robin Spencer. "Manet, Rossetti, London and Derby Day." *Burlington Magazine* 133 (April 1991), pp. 231–35.

Spielmann 1886 Marion Harry Spielmann. *The Works of G. F. Watts, with a Complete Catalogue of His Pictures, Fourteen Drawings Contributed by Himself, and Other Illustrations.* Pall Mall Gazette extra, no. 22. London, 1886.

Spike 1981 John T. Spike. "Ingres at the Fogg Art Museum." *Burlington Magazine* 123 (March 1981), pp. 189–90.

Spirit Summonings **1989** *Spirit Summonings,* by the editors of Time-Life Books. Alexandria, Va., 1989.

Spoleto 1992 *Gustave Moreau: L'elogio del poeta.* Exhibition, Palazzo Racani Arroni, Spoleto, June 25–September 6, 1992. Catalogue edited by Bruno Mantura and Geneviève Lacambre. Rome, 1992.

Springfield–New York 1939–40 *David and Ingres: Paintings and Drawings.* Exhibition, Springfield Museum of Fine Arts, November 20–December 17, 1939; M. Knoedler and Co., New York, January 8–27, 1940. Catalogue. [Springfield], 1939.

Stafford 1994 Barbara M. Stafford. *Artful Science: Enlightenment, Entertainment and the Eclipse of Visual Education.* Cambridge, Mass., 1994.

Staley 1967 Allen Staley. "The Condition of Music." *Art News Annual* 33 (1967), pp. 80–87.

Staniszewski 1995 Mary Anne Staniszewski. *Believing Is Seeing: Creating the Culture of Art.* New York, 1995.

Stebbins 1976 Theodore E. Stebbins Jr., with John Caldwell and Carol Troyen. *American Master Drawings and Watercolors: A History of Works on Paper from Colonial Times to the Present.* New York, 1976.

Steinberg 1972 Leo Steinberg. "Rodin." In *Other Criteria: Confrontations with Twentieth-Century Art,* pp. 322–403. Oxford, 1972.

Stephens 1862 Frederic G[eorge] Stephens. "Fine Arts: The Royal Academy." *Athenaeum,* May 3, 1862, p. 602.

Stephens 1883 Frederic George Stephens. "The Earlier Works of Rossetti," 2 parts. *Portfolio* (London) 14 (1883), pp. 87–89, 118.

Stephens 1885 Frederic George Stephens. "Edward Burne-Jones, A.R.A., II." *Portfolio* 16 (1885), pp. 229–30.

Stephens 1886 Frederic George Stephens. "The Society of Painters in Water Colours (First Notice)." *Athenaeum,* no. 3054 (May 8, 1886), p. 623.

Stephens 1891 Frederic George Stephens. "*Beata Beatrix* by Dante Gabriel Rossetti." *Portfolio* 22 (May 1891), p. 46.

Stephens 1894 Frederic George Stephens. *Dante Gabriel Rossetti.* London, 1894.

Stolte 1978 Wolfgang Stolte. "Zur Imagination im Werk von Eugène Delacroix." Ph.D. dissertation, Rheinischen Friedrich-Wilhelms-Universität, Bonn, 1978.

Stratis and Tedeschi 1998 Harriet K. Stratis and Martha Tedeschi, eds. *The Lithographs of James McNeill Whistler.* 2 vols. Chicago, 1998.

Stubbs 1948 Burns A. Stubbs. *Paintings, Pastels, Drawings, Prints and Copper Plates by and Attributed to American and European Artists, together with a List of Original Whistleriana in the Freer Gallery of Art.* Washington, D.C., 1948.

Stuckey 1985 Charles F. Stuckey, ed. *Monet: A Retrospective.* New York, 1985.

Stuffmann 1978 Margret Stuffmann. "Courbet Zeichnungen." In Hamburg–Frankfurt 1978–79.

Sturgis 1998 Matthew Sturgis. *Aubrey Beardsley: A Biography.* London, 1998.

Stuttgart 1993 *Henri Matisse: Zeichnungen und Gouaches Découpées. Graphische Sammlung, Staatsgalerie Stuttgart, Stuttgarter Galerieverein.* Exhibition, Staatsgalerie Stuttgart, 1993. Catalogue edited by Ulrike Gauss. Stuttgart, 1993.

Sullivan and Meyer 1995 Edward J. Sullivan and Ruth Krueger Meyer, eds. *The Taft Museum: Its History and Collections.* 2 vols. New York, 1995.

Surtees 1971 Virginia Surtees. *The Paintings and Drawings of Dante Gabriel Rossetti: A Catalogue Raisonné.* 2 vols. Oxford, 1971.

Sussman 1979 Herbert L. Sussman. *Fact into Figure: Typology in Carlyle, Ruskin, and the Pre-Raphaelite Brotherhood.* Columbus, Ohio, 1979.

Sutton 1963 Denys Sutton. *Nocturne: The Art of James McNeill Whistler.* London, 1963.

Sutton 1966 Denys Sutton. *James McNeill Whistler: Paintings, Etchings, Pastels and Watercolors.* London, 1966.

Sutton 1978a [Denys Sutton]. "Editorial: The Pursuit of Beauty." *Apollo,* n.s., 107 (June 1978), pp. 446–51.

Sutton 1978b Denys Sutton. "Editorial: The Victorian Scene." *Apollo,* n.s., 108 (November 1978), pp. 290–95.

Sweeney 1944 John L. Sweeney. "Imaginative Design: Blake to Pre-Raphaelites." *Art News* 42 (January 1, 1944), pp. 19, 35–36.

Swinburne 1875 Algernon Charles Swinburne. "Notes on Designs of the Old Masters at Florence." In *Essays and Studies.* London, 1875.

Swinburne 1959–62 Algernon Charles Swinburne. *Letters.* 6 vols. Edited by Cecil Y. Lang. New Haven, 1959–62.

Symmons 1979 Sarah Symmons. *Daumier.* London, 1979.

Symmons 1984 Sarah Symmons. *Flaxman and Europe: The Outline Illustrations and Their Influence.* Outstanding Theses from the Courtauld Institute of Art. New York, 1984.

Symons 1910 Arthur Symons. *Dante Gabriel Rossetti.* Paris, 1910.

Szczepinska-Tramer 1973 Joanna Szczepinska-Tramer. "Recherches sur les paysages de Géricault." *Bulletin de la Société de l'Histoire de l'Art Français,* 1973, pp. 299–317.

Tabarant 1931 Adolphe Tabarant. *Manet: Histoire catalographique.* Paris, 1931.

Tabarant 1947 Adolphe Tabarant. *Manet et ses oeuvres.* Paris, 1947.

Tabourier sale 1933 *Tableau par Corot; aquarelle et dessins modernes; sculptures par Barye . . . Monsieur J. T[abourier].* Sale, Hôtel Drouot, Paris, December 1, 1933.

Tahinci 1995 Anna Tahinci. "Le portrait masculin chez Rodin." Mémoire de maîtrise en Histoire de l'art, Université de Paris X-Nanterre, 1995.

Tailhades 1877 B. Tailhades. "L'oeuvre de Prud'hon" [omissions and errors in Goncourt 1876]. *La chronique des arts et de la curiosité,* November 10, 1877, pp. 328–30.

Tait 1900 E. M. Tait. "Pioneer of Art Furniture: Madox Brown's Furniture Designs." *The Furnisher: A Journal of Eight Trades,* October 1900, pp. 61–63.

Takahashi and Takahashi 1993 Hiroko Takahashi and Tatsushi Takahashi. *Vikutoria-cho mangekyo.* Tokyo, 1993.

Takashina and Senzoku 1996 Shūji Takashina and Nobuyuki Senzoku. *Seikimatsu to shōchō shugi / New History of World Art.* Sekai bijutsu daizenshū Seiyō hen, vol. 24. Tokyo, 1996.

Talmey 1947 Allene Talmey. "The Fogg Art Museum at Harvard." *Vogue,* July 15, 1947.

Tancock 1976 John L. Tancock. *The Sculpture of Auguste Rodin.* Philadelphia: Philadelphia Museum of Art, 1976.

Tannenbaum 1975 Leslie Tannenbaum. "Lord Byron in the Wilderness: Biblical Tradition in Byron's *Cain* and Blake's *The Ghost of Abel.*" *Modern Philology* 72 (1975), pp. 350–64.

Tarbell 1895 Ida M. Tarbell. *A Short Life of Napoleon Bonaparte.* New York, 1895.

Tate Gallery 1924 Tate Gallery, London. *Catalogue: British School.* 23rd ed. London, 1924.

Tatham 1990 David Tatham. "Winslow Homer at the North Woods Club." In *Winslow Homer: A Symposium,* edited by Nicolai Cikovsky Jr., pp. 115–30. Proceedings of a symposium sponsored by the Center for Advanced Study in the Visual Arts, National Gallery of Art, April 18, 1986. Studies in the History of Art, vol. 26. Washington, D.C., 1990.

Tatham 1996 David Tatham. *Winslow Homer in the Adirondacks.* Syracuse, 1996.

Taylor 1862 Tom Taylor. "Royal Academy Exhibition." *Times* (London), May 3, 1862, p. 14.

Taylor 1987 Joshua C. Taylor, ed. *Nineteenth-Century Theories of Art.* Berkeley and Los Angeles, 1987.

Taylor 1997 Eugene Taylor. "The Interior Landscape: George Inness and William James on Art from a Swedenborgian Point of View."

Archives of American Art Journal 37 (1997), pp. 2–10.

Taylor and Finley 1997 Charles H. Taylor and Patricia Finley. *Images of the Journey in Dante's Divine Comedy.* New Haven, 1997.

Tedeschi 1985 Martha Tedeschi. *Great Drawings from the Art Institute of Chicago: The Harold Joachim Years. . . .* Chicago and New York, 1985.

Tedeschi 1997 Martha Tedeschi. "Whistler and the English Print Market." *Print Quarterly* 14 (March 1997), pp. 15–41.

Temple 1896 A. G. Temple. "Collection of William Coltart Esq. of Woodleigh, Birkenhead." *Art Journal,* n.s., 58 (April 1896), pp. 97–101.

Temple 1897 A. G. Temple. *The Art of Painting in the Queen's Reign.* London, 1897.

Ternois 1956 Daniel Ternois. "Les livres de comptes de Madame Ingres (Ingres à Rome et à Paris, 1835–1843)." *Gazette des beaux-arts,* ser. 6, 48 (December 1956), pp. 163–76.

Ternois 1959 Daniel Ternois. *Les dessins d'Ingres au Musée de Montauban: Les portraits.* Inventaire général des dessins des musées de Province, vol. 3. Paris, 1959.

Ternois 1962 Daniel Ternois. "Lettres inédites d'Ingres à Hippolyte Flandrin." *Bulletin du Musée Ingres,* no. 11 (July 1962), pp. 5–26.

Ternois 1965a Daniel Ternois. *Montauban—Musée Ingres. Peintures: Ingres et son temps (artistes nés entre 1740–1830).* [Inventaire des collections publiques françaises, 7]. Paris, 1965.

Ternois 1965b Daniel Ternois. "Ingres et le 'Songe d'Ossian.'" In *Walter Friedlaender zum 90. Geburtstag: Eine Festgabe seiner europäischen Schüler, Freunde und Verehrer,* edited by Georg Kauffmann and Willibald Sauerländer, pp. 185–92. Berlin, 1965.

Ternois 1969 Daniel Ternois. "Ossian et les peintres." In *Colloque Ingres [1967],* pp. 165–213. [Montauban, 1969].

Ternois 1980 Daniel Ternois. *Ingres.* Paris, 1980.

Ternois 1986 Daniel Ternois. "Une amitié romaine: Les lettres d'Ingres à Édouard Gatteaux." In *Actes du colloque: Ingres et Rome, Montauban, septembre 1986,* pp. 17–61. [Montauban, 1986].

Ternois 1995 Daniel Ternois. "Du bon usage des correspondances d'artistes: Les lettres d'Ingres à Marcotte et à Gilbert." *Bulletin de la Société de l'Histoire de l'Art français,* 1995, pp. 213–38.

Ternois 1997 Daniel Ternois. "Ingres et la photographie." *Bulletin du Musée Ingres,* no. 70 (1997), pp. 41–50.

Ternois 1998 Daniel Ternois. *Ingres: Monsieur Bertin.* Paris, 1998.

Ternois 2001 Daniel Ternois. *Lettres d'Ingres à Marcotte d'Argenteuil: Dictionaire.* Société de l'Histoire de l'Art Francais, Archives de l'art français, n.s., 36. Nogent-le-Roi, 2001.

Ternois and Camesasca 1971 Daniel Ternois and Ettore Camesasca. *Tout l'oeuvre peint d'Ingres.* Paris, 1971.

Terry and Craig 1933 Ellen Terry and Edith Craig, eds. *Memoirs.* London, 1933.

Thiébault-Sisson 1921 François Thiébault-Sisson. "Degas sculpteur par lui-même." *Le Temps,* May 23, 1921.

Thieme and Becker 1907–50 Ulrich Thieme and Felix Becker, eds. *Allgemeines Lexikon der bildenden Kunstler.* 37 vols. Leipzig, 1907–50.

Thomas 1823 Antoine-Jean-Baptiste Thomas. *Un an à Rome et dans ses environs: Recueil de dessins lithographiés, représentant les costumes, les usages et les cérémonies civiles et relieuses des états romains et généralement tout ce qu'on y voit de remarquable pendant le cours d'une année.* Paris, 1823.

Thomas 2000 David Wayne Thomas. "Replicas and Originality: Picturing Agency in Dante Gabriel Rossetti and Victorian Manchester." *Victorian Studies* 43 (autumn 2000), pp. 67–102.

Thomé 1826 A[ntoine] Th[omé]. *Vie de David, premier peintre de Napoléon.* Brussels, 1826.

Thompson 1955 J. M. Thompson. "Lucien Bonaparte, Napoleon's Ablest Brother." *History Today* 5, no. 5 (May 1955).

Thompson 1983 David Thompson. *Raphael: The Life and the Legacy.* London, 1983.

Thomson 1985 Richard Thomson. *Seurat.* Oxford, 1985.

Thoré 1843 T[héophile] Thoré. "Léopold Robert [part] II." *Les beaux-arts: Illustration des arts et de la littérature* 1, no. 18 (1843), p. 284.

Thoré 1844 [Théophile Thoré]. "Galeries particulières: Collection de M. Marcotte, d'Argenteuil." *Les beaux-arts: Illustration des arts et de la littérature* 2, no. 48 (1844), p. 298.

Thoré 1846 Théophile Thoré. "Études sur la peinture française depuis la fin de 18e siècle, à propos de l'exposition de la société des peintures." *Le constitutionnel,* March 10, 1846. Reprinted in Foucart et al. 1995.

Thoré 1868 Théophile Thoré. *Salons de T. Thoré.* Paris, 1868.

Thorson 1975 Victoria Thorson. "Reassessing Rodin's Graphics." *Art News* 74 (September 1975), pp. 40–46.

Thorson 1979 Victoria Thorson, ed. *Great Drawings of All Time.* Vol. 5, *The Twentieth Century.* 2 parts. New York, 1979.

"Thought" 1990 "Thought: A Review of Culture and Idea." *Fordham University Quarterly* 65, no. 259 (December 1990).

Thuillant 1991 Pascale Thuillant. "À l'aube du realisme: Géricault peintre." *Dossier de l'art,* no. 4 (October–November 1991).

Tiénot 1965 Yvonne Tiénot, ed. *Chabrier, par lui-même et par ses intimes.* Paris, 1965.

Tietze 1937 Hans Tietze, ed. *Meisterwerke Europäischer Malerei in Amerika.* Vienna, 1937.

Tietze 1939 Hans Tietze, ed. *Masterpieces of European Painting in America.* New York, 1939.

Tietze 1947 Hans Tietze. *European Master Drawings in the United States.* New York, 1947.

Tilston 1991 Richard Tilston. *Seurat.* London, 1991.

Todd 1971 Ruthven Todd. *William Blake the Artist.* London, 1971.

Tokyo 1995 *Gyusutavu Moro / Gustave Moreau.* Exhibition, Kokuritsu Seiyō Bijutsukan, March 21–May 14, 1995; Kyōto Kokuritsu Kindai Bijutsukan, May 23–July 9, 1995. Tokyo, 1995.

Tokyo 2002 *Between Reality and Dreams: Nineteenth Century British and French Art from the Winthrop Collection of the Fogg Art Museum.* Exhibition, National Museum of Western Art, Tokyo, September 14–December 8, 2002. Catalogue edited by Chikashi Kitazaki and Mina Oya. Tokyo, 2002.

Tokyo–Osaka 1981 *Ingres.* Exhibition, National Museum of Western Art, Tokyo, April 28–June 14, 1981; National Museum of Art, Osaka, June 23–July 19, 1981. Catalogue. Tokyo, 1981.

Tokyo–Yamaguchi 1990 *Inshoha koki inshoha ten: Havado Daigaku Foggu Bijutsukan Watohaimu korekushon / Maurice Wertheim Collection and Selected Impressionist and Post-Impressionist Paintings and Drawings in the Fogg Art Museum.* Exhibition, Isetan Bijutsukan, Tokyo, March 1–April 10, 1990; Yamaguchi Kenritsu Bijutsukan, April 14–May 13, 1990. Catalogue. Tokyo, 1990.

Toohey 1995 Jeanette M. Toohey. *Pre-Raphaelites: The Samuel and Mary R. Bancroft Collection of the Delaware Art Museum.* Wilmington, 1995.

Toronto 1975 *Puvis de Chavannes and the Modern Tradition.* Exhibition, Art Gallery of Ontario, Toronto, October 24–November 30, 1975. Catalogue by Richard J. Wattenmaker. Toronto, 1975. Rev. ed., Toronto, 1976.

Toronto and other cities 1993–94 *The Earthly Paradise: Arts and Crafts by William Morris and His Circle from Canadian Collections.* Exhibition, Art Gallery of Ontario, Toronto, June 25–September 6, 1993; and at three other locations in Canada through October 9, 1994. Catalogue edited by Katharine A. Lochnan, Douglas E. Schoenherr, and Carole Silver. Toronto, 1993.

Toulouse-Lautrec 1905 Henri de Toulouse-Lautrec. *Au cirque: Vingt-deux dessins aux crayons de couleur.* Paris, 1905.

Toulouse-Lautrec 1969 Henri de Toulouse-Lautrec. *Unpublished Correspondence of Henri de Toulouse-Lautrec: 273 Letters by and about Lautrec Written to His Family and Friends in the Collection of Herbert Schimmel.* Edited by Lucien Goldschmidt and Herbert Schimmel; introduction and notes by Jean Adhémar and Theodore Reff; letters translated by Edward B. Garside. London, 1969.

Toulouse-Lautrec 1983 Henri de Toulouse-Lautrec. *The Henri de Toulouse-Lautrec, W. H. B. Sands Correspondence.* Edited by Herbert D. Schimmel and Phillip Dennis Cate. New York, 1983.

Toulouse-Lautrec 1991 Henri de Toulouse-Lautrec. *The Letters of Henri de Toulouse-Lautrec.* Edited by Herbert D. Schimmel; translated by diverse hands. Oxford, 1991.

Toulouse–Montauban 1955 *Ingres et ses maîtres: De Roques à David.* Exhibition, Musée des Augustins, Toulouse, May 14–June 26, 1955; Musée Ingres, Montauban, July 6–August 21, 1955. Catalogue by Paul Mesplé and Daniel Ternois. Toulouse, 1955.

Toussaint 1986 Helene Toussaint. "Ingres et la Fornarina." *Bulletin du Musée Ingres,* September 1986, pp. 63–74.

Towndrow 1939 Kenneth Romney Towndrow. *Alfred Stevens, Architectural Sculptor, Painter, and Designer.* London, 1939.

Townsend 1994 Joyce H. Townsend. "Whistler's Oil Painting Materials." *Burlington Magazine* 136 (1994), pp. 690–95.

Toynbee 1910 Paget Toynbee. *Dante Alighieri: His Life and Works*. London, 1910.

Toynbee 1912 Paget Toynbee. *Chronological List with Notes of Paintings and Drawings from Dante by Dante Gabriel Rossetti*. Turin, 1912. Reprinted from *Scritti varii di erudizione e di critica in onore di Rodolfo Renier*, Turin, 1912.

Trapp 1971 Frank Anderson Trapp. *The Attainment of Delacroix*. Baltimore, 1971.

Traubner 1985 Richard Traubner. "Chabrier's Operas Make a Case for Popularity." *New York Times*, April 7, 1985, Arts and Entertainment section, p. 25.

"Treasures from New England" 1976 "Treasures from New England: Special Section for the Nation's Bicentennial." *Boston Globe*, September 12, 1976, pp. 9–10.

Treuherz 1985 Julian Treuherz. "Ford Madox Brown and the Manchester Murals." In *Art and Architecture in Victorian Manchester*, edited by John H. G. Archer, pp. 162–97. Manchester, 1985.

Trévise 1927 Duc de Trévise. "Théodore Géricault." *The Arts* 12, no. 4 (October 1927), pp. 183–200.

Trévise 1938a Anonymous. "La collection du duc de Trévise." *Beaux-Arts Magazine*, April 29, 1938, p. 7.

Trévise 1938b Duc de Trévise. "European Auctions: Duc de Trévise, XIX Century French Painting." *Art News* 36, no. 27 (April 2, 1938), p. 22.

Trévise sale 1938 *Collection du duc de Trévise: Catalogue des tableaux et dessins du XIXme siècle. . . .* Sale, Galerie Charpentier, Paris, May 19, 1938.

Tschudi 1906 Hugo von Tschudi. *Adolf von Menzel: Abbildungen seiner Gemälde und Studien, auf Grund der von der Kgl. Nationalgalerie im frühjahr 1905 veranstalteten Ausstellung unter Mitwirkung von Dr. E. Schwedeler-Meyer und Dr. J. Kern*. Munich, 1906.

Tübingen–Brussels 1986 *Ingres und Delacroix: Aquarelle und Zeichnungen*. Exhibition, Kunsthalle, Tübingen, September 12–October 28, 1986; Palais des Beaux-Arts, Brussels, November 7–December 21, 1986. Catalogue by Ernst Goldschmidt and Götz Adriani. Cologne, 1986. French ed., *Ingres et Delacroix: Dessins et aquarelles*. Ghent, 1986.

Tulsa–Jacksonville–Hanover 1996–97 *Dürer to Matisse: Master Drawings from The Nelson-Atkins Museum of Art*. Exhibition, Philbroook Museum of Art, Tulsa, Okla., June 23–August 18, 1996; Cummer Museum of Art and Gardens, Jacksonville, Fla., September 20–November 29, 1996; Hood Museum of Art, Hanover, N.H., December 21, 1996–March 2, 1997. Catalogue by Roger B. Ward. Kansas City, 1996.

Turner 1999 James Turner. *The Liberal Education of Charles Eliot Norton*. Baltimore, 1999.

Twenty-five Great Masters 1981 *Anguru ten / Ingres*. 25-nin no gaku (Twenty-five Great Masters of Modern Art). Tokyo, 1981.

Uhde 1936 Wilhelm Uhde. *Vincent van Gogh*. Vienna, 1936.

van Uitert 1977 Evert van Uitert. *Vincent van Gogh: Zeichnungen*. Cologne, 1977.

van Uitert 1978 Evert van Uitert. *Van Gogh Drawings*. Translated by Elizabeth Willems-Treeman. Woodstock, 1978.

Underwood 1931 Eric G. Underwood. *A Short History of French Painting*. London, 1931.

Urban Utopia 1993 *Urban Utopia: 19th century*. Tokyo, 1993.

Uzanne 1906a Octave Uzanne. *Jean-Auguste-Dominique Ingres: Painter*. Translated by Helen Chisholm. London, [1906].

Uzanne 1906b Octave Uzanne. "The Paintings of Jean Auguste Dominique Ingres." *Magazine of Fine Arts* 1 (November 1905–April 1906), pp. 269–79.

Vachon 1877 Marius Vachon. "Les peintures de M. Puvis de Chavannes au Panthéon." *La France*, May 28, 1877.

Vachon 1878 Marius Vachon. "H. Daumier." *La France*, April 25, 1878, p. 3.

Vachon 1895 Marius Vachon. *Puvis de Chavannes*. Paris, 1895. New ed., Paris, 1900.

Vachon [1900] Marius Vachon. *Puvis de Chavannes, un maître de ce temps*. Paris, n.d. [1900].

Vaillat 1913 Léandre Vaillat. "L'oeuvre de Théodore Chassériau (Arthur Chassériau collection)." *Les Arts*, no. 140 (August 1913), pp. 1–32.

Vaisse 1977 Pierre Vaisse. "Styles et sujets dans la peinture officielle de la IIIe république: Ferdinand Humbert au Panthéon." *Bulletin de la Société de l'Histoire de l'Art français*, December 3, 1977, pp. 297–311.

Vaisse 1989 Pierre Vaisse. "La peinture monumentale au Panthéon sous la IIIe République." In *Le Panthéon. Symbole des révolutions: De l'église de la nation au temple des grands hommes*, pp. 252–58. Paris, 1989.

Vallance 1897 Aymer Vallance. "Iconography." In Beardsley 1897.

Vallance 1909 Aymer Vallance, comp. "List of Drawings by Aubrey Beardsley" [revised]. In Ross 1909, pp. 57–112.

Vancouver 1997 *Théodore Géricault, the Alien Body: Tradition in Chaos*. Exhibition, Morris and Helen Belkin Art Gallery, University of British Columbia, Vancouver, August 15–October 19, 1997. Catalogue edited by Serge Guilbaut, Maureen Ryan, and Scott Watson. Vancouver, 1997.

Van Dyck 1919 John Charles Van Dyck. *American Painting and Its Tradition, as Represented by Inness, Wyant, Martin, Homer, La Farge, Whistler, Chase, Alexander, Sargent*. New York, 1919.

Van Liere 1981 Eldon N. Van Liere. "Ingres 'Raphael and the Fornarina': Reverence and Testimony." *Arts Magazine* 56, no. 4 (December 1981), pp. 108–15.

Van Rensselaer 1881 M. G. Van Rensselaer. "The Water-Color Exhibition in New York." *American Architect and Building News* 9 (March 19, 1881), pp. 135–36.

Van Rensselaer 1882 M. G. Van Rensselaer. "Water-Colors in New York." *American Architect and Building News* 11 (April 8, 1882), p. 160.

Van Rensselaer 1883 M. G. Van Rensselaer. "An American Artist in England." *Century Magazine* 28 (November 1883), p. 17.

Varnier 1841 Jules Varnier. "M. Ingres." *L'artiste*, ser. 2, 8 (1841), pp. 305–8.

Vasari (1906) 1973 *Le opere di Giorgio Vasari con nuove annotazioni e commenti di Gaetano Milanesi*. Reprint of 1906 ed., edited by Paola Barocchi. 9 vols. Florence, 1973.

Vassalo 1992 Isabelle Vassalo. "Barbedienne et Rodin: L'histoire d'un succès." In Paris 1992–93, pp. 187–90.

Vauchelet 1894 Vauchelet. *La Guadeloupe, ses enfants célèbres (Léonard, Lethière, Bernard, Poirié St. Aurèle)*. Paris, 1894.

Vaughan 1979 W. Vaughan. *German Romanticism and English Art*. London, 1979.

Vauxcelles 1924 Louis Vauxcelles. "La méthode et la leçon de Géricault." *L'art d'aujourd'hui*, spring–summer 1924, p. 31.

Veith 1991 Gene Edward Veith. *State of the Arts: From Bezalel to Mapplethorpe*. Wheaton, Ill., 1991.

Venice 1934 *XIXa esposizione biennale internazionale d'arte*. Exhibition, Palazzo Centrale, Venice, May–October 1934. Catalogue introduction by Antonio Maraini. Venice, 1934.

Verhaeren 1891 Emile Verhaeren. "Georges Seurat." *La société nouvelle* 7 (1891).

Verner 1985 William K. Verner. "Adirondack Park—a Painterly Celebration of the First Wilderness Preserve." *Wilderness*, summer 1985.

Vienna 1996 *August Rodin: Eros und Leidenschaft*. Exhibition, Kunsthistorisches Museum Wien, Palais Harrach, May 21–August 26, 1996. Catalogue edited by Wilfried Seipel, with contributions by Michael Kausch et al. Vienna and Milan, 1996.

Vigne 1995a Georges Vigne. *Dessins d'Ingres: Catalogue raisonné des dessins du musée de Montauban*. Paris, 1995.

Vigne 1995b Georges Vigne. *Ingres*. Paris, 1995. English ed. translated by John Goodman. New York, 1995.

Vigne 1999 Georges Vigne. "Monsieur Ingres, dessiné-moi un portrait." *L'estampille / L'objet d'art*, no. 334 (March 1999), pp. 40–51.

Vignon 1855 Claude Vignon [Noémie Cadiot]. *Exposition universelle de 1855: Beaux-arts*. Paris, 1855.

Viguié 1967 Pierre Viguié. "Ingres et l'Âge d'Or." *La revue des deux mondes*, December 15, 1967, p. 542.

Vilain et al. 1996 Jacques Vilain, ed., with Alain Beausire, Claudie Judrin, Stéphanie Le Follic, Antoinette Le Normand-Romain, and Hélène Pinet. *Rodin: Le musée et ses collections*. Paris, 1996. Also published in English as *Rodin at the Musée Rodin*, 1996 and 1997.

Vincent 1968 Howard P. Vincent. *Daumier and His World*. Evanston, Ill., 1968.

Visconti 1782–1807 Ennio Quirino Visconti, with descriptions by Giambattista Visconti in vol. 1. *Il Museo Pio-Clementino*. 7 vols. Rome, 1782–1807.

Visites et études 1856 *Visites et études de S.A.I. le Prince Napoléon au Palais des Beaux-Arts ou description complete de cette exposition*. Paris, 1856.

Vitta sale 1935 Jean Guiffrey. *Catalogue des tableaux modernes, aquarelles, dessins, par Delacroix, Ingres, Manet Millet, Prud'hon, Rodin, important portrait (M. de Nogent par Ingres); collection de M. le Baron Vitta*. Sale, Galerie Charpentier, Paris, March 15, 1935.

Voïart 1824 Jacques-Philippe Voïart. *Notice historique sur la vie et les ouvrages de P. P. Prudhon, peintre, membre de la Légion-d'honneur et de l'Institut*. Paris, 1824.

Vollard 1918 Ambroise Vollard. *Ninety-Eight Reproductions Signed by Degas*. Paris, 1918.

Volpi 1994 M. Volpi. "David anacronista." In *Studi in onore di Giulio Carlo Argan*, pp. 287–91. Florence, 1994.

Wadley 1969 Nicholas Wadley. *The Drawings of Van Gogh*. London, 1969.

Wadley 1987 Nicholas Wadley, ed. *Renoir: A Retrospective*. New York, 1987.

Wadley 1991 Nicholas Wadley. *Impressionist and Post-Impressionist Drawing*. London, 1991.

Waern 1896 Cecilia Waern. *John La Farge, Artist and Writer*. London, 1896.

Wakeham and Mendelowitz 1982 Duane A. Wakeham and Daniel M. Mendelowitz. *Mendelowitz's Guide to Drawing*. 3rd ed., revised by Duane A. Wakeham. New York, 1982.

Walch 1967 Peter S. Walch. "Charles Rollin and Early Neoclassicism." *Art Bulletin* 49 (June 1967), pp. 123–26.

Waldemar George 1927 Waldemar George. *Van Gogh*. Les albums d'art Druet. Paris, 1927.

Waldemar George 1934 Waldemar George. "Portraits par Ingres et ses élèves." *La renaissance* 17 (October–November 1934), pp. 193–200.

Waldemar George 1967 Waldemar George. *Dessins d'Ingres*. Paris, 1967.

Walker 1950 R[ainforth] A[rmitage] Walker. "Aubrey Beardsley." *Graphis* 6, no. 31 (1950), pp. 250–57.

Walker Art Gallery 1927 Walker Art Gallery. *Illustrated Catalogue of the Permanent Collection*. Liverpool, 1927.

Wallen 1992 Jeffrey Wallen. "Illustrating Salome: Perverting the Text?" *Word and Image* 8, no. 2 (April–June 1992), pp. 124–32.

Walther 1992 Ingo F. Walther. *Malerei des Impressionismus, 1860–1920*. Cologne, 1992.

Walton 1975 Stephen John Walton. "The Sculpture of Alfred Stevens." M.A. thesis, Courtauld Institute of Art, London, 1975.

Wark 1975 Robert R. Wark. *Drawings by Thomas Rowlandson in the Huntington Collection*. San Marion, Calif., 1975.

Warner 1992 Malcolm Warner. "The Pre-Raphaelites and the National Gallery." *Huntington Library Quarterly* 55, no. 1 (winter 1992), pp. 1–11.

Waroquier 1959 Henry de Waroquier. "À Propos d'Ingres: Textes inédits." *Bulletin du Musée Ingres*, no. 6 (December 1959), pp. 6–16.

Washington 1981–82 *Rodin Rediscovered*. Exhibition, National Gallery of Art, Washington, D.C., June 28, 1981–May 2, 1982. Catalogue edited by Albert E. Elsen, with contributions by Albert Alhadeff et al. Washington, D.C., 1981.

Washington 1982–83 *Manet and Modern Paris: One Hundred Paintings, Drawings, Prints, and Photographs by Manet and His Contemporaries*. Exhibition, National Gallery of Art, Washington, D.C., December 5, 1982–March 6, 1983. Catalogue by Theodore Reff. Washington, D.C., 1982.

Washington 1983–84 *The Capital Image: Painters in Washington, 1800–1915*. Exhibition, National Museum of American Art, Smithsonian Institution, Washington, D.C., October 19, 1983–January 22, 1984. Catalogue by Andrew J. Cosentino and Henry H. Glassie. Washington, D.C., 1983.

Washington 1984 *James McNeill Whistler at the Freer Gallery of Art*. Exhibition, Freer Gallery of Art,

Washington, D.C., May 11–November 5, 1984. Catalogue by David Park Curry. Washington, D.C., and New York, 1984.

Washington 1986–87 *Henri Matisse: The Early Years in Nice, 1916–1930*. Exhibition, National Gallery of Art, Washington, D.C., November 2, 1986–March 29, 1987. Catalogue by Jack Cowart and Dominique Fourcade. Washington, D.C., 1986.

Washington 1998 *Degas at the Races*. National Gallery of Art, Washington, D.C., April 12–July 12, 1998. Catalogue by Jean Sutherland Boggs, with contributions by Shelley G. Sturman, Daphne S. Barbour, and Kimberly Jones. Washington, D.C., 1998.

Washington and other cities 1952–53 *French Drawings: Masterpieces from Five Centuries. A Loan Exhibition Organized by L'Association Française d'Action Artistique and Circulated by the Smithsonian Institution*. National Gallery of Art, Washington, D.C.; Cleveland Museum of Art; City Art Museum, Saint Louis; Fogg Art Museum, Harvard University Art Museums, Cambridge, Mass.; The Metropolitan Museum of Art, New York, 1952–53. Catalogue by Jacqueline Bouchot-Saupique, Maurice Sérullaz, and Roseline Bacou. [New York], 1952.

Washington–Boston 1989 *Still Lifes of the Golden Age: Northern European Paintings from the Heinz Family Collection*. Exhibition, National Gallery of Art, Washington, D.C., May 14–September 4, 1989; Museum of Fine Arts, Boston, October 18–December 31, 1989. Catalogue by Ingvar Bergstrom; edited by Arthur K. Wheelock Jr. Washington, D.C., 1989.

Washington–Boston–New York 1995–96 *Winslow Homer*. Exhibition, National Gallery of Art, Washington, D.C., October 15, 1995–January 28, 1996; Museum of Fine Arts, Boston, February 21–May 26, 1996; The Metropolitan Museum of Art, New York, June 17–September 22, 1996. Catalogue by Nicolai Cikovsky Jr. and Franklin Kelly, with contributions by Judith Walsh and Charles Brock. Washington, D.C., and New Haven, 1995.

Washington–Fort Worth–New Haven 1986 *Winslow Homer Watercolors*. Exhibition, National Gallery of Art, Washington, D.C., March 2–May 11, 1986; Amon Carter Museum, Fort Worth, June 6–July 27, 1986; Yale University Art Gallery, New Haven, September 11–November 2, 1986. Catalogue by Helen A. Cooper. Washington, D.C., and New Haven, 1986.

Washington–Los Angeles 1998–99 *Van Gogh's Van Goghs: Masterpieces from the Van Gogh Museum, Amsterdam*. Exhibition, National Gallery of Art, Washington, D.C., October 4, 1998–January 3, 1999; Los Angeles County Museum of Art, January 17–April 4, 1999. Catalogue by Richard Kendall. Washington, D.C., 1998.

Washington–San Francisco 1998–99 *Impressionists in Winter: Effets de neige*. Exhibition, Phillips Collection, Washington, D.C., September 19, 1998–January 3, 1999; Fine Arts Museums of San Francisco, Center for the Arts at Yerba Buena Gardens, January 30–May 2, 1999. Catalogue by Charles S. Moffett et al. Washington, D.C., 1998.

Wasserman 1982 Jeanne L. Wasserman, with technical assistance by Arthur Beale. *Sculpture by Antoine-*

Louis Barye in the Collection of the Fogg Art Museum. Fogg Art Museum Handbooks, vol. 4. Cambridge, Mass., 1982. Based on the exhibition Cambridge, Mass., 1981.

Watkin 1968 David Watkin. *Thomas Hope, 1769–1831, and the Neo-classical Idea*. London, 1968.

Watrous 1957 James Watrous. *The Craft of Old-Master Drawings*. Madison, Wis., 1957.

Watts 1912 Mary S. Watts. *George Frederic Watts: The Annals of an Artist's Life*. 2 vols. London, 1912.

Watts 1926 Harvey M. Watts. "The John F. Braun Collection of American Art." *Arts and Decoration*, July 1926.

"Watts Catalogue," ca. 1910 Mary S. Watts. "Catalogue of the Works of G. F. Watts Compiled by His Widow." Watts Gallery, Compton, Surrey, ca. 1910.

Waugh 1928 Evelyn Waugh. *Rossetti, His Life and Works*. London, 1928.

Way 1912 Thomas R. Way. *Memories of James McNeill Whistler, the Artist*. London and New York, 1912.

Way and Dennis 1903 Thomas R. Way and G. R. Dennis. *The Art of James McNeill Whistler: An Appreciation*. London, 1903.

Wechsler 1999 Judith Wechsler. *Daumier*. Paris: Musée du Louvre, Cabinet des Dessins, 1999.

Wedmore 1878 F[rederick] Wedmore. "Some Tendencies in Recent Painting." *Temple Bar* 53 (1878), pp. 336, 339.

Wedmore 1886 Frederick Wedmore. "The Royal Society of Painters in Water-Colours." *Academy* 29 (June 5, 1886), p. 404.

Weinberg 1987 Gail S. Weinberg. "Ruskin, Pater, and the Rediscovery of Botticelli." *Burlington Magazine* 129 (January 1987), pp. 25–27.

Weinberg 1995 Gail S. Weinberg. "Aubrey Beardsley, the Last Pre-Raphaelite." In *Pre-Raphaelite Art in Its European Context*, edited by Susan P. Casteras and A. Craig Faxon, pp. 210–33. Madison, N.J., and London, 1995.

Weinberg 1997 Gail S. Weinberg. "'Looking Backward': Opportunities for the Pre-Raphaelites to See 'Pre-Raphaelite' Art." In *Collecting the Pre-Raphaelites*, edited by Margaretta Frederick Watson, pp. 51–64. Aldershot, Hants., 1997.

Weinberg 1999 Gail S. Weinberg. "Dante Gabriel Rossetti's 'Salutation of Beatrice' and Camille Bonnard's 'Costumes Historiques.'" *Burlington Magazine* 141 (October 1999), pp. 622–23.

Weintraub 1974 Stanley Weintraub. *Whistler: A Biography*. New York, 1974.

Weintraub 1976 Stanley Weintraub. *Aubrey Beardsley: Imp of the Perverse*. University Park, Pa., 1976.

Weitenkampf 1912 Frank Weitenkampf. "Félix Bracquemond: An Etcher of Birds." In *Prints and Their Makers*, edited by Fitzroy Carrington. New York, 1912.

West 1998 Alison West. *From Pigalle to Préault: Neoclassicism and the Sublime in French Sculpture, 1760–1840*. Cambridge, 1998.

West and Pantini 1904 W. K. West and R. Pantini. *G. F. Watts*. London and New York, 1904.

Westheimer 1993 Ruth Westheimer. *The Art of Arousal*. New York, 1993.

Weston (1997) 2001 Helen Weston. "Pierre-Paul Prud'hon, Jean-Jacques Rousseau et la notion de

vertu." In Prud'hon colloque (1997) 2001, pp. 19–45.

Wexler 1998 Dorothy B. Wexler. *Reared in a Greenhouse: The Stories and Story of Dorothy Winthrop Bradford.* New York, 1998.

Wharton 1988 Edith Wharton. *The Letters of Edith Wharton.* Edited by R. W. B. Lewis and Nancy Lewis. London, 1988.

Wheeler 1990 Michael Wheeler. *Death and the Future Life in Victorian Literature and Theology.* Cambridge, 1990.

Whistler 1904 James McNeill Whistler. *The Gentle Art of Making Enemies.* 3rd ed. New York, 1904.

Whistler (1892) 1967 James McNeill Whistler. *The Gentle Art of Making Enemies.* New York, 1967. Reprint of 2nd ed., 1892.

White 1897 Gleeson White. "An Epoch-Making House." *Studio,* no. 12 (November 1897), pp. 111–12.

White 1964 H. Wade White. "A Significant Addition to the Museum's Napoleonic Collection." *Fogg Art Museum Newsletter* 2, no. 1 (October 1964).

White 1970 H. Wade White. "Nineteenth-Century American Sculpture at Harvard: A Glance at the Collection." *Harvard Library Bulletin* 18, no. 4 (October 1970), pp. 359–66.

White 1984 Barbara Ehrlich White. *Renoir: His Life, Art, and Letters.* New York, 1984.

White 1993 Harrison C. White. *Careers and Creativity: Social Forces in the Arts.* Boulder, 1993.

Whiteley 1977 Jon Whiteley. *Ingres.* London, 1977.

Whiteley 1989 Jon Whiteley. *Pre-Raphaelite Paintings and Drawings.* Oxford, 1989.

Whiteley 1994 Jon Whiteley. "The Role of Drawing in the Work of Puvis de Chavannes." In Amsterdam 1994.

Whitfield 1991 Sarah Whitfield. *Fauvism.* New York, 1991.

Whitley 1939 A. E. Whitley, comp. *Birmingham City Museum and Art Gallery: Catalogue of Drawings.* Birmingham, 1939.

Whitney 1997 Wheelock Whitney. *Gericault in Italy.* New Haven, 1997.

Whitney 2001 Wheelock Whitney. "Géricault in Rome: Drawing and Monumentality." In *Zeichnen in Rom, 1790–1830,* edited by Margret Stuffmann and Werner Busch. Cologne, 2001.

Wichmann 1954 Siegfried Wichmann. "Rezensionen: Klaus Berger, *Géricault und sein Werk*" [review of 1952 Vienna edition of Berger 1955]. *Kunstchronik* 7, no. 4 (April 1954), pp. 108–9.

Wight 1976 Frederick S. Wight. *The Potent Image: Art in the Western World from Cave Paintings to the 1970s.* New York, 1976.

Wilcox 1993 Timothy Wilcox. "The Aesthete Expunged: The Career and Collection of T. Eustace Smith, M.P." *Journal of the History of Collections* 5 (1993), pp. 43–57.

Wilde 1894 Oscar Wilde. *Salome: A Tragedy in One Act.* London, 1894.

Wilde 2000 Oscar Wilde. *The Complete Letters.* Edited by M. Holland and R. Hart-Davis. London, 2000.

Wildenstein 1954 Georges Wildenstein. *Ingres.* London, 1954.

Wildenstein 1956a Georges Wildenstein. *Ingres.* 2nd ed. London, 1956.

Wildenstein 1956b Georges Wildenstein. "Les portraits du duc d'Orléans par Ingres." *Gazette des beaux-arts,* ser. 6, 48 (November 1956), pp. 75–80.

Wildenstein 1974–91 Daniel Wildenstein. *Claude Monet: Biographie et catalogue raisonné.* Lausanne, 1974–91.

Wildenstein 1992–98 Alec Wildenstein, with contributions by Agnès Lacau St. Guily, Marie-Christine Decroocq, Sylvie Crussard, and Emilie Offenstadt. *Odilon Redon: Catalogue raisonné de l'oeuvre peint et dessiné.* 4 vols. Paris, 1992–98.

Wildenstein 1996 Daniel Wildenstein. *Monet.* 4 vols. Translated by Chris Miller, Peter Snowden, and Josephine Bacon. *Catalogue raisonné,* vols. 2–4. Cologne, 1996.

Wildenstein and Wildenstein 1973 Daniel Wildenstein and Guy Wildenstein. *Documents complémentaires au catalogue de l'oeuvre de Louis David.* Paris, 1973.

Wilkinson 1990 Todd Wilkinson. "Winslow Homer: The Essence of Wildlife Art." *Wildlife Art News,* May–June 1990, pp. 64–71.

Willard 1953 *Blake's Illustrations for Dante. Selections from the Originals in the National Gallery of Victoria, Melbourne, Australia and the Fogg Art Museum, Cambridge, Massachusetts.* Introduction by Helen Willard. Fogg Picture Book, no. 2. Cambridge, Mass., 1953.

Williams 1831 D. E. Williams. *Life and Correspondence of Sir Thomas Lawrence, Kt.* 2 vols. London, 1831.

Williamstown 1985–86 *Cast in the Shadow: Models for Public Sculpture in America.* Exhibition, Sterling and Francine Clark Art Institute, Williamstown, Mass., October 12, 1985–January 5, 1986. Catalogue by Jennifer A. Gordon. Williamstown, Mass., 1985.

Wilmerding 1972 John Wilmerding. *Winslow Homer.* New York, 1972.

Wilmerding 1978 John Wilmerding. "Harvard and American Art." *Apollo* 107 (June 1978), pp. 490–95.

Wilmerding 1992 John Wilmerding. "Notes of Change: Harnett's Paintings of the Late 1870s." In New York and other cities 1992–93, pp. 149–59.

Wilson 1927 Mona Wilson. *The Life of William Blake.* London, 1927.

Wilson 1983 Simon Wilson. *Beardsley.* Rev. ed. Oxford, 1983.

Wilson-Bareau 1991 Juliet Wilson-Bareau. *Manet by Himself: Correspondence and Conversation, Paintings, Pastels, Prints and Drawings.* Boston, 1991.

Winner 1982 Ellen Winner. *Invented Worlds: The Psychology of the Arts.* Cambridge, Mass., 1982.

"Winthrop Collection Goes to Fogg" 1943 "Winthrop Collection Goes to Fogg." *Art Digest* 18 (November 1, 1943).

Wirth 1974 Irmgard Wirth. *Mit Menzel in Bayern und Österreich.* Bilder aus deutscher Vergangenheit, vol. 34. Munich, 1974.

Wisneski 1995 Kurt Wisneski. *Monotype/Monoprint: History and Techniques.* Ithaca, N.Y., 1995.

Witemeyer 1979 Hugh Witemeyer. *George Eliot and the Visual Arts.* New Haven, 1979.

van Witsen 1981 Leo van Witsen. *Costuming for Opera.* Bloomington, Ind., 1981.

van Witsen 1994 Leo van Witsen. *Costuming for Opera: Who Wears What and Why.* Metuchen, N.J., 1994.

Wold et al. 1996 Milo Wold et al. *An Introduction to Music and Art in the Western World.* 10th ed. Dubuque, 1996.

van der Wolk 1987 Johannes van der Wolk. *The Seven Sketchbooks of Vincent Van Gogh.* London, 1987.

Wollheim 1987 Richard Wollheim. *Painting as an Art.* The A.W. Mellon Lectures in the Fine Arts, 1984, Bollingen Series XXXV.33. Princeton, 1987.

Wolverhampton 1902 *Art and Industrial Exhibition.* Exhibition, Wolverhampton, Eng., 1902.

Wood 1907 T. Martin Wood. *The Drawings of Sir Edward Burne-Jones.* London, 1907.

Wood 1908 T. Martin Wood. *Whistler.* Masterpieces in Color. London, 1908.

Wood 1981 Christopher Wood. *The Pre-Raphaelites.* London, 1981.

Wood 1983 Christopher Wood. *Olympian Dreamers: Victorian Classical Painters, 1860–1914.* London, 1983.

Wood 1997 Christopher Wood. *Burne-Jones.* New York, 1997.

Wood 1998 Christopher Wood. *Burne-Jones: The Life and Works of Sir Edward Burne-Jones (1833–1898).* London, 1998.

Wood 1999 Christopher Wood. *Victorian Painting.* London, 1999.

Woodall 1997 Joanna Woodall. *Portraiture: Facing the Subject.* Manchester, 1997.

Wooster 1974 Robert H. Getscher. *Félix Bracquemond and the Etching Process: An Exhibition of Prints and Drawings from the John Taylor Arms Collection.* Exhibition, College of Wooster (Ohio) Art Center Museum, February 3–24, 1974; John Carroll University Fine Arts Gallery, Cleveland, March 23–April 20, 1974. Catalogue by Robert H. Getscher. Wooster, Ohio, 1974.

World of Art Nouveau **1987** *The World of Art Nouveau.* Vol. 4, *Beardsley and London.* Tokyo, 1987.

Wright 1929 Thomas Wright. *The Life of William Blake.* 2 vols. Olney, Bucks., 1929.

Wright 1972 Barbara Wright. "Gustave Moreau and Eugène Fromentin: A Reassessment of Their Relationship in the Light of New Documentation." *Connoisseur* 180 (July 1972), pp. 191–97.

Wright 1975 Samuel Wright. *A Bibliography of the Writings of Walter H. Pater.* New York, 1975.

Wright 1997 Alastair Wright. "Failed Identities: The Collapse of Tradition and the Shortcoming of Cultural Meaning in the Painting of Henri Matisse, 1905–1914." Ph.D. dissertation, Columbia University, New York, 1997.

Wyzewa 1907 Téodor de Wyzewa. *L'oeuvre peint de Jean-Dominique Ingres.* Paris, 1907.

Yamaguchi 2000 Eriko Yamaguchi. "Rossetti's Use of Bonnard's *Costumes Historiques*: A Further Examination, with an Appendix on Other Pre-Raphaelite Artists." *Journal of Pre-Raphaelite Studies,* n.s., 9 (fall 2000), pp. 6–11.

Yamazaki, Tomiyama, and Takashina 1972 Masakazu Yamazaki, Hideo Tomiyama, and Shūji Takashina. *Runowaru / Renoir.* Sekai no meiga, no. 7. Tokyo, 1972.

Yarker 2000 Gwen Yarker. "Alfred Stevens, Painter, Designer and Sculptor, and His Depiction of the Figure 1845–1875." Thesis, Courtauld Institute of Art, London, 2000.

Yeats 1955 William Butler Yeats. "The Tragic Generation." In *Autobiographies*, by William Butler Yeats. London, 1955.

Young 1969 Mahonri Sharp Young. "Letter from U.S.A. Amateurs of Art." *Apollo*, n.s., 89 (March 1969), pp. 236–38.

Young 1987 David Young. *Troubled Mirror: A Study of Yeats's "The Tower."* Iowa City, 1987.

Young, MacDonald, and Spencer 1980 Andrew McLaren Young, Margaret F. MacDonald, and Robin Spencer, with the assistance of Hamish Miles. *The Paintings of James McNeill Whistler*. 2 vols. New Haven, 1980.

Youngstown 1986 *Fireworks: American Artists Celebrate the Eighth Art*. Exhibition, Butler Institute of American Art, Youngstown, Ohio, September 14–October 26, 1986. Catalogue. Youngstown, Ohio, 1986.

Yriarte 1876 Charles Yriarte. "Le Salon de 1876." *Gazette des beaux-arts*, ser. 2, 13 (June 1, 1876), pp. 689–729.

Zabel 1929 Morton Zabel. "The Portrait Methods of Ingres." *Art and Archaeology* 28 (October 1929), pp. 103–16.

Zabel 1930 Morton Zabel. "Ingres in America." *The Arts* 16 (February 1930), pp. 369–84.

Zamoyski 1999 Adam Zamoyski. *Holy Madness: Romantics, Patriots, and Revolutionaries, 1776–1871*. London, 1999.

Zanni 1990 Annalisa Zanni. *Ingres: Catalogo completo dei dipinti*. Florence, 1990.

Zatlin 1990 Linda Gertner Zatlin. *Aubrey Beardsley and Victorian Sexual Politics*. Oxford, 1990.

Zatlin 1997 Linda Gertner Zatlin. *Beardsley, Japonisme, and the Perversion of the Victorian Ideal*. Cambridge, 1997.

Zerner 1978 Henri Zerner. "Théodore Géricault: Artist of Man and Beast." *Apollo* 107 (June 1978), pp. 480–86.

Zerner 1993 Henri Zerner. "La problématique de la narration chez Géricault." In *Künstlerischer Austausch / Artistic Exchange: Akten des XXXVIII. Internationalen Kongresses für Kunstgeschichte, Berlin, 15.–20. Juli 1992*, edited by Thomas W. Gaehtgens, vol. 2, pp. 569–78. Berlin, 1993.

Zervos 1927 Christian Zervos. "Idéalisme et naturalisme dans la peinture moderne. I, Corot, Courbet, Manet, Degas, Seurat, Daumier, Toulouse-Lautrec; II, Cézanne, Gauguin, Van Gogh." *Cahiers d'art* 2, nos. 7–8 (1927), pp. 293–309, 329–46.

Zervos and Fuchs 1928 Christian Zervos and Eduard Fuchs. "Révisions Honoré Daumier" and "Honoré Daumier." *Cahiers d'art* 3, nos. 5–6 (1928), pp. 181–86, 187–97.

Zieseniss 1954 Charles Otto Zieseniss. *Les aquarelles de Barye: Étude critique et catalogue raisonné*. Paris, 1954.

Ziff 1977 Norman Ziff. *Paul Delaroche: A Study in Nineteenth-Century French History Painting*. New York, 1977.

Zimmermann 1991 Michael F. Zimmermann. *Seurat and the Art Theory of his Time*. Translated by Patricia Crampton [et al.]. Antwerp, 1991.

Zoubaloff sale 1927 *Tableaux modernes, aquarelles, pastels, dessins, etc.* [Jacques Zoubaloff collection]. Sale, Galerie Georges Petit, Paris, June 16, 1927.

Zürich 1932 *Collection Oskar Schmitz*. Exhibition, Kunsthaus, Zürich, 1932.

Zürich 1986 *Gustave Moreau, Symboliste*. Exhibition, Kunsthaus, Zürich, March 14–May 25, 1986. Catalogue by Toni Stooss, with contributions by Pierre-Louis Mathieu. Zürich, 1986.

Index of Former Owners

Numbers refer to catalogue numbers.

A

Ackermann, Otto, 45
Agnew, Thomas, and Sons, London, 155, 156, 157, 161–65, 175, 213
Aguillon, Louis, 72
Alexandre, Arsène, 32
Allard, 87
Altieri, Countess Lorenzo, 78
Ames, F. L., 31
Amsinck, Antonie, 215
Amsinck, Edwin, 215
Appert, Léon, 128
Appert, Maurice, 128
Arnould, P., 83
Arnould, Paule, 83
Artz en De Bois, The Hague, 46

B

Baillehache, Alfred, 97
Baltard, Victor, 83
Barbedienne, Ferdinand, 1
Barbizon House, 153, 187
Bassano, duc de, 178
Bassano, Mlle de, 19, 20
Bassano, Mme la duchesse de, 19, 20
Bauchy, 109
Béarn, comtesse de, 65–68
Beausire, Mr. and Mrs. Joseph, 187
Beecham, Henry, 186
Béhague, comtesse de, 65–68, 70
Bénédite, Rosa, 118
Bénédite-Ungemach, Eva, 118
Benson, Robert Henry, 158
Béranger, Henri, vicomte de, 16, 21
Bernheim, Georges, 55, 87, 95
Bernheim-Jeune, Paris, 25, 61, 64, 86
Besnard, Albert, 460
Beurdeley, (Alfred?), 94
Beurnonville, baron de, 31
Bignou, Etienne, 14, 98, 128, 130
Blair, Walter D., 204
Blanche, Jacques-Émile, 126
Blondin, Léopold, 119
Blumenthal, Willy, 93

Bocquet, 93
Bonaparte, Mme Lucien, 55
Bonaventure, E. F., Art Galleries, New York, 23, 127
B[oucher], A[chille], 44
Bouchet, 44
Boussod, Valadon et Cie, Paris, 31, 218
Brame, Hector, 460
Braun, John F., 213
Braun, Mrs. John F., 213
Bullard, Francis, 160
Bureau, Paul, 12
Burne-Jones, Philip, 166, 167, 168, 169
Butts, Thomas, 144
Butts, Thomas Jr., 144
Buxford, 152

C

Cabinet de M****, Paris, 42
Cahen d'Anvers, Albert, 89, 92
Cahen d'Anvers, Mme Albert, 89, 92
Cain, Auguste Nicolas, 100
Cain, Georges, 100
Cain, Mme Georges, 100
Calamatta, Luigi, 49
Camentron, Gaston-Alexandre, 111
Carrière, Eugène, 119
Carrington, Fitzroy, 143
Cassavetti, Euphrosyne, 157
Castagnary, Jules-Antoine, 9
Castro Maya, Raimundo de, 30
Cazalens (Cayalens?), Louis, 98
Chabrier, André, 87
Chabrier, Emmanuel, 87
Chabrier-Bretton, Mme, 87
Chapman, Alfred, 215
Charpentier, Mme Théodore, 104
Charpentier, Théodore, 104
Chatillon, Charles de, 55
Chéramy, Paul Arthur, 30
Chocquet, Victor, 30, 112
Claburn, 30
Clark, Stephen Carlton, 83
Clarke, Thomas B., 201
Cochin, Baron Denys, 86
Colin, Alexandre, 35, 39
Colnaghi, London, 214, 217
Coltart, William, 187

Colthurst, Lady Annie C., 57
Combes, Mme, 21
Connolly, Colonel T., 127
Connolly, Mrs. T., 127
Constantini, 101
Contini Bonacossi, Count Alessandro, 78
Conway Colthurst, Lady George, 57
Conway Colthurst, Sir George, 57
Conway Colthurst, Lady Nicholas, 57
Cornforth, Fanny, 183
Cottier and Co., New York, 90
Courbet, Juliette, 10, 11
Coutan, Louis-Joseph Auguste?, 22
Coutot, Maurice, 42
Couvreur, 36
Cowan, John James, 215, 216, 219
Craven, Frederick W., 186
Curel, vicomte of, 96

D

Dagoumer, Dr. Thomas, 106
Dale, Chester, 87
Daru, vicomte Paul, 26
David, Baron J. (Jules?), 16
Davies, Arthur Bowen, 83
Davis, Mrs. Edmund (Mary), 4, 119
Davis, Sir Edmund, 4, 119, 196
Davis, Reginald, 14, 24, 51, 52, 75, 105
de Beaumont family, 69
Dechaume, Adolphe Victor Geoffroy, 13
Defresne, M., 18
Degas, Hilaire-Germain-Edgar, 49, 61, 64
Delaroche, Hippolyte-Paul, 60
Delaroche, Joseph-Carle-Paul-Horace, 60
Delécluze, Étienne-Jean, 77
Delestre, 104
Delvolvé, Jean, 119
Despatys, Augustin-Omer, 58, 59
Despatys, Pierre-Jérôme, 58, 59
Despatys de Courteilles, baronne Octave, 58, 59
Didot, Ambroise Firmin, 22
Doll and Richards, Boston, 206
Dollfus, Jean, 35, 105
Dortu, M. G., 133
Dowdeswell Galleries, London, 214
Drouin, 93
Duban, Mme Félix, née Marguerite-Françoise Hayard, 56

Dubaut, Pierre-Olivier, 34, 35, 36, 37, 39, 40
Du Boys, 105
Duchesne, 44
Dugléré, 106
Dulac, Mme, 15
Dupré family, 6
Durand-Ruel, Paris and New York, 13, 107, 111, 112, 130
Duruflé, Gustave, 95

E

Ederheimer, Richard, Print Cabinet, New York, 101
Edwards, Hannah, 107
"Elisabeth, Mlle," 106
Ellis, Frederick S., 190

F

Fåhraeus, Klas, 47
Faina, Countess Zeffirino, 55
Faivre, 92
Falabert, Charles-François, 62
Ferargil Gallery, New York, 83
Fine Art Society, 194, 196
Flachéron, Félix-Raphaël-Alexandre, 56
Flachéron, Mme Frédéric (formerly Mme Edmond Duvivier), née Caroline-Julie-Antoinette Hayard, 56
Flower?, C., 190
Folwell, William Hazelton, 198
Fontane, Theodore, 134
Forget, baronne Tony de, née Joséphine de Lavalette, 29
Fortuny y Madrazo, Mariano, 17
Fortuny y Marsal, Mariano, 17
Foucher de Careil, comte Louis-Alexandre, 73
Fournier, Fiorillo-del Florido-Henri-Edmond, 54
Fournier, Jean-Joseph, 54
Fraissinet, Léon, 31
French, Cecil, 187
"French collector," 79
Frey, Dr. A. C. de, 48
Fullerton, J., 205

G

Galerie Adolphe Le Goupy, Paris, 102, 103
Galerie Brame, Paris, 97
Galerie Brame et Lorenceau, Paris, 95
Galerie Caspari, Munich, 134, 136
Galerie Férault, Paris, 49
Galerie Georges Bernheim, Paris, 55; see also Bernheim, Georges
Galerie Georges Petit, Paris, 90, 96
Galerie Thannhauser, Munich, 111
Galerien Thannhauser, Berlin, 135
Galerie Trotti et Cie, Paris, 106
Gallatin, Goelet, 203
Galliéra, duchesse de, 36
Garnier, Henri, 13

Gauchez, L[eon?], 27
Gérard, Felix (?), 10, 11
Gérard Frères, 98
Gérôme, Jean-Léon, 62
Gérôme, Mme, née Marie Goupil, 62
Gerstenberg, Otto, 133
Gilbertson, E., 191
Gillet, 97
Gillibert, Paul, 96
Gillum, Colonel William, 154
Glaenzer, Eugene, and Co., New York, 13
Gobin, Maurice, 12
Gogh, Wilhelmina van, 46
Gogh-Bonger, Mrs. J. van, 47
Goupil, Albert, 62, 63
Goupil et Cie, Paris, 26
Gourgaud, Baroness, 84
Gradt, M., 86
Graham, William, 158, 161–65, 184, 188
Gray, Miss, 166, 167, 168, 169
Guasco, Charles, 96
Guérard, Henri, 86
Guilhermoy (or Guilhermy), 72
Guille, Fernand, 61, 64

H

Hamilton, George, 159
Hamilton, Mrs. George, 159
Haniel, F., 46
Haro, Étienne-François, 51, 52, 65–68, 70, 71, 73, 83
Haro, Henri, 30, 71
Harris, Alfred, 177
Hartmann, Alfred, 94
Harvey, Francis, 144
Hauke, César Mange de , 25
Hayard, Charles-Roch, 56
Hayard, Mme Charles-Roch, 56
Hayem, Charles, 97
Hazard, Nicolas Auguste, 12
Hébrard, Adrien, 111, 112
Heilbuth, Herman, 31, 55
Henderson, Alexander, 161–65, 194
Henderson, Hunt, 212, 214, 219
Henriquet, Édouard, 42
Heseltine, John Postle, 180, 217
Hirsch, Leopold, 196
Hoe, Robert, 101
Hofer, Philip, 133
Holme, Charles, 141
Homer, Arthur P., 200, 202
Homer, Mrs. Arthur P., 202
Homer, Charles L., 200
Homer, Charles S. Jr., 200, 202
Homer, Mrs. Charles S. Jr., 200, 202
Hope, Lord Francis Pelham Clinton, 171
Hope, Thomas, 171
Howell, C. A., 215

Hulot, Anatole-Auguste, 38
Hunt, Edith Holman, 176
Hunt, Hilary Holman, 176

I

Ingres, Mme Delphine, née Ramel, 50, 64, 76, 80, 81, 82

J

Jarves, James Jackson, 144
Jonas, Edouard, of Paris, Inc., 83
Jordan, Augustin, 58, 59
Journet, Robert, 8
Joyant, Maurice, 131, 132, 133

K

Kann, Alphonse, 217, 218
Karnicki, Senator Justynian, 102, 103
Kerr, Mrs. Annabel, 144
Kerrigan, Joseph John, 29
Klotz, Mme Victor, 32
Knoedler, M., New York and Paris, 90, 128, 133, 203, 204, 460
Kraushaar, C. W., Galleries, New York, 213
Kronberg, Louis, 82
Kunsthalle, Hamburg, 215

L

Laffon, M. and Mme Émile, 129, 130
Lamoignon, vicomte, 36
Lane, Annie, 139, 140, 142
Lane, John, 139, 140, 142
Laperlier, Laurent, 106
Lapeyrière, L., 102, 103
Lapierre, Mme, 11
Laurent, 45
Laurin, Thorsten, 47
Lawlor, Lilly, 101
Lawrence, Lord Charles Napier, 170
Lawrence, Cyrus J., 13
Leathart, James, 182
Le Boulanger de Boisfremont, Charles-Pompée, 105
Le Boulanger de Boisfremont, Oscar, 105
LeBrun, L., 91
Le Coeur, Charles, 110
Lecomte, Eugène, 70
Lefè, 105
Leggatt Brothers, 155, 156
Lehmann, Henri, 65–68
Leloir, 35
Leverhulme, Viscount, 181
Levy, John, Galleries, New York, 204
Lewin, Leo, 134
Leyland, Frederick R., 155, 156
Leyland, Mrs. F. R., 212
Liard, 3

Lincoln, Mrs. Roland C., 206
Linnell, John, 145, 146, 147, 148, 149, 150, 151
Lion, Louis, 48
Lippert, B., 135

M

Madrazo y Agudo, José de, 17
Madrazo y Kuntz, Federigo de, 17
Mahérault, Marie Joseph François, 35
Mansfield, Burton, 201
Marchesi, Mme Blanche, 217
Marcotte, Charles-Marie-Jean-Baptiste, called
 Marcotte d'Argenteuil, 72
Marcotte, Louis-Marie-Joseph, 72
Marcotte de Quivières, Louis, 72
Marcotte family, 72
Martel (possibly Édouard Martell), 91
Martel, Mme, née Caroline Estelle Elisabeth Mallet, 91
Martin, Alec, 148, 149, 150, 151
Matthews, Muriel, 205
Max, 76
Mène, Pierre-Jules, 100
Millet, Mme Jean-François, 89
Mills, Mrs. John D. (Anna R.), 460
Mme X, 44
Montaignac, Isidore, 31
More, Mrs. Blomfield, 218
Morgan, J. Pierpont, 13
Mornay, comte Charles de, 26, 27
Morot, Mme Aimé-Nicolas, 62
Morris, May, 189
Morris, Mrs. William, 189
Morrison, Alfred, 4
Morse, Esmond, 175
Morse, Juliet M. (Mrs. Sydney), 154, 175
Moss, Colonel W. E., 190
Moss, W. R., 190
Moy, marquise Adolphe-Marie de, 75
Murray, Charles Fairfax, 157, 160, 182, 183, 185
Musée du Luxembourg, Paris, 33

N

National Art-Collections Fund, London, 148, 149, 150,
 151
Newall, Mrs. William, 179
Newall, William, 179
Nieuwerkerke, comte Émilien de, 78
Nogent, Joseph-Antoine de, 54

P

Pellerin, Auguste, 86
Péreire, Gustave, 72
Péreire, Mme Gustave, 72
Péreire, Isaac, 7, 79
Péreire, Mme Isaac, 7
Perrins, C. W. Dyson, 188

Perrins, J. Dyson, 188
Poiret, Mme, 101
Poulain, Jean-Baptiste Martial, 101
Pourtalès-Gorgier, Count de, 53
Primoli, Count Giuseppe Napoleone, 55
Proust, Antonin, 117

R

Rae, George, 181
Raffalovich, Marie, 96
Ramel, Albert, 50, 80, 81
Ramel, Mme Albert, 50, 80, 81
Rasmussen, Gorm, 55
Reid, Alexander, 130
Reiset, 41
Reiset, Hortense, 74
Reiset, Marie-Eugène-Frédéric, 74, 75
Renou, 31
Riant, Emmanuel, 80
Ricketts, Charles, 151, 192, 193
Rikoff, 117
Rivoli, duc de, 100
Robson and Co., Messrs., 143
Roederer, comte, 92
Roehn the elder, 106
Roger, Baron Barthélemy, 101, 104
Roger-Marx, Claude, 9, 10, 11, 39
Roll, Alfred, 116
Romilly, Félix de, 94
Rosenberg, Paul, 26, 44, 91
Ross, James, 155, 156
Rothschild, Baron Henri de, 2, 27, 43, 53
Rothschild, Baroness James de, 53
Rothschild, James Nathaniel de, 43
Rothschild, Baron Nathaniel de, 53
Rouillier, Albert, 218
Rushton, Joseph, 155, 156
Russell, Cooke and Co., 186

S

Sabin, Frank T., 145, 146, 147
Sackville-West, Josephine Victoria, Lady Sackville of
 Knowle, 22
Saint-Péreux, Mme de, 96
Saisset, Édouard, 97
Sallé, 102, 103
Salz, Sam, 98
Sargent, John Singer, 114, 120
Sarlin, Louis, 31, 94
Saucède, Alfred, 13
Schall, Erich, 46
Scheffer, Ary, 38
Schmitz, Édouard, 111
Schmitz, Oskar, 111
Schoeller, 79
Schoeller, André, 12
Schwab, Charles M., 204

Schwabe, Frau, 135
Scott, Sir John Murray, 22
Scott and Fowles, New York, 12, 24, 26, 28, 29, 33, 56,
 61, 63, 64, 79, 89, 90, 94, 97, 99, 108, 114, 115, 116,
 121–25, 137, 138, 139, 140, 141, 142, 143, 144, 148,
 149, 150, 152, 155, 156, 158, 159, 171, 177, 181, 183,
 184, 190, 201, 206, 208, 209, 210, 211, 214, 215, 216
Seaman, W. W., 177
Secrétan, E., 31
Ségur-Lamoignon, comtesse Adolphe-Louis-Edgar de,
 74, 75
Ségur-Lamoignon, comte Louis-Marie-Frédéric-
 Guillaume de, 74
Seligmann, Arnold, 48
Seligmann, Jacques, and Co., New York, 8, 22, 55, 78,
 96, 112, 113, 131, 170
Seligmann, Jacques, et Cie, Paris, 22
Seligmann, P., 46
Seney, George I., 31
Seurat, Mme, *mère*, 128
Shannon, Charles Hazelwood, 151, 192, 193
Sieyès, Emmanuel-Joseph, 21
Simon, Jacques, 48
Smith, Eustace, 194
Smith, Frank Bulkeley, 177
Smithers, Leonard, 143
Spartali Stillman, Marie, 157
Spencer, 166, 167
Stanley, Edward Arthur Vestey, 152
Stanley, Edward James, 152
Stein, Adolphe, 30
Stonborough, Jerome, 1, 3
Strange, J. C., 144
Strauss, 105
Strauss, Jules, 86

T

Tastes, Mme de, 11
Tauber, 95
Taunton, Henry Labouchère, Baron, 152
Tedesco Frères, Paris, 31
Thaw, Mrs. Benjamin, 213
Thibaudeau (or Thibaudot), 65–68
Thomson, Croal, 120
Tong, Mrs., 187
Travor and Co. Ltd, London, 48
Trévise, Édouard Mortier, duc de, 18, 36, 106
Tulane University, New Orleans, 212, 214, 219
Turckheim, Baron de, 157
Turner, Major (Percy Moore?), 25
Turquois, M., 15
Turquois, Mlle, 15
Tyson, Carroll S., 72

V

Van Cuyck, Paul, 7
Vauchin, 49

Vaudoyer, Alfred, 77

Vaudoyer, Léon-Jean-Georges, 77

Verhaeren, Émile, 129

Vesey, Colonel and Mrs. George, 57

Viollet-le-Duc, Adolphe-Étienne, 77

Viollet-le-Duc, Mme Adolphe-Étienne, née Louise-
 Stéphanie Girard, 77

Vipan, Major, 184, 186

Vipan, Mrs., 184, 186

Viron, 33

Vitta, Baron Joseph, 6, 38, 41, 44, 54, 63, 71, 113, 117

Vollard, Ambroise, 25

W

Wagram, Alexandre Berthier, prince de, 112

Walker, Thomas R., 205

Wallace, Lady Julia Amélie Castelnau, 22

Wallace, Richard, 22

Wallis and Co., 177

Ward and Downey, publishers, 142

Wardwell, Jacob Otis, 199

Wardwell, Sheldon Eaton, 199

Watts, Mary, 195

Watts-Dunton, Clara, 153

Watts-Dunton, Theodore, 153

Way, Misses, 213

Way, Thomas R. Sr., 213

Wells, Gabriel, 145, 146, 147

Weyhe, E., and Co., New York, 88

Whistler, James Abbott McNeill, 215

Wildenstein and Co., Paris and New York, 15, 30, 46,
 57, 58, 59, 60, 72, 80, 84, 87, 91, 98, 110, 111, 130

Wolsey, Moreau, 22

Woodburn, Samuel, 178

Z

Zoubaloff, Jacques, 1

General Index

Page numbers in italics refer to illustrations.

A

Abraham Lincoln (French), 440, *440*, 442
Abraham Lincoln Seated (French), 440, *441*, 442;
 cat. no. 197
Académie des Beaux-Arts, 201
Ackermann, Otto, 140
Actor Albouis Dazincourt (Vincent), 214
Adam Naming the Beasts (Blake), 338, *338*
Adirondack Lake (Homer), 449, 451, *451*; cat. no. 203
Aeschylus
 The Persians, Flaxman's drawings of, 390, 393, *393*
 The Furies, Flaxman's drawings of, 390, 392, *392*
Aesthetic Movement, 10*n*19, 16, 18, 21, 356, 370, 375,
 402
After Dinner at Ornans (Courbet), 63
After the Hunt (Harnett), 444
Agnello Brunelleschi Half Transformed by the Serpent
 (Blake), 347, 348, 350–51, *351*; cat. no. 150
Agnew, Colin, 43
Agoult, Marie d', 187
Aimé-Azam, Denise, 131*n*2
Á la Gaîté Rochechouart (Seurat), 307, *308*
Albanian Olive Gatherers (Sargent), 464*n*1
Album of Drawings for the "Divine Comedy" (Flaxman),
 348, 386, *387*, 388–89, *388*, *389*, 390; cat. no. 171
Ali Baba (Beardsley), 336–37, *337*; cat. no. 143
Allegory of the Arts (Luttichuys), 456
Allingham, William, 368
Allston, Washington, 454
 Belshazzar's Feast, 456
Alston, Rowland, 436
Aman-Jean (Seurat), 306*n*3
Les Amants dans la campagne (Courbet), *62*, 63
L'Amateur de caricatures (Daumier), 70*n*2
Amaury-Duval, Eugène-Emmanuel, 152, 189*n*8, 238
American school, 440–78
L'Amour séduit l'Innocence, le Plaisir l'entraîne, le
 Repentir suit (Prud'hon), 260, *260*
L'Amour séduit l'Innocence, le Plaisir l'entraîne, le
 Repentir suit (Roger, after Prud'hon), 260, *260*
Ancient Sacrifice (Gericault), *121*, 122
André, Albert, 274
Angelico, Fra, 267
Angels, The, Hovering over the Body of Jesus in the
 Sepulchre (Blake), 340*n*3

Anger of Achilles, The (David), 90*n*4
Antoinette Hébert devant le miroir (Millet), 227
Antonin Proust (Rodin), 287–89, *288*; cat. no. 117
Aphrodite, or *Birth of Venus* (Moreau), 30, 238–40, *239*;
 cat. no. 94
Apollo Belvedere, 454
Apollo Cauroctonus, 252
Apollon Pythien, 191
Apotheosis of Homer, The (Ingres), 183, 186, 189
Apparition, The (Moreau), 11, 240, *241*, 242; cat. no. 95
Apponyi, Count and Countess Antoine, 175–76
Apponyi, Count Rodolphe, 176
Arab (Turk) Saddling His Horse (Delacroix), 104
Arab about to Saddle His Horse (Delacroix), 104, *106*
Arab Actors or Clowns (Delacroix), 103, 104
Arab Battle, or *Battle of Arab Horsemen* (Chassériau),
 60–61, *61*; cat. no. 8
Arab Carrying Wounded Man and Women in Sorrow
 (Chassériau), 58
Arab Horsemen Carrying Away Their Dead
 (Chassériau), 24, 58–60, *59*; cat. no. 7
Arabian Fantasy before a Doorway in Meknès
 (Delacroix), *105*
Arabs and Horses near Tangier (Delacroix), *106*
Arago, Étienne, 282
Archaeological Institute of America, 8
Aretino and the Envoy from Charles V (Ingres), 160*n*7
Aretino in the Studio of Tintoretto (Ingres), 160*n*7
Ariadne (Watts), 437, *438*, 439; cat. no. 196
Ariadne (Watts, private coll.), 437
Ariadne in Naxos (Watts, 1894), 439, *439*
Ariadne in Naxos (Watts, ca. 1868–75), 437, *437*
Ariadne Sleeping, 234
Ariosto, Ludovico, 170, 172
Arlet, comte d', Auguste-Louis-César-Hippolyte-
 Théodose de Lespinasse de Langeac, 254, 256
Armory Show, New York City (1913), 5
Arrangement in Grey and Black No. 1: Portrait of the
 Artist's Mother (Whistler), 358*n*11, 446, 468
L'art, 116
art forgeries, 36*n*108
L'artiste, 282
Artist in the Simplon (Sargent), 464–65, *465*; cat. no. 211
Art Nouveau, 328
Asia, art of, 13–14, 34, 38, 42
Assumption of the Virgin (Prud'hon), 266
Athenaeum, 371, 433
Athlete Wrestling with a Python (Leighton), 430*n*21

Atlas Turned to Stone (Burne-Jones), *371*
At the Circus: The Curtain Call (Toulouse-Lautrec),
 314, 316
At the Circus: In the Wings (Toulouse-Lautrec), 314,
 315, 316; cat. no. 132
At the Circus: Jockey (Toulouse-Lautrec), 34, 316–17,
 317; cat. no. 133
At the Races (Manet), *219*, 220
At the Races in the Countryside (Degas), 97
Au cirque: Écuyère de panneau (Toulouse-Lautrec), 316
Au cirque Fernando (Toulouse-Lautrec), 316
Audubon Society, 23*n*68
Aurier, Albert, 449
L'aurore de la raison commence à Lucre (Pérée), 251, *252*
Autour du piano (Fantin-Latour), 223*n*11
Avery, Samuel P., 56*n*2
Avril, Jane, 312
Ayrton, Acton Smee, 428

B

Babbott, Frank Lusk, 458
Bacchus and Ariadne (Titian), 437
Bacon, Henry, 440, 442
Bailey, Philip James, 419
Baillehache, Alfred, 244*n*13
Bailly, Jean-Sylvain, 78
Bakst, Léon, 272
Balcony, The (Manet), 115
Balcony Room, The (Menzel), 318
Balfour, Arthur James, first earl of, 371
Baltard, Victor, 249
Bancroft, Samuel Jr., 25
Banks of the Oise, The (Daubigny), 248, *248*
Banks of the Oise River (Pissaro), 246, *247*, 248;
 cat. no. 98
Banks of the Seine (Monet), 223*n*8
Bar at the Folies-Bergère, A (Manet), 221
Barbault, Jean, D'après l'Antique, 255, *256*
Barbedienne foundry, 49
Barbizon school, 452, 457–58
Le barde Ossian évoquant les fantômes sur le bord du Lora
 (Gérard), 182
Barlach, Ernst, 18
Baroque, 125
Barque de Dante, The (Delacroix), 127*n*8
Bartolini, Lorenzo, 198

Barye, Antoine-Louis, 46, 48–51, 60, 106, 108
 Deer, 51n4
 Eagle with Outstretched Wings and Open Beak, 51n4
 A Jaguar Devouring a Hare, 51n4
 A Jaguar in a Landscape, 50–51, 50; cat. no. 2
 Reclining Panther, 51n4
 Tiger Attacking a Peacock (after 1876), 48, 49
 Tiger Attacking a Peacock (ca. 1830–40), 48–50, 49, 51n4; cat. no. 1
 Tiger Attacking a Pelican, 48, 49n1
 Tiger Devouring a Peacock, 48, 49
 Tiger Hunt group, 48–49
 Tiger in Its Lair, 51n3
 Two Jaguars in Their Lair, 50n4, 51, 51; cat. no. 3
 Two Tigers Fighting, 51n3
 Walking Lion, 51n4
Bassano, duc de, 28
Bather, The (Ingres), 28n90, 152, 153; cat. no. 50
Bather, The (Ingres, Louvre), 152
Bather and Death (Bresdin), 55
Bather and Time (Bresdin), 55
Bath of Venus, The (Burne-Jones), 383
Battle between Arab Tribes (Chassériau), 60
Battle of Constantine (Raphael), 148
Battle of the Gaiour and the Pasha (Delacroix), 112, 112
Battle of the Romans and the Sabines (David), 121, 122
Battle on the Edge of a Ravine between Spahis and Kabyles (Chassériau), 60, 61n3
Battles of Alexander (Le Brun), 148
Battles of the Amazons (Rubens), 148
Baudelaire, Charles, 73, 189n8
Bazille, Frédéric, 46, 230, 310
Beardsley, Aubrey Vincent, 5, 18, 37, 42, 328–37, 386
 Ali Baba, 336–37, 337; cat. no. 143
 Black Coffee, 332, 332
 Bon-Mots series, 328, 329
 The Climax, John and Salome, 329–30
 The Dancer's Reward for Salome, 330–31, 331; cat. no. 140
 Design for Frontispiece of "The Wonderful Mission of Earl Lavender," 334–35, 334; cat. no. 142
 The Eyes of Herod, 332
 Isolde, 332, 333; cat. no. 141
 The Peacock Skirt for Salome, 328–30, 329, 332; cat. no. 139
 Stomach Dance, 328, 330
 The Yellow Book, 334, 335, 336
Beata Beatrix (Rossetti), 366, 416–17, 416; cat. no. 186
Becoeur, Charles-Jérôme, The Death of Virginia, 217
Before Confession (Menzel), 318, 320–21, 321, 322; cat. no. 135
Béhague, comtesse de, 26
Behold Now Behemoth Which I Made with Thee (Blake), 344, 344, 345; cat. no. 147
Bell, Jacob, 400
Bell, Malcolm, 361
La Belle Ferronière (Leonardo), 354

Bellini, Giovanni, 356n9
 Pietà, 258
Bellini workshop, Madonna, 12n31
Belshazzar's Feast (Allston), 456
Bénédite, Léonce, 41, 289
Bénédite, Rosa, 289
Bénédite-Ungemach, Eva, 289
Bengal Tiger (Delacroix), 106
Benson, R. H., 366, 370
Béranger, Henri, vicomte de, 76
Berenson, Bernard, 9–10, 11–14, 15, 16
Bergeret, Pierre-Nolasque, Rinaldo and Armida, 170
Berlin Photographic Company, 18
Berlin-Potsdam Railway, The (Menzel), 318
Berlioz, Hector, 114
Bernard, Émile, 142, 144n8, 146, 307
Bernheim-Jeune, Paris, 99
Berthier, Paul, 242
Bertin, Louis-François, 179, 199
Besnard, Albert, 282, 460
Besson, George, 224
Betrothal of Raphael and the Niece of Cardinal Bibbiena, The (Ingres, 1813–14), 159n4, 160n3, 209, 211
Betrothal of Raphael and the Niece of Cardinal Bibbiena, The (Ingres, 1864), 209, 210, 211; cat. no. 82
Bianchi, Gaetano, 212
Bibescu, George, 276
Biennale, Venice, 18
Bingen, Pierre, 287
Bingham, photographer, 238n14
Birnbaum, Martin
 as agent, 17, 23–31, 23, 34, 39, 42, 48, 50–51, 52, 73, 131, 132, 134, 136, 140, 204, 206, 288, 289, 291, 294, 299, 300, 318, 379, 420, 429, 433, 436, 439, 465
 Christmas card from, 17
 as critic, 18
 first meeting of Winthrop and, 16–19
 gallery of, 17, 18
 installation advice from, 42
 as musician, 17, 18
 personal traits of, 23–25
 with Scott and Fowles, 19, 23, 26, 389
 and Winthrop's bequest, 45
Birth of Venus (Botticelli), 238, 239, 368
Black Africans Dancing in a Street in Tangier (Delacroix), 100, 103–4, 103; cat. no. 27
Black Coffee (Beardsley), 332, 332
Blake, William, 5, 24, 30, 37, 42, 338–53, 378n5, 386, 391
 Adam Naming the Beasts, 338, 338
 Agnello Brunelleschi Half Transformed by the Serpent, 347, 348, 350–51, 351; cat. no. 150
 The Angels Hovering over the Body of Jesus in the Sepulchre, 340n3
 Behold Now Behemoth Which I Made with Thee, 344, 344, 345; cat. no. 147
 The Body of Abel Found by Adam and Eve; Cain, Who Was about to Bury It, Fleeing from the Face of His Parents, 340, 341, 391; cat. no. 145

 The Book of Job, watercolors, 40, 342–45, 342, 343, 344, 345
 Buoso Donati Transformed into a Serpent, 350
 Christ Blessing, 40, 338, 339, 340; cat. no. 144
 Divine Comedy, illustrations, 346–53
 Eve Naming the Birds, 338, 338
 The Four Zoas, 350
 Illustrations of the Book of Job (engravings), 342, 342, 344
 The Inscription over the Gate, 348
 Jacob's Ladder, 340n3
 Jerusalem, 348
 The Laborious Passage along the Rocks, 348, 350
 The Lawn with the Kings and Angels, 352
 Los as He Entered the Door of Death, 348
 Lucia Carrying Dante in His Sleep, 350, 352–53, 353; cat. no. 151
 The Marriage of Heaven and Hell, 348
 The Punishment of Jacopo Rusticucci and His Companions, 346–47, 346, 348; cat. no. 148
 The Soldiers Casting Lots for Christ's Garment, 340n3
 Thy Sons and Thy Daughters Were Eating and Drinking Wine, 342, 342, 343; cat. no. 146
 Virgil Rescuing Dante from the Evil Demons, 347–48, 349; cat. no. 149
 The Virgin and Child in Egypt, 338, 338
 in Winthrop's collection, 39, 40
Blanc, Alexandre, 293n8
Blanc, Blanche-Marie, 277
Blanche, Jacques-Émile, 24, 300
Blanche, Joséphine, 277
Blashfield, Edwin, 268
Blavot, Marie-Élizabeth, 191
Blessed Damozel, The (Rossetti), 24, 30, 42, 366, 414, 419–20, 421, 422; cat. no. 188
Blue Cart, The (Harvest at La Crau) (van Gogh), 34, 142–44, 143; cat. no. 46
Blue Closet, The (Rossetti), 409
Blumenthal, George, 29, 43
Boats, Venice (Sargent), 465n3
Bocca Baciata (Rossetti), 412
Bocquet, M., 236
Bodmer, Charles, 283, 284
 photograph of Eternal Spring, 285, 286
Body of Abel Found by Adam and Eve, The; Cain, Who Was about to Bury It, Fleeing from the Face of His Parents (Blake), 340, 341, 391; cat. no. 145
Bonaparte, Lucien, 162–63, 163, 209
Bonaparte, Madame-Mère Laetizia, 86, 163
Bonaparte, Mathilde, 200
Bonington, Richard Parkes, 46
 Evening in Venice, 354, 355, 356; cat. no. 152
Bon-Mots series (Beardsley), 328, 329
Bonnard, Camille, 406, 407, 417
Bonnat, Léon, 25
Book of Job, The, watercolors (Blake), 40, 342–45, 342, 343, 344, 345
Borgia, Lucrezia, 417–18, 418

Botticelli, Sandro, 10, 348, 361, 370, 388, 423n3
 Birth of Venus, 238, 239, 368
 Mystic Nativity, 420, 422
 Saint Sebastian, 361
Botticelli, Sandro, workshop, *Virgin and Child*, 12n31
Bouchers de Rome (Gericault), *117*, 118
Bouchet, Louis-André-Gabriel, 94–95n6
Boudin, Eugène, 230
Boulanger, Clément, 191
Bouvenne, Aglaüs, 108
Bower Meadow, The (Rossetti), 407
Boydell, John, 356n2
Bracquemond, Félix-Auguste-Joseph, 282
 Le Haut d'un battant de porte, 52
 Self-Portrait, 52, *53*, 54; cat. no. 4
Breakfast Table, The (Sargent), 458, *459*, 460;
 cat. no. 207
Brejon de Lavergnée, Arnaud, 148
Bresdin, Rodolphe
 Bather and Death, 55
 Bather and Time, 55
 The Comedy of Death, 55
 The Good Samaritan, 54, 56
 Hunters Surprised by Death, 55
 Medieval Town, 56n1
 The Mother and Death, 56n6
 My Dream, 56n1
 Nightmare, 56n6
 Peasant Interiors, 54
 Rocky Landscape with a Distant Town, 56n1
 Schamyl in his Youth, 54
 Two Bathers, 54, 55, 56n12
 Women in a Landscape, 54–56, *55*; cat. no. 5
Brewster, Walter S., 56n2
Bridge at Villeneuve-la-Garenne, The (Sisley), 310, *311*;
 cat. no. 130
British school, 18, 25, 30, 328–439
Bromley, W., 402
Brown and Gold: Lillie "In Our Alley!" (Whistler),
 477–78, *477*; cat. no. 219
Brown, Catherine, 356
Brown, Ford Madox, 365n4
 The Last of England, 358n2
 portraits of, 356, 358n9
 Self-Portrait, 46, 356, *357*, 358; cat. no. 153
Brown, Oliver, 356
Browning, Elizabeth Barrett, 420
Browning, Robert, 420
 Pippa Passes, 408
Brummer, Joseph, 40n115, 43
Brunelleschi, Agnello, 350, *351*
Brunet, Auguste, 130
Brutus Condemning His Sons to Death (Lethière), 216
Bruyas, Alfred, 63
Buhot, 52
Bullard, Francis, 11, 14–16, 17, 18
Bulloz, Jacques-Ernest, photograph of *Antonin Proust*,
 287, 288–89

Bull Tamer (Gericault), 122
Buoso Donati Transformed into a Serpent (Blake), 350
Burghers of Calais, The, reductions (Rodin), 296–99,
 296, *297*, *298*, *299*; cat. nos. 121–25
Burne-Jones, Edward, 5, 10, 36, 42, 359–86, 407, 409,
 418, 431, 446
 Atlas Turned to Stone, *371*
 The Bath of Venus, 383
 Cupid's Hunting Fields, 364
 Danaë or *The Tower of Brass*, *366*, 367
 Danaë Watching the Building of the Brazen Tower,
 366–67, *367*, 370; cat. no. 158
 Dawn, 382
 Day, 361–63, *362*, 383n6; cat. no. 155
 Days of Creation, 30, 42, 366, 375–78, *376–77*, *378*;
 cat. nos. 161–65
 The Depths of the Sea (1886), 384–85, *384*
 The Depths of the Sea (1887), 384–86, *385*; cat. no. 170
 Designs for "The Story of Perseus," 371, *371*
 The Doom Fulfilled, 371, *371*, *372*, 373, 374
 Dying Slave, 380
 Evening, 383n6
 The Fall of Lucifer, 382
 Flamma Vestalis, 383
 Flodden Field, 382
 Head of a Girl, 384–85
 Hill Fairies, 383
 The Hours, 378n3, 383
 Laus Veneris, 360, 362n11
 Masque of Cupid, 374n19
 Night, 361–63, *363*, 382; cat. no. 156
 Pan and Psyche, 368, *369*, 370; cat. no. 159
 Pan and Psyche (private coll.), *368*, 370
 The Passing of Venus, 380
 Perseus and Andromeda, 16, 371–74, *372*, *373*, 380;
 cat. no. 160
 Phyllis and Demophoön, 366, 382
 The Rock of Doom, 371, *371*, *372*, 373, 374, 381
 The Seasons, 378n3
 Sidonia von Bork, 365n4, 418
 Sir Galahad, 359–60, *359*, 433n2; cat. no. 154
 Six Days of Creation, 30, 42
 sketchbooks, 379–83, *380*, *381*, *382*, *383*;
 cat. nos. 166–69
 The Sleep of Arthur in Avalon, 379, 383
 Study of Andromeda Viewed from the Back, *372*, 373,
 380n2
 The Tree of Forgiveness, 381, 382
 Venus Concordia, 364
 Venus Discordia, 364
 Venus Epithalamia, 364–65, *365*, 370; cat. no. 157
 The Wheel of Fortune, 380, 381
Burne-Jones, Georgiana, 364, 366, 368, 380
Burne-Jones, Margaret, 383
Burne-Jones, Philip, 383
Burty, Philippe, 102, 208
Butcher, The (Daumier), 25, 72–73, *72*; cat. no. 14
Butchered Ox (Rembrandt), 73

Butts, Thomas, 338, 340, 342
Byl, Arthur, 312
Byron, Lord (George Gordon), 112, 340
Byvanck, Willem Geertrudus Cornelis, 291, 293

C

Cabanel, Alexandre, 238
Cadart, Alfred, 52
Café-Concert (Á la Gaîté Rochechouart) (Seurat), 307–8,
 309; cat. no. 129
Cahen d'Anvers, Albert, 234
"Cahiers d'Aujourdhui" series (Matisse), 224
Caine, Hall, 422
Calamatta, Luigi, 150, 187
Callcot, Sir Augustus Wall, 400
Callet, Félix-Emmanuel, 249
Camentron, Gaston-Alexandre, 277, 279
Campana collection, 201
Canaletto
 etchings, 16
 Piazza San Marco, Venice, 34, *34*, 46
Canova, Antonio, 163
 Hercules and Lychas, 125n6
Cariani, Giovanni, *Portrait of Gentile and Jacopo
 Bellini*, 354
Carracci, Agostino, 208
Carrier-Belleuse, Albert-Ernest, 283
Carrière, Eugène, 291
Carriès, Jean, 287
*Cart, The, Snowy Road at Honfleur, with the Farm
 Saint-Siméon* (Monet), 230, 230
Cary, Henry Francis, 348
Cassatt, Mary, 52
Cassavetti, Euphrosyne "the Duchess," 364, 365
Castagnary, Jules-Antoine, 63n1, 66
Castel, René-Richard, 130
Cathedral, Granada, Spain (Sargent), 465n3
Cattle Market (Gericault), 118, 121–22, *123*; cat. no. 36
Cattle Market (Gericault, private coll.), *121*, 122
Cavalcanti, Guido, 411, 412
Cavé, Edmond, 191
Caylus, comte de, 386
Celestial Sphere (Manship), 19, *19*
Centaur (Moreau), 236
Ceres (Rodin), 289
Cervantes Saavedra, Miguel de, 354
Cézanne, Paul, 144, 221, 279
Chabrier, Alexis-Emmanuel, 221, 222, 223
Cham, *Cela t'amuse de venir aux courses?*, 218, *219*
Champfleury, 56n12
Chaplin, Charles, 16–17
Chardin, Jean-Baptiste-Siméon, 266
 Portrait of a Man, 34, *34*
Le Charivari, 70n2, 72
Charles Hayard and His Daughter Marguerite (Ingres),
 164, *165*
Charles Marcotte d'Argenteuil (Ingres), 168, 187

Charles X (Ingres), 203

Charpentier, Alexandre, 282

Chassériau, Baron Arthur, 24, 24*n*74, 59*n*8

Chassériau, Théodore, 23, 56–61, 148, 232, 234, 267, 270, 271
 Arab Battle, or *Battle of Arab Horsemen*, 60–61, *61*; cat. no. 8
 Arab Carrying Wounded Man and Women in Sorrow, 58
 Arab Horsemen Carrying Away Their Dead, 24, 58–60, *59*; cat. no. 7
 Battle between Arab Tribes, 60
 Battle on the Edge of a Ravine between Spahis and Kabyles, 60, 61*n*3
 Clash of Arab Horsemen, 60
 A Fellow Student of Chassériau's at Ingres's Studio, 56–57
 Portrait Drawing of a Young Family in Medieval Costume, 57*n*4
 Portrait of Victor Dupré (?), 56–57, *57*; cat. no. 6
 Sea Venus, 239
 Standing Portrait of a Young Man, 57

Chateaubriand, François-René de, 167

Chen Chi Fou, 17

Chennevières, Philippe de, 148

Chéret, Jules, 52, 282, 307

Cherubini and the Muse of Lyric Poetry (Ingres), 187, 202*n*13

Chesneau, Ernest, 236

Children's Album (Menzel), 320

Chimera, The (Moreau), 11, 236–38, *237*; cat. no. 93

Chimera, The: After Gustave Moreau (Manchon), 236

China, art of, 13–14, 42

Chocquet, Caroline, 279, 281

Chocquet, Victor, 42, 109, 279, *280*, 281

Chouanard, Émile, 299*n*5

Christ Blessing (Blake), 40, 338, *339*, 340; cat. no. 144

Christmas Carol, A (Rossetti), 407–9, *408*; cat. no. 182

Christ Walking on the Sea (Delacroix), 110

Christ Walking on the Waters (Delacroix, 1852), 46, 109–10, *111*; cat. no. 30

Christ Walking on the Waters (Delacroix, 1852, Bremen), *109*, 110

Christ Walking on the Waters (Delacroix, ca. 1857–60, Rouen), 109, *109*

Christ Walking on the Waters (private coll., attrib. to Delacroix), *110*

Christ Walking on the Waters (Rubens), 109, 110

Chronique des arts, 208

Chudant, Adolphe, 66

Cinquante dessins (Matisse), 224

Clarac, comte F. de, *Musée de Sculpture Antique et Moderne*, 191

Clark, Kenneth, 28

Clash of Arab Horsemen (Chassériau), 60

classical art, 118, 120, 133, 138, 252

Claudel, Camille, 285
 Sakuntala or *Abandonment*, 293

Claude Monet Painting by the Edge of a Wood (Sargent), 464

Clayton, John R., 430*n*10

Clément, Charles, 118, 120, 121, 132, 133, 136

Climax, The, John and Salome (Beardsley), 329–30

Clinton, Charles William, 10*n*19

Clodion (Claude Michel), 283

Coal Wagon Hauled by Seven Horses (Gericault), 134, *134*

Cogniet, Léon, 133, 136

Colin, Alexandre, 120

Collman, Leonard, 430*n*19

Colonna, Francesco, 368

Colthurst, Sir Nicholas Conway, fourth baronet, 166

La comédienne (Watteau), 12*n*27

Comedy of Death, The (Bresdin), 55

Companions (Moore), 402–3, *403*; cat. no. 179

Comparative Anatomy: Resemblances between the Countenances of Men and Beasts (Rowlandson), 425–26, *425*, *426*; cat. no. 191

Compositions from the Tragedies of Aeschylus Designed by John Flaxman Engraved by Thomas Piroli
 Plate 25, 392, *392*
 Plate 29, 393, *393*

Comte Louis-Mathieu Molé (Ingres), 179*n*1

Comtesse de la Rue (Ingres), 160*n*5

Comtesse de Tournon (Ingres), 27, *27*

Conant, James B., 46*n*131

Conder, Charles, *The Rendezvous*, *18*, 19

Confetti (Toulouse-Lautrec), 312, *312*

Constable, John, 138, 310, 354

Copia, Jacques-Louis, 254, 257, 259

Coquiot, Gustave, 287

Corfu: A Rainy Day (Sargent), 464*n*1

Corfu: Lights and Shadows (Sargent), 464*n*1

Corneille, Pierre, 73

Cornforth, Fanny, 418

Cornu, Sébastien, 201

Coronation of the Emperor Napoleon I and the Crowning of the Empress Joséphine at Notre-Dame (David), 28, 79, 83, *83*, 84, 86

Coronation sketchbooks (David), 29, 82–89

Corot, Camille, 12, 70, 230, 248, 272, 310, 452, 458
 Goatherd in a Landscape, 12*n*27

Corréard, Alexandre, 125

Correggio, 260

Cortissoz, Royal, 3, 16*n*48, 34, 40, 45

Cortois de Pressigny, Gabriel, 167

Costumes of Morocco (Delacroix), 106

Coupin, Pierre-Alexandre, 81

Couple on a Bench (Menzel), 322, *322*

Courbet, Gustave, 62–68, 232, 274
 After Dinner at Ornans, 63
 Les Amants dans la campagne, 62, 63
 L'Homme à la pipe (Montpellier), 62
 Man with a Pipe (Hartford), 62
 Mlle Zélie, 67*n*1
 The Painter at His Easel, 63–65, *65*, 66; cat. no. 10

self-portraits, 64*n*1
 The Smoker, or *Profile Portrait of the Artist with a Pipe*, 62–63, *62*; cat. no. 9
 The Studio of the Painter, 63
 Young Woman with a Guitar, Reverie, 64, 66–68, *67*; cat. no. 11

Courbet, Juliette, 63*n*1, 66, 67

Courbet, Zélie, 66

Courcy, Frédéric de, 236

Coustou, Guillaume, *Horse Tamers*, 120

Couture, Thomas, 270, 287, 457
 Day Dreaming (Soap Bubbles), 41, *41*
 The Illness of Pierrot, 36, *37*
 Paul Barroilhet, 36, *37*
 Romans of the Decadence, 36, *36*

Covered Market, Les Halles Centrales, rue Solferino (unknown), 249, *249*

Cowper-Temple, William, 416

Craven, Frederick, 416

Creation of Eve (Watts), 439

Cresson, Margaret French, 442*n*10

Crucifixion (Lorenzetti), 13, 14

Cruelty Laughs at the Tears He Has Caused to Flow (Prud'hon), 30, 254–56, *255*, 259; cat. no. 101

Cubism, 464

Cupid Seller (Vien), 256

Cupid's Hunting Fields (Burne-Jones), 364

Custine, marquis de, 189

D

Dadaists, 12

Dagoumer, Thomas, 264, *265*, 266

Danaë or *The Tower of Brass* (Burne-Jones), *366*, 367

Danaë Watching the Building of the Brazen Tower (Burne-Jones), 366–67, *367*, 370; cat. no. 158

Dancer (Degas), 42, *44*

Dancer's Reward, The, for *Salome* (Beardsley), 330–31, *331*; cat. no. 140

Daniel, Samuel, 277

D'Annunzio, Gabriele, *Martyrdom of Saint Sebastian, The*, 272, 273

Dante Alighieri, 37, 410–12
 Divine Comedy, 40, 284, 346–53, 386–90, 406, 411, 416, 417
 Vita nuova, 405, 407, 410, 416–17, 419, 423

Dante at Verona (Rossetti), 419

Dante Drawing an Angel on the Anniversary of Beatrice's Death (Rossetti), 417–18

Dante Society, 8

D'après l'Antique (Barbault), *255*, 256

Darius Fleeing after the Battle of Arbela (Moreau), 232

Daubigny, Charles-François
 The Banks of the Oise, 248, *248*
 The Toutain Farm at Honfleur, 230, *230*

Daumier, Honoré-Victorin, 31, 42, 64, 68–75, 307
 L'Amateur de caricatures, 70*n*2
 The Butcher, 25, 72–73, *72*; cat. no. 14

The Market, 68n4

The Miller, His Son, and the Ass, 74

Mother and Two Children, 68n2

On the Street in Paris, 68n1

The Print Amateur, 70, *71*; cat. no. 13

The Saltimbanques Changing Place, 25

Scapin, or *Scapin and Géronte*, 34, 73–74, *75*; cat. no. 15

Scapin et Crispin, 73–74

Study of Female Dancers, 68n3

Woman and Child on a Bridge at Night, 68n1

A Woman with a Basket and a Child by the Hand, Walking with a Crowd of People, 68, *69*; cat. no. 12

Women Pursued by Satyrs, 74

David (Moreau), 240, 244

David, Eugène, 76, 82, 84

David, Gerard, *Marriage at Cana*, 354

David, Jacques-Louis, 5, 36, 76–91, 125n3, 150, 157, 170, 198, 199, 208, 214, 218, 260, 270

The Anger of Achilles, 90n4

Battle of the Romans and the Sabines, *121*, 122

Coronation of the Emperor Napoleon I and the Crowning of the Empress Joséphine at Notre-Dame, 28, 79, 83, *83*, 84, 86

Coronation sketchbooks, 29

The Distribution of the Eagle Standards, 86

Emmanuel Joseph Sieyès, 28, 89–90, *91*; cat. no. 21

Homer and Calliope, *28*, 29

Mars Disarmed by Venus and the Three Graces, 86, 90n8

The Oath of the Horatii, 76

The Oath of the Tennis Court at Versailles, June 20, 1789, 78–79, *78*, 89

Pierre-Marie Baille and Charles Beauvais de Préault, 80–82, *81*; cat. no. 18

Pius VII and Cardinal Caprara, 29

Roman Album No. 1, 29, 76–77, *77*, 82; cat. no. 16

self-portrait, 86

Sketchbook No. 14: Studies for "The Coronation of Napoleon I," 28, 82–86, *83*, *84*, *85*, 379; cat. no. 19

Sketchbook No. 20: Studies for "The Coronation of Napoleon I," 28, 86–89, *87*, *88*, 379; cat. no. 20

sketchbooks, 28–29, 76, 78, 86

Study for "The Oath of the Tennis Court," 29, 78–80, *79*; cat. no. 17

Telemachus and Eucharis, 90n8

Triumph of the French People (Carnavelet), 80, *81*, 82

Triumph of the French People (Louvre), 80, *80*

David, Jacques-Louis, and studio, *Emperor Napoleon I*, 92, *93*; cat. no. 22

David, Jacques-Louis, circle, *Portrait of a Young Woman*, 29, 94–95, *95*; cat. no. 23

David, Jules, 76, 78, 90n8

David Johnston (Prud'hon), 264, *264*

Davidson, John, *Earl Lavender*, 334–35

Davies, Marion, 43

Davis, Sir Edmund, 18, 25, 291, 429, 439

Davis, Reginald, 25

Dawn (Burne-Jones), 382

Dawn, The (La Farge), 40, 457–58, *457*; cat. no. 206

Day (Burne-Jones), 361–63, *362*, 383n6; cat. no. 155

Day Dreaming (Soap Bubbles) (Couture), 41, *41*

Days of Creation (Burne-Jones), 30, 42, 366, 375–78, *376–77*, *378*; cat. nos. 161–65

Death of a Young Mason (Gericault), 130–31, *131*; cat. no. 40

Death of Procris, The (Piero di Cosimo), 368, *368*, 370

Death of Raphaël, The (Harriet), 157

Death of Sardanapalus (Delacroix), 109

Death of Virginia, The (Becoeur and Péronard, after Lethière), 216–17, *217*

Death of Virginia, The (Lethière), 216–18, *217*; cat. no. 85

Death of Virginia, The (Lethière, Louvre), *216*

Debussy, Claude, 221, 272–73

Decaisne, Henri, 90n8

Decamps, Alexandre-Gabriel, 64, 204

Dedreux-Dorcy, 122, 138

Deer (Barye), 51n4

Defeat of the Cimbri (Heim), 148

Defeat of the Cimbri and the Teutons by Marius (Heim), 148–49, *149*; cat. no. 48

Degas, Hilaire-Germain-Edgar, 19, 26, 52, 96–100, 150, 166, 172, 202, 204, 218, 300, 307

At the Races in the Countryside, 97

Dancer, 42, 44

The Depart for the Hunt, 96–97, *97*

Horse at Rest, 97

Horse with Saddle and Bridle, 96–98, *96*; cat. no. 24

Lepic and His Daughters in the Place de la Concorde, 98

Orchestra at the Opera, 221

Sheet of Five Horse Studies, *97*, 98

Two Dancers Entering the Stage, 98–100, *99*; cat. no. 25

Degas, René, 99

Degotti, Ignace-Eugène-Marie, 78

Dejean, Alice, 221

Delaborde, Henri, 157

Delacroix, Eugène, 5, 42, 50, 58, 60, 64, 89–90, 146, 148, 199, 242, 244, 262, 279, 302, 354, 356, 361, 457

Arab (Turk) Saddling His Horse, 104

Arab about to Saddle His Horse, 104, *106*

Arab Actors or Clowns, 103, 104

Arabian Fantasy before a Doorway in Meknès, *105*

Arabs and Horses near Tangier, *106*

The Barque of Dante, 127n8

Battle of the Gaiour and the Pasha, 112, *112*

Bengal Tiger, 106

Black Africans Dancing in a Street in Tangier, 100, 103–4, *103*; cat. no. 27

Christ Walking on the Sea, 110

Christ Walking on the Waters (1852), 46, 109–10, *111*; cat. no. 30

Christ Walking on the Waters (1852, Bremen), *109*, 110

Christ Walking on the Waters (ca. 1857–60, Rouen), 109, *109*

Christ Walking on the Waters (private coll., attrib. to Delacroix), *110*

Costumes of Morocco, 106

Death of Sardanapalus, 109

Entry of the Crusaders in Constantinople, 112

Fanatics in Tangier, 104

Faust series, 109n6

Greece on the Ruins of Missolonghi, 112

Hercules Rescues Hesione, 281

Itinerant Actors, 104

Jewish Musicians of Mogador, 103

Jewish Wedding in Morocco, 103

Lion Hunt, 60, 108

Lion of Atlas, 106, *107*

Mamluk Holding Back His Horse, 104, 106n3

Massacres of Chios, 104, 112, 127n8

Mephistopheles Presents Himself at Martha's House, *108*, 109n6

A Moorish Woman with Her Servant by the River, 100, *101*, 102, 103; cat. no. 26

Moroccans Dancing in a Street in Tangier, 103, *103*

Souvenirs d'un voyage dans le Maroc, 102

Studies of Lions (ca. 1828), 108, *108*

Studies of Lions (ca. 1830), *107*, 108n6

A Turk Leading His Horse or *Arab with Steed*, 104–6, *105*; cat. no. 28

Turk Mounting on Horseback, 104

A Turk Surrenders to a Greek Horseman, 112–13, *113*; cat. no. 31

Two Lions at Rest, 106–9, *107*; cat. no. 29

Washerwomen of Morocco, 100, 102

Woman of Tangier Hanging the Wash, *100*, 102

Women of Algiers in Their Apartment (Femmes d'Algier dans leur appartement), 102, *188*, 189

Young Tiger Playing with Its Mother, 108

Delaroche, Paul, 170, 227, 354, 361

Execution of Lady Jane Grey, 183

Delécluze, Étienne-Jean, 78, 198–99, *198*, 208

Della Robbia Pottery, 378n9

Dell'Era, Giovanni Battista, 120

Delton, Louis-Jean, *Thoroughbred English Stallion Belonging to Count Aguado*, *97*, 98

Deluge (Gericault), 126

Demidov, Count Anatoly, 192, 200

Denis, Maurice, 268

Denon, Dominique-Vivant, 266n10

Study of Robespierre and Dubois-Crancé in "The Oath of the Tennis Court," 29, *31*

Dent, J. M., 332

Depart for the Hunt, The (Degas), 96–97, *97*

Depths of the Sea, The (Burne-Jones, 1886), 384–85, *384*

Depths of the Sea, The (Burne-Jones, 1887), 384–86, *385*; cat. no. 170

Desgoffe, Alexandre, 208

Desiderio da Settignano, 12n28

Design for Frontispiece of "The Wonderful Mission of Earl Lavender" (Beardsley), 334–35, *334*; cat. no. 142

Design for Matting; verso: *Design for Paneling*
 (Whistler), 470–71, *470*; cat. no. 214
Designs for "The Story of Perseus" (Burne-Jones), 371,
 371
Desportes, Alexandre, 60
Detaille, Édouard, 223*n*11
Devaucey, Mme, 192
Deveria, Achille, 64
Devonshire, duke of, 400
Devosge, François, 252, 253, 262
Diaghilev, Sergey Pavlovich, 273
Diaz de la Peña, Narcisse-Virgile, 12
 Le maléfice, 12*n*27
 Les séductions de l'amour, 12*n*27
Dickens, Charles, 472
Dignity and Impudence (Landseer), 449
Dinner Table at Night, A (Sargent), 460*n*3
Distribution of the Eagle Standards, The (David), 86
Divine Comedy, illustrations (Blake), 346–53
Doll and Richards, 458
Domenichino, 77
Donizetti, Gaetano, 418
Donna della Finestra, La (Rossetti), 423–24, *424*;
 cat. no. 190
*Don Pedro of Toledo, the Spanish Ambassador, Kisses
 the Sword of Henry IV* (Ingres), 160*n*8
Doom Fulfilled, The (Burne-Jones), 371, *371*, *372*, 373,
 374
Dormeuse de Naples (Ingres), 159–60, 170, 189, 209
Dou, Gerard, 160
Doyen, Gabriel-François, 148, 216
Dream of Atossa, The (Flaxman), 390, 393, *393*;
 cat. no. 174
Dream of Atossa, The (Flaxman, Royal Academy), 393,
 393
Dream of Happiness, The (Mayer), 266
Dream of Ossian, The (Ingres), 181–82, *181*; cat. no. 69
Dream of the Past, A: Sir Isumbras at the Ford (Millais),
 360
Drexel, Anthony, 6
Druidism, 414
Drummond, Mrs., née Margaret Benson, 380
Duban, Félix, 207
Dubaut, Pierre-Olivier, 131, 136, 140
Dubois-Crancé, Edmond Louis Alexis, 78
Dubourg, Paris, 25
Dubourg, Victoria, 115, *115*
Dubourg Family, The (Fantin-Latour), 115–16, *115*;
 cat. no. 33
Du Camp, Maxime, 234, 240
Duc Ferdinand-Philippe d'Orléans (Ingres), 179*n*1
Duchamp, Marcel, 294
Duchamp-Villon, Raymond, *The Lovers*, 285
Dufresnoy, Charles-Alphonse, 253
Dulac, Edmund, 19
Dumas, Paul, 276
Dunn, Henry Treffry, 416, 418–19
du Pont, Henry Francis, 43

Dupré, Jules, 57
Dupré, Léon-Victor, 57
Dürer, Albrecht, 16, 191, 417
 Knight, Death and the Dragon, 15*n*42
 The Knight, Death, and the Devil, 360
Duret, Théodore, 70*n*3
Duruflé, Gustave, 236*n*1, 240
Dusolier, Alcide, 56*n*12
Duval-Destan, L., 204*n*2
Duveen, Sir Joseph, 24, 43, 366
Dying Slave (Burne-Jones), 380

E

Eagle with Outstretched Wings and Open Beak (Barye),
 5*n*4
Eakins, Thomas, 443
Earl Lavender (Davidson), 334–35
Early Morning in the Café (Menzel), 324, *324*
Eastlake, Sir Charles, 368
Ecce Acilla Domini (Rossetti), 419
École des Beaux-Arts, 49, 64, 114, 121, 179, 234, 304
Écorché (Houdon), 234
Eden Concert (Seurat), 308*n*3
Elgin Marbles, 434, 437
Eliot, George, 368
Elisseieff, Barbe, 300
Embroidery: The Artist's Mother (Seurat), 306*n*1
Emerson, Edwin, 324
Emmanuel Chabrier (attrib. to Manet), 221, *222*, 223,
 232*n*14; cat. no. 87
Emmanuel Joseph Sieyès (David), 28, 89–90, *91*;
 cat. no. 21
Emperor Napoleon I (David and studio), 92, *93*;
 cat. no. 22
L'Enfance de Sainte Geneviève, or *The Meeting of Saint
 Genevieve and Saint Germain* (Puvis de Chavannes),
 268*nn*8, 9
English Cavalryman (formerly *Horse Guard*)
 (Gericault), 136–37, *137*; cat. no. 43
Enlightenment, 253
Ensor, James, 17
Entombment (Raphael), 58
Entombment, The (Gericault), 130, *130*
Entry of the Crusaders in Constantinople (Delacroix), 112
Escalier, Patience, 145–46, *145*, *147*
Escaped (Watts), 436
Escoffier, Auguste, 314*n*3
Escoula, Jean, 291
Estignard, Alexandre, 66, 67
Eternal Idol (Rodin), 46, 291, *292*, 293, 300; cat. no. 119
Eternal Spring (Rodin), 285–86, *285*, *286*, 300;
 cat. no. 116
Études de chevaux (Gericault), 133
Eustache de Saint-Pierre (Rodin), 296–97, *297*, 299;
 cat. no. 122
Eve (Moreau), 245, 246
Eve Naming the Birds (Blake), 338, *338*

Evening (Burne-Jones), 383*n*6
Evening in Venice (Bonington), 354, *355*, 356;
 cat. no. 152
Eve of Peace, The (Watts), 431, 433
Execution of Lady Jane Grey (Delaroche), 183
Exposition Universelle, Paris
 (1855), 189, 199, 200
 (1867), 219, 267
 (1878), 240, 244
 (1889), 250
Expulsion of Adam and Eve (Watts), 439
Eyes of Herod, The (Beardsley), 332

F

Falchetti, Alberto, 464
Falcon, The (Landseer), 398, *399*, 400; cat. no. 177
Falguière, Alexandre, 282
Fall of Lucifer, The (Burne-Jones), 382
*Family Group from "The Mutiny on the Raft of the
 Medusa"* (Gericault), 122, 128–29, *129*, 130;
 cat. no. 39
*Family Group from "The Mutiny on the Raft of the
 Medusa"* (Gericault, private coll.), 128, *128*
Fanatics in Tangier (Delacroix), 104
Fantin-Latour, Ignace-Henri-Jean-Théodore, 114–16,
 274, 300
 Autour du piano, 223*n*11
 The Dubourg Family, 115–16, *115*; cat. no. 33
 Self-Portrait, 114–15, *114*; cat. no. 32
Faringdon, Alexander Henderson, Lord, 433
Farnese Bull, Naples, 122
Faure, Elie, 224
Faust series (Delacroix), 109*n*6
Fauvism, 146, 224
Fazio's Mistress (Rossetti), 409
Feininger, Lyonel, 17
Fellow Student of Chassériau's at Ingres's Studio, A
 (Chassériau), 56–57
Fernier, Robert, 67
Fête Familiale (Sargent), 460*n*3
Fête Nationale, Rue St-Denis, Paris (Monet), 223*n*8
Figure Study: Subject Unknown (Gericault), 124–25,
 124, 131; cat. no. 37
Finberg, Alexander J., 15*n*41
Fisherman and the Syren, The (Leighton), 384
Flamma Vestalis (Burne-Jones), 383
Flandrin, Hippolyte, 202*n*13, 406
Flandrin, Paul, 189
Flaxman, John, 5, 36, 37, 348, 386–93
 Album of Drawings for the "Divine Comedy," 348, 386,
 387, 388–89, *388*, *389*, 390; cat. no. 171
 drawings for works by Homer and Aeschylus, 390–
 93, *391*, *392*, *393*
 The Dream of Atossa, 390, 393, *393*; cat. no. 174
 The Dream of Atossa (Royal Academy), 393, *393*
 The Fury of Athemas, 390
 The Ghost of Clytemnestra, 390, 392, *392*; cat. no. 173

*The King of the Lestrigens Seizing One of the
 Companions of Ulysses*, 390–91, *391*, 392;
 cat. no. 172
Torso Belvedere, 390
Flaxman, Nancy, 391
Flodden Field (Burne-Jones), 382
Fogg Art Museum, Harvard University Art Museums,
 3, 5, 10, 14*n*34, 15, 16*n*48, 25–26, 42, 43, 45, 46
Folwell, William Hazelton, 444
Fontane, Theodore, 318
Fontenay, Gabriel de, 167
Foppa, Vincenzo, *Virgin and Child*, 12*n*31
Forbes, Edward W., 9, 10, 15*n*42
Forbin, comte Auguste de, 170
Ford Madox Brown (Millais), 358*n*9
Ford Madox Brown (Rossetti), 358*n*9
Forestier, Julie, 176–78, *177*
Forestier family, 176–78, *177*
forgeries, art, 36*n*108
Forget, Joséphine de, 108
Fortuny y Madrazo, Mariano, 29
Foucart, Jacques, 148
Found (Rossetti), 422
Fournier, Jean-Joseph, 159, 160
Four Zoas, The (Blake), 350
Fragonard, Jean-Honoré, 12*n*27, 316
Francia, Louis, 354
François-Marius Granet (Ingres), 168
Franklin, Maud, 468
Frauenholz, publisher, 157
Frederick II, king of Prussia, 318
Frémiet, Sophie, 90*n*8
French, Daniel Chester, 21
 Abraham Lincoln, 440, *440*, 442
 Abraham Lincoln Seated, 440, *441*, 442; cat. no. 197
 Spirit of the Waters, 440
 Standing Lincoln, 440
French Constitution, The (Prud'hon), 252
French school, 25, 29, 38, 48–317
Frick, Henry Clay, 43
Friedländer, Max, 43
Froissart, Jean, 296
Fromentin, Eugène, 234, 240
Fualdès Affair (Gericault), 126
Fury of Athemas, The (Flaxman), 390
Fuseli, Henry, 340, 386, 391
Futurists, 294

G

Galatea (Moreau), 246
Galerie Durand-Ruel, Paris, 234, 277
Galland, Pierre Victor, 268
Gallery of the Louvre (Morse), 456
Garden at Florence (Sargent), 465*n*3
Gardner, Isabella Stewart, 6, 9–10, 11*n*22, 465
Garnier, Alfred, 236
Garzoli, Francesco, *Perseus*, 212

Gates of Hell, The (Rodin), 284, 285, 287, 289, 291, 293
Gatteaux, Jacques-Édouard, 152, 187, 198, 204
Gauguin, Paul, 46
Gautier, Théophile, 26, 56*n*12, 58, 186, 200–201
Gay, Mr. and Mrs. Walter, 43
Gaylor, Julius, 14*n*36, 38
Gelée blanche (Pissaro), 248
Genevieve (Rossetti), 408
Géniaux, Paul, *Les Halles, Paris: Snail and Fish
 Sellers*, 249, *249*
Genius of Greek Poetry, The (Watts), 433, 436
Gentle Art of Making Enemies, The (Whistler), 471
Geoffroy, L. de, 58
Gérard, Félix, 66
Gérard, François, 94, 156
 *Le barde Ossian évoquant les fantômes sur le bord du
 Lora*, 182
Gericault, Jean-Louis-André-Théodore, 5, 64, 116–40
 302, 390
 Ancient Sacrifice, *121*, 122
 Bouchers de Rome, *117*, 118
 Bull Tamer, 122
 Cattle Market, 118, 121–22, *123*; cat. no. 36
 Cattle Market (private coll.), *121*, 122
 Coal Wagon Hauled by Seven Horses, 134, *134*
 Death of a Young Mason, 130–31, *131*; cat. no. 40
 Deluge, 126
 English Cavalryman (formerly *Horse Guard*), 136–37,
 137; cat. no. 43
 The Entombment, 130, *130*
 Études de chevaux, 133
 *Family Group from "The Mutiny on the Raft of the
 Medusa,"* 122, 128–29, *129*, 130; cat. no. 39
 *Family Group from "The Mutiny on the Raft of the
 Medusa"* (private coll.), 128, *128*
 Figure Study: Subject Unknown, 124–25, *124*, 131;
 cat. no. 37
 Fualdès Affair, 126
 Groom Exercising Two Horses (1823), 133, *134*
 Groom Exercising Two Horses (ca. 1821–22), 133–35,
 135; cat. no. 42
 Hercules and Lychas, 125*n*2
 Hercules Taming the Cretan Bull, 125*n*5
 Horserace on the Corso in Rome: La Mossa, 242
 Lime Kiln, 138
 Medusa project, 129
 The Mutiny on the Raft, 126, *126*, 128
 The Mutiny on the Raft of the Medusa, 122, 125–27,
 127, 128; cat. no. 38
 The Mutiny on the Raft of the Medusa (Amsterdam),
 126, *126*, 128
 Postillion at the Door of an Inn or *White Horse Tavern*,
 31, 138, *139*, 140; cat. no. 44
 Raft of the Medusa, 122, 125, *126*, 130, 132, 138, 140
 Roman Herdsmen, 116–18, *117*, 133; cat. no. 34
 Scene of Cannibalism, 125
 Start of the Race of the Barberi Horses, 118, *119*
 Studies of a Cat, 132–33, *132*; cat. no. 41

 Study for the "Start of the Race of the Barberi Horses,"
 46, 118–20, *119*, 121, 122, 126, 133; cat. no. 35
 The Village Forge, 138, 140
 in Winthrop's collection, 31, *33*
Gericault, Jean-Louis-André-Théodore, circle,
 Portrait of a Young Man, 140, *141*, 142; cat. no. 45
Germ, The, 419, 422
German school, 18, 318–27
Gérôme, Jean-Léon, 24
Gerothwohl and Tanner, 206
Gessner, Solomon, 340
Ghost of Clytemnestra, The (Flaxman), 390, 392, *392*;
 cat. no. 173
Gijsbrechts, Cornelis, 456
Gilder, Richard Watson, 445
Gimpel, René, 43
Giorgione, 258, 414, 433
Giotto, 406, 411, 412
Giotto Painting Dante's Portrait (Rossetti, 1852), 410,
 410
Giotto Painting Dante's Portrait (Rossetti, ca. 1859),
 410–12, *411*; cat. no. 183
Giovanni di Paolo, *The Nativity*, *12*, 13, 29*n*96
Giraudon, Auguste, 460*n*1
Girlhood of Mary Virgin, The (Rossetti), 407
Girodet-Trioson, Anne-Louis, 94, 156, 182
Gleaners, The (Millet), 228
Gleyre, Charles, 310
Goatherd in a Landscape (Corot), 12*n*27
Goethe, Johann Wolfgang von, 354, 384, 386, 390
Gogh, Theo van, 142, 145, 146
Gogh, Vincent van, 142–47
 The Blue Cart (Harvest at La Crau), 34, 142–44, *143*;
 cat. no. 46
 Harvest at La Crau, 142, *143*
 La moisson en Provence, 142, *143*
 *Peasant of the Camargue (Portrait of Patience
 Escalier)*, 145–46, *147*; cat. no. 47
 Portrait of a Peasant (Patience Escalier), 145, *145*
 The Potato Eaters, 145
 Self-Portrait, 145–46
 Wheat Field, 144*n*2
Golden Age, The (Ingres), 27, 28*n*90, 56*n*7, 190, 207–9,
 207, 212; cat. no. 81
Goncourt, Edmond and Jules de, 200, 201
Gonon, Eugène, 287
Good Samaritan, The (Bresdin), 54, 56
Gouriev, Count, 175
Goya, Francisco de, 386, 390
Graham, Amy, 414
Graham, Frances, 414
Graham, William, 366, 370, 385, 414, 419, 420
Grande Odalisque (Ingres), 159–60, 189, 209
Grandhomme, Paul, 236
Granet, François-Marius, 198, 199
Granger, Mme Jean-Pierre, 150
Granier, Jeanne, 312, *312*, *313*, *314*
Great Depression, 34, 35, 46

Greece on the Ruins of Missolonghi (Delacroix), 112

Green and Violet: Mrs. Walter Sickert (Whistler), *475, 476*

Greuze, Jean-Baptiste, 256

Griffoul and Lorge, 286, 300

Grisi, Giulia, 418

Groom Exercising Two Horses (Gericault, ca. 1821–22), 133–35, *135*; cat. no. 42

Groom Exercising Two Horses (Gericault with J. Volmar, 1823), 133, *134*

Gros, Baron Antoine-Jean, 90, 198, 354

Groton Place, Lenox, *2*, 14, *15*, 19–21, *20, 21*, 38

Group of a Warrier with a Child (Baths of Caracalla), 125*n*3

Guérin, Pierre, 302

Guichard, Joseph, 52

Guilbert, Yvette, 312

Guillemard, Sophie, *Portrait of a Young Lady Distracted from Her Music Lesson*, 94, *94*

H

Halles, Les, Paris: Snail and Fish Sellers (Géniaux), 249, *249*

Hamilton, George, 370

Hare-Naylor, Francis and Giorgiana, 391

Harmony in Grey and Peach Color (Whistler), 37, 468, *469*; cat. no. 213

Harnett, William Michael
 After the Hunt, 444
 Old Models, 444
 Still Life with Bric-a-Brac, 443-44, *443*; cat. no. 198

Haro, Étienne-François, 191, 288

Harriet, Fulchran-Jean, *The Death of Raphaël*, 157

Harris, Alfred, 400

Hartmann, Alfred, 239

Harvard University
 Winthrop as student at, 8–10, *9*
 Winthrop's bequest to, 3, 5, 10, 15, 16*n*48, 25–26, 43, 45, 46

Harvest at La Crau (van Gogh), 142, *143*

Harvey, Henrietta, 150

Hauke, César Mange de, 99, 306

Haussonville, comtesse de, 192

Le Haut d'un battant de porte (Bracquemond), 52

Hayard, Charles, 164, *165*

Hayard, Mme Charles, née Jeanne-Susanne Alliou, 164, *165*, 167

Hayem, Charles, 236, 245–46

Hayley, William, 390

Head of a Bearded Man Facing Right (Menzel), 324, *325*, 326; cat. no. 137

Head of a Boy (Millet), 227–28, *227*; cat. no. 89

Head of a Girl (Burne-Jones), 384–85

Head of a Man with Short Hair, Seen in Left Profile (Prud'hon), *258*, 259

Head of a Woman (Menzel), 326, *327*; cat. no. 138

Head of a Woman (Puvis de Chavannes), 270–72, *271*; cat. no. 108

Head of Benoit-Joseph Labre (Ingres), 160*n*5

Head of Buddha (Northern Wei dynasty), 232

Head of Orpheus (Moreau), 240

Hearst, William Randolph, 8, 43

Heenk, Elizabeth, 144*n*1

Heilbut, Emil, 288

Heim, François-Joseph
 Defeat of the Cimbri, 148
 Defeat of the Cimbri and the Teutons by Marius, 148–49, *149*; cat. no. 48

Helena de Kay (Homer), 446

Heliodorus Chased from the Temple (Raphael), 242

Henderson, Hunt, 46

Hercules and Lychas (Canova), 125*n*6

Hercules and Lychas (Gericault), 125*n*2

Hercules and Omphale (Moreau), 234

Hercules Rescues Hesione (Delacroix), 281

Hercules Taming the Cretan Bull (Gericault), 125*n*5

Hermit, The (Sargent), 465*n*1

Hill Fairies (Burne-Jones), 383

Hill Prayer, A (Parrish), 19, *19*

Hireling Shepherd, The (Hunt), 396

Hirsch, Leopold, 439

history painting, 125, 154, 156, 164, 178, 194, 253, 302

"Hist"—said Kate the queen (Rossetti), 408

Hofer, Philip, 7, 34, 40

Holiday, Henry, 384

Hollyer, Frederick, 378

Holme, Charles, 332

Holy Family, The (David, after Tiarini), 76–77

Homer, *Odyssey*, Flaxman's drawings for, 390–91, *391, 392*

Homer, Winslow, 19, 444–51
 Adirondack Lake, 449, 451, *451*; cat. no. 203
 Helena de Kay, 446
 Mink Pond, 21, 46, 449–50, *450*; cat. no. 202
 Prisoners from the Front, 447
 Sailboat and Fourth of July Fireworks, 444–46, *445*; cat. no. 199
 Schooner at Sunset, 446–47, *447*; cat. no. 200
 Watching the Tempest, 448–49, *448*; cat. no. 201

Homer and Calliope (David), 28, *29*

Homer Deified (Ingres), 208

L'Homme à la pipe (Courbet), 62

Honorable Laura Lister, The (Sargent), 40, *40*

Hope, Thomas, 386

Hoppe, Ragnar, 224

Horner, Frances, 366, 385

Horse at Rest (Degas), 97

Horserace on the Corso in Rome: La Mossa (Gericault), 242

Horse Tamers (Coustou), 120

Horse with Saddle and Bridle (Degas), 96–98, *96*; cat. no. 24

Houdon, Jean-Antoine, 46*n*133
 Écorché, 234

Hours, The (Burne-Jones), 378*n*3, 383

Howell, Charles Augustus, 367

Hubert, Auguste, 264

Hudson River Museum, Yonkers, 10*n*19

Hudson River School, 452

Hueffer, Ford Madox, 356

Huet, Paul, 354

Hughes, Arthur, 356

Hugo, Victor, 418

Hunnewell Gold Medal (1934), 21

Hunt, Edith Holman, 397

Hunt, William Holman, 23, 394–98
 The Hireling Shepherd, 396
 The Light of the World, 360
 Miracle of the Sacred Fire in the Church of the Holy Sepulchre, Jerusalem, 42, 396–98, *396, 397*; cat. no. 176
 The Triumph of the Innocents (1870–1903), 394–95, *395*; cat. no. 175
 The Triumph of the Innocents (1876–87), 394, *394*

Hunt, William Morris, 458

Hunters Surprised by Death (Bresdin), 55

Huysmans, Joris-Karl, 6

I

Iconologia (Ripa), 427

Illness of Pierrot, The (Couture), 36, *37*

Illustrations of the Book of Job (Blake, engravings), 342, *342, 344*

Impressionists, 52, 109, 248, 279, 310, 444–45

Indépendants, 307

Infant Moses, The (Moreau), 30, *32*, 244

Ingres, Mme Delphine, née Ramel, 196, 203, 206, 208, 211

Ingres, Jean-Auguste-Dominique, 5, 19, 23, 42, 52, 56, 57, 116, 150–213, 224, 226, 227, 386, 389, 390
 The Apotheosis of Homer, 183, 186, 189
 Aretino and the Envoy from Charles V, 160*n*7
 Aretino in the Studio of Tintoretto, 160*n*7
 The Bather, 28*n*90, 152, *153*; cat. no. 50
 The Bather (Louvre), 152
 The Betrothal of Raphael and the Niece of Cardinal Bibbiena (1813–14), 159*n*4, 160*n*3, 209, *211*
 The Betrothal of Raphael and the Niece of Cardinal Bibbiena (1864), 209, *210*, 211; cat. no. 82
 Charles Hayard and His Daughter Marguerite, 164, *165*
 Charles Marcotte d'Argenteuil, 168, 187
 Charles X, 203
 Cherubini and the Muse of Lyric Poetry, 187, 202*n*13
 Comte Louis-Mathieu Molé, 179*n*1
 Comtesse de la Rue, 160*n*5
 Comtesse de Tournon, 27, *27*
 Don Pedro of Toledo, the Spanish Ambassador, Kisses the Sword of Henry IV, 160*n*8
 Dormeuse de Naples, 159–60, 170, 189, 209
 The Dream of Ossian, 181–82, *181*; cat. no. 69
 Duc Ferdinand-Philippe d'Orléans, 179*n*1
 François-Marius Granet, 168

The Golden Age, 27, 28n90, 56n7, 190, 207–9, *207,* 212; cat. no. 81

Grande Odalisque, 159–60, 189, 209

Head of Benoit-Joseph Labre, 160n5

Homer Deified, 208

The Iron Age, 208

Joseph-Antoine de Nogent, 26, 52, 159–60, *161,* 162; cat. no. 54

Jupiter and Thetis, 157

Louis-François Bertin, 179n1, 199

Madame Frédéric Reiset, née Augustine-Modeste-Hortense Reiset, 26, 27, 192, *193,* 194; cat. no. 74

Madame Paul-Sigisbert Moitessier, 27, 28, 192

The Martyrdom of Saint Symphorien (1834), 183, *183,* 189, 203

The Martyrdom of Saint Symphorien (1858), 26, 203–4, *203;* cat. no. 79

The Murat Family, 160n3

notebooks, 206, 208, 209

Odalisque en Grisaille, 27

Odalisque with the Slave, 26, 27, 28n93, 34–35, 187–90, *188;* cat. no. 72

Paolo and Francesca, 160n3, 209

Philémon et Baucis, 202n8

Portrait of Alfred-Émilien O'Hara, Comte de Nieuwerkerke, 200–202, *201;* cat. no. 78

Portrait of a Man, 160n5

Portrait of Augustin Jordan and His Daughter Adrienne, 167–69, *168;* cat. no. 58

Portrait of a Young Woman, 150–51, *151;* cat. no. 49

Portrait of Countess Antoine Apponyi, 24, 174–76, *174;* cat. no. 62

Portrait of Count Rodolphe (?) Apponyi, 174–76, *175;* cat. no. 63

Portrait of Étienne-Jean Delécluze, 198–99, *198;* cat. no. 77

Portrait of Jean-Charles-Auguste Simon, 150

Portrait of Madame Augustin Jordan and Her Son Gabriel, 167–69, *169;* cat. no. 59

Portrait of Madame Charles Hayard, 164, *165*

Portrait of Madame Charles Hayard and Her Daughter Caroline, 164–66, *165,* 167; cat. no. 56

Portrait of Madame Ingres, 150

Portrait of Mrs. George Vesey and Her Daughter Elizabeth Vesey, later Lady Colthurst, 26, 166–67, *166;* cat. no. 57

Portrait of the Family of Lucien Bonaparte, 26, 162–64, *163;* cat. no. 55

Portrait of the Forestier Family, 26, 176–78, *177;* cat. no. 64

Queen Caroline Murat, 160, 209

The Rape of Europa, 211–12, *213;* cat. no. 83

The Rape of Europa by Jupiter, 212, *213*

Raphael and the Fornarina, 26, 157, *158,* 159, 209; cat. no. 53

Reclining Nude (Madame Ingres), 170

Roger Freeing Angelica, 27, 170, 172–73, *173;* cat. no. 61

Roger Freeing Angelica (London), 170, *170,* 202n13

Le roi Midas et son barbier, 200, 202

Romulus, 203

Romulus, Conqueror of Acron, 181

Romulus Victorious over Acron, 157

Self-Portrait, 26, 35, 204, *205,* 206; cat. no. 80

Self-Portrait at the Age of Twenty-Four, 52, 54

The Sistine Chapel, 187

Sleeping Odalisque, *188,* 189

La Source, 170

Stratonice, 187

Studies for the "Martyrdom of Saint Symphorien" (Lictors, Stone-Thrower, and Spectator), 26, 183, *185,* 186–87; cat. no. 71

Studies for "The Martyrdom of Saint Symphorien" (Saint, Mother, and Proconsul), 26, 183, *184,* 186–87; cat. no. 70

Studies of a Man and a Woman for "The Golden Age," 190–91, *191,* 208; cat. no. 73

Study for the Head of Octavia in "Virgil Reading the 'Aeneid' to Augustus," 25, 154, *155,* 156, 194; cat. no. 51

Study for the Left Hand of Comte Louis-Mathieu Molé, 179–81, *180;* cat. no. 66

Study for the Right Hand of Comte Louis-Mathieu Molé, 179–81, *180;* cat. no. 67

Study for the Right Hand of the Duc d'Orléans, 179–81, *180;* cat. no. 68

Study for "Roger Freeing Angelica," 27, 170, *171,* 172; cat. no. 60

Study for "Virgil Reading the 'Aeneid' to Augustus" (ca. 1811–12), *154,* 156

Study for "Virgil Reading the 'Aeneid' to Augustus" (ca. 1814), 25, 154, *155,* 156, 194; cat. no. 52

Study of the Right Hand of Monsieur Louis Bertin, 179–81, *180;* cat. no. 65

The Turkish Bath, 192, 208

Venus Anadyomene, 170, 192, 212, 238

Virgil Reading the "Aeneid" to Augustus, 25, 181, 182, 194, *195;* cat. no. 75

The Virgin and Child Appearing to Saints Anthony of Padua and Leopold of Carinthia, 196, *197;* cat. no. 76

Virgin with the Host, 196

Vow of Louis XIII, 174, 183, 186, 187, 189, 196

will of, 35

in Winthrop's collection, 26–28, 29, *35,* 36, 38, *41,* 299

Ingres, Jean-Marie-Joseph, 178n11

Ingres, Mme Madeleine, née Chapelle, 192, 196, 208, 209

Inness, George, *October Noon,* 453, *454;* cat. no. 204

Innocence and Love (Prud'hon), 259

Inscription over the Gate, The (Blake), 348

In Switzerland (Sargent), 461

In the Park (Menzel), 318, 320, 322, *323;* cat. no. 136

In the Simplon Valley (Sargent), 462–63, *462;* cat. no. 209

Ionides, Alexander, 364, 370

Iron Age, The (Ingres), 208

Iron-Rolling Mill, The (Menzel), 318

Isolde (Beardsley), 332, *333;* cat. no. 141

Italian Futurists, 294

Itinerant Actors (Delacroix), 104

Ivory Beads (Moore), 403

J

Jacob and the Angel (Moreau), 30, 242, *243,* 244–45; cat. no. 96

Jacob's Ladder (Blake), 340n3

Jacques, Charles, 52

Jaguar Devouring a Hare, A (Barye), 51n4

Jaguar in a Landscape, A (Barye), 50–51, *50;* cat. no. 2

James, Henry, 268, 375

japonisme, 468

Jarves, James Jackson, 40

Jason (Moreau), 234

Jean de Fiennes (Rodin), 296–97, *297,* 299, cat. no. 123

Jeanne Granier (photographs), 312, *312,* 314, *314*

Jeanne Granier (Toulouse-Lautrec, 1897), 312, *313,* 314; cat. no. 131

Jeanne Granier (Toulouse-Lautrec, 1898), 312, *312*

Jeanron, Philippe-Auguste, 64

Jerome, king of Westphalia, 92

Jerusalem (Blake), 348

Jewish Musicians of Mogador (Delacroix), 103

Jewish Wedding in Morocco (Delacroix), 103

Johnson, Dorothy, 89

Johnson, John G., 6

Johnson, Lee, 109

Johnston, John Taylor, 447

Jonah Thrown from the Boat (Rubens), 109

Jones, Edward, *see* Burne-Jones, Edward

Jongkind, Johan Barthold, 46

Jordan, Augustin, 167–69, *167*

Jordan, Madame Augustin, née Augustine-Louise-Euphrasie de Mauduit Du Plessis, 167–69, *169*

Joseph-Antoine de Nogent (Ingres), 26, 52, 159–60, *161,* 162; cat. no. 54

Joséphine, Empress, 84, 86, 181

Jouberthon, Alexandrine, 162, 163

Jourdy, Paul, 218

Jour et la nuit, Le, 52

Journal des artistes, 266n6

Journal des débats, 199

Joyant, Maurice, 316

Jupiter and Thetis (Ingres), 157

Jursanvault, Baron de, 253

Justice and Divine Vengeance Pursuing Crime (Prud'hon), 262

K

Kahn, Albert, 286

Kaplan, Jules, 234

Kay, Charles de, 445

Kay, Helena de, 445, 446

Kean, Charles, 409

Kean, Edmund, 354

Kelmscott Press, 368

King, Charles Bird

 Poor Artist's Cupboard, 454, *454*, 456

 The Vanity of the Artist's Dream (The Anatomy of Art Appreciation, Poor Artist's Study), 454, *455*, 456; cat. no. 205

King of the Lestrigens Seizing One of the Companions of Ulysses, The (Flaxman), 390–91, *391*, 392; cat. no. 172

Kirkup, Seymour, *"Giotto's" Portrait of Dante*, *410*, 412

Kirstein, Lincoln, 43

Kiss, The (Rodin), 285, 286, 293, 300

Klee, Paul, 17

Knewstub, Walter, 418

Knight, Death and the Dragon (Dürer), 15n42

Knight, The, Death, and the Devil (Dürer), 360

Knoedler, M., New York and Paris, 40

Koch, Joseph Anton, 386

Koechlin, Raymond, 289

Kokoschka, Oskar, 17

Kugler, Franz, 318

Kupka, František, 294

L

Labille-Guiard, Adelaïde

 Lawyer Delamalle, 214

 Portrait of Tournelle, called Dublin, Actor at the Théâtre Français, 29, 214, *215*, 216; cat. no. 84

Laborious Passage along the Rocks, The (Blake), 348, 350

La Farge, John

 The Dawn, 40, 457–58, *457*; cat. no. 206

 When the Morning Stars Sang Together and All the Sons of God Shouted for Joy, *39*, 40

Lafayette, marquis de, 46, 302, *303*, 304

Lami, Eugene, 354

Lancret, Nicolas, 12

 Portraits of Monsieur and Madame Gaignat, 12n27

Landseer, Jessica, 400

Landseer, Sir Edwin, 138

 Dignity and Impudence, 449

 The Falcon (Study for Scene in the Olden Time at Bolton Abbey), 398, *399*, 400; cat. no. 177

 Scene in the Olden Time at Bolton Abbey, 398, 400

Lane, John, 328, 334, 335

Lapauze, Henry, 26, 28, 204, 208n3

Largillière, Nicolas de, 92

Larroumet, Gustave, 240

Lasteyrie, Jules de, 304

Last Judgment (Michelangelo), 124

Last of England, The (Brown), 358n2

La Tour, Georges de, 98

Laus Veneris (Burne-Jones), 360, 362n11

Lavallée, Antoine, 266

La vie pastorale de sainte Geneviève (Puvis de Chavannes), 267

Lawn with the Kings and Angels, The (Blake), 352

Lawrence, Sir Thomas, 29, 138, 354

 Napoléon-François-Charles-Joseph Bonaparte (1811–1832), duc de Reichstadt, Styled King of Rome, 28n94, 401–2, *401*; cat. no. 178

Lawyer Delamalle (Labille-Guiard), 214

Leadbeater, Charles W., 274

Leathart, James, 409

Leblanc, Jacques-Louis, 174, 175

Leblanc-Barbedienne, Gustave, 286

Lebossé, Henri, 294

Le Brun, Charles, 60, 257, 426

 Battles of Alexander, 148

Le Coeur, Charles, 276

Le Coeur, Jules, 274, 276

Legros, Alphonse, 24, 52, 300

Lehman, Philip, 5

Lehman, Robert, 43

Lehmann, Henri, 187

Leighton, Frederic, 356, 427

 Athlete Wrestling with a Python, 430n21

 The Fisherman and the Syren, 384

 Self-Portrait, 358n11

 Summer Moon, 374n19

Lemaire, Louis, 70

Lemercier Bernard, 90n9

Lenbach, Franz von, 324

Lenoir, Alexandre, 80

Lenormant, Charles, 212

Lenox, Massachusetts

 Groton Place in, *2*, 14, *15*, 19–21, *20*, *21*, 38

 Pleasant Valley Sanctuary in, 20n58

 Winthrop's friends in, 15

Leonardo da Vinci, 60, 209, 257, 260, 382, 422

 La Belle Ferronière, 354

Leopold of Carinthia, margrave of Hungary, 196

Lepère, Auguste, 284

Lepic and His Daughters in the Place de la Concorde (Degas), 98

Leprieur, Paul, 240, 244, 246

Leroux, Jean-Marie, 304

L'Estampe originale, 52

Le Sueur, Jean-François, 182

Les XX, 307

Lethière, Guillaume Guillon

 Brutus Condemning His Sons to Death, 216

 The Death of Virginia, 216–18, *217*; cat. no. 85

 The Death of Virginia (Louvre), *216*

Letts, Sydney, 21n64

Leveillé, Auguste-Hilaire, 116

Leyland, Frances, 466

Leyland, Frederick Richards, 361, 466

Liber Studiorum (Turner), 15, 16

Life of Constantine, The (Raphael), 60

Light of the World, The (Hunt), 360

Ligorio, Pirro, 125n3

Lime Kiln (Gericault), 138

Lincoln Memorial, Washington, D.C., 440, *440*, 442

Linnell, John, 340, 342, 350

Lion Hunt (Delacroix), 60, 108

Lion Hunt (Vernet), 60

Lion of Atlas (Delacroix), 106, *107*

Little Mary and Her Cows or *Peasant Girl Keeping Her Cows* (Roll), 286

Loeser, Charles, 8, 10, 15, 25n79

Loqueyssie, M. and Mme de, 174–75

Lorenzetti, Pietro, *Crucifixion*, 13, 14

Lorrain, Jean, 236, 246

Los as He Entered the Door of Death (Blake), 348

Louis Bonaparte, king of Holland, 302

Louis-François Bertin (Ingres), 179n1, 199

Louis Philippe, king of France, 200

Louis XIV (Rigaud), 202n4

Louis XVI, king of France, 89

Love (Prud'hon), 260, *260*, 262

Love and Wisdom (Prud'hon), 30, 251–54, *253*, 254; cat. no. 100

Love Reduced to Reason (Prud'hon), 254, 256, 259

Lovers, The (Duchamp-Villon), 285

Love Seduces Innocence, Pleasure Entraps, Remorse Follows (Prud'hon), 30, 252, 260–61, *261*; cat. no. 104

Lowell, James Russell, 8

Lucas, George A., 56n2

Lucia Carrying Dante in His Sleep (Blake), 350, 352–53, *353*; cat. no. 151

Lucrezia Borgia (Rossetti), 417–19, *418*; cat. no. 187

Ludlow, James B., 10

Lugt, Frits, 15

Lusitania, 19

Luttichuys, Simon, *Allegory of the Arts*, 456

Luxmoore, H. E., 433

Luynes, Honoré-Théodore-Paul-Joseph d'Albert, duc de, 207, 208

Lyttleton, Laura Tennant, 384–85

M

MacColl, Dugald S., *Wellington Monument* (photograph), 427, *428*

MacDonald, Alexander, 182

Macdonald, Georgiana, 360

McIlhenny, Henry, 29, 43

McKim, Mead and White, 39n114

Maclaren, Archibald, 360

MacPherson, James, 182

Madame Frédéric Reiset, née Augustine-Modeste-Hortense Reiset (Ingres), 26, 27, 192, *193*, 194; cat. no. 74

Madame Paul-Sigisbert Moitessier (Ingres), 27, 28, 192

Madame X (Sargent), 460

Madonna (Bellini workshop), 12n31

Madonna and Child (Master of the Ursula Legend), 13, 29n96

Madonna della Seggiola (Raphael), 157, 159

Madonna di Foligno (Raphael), 196

Madrazo y Agudo, José de, 29

Magazine of Art, 10

Le maléfice (Diaz de la Peña), 12n27

Maleterre, Rose-Cécile, 56n6

Malory, Sir Thomas, *Morte d'Arthur*, 328, 360, 431

Mamluk Holding Back His Horse (Delacroix), 104, 106n3

Manchon, Gaston, *The Chimera: After Gustave Moreau*, 236

Mancini, Antonio, *Self-Portrait*, 232n14

Manet, Édouard, 19, 24, 52, 114, 287, 288, 300, 458

 At the Races, 219, 220

 The Balcony, 115

 A Bar at the Folies-Bergère, 221

 Masked Ball at the Opera, 221

 Race Course at Longchamp, 218–20, *219*; cat. no. 86

Manet, Édouard, attrib. to, *Emmanuel Chabrier*, 221, *222*, 223, 232n14; cat. no. 87

Manet, Suzanne, 221

Man in a Felt Hat (unknown artist), *35*, 36

Man of Sorrows (Oderisi), 13, *13*

Man Reading (Sargent), 460–61, *461*, 465n3; cat. no. 208

Manship, Paul, 17, 43, 48

 Celestial Sphere, 19, *19*

 Sarah Jane Manship, 19n55

Mantegna, Andrea, 368

 Saint Sebastian, 361

 Virgin and Child with Saint John the Baptist and the Magdalen, 361

Manutius, Aldus, 368

Man with a Glove (Titian), 200

Man with a Pipe (Courbet), 62

Man with the Key, The, Jean d'Aire (Rodin), 296–97, *296*, 299; cat. no. 121

Marat, Jean-Paul, 94

Marché St. Honore, The (Pissaro), 250

Marcotte d'Argenteuil, Charles, 154, 160, 187, 189, 194, 196, 203, 208, 209

Marcotte d'Argenteuil, Mme Charles, 196

Margaret, Lady Brook, 378

Margueritte, Paul, 293

Marianna Russell (Mrs. John Russell) (Rodin), 23, 289, *290*, 291; cat. no. 118

Marin, John, 18

Marin, Joseph-Charles, 162–63

Maris, Matthijs, 46

Market, The (Daumier), 68n4

Market Place, The (Pissaro), 249–51, *250*; cat. no. 99

Marquis de Lafayette, The (Scheffer), 302, *303*, 304; cat. no. 127

Marriage at Cana (G. David), 354

Marriage of Heaven and Hell, The (Blake), 348

Marriage of the Virgin (Raphael), 209

Mars Disarmed by Venus and the Three Graces (David), 86, 90n8

Martyrdom of Saint Symphorien, The (Ingres, 1834), 183, *183*, 189, 203

Martyrdom of Saint Symphorien, The (Ingres, 1858), 26, 203–4, *203*; cat. no. 79

Marville, Charles, 152

Marx, Roger, 67, 236

Masked Ball at the Opera (Manet), 221

Masque of Cupid (Burne-Jones), 374n19

Massacres of Chios (Delacroix), 104, 112, 127n8

Master of the Ursula Legend, *Madonna and Child*, 13, 29n96

Mathews, Elkin, 334

Matisse, Henri, 146, 272

 "Cahiers d'Aujourdhui" series, 224

 Cinquante dessins, 224

 Mlle Yvonne Landsberg, 224

 The Plumed Hat, 223–24, *225*, 226; cat. no. 88

 Portraits, 224

 The Red Madras Headdress, 226n10

 The White Plumes, 224, 226n1

Matisse, Pierre, 43

Mauclair, Camille, 282

Mayer, Constance, 264

 The Dream of Happiness, 266

Medieval Town (Bresdin), 56n1

Medusa (Gericault), 129

Meeting of Attila and Leo the Great (Raphael), 117

Mendès, Catulle, 55, 223n3

Mengs, Anton Raphael, 208, 253

Menzel, Adolph, 318–27

 The Balcony Room, 318

 Before Confession, 318, 320–21, *321*, 322; cat. no. 135

 The Berlin-Potsdam Railway, 318

 Children's Album, 320

 Couple on a Bench, 322, *322*

 Early Morning in the Café, 324, *324*

 Head of a Bearded Man Facing Right, 324, *325*, 326; cat. no. 137

 Head of a Woman, 326, *327*; cat. no. 138

 In the Park, 318, 320, 322, *323*; cat. no. 136

 The Iron-Rolling Mill, 318

 Portrait Group: Jean Paul, Schiller, Goethe, and Herder, 318, *319*

 The Statue, 318–20, *319*; cat. no. 134

 Travel Plans, 322, *323*

 Woman Combing Her Hair, 326, *326*

Mephistopheles Presents Himself at Martha's House (Delacroix), *108*, 109n6

Mercier, Louis-Sébastien, 94

Mesoamerican masks, 38

Metamorphoses (Ovid), 234, 236

Metropolitan Museum of Art, The, New York, 5, 27, 29, 38, 40

Meurs, Otto van, clock, 21, *22*

Meyrick, Samuel, 354

Michelangelo, 60, 122, 131, 281, 284, 294, 380, 422, 427

 Last Judgment, 124

 Night, 234

 Sistine Chapel, 128, 375, 382

Mignard, Pierre, 12

Portrait of the Duchesse d'Aiguillon, 12n27

Miles, Emily Winthrop, 10, 11, 21–23, 38

Millais, John Everett, 356

 A Dream of the Past: Sir Isumbras at the Ford, 360

 Ford Madox Brown, 358n9

 Six Parables, 366

Miller, The, His Son, and the Ass (Daumier), 74

Millet, Frank, 460

Millet, Jean-François, 144, 145, 227–29, 305, 452, 458

 Antoinette Hébert devant le miroir, 227

 The Gleaners, 228

 Head of a Boy, 227–28, *227*; cat. no. 89

 Pauline Ono en déshabillé, 227

 Peasant Mother at the Hearth (Le Pot au Feu), 228, *229*; cat. no. 90

Millet, Pierre, 228

Millingen, James V., 212, 213

Minerva Wearing a Helmet (Rodin), 289

Minerva without a Helmet (Rodin), 289

Mink Pond (Homer), 21, 46, 449–50, *450*; cat. no. 202

Miollis, General Sextius-Alexandre-François, 154, 156, 181, 194

Miracle of the Sacred Fire in the Church of the Holy Sepulchre (Hunt), 42, 396–98, *396*, *397*; cat. no. 176

Mirbeau, Octave, 287

Mlle Yvonne Landsberg (Matisse), 224

Mlle Zélie (Courbet), 67n1

La moisson en Provence (van Gogh), 142, *143*

Molé, comte Louis-Mathieu, 179

Molière, 73

 Imaginary Invalid, 70

Monet, Claude, 46n132, 221, 248, 274, 300, 310, 460n2

 Banks of the Seine, 223n8

 The Cart, Snowy Road at Honfleur, with the Farm Saint-Siméon, 230, *230*

 Fête Nationale, Rue St-Denis, Paris, 223n8

 Road toward the Farm Saint-Siméon, Honfleur, 34, 230–32, *231*; cat. no. 91

Moore, Albert Joseph, 361, 402–5

 Companions, 402–3, *403*; cat. no. 179

 Ivory Beads, 403

 Myrtle, 402, 404–5, *404*; cat. no. 180

 Silver, 404

 A Summer Night, 404

 The Toilette, 404

Moore, Charles Herbert, 16

Moore, Florence Morris, 428

Moore, John Morris, 428

Moorish Woman, A, with Her Servant by the River (Delacroix), 100, *101*, 102, 103; cat. no. 26

Moreau, Charles, 78

Moreau, Gustave, 5, 36, 37, 232–46, 272, 378

 Aphrodite or *Birth of Venus*, 30, 238–40, *239*; cat. no. 94

 The Apparition, 11, 240, *241*, 242; cat. no. 95

 Centaur, 236

 The Chimera, 11, 236–38, *237*; cat. no. 93

Darius Fleeing after the Battle of Arbela, 232

David, 240, 244

Eve, 245, 246

Galatea, 246

Head of Orpheus, 240

Hercules and Omphale, 234

The Infant Moses, 30, *32*, 244

Jacob and the Angel, 30, 242, *243*, 244–45; cat. no. 96

Jason, 234

Moses Exposed, 235

Moses in Sight of the Promised Land, Removing His Sandals, 242

Oedipus and the Sphinx, 234

Poet and Satyrs, 30, *33*

Saint Sebastian and the Angel, 25, 30, *33*, 42

Salome, 240

The Sirens, 245–46, *245*; cat. no. 97

The Song of Songs, 232

The Springs, 236

Venus Anadyomene, 238–39, *238*

The Young Man and Death in Memory of Théodore Chassériau, 232, *233*, 234–35, 238; cat. no. 92

Moreau, Pauline, 239

Morgan, J. Pierpont, 6, 7, 25

Morgan, J. P. Jr., 40

Morgannwg, Iolo, 414

Mornay, comte de, 100, 103–4

Moroccans Dancing in a Street in Tangier (Delacroix), 103, *103*

Moroni, Giovanni Battista (after), *Portrait of a Man*, 12n31

Morris, Jane Burden, 415, *415*, 420, 423

Morris, William, 358, 359, 360, 361, 366, 368, 370, 371, 376, 380, 407, 409, 415, 420, 423, 431

Morse, Juliet, 394

Morse, Samuel F. B., 454

 Gallery of the Louvre, 456

Morte d'Arthur (Dent ed.), 332

Morte d'Arthur (Malory), 328, 360, 431

Moses Exposed (Moreau), 235

Moses in Sight of the Promised Land, Removing His Sandals (Moreau), 242

Mother and Death, The (Bresdin), 56n6

Mother and Two Children (Daumier), 68n2

Mrs. John Hay Whitney (Sargent), 460n3

Mrs. Vicuña (Rodin), 291n3

Munch, Edvard, 17

Murat, Caroline, queen of Naples, 159–60, 189, 209

Murat, Joachim, king of Naples, 154, 159–60, 189, 209, 211

Murat Family, The (Ingres), 160n3

Murray, Charles Fairfax, 365, 415

Museum of Fine Arts, Boston, 16

Mutiny on the Raft, The (Gericault), 126, *126*, 128

Mutiny on the Raft of the Medusa, The (Gericault), 122, 125–27, *127*, 128; cat. no. 38

Mutiny on the Raft of the Medusa, The (Gericault, Amsterdam), 126, *126*, 128

My Dream (Bresdin), 56n1

Mygatt, Otis, 304

Myrtle (Moore), 402, 404–5, *404*; cat. no. 180

Mystic Nativity (Botticelli), 420, 422

N

Nadar, 116

Naiad and Sea Bull or *Rape of Europa* (Prud'hon), 264, 266n4

La Naissance de Sainte Geneviève, or *The Three Theological Virtues Watching the Saint in Her Cradle* (Puvis de Chavannes), 268n8

Napoleon I, 78, 84, 86, 89, 92, *93*, 159–60, 162, 164, 181, 200, 211, 302, 401

Napoleon III, 200, 201, 240, 251n1

Napoléon-François-Charles-Joseph Bonaparte (1811–1832), duc de Reichstadt, Styled King of Rome (Lawrence), 28n94, 401–2, *401*; cat. no. 178

Natanson, Misia and Thadée, 314

National Gallery of Art, Washington, D.C., 45

Nativity, The (Giovanni di Paolo), *12*, 13, 29n96

neoclassical art, 94, 162, 208, 218, 253, 256, 302

Neo-Impressionists, 308

Neumann, J. B., 56n2

Newcomb, sculpture base made by, 41

New Sculpture movement, 430

Nicolo di Tomaso, *Virgin and Child*, 16n42

Nieuwerkerke, Alfred-Émilien O'Hara, comte de, 200–202, *201*

Night (Burne-Jones), 361–63, *363*, 382; cat. no. 156

Night (Michelangelo), 234

Nightmare (Bresdin), 56n6

Noailles, vicomte de, 46n133

Nocturne in Black and Gold: The Falling Rocket (Whistler), 445, 466

Nocturne in Black and Gold: Rag Shop, Chelsea (Whistler), 37, 472–73, *473*; cat. no. 216

Nocturne in Blue and Silver (Whistler), 37, 46, 466–67, *467*; cat. no. 212

Nocturne in Grey and Gold: Chelsea Snow (Whistler), 37, 471–72, *471*; cat. no. 215

Noël, Léon, 90

Nogent, Joseph-Antoine de, 52, 159–60, *161*

Norblin de la Gourdaine, Jean-Pierre

 The Oath of the Tennis Court, 29, *30*

 Study for "The Oath of the Tennis Court" (Fogg, 1943.801), 29, *30*

 Study for "The Oath of the Tennis Court" (Fogg, 1943.802), 29, *31*

 Study for "The Oath of the Tennis Court" (Fogg, 1943.803), 29, *30*

Norton, Charles Eliot, 8–10, 14, 15n42, 16, 25, 382

Norton, Elizabeth, *Self-Portrait*, 150

Norton, Sara, 7

Note in Black and Grey (Whistler), 475–76, *476*; cat. no. 218

O

Oath of the Horatii, The (David), 76

Oath of the Tennis Court, The (Norblin de la Gourdaine), 29, *30*

Oath of the Tennis Court at Versailles, June 20, 1789 (David), 78–79, *78*, 89

October Noon (Inness), 453, *454*; cat. no. 204

Odalisque en Grisaille (Ingres), 27

Odalisque with the Slave (Ingres), 26, 27, 28n93, 34–35, 187–90, *188*; cat. no. 72

Oderisi, Roberto, *Man of Sorrows*, 13, *13*

Odyssey of Homer, The, Engraved from the Compositions of John Flaxman R.A. Sculptor, 390, *391*

Oedipus and the Sphinx (Moreau), 234

Officier anglais à cheval (Taylor, after Gericault), 136, *137*

Old Models (Harnett), 444

Olive Trees, Corfu (Sargent), 463–64, *463*, 465n3; cat. no. 210

On the Street in Paris (Daumier), 68n1

Oranges at Corfu (Sargent), 464n1

Orchestra at the Opera (Degas), 221

Orléans, duc Ferdinand-Philippe d', 179, 187, 200, 354

Orpheus and Eurydice (Watts, 1868–69), 434, *435*

Orpheus and Eurydice (Watts, 1868–72), 434, *436*

Orpheus and Eurydice (Watts, 1870–80), 434–36, *435*; cat. no. 195

Oudry, Jean-Baptiste, 60

Ovid, *Metamorphoses*, 234, 236

Oyster Gatherers of Cancale (Sargent), 449

P

Pach, Walter, 5, 140

Painter at His Easel, The (Courbet), 63–65, *65*, 66; cat. no. 10

Pallas Wearing a Helmet (Rodin), 289

Pallas with the Parthenon (Rodin), 289

Pamington, Lillie, 477, *477*

Pan and Psyche (Burne-Jones), 368, *369*, 370; cat. no. 159

Pan and Psyche (Burne-Jones, private coll.), *368*, 370

Panofsky, Erwin, 43

Paolo and Francesca (Ingres), 160n3, 209

Papety, Dominique, *Un rêve de bonheur*, 208

Parker, Thomas, 390

Parrish, Maxfield, *A Hill Prayer*, 19, *19*

Pascin, Jules, 19

Passage du Puits Bertin (Signac), 308

Passing of Venus, The (Burne-Jones), 380

Pater, Walter, 16, 37, 366

Paul Barroilhet (Couture), 36, *37*

Paulet, John, clock, 21, *22*

Pauline Ono en déshabillé (Millet), 227

Peacock Skirt, The, for Salome (Beardsley), 328–30, *329*, 332; cat. no. 139

Peale, Charles Willson, *Portrait of George Washington*, 46

Peale, Raphaelle and James, 454

Peasant Interiors (Bresdin), 54

Peasant Mother at the Hearth (Le Pot au Feu) (Millet),
228, *229*; cat. no. 90

Peasant of the Camargue (Portrait of Patience Escalier)
(van Gogh), 145–46, *147*; cat. no. 47

Penitence of Saint Joseph, The (David, after Tiarini),
76–77

Pennell, Elizabeth, 468

Pérée, Jacques-Louis, *L'aurore de la raison commence à*
Lucre, 251, *252*

Péreire, Isaac, 59

Perlmutter, Michael, 212

Péronard, Melchior, 217

Perrins, C. W. Dyson, 420

Perseus (Garzoli), 212

Perseus and Andromeda (Burne-Jones), 16, 371–74,*372*,
373, 380; cat. no. 160

Peter Harrison Asleep (Sargent), 461*n*3

Peytel, Joanny, 293*n*8, 297

Philémon et Baucis (Ingres), 202*n*8

Phillips, Frederick, 10

Phyllis and Demophoön (Burne-Jones), 366, 382

La Pia de' Tolomei (Rossetti), 423

Piazza San Marco, Venice (Canaletto), 34,*34*, 46

Picasso, Pablo, 134, 224, 268, 272, 308

Piccirilli Brothers, 442*n*9

Pichot, Amédée, 208

Piero di Cosimo, *The Death of Procris*, 368,*368*, 370

Pierpont Morgan Library, New York, 40

Pierre-Cécile Puvis de Chavannes (Rodin), 41, *41*

Pierre de Wiessant (Rodin), 296–97, *298*, 299;
cat. no. 124

Pierre-Marie Baille and Charles Beauvais de Préault
(David), 80–82, *81*; cat. no. 18

Pietà (Bellini), 258

Pinelli, Bartolomeo, 116, 120, 122

Piroli, Tommaso (Thomas), 348, 386, 388, 390

Pissaro, Camille, 52, 232, 246–51, 310
Banks of the Oise River, 246, *247*, 248; cat. no. 98
Gelée blanche, 248
The Marché St. Honoré, 250
The Market Place, 249–51, *250*; cat. no. 99
Study of a Man, Seated in an Interior, 249, *251*

Pius VII, Pope, 84, *84*

Pius VII and Cardinal Caprara (David), 29

Pleasant Valley Bird and Wild Flower Sanctuary
Association, Lenox, 20*n*58

Plumed Hat, The (Matisse), 223–24, *225*, 226;
cat. no. 88

Poe, Edgar Allan, 415, 419, 422

Poet and Satyrs (Moreau), 30,*33*

Pollitt, Herbert, 336

Pollonera, Carlo, 464

Pompeiian frescoes, 256

Poor Artist's Cupboard (King), 454, *454*, 456

Pope, Alexander, 390

Portalès-Gorgier, James-Alexandre, comte de, 189

Portland Vase, 13, *14*

Portrait de femme (Mme de Pourtalès) (Renoir), 279*n*4

Portrait Drawing of a Young Family in Medieval
Costume (Chassériau), 57*n*4

Portrait Group: Jean Paul, Schiller, Goethe, and Herder
(Menzel), 318,*319*

Portrait Head of Jane Morris (Rossetti), 415, *415*;
cat. no. 185

Portrait of Alfred-Émilien O'Hara, Comte de
Nieuwerkerke (Ingres), 200–202, *201*; cat. no. 78

Portrait of a Man (after Moroni), 12*n*31

Portrait of a Man (Chardin), 34,*34*

Portrait of a Man (Ingres), 160*n*5

Portrait of a Peasant (Patience Escalier) (van Gogh),
145, *145*

Portrait of Augustin Jordan and His Daughter Adrienne
(Ingres), 167–69, *168*; cat. no. 58

Portrait of a Woman (Prud'hon), 266

Portrait of a Young Lady Distracted from Her Music
Lesson (Guillemard), 94,*94*

Portrait of a Young Man (Gericault circle), 140, *141*,
142; cat. no. 45

Portrait of a Young Man (Raphael), 157

Portrait of a Young Woman (David circle), 29, 94–95,
95; cat. no. 23

Portrait of a Young Woman (Ingres), 150–51, *151*;
cat. no. 49

Portrait of Bibbiena (Raphael), 209, 211

Portrait of Bindo Altoviti (Raphael), 157, 211

Portrait of Countess Antoine Apponyi (Ingres), 24,
174–76, *174*; cat. no. 62

Portrait of Count Rodolphe (?) Apponyi (Ingres),
174–76, *175*; cat. no. 63

Portrait of Dr. Thomas Dagoumer (Prud'hon), 264, *265*,
266; cat. no. 106

Portrait of Étienne-Jean Delécluze (Ingres), 198–99, *198*;
cat. no. 77

Portrait of Gentile and Jacopo Bellini (Cariani), 354

Portrait of George Washington (C. W. Peale), 46

Portrait of Jean-Charles-Auguste Simon (Ingres), 150

Portrait of Madame Augustin Jordan and Her Son
Gabriel (Ingres), 167–69, *169*; cat. no. 59

Portrait of Madame Charles Hayard (Ingres), 164,
165

Portrait of Madame Charles Hayard and Her Daughter
Caroline (Ingres), 164–66, *165*, 167; cat. no. 56

Portrait of Madame Ingres (Ingres), 150

Portrait of Madame Pierre-Henri Renoir (Renoir), 277,
278, 279; cat. no. 111

Portrait of Mrs. George Vesey and Her Daughter
Elizabeth Vesey, later Lady Colthurst (Ingres), 26,
166–67, *166*; cat. no. 57

Portrait of Pierre-Henri Renoir (Renoir), 277, *277*

Portrait of the Duchesse d'Aiguillon (Mignard), 12*n*27

Portrait of the Family of Lucien Bonaparte (Ingres), 26,
162–64, *163*; cat. no. 55

Portrait of the Forestier Family (Ingres), 26, 176–78,
177; cat. no. 64

Portrait of the Son of M. Baron de C[ourval]
(Prud'hon), 266

Portrait of Tournelle, called Dublin, Actor at the Théâtre
Français (Labille-Guiard), 29, 214, *215*, 216;
cat. no. 84

Portrait of Victor Chocquet (Renoir), 42, 279, *280*, 281;
cat. no. 112

Portrait of Victor Dupré (?) (Chassériau), 56–57, *57*;
cat. no. 6

Portraits (Matisse), 224

Portraits of Monsieur and Madame Gaignat (Lancret),
12*n*27

Postillion at the Door of an Inn or *White Horse Tavern*
(Gericault), 31, 138, *139*, 140; cat. no. 44

Post-Impressionism, 464

Potato Eaters, The (van Gogh), 145

Poulenc, Francis-Jean-Marcel, 221

Pourtalès, Countess Edmond de, 277

Poussin, Nicolas, 79–80, 208, 270

Pradier, Charles-Simon, 157, 182, 194

Pre-Raphaelites, 16, 18, 25, 30, 34, 39, *43*, 356, 360,
366, 368, 370, 379, 405, 409, 410, 414, 419, 422,
429, 431, 433, 458

Prince Leopold I von Anhalt-Dessau (Schadow), 318,*319*

Prinsep, Arthur, 433*n*3

Prinsep, Val, 412

Print Amateur, The (Daumier), 70, *71*; cat. no. 13

Prisoners from the Front (Homer), 447

Proust, Antonin, 287–88, *288*

Prud'hon, Pierre-Paul, 30, 251–66
Assumption of the Virgin, 266
Cruelty Laughs at the Tears He Has Caused to Flow,
30, 254–56, *255*, 259; cat. no. 101
David Johnston, 264, *264*
The French Constitution, 252
Head of a Man with Short Hair, Seen in Left Profile,
258, 259
Innocence and Love, 259
Justice and Divine Vengeance Pursuing Crime, 262
L'Amour séduit l'Innocence, le Plaisir l'entraîne, le
Repentir suit (1809), 260, *260*
Love, 260, *260*, 262
Love and Wisdom, 30, 251–54, *253*; cat. no. 100
Love Reduced to Reason, 254, 256, 259
Love Seduces Innocence, Pleasure Entraps, Remorse
Follows (1805), 30, 252, 260–61, *261*; cat. no. 104
Naiad and Sea Bull or *Rape of Europa*, 264, 266*n*4
Portrait of a Woman, 266
Portrait of Dr. Thomas Dagoumer, 264, *265*, 266; cat.
no. 106
Portrait of the Son of M. Baron de C[ourval], 266
Psyche, 262
Reason Speaks, Pleasure Entraps, 30, 257–59, *257*,
258; cat. no. 102
Reason Speaks, Pleasure Entraps (private coll.), 257,
257
The Revenge of Ceres, 254, 256
La Sagesse et la Vérité descendent sur la terre, 253

Self-Portrait, 264, *264*, 266n3
So-called Portrait of Prud'hon's Physician, 264, *264*
Study of a Seated Man, Half Reclining, Leaning on His Right Hand, 30, 262, *263*; cat. no. 105
Study of a Young Man, 252, *252*
The Union of Love and Friendship, 251, 252, *252*
Venus and Adonis, 262
Virtue Struggling with Vice, 30, 257–59, *257*, *259*; cat. no. 103
in Winthrop's collection, 31, *33*
Woman Holding a Fawn Suckled by a Doe, 255, 256
A Young Zephyr, 262
Psyche (Prud'hon), 262
Pulitzer, Joseph, 43
Punishment of Jacopo Rusticucci and His Companions (Blake), 346–47, *346*, 348; cat. no. 148
Puvis de Chavannes, Pierre-Cécile, 10, 267–72
L'Enfance de Sainte Geneviève, or The Meeting of Saint Genevieve and Saint Germain, 268nn 8, 9
Head of a Woman, 270–72, *271*; cat. no. 108
La vie pastorale de sainte Geneviève, 267
La Naissance de Sainte Geneviève, or The Three Theological Virtues Watching the Saint in Her Cradle, 268n8
Rodin's bust of, 41, *41*
The Sacred Grove, Beloved of the Arts and Muses, 270, *271*
Sainte Geneviève enfant en prière (1875–76), 268, *268*
Sainte Geneviève enfant en prière (1876), 267, 268n2, *268*
Saint Genevieve as a Child at Prayer (1879), 267–68, *269*, 270; cat. no. 107
The Toilette, 272n6

Q

Quare, Daniel, clock, 21, *22*
Queen Caroline Murat (Ingres), 160, 209
Quillenbois, "M. Courbet enrhumé," 63, *64*
Quinn, John, 6

R

Race Course at Longchamp (Manet), 218–20, *219*; cat. no. 86
Racine, Jean, 73
Raffalovich, André, 336
Raffalovich, Marie, 244
Raffele, Ambrogio, 464, 465
Raft of the Medusa (Gericault), 122, 125, *126*, 130, 132, 138, 140
Il Ramoscello (Bella e Buona) (Rossetti), 366, 412, *413*, 414; cat. no. 184
Rape of Europa, The (Ingres), 211–12, *213*; cat. no. 83
Rape of Europa by Jupiter, The (Ingres), 212, *213*
Raphael, 120, 157, 201, 203, 208, 209, 427
Battle of Constantine, 148

Entombment, 58
Heliodorus Chased from the Temple, 242
The Life of Constantine, 60
Madonna della Seggiola, 157, 159
Madonna di Foligno, 196
Marriage of the Virgin, 209
Meeting of Attila and Leo the Great, 117
Portrait of a Young Man, 157
Portrait of Bibbiena, 209, 211
Portrait of Bindo Altoviti, 157, 211
School of Athens, 157
Self-Portrait with a Friend, 354
Sistine Madonna, 196
Solomon Building the Temple in Jerusalem, 430n5
Vatican Stanze, 207
Raphael and the Fornarina (Ingres), 26, 157, *158*, 159, 209; cat. no. 53
Ravel, Maurice, 221
Read, David Charles, 342, 344n3
Reason Speaks, Pleasure Entraps (Prud'hon), 30, 257–59, *257*, *258*; cat. no. 102
Reason Speaks, Pleasure Entraps (Prud'hon, private coll.), 257, *257*
Reclining Nude (Madame Ingres) (Ingres), 170
Reclining Panther (Barye), 51n4
Reconnoitering (Sargent), 465n1
Red Madras Headdress, The (Matisse), 226n10
Redon, Odilon, 54, 55
Saint Sebastian (1910), 272, 273
Saint Sebastian (1912), 272–74, *273*; cat. no. 109
Regnault, Jean-Baptiste, 94, 251
Reiset, Marie-Eugène-Frédéric, 192, 194, 201
Reiset, Mme Frédéric, née Augustine-Modeste-Hortense, 192, *193*, 194
Rembrandt van Rijn, 114, 142, 302, 305
Butchered Ox, 73
Renaissance, 16, 118, 120, 121, 125, 133, 202n4, 361, 370, 414, 422, 423, 427, 431
Renan, Ary, 236, 240, 246
Renard, Jules, 291
Rendezvous, The (Conder), *18*, 19
Renoir, Jean, 277
Renoir, Pierre-Auguste, 221, 274–81, 300, 310
Flowers in a Vase, *274*, 276
Portrait de femme (Mme de Pourtalès), 279n4
Portrait of Madame Pierre-Henri Renoir, 277, *278*, 279; cat. no. 111
Portrait of Pierre-Henri Renoir, 277, *277*
Portrait of Victor Chocquet, 42, 279, *280*, 281; cat. no. 112
Self-Portrait, 276
Spring Bouquet, 34, 46, 274, *275*, 276; cat. no. 110
Réveil, Achille, 157, 178, 182, 211
Revenge of Ceres, The (Prud'hon), 254, 256
Revue illustrée, 223n11
Reynolds, Sir Joshua, 386, 401
Riant, Emmanuel, 204, 206
Richardson, H. H., 458

Ricketts, Charles, 18, 24, 379, 429, 436
Rido, Antonio de, 172
Riepenhausen brothers, 157
Riffaut, M., 200
Rigaud, Hyacinthe, *Louis XIV*, 202n4
Rinaldo and Armida (Bergeret), 170
Ripa, Cesare, *Iconologia*, 427
Rivera, Diego, 43
Road toward the Farm Saint-Siméon, Honfleur (Monet), 34, 230–32, *231*; cat. no. 91
Robaut, Alfred, 104, 106, 108, 112
Robert Louis Stevenson and His Wife (Sargent), 460n3
Robertson, Graham, 382, 383
Rockefeller, Nelson A., 43
Rock of Doom, The (Burne-Jones), 371, *371*, *372*, 373, 374, 381
Rocky Landscape with a Distant Town (Bresdin), 56n1
Rodin, Auguste, 5, 52, 281–301
Antonin Proust, 287–89, *288*; cat. no. 117
The Burghers of Calais, five reductions of, 296–99, *296*, *297*, *298*, *299*; cat. nos. 121–25
Ceres, 289
Eternal Idol, 46, 291, *292*, 293, 300; cat. no. 119
Eternal Spring, 285–86, *285*, *286*, 300; cat. no. 116
Eustache de Saint-Pierre, 296–97, *297*, 299; cat. no. 122
The Gates of Hell, 284, 285, 287, 289, 291, 293
Jean de Fiennes, 296–97, *297*, 299; cat. no. 123
The Kiss, 285, 286, 293, 300
The Man with the Key, Jean d'Aire, 296–97, *296*, 299; cat. no. 121
Marianna Russell (Mrs. John Russell), 23, 289, *290*, 291; cat. no. 118
Minerva Wearing a Helmet, 289
Minerva without a Helmet, 289
Mrs. Vicuña, 291n3
Pallas Wearing a Helmet, 289
Pallas with the Parthenon, 289
Pierre-Cécile Puvis de Chavannes, 41, *41*
Pierre de Wiessant, 296–97, *298*, 299; cat. no. 124
Portrait of Antonin Proust, 287, *288*
Romeo and Juliet, 300, *300*
Saint John the Baptist, 281–82, *282*, 294; cat. no. 113
Study for "Romeo and Juliet," 24, 300, *301*; cat. no. 126
Study for "The Gates of Hell": Shades Speaking to Dante, 284, *284*; cat. no. 115
Torso of Adèle, 285
Vase Clodion (Lovers), 283, *283*; cat. no. 114
Walking Man, 294, *295*; cat. no. 120
The Weeping Burgher, Andrieu d'Andres, 296–97, 299, *299*; cat. no. 125
Roger, Barthélemy, 257, 259
L'Amour séduit l'Innocence, le Plaisir l'entraîne, le Repentir suit (after Prud'hon), 260, *260*
Roger Freeing Angelica (Ingres), 27, 170, 172–73, *173*; cat. no. 61
Roger Freeing Angelica (Ingres, London), 170, *170*, 202n13

Roger-Marx, Claude, 67

Le roi Midas et son barbier (Ingres), *200*, 202

Roll, Alfred, *Little Mary and Her Cows* or *Peasant Girl Keeping Her Cows*, 286

Roll, Mme Alfred, 286

Rollins, Charles, 216

Romains, Jules, 224

Roman Album No. 1 (David), 29, 76–77, *77*, 82; cat. no. 16

Roman Herdsmen (Gericault), 116–18, *117*, 133; cat. no. 34

Romano, Giulio, 208

Romans of the Decadence (Couture), 36, *36*

Romanticism, 50, 51, 108, 114, 186, 199, 203, 227, 302, 356, 361

Romeo and Juliet (Rodin), 300, *300*

Romero, G. B., 120

Romilly, Félix de, 239

Romney, George, 348, 390

Romulus (Ingres), 203

Romulus, Conqueror of Acron (Ingres), 181

Romulus Victorious over Acron (Ingres), 157

Rooke, Thomas Matthews, 382

Roosevelt, Eleanor, 43

Roosevelt, Sara Delano, 7

Rossetti, Dante Gabriel, 5, 356, 358, 360, 361, 365*n*4, 405–24, 431

 Beata Beatrix, 366, 416–17, *416*; cat. no. 186

 Blessed Damozel, The, 24, 30, 42, 366, 414, 419–20, *421*, 422; cat. no. 188

 The Blue Closet, 409

 Bocca Baciata, 412

 The Bower Meadow, 407

 A Christmas Carol, 407–9, *408*; cat. no. 182

 Dante at Verona, 419

 Dante Drawing an Angel on the Anniversary of Beatrice's Death, 417–18

 La Donna della Finestra, 423–24, *424*; cat. no. 190

 Ecce Acilla Domini, 419

 Fazio's Mistress, 409

 Ford Madox Brown, 358*n*9

 Found, 422

 Genevieve, 408

 Giotto Painting Dante's Portrait (1852), 410, *410*

 Giotto Painting Dante's Portrait (ca. 1859), 410–12, *411*; cat. no. 183

 The Girlhood of Mary Virgin, 407

 "Hist"—said Kate the queen, 408

 Lucrezia Borgia, 417–19, *418*; cat. no. 187

 La Pia de' Tolomei, 423

 Portrait Head of Jane Morris, 415, *415*; cat. no. 185

 Il Ramoscello (Bella e Buona), 366, 412, *413*, 414; cat. no. 184

 The Salutation of Beatrice, 405–7, *406*, 422; cat. no. 181

 Sea Spell, 37

 Sir Galahad at the Ruined Chapel, 433*n*2

 Study for "The Blessed Damozel" (First Sketch for Background), 407, 420, 422–23, *422*; cat. no. 189

Rossetti, Gabriele, 412

Rossetti, William Michael, 414, 423, 433

Ross, James, 362

Rothschild family, 23

Rothschild, Adolphe de, 11*n*22

Rothschild, Baron Henri de, 26, 50–51, 136

Rothschild, M. James Nathaniel de, 136

Rougeron, Marcel Jules, 7

Rouget, Georges, 92

Rousseau, Théodore, 64, 248, 310

Roux, Antony, 239, 291

Rowlandson, Thomas, 31

 Comparative Anatomy: Resemblances between the Countenances of Men and Beasts, 425–26, *425*, *426*; cat. no. 191

Rubens, Peter Paul, 60, 108

 Battles of the Amazons, 148

 Christ Walking on the Waters, 109, 110

 Jonah Thrown from the Boat, 109

Rubinstein, Ida, 273

Rushton, Joseph, 362

Ruskin, John, 8, 9, 16, 367, 378*n*5, 414, 445, 446, 447, 449, 466, 468

Russell, John, 142

Russell, Marianna (Mrs. John), née Anna Maria Antonietta Mattiocco, 23, 289, *290*

Ryder, Albert Pinkham, 452

S

Sachs, Paul, 16, 20, 25, 27, 51

Sacred Grove, The, Beloved of the Arts and Muses (Puvis de Chavannes), 270

La Sagesse et la Vérité descendent sur la terre (Prud'hon), 253

Sailboat and Fourth of July Fireworks (Homer), 444–46, *445*; cat. no. 199

Saint Dominic Resuscitating a Child (David, after Tiarini), 76–77

Sainte Geneviève enfant en prière (Puvis de Chavannes, 1875–76), 268, *268*

Sainte Geneviève enfant en prière (Puvis de Chavannes, 1876), 267, 268*n*2, *268*

Saint-Gaudens, Augustus, *Standing Lincoln*, 442

Saint Genevieve as a Child at Prayer (Puvis de Chavannes, 1879), 267–68, *269*, 270; cat. no. 107

Saint John the Baptist (Rodin), 281–82, *282*, 294; cat. no. 113

Saint Sebastian (Botticelli), 361

Saint Sebastian (Mantegna), 361

Saint Sebastian (Redon, 1910), *272*, 273

Saint Sebastian (Redon, 1912), 272–74, *273*; cat. no. 109

Saint Sebastian and the Angel (Moreau), 25, 30, *33*, 42

Saisset, Édouard, 245

Sakuntala or *Abandonment* (Claudel), 293

"Sally in Our Alley" (English ballad), 478

Salome (Moreau), 240

Salome (Wilde), 328, 334

Salon des Arts-Unis (1861), 204

Salon, Paris

 (1759), 216

 (1763), 256

 (1791), 78, 89

 (1793), 252, 253, 254

 (1799), 214

 (1800), 157

 (1801), 94

 (1806), 178, 183

 (1808), 92, 152

 (1814), 156, 157

 (1819), 125, 138, 170, 172, 266, 304

 (1822), 304

 (1824), 183, 354

 (1831), 108, 216, 217–18

 (1833), 106, 194

 (1834), 183, 203

 (1839), 57, 240*n*4

 (1849), 63, 67*n*1

 (1850–51), 58

 (1853, 52), 148, 232

 (1855), 64

 (1861), 114

 (1864), 236

 (1865), 234

 (1869), 236

 (1876), 240, 268*n*2

 (1878), 116, 449

 (1880), 281, 294

 (1883), 283

 (1884), 460

 (1885), 287

 (1891), 236

Salons, juries of, 201

Saltimbanques Changing Place, The (Daumier), 25

Salutation of Beatrice, The (Rossetti), 405–7, *406*, 422; cat. no. 181

Sands, W. H. B., 312

Santayana, George, 8, 14

Sarah Jane Manship (Manship), 19*n*55

Sargent, John Singer, 18, 19, 26, 42, 204, 283, 294, 458–65

 Albanian Olive Gatherers, 464*n*1

 Artist in the Simplon, 464–65, *465*; cat. no. 211

 Boats, Venice, 465*n*3

 The Breakfast Table, 458, *459*, 460; cat. no. 207

 Cathedral, Granada, Spain, 465*n*3

 Claude Monet Painting by the Edge of a Wood, 464

 Corfu: A Rainy Day, 464*n*1

 Corfu: Lights and Shadows, 464*n*1

 A Dinner Table at Night, 460*n*3

 Fête Familiale, 460*n*3

 Garden at Florence, 465*n*3

 The Hermit, 465*n*1

 The Honorable Laura Lister, 40, *40*

 In Switzerland, 461

 In the Simplon Valley, 462–63, *462*; cat. no. 209

Madame X, 460

Man Reading, 460–61, *461*, 465*n*3; cat. no. 208

Mrs. John Hay Whitney, 460*n*3

Olive Trees, Corfu, 463–64, *463*, 465*n*3; cat. no. 210

Oranges at Corfu, 464*n*1

Oyster Gatherers of Cancale, 449

Peter Harrison Asleep, 461*n*3

Reconnoitering, 465*n*1

Robert Louis Stevenson and His Wife, 460*n*3

The Sketches, 464*n*2

Sketching on the Giudecca, 464*n*2

Sargent, Violet, 460

Sassetta, 267

Satie, Erik-Alfred-Leslie, 221

Saucède, Alfred, 70

Savigny, Henri, 125

Scapin, or *Scapin and Géronte* (Daumier), 34, 73–74, *75*; cat. no. 15

Scapin et Crispin (Daumier), 73–74

Scene in the Olden Time at Bolton Abbey (Landseer), *398*, 400

Scene of Cannibalism (Gericault), 125

Schadow, Johann Gottfried, *Prince Leopold I von Anhalt-Dessau*, 318, *319*

Schamyl in his Youth (Bresdin), 54

Scheffer, Arnold, 302

Scheffer, Ary, 148, 361

 The Marquis de Lafayette, 302, *303*, 304; cat. no. 127

Scheffer, Johann-Bernhard, 302

Schlegel, August Wilhelm von, 386, 388, 390

Schmitz, Oskar, 279*n*4

Schoeller collection, 48, 51

School of Athens (Raphael), 157

Schooner at Sunset (Homer), 446–47, *447*; cat. no. 200

Scolari, Margaret, 226*n*11

Scott, Sir Walter, 354, 400

Scott, William Bell, 409

Scott and Fowles, 19, 23, 26, 318, 389

Scribner's Monthly, 445, 446

Seasons, The (Burne-Jones), 378*n*3

Sea Spell (Rossetti), 37

Sea Venus (Chassériau), 239

Sebastiano del Piombo, *Triple Portrait*, 258

Sedding, Edmund, 409*n*11

Les séductions de l'amour (Diaz de la Peña), 12*n*27

Self-Portrait (Bracquemond), 52, *53*, 54; cat. no. 4

Self-Portrait (Brown), 46, 356, *357*, 358; cat. no. 153

Self-Portrait (Fantin-Latour), 114–15, *114*; cat. no. 32

Self-Portrait (Ingres), 26, 35, 204, *205*, 206; cat. no. 80

Self-Portrait (Leighton), 358*n*11

Self-Portrait (Mancini), 232*n*14

Self-Portrait (Norton), 150

Self-Portrait (Prud'hon), 264, *264*, 266*n*3

Self-Portrait (Renoir), 276

Self-Portrait (van Gogh), 145–46

Self-Portrait at the Age of Twenty-Four (Ingres), 52, 54

Self-Portrait with a Friend (Raphael), 354

Seligmann, Jacques, 36

Seurat, Georges Pierre, 304–9

 Á la Gaîté Rochechouart, 307, *308*

 Aman-Jean, 306*n*3

 Café-Concert (Á la Gaîté Rochechouart), 307–8, *309*; cat. no. 129

 Eden Concert, 308*n*3

 Embroidery: The Artist's Mother, 306*n*1

 A Sunday Afternoon on the Island of the Grande Jatte, 305

 Woman Reading: The Artist's Mother, 306*n*1

 Woman Sewing, 304–6, *305*; cat. no. 128

Sèvres Manufactory, 283, 291

Shakespeare, William, 300, 354, 409

Shannon, Charles, 18, 436

Shchukin, Sergei, 238*n*11

Sheet of Five Horse Studies (Degas), *97*, 98

Sickert, Walter, 308*n*1

Siddal, Elizabeth, 407, 409, 415, 416, 417, 419, 420

Sidonia von Bork (Burne-Jones), 365*n*4, 418

Signac, Paul, 305

 Passage du Puits Bertin, 308

Silver (Moore), 404

Simart, Charles, 207

Sinclair, Upton, 16

Singer, J. W., and Sons, 428

Siren, Oswald, 43

Sirens, The (Moreau), 245–46, *245*; cat. no. 97

Sir Galahad (Burne-Jones), 359–60, *359*, 433*n*2; cat. no. 154

Sir Galahad (Watts), 30, 431, *431*, *432*, 433–34; cat. no. 194

Sir Galahad at the Ruined Chapel (Rossetti), 433*n*2

Sisley, Alfred, 221, 248, 276

 The Bridge at Villeneuve-la-Garenne, 310, *311*; cat. no. 130

Sistine Chapel, The (Ingres), 187

Sistine Madonna (Raphael), 196

Six Parables (Millais), 366

Sketchbook No. 14: Studies for "The Coronation of Napoleon I" (David), 28, 82–86, *83*, *84*, *85*, 379; cat. no. 19

Sketchbook No. 20: Studies for "The Coronation of Napoleon I" (David), 28, 86–89, *87*, *88*, 379; cat. no. 20

sketchbooks (Burne-Jones), 379–83

 (1870s–1880s), 381, *381*; cat. no. 167

 (1880s?), 382–83, *382*; cat. no. 168

 (ca. 1870–78), 380–81, *380*; cat. no. 166

 (ca. 1880–86), 383, *383*; cat. no. 169

Sketches, The (Sargent), 464*n*2

Sketching on the Giudecca (Sargent) 464*n*2

Slave Ship, The (Turner), 447

Sleeping Odalisque (Ingres), *188*, 189

Sleep of Arthur in Avalon, The (Burne-Jones), 379, 383

Sloan, John, 18

Smith, Mary and Thomas Eustace, 433

Smithers, Leonard, 336–37

Smoker, The, or *Profile Portrait of the Artist with a Pipe* (Courbet), 62–63, *62*; cat. no. 9

So-called Portrait of Prud'hon's Physician (Prud'hon?), 264, *264*

Société Anonyme des Artistes Peintres, Sculpteurs, Graveurs, 248

Société des Aquafortistes, 52

Soldiers Casting Lots for Christ's Garment, The (Blake), 340*n*3

Solomon Building the Temple in Jerusalem (Raphael), 430*n*5

Song of Songs, The (Moreau), 232

Soufflot, Jacques Germain, 268*n*4

Soulier-François, Françoise, 67

La Source (Ingres), 170

Souvenirs d'un voyage dans le Maroc (Delacroix), 102

Spartali, Marie, 364, 365

Spencer, Herbert, 452

Spencer, Margaret Georgiana, Viscountess, 392

Spirit of the Waters (French), 440

Spring Bouquet (Renoir), 34, 46, 274, *275*, 276; cat. no. 110

Springs, The (Moreau), 236

Standing Lincoln (French), 440

Standing Lincoln (Saint-Gaudens), 442

Standing Portrait of a Young Man (Chassériau), 57

Start of the Race of the Barberi Horses (Gericault), 118, *119*

Statue, The (Menzel), 318–20, *319*; cat. no. 134

Stephens, Frederic G., 371, 405, 417, 433

Stern, Julius, 293*n*8

Sterne, Maurice, 19

Sterner, Albert, 42

Stevens, Alfred George

 Truth and Falsehood, 427–30, *427*, *429*; cat. no. 193

 Valour and Cowardice, 427–30, *427*, *428*; cat. no. 192

Stevenson, Fanny, 460

Stevenson, Robert Louis, 286, 460

Still Life with Bric-a-Brac (Harnett), 443–44, *443*; cat. no. 198

Stillman, Marie Spartali, 364, 365

Stillman, W. J., 364

Stomach Dance (Beardsley), *328*, 330

Stonborough, Jerome, 51

Storm-Sunset, The (Whistler), *466*, 467

Stradanus, Johannes, 60

Stratonice (Ingres), 187

Stratta, Carlo, 464

Straus, Percy Selden, 43

Studies for the "Martyrdom of Saint Symphorien" (Lictors, Stone-Thrower, and Spectator) (Ingres), 26, 183, *185*, 186–87; cat. no. 71

Studies for "The Martyrdom of Saint Symphorien" (Saint, Mother, and Proconsul) (Ingres), 26, 183, *184*, 186–87; cat. no. 70

Studies of a Cat (Gericault), 132–33, *132*; cat. no. 41

Studies of a Man and a Woman for "The Golden Age" (Ingres), 190–91, *191*, 208; cat. no. 73

Studies of Lions (Delacroix, ca. 1828), 108, *108*

Studies of Lions (Delacroix, ca. 1830), *107*, 108*n6*

Studio of the Painter, The (Courbet), 63

Study for "The Blessed Damozel" (First Sketch for Background) (Rossetti), 407, 420, 422–23, *422*; cat. no. 189

Study for "The Gates of Hell": Shades Speaking to Dante (Rodin), 284, *284*; cat. no. 115

Study for the Head of Octavia in "Virgil Reading the 'Aeneid' to Augustus" (Ingres), 25, 154, *155*, 156, 194; cat. no. 51

Study for the Left Hand of Comte Louis-Mathieu Molé (Ingres), 179–81, *180*; cat. no. 66

Study for "The Oath of the Tennis Court" (Fogg, 1943.801) (Norblin de la Gourdaine), 29, *30*

Study for "The Oath of the Tennis Court" (Fogg, 1943.802) (Norblin de la Gourdaine), 29, *31*

Study for "The Oath of the Tennis Court" (Fogg, 1943.803) (Norblin de la Gourdaine), 29, *30*

Study for "The Oath of the Tennis Court" (David), 29, 78–80, *79*; cat. no. 17

Study for the Right Hand of Comte Louis-Mathieu Molé (Ingres), 179–81, *180*; cat. no. 67

Study for the Right Hand of the Duc d'Orléans (Ingres), 179–81, *180*; cat. no. 68

Study for "Roger Freeing Angelica" (Ingres), 27, 170, *171*, 172; cat. no. 60

Study for "Romeo and Juliet" (Rodin), 24, 300, *301*; cat. no. 126

Study for the "Start of the Race of the Barberi Horses" (Gericault), 46, 118–20, *119*, 121, 122, 126, 133; cat. no. 35

Study for "Virgil Reading the 'Aeneid' to Augustus" (Ingres, ca. 1811–12), *154*, 156

Study for "Virgil Reading the 'Aeneid' to Augustus" (Ingres, ca. 1814), 25, 154, *155*, 156, 194; cat. no. 52

Study of a Man, Seated in an Interior (Pissaro), 249, *251*

Study of Andromeda Viewed from the Back (Burne-Jones), *372*, 373, 380*n2*

Study of a Seated Man, Half Reclining, Leaning on His Right Hand (Prud'hon), 30, 262, *263*

Study of a Seated Man, Half Reclining, Leaning on His Right Hand (unknown artist near Prud'hon), 262, *263*; cat. no. 105

Study of a Young Man (Prud'hon), 252, *252*

Study of Female Dancers (Daumier), 68*n3*

Study of the Right Hand of Monsieur Louis Bertin (Ingres), 179–81, *180*; cat. no. 65

Study of Robespierre and Dubois-Crancé in "The Oath of the Tennis Court" (Denon), 29, *31*

Sully, Thomas, 454

Summer Moon (Leighton), 374*n19*

Summer Night, A (Moore), 404

Sunday Afternoon on the Island of the Grande Jatte, A (Seurat), 305

Sunset; Red and Gold—The Gondolier (Whistler), 474–75, *474*; cat. no. 217

Surrealists, 12

Swedenborg, Emanuel, 417, 420, 452

Swinburne, Algernon Charles, 335, 368, 409, 412, 418

Symbolism, 34, 114, 436, 449, 452

T

Tanaka, Kichijiro, 13

Tassie ceramics, 13, 23*n68*

Taylor, Frederick, after Gericault, *Officier anglais à cheval*, 136, *137*

Taylor, Moses, 6

Taylor, Tom, 433

Tedesco, M., 112

Telemachus and Eucharis (David), 90*n8*

Tempesta, Antonio, 60

Tennant, Sir Charles, 384

Tennyson, Alfred, Lord, 359–60, 431

Thévenin, J.-Ch., 189

Thomas, Ambroise, 29

Thomas, Antoine-Jean-Baptiste, 116, 120, 122

Thoré, Théophile, 189

Thoroughbred English Stallion Belonging to Count Aguado (Delton), *97*, 98

Thwaites, John, clock, 21, *22*

Thy Sons and Thy Daughters Were Eating and Drinking Wine (Blake), 342, *342*, *343*; cat. no. 146

Tiarini, Alessandro, David after

 The Holy Family, 76–77

 The Penitence of Saint Joseph, 76–77

 Saint Dominic Resuscitating a Child, 76–77

Tiger Attacking a Peacock (Barye, after 1876), *48*, 49

Tiger Attacking a Peacock (Barye, ca. 1830–40), 48–50, *49*, 51*n4*; cat. no. 1

Tiger Attacking a Pelican (Barye), 48, 49*n1*

Tiger Devouring a Peacock (Barye), *48*, 49

Tiger Hunt group (Barye), 48–49

Tiger in Its Lair (Barye), 51*n3*

Tintoretto, 209

Tissot, James, 52, 97, 221

Titian, 258, 414

 Bacchus and Ariadne, 437

 Man with a Glove, 200

Toilette, The (Moore), 404

Toilette, The (Puvis de Chavannes), 272*n6*

Torso Belvedere (Flaxman), 390

Torso of Adèle (Rodin), 285

Toulouse-Lautrec, Henri de, 307, 308*n1*, 312–17

 At the Circus: The Curtain Call, *314*, 316

 At the Circus: In the Wings, 314, *315*, 316; cat. no. 132

 At the Circus: Jockey, 34, 316–17, *317*; cat. no. 133

 Au cirque: Écuyère de panneau, 316

 Au cirque Fernando, 316

 Au cirque series, 34, 314–17, *314*, *315*, *317*

 Confetti, 312, *312*

 Jeanne Granier (1897), 312, *313*, 314; cat. no. 131

 Jeanne Granier (1898), 312, *312*

 Trieze lithographies, 312

Toussaint, Hélène, 150, 157

Toutain Farm at Honfleur, The (Daubigny), 230, *230*

Travel Plans (Menzel), 322, *323*

Tree of Forgiveness, The (Burne-Jones), 381, 382

Trévise, Édouard Mortier, duc de, 23, 140

Trevor, Emily Norwood, 11*n23*

Trevor, John, 11*n23*, 13*n33*

Trézel, Félix, 262

Trichot-Garneri, 203

Trieze lithographies (Toulouse-Lautrec), 312

Trinity Church, Boston, 458

Triple Portrait (del Piombo), 258

Triumph of the French People (David, Carnavelet), 80, *81*, 82

Triumph of the French People (David, Louvre), 80, *80*

Triumph of the Innocents, The (Hunt, 1870–1903), 394–95, *395*; cat. no. 175

Triumph of the Innocents, The (Hunt, 1876–87), 394, *394*

Truth and Falsehood (Stevens), 427–30, *427*, *429*; cat. no. 193

Tunnel über der Spree, 318

Turgenev, Ivan, 450

Turkish Bath, The (Ingres), 192, 208

Turk Leading His Horse, A, or *Arab with Steed* (Delacroix), 104–6, *105*; cat. no. 28

Turk Mounting on Horseback (Delacroix), 104

Turk Surrenders to a Greek Horseman, A (Delacroix), 112–13, *113*; cat. no. 31

Turner, J. M. W., 14, 310, 385

 Liber Studiorum, 15, 16

 The Slave Ship, 447

 Winthrop's catalogue of Bullard's collection of works by, 16

Turner, Percy Moore, 99

Tweed, John, 427

Two Bathers (Bresdin), *54*, 55, 56*n12*

Two Dancers Entering the Stage (Degas), 98–100, *99*; cat. no. 25

Two Jaguars in Their Lair (Barye), 50*n4*, 51, *51*; cat. no. 3

Two Lions at Rest (Delacroix), 106–9, *107*; cat. no. 29

Two Tigers Fighting (Barye), 51*n3*

U

Udny, John, 391

Union of Love and Friendship, The (Prud'hon), 251, 252, *252*

Un rêve de bonheur (Papety), 208

Uzanne, Octave, 336

V

Vachon, Marius, 70*n1*

Vallet de Villeneuve, Louis-Auguste-Claude, 266

Valour and Cowardice (Stevens), 427–30, *427*, *428*; cat. no. 192

Vanderbilt, Cornelius II, 25, 458

Vanderbilt, William H., 458

van Dyck, Anthony, 92

vanitas pictures, 456

Vanity of the Artist's Dream, The (The Anatomy of Art Appreciation, Poor Artist's Study) (King), 454, *455*, 456; cat. no. 205

Vasari, Giorgio, 157, 368, 411

Vase Clodion (Lovers), 283, *283*, cat. no. 114

Vatican *Stanze* (Raphael), 207

Vedder, Elihu, 452

Venus Anadyomene (Ingres), 170, 192, 212, 238

Venus Anadyomene (Moreau), 238–39, *238*

Venus and Adonis (Prud'hon), 262

Venus Concordia (Burne-Jones), 364

Venus de Milo, 364

Venus Discordia (Burne-Jones), 364

Venus Epithalamia (Burne-Jones), 364–65, *365*, 370; cat. no. 157

Verhaeren, Émile, 308n2

Verlaine, Paul, 17, 221

Vernet, Carle, 134n8

Vernet, Horace, 138
 Lion Hunt, 60

Vesey, Colonel George, 166, 167

Vesey, Mrs. George, née Emily La Touche, 166–67, *166*

Victorian narrative painting, 449

Vien, Joseph-Marie, *Cupid Seller*, 256

Vieuzac, Bertrand Barère de, 78

Vildrac, Charles, 224

Village Forge, The (Gericault), 138, 140

Villot, Frédéric, 201

Vincent, François-André, 148
 Actor Albouis Dazincourt, 214

Virgil Reading the "Aeneid" to Augustus (Ingres), 25, 181, 182, 194, *195*; cat. no. 75

Virgil Rescuing Dante from the Evil Demons (Blake), 347–48, *349*; cat. no. 149

Virgin and Child (Foppa), 12n31

Virgin and Child (Nicolo di Tomaso), 16n42

Virgin and Child (workshop of Botticelli), 12n31

Virgin and Child Appearing to Saints Anthony of Padua and Leopold of Carinthia, The (Ingres), 196, *197*; cat. no. 76

Virgin and Child in Egypt, The (Blake), 338, *338*

Virgin and Child with Saint John the Baptist and the Magdalen (Mantegna), 361

Virgin with the Host (Ingres), 196

Virtue Struggling with Vice (Prud'hon), 30, 257–59, *257*, *259*; cat. no. 103

Vitta, Baron Joseph, 23, 26, 52, 132, 281–82, 288

Voïart, Jacques-Philippe, 254

Vollard, Ambroise, 99, 277

Volmar, Joseph, 133, 134, 140

Voltaire, 335

Voragine, Jacobus de, 272

Vow of Louis XIII (Ingres), 174, 183, 186, 187, 189, 196

Voyages pittoresques, 64

W

Wadley, Nicholas, 145, 146

Wagner, Richard, 114, 332, 384

Walker, John, 43

Walking Lion (Barye), 51n4

Walking Man (Rodin), 294, *295*; cat. no. 120

Wallace Collection, London, 11

Ward, James, 138

Ward, William, 16n42

Ward and Downey, 334

Washerwomen of Morocco (Delacroix), *100*, 102

Washington, George, 302
 portrait of (C. W. Peale), 46

Watching the Tempest (Homer), 448–49, *448*; cat. no. 201

Watson, William, 335

Watteau, Antoine, 207, 316
 La comédienne, 12n27

Watts, George Frederic, 23
 Ariadne, 437, *438*, 439; cat. no. 196
 Ariadne (private coll.), 437
 Ariadne in Naxos (1894), 439, *439*
 Ariadne in Naxos (ca. 1868–75), 437, *437*
 Creation of Eve, 439
 Escaped, 436
 The Eve of Peace, 431, 433
 Expulsion of Adam and Eve, 439
 The Genius of Greek Poetry, 433, 436
 Orpheus and Eurydice (1868–69), 434, *435*
 Orpheus and Eurydice (1868–72), 434, *436*
 Orpheus and Eurydice (1870–80), 434–36, *435*; cat. no. 195
 Sir Galahad, 30, 431, *431*, *432*, 433–34; cat. no. 194

Watts, Mary, 434, 437

Watts-Dunton, Theodore, 358, 423

Webb, Philip, 358n16

Wedgwood, Josiah, ceramics, 13, *14*, 23n68

Weeping Burgher, The, Andrieu d'Andres (Rodin), 296–97, 299, *299*; cat. no. 125

Wellington Monument, London, 427, *428*

Wells, Gabriel, 342

Werth, Leon, 224

Wertheimer, Asher, 236, 465

West, Benjamin, 454

Westall, Richard, 356n2

Wharton, Edith, 7, 14n38

Wheat Field (van Gogh), 144n2

Wheel of Fortune, The (Burne-Jones), 380, 381

When the Morning Stars Sang Together and All the Sons of God Shouted for Joy (La Farge), *39*, 40

Whistler, James Abbott McNeill, 5, 19, 24, 42, 98, 300, 332, 356, 358, 361, 466–78
 Arrangement in Grey and Black No. 1: Portrait of the Artist's Mother, 358n11, 446, 468
 as author, 471
 Brown and Gold: Lillie "In Our Alley!," 477–78, *477*; cat. no. 219

butterfly as signature of, 467
 Design for Matting; verso: Design for Paneling, 470–71, *470*; cat. no. 214
 Green and Violet: Mrs. Walter Sickert, *475*, 476
 Harmony in Grey and Peach Color, 37, 468, *469*; cat. no. 213
 Nocturne in Black and Gold: The Falling Rocket, 445, 466
 Nocturne in Black and Gold: Rag Shop, Chelsea, 37, 472–73, *473*; cat. no. 216
 Nocturne in Blue and Silver, 37, 46, 466–67, *467*; cat. no. 212
 Nocturne in Grey and Gold: Chelsea Snow, 37, 471–72, *471*; cat. no. 215
 Nocturnes, Harmonies, and Notes, 37, 46, 466, 475–76, 477
 Note in Black and Grey or *Arrangement in Brown and Gold*, 475–76, *476*; cat. no. 218
 The Storm-Sunset, 466, 467
 Sunset; Red and Gold—The Gondolier, 474–75, *474*; cat. no. 217
 White and Grey: Courtyard, House in Dieppe, 472, *473*

Whistler v. Ruskin, 445, 446, 466, 468

White and Grey: Courtyard, House in Dieppe (Whistler), 472, *473*

White Plumes, The (Matisse), 224, 226n1

Wicksteed, Joseph, *Blake's Vision of the Book of Job*, 342

Widener, P. A. B., 5, 13

Wilde, Oscar, 16, 18, 328, 330, 332, 334, 335, 378

Wildenstein and Co., New York, 34, 35, 43, 206, 232

Wilding, Alexa, 414, 420, 422

Wilkie, David, 138

Winckelmann, Johann Joachim, 389

Winthrop, Albertina "Tina," 7n8

Winthrop, Beekman, 10n21, 38

Winthrop, Dudley, 7n9, 14n37

Winthrop, Egerton, 7n9

Winthrop, Emily, *see* Miles, Emily Winthrop

Winthrop, Frederic, 7n9, 10n21, 11, 14n37

Winthrop, Grenville L.
 on art and music, 16
 art lending avoided by, 40
 Asian art as interest of, 13–14, 34, 38, 42
 bequest to Harvard, 3, 5, 10, 15, 16n48, 25–26, 43, 45, 46
 Birnbaum as agent for, *see* Birnbaum, Martin
 catalogue of works owned by, 39
 childhood of, 6, 7
 children of, 10, 11, 21–23, 38
 collections of, 5, 6, 10, 12–14, 15, 17, 19, 21, *22*, 25, 29–31, 34–42, *41*, 43, *44*, *45*
 community activities of, 20n56
 desk of, *38*, 39
 European tours of, 15–16
 family background of, 6–7, 11n22, 14
 Groton Place in Lenox, *2*, 14, *15*, 19–21, *20*, *21*, 38
 at Harvard, 8–10

Hunnewell Gold Medal awarded to, 21
journals of, 39, 43
on landscape design, 20–21
last years of, 46
marriage of, 10, 11
New York City home of, 3, *4*, 5, 6–7, *8*, 14*n*36, 17,
 31, *33*, *35*, 36, 38–39, *38*, *39*, 40, 42, *43*, *44*, *45*,
 231, 232, 299, 300, *427*, 429, *431*
and nineteenth-century art, 25, 34, 36
personal habits of, 3, 6, 21, 40
personality traits of, 5–6, 7
scrapbooks of, 10–11, *10*
Sterner's portrait of, 42
and student visitors, 36–37, 43, 45
Turner catalogue produced by, 16
uniform frames and mats for artworks of,
 41–42, *41*
Western art as interest of, 17, 23, 34
and works on paper, 25–26, 41
Winthrop, John, 6

Winthrop, John Jr., 6
Winthrop, Kate (daughter), 10, 11, 21–23, 38
Winthrop, Kate Taylor (mother), 6
Winthrop, Mary Tallmadge Trevor, 10, 11
Winthrop, Robert, 6
"Winthrop package," 41–42, *41*
Witte, Baron J. de, 212
Woman and Child on a Bridge at Night (Daumier),
 68*n*1
Woman Combing Her Hair (Menzel), 326, *326*
Woman Holding a Fawn Suckled by a Doe (Prud-hon),
 255, 256
Woman of Tangier Hanging the Wash (Delacroix), *100*,
 102
Woman Reading: The Artist's Mother (Seurat), 306*n*1
Woman Sewing (Seurat), 304–6, *305*; cat. no. 128
Woman with a Basket and a Child by the Hand, A,
 Walking with a Crowd of People (Daumier), 68, *69*;
 cat. no. 12
Women in a Landscape (Bresdin), 54–56, *55*; cat. no. 5

Women of Algiers in Their Apartment (Femmes d'Algier
 dans leur appartement) (Delacroix), 102
Women Pursued by Satyrs (Daumier), 74

Y

Yamanaka and Co., 13
Yeats, W. B., 335*n*1
Yellow Book, The (Beardsley), 334, 335, 336
Young Man and Death, The, in Memory of Théodore
 Chassériau (Moreau), 232, *233*, 234–35, 238; cat. no. 92
Young Tiger Playing with Its Mother (Delacroix), 108
Young Woman with a Guitar, Reverie (Courbet), 64,
 66–68, *67*; cat. no. 11
Young Zephyr, A (Prud'hon), 262

Z

Zambaco, Maria, 364, 365
Zola, Émile, 249